Art and Interpretation

Art and Interpretation

An Anthology of Readings in Aesthetics and the Philosophy of Art

EDITED BY ERIC DAYTON

Canadian Cataloguing in Publication Data
Art and interpretation: an anthology of readings in aesthetics and the philosophy of art

Includes bibliographical references.
ISBN 1-55111-190-X

1. Aesthetics. 2. Art—Philosophy. I. Dayton, Eric, 1946—

BH39.A772 1998 111'.85 C98-931097-3

Broadview Press is an independent, international publishing house, incorporated in 1985.

North America:
Post Office Box 1243, Peterborough, Ontario, Canada, K9J 7H5
3576 California Road, Orchard Park, NY 14127
TEL: (705) 743-8990; FAX: (705) 743-8353
75322.44@compuserve.com

United Kingdom:
Turpin Distribution Services Ltd., Blackhorse Rd., Letchworth, Hertfordshire SG6 1HN
TEL: (1462) 672555; FAX (1462) 480947; E-mail turpin @rsc.org

Australia:
St. Clair Press, P. O. Box 287, Rozelle, NSW 2039
TEL: (02) 818-1942; FAX: (02) 418-1923

www.broadviewpress.com

Broadview Press gratefully acknowledges the support of the Ontario Arts Council and the Ministry of Canadian Heritage. We acknowledge the financial support of the government of Canada through the Book Publishing Industry Development Program for our publishing activities.

PRINTED IN CANADA

Contents

Part 3: The Task of Definition
Introduction 221

Part 4: Psychology and Interpretation
Introduction 298

Part 5: Hermeneutics and Interpretation
Introduction 328

Preface

Art as expression, as making, as a way to truth, is central to human experience. Thinking about beauty, creativity and the power of art to transform life is as old as philosophy. These topics do not belong to philosophy alone, but to the arts as well; indeed they belong to all of the disciplines which make a place for thoughtful reflection on the cultural side of human life. The very breadth of philosophical thinking about art imposes a difficulty particular to the teaching of aesthetics in the university. Critical thought about art and how to understand it is an endeavour common to all of the humane disciplines. Aesthetics thus contains issues and topics which can be treated in a narrowly philosophical way, in the sense that they are brought into relation with other philosophical issues and positions narrowly conceived by philosophers, or can be treated in a way which is broadly philosophical, in the sense that they are seen as part of the larger intellectual culture. An aesthetics course ought to treat its subject matter in both ways, but there remains a question of balance. Unless it is taught as an advanced course for philosophy majors, its students are likely to come from a variety of disciplines, each with a special interest and stake in the subject, as well as a set of disciplinary assumptions about how to approach the material.

A good course on aesthetics will not ignore this fact, but will resolve it by using philosophical analysis as a means for providing students from different backgrounds with a common vocabulary for discussing common interests. It will also ground the aesthetic concerns that students bring to the course within a substantive philosophical discussion. This discussion will at least potentially transform those concerns into philosophical understanding, while avoiding the danger of becoming an exercise in philosophical problem solving divorced from the concerns which motivate the students to seek philosophical clarification in the first place. Achieving these goals is no easy task, but it sets the agenda for this anthology.

I have designed this book to reflect the needs of a mixed constituency of students in philosophy, studio arts, art history, music and literary criticism who are engaged by philosophical issues in the arts. Although almost all of these students have an interest in, and backgrounds sufficient for, topics in aesthetics, their backgrounds are importantly different from each other. Students from different disciplines tend to approach the topics with the assumptions and vocabularies of their chosen disciplines, and thus face a problem of mutual understanding. Consequently, I have focussed less on narrowly philosophical topics in analytic aesthetics than on broadly philosophical issues relating to the assessment, criticism and evaluation of artworks and their aesthetic content. The aim of this anthology is to present fundamental philosophical issues; it is

not an interdisciplinary text. It provides a wide range of readings—from the history of the philosophy of art and from contemporary work, providing a variety of perspectives on art theory.

Philosophical argument typically presents itself as a line of thought within a web of conflicting positions that develop in relation to each other and to uncontroversial presuppositions. As a result, philosophers are much concerned with establishing burdens of proof. Solving problems in philosophy, and thus making progress, always presupposes a point of view against which the progress is measured, and philosophy courses are almost inevitably taught from some point of view or another about what does and what does not require defence. Although it might be helpful for serious philosophy majors who are being initiated into a particular philosophical program to see how aesthetic problems receive solution according to that program, this is not so helpful for majors in other disciplines. Literature, music, and fine arts students will typically make very different initial assumptions than philosophy students about what positions in aesthetics are in need of argument and which are noncontroversial, and it is important to recognize that these assumptions are grounded not in their ignorance of the issues but in their familiarity with them as disciplinary commonplaces which as students they absorb in the process of their education. These assumptions are sufficiently different from those presupposed in philosophy departments that philosophical problem solving of that sort would not be as useful to the intellectual development of students in these disciplines as would be a grounding in fundamental philosophical ideas. Accordingly, this anthology focusses on introducing the student to a variety of texts which converge on no single philosophical program, but jointly provide a rich background for aesthetic theorizing. The result offers the students a common vocabulary for fruitful discussion about art and aesthetics and, by connecting them with the philosophical tradition, provides them with a richer sense of the meaning and consequences of the issues being debated in art, literature, and music departments.

The anthology begins with a historical section containing substantial selections from Plato, Aristotle, Hume, Kant, Shelley, and Nietzsche. These readings introduce themes which recur and are developed in the remainder of the anthology. What follows are analytic, hermeneutical, psychoanalytic, Marxist and postmodern reflections on expression, interpretation, modernity and difference. These selections are divided chronologically, into writings from the first half of the century containing selections from Dewey, Collingwood, Freud, Jung, Heidegger, Wittgenstein and others, and a set of more or less contemporary writings which reflect a variety of philosophical positions. Care has been taken to group selections that develop common issues and build upon the philosophical ideas from the historical readings. The text thus contains a number of somewhat independent parts which can be combined in a variety of ways. Philosophers from both the Anglo-American and European traditions will find plenty of material for a fruitful course.

Part 1

Historical Readings

Part 1: Historical Readings

Introduction

Art is as old as culture itself, and the challenges it poses for living well and authentically have been the subject of philosophical debate since the beginning of philosophy. By the time Greek philosophy reached mature expression in the writings of Plato and Aristotle in the fourth century BCE, philosophical discussion about art already had a history. The Greek concept of art, or *technē* (from which we derive the words *technique* and *technology*), was broader than the modern concept, and referred to a way of doing or the kind of knowledge involved in any form of intentional making. Making things to a purpose and enjoying them is a distinctly human activity. The urge to make, to mimic, to express, and to understand are universal and mysterious human attributes. By making representations of the world and life in song, narratives and dramas, or paint or stone, human beings project new forms of being onto the world; forms of being which both reveal and disguise that which they represent. Greek society, rich in both literary and material culture, was fascinated by the problems making and enjoyment posed. Can artistic representations be true, and what are they true (or false) of? What is the relation of art to the desire and emotions; what is its social and educational value; what are its dangers? The Greeks did not segregate the fine arts from other forms of making. Artistic display, theatre and song were intimately bound up in religious rites and celebrations, or the re-enactment of events in history, in which the culture's identity was consummated. Accordingly, the importance for philosophy of an understanding of art and its effects on culture was generally more visible than it is today. On the other hand, the Athenian culture in which Plato lived was a society in which a small leisure class, valuing contemplation, was supported by the domestic and utilitarian labour of slaves, and the knowledge of making involved in arts and entertainments was considered servile and inferior to theoretical knowledge.

Plato, who lived roughly between 427 and 347 BCE, was the first great philosopher in the European tradition to write extensively about art and beauty and their relation to truth. The fine arts belong, for Plato, in the broader class of *technē* which includes all the skills, both human and divine, in making and doing. The productive arts divide into the making of actual objects (chairs and shoes by humans, the objects of nature by God) and the production of images or imitations of objects (images of chairs by humans, dreams by God). Imitation (*mimesis*) is a troubling notion for Plato. On the one hand, all created things or artifacts are imitations of their eternal archetypes. Plato considered true knowledge, as opposed to mere opinion, to be the understanding of eternal forms of which the

things in the world are but copies. Knowledge of artefacts (e.g., this chair) is thus the recognition of the archetype in the copy. Chairs will vary in how well they imitate the form, and all of them are inferior to the form itself. The knowledge of a particular chair is inferior to the knowledge of the form it imperfectly imitates and is thus at one remove from true knowledge. The depiction of a chair in word or paint is the imitation of an imitation and at two removes from true knowledge.

Art is hardly knowledge for Plato and, because it may be inspired by madness, artists may not know what they are saying or whether it is right or wrong. Art is thus dangerous to the truth. The first selection from Plato, from Book X of the *Republic*, takes up this thought. After a discussion of the nature of imitation and imitative art, Plato asks whether the poets, who are said to know the truth about virtue and vice, can really lead us to truth, or whether they are illusionists to be banished from the Republic.

The question of truth in art is however more complex than this discussion brings out. A work of art may merely imitate its subject matter, but to the extent that the work is beautiful, it also stands directly in relation to the form of beauty. Furthermore, though irrational, poetic inspiration—as divine possession—may be a genuine vehicle for truths. The other selection, Socrates' speech in the *Symposium*, discusses the knowledge of beauty and uses the relationship of love to beauty as a model for understanding the love of the forms generally. Although love is irrational it is a mediator; by reflecting on the effect of beauty on us we can be moved to love the forms themselves.

Aristotle (384-322 BCE) was Plato's student. His contribution to aesthetics is largely confined to the *Poetics*, from which our selection is taken. In the *Poetics* Aristotle is concerned to define the art of poetry as the imitation of human action through verse. While sharing Plato's conception of art as *technē*, Aristotle did not follow him in his account of the forms or in his view of imitation. For Aristotle imitation is not only copying, it is a form of generalization. Unlike the historian, whose task is the depiction of particular events as they happened, the poet attempts to depict the universal in human action. In a well-made poem the narration of events must make the outcome plausible in light of the nature of the characters. Aristotle's account of imitation thus makes poetic imitation or *mimesis* a kind of knowledge. Aristotle's definition of tragedy, "an imitation of an action that is serious, complete, and of a certain magnitude; in language embellished with each kind of artistic ornament, the several kinds being found in separate parts of the play; in the form of action, not of narrative; through pity and fear effecting the proper purgation of these emotions," has had an enormous influence on writing about literature.

Until the Enlightenment the word 'art' simply meant skill or craft (the Latin *ars* simply being a translation of the Greek *technē*). But in the eighteenth century, the distinction between the 'fine' arts and the 'useful' arts began to be made. Aesthetic theorizing became focussed on new issues which conformed to the broadly psychological focus of empiricism. What is the basis of aesthetic qualities like beauty and the sublime? And how do we justify taste or the critical judgment of a work?

This latter question is the Hume's focus in "Of the Standard of Taste." In this work, Hume (1711-1776) offers an account of the subjectivity of taste and a qualified defence of the objectivity of judgments of taste. Hume argued that we naturally seek a

standard of taste by which aesthetic judgments can be called correct or incorrect. Though reasonably universal, the principles of taste are not known to be so *a priori*, but only as a matter of inductive inference. The psychological variability of delicacy of taste, opinions and manner among people guarantees that the principles of taste are limited in their application.

In *The Critique of Judgment*, from which the next selection is drawn, Kant (1724-1804) sets out to answer the question regarding aesthetic qualities. How is it that valid judgments of the sublime and the beautiful are possible, given their evident subjectivity? Judgments of taste are curious in that they rest on feeling and also claim universal validity. Kant's analysis examines judgments of taste in terms of four fundamental categories: relation, quantity, quality and modality. He argues first that unlike an ordinary judgment, a judgment of taste does not subsume a representation under a concept but instead states a relation between the representation and an attitude of pure disinterested satisfaction. Secondly, he argues that a judgment of taste lays title to universal acceptance (unlike a mere report of pleasure to which others have no obligation to assent) while at the same time not claiming to be supportable by reasons (as no argument can bind anyone to agree with a judgment of taste). The universality attaching to judgments of taste is not objective but subjective; when we contemplate an object aesthetically the faculties of imagination and understanding do not fix upon a concept but are in free play. It is the harmony of the free play of the faculties which is universally communicable. Third, Kant argues that aesthetic satisfaction derives from an object which is purposive in form though in fact it has no purpose. "Beauty is the form of the purposiveness of an object, so far as this is perceived in it *without any representation of a purpose*." Finally, beauty has a necessary connection to aesthetic satisfaction, not in the sense that if we find satisfaction in an object all others will as well, but in the sense that they ought to find the same delight that we do.

Kant's treatment of judgments regarding the sublime is somewhat different from his treatment of the beautiful. The sublime is a kind of satisfaction deriving from the nobility either of reason itself or of human moral destiny. In the first case, when we are confronted in nature with the extremely vast, our imagination falters in the task of comprehending it, and we become aware of the supremacy of reason, which can think the infinite and thus surpasses every standard of sense. In the second case, when we are confronted with the overwhelming power of nature and as a consequence our own human inadequacy, we find within us a different power, reason, in comparison with which everything in nature is small. The ideas of reason, particularly our moral conception of duty and worth, are so much more perfect than the might of nature, that our experience of the power of nature only makes us conscious of our superiority over everything natural.

In the final part of the selection, Kant formulates the notion of *genius* as the talent for producing that for which no definite rule can be given. To do so genius must have the property of originality; without copying the past, its products must be exemplary for future works, and it must "give the rule just as nature does"—that is, in the structure of the work itself. Kant takes genius to be entirely opposed to the spirit of imitation, instead expressing harmonious free play of the imagination and the understanding.

Finally, taste is required for judging beautiful objects but genius is required for their production. Kant's views were quickly adopted by Schiller and then Schelling, in whose hands Kant's aesthetics and its relation to the will became the basis for an absolute idealism in which art is the organic goal towards which all intelligence moves. In art, which is completely free of abstraction, intelligence becomes fully self-conscious, realizing its infinite nature. Kant's views on the aesthetic attitude, imagination, and genius transformed aesthetic theory. His ideas, particularly as they were taken up by idealism, helped to ground both the Romantic cult of genius and the modern preoccupation with authenticity and originality in art.

The Romantic revolution in the nineteenth century saw the emergence of several themes deriving from an idealist reading of Kant, and the establishment of some tendencies which would show themselves fully only in modernist aesthetic movements. First of all, in Romanticism we find a new impulse to the expression and enjoyment of feeling. The imitative function of art was subordinated to the expressive, the preeminence of reason to the primacy of the will, productive arts to the creative. Artistic creation was seen by many Romantics as an act of spiritual self-expression. Criticism, taking the work as the product of genius and expressive of the artist's emotions, became more preoccupied with the biography and character of the artist. Feeling was conceived as a source of knowledge. The imagination was taken to be a faculty not only responsible for creative assembly, but also a type of insight into the truth of an immediate, sensuous kind, distinct from and superior to the abstractions of the understanding. The fusion of cognition with creative activity in a single faculty of superior insight blurred the distinction between seeing reality and creating it, and opened the way for a conception of the *avant-garde* and the artist as cultural hero who goes where no one has gone before and whose poetic genius opens up new realms of meaning. Other important tendencies included a pervasive use of organic metaphors for describing the unity of the work and its relation to the creative activity of the artist, an emphasis on the poet's sincerity and seriousness of spirit, and the elevation of metaphor and symbolism—as the sensuous manifestation of spiritual meaning—to higher knowledge. The Romantic vision of symbolism, as an instinct possessed by the imagination of the genius—enabling it to find hidden analogies and to make the invisible and infinite become sensuously present in the concrete image—was to become a fertile ground for Freudian and Nietzschean revaluation, and prepared the way for new visions of the unconscious, first in the surrealist and expressionist movements in this century, and then more broadly in critical theory.

Percy Bysshe Shelley (1792-1822) wrote an exuberant and extravagant defence of Romantic intuitionism. In *A Defense of Poetry*, Shelley extols the power of the imagination as well as the sincerity and heroic stature of the poet in society. He begins by distinguishing between the analytic and synthetic powers of the mind, and defines poetry in terms of the latter as "the expression of imagination." Poetry thus does not arise as a need to describe, but as an original making of language in the creative ordering of experience. Poetry presents "the image of life expressed in its eternal truth." Having defined poetry so grandly, he goes on to assess its effects on society, arguing that the great instrument of moral good is not ethical science but the imagination.

While ethics arranges the elements which poetry has created, poetry acts in a more fundamental manner, exposing to us the hidden beauty of the world, and expanding the capacity of the imagination. Shelley illustrates this claim with an extended historical catalogue of the moral enlargement of life through poetry. He concludes his essay with a defence of the imagination against the claim that reason is more useful, arguing that the imagination is both more fundamental and broader. Poetry is "at once the centre and circumference of knowledge; it is that which comprehends all science and to which all science must be referred."

Friedrich Nietzsche (1844-1900) repudiated Romantic art as escapist, but shared many Romantic tenets, including the primacy of the will and the metaphorical origin of language. Whereas the Romantics prized art as a higher form of knowledge, Nietzsche argued that art is the illusion which makes life bearable. In our first selection, taken from *The Birth of Tragedy from the Spirit of Music,* Nietzsche's focus is the origin of artistic creation in the unconscious. Tragedy arises from the interplay of two forces in the human psyche, the Apollonian and Dionysian, which may be represented respectively by the world of dreams and intoxication, the desire for the illusion of order and the orgiastic celebration of union. Dionysian intoxication is a flooding life force that overflows into creativity, transfiguring the ordinary with beauty and meaning, but as the moment of intoxication passes reality returns and with it a sense of repulsion and nausea. It is at this point that art approaches "as a redeeming and healing enchantress; she alone may transform these horrible reflections on the terror and absurdity of existence into representations with which man may live." It is in music that Dionysian wildness is made to submit to Apollonian order and is formalized into art, and it is music in its joining of these antagonistic impulses that gives rise to tragedy. "It is only through the spirit of music that we can understand the joy involved in the annihilation of the individual...the hero, the highest manifestation of the will, is disavowed for our pleasure, because he is only a phenomenon, and because the eternal life of the will is not affected by his annihilation. 'We believe in eternal life' exclaims tragedy."

In the second selection, "On Truth and Lies in a Nonmoral Sense," Nietzsche argues that consciousness is everywhere a surface phenomenon and that truth is not insight but projection. Through the ineliminably metaphorical use of language, humans invent the concepts and relations which they then purport to discover in the world, creating useful illusions and calling them truth. "In short, only by forgetting that he himself is an *artistically creating* subject, does man live with any repose, security and consistency."

Nietzsche analysed truth and knowledge genealogically, seeing knowledge not as the attempt to mirror an independently real world, but as the reification of projected needs, as an accommodation to life and its demands. The whole of reality is accordingly a kind of fiction; truth is just a set of humanly constructed instruments to meet human needs. The will to know is illusory because it purports to discover what it actually invents and it confuses what is essentially a need to facilitate social life with the nature of reality. Furthermore, it is contemptible because it is pedestrian and arrogant. No genuine culture can be built on a scientific view of human beings because such a view is incapable of distinguishing between what is great and what is small, and it is further antithetical to illusion

while at the same time essentially nihilistic in its effects. Only as art can culture exist because genuine culture calls for a unifying mastery which subordinates what is small to what is great. For Nietzsche, both reason and art are manifestations of the will to rule over life. But whereas reason offers the illusory truth of security, foresight, and regularity, art is truer because it presents illusion *as* illusion, and thus achieves a mastery over life through acceptance.

As we will see in the subsequent sections, the leading aesthetic themes of the eighteenth and nineteenth centuries recur in twentieth-century aesthetic theory. Notable among these are the Nietzschean themes in Freud's explanation of the affairs of consciousness by way of unconscious motives, and the essentially Romantic emphasis on form and art for its own sake in high modernism.

Plato (429-347 BCE)

Selections from

The Republic Book X

Translated by Benjamin Jowett

"The imitative art is an inferior who marries an inferior, and has inferior offspring."
360 BC

[SOCRATES talking to GLAUCON]

Of the many excellences which I perceive in the order of our State, there is none which upon reflection pleases me better than the rule about poetry.

To what do you refer?

To the rejection of imitative poetry, which certainly ought not to be received; as I see far more clearly now that the parts of the soul have been distinguished.

What do you mean?

Speaking in confidence, for I should not like to have my words repeated to the tragedians and the rest of the imitative tribe—but I do not mind saying to you, that all poetical imitations are ruinous to the understanding of the hearers, and that the knowledge of their true nature is the only antidote to them.

Explain the purport of your remark.

Well, I will tell you, although I have always from my earliest youth had an awe and love of Homer, which even now makes the words falter on my lips, for he is the great captain and teacher of the whole of that charming tragic company; but a man is not to be reverenced more than the truth, and therefore I will speak out.

Very good, he said.

Listen to me then, or rather, answer me.

Put your question.

Can you tell me what imitation is? for I really do not know.

A likely thing, then, that I should know.

Why not? for the duller eye may often see a thing sooner than the keener.

Very true, he said; but in your presence, even if I had any faint notion, I could not muster courage to utter it. Will you enquire yourself?

Well then, shall we begin the enquiry in our usual manner: Whenever a number of individuals have a common name, we assume them to have also a corresponding idea or form. Do you understand me?

I do.

Let us take any common instance; there are beds and tables in the world—plenty of them, are there not?

Yes.

But there are only two ideas or forms of them—one the idea of a bed, the other of a table.

True.

And the maker of either of them makes a bed or he makes a table for our use, in accordance with the idea—that is our way of speaking in this and similar instances—but no artificer makes the ideas themselves: how could he?

Impossible.

And there is another artist,—I should like to know what you would say of him.

Who is he?

One who is the maker of all the works of all other workmen.

What an extraordinary man!

Wait a little, and there will be more reason for your saying so. For this is he who is able to make not only vessels of every kind, but plants and animals, himself and all other things—the earth and heaven, and the

things which are in heaven or under the earth; he makes the gods also.

He must be a wizard and no mistake.

Oh! you are incredulous, are you? Do you mean that there is no such maker or creator, or that in one sense there might be a maker of all these things but in another not? Do you see that there is a way in which you could make them all yourself?

What way?

An easy way enough; or rather, there are many ways in which the feat might be quickly and easily accomplished, none quicker than that of turning a mirror round and round—you would soon enough make the sun and the heavens, and the earth and yourself, and other animals and plants, and all the other things of which we were just now speaking, in the mirror.

Yes, he said; but they would be appearances only.

Very good, I said, you are coming to the point now. And the painter too is, as I conceive, just such another—a creator of appearances, is he not?

Of course.

But then I suppose you will say that what he creates is untrue. And yet there is a sense in which the painter also creates a bed?

Yes, he said, but not a real bed.

And what of the maker of the bed? Were you not saying that he too makes, not the idea which, according to our view, is the essence of the bed, but only a particular bed?

Yes, I did.

Then if he does not make that which exists he cannot make true existence, but only some semblance of existence; and if any one were to say that the work of the maker of the bed, or of any other workman, has real existence, he could hardly be supposed to be speaking the truth.

At any rate, he replied, philosophers would say that he was not speaking the truth.

No wonder, then, that his work too is an indistinct expression of truth.

No wonder.

Suppose now that by the light of the examples just offered we enquire who this imitator is?

If you please.

Well then, here are three beds: one existing in nature, which is made by God, as I think that we may say—for no one else can be the maker?

No.

There is another which is the work of the carpenter?

Yes.

And the work of the painter is a third?

Yes.

Beds, then, are of three kinds, and there are three artists who superintend them: God, the maker of the bed, and the painter?

Yes, there are three of them.

God, whether from choice or from necessity, made one bed in nature and one only; two or more such ideal beds neither ever have been nor ever will be made by God.

Why is that?

Because even if He had made but two, a third would still appear behind them which both of them would have for their idea, and that would be the ideal bed and the two others.

Very true, he said.

God knew this, and He desired to be the real maker of a real bed, not a particular maker of a particular bed, and therefore He created a bed which is essentially and by nature one only.

So we believe.

Shall we, then, speak of Him as the natural author or maker of the bed?

Yes, he replied; inasmuch as by the natural process of creation He is the author of this and of all other things.

And what shall we say of the carpenter—is not he also the maker of the bed?

Yes.

But would you call the painter a creator and maker?

Certainly not.

Yet if he is not the maker, what is he in relation to the bed?

I think, he said, that we may fairly designate him as the imitator of that which the others make.

Good, I said; then you call him who is third in the descent from nature an imitator?

Certainly, he said.

And the tragic poet is an imitator, and therefore,

like all other imitators, he is thrice removed from the king and from the truth?

That appears to be so.

Then about the imitator we are agreed. And what about the painter?—I would like to know whether he may be thought to imitate that which originally exists in nature, or only the creations of artists?

The latter.

As they are or as they appear? You have still to determine this.

What do you mean?

I mean, that you may look at a bed from different points of view, obliquely or directly or from any other point of view, and the bed will appear different, but there is no difference in reality. And the same of all things.

Yes, he said, the difference is only apparent.

Now let me ask you another question: Which is the art of painting designed to be—an imitation of things as they are, or as they appear—of appearance or of reality?

Of appearance.

Then the imitator, I said, is a long way off the truth, and can do all things because he lightly touches on a small part of them, and that part an image. For example: A painter will paint a cobbler, carpenter, or any other artist, though he knows nothing of their arts; and, if he is a good artist, he may deceive children or simple persons, when he shows them his picture of a carpenter from a distance, and they will fancy that they are looking at a real carpenter.

Certainly.

And whenever any one informs us that he has found a man knows all the arts, and all things else that anybody knows, and every single thing with a higher degree of accuracy than any other man— whoever tells us this, I think that we can only imagine to be a simple creature who is likely to have been deceived by some wizard or actor whom he met, and whom he thought all-knowing, because he himself was unable to analyse the nature of knowledge and ignorance and imitation.

Most true.

And so, when we hear persons saying that the tragedians, and Homer, who is at their head, know all the arts and all things human, virtue as well as vice, and divine things too, for that the good poet cannot compose well unless he knows his subject, and that he who has not this knowledge can never be a poet, we ought to consider whether here also there may not be a similar illusion. Perhaps they may have come across imitators and been deceived by them; they may not have remembered when they saw their works that these were but imitations thrice removed from the truth, and could easily be made without any knowledge of the truth, because they are appearances only and not realities? Or, after all, they may be in the right, and poets do really know the things about which they seem to the many to speak so well?

The question, he said, should by all means be considered.

Now do you suppose that if a person were able to make the original as well as the image, he would seriously devote himself to the image-making branch? Would he allow imitation to be the ruling principle of his life, as if he had nothing higher in him?

I should say not.

The real artist, who knew what he was imitating, would be interested in realities and not in imitations; and would desire to leave as memorials of himself works many and fair; and, instead of being the author of encomiums, he would prefer to be the theme of them.

Yes, he said, that would be to him a source of much greater honour and profit.

Then, I said, we must put a question to Homer; not about medicine, or any of the arts to which his poems only incidentally refer: we are not going to ask him, or any other poet, whether he has cured patients like Asclepius, or left behind him a school of medicine such as the Asclepiads were, or whether he only talks about medicine and other arts at second hand; but we have a right to know respecting military tactics, politics, education, which are the chiefest and noblest subjects of his poems, and we may fairly ask him about them. 'Friend Homer,' then we say to him, 'if you are only in the second remove from truth in what you say of virtue, and not in the third—not an image maker or imitator—and if you are able to discern what pursuits make men better or worse in private or public life, tell us what State was ever better governed by your help? The good

order of Lacedaemon is due to Lycurgus, and many other cities great and small have been similarly benefited by others; but who says that you have been a good legislator to them and have done them any good? Italy and Sicily boast of Charondas, and there is Solon who is renowned among us; but what city has anything to say about you?' Is there any city which he might name?

I think not, said Glaucon; not even the Homerids themselves pretend that he was a legislator.

Well, but is there any war on record which was carried on successfully by him, or aided by his counsels, when he was alive?

There is not.

Or is there any invention of his, applicable to the arts or to human life, such as Thales the Milesian or Anacharsis the Scythian, and other ingenious men have conceived, which is attributed to him?

There is absolutely nothing of the kind.

But, if Homer never did any public service, was he privately a guide or teacher of any? Had he in his lifetime friends who loved to associate with him, and who handed down to posterity an Homeric way of life, such as was established by Pythagoras who was so greatly beloved for his wisdom, and whose followers are to this day quite celebrated for the order which was named after him?

Nothing of the kind is recorded of him. For surely, Socrates, Creophylus, the companion of Homer, that child of flesh, whose name always makes us laugh, might be more justly ridiculed for his stupidity, if, as is said, Homer was greatly neglected by him and others in his own day when he was alive?

Yes, I replied, that is the tradition. But can you imagine, Glaucon, that if Homer had really been able to educate and improve mankind—if he had possessed knowledge and not been a mere imitator—can you imagine, I say, that he would not have had many followers, and been honoured and loved by them? Protagoras of Abdera, and Prodicus of Ceos, and a host of others, have only to whisper to their contemporaries: 'You will never be able to manage either your own house or your own State until you appoint us to be your ministers of education'—and this ingenious device of theirs has such an effect in making them love them that their companions all but carry them about on their shoulders. And is it

conceivable that the contemporaries of Homer, or again of Hesiod, would have allowed either of them to go about as rhapsodists, if they had really been able to make mankind virtuous? Would they not have been as unwilling to part with them as with gold, and have compelled them to stay at home with them? Or, if the master would not stay, then the disciples would have followed him about everywhere, until they had got education enough?

Yes, Socrates, that, I think, is quite true.

Then must we not infer that all these poetical individuals, beginning with Homer, are only imitators; they copy images of virtue and the like, but the truth they never reach? The poet is like a painter who, as we have already observed, will make a likeness of a cobbler though he understands nothing of cobbling; and his picture is good enough for those who know no more than he does, and judge only by colours and figures.

Quite so.

In like manner the poet with his words and phrases may be said to lay on the colours of the several arts, himself understanding their nature only enough to imitate them; and other people, who are as ignorant as he is, and judge only from his words, imagine that if he speaks of cobbling, or of military tactics, or of anything else, in metre and harmony and rhythm, he speaks very well—such is the sweet influence which melody and rhythm by nature have. And I think that you must have observed again and again what a poor appearance the tales of poets make when stripped of the colours which music puts upon them, and recited in simple prose.

Yes, he said.

They are like faces which were never really beautiful, but only blooming; and now the bloom of youth has passed away from them?

Exactly.

Here is another point: The imitator or maker of the image knows nothing of true existence; he knows appearances only. Am I not right?

Yes.

Then let us have a clear understanding, and not be satisfied with half an explanation.

Proceed.

Of the painter we say that he will paint reins, and he will paint a bit?

Yes.

And the worker in leather and brass will make them?

Certainly.

But does the painter know the right form of the bit and reins? Nay, hardly even the workers in brass and leather who make them; only the horseman who knows how to use them—he knows their right form.

Most true.

And may we not say the same of all things?

What?

That there are three arts which are concerned with all things: one which uses, another which makes, a third which imitates them?

Yes.

And the excellence or beauty or truth of every structure, animate or inanimate, and of every action of man, is relative to the use for which nature or the artist has intended them.

True.

Then the user of them must have the greatest experience of them, and he must indicate to the maker the good or bad qualities which develop themselves in use; for example, the flute-player will tell the flute-maker which of his flutes is satisfactory to the performer; he will tell him how he ought to make them, and the other will attend to his instructions?

Of course.

The one knows and therefore speaks with authority about the goodness and badness of flutes, while the other, confiding in him, will do what he is told by him?

True.

The instrument is the same, but about the excellence or badness of it the maker will only attain to a correct belief; and this he will gain from him who knows, by talking to him and being compelled to hear what he has to say, whereas the user will have knowledge?

True.

But will the imitator have either? Will he know from use whether or no his drawing is correct or beautiful? Or will he have right opinion from being compelled to associate with another who knows and gives him instructions about what he should draw?

Neither.

Then he will no more have true opinion than he will have knowledge about the goodness or badness of his imitations?

I suppose not.

The imitative artist will be in a brilliant state of intelligence about his own creations?

Nay, very much the reverse.

And still he will go on imitating without knowing what makes a thing good or bad, and may be expected therefore to imitate only that which appears to be good to the ignorant multitude?

Just so.

Thus far then we are pretty well agreed that the imitator has no knowledge worth mentioning of what he imitates. Imitation is only a kind of play or sport, and the tragic poets, whether they write in iambic or in Heroic verse, are imitators in the highest degree?

Very true.

And now tell me, I conjure you, has not imitation been shown by us to be concerned with that which is thrice removed from the truth?

Certainly.

And what is the faculty in man to which imitation is addressed?

What do you mean?

I will explain: The body which is large when seen near, appears small when seen at a distance?

True.

And the same object appears straight when looked at out of the water, and crooked when in the water; and the concave becomes convex, owing to the illusion about colours to which the sight is liable. Thus every sort of confusion is revealed within us; and this is that weakness of the human mind on which the art of conjuring and of deceiving by light and shadow and other ingenious devices imposes, having an effect upon us like magic.

True.

And the arts of measuring and numbering and weighing come to the rescue of the human understanding—there is the beauty of them—and the apparent greater or less, or more or heavier, no longer have the mastery over us, but give way before calculation and measure and weight?

Most true.

And this, surely, must be the work of the calculating and rational principle in the soul?

To be sure.

And when this principle measures and certifies that some things are equal, or that some are greater or less than others, there occurs an apparent contradiction?

True.

But were we not saying that such a contradiction in the same faculty cannot have contrary opinions at the same time about the same thing?

Very true.

Then that part of the soul which has an opinion contrary to measure is not the same with that which has an opinion in accordance with measure?

True.

And the better part of the soul is likely to be that which trusts to measure and calculation?

Certainly.

And that which is opposed to them is one of the inferior principles of the soul?

No doubt.

This was the conclusion at which I was seeking to arrive when I said that painting or drawing, and imitation in general, when doing their own proper work, are far removed from truth, and the companions and friends and associates of a principle within us which is equally removed from reason, and that they have no true or healthy aim.

Exactly.

The imitative art is an inferior who marries an inferior, and has inferior offspring.

Very true.

And is this confined to the sight only, or does it extend to the hearing also, relating in fact to what we term poetry?

Probably the same would be true of poetry.

Do not rely, I said, on a probability derived from the analogy of painting; but let us examine further and see whether the faculty with which poetical imitation is concerned is good or bad.

By all means.

We may state the question thus:—Imitation imitates the actions of men, whether voluntary or involuntary, on which, as they imagine, a good or bad result has ensued, and they rejoice or sorrow accordingly. Is there anything more?

No, there is nothing else.

But in all this variety of circumstances is the man at unity with himself—or rather, as in the instance of sight there was confusion and opposition in his opinions about the same things, so here also is there not strife and inconsistency in his life? Though I need hardly raise the question again, for I remember that all this has been already admitted; and the soul has been acknowledged by us to be full of these and ten thousand similar oppositions occurring at the same moment?

And we were right, he said.

Yes, I said, thus far we were right; but there was an omission which must now be supplied.

What was the omission?

Were we not saying that a good man, who has the misfortune to lose his son or anything else which is most dear to him, will bear the loss with more equanimity than another?

Yes.

But will he have no sorrow, or shall we say that although he cannot help sorrowing, he will moderate his sorrow?

The latter, he said, is the truer statement.

Tell me: will he be more likely to struggle and hold out against his sorrow when he is seen by his equals, or when he is alone?

It will make a great difference whether he is seen or not.

When he is by himself he will not mind saying or doing many things which he would be ashamed of any one hearing or seeing him do?

True.

There is a principle of law and reason in him which bids him resist, as well as a feeling of his misfortune which is forcing him to indulge his sorrow?

True.

But when a man is drawn in two opposite directions, to and from the same object, this, as we affirm, necessarily implies two distinct principles in him?

Certainly.

One of them is ready to follow the guidance of the law?

How do you mean?

The law would say that to be patient under suffering is best, and that we should not give way to impatience, as there is no knowing whether such things are good or evil; and nothing is gained by impatience; also, because no human thing is of serious importance,

and grief stands in the way of that which at the moment is most required.

What is most required? he asked.

That we should take counsel about what has happened, and when the dice have been thrown order our affairs in the way which reason deems best; not, like children who have had a fall, keeping hold of the part struck and wasting time in setting up a howl, but always accustoming the soul forthwith to apply a remedy, raising up that which is sickly and fallen, banishing the cry of sorrow by the healing art.

Yes, he said, that is the true way of meeting the attacks of fortune.

Yes, I said; and the higher principle is ready to follow this suggestion of reason?

Clearly.

And the other principle, which inclines us to recollection of our troubles and to lamentation, and can never have enough of them, we may call irrational, useless, and cowardly?

Indeed, we may.

And does not the latter—I mean the rebellious principle—furnish a great variety of materials for imitation? Whereas the wise and calm temperament, being always nearly equable, is not easy to imitate or to appreciate when imitated, especially at a public festival when a promiscuous crowd is assembled in a theatre. For the feeling represented is one to which they are strangers.

Certainly.

Then the imitative poet who aims at being popular is not by nature made, nor is his art intended, to please or to affect the principle in the soul; but he will prefer the passionate and fitful temper, which is easily imitated?

Clearly.

And now we may fairly take him and place him by the side of the painter, for he is like him in two ways: first, inasmuch as his creations have an inferior degree of truth—in this, I say, he is like him; and he is also like him in being concerned with an inferior part of the soul; and therefore we shall be right in refusing to admit him into a well-ordered State, because he awakens and nourishes and strengthens the feelings and impairs the reason. As in a city when the evil are permitted to have authority and the good are put out of the way, so in the soul of man, as we maintain, the imitative poet implants an evil constitution, for he indulges the irrational nature which has no discernment of greater and less, but thinks the same thing at one time great and at another small—he is a manufacturer of images and is very far removed from the truth.

Exactly.

But we have not yet brought forward the heaviest count in our accusation:—the power which poetry has of harming even the good (and there are very few who are not harmed), is surely an awful thing?

Yes, certainly, if the effect is what you say.

Hear and judge: The best of us, as I conceive, when we listen to a passage of Homer, or one of the tragedians, in which he represents some pitiful hero who is drawling out his sorrows in a long oration, or weeping, and smiting his breast—the best of us, you know, delight in giving way to sympathy, and are in raptures at the excellence of the poet who stirs our feelings most.

Yes, of course I know.

But when any sorrow of our own happens to us, then you may observe that we pride ourselves on the opposite quality—we would fain be quiet and patient; this is the manly part, and the other which delighted us in the recitation is now deemed to be the part of a woman.

Very true, he said.

Now can we be right in praising and admiring another who is doing that which any one of us would abominate and be ashamed of in his own person?

No, he said, that is certainly not reasonable.

Nay, I said, quite reasonable from one point of view.

What point of view?

If you consider, I said, that when in misfortune we feel a natural hunger and desire to relieve our sorrow by weeping and lamentation, and that this feeling which is kept under control in our own calamities is satisfied and delighted by the poets;—the better nature in each of us, not having been sufficiently trained by reason or habit, allows the sympathetic element to break loose because the sorrow is another's; and the spectator fancies that there can be no disgrace to himself in praising and pitying any

one who comes telling him what a good man he is, and making a fuss about his troubles; he thinks that the pleasure is a gain, and why should he be supercilious and lose this and the poem too? Few persons ever reflect, as I should imagine, that from the evil of other men something of evil is communicated to themselves. And so the feeling of sorrow which has gathered strength at the sight of the misfortunes of others is with difficulty repressed in our own.

How very true!

And does not the same hold also of the ridiculous? There are jests which you would be ashamed to make yourself, and yet on the comic stage, or indeed in private, when you hear them, you are greatly amused by them, and are not at all disgusted at their unseemliness;—the case of pity is repeated;—there is a principle in human nature which is disposed to raise a laugh, and this which you once restrained by reason, because you were afraid of being thought a buffoon, is now let out again; and having stimulated the risible faculty at the theatre, you are betrayed unconsciously to yourself into playing the comic poet at home.

Quite true, he said.

And the same may be said of lust and anger and all the other affections, of desire and pain and pleasure, which are held to be inseparable from every action—in all of them poetry feeds and waters the passions instead of drying them up; she lets them rule, although they ought to be controlled, if mankind are ever to increase in happiness and virtue.

I cannot deny it.

Therefore, Glaucon, I said, whenever you meet with any of the eulogists of Homer declaring that he has been the educator of Hellas, and that he is profitable for education and for the ordering of human things, and that you should take him up again and again and get to know him and regulate your whole life according to him, we may love and honour those who say these things—they are excellent people, as far as their lights extend; and we are ready to acknowledge that Homer is the greatest of poets and first of tragedy writers; but we must remain firm in our conviction that hymns to the gods and praises of famous men are the only poetry which ought to be admitted into our State. For if you go beyond this and allow the honeyed muse to enter, either in epic or lyric verse, not law and the reason of mankind, which by common consent have ever been deemed best, but pleasure and pain will be the rulers in our State.

That is most true, he said.

And now since we have reverted to the subject of poetry, let this our defence serve to show the reasonableness of our former judgment in sending away out of our State an art having the tendencies which we have described; for reason constrained us. But that she may impute to us any harshness or want of politeness, let us tell her that there is an ancient quarrel between philosophy and poetry; of which there are many proofs, such as the saying of 'the yelping hound howling at her lord,' or of one 'mighty in the vain talk of fools,' and 'the mob of sages circumventing Zeus,' and the 'subtle thinkers who are beggars after all'; and there are innumerable other signs of ancient enmity between them. Notwithstanding this, let us assure our sweet friend and the sister arts of imitation that if she will only prove her title to exist in a well-ordered State we shall be delighted to receive her—we are very conscious of her charms; but we may not on that account betray the truth. I dare say, Glaucon, that you are as much charmed by her as I am, especially when she appears in Homer?

Yes, indeed, I am greatly charmed.

Shall I propose, then, that she be allowed to return from exile, but upon this condition only—that she make a defence of herself in lyrical or some other metre?

Certainly.

And we may further grant to those of her defenders who are lovers of poetry and yet not poets the permission to speak in prose on her behalf: let them show not only that she is pleasant but also useful to States and to human life, and we will listen in a kindly spirit; for if this can be proved we shall surely be the gainers—I mean, if there is a use in poetry as well as a delight?

Certainly, he said, we shall be the gainers.

If her defence fails, then, my dear friend, like other persons who are enamoured of something, but put a restraint upon themselves when they think their desires are opposed to their interests, so too must we

after the manner of lovers give her up, though not without a struggle. We too are inspired by that love of poetry which the education of noble States has implanted in us, and therefore we would have her appear at her best and truest; but so long as she is unable to make good her defence, this argument of ours shall be a charm to us, which we will repeat to ourselves while we listen to her strains; that we may not fall away into the childish love of her which captivates the many. At all events we are well aware that poetry being such as we have described is not to be regarded seriously as attaining to the truth; and he who listens to her, fearing for the safety of the city which is within him, should be on his guard against her seductions and make our words his law.

Yes, he said, I quite agree with you.

Yes, I said, my dear Glaucon, for great is the issue at stake, greater than appears, whether a man is to be good or bad. And what will any one be profited if under the influence of honour or money or power, aye, or under the excitement of poetry, he neglect justice and virtue?

Yes, he said; I have been convinced by the argument, as I believe that any one else would have been.

The Speech of Socrates from

Symposium

translated by Benjamin Jowett

And now, taking my leave of you, I would rehearse a tale of love which I heard from Diotima of Mantineia, a woman wise in this and in many other kinds of knowledge, who in the days of old, when the Athenians offered sacrifice before the coming of the plague, delayed the disease ten years. She was my instructress in the art of love, and I shall repeat to you what she said to me, beginning with the admissions made by Agathon, which are nearly if not quite the same which I made to the wise woman when she questioned me—I think that this will be the easiest way, and I shall take both parts myself as well as I can. As you, Agathon, suggested, I must speak first of the being and nature of Love, and then of his works. First I said to her in nearly the same words which he used to me, that Love was a mighty god, and likewise fair and she proved to me as I proved to him that, by my own showing, Love was neither fair nor good. "What do you mean, Diotima," I said, "is love then evil and foul?" "Hush," she cried; "must that be foul which is not fair?" "Certainly," I said. "And is that which is not wise, ignorant? do you not see that there is a mean between wisdom and ignorance?" "And what may that be?" I said. "Right opinion," she replied; "which, as you know, being incapable of giving a reason, is not knowledge (for how can knowledge be devoid of reason? nor again, ignorance, for neither can ignorance attain the truth), but is clearly something which is a mean between ignorance and wisdom." "Quite true," I replied. "Do not then insist," she said, "that what is not fair is of necessity foul, or what is not good evil; or infer that because love is not fair and good he is therefore foul and

evil; for he is in a mean between them." "Well," I said, "Love is surely admitted by all to be a great god." "By those who know or by those who do not know?" "By all." "And how, Socrates," she said with a smile, "can Love be acknowledged to be a great god by those who say that he is not a god at all?" "And who are they?" I said. "You and I are two of them," she replied. "How can that be?" I said. "It is quite intelligible," she replied; "for you yourself would acknowledge that the gods are happy and fair of course you would—would to say that any god was not?" "Certainly not," I replied. "And you mean by the happy, those who are the possessors of things good or fair?" "Yes." "And you admitted that Love, because he was in want, desires those good and fair things of which he is in want?" "Yes, I did." "But how can he be a god who has no portion in what is either good or fair?" "Impossible." "Then you see that you also deny the divinity of Love."

"What then is Love?" I asked; "Is he mortal?" "No." "What then?" "As in the former instance, he is neither mortal nor immortal, but in a mean between the two." "What is he, Diotima?" "He is a great spirit (daimon), and like all spirits he is intermediate between the divine and the mortal." "And what," I said, "is his power?" "He interprets," she replied, "between gods and men, conveying and taking across to the gods the prayers and sacrifices of men, and to men the commands and replies of the gods; he is the mediator who spans the chasm which divides them, and therefore in him all is bound together, and through him the arts of the prophet and the priest, their sacrifices and mysteries and charms, and all, prophecy and incantation, find their way. For God mingles not with man; but through Love. All the intercourse, and converse of god with man, whether awake or asleep, is carried on. The wisdom which understands this is spiritual; all other wisdom, such as that of arts and handicrafts, is mean and vulgar. Now these spirits or intermediate powers are many and diverse, and one of them is Love. "And who," I said, "was his father, and who his mother?" "The tale," she said, "will take time; nevertheless I will tell you. On the birthday of Aphrodite there was a feast of the gods, at which the god Poros or Plenty, who is the son of Metis or Discretion, was one of the guests. When the feast was over, Penia or Poverty, as the manner is on such occasions, came about the doors to beg. Now Plenty who was the worse for nectar (there was no wine in those days), went into the garden of Zeus and fell into a heavy sleep, and Poverty considering her own straitened circumstances, plotted to have a child by him, and accordingly she lay down at his side and conceived love, who partly because he is naturally a lover of the beautiful, and because Aphrodite is herself beautiful, and also because he was born on her birthday, is her follower and attendant. And as his parentage is, so also are his fortunes. In the first place he is always poor, and anything but tender and fair, as the many imagine him; and he is rough and squalid, and has no shoes, nor a house to dwell in; on the bare earth exposed he lies under the open heaven, in the streets, or at the doors of houses, taking his rest; and like his mother he is always in distress. Like his father too, whom he also partly resembles, he is always plotting against the fair and good; he is bold, enterprising, strong, a mighty hunter, always weaving some intrigue or other, keen in the pursuit of wisdom, fertile in resources; a philosopher at all times, terrible as an enchanter, sorcerer, sophist. He is by nature neither mortal nor immortal, but alive and flourishing at one moment when he is in plenty, and dead at another moment, and again alive by reason of his father's nature. But that which is always flowing in is always flowing out, and so he is never in want and never in wealth; and, further, he is in a mean between ignorance and knowledge. The truth of the matter is this: No god is a philosopher, or seeker after wisdom, for he is wise already; nor does any man who is wise seek after wisdom. Neither do the ignorant seek after Wisdom. For herein is the evil of ignorance, that he who is neither good nor wise is nevertheless satisfied with himself: he has no desire for that of which he feels no want." "But—who then, Diotima," I said, "are the lovers of wisdom, if they are neither the wise nor the foolish?" "A child may answer that question," she replied; "they are those who are in a mean between the two; Love is one of them. For wisdom is a most beautiful thing, and Love is of the beautiful; and therefore Love is also a philosopher: or lover of

wisdom, and being a lover of wisdom is in a mean between the wise and the ignorant. And of this too his birth is the cause; for his father is wealthy and wise, and his mother poor and foolish. Such, my dear Socrates, is the nature of the spirit Love. The error in your conception of him was very natural, and as I imagine from what you say, has arisen out of a confusion of love and the beloved, which made you think that love was all beautiful. For the beloved is the truly beautiful, and delicate, and perfect, and blessed; but the principle of love is of another nature, and is such as I have described."

I said, "O thou stranger woman, thou sayest well; but, assuming Love to be such as you say, what is the use of him to men?" "That, Socrates," she replied, "I will attempt to unfold: of his nature and birth I have already spoken; and you acknowledge that love is of the beautiful. But some one will say: Of the beautiful in what, Socrates and Diotima?— or rather let me put the question more clearly, and ask: When a man loves the beautiful, what does he desire?" I answered her "That the beautiful may be his." "Still," she said, "the answer suggests a further question: What is given by the possession of beauty?" "To what you have asked," I replied, "I have no answer ready." "Then," she said, "Let me put the word 'good' in the place of the beautiful, and repeat the question once more: If he who loves *loves the good*, what is it then that he loves?" "The possession of the good," I said. "And what does he gain who possesses the good?" "Happiness," I replied; "there is less difficulty in answering that question." "Yes," she said, "the happy are made happy by the acquisition of good things. Nor is there any need to ask why a man desires happiness; the answer is already final." "You are right." I said. "And is this wish and this desire common to all? and do all men always desire their own good, or only some men?—what say you?" "All men," I replied; "the desire is common to all." "Why, then," she rejoined, "are not all men, Socrates, said to love, but only some them? whereas you say that all men are always loving the same things." "I myself wonder," I said, "why this is." "There is nothing to wonder at," she replied; "the reason is that one part of love is separated off and receives the name of the whole, but the other parts have other names." "Give an illustration," I said. She answered me as follows: "There is poetry, which, as you know, is complex; and manifold. All creation or passage of non-being into being is poetry or making, and the processes of all art are creative; and the masters of arts are all poets or makers." "Very true." "Still," she said, "you know that they are not called poets, but have other names; only that portion of the art which is separated off from the rest, and is concerned with music and metre, is termed poetry, and they who possess poetry in this sense of the word are called poets." "Very true," I said. "And the same holds of love. For you may say generally that all desire of good and happiness is only the great and subtle power of love; but they who are drawn towards him by any other path, whether the path of money-making or gymnastics or philosophy, are not called lovers—the name of the whole is appropriated to those whose affection takes one form only—they alone are said to love, or to be lovers." "I dare say," I replied, "that you are right." "Yes," she added, "and you hear people say that lovers are seeking for their other half; but I say that they are seeking neither for the half of themselves, nor for the whole, unless the half or the whole be also a good. And they will cut off their own hands and feet and cast them away, if they are evil; for they love not what is their own, unless perchance there be some one who calls what belongs to him the good, and what belongs to another the evil. For there is nothing which men love but the good. Is there anything?" "Certainly, I should say, that there is nothing." "Then," she said, "the simple truth is, that men love the good." "Yes," I said. "To which must be added that they love the possession of the good?" "Yes, that must be added." "And not only the possession, but the everlasting possession of the good?" "That must be added too." "Then love," she said, "may be described generally as the love of the everlasting possession of the good?" "That is most true."

"Then if this be the nature of love, can you tell me further," she said, "what is the manner of the pursuit? what are they doing who show all this eagerness and heat which is called love? and what is the object which they have in view? Answer me."

"Nay, Diotima," I replied, "if I had known, I should not have wondered at your wisdom, neither should I have come to learn from you about this very matter." "Well," she said, "I will teach you: The object which they have in view is birth in beauty, whether of body or soul." "I do not understand you," I said; "the oracle requires an explanation." "I will make my meaning clearer," she replied. "I mean to say, that all men are bringing to the birth in their bodies and in their souls. There is a certain age at which human nature is desirous of procreation—procreation which must be in beauty and not in deformity; and this procreation is the union of man and woman, and is a divine thing; for conception and generation are an immortal principle in the mortal creature, and in the inharmonious they can never be. But the deformed is always inharmonious with the divine, and the beautiful harmonious. Beauty, then, is the destiny or goddess of parturition who presides at birth, and therefore, when approaching beauty, the conceiving power is propitious, and diffusive, and benign, and begets and bears fruit: at the sight of ugliness she frowns and contracts and has a sense of pain, and turns away, and shrivels up, and not without a pang refrains from conception. And this is the reason why, when the hour of conception arrives, and the teeming nature is full, there is such a flutter and ecstasy about beauty whose approach is the alleviation of the pain of travail. For love, Socrates, is not, as you imagine, the love of the beautiful only." "What then?" "The love of generation and of birth in beauty." "Yes," I said. "Yes, indeed," she replied. "But why of generation?" "Because to the mortal creature, generation is a sort of eternity and immortality," she replied; "and if, as has been already admitted, love is of the everlasting possession of the good, all men will necessarily desire immortality together with good: Wherefore love is of immortality."

All this she taught me at various times when she spoke of love. And I remember her once saying to me, "What is the cause, Socrates, of love, and the attendant desire? See you not how all animals, birds, as well as beasts, in their desire of procreation, are in agony when they take the infection of love, which begins with the desire of union; whereto is added the care of offspring, on whose behalf the weakest are ready to battle against the strongest even to the uttermost, and to die for them, and will let themselves be tormented with hunger or suffer anything in order to maintain their young. Man may be supposed to act thus from reason; but why should animals have these passionate feelings? Can you tell me why?" Again I replied that I did not know. She said to me: "And do you expect ever to become a master in the art of love, if you do not know this?" "But I have told you already, Diotima, that my ignorance is the reason why I come to you; for I am conscious that I want a teacher; tell me then the cause of this and of the other mysteries of love." "Marvel not," she said, "if you believe that love is of the immortal, as we have several times acknowledged; for here again, and on the same principle too, the mortal nature is seeking as far as is possible to be everlasting and immortal: and this is only to be attained by generation, because generation always leaves behind a new existence in the place of the old. Nay even in the life, of the same individual there is succession and not absolute unity: a man is called the same, and yet in the short interval which elapses between youth and age, and in which every animal is said to have life and identity, he is undergoing a perpetual process of loss and reparation—hair, flesh, bones, blood, and the whole body are always changing. Which is true not only of the body, but also of the soul, whose habits, tempers, opinions, desires, pleasures, pains, fears, never remain the same in any one of us, but are always coming and going; and equally true of knowledge, and what is still more surprising to us mortals, not only do the sciences in general spring up and decay, so that in respect of them we are never the same; but each of them individually experiences a like change. For what is implied in the word 'recollection,' but the departure of knowledge, which is ever being forgotten, and is renewed and preserved by recollection, and appears to be the same although in reality new, according to that law of succession by which all mortal things are preserved, not absolutely the same, but by substitution, the old worn-out mortality leaving another new and similar existence behind unlike the divine, which is always the same and not another? And in this

way, Socrates, the mortal body, or mortal anything, partakes of immortality; but the immortal in another way. Marvel not then at the love which all men have of their offspring; for that universal love and interest is for the sake of immortality."

I was astonished at her words, and said: "Is this really true, O thou wise Diotima?" And she answered with all the authority of an accomplished sophist: "Of that, Socrates, you may be assured;— think only of the ambition of men, and you will wonder at the senselessness of their ways, unless you consider how they are stirred by the love of an immortality of fame. They are ready to run all risks greater far than they would have for their children, and to spend money and undergo any sort of toil, and even to die, for the sake of leaving behind them a name which shall be eternal. Do you imagine that Alcestis would have died to save Admetus, or Achilles to avenge Patroclus, or your own Codrus in order to preserve the kingdom for his sons, if they had not imagined that the memory of their virtues, which still survives among us, would be immortal? Nay," she said, "I am persuaded that all men do all things, and the better they are the more they do them, in hope of the glorious fame of immortal virtue; for they desire the immortal.

"Those who are pregnant in the body only, betake themselves to women and beget children—this is the character of their love; their offspring, as they hope, will preserve their memory and give them the blessedness and immortality which they desire in the future. But souls which are pregnant—for there certainly are men who are more creative in their souls than in their bodies—conceive that which is proper for the soul to conceive or contain. And what are these conceptions?—wisdom and virtue in general. And such creators are poets and all artists who are deserving of the name inventor. But the greatest and fairest sort of wisdom by far is that which is concerned with the ordering of states and families, and which is called temperance and justice. And he who in youth has the seed of these implanted in him and is himself inspired, when he comes to maturity desires to beget and generate. He wanders about seeking beauty that he may beget offspring—for in deformity he will beget nothing—and naturally embraces the beautiful rather than the deformed body; above all when he finds a fair and noble and well-nurtured soul, he embraces the two in one person, and to such an one he is full of speech about virtue and the nature and pursuits of a good man; and he tries to educate him; and at the touch of the beautiful which is ever present to his memory, even when absent, he brings forth that which he had conceived long before, and in company with him tends that which he brings forth; and they are married by a far nearer tie and have a closer friendship than those who beget mortal children, for the children who are their common offspring are fairer and more immortal. Who, when he thinks of Homer and Hesiod and other great poets, would not rather have their children than ordinary human ones? Who would not emulate them in the creation of children such as theirs, which have preserved their memory and given them everlasting glory? Or who would not have such children as Lycurgus left behind him to be the saviours, not only of Lacedaemon, but of Hellas, as one may say? There is Solon, too, who is the revered father of Athenian laws; and many others there are in many other places, both among hellenes and barbarians, who have given to the world many noble works, and have been the parents of virtue of every kind; and many temples have been raised in their honour for the sake of children such as theirs; which were never raised in honour of any one, for the sake of his mortal children. These are the lesser mysteries of love, into which even you, Socrates, may enter; to the greater and more hidden ones which are the crown of these, and to which, if you pursue them in a right spirit, they will lead, I know not whether you will be able to attain. But I will do my utmost to inform you, and do you follow if you can. For he who would proceed aright in this matter should begin in youth to visit beautiful forms; and first, if he be guided by his instructor aright, to love one such form only—out of that he should create fair thoughts; and soon he will of himself perceive that the beauty of one form is akin to the beauty of another; and then if beauty of form in general is his pursuit, how foolish would he be not to recognize that the beauty in every form is one and the same! And when he perceives this he will abate his violent

love of the one, which he will despise and deem a small thing, and will become a lover of all beautiful forms; in the next stage he will consider that the beauty of the mind is more honourable than the beauty of the outward form. So that if a virtuous soul have but a little comeliness, he will be content to love and tend him, and will search out and bring to the birth thoughts which may improve the young, until he is compelled to contemplate and see the beauty of institutions and laws, and to understand that the beauty of them all is of one family, and that personal beauty is a trifle; and after laws and institutions he will go on to the sciences, that he may see their beauty, being not like a servant in love with the beauty of one youth or man or institution, himself a slave mean and narrow-minded, but drawing towards and contemplating the vast sea of beauty, he will create many fair and noble thoughts and notions in boundless love of wisdom; until on that shore he grows and waxes strong, and at last the vision is revealed to him of a single science, which is the science of beauty everywhere. To this I will proceed; please to give me your very best attention:

"He who has been instructed thus far in the things of love, and who has learned to see the beautiful in due order and succession, when he comes toward the end will suddenly perceive a nature of wondrous beauty (and this, Socrates, is the final cause of all our former toils)—a nature which in the first place is everlasting, not growing and decaying, or waxing and waning; secondly, not fair in one point of view and foul in another, or at one time or in one relation or at one place fair, at another time or in another relation or at another place foul, as if fair to some and foul to others, or in the likeness of a face or hands or any other part of the bodily frame, or in any form of speech or knowledge, or existing in any other being, as for example, in an animal, or in heaven or in earth, or in any other place; but beauty absolute, separate, simple, and everlasting, which without diminution and without increase, or any change, is imparted to the ever-growing and perishing beauties of all other things. He who from these

ascending under the influence of true love, begins to perceive that beauty, is not far from the end. And the true order of going, or being led by another, to the things of love, is to begin from the beauties of earth and mount upwards for the sake of that other beauty, using these as steps only, and from one going on to two, and from two to all fair forms, and from fair forms to fair practices, and from fair practices to fair notions, until from fair notions he arrives at the notion of absolute beauty, and at last knows what the essence of beauty is. This, my dear Socrates," said the stranger of Mantineia, "is that life above all others which man should live, in the contemplation of beauty absolute; a beauty which if you once beheld, you would see not to be after the measure of gold, and garments, and fair boys and youths, whose presence now entrances you; and you and many a one would be content to live seeing them only and conversing with them without meat or drink, if that were possible—you only want to look at them and to be with them. But what if man had eyes to see the true beauty—the divine beauty, I mean, pure and dear and unalloyed, not clogged with the pollutions of mortality and all the colours and vanities of human life—thither looking, and holding converse with the true beauty simple and divine? Remember how in that communion only, beholding beauty with the eye of the mind, he will be enabled to bring forth, not images of beauty, but realities (for he has hold not of an image but of a reality), and bringing forth and nourishing true virtue to become the friend of God and be immortal, if mortal man may. Would that be an ignoble life?"

Such, Phaedrus—and I speak not only to you, but to all of you—were the words of Diotima; and I am persuaded of their truth. And being persuaded of them, I try to persuade others, that in the attainment of this end human nature will not easily find a helper better than love: And therefore, also, I say that every man ought to honour him as I myself honour him, and walk in his ways, and exhort others to do the same, and praise the power and spirit of love according to the measure of my ability now and ever.

Aristotle (384-322 B.C.E)

Selections from
Poetics

Translated by S. H. Butcher

"Poetry, therefore, is a more philosophical and a higher thing than history:
for poetry tends to express the universal, history the particular."

1

I propose to treat of Poetry in itself and of its various kinds, noting the essential quality of each, to inquire into the structure of the plot as requisite to a good poem; into the number and nature of the parts of which a poem is composed; and similarly into whatever else falls within the same inquiry. Following, then, the order of nature, let us begin with the principles which come first.

Epic poetry and Tragedy, Comedy also and Dithyrambic poetry, and the music of the flute and of the lyre in most of their forms, are all in their general conception modes of imitation. They differ, however, from one another in three respects—the medium, the objects, the manner or mode of imitation, being in each case distinct.

For as there are persons who, by conscious art or mere habit, imitate and represent various objects through the medium of colour and form, or again by the voice; so in the arts above mentioned, taken as a whole, the imitation is produced by rhythm, language, or 'harmony,' either singly or combined.

Thus in the music of the flute and of the lyre, 'harmony' and rhythm alone are employed; also in other arts, such as that of the shepherd's pipe, which are essentially similar to these. In dancing, rhythm alone is used without 'harmony'; for even dancing imitates character, emotion, and action, by rhythmical movement.

There is another art which imitates by means of language alone, and that either in prose or verse—which verse, again, may either combine different metres or consist of but one kind—but this has hitherto been without a name. For there is no common term we could apply to the mimes of Sophron and Xenarchus and the Socratic dialogues on the one hand; and, on the other, to poetic imitations in iambic, elegiac, or any similar metre. People do, indeed, add the word 'maker' or 'poet' to the name of the metre, and speak of elegiac poets, or epic (that is, hexameter) poets, as if it were not the imitation that makes the poet, but the verse that entitles them all to the name. Even when a treatise on medicine or natural science is brought out in verse, the name of poet is by custom given to the author; and yet Homer and Empedocles have nothing in common but the metre, so that it would be right to call the one poet, the other physicist rather than poet. On the same principle, even if a writer in his poetic imitation were to combine all metres, as Chaeremon did in his *Centaur*, which is a medley composed of metres of all kinds, we should bring him too under the general term poet. So much then for these distinctions.

There are, again, some arts which employ all the means above mentioned—namely, rhythm, tune, and metre. Such are Dithyrambic and Nomic poetry, and also Tragedy and Comedy; but between them originally the difference is, that in the first two cases these means are all employed in combination, in the latter, now one means is employed, now another.

Such, then, are the differences of the arts with respect to the medium of imitation.

2

Since the objects of imitation are men in action, and these men must be either of a higher or a lower type (for moral character mainly answers to these divisions, goodness and badness being the distinguishing marks of moral differences), it follows that we must represent men either as better than in real life, or as worse, or as they are. It is the same in painting. Polygnotus depicted men as nobler than they are, Pauson as less noble, Dionysius drew them true to life.

Now it is evident that each of the modes of imitation above mentioned will exhibit these differences, and become a distinct kind in imitating objects that are thus distinct. Such diversities may be found even in dancing, flute-playing, and lyre-playing. So again in language, whether prose or verse unaccompanied by music. Homer, for example, makes men better than they are; Cleophon as they are; Hegemon the Thasian, the inventor of parodies, and Nicochares, the author of the *Deiliad*, worse than they are. The same thing holds good of Dithyrambs and Nomes; here too one may portray different types, as Timotheus and Philoxenus differed in representing their Cyclopes. The same distinction marks off Tragedy from Comedy; for Comedy aims at representing men as worse, Tragedy as better than in actual life.

3

There is still a third difference—the manner in which each of these objects may be imitated. For the medium being the same, and the objects the same, the poet may imitate by narration—in which case he can either take another personality as Homer does, or speak in his own person, unchanged—or he may present all his characters as living and moving before us.

These, then, as we said at the beginning, are the three differences which distinguish artistic imitation—the medium, the objects, and the manner. So that from one point of view, Sophocles is an imitator of the same kind as Homer—for both imitate higher types of character; from another point of view, of the same kind as Aristophanes—for both imitate persons acting and doing. Hence, some say, the name of 'drama' is given to such poems, as representing action. For the same reason the Dorians claim the invention both of Tragedy and Comedy. The claim to Comedy is put forward by the Megarians—not only by those of Greece proper, who allege that it originated under their democracy, but also by the Megarians of Sicily, for the poet Epicharmus, who is much earlier than Chionides and Magnes, belonged to that country. Tragedy too is claimed by certain Dorians of the Peloponnese. In each case they appeal to the evidence of language. The outlying villages, they say, are by them called *komai*, by the Athenians *demoi*: and they assume that comedians were so named not from *komazein*, 'to revel,' but because they wandered from village to village (*kata komas*), being excluded contemptuously from the city. They add also that the Dorian word for 'doing' is *dran*, and the Athenian, *prattein*.

This may suffice as to the number and nature of the various modes of imitation.

4

Poetry in general seems to have sprung from two causes, each of them lying deep in our nature. First, the instinct of imitation is implanted in man from childhood, one difference between him and other animals being that he is the most imitative of living creatures, and through imitation learns his earliest lessons; and no less universal is the pleasure felt in things imitated. We have evidence of this in the facts of experience. Objects which in themselves we view with pain, we delight to contemplate when reproduced with minute fidelity: such as the forms of the most ignoble animals and of dead bodies. The cause of this again is, that to learn gives the liveliest pleasure, not only to philosophers but to men in general; whose capacity, however, of learning is more limited. Thus the reason why men enjoy seeing a likeness is, that in contemplating it they find themselves learning or inferring, and saying perhaps, 'Ah, that is he.' For if you happen not to have seen the original, the pleasure will be due not to the imitation as such, but to the execution, the colouring, or some such other cause.

Imitation, then, is one instinct of our nature. Next, there is the instinct for 'harmony' and rhythm, metres

being manifestly sections of rhythm. Persons, therefore, starting with this natural gift developed by degrees their special aptitudes, till their rude improvisations gave birth to Poetry.

Poetry now diverged in two directions, according to the individual character of the writers. The graver spirits imitated noble actions, and the actions of good men. The more trivial sort imitated the actions of meaner persons, at first composing satires, as the former did hymns to the gods and the praises of famous men. A poem of the satirical kind cannot indeed be put down to any author earlier than Homer; though many such writers probably there were. But from Homer onward, instances can be cited—his own *Margites*, for example, and other similar compositions. The appropriate metre was also here introduced; hence the measure is still called the iambic or lampooning measure, being that in which people lampooned one another. Thus the older poets were distinguished as writers of heroic or of lampooning verse.

As, in the serious style, Homer is pre-eminent among poets, for he alone combined dramatic form with excellence of imitation so he too first laid down the main lines of comedy, by dramatizing the ludicrous instead of writing personal satire. His *Margites* bears the same relation to comedy that the *Iliad* and *Odyssey* do to tragedy. But when Tragedy and Comedy came to light, the two classes of poets still followed their natural bent: the lampooners became writers of Comedy, and the Epic poets were succeeded by Tragedians, since the drama was a larger and higher form of art.

Whether Tragedy has as yet perfected its proper types or not; and whether it is to be judged in itself, or in relation also to the audience—this raises another question. Be that as it may, Tragedy—as also Comedy—was at first mere improvisation. The one originated with the authors of the Dithyramb, the other with those of the phallic songs, which are still in use in many of our cities. Tragedy advanced by slow degrees; each new element that showed itself was in turn developed. Having passed through many changes, it found its natural form, and there it stopped.

Aeschylus first introduced a second actor; he diminished the importance of the Chorus, and assigned the leading part to the dialogue. Sophocles raised the number of actors to three, and added scene-painting. Moreover, it was not till late that the short plot was discarded for one of greater compass, and the grotesque diction of the earlier satyric form for the stately manner of Tragedy. The iambic measure then replaced the trochaic tetrameter, which was originally employed when the poetry was of the satyric order, and had greater association with dancing. Once dialogue had come in, Nature herself discovered the appropriate measure. For the iambic is, of all measures, the most colloquial. We see it in the fact that conversational speech runs into iambic lines more frequently than into any other kind of verse; rarely into hexameters, and only when we drop the colloquial intonation. The additions to the number of 'episodes' or acts, and the other accessories of which tradition tells, must be taken as already described; for to discuss them in detail would, doubtless, be a large undertaking.

5

Comedy is, as we have said, an imitation of characters of a lower type—not, however, in the full sense of the word bad, the ludicrous being merely a subdivision of the ugly. It consists in some defect or ugliness which is not painful or destructive. To take an obvious example, the comic mask is ugly and distorted, but does not imply pain.

The successive changes through which Tragedy passed, and the authors of these changes, are well known, whereas Comedy has had no history, because it was not at first treated seriously. It was late before the Archon granted a comic chorus to a poet; the performers were till then voluntary. Comedy had already taken definite shape when comic poets, distinctively so called, are heard of. Who furnished it with masks, or prologues, or increased the number of actors—these and other similar details remain unknown. As for the plot, it came originally from Sicily; but of Athenian writers Crates was the first who abandoning the 'iambic' or lampooning form, generalized his themes and plots.

Epic poetry agrees with Tragedy in so far as it is an imitation in verse of characters of a higher type.

They differ in that Epic poetry admits but one kind of meter and is narrative in form. They differ, again, in their length: for Tragedy endeavors, as far as possible, to confine itself to a single revolution of the sun, or but slightly to exceed this limit, whereas the Epic action has no limits of time. This, then, is a second point of difference; though at first the same freedom was admitted in Tragedy as in Epic poetry.

Of their constituent parts some are common to both, some peculiar to Tragedy: whoever, therefore, knows what is good or bad Tragedy, knows also about Epic poetry. All the elements of an Epic poem are found in Tragedy, but the elements of a Tragedy are not all found in the Epic poem.

6

Of the poetry which imitates in hexameter verse, and of Comedy, we will speak hereafter. Let us now discuss Tragedy, resuming its formal definition, as resulting from what has been already said.

Tragedy, then, is an imitation of an action that is serious, complete, and of a certain magnitude; in language embellished with each kind of artistic ornament, the several kinds being found in separate parts of the play; in the form of action, not of narrative; through pity and fear effecting the proper purgation of these emotions. By 'language embellished,' I mean language into which rhythm, 'harmony' and song enter. By 'the several kinds in separate parts,' I mean, that some parts are rendered through the medium of verse alone, others again with the aid of song.

Now as tragic imitation implies persons acting, it necessarily follows in the first place, that Spectacular equipment will be a part of Tragedy. Next, Song and Diction, for these are the media of imitation. By 'Diction' I mean the mere metrical arrangement of the words: as for 'Song,' it is a term whose sense every one understands.

Again, Tragedy is the imitation of an action; and an action implies personal agents, who necessarily possess certain distinctive qualities both of character and thought; for it is by these that we qualify actions themselves, and these—thought and character—are the two natural causes from which actions spring, and on actions again all success or failure depends. Hence, the Plot is the imitation of the action—for by plot I here mean the arrangement of the incidents. By Character I mean that in virtue of which we ascribe certain qualities to the agents. Thought is required wherever a statement is proved, or, it may be, a general truth enunciated. Every Tragedy, therefore, must have six parts, which parts determine its quality—namely, Plot, Character, Diction, Thought, Spectacle, Song. Two of the parts constitute the medium of imitation, one the manner, and three the objects of imitation. And these complete the first. These elements have been employed, we may say, by the poets to a man; in fact, every play contains Spectacular elements as well as Character, Plot, Diction, Song, and Thought.

But most important of all is the structure of the incidents. For Tragedy is an imitation, not of men, but of an action and of life, and life consists in action, and its end is a mode of action, not a quality. Now character determines men's qualities, but it is by their actions that they are happy or the reverse. Dramatic action, therefore, is not with a view to the representation of character: character comes in as subsidiary to the actions. Hence the incidents and the plot are the end of a tragedy; and the end is the chief thing of all. Again, without action there cannot be a tragedy; there may be without character. The tragedies of most of our modern poets fail in the rendering of character; and of poets in general this is often true. It is the same in painting; and here lies the difference between Zeuxis and Polygnotus. Polygnotus delineates character well; the style of Zeuxis is devoid of ethical quality. Again, if you string together a set of speeches expressive of character, and well finished in point of diction and thought, you will not produce the essential tragic effect nearly so well as with a play which, however deficient in these respects, yet has a plot and artistically constructed incidents. Besides which, the most powerful elements of emotional interest in Tragedy—*Peripeteia* or Reversal of the Situation, and Recognition scenes—are parts of the plot. A further proof is, that novices in the art attain to finish of diction and precision of portraiture before they can construct the plot. It is the same with almost all the early poets.

The plot, then, is the first principle, and, as it were, the soul of a tragedy; Character holds the second place. A similar fact is seen in painting. The most beautiful colors, laid on confusedly, will not give as much pleasure as the chalk outline of a portrait. Thus Tragedy is the imitation of an action, and of the agents mainly with a view to the action.

Third in order is Thought—that is, the faculty of saying what is possible and pertinent in given circumstances. In the case of oratory, this is the function of the political art and of the art of rhetoric: and so indeed the older poets make their characters speak the language of civic life; the poets of our time, the language of the rhetoricians. Character is that which reveals moral purpose, showing what kind of things a man chooses or avoids. Speeches, therefore, which do not make this manifest, or in which the speaker does not choose or avoid anything whatever, are not expressive of character. Thought, on the other hand, is found where something is proved to be or not to be, or a general maxim is enunciated.

Fourth among the elements enumerated comes Diction; by which I mean, as has been already said, the expression of the meaning in words; and its essence is the same both in verse and prose.

Of the remaining elements Song holds the chief place among the embellishments.

The Spectacle has, indeed, an emotional attraction of its own, but, of all the parts, it is the least artistic, and connected least with the art of poetry. For the power of Tragedy, we may be sure, is felt even apart from representation and actors. Besides, the production of spectacular effects depends more on the art of the stage machinist than on that of the poet.

7

These principles being established, let us now discuss the proper structure of the Plot, since this is the first and most important thing in Tragedy.

Now, according to our definition Tragedy is an imitation of an action that is complete, and whole, and of a certain magnitude; for there may be a whole that is wanting in magnitude. A whole is that which has a beginning, a middle, and an end. A beginning is that which does not itself follow anything by causal necessity, but after which something naturally is or comes to be. An end, on the contrary, is that which itself naturally follows some other thing, either by necessity, or as a rule, but has nothing following it. A middle is that which follows something as some other thing follows it. A well constructed plot, therefore, must neither begin nor end at haphazard, but conform to these principles.

Again, a beautiful object, whether it be a living organism or any whole composed of parts, must not only have an orderly arrangement of parts, but must also be of a certain magnitude; for beauty depends on magnitude and order. Hence a very small animal organism cannot be beautiful; for the view of it is confused, the object being seen in an almost imperceptible moment of time. Nor, again, can one of vast size be beautiful; for as the eye cannot take it all in at once, the unity and sense of the whole is lost for the spectator; as for instance if there were one a thousand miles long. As, therefore, in the case of animate bodies and organisms a certain magnitude is necessary, and a magnitude which may be easily embraced in one view; so in the plot, a certain length is necessary, and a length which can be easily embraced by the memory. The limit of length in relation to dramatic competition and sensuous presentment is no part of artistic theory. For had it been the rule for a hundred tragedies to compete together, the performance would have been regulated by the water-clock—as indeed we are told was formerly done. But the limit as fixed by the nature of the drama itself is this: the greater the length, the more beautiful will the piece be by reason of its size, provided that the whole be perspicuous. And to define the matter roughly, we may say that the proper magnitude is comprised within such limits, that the sequence of events, according to the law of probability or necessity, will admit of a change from bad fortune to good, or from good fortune to bad.

8

Unity of plot does not, as some persons think, consist in the unity of the hero. For infinitely various are the incidents in one man's life which cannot be reduced to unity; and so, too, there are many actions of one man out of which we cannot make one

action. Hence the error, as it appears, of all poets who have composed a *Heracleid*, a *Theseid*, or other poems of the kind. They imagine that as Heracles was one man, the story of Heracles must also be a unity. But Homer, as in all else he is of surpassing merit, here too—whether from art or natural genius—seems to have happily discerned the truth. In composing the *Odyssey* he did not include all the adventures of Odysseus—such as his wound on Parnassus, or his feigned madness at the mustering of the host—incidents between which there was no necessary or probable connection: but he made the *Odyssey*, and likewise the *Iliad*, to centre round an action that in our sense of the word is one. As therefore, in the other imitative arts, the imitation is one when the object imitated is one, so the plot, being an imitation of an action, must imitate one action and that a whole, the structural union of the parts being such that, if any one of them is displaced or removed, the whole will be disjointed and disturbed. For a thing whose presence or absence makes no visible difference, is not an organic part of the whole.

9

It is, moreover, evident from what has been said, that it is not the function of the poet to relate what has happened, but what may happen—what is possible according to the law of probability or necessity. The poet and the historian differ not by writing in verse or in prose. The work of Herodotus might be put into verse, and it would still be a species of history, with metre no less than without it. The true difference is that one relates what has happened, the other what may happen. Poetry, therefore, is a more philosophical and a higher thing than history: for poetry tends to express the universal, history the particular. By the universal I mean how a person of a certain type on occasion speak or act, according to the law of probability or necessity; and it is this universality at which poetry aims in the names she attaches to the personages. The particular is—for example—what Alcibiades did or suffered. In Comedy this is already apparent: for here the poet first constructs the plot on the lines of probability, and then inserts characteristic names—unlike the lampooners who write about particular

individuals. But tragedians still keep to real names, the reason being that what is possible is credible: what has not happened we do not at once feel sure to be possible; but what has happened is manifestly possible: otherwise it would not have happened. Still there are even some tragedies in which there are only one or two well-known names, the rest being fictitious. In others, none are well-known—as in Agathon's *Antheus*, where incidents and names alike are fictitious, and yet they give none the less pleasure. We must not, therefore, at all costs keep to the received legends, which are the usual subjects of Tragedy. Indeed, it would be absurd to attempt it; for even subjects that are known are known only to a few, and yet give pleasure to all. It clearly follows that the poet or 'maker' should be the maker of plots rather than of verses; since he is a poet because he imitates, and what he imitates are actions. And even if he chances to take a historical subject, he is none the less a poet; for there is no reason why some events that have actually happened should not conform to the law of the probable and possible, and in virtue of that quality in them he is their poet or maker.

Of all plots and actions the episodic are the worst. I call a plot 'episodic' in which the episodes or acts succeed one another without probable or necessary sequence. Bad poets compose such pieces by their own fault, good poets, to please the players; for, as they write show pieces for competition, they stretch the plot beyond its capacity, and are often forced to break the natural continuity.

But again, Tragedy is an imitation not only of a complete action, but of events inspiring fear or pity. Such an effect is best produced when the events come on us by surprise; and the effect is heightened when, at the same time, they follows as cause and effect. The tragic wonder will then be greater than if they happened of themselves or by accident; for even coincidences are most striking when they have an air of design. We may instance the statue of Mitys at Argos, which fell upon his murderer while he was a spectator at a festival, and killed him. Such events seem not to be due to mere chance. Plots, therefore, constructed on these principles are necessarily the best.

10

Plots are either Simple or Complex, for the actions in real life, of which the plots are an imitation, obviously show a similar distinction. An action which is one and continuous in the sense above defined, I call Simple, when the change of fortune takes place without Reversal of the Situation and without Recognition.

A Complex action is one in which the change is accompanied by such Reversal, or by Recognition, or by both. These last should arise from the internal structure of the plot, so that what follows should be the necessary or probable result of the preceding action. It makes all the difference whether any given event is a case of *propter hoc* or *post hoc*.

11

Reversal of the Situation is a change by which the action veers round to its opposite, subject always to our rule of probability or necessity. Thus in the *Oedipus*, the messenger comes to cheer Oedipus and free him from his alarms about his mother, but by revealing who he is, he produces the opposite effect. Again in the *Lynceus*, Lynceus is being led away to his death, and Danaus goes with him, meaning to slay him; but the outcome of the preceding incidents is that Danaus is killed and Lynceus saved.

Recognition, as the name indicates, is a change from ignorance to knowledge, producing love or hate between the persons destined by the poet for good or bad fortune. The best form of recognition is coincident with a Reversal of the Situation, as in the *Oedipus*. There are indeed other forms. Even inanimate things of the most trivial kind may in a sense be objects of recognition. Again, we may recognize or discover whether a person has done a thing or not. But the recognition which is most intimately connected with the plot and action is, as we have said, the recognition of persons. This recognition, combined with Reversal, will produce either pity or fear; and actions producing these effects are those which, by our definition, Tragedy represents. Moreover, it is upon such situations that the issues of good or bad fortune will depend. Recognition, then, being between persons, it may happen that one person only is recognized by the other—when the latter is already known—or it may be necessary that the recognition should be on both sides. Thus Iphigenia is revealed to Orestes by the sending of the letter; but another act of recognition is required to make Orestes known to Iphigenia.

Two parts, then, of the Plot—Reversal of the Situation and Recognition—turn upon surprises. A third part is the Scene of Suffering. The Scene of Suffering is a destructive or painful action, such as death on the stage, bodily agony, wounds, and the like.

12

The parts of Tragedy which must be treated as elements of the whole have been already mentioned. We now come to the quantitative parts—the separate parts into which Tragedy is divided—namely, Prologue, Episode, Exode, Choric song; this last being divided into Parode and Stasimon. These are common to all plays: peculiar to some are the songs of actors from the stage and the *Commoi*.

The Prologue is that entire part of a tragedy which precedes the Parode of the Chorus. The Episode is that entire part of a tragedy which is between complete choric songs. The Exode is that entire part of a tragedy which has no choric song after it. Of the Choric part the Parode is the first undivided utterance of the Chorus: the Stasimon is a Choric ode without anapaests or trochaic tetrameters: the *Commos* is a joint lamentation of Chorus and actors. The parts of Tragedy which must be treated as elements of the whole have been already mentioned. The quantitative parts—the separate parts into which it is divided—are here enumerated.

13

As the sequel to what has already been said, we must proceed to consider what the poet should aim at, and what he should avoid, in constructing his plots; and by what means the specific effect of Tragedy will be produced.

A perfect tragedy should, as we have seen, be arranged not on the simple but on the complex plan. It should, moreover, imitate actions which excite pity and fear, this being the distinctive mark of tragic imitation. It follows plainly, in the first place, that the change of fortune presented must not be the

spectacle of a virtuous man brought from prosperity to adversity: for this moves neither pity nor fear; it merely shocks us. Nor, again, that of a bad man passing from adversity to prosperity: for nothing can be more alien to the spirit of Tragedy; it possesses no single tragic quality; it neither satisfies the moral sense nor calls forth pity or fear. Nor, again, should the downfall of the utter villain be exhibited. A plot of this kind would, doubtless, satisfy the moral sense, but it would inspire neither pity nor fear; for pity is aroused by unmerited misfortune, fear by the misfortune of a man like ourselves. Such an event, therefore, will be neither pitiful nor terrible. There remains, then, the character between these two extremes—that of a man who is not eminently good and just, yet whose misfortune is brought about not by vice or depravity, but by some error or frailty. He must be one who is highly renowned and prosperous—a personage like Oedipus, Thyestes, or other illustrious men of such families.

A well-constructed plot should, therefore, be single in its issue, rather than double as some maintain. The change of fortune should be not from bad to good, but, reversely, from good to bad. It should come about as the result not of vice, but of some great error or frailty, in a character either such as we have described, or better rather than worse. The practice of the stage bears out our view. At first the poets recounted any legend that came in their way. Now, the best tragedies are founded on the story of a few houses—on the fortunes of Alcmaeon, Oedipus, Orestes, Meleager, Thyestes, Telephus, and those others who have done or suffered something terrible. A tragedy, then, to be perfect according to the rules of art should be of this construction. Hence they are in error who censure Euripides just because he follows this principle in his plays, many of which end unhappily. It is, as we have said, the right ending. The best proof is that on the stage and in dramatic competition, such plays, if well worked out, are the most tragic in effect; and Euripides, faulty though he may be in the general management of his subject, yet is felt to be the most tragic of the poets.

In the second rank comes the kind of tragedy which some place first. Like the *Odyssey*, it has a double thread of plot, and also an opposite catastrophe for the good and for the bad. It is accounted the best because of the weakness of the spectators; for the poet is guided in what he writes by the wishes of his audience. The pleasure, however, thence derived is not the true tragic pleasure. It is proper rather to Comedy, where those who, in the piece, are the deadliest enemies—like Orestes and Aegisthus—quit the stage as friends at the close, and no one slays or is slain.

14

Fear and pity may be aroused by spectacular means; but they may also result from the inner structure of the piece, which is the better way, and indicates a superior poet. For the plot ought to be so constructed that, even without the aid of the eye, he who hears the tale told will thrill with horror and melt to pity at what takes place. This is the impression we should receive from hearing the story of the *Oedipus*. But to produce this effect by the mere spectacle is a less artistic method, and dependent on extraneous aids. Those who employ spectacular means to create a sense not of the terrible but only of the monstrous, are strangers to the purpose of Tragedy; for we must not demand of Tragedy any and every kind of pleasure, but only that which is proper to it. And since the pleasure which the poet should afford is that which comes from pity and fear through imitation, it is evident that this quality must be impressed upon the incidents.

Let us then determine what are the circumstances which strike us as terrible or pitiful.

Actions capable of this effect must happen between persons who are either friends or enemies or indifferent to one another. If an enemy kills an enemy, there is nothing to excite pity either in the act or the intention—except so far as the suffering in itself is pitiful. So again with indifferent persons. But when the tragic incident occurs between those who are near or dear to one another—if, for example, a brother kills, or intends to kill, a brother, a son his father, a mother her son, a son his mother, or any other deed of the kind is done—these are the situations to be looked for by the poet. He may not indeed destroy the framework of the received legends—the fact, for instance, that Clytemnestra

was slain by Orestes and Eriphyle by Alcmaeon—but he ought to show of his own, and skillfully handle the traditional material. Let us explain more clearly what is meant by skillful handling.

The action may be done consciously and with knowledge of the persons, in the manner of the older poets. It is thus too that Euripides makes Medea slay her children. Or, again, the deed of horror may be done, but done in ignorance, and the tie of kinship or friendship be discovered afterwards. The *Oedipus* of Sophocles is an example. Here, indeed, the incident is outside the drama proper; but cases occur where it falls within the action of the play: one may cite the *Alcmaeon* of Astydamas, or Telegonus in the *Wounded Odysseus*. Again, there is a third case—[to be about to act with knowledge of the persons and then not to act. The fourth case] is when some one is about to do an irreparable deed through ignorance, and makes the discovery before it is done. These are the only possible ways. For the deed must either be done or not done—and that wittingly or unwittingly. But of all these ways, to be about to act knowing the persons, and then not to act, is the worst. It is shocking without being tragic, for no disaster follows It is, therefore, never, or very rarely, found in poetry. One instance, however, is in the *Antigone*, where Haemon threatens to kill Creon. The next and better way is that the deed should be perpetrated. Still better, that it should be perpetrated in ignorance, and the discovery made afterwards. There is then nothing to shock us, while the discovery produces a startling effect. The last case is the best, as when in the *Cresphontes* Merope is about to slay her son, but, recognizing who he is, spares his life. So in the *Iphigenia*, the sister recognizes the brother just in time. Again in the Helle, the son recognizes the mother when on the point of giving her up. This, then, is why a few families only, as has been already observed, furnish the subjects of tragedy. It was not art, but happy chance, that led the poets in search of subjects to impress the tragic quality upon their plots. They are compelled, therefore, to have recourse to those houses whose history contains moving incidents like these.

Enough has now been said concerning the structure of the incidents, and the right kind of plot.

15

In respect of Character there are four things to be aimed at. First, and most important, it must be good. Now any speech or action that manifests moral purpose of any kind will be expressive of character: the character will be good if the purpose is good. This rule is relative to each class. Even a woman may be good, and also a slave; though the woman may be said to be an inferior being, and the slave quite worthless. The second thing to aim at is propriety. There is a type of manly valor; but valor in a woman, or unscrupulous cleverness is inappropriate. Thirdly, character must be true to life: for this is a distinct thing from goodness and propriety, as here described. The fourth point is consistency: for though the subject of the imitation, who suggested the type, be inconsistent, still he must be consistently inconsistent. As an example of motiveless degradation of character, we have Menelaus in the *Orestes*; of character indecorous and inappropriate, the lament of Odysseus in the *Scylla*, and the speech of Melanippe; of inconsistency, the *Iphigenia at Aulis*—for Iphigenia the suppliant in no way resembles her later self.

As in the structure of the plot, so too in the portraiture of character, the poet should always aim either at the necessary or the probable. Thus a person of a given character should speak or act in a given way, by the rule either of necessity or of probability; just as this event should follow that by necessary or probable sequence. It is therefore evident that the unraveling of the plot, no less than the complication, must arise out of the plot itself, it must not be brought about by the *Deus ex Machina*—as in the *Medea*, or in the return of the Greeks in the *Iliad*. The *Deus ex Machina* should be employed only for events external to the drama—for antecedent or subsequent events, which lie beyond the range of human knowledge, and which require to be reported or foretold; for to the gods we ascribe the power of seeing all things. Within the action there must be nothing irrational. If the irrational cannot be excluded, it should be outside the scope of the tragedy. Such is the irrational element in the *Oedipus* of Sophocles.

Again, since Tragedy is an imitation of persons

who are above the common level, the example of good portrait painters should be followed. They, while reproducing the distinctive form of the original, make a likeness which is true to life and yet more beautiful. So too the poet, in representing men who are irascible or indolent, or have other defects of character, should preserve the type and yet ennoble it. In this way Achilles is portrayed by Agathon and Homer.

These then are rules the poet should observe. Nor should he neglect those appeals to the senses, which, though not among the essentials, are the concomitants of poetry; for here too there is much room for error. But of this enough has been said in our published treatises.

16

What Recognition is has been already explained. We will now enumerate its kinds.

First, the least artistic form, which, from poverty of wit, is most commonly employed—recognition by signs. Of these some are congenital—such as 'the spear which the earth-born race bear on their bodies,' or the stars introduced by Carcinus in his *Thyestes*. Others are acquired after birth; and of these some are bodily marks, as scars; some external tokens, as necklaces, or the little ark in the *Tyro* by which the discovery is effected. Even these admit of more or less skillful treatment. Thus in the recognition of Odysseus by his scar, the discovery is made in one way by the nurse, in another by the swineherds. The use of tokens for the express purpose of proof—and, indeed, any formal proof with or without tokens—is a less artistic mode of recognition. A better kind is that which comes about by a turn of incident, as in the Bath Scene in the Odyssey.

Next come the recognitions invented at will by the poet, and on that account wanting in art. For example, Orestes in the *Iphigenia* reveals the fact that he is Orestes. She, indeed, makes herself known by the letter; but he, by speaking himself, and saying what the poet, not what the plot requires. This, therefore, is nearly allied to the fault above mentioned—for Orestes might as well have brought tokens with him. Another similar instance is the 'voice of the shuttle' in the *Tereus* of Sophocles.

The third kind depends on memory when the sight of some object awakens a feeling: as in the *Cyprians* of Dicaeogenes, where the hero breaks into tears on seeing the picture; or again in the *Lay of Alcinous*, where Odysseus, hearing the minstrel play the lyre, recalls the past and weeps; and hence the recognition.

The fourth kind is by process of reasoning. Thus in the *Choephori*: 'Some one resembling me has come: no one resembles me but Orestes: therefore Orestes has come.' Such too is the discovery made by Iphigenia in the play of Polyidus the Sophist. It was a natural reflection for Orestes to make, 'So I too must die at the altar like my sister.' So, again, in the *Tydeus* of Theodectes, the father says, 'I came to find my son, and I lose my own life.' So too in the Phineidae: the women, on seeing the place, inferred their fate—'Here we are doomed to die, for here we were cast forth.' Again, there is a composite kind of recognition involving false inference on the part of one of the characters, as in the *Odysseus Disguised as a Messenger*. A said [that no one else was able to bend the bow;...hence B (the disguised Odysseus) imagined that A would] recognize the bow which, in fact, he had not seen; and to bring about a recognition by this means—the expectation that A would recognize the bow—is false inference.

But, of all recognitions, the best is that which arises from the incidents themselves, where the startling discovery is made by natural means. Such is that in the *Oedipus* of Sophocles, and in the *Iphigenia*; for it was natural that Iphigenia should wish to dispatch a letter. These recognitions alone dispense with the artificial aid of tokens or amulets. Next come the recognitions by process of reasoning.

17

In constructing the plot and working it out with the proper diction, the poet should place the scene, as far as possible, before his eyes. In this way, seeing everything with the utmost vividness, as if he were a spectator of the action, he will discover what is in keeping with it, and be most unlikely to overlook inconsistencies. The need of such a rule is shown by the fault found in Carcinus. Amphiaraus was on his way from the temple. This fact escaped

the observation of one who did not see the situation. On the stage, however, the piece failed, the audience being offended at the oversight.

Again, the poet should work out his play, to the best of his power, with appropriate gestures; for those who feel emotion are most convincing through natural sympathy with the characters they represent; and one who is agitated storms, one who is angry rages, with the most lifelike reality. Hence poetry implies either a happy gift of nature or a strain of madness. In the one case a man can take the mould of any character; in the other, he is lifted out of his proper self.

As for the story, whether the poet takes it ready made or constructs it for himself, he should first sketch its general outline, and then fill in the episodes and amplify in detail. The general plan may be illustrated by the *Iphigenia*. A young girl is sacrificed; she disappears mysteriously from the eyes of those who sacrificed her; she is transported to another country, where the custom is to offer up all strangers to the goddess. To this ministry she is appointed. Some time later her own brother chances to arrive. The fact that the oracle for some reason ordered him to go there, is outside the general plan of the play. The purpose, again, of his coming is outside the action proper. However, he comes, he is seized, and, when on the point of being sacrificed, reveals who he is. The mode of recognition may be either that of Euripides or of Polyidus, in whose play he exclaims very naturally: 'So it was not my sister only, but I too, who was doomed to be sacrificed'; and by that remark he is saved.

After this, the names being once given, it remains to fill in the episodes. We must see that they are relevant to the action. In the case of Orestes, for example, there is the madness which led to his capture, and his deliverance by means of the purificatory rite. In the drama, the episodes are short, but it is these that give extension to Epic poetry. Thus the story of the *Odyssey* can be stated briefly. A certain man is absent from home for many years; he is jealously watched by Poseidon, and left desolate. Meanwhile his home is in a wretched plight—suitors are wasting his substance and plotting against his son. At length, tempest-tost, he himself arrives;

he makes certain persons acquainted with him; he attacks the suitors with his own hand, and is himself preserved while he destroys them. This is the essence of the plot; the rest is episode.

18

Every tragedy falls into two parts—Complication and Unravelling or *Denouement*. Incidents extraneous to the action are frequently combined with a portion of the action proper, to form the Complication; the rest is the Unravelling. By the Complication I mean all that extends from the beginning of the action to the part which marks the turning-point to good or bad fortune. The Unravelling is that which extends from the beginning of the change to the end. Thus, in the *Lynceus* of Theodectes, the Complication consists of the incidents presupposed in the drama, the seizure of the child, and then again...[the Unravelling] extends from the accusation of murder to the end.

There are four kinds of Tragedy: the Complex, depending entirely on Reversal of the Situation and Recognition; the Pathetic (where the motive is passion)—such as the tragedies on Ajax and Ixion; the Ethical (where the motives are ethical)—such as the *Phthiotides* and the *Peleus*. The fourth kind is the Simple. [We here exclude the purely spectacular element], exemplified by the *Phorcides*, the *Prometheus*, and scenes laid in Hades. The poet should endeavour, if possible, to combine all poetic elements; or failing that, the greatest number and those the most important; the more so, in face of the cavilling criticism of the day. For whereas there have hitherto been good poets, each in his own branch, the critics now expect one man to surpass all others in their several lines of excellence.

In speaking of a tragedy as the same or different, the best test to take is the plot. Identity exists where the Complication and Unravelling are the same. Many poets tie the knot well, but unravel it. Both arts, however, should always be mastered. Again, the poet should remember what has been often said, and not make an Epic structure into a tragedy—by an Epic structure I mean one with a multiplicity of plots—as if, for instance, you were to make a tragedy out of the entire story of the *Iliad*. In the Epic

poem, owing to its length, each part assumes its proper magnitude. In the drama the result is far from answering to the poet's expectation. The proof is that the poets who have dramatized the whole story of the Fall of Troy, instead of selecting portions, like Euripides; or who have taken the whole tale of Niobe, and not a part of her story, like Aeschylus, either fail utterly or meet with poor success on the stage. Even Agathon has been known to fail from this one defect. In his Reversals of the Situation, however, he shows a marvelous skill in the effort to hit the popular taste—to produce a tragic effect that satisfies the moral sense. This effect is produced when the clever rogue, like Sisyphus, is outwitted, or the brave villain defeated. Such an event is probable in Agathon's sense of the word: 'is probable,' he says, 'that many things should happen contrary to probability.'

The Chorus too should be regarded as one of the actors; it should be an integral part of the whole, and share in the action, in the manner not of Euripides but of Sophocles. As for the later poets, their choral songs pertain as little to the subject of the piece as to that of any other tragedy. They are, therefore, sung as mere interludes—a practice first begun by Agathon. Yet what difference is there between introducing such choral interludes, and transferring a speech, or even a whole act, from one play to another.

. . .

23

As to that poetic imitation which is narrative in form and employs a single meter, the plot manifestly ought, as in a tragedy, to be constructed on dramatic principles. It should have for its subject a single action, whole and complete, with a beginning, a middle, and an end. It will thus resemble a living organism in all its unity, and produce the pleasure proper to it. It will differ in structure from historical compositions, which of necessity present not a single action, but a single period, and all that happened within that period to one person or to many, little connected together as the events may be. For as the sea-fight at Salamis and the battle with the Carthaginians in Sicily took place at the same time,

but did not tend to any one result, so in the sequence of events, one thing sometimes follows another, and yet no single result is thereby produced. Such is the practice, we may say, of most poets. Here again, then, as has been already observed, the transcendent excellence of Homer is manifest. He never attempts to make the whole war of Troy the subject of his poem, though that war had a beginning and an end. It would have been too vast a theme, and not easily embraced in a single view. If, again, he had kept it within moderate limits, it must have been over-complicated by the variety of the incidents. As it is, he detaches a single portion, and admits as episodes many events from the general story of the war—such as the Catalogue of the ships and others—thus diversifying the poem. All other poets take a single hero, a single period, or an action single indeed, but with a multiplicity of parts. Thus did the author of the *Cypria* and of the *Little Iliad*. For this reason the *Iliad* and the *Odyssey* each furnish the subject of one tragedy, or, at most, of two; while the *Cypria* supplies materials for many, and the *Little Iliad* for eight—the *Award of the Arms*, the *Philoctetes*, the *Neoptolemus*, the *Eurypylus*, the *Mendicant Odysseus*, the *Laconian Women*, the *Fall of Ileum*, the *Departure of the Fleet*.

. . .

26

The question may be raised whether the Epic or Tragic mode of imitation is the higher. If the more refined art is the higher, and the more refined in every case is that which appeals to the better sort of audience, the art which imitates anything and everything is manifestly most unrefined. The audience is supposed to be too dull to comprehend unless something of their own is thrown by the performers, who therefore indulge in restless movements. Bad flute-players twist and twirl, if they have to represent 'the quoit-throw,' or hustle the coryphaeus when they perform the Scylla. Tragedy, it is said, has this same defect. We may compare the opinion that the older actors entertained of their successors. Mynniscus used to call Callippides 'ape' on account of the extravagance of his action, and the same view was held of Pindarus. Tragic art, then, as a whole,

stands to Epic in the same relation as the younger to the elder actors. So we are told that Epic poetry is addressed to a cultivated audience, who do not need gesture; Tragedy, to an inferior public. Being then unrefined, it is evidently the lower of the two.

Now, in the first place, this censure attaches not to the poetic but to the histrionic art; for gesticulation may be equally overdone in epic recitation, as by Sosistratus, or in lyrical competition, as by Mnasitheus the Opuntian. Next, all action is not to be condemned—any more than all dancing—but only that of bad performers. Such was the fault found in Callippides, as also in others of our own day, who are censured for representing degraded women. Again, Tragedy like Epic poetry produces its effect even without action; it reveals its power by mere reading. If, then, in all other respects it is superior, this fault, we say, is not inherent in it.

And superior it is, because it has all the epic elements—it may even use the epic meter—with the music and spectacular effects as important accessories; and these produce the most vivid of pleasures. Further, it has vividness of impression in reading as well as in representation. Moreover, the art attains its end within narrower limits for the concentrated effect is more pleasurable than one which is spread over a long time and so diluted. What, for example, would be the effect of the *Oedipus* of Sophocles, if it were cast into a form as long as the *Iliad*? Once more, the Epic imitation has less unity; as is shown by this, that any Epic poem will furnish subjects for several tragedies. Thus if the story adopted by the poet has a strict unity, it must either be concisely told and appear truncated; or, if it conforms to the Epic canon of length, it must seem weak and watery. [Such length implies some loss of unity,] if, I mean, the poem is constructed out of several actions, like the *Iliad* and the *Odyssey*, which have many such parts, each with a certain magnitude of its own. Yet these poems are as perfect as possible in structure; each is, in the highest degree attainable, an imitation of a single action.

If, then, tragedy is superior to epic poetry in all these respects, and, moreover, fulfills its specific function better as an art—for each art ought to produce, not any chance pleasure, but the pleasure proper to it, as already stated—it plainly follows that tragedy is the higher art, as attaining its end more perfectly.

Thus much may suffice concerning Tragic and Epic poetry in general; their several kinds and parts, with the number of each and their differences; the causes that make a poem good or bad; the objections of the critics and the answers to these objections.

David Hume (1711-1776)

Of the Standard of Taste

The great variety of Taste, as well as of opinion, which prevails in the world, is too obvious not to have fallen under every one's observation. Men of the most confined knowledge are able to remark a difference of taste in the narrow circle of their acquaintance, even where the persons have been educated under the same government, and have early imbibed the same prejudices. But those, who can enlarge their view to contemplate distant nations and remote ages, are still more surprized at the great inconsistence and contrariety. We are apt to call *barbarous* whatever departs widely from our own taste and apprehension: But soon find the epithet of reproach retorted on us. And the highest arrogance and self-conceit is at last startled, on observing an equal assurance on all sides, and scruples, amidst such a contest of sentiment, to pronounce positively in its own favour.

As this variety of taste is obvious to the most careless enquirer; so will it be found, on examination, to be still greater in reality than in appearance. The sentiments of men often differ with regard to beauty and deformity of all kinds, even while their general discourse is the same. There are certain terms in every language, which import blame, and others praise; and all men, who use the same tongue, must agree in their application of them. Every voice is united in applauding elegance, propriety, simplicity, spirit in writing; and in blaming fustian, affectation, coldness, and a false brilliancy: But when critics come to particulars, this seeming unanimity vanishes; and it is found, that they had affixed a very different meaning to their expressions. In all matters of opinion and science, the case is opposite: The difference among men is there oftener found to lie in generals than in particulars; and to be less in

reality than in appearance. An explanation of the terms commonly ends the controversy; and the disputants are surprized to find, that they had been quarrelling, while at bottom they agreed in their judgment.

Those who found morality on sentiment, more than on reason, are inclined to comprehend ethics under the former observation, and to maintain, that, in all questions, which regard conduct and manners, the difference among men is really greater than at first sight it appears. It is indeed obvious, that writers of all nations and all ages concur in applauding justice, humanity, magnanimity, prudence, veracity; and in blaming the opposite qualities. Even poets and other authors, whose compositions are chiefly calculated to please the imagination, are yet found from HOMER down to FENELON, to inculcate the same moral precepts, and to bestow their applause and blame on the same virtues and vices. This great unanimity is usually ascribed to the influence of plain reason; which, in all these cases, maintains similar sentiments in all men, and prevents those controversies, to which the abstract sciences are so much exposed. So far as the unanimity is real, this account may be admitted as satisfactory: But we must also allow that some part of the seeming harmony in morals may be accounted for from the very nature of language. The word *virtue*, with its equivalent in every tongue, implies praise; as that of *vice* does blame: And no one, without the most obvious and grossest impropriety, could affix reproach to a term, which in general acceptation is understood in a good sense; or bestow applause, where the idiom requires disapprobation. HOMER's general precepts, where he delivers any such, will never be controverted; but it is obvious, that, when he draws particular

pictures of manners, and represents heroism in ACHILLES and prudence in ULYSSES, he intermixes a much greater degree of ferocity in the former, and of cunning and fraud in the latter, than FENELON would admit of. The sage ULYSSES in the GREEK poet seems to delight in lies and fictions, and often employs them without any necessity or even advantage: But his more scrupulous son, in the FRENCH epic writer, exposes himself to the most imminent perils, rather than depart from the most exact line of truth and veracity.

The admirers and followers of the ALCORAN insist on the excellent moral precepts interspersed throughout that wild and absurd performance. But it is to be supposed, that the ARABIC words, which correspond to the ENGLISH, equity, justice, temperence, meekness, charity, were such as, from the constant use of that tongue, must always be taken in a good sense; and it would have argued the greatest ignorance, not of morals, but of language, to have mentioned them with any epithets, besides those of applause and approbation. But would we know, whether the pretended prophet had really attained a just sentiment of morals? Let us attend to his narration; and we shall soon find, that he bestows praise on such instances of treachery, inhumanity, cruelty, revenge, bigotry, as are utterly incompatible with civilized society. No steady rule of right seems there to be attended to; and every action is blamed or praised, so far only as it is beneficial or hurtful to the true believers.

The merit of delivering true general precepts in ethics is indeed very small. Whoever recommends any moral virtues, really does no more than is implied in the terms themselves. That people, who invented the word *charity*, and used it in a good sense, inculcated more clearly and much more efficaciously, the precept, *be charitable*, than any pretended legislator or prophet, who should insert such a *maxim* in his writings. Of all expressions, those, which, together with their other meaning, imply a degree either of blame or approbation, are the least liable to be perverted or mistaken.

It is natural for us to seek a *Standard of Taste*; a rule, by which the various sentiments of men may be reconciled; at least, a decision, afforded, confirming one sentiment, and condemning another.

There is a species of philosophy, which cuts off all hopes of success in such an attempt, and represents the impossibility of ever attaining any standard of taste. The difference, it is said, is very wide between judgment and sentiment. All sentiment is right; because sentiment has a reference to nothing beyond itself, and is always real, wherever a man is conscious of it. But all determinations of the understanding are not right; because they have a reference to something beyond themselves, to wit, real matter of fact; and are not always conformable to that standard. Among a thousand different opinions which different men may entertain of the same subject, there is one, and but one, that is just and true; and the only difficulty is to fix and ascertain it. On the contrary, a thousand different sentiments, excited by the same object, are all right: Because no sentiment represents what is really in the object. It only marks a certain conformity or relation between the object and the organs or faculties of the mind; and if that conformity did not really exist, the sentiment could never possibly have being. Beauty is no quality in things themselves: It exists merely in the mind which contemplates them; and each mind perceives a different beauty. One person may even perceive deformity, where another is sensible of beauty; and every individual ought to acquiesce in his own sentiment, without pretending to regulate those of others. To seek the real beauty, or real deformity, is as fruitless an enquiry, as to pretend to ascertain the real sweet or real bitter. According to the disposition of the organs, the same object may be both sweet and bitter; and the proverb has justly determined it to be fruitless to dispute concerning tastes. It is very natural, and even quite necessary, to extend this axiom to mental, as well as bodily taste; and thus common sense, which is so often at variance with philosophy, especially with the sceptical kind, is found, in one instance at least, to agree in pronouncing the same decision.

But though this axiom, by passing into a proverb, seems to have attained the sanction of common sense; there is certainly a species of common sense which opposes it, at least serves to modify and restrain it. Whoever would assert an equality of genius and elegance between OGILBY and MILTON, or BUNYAN and ADDISON, would be thought to defend no less

an extravagance, than if he had maintained a molehill to be as high as TENERIFFE, or a pond as extensive as the ocean. Though there may be found persons, who give the preference to the former authors; no one pays attention to such a taste; and we pronounce without scruple the sentiment of these pretended critics to be absurd and ridiculous. The principle of the natural equality of tastes is then totally forgot, and while we admit it on some occasions, where the objects seem near an equality, it appears an extravagant paradox, or rather a palpable absurdity, where objects so disproportioned are compared together.

It is evident that none of the rules of composition are fixed by reasonings *a priori*, or can be esteemed abstract conclusions of the understanding, from comparing those habitudes and relations of ideas, which are eternal and immutable. Their foundation is the same with that of all the practical sciences, experience; nor are they any thing but general observations, concerning what has been universally found to please in all countries and in all ages. Many of the beauties of poetry and even of eloquence are founded on falsehood and fiction, on hyperboles, metaphors, and an abuse or perversion of terms from their natural meaning. To check the sallies of the imagination, and to reduce every expression to geometrical truth and exactness, would be the most contrary to the laws of criticism; because it would produce a work, which, by universal experience, has been found the most insipid and disagreeable. But though poetry can never submit to exact truth, it must be confined by rules of art, discovered to the author either by genius or observation. If some negligent or irregular writers have pleased, they have not pleased by their transgressions of rule or order, but in spite of these transgressions: They have possessed other beauties, which were conformable to just criticism; and the force of these beauties has been able to overpower censure, and give the mind a satisfaction superior to the disgust arising from the blemishes. ARIOSTO pleases; but not by his monstrous and improbable fictions, by his bizarre mixture of the serious and comic styles, by the want of coherence in his stories, or by the continual interruptions of his narration. He charms by the force and clearness of his expression, by the readiness and variety of his inventions, and by his natural pictures of the passions, especially those of the gay and amorous kind: And however his faults may diminish our satisfaction, they are not able entirely to destroy it. Did our pleasure really arise from those parts of his poem, which we denominate faults, this would be no objection to criticism in general: It would only be an objection to those particular rules of criticism, which would establish such circumstances to be faults, and would represent them as universally blameable. If they are found to please, they cannot be faults; let the pleasure, which they produce, be ever so unexpected and unaccountable.

But though all the general rules of art are founded only on experience and on the observation of the common sentiments of human nature, we must not imagine, that, on every occasion, the feelings of men will be conformable to these rules. Those finer emotions of the mind are of a very tender and delicate nature, and require the concurrence of many favourable circumstances to make them play with facility and exactness, according to their general and established principles. The least exterior hindrance to such small springs, or the least internal disorder, disturbs their motion, and confounds the operation of the whole machine. When we would make an experiment of this nature, and would try the force of any beauty or deformity, we must choose with care a proper time and place, and bring the fancy to a suitable situation and disposition. A perfect serenity of mind, a recollection of thought, a due attention to the object; if any of these circumstances be wanting, our experiment will be fallacious, and we shall be unable to judge of the catholic and universal beauty. The relation, which nature has placed between the form and the sentiment, will at least be more obscure; and it will require greater accuracy to trace and discern it. We shall be able to ascertain its influence not so much from the operation of each particular beauty, as from the durable admiration, which attends those works, that have survived all the caprices of mode and fashion, all the mistakes of ignorance and envy.

The same HOMER, who pleased at ATHENS and ROME two thousand years ago, is still admired at PARIS and at LONDON. All the changes of climate, government, religion, and language, have not been

able to obscure his glory. Authority or prejudice may give a temporary vogue to a bad poet or orator; but his reputation will never be durable or general. When his compositions are examined by posterity or by foreigners, the enchantment is dissipated, and his faults appear in their true colours. On the contrary, a real genius, the longer his works endure, and the more wide they are spread, the more sincere is the admiration which he meets with. Envy and jealousy have too much place in a narrow circle; and even familiar acquaintance with his person may diminish the applause due to his performances: But when these obstructions are removed, the beauties, which are naturally fitted to excite agreeable sentiments, immediately display their energy; and while the world endures, they maintain their authority over the minds of men.

It appears then, that, amidst all the variety and caprice of taste, there are certain general principles of approbation or blame, whose influence a careful eye may trace in all operations of the mind. Some particular forms or qualities, from the original structure of the internal fabric, are calculated to please, and others to displease; and if they fail of their effect in any particular instance, it is from some apparent defect or imperfection in the organ. A man in a fever would not insist on his palate as able to decide concerning flavours; nor would one, affected with the jaundice, pretend to give a verdict with regard to colours. In each creature, there is a sound and a defective state; and the former alone can be supposed to afford us a true standard of taste and sentiment. If, in the sound state of the organ, there be an entire or a considerable uniformity of sentiment among men, we may thence derive an idea of the perfect beauty; in like manner as the appearance of objects in day-light, to the eye of a man in health, is denominated their true and real colour, even while colour is allowed to be merely a phantasm of the senses.

Many and frequent are the defects in the internal organs, which prevent or weaken the influence of those general principles, on which depends our sentiment of beauty or deformity. Though some objects, by the structure of the mind, be naturally calculated to give pleasure, it is not to be expected, that in every individual the pleasure will be equally felt. Particular incidents and situations occur, which either throw a false light on the objects, or hinder the true from conveying to the imagination the proper sentiment and perception.

One obvious cause, why many feel not the proper sentiment of beauty, is the want of that *delicacy* of imagination, which is requisite to convey a sensibility of those finer emotions. This delicacy every one pretends to: Every one talks of it; and would reduce every kind of taste or sentiment to its standard. But as our intention in this essay is to mingle some light of the understanding with the feelings of sentiment, it will be proper to give a more accurate definition of delicacy, than has hitherto been attempted. And not to draw our philosophy from too profound a sourse, we shall have recourse to a noted story in DON QUIXOTE.

It is with good reason, says SANCHO to the squire with the great nose, that I pretend to have a judgment in wine: This is a quality hereditary in our family. Two of my kinsmen were once called to give their opinion of a hogshead, which was supposed to be excellent, being old and of a good vintage. One of them tastes it; considers it; and after mature reflection pronounces the wine to be good, were it not for a small taste of leather, which he perceived in it. The other, after using the same precautions, gives also his verdict in favour of the wine; but with the reserve of a taste of iron, which he could easily distinguish. You cannot imagine how much they were both ridiculed for their judgment. But who laughed in the end? On emptying the hogshead, there was found at the bottom, an old key with a leathern thong tied to it.

The great resemblance between mental and bodily taste will easily teach us to apply this story. Though it be certain, that beauty and deformity, more than sweet and bitter, are not qualities in objects, but belong entirely to the sentiment, internal or external; it must be allowed, that there are certain qualities in objects, which are fitted by nature to produce those particular feelings. Now as these qualities may be found in a small degree, or may be mixed and confounded with each other, it often happens, that the taste is not affected with such minute

qualities, or is not able to distinguish all the particular flavours, amidst the disorder, in which they are presented. Where the organs are so fine, as to allow nothing to escape them; and at the same time so exact as to perceive every ingredient in the composition: This we call delicacy of taste, whether we employ these terms in the literal or metaphorical sense. Here then the general rules of beauty are of use; being drawn from established models, and from the observation of what pleases or displeases, when presented singly and in a high degree: And if the same qualities, in a continued composition and in a smaller degree, affect not the organs with a sensible delight or uneasiness, we exclude the person from all pretentions to this delicacy. To produce these general rules or avowed patterns of composition is like finding the key with the leathern thong; which justified the verdict of SANCHO's kinsmen, and confounded those pretended judges who had condemned them. Though the hogshead had never been emptied, the taste of the one was still equally delicate, and that of the other equally dull and languid: But it would have been more difficult to have proved the superiority of the former, to the conviction of every by-stander. In like manner, though the beauties of writing had never been methodized, or reduced to general principles; though no excellent models had ever been acknowledged; the different degrees of taste would still have subsisted, and the judgment of one man been preferable to that of another; but it would not have been so easy to silence the bad critic, who might always insist upon his particular sentiment, and refuse to submit to his antagonist. But when we show him an avowed principle of art; when we illustrate this principle by examples, whose operation, from his own particular taste, he acknowledges to be conformable to the principle; when we prove, that the same principle may be applied to the present case, where he did not perceive or feel its influence: He must conclude, upon the whole, that the fault lies in himself, and that he wants the delicacy, which is requisite to make him sensible of every beauty and every blemish, in any composition or discourse.

It is acknowledged to be the perfection of every sense or faculty, to perceive with exactness its most minute objects, and allow nothing to escape its notice and observation. The smaller the objects are, which become sensible to the eye, the finer is that organ, and the more elaborate its make and composition. A good palate is not tried by strong flavours; but by a mixture of small ingredients, where we are still sensible of each part, notwithstanding its minuteness and its confusion with the rest. In like manner, a quick and acute perception of beauty and deformity must be the perfection of our mental taste; nor can a man be satisfied with himself while he suspects, that any excellence or blemish in a discourse has passed him unobserved. In this case, the perfection of the man, and the perfection of the sense or feeling, are found to be united. A very delicate palate, on many occasions, may be a great inconvenience both to a man himself and to his friends: But a delicate taste of wit or beauty must always be a desirable quality; because it is the source of all the finest and most innocent enjoyments, of which human nature is susceptible. In this decision the sentiments of all mankind are agreed. Wherever you can ascertain a delicacy of taste, it is sure to meet with approbation; and the best way of ascertaining it is to appeal to those models and principles, which have been established by the uniform consent an experience of nations and ages.

But though there be naturally a wide difference in point of delicacy between one person and another, nothing tends further to encrease and improve this talent, than *practice* in a particular art, and the frequent survey or contemplation of a particular species of beauty. When objects of any kind are first presented to the eye or imagination, the sentiment, which attends them, is obscure and confused; and the mind is, in a great measure, incapable of pronouncing concerning their merits or defects. The taste cannot perceive the several excellencies of the performance; much less distinguish the particular character of each excellency, and ascertain its quality and degree. If it pronounce the whole in general to be beautiful or deformed, it is the utmost that can be expected; and even this judgment, a person, so unpractised, will be apt to deliver with great hesitation and reserve. But allow him to acquire experience in those objects, his feeling becomes more

exact and nice: He not only perceives the beauties and defects of each part, but marks the distinguishing species of each quality, and assigns it suitable praise or blame. A clear and distinct sentiment attends him through the whole survey of the objects; and he discerns that very degree and kind of approbation or displeasure, which each part is naturally fitted to produce. The mist dissipates, which seemed formerly to hang over the object: The organ acquires greater perfection in its operations; and can pronounce, without danger of mistake, concerning the merits of every performance. In a word, the same address and dexterity, which practice gives to the execution of any work, is also acquired by the same means, in the judging of it.

So advantageous is practice to the discernment of beauty, that, before we can give judgment on any work of importance, it will even be requisite, that that very individual performance be more than once perused by us, and be surveyed in different lights with attention and deliberation. There is a flutter or hurry of thought which attends the first perusal of any piece, and which confounds the genuine sentiment of beauty. The relation of the parts is not discerned: The true characters of style are little distinguished: The several perfections and defects seem wrapped up in a species of confusion, and present themselves indistinctly to the imagination. Not to mention, that there is a species of beauty, which, as it is florid and superficial, pleases at first; but being found incompatible with a just expression either of reason or passion, soon palls upon the taste, and is then rejected with disdain, at least rated at a much lower value.

It is impossible to continue in the practice of contemplating any order of beauty, without being frequently obliged to form *comparisons* between the several species and degrees of excellence, and estimating their proportion to each other. A man, who has had no opportunity of comparing the different kinds of beauty, is indeed totally unqualified to pronounce an opinion with regard to any object presented to him. By comparison alone we fix the epithets of praise or blame, and learn how to assign the due degree of each. The coarsest daubing contains a certain lustre of colours and exactness of imitation, which are so far beauties, and would affect the mind of a peasant or Indian with the highest admiration. The most vulgar ballads are not entirely destitute of harmony or nature; and none but a person, familiarized to superior beauties, would pronounce their numbers harsh, or narration uninteresting. A great inferiority of beauty gives pain to a person conversant in the highest excellence of the kind, and is for that reason pronouncd a deformity: As the most finished object, with which we are acquainted, is naturally supposed to have reached the pinnacle of perfection, and to be entitled to the highest applause. One accustomed to see, and examine, and weigh the several performances, admired in different ages and nations, can alone rate the merits of a work exhibited to his view, and assign its proper rank among the productions of genius.

But to enable a critic the more fully to execute this undertaking, he must preserve his mind free from all *prejudice*, and allow nothing to enter into his consideration, but the very object which is submitted to his examination. We may observe, that every work of art, in order to produce its due effect on the mind, must be surveyed in a certain point of view, and cannot be fully relished by persons, whose situation, real or imaginary, is not conformable to that which is required by the performance. An orator addresses himself to a particular audience, and must have a regard to their particular genius, interests, opinions, passions, and prejudices; otherwise he hopes in vain to govern their resolutions, and inflame their affections. Should they even have entertained some prepossessions against him, however unreasonable, he must not overlook this disadvantage; but, before he enters upon the subject, must endeavour to conciliate their affection, and acquire their good graces. A critic of a different age or nation, who should peruse this discourse, must have all these circumstances in his eye, and must place himself in the same situation as the audience, in order to form a true judgment of the oration. In like manner, when any work is addressed to the public, though I should have a friendship or enmity with the author, I must depart from this situation; and considering myself as a man in general, forget, if possible, my individual being and my peculiar circumstances.

A person influenced by prejudice, complies not with this condition; but obstinately maintains his natural position, without placing himself in that point of view, which the performance supposes. If the work be addressed to persons of a different age or nation, he makes no allowance for their peculiar views and prejudices; but, full of the manners of his own age and country, rashly condemns what seemed admirable in the eyes of those for whom alone the discourse was calculated. If the work be executed for the public, he never sufficiently enlarges his comprehension, or forgets his interest as a friend or enemy, as a rival or commentator. By this means, his sentiments are perverted; nor have the same beauties and blemishes the same influence upon him, as if he had imposed a proper violence on his imagination, and had forgotten himself for a moment. So far his taste evidently departs from the true standard; and of consequence loses all credit and authority.

It is well known, that in all questions, submitted to the understanding, prejudice is destructive of sound judgment, and perverts all operations of the intellectual faculties: It is no less contrary to good taste; nor has it less influence to corrupt our sentiment of beauty. It belongs to *good sense* to check its influence in both cases; and in this respect, as well as in many others, reason, if not an essential part of taste, is at least requisite to the operations of this latter faculty. In all the nobler productions of genius, there is a mutual relation and correspondence of parts; nor can either the beauties or blemishes be perceived by him, whose thought is not capacious enough to comprehend all those parts, and compare them with each other, in order to perceive the consistence and uniformity of the whole. Every work of art has also a certain end or purpose, for which it is calculated; and is to be deemed more or less perfect, as it is more or less fitted to attain this end. The object of eloquence is to persuade, of history to instruct, of poetry to please by means of the passions and the imagination. These ends we must carry constantly in our view, when we peruse any performance; and we must be able to judge how far the means employed are adapted to their respective purposes. Besides, every kind of composition, even the most

poetical, is nothing but a chain of propositions and reasonings; not always, indeed, the justest and most exact, but still plausible and specious, however disguised by the colouring of the imagination. The persons introduced in tragedy and epic poetry, must be represented as reasoning, and thinking, and concluding, and acting, suitably to their character and circumstances; and without judgment, as well as taste and invention, a poet can never hope to succeed in so delicate an undertaking. Not to mention, that the same excellence of faculties which contributes to the improvement of reason, the same clearness of conception, the same exactness of distinction, the same vivacity of apprehension, are essential to the operations of true taste, and are its infallible concomitants. It seldom, or never happens, that a man of sense, who has experience in any art, cannot judge of its beauty; and it is no less rare to meet with a man who has a just taste without a sound understanding.

Thus, though the principles of taste be universal, and nearly, if not entirely the same in all men; yet few are qualified to give judgment on any work of art, or establish their own sentiment as the standard of beauty. The organs of internal sensation are seldom so perfect as to allow the general principles their full play, and produce a feeling correspondent to those principles. They either labour under some defect, or are vitiated by some disorder; and by that means, excite a sentiment, which may be pronounced erroneous. When the critic has no delicacy, he judges without any distinction, and is only affected by the grosser and more palpable qualitites of the object: The finer touches pass unnoticed and disregarded. Where he is not aided by practice, his verdict is attended with confusion and hesitation. Where no comparison has been employed, the most frivolous beauties, such as rather merit the name of defects, are the object of his admiration. Where he lies under the influence of prejudice, all his natural sentiments are perverted. Where good sense is wanting, he is not qualified to discern the beauties of design and reasoning, which are the highest and most excellent. Under some or other of these imperfections, the generality of men labour; and hence a true judge in the finer arts is observed, even during the most

polished ages, to be so rare a character: Strong sense, united to delicate sentiment, improved by practice, perfected by comparison, and cleared of all prejudice, can alone entitle critics to this valuable character; and the joint verdict of such, wherever they are to be found, is the true standard of taste and beauty.

But where are such critics to be found? By what marks are they to be known? How distinguish them from pretenders? These questions are embarrassing; and seem to throw us back into the same uncertainty, from which, during the course of this essay, we have endeavoured to extricate ourselves.

But if we consider the matter aright, these are questions of fact, not of sentiment. Whether any particular person be endowed with good sense and a delicate imagination, free from prejudice, may often be the subject of dispute, and be liable to great discussion and enquiry: But that such a character is valuable and estimable will be agreed in by all mankind. Where these doubts occur, men can do no more than in other disputable questions, which are submitted to the understanding: They must produce the best arguments, that their invention suggests to them; they must acknowledge a true and decisive standard to exist somewhere, to wit, real existence and matter of fact; and they must have indulgence to such as differ from them in their appeals to this standard. It is sufficient for our present purpose, if we have proved, that the taste of all individuals is not upon an equal footing, and that some men in general, however difficult to be particularly pitched upon, will be acknowledged by universal sentiment to have a preference above others.

But in reality the difficulty of finding, even in particulars, the standard of taste, is not so great as it is represented. Though in speculation, we may readily avow a certain criterion in science and deny it in sentiment, the matter is found in practice to be much more hard to ascertain in the former case than in the latter. Theories of abstract philosophy, systems of profound theology, have prevailed during one age: In a successive period, these have been universally exploded: Their absurdity has been detected: Other theories and systems have supplied their place, which again gave place to their successors: And nothing

has been experienced more liable to the revolutions of chance and fashion than these pretended decisions of science. The case is not the same with the beauties of eloquence and poetry. Just expressions of passion and nature are sure, after a little time, to gain public applause, which they maintain for ever. Aristotle, and Plato, and Epicurus, and Descartes, may successively yield to each other: But Terence and Virgil maintain an universal, undisputed empire over the minds of men. The abstract philosophy of Cicero has lost its credit: The vehemence of his oratory is still the object of our admiration.

Though men of delicate taste be rare, they are easily to be distinguished in society, by the soundness of their understanding and the superiority of their faculties above the rest of mankind. The ascendant, which they acquire, gives a prevalence to that lively approbation, with which they receive any productions of genius, and renders it generally predominant. Many men, when left to themselves, have but a faint and dubious perception of beauty, who yet are capable of relishing any fine stroke, which is pointed out to them. Every convert to the admiration of the real poet or orator is the cause of some new conversion. And though prejudices may prevail for a time, they never unite in celebrating any rival to the true genius, but yield at last to the force of nature and just sentiment. Thus, though a civilized nation may easily be mistaken in the choice of their admired philosopher, they never have been found long to err, in their affection for a favourite epic or tragic author.

But notwithstanding all our endeavours to fix a standard of taste, and reconcile the discordant apprehensions of men, there still remain two sources of variation, which are not sufficient indeed to confound all the boundaries of beauty and deformity, but will often serve to produce a difference in the degrees of our approbation or blame. The one is the different humours of particular men; the other, the particular manners and opinions of our age and country. The general principles of taste are uniform in human nature: Where men vary in their judgments, some defect or perversion in the faculties may commonly be remarked; proceeding either from

prejudice, from want of practice, or want of delicacy; and there is just reason for approving one taste, and condemning another. But where there is such a diversity in the internal frame or external situation as is entirely blameless on both sides, and leaves no room to give one the preference above the other; in that case a certain degree of diversity in judgment is unavoidable, and we seek in vain for a standard, by which we can reconcile the contrary sentiments.

A young man, whose passions are warm, will be more sensibly touched with amorous and tender images, than a man more advanced in years, who takes pleasure in wise, philosophical reflections concerning the conduct of life and moderation of the passions. At twenty, OVID may be the favourite author; HORACE at forty; and perhaps TACITUS at fifty. Vainly would we, in such cases, endeavour to enter into the sentiments of others, and divest ourselves of those propensities, which are natural to us. We choose our favourite author as we do our friend, from a conformity of humour and disposition. Mirth or passion, sentiment or reflection; whichever of these most predominates in our temper, it gives us a peculiar sympathy with the writer who resembles us.

One person is more pleased with the sublime; another with the tender; a third with raillery. One has a strong sensibility to blemishes, and is extremely studious of correctness: Another has a more lively feeling of beauties, and pardons twenty absurdities and defects for one elevated or pathetic stroke. The ear of this man is entirely turned towards conciseness and energy; that man is delighted with a copious, rich, and harmonious expression. Simplicity is affected by one; ornament by another. Comedy, tragedy, satire, odes, have each its partizans, who prefer that particular species of writing to all others. It is plainly an error in a critic, to confine his approbation to one species or style of writing, and condemn all the rest. But it is almost impossible not to feel a predilection for that which suits our particular turn and disposition. Such preferences are innocent and unavoidable, and can never reasonably be the object of dispute, because there is no standard, by which they can be decided.

For a like reason, we are more pleased, in the course of our reading, with pictures and characters, that resemble objects which are found in our own age or country, than with those which describe a different set of customs. It is not without some effort, that we reconcile ourselves to the simplicity of ancient manners, and behold princesses carrying water from the spring, and kings and heroes dressing their own victuals. We may allow in general, that the representation of such manners is no fault in the author, nor deformity in the piece; but we are not so sensibly touched with them. For this reason, comedy is not easily transferred from one age or nation to another. A FRENCHMAN or ENGLISHMAN is not pleased with the ANDRIA of TERENCE, or CLITIA of MACHIAVEL; where the fine lady, upon whom all the play turns, never once appears to the spectators, but is always kept behind the scenes, suitably to the reserved humour of the ancient GREEKS and modern ITALIANS. A man of learning and reflection can make allowance for these peculiarities of manners; but a common audience can never divest themselves so far of their usual ideas and sentiments, as to relish pictures which no wise resemble them.

But here there occurs a reflection, which may, perhaps, be useful in examining the celebrated controversy concerning ancient and modern learning; where we often find the one side excusing any seeming absurdity in the ancients from the manners of the age, and the other refusing to admit this excuse, or at least, admitting it only as an apology for the author, not for the performance. In my opinion, the proper boundaries in this subject have seldom been fixed between the contending parties. Where any innocent peculiarities of manners are represented, such as those above mentioned, they ought certainly to be admitted; and a man, who is shocked with them, gives an evident proof of false delicacy and refinement. The poet's *monument more durable than brass*, must fall to the ground like common brick or clay, were men to make no allowance for the continual revolutions of manners and customs, and would admit of nothing but what was suitable to the prevailing fashion. Must we throw aside the pictures of our ancestors, because of their ruffs and fardingales? But where the ideas of morality and decency alter from one age to another, and where vicious manners are described, without being

marked with the proper characters of blame and disapprobation; this must be allowed to disfigure the poem, and to be a real deformity. I cannot, nor is it proper I should, enter into such sentiments; and however I may excuse the poet, on account of the manners of his age, I never can relish the composition. The want of humanity and of decency, so conspicuous in the characters drawn by several of the ancient poets, even sometimes by HOMER and the GREEK tragedians, diminishes considerably the merit of their noble performances, and gives modern authors an advantage over them. We are not interested in the fortunes and sentiments of such rough heroes: We are displeased to find the limits of vice and virtue so much confounded: And whatever indulgence we may give to the writer on account of his prejudices, we cannot prevail on ourselves to enter into his sentiments, or bear an affection to characters, which we plainly discover to be blameable.

The case is not the same with moral principles, as with speculative opinions of any kind. These are in continual flux and revolution. The son embraces a different system from the Father. Nay, there scarcely is any man, who can boast of great constancy and uniformity in this particular. Whatever speculative errors may be found in the polite writings of any age or country, they detract but little from the value of those compositions. There needs but a certain turn of thought or imagination to make us enter into all the opinions, which then prevailed, and relish the sentiments or conclusions derived from them. But a very violent effort is requisite to change our judgment of manners, and excite sentiments of approbation or blame, love or hatred, different from those to which the mind from long custom has been familiarized. And where a man is confident of the rectitude of that moral standard, by which he judges, he is justly jealous of it, and will not pervert the sentiments of his heart for a moment, in complaisance to any writer whatsoever.

Of all speculative errors, those which regard religion, are the most excusable in compositions of genius; nor is it ever permitted to judge of the civility or wisdom of any people, or even of single persons, by the grossness or refinement of their theological principles. The same good sense, that directs men in the ordinary occurences of life, is not hearkened

to in religious matters, which are supposed to be placed altogether above the cognizance of human reason. On this account, all the absurdities of the pagan system of theology must be overlooked by every critic, who would pretend to form a just notion of ancient poetry; and our posterity, in their turn, must have the same indulgence to their forefathers. No religious principles can ever be imputed as a fault to any poet, while they remain merely principles, and take not such strong possession of his heart, as to lay him under the imputation of *bigotry* or *superstition*. Where that happens, they confound the sentiments of morality, and alter the natural boundaries of vice and virtue. They are therefore eternal blemishes, according to the principle above mentioned; nor are the prejudices and false opinions of the age sufficient to justify them.

It is essential to the ROMAN catholic religion to inspire a violent hatred of every other worship, and to represent all pagans, mahometans, and heretics as the objects of divine wrath and vengeance. Such sentiments, though they are in reality very blameable, are considered as virtues by the zealots of that communion, and are represented in their tragedies and epic poems as a kind of divine heroism. This bigotry has disfigured two very fine tragedies of the FRENCH theatre, POLIEUCTE and ATHALIA; where an intemperate zeal for particular modes of worship is set off with all the pomp imaginable, and forms the predominant character of the heroes. "What is this," says the sublime JOAD to JOSABET, finding her in discourse with MATHAN, the priest of BAAL, "Does the daughter of DAVID speak to this traitor? Are you not afraid, lest the earth should open and pour forth flames to devour you both? Or lest these holy walls should fall and crush you together? What is his purpose? Why comes that enemy of God hither to poison the air, which we breathe, with his horrid presence?" Such sentiments are received with great applause on the theatre of PARIS; but at LONDON the specators would be full as much pleased to hear ACHILLES tell AGAMEMNON, that he was a dog in his forehead, and a deer in his heart, or JUPITER threaten JUNO with a sound drubbing, if she will not be quiet.

RELIGIOUS principles are also a blemish in any polite composition, when they rise up to superstition, and intrude themselves into every sentiment, however

remote from any connection with religion. It is no excuse for the poet, that the customs of his country had burthened life with so many religious ceremonies and observances, that no part of it was exempt from that yoke. It must for ever be ridiculous in PETRARCH to compare his mistress, LAURA, to JESUS CHRIST. Nor is it less ridiculous in that agreeable libertine, BOCCACE, very seriously to give thanks to GOD ALMIGHTY and the ladies, for their assistance in defending him against his enemies.

Immanuel Kant (1724-1804)

Selections from
Analytic of the Beautiful and Analytic of the Sublime

Translated by J. D. Bernard

FIRST DIVISION

Analytic of the Aesthetical Judgment

FIRST BOOK

ANALYTIC OF THE BEAUTIFUL

FIRST MOMENT

OF THE JUDGMENT OF TASTE, [1] ACCORDING TO QUALITY

§ 1. THE JUDGMENT OF TASTE IS AESTHETICAL

In order to distinguish whether anything is beautiful or not, we refer the representation, not by the understanding to the object for cognition, but by the imagination (perhaps in conjunction with the understanding) to the subject and its feeling of pleasure or pain. The judgment of taste is therefore not a judgment of cognition, and is consequently not logical but aesthetical, by which we understand that whose determining ground can be *no other than subjective*. Every reference of representations, even that of sensations, may be objective (and then it signifies the real [element] of an empirical representation),

save only the reference to the feeling of pleasure and pain, by which nothing in the object is signified, but through which there is a feeling in the subject as it is affected by the representation.

To apprehend a regular, purposive building by means of one's cognitive faculty (whether in a clear or a confused way of representation) is something quite different from being conscious of this representation as connected with the sensation of satisfaction. Here the representation is altogether referred to the subject and to its feeling of life, under the name of the feeling of pleasure or pain. This establishes a quite separate faculty of distinction and of judgment, adding nothing to cognition, but only comparing the given representation in the subject with the whole faculty of representations, of which the mind is conscious in the feeling of its state. Given representations in a judgment can be empirical (consequently, aesthetical); but the judgment which is formed by means of them is logical, provided they are referred in the judgment to the object. Conversely, if the given representations are rational, but are referred in a judgment simply to the subject (to its feeling), the judgment is so far always aesthetical.

§ 2. THE SATISFACTION WHICH DETERMINES THE JUDGMENT OF TASTE IS DISINTERESTED

The satisfaction which we combine with the representation of the existence of an object is called "interest." Such satisfaction always has reference to the faculty of desire, either as its determining ground or as necessarily connected with its determining ground. Now when the question is if a thing is

1. The definition of "taste" which is laid down here is that it is the faculty of judging the beautiful. But the anaylsis of judgments of taste must show what is required in order to call an object beautiful. The moments to which this judgment has regard in its reflection I have sought in accordance with the guidance of the logical functions of judgment (for in a judgment of taste a reference to the understanding is always involved). I have considered the moment of quality first because the aesthetical judgment upon the beautiful first pays attention to it.

beautiful, we do not want to know whether anything depends or can depend on the existence of the thing, either for myself or for anyone else, but how we judge it by mere observation (intuition or reflection). If anyone asks me if I find that palace beautiful which I see before me, I may answer: I do not like things of that kind which are made merely to be stared at. Or I can answer like that Iroquois Sachem, who was pleased in Paris by nothing more than by the cook shops. Or again, after the manner of Rousseau, I may rebuke the vanity of the great who waste the sweat of the people on such superfluous things. In fine, I could easily convince myself that if I found myself on an uninhabited island without the hope of ever again coming among men, and could conjure up just such a splendid building by my mere wish, I should not even give myself the trouble if I had a sufficiently comfortable hut. This may all be admitted and approved, but we are not now talking of this. We wish only to know if this mere representation of the object is accompanied in me with satisfaction, however indifferent I may be as regards the existence of the object of this representation. We easily see that, in saying it is *beautiful* and in showing that I have taste, I am concerned, not with that in which I depend on the existence of the object, but with that which I make out of this representation in myself. Everyone must admit that a judgment about beauty, in which the least interest mingles, is very partial and is not a pure judgment of taste. We must not be in the least prejudiced in favor of the existence of the things, but be quite indifferent in this respect, in order to play the judge in things of taste.

We cannot, however better elucidate this proposition, which is of capital importance, than by contrasting the pure disinterested[2] satisfaction in judgments of taste with that which is bound up with an interest, especially if we can at the same time be certain that there are no other kinds of interest than those which are to be now specified.

2. A judgment upon an object of satisfaction may be quite *disinterested*, but yet very *interesting*, i.e. not based upon an interest, but bringing an interest with it; of this kind are all pure moral judgments. Judgments of taste, however, do not in themselves establish any interest. Only in society is it *interesting* to have taste; the reason of this will be shown in the sequel.

§ 3. THE SATISFACTION IN THE PLEASANT IS BOUND UP WITH INTEREST

That which pleases the senses in sensation is "pleasant." Here the opportunity presents itself of censuring a very common confusion of the double sense which the word "sensation" can have, and of calling attention to it. All satisfaction (it is said or thought) is itself sensation (of a pleasure). Consequently everything that pleases is pleasant because it pleases (and according to its different degrees or its relations to other pleasant sensations it is *agreeable*, *lovely*, *delightful*, *enjoyable*, etc.) But if this be admitted, then impressions of sense which determine the inclination, fundamental propositions of reason which determine the will, mere reflective forms of intuition which determine the judgment, are quite the same as regards the effect upon the feeling of pleasure. For this would be pleasantness in the sensation of one's state; and since in the end all the operations of our faculties must issue in the practical and unite in it as their goal, we could suppose no other way of estimating things and their worth than that which consists in the gratification that they promise. It is of no consequence at all how this is attained, and since then the choice of means alone could make a difference, men could indeed blame one another for stupidity and indiscretion, but never for baseness and wickedness. For thus they all, each according to his own way of seeing things, seek one goal, that is, gratification.

If a determination of the feeling of pleasure or pain is called sensation, this expression signifies something quite different from what I mean when I call the representation of a thing (by sense, as a receptivity belonging to the cognitive faculty) sensation. For in the latter case the representation is referred to the object, in the former simply to the subject, and is available for no cognition whatever, not even for that by which the subject *cognizes* itself.

In the above elucidation we understand by the word "sensation" an objective representation of sense; and, in order to avoid misinterpretation, we shall call that which must always remain merely subjective and can constitute absolutely no representation of an object by the ordinary term "feeling." The green color of the meadows belongs to

objective sensation, as a perception of an object of sense; the pleasantness of this belongs to *subjective* sensation by which no object is represented, i.e. to feeling, by which the object is considered as an object of satisfaction (which does not furnish a cognition of it).

Now that a judgment about an object by which I describe it as pleasant expresses an interest in it, is plain from the fact that by sensation it excites a desire for objects of that kind; consequently the satisfaction presupposes, not the mere judgment about it, but the relation of its existence to my state, so far as this is affected by such an object. Hence we do not merely say of the pleasant, *it pleases*, but, *it gratifies*. I give to it no mere assent, but inclination is aroused by it; and in the case of what is pleasant in the most lively fashion there is no judgment at all upon the character of the object, for those [persons] who always lay themselves out for enjoyment (for that is the word describing intense gratification) would fain dispense with all judgment.

§ 4. THE SATISFACTION IN THE GOOD IS BOUND UP WITH INTEREST

Whatever by means of reason pleases through the mere concept is *good*. That which pleases only as a means we call *good for something* (the useful), but that which pleases for itself is *good in itself*. In both there is always involved the concept of a purpose, and consequently the relation of reason to the (at least possible) volition, and thus a satisfaction in the *presence* of an object or an action, i.e. some kind of interest.

In order to find anything good, I must always know what sort of a thing the object ought to be, i.e. I must have a concept of it. But there is no need of this to find a thing beautiful. Flowers, free delineations, outlines intertwined with one another without design and called [conventional] foliage, have no meaning, depend on no definite concept, and yet they please. The satisfaction in the beautiful must depend on the reflection upon an object, leading to any concept (however indefinite), and it is thus distinguished from the pleasant, which rests entirely upon sensation.

It is true, the pleasant seems in many cases to be the same as the good. Thus people are accustomed to say that all gratification (especially if it lasts) is good in itself, which is very much the same as to say that lasting pleasure and the good are the same. But we can soon see that this is merely a confusion of words, for the concepts which properly belong to these expressions can in no way be interchanged. The pleasant, which, as such, represents the object simply in relation to sense, must first be brought by the concept of a purpose under principles of reason, in order to call it good, as an object of the will. But that there is [involved] a quite different relation to satisfaction in calling that which gratifies at the same time *good* may be seen from the fact that, in the case of the good, the question always is whether it is mediately or immediately good (useful or good in itself); but on the contrary in the case of the pleasant, there can be no question about this at all, for the word always signifies something which pleases immediately. (The same is applicable to what I call beautiful.)

Even in common speech men distinguish the pleasant from the good. Of a dish which stimulates the taste by spices and other condiments we say unhesitatingly that it is pleasant, though it is at the same time admitted not to be good; for though it immediately *delights* the senses, yet mediately, i.e. considered by reason which looks to the after results, it displeases. Even in the judging of health we may notice this distinction. It is immediately pleasant to everyone possessing it (at least negatively, i.e. as the absence of all bodily pains). But in order to say that it is good, it must be considered by reason with reference to purposes, viz. that it is a state which makes us fit for all our business. Finally, in respect of happiness, everyone believes himself entitled to describe the greatest sum of the pleasantness of life (as regards both their number and their duration) as a true, even as the highest, good. However, reason is opposed to this. Pleasantness is enjoyment. And if we were concerned with this alone, it would be foolish to be scrupulous as regards the means which procure it for us, or [to care] whether it is obtained passively by the bounty of nature or by our own activity and work. But reason can never be persuaded

that the existence of a man who merely lives for *enjoyment* (however busy he may be in this point of view) has a worth in itself, even if he at the same time is conducive as a means to the best enjoyment of others and shares in all their gratifications by sympathy. Only what he does, without reference to enjoyment, in full freedom and independently of what nature can procure for him passively, gives an [absolute][3] worth to his presence [in the world] as the existence of a person; and happiness, with the whole abundance of its pleasures, is far from being an unconditioned good.[4]

However, notwithstanding all this difference between the pleasant and the good, they both agree in this that they are always bound up with an interest in their object; so are not only the pleasant (§ 3), and the mediate good (the useful) which is pleasing as a means toward pleasantness somewhere, but also that which is good absolutely and in every aspect, viz. moral good, which brings with it the highest interest. For the good is the object of will (i.e. of a faculty of desire determined by reason). But to wish for something and to have a satisfaction in its existence, i.e. to take an interest in it, are identical.

§ 5. COMPARISON OF THE THREE SPECIFICALLY DIFFERENT KINDS OF SATISFACTION

The pleasant and the good have both a reference to the faculty of desire, and they bring with them, the former a satisfaction pathologically conditioned (by impulses, *stimuli*), the latter a pure practical satisfaction which is determined not merely by the representation of the object but also by the represented connection of the subject with the existence of the object. [It is not merely the object that pleases, but also its existence.][5] On the other hand, the judgment of taste is merely *contemplative*; i.e., it is a judgment which, indifferent as regards the existence of an object, compares its character with the feeling

of pleasure and pain. But this contemplation itself is not directed to concepts; for the judgment of taste is not a cognitive judgment (either theoretical or practical), and thus is not *based* on concepts, nor has it concepts as its *purpose*.

The pleasant, the beautiful, and the good designate then three different relations of representations to the feeling of pleasure and pain, in reference to which we distinguish from one another objects or methods of representing them. And the expressions corresponding to each, by which we mark our complacency in them, are not the same. That which *gratifies* a man is called *pleasant*; that which merely *pleases* him is *beautiful*; that which is *esteemed* [or *approved*][6] by him, i.e. that to which he accords an objective worth, is *good*. Pleasantness concerns irrational animals also, but beauty only concerns men, i.e. animal, but still rational, beings—not merely *quâ* rational (e.g. spirits), but *quâ* animal also—and the good concerns every rational being in general. This is a proposition which can only be completely established and explained in the sequel. We may say that, of all these three kinds of satisfaction, that of taste in the beautiful is alone a disinterested and *free* satisfaction; for no interest, either of sense or of reason, here forces our assent. Hence we may say of satisfaction that it is related in the three aforesaid cases to *inclination*, to *favor*, or to *respect*. Now *favor* is the only free satisfaction. An object of inclination and one that is proposed to our desire by a law of reason leave us no freedom in forming for ourselves anywhere an object of pleasure. All interest presupposes or generates a want, and, as the determining ground of assent, it leaves the judgment about the object no longer free.

As regards the interest of inclination in the case of the pleasant, everyone says that hunger is the best sauce, and everything that is eatable is relished by people with a healthy appetite; and thus a satisfaction of this sort shows no choice directed by taste. It is only when the want is appeased that we can distinguish which of many men has or has not taste. In the same way there may be manners (conduct) without virtue, politeness without good will, decorum without modesty, etc. For where the moral law

3. [Second edition.]

4. An obligation to enjoyment is a manifest absurdity. Thus the obligation to all actions which have merely enjoyment for their aim can only be a pretended one, however spiritually it may be conceived (or decked out), even if it is a mystical, or so-called heavenly, enjoyment.

5. [Second edition.]

6. [Second edition.]

speaks there is no longer, objectively, a free choice as regards what is to be done; and to display taste in its fulfillment (or in judging of another's fulfillment of it) is something quite different from manifesting the moral attitude of thought. For this involves a command and generates a want, while moral taste only plays with the objects of satisfaction, without attaching itself to one of them.

Explanation of the Beautiful Resulting from the First Moment

Taste is the faculty of judging of an object or a method of representing it by an *entirely disinterested* satisfaction or dissatisfaction. The object of such satisfaction is called *beautiful*.[7]

SECOND MOMENT

OF THE JUDGMENT OF TASTE, ACCORDING TO QUANTITY

§ 6. THE BEAUTIFUL IS THAT WHICH APART FROM CONCEPTS IS REPRESENTED AS THE OBJECT OF A UNIVERSAL SATISFACTION

This explanation of the beautiful can be derived from the preceding explanation of it as the object of an entirely disinterested satisfaction. For the fact of which everyone is conscious, that the satisfaction is for him quite disinterested, implies in his judgment a ground of satisfaction for all men. For since it does not rest on any inclination of the subject (nor upon any other premeditated interest), but since the person who judges feels himself quite *free* as regards the satisfaction which he attaches to the object, he

cannot find the ground of this satisfaction in any private conditions connected with his own subject, and hence it must be regarded as grounded on what he can presuppose in every other person. Consequently he must believe that he has reason for attributing a similar satisfaction to everyone. He will therefore speak of the beautiful as if beauty were a characteristic of the object and the judgment logical (constituting a cognition of the object by means of concepts of it), although it is only aesthetical and involves merely a reference of the representation of the object to the subject. For it has this similarity to a logical judgment that we can presuppose its validity for all men. But this universality cannot arise from concepts; for from concepts there is no transition to the feeling of pleasure or pain (except in pure practical laws, which bring an interest with them such as is not bound up with the pure judgment of taste). Consequently the judgment of taste, accompanied with the consciousness of separation from all interest, must claim validity for every man, without this universality depending on objects. That is, there must be bound up with it a title to subjective universality.

§ 7. COMPARISON OF THE BEAUTIFUL WITH THE PLEASANT AND THE GOOD BY MEANS OF THE ABOVE CHARACTERISTIC

As regards the pleasant, everyone is content that his judgment, which he bases upon private feeling and by which he says of an object that it pleases him, should be limited merely to his own person. Thus he is quite contented that if he says, "Canary wine is pleasant," another man may correct his expression and remind him that he ought to say, "It is pleasant *to me*." And this is the case not only as regards the taste of the tongue, the palate, and the throat, but for whatever is pleasant to anyone's eyes and ears. To one, violet color is soft and lovely; to another, it is washed out and dead. One man likes the tone of wind instruments, another that of strings. To strive here with the design of reproving as incorrect another man's judgment which is different from our own, as if the judgments were logically opposed, would be folly. As regards the pleasant, therefore, the fundamental proposition is valid: *everyone has his own taste* (the taste of sense).

7. [Uberweg points out (*History of Philosophy*, *II*, 528, English translation) that Mendelssohn had already called attention to the disinterestedness of our satisfaction in the beautiful. "It appears," says Mendelssohn, "to be a particular mark of the beautiful, that it is contemplated with quiet satisfaction, that it pleases, even though it be not in our possession, and even though we be never so far removed from the desire to put it to our use." But, of course, as Uberweg remarks, Kant's conception of disinterestedness extends far beyond the idea of merely not desiring to possess the object.]

The case is quite different with the beautiful. It would (on the contrary) be laughable if a man who imagined anything to his own taste thought to justify himself by saying: "This object (the house we see, the coat that person wears, the concert we hear, the poem submitted to our judgment) is beautiful *for me*." For he must not call it *beautiful* if it merely pleases him. Many things may have for him charm and pleasantness—no one troubles himself at that—but if he gives out anything as beautiful, he supposes in others the same satisfaction; he judges not merely for himself, but for everyone, and speaks of beauty as if it were a property of things. Hence he says "the *thing* is beautiful"; and he does not count on the agreement of others with this his judgment of satisfaction, because he has found this agreement several times before, but he *demands* it of them. He blames them if they judge otherwise and he denies them taste, which he nevertheless requires from them. Here, then, we cannot say that each man has his own particular taste. For this would be as much as to say that there is no taste whatever, i.e. no aesthetical judgment which can make a rightful claim upon everyone's assent.

At the same time we find as regards the pleasant that there is an agreement among men in their judgments upon it in regard to which we deny taste to some and attribute it to others, by this not meaning one of our organic senses, but a faculty of judging in respect of the pleasant generally. Thus we say of a man who knows how to entertain his guests with pleasures (of enjoyment for all the senses), so that they are all pleased, "he has taste." But here the universality is only taken comparatively; and there emerge rules which are only *general* (like all empirical ones), and not *universal*, which latter the judgment of taste upon the beautiful undertakes or lays claim to. It is a judgment in reference to sociability, so far as this rests on empirical rules. In respect of the good it is true that judgments make rightful claim to validity for everyone; but the good is represented only *by means of a concept* as the object of a universal satisfaction, which is the case neither with the pleasant nor with the beautiful.

§ 8. THE UNIVERSALITY OF THE SATISFACTION IS REPRESENTED IN A JUDGMENT OF TASTE ONLY AS SUBJECTIVE

This particular determination of the universality of an aesthetical judgment, which is to be met with in a judgment of taste, is noteworthy, not indeed for the logician, but for the transcendental philosopher. It requires no small trouble to discover its origin, but we thus detect a property of our cognitive faculty which without this analysis would remain unknown.

First, we must be fully convinced of the fact that in a judgment of taste (about the beautiful) the satisfaction in the object is imputed to *everyone*, without being based on a concept (for then it would be the good). Further, this claim to universal validity so essentially belongs to a judgment by which we describe anything as *beautiful* that, if this were not thought in it, it would never come into our thoughts to use the expression at all, but everything which pleases without a concept would be counted as pleasant. In respect of the latter, everyone has his own opinion; and no one assumes in another agreement with his judgment of taste, which is always the case in a judgment of taste about beauty. I may call the first the taste of sense, the second the taste of reflection, so far as the first lays down mere private judgments and the second judgments supposed to be generally valid (public), but in both cases aesthetical (not practical) judgments about an object merely in respect of the relation of its representation to the feeling of pleasure and pain. Now here is something strange. As regards the taste of sense, not only does experience show that its judgment (of pleasure or pain connected with anything) is not valid universally, but everyone is content not to impute agreement with it to others (although actually there is often found a very extended concurrence in these judgments). On the other hand, the taste of reflection has its claim to the universal validity of its judgments (about the beautiful) rejected often enough, as experience teaches, although it may find it possible (as it actually does) to represent judgments which can demand this universal agreement. In fact it imputes this to everyone for each of its judgments of

taste, without the persons that judge disputing as to the possibility of such a claim, although in particular cases they cannot agree as to the correct application of this faculty.

Here we must, in the first place, remark that a universality which does not rest on concepts of objects (not even on empirical ones) is not logical but aesthetical; i.e. it involves no objective quantity of the judgment, but only that which is subjective. For this I use the expression *general validity*, which signifies the validity of the reference of a representation, not to the cognitive faculty, but to the feeling of pleasure and pain for every subject. (We can avail ourselves also of the same expression for the logical quantity of the judgment, if only we prefix "objective" to "universal validity," to distinguish it from that which is merely subjective and aesthetical.)

A judgment with *objective universal validity* is also always valid subjectively; i.e. if the judgment holds for everything contained under a given concept, it holds also for everyone who represents an object by means of this concept. But from a *subjective universal validity*, i.e. if the judgment holds for everything contained under a given concept, it holds also for everyone who represents an object by means of this concept. But from a subjective universal validity, i.e. aesthetical and resting on no concept, we cannot infer that which is logical because that kind of judgment does not extend to the object. But, therefore, the aesthetical universality which is ascribed to a judgment must be of a particular kind, because it does not unite the predicate of beauty with the concept of the object, considered in its whole logical sphere, and yet extends it to the whole sphere of judging persons.

In respect of logical quantity, all judgments of taste are *singular* judgments. For because I must refer the object immediately to my feeling of pleasure and pain, and that not by means of concepts, they cannot have the quantity of objective generally valid judgments. Nevertheless, if the singular representation of the object of the judgment of taste, in accordance with the conditions determining the latter, were transformed by comparison into a concept, a logically universal judgment could result therefrom. E.g., I describe by a judgment of taste

the rose that I see as beautiful. But the judgment which results from the comparison of several singular judgments, "Roses in general are beautiful," is no longer described simply as aesthetical, but as a logical judgment based on an aesthetical one. Again the judgment, "The rose is pleasant" (to use) is, although aesthetical and singular, not a judgment of taste but of sense. It is distinguished from the former by the fact that the judgment of taste carries with it an *aesthetic quantity* of universality, i.e. of validity for everyone, which cannot be found in a judgment about the pleasant. It is only judgments about the good which, although they also determine satisfaction in an object, have logical and not merely aesthetical universality, for they are valid of the object as cognitive of it, and thus are valid for everyone.

If we judge objects merely according to concepts, then all representation of beauty is lost. Thus there can be no rule according to which anyone is to be forced to recognize anything as beautiful. We cannot press [upon others] by the aid of any reasons or fundamental propositions our judgment that a coat, a house, or a flower is beautiful. People wish to submit the object to their own eyes, as if the satisfaction in it depended on sensation; and yet, if we then call the object beautiful, we believe that we speak with a universal voice, and we claim the assent of everyone, although on the contrary all private sensation can only decide for the observer himself and his satisfaction.

We may see now that in the judgment of taste nothing is postulated but such a *universal voice*, in respect of the satisfaction without the intervention of concepts, and thus the *possibility* of an aesthetical judgment that can, at the same time, be regarded as valid for everyone. The judgment of taste itself does not *postulate* the agreement of everyone (for that can only be done by a logically universal judgment because it can adduce reasons); it only *imputes* this agreement to everyone, as a case of the rule in respect of which it expects, not confirmation by concepts, but assent from others. This universal voice is, therefore, only an idea (we do not yet inquire upon what it rests). It may be uncertain whether or not the man who believes that he is laying down a judgment of taste is, as a matter of fact, judging in

conformity with that idea; but that he refers his judgment thereto, and consequently that it is intended to be a judgment of taste, he announces by the expression "beauty." He can be quite certain of this for himself by the mere consciousness of the separating off everything belonging to the pleasant and the good from the satisfaction which is left; and this is all for which he promises himself the agreement of everyone—a claim which would be justifiable under these conditions, provided only he did not often make mistakes, and thus lay down an erroneous judgment of taste.

§ 9. INVESTIGATION OF THE QUESTION WHETHER IN THE JUDGMENT OF TASTE THE FEELING OF PLEASURE PRECEDES OR FOLLOWS THE JUDGING OF THE OBJECT

The solution of this question is the key to the critique of taste, and so is worthy of all attention.

If the pleasure in the given object precedes, and it is only its universal communicability that is to be acknowledged in the judgment of taste about the representation of the object, there would be a contradiction. For such pleasure would be nothing different from the mere pleasantness in the sensation, and so in accordance with its nature could have only private validity, because it is immediately dependent on the representation through which the object *is given*.

Hence it is the universal capability of communication of the mental state in the given representation which, as the subjective condition of the judgment of taste, must be fundamental and must have the pleasure in the object as its consequent. But nothing can be universally communicated except cognition and representation, so far as it belongs to cognition. For it is only thus that this latter can be objective, and only through this has it a universal point of reference, with which the representative power of everyone is compelled to harmonize. If the determining ground of our judgment as to this universal communicability of the representation is to be merely subjective, i.e. is conceived independently of any concept of the object, it can be nothing else than the state of mind, which is to be met with in the relation of our representative powers to each other, so far as they refer a given representation to *cognition in general*.

The cognitive powers, which are involved by this representation, are here in free play, because no definite concept limits them to a definite[8] rule of cognition. Hence the state of mind in this representation must be a feeling of the free play of the representative powers in a given representation with reference to a cognition in general. Now a representation by which an object is given that is to become a cognition in general requires *imagination* for the gathering together the manifold of intuition, and *understanding* for the unity of the concept uniting the representations. This state of *free play* of the cognitive facilitates in a representation by which an object is given must be universally communicable, because cognition, as the determination of the object with which given representations (in whatever subject) are to agree, is the only kind of representation which is valid for everyone.

The subjective universal communicability of the mode of representation in a judgment of taste, since it is to be possible without presupposing a definite concept, can refer to nothing else than the state of mind in the free play of the imagination and the understanding (so far as they agree with each other, as is requisite for *cognition in general*). We are conscious that this subjective relation, suitable for cognition in general, must be valid for everyone, and thus must be universally communicable, just as if it were a **definite** cognition, resting always on that relation as its subjective condition.

This merely subjective (aesthetical) judging of the object, or of the representation by which it is given, precedes the pleasure in the same and is the ground of this pleasure in the harmony of the cognitive faculties; but on that universality of the subjective conditions for judging of objects is alone based the universal subjective validity of the satisfaction bound up by us with the representation of the object that we call beautiful.

That the power of communicating one's state of mind, even though only in respect of the cognitive faculties, carries a pleasure with it, this we can easily show from the natural propension of man toward sociability (empirical and psychological). But this is not enough for our design. The pleasure that we

8. [First edition has "particular."]

feel is, in a judgment of taste, necessarily imputed by us to everyone else, as if, when we call a thing beautiful, it is to be regarded as a characteristic of the object which is determined in it according to concepts, though beauty, without a reference to the feeling of the subject, is nothing by itself. But we must reserve the examination of this question until we have answered that other—if and how aesthetical judgments are possible *a priori*.

We now occupy ourselves with the easier question, in what way we are conscious of a mutual subjective harmony of the cognitive powers with one another in the judgment of taste—is it aesthetically by mere internal sense and sensation, or is it intellectually by the consciousness of our designed activity, by which we bring them into play?

If the given representation which occasions the judgment of taste were a concept uniting understanding and imagination in the judging of the object, into a cognition of the object, the consciousness of this relation would be intellectual (as in the objective schematism of the judgment of which the *Critique*[9] treats). But then the judgment would not be laid down in reference to pleasure and pain, and consequently would not be a judgment of taste. But the judgment of taste, independently of concepts, determines the object in respect of satisfaction and of the predicate of beauty. Therefore that subjective unity of relation can only make itself known by means of sensation. The excitement of both faculties (imagination and understanding) to indeterminate but yet, through the stimulus of the given sensation, harmonious activity, viz. that which belongs to cognition in general, is the sensation whose universal communicability is postulated by the judgment of taste. An objective relation can only be thought, but yet, so far as it is subjective according to its conditions, can be felt in its effect on the mind; and, of a relation based on no concept (like the relation of the representative powers to a cognitive faculty in general), no other consciousness is possible than that through the sensation of the effect, which consists in the more lively play of both mental powers (the imagination and the understanding) when animated by mutual agreement. A representation which, as individual and

apart from comparison with others, yet has an agreement with the conditions of universality which it is the business of the understanding to supply, brings the cognitive faculties into that proportionate accord which we require for all cognition, and so regard as holding for everyone who is determined to judge by means of understanding and sense in combination (i.e. for every man).

Explanation of the Beautiful Resulting from the Second Moment

The *beautiful* is that which pleases universally without [requiring] a concept.

THIRD MOMENT

OF JUDGMENTS OF TASTE, ACCORDING TO THE RELATION OF THE PURPOSES WHICH ARE BROUGHT INTO CONSIDERATION IN THEM

§ 10. OF PURPOSIVENESS IN GENERAL

If we wish to explain what a purpose is according to its transcendental determinations (without presupposing anything empirical like the feeling of pleasure), [we say that] the purpose is the object of a concept, in so far as the concept is regarded as the cause of the object (the real ground of its possibility); and the causality of a *concept* in respect of its *object* is its purposiveness (*forma finalis*). Where then not merely the cognition of an object but the object itself (its form and existence) is thought as an effect only possible by means of the concept of this latter, there we think a purpose. The representation of the effect is here the determining ground of its cause and precedes it. The consciousness of the causality of a representation, for *maintaining* the subject in the same state, may here generally denote what we call pleasure; while on the other hand pain is that representation which contains the ground of the determination of the state of representations into their opposite [of restraining or removing them].[10]

9. [*The Critique of Pure Reason*, "Analytic," Bk. II, Ch. 1.]

10. [Second edition. Mr. Herbert Spencer expresses much more concisely what Kant has in mind here. "Pleasure...is a feeling which we seek to bring into consciousness and retain there; pain is...a feeling which we seek to get out of consciousness and to keep out." *Principles of Psychology*, § 125.]

The faculty of desire, so far as it is determinable to act only through concepts, i.e. in conformity with the representation of a purpose, would be the will. But an object, or a state of mind, or even an action is called purposive, although its possibility does not necessarily presuppose the representation of a purpose, merely because its possibility can be explained and conceived by us only so far as we assume for its ground a causality according to purposes, i.e. in accordance with a will which has regulated it according to the representation of a certain rule. There can be, then, purposiveness without[11] purpose, so far as we do not place the causes of this form in a will, but yet can only make the explanation of its possibility intelligible to ourselves by deriving it from a will. Again, we are not always forced to regard what we observe (in respect of its possibility) from the point of view of reason. Thus we can at least observe a purposiveness according to form, without basing it on a purpose (as the material of the *nexus finalis*), and remark it in objects, although only by reflection.

§ 11. THE JUDGMENT OF TASTE HAS NOTHING AT ITS BASIS BUT THE FORM OF THE PURPOSIVENESS OF AN OBJECT (OR OF ITS MODE OF REPRESENTATION)

Every purpose, if it be regarded as a ground of satisfaction, always carries with it an interest—as the determining ground of the judgment—about the object of pleasure. Therefore no subjective purpose can lie at the basis of the judgment of taste. But also the judgment of taste can be determined by no representation of an objective purpose, i.e. of the possibility of the object itself in accordance with principles of purposive combination, and consequently by no concept of the good, because it is an aesthetical and not a cognitive judgment. It therefore has to do with no *concept* of the character and internal or external possibility of the object by means of this or that cause, but merely with the relation of the representative powers to one another, so far as they are determined by a representation.

Now this relation in the determination of an object as beautiful is bound up with the feeling of pleasure, which is declared by the judgment of taste to be valid for everyone; hence a pleasantness [merely] accompanying the representation can as little contain the determining ground [of the judgment] as the representation of the perfection of the object and the concept of the good can. Therefore it can be nothing else than the subjective purposiveness in the representation of an object without any purpose (either objective or subjective), and thus it is the mere form of purposiveness in the representation by which an object is *given* to us, so far as we are conscious of it, which constitutes the satisfaction that we without a concept judge to be universally communicable; and, consequently, this is the determining ground of the judgment of taste.

§ 12. THE JUDGMENT OF TASTE RESTS ON A PRIORI GROUNDS

To establish *a priori* the connection of the feeling of a pleasure or pain as an effect, with any representation whatever (sensation or concept) as its cause, is absolutely impossible, for that would be a [particular][12] causal relation which (with objects of experience) can always only be cognized *a posteriori* and through the medium of experience itself. We actually have, indeed, in the *Critique of Practical Reason*, derived from universal moral concepts *a priori* the feeling of respect (as a special and peculiar modification of feeling which will not strictly correspond either to the pleasure or the pain that we get from empirical objects). But there we could go beyond the bounds of experience and call in a causality which rested on a supersensible attribute of the subject, viz. freedom. And even there, properly speaking, it was not this *feeling* which we derived from the idea of the moral as cause, but merely the determination of the will. But the state of mind which accompanies any determination of the will is in itself a feeling of pleasure and identical with it, and therefore does not follow from it as its effect. This last must only be assumed if the concept of the moral as a good precede the determination of the will by the law, for in that case the pleasure that is

11. [The editions of Hartenstein and Kirchmann omit "*ohne*" before "*Zweck*," which makes havoc of the sentence. It is correctly printed by Rosenkranz.]

12. [First edition.]

bound up with the concept could not be derived from it as from a mere cognition.

Now the case is similar with the pleasure in aesthetical judgments, only that here it is merely contemplative and does not bring about an interest in the object, while on the other hand in the moral judgment it is practical.[13] The consciousness of the mere formal purposiveness in the play of the subject's cognitive powers, in a representation through which an object is given, is the pleasure itself, because it contains a determining ground of the activity of the subject in respect of the excitement of its cognitive powers, and therefore an inner causality (which is purposive) in respect of cognition in general, without however being limited to any definite cognition, and consequently contains a mere form of the subjective purposiveness of a representation in an aesthetical judgment. This pleasure is in no way practical, neither like that arising from the pathological ground of pleasantness, nor that from the intellectual ground of the presented good. But yet it involves causality, viz. of *maintaining* without further design the state of the representation itself and the occupation of the cognitive powers. We *linger* over the contemplation of the beautiful because this contemplation strengthens and reproduces itself, which is analogous to (though not of the same kind as) that lingering which takes place when a [physical] charm in the representation of the object repeatedly arouses the attention, the mind being passive.

§ 13. THE PURE JUDGMENT OF TASTE IS INDEPENDENT OF CHARM AND EMOTION

Every interest spoils the judgment of taste and takes from its impartiality, especially if the purposiveness is not, as with the interest of reason,

placed before the feeling of pleasure but grounded on it. This last always happens in an aesthetical judgment upon anything, so far as it gratifies or grieves us. Hence judgments so affected can lay no claim at all to a universally valid satisfaction, or at least so much the less claim, in proportion as there are sensations of this sort among the determining grounds of taste. That taste is always barbaric which needs a mixture of *charms* and *emotions* in order that there may be satisfaction, and still more so if it make these the measure of its assent.

Nevertheless charms are often not only taken account of in the case of beauty (which properly speaking ought merely to be concerned with form) as contributory to the aesthetical universal satisfaction, but they are passed off as in themselves beauties; and thus the matter of satisfaction is substituted for the form. This misconception, however, which like so many others, has something true at its basis, may be removed by a careful determination of these concepts.

A judgment of taste on which charm and emotion have no influence (although they may be bound up with the satisfaction in the beautiful)—which therefore has as its determining ground merely the purposiveness of the form—is a *pure judgment of taste*.

§ 14. ELUCIDATION BY MEANS OF EXAMPLES

Aesthetical judgments can be divided just like theoretical (logical) judgments into empirical and pure. The first assert pleasantness or unpleasantness; the second assert the beauty of an object or of the manner of representing it. The former are judgments of sense (material aesthetical judgments); the latter [as formal][14] are alone strictly judgments of taste.

A judgment of taste is therefore pure only so far as no merely empirical satisfaction is mingled with its determining ground. But this always happens if charm or emotion have any share in the judgment by which anything is to be described as beautiful.

Now here many objections present themselves which, fallaciously put forward, charm not merely

13. [Cf. *Metaphysic of Morals*, Introduction I. "The pleasure which is necessarily bound up with the desire (of the object whose representation affects feeling) may be called *practical* pleasure, whether it be cause or effect of the desire. On the contrary, the pleasure which is not necessarily bound up with the desire of the object, and which, therefore, is at bottom not a pleasure in the existence of the object of the representation, but clings to the representation only, may be called mere contemplative pleasure or *passive satisfaction*. The feeling of the latter kind of pleasure we call *taste*." (Abbott trans.—Ed.)]

14. [Second edition.]

as a necessary ingredient of beauty, but as alone sufficient [to justify] a thing's being called beautiful A mere color, e.g. the green of a grass plot, a mere tone (as distinguished from sound and noise), like that of a violin, are by most people described as beautiful in themselves, although both seem to have at their basis merely the matter of representations, viz. simply sensation, and therefore only deserve to be called pleasant. But we must at the same time remark that the sensations of colors and of tone have a right to be regarded as beautiful only in so far as they are *pure*. This is a determination which concerns their form and is the only [element] of these representations which admits with certainty of universal communicability; for we cannot assume that the quality of sensations is the same in all subjects, and we can hardly say that the pleasantness of one color or the tone of one musical instrument is judged preferable to that of another in the same[15] way by everyone.

If we assume with Euler that colors are isochronous vibrations (*pulsus*) of the ether, as sounds are of the air in a state of disturbance, and—what is the most important—that the mind not only perceives by sense the effect of these in exciting the organ, but also perceives by reflection the regular play of impressions (and thus the form of the combination of different representations)—which I very much doubt[16]—then colors and tone cannot be reckoned as mere sensations, but as the formal determination of the unity of a manifold of sensations, and thus as beauties.

But "pure" in a simple mode of sensation means that its uniformity is troubled and interrupted by no foreign sensation, and it belongs merely to the form; because here we can abstract from the quality of that mode of sensation (abstract from the colors and tone, if any, which it represents). Hence all simple colors, so far as they are pure, are regarded as beautiful; composite colors have not this advantage because, as they are not simple, we have no standard for judging whether they should be called pure or not.

But as regards the beauty attributed to the object on account of its form, to suppose it to be capable of augmentation through the charm of the object is a common error and one very prejudicial to genuine, uncorrupted, well-founded taste. We can doubtless add these charms to beauty, in order to interest the mind by the representation of the object, apart from the bare satisfaction [received], and thus they may serve as a recommendation of taste and its cultivation, especially when it is yet crude and unexercised. But they actually do injury to the judgment of taste if they draw attention to themselves as the grounds for judging of beauty. So far are they from adding to beauty that they must only be admitted by indulgence as aliens, and provided always that they do not disturb the beautiful form in cases when taste is yet weak and unexercised.

In painting, sculpture, and in all the formative arts—in architecture and horticulture, so far as they are beautiful arts—the *delineation* is the essential thing; and here it is not what gratifies in sensation but what pleases by means of its form that is fundamental for taste. The colors which light up the sketch belong to the charm; they may indeed enliven[17] the object for sensation, but they cannot make it worthy of contemplation and beautiful. In most cases they are rather limited by the requirements of the beautiful form, and even where charm is permissible it is ennobled solely by this.

Every form of the objects of sense (both of external sense and also mediately of internal) is either *figure* or *play*. In the latter case it is either play of figures (in space, viz. pantomime and dancing) or the mere play of sensations (in time). The *charm* of colors or of the pleasant tones of an instrument may be added, but the *delineation* in the first case and the composition in the second constitute the proper object of the pure judgment of taste. To say that the purity of colors and of tones, or their variety and contrast, seem to add to beauty does not mean that they supply a homogeneous addition to our satisfaction in the form because they are pleasant in themselves; but they do so because they make the form more exactly, definitely, and completely,

15. [First edition has "*gleiche*"; second edition has "*solche*."]

16. [First edition has "*nicht zweifle*" for "*sehr zweifle*," but this was apparently only a misprint.]

17. ["*Belebt machen*"; first edition had "*beliebt*."]

intuitible, and besides, by their charm [excite the representation, while they][18] awaken and fix our attention on the object itself.

Even what we call "ornaments" [*parerga*],[19] i.e. those things which do not belong to the complete representation of the object internally as elements, but only externally as complements, and which augment the satisfaction of taste, do so only by their form; as, for example, [the frames of pictures[20] or] the draperies of statues or the colonnades of palaces. But if the ornament does not itself consist in beautiful form, and if it is used as a golden frame is used, merely to recommend the painting by its *charm*, it is then called *finery* and injures genuine beauty.

Emotion, that is a sensation in which pleasantness is produced by means of a momentary checking and a consequent more powerful outflow of the vital force, does not belong at all to beauty. But sublimity [with which the feeling of emotion is bound up][21] requires a different standard of judgment from that which is at the foundation of taste; and thus a pure judgment of taste has for its determining ground neither charm nor emotion—in a word, no sensation as the material of the aesthetical judgment.

§ 15. THE JUDGMENT OF TASTE IS QUITE INDEPENDENT OF THE CONCEPT OF PERFECTION

Objective purposiveness can only be cognized by means of the reference of the manifold to a definite purpose, and therefore only through a concept. From this alone it is plain that the beautiful, the judging of which has at its basis a merely formal purposiveness, i.e. a purposiveness without purpose, is quite independent of the concept of the good, because the latter presupposes an objective purposiveness, i.e. the reference of the object to a definite purpose.

Objective purposiveness is either external, i.e. the *utility*, or internal, i.e. the *perfection* of the object. That the satisfaction in an object, on account of

which we call it beautiful, cannot rest on the representation of its utility is sufficiently obvious from the two preceding sections; because in that case it would not be an immediate satisfaction in the object, which is the essential condition of a judgment about beauty. But objective internal purposiveness, i.e. perfection, comes nearer to the predicate of beauty; and it has been regarded by celebrated philosophers[22] as the same as beauty, with the proviso, *if it is thought in a confused way*. It is of the greatest importance in a critique of taste to decide whether beauty can thus actually be resolved into the concept of perfection.

To judge of objective purposiveness we always need, not only the concept of a purpose, but (if that purposiveness is not to be external utility but internal) the concept of an internal purpose which shall contain the ground of the internal possibility of the object. Now as a purpose in general is that whose *concept* can be regarded as the ground of the possibility of the object itself; so, in order to represent objective purposiveness in a thing, the concept of *what sort of thing it is to be* must come first. The agreement of the manifold in it with this concept (which furnishes the rule for combining the manifold) is the *qualitative perfection* of the thing. Quite different from this is *quantitative* perfection, the completeness of a thing after its kind, which is a mere concept of magnitude (of totality).[23] In this *what the thing ought to be* is conceived as already determined, and it is only asked if it has *all* its requisites. The formal [element] in the representation of a thing,

18. [Second edition.]

19. [Second edition.]

20. [Second edition.]

21. [Second edition.]

22. [Kant probably refers here to Baumgarten (1714-1762), who was the first writer to give the name of aesthetics to the philosophy of taste. He defined beauty as "perfection apprehended through the senses." Kant is said to have used as a textbook at lectures a work by Meier, a pupil of Baumgarten's, on this subject.]

23. [Cf. Preface to the *Metaphysical Elements of Ethics*, p. v: "The word *perfection* is liable to many misconceptions. It is sometimes understood as a concept belonging to Transcendental Philosophy; viz. the concept of the *totality* of the manifold, which, taken together, constitutes a Thing; sometimes, again, it is understood as belonging to *Teleology*, so that it signifies the agreement of the characteristics of a thing with a purpose. Perfection in the former sense might be called *quantitative* (material), in the latter *qualitative* (formal), perfection."]

i.e. the agreement of the manifold with a unity (it being undetermined what this ought to be), gives to cognition no objective purposiveness whatever. For since abstraction is made of this unity as *purpose* (what the thing ought to be), nothing remains but the subjective purposiveness of the representations in the mind of the intuiting subject. And this, although it furnishes a certain purposiveness of the representative state of the subject, and so a facility of apprehending a given form by the imagination, yet furnishes no perfection of an object, since the object is not here conceived by means of the concept of a purpose. For example, if in a forest I come across a plot of sward around which trees stand in a circle and do not then represent to myself a purpose, viz. that it is intended to serve for country dances, not the least concept of perfection is furnished by the mere form. But to represent to oneself a formal *objective* purposiveness without purpose, i.e. the mere form of a *perfection* (without any matter and without the *concept* of that with which it is accordant, even if it were merely the idea of conformity to law in general),[24] is a veritable contradiction.

Now the judgment of taste is an aesthetical judgment, i.e. such as rests on subjective grounds, the determining ground of which cannot be a concept, and consequently cannot be the concept of a definite purpose. Therefore by means of beauty, regarded as a formal subjective purposiveness, there is in no way thought a perfection of the object, as a purposiveness alleged to be formal but which is yet objective. And thus to distinguish between the concepts of the beautiful and the good as if they were only different in logical form, the first being a confused, the second a clear concept of perfection, but identical in content and origin, is quite fallacious. For then there would be no *specific* difference between them, but a judgment of taste would be as much a cognitive judgment as the judgment by which a thing is described as good; just as when the ordinary man says that fraud is unjust he bases his judgment on confused grounds, while the philosopher bases it on clear grounds, but both on identical principles of reason. I have already, however, said that an aesthetical judgment is unique of its kind and gives absolutely no cognition (not even a confused cognition) of the object; this is only supplied by a logical judgment. On the contrary, it simply refers the representation, by which an object is given, to the subject, and brings to our notice no characteristic of the object, but only the purposive form in the determination of the representative powers which are occupying themselves therewith. The judgment is called aesthetical just because its determining ground is not a concept, but the feeling (of internal sense) of that harmony in the play of the mental powers, so far as it can be felt in sensation. On the other hand, if we wish to call confused concepts and the objective judgment based on them aesthetical, we will have an understanding judging sensibly or a sense representing its objects by means of concepts [both of which are contradictory].[25] The faculty of concepts, be they confused or clear, is the understanding; and although understanding has to do with the judgment of taste as an aesthetical judgment (as is has with all judgments), yet it has to do with it, not as a faculty by which an object is cognized, but as the faculty which determines the judgment and its representation (without any concept) in accordance with its relation to the subject and the subject's internal feeling, in so far as this judgment may be possible in accordance with a universal rule.

§ 16. THE JUDGMENT OF TASTE, BY WHICH AN OBJECT IS DECLARED TO BE BEAUTIFUL UNDER THE CONDITION OF A DEFINITE CONCEPT, IS NOT PURE

There are two kinds of beauty: free beauty (*pulchritudo vaga*), or merely dependent beauty (*pulchritudo adhaerens*). The first presupposes no concept of what the object ought to be; the second does presuppose such a concept and the perfection of the object in accordance therewith. The first is called the (self-subsistent) beauty of this or that thing; the second, as dependent upon a concept (conditioned beauty), is ascribed to objects which come under the concept of a particular purpose.

24. [The words "even if...general" were added in the second edition.]

25. [Second edition.]

Flowers are free natural beauties. Hardly anyone but a botanist knows what sort of a thing a flower ought to be; and even he, though recognizing in the flower the reproductive organ of the plant, pays no regard to this natural purpose if he is passing judgment on the flower by taste. There is, then, at the basis of this judgment no perfection of any kind, no internal purposiveness, to which the collection of the manifold is referred. Many birds (such as the parrot, the humming bird, the bird of paradise) and many sea shells are beauties in themselves, which do not belong to any object determined in respect of its purpose by concepts, but please freely and in themselves. So also delineations *à la grecque*, foliage for borders or wall papers, mean nothing in themselves; they represent nothing—no object under a definite concept—and are free beauties. We can refer to the same class what are called in music phantasies (i.e. pieces without any theme), and in fact all music without words.

In the judging of a free beauty (according to the mere form), the judgment of taste is pure. There is presupposed no concept of any purpose which the manifold of the given object is to serve, and which therefore is to be represented in it. By such a concept the freedom of the imagination which disports itself in the contemplation of the figure would be only limited.

But human beauty (i.e. of a man, a woman, or a child), the beauty of a horse, or a building (be it church, palace, arsenal, or summer house), presupposes a concept of the purpose which determines what the thing is to be, and consequently a concept of its perfection; it is therefore adherent beauty. Now as the combination of the pleasant (in sensation) with beauty, which properly is only concerned with form, is a hindrance to the purity of the judgment of taste, so also is its purity injured by the combination with beauty of the good (viz. that manifold which is good for the thing itself in accordance with its purpose).

We could add much to a building which would immediately please the eye if only it were not to be a church. We could adorn a figure with all kinds of spirals and light but regular lines, as the New Zealanders do with their tattooing, if only it were not the figure of a human being. And again this could have much finer features and a more pleasing and gentle cast of countenance provided it were not intended to represent a man, much less a warrior.

Now the satisfaction in the manifold of a thing in reference to the internal purpose which determines its possibility is a satisfaction grounded on a concept; but the satisfaction in beauty is such as presupposes no concept, but is immediately bound up with the representation through which the object is given (not through which it is thought). If now the judgment of taste in respect of the beauty of a thing is made dependent on the purpose in its manifold, like a judgment of reason, and thus limited, it is no longer a free and pure judgment of taste.

It is true that taste gains by this combination of aesthetical with intellectual satisfaction, inasmuch as it becomes fixed; and though it is not universal, yet in respect to certain purposively determined objects it becomes possible to prescribe rules for it. These, however, are not rules of taste, but merely rules for the unification of taste with reason, i.e. of the beautiful with the good, by which the former becomes available as an instrument of design in respect of the latter. Thus the tone of mind which is self-maintaining and of subjective universal validity is subordinated to the way of thinking which can be maintained only by painful resolve, but is of objective universal validity. Properly speaking, however, perfection gains nothing by beauty, or beauty by perfection; but when we compare the representation by which an object is given to us with the object (as regards what it ought to be) by means of a concept, we cannot avoid considering along with it the sensation in the subject. And thus when both states of mind are in harmony our *whole faculty* of representative power gains.

A judgment of taste, then, in respect of an object with a definite internal purpose, can only be pure if either the person judging has no concept of this purpose or else abstracts from it in his judgment. Such a person, although forming an accurate judgment of taste in judging of the object as free beauty, would yet by another who considers the beauty in it only as a dependent attribute (who looks to the purpose of the object) be blamed and accused of false taste,

although both are right in their own way—the one in reference to what he has before his eyes, the other in reference to what he has in his thought. By means of this distinction we can settle many disputes about beauty between judges of taste, by showing that the one is speaking of free, the other of dependent, beauty—that the first is making a pure, the second an applied, judgment of taste.

§ 17. OF THE IDEAL OF BEAUTY

There can be no objective rule of taste which shall determine by means of concepts what is beautiful. For every judgment from this source is aesthetical; i.e. the feeling of the subject, and not a concept of the object, is its determining ground. To seek for a principle of taste which shall furnish, by means of definite concepts, a universal criterion of the beautiful is fruitless trouble, because what is sought is impossible and self-contradictory. The universal communicability of sensation (satisfaction or dissatisfaction) without the aid of a concept—the agreement, as far as is possible, of all times and peoples as regards this feeling in the representation of certain objects—this is the empirical criterion, although weak and hardly sufficing for probability, of the derivation of a taste, thus confirmed by examples, from the deep-lying general grounds of agreement in judging of the forms under which objects are given.

Hence we consider some products of taste as *exemplary*. Not that taste can be acquired by imitating others, for it must be an original faculty. He who imitates a model shows no doubt, in so far as he attains to it, skill; but only shows taste in so far as he can judge of this model itself.[26] It follows from hence that the highest model, the archetype of taste, is a mere idea, which everyone must produce in himself and according to which he must judge every object of taste, every example of judgment by taste, and even the taste of everyone. *Idea* properly means a rational concept, and *ideal* the representation of an individual being, regarded as adequate to an idea.[27] Hence that archetype of taste, which certainly rests on the indeterminate idea that reason has of a maximum, but which cannot be represented by concepts but only in an individual presentation, is better called the ideal of the beautiful. Although we are not in possession of this, we yet strive to produce it in ourselves. But it can only be an ideal of the imagination, because it rests on a presentation and not on concepts, and the imagination is the faculty of presentation. How do we arrive at such an ideal of beauty? *A priori*, or empirically? Moreover, what species of the beautiful is susceptible of an ideal?

First, it is well to remark that the beauty for which an ideal is to be sought cannot be *vague* beauty, but is *fixed* by a concept of objective purposiveness; and thus it cannot appertain to the object of a quite pure judgment of taste, but to that of a judgment of taste which is in part intellectual. That is, in whatever grounds of judgment an ideal is to be found, an idea of reason in accordance with definite concepts must lie at its basis, which determines *a priori* the purpose on which the internal possibility of the object rests. An ideal of beautiful flowers, of a beautiful piece of furniture, of a beautiful view, is inconceivable. But neither can an ideal be represented of a beauty dependent on definite purposes, e.g. of a beautiful dwelling house, a beautiful tree, a beautiful garden, etc.; presumably because their purpose is not sufficiently determined and fixed by the concept, and thus the purposiveness is nearly as free as in the case of *vague* beauty. The only being which has the purpose of its existence in itself is *man*, who can determine his purposes by reason; or, where he must receive them from external perception, yet can compare them with essential and universal purposes and can judge this their accordance aesthetically. This *man* is, then, alone of all objects in the world, susceptible of an ideal of *beauty*, as it is only *humanity* in his person, as an intelligence, that is susceptible of the ideal of *perfection*.

26. Models of taste as regards the arts of speech must be composed in a dead and learned language. The first in order that they may not suffer that change which inevitably comes over living languages, in which noble expressions become flat, common ones antiquated, and newly created ones have only a short circulation. The second because learned languages have a grammar which is subject to no wanton change of fashion, but the rules of which are preserved unchanged.

27. [This distinction between an *idea* and an *ideal*, as also the further contrast between ideals of the reason and ideals of the imagination, had already been given by Kant in the *Critique of Pure Reason*, "Dialectic," Bk. II, Ch. 3, § 1.]

But there are here two elements. *First*, there is the aesthetical *normal idea*, which is an individual intuition (of the imagination), representing the standard of our judgment [upon man] as a thing belonging to a particular animal species. *Secondly*, there is the *rational idea* which makes the purposes of humanity, so far as they cannot be sensibly represented the principle for judging of a figure through which, as their phenomenal effect, those purposes are revealed. The normal idea of the figure of an animal of a particular race must take its elements from experience. But the greatest purposiveness in the construction of the figure that would be available for the universal standard of aesthetical judgment upon each individual of this species—the image which is as it were designedly at the basis of nature's technique, to which only the whole race and not any isolated individual is adequate—this lies merely in the idea of the judging [subject]. And this, with its proportions as an aesthetical idea, can be completely presented *in concreto* in a model. In order to make intelligible in some measure (for who can extract her whole secret from nature?) how this comes to pass, we shall attempt a psychological explanation.

We must remark that, in a way quite incomprehensible by us, the imagination cannot only recall on occasion the signs for concepts long past, but can also reproduce the image of the figure of the object out of an unspeakable number of objects of different kinds or even of the same kind. Further, if the mind is concerned with comparisons, the imagination can, in all probability, actually, though unconsciously, let one image glide into another; and thus, by the concurrence of several of the same kind, come by an average, which serves as the common measure of all. Everyone has seen a thousand full-grown men. Now if you wish to judge of their normal size, estimating it by means of comparison, the imagination (as I think) allows a great number of images (perhaps the whole thousand) to fall on one another. If I am allowed to apply here the analogy of optical presentation, it is in the space where most of them are combined and inside the contour, where the place is illuminated with the most vivid colors, that the *average size* is cognizable, which, both in height and breadth, is equally far removed from the extreme bounds of the greatest and smallest stature. And this is the stature of a beautiful man. (We could arrive at the same thing mechanically by adding together all thousand magnitudes, heights, breadths, and thicknesses, and dividing the sum by a thousand. But the imagination does this by means of a dynamical effect, which arises from the various impressions of such figures on the organ of internal sense.) If now, in a similar way, for this average man we seek the average head, for this head the average nose, etc., such figure is at the basis of the normal idea in the country where the comparison is instituted. Thus necessarily under these empirical conditions a Negro must have a different normal idea of the beauty of the [human figure] from a white man, a Chinaman a different normal idea from a European, etc. And the same is the case with the model of a beautiful horse or dog (of a certain breed). This *normal idea* is not derived from proportions gotten from experience [and regarded] *as definite rules*, but in accordance with it rules for judging become in the first instance possible. It is the image for the whole race, which floats among all the variously different intuitions of individuals, which nature takes as archetype in her productions of the same species, but which appears not to be fully reached in any individual case. It is by no means the whole *archetype of beauty* in the race, but only the form constituting the indispensable condition of all beauty, and thus merely *correctness* in the [mental] presentation of the race. It is, like the celebrated "Doryphorus" of Polycletus,[28] the *rule* (Myron's[29] Cow might also be used thus for its kind). It can therefore contain nothing specifically characteristic, for otherwise it would not be the *normal idea* for the race. Its presentation pleases, not by its beauty, but merely because it contradicts no condition, under which alone a thing of

28. [Polycletus of Argos flourished about 430 B. C. His statue of the "Spearbearer" (*Doryphorus*), afterward became known as the "Canon," because in it the artist was supposed to have embodied a perfect representation of the ideal of the human figure.]

29. [This was a celebrated statue executed by Myron, a Greek sculptor, contemporary with Polycletus.]

this kind can be beautiful. The presentation is merely correct.[30]

We must yet distinguish the *normal idea* of the beautiful from the *ideal*, which latter, on grounds already alleged, we can only expect in the *human* figure. In this the ideal consists in the expression of the *moral*, without which the object would not please universally and thus positively (not merely negatively in an accurate presentation). The visible expression of moral ideas that rule men inwardly can indeed only be gotten from experience; but to make its connection with all which our reason unites with the morally good in the idea of the highest purposiveness—goodness of heart, purity, strength, peace, etc.—visible as it were in bodily manifestation (as the effect of that which is internal) requires a union of pure ideas of reason with great imaginative power even in him who wishes to judge of it, still more in him who wishes to present it. The correctness of such an ideal of beauty is shown by its permitting no sensible charm to mingle with the satisfaction in the object, and yet allowing us to take a great interest therein. This shows that a judgment in accordance with such a standard can never be purely aesthetical, and that a judgment in accordance with an ideal of beauty is not a mere judgment of taste.

Explanation of the Beautiful Derived from this Third Moment

Beauty is the form of the *purposiveness* of an object, so far as this is perceived in it *without any representation of a purpose*.[31]

FOURTH MOMENT

OF THE JUDGMENT OF TASTE, ACCORDING TO THE MODALITY OF THE SATISFACTION IN THE OBJECT

§ 18. WHAT THE MODALITY IN A JUDGMENT OF TASTE IS

I can say of every representation that it is at least *possible* that (as a cognition) it should be bound up with a pleasure. Of a representation that I call *pleasant* I say that it *actually* excites pleasure in me. But the *beautiful* we think as having a *necessary* reference to satisfaction. Now this necessity is of a peculiar kind. It is not a theoretical objective necessity, in which case it would be cognized *a priori* that everyone *will feel* this satisfaction in the object called beautiful by me. It is not a practical necessity, in which case, by concepts of a pure rational will serving as a rule for freely acting beings, the satisfaction is the necessary result of an objective law and only indicates that we absolutely (without any further design) ought to act in a certain way. But the necessity which is thought in an aesthetical judgment can only be called exemplary, i.e. a necessity of the assent of *all* to a judgment which is regarded as the example of a universal rule that we cannot state. Since an aesthetical judgment is not an objective cognitive judgment, this necessity cannot be derived from definite concepts and is therefore not apodictic. Still less can it be inferred from the universality of experience (of a complete agreement of judgments as to the beauty of a certain object). For not only

30. It will be found that a perfectly regular countenance, such as a painter might wish to have for a model, ordinarily tells us nothing because it contains nothing characteristic, and therefore rather expresses the idea of the race than the specific [traits] of a person. The exaggeration of a characteristic of this kind, i.e. such as does violence to the normal idea (the purposiveness of the race), is called *caricature*. Experience also shows that these quite regular countenances commonly indicate internally only a mediocre man, presumably (if it may be assumed that external nature expresses the proportions of internal) because, if no mental disposition exceeds that proportion which is requisite in order to constitute a man free from faults, nothing can be expected of what is called genius, in which nature seems to depart from the ordinary relations of the mental powers on behalf of some special one.

31. It might be objected to this explanation that there are things in which we see a purposive form without cognizing any purpose in them, like the stone implements often gotten from old sepulchral tumuli with a hole in them, as if for a handle. These, although they plainly indicate by their shape purposiveness of which we do not know the purpose, are nevertheless not described as beautiful. But if we regard a thing as a work of art, that is enough to make us admit that its shape has reference to some design and definite purpose. And hence there is no immediate satisfaction in the contemplation of it. On the other hand a flower, e.g. a tulip, is regarded as beautiful, because in perceiving it we find a certain purposiveness which, in our judgment, is referred to no purpose at all.

would experience hardly furnish sufficiently numerous vouchers for this, but also, on empirical judgments, we can base no concept of the necessity of these judgments.

§ 19. THE SUBJECTIVE NECESSITY, WHICH WE ASCRIBE TO THE JUDGMENT OF TASTE, IS CONDITIONED

The judgment of taste requires the agreement of everyone, and he who describes anything as beautiful claims that everyone *ought* to give his approval to the object in question and also describe it as beautiful. The *ought* in the aesthetical judgment is therefore pronounced in accordance with all the data which are required for judging, and yet is only conditioned. We ask for the agreement of everyone else, because we have for it a ground that is common to all; and we could count on this agreement, provided we were always sure that the case was correctly subsumed under that ground as a rule of assent.

§ 20. THE CONDITION OF NECESSITY WHICH A JUDGMENT OF TASTE ASSERTS IS THE IDEA OF A COMMON SENSE

If judgments of taste (like cognitive judgments) had a definite objective principle, then the person who lays them down in accordance with this latter would claim an unconditioned necessity for his judgment. If they were devoid of all principle, like those of the mere taste of sense, we would not allow them in thought any necessity whatever. Hence they must have a subjective principle which determines what pleases or displeases only by feeling and not by concepts, but yet with universal validity. But such a principle could only be regarded as a *common sense*, which is essentially different from common understanding which people sometimes call common sense (*sensus communis*); for the latter does not judge by feeling but always by concepts, although ordinarily only as by obscurely represented principles.

Hence it is only under the presupposition that there is a common sense (by which we do not understand an external sense, but the effect resulting from the free play of our cognitive powers)—it is only under this presupposition, I say, that the judgment of taste can be laid down.

§ 21. HAVE WE GROUND FOR PRESUPPOSING A COMMON SENSE?

Cognitions and judgments must, along with the conviction that accompanies them, admit of universal communicability; for otherwise there would be no harmony between them and the object, and they would be collectively a mere subjective play of the representative powers, exactly as scepticism desires. But if cognitions are to admit of communicability, so must also the state of mind—i.e. the accordance of the cognitive powers with a cognition generally and that proportion of them which is suitable for a representation (by which an object is given to us) in order that a cognition may be made out of it—admit of universal communicability. For without this as the subjective condition of cognition, cognition as an effect could not arise. This actually always takes place when a given object by means of sense excites the imagination to collect the manifold, and the imagination in its turn excites the understanding to bring about a unity of this collective process in concepts. But this accordance of the cognitive powers has a different proportion according to the variety of the objects which are given. However, it must be such that this internal relation, by which one mental faculty is excited by another, shall be generally the most beneficial for both faculties in respect of cognition (of given objects); and this accordance can only be determined by feeling (not according to concepts). Since now this accordance itself must admit of universal communicability, and consequently also our feeling of it (in a given representation), and since the universal communicability of a feeling presupposes a common sense, we have grounds for assuming this latter. And this common sense is assumed without relying on psychological observations, but simply as the necessary condition of the universal communicability of our knowledge, which is presupposed in every logic and in every principle of knowledge that is not sceptical.

THE NECESSITY OF THE UNIVERSAL AGREEMENT THAT IS THOUGHT IN A JUDGMENT OF TASTE IS A SUBJECTIVE NECESSITY, WHICH IS REPRESENTED AS OBJECTIVE UNDER THE PRESUPPOSITION OF A COMMON SENSE

In all judgments by which we describe anything as beautiful, we allow no one to be of another opinion, without, however, grounding our judgment on concepts, but only on our feeling, which we therefore place at its basis, not as a private, but as a common feeling. Now this common sense cannot be grounded on experience, for it aims at justifying judgments which contain an *ought*. It does not say that everyone will agree with my judgment, but that he *ought*. And so common sense, as an example of whose judgment I here put forward my judgment of taste and on account of which I attribute to the latter an *exemplary* validity, is a mere ideal norm, under the supposition of which I have a right to make into rule for everyone a judgment that accords therewith, as well as the satisfaction in an object expressed in such judgment. For the principle which concerns the agreement of different judging persons, although only subjective, is yet assumed as subjectively universal (an idea necessary for everyone), and thus can claim universal assent (as if it were objective) provided we are sure that we have correctly subsumed [the particulars] under it.

This indeterminate norm of a common sense is actually presupposed by us, as is shown by our claim to lay down judgments of taste. Whether there is in fact such a common sense, as a constitutive principle of the possibility of experience, or whether a yet higher principle of reason makes it only into a regulative principle for producing in us a common sense for higher purposes; whether, therefore, taste is an original and natural faculty or only the idea of an artificial one yet to be acquired, so that a judgment of taste with its assumption of a universal assent in fact is only a requirement of reason for producing such harmony of sentiment; whether the ought, i.e. the objective necessity of the confluence of the feeling of any one man with that of every other, only signifies the possibility of arriving at this accord, and the judgment of taste only affords an example of the application of this principle—these questions we have neither the wish nor the power to investigate as yet; we have now only to resolve the faculty of taste into its elements in order to unite them at last in the idea of a common sense.

Explanation of the Beautiful Resulting from the Forth Moment

The *beautiful* is that which without any concept is cognized as the object of a *necessary* satisfaction.

GENERAL REMARK ON THE FIRST SECTION OF THE ANALYTIC

If we seek the result of the preceding analysis, we find that everything runs up into this concept of taste—that it is a faculty for judging an object in reference to the imagination's *free conformity to law*. Now, if in the judgment of taste the imagination must be considered in its freedom, it is in the first place not regarded as reproductive, as it is subject to the laws of association, but as productive and spontaneous (as the author of arbitrary forms of possible intuition). And although in the apprehension of a given object of sense it is tied to a definite form of this object and so far has no free play (such as that of poetry), yet it may readily be conceived that the object can furnish it with such a form containing a collection of the manifold as the imagination itself, if it were left free, would project in accordance with the *conformity to law of the understanding* in general. But that the *imaginative power* should be *free* and yet *of itself conformed to law*, i.e. bringing autonomy with it, is a contradiction. The understanding alone gives the law. If, however, the imagination is compelled to proceed according to a definite law, its product in respect of form is determined by concepts as to what it ought to be. But then, as is above shown, the satisfaction is not that in the beautiful, but in the good (in perfection, at any rate in mere formal perfection), and the judgment is not a judgment of taste. Hence it is a conformity to law without a law; and a subjective agreement of the imagination and understanding—without such an objective agreement as there is when the representation is referred to a definite concept of an object—can subsist along with the free conformity to law of the understanding (which is also called purposiveness without purpose) and with the peculiar feature of a judgment of taste.

SECOND BOOK

ANALYTIC OF THE SUBLIME

§ 23. TRANSITION FROM THE FACULTY WHICH JUDGES OF THE BEAUTIFUL TO THAT WHICH JUDGES OF THE SUBLIME

The beautiful and the sublime agree in this that both please in themselves. Further, neither presupposes a judgment of sense nor a judgment logically determined, but a judgment of reflection. Consequently the satisfaction [belonging to them] does not depend on a sensation, as in the case of the pleasant, nor on a definite concept, as in the case of the good; but it is nevertheless referred to concepts, although indeterminate ones. And so the satisfaction is connected with the mere presentation [of the object] or with the faculty of presentation, so that in the case of a given intuition this faculty or the imagination is considered as in agreement with the *faculty of concepts* of understanding or reason, regarded as promoting these latter. Hence both kinds of judgments are *singular*, and yet announce themselves as universally valid for every subject; although they lay claim merely to the feeling of pleasure, and not to any cognition of the object.

But there are also remarkable differences between the two. The beautiful in nature is connected with the form of the object, which consists in having [definite] boundaries. The sublime, on the other hand, is to be found in a formless object, so far as in it or by occasion of it *boundlessness* is represented, and yet its totality is also present to thought. Thus the beautiful seems to be regarded as the presentation of an indefinite concept of understanding, the sublime as that of a like concept of reason. Therefore the satisfaction in the one case is bound up with the representation of *quality*, in the other with that of *quantity*. And the latter satisfaction is quite different in kind from the former, for this [the beautiful][1] directly brings with it a feeling of the furtherance of life, and thus is compatible with charms and with the play of the imagination. But the other [the

feeling of the sublime][2] is a pleasure that arises only indirectly; viz. it is produced by the feeling of a momentary checking of the vital powers and a consequent stronger outflow of them, so that it seems to be regarded as emotion—not play, but earnest in the exercise of the imagination. Hence it is incompatible with [physical] charm; and as the mind is not merely attracted by the object but is ever being alternately repelled, the satisfaction in the sublime does not so much involve a positive pleasure as admiration or respect, which rather deserves to be called negative pleasure.

But the inner and most important distinction between the sublime and beautiful is, certainly, as follows. (Here, as we are entitled to do, we only being under consideration in the first instance the sublime in natural objects, for the sublime of art is always limited by the conditions of agreement with nature.) Natural beauty (which is independent) brings with it a purposiveness in its form by which the object seems to be, as it were, preadapted to our judgment, and thus constitutes in itself an object of satisfaction. On the other hand, that which excites in us, without any reasoning about it, but in the mere apprehension of it, the feeling of the sublime may appear, as regards its form, to violate purpose in respect of the judgment, to be unsuited to our presentative faculty, and as it were to do violence to the imagination; and yet it is judged to be only the more sublime.

Now we may see from this that, in general, we express ourselves incorrectly if we call any object of nature sublime, although we can quite correctly call many *objects of nature* beautiful. For how can that be marked by an expression of approval which is apprehended in itself as being a violation of purpose? All that we can say is that the object is fit for the presentation of a sublimity which can be found in the mind, for no sensible form can contain the sublime properly so-called. This concerns only ideas of the reason which, although no adequate presentation is possible for them, by this inadequateness that admits of sensible presentation are aroused and summoned into the mind. Thus the wide ocean,

1. [Second edition.]

2. [Second edition.]

disturbed by the storm, cannot be called sublime. Its aspect is horrible; and the mind must be already filled with manifold ideas if it is to be determined by such an intuition to a feeling itself sublime, as it is incited to abandon sensibility and to busy itself with ideas that involve higher purposiveness.

Independent natural beauty discovers to us a technique of nature which represents it as a system in accordance with laws, the principle of which we do not find in the whole of our faculty of understanding. That principle is the principle of purposiveness, in respect of the use of our judgment in regard to phenomena, [which requires] that these must not be judged as merely belonging to nature in its purposeless mechanism, but also as belonging to something analogous to art. It therefore actually extends, not indeed our cognition of natural objects, but our concept of nature, [which is now not regarded] as mere mechanism but as art. This leads to profound investigations as to the possibility of such a form. But in what we are accustomed to call sublime there is nothing at all that leads to particular objective principles and forms of nature corresponding to them; so far from it that, for the most part, nature excites the ideas of the sublime in its chaos or in its wildest and most irregular disorder and desolation, provided size and might are perceived. Hence, we see that the concept of the sublime is not nearly so important or rich in consequences as the concept of the beautiful; and that, in general, it displays nothing purposive in nature itself, but only in that possible use of our intuitions of it by which there is produced in us a feeling of a purposiveness quite independent of nature. We must seek a ground external to ourselves for the beautiful of nature, but seek it for the sublime merely in ourselves and in our attitude of thought, which introduces sublimity into the representation of nature. This is a very needful preliminary remark, which quite separates the ideas of the sublime from that of a purposiveness of *nature* and makes the theory of the sublime a mere appendix to the aesthetical judging of that purposiveness, because by means of it no particular form is represented in nature, but there is only developed a purposive use which the imagination makes of its representation.

§ 24. OF THE DIVISIONS OF AN INVESTIGATION INTO THE FEELING OF THE SUBLIME

As regards the division of the moments of the aesthetical judging of objects in reference to the feeling of the sublime, the Analytic can proceed according to the same principle as was adopted in the analysis of judgments of taste. For as an act of the aesthetical reflective judgment, the satisfaction in the sublime must be represented just as in the case of the beautiful—according to *quantity* as universally valid, according to *quality* as devoid of *interest*, according to *relation* as subjective purposiveness, and according to *modality* as necessary. And so the method here will not diverge from that of the preceding section, unless indeed we count it a difference that in the case where the aesthetical judgment is concerned with the form of the object we began with the investigation of its quality, but here, in view of the formlessness which may belong to what we call sublime, we will begin with quantity, as the first moment of the aesthetical judgment as to the sublime. The reason for this may be seen from the preceding paragraph.

But the analysis of the sublime involves a division not needed in the case of the beautiful, viz. a division into the *mathematically* and the *dynamically sublime*.

For the feeling of the sublime brings with it as its characteristic feature a *movement* of the mind bound up with the judging of the object, while in the case of the beautiful taste presupposes and maintains the mind in *restful* contemplation. Now this movement ought to be judged as subjectively purposive (because the sublime pleases us), and thus it is referred through the imagination either to the *faculty of cognition* or of *desire*. In either reference the purposiveness of the given representation ought to be judged only in respect of this *faculty* (without purpose or interest), but in the first case it is ascribed to the object as a *mathematical* determination of the imagination, in the second as *dynamical*. And hence we have this twofold way of representing the sublime.

A. OF THE MATHEMATICALLY SUBLIME

§ 25. EXPLANATION OF THE TERM SUBLIME

We call that *sublime* which is *absolutely great*. But to be great and to be a great something are quite different concepts (*magnitudo* and *quantitas*). In like manner to say simply (*simpliciter*) that anything is *great* is quite different from saying that it is *absolutely great* (*absolute, non comparative magnum*). The latter is *what is great beyond all comparison*. What now is meant by the expression that anything is great or small or of medium size? It is not a pure concept of understanding that is thus signified; still less is it an intuition of sense; and just as little is it a concept of reason, because it brings with it no principle of cognition. It must therefore be a concept of judgment or derived from one, and a subjective purposiveness of the representation in reference to the judgment must lie at its basis. That anything is a magnitude (*quantum*) may be cognized from the thing itself, without any comparison of it with other things, viz. if there is a multiplicity of the homogeneous constituting one thing. But to cognize *how great* it is always requires some other magnitude as a measure. But because the judging of magnitude depends, not merely on multiplicity (number), but also on the magnitude of the unit (the measure), and since, to judge of the magnitude of this latter again requires another as measure with which it may be compared, we see that the determination of the magnitude of phenomena can supply no absolute concept whatever of magnitude, but only a comparative one.

If now I say simply that anything is great, it appears that I have no comparison in view, at least none with an objective measure, because it is thus not determined at all how great the object is. But although the standard of comparison is merely subjective, yet the judgment nonetheless claims universal assent; "this man is beautiful" and "he is tall" are judgments, not limited merely to the judging subject, but, like theoretical judgments, demanding the assent of everyone.

In a judgment by which anything is designated simply as great, it is not merely meant that the object has a magnitude, but that this magnitude is superior to that of many other objects of the same kind, without, however, any exact determination of this superiority. Thus there is always at the basis of our judgment a standard which we assume as the same for everyone; this, however, is not available for any logical (mathematically definite) judging of magnitude, but only for aesthetical judging of the same, because it is a merely subjective standard lying at the basis of the reflective judgment upon magnitude. It may be empirical, as, e.g., the average size of the men known to us, of animals of a certain kind, trees, houses, mountains, etc. Or it may be a standard given *a priori* which, through the defects of the judging subject, is limited by the subjective conditions of presentation *in concreto*, as, e.g., in the practical sphere, the greatness of a certain virtue or of the public liberty and justice in a country, or, in the theoretical sphere, the greatness of the accuracy or the inaccuracy of an observation or measurement that has been made, etc.

Here it is remarkable that, although we have no interest whatever in an object—i.e. its existence is indifferent to us—yet its mere size, even if it is considered as formless, may bring a satisfaction with it that is universally communicable and that consequently involves the consciousness of a subjective purposiveness in the use of our cognitive faculty. This is not indeed a satisfaction in the object (because it may be formless), as in the case of the beautiful, in which the reflective judgment finds itself purposively determined in reference to cognition in general, but [a satisfaction] in the extension of the imagination by itself.

If (under the above limitation) we say simply of an object "it is great," this is no mathematically definite judgment, but a mere judgment of reflection upon the representation of it, which is subjectively purposive for a certain use of our cognitive powers in the estimation of magnitude; and we always then bind up with the representation a kind of respect, as also a kind of contempt, for what we simply call "small." Further, the judging of things as great or small extends to everything, even to all their characteristics; thus we describe beauty as great or small. The reason of this is to be sought in the fact that whatever we present in intuition according to the

precept of the judgment (and thus represent aesthetically) is always a phenomenon, and thus a quantum.

But if we call anything, not only great, but absolutely great in every point of view (great beyond all comparison), i.e. sublime, we soon see that it is not permissible to seek for an adequate standard of this outside itself, but merely in itself. It is a magnitude which is like itself alone. It follows hence that the sublime is not to be sought in the things of nature, but only in our ideas; but in which of them it lies must be reserved for the "Deduction."

The foregoing explanation can be thus expressed: *the sublime is that in comparison with which everything else is small.* Here we easily see that nothing can be given in nature, however great it is judged by us to be, which could not, if considered in another relation, be reduced to the infinitely small; and conversely there is nothing so small which does not admit of extension by our imagination to the greatness of a world if compared with still smaller standards. Telescopes have furnished us with abundant material for making the first remark, microscopes for the second. Nothing, therefore, which can be an object of the senses is, considered on this basis, to be called sublime. But because there is in our imagination a striving toward infinite progress and in our reason a claim for absolute totality, regarded as a real idea, therefore this very inadequateness for that idea in our faculty for estimating the magnitude of things of sense excites in us the feeling of a supersensible faculty. And it is not the object of sense, but the use which the judgment naturally makes of certain objects on behalf of this latter that is absolutely great, and in comparison every other use is small. Consequently it is the state of mind produced by a certain representation with which the reflective judgment is occupied, and not the object, that it to be called sublime.

We can therefore append to the preceding formulas explaining the sublime this other: *the sublime is that, the mere ability to think which shows a faculty of the mind surpassing every standard of sense.*

. . .

. . .

But now the mind listens to the voice of reason which, for every given magnitude—even for those that can never be entirely apprehended, although (in sensible representation) they are judged as entirely given—requires totality. Reason consequently desires comprehension in *one* intuition, and so the [joint] *presentation* of all these members of a progressively increasing series. It does not even exempt the infinite (space and past time) from this requirement; it rather renders it unavoidable to think the infinite (in the judgment of common reason) as *entirely given* (according to its totality).

But the infinite is absolutely (not merely comparatively) great. Compared with it everything else (of the same kind of magnitudes) is small. And what is most important is that to be able only to think it as *a whole* indicates a faculty of mind which surpasses every standard of sense. For [to represent it sensibly] would require a comprehension having for unit a standard bearing a definite relation, expressible in numbers, to the infinite, which is impossible. Nevertheless, the *bare capability of thinking* this infinite without contradiction requires in the human mind a faculty itself supersensible. For it is only by means of this faculty and its idea of a noumenon— which admits of no intuition, but which yet serves as the substrate for the intuition of the world, as a mere phenomenon—that the infinite of the world of sense, in the pure intellectual estimation of magnitude, can be *completely* comprehended *under* one concept, although in the mathematical estimation of magnitude by means of *concepts of number* it can never by completely thought. The faculty of being able to think the infinite of supersensible intuition as given (in its intelligible substrate) surpasses every standard of sensibility and is great beyond all comparison even with the faculty of mathematical estimation, not, of course, in a theoretical point of view and on behalf of the cognitive faculty, but as an extension of the mind which feels itself able in another (practical) point of view to go beyond the limits of sensibility.

Nature is therefore sublime in those of its phenomena whose intuition brings with it the idea of its infinity. This last can only come by the inadequacy of the greatest effort of our imagination to estimate the magnitude of an object. But now, in mathematical estimation of magnitude, the imagination is equal to providing a sufficient measure for every object, because the numerical concepts of the understanding, by means of progression, can make any measure adequate to any given magnitude. Therefore it must be the *aesthetical* estimation of magnitude in which the effort toward comprehension surpasses the power of the imagination. Here it is felt that we can comprehend in a whole of intuition the progressive apprehension, and at the same time we perceive the inadequacy of this faculty, unbounded in its progress, for grasping and using any fundamental measure available for the estimation of magnitude with the easiest application of the understanding. Now the proper unchangeable fundamental measure of nature is its absolute whole, which, regarding nature as a phenomenon, would be infinity comprehended. But since this fundamental measure is a self-contradictory concept (on account of the impossibility of the absolute totality of an endless progress), that magnitude of a natural object on which the imagination fruitlessly spends its whole faculty of comprehension must carry our concept of nature to a supersensible substrate (which lies at its basis and also at the basis of our faculty of thought). As this, however, is great beyond all standards of sense, it makes us judge as *sublime*, not so much the object, as our own state of mind in the estimation of it.

Therefore, just as the aesthetical judgment in judging the beautiful refers the imagination in its free play to the *understanding*, in order to harmonize it with the *concepts* of the latter in general (without any determination of them), so does the same faculty, when judging a thing as sublime, refer itself to the reason, in order that it may subjectively be in accordance with its *ideas* (no matter what they are)— i.e. that it may produce a state of mind conformable to them and compatible with that brought about by the influence of definite (practical) ideas upon feeling.

We hence see also that true sublimity must be sought only in the mind of the [subject] judging, not in the natural object the judgment upon which occasions this state. Who would call sublime, e.g., shapeless mountain masses piled in wild disorder upon one another with their pyramids of ice, or the gloomy, raging sea? But the mind feels itself raised in its own judgment if, while contemplating them without any reference to their form, and abandoning itself to the imagination and to the reason— which, although placed in combination with the imagination without any definite purpose, merely extends it—it yet finds the whole power of the imagination inadequate to its ideas.

...

§ 27 OF THE QUALITY OF THE SATISFACTION IN OUR JUDGMENTS UPON THE SUBLIME

The feeling of our incapacity to attain to an idea *which is a law for us* is *respect*. Now the idea of the comprehension of every phenomenon that can be given us in the intuition of a whole is an idea prescribed to us by a law of reason, which recognizes no other measure, definite, valid for everyone, and invariable, than the absolute whole. But our imagination, even in its greatest efforts, in respect of that comprehension which we expect from it of a given object in a whole of intuition (and thus with reference to the presentation of the idea of reason) exhibits its own limits and inadequacy, although at the same time it shows that its destination is to make itself adequate to this idea regarded as a law. Therefore the feeling of the sublime in nature is respect for our own destination, which, by a certain subreption, we attribute to an object of nature (conversion of respect for the idea of humanity in our own subject into respect for the object). This makes intuitively evident the superiority of the rational determination of our cognitive faculties to the greatest faculty of our sensibility.

The feeling of the sublime is therefore a feeling of pain arising from the want of accordance between the aesthetical estimation of magnitude formed by the imagination and the estimation of the same formed by reason. There is at the same time a pleasure thus

excited, arising from the correspondence with rational ideas of this very judgment of the inadequacy of our greatest faculty of sense, in so far as it is a law for us to strive after these ideas. In fact it is for us a law (of reason) and belongs to our destination to estimate as small, in comparison with ideas of reason, everything which nature, regarded as an object of sense, contains that is great for us; and that which arouses in us the feeling of this supersensible destination agrees with that law. Now the greatest effort of the imagination in the presentation of the unit for the estimation of magnitude indicates a reference to something *absolutely great*, and consequently a reference to the law of reason, which bids us take this alone as our highest measure of magnitude. Therefore the inner perception of the inadequacy of all sensible standards for rational estimation of magnitude indicates a correspondence with rational laws; it involves a pain, which arouses in us the feeling of our supersensible destination, according to which it is purposive and therefore pleasurable to find every standard of sensibility inadequate to the ideas of understanding.

The mind feels itself *moved* in the representation of the sublime in nature, while in aesthetical judgments about the beautiful it is in *restful* contemplation.

. . .

B. OF THE DYNAMICALLY SUBLIME IN NATURE

§ 28. OF NATURE REGARDED AS MIGHT

Might is that which is superior to great hindrances. It is called *dominion* if it is superior to the resistance of that which itself possesses might. Nature, considered in an aesthetical judgment as might that has no dominion over us, is *dynamically sublime*.

If nature is to be judged by us as dynamically sublime, it must be represented as exciting fear (although it is not true conversely that every object which excites fear is regarded in our aesthetical judgment as sublime). For in aesthetical judgments (without the aid of concepts) superiority to hindrances can only be judged according to the greatness of the resistance. Now that which we are driven to resist is an evil and, if we do not find our faculties a match for it, is an object of fear. Hence nature can be regarded by the aesthetical judgment as might, and consequently as dynamically sublime, only so far as it is considered an object of fear.

But we can regard an object as *fearful* without being afraid *of* it, viz. if we judge of it in such a way that we merely *think* a case in which we would wish to resist it and yet in which all resistance would be altogether vain. Thus the virtuous man fears God without being afraid of Him, because to wish to resist Him and His commandments he thinks is a case that *he* need not apprehend. But in every such case that he thinks as not impossible, he cognizes Him as fearful.

He who fears can form no judgment about the sublime in nature, just as he who is seduced by inclination and appetite can form no judgment about the beautiful. The former flies from the sight of an object which inspires him with awe, and it is impossible to find satisfaction in a terror that is seriously felt. Hence the pleasurableness arising from the cessation of an uneasiness is *a state of joy*. But this, on account of the deliverance from danger [which is involved], is a state of joy when conjoined with the resolve that we shall no more be exposed to the danger; we cannot willingly look back upon our sensations [of danger], much less seek the occasion for them again.

Bold, overhanging, and as it were threatening rocks; clouds piled up in the sky, moving with lightning flashes and thunder peals; volcanoes in all their violence of destruction; hurricanes with their track of devastation; the boundless ocean in a state of tumult; the lofty waterfall of a mighty river, and such like—these exhibit our faculty of resistance as insignificantly small in comparison with their might. But the sight of them is the more attractive, the more fearful it is, provided only that we are in security; and we willingly call these objects sublime, because they raise the energies of the soul above their accustomed height and discover in us a faculty of resistance of a quite different kind, which gives us courage to measure ourselves against the apparent almightiness of nature.

Now, in the immensity of nature and in the insufficiency of our faculties to take in a standard proportionate to the aesthetical estimation of the magnitude of its *realm*, we find our own limitation, although at the same time in our rational faculty we find a different, nonsensuous standard, which has that infinity itself under it as a unity, in comparison with which everything in nature is small, and thus in our mind we find a superiority to nature even in its immensity. And so also the irresistibility of its might, while making us recognize our own [physical][3] impotence, considered as beings of nature, discloses to us a faculty of judging independently of and a superiority over nature, on which is based a kind of self-preservation entirely different from that which can be attacked and brought into danger by external nature. Thus humanity in our person remains unhumiliated, though the individual might have to submit to this dominion. In this way nature is not judged to be sublime in our aesthetical judgments in so far as it excites fear, but because it calls up that power in us (which is not nature) of regarding as small the things about which we are solicitous (goods, health, and life), and of regarding its might (to which we are no doubt subjected in respect of these things) as nevertheless without any dominion over us and our personality to which we must bow where our highest fundamental propositions, and their assertion or abandonment, are concerned. Therefore nature is here called sublime merely because it elevates the imagination to a presentation of those cases in which the mind can make felt the proper sublimity of its destination, in comparison with nature itself.

This estimation of ourselves loses nothing through the fact that we must regard ourselves as safe in order to feel this inspiriting satisfaction and that hence, as there is no seriousness in the danger, there might be also (as might seem to be the case) just as little seriousness in the sublimity of our spiritual faculty. For the satisfaction here concerns only the *destination* of our faculty which discloses itself in such a case, so far as the tendency to this destination lies in our nature, while its development and exercise remain incumbent and obligatory. And in this there is truth [and reality], however conscious the man may be of his present actual powerlessness, when he turns his reflection to it.

. . .

DEDUCTION OF [PURE][4] AESTHETICAL JUDGMENTS

§ 30 THE DEDUCTION OF AESTHETICAL JUDGMENTS ON THE OBJECTS OF NATURE MUST NOT BE DIRECTED TO WHAT WE CALL SUBLIME IN NATURE, BUT ONLY TO THE BEAUTIFUL

The claim of an aesthetical judgment to universal validity for every subject requires, as a judgment resting on some *a priori* principle, a deduction (or legitimatizing of its pretensions), in addition to its exposition, if it is concerned with satisfaction or dissatisfaction in the *form of the object*. Of this kind are judgments of taste about the beautiful in nature. For in that case the purposiveness has its ground in the object and in its figure, although it does not indicate its reference to other objects in accordance with concepts (for a cognitive judgment), but merely has to do in general with the apprehension of this form, so far as it shows itself conformable to the *faculty* of concepts and of the presentation (which is identical with the apprehension) of them in the mind. We can thus, in respect of the beautiful in nature, suggest many questions touching the cause of this purposiveness of their forms, e.g. to explain why nature has scattered abroad beauty with such profusion, even in the depth of the ocean, where the human eye (for which alone that purposiveness exists) but seldom penetrates.

But the sublime in nature—if we are passing upon it a pure aesthetical judgment, not mixed up with any concepts of perfection or objective purposiveness, in which case it would be a teleological judgment—may be regarded as quite formless or devoid of figure, and yet as the object of a pure satisfaction; and it may display a subjective purposiveness in the given representation. And we ask if, for an aesthetical judgment of this kind—over and above the exposition of what is thought in it—a deduction also of its claim to any (subjective) *a priori* principle may be demanded.

To which we may answer that the sublime in nature is improperly so called and that, properly speaking,

3. [Second edition.]

4. [Second edition.]

the word should only be applied to a state of mind, or rather to its foundation in human nature. The apprehension of an otherwise formless and unpurposive object gives merely the occasion through which we become conscious of such a state; the object is thus *employed* as subjectively purposive, but is not judged as such *in itself* and on account of its form (it is, as it were, a *species finalis accepta, non data*). Hence our exposition of judgments concerning the sublime in nature was at the same time their deduction. For when we analyzed the reflection of the judgment in such acts, we found in them a purposive relation of the cognitive faculties, which must be ascribed ultimately to the faculty of purposes (the will), and hence is itself purposive *a priori*. This, then, immediately involves the deduction, i.e. the justification of the claim of such a judgment to universal and necessary validity.

We shall therefore only have to seek for the deduction of judgments of taste, i.e. of judgments about the beauty of natural things; we shall thus treat satisfactorily the problem with which the whole faculty of aesthetical judgment is concerned.

§ 31 OF THE METHOD OF DEDUCTION OF JUDGMENTS OF TASTE

A deduction, i.e. the guarantee of the legitimacy of a class of judgments, is only obligatory if the judgment lays claim to necessity. This it does if it demands even subjective universality or the agreement of everyone, although it is not a judgment of cognition, but only one of pleasure or pain in a given object, i.e. it assumes a subjective purposiveness thoroughly valid for everyone, which must not be based on any concept of the thing, because the judgment is one of taste.

We have before us in the latter case no cognitive judgment—neither a theoretical one based on the concept of a *nature* in general formed by the understanding, nor a (pure) practical one based on the idea of *freedom*, as given *a priori* by reason. Therefore we have to justify *a priori* the validity, neither of a judgment which represents what a thing is, nor of one which prescribes that I ought to do something in order to produce it. We have merely to prove for the judgment generally the *universal validity* of a

singular judgment that expresses the subjective purposiveness of an empirical representation of the form of an object, in order to explain how it is possible that a thing can please in the mere act of judging it (without sensation or concept) and how the satisfaction of one man can be proclaimed as a rule for every other, just as the act of judging of an object for the sake of a *cognition* in general has universal rules.

If, now, this universal validity is not to be based on any collecting of the suffrages of others or on any questioning of them as to the kind of sensations they have, but is to rest, as it were, on an autonomy of the judging subject in respect of the feeling of pleasure (in the given representation), i.e. on his own taste, and yet is not to be derived from concepts, then a judgment like this—such as the judgment of taste is, in fact—has a twofold logical peculiarity. First, there is its *a priori* universal validity, which is not a logical universality in accordance with concepts, but the universality of a singular judgment. Secondly, it has a necessity (which must always rest on *a priori* grounds), which however does not depend on any *a priori* grounds of proof, through the representation of which the assent that everyone concedes to the judgment of taste could be exacted.

The explanation of these logical peculiarities, wherein a judgment of taste is different from all cognitive judgments—if we at the outset abstract from all content, viz. from the feeling of pleasure, and merely compare the aesthetical form with the form of objective judgments as logic prescribes it—is sufficient by itself for the deduction of this singular faculty. We shall then represent and elucidate by examples these characteristic properties of taste.

§ 32 FIRST PECULIARITY OF THE JUDGMENT OF TASTE

The judgment of taste determines its object in respect of satisfaction (in its beauty) with an accompanying claim for the assent of *everyone*, just as if it were objective.

To say that "this flower is beautiful" is the same as to assert its proper claim to satisfy everyone. By the pleasantness of its smell it has no such claim. A smell which one man enjoys gives another a headache. Now what are we to presume from this except

that beauty is to be regarded as a property of the flower itself, which does not accommodate itself to any diversity of persons or of their sensitive organs, but to which these must accommodate themselves if they are to pass any judgment upon it? And yet this is not so. For a judgment of taste consists in calling a thing beautiful just because of that characteristic in respect of which it accommodates itself to our mode of apprehension.

Moreover, it is required of every judgment which is to prove the taste of the subject that the subject shall judge by himself, without needing to grope about empirically among the judgments of others, and acquaint himself previously as to their satisfaction or dissatisfaction with the same object; thus his judgment should be pronounced *a priori*, and not be a mere imitation, because the thing actually gives universal pleasure. However, we ought to think that an *a priori* judgment must contain a concept of the object for the cognition of which it contains the principle, but the judgment of taste is not based upon concepts at all and is in general, not a cognitive, but an aesthetical judgment.

Thus a young poet does not permit himself to be dissuaded out of his conviction that his poem is beautiful, by the judgment of the public or of his friends; and if he gives ear to them he does so, not because he now judges differently, but because, although (in regard to him) the whole public has false taste, in his desire for applause he finds reason for accommodating himself to the common error (even against his judgment). It is only at a later time, when his judgment has been sharpened by exercise, that he voluntarily departs from his former judgments, just as he proceeds with those of his judgments which rest upon reason. Taste [merely][5] claims autonomy. To make the judgments of others the determining grounds of his own would be heteronomy.

That we, and rightly, recommend the works of the ancients as models and call their authors classical, thus forming among writers a kind of noble class who give laws to the people by their example, seems to indicate *a posteriori* sources of taste and to contradict the autonomy of taste in every subject. But we might just as well say that the old mathematicians—who are regarded up to the present day as supplying models not easily to be dispensed with for the supreme profundity and elegance of their synthetical methods—prove that our reason is only imitative and that we have not the faculty of producing from it, in combination with intuition, rigid proofs by means of the construction of concepts.[6] There is no use of our powers, however free, no use of reason itself (which must create all its judgments *a priori* from common sources) which would not give rise to faulty attempts if every subject had always to begin anew from the rude basis of his natural state and if others had not preceded him with their attempts. Not that these make mere imitators of those who come after them, but rather by their procedure they put others on the track of seeking in themselves principles and so of pursuing their own course, often a better one. Even in religion—where certainly everyone has to derive the rule of his conduct from himself, because he remains responsible for it and cannot shift the blame of his transgressions upon others, whether his teachers or his predecessors—there is never as much accomplished by means of universal precepts, either obtained from priests or philosophers or gotten from oneself, as by means of an example of virtue or holiness which, exhibited in history, does not dispense with the autonomy of virtue based on the proper and original idea of morality (*a priori*) or change it into a mechanical imitation. *Following*, involving something precedent, not "imitation," is the right expression for all influence that the products of an exemplary author may have upon others. And this only means that we draw from the same sources as our predecessor did and learn from him only the way to avail ourselves of them. But of all faculties and talents, taste, because its judgment is not determinable by concepts and precepts, is just that one which most needs examples of what has in the progress of culture received the longest approval, that it may not become again uncivilized and return to the crudeness of its first essays.

5. [Second edition.]

6. [Cf. *Critique of Pure Reason*, "Methodology," Ch. I, § 1. "The construction of a concept is the *a priori* presentation of the corresponding intuition."]

§ 33. SECOND PECULIARITY OF THE JUDGMENT OF TASTE

The judgment of taste is not determinable by grounds of proof, just as if it were merely *subjective*.

If a man, *in the first place*, does not find a building, a prospect, or a poem beautiful, a hundred voices all highly praising it will not force his inmost agreement. He may indeed feign that it pleases him, in order that he may not be regarded as devoid of taste; he may even begin to doubt whether he has formed his taste on a knowledge of a sufficient number of objects of a certain kind (just as one who believes that he recognizes in the distance as a forest something which all others regard as a town doubts the judgment of his own sight). But he clearly sees that the agreement of others gives no valid proof of the judgment about beauty. Others might perhaps see and observe for him; and what many have seen in one way, although he believes that he has seen it differently, might serve him as an adequate ground of proof of a theoretical and consequently logical judgment. But that a thing has pleased others could never serve as the basis of an aesthetical judgment. A judgment of others which is unfavorable to ours may indeed rightly make us scrutinize our own carefully, but it can never convince us of its incorrectness. There is therefore no empirical *ground of proof* which would force a judgment of taste upon anyone.

Still less, *in the second place*, can an *a priori* proof determine according to definite rules a judgment about beauty. If a man reads me a poem of his or brings me to a play which does not on the whole suit my taste, he may bring forward in proof of the beauty of his poem Batteux[7] or Lessing, or still more ancient and famous critics of taste, and all the rules laid down by them. Certain passages which displease me may agree very well with rules of beauty (as they have been put forth by these writers and are universally recognized); but I stop my ears, I will listen to no arguments and no reasoning; and I will rather assume that these rules of the critics are false, or at least that they do not apply to the case in question, than admit that my judgment should be determined by grounds of proof *a priori*. For it is to be a judgment of taste, and not of understanding or reason.

It seems that this is one of the chief reasons why this aesthetical faculty of judgment has been given the name of "taste." For though a man enumerate to me all the ingredients of a dish and remark that each is separately pleasant to me, and further extol with justice the wholesomeness of this particular food, yet am I deaf to all these reasons; I try the dish with my tongue and my palate, and thereafter (and not according to universal principles) do I pass my judgment.

In fact, the judgment of taste always takes the form of a singular judgment about an object. The understanding can form a universal judgment by comparing the object in point of the satisfaction it affords with the judgment of others upon it: e.g., "All tulips are beautiful." But then this is not a judgment of taste but a logical judgment, which takes the relation of an object to taste as the predicate of things of a certain species. That judgment, however, in which I find an individual given tulip beautiful, i.e. in which I find my satisfaction in the object to be universally valid, is alone a judgment of taste. Its peculiarity consists in the fact that, although it has merely subjective validity, it claims the assent of *all* subjects, exactly as it would do if it were an objective judgment resting on grounds of knowledge that could be established by a proof.

§ 34. THERE IS NO OBJECTIVE PRINCIPLE OF TASTE POSSIBLE

By a principle of taste I mean a principle under the condition of which we could subsume the concept of an object and thus infer, by means of a syllogism, that the object is beautiful. But that is absolutely impossible. For I must immediately feel pleasure in the representation of the object, and of that I can be persuaded by no grounds of proof whatever. Although, as Hume says,[8] all critics can reason more plausibly than cooks, yet the same fate awaits them. They cannot expect the determining ground of their

7. [Charles Batteux (1713-1780), author of *Les Beaux Arts reduits à un même principe*.]

8. [Essay XVIII, "The Sceptic": "Critics can reason and dispute more plausibly than cooks or perfumers. We may observe, however, that this uniformity among human kind, hinders not, but that there is a considerable diversity in the sentiments of beauty and worth, and that education, custom, prejudice, caprice, and humour, frequently vary our taste of this kind.... Beauty and worth are merely of a relative nature, and consist in an agreeable sentiment, produced by an object of a particular mind, according to the peculiar structure and constitution of that mind."]

judgment [to be derived] from the force of the proofs, but only from the reflection of the subject upon its own proper state (of pleasure or pain), all precepts and rules being rejected.

But although critics can and ought to pursue their reasonings so that our judgments of taste may be corrected and extended, it is not with a view to set forth the determining ground of this kind of aesthetical judgments in a universally applicable formula, which is impossible; but rather to investigate the cognitive faculties and their exercise in these judgments, and to explain by examples the reciprocal subjective purposiveness, the form of which, as has been shown above, in a given representation, constitutes the beauty of the object. Therefore the critique of taste is only subjective as regards the representation through which an object is given to us, viz. it is the art or science of reducing to rules the reciprocal relation between the understanding and the imagination in the given representation (without reference to any preceding sensation or concept). That is, it is the art or science of reducing to rules their accordance or discordance, and of determining the conditions of this. It is an *art*, if it only shows this by examples; it is a *science* if it derives the possibility of such judgments from the nature of these faculties, as cognitive faculties in general. We have here, in Transcendental Critique, only to do with the latter. It should develop and justify the subjective principle of taste, as an *a priori* principle of the judgment. This critique, as an art, merely seeks to apply, in the judging of objects, the physiological (here psychological), and therefore empirical, rules according to which taste actually proceeds (without taking any account of their possibility); and it criticizes the products of beautiful art just as, regarded as a science, it criticizes the faculty by which they are judged.

§ 35. THE PRINCIPLE OF TASTE IS THE SUBJECTIVE PRINCIPLE OF JUDGMENT IN GENERAL

The judgment of taste is distinguished from a logical judgment in this that the latter subsumes a representation under the concept of the object, while the former does not subsume it under any concept; because otherwise the necessary universal agreement [in these judgments] would be capable of being compelled by proofs. Nevertheless it is like the latter in this that it claims universality and necessity, though not according to concepts of the object, and consequently a merely subjective necessity. Now because the concepts in a judgment constitute its content (what belongs to the cognition of the object), but the judgment of taste is not determinable by concepts, it is based only on the subjective formal condition of a judgment in general. The subjective condition of all judgments is the faculty of judgment itself. This, when used with reference to a representation by which an object is given, requires the accordance of two representative powers, viz. imagination (for the intuition and comprehension of the manifold) and understanding (for the concept as a representation of the unity of this comprehension). Now because no concept of the object lies here at the basis of the judgment, it can only consist in the subsumption of the imagination itself (in the case of a representation by which an object is given), under the conditions that the understanding requires to pass from intuition to concepts. That is, because the freedom of the imagination consists in the fact that it schematizes without any concept, the judgment of taste must rest on a mere sensation of the reciprocal activity of the imagination in its *freedom* and the understanding with its *conformity to law*. It must therefore rest on a feeling, which makes us judge the object by the purposiveness of the representation (by which an object is given) in respect of the furtherance of the cognitive faculty in its free play. Taste, then, as subjective judgment, contains a principle of subsumption, not of intuitions under concepts, but of the *faculty* of intuitions or presentations (i.e. the imagination) under the *faculty* of the concepts (i.e. the understanding), so far as the former *in its freedom* harmonizes with the latter *in its conformity to law*.

In order to discover this ground of legitimacy by a deduction of the judgments of taste, we can only take as a clue the formal peculiarities of this kind of judgments, and consequently can only consider their logical form.

§ 36. OF THE PROBLEM OF A DEDUCTION OF JUDGMENTS OF TASTE

The concept of an object in general can immediately be combined with the perception of an object, containing its empirical predicates, so as to form a cognitive judgment; and it is thus that a judgment of experience is produced.[9] At the basis of this lie *a priori* concepts of the synthetical unity of the manifold of intuition, by which the manifold is thought as the determination of an object. These concepts (the categories) require a deduction, which is given in the *Critique of Pure Reason*; and by it we can get the solution of the problem: how are synthetical a priori cognitive judgments possible? This problem concerns then the *a priori* principles of the pure understanding and its theoretical judgments.

But with a perception there can also be combined a feeling of pleasure (or pain) and a satisfaction, that accompanies the representation of the object and serves instead of its predicate; thus there can result an aesthetical noncognitive judgment. At the basis of such a judgment—if it is not a mere judgment of sensation but a formal judgment of reflection, which imputes the same satisfaction necessarily to everyone—must lie some *a priori* principle, which may be merely subjective (if an objective one should prove impossible for judgments of this kind), but also as such may need a deduction, that we may thereby comprehend how an aesthetical judgment can lay claim to necessity. On this is founded the problem with which we are now occupied: how are judgments of taste possible? This problem, then, has to do with the *a priori* principles of the pure faculty of judgment in *aesthetical* judgments, i.e. judgments in which it has not (as in theoretical ones) merely to subsume under objective concepts of understanding and in which it is subject to a law, but in which it is itself, subjectively, both object and law.

This problem then may be thus represented: how is a judgment possible in which merely from *our own* feeling of pleasure in an object, independently of its concept, we judge that this pleasure attaches to the representation of the same object *in every other subject*, and that *a priori* without waiting for the accordance of others?

It is easy to see that judgments of taste are synthetical, because they go beyond the concept and even beyond the intuition of the object, and add to that intuition as predicate something that is not a cognition, viz. a feeling of pleasure (or pain). Although the predicate (of the *personal* pleasure bound up with the representation) is empirical, nevertheless, as concerns the required assent of *everyone* the judgments are *a priori*, or desire to be regarded as such; and this is already involved in the expressions of this claim. Thus this problem of the *Critique of Judgment* belongs to the general problem of transcendental philosophy: how are synthetical *a priori* judgments possible?

§ 37. WHAT IS PROPERLY ASSERTED A PRIORI OF AN OBJECT IN A JUDGMENT OF TASTE

That the representation of an object is immediately bound up with pleasure can only be internally perceived; an if we did not wish to indicate anything more than this, it would give a merely empirical judgment. For I cannot combine a definite feeling (of pleasure or pain) with any representation, except where there is at bottom an *a priori* principle in the reason determining the will. In that case the pleasure (in the moral feeling) is the consequence of the principle, but cannot be compared with the pleasure in taste, because it requires a definite concept of a law; and the latter pleasure, on the contrary, must be bound up with the mere act of judging, prior to all concepts. Hence also all judgments of taste are singular judgments, because they do not combine their predicate of satisfaction with a concept, but with a given individual empirical representation.

And so it is not the pleasure, but the *universal validity of this pleasure*, perceived as mentally bound up with the mere judgment upon an object, which is represented *a priori* in a judgment of taste as a universal rule for the judgment and valid for everyone. It is an empirical judgment [to say] that I perceive and judge an object with pleasure. But it is an *a priori* judgment [to say] that I find it beautiful, i.e. I attribute this satisfaction necessarily to everyone.

9. [For the distinction—an important one in Kant—between judgments of experience and judgments of perception, see his *Prolegomena*, § 18.]

If it be admitted that, in a pure judgment of taste, the satisfaction in the object is combined with the mere act of judging its form, it is nothing else than its subjective purposiveness for the judgment which we feel to be mentally combined with the representation of the object. The judgment, as regards the formal rules of its action, apart from all matter (whether sensation or concept), can only be directed to the subjective conditions of its employment in general (it is applied[10] neither to a particular mode of sense nor to a particular concept of the understanding), and consequently to that subjective [element] which we can presuppose in all men (as requisite for possible cognition in general). Thus the agreement of a representation with these conditions of the judgment must be capable of being assumed as valid *a priori* for everyone. That is, we may rightly impute to everyone the pleasure or the subjective purposiveness of the representation for the relation between the cognitive faculties in the act of judging a sensible object in general.[11]

Remark

This deduction is thus easy, because it has no need to justify the objective reality of any concept, for beauty is not a concept of the object and the judgment of taste is not cognitive. It only maintains that we are justified in presupposing universally in every man those subjective conditions of the judgment which we find in ourselves; and further, that we have

rightly subsumed the given object under these conditions. The latter has indeed unavoidable difficulties which do not beset the logical judgment. There we subsume under concepts, but in the aesthetical judgment under a merely sensible relation between the imagination and understanding mutually harmonizing in the representation of the form of the object—in which case the subsumption may easily be deceptive. Yet the legitimacy of the claim of the judgment in counting upon universal assent is not thus annulled; it reduces itself merely to judging as valid for everyone the correctness of the principle from subjective grounds. For as to the difficulty or doubt concerning the correctness of the subsumption under that principle, it makes the legitimacy of the claim of an aesthetical judgment in general to such validity and the principle of the same as little doubtful as the alike (though neither so commonly nor readily) faulty subsumption of the logical judgment under its principle can make the latter, an objective principle, doubtful. But if the question were to be, "How is it possible to assume nature *a priori* to be a complex of objects of taste?" this problem has reference to teleology, because it must be regarded as a purpose of nature essentially belonging to its concept to exhibit forms that are purposive for our judgment. But the correctness of this latter assumption is very doubtful, whereas the efficacy of natural beauties is patent to experience.

. . .

§ 43. OF ART IN GENERAL

(1) Art is distinguished from nature as doing (*facere*) is distinguished from acting or working generally (*agere*), and as the product or result of the former is distinguished as work (*opus*) from the working (*effectus*) of the latter.

By right we ought only to describe as art, production through freedom, i.e. through a will that places reason at the basis of its actions. For although we like to call the product of bees (regularly built cells of wax) a work of art, this is only by way of analogy; as soon as we feel that this work of theirs is based on no proper rational deliberation, we say that it is a product of nature (of instinct), and as art only ascribe it to their Creator.

10. [First edition has "limited."]

11. In order to be justified in claiming universal assent for an aesthetical judgment that rests merely on subjective grounds, it is sufficient to assume:
(1) That the subjective conditions of the judgment, as regards the relation of the cognitive powers thus put into activity to a cognition in general, are the same in all men. This must be true, because otherwise men would not be able to communicate their representations or even their knowledge.
(2) The judgment must merely have reference to this relation (consequently to the *formal condition* of the judgment) and be pure, i.e. not mingled either with concepts of the object or with sensations, as determining grounds. If there has been any mistake as regards this latter condition, then there is only an inaccurate application of the privilege, which a law gives us, to a particular case; but that does not destroy the privilege itself in general.

If, as sometimes happens, in searching through a bog we come upon a bit of shaped wood, we do not say, this is a product of nature, but of art. Its producing cause has conceived a purpose to which the plank owes its form. Elsewhere too we should see art in everything which is made, so that a representation of it in its cause must have preceded its actual existence (as even in the case of the bees), though without the effect of it even being capable of being *thought*. But if we call anything absolutely a work of art, in order to distinguish it from a natural effect, we always understand by that a work of man.

(2) Art regarded as human skill differs from science (as *can* from *know*) as a practical faculty does from a theoretical, as technique does from theory (as mensuration from geometry). And so what we *can* do, as soon as we merely *know* what ought to be done and therefore are sufficiently cognizant of the desired effect, is not called art. Only that which a man, even if he knows it completely, may not therefore have the skill to accomplish belongs to art. Camper[12] describes very exactly how the best shoes must be made, but he certainly could not make one.[13]

(3) Art also differs from handicraft; the first is called "free," the other may be called "mercenary." We regard the first as if it could only prove purposive as play, i.e. as occupation that is pleasant in itself. But the second is regarded as if it could only be compulsorily imposed upon one as work, i.e. as occupation which is unpleasant (a trouble) in itself and which is only attractive on account of its effect (e.g. the wage). Whether or not in the grade of the professions we ought to count watchmakers as artists, but smiths only as handicraftsmen, would require another point of view from which to judge than that which we are here taking up, viz. [we should have to consider] the proportion of talents which must be assumed requisite in these several occupations.

12. [Peter Camper (1722-1789), a celebrated naturalist and comparative anatomist, for some years professor at Groningen.]

13. In my country a common man, if you propose to him such a problem as that of Columbus with his egg, says, "That is not art, it is only science." That is, if we *know* how, we can *do* it; and he says the same of all the pretended arts of jugglers. On the other hand, he will not refuse to apply the term "art" to the performance of a rope dancer.

Whether or not, again, under the so-called seven free arts, some may be included which ought to be classed as sciences and many that are akin rather to handicraft I shall not here discuss. But it is not inexpedient to recall that, in all free arts, there is yet requisite something compulsory or, as it is called, mechanism, without which the spirit, which must be free in art and which alone inspires the work, would have no body and would evaporate altogether; e.g. in poetry there must be an accuracy and wealth of language, and also prosody and measure. [It is not inexpedient, I say, to recall this], for many modern educators believe that the best way to produce a free art is to remove it from all constraint, and thus to change it from work into mere play.

§ 44. OF BEAUTIFUL ART

There is no science of the beautiful, but only a critique of it; and there is no such thing as beautiful science, but only beautiful art. For as regards the first point, if it could be decided scientifically, i.e. by proofs, whether a thing was to be regarded as beautiful or not, the judgment upon beauty would belong to science and would not be a judgment of taste. And as far as the second point is concerned, a science which should be beautiful as such is a nonentity. For if in such a science we were to ask for grounds and proofs, we would be put off with tasteful phrases (*bon-mots*). The source of the common expression, *beautiful science*, is without doubt nothing else than this, as it has been rightly remarked, that for beautiful art in its entire completeness much science is requisite, e.g. a knowledge of ancient languages, a learned familiarity with classical authors, history, a knowledge of antiquities, etc. And hence these historical sciences, because they form the necessary preparation and basis for beautiful art, and also partly because under them is included the knowledge of the products of beautiful art (rhetoric and poetry), have come to be called beautiful sciences by a transposition of words.

If art which is adequate to the *cognition* of a possible object performs the actions requisite therefore merely in order to make it actual, it is *mechanical* art; but if it has for its immediate design the feeling of pleasure, it is called *aesthetical* art. This is again

either *pleasant* or *beautiful*. It is the first if its purpose is that the pleasure should accompany the representations [of the object] regarded as mere *sensations*; it is the second if they are regarded as *modes of cognition*.

Pleasant arts are those that are directed merely to enjoyment. Of this class are all those charming arts that can gratify a company at table, e.g. the art of telling stories in an entertaining way, of starting the company in frank and lively conversation, of raising them by jest and laugh to a certain pitch of merriment;[14] when, as people say, there may be a great deal of gossip at the feast, but no one will be answerable for what he says, because they are only concerned with momentary entertainment, and not with any permanent material for reflection or subsequent discussion. (Among these are also to be reckoned the way of arranging the table for enjoyment and, at great feasts, the management of the music. This latter is a wonderful thing. It is meant to dispose to gaiety the minds of the guests, regarded solely as a pleasant noise, without anyone paying the least attention to its composition; and it favors the free conversation of each with his neighbor.) Again, to this class belong all games which bring with them no further interest than that of making the time pass imperceptibly.

On the other hand, beautiful art is a mode of representation which is purposive for itself and which, although devoid of [definite] purpose, yet furthers the culture of the mental powers in reference to social communication.

The universal communicability of a pleasure carries with it in its very concept that the pleasure is not one of enjoyment, from mere sensation, but must be derived from reflection; and thus aesthetical art, as the art of beauty, has for standard the reflective judgment and not sensation.

§ 45. BEAUTIFUL ART IS AN ART IN SO FAR AS IT SEEMS LIKE NATURE

In a product of beautiful art, we must become conscious that it is art and not nature; but yet the purposiveness in its form must seem to be as free from all constraint of arbitrary rules as if it were a product of mere nature. On this feeling of freedom in the play of our cognitive faculties, which must at the same time be purposive, rests that pleasure which alone is universally communicable, without being based on concepts. Nature is beautiful because it looks like art, and art can only be called beautiful if we are conscious of it as art while yet it looks like nature.

For whether we are dealing with natural or with artificial beauty, we can say generally: *That is beautiful which pleases in the mere act of judging it* (not in the sensation of it or by means of a concept). Now art has always a definite design of producing something. But if this something were bare sensation (something merely subjective), which is to be accompanied with pleasure, the product would please in the act of judgment only by mediation of sensible feeling. And again, if the design were directed toward the production of a definite object, then, if this were attained by art, the object would only please by means of concepts. But in both cases the art would not please *in the mere act of judging*, i.e. it would not please as beautiful but as mechanical.

Hence the purposiveness in the product of beautiful art, although it is designed, must not seem to be designed, i.e. beautiful art must *look* like nature, although we are conscious of it as art. But a product of art appears like nature when, although its agreement with the rules, according to which alone the product can become what it ought to be, is *punctiliously* observed, yet this is not *painfully* apparent; [the form of the schools does not obtrude itself][15]—it shows no trace of the rule having been before the eyes of the artist and having fettered his mental powers.

§ 46. BEAUTIFUL ART IS THE ART OF GENIUS

Genius is the talent (or natural gift) which gives the rule to art. Since talent, as the innate productive faculty of the artist, belongs itself to nature, we may express the matter thus: Genius is the innate mental disposition (*ingenium*) *through which* nature gives the rule to art.

14. [Kant was accustomed to say that the talk at a dinner table should always pass through these three stages: narrative, discussion, and just; and punctilious in this, as in all else, he is said to have directed the conversation at his own table accordingly (Wallace's *Kant*, p. 39).]

15. [Second edition.]

Whatever may be thought of this definition, whether it is merely arbitrary or whether it is adequate to the concept that we are accustomed to combine with the word *genius* (which is to be examined in the following paragraphs), we can prove already beforehand that, according to the signification of the word here adopted, beautiful arts must necessarily be considered as arts of *genius*.

For every art presupposes rules by means of which in the first instance a product, if it is to be called artistic, is represented as possible. But the concept of beautiful art does not permit the judgment upon the beauty of a product to be derived from any rule which has a *concept* as its determining ground, and therefore has at its basis a concept of the way in which the product is possible. Therefore beautiful art cannot itself devise the rule according to which it can bring about its product. But since at the same time a product can never be called art without some precedent rule, nature in the subject must (by the harmony of its faculties) give the rule to art; i.e. beautiful art is only possible as a product of genius.

We thus see (1) that genius is a *talent* for producing that for which no definite rule can be given; it is not a mere aptitude for what can be learned by a rule. Hence *originality* must be its first property. (2) But since it also can produce original nonsense, its products must be models, i.e. *exemplary*, and they consequently ought not to spring from imitation, but must serve as a standard or rule of judgment for others. (3) It cannot describe or indicate scientifically how it brings about its products, but it gives the rule just as nature does. Hence the author of a product for which he is indebted to his genius does not know himself how he has come by his ideas; and he has not the power to devise the like at pleasure or in accordance with a plan, and to communicate it to others in precepts that will enable them to produce similar products. (Hence it is probably that the word "genius" is derived from *genius*, that peculiar guiding and guardian spirit given to a man at his birth, from whose suggestion these original ideas proceed.) (4) Nature, by the medium of genius, does not prescribe rules to science but to art, and to it only in so far as it is to be beautiful art.

§ 47. ELUCIDATION AND CONFIRMATION OF THE ABOVE EXPLANATION OF GENIUS

Everyone is agreed that genius is entirely opposed to the *spirit of imitation*. Now since learning is nothing but imitation, it follows that the greatest ability and teachableness (capacity) regarded *quâ* teachableness cannot avail for genius. Even if a man thinks or composes for himself and does not merely take in what others have taught, even if he discovers many things in art and science, this is not the right ground for calling such a (perhaps great) *head* a genius (as opposed to him who, because he can only learn and imitate, is called a *shallowpate*). For even these things could be learned; they lie in the natural path of him who investigates and reflects according to rules, and they do not differ specifically from what can be acquired by industry through imitation. Thus we can readily learn all that Newton has set forth in his immortal work on the *Principles of Natural Philosophy*, however great a head was required to discover it, but we cannot learn to write spirited poetry, however express may be the precepts of the art and however excellent its models. The reason is that Newton could make all his steps, from the first elements of geometry to his own great and profound discoveries, intuitively plain and definite as regards consequence, not only to himself but to everyone else. But a Homer or a Wieland cannot show how his ideas, so rich in fancy and yet so full of thought, come together in his head, simply because he does not know and therefore cannot teach others. In science, then, the greatest discoverer only differs in degree from his laborious imitator and pupil, but he differs specifically from him whom nature has gifted for beautiful art. And in this there is no depreciation of those great men to whom the human race owes so much gratitude, as compared with nature's favourites in respect of the talent for beautiful art. For in the fact that the former talent is directed to the ever advancing greater perfection of knowledge and every advantage depending on it, and at the same time to the imparting this same knowledge to others—in this it has a great superiority over [the talent of] those who deserve the honor of being called geniuses. For art stands still at a certain point; a boundary is set to it beyond which it cannot go,

which presumably has been reached long ago and cannot be extended further. Again, artistic skill cannot be communicated; it is imparted to every artist immediately by the hand of nature; and so it dies with him, until nature endows another in the same way, so that he only needs an example in order to put in operation in a similar fashion the talent of which he is conscious.

If now it is a natural gift which must prescribe its rule to art (as beautiful art), of what kind is this rule? It cannot be reduced to a formula and serve as a precept, for then the judgment upon the beautiful would be determinable according to concepts; but the rule must be abstracted from the fact, i.e. from the product, on which others may try their own talent by using it as a model, not to be *copied* but to be *imitated*. How this is possible is hard to explain. The ideas of the artist excite like ideas in his pupils if nature has endowed them with a like proportion of their mental powers. Hence models of beautiful art are the only means of handing down these ideas to posterity. This cannot be done by mere descriptions, especially not in the case of the arts of speech; and in this latter classical models are only to be had in the old dead languages, now preserved only as "the learned languages."

Although mechanical and beautiful art are very different, the first being a mere art of industry and learning and the second of genius, yet there is no beautiful art in which there is not a mechanical element that can be comprehended by rules and followed accordingly, and in which therefore there must be something *scholastic* as an essential condition. For [in every art] some purpose must be conceived; otherwise we could not ascribe the product to art at all; it would be a mere product of chance. But in order to accomplish a purpose, definite rules from which we cannot dispense ourselves are requisite. Now since the originality of the talent constitutes an essential (though not the only) element in the character of genius, shallow heads believe that they cannot better show themselves to be full-blown geniuses than by throwing off the constraint of all rules; they believe, in effect, that one could make a braver show on the back of a wild horse than on the back of a trained animal. Genius can only furnish rich *material* for products of beautiful art; its execution and its *form* require talent cultivated in the schools, in order to make such a use of this material as will stand examination by the judgment. But it is quite ridiculous for a man to speak and decide like a genius in things which require the most careful investigation by reason. One does not know whether to laugh more at the impostor who spreads such a mist round him that we cannot clearly use our judgment, and so use our imagination the more, or at the public which naïvely imagines that his inability to cognize clearly and to comprehend the masterpiece before him arises from new truths crowding in on him in such abundance that details (duly weighed definitions and accurate examination of fundamental propositions) seem but clumsy work.

§ 48. OF THE RELATION OF GENIUS TO TASTE

For *judging* of beautiful objects as such, *taste* is requisite; but for beautiful art, i.e. for the *production* of such objects, *genius* is requisite.

If we consider genius as the talent for beautiful art (which the special meaning of the word implies) and in this point of view analyze it into the faculties which must concur to constitute such a talent, it is necessary in the first instance to determine exactly the difference between natural beauty, the judging of which requires only taste, and artificial beauty, the possibility of which (to which reference must be made in judging such an object) requires genius.

A natural beauty is a *beautiful thing*; artificial beauty is a *beautiful representation* of a thing.

In order to judge of a natural beauty as such, I need not have beforehand a concept of what sort of thing the object is to be; i.e. I need not know its material purposiveness (the purpose), but its mere form pleases by itself in the act of judging it without any knowledge of the purpose. But if the object is given as a product of art and as such is to be declared beautiful, then, because art always supposes a purpose in the cause (and its causality), there must be at bottom in the first instance a concept of what the thing is to be. And as the agreement of the manifold in a thing with its inner destination, its purpose, constitutes the perfection of the thing, it follows that in judging of artificial beauty the perfection of the

thing must be taken into account; but in judging of natural beauty (as *such*) there is no question at all about this. It is true that in judging of objects of nature, especially objects endowed with life, e.g. a man or a horse, their objective purposiveness also is commonly taken into consideration in judging of their beauty; but then the judgment is no longer purely aesthetical, i.e. a mere judgment of taste. Nature is no longer judged inasmuch as it appears like art, but in so far as it *is* actual (although superhuman) art; and the teleological judgment serves as the basis and condition of the aesthetical, as a condition to which the latter must have respect. In such a case, e.g. if it is said "That is a beautiful woman," we think nothing else than this: nature represents in her figure the purposes in view in the shape of a woman's figure. For we must look beyond the mere form to a concept, if the object is to be thought in such a way by means of a logically conditioned aesthetical judgment.

Beautiful art shows its superiority in this, that it describes as beautiful things which may be in nature ugly or displeasing.[16] The Furies, diseases, the devastations of war, etc., may [even regarded as calamitous][17] be described as very beautiful, as they are represented in a picture. There is only one kind of ugliness which cannot be represented in accordance with nature without destroying all aesthetical satisfaction, and consequently artificial beauty, viz. that which excites *disgust*. For in this singular sensation, which rests on mere imagination, the object is represented as it were obtruding itself for our enjoyment, while we strive against it with all our might. And the artistic representation of the object is no longer distinguished from the nature of the object itself in our sensation, and thus it is impossible

that it can be regarded as beautiful. The art of sculpture again, because in its products art is almost interchangeable with nature, excludes from its creations the immediate representation of ugly objects; e.g. it represents death by a beautiful genius, the warlike spirit by Mars, and permits [all such things] to be represented only by an allegory or attribute that has a pleasing effect, and thus only indirectly by the aid of the interpretation of reason, and not for the mere aesthetical judgment.

So much for the beautiful representation of an object, which is properly only the form of the presentation of a concept, by means of which this latter is communicated universally. But to give this form to the product of beautiful art, mere taste is requisite. By taste the artist estimates his work after he has exercised and corrected it by manifold examples from art or nature, and after many, often toilsome, attempts to content himself he finds that form which satisfies him. Hence this form is not, as it were, a thing of inspiration or the result of a free swing of the mental powers, but of a slow and even painful process of improvement, by which he seeks to render it adequate to his thought, without detriment to the freedom of the play of his powers.

But taste is merely a judging and not a productive faculty, and what is appropriate to it is therefore not a work of beautiful art. It can only be a product belonging to useful and mechanical art or even to science, produced according to definite rules that can be learned and must be exactly followed. But the pleasing form that it given to it is only the vehicle of communication and a mode, as it were, of presenting it, in respect of which we remain free to a certain extent, although it is combined with a definite purpose. Thus we desire that table appointments, a moral treatise, even a sermon, should have in themselves this form of beautiful art, without it seeming to be *sought*; but we do not therefore call these things works of beautiful art. Under the latter class are reckoned a poem, a piece of music, a picture gallery, etc.; and in some works of this kind asserted to be works of beautiful art we find genius without taste, while in others we find taste without genius.

16. [Cf. Aristotle Poetics iv. 1448b: ἃ γὰρ αὐτὰ ʼλυπηρῶς δρῶμεν, τούτων τὰς εἰχόνας τὰς μάλιστα ἠχρβωμένας χαίρομεν θεωροῦντες oἶoν θηρίων τε μορφὰς τῶν ἀτιμοτάτων xαὶ νεxρῶν. Cf. also Rhetoric i. 11. 1371b; and Burke on the Sublime and Beautiful, Pt. I, § 16. Boileau L'art poétique, chant 3 makes a similar observation:
"Il n'est point de serpent ni de monstre odieux
Qui, par l'art imité, ne puisse plaire aux yeux.
D'un pinceau délicat l'artifice agréable
Du plus affreux objet fait un objet aimable."]

17. [Second edition.]

§ 49. OF THE FACULTIES OF THE MIND THAT CONSTITUTE GENIUS

We say of certain products of which we expect that they should at least in part appear as beautiful art, they are without *spirit*,[18] although we find nothing to blame in them on the score of taste. A poem may be very neat and elegant, but without spirit. A history may be exact and well arranged, but without spirit. A festal discourse may be solid and at the same time elaborate, but without spirit. Conversation is often not devoid of entertainment, but it is without spirit; even of a woman we say that she is pretty, an agreeable talker, and courteous, but without spirit. What then do we mean by spirit?

Spirit, in an aesthetical sense, is the name given to the animating principle of the mind. But that by means of which this principle animates the soul, the material which it applies to that [purpose], is what puts the mental powers purposively into swing, i.e. into such a play as maintains itself and strengthens the mental powers in their exercise.

Now I maintain that this principle is no other than the faculty of presenting *aesthetical ideas*. And by an aesthetical idea I understand that representation of the imagination which occasions much thought, without however any definite thought, i.e. any *concept*, being capable of being adequate to it; it consequently cannot be completely compassed and made intelligible by language. We easily see that it is the counterpart (pendant) of a *rational idea*, which conversely is a concept to which no *intuition* (or representation of the imagination) can be adequate.

The imagination (as a productive faculty of cognition) is very powerful in creating another nature, as it were, out of the material that actual nature gives it. We entertain ourselves with it when experience becomes too commonplace, and by it we remold experience, always indeed in accordance with analogical laws, but yet also in accordance with principles which occupy a higher place in reason (laws, too, which are just as natural to us as those by which understanding comprehends empirical nature).

Thus we feel our freedom from the law of association (which attaches to the empirical employment of imagination), so that the material supplied to us by nature in accordance with this law can be worked up into something different which surpasses nature.

Such representations of the imagination we may call *ideas*, partly because they at least strive after something which lies beyond the bounds of experience and so seek to approximate to a presentation of concepts of reason (intellectual ideas), thus giving to the latter the appearance of objective reality, but especially because no concept can be fully adequate to them as internal intuitions. The poet ventures to realize to sense, rational ideas of invisible beings, the kingdom of the blessed, hell, eternity, creation, etc.; or even if he deals with things of which there are examples in experience—e.g. death, envy and all vices, also love, fame, and the like—he tries, by means of imagination, which emulates the play of reason in its quest after a maximum, to go beyond the limits of experience and to present them to sense with a completeness of which there is no example in nature. This is properly speaking the art of the poet, in which the faculty of aesthetical ideas can manifest itself in its entire strength. But this faculty, considered in itself, is properly only a talent (of the imagination).

If now we place under a concept a representation of the imagination belonging to its presentation, but which occasions in itself more thought than can ever be comprehended in a definite concept and which consequently aesthetically enlarges the concept itself in an unbounded fashion, the imagination is here creative, and it brings the faculty of intellectual ideas (the reason) into movement; i.e. by a representation more thought (which indeed belongs to the concept of the object) is occasioned than can in it be grasped or made clear.

Those forms which do not constitute the presentation of a given concept itself but only, as approximate representations of the imagination, express the consequences bound up with it and its relationship to other concepts, are called (aesthetical) *attributes* of an object whose concept as a rational idea cannot be adequately presented. Thus Jupiter's eagle with the lightning in its claws is an attribute of the mighty

18. [In English we would rather say "without soul," but I prefer to translate "*Geist*" consistently by "spirit," to avoid the confusion of it with "*Seele*."]

king of heaven, as the peacock is of his magnificent queen. They do not, like *logical attributes*, represent what lies in our concepts of the sublimity and majesty of creation, but something different, which gives occasion to the imagination to spread itself over a number of kindred representations that arouse more thought than can be expressed in a concept determined by words. They furnish an *aesthetical idea*, which for that rational idea takes the place of logical presentation; and thus, as their proper office, they enliven the mind by opening out to it the prospect into an illimitable field of kindred representations. But beautiful art does this not only in the case of painting or sculpture (in which the term "attribute" is commonly employed); poetry and rhetoric also get the spirit that animates their works simply from the aesthetical attributes of the object, which accompany the logical and stimulate the imagination, so that it thinks more by their aid, although in an undeveloped way, than could be comprehended in a concept and therefore in a definite form of words. For the sake of brevity, I must limit myself to a few examples only.

When the great King[19] in one of his poems expresses himself as follows:

Oui, finissons sans trouble et mourons sans regrets,
En laissant l'univers comblé de nos bienfaits.
Ainsi l'astre du jour au bout de sa carriere,
Répand sur l'horizon une douce lumière;
Et les derniers rayons qu'il darde dans les airs,
Sont les derniers soupirs qu'il donne à l'univers;

he quickens his rational idea of a cosmopolitan disposition at the end of life by an attribute which the imagination (in remembering all the pleasures of a beautiful summer day that are recalled at its close by a serene evening) associates with that representation, and which excites a number of sensations and secondary representations for which no expression is found. On the other hand, an intellectual concept may serve conversely as an attribute for a representation of sense, and so can quicken this latter by means of the idea of the supersensible, but only by the aesthetical [element], that subjectively attaches to the concept of the latter, being here employed. Thus, for example, a certain poet[20] says, in his description of a beautiful morning:

The sun arose
As calm from virtue springs.

The consciousness of virtue, if we substitute it in our thoughts for a virtuous man, diffuses in the mind a multitude of sublime and restful feelings, and a boundless prospect of a joyful future, to which no expression that is measured by a definite concept completely attains.[21]

In a word, the aesthetical idea is a representation of the imagination associated with a given concept, which is bound up with such a multiplicity of partial representations in its free employment that for it no expression marking a definite concept can be found; and such a representation, therefore, adds to a concept much ineffable thought, the feeling of which quickens the cognitive faculties, and with language, which is the mere letter, binds up spirit also.

The mental powers, therefore, whose union (in a certain relation) constitutes genius are imagination and understanding. In the employment of the imagination for cognition, it submits to the constraint of the understanding and is subject to the limitation of being conformable to the concept of the latter. On the contrary, in an aesthetical point of view it is free to furnish unsought, over and above that agreement with a concept, abundance of undeveloped material for the understanding, to which the understanding paid no regard in its concept but which it applies, though not objectively for cognition, yet subjectively to quicken the cognitive powers and

19. [Barni quotes these lines as occurring in one of Frederick the Great's French poems: "Epître au maréchal Keith, sur les vaines terreurs de la mort et les frayeurs d'une autre vie"; but I have not been able to verify his reference. Kant here translates them into German.]

20. [I have not been able to identify this poet.]

21. Perhaps nothing more sublime was ever said and no sublimer thought ever expressed than the famous inscription on the Temple of Isis (Mother Nature): "I am all that is and that was and that shall be, and no mortal hath lifted my veil." Segner availed himself of this idea in a *suggestive* vignette prefixed to his *Natural Philosophy*, in order to inspire beforehand the pupil whom he was about to lead into that temple with a holy awe, which should dispose his mind to serious attention. [J. A. de Segner (1704-1777) was Professor of Natural Philosophy at Göttingen and the author of several scientific works of repute.]

therefore also indirectly to cognitions. Thus genius properly consists in the happy relation [between these faculties], which no science can teach and no industry can learn, by which ideas are found for a given concept; and, on the other hand, we thus find for these ideas the expression by means of which the subjective state of mind brought about by them, as an accompaniment of the concept, can be communicated to others. The latter talent is, properly speaking, what is called spirit; for to express the ineffable element in the state of mind implied by a certain representation and to make it universally communicable—whether the expression be in speech or painting or statuary—this requires a faculty of seizing the quickly passing play of imagination and of unifying it in a concept (which is even on that account original and discloses a new rule that could not have been inferred from any preceding principles or examples) that can be communicated without any constraint [of rules].[22]

If, after this analysis, we look back to the explanation given above of what is called *genius*, we find: first, that it is a talent for art, not for science, in which clearly known rules must go beforehand and determine the procedure. Secondly, as an artistic talent it presupposes a definite concept of the product as the purpose, and therefore understanding; but it also presupposes a representation (although an indeterminate one) of the material, i.e. of the intuition, for the presentment of this concept, and, therefore a relation between the imagination and the understanding. Thirdly, it shows itself, not so much in the accomplishment of the proposed purpose in a presentment of a definite concept, as in the enunciation or expression of aesthetical ideas which contain abundant material for that very design; and consequently it represents the imagination as free from all guidance of rules and yet as purposive in reference to the presentment of the given concept. Finally, in the fourth place, the unsought undesigned subjective purposiveness in the free accordance of the imagination with the legality of the understanding presupposes such a proportion and disposition

of these faculties as no following of rules, whether of science or of mechanical imitation, can bring about, but which only the nature of the subject can produce.

In accordance with these suppositions, genius is the exemplary originality of the natural gifts of a subject in the *free* employment of his cognitive faculties. In this way the product of a genius (as regards what is to be ascribed to genius and not to possible learning or schooling) is an example, not to be imitated (for then that which in it is genius and constitutes the spirit of the work would be lost), but to be followed by another genius, whom it awakens to a feeling of his own originality and whom it stirs so to exercise his art in freedom from the constraint of rules, that thereby a new rule is gained for art; and thus his talent shows itself to be exemplary. But because a genius is a *favorite* of nature and must be regarded by us as a rare phenomenon, his example produces for other good heads a school, i.e. a methodical system of teaching according to rules, so far as these can be derived from the peculiarities of the products of his spirit. For such persons beautiful art is so far imitation, to which nature through the medium of a genius supplied the rule.

But this imitation becomes a mere *aping* if the scholar *copies* everything down to the deformities, which the genius must have let pass only because he could not well remove them without weakening his idea. This mental characteristic is meritorious only in the case of a genius. A certain *audacity* in expression—and in general many a departure from common rules—becomes him well, but it is in no way worthy of imitation; it always remains a fault in itself which we must seek to remove, though the genius is, as it were, privileged to commit it, because the inimitable rush of his spirit would suffer from overanxious carefulness. *Mannerism* is another kind of aping, viz. of mere *peculiarity* (originality) in general, by which a man separates himself as far as possible from imitators, without however possessing the talent to be at the same time *exemplary*. There are indeed in general two ways (*modi*) in which such a man may put together his notions of expressing himself; the one is called a *manner* (*modus aestheticus*), the other a *method* (*modus logicus*). They differ in

22. [Second edition.]

this that the former has no other standard than the *feeling* of unity in the presentment, but the latter follows definite *principles*; hence the former alone avails for beautiful art. But an artistic product is said to show *mannerism* only when the exposition of the artist's idea is *founded* on its very singularity and is not made appropriate to the idea itself. The ostentatious (*précieux*), contorted, and affected [manner adopted] to differentiate oneself from ordinary persons (though devoid of spirit) is like the behavior of a man of whom we say that he hears himself talk, or who stands and moves about as if he were on a stage in order to be stared at; this always betrays a bungler.

Percy Bysshe Shelley (1792-1882)

A Defense of Poetry

According to one mode of regarding those two classes of mental action, which are called reason and imagination, the former may be considered as mind contemplating the relations borne by one thought to another, however produced; and the latter, as mind acting upon those thoughts so as to color them with its own light, and composing from them, as from elements, other thoughts, each containing within itself the principle of its own integrity. The one is the τò ποιεῖν, or the principle of synthesis, and has for its objects those forms which are common to universal nature and existence itself; the other is the τò λογὶζειν, or principle of analysis, and its action regards the relations of things, simply as relations; considering thoughts, not in their integral unity, but as the algebraical representations which conduct to certain general results. Reason is the enumeration of quantities already known; imagination is the perception of the value of those quantities, both separately and as a whole. Reason respects the differences, and imagination the similitudes of things. Reason is to the imagination as the instrument to the agent, as the body to the spirit, as the shadow to the substance.

Poetry, in a general sense, may be defined to be "the expression of the imagination": and poetry is connate with the origin of man. Man is an instrument over which a series of external and internal impressions are driven, like the alternations of an ever-changing wind over an Aeolian lyre, which move it by their motion to ever-changing melody. But there is a principle within the human being, and perhaps within all sentient beings, which acts otherwise than in the lyre, and produces not melody alone, but harmony, by an internal adjustment of the sounds or motions thus excited to the impressions which excite them. It is as if the lyre could accommodate its chords to the motions of that which strikes them, in a determined proportion of sound; even as the musician can accommodate his voice to the sound of the lyre. A child at play by itself will express its delight by its voice and motions; and at every inflection of tone and every gesture will bear exact relation to a corresponding antitype in the pleasurable impressions which awakened it; it will be the reflected image of that impression; and as the lyre trembles and sounds after the wind has died away, so the child seeks, by prolonging in its voice and motions the duration of the effect, to prolong also a consciousness of the cause. In relation to the objects which delight a child, these expressions are what poetry is to higher objects. The savage (for the savage is to ages what the child is to years) expresses the emotions produced in him by surrounding objects in a similar manner; and language and gesture, together with plastic or pictorial imitation, become the image of the combined effect of those objects, and of his apprehension of them. Man in society, with all his passions and his pleasures, next becomes the object of the passions and pleasures of man; an additional class of emotions produces an augmented treasure of expressions; and language, gesture, and the imitative arts, become at once the representation and the medium, the pencil and the picture, the chisel and the statue, the chord and the harmony. The social sympathies, or those laws from which, as from its elements, society results, begin to develop themselves from the moment that two human beings coexist; the future is contained within the present, as the plant within the seed; and equality, diversity, unity, contrast, mutual dependence, become the principles alone capable of affording the motives according to which the will of a social being is determined to action, inasmuch as he is social;

and constitute pleasure in sensation, virtue in sentiment, beauty in art, truth in reasoning, and love in the intercourse of kind. Hence men, even in the infancy of society, observe a certain order in their words and actions, distinct from that of the objects and the impressions represented by them, all expressions being subject to the laws of that from which it proceeds. But let us dismiss those more general considerations which might involve an inquiry into the principles of society itself, and restrict our view to the manner in which the imagination is expressed upon its forms.

In the youth of the world, men dance and sing and imitate natural objects, observing in these actions, as in all others, a certain rhythm or order. And, although all men observe a similar, they observe not the same order, in the motions of the dance, in the melody of the song, in the combinations of language, in the series of their imitations of natural objects. For there is a certain order or rhythm belonging to each of these classes of mimetic representation, from which the hearer and the spectator receive an intenser and purer pleasure than from any other: the sense of an approximation to this order has been called taste by modern writers. Every man in the infancy of art observes an order which approximates more or less closely to that from which this highest delight results: but the diversity is not sufficiently marked, as that its gradations should be sensible, except in those instances where the predominance of this faculty of approximation to the beautiful (for so we may be permitted to name the relation between this highest pleasure and its cause) is very great. Those in whom it exists in excess are poets, in the most universal sense of the word; and the pleasure resulting from the manner in which they express the influence of society or nature upon their own minds, communicates itself to others, and gathers a sort of reduplication from that community. Their language is vitally metaphorical; that is, it marks the before unapprehended relations of things and perpetuates their apprehension, until the words which represent them become, through time, signs for portions or classes of thoughts instead of pictures of integral thoughts; and then if no new poets should arise to create afresh the associations which have been thus disorganized, language will be dead to all the nobler purposes of human intercourse. These similitudes or relations are finely said by Lord Bacon to be "the same footsteps of nature impressed upon the various subjects of the world"; and he considers the faculty which perceives them as the storehouse of axioms common to all knowledge. In the infancy of society every author is necessarily a poet, because language itself is poetry; and to be a poet is to apprehend the true and the beautiful, in a word, the good which exists in the relation, subsisting, first between existence and perception, and secondly between perception and expression. Every original language near to its source is in itself the chaos of a cyclic poem: the copiousness of lexicography and the distinctions of grammar are the works of a later age, and are merely the catalogue and the form of the creations of poetry.

But poets, or those who imagine and express this indestructible order, are not only the authors of language and of music, of the dance, and architecture, and statuary, and painting; they are the institutors of laws, and the founders of civil society, and the inventors of the arts of life, and the teachers, who draw into a certain propinquity with the beautiful and the true, that partial apprehension of the agencies of the invisible world which is called religion. Hence all original religions are allegorical, or susceptible of allegory, and, like Janus, have a double face of false and true. Poets, according to the circumstances of the age and nation in which they appeared, were called, in the earlier epochs of the world, legislators, or prophets: a poet essentially comprises and unites both these characters. For he not only beholds intensely the present as it is, and discovers those laws according to which present things ought to be ordered, but he beholds the future in the present, and his thoughts are the germs of the flower and the fruit of latest time. Not that I assert poets to be prophets in the gross sense of the word, or that they can foretell the form as surely as they foreknow the spirit of events: such is the pretense of superstition, which would make poetry an attribute of prophecy, rather than prophecy an attribute of poetry. A poet participates in the eternal, the infinite, and the one; as far as relates to his conceptions, time and place and number are not. The grammatical forms which express the moods of

time, and the difference of persons, and the distinction of place, are convertible with respect to the highest poetry without injuring it as poetry; and the choruses of Aeschylus, and the book of Job, and Dante's "Paradise," would afford, more than any other writings, examples of this fact, if the limits of this essay did not forbid citation. The creation of sculpture, painting, and music, are illustrations still more decisive.

Language, colour, form, and religious and civil habits of action, are all the instruments and materials of poetry; they may be called poetry by that figure of speech which considers the effect as a synonym of the cause. But poetry in a more restricted sense express those arrangements of language, and especially metrical language, which are created by that imperial faculty, whose throne is curtained within the invisible nature of man. And this springs from the nature itself of language, which is a more direct representation of the actions and passions of our internal being, and is susceptible of more various and delicate combinations, than colour, form, or motion, and is more plastic and obedient to the control of that faculty of which it is the creation. For language is arbitrarily produced by the imagination, and has relation to thoughts alone; but all other materials, instruments, and conditions of art, have relations among each other, which limit and interpose between conception and expression. The former is as a mirror which reflects, the latter as a clout which enfeebles, the light of which both are mediums of communications. Hence the fame of sculptors, painters, and musicians, although the intrinsic powers of the great masters of these arts may yield in no degree to that of those who have employed language as the hieroglyphic of their thoughts, has never equalled that of poets in the restricted sense of the term; as two performers of equal skill will produce unequal effects from a guitar and a harp. The fame of legislators and founders of religions, so long as their institutions last, alone seems to exceed that of poets in the restricted sense; but it can scarcely be a question, whether, if we deduct the celebrity which their flattery of the gross opinions of the vulgar usually conciliates, together with that which belonged to them in their higher character of poets, any excess will remain.

We have thus circumscribed the word *poetry* within the limits of that art which is the most familiar and the most perfect expression of the faculty itself. It is necessary, however, to make the circle still narrower, and to determine the distinction between measured and unmeasured language; for the popular division into prose and verse is inadmissible in accurate philosophy.

Sounds as well as thoughts have relation both between each other and towards that which they represent, and a perception of the order of those relations has always been found connected with a perception of the order of the relations of thoughts. Hence the language of poets have ever affected a certain uniform and harmonious recurrence of sound, without which it were not poetry, and which is scarcely less indispensable to the communication of its influence, than the words themselves, without reference to that peculiar order. Hence the vanity of translation; it were as wise to cast a violet into a crucible that you might discover the formal principle of its colour and odour, as seek to transfuse from one language into another the creations of a poet. The plant must spring again from its seed, or it will bear no flower—and this is the burthen of the curse of Babel.

An observation of the regular mode of the recurrence of harmony in the language of poetical minds, together with its relation to music, produced meter, or a certain system of traditional forms of harmony and language. Yet it is by no means essential that a poet should accommodate his language to this traditional form, so that the harmony, which is its spirit, be observed. The practice is indeed convenient and popular, and to be preferred, especially in such composition as includes much action: but every great poet must inevitably innovate upon the example of his predecessors in the exact structure of his peculiar versification. The distinction between poets and prose writers is a vulgar error. The distinction between philosophers and poets has been anticipated. Plato was essentially a poet—the truth and splendour of his imagery, and the melody of his language, are the most intense that it is possible to conceive. He rejected the measure of the epic, dramatic, and lyrical forms, because he sought to kindle a harmony in thoughts divested of shape and action, and

he forbore to invent any regular plan of rhythm which would include, under determinate forms, the varied pauses of his style. Cicero sought to imitate the cadence of his periods, but with little success. Lord Bacon was a poet. His language has a sweet and majestic rhythm, which satisfies the sense, no less than the almost superhuman wisdom of his philosophy satisfies the intellect; it is a strain which distends, and then bursts the circumference of the hearer's mind, and pours itself forth together with it into the universal element with which it has perpetual sympathy. All the authors of revolutions in opinion are not only necessary poets as they are inventors, nor even as their words unveil the permanent analogy of things by images which participate in the life of truth; but as their periods are harmonious and rhythmical, and contain in themselves the elements of verse; being the echo of the eternal music. Nor are those supreme poets, who have employed traditional forms of rhythm on account of the form and action of their subjects, less capable of perceiving and teaching the truth of things, than those who have omitted that form. Shakespeare, Dante, and Milton (to confine ourselves to modern writers) are philosophers of the very loftiest power.

A poem is the very image of life expressed in its eternal truth. There is this difference between a story and a poem, that a story is a catalogue of detached facts, which have no other connection than time, place, circumstance, cause and effect; the other is the creation of actions according to the unchangeable forms of human nature, as existing in the mind of the creator, which is itself the image of all other minds. The one is partial, and applies only to a definite period of time, and a certain combination of events which can never again recur; the other is universal, and contains within itself the germ of a relation to whatever motives or actions have place in the possible varieties of human nature. Time, which destroys the beauty and the use of the story of particular facts, stripped of the poetry which should invest them, augments that of poetry, and forever develops new and wonderful applications of the eternal truth which it contains. Hence epitomes have been called the moths of just history; they eat out the poetry of it. A story of particular facts is as a mirror which obscures and distorts that which

should be beautiful: poetry is a mirror which makes beautiful that which is distorted.

The parts of a composition may be poetical, without the composition as a whole being a poem. A single sentence may be considered as a whole, though it may be found in the midst of a series of unassimilated portions; a single word even may be a spark of inextinguishable thought. And thus all the great historians, Herodotus, Plutarch, Livy, were poets; and although the plan of these writers, especially that of Livy, restrained them from developing this faculty in its highest degree, they made copious and ample amends for their subjection, by filling all the interstices of their subjects with living images.

Having determined what is poetry, and who are poets, let us proceed to estimate its effects upon society.

Poetry is ever accompanied with pleasure: all spirits on which it falls open themselves to receive the wisdom which is mingled with its delight. In the infancy of the world, neither poets themselves nor their auditors are fully aware of the excellence of poetry: for it acts in a divine and unapprehended manner, beyond and above consciousness; and it is reserved for future generations to contemplate and measure the mighty cause and effect in all the strength and splendor of their union. Even in modern times, no living poet ever arrived at the fullness of his fame; the jury which sits in judgment upon a poet, belonging as he does to all time, must be composed of his peers: it must be impaneled by time from the selectest of the wide of many generations. A poet is a nightingale, who sits in darkness and sings to cheer its own solitude with sweet sounds; his auditors are as men entranced by the melody of an unseen musician, who feel that they are moved and softened, yet know not whence or why. The poems of Homer and his contemporaries were the delight of infant Greece; they were the elements of that social system which is the column upon which all succeeding civilization has reposed. Homer embodied the ideal perfection of his age in human character; nor can we doubt that those who read his verses were awakened to an ambition of becoming like to Achilles, Hector, and Ulysses: the truth and beauty of friendship, patriotism, and persevering devotion to an

object, were unveiled to the depths in these immortal creations: the sentiments of the auditors must have been refined and enlarged by a sympathy with such great and lovely impersonations, until from admiring they imitated, and from imitation they identified themselves with the objects of their admiration. Nor let it be objected, that these characters are remote from moral perfection, and that they are by no means to be considered as edifying patterns for general imitation. Every epoch, under names more or less specious, has deified its peculiar errors; revenge is the naked idol of the worship of a semi-barbarous age; and self-deceit is the veiled image of unknown evil, before which luxury and satiety lie prostrate. But a poet considers the vices of his contemporaries as a temporary dress in which his creations must be arrayed, and which cover without concealing the eternal proportions of their beauty. An epic of dramatic personage is understood to wear them around his soul, as he may be the ancient armour or the modern uniform around his body; whilst it is easy to conceive a dress more graceful than either. The beauty of the internal nature cannot be so far concealed by its accidental vesture, but that the spirit of its form shall communicate itself to the very disguise, and indicate the shape it hides from the manner in which it is worn. A majestic form and graceful motions will express themselves through the most barbarous and tasteless costume. Few poets of the highest class have chosen to exhibit the beauty of their conceptions in its naked truth and splendour; and it is doubtful whether the alloy of costume, habit, &c., be not necessary to temper this planetary music for mortal ears.

The whole objection, however, of the immorality of poetry rests upon a misconception of the manner in which poetry acts to produce the moral improvement of man. Ethical science arranges the elements which poetry has created, and propounds schemes and proposes examples of civil and domestic life: nor is it for want of admirable doctrines that men hate, and despise, and censure, and deceive, and subjugate one another. But poetry acts in another and diviner manner. It awakens and enlarges the mind itself by rendering it the receptacle of a thousand unapprehended combinations of thought. Poetry lifts the veil from the hidden beauty of the world, and makes familiar objects be as if they were not familiar; it reproduces all that it represents, and the impersonations clothed in its Elysian light stand thenceforward in the minds of those who have once contemplated them as memorials of that gentle and exalted content which extends itself over all thoughts and actions with which it coexists. The great secret of morals is love; or a going out of our own nature, and an identification of ourselves with the beautiful which exists in thought, action, or person, not our own. A man, to be greatly good, must imagine intensely and comprehensively; he must put himself in the place of another and of many others; the pains and pleasures of his species must become his own. The great instrument of moral good is the imagination; and poetry administers to the effect by acting upon the cause. Poetry enlarges the circumference of the imagination by replenishing it with thoughts of ever new delight, which have the power of attracting and assimilating to their own nature all other thoughts, and which form new intervals and interstices whose void forever craves fresh food. Poetry strengthens the faculty which is the organ of the moral nature of man, in the same manner as exercise strengthens a limb. A poet therefore would do ill to embody his own conceptions of right and wrong, which are usually those of his place and time, in his poetical creations, which participate in neither. By this assumption of the inferior office of interpreting the effect, in which perhaps after all he might acquit himself but imperfectly, he would resign a glory in a participation in the cause. There was little danger that Homer, or any of the eternal poets, should have so far misunderstood themselves as to have abdicated this throne of their widest dominion. Those in whom the poetical faculty, though great, is less intense, as Euripides, Lucan, Tasso, Spenser, have frequently affected a moral aim, and the effect of their property is diminished in exact proportion to the degree in which they compel us to advert to this purpose.

Homer and the cyclic poets were followed at a certain interval by the dramatic and lyrical poets of Athens, who flourished contemporaneously with all that is most perfect in the kindred expressions of the poetical faculty; architecture, painting, music, the dance, sculpture, philosophy, and, we may add,

the forms of civil life. For although the scheme of Athenian society was deformed by many imperfections which the poetry existing in chivalry and Christianity has erased from the habits and institutions of modern Europe; yet never at any other period has so much energy, beauty, and virtue, been developed; never was blind strength and stubborn form so disciplined and rendered subject to the will of man, or that will less repugnant to the dictates of the beautiful and the true, as during the century which preceded the death of Socrates. Of no other epoch in the history of our species have we records and fragments stamped so visibly with the image of the divinity in man. But it is poetry alone, in form, in action, and in language, which has rendered this epoch memorable above all others, and the storehouse of examples to everlasting time. For written poetry existed at that epoch simultaneously with the other arts, and it is an idle inquiry to demand which gave and which received the light, which all, as from a common focus, have scattered over the darkest periods of succeeding time. We know no more of cause and effect than a constant conjunction of events: poetry is ever found to coexist with whatever other arts contribute to the happiness and perfection of man. I appeal to what has already been established to distinguish between the cause and the effect.

It was at the period here adverted to, that the drama had its birth; and however a succeeding writer may have equaled or surpasses those few great specimens of the Athenian drama which have been preserved to us, it is indisputable that the art itself never was understood or practiced according to the true philosophy of it, as at Athens. For the Athenians employed language, action, music, painting, the dance, and religious institutions, to produce a common effect in the representation of the highest idealisms of passion and of power; each division in the art was made perfect in its kind by artists of the most consummate skill, and was disciplined into a beautiful proportion and unity one towards the other. On the modern stage a few only of the elements capable of expressing the image of the poet's conception are employed at once. We have tragedy without music and dancing; and music and dancing without the highest impersonations of which they are

the fit accompaniment, and both without religion and solemnity. Religious institution has indeed been usually banished from the stage. Our system of divesting the actor's face of a mask, on which the many expressions appropriated to his dramatic character might be molded into one permanent and unchanging expression, it is favorable only to a partial and inharmonious effect; it is fit for nothing but a monologue, where all the attention may be directed to some great master of ideal mimicry. The modern practice of blending comedy with tragedy, though liable to great abuse in point of practice, is undoubtably and extension of the dramatic circle; but the comedy should be as in *King Lear*, universal, ideal, and sublime. It is perhaps the intervention of this principle which determines the balance in favor of *King Lear* against the *Oedipus Tyrannus*, or the *Agamemnon*; or, if you will, the trilogies with which they are connected; unless the intense power of the choral poetry, especially that of the latter, should be considered as restoring the equilibrium. King Lear, if it can sustain this comparison, may be judged to be the most perfect specimen of the dramatic art existing in the world; in spite of the narrow conditions to which the poet was subjected by the ignorance of the philosophy of the drama which has prevailed in modern Europe. Calderón, in his religious *autos*,[1] has attempted to fulfill some of the high conditions of dramatic representation neglected by Shakespeare; such as the establishing a relation between the drama and religion, and the accommodating them to music and dancing; but he omits the observation of conditions still more important, and more is lost than gained by the substitution of the rigidly defined and ever-repeated idealisms of a distorted superstition for the living impersonations of the truth of human passion.

But I digress. The connection of scenic exhibitions with the improvement or corruption of the manners of men, has been universally recognized: in other words, the presence or absence of poetry in its most perfect and universal form, has been found to be connected with good and evil in conduct or habit. The corruption which has been imputed to the drama as an effect, begins, when the poetry employed in its constitution ends: I appeal to the

1. One act sacramental plays.

history of manners whether the periods of the growth of the one and the decline of the other have not corresponded with an exactness equal to any example of moral cause and effect.

The drama at Athens, or wheresoever else it may have approached to its perfection, ever coexisted with the moral and intellectual greatness of the age. The tragedies of the Athenian poets are as mirrors in which the spectator beholds himself, under a thin disguise of circumstance, stripped of all but that ideal perfection and energy which everyone feels to be the internal type of all that he loves, admires, and would become. The imagination is enlarged by a sympathy with pains and passions so mighty, that they distend in their conception of the capacity of that by which they are conceived; the good affections are strengthened by pity, indignation, terror, and sorrow; and an exalted calm is prolonged from the satiety of this high exercise of them into the tumult of familiar life; even crime is disarmed of half its horror and all its contagion by being represented as the fatal consequence of the unfathomable agencies of nature; error is thus divested of its willfulness; men can no longer cherish it as the creation of their choice. In a drama of the highest order there is little food for censure or hatred; it teaches rather self-knowledge and self-respect. Neither the eye nor the mind can see itself, unless reflected upon that which it resembles. The drama, so long as it continues to express poetry, is as a prismatic and many-sided mirror, which collects the brightest rays of human nature and divides and reproduces them from the simplicity of their elementary forms, and touches them with majesty and beauty, and multiplies all that it reflects, and endows it with the power of propagating its like wherever it may fall.

But in periods of the decay of social life, the drama sympathizes with that decay. Tragedy becomes a cold imitation of the forms of the great masterpieces of antiquity, divested of all harmonious accompaniment of the kindred arts; and often the very form misunderstood, or a weak attempt to teach certain doctrines, which the writer considers as moral truths; and which are usually no more than specious flatteries of some gross vice or weakness, with which the author, common with his auditors, are infected. Hence what has been called the classical and domestic drama. Addison's *Cato* is a specimen of the one; and would it were not superfluous to cite examples of the other! To such purposes poetry cannot be made subservient. Poetry is a sword of lightning, ever unsheathed, which consumes the scabbard that would contain it. And thus we observe that all the dramatic writings of this nature are unimaginative in a singular degree; they affect sentiment and passion, which, divested of imagination, are other names for caprice and appetite. The period in our own history of the grosses degradation of the drama is the reign of Charles II, when all forms in which poetry had been accustomed to be expressed became hymns to the triumph of kingly power over liberty and virtue. Milton stood alone illuminating an age unworthy of him. At such periods the calculating principle pervades all the forms of dramatic exhibition, and poetry ceases to be expressed upon them. Comedy loses its ideal universality: wit succeeds to humor; we laugh from self-complacency and triumph, instead of pleasure; malignity, sarcasm, and contempt, succeed to sympathetic merriment; we hardly laugh, but we smile. Obscenity, which is ever blasphemy against the divine beauty in life, becomes, from a very veil which it assumes, more active if less disgusting: it is a monster for which the corruption of society forever brings forth new food, which it devours in secret.

The drama being that form under which a greater number of modes of expression of poetry are susceptible of being combined than any other, the connection of poetry and social good is more observable in the drama than in whatever other form. And it is indisputable that the highest perfection of human society has ever corresponded with the highest dramatic excellence; and that the corruption or the extinction of the drama in a nation where it has once flourished, is a mark of a corruption of manners, and an extinction of the energies which sustain the soul of social life. But, as Machiavelli says of political institutions, that life may be preserved and renewed, if men should arise capable of bringing back the drama to its principles. And this is true with respect to poetry in its most extended sense: all language, institution and form, require not only to be produced but to be sustained: the office and character of a poet participates in the divine nature as

regards providence, no less than as regards creation.

Civil war, the spoils of Asia, and the fatal predominance first of the Macedonian, and then of the Roman arms, were so many symbols of the extinction or suspension of the creative faculty in Greece. The bucolic writers, who found patronage under the lettered tyrants of Sicily and Egypt, were the latest representatives of its most glorious reign. Their poetry is intensely melodious; like the odor of the tuberose, it overcomes and sickens the spirit with excess sweetness; whilst the poetry of the preceding age was as a meadow-gale of June, which mingles the fragrance of all the flowers of the field, and adds a quickening and harmonizing spirit of its own, which endows the sense with a power of sustaining its extreme delight. The bucolic and erotic delicacy in written poetry is correlative with that softness in statuary, music, and the kindred arts, and even in manners and institutions, which distinguished the epoch to which I now refer. Nor is it the poetical faculty itself, or any misapplication of it, to which this want of harmony is to be imputed. An equal sensibility to the influence of the senses and the affections is to be found in the writings of Homer and Sophocles: the former, especially, has clothed sensual and pathetic images with irresistible attractions. Their superiority over these succeeding writers consists in the presence of those thoughts which belong to the inner faculties of our nature, not in the absence of those which are connected with the external: their incomparable perfection consists in a harmony of the union of all. It is not what the erotic poets have, but what they have not, in which their imperfection consists. It is not inasmuch as they were poets, but inasmuch as they were not poets, that they can be considered with any plausibility as connected with the corruption of their age. Had that corruption availed so as to extinguish in them the sensibility to pleasure, passion, and natural scenery, which is imputed to them as an imperfection, the last triumph of evil would have been achieved. For the end of social corruption is to destroy all sensibility to pleasure; and therefore it is corruption. It begins at the imagination and the intellect as at the core, and distributes itself thence as a paralyzing venom, through the affections into the very appetites, until all become a torpid mass in which hardly sense survives. At the approach of such a period, poetry ever addresses itself to those faculties which are the last to be destroyed, and its voice is heard, like the footsteps of Astraea, departing from the world. Poetry ever communicates all the pleasure which men are capable of receiving: it is ever still the light of life; the source of whatever of beautiful or generous or true can have place in an evil time. It will readily be confessed that those among the luxurious citizens of Syracuse and Alexandria, who were delighted with the poems of Theocritus, were less cold, cruel, and sensual than the remnant of their tribe. But corruption must utterly have destroyed the fabric of human society before poetry can ever cease. The sacred links of that chain have never been entirely disjoined, which descending through the minds of many men is attached to those great minds, whence as from a magnet the invisible effluence is sent forth, which at once connects, animates, and sustains the life of all. It is the faculty which contains within itself the seeds at once of its own and of social renovation. And let us not circumscribe the effects of the bucolic and erotic poetry within the limits of the sensibility of those to whom it was addressed. They may have perceived the beauty of those immortal compositions, simply as fragments and isolated portions: those who are more finely organized, or born in a happier age, may recognize them as episodes to that great poem, which all poets, like the cooperating thoughts of one great mind, have built up since the beginning of the world.

The same revolutions within a narrower sphere had place in ancient Rome; but the actions and forms of its social life never seem to have been perfectly saturated with the political element. The Romans appear to have considered the Greeks as the selectest treasuries of the selectest forms of manners and of nature, and to have abstained from creating in measured language, sculpture, music, or architecture, anything which might bear a particular relation to their own condition, whilst it should bear a general one to the universal constitution of the world. But we judge from partial evidence, and we judge perhaps partially. Ennius, Varro, Pacuvius, and Accius, all great poets, have been lost. Lucretius is in the highest, and Virgil in a very high sense, a creator. The chosen delicacy of expressions of the latter, are

as a mist of light which conceal from us the intense and exceeding truth of his conceptions of nature. Livy is instinct with poetry. Yet Horace, Catullus, Ovid, and generally the other great writers of the Virgilian age, saw man and nature in the mirror of Greece. The institutions also, and the religion, of Rome were less poetical than those of Greece, as the shadow is less vivid than the substance. Hence poetry in Rome, seemed to follow, rather than accompany, the perfection of political and domestic society. The true poetry of Rome lived in its institutions; for whatever of beautiful, true, and majestic, they contained, could have sprung only from the faculty which creates the order in which they consist. The life of Camillus, the death of Regulus; the expectation of the senators, in their godlike state, of the victorious Gauls; the refusal of the republic to make peace with Hannibal, after the battle of Cannae, were not the consequences of a refined calculation of the probable personal advantage to result from such a rhythm and order in the shows of life, to those who were at once the poets and the actors of these immortal dramas. The imagination beholding the beauty of this order, created it out of itself according to its own idea; the consequence was empire, and the reward everlasting fame. These things are not the less poetry, *quia carent vate sacro*.[2] They are the episodes of that cyclic poem written by time upon the memories of men. The past, like an inspired rhapsodist, fills the theatre of everlasting generations with their harmony.

At length the ancient system of religion and manners had fulfilled the circle of its evolutions. And the world would have fallen into utter anarchy and darkness, but that there were found poets among the authors of the Christian and chivalric systems of manners and religion, who created forms of opinion and action never before conceived; which, copied into the imaginations of men, become as generals to the bewildered armies of their thoughts. It is foreign to the present purpose to touch upon the evil produced by these systems: except that we protest, on the ground of the principles already established, that no portion of it can be attributed to the poetry they contain.

It is probable that the poetry of Moses, Job, David, Solomon, and Isiah, had produced a great effect upon the mind of Jesus and his disciples. The scattered fragments preserved to us by the biographers of this extraordinary person, are all instinct with the most vivid poetry. But his doctrines seem to have been quickly distorted. At a certain period after the prevalence of a system of opinions founded upon those promulgated by him, the three forms into which Plato had distributed the faculties of mind underwent a sort of apotheosis, and became the object of the worship of the civilized world. Here it is to be confessed that "Light seems to thicken," and

The crow makes wing to the rooky wood,
Good things of day begin to droop and drowse,
And night's black agents to their prey do rouse.[3]

But mark how beautiful an order has sprung from the dust and blood of this fierce chaos! How the world, as from a resurrection, balancing itself on the golden wings of knowledge and of hope, has reassumed its yet unwearied flight into the heaven of time. Listen to the music, unheard by outward ears, which is as a ceaseless and invisible wind, nourishing its everlasting course with strength and swiftness.

The poetry in the doctrines of Jesus Christ, and the mythology and institutions of the Celtic conquerors of the Roman Empire, outlived the darkness and the convulsions connected with their growth and victory, and blended themselves in a new fabric of manners and opinion. It is an error to impute the ignorance of the Dark Ages to the Christian doctrines or the predominance of the Celtic nations. Whatever of evil their agencies may have contained sprang from the extinction of the poetical principle, connected with the progress of despotism and superstition. Men, from causes too intricate to be here discussed, had become insensible and selfish: their own will had become feeble, and yet they were its slaves, and thence the slaves of the will of others: lust, fear, avarice, cruelty, and fraud, characterized a race amongst whom no one was to be found capable of *creating* in form, language, or institution. The moral anomalies of such a state of society are not justly to be charged upon any class of events immediately connected with them, and those events are most

2. "Because they lack the divine prophet." Horace, *Odes*, IV. ix. 28, but misquoted.

3. *Macbeth* III ii. 50-53.

entitled to our approbation which could dissolve it most expeditiously. It is unfortunate for those who cannot distinguish words from thoughts, that many of these anomalies have been incorporated into our popular religion.

It was not until the eleventh century that the effects of the poetry of the Christian and chivalric systems began to manifest themselves. The principle of equality had been discovered and applied by Plato in his *Republic*, as the theoretical rule of the mode in which the materials of pleasure and of power produced by the common skill and labor of human beings, ought to be distributed among them. The limitations of this rule were asserted by him to be determined only by the sensibility of each, or the utility to result to all. Plato, following the doctrines of Timaeus an Pythagoras, taught also a moral and intellectual system of doctrine, comprehending at once the past, the present, and the future condition of man. Jesus Christ divulged the sacred and eternal truths contained in these views to mankind, and Christianity, in its abstract purity, became the exoteric expression of the esoteric doctrines of the poetry and wisdom of antiquity. The incorporation of the Celtic nations with the exhausted population of the south, impressed upon it the figure of the poetry existing in their mythology and institutions. The result was a sum of the action and reaction of all the causes included in it; for it may be assumed as a maxim that no nation or religion can supersede any other without incorporating into itself a portion of that which it supersedes. The abolition of personal and domestic slavery, and the emancipation of women from a great part of the degrading restraints of antiquity, were among the consequences of these events.

The abolition of personal slavery is the basis of the highest political hope that it can enter into the mind of man to conceive. The freedom of women produced the poetry of sexual love. Love became a religion, the idols of whose worship were ever present. It was as if the statues of Apollo and the Muses had been endowed with life and motion, and had walked forth among their worshippers; so that earth became peopled by the inhabitants of a diviner world. The familiar appearance and proceedings of life became wonderful and heavenly, and a paradise was created as out of the wrecks of Eden. And as this creation itself is poetry, so its creators were poets; and language was the instrument of their art: "*Galeotto fù il libro, e chi lo scrisse.*"[4] The Provençal trouveurs, or inventors, preceded Petrarch, whose verses are as spells, which unseal the inmost enchanted fountains of the delight which is in the grief of love. It is impossible to feel them without becoming a portion of that beauty which we contemplate: it were superfluous to explain how the gentleness and the elevation of mind connected with these sacred emotions can render men more amiable, more generous and wise, and lift them out of the dull vapors of the little world of self. Dante understood the secret things of love even more than Petrarch. His *Vita Nuova* is an inexhaustible fountain of purity of sentiment and language: it is the idealized history of that period, and those intervals of his life which were dedicated to love. His apotheosis of Beatrice in Paradise, and the gradations of his own love and her loveliness, by which as by steps he feigns himself to have ascended to the throne of the Supreme Cause, is the most glorious imagination of modern poetry. The acutest critics have justly reversed the judgment of the vulgar, and the order of the great acts of the *Divina Commedia*, in the measure of the admiration which they accord to the "Hell," "Purgatory," and "Paradise." The latter is a perpetual hymn of everlasting love. Love, which found a worthy poet in Plato alone of all the ancients, has been celebrated by a chorus of the greatest writers of the renovated world; and the music has penetrated the caverns of society, and its echoes still drown the dissonance of arms and superstition. At successive intervals, Ariosto, Tasso, Shakespeare, Spenser, Calderon, Rousseau, and the great writers of our own age, have celebrated the dominion of love, planting as it were trophies in the human mind of that sublimest victory over sensuality and force. The true relation borne to each other by the sexes into which humankind is distributed, has become less misunderstood; and if the error which confounded diversity with inequality of the powers of the two sexes has been partially recognized in the opinions and institutions of modern Europe, we owe

4. "Galeott was the book, and he wrote it." Dante, *The Divine Comedy,* "Inferno," V 137.

this great benefit to the worship of which chivalry was the law, and poets the prophets.

The poetry of Dante may be considered as the bridge thrown over the stream of time, which unites the modern and ancient world. The distorted notions of the invisible things which Dante and his rival Milton have idealized, are merely the mask and the mantle in which these great poets walk through eternity enveloped and disguised. It is a difficult question to determine how far they were conscious of the distinction which must have subsisted in their minds between their own creeds and that of the people. Dante at least appears to wish to mark the full extent of it by placing Riphaeus, whom Virgil calls *"justissimus unus,"*[5] in Paradise, and observing a most heretical caprice in his distribution of rewards and punishments. And Milton's poem contains within itself a philosophical refutation of that system, of which, by a strange and natural antithesis, it has been a chief popular support. Nothing can exceed the energy and magnificence of the character of Satan as expressed in *Paradise Lost*. It is a mistake to suppose that he could ever have been intended for the popular personification of evil. Implacable hate, patient cunning, and a sleepless refinement of device to inflict the extremest anguish on an enemy, these things are evil; and, although venial in a slave, are not to be forgiven in a tyrant; although redeemed by much that enobles his defeat in one subdued, are marked by all that dishonours his conquest in the victor. Milton's Devil as a moral being is as far superior to his God, as one who perseveres in some purpose which he has conceived to be excellent in spite of adversity and torture, is to one who in the cold security of undoubted triumph inflicts the most horrible revenge upon his enemy, not from any mistaken notion of inducing him to repent of a perseverance in enmity, but with the alleged design of exasperating him to deserve new torments. Milton has so far violated the popular creed (if this shall be judged to be a violation) as to have alleged no superiority of moral virtue to his god over his devil. And this bold neglect of a direct moral purpose is the most decisive proof of the supremacy of Milton's genius. He mingled as it were the elements of human nature as

colours upon a single pallet, and arranged them in the composition of his great picture according to the laws of epic truth; that is, according to the laws of that principle by which a series of actions of the external universe and of intelligent and ethical beings is calculated to excite the sympathy of succeeding generations of mankind. The *Divina Commedia* and *Paradise Lost* have conferred upon modern mythology a systemic form; and when change and time shall have added one more superstition to the mass of those which have arisen and decayed upon the earth, commentators will be learnedly employed in elucidating the religion of ancestral Europe, only not utterly forgotten because it will have been stamped with the eternity of genius.

Homer was the first and Dante the second epic poet: that is, the second poet, the series of whose creations bore a defined and intelligible relation to the knowledge and sentiment and religion of the age in which he lived, and of the ages which followed it: developing itself in correspondence with their development. For Lucretius had limed the wings of his swift spirit in the dregs of the sensible world; and Virgil, with a modesty that ill became his genius, had affected the fame of an imitator, even whilst he created anew all that he copied; and none among the flock of mock birds, though their notes were sweet, Apollonius Rhodius, Quintus Calaber Smyrnaeus, Nonnus, Lucan, Statius, or Claudian, have sought even to fulfill a single condition of epic truth. Milton was the third epic poet. For if the title of epic in its highest sense be refused to the *Aeneid*, still less can be conceded to the *Orlando Furioso*, the *Gerusalemme Liberata*, the *Lusiad*, or the *Faerie Queene*.

Dante and Milton were both deeply penetrated with the ancient religion of the civilized world; and its spirit exists in their poetry probably in the same proportion as its forms survived in the unreformed worship of modern Europe. The one preceded and the other followed the Reformation at almost equal intervals. Dante was the first religious reformer, and Luther surpassed him rather in the rudeness and acrimony, than in the boldness of his censures of papal usurpation. Dante was the first awakener of entranced Europe; he created a language, in itself music and persuasion, out of a chaos of inharmonious barbarisms.

5. "The most just one." *or* "The Justest man of men." *Aeneid*, II. 426-27.

He was the congregator of those great spirits who presided over the resurrection of learning; the Lucifer of that starry flock which in the thirteenth century shone forth from republican Italy, as from a heaven, into the darkness of the benighted world. His very words are instinct with spirit; each is as a spark, a burning atom of inextinguishable thought; and many yet lie covered in the ashes of their birth, and pregnant with a lightning which has yet found no conductor. All high poetry is infinite; it is as the first acorn, which contained all oaks potentially. Veil after veil may be undrawn, and the inmost naked beauty of the meaning never exposed. A great poem is a fountain forever overflowing with the waters of wisdom and delight; and after one person and one age has exhausted all its divine effluence which their peculiar relations enable them to share, another and yet another succeeds, and new relations are ever developed, the source of an unforeseen and an unconceived delight.

The age immediately succeeding to that of Dante, Petrarch, and Boccaccio, was characterized by a revival of painting, sculpture, and architecture. Chaucer caught the sacred inspiration, and the superstructure of English literature is based upon the materials of Italian invention.

But let us not be betrayed from a defense into a critical history of poetry and its influence on society. Be it enough to have pointed out the effects of poets, in a large and true sense of the word, upon their own and all succeeding times.

But poets have been challenged to resign the civic crown of reasoners and mechanists, on another plea. It is admitted that the exercise of the imagination is most delightful, but it is alleged that that of reason is more useful. Let us examine, as the grounds of this distinction, what is here meant by utility. Pleasure or good, in a general sense, is that which the consciousness of a sensitive and intelligent being seeks, and in which, when found, it acquiesces. There are two kinds of pleasure, one durable, universal and permanent; the other transitory and particular. Utility may either express the means of producing the former or the latter. In the former sense, whatever strengthens and purifies the affections, enlarges the imagination, and adds spirit to sense, is useful. But a narrower meaning may be assigned to the word utility, confining it to express that which

banishes the importunity of the wants of our animal nature, the surrounding men with security of life, the dispersing the grosser delusions of superstition, and the conciliating such a degree of mutual forbearance among men as may consist with the motives of personal advantage.

Undoubtedly the promoters of utility, in this limited sense, have their appointed office in society. They follow the footsteps of poets, and copy the sketches of their creations into the book of common life. They make space, and give time. Their exertions are of the highest value, so long as they confine their administration of the concerns of the inferior powers of our nature within the limits due to the superior ones. But whilst the skeptic destroys gross superstitions, let him spare to deface, as some of the French writers have defaced, the eternal truths charactered upon the imaginations of men. Whilst the mechanist abridges, and the political economist combines labor, let them beware that their speculations, for want of correspondence with those first principles which belong to the imagination, do not tend, as they have in modern England, to exasperate at once the extremes of luxury and want. They have exemplified the saying, "To him that hath, more shall be given; and from him that hath not, the little that he hath shall be taken away." The rich have become richer, and the poor have become poorer; and the vessel of the state is driven between the Scylla and Charybdis of anarchy and despotism. Such are the effects which must ever flow from an unmitigated exercise of the calculating faculty.

It is difficult to define pleasure in its highest sense; the definition involving a number of apparent paradoxes. For, from an inexplicable defect of harmony in the constitution of human nature, the pain of the inferior is frequently connected with the pleasures of the superior portions of our being. Sorrow, terror, anguish, despair itself, are often the chosen expressions of an approximation to the highest good. Our sympathy in tragic fiction depends on this principle; tragedy delights by affording a shadow of the pleasure which exists in pain. This is the source also of the melancholy which is inseparable from the sweetest melody. The pleasure that is in sorrow is sweeter than the pleasure of pleasure itself. And hence the saying, "It is better to go to the house of mourning, than to the house of mirth." Not that this highest species

The production and assurance of pleasure in this highest sense is true utility. Those who produce and preserve this pleasure are poets or poetical philosophers.

The exertions of Locke, Hume, Gibbon, Voltaire, Rousseau, and their disciples, in favor of oppressed and deluded humanity, are entitled to the gratitude of mankind. Yet it is easy to calculate the degree of moral and intellectual improvement which the world would have exhibited, had they never lived. A little more nonsense would have been talked for a century or two; and perhaps a few more men, women, and children, burnt as heretics. We might not at this moment have been congratulating each other on the abolition of the Inquisition in Spain. But it exceeds all imagination to conceive what would have been the moral condition of the world if neither Dante, Petrarch, Boccaccio, Chaucer, Shakespeare, Calderon, Lord Bacon, nor Milton, had ever existed; if Raphael and Michelangelo had never been born; if the Hebrew poetry had never been translated; if a revival of the study of Greek literature had never taken place; if no monuments of ancient sculpture had been handed down to us; and if the poetry of the religion of the ancient world had been extinguished together with its belief. The human mind could never, except by the intervention of these excitements, have been awakened to the invention of these excitements, have been awakened to the invention of the grosser sciences, and that application of analytical reasoning to the aberrations of society, which it is now attempted to exalt over the direct expression of the inventive and creative faculty itself.

We have more moral, political and historical wisdom, than we know how to reduce into practice; we have more scientific and economical knowledge than can be accommodated to the just distribution of the produce which it multiplies. The poetry in these systems of thought, is concealed by the accumulation of facts and calculating processes. There is no want of knowledge respecting what is wisest and best in morals, government, and political economy, or at least what is wiser and better than what men now practice and endure. But we let *"I dare not* wait upon *I would,* like the poor cat in the adage."￼ We want the creative faculty to imagine that which we know; we want the generous impulse to act that which we imagine; we want the poetry of life: our calculations have outrun conception; we have eaten more than we can digest. The cultivation of those sciences which have enlarged the limits of the empire of man over the external world, has, for want of the poetical faculty, proportionally circumscribed those of the internal world; and man, having enslaved the elements, remains himself a slave. To what but a cultivation of the mechanical arts in a degree disproportioned to the presence of the creative faculty, which is the basis for all knowledge, is to be attributed the abuse of all invention for abridging and combining labor, to the exasperation of the inequality of mankind. From what other cause has it arisen that the discoveries which should have lightened, have added a weight to the curse imposed on Adam. Poetry, and the principle of self of which money is the visible incarnation, are the God and Mammon of the world.

The functions of the poetical faculty are twofold; by one it creates new materials of knowledge and power and pleasure; by the other it engenders in the mind a desire to reproduce and arrange them according to a certain rhythm and order which may be called the beautiful and the good. The cultivation of poetry is never more to be desired than at periods when, from an excess of the selfish and calculating principle, the accumulation of the materials of external life exceed the quantity of the power of assimilating them to the internal laws of human nature. The body has then become too unwieldy for that which animates it.

Poetry is indeed something divine. It is at once the center and circumference of knowledge; it is that which comprehends all science, and that to which all science must be referred. It is at the same time the root and blossom of all other systems of thought; it is that from which all spring, and that which adorns all; and that which, if blighted, denies the fruit and the seed, and withholds from the barren world the nourishment and the succession of the scions of the tree of life. It is the perfect and consummate surface and bloom of all things; it is as the odor and color of the rose to the texture of the elements which compose it, as the form and splendor of unfaded beauty to the secrets of anatomy and corruption. What were virtue, love, patriotism, friendship—what were the scenery

of this beautiful universe which we inhabit; what were our consolations on this side of the grave—and what were our aspirations beyond it, if poetry did not ascend to bring light and fire from those eternal regions where the owl-winged faculty of calculation dare not ever soar? Poetry is not like reasoning, a power to be exerted according to the determination of the will. A man cannot say, "I will compose poetry." The greatest poet even cannot say it; for the mind in creation is as a fading coal, which some invisible influence, like an inconstant wind, awakens to transitory brightness; this power arises from within, like the color of a flower which fades and changes as it is developed, and the conscious portions of our natures are unprophetic either of its approach or its departure. Could this influence be durable in its original purity and force, it is impossible to predict the greatness of the results; but when composition begins, inspiration is already on the decline, and the most glorious poetry that has ever been communicated to the world is probably a feeble shadow of the original conceptions of the poet. I appeal to the greatest poets of the present day, whether it is not an error to assert that the finest passages of poetry are produced by labor and study. The toil and the delay recommended by critics, can be justly interpreted to mean no more than a careful observation of the inspired moments, and an artificial connection of the spaces between their suggestions, by the intertexture of conventional expressions; a necessity only imposed by the limitedness of the poetical faculty itself; for Milton conceived the *Paradise Lost* as a whole before he executed it in portions. We have his own authority also for the Muse having "dictated" to him the "unpremeditated song."[6] And let this be an answer to those who would allege the fifty-six various readings of the first line of the *Orlando Furioso*. Compositions so produced are to poetry what mosaic is to painting. This instinct and intuition of the poetical faculty is still more observable in the plastic and pictorial arts; a great statue or picture grows under the power of the artist as a child in the mother's womb; and the very mind which directs the hands in formation is incapable of accounting to itself for the origin, the gradations, or the media of the process.

6. Paradise Lost IX 23-24.

Poetry is the record of the best and happiest moments of the happiest and best minds. We are aware of evanescent visitations of thought and feeling, sometimes associated with place or person, sometimes regarding our own mind alone, and always arising unforeseen and departing unbidden, but elevating and delightful beyond all expression: so that even in the desire and regret they leave, there cannot but be pleasure, participating as it does in the nature of its object. It is as it were the interpretation of a diviner nature through our own; but its footsteps are like those of a wind over the sea, which the morning calm erases, and whose traces remain only, as on the wrinkled sand which paves it. These and corresponding conditions of being are experienced principally by those of the most delicate sensibility and the most enlarged imagination; and the state of mind produced by them is at war with every base desire. The enthusiasm of virtue, love, patriotism, and friendship, is essentially linked with such emotions; and whilst they last, self appears as what it is, an atom to a universe. Poets are not only subject to these experiences as spirits of the most refined organization, but they can color all that they combine with the evanescent hues of this ethereal world; a word, a trait in the representation of a scene or a passion, will touch the enchanted chord, and reanimate, in those who have ever experienced these emotions, the sleeping, the cold, the buried image of the past. Poetry thus makes immortal all that is best and most beautiful in the world; it arrests the vanishing apparitions which haunt the interlunations of life, and veiling them, or in language or in form, sends them forth among mankind, bearing sweet news of kindred joy to those with whom their sisters abide—abide, because there is no portal of expression from the caverns of the spirit which they inhabit into the universe of things. Poetry redeems from decay the visitations of the divinity in man.

Poetry turns all things to loveliness; it exalts the beauty of that which is most beautiful, and it adds beauty to that which is most deformed; it marries exultation and horror, grief and pleasure, eternity and change; it subdues to union under its light yoke, all irreconcilable things. It transmutes all that it touches, and every form moving within the radiance of its presence is changed by wondrous sympathy to an incarnation of the spirit which it breathes; its secret alchemy

turns to potable gold the poisonous waters which flow from death through life; it strips the evil of familiarity from the world, and lays bare the naked and sleeping beauty, which is the spirit of its forms.

All things exist as they are perceived; at least in relation to the percipient. "The mind is its own place, and of itself can make a heaven of hell, a hell of heaven."[7] But poetry defeats the curse which binds us to be subjected to the accident of surrounding impressions. And whether it spreads its own figured curtain, or withdraws life's dark veil from before the scene of things, it equally creates for us a being within our being. It makes us the inhabitants of a world to which the familiar world is a chaos. It reproduces the common universe of which we are portions and percipients, and it purges from our inward sight the film of familiarity which obscures from us the wonder of our being. It compels us to feel that which we perceive, and to imagine that which we know. It creates anew the universe, after it has been annihilated in our minds by the recurrence of impressions blunted by reiteration. It justifies the bold and true words of Tasso: *"Non merita nome di creatore, se non Iddio ed il poeta."*[8]

A poet, as he is the author to others of the highest wisdom, pleasure, virtue and glory, so he ought personally to be the happiest, the best, the wisest, and the most illustrious of men. As to his glory, let time be challenged to declare whether the fame of any other institutor of human life be comparable to that of a poet. That he is the wisest, the happiest, and the best, inasmuch as he is a poet, is equally incontrovertible; the greatest of poets have been men of the most spotless virtue, of the most consummate prudence, and, if we would look into the interior of their lives, the most fortunate of men: and the exceptions, as they regard those who possessed the poetic faculty in a high yet inferior degree, will be found on consideration to confine rather than destroy the rule. Let us for a moment stoop to the arbitration of popular breath, and usurping and uniting in our own persons the incompatible characters of accuser, witness, judge, and executioner, let us decide without trial, testimony, or form, that certain motives of those who are "there sitting where

we dare not soar,"[9] are reprehensible. Let us assume that Homer was a drunkard, that Virgil was a flatterer, that Horace was a coward, that Tasso was a madman, that Lord Bacon was a peculator, that Raphael was a libertine, that Spenser was a poet laureate. It is inconsistent with this division of our subject to cite living poets, but posterity has done ample justice to the great names now referred to. Their errors have been weighed and found to have been dust in the balance; if their sins "were as scarlet, they are now white as snow":[10] they have been washed in the blood of the mediator and redeemer, time. Observe in what a ludicrous chaos the imputations of real or fictitious crime have been confused in the contemporary calumnies against poetry and poets; consider how little is as it appears—or appears, as it is; look to your own motives, and judge not, lest ye be judged.

Poetry, as has been said, differs in this respect from logic, that it is not subject to the control of the active powers of the mind, and that its birth and recurrence have no necessary connection with the consciousness or will. It is presumptuous to determine that these are the necessary conditions of all mental causation, when mental effects are experienced insusceptible of being referred to them. The frequent recurrence of the poetical power, it is obvious to suppose, may produce in the mind a habit of order and harmony correlative with its own nature and with its effects upon other minds. But in the intervals of inspiration, and they may be frequent without being durable, a poet becomes a man, and is abandoned to the sudden reflex of the influences under which others habitually live. But as he is more delicately organized than other men, and sensible to pain and pleasure, both his own and that of others, in a degree unknown to them, he will avoid the one and pursue the other with an ardor proportioned to this difference. And he renders himself obnoxious to calumny, when he neglects to observe the circumstances under which these objects of universal pursuit and flight have disguised themselves in one another's garments.

But there is nothing necessarily evil in this error, and thus cruelty, envy, revenge, avarice, and the passions purely evil, have never formed any portion of the popular imputations on the lives of poets.

7. *Paradise Lost* I 254-55.

8. "No one deserves the name of creator except God and the poet." *Discourses on the Heroic Poem*, but misquoted.

9. *Paradise Lost* IV 829.

10. Suggestive of Isaiah i 18 "were as scarlet...snow."

I have thought it most favorable to the cause of truth to set down these remarks according to the order in which they were suggested to my mind, by a consideration of the subject itself, instead of observing the formality of a polemical reply; but if the view which they contain be just, they will be found to involve a refutation of the arguers against poetry, so far at least as regards the first division of the subject. I can readily conjecture what should have moved the gall of some learned and intelligent writers who quarrel with certain versifiers; I, like them, confess myself unwilling to be stunned by Theseids of the hoarse Codri of the day. Bavius and Maevius undoubtedly are, as they ever were, insufferable persons. But it belongs to a philosophical critic to distinguish rather than confound.

The first part of these remarks has related to poetry in its elements and principles; and it has been shown, as well as the narrow limits assigned them would permit, that what is called poetry in a restricted sense, has a common source with all other forms of order and beauty, according to which the materials of human life are susceptible of being arranged, and which is poetry in a universal sense.

The second part will have for its object an application of these principles to the present state of the cultivation of poetry, and a defense of the attempt to idealize the modern forms of manners and opinions, and compel them into a subordination to the imaginative and creative faculty. For the literature of England, an energetic development of which has ever preceded or accompanied a great and free development of the national will, has arisen as it were from a new birth. In spite of the low-thoughted envy which would undervalue contemporary merit, our own will be a memorable age in intellectual achievements, and we live among such philosophers and poets as surpass beyond comparison any who have appeared since the last national struggle for civil and religious liberty. The most unfailing herald, companion, and follower of the awakening of a great people to work a beneficial change in opinion or institution, is poetry. At such periods there is an accumulation of the power of communicating and receiving intense and impassioned conceptions respecting man and nature. The persons in whom this power resides may often, as far as regards many portions of their nature, have little apparent correspondence with that spirit of good of which they are the ministers. But even whilst they deny and abjure they are yet compelled to serve, the power which is seated on the throne of their own soul. It is impossible to read the compositions of the most celebrated writers of the present day without being startled with the electric life which burns within their words. They measure the circumference and sound the depths of human nature with a comprehensive and all-penetrating spirit, and they are themselves perhaps the most sincerely astonished at its manifestations; for it is less their spirit than the spirit of the age. Poets are the hierophants of an unapprehended inspiration; the mirrors of the gigantic shadows which futurity casts upon the present; the words which express what they understand not; the trumpets which sing to battle, and feel not what they inspire; the influence which is moved not, but moves. Poets are the unacknowledged legislators of the world.

Friedrich Nietzsche (1844-1900)

Selections from
The Birth of Tragedy

Translated by Clifton P. Fadiman

1

We shall do a great deal for the science of esthetics, once we perceive not merely by logical interference, but with the immediate certainty of intuition, that the continuous development of art is bound up with the *Apollonian* and *Dionysian* duality: just as procreation depends on the duality of the sexes, involving perpetual strife with only periodically intervening reconciliations. The terms Dionysian and Apollonian we borrow from the Greeks, who disclose to the discerning mind the profound mysteries of their view of art, not, to be sure, in concepts, but in the impressively clear figures of their gods. Through Apollo, and Dionysus, the two art-deities of the Greeks, we come to recognize that in the Greek world there existed a sharp opposition, in origin and aims, between the Apollonian art of sculpture, and the non-plastic, Dionysian, art of music. These two distinct tendencies run parallel to each other, for the most part openly at variance; and they continually incite each other to new and more powerful births, which penetrate an antagonism, only superficially reconciled by the common term "Art"; till at last, by a metaphysical miracle of the Hellenic will, they appear coupled with each other, and through this coupling eventually generate the art-product, equally Dionysian and Apollonian, of the Attic tragedy.

In order to grasp these two tendencies, let us first conceive of them as the separate art-worlds of *dreams* and *drunkenness*. These physiological phenomena present a contrast analogous to that existing between the Apollonian and the Dionysian. It was in dreams, says Lucretius, that the glorious divine figures first appeared to the souls of men; in dreams the great shaper beheld the splendid corporeal structure of superhuman beings; and the Hellenic poet, if questioned about the mysteries of poetic inspiration, would likewise have suggested dreams and he might have given an explanation like that of Hans Sachs in the *Mastersingers*:

> *"Mein Freund, das grad' ist Dichters Werk,*
> *dass er sein Träumen deut' und merk'.*
> *Glaubt mir, des Menschen wahrster Wahn*
> *wird ihm im Traume aufgethan:*
> *all' Dichtkunst und Poëterei*
> *ist nichts als Wahrtraum-Deuterei."*[1]

The beautiful appearance of the dream-worlds, in creating which every man is a perfect artist, is the prerequisite of all plastic art, and in fact, as we shall see, of an important part of poetry also. In our dreams we delight in the immediate apprehension of form; all forms speak to us; none are unimportant, none are superfluous. But, when this dream-reality is most intense, we also have, glimmering through it, the sensation of its appearance: at least this is my experience, as to whose frequency, aye, normality, I could adduce many proofs, in addition to the sayings of the poets. Indeed, the man of philosophic mind has a presentiment that underneath this

1. "My friend, that is exactly the poet's task, to mark his dreams and to attach meanings to them. Believe me, man's most profound illusions are revealed to him in dreams; and all versifying and poetizing is nothing but an interpretation of them."

reality in which we live and have our being, is concealed another and quite different reality, which, like the first, is an appearance; and Schopenhauer actually indicates as the criterion of philosophical ability the occasional ability to view men and things as mere phantoms or dream-pictures. Thus the esthetically sensitive man stands in the same relation to the reality of dreams as the philosopher does to the reality of existence; he is a close and willing observer, for these pictures afford him an interpretation of life, and it is by these processes that he trains himself for life. And it is not only the agreeable and friendly pictures that he experiences in himself with such perfect understanding: but the serious, the troubled, the sad, the gloomy, the sudden restraints, the tricks of fate, the uneasy presentiments, in short, the whole Divine Comedy of life, and the Inferno, also pass before him, not like mere shadows on the wall—for in these scenes he lives and suffers—and yet not without that fleeting sensation of appearance. And perhaps many will, like myself, recall that amid the dangers and terrors of dream-life they would at times, cry out in self-encouragement, and not without success. "It is only a dream! I will dream on!" I have likewise heard of persons capable of continuing one and the same dream for three and even more successive nights: facts which indicate clearly that our innermost beings, our common subconscious experiences, express themselves in dreams because they must do so and because they take profound delight in so doing.

This joyful necessity of the dream-experience has been embodied by the Greeks in their Apollo: for Apollo, the god of all plastic energies, is at the same time the soothsaying god. He, who (as the etymology of the name indicates) is the "shining one," the deity of light, is also ruler over the fair appearance of the inner world of fantasy. The higher truth, the perfection of these states in contrast to the incompletely intelligible everyday world, this deep consciousness of nature, healing and helping in sleep and dreams, is at the same time the symbolical analogue of the soothsaying faculty and of the arts generally, which make life possible and worth living. But we must also include in our picture of Apollo that delicate boundary, which the dream-picture must not overstep—lest it act pathologically (in which case appearance would impose upon us as pure reality). We must keep in mind that measured restraint, that freedom from the wilder emotions, that philosophical calm of the sculptor-god. His eye must be "sunlike," as befits his origin; even when his glance is angry and distempered, the sacredness of his beautiful appearance must still be there. And so, in one sense, we might apply to Apollo the words of Schopenhauer when he speaks of the man wrapped in the veil of Mâyâ:[2] *Welt als Wille und Vorstellung*, I. p. 416: "Just as in a stormy sea, unbounded in every direction, rising and falling with howling mountainous waves, a sailor sits in a boat and trusts in his frail barque: so in the midst of a world of sorrows the individual sits quietly, supported by and trusting in his *principium individuationis*." In fact, we might say of Apollo, that in him the unshaken faith in this *principium* and the calm repose of the man wrapped therein receive their sublimest expression; and we might consider Apollo himself as the glorious divine image of the *principium individuationis*, whose gestures and expression tell us of all the joy and wisdom of "appearance," together with its beauty.

In the same work Schopenhauer has depicted for us the terrible *awe* which seizes upon man, when he is suddenly unable to account for the cognitive forms of a phenomenon, when the principle of reason, in some one of its manifestations, seems to admit of an exception. If we add to this awe the blissful ecstasy which rises from the innermost depths of man, aye, of nature, at this very collapse of the *principium individuationis*, we shall gain an insight into the nature of the *Dionysian*, which is brought home to us most intimately perhaps by the analogy of *drunkenness*. It is either under the influence of the narcotic draught, which we hear of in the songs of all primitive men and peoples, or with the potent coming of spring penetrating all nature with joy, that these Dionysian emotions awake, which, as they intensify, cause the subjective to vanish into complete self-forgetfulness. So also in the German Middle Ages singing and dancing crowds, ever increasing in number,

2. Cf. *World as Will and Idea*, I. 455 ff., trans. by Haldane and Kemp, 6th ed.

were whirled from place to place under this same Dionysian impulse. In these dancers of St. John and St. Vitus, we rediscover the Bacchic choruses of the Greeks, with their early history in Asia Minor, as far back as Babylon and the orgiastic Sacæa. There are some, who, from obtuseness, or lack of experience, will deprecate such phenomena as "folk-diseases," with contempt or pity born of the consciousness of their own "healthy-mindedness." But, of course, such poor wretches can not imagine how anemic and ghastly their so-called "healthy-mindedness" seems in contrast to the glowing life of the Dionysian revellers rushing past them.

Under the charm of the Dionysian not only is the union between man and man reaffirmed, but Nature which has become estranged, hostile, or subjugated, celebrates once more her reconciliation with her prodigal son, man. Freely earth proffers her gifts, and peacefully the beasts of prey approach from desert and mountain. The chariot of Dionysus is bedecked with flowers and garlands; panthers and tigers pass beneath his yoke. Transform Beethoven's "Hymn to Joy" into a painting; let your imagination conceive the multitudes bowing to the dust, awestruck—then you will be able to appreciate the Dionysian. Now the slave is free; now all the stubborn, hostile barriers, which necessity, caprice or "shameless fashion" have erected between man and man, are broken down. Now, with the gospel of universal harmony, each one feels himself no only united, reconciled, blended with his neighbor, but as one with him; he feels as if the veil of Mâyâ had been torn aside and were now merely fluttering in tatters before the mysterious Primordial Unity. In song and in dance man expresses himself as a member of a higher community; he has forgotten how to walk and speak; he is about to take a dancing flight into the air. His very gestures bespeak enchantment. Just as the animals now talk, just as the earth yields milk and honey, so from him emanate supernatural sounds. He feels himself a god, he himself now walks about enchanted, in ecstasy, like to the gods whom he saw walking about in his dreams. He is no longer an artist, he has become a work of art: in these paroxysms of intoxication the artistic power of all nature reveals itself to the highest gratification of the Primordial Unity. The noblest clay, the most costly marble, man, is here kneaded and cut, and to the sound of the chisel strokes of the Dionysian world-artist rings out the cry of the Eleusinian mysteries: "Do ye bow in the dust, O millions? Do you divine your creator, O world?"

2

Thus far we have considered the Apollonian and its antithesis, the Dionysian, as artistic energies which burst forth from nature herself, *without the mediation of the human artist*; energies in which nature's art-impulses are satisfied in the most immediate and direct way: first, on the one hand, in the pictorial world of dreams, whose completeness is not dependent upon the intellectual attitude or the artistic culture of any single being; and, on the other hand, as drunken reality, which likewise does not heed the single unit, but even seeks to destroy the individual and redeem him by a mystic feeling of Oneness. With reference to these immediate art-states of nature, every artist is an "imitator," that is to say, either an Apollonian artist in dreams, or a Dionysian artist in ecstasies, or finally—as for example in Greek tragedy—at once artist in both dreams and ecstasies: so we may perhaps picture him sinking down in his Dionysian drunkenness and mystical self-abnegation, alone, and apart from the singing revelers, and we may imagine how now, through Apollonian dream-inspiration, his own state, *i.e.*, his oneness with the primal nature of the universe, is revealed to him in a *symbolical dream-picture*.

So much for these general premises and contrasts. Let us now approach the *Greeks* in order to learn how highly these *art-impulses of nature* were developed in them. Thus we shall be in a position to understand and appreciate more deeply that relation of the Greek artist to his archetypes, which, according to the Aristotelian expression, is "the imitation of nature." In spite of all the dream-literature and the numerous dream-anecdotes of the Greeks, we can speak only conjecturally, though with reasonable assurance, of their *dreams*. If we consider the incredibly precise and unerring plastic power of their eyes, together with their vivid, frank delight in colors, we can hardly refrain (to the shame of all those born later) from assuming even for their dreams a certain

logic of line and contour, colors and groups, a certain pictorial sequence reminding us of their finest bas-reliefs, whose perfection would certainly justify us, if a comparison were possible, in designating the dreaming Greeks as Homers and Homer as a dreaming Greek: in a deeper sense than that in which modern man, speaking of his dreams, ventures to compare himself with Shakespeare.

On the other hand, there is no conjecture as to the immense gap which separates the *Dionysian Greek* from the Dionysian barbarian. From all quarters of the Ancient World,—to say nothing here of the modern,—from Rome to Babylon, we can point to the existence of Dionysian festivals, types which bear, at best, the same relation to the Greek festivals as the bearded satyr, who borrowed his name and attributes from the goat, does to Dionysus himself. In nearly every case these festivals centered in extravagant sexual licentiousness, whose waves overwhelmed all family life and its venerable traditions; the most savage natural instincts were unleashed, including even that horrible mixture of sensuality and cruelty which has always seemed to me to be the genuine "witches' brew." For some time, however, it would appear that the Greeks were perfectly insulated and guarded against the feverish excitements of these festivals by the figure of Apollo himself rising here in full pride, who could not have held out the Gorgon's head to any power more dangerous than this grotesquely uncouth Dionysian. It is in Doric art that this majestically-rejecting attitude of Apollo is eternized. The opposition between Apollo and Dionysus became more hazardous and even impossible, when, from the deepest roots of the Hellenic nature, similar impulses finally burst forth and made a path for themselves: the Delphic god, by a seasonably effected reconciliation, now contented himself with taking the destructive weapons from the hands of his powerful antagonist. This reconciliation is the most important moment in the history of the Greek cult: wherever we turn we note the revolutions resulting from this event. The two antagonists were reconciled; the boundary lines thenceforth to be observed by each were sharply defined, and there was to be a periodical exchange of gifts of esteem. At bottom, however, the chasm was not bridged over. But if we observe how, under the pressure of this treaty of peace, the Dionysian power revealed itself, we shall now recognize in the Dionysian orgies of the Greeks, as compared with the Babylonian Sacæa with their reversion of man to the tiger and the ape, the significance of festivals of world-redemption and days of transfiguration. It is with them that nature for the first time attains her artistic jubilee; it is with them that the destruction of the *principium individuationis* for the first time becomes an artistic phenomenon. The horrible "witches' brew" of sensuality and cruelty becomes ineffective: only the curious blending and duality in the emotions of the Dionysian revelers remind us— as medicines remind us of deadly poisons—of the phenomenon that pain begets joy, that ecstasy may wring sounds of agony from us. At the very climax of joy there sounds a cry of horror or a yearning lamentation for an irretrievable loss. In these Greek festivals, nature seems to reveal a sentimental trait; it is as if she were heaving a sigh at her dismemberment into individuals. The song and pantomime of such dually-minded revelers was something new and unheard-of for the Homeric-Grecian world: and the Dionysian *music* in particular excited awe and terror. If music, as it would seem, had been known previously as an Apollonian art, it was so, strictly speaking, only as the wave-beat of rhythm, whose formative power was developed for the representation of Apollonian states. The music of Apollo was Doric architectonics in tones, but in tones that were merely suggestive, such as those of the cithara. The very element which forms the essence of Dionysian music (and hence of music in general) is carefully excluded as un-Apollonian: namely, the emotional power of the tone, the uniform flow of the melos, and the utterly incomparable world of harmony. In the Dionysian dithyramb man is incited to the greatest exaltation of all his symbolic faculties; something never before experienced struggles for utterance— the annihilation of the veil of Mâyâ, Oneness as the soul of the race, and of nature itself. The essence of nature is now to be expressed symbolically; we need a new world of symbols; for once the entire symbolism of the body is called into play, not the mere symbolism of the lips, face, and speech, but the whole pantomime of dancing, forcing every member into rhythmic movement. Thereupon the other

symbolic powers suddenly press forward, particularly those of music, in rhythmics, dynamics, and harmony. To grasp this collective release of all the symbolic powers, man must have already attained that height of self-abnegation which wills to express itself symbolically through all these powers: and so the dithyrambic votary of Dionysus is understood only by his peers! With what astonishment must the Apollonian Greek have beheld him! With an astonishment that was all the greater the more it was mingled with the shuddering suspicion that all this was actually not so very alien to him after all, in fact, that it was only his Apollonian consciousness which, like a veil, hid this Dionysian world from his vision.

3

To understand this, it becomes necessary to level the artistic structure of the *Apollonian culture*, as it were, stone by stone, till the foundations on which it rests become visible. First of all we see the glorious *Olympian* figures of the gods, standing on the gables of this structure. Their deeds, pictured in brilliant reliefs, adorn its friezes. We must not be misled by the fact that Apollo stands side by side with the others as an individual deity, without any claim to priority of rank. For the same impulse which embodied itself in Apollo gave birth in general to this entire Olympian world, and so in this sense Apollo is its father. What terrific need was it that could produce such an illustrious company of Olympian beings?

He who approaches these Olympians with another religion in his heart, seeking among them for moral elevation, even for sanctity, for disincarnate spirituality, for charity and benevolence, will soon be forced to turn his back on them, discouraged and disappointed. For there is nothing here that suggests asceticism, spirituality, or duty. We hear nothing but the accents of an exuberant, triumphant life, in which all things, whether good or bad, are deified. And so the spectator may stand quite bewildered before this fantastic superfluity of life, asking himself what magic potion these mad glad men could have imbibed to make life so enjoyable that, wherever they turned, their eyes beheld the smile of Helen, the ideal picture of their own existence, "floating in sweet sensuality." But to this spectator, who has his back already turned, we must perforce cry: "Go not away, but stay and hear what Greek folk-wisdom has to say of this very life, which with such inexplicable gayety unfolds itself before your eyes. There is an ancient story that King Midas hunted in the forest a long time for the wise *Silenus*, the companion of Dionysus, without capturing him. When Silenus at last fell into his hands, the king asked what was the best and most desirable of all things for man. Fixed and immovable, the demigod said not a word; till at last, urged by the king, he gave a shrill laugh and broke out into these words: 'Oh, wretched ephemeral race, children of chance and misery, why do ye compel me to tell you what it were most expedient for you not to hear? What is best of all is beyond your reach forever: not to be born, not to *be*, to be *nothing*. But the second best for you—is quickly to die.'"

How is the Olympian world of deities related to this folk-wisdom? Even as the rapturous vision of the tortured martyr to his suffering.

Now it is as if the Olympian magic mountain had opened before us and revealed its roots to us. The Greek knew and felt the terror and horror of existence. That he might endure this terror at all, he had to interpose between himself and life the radiant dream-birth of the Olympians. That overwhelming dismay in the face of the titanic powers of nature, the Moira enthroned inexorably over all knowledge, the vulture of the great lover of mankind, Prometheus, the terrible fate of the wise Œdipus, the family curse of the Atridæ which drove Orestes to matricide: in short, that entire philosophy of the sylvan god, with its mythical exemplars, which caused the downfall of the melancholy Etruscans—all this was again and again overcome by the Greeks with the aid of the Olympian *middle world* of art; or at any rate it was veiled and withdrawn from sight. It was out of the direst necessity to live that the Greeks created these gods. Perhaps we may picture the process to ourselves somewhat as follows: out of the original Titan thearchy of terror the Olympian thearchy of joy gradually evolved through the Apollonian impulse towards beauty, just as roses bud from thorny bushes. How else could this people, so sensitive, so vehement in

FRIEDRICH NIETZSCHE

its desires, so singularly constituted for *suffering*, how could they have endured existence, if it had not been revealed to them in their gods, surrounded with a higher glory? The same impulse which calls art into being, as the complement and consummation of existence, seducing one to a continuation of life, was also the cause of the Olympian world which the Hellenic "will" made use of as a transfiguring mirror. Thus do the gods justify the life of man, in that they themselves live it—the only satisfactory Theodicy! Existence under the bright sunshine of such gods is regarded as desirable in itself, and the real *grief* of the Homeric men is caused by parting from it, especially by early parting: so that now, reversing the wisdom of Silenus, we might say of the Greeks that "to die early is worst of all for them, the next worst—some day to die at all." Once heard, it will ring out again; forget not the lament of the short-lived Achilles, mourning the leaflike change and vicissitude of the race of men and the decline of the heroic age. It is not unworthy of the greatest hero to long for a continuation of life, aye, even though he live as a slave. At the Apollonian stage of development, the "will" longs so vehemently for this existence, the Homeric man feels himself so completely at one with it, that lamentation itself becomes a song of praise.

Here we should note that this harmony which is contemplated with such longing by modern man, in fact, this oneness of man with nature (to express which Schiller introduced the technical term "naïve"), is by no means a simple condition, resulting naturally, and as if inevitably. It is not a condition which, like a terrestrial paradise, *must* necessarily be found at the gate of every culture. Only a romantic age could believe this, an age which conceived of the artist in terms of Rousseau's *Emile* and imagined that in Homer it had found such an artist Emile, reared in Nature's bosom. Wherever we meet with the "naïve" in art, we recognize the highest effect of the Apollonian culture, which in the first place has always to overthrow some Titanic empire and slay monsters, and which, through its potent dazzling representations and its pleasurable illusions, must have triumphed over a terrible depth of world-contemplation and a most keen sensitivity to suffering.

But how seldom do we attain to the naïve—that complete absorption in the beauty of appearance! And hence how inexpressibly sublime is *Homer*, who, as individual being, bears the same relation to this Apollonian folk-culture as the individual dream-artist does to the dream-faculty of the people and of Nature in general. The Homeric "naïveté" can be understood only as the complete victory of the Apollonian illusion: an illusion similar to those which Nature so frequently employs to achieve her own ends. The true goal is veiled by a phantasm: and while we stretch out our hands for the latter, Nature attains the former by means of your illusion. In the Greeks the "will" wished to contemplate itself in the transfiguration of genius and the world of art; in order to glorify themselves, its creatures had to feel themselves worthy of glory; they had to behold themselves again in a higher sphere, without this perfect world of contemplation acting as a command or a reproach. Such is the sphere of beauty, in which they saw their mirrored images, the Olympians. With this mirroring of beauty the Hellenic will combated its artistically correlative talent for suffering and for the wisdom of suffering: and, as a monument of its victory, we have Homer, the naïve artist.

4

Now the dream-analogy may throw some light on the problem of the naïve artist. Let us imagine the dreamer: in the midst of the illusion of the dream-world and without disturbing it, he calls out to himself: "It is a dream, I will dream on." What must we infer? That he experiences a deep inner joy in dream-contemplation; on the other hand, to be at all able to dream with this inner joy and contemplation, he must have completely lost sight of the waking reality and its ominous obtrusiveness. Guided by the dream-reading Apollo, we may interpret all these phenomena to ourselves somewhat in this way. Though it is certain that of the two halves of our existence, the waking and the dreaming states, the former appeals to us as infinitely preferable, important, excellent and worthy of being lived, indeed, as that which alone is lived: yet, in relation to that mysterious substratum of our nature of which

we are the phenomena, I should, paradoxical as it may seem, maintain the very opposite estimate of the value of dream life. For the more clearly I perceive in Nature those omnipotent art impulses, and in them an ardent longing for release, for redemption through release, the more I feel myself impelled to the metaphysical assumption that the Truly-Existent and Primal Unity, eternally suffering and divided against itself, has need of the rapturous vision, the joyful appearance, for its continuous salvation: which appearance we, completely wrapped up in it and composed of it, are compelled to apprehend as the True Non-Being,—*i.e.*, as a perpetual becoming in time, space and causality,—in other words, as empiric reality. If, for the moment, we do not consider the question of our own "reality," if we conceive of our empirical existence, and that of the world in general, as a continuous representation of the Primal Unity, we shall then have to look upon the dream as an *appearance of appearance*, hence as a still higher appeasement of the primordial desire for appearance. And that is why the innermost heart of Nature feels that ineffable joy in the naïve artist and the naïve work of art, which is likewise only "an appearance of appearance." In a symbolic painting, *Raphael*, himself one of those immortal "naïve" ones, has represented for us this devolution of appearance to appearance, the primitive process of the naïve artist, and of Apollonian culture. In his "Transfiguration," the lower half of the picture, with the possessed boy, the despairing bearers, the bewildered, terrified disciples, shows us the reflection of suffering, primal and eternal, the sole basis of the world: the "appearance" here is the counter-appearance of eternal contradiction, the father of things. From this appearance now arises, like ambrosial vapor, a new visionary world of appearances, invisible to those wrapped the first appearance—a radiant floating in purest bliss, a serene contemplation beaming from wide-open eyes. Here we have presented, in the most sublime artistic symbolism, that Apollonian world of beauty and its substratum, the terrible wisdom of Silenus; and intuitively we comprehend their necessary interdependence. Apollo, however, again appears to us as the apotheosis of the *principium individuationis*, in which alone is consummated the perpetually attained goal of the Primal Unity, its redemption through appearance. With his sublime gestures, he shows us how necessity is the entire world of suffering, that by the means of it, the individual may be impelled to realize the redeeming vision, and then, sunk in contemplation of it, sit quietly in his tossing barque, amid the waves.

If we at all conceive of it as imperative and mandatory, this apotheosis of individuation knows but one law—the individual, *i.e.*, the delimiting of the boundaries of the individual, *measure* in the Hellenic sense. Apollo, as ethical deity, exacts measure of his disciples, and, that to this end, he requires self-knowledge. And so, side by side with the aesthetic necessity for beauty, there occur the demands "know thyself" and "nothing overmuch"; consequently pride and excess are regarded as the truly inimical demons of the non-Apollonian sphere, hence as characteristics of the pre-Apollonian age—that of the Titans; and of the extra-Apollonian world—that of the barbarians. Because of his Titan-like love for man, Prometheus must be torn to pieces by vultures; because of his excessive wisdom, which could solve the riddle of the Sphinx, Œdipus must be plunged into a bewildering vortex of crime. Thus did the Delphic god interpret the Greek past.

Similarly the effects wrought by the *Dionysian* seemed "titan-like" and "barbaric" to the Apollonian Greek: while at the same time he could not conceal from himself that he too was inwardly related to these overthrown Titans and heroes. Indeed, he had to recognize even more than this: despite all its beauty and moderation, his entire existence rested on a hidden substratum of suffering and of knowledge, which was again revealed to him by the Dionysian. And lo! Apollo could not live without Dionysus! The "titanic" and the "barbaric" were in the last analysis as necessary as the Apollonian.

And now let us take this artistically limited world, based on appearance and moderation; let us imagine how into it there penetrated, in tones ever more bewitching and alluring, the ecstatic sound of the Dionysian festival; let us remember that in these strains all of Nature's excess in joy, sorrow, and knowledge become audible, even in piercing shrieks; and finally, let us ask ourselves what significance

remains to the psalmodizing artist of Apollo, with his phantom harp-sound, once it is compared with this demonic folk-song! The muses of the arts of "appearance" paled before an art which, in its intoxication, spoke the truth. The wisdom of Silenus cried "Woe! woe!" to the serene Olympians. The individual, with all his restraint and proportion, succumbed to the self-oblivion of the Dionysian state, forgetting the precepts of Apollo. Excess revealed itself as truth. Contradiction, the bliss born of pain, spoke out from the very heart of Nature. And so, wherever the Dionysian prevailed, the Apollonian was checked and destroyed. But, on the other hand, it is equally certain that, wherever the first Dionysian onslaught was successfully withstood, the authority and majesty of the Delphic god exhibited itself as more rigid and menacing than ever. For to me the *Doric* state and Doric art are explicable only as a permanent citadel of the Apollonian. For an art so defiantly prim, and so encompassed with bulwarks, a training so warlike and rigorous, a political structure so cruel and relentless, could endure for any length of time only by incessant opposition to the titanic-barbaric nature of the Dionysian.

Up to this point we have simply enlarged upon the observation made at the beginning of this essay: that the Dionysian and the Apollonian, in new births ever following and mutually augmenting one another, controlled the Hellenic genius; that from out the age of "bronze," with its wars of the Titans and its rigorous folk-philosophy, the Homeric world developed under the sway of the Apollonian impulse to beauty; that this "naïve" splendor was again overwhelmed by the influx of the Dionysian; and that against this new power the Apollonian rose to the austere majesty of Doric art and the Doric view of the world. If, then, amid the strife of these two hostile principles, the older Hellenic history thus falls into four great periods of art, we are now impelled to inquire after the *final goal* of these developments and processes, lest perchance we should regard the last-attained period, the period of Doric art, as the climax and the aim of these artistic impulses. And here the sublime and celebrated art of *Attic tragedy* and the dramatic dithyramb presents itself as the common goal of both these tendencies, whose mysterious union, after many and long precursory struggles, found glorious consummation in this child,—at once Antigone and Cassandra.

5

We now approach the real goal of our investigation, which is directed towards the acquiring a knowledge of the Dionysian-Apollonian genius and its art-product, or at least an anticipatory understanding of its mysterious union. Here we shall first of all inquire after the first evidence in Greece of that new germ which subsequently developed into tragedy and the dramatic dithyramb. The ancients themselves give us a symbolic answer, when they place the faces of *Homer* and *Archilochus* as the forefathers and torchbearers of Greek poetry side by side on gems, sculptures, etc., with a sure feeling that consideration should be given only to these two thoroughly original compeers, from whom a stream of fire flows over the whole of later Greek history. Homer, the aged self-absorbed dreamer, the type of the Apollonian naïve artist, now beholds with astonishment the passionate genius of the war-like votary of the muses, Archilochus, passing through life with fury and violence; and modern esthetics, by way of interpretation, can only add that here the first "objective" artist confronts the first "subjective" artist. But this interpretation helps us but little, because we know the subjective artist only as the poor artist, and throughout the entire range of art we demand specially and first of all the conquest of the Subjective, the release from the ego and the silencing of the individual will and desire; indeed, we find it impossible to believe in any truly artistic production, however insignificant, if it is without objectivity, without pure, detached contemplation. Hence our esthetic must first solve the problem of how the "lyrist" is possible as an artist—he who, according to the experience of all ages, is continually saying "I" and running through the entire chromatic scale of his passions and desires. Compared with Homer, this very Archilochus appalls us by his cries of hatred and scorn, by his drunken outbursts of desire. Therefore is not he, who has been called the first subjective artist, essentially the non-artist? But in this case, how explain the reverence which was shown

to him—the poet—in very remarkable utterances by the Delphic oracle itself, the center of "objective" art?

Schiller has thrown some light on the poetic process by a psychological observation, inexplicable to himself, yet apparently valid. He admits that before the act of creation he did not perhaps have before him or within him any series of images accompanied by an ordered thought-relationship; but his condition was rather that of a *musical mood*. ("With me the perception has at first no clear and definite object; this is formed later. A certain musical mood of mind precedes, and only after this ensues the poetical idea.") Let us add to this the natural and most important phenomenon of all ancient lyric poetry, *the union*, indeed, the *identity*, of the *lyrist with the musician*, —compared with which our modern lyric poetry appears like the statue of a god without a head, —with this in mind we may now, on the basis of our metaphysics of esthetics set forth above, explain the lyrist to ourselves in this manner: In the first place, as Dionysian artist he has identified himself with the Primal Unity, its pain and contradiction. Assuming that music has been correctly termed a repetition and a recast of the world, we may say that he produces the copy of this Primal Unity as music. Now, however, under the Apollonian dream-inspiration, this music reveals itself to him again as a *symbolic dream-picture*. The inchoate, intangible reflection of the primordial pain in music, with its redemption in appearance, now produces a second mirroring as a specific symbol or example. The artist has already surrendered his subjectivity in the Dionysian process. The picture which now shows him his identity with the heart of the world, is a dream-scene, which embodies the primordial contradiction and primordial pain, together with the primordial joy, of appearance. The "I" of the lyrist therefore sounds from the depth of his being: its "subjectivity," in the sense of the modern esthetes, is pure imagination. When Archilochus, the first Greek lyrist, proclaims to the daughters of Lycambes both his mad love and his contempt, it is not his passion alone which dances before us in orgiastic frenzy; but we see Dionysus and the Mænads, we see the drunken reveler Archilochus sunk down in slumber—

as Euripides depicts it in the *Bacchæ*, the sleep on the high mountain pasture, in the noonday sun. And now Apollo approaches and touches him with the laurel. Then the Dionyso-musical enchantment of the sleeper seems to emit picture sparks, lyrical poems, which in their highest form are called tragedies and dramatic dithyrambs.

The plastic artist, as also the epic poet, who is related to him, is sunk in the pure contemplation of images. The Dionysian musician is, without any images, himself pure primordial pain and its primordial reëchoing. The lyric genius is conscious of a world of pictures and symbols—growing out of his state of mystical self-abnegation and oneness. This state has a coloring, a causality and a velocity quite different from that of the world of the plastic artist and the epic poet. For the latter lives in these pictures, and only in them, with joyful satisfaction. He never grows tired of contemplating lovingly even their minutest traits. Even the picture of the angry Achilles is only a picture to him, whose angry expression he enjoys with the dream-joy in appearance. Thus, by this mirror of appearance, he is protected against being united and blended with his figures. In direct contrast to this, the pictures of the *lyrist* are nothing but *his very* self and, as it were, only different projection of himself, by force of which he, as the moving center of this world, may say "I": only of course this self is not the same as that of the waking, empirically real man, but the only truly existent and eternal self resting at the basis of things, and with the help of whose images, the lyric genius can penetrate to this very basis.

Now let us suppose that among these images he also beholds *himself* as non-genius, *i.e.*, his subject, the whole throng of subjective passions and agitations directed to a definite object which appears real to him. It may now seem as if the lyric genius and the allied non-genius were one, as if the former had of its own accord spoken that little word "I." But this identity is but superficial and it will no longer be able to lead us astray, as it certainly led astray those who designated the lyrist as the subjective poet. For, as a matter of fact, Archilochus, the passionately inflamed, loving and hating man, is but a version of the genius, who by this time is no longer

merely Archilochus, but a world-genius expressing his primordial pain symbolically in the likeness of the man Archilochus: while the subjectively willing and desiring man, Archilochus, can never at any time be a poet. It is by no means necessary, however, that the lyrist should see nothing but the phenomenon of the man Archilochus before him as a reflection of eternal being; and tragedy shows how far the visionary world of the lyrist may be removed from this phenomenon, which, of course, is intimately related to it.

Schopenhauer, who did not conceal from himself the difficulty the lyrist presents in the philosophical contemplation of art, thought he had found a solution, with which, however, I am not in entire accord. (Actually, it was in his profound metaphysics of music that he alone held in his hands the means whereby this difficulty might be definitely removed: as I believe I have removed it here in his spirit and to his honor). In contrast to our view, he describes the peculiar nature of song as follows[3] (*Welt als Wille und Vorstellung*, I. 295):

"It is the subject of will, *i.e.*, his own volition, which the consciousness of the singer feels; often as a released and satisfied desire (joy), but still oftener as a restricted desire (grief), always as an emotion, a passion, a moved frame of mind. Besides this, however, and along with it, by the sight of surrounding nature, the singer becomes conscious of himself as the subject of pure will-less knowing, whose unbroken, blissful peace now appears, in contrast to the stress of desire, which is always restricted and always needy. The feeling of this contrast, this alternation, is really what the lyric as a whole expresses and what principally constitutes the lyrical state of mind. In it pure knowing comes to us as it were to deliver us from desire and its strain; we follow, but only for an instant; desire, the remembrance of our own personal ends, tears us anew from peaceful contemplation; yet ever again the next beautiful surrounding in which the pure will-less knowledge presents itself to us, allures us away from desire. Therefore, in the lyric and they lyrical mood, desire (the personal interest of the ends) and pure

perception of the surrounding presented are wonderfully mingled with each other; connections between them are sought for and imagined; the subjective disposition, the affectation of the will, imparts its own hue to the perceived surrounding, and conversely, the surroundings communicate the reflex of their color to the will. The true lyric is the expression of the whole of this mingled and divided state of mind."

Who could fail to recognize in this description that lyric poetry is here characterized as an incompletely attained art, which arrives at its goal infrequently and only as it were by leaps? Indeed, it is described as a semi-art, whose essence is said to consist in this, that desire and pure contemplation, *i.e.*, the unesthetic and the esthetic condition, are wonderfully mingled with each other. It follows that Schopenhauer still classifies the arts as subjective or objective, using the antithesis as if it were a criterion of value. But it is our contention, on the contrary, that this antithesis between the subjective and the objective is especially irrelevant in esthetics, since the subject, the desiring individual furthering his own egoistic ends, can be conceived of only as the antagonist, not as the origin of art. In so far as the subject is the artist, however, he has already been released from his individual will, and has become as it were the medium through which the one truly existent Subject celebrates his release in appearance. For, above all, to our humiliation *and* exultation, one thing must be clear to us. The entire comedy of art is neither performed for our betterment or education nor are we the true authors of this art-world. On the contrary, we may assume that we are merely pictures and artistic projections for the true author, and that we have our highest dignity in our significance as works of art—for it is only as an *esthetic phenomenon* that existence and the world are eternally *justified*—while of course our consciousness of our own significance hardly differs from that which the soldiers painted on canvas have of the battle represented on it. Thus all our knowledge of art is basically quite illusory, because as knowing beings we are not one and identical with that Being who, as the sole author and spectator of this comedy of art, prepares a perpetual entertainment for himself. Only in so far as the genius in the act of artistic creation

3. *World as Will and Idea*, I. 322, trans. by Haldane and Kemp, 6th ed.

coalesces with this primordial artist of the world, does he catch sight of the eternal essence of art; for in this state he is, in a marvelous manner, like the weird picture of the fairy-tale which can turn its eyes at will and behold itself; he is now at once subject and object, at once poet, actor, and spectator.

On Truth and Lies in a Nonmoral Sense[1]

Translated by Daniel Breazeale

1

Once upon a time, in some out of the way corner of that universe which is dispersed into numberless twinkling solar systems, there was a star upon which clever beasts invented knowing. That was the most arrogant and mendacious minute of "world history," but nevertheless, it was only a minute. After nature had drawn a few breaths, the star cooled and congealed, and the clever beasts had to die. —One might invent such a fable, and yet he still would not have adequately illustrated how miserable, how shadowy and transient, how aimless and arbitrary the human intellect looks within nature. There were eternities during which it did not exist. And when it is all over with the human intellect, nothing will have happened. For this intellect has no additional mission which would lead it beyond human life. Rather, it is human, and only its possessor and begetter takes it so solemnly—as though the world's axis turned within it. But if we could communicate with the gnat, we would learn that he likewise flies through the air with the same solemnity,[2] that he feels the flying center of the universe within himself. There is nothing so reprehensible and unimportant in nature that it would not immediately swell up like a balloon at the slightest puff of this power of knowing. And just as every porter wants to have an admirer, so even the proudest of men, the philosopher, supposes that he sees on all sides the eyes of the universe telescopically focused upon his action and thought.

It is remarkable that this was brought about by the intellect, which was certainly allotted to these most unfortunate, delicate, and ephemeral beings merely as a device for detaining them a minute within existence. For within this addition they would have every reason to flee this existence as quickly as Lessing's son.[3] The pride connected with knowing and sensing lies like a blinding fog over the eyes and senses of men, thus deceiving them concerning the value of existence. For this pride contains within itself the most flattering estimation of the value of knowing. Deception is the most general effect of such pride, but even its most particular effects contain within themselves something of the same deceitful character.

1. A more literal, though less English, translation of *Über Wahrheit und Lüge im aussermoralischen Sinne* might be "On Truth and Lie in the Extramoral Sense."

2. *Pathos*.

3. A reference to the offspring of Lessing and Eva König, who died on the day of his birth.

As a means for the preserving of the individual, the intellect unfolds its principle powers in dissimulation, which is the means by which weaker, less robust individuals preserve themselves—since they have been been denied the chance to wage the battle for existence with horns or with the sharp teeth of beasts of prey. This art of dissimulation reaches its peak in man. Deception, flattering, lying, deluding, talking behind the back, putting up a false front, living in borrowed splendor, wearing a mask, hiding behind convention, playing a role for others and for oneself—in short, a continuous fluttering around the *solitary* flame of vanity—is so much the rule and the law among men that there is almost nothing which is less comprehensible than how an honest and pure drive for truth could have arisen among them. They are deeply immersed in illusions and in dream images; their eyes merely glide over the surface of things and see "forms." Their senses nowhere lead to truth; on the contrary, they are content to receive stimuli and, as it were, to engage in a groping game on the backs of things. Moreover, man permits himself to be deceived in his dreams every night of his life. His moral sentiment does not even make an attempt to prevent this, whereas there are supposed to be men who have stopped snoring through sheer will power. What does man actually know about himself? Is he, indeed, ever able to perceive himself completely, as if laid out in a lighted display case? Does nature not conceal most things from him—even concerning his own body—in order to confine and lock him within a proud, deceptive consciousness, aloof from the coils of the bowels, the rapid flow of the blood stream, and the intricate quivering of the fibers! She threw away the key. And woe to that fatal curiosity which might one day have the power to peer out and down through a crack in the chamber of consciousness and then suspect that man is sustained in the indifference of his ignorance by that which is pitiless, greedy, insatiable, and murderous—as if hanging in dreams on the back of a tiger. Given this situation, where in the world could the drive for truth have come from?

Insofar as the individual wants to maintain himself against other individuals, he will under natural circumstances employ the intellect mainly for dissimulation. But at the same time, from boredom and necessity, man wishes to exist socially and with the herd; therefore, he needs to make peace and strives accordingly to banish from his world at least the most flagrant *bellum omni contra omnes*.[4] This peace treaty brings in its wake something which appears to be the first step toward acquiring that puzzling truth drive: to wit, *that* which shall count as "truth" from now on is established. That is to say, a uniformly valid and binding designation is invented for things, and this legislation of language likewise establishes the first laws of truth. For the contrast between truth and lie arises here for the first time. The liar is a person who uses the valid designations, the words, in order to make something which is unreal appear to be real. He says, for example, "I am rich," when the proper designation for his condition would be "poor." He misuses fixed conventions by means of arbitrary substitutions or even reversals of names. If he does this in a selfish and moreover harmful manner, society will cease to trust him and will thereby exclude him. What men avoid by excluding the liar is not so much being defrauded as it is being harmed by means of fraud. Thus, even at this stage, what they hate is basically not deception itself, but rather the unpleasant, hated consequences of certain sorts of deception. It is in a similarly restricted sense that man now wants nothing but truth: he desires the pleasant, life-preserving consequences of truth. He is indifferent toward pure knowledge which has no consequences; toward those truths which are possibly harmful and destructive he is even hostilely inclined. And besides, what about these linguistic conventions themselves? Are they perhaps products of knowledge, that is, of the sense of truth? Are designations congruent with things? Is language the adequate expression of all realities?

It is only by means of forgetfulness that man can ever reach the point of fancying himself to possess a "truth" of the grade just indicated. If he will not be satisfied with the truth in the form of tautology, that is to say, if he will not be content with empty husks, then he will always exchange truths for illusions. What is a word? It is the copy in sound of a nerve stimulus. But the further inference from the nerve

4. "War of each against all."

stimulus to a cause outside of us is already the result of a false and unjustifiable application of the principle of sufficient reason.[5] If truth alone had As the deciding factor in the genesis of language, and if the standpoint of certainty had been decisive for designations, then how could we still dare to say "the stone is hard," as if "hard" were something otherwise familiar to us, and not merely a totally subjective stimulation! We separate things according to gender, designating the tree as masculine and the plant as feminine. What arbitrary assignments![6] How far this oversteps the canons of certainty! We speak of a "snake": this designation touches only upon its ability to twist itself and could therefore also fit a worm.[7] What arbitrary differentiations! What one-sided preferences, first for this, then for that property of a thing! The various languages placed side by side show that with words it is never a question of truth, never a question of adequate expression; otherwise, there would not be so many languages.[8] The "thing in itself" (which is precisely what the pure truth, apart from any of its consequences, would be) is likewise something quite incomprehensible to the creator of language and something not in the least worth striving for. This creator only designates the relations of things to men,

and for expressing these relations he lays hold of the boldest metaphors. To begin with, a nerve stimulus is transferred into an image:[9] first metaphor. The image, in turn, is imitated in a sound: second metaphor. And each time there is a complete overleaping of one sphere, right into the middle of an entirely new and different one. One can imagine a man who is totally deaf and has never had a sensation of sound and music. Perhaps such a person will gaze with astonishment at Chladni's sound figures; perhaps he will discover their causes in the vibrations of string and will now swear that he must know what men mean by "sound." It is this way with all of us concerning language: we believe that we know something about the things themselves when we speak of trees, colors, snow, and flowers; and yet we possess nothing but metaphors for things—metaphors which correspond in no way to the original entities.[10] In the same way that the sound appears as a sand figure, so the mysterious X of the thing in itself first appears as a nerve stimulus, then as an image, and finally as a sound. Thus the genesis of language does not proceed logically in any case, and all the material within and with which the man of truth, the scientist, and the philosopher later work and build, if not derived from never-never land,[11] is at least not derived from the essence of things.

In particular, let us further consider the formation of concepts. Every word instantly becomes a concept precisely insofar as it is not supposed to serve as a reminder of the unique and entirely individual original experience to which it owes its origin; but rather, a word becomes a concept insofar as it simultaneously has to fit countless more or less similar cases—which means, purely and simply, cases which are never equal and thus altogether unequal. Every concept arises from the equation of unequal things. Just as it is certain that one leaf is never totally the same as another, so it is certain that the concept "leaf" is formed by arbitrarily discarding these individual differences and by forgetting the

5. Note that Nietzsche is here engaged in an implicit critique of Schopenhauer, who had been guilty of precisely this misapplication of the principle of sufficient reason in his first book, *The Fourfold Root of the Principle of Sufficient Reason*. It is quite wrong to think that Nietzsche was ever wholly uncritical of Schopenhauer's philosophy (see, for example, the little essay, *Kritic der Schopenhauerischen Philosophie* from 1867, in Nietsche's *Gesammelte Werke*, München, Mucarion (1920-1929) I, pp. 392-401).

6. *welche willkürlichen Übertragungen.* The specific sense of this passage depends upon the fact that all ordinary nouns in the German language are assigned a gender: the tree is *der Baum*; the plant is *die Pflanze.* This assignment of an original sexual property to all things is the "transference" in question.

7. This passage depends upon the etymological relation between the German words *Schlange* (snake) and *schlingen* (to wind or twist), both of which are related to the old High German *slango.*

8. What Nietzsche is rejecting here is the theory that there is a sort of "naturally appropriate" connection between certain words (or sounds) and things. Such a theory is defended by Socrates in Plato's *Cratylus.*

9. *Ein Nervenreiz, zuerst übertragen in ein Bild.* The "image" in this case is the visual image, what we "see."

10. *Wesenheiten.*

11. *Wolkenkukuksheim*: literally, "cloud-cuckoo-land."

distinguishing aspects. This awakens the idea that, in addition to the leaves, there exists in nature the "leaf": the original model according to which all the leaves were perhaps woven, sketched, measured, colored, curled, and painted—but with incompetent hands, so that no specimen has turned out to be correct, trustworthy, and faithful likeness of the original model. We call a person "honest," and then we ask, "why has he behaved so honestly today?" Our usual answer is, "on account of his honesty." Honesty! This in turn means that the leaf is the cause of the leaves. We know nothing whatsoever about an essential quality called "honesty"; but we do know of countless individualized and consequently unequal actions which we equate by omitting the aspects in which they are unequal and which we now designate as "honest" actions. Finally we formulate from them a *qualitas occulta*[12] which has the name "honesty." We obtain the concept, as we do the form, by overlooking what is individual and actual; whereas nature is acquainted with no forms and no concepts, and likewise with no species, but only with an X which remains inaccessible and undefinable for us. For even our contrast between individual and species is something anthropomorphic and does not originate in the essence of things; although we should not presume to claim that this contrast does not correspond to the essence of things: that would of course be a dogmatic assertion and, as such, would be just as indemonstrable as its opposite.

What then is truth? A movable host of metaphors, metonymies, and anthropomorphisms: in short, a sum of human relations which have been poetically and rhetorically intensified, transferred, and embellished, and which, after long usage, seem to a people to be fixed, canonical, and binding. Truths are illusions which we have forgotten are illusions; they are metaphors that have become worn out and have been drained of sensuous force, coins which have lost their embossing and are now considered as metal and no longer as coins.

We still do not yet know where the drive for truth comes from. For so far we have heard only of the duty which society imposes in order to exist: to be truthful means to employ the usual metaphors. Thus, to express it morally, this is the duty to lie according to a fixed convention, to lie with the herd and in a manner binding upon everyone. Now man of course forgets that this is the way things stand for him. Thus he lies in the manner indicated, unconsciously and in accordance with habits which are centuries' old; and precisely *by means of this unconsciousness* and forgetfulness he arrives at his sense of truth. From the sense that one is obliged to designate one thing as "red," another as "cold," and a third as "mute," there arises a moral impulse in regard to truth. The venerability, reliability, and utility of truth is something which a person demonstrates for himself from the contrast with the liar, whom no one trusts and everyone excludes. As a "*rational*" being, he now places his behavior under the control of abstractions. He will no longer tolerate being carried away by sudden impressions, by intuitions. First he universalizes all these impressions into less colorful, cooler concepts, so that he can entrust the guidance of his life and conduct to them. Everything which distinguishes man from the animals depends upon this ability to volatilize perceptual metaphors[13] in a schema, and thus to dissolve an image into a concept. For something is possible in the realm of these schemata which could never be achieved with the vivid first impressions: the construction of a pyramidal order according to castes and degrees, the creation of a new world of laws, privileges, subordinations, and clearly marked boundaries—a new world, one which now confronts that other vivid world of first impressions as more solid, more universal, better known, and more human than the immediately perceived world, and thus as the regulative and imperative world. Whereas each perceptual metaphor is individual and without equals and is therefore able to elude all classification, the great edifice of concepts displays the rigid regularity of a Roman columbarium[14] and exhales in logic that strength and coolness which is characteristic of mathematics.

13. *die anschaulichen Mataphern.* The adjective *anschaulich* has the additional sense of "vivid"—as in the next sentence ("vivid first impressions").

14. A columbarium is a vault with niches for funeral urns containing the ashes of cremated bodies.

12. "Occult quality."

Anyone who has felt this cool breath [of logic] will hardly believe that even the concept—which is as bony, foursquare, and transposable as a die—is nevertheless merely the *residue of a metaphor*, and that the illusion which is involved in the artistic transference of a nerve stimulus into images is, if not the mother, then the grandmother of every single concept.[15] But in this conceptual crap game "truth" means using every die in the designated manner, counting its spots accurately, fashioning the right categories, and never violating the order of caste and class rank. Just as the Romans and Etruscans cut up the heavens with rigid mathematical lines and confined a god within each of the spaces thereby delimited, as within a *templum*,[16] so every people has a similarly mathematically divided conceptual heaven above themselves and henceforth thinks that truth demands that each conceptual god be sought only within *his own* sphere. Here one may certainly admire man as a mighty genius of construction, who succeeds in piling up an infinitely complicated dome of concepts upon an unstable foundation, and, as it were, on running water. Of course, in order to be supported by such a foundation, his construction must be like one constructed of spiders' webs: delicate enough to be carried along by the waves, strong enough not to be blown apart by every wind. As a genius of construction man raises himself far above the bee in the following way: whereas the bee builds with wax that he gathers from nature, man builds with the far more delicate conceptual material which he first has to manufacture from himself. In this he is greatly to be admired, but not on account of his drive for truth or for pure knowledge of things. When someone hides something behind a bush and looks for it again in the same place and finds it there as well, there is not much to praise in such seeking and finding. Yet this is how matters stand regarding seeking and finding "truth" within the realm of reason. If I make up the definition of a mammal, and then, after inspecting a camel, declare "look, a mammal," I have indeed brought a truth to light in this way, but it is a truth of limited value. That is to say, it is a thoroughly anthropomorphic truth which contains not a single point which would be "true in itself" or really and universally valid apart from man. At bottom, what the investigator of such truths is seeking is only the metamorphosis of the world into man. He strives to understand the world as something analogous to man and at best he achieves by his struggles the feeling of assimilation. Similar to the way in which astrologers considered the stars to be in man's service and connected with his happiness and sorrow, such an investigator considers the entire universe in connection with man: the entire universe as the infinitely fractured echo of one original sound—man; the entire universe as the infinitely multiplied copy of one original picture—man. His method is to treat man as the measure of all things, but in doing so he again proceeds from the error of believing that he has these things [which he intends to measure] immediately before him as mere objects. He forgets that the original perceptual metaphors are metaphors and takes them to be the things themselves.

Only by forgetting this primitive world of metaphor can one live with any repose, security, and consistency: only by means of the petrification and coagulation of a mass of images which originally streamed from the primal faculty of human imagination like a fiery liquid, only in the invincible faith that *this* sun, *this* window, *this* table is a truth in itself, in short, only by forgetting that he himself is an *artistically creating subject*, does man live with any repose, security, and consistency. If but for an instant could he escape from the prison walls of this faith, his "self consciousness" would be immediately destroyed. It is even a difficult thing for him to admit to himself that the insect or the bird perceives an entirely different world from the one that man does, and that the question of which of these perceptions of the world is the more correct one is quite meaningless, for this would have to have been decided previously in accordance with the criterion of the *correct perception*, which means, in accordance with a criterion which is *not available*. But in any case it seems to me that "the correct perception"—which would mean "the adequate expression of an

15. I.e. concepts are derived from images, which are, in turn, derived from nerve stimuli.

16. A delimited space restricted to a particular purpose, especially a religiously sanctified area.

object in the subject"—is a contradictory impossibility.[17] For between two absolutely different spheres, as between subject and object, there is no causality, no correctness, and no expression; there is, at most, and *aesthetic* relation:[18] I mean, a suggestive transference, a stammering translation into a completely foreign tongue—for which there is required, in any case, a freely inventive intermediate sphere and mediating force. "Appearance" is a word that contains many temptations, which is why I avoid it as much as possible. For it is not true that the essence of things "appears" in the empirical world. A painter without hands who wished to express in song the picture before his mind would, by means of this substitution of spheres, still reveal more about the essence of things than does the empirical world. Even the relationship of a nerve stimulus to the generated image is not a necessary one. But when the same image has been generated millions of times and has been handed down for many generations and finally appears on the same occasion every time for all mankind, then it acquires at last the same meaning for men it would have if it were the sole necessary image and if the relationship of the original nerve stimulus to the generated image were a strictly causal one. In the same manner, an eternally repeated dream would certainly be felt and judged to be reality. But the hardening and congealing of a metaphor guarantees absolutely nothing concerning its necessity and exclusive justification.

Every person who is familiar with such consideration has no doubt felt a deep mistrust of all idealism of this sort: just as often as he has quite clearly convinced himself of the eternal consistency, omnipresence, and infallibility of the laws of nature. He has concluded that so far as we can penetrate here—from the telescopic heights to the microscopic depths—everything is secure, complete, infinite, regular, and without any gaps. Science will be able to dig successfully in this shaft forever, and all the things that are discovered will harmonize with and not contradict each other. How little does this resemble a product of the imagination, for if it were such, there should be some place where the illusion and unreality can be divined. Against this, the following must be said: if each of us had a different kind of sense perception—if we could only perceive things now as a bird, now as a worm, now as a plant, or if one of us saw a stimulus as red, another as blue, while a third even heard the same stimulus as a sound—then no one would speak of such a regularity of nature, rather, nature would be grasped only as a creation which is subjective in the highest degree. After all, what is a law of nature as such for us? We are not acquainted with it in itself, but only with its effects, which means in its relation to other laws of nature—which, in turn, are known to us only as sums of relations. Therefore all these relations always refer again to others and are thoroughly incomprehensible to us in their essence. All that we actually know about these laws of nature is what we ourselves bring to them—time and space, and therefore relationships of succession and number. But everything marvelous about the laws of nature, everything that quite astonishes us therein and seems to demand our explanation, everything that might lead us to distrust idealism: all this is completely and solely contained within the mathematical strictness and inviolability of our representations of time and space. But we produce these representations in and from ourselves with the same necessity with which the spider spins. If we are forced to comprehend all things only under these forms, then it ceases to be amazing that in all things we actually comprehend nothing but these forms. For they must all bear within themselves the laws of number, and it is precisely number which is most astonishing in things. All that conformity to law, which impresses us so much in the movement of the stars and in chemical processes, coincides at bottom with those properties which we bring to things. Thus it is we who impress ourselves in this way. In conjunction with this, it of course follows that the artistic process of metaphor formation with which every sensation begins in us already presupposes these forms and thus occurs within them. The only way in which the possibility of subsequently constructing a new conceptual edifice from metaphors themselves can be explained

17. *ein widerspruchsvolles Unding.* See *P,* n. 95.

18. *ein ästhetisches Verhalten.* A more literal translation of *Verhalten* is "behavior," "attitude," or perhaps "disposition."

is by the firm persistence of these original forms. That is to say, this conceptual edifice is an imitation of temporal, spatial, and numerical relationships in the domain of metaphor.[19]

2

We have seen how it is originally *language* which works on the construction of concepts, a labor taken over in later ages by *science*.[20] Just as the bee simultaneously constructs cells and fills them with honey, so science works unceasingly on this great columbarium of concepts, the graveyard of perceptions. It is always building new, higher stories and shoring up, cleaning, and renovating the old cells; above all, it takes pains to fill up this monstrously towering framework and to arrange therein the entire empirical world, which is to say, the anthropomorphic world. Whereas the man of action binds his life to reason and its concepts so that he will not be swept away and lost, the scientific investigator builds his hut right next to the tower of science so that he will be able to work on it and to find shelter for himself beneath those bulwarks which presently exist. And he requires shelter, for there are frightful powers which continuously break in upon him, powers which oppose scientific "truth" with completely different kinds of "truths" which bear on their shields the most varied sorts of emblems.

The drive toward the formation of metaphors is the fundamental human drive, which one cannot for a single instant dispense with in thought, for one would thereby dispense with man himself. This drive is not truly vanquished and scarcely subdued by the fact that a regular and rigid new world is constructed as its prison from its own ephemeral products, the concepts. It seeks a new realm and another channel for its activity, and it finds this in *myth* and in *art* generally. This drive continually confuses the conceptual categories and cells by bringing forward new transferences, metaphors, and metonymies. It continually manifests an ardent desire to refashion the world which presents itself to waking man, so that it will be as colorful, irregular, lacking in results and coherence, charming, and eternally new as the world of dreams. Indeed, it is only by means of the rigid and regular web of concepts that the waking man clearly sees that he is awake; and it is precisely because of this that he sometimes thinks that he must be dreaming when this web of concepts is torn by art. Pascal is right in maintaining that if the same dream came to us every night we would be just as occupied with it as we are with the things that we see every day. "If a workman were sure to dream for twelve straight hours every night that he was king," said Pascal, "I believe that he would be just as happy as a king who dreamt for twelve hours every night that he was a workman."[21] In fact, because of the way that myth takes it for granted that miracles are always happening, the waking life of a mythically inspired people—the ancient Greeks, for instance—more closely resembles a dream than it does the waking world of a scientifically disenchanted thinker. When every tree can suddenly speak as a nymph, when a god in the shape of a bull can drag away maidens, when even the goddess Athena herself is suddenly seen in the company of Peisastratus driving through the market place of Athens with a beautiful team of horses[22]—and this is what the honest Athenian believed—then, as in a dream, anything is possible at each moment, and all of nature swarms around man as if it were nothing but a masquerade of the gods, who were merely amusing themselves by deceiving men in all these shapes.

19. This is where section 1 of the fair copy made by von Gersdorff ends. But according to Schlechta (in Schlechta/Anders, pp. 14-5) Nietzsche's preliminary version continued as follows:

"Empty space and empty time are ideas which are possible at any time. Every concept, thus an empty metaphor, is only an imitation of these first ideas: space, time, and causality. Afterwards, the original imaginative act of transference into images: the first provides the matter, the second the qualities which we believe in. Comparison to music. How can one speak of it?"

20. *Wissenschaft*.

21. *Penseés*, number 386. Actually, Pascal says that the workman would be "almost as happy" as the king in this case!

22. According to the story told by Herodotus (*Histories* I, 60) the tyrant Peisistratus adopted the following ruse to secure his popular acceptance upon his return from exile: he entered Athens in a chariot accompanied by a woman named Phye who was dressed in the costume of Athena. Thus the people were supposed to have been convinced that it was the goddess herself who was conducting the tyrant back to the Acropolis.

But man has an invincible inclination to allow himself to be deceived and is, as it were, enchanted with happiness when the rhapsodist tells him epic fables as if they were true, or when the actor in the theater acts more royally than any real king. So long as it is able to deceive without *injuring*, that master of deception, the intellect, is free; it is released from its former slavery and celebrates its Saturnalia. It is never more luxuriant, richer, prouder, more clever and more daring. With creative pleasure it throws metaphors into confusion and displaces the boundary stones of abstractions, so that, for example, it designates the stream as "the moving path which carries man where he would otherwise walk." The intellect has now thrown the token of bondage from itself. At other times it endeavors, with gloomy officiousness, to show the way and to demonstrate the tools to a poor individual who covets existence; it is like a servant who goes in search of booty and prey for his master. But now it has become the master and it dares to wipe from its face the expression of indigence. In comparison with its previous conduct, everything that it now does bears the mark of dissimulation,[23] just as the previous conduct did of distortion.[24] The free intellect copies human life, but it considers this life to be something good and seems to be quite satisfied with it. That immense framework and planking of concepts to which the needy man clings his whole life long in order to preserve himself is nothing but a scaffolding and toy for the most audacious feats of the liberated intellect. And when it smashes this framework to pieces, throws it into confusion, and puts it back together in an ironic fashion, pairing the most alien things and separating the closest, it is demonstrating that it has no need of these makeshifts of indigence and that it will now be guided by intuition rather than by concepts. There is no regular path which leads from these intuitions into the land of ghostly schemata, the land of abstractions. There exists no word for these intuitions; when man sees them he grows dumb, or else he speaks only in forbidden metaphors and in unheard-of combinations of concepts. He does this

so that by shattering and mocking the old conceptual barriers he may at least correspond creatively to the impression of the powerful present intuition.

There are ages in which the rational man and the intuitive man stand side by side, the one in fear of intuition, the other with scorn for abstraction. The latter is just as irrational as the former is inartistic. They both desire to rule over life: the former, by knowing how to meet his principle needs by means of foresight, prudence, and regularity; the latter, by disregarding these needs and, as an "overjoyed hero," counting as real only that life which has been disguised as illusion and beauty. Whenever, as was perhaps the case in ancient Greece, the intuitive man handles his weapons more authoritatively and victoriously than his opponent, then, under favorable circumstances, a culture can take shape and art's mastery over life can be established. All the manifestations of such a life will be accompanied by this dissimulation, this disavowal of indigence, this glitter of metaphorical intuitions, and, in general, this immediacy of deception: neither the house, nor the gait, nor the clothes, nor the clay jugs give evidence of having been invented because of a pressing need. It seems as if they were all intended to express an exalted happiness, an Olympian cloudlessness, and, as it were, a playing with seriousness. The man who is guided by concepts and abstractions only succeeds by such means in warding off misfortune, without ever gaining any happiness for himself from these abstractions. And while he aims for the greatest possible freedom from pain, the intuitive man, standing in the midst of a culture, already reaps from his intuition a harvest of continually inflowing illumination, cheer, and redemption—in addition to obtaining a defense of misfortune. To be sure, he suffers more intensely, *when* he suffers; he even suffers more frequently, since he does not understand how to learn from experience and keeps falling over and over again into the same ditch. He is then just as irrational in sorrow as he is in happiness: he cries aloud and will not be consoled. How differently the stoical man who learns from experience and governs himself by concepts is affected by the same misfortunes! This man, who at other times seeks nothing but sincerity, truth, freedom from deception, and

23. *Verstellung.*
24. *Verzerrung.*

protection against ensnaring surprise attacks, now executes a masterpiece of deception: he executes his masterpiece of deception in misfortune, as the other type of man executes his in times of happiness. He wears no quivering and changeable human face, but, as it were, a mask with dignified, symmetrical features. He does not cry; he does not even alter his voice. When a real storm cloud thunders above him, he wraps himself in his cloak, and with slow steps he walks from beneath it.

Part 2

Expression and the Aesthetic Object

Part 2: Expression and the Aesthetic Object
Introduction

The philosophy of art in the first part of this century continued to be dominated by the Romantic reformulation of Kant's aesthetics: the view of aesthetics as involving a special attitude or kind of contemplation characterized by its own form of pleasure; the analysis of the work of art as an expression of emotion characterized by harmonious form; the equation of aesthetic value with expressive form rather than mimetic accuracy; the denigration of craft and technical skill as mechanical in comparison with the free play of imaginative insight in high art—all continued to play an important role in aesthetic theorizing. However, with the rapid expansion of naturalistic methods to new subjects and the separation of psychology and the other sciences from philosophy, idealism—which had been dominant until the turn of the century—came under strong attack. Advances in the psychology of vision, Nietzsche's ferocious attack on nineteenth-century culture, Freud's discovery (or invention) of the unconscious, Marx's account of ideology, and many other currents of thought contributed to the collapse of idealist assumptions about the role of the artist in culture as the producer of spiritual truths.

The readings in this section examine the role of expression in some important philosophers of this century, as well as the role of form in the apprehension of the aesthetic object. The first selection, from *The Principles of Art* by Robin Collingwood (1889-1943), was published in 1934. A philosopher of history and art at Oxford for most of his life, Collingwood presented an account of art as the expression of emotion which drew its inspiration from the great Italian idealist aesthetician Benedetto Croce. Collingwood begins by proposing to answer the question "What is art?"—first by clarifying the correct use of the term and then providing a definition of it. He distinguishes the correct use of 'art' from the obsolete use of the term according to which it means craft, by offering a series of six characteristics of craft which do not apply to art proper. He then proceeds to offer and discuss a set of characteristics definitive of art proper, according to which, ultimately, a work of art is an active or creative exercise of the imagination which expresses emotion.

The second selection, from *Art as Experience* by John Dewey (1859-1952), was also published in 1934. Dewey, a pragmatist, educational reformer and founder of the Chicago school of social psychology, was one of the central figures in twentieth-century American intellectual life. The key concept in his philosophy is *experience*, which Dewey conceived of as a set of natural transactions with the environment within which both values and goals

emerge. In the chapter "Having and Experience," Dewey focuses on emergent experiential wholes which are ordered by their own individualizing qualities and self-sufficiency. They are aesthetically satisfying and valuable in a way which ordinary experience is not, because they are parts of a unified process of experience which runs its full course towards fulfilment. Experience for Dewey is not internal but rather the field of lived human activity; accordingly, art is not something esoteric and removed from ordinary living, but merely an intensification of the meaning potential which every experiential transaction has. An art object is an expression of this intensification of significance in experience. Art is also communicative because experience is social and meaning is a collective property of a community of experiencers. The opposite of the aesthetic is not for Dewey the intellectual or the technical, as it is for the Romantics, but the slack, the dull, and the rigidly mechanical parts of life which reflect oppression and disempowerment and in which the consummatory character of experience is lost. We find art where experience is most fully unified, where the gap between need and satisfaction, production and enjoyment, work and leisure is bridged.

The selection by American philosopher Susanne Langer (1895-1985) offers an account of art through the notion of symbolic form. One of the most important aestheticians of the century, her view of the human animal as symbol user offers an anthropologically rich and intricate account of the human potential for creativity and meaning. A work of art is an expressive form, a perceptible whole that exhibits relationships of parts, or formal properties, expressing human feeling or emotion. What a work does is present feeling to us in some vehicle for our appreciation in a perceptible symbolic form. An artwork is a symbol much like the symbols in language, though rather than a discursive symbol, it is presentational. Langer's work offers suggestions for how aesthetic value can inhere in the aesthetic object, a topic taken up explicitly in the next two selections.

The selections by Pepper and Ingarden deal with the formation and cognition of the aesthetic object. Stephen Pepper (1891-1972), distinguished philosopher of art and value-theory, was for many years at the University of California at Berkeley as Chair of the Department of Art and then Philosophy. The selection here is taken from his Mahlon Powell lectures at Indiana University, published in 1955 as *The Work of Art*. According to Pepper, the work of art is not a single object but rather a nested series of objects. The first object is the vehicle, generally a physical thing, which carries the aesthetic values and controls perception of them; the second object in Pepper's series is the object of perceptual immediacy. It lasts at best only for a few seconds, and while necessary and pivotal as the source of all aesthetic data, is not sufficient by itself for the determination of aesthetic properties. A melody, for example, is not contained in any single object of immediacy, but requires a series or succession of perceptual immediacies for an integral perception of it. The same of course is true for any aesthetic object which unfolds temporally, such as a poem or a work of fiction, a play or a film. Because the object of sensuous immediacy is too short for any integral perception of a work of art, any theory which restricts the aesthetic to the immediately perceivable is inadequate. The cognition of a work of art involves a succession of perceptual immediacies in which later moments refer to earlier ones. Pepper borrows Dewey's term "funding" for this process: "funding is the fusion of meanings from past experiences into a present experience." The third object, which

Pepper calls the object of criticism, is the synthesis and evaluative goal of the successive moments of perceptual immediacy which are called forth by the apprehension of the vehicle.

Pepper goes on to argue that the process of progressive discrimination and appreciation of the object of criticism can be described naturalistically as a selective system guided by the control object or vehicle, on the model of an appetitive drive. Just as hunger makes the activities which lead to eating selectively more attractive than other activities which do not, aesthetic appreciation is a value-guided dynamic process in which appreciative activity, leading to the area of maximal satisfaction, is selectively reinforced, generating a consummatory field in which the viewer is guided by successive acts toward the maximal location of satisfaction. Appreciative acts are right or wrong in proportion as they conduce or fail to conduce to the attainment of the optimum location for satisfaction, and once there to the maintenance of optimum satisfaction. The object of criticism is this terminal area of optimum receptivity for the vehicle of a work of art. Thus, for Pepper, judgements of the aesthetic value of a work involve objective dispositional properties of the vehicle of the work to support appreciative satisfaction.

The next selection by Roman Ingarden (1893-1970), the prominent Polish phenomenologist and aesthetician, discusses the phenomenological formation of the aesthetic object and the way value properties inhere in it. He distinguishes between the physical vehicle which the viewer sees and the aesthetic object which is the work proper. No work is completely determined by its primary-level features: it requires interpretation or "reconstruction in its effective characteristics." Much of the selection is a discussion of how the viewer reconstructs the work and becomes aware of its value properties. In order to produce an appropriate object of criticism, the viewer must adopt an authentic aesthetic attitude. Ingarden acknowledges that the aesthetic object is observer-relative in certain ways, but denies that value subjectivism or instrumentalism follows from this fact. He gives an extended argument that the value properties of a work are determined by axiologically neutral base properties of the work, that are not subjective features of the work.

Both Pepper and Ingarden raise the question of the point of view from which critical judgements can be made. This is the topic of the next selection, "The Aesthetic Point of View" by Monroe Beardsley (1915-1985). Among analytic philosophers, Beardsley is the most prominent defender of aesthetic experience and a distinctively aesthetic point of view. To adopt the aesthetic point of view with respect to some object is to take an interest in whatever aesthetic value that thing might have. Aesthetic value, in turn, Beardsley argues, is the value that an object has in virtue of its capacity to provide aesthetic gratification. But is there such a kind of gratification, and what makes it aesthetic? Beardsley considers a number of objections grounded in facts about observer relativity, and concludes with some observations about aesthetic education and the improvement of taste.

This section concludes with two selections which take up the problem of aesthetic value in approximately the terms in which it was posed by Kant. The first, "The Judgement of Taste" is from Chapter 3 of *Beauty Restored* by Mary Mothersill (1923-), professor emeritus

of philosophy at Barnard College of Columbia University and author of many papers on aesthetics and ethics. As we have seen in the past three selections, the question of aesthetic value runs squarely into the problem first laid out by Kant: how to understand the cognitive content of aesthetic value claims, given the subjectivity of the judgement of taste. Mothersill's contribution returns to that question and discusses the logical structure of the judgement of taste. Arguing that the judgement of taste is singular, categorical and affirmative, Mothersill asks when and where these conditions are satisfied. She examines the views of Santayana and Kant—each of whom claim that the judgement of taste is normative or make a claim on the assent of others—but whose views are otherwise opposed. For Santayana, the expression of a judgement of taste is fundamentally a confession that the speaker finds the object in question a source of pleasure, and its normative aspect is merely a mask to protect the speaker. For Kant, the normative character of the judgement is inconsistent with its reduction to a confession of preference. But both philosophers take for granted that there is a conceptual connection between finding a thing a source of pleasure and taking it to be beautiful. If there were valid laws of taste, this connection could be understood, but the very idea of a law of taste is—as Kant puts it—absolutely impossible. Despite this, Mothersill argues, both supporters and opponents of the idea of aesthetic value tacitly presuppose the idea that such laws exist, and it is instructive to see why they are (mistakenly) led in this direction.

The final selection of this section is "Situating the Aesthetic: a Feminist Defence," a 1990 public talk at the Institute of Contemporary Art in London by Christine Battersby. Senior Lecturer in modern philosophy, aesthetics and feminism at the University of Warwick, Battersby offers a feminist critique of aesthetic value arguing that historical formulations of its content in the Humean and Kantian traditions—the judgements of a trained sensibility—are sexist and elitist. But unlike some critics who view aesthetic value simply as an ideological construct, Battersby argues that those traditions have misidentified the principles of aesthetic value. After identifying eight characteristics of aesthetic judgement in Kant's account, she argues that neither disinterestedness nor immediacy are essential to aesthetic judgements. She argues that aesthetic evaluation is implicitly historical. Aesthetic judgements express the approval or disapproval of ideal observers who represent standards derived from traditions. This opens the way for a feminist critique of those standards and traditions as sexist and elitist, for tracing alternative lines of influence, and reconstructing and formulating new critical standards. While feminists must fracture the illusion of a single universal and timeless canon of great art, they need not accept the rhetoric of a feminine essence governing women's art and give up on the task of formulating more inclusive norms for assessing aesthetic value.

R. G. Collingwood (1889-1943)

The Craft Theory of Art and Art as Expression

I
INTRODUCTION

§ 1. The Two Conditions of an Aesthetic Theory

The business of this book is to answer the question: What is art?

A question of this kind has to be answered in two stages. First, we must make sure that the key word (in this case 'art') is a word which we know how to apply where it ought to be applied and refuse where it ought to be refused. It would not be much use beginning to argue about the correct definition of a general term whose instances we could not recognize when we saw them. Our first business, then, is to bring ourselves into a position in which we can say with confidence 'this and this and this are art; that and that and that are not art'.

This would be hardly worth insisting upon, but for two facts: that the word 'art' is a word in common use, and that it is used equivocally. If it had not been a word in common use, we could have decided for ourselves when to apply it and when to refuse it. But the problem we are concerned with is not one that can be approached in that way. It is one of those problems where what we want to do is to clarify and systematize ideas we already possess; consequently there is no point in using words according to a private rule of our own, we must use them in a way which fits on to common usage. This again would have been easy, but for the fact that common usage is ambiguous. The word 'art' means several different things; and we have to decide which of these usages is the one that interests us. Moreover, the other usages must not be simply jettisoned as irrelevant. They are very important for our inquiry; partly because false theories are generated by failure to distinguish them, so that in expounding one usage we must give a certain attention to others;

partly because confusion between the various senses of the word may produce bad practice as well as bad theory. We must therefore review the improper senses of the word 'art' in a careful and systematic way; so that at the end of it we can say not only 'that and that and that are not art,' but 'that is not art because it is pseudo-art of kind A; that, because it is pseudo-art of kind B; and that, because it is pseudo-art of kind C'.

Secondly, we must proceed to a definition of the term 'art'. This comes second, and not first, because no one can even try to define a term until he has settled in his own mind a definite usage of it: no one can define a term in common use until he has satisfied himself that his personal usage of it harmonizes with the common usage. Definition necessarily means defining one thing in terms of something else; therefore, in order to define any given thing, one must have in one's head not only a clear idea of the thing to be defined, but an equally clear idea of all other things by reference to which one defines it. People often go wrong over this. They think that in order to construct a definition or (what is the same thing) a 'theory' of something, it is enough to have a clear idea of that one thing. That is absurd. Having a clear idea of the thing enables them to recognize it when they see it, just as having a clear idea of a certain house enables them to recognize it when they are there; but defining the thing is like explaining where the house is or pointing out its position on the map; you must know its relations to other things as well, and if your ideas of these other things are vague, your definition will be worthless.

. . .

§ 4. *History of the Word 'Art'*

In order to clear up the ambiguities attaching to the word 'art', we must look to its history. The aesthetic sense of the word, the sense which here concerns us, is very recent in origin. *Ars* in ancient Latin, like τέχνη [*technē*] in Greek, means something quite different. It means a craft or specialized form of skill, like carpentry or smithying or surgery. The Greeks and Romans had no conception of what we call art as something different from craft; what we call art they regarded merely as a group of crafts, such as the craft of poetry (ποιητικὴ τέχνη [*poiētikē technē*], *ars poetica*), which they conceived, sometimes no doubt with misgivings, as in principle just like carpentry and the rest, and differing from any one of these only in the sort of way in which any one of them differs from any other.

It is difficult for us to realize this fact, and still more so to realize its implications. If people have no word for a certain kind of thing, it is because they are not aware of it as a distinct kind. Admiring as we do the art of the ancient Greeks, we naturally suppose that they admired it in the same kind of spirit as ourselves. But we admire it as a kind of art, where the word 'art' carries with it all the subtle and elaborate implications of the modern European aesthetic consciousness. We can be perfectly certain that the Greeks did not admire it in any such way. They approached it from a different point of view. What this was, we can perhaps discover by reading what people like Plato wrote about it; but not without great pains, because the first thing every modern reader does, when he reads what Plato has to say about poetry, is to assume that Plato is describing an aesthetic experience similar to our own. The second thing he does is to lose his temper because Plato describes it so badly. With most readers there is no third stage.

Ars in medieval Latin, like 'art' in the early modern English which borrowed both word and sense, meant any special form of book-learning, such as grammar or logic, magic or astrology. That is still its meaning in the time of Shakespeare: 'lie there, my art', says Prospero, putting off his magic gown. But the Renaissance, first in Italy and then elsewhere, re-established the old meaning; and the Renaissance artists,

like those of the ancient world, did actually think of themselves as craftsmen. It was not until the seventeenth century that the problems and conceptions of aesthetic began to be disentangled from those of technic or the philosophy of craft. In the late eighteenth century the disentanglement had gone so far as to establish a distinction between the fine arts and the useful arts; where 'fine' arts meant, not delicate or highly skilled arts, but 'beautiful' arts (*les beaux arts, le belle arti, die schöne Kunst*). In the nineteenth century this phrase, abbreviated by leaving out the epithet and generalized by substituting the singular for the distributive plural, became 'art'.

At this point the disentanglement of art from craft is theoretically complete. But only theoretically. The new use of the word 'art' is a flag placed on a hill-top by the first assailants; it does not prove that the hill-top is effectively occupied.

· · ·

II
ART AND CRAFT

§1. *The Meaning of Craft*

The first sense of the word 'art' to be distinguished from art proper is the obsolete sense in which it means what in this book I shall call craft. This is what *ars* means in ancient Latin, and what τέχνη [*technē*] means in Greek: the power to produce a preconceived result by means of consciously controlled and directed action. In order to take the first step towards a sound aesthetic, it is necessary to disentangle the notion of craft from that of art proper. In order to do this, again, we must first enumerate the chief characteristics of craft.

(1) Craft always involves a distinction between means and end, each clearly conceived as something distinct from the other but related to it. The term 'means' is loosely applied to things that are used in order to reach the end, such as tools, machines, or fuel. Strictly, it applies not to the things but to the actions concerned with them: manipulating the tools, tending the machines, or burning the fuel. These actions (as implied by the literal sense of the word means) are passed through or traversed in order to reach the end, and are left behind when the end is

reached. This may serve to distinguish the idea of means from two other ideas with which it is sometimes confused: that of part, and that of material. The relation of part to whole is like that of means to end, in that the part is indispensable to the whole, is what it is because of its relation to the whole, and may exist by itself before the whole comes into existence; but when the whole exists the part exists too, whereas, when the end exists, the means have ceased to exist. As for the idea of material, we shall return to that in (4) below.

(2) It involves a distinction between planning and execution. The result to be obtained is preconceived or thought out before being arrived at. The craftsman knows what he wants to make before he makes it. This foreknowledge is absolutely indispensable to craft: if something, for example stainless steel, is made without such foreknowledge, the making of it is not a case of craft but an accident. Moreover, this foreknowledge is not vague but precise. If a person sets out to make a table, but conceives the table only vaguely, as somewhere between two by four feet and three by six, he is no craftsman.

(3) Means and end are related in one way in the process of planning; in the opposite way in the process of execution. In planning the end is prior to the means. The end is thought out first, and afterwards the means are thought out. In execution the means comes first, and the end is reached through them.

(4) There is a distinction between raw material and finished product or artifact. A craft is always exercised upon something, and aims at the transformation of this into something different. That upon which it works begins as raw material and ends as finished product. The raw material is found ready made before the special work of the craft begins.

(5) There is a distinction between form and matter. The matter is what is identical in the raw material and the finished product; the form is what is different, what the exercise of the craft changes. To describe the raw material as raw is not to imply that it is formless, but only that it has not yet the form which it is to acquire through 'transformation' into finished product.

(6) There is a hierarchical relation between various crafts, one supplying what another needs, one using what another provides. There are three kinds of hierarchy: of materials, of means, and of parts. (*a*) The raw material of one craft is the finished product of another. Thus the silviculturalist propagates trees and looks after them as they grow, in order to provide raw material for the felling-men who transform them into logs; these are raw material for the saw-mill which transforms them into planks; and these, after a further process of selection and seasoning, become raw material for a joiner. (*b*) In the hierarchy of means, one craft supplies another with tools. Thus the timber-merchant supplies pit-props to the miner; the miner supplies coal to the blacksmith; the blacksmith supplies horseshoes to the farmer; and so on. (*c*) In the hierarchy of parts, a complex operation like the manufacture of a motor-car is parcelled out among a number of trades: one firm makes the engine, another the gears, another the chassis, another the tyres, another the electrical equipment, and so on; the final assembling is not strictly the manufacture of the car but only the bringing together of these parts. In one or more of these ways every craft has a hierarchical character; either as hierarchically related to other crafts, or as itself consisting of various heterogeneous operations hierarchically related among themselves.

Without claiming that these features together exhaust the notion of craft, or that each of them separately is peculiar to it, we ma claim with tolerable confidence that where most of them are absent from a certain activity that activity is not a craft, and, if it is called by that name, is so called either by mistake or in a vague and inaccurate way.

§ 2. *The Technical Theory of Art*

It was the Greek philosophers who worked out the idea of craft, and it is in their writings that the above distinctions have been expounded once for all. The philosophy of craft, in fact, was one of the greatest and most solid achievements of the Greek mind, or at any rate of that school, from Socrates to Aristotle, whose work happens to have been most completely preserved.

Great discoveries seem to their makers even greater than they are. A person who has solved one problem is inevitably led to apply that solution to

others. Once the Socratic school had laid down the main lines of a theory of craft, they were bound to look for instances of craft in all sorts of likely and unlikely places. To show how they met this temptation, here yielding to it and there resisting it, or first yielding to it and then laboriously correcting their error, would need a long essay. Two brilliant cases of successful resistance may, however, be mentioned: Plato's demonstration (*Republic*, 330D-336A) that justice is not a craft, with the pendant (336E-354A) that injustice is not one either; and Aristotle's rejection (*Metaphysics*, L) of the view stated in Plato's *Timaeus*, that the relation between God and the world is a case of the relation between craftsman and artifact.

When they came to deal with aesthetic problems, however, both Plato and Aristotle yielded to the temptation. They took it for granted that poetry, the only art which they discussed in detail, was a kind of craft, and spoke of this craft as ποιητική τέχνη, poet-craft. What kind of craft was this?

There are some crafts, like cobbling, carpenting, or weaving, whose end is to produce a certain type of artifact; others, like agriculture or stock-breeding or horse-breaking, whose end is to produce or improve certain non-human types of organism; others again, like medicine or education or warfare, whose end is to bring certain human beings into certain stages of body or mind. But we need not ask which of these is the genus of which poet-craft is a species, because they are not mutually exclusive. The cobbler or carpenter or weaver is not simply trying to produce shoes or carts or cloth. He produces these because there is a demand for them; that is, they are not ends to him, but means to the end of satisfying a specific demand. What he is really aiming at is the production of a certain state of mind in his customers, the state of having these demands satisfied. The same analysis applies to the second group. Thus in the end these three kinds of craft reduce to one. They are all ways of bringing human beings into certain desired conditions.

The same description is true of poet-craft. The poet is a kind of skilled producer; he produces for consumers; and the effect of his skill is to bring about in them certain states of mind, which are conceived in advance as desirable states. The poet, like any other kind of craftsman, must know what effect he is aiming at, and must learn by experience and precept, which is only the imparted experience of others, how to produce it. This is poet-craft, as conceived by Plato and Aristotle and, following them, such writers as Horace in his *Ars Poetica*. There will be analogous crafts of painting, sculpture, and so forth; music, at least for Plato, is not a separate art but is a constituent part of poetry.

I have gone back to the ancients, because their thought, in this matter as in so many others, has left permanent traces on our own, both for good and for ill. There are suggestions in some of them, especially in Plato, of a quite different view; but this is the one which they have made familiar, and upon which both the theory and the practice of the arts has for the most part rested down to the present time. Present-day fashions of thought have in some ways even tended to reinforce it. We are apt nowadays to think about most problems, including those of art, in terms either of economics or of psychology; and both ways of thinking tend to subsume the philosophy of art under the philosophy of craft. To the economist, art presents the appearance of a specialized group of industries; the artist is a producer, his audience consumers who pay him for benefits ultimately definable in terms of the states of mind which his productivity enables them to enjoy. To the psychologist, the audience consists of persons reacting in certain ways to stimuli provided by the artist; and the artist's business is to know what reactions are desired or desirable, and to provide the stimuli which will elicit them.

The technical theory of art is thus by no means a matter of merely antiquarian interest. It is actually the way in which most people nowadays think of art; and especially economists and psychologists, the people to whom we look (sometimes in vain) for special guidance in the problems of modern life.

But this theory is simply a vulgar error, as anybody can see who looks at it with a critical eye. It does not matter what kind of craft in particular is identified with art. It does not matter what the benefits are which the artist is regarded as conferring on his audience, or what the reactions are which he

is supposed to elicit. Irrespectively of such details, our question is whether art is any kind of craft at all. It is easily answered by keeping in mind the half-dozen characteristics of craft enumerated in the preceding section, and asking whether they fit the case of art. And there must be no chopping of toes or squeezing of heels; the fit must be immediate and convincing. It is better to have no theory of art at all, than to have one which irks us from the first.

§ 3. *Break-down of the Theory*

(1) The first characteristic of craft is the distinction between means and end. Is this present in works of art? According to the technical theory, yes. A poem is means to the production of a certain state of mind in the audience, as a horseshoe is means to the production of a certain state of mind in the man whose horse is shod. And the poem in its turn will be an end to which other things are means. In the case of the horseshoe, this stage of the analysis is easy: we can enumerate lighting the forge, cutting a piece of iron off a bar, heating it, and so on. What is there analogous to these processes in the case of a poem? The poet may get paper and pen, fill the pen, sit down and square his elbows; but these actions are preparatory not to composition (which may go on in the poet's head) but to writing. Suppose the poem is a short one, and composed without the use of any writing materials; what are the means by which the poet composes it? I can think of no answer, unless comic answers are wanted, such as 'using a rhyming dictionary', 'pounding his foot on the floor or wagging his head or hand to mark the metre', or 'getting drunk'. If one looks at the matter seriously, one sees that the only factors in the situation are the poet, the poetic labour of his mind, and the poem. And if any supporter of the technical theory says 'Right: then the poetic labour is the means, the poem the end', we shall ask him to find a blacksmith who can make a horseshoe by sheer labour, without forge, anvil, hammer, or tongs. It is because nothing corresponding to these exists in the case of the poem that the poem is not an end to which there are means.

Conversely, is a poem means to the production of a certain state of mind in an audience? Suppose a poet had read his verses to an audience, hoping that they would produce a certain result; and suppose the result were different; would that in itself prove the poem a bad one? It is a difficult question; some would say yes, others no. But if poetry were obviously a craft, the answer would be a prompt and unhesitating yes. The advocate of the technical theory must do a good deal of toe-chopping before he can get his facts to fit his theory at this point.

So far, the prospects of the technical theory are not too bright. Let us proceed.

(2) The distinction between planning and executing certainly exists in some works of art, namely those which are also works of craft or artifacts; for there is, of course, an overlap between these two things, as may be seen by the example of a building or a jar, which is made to order for the satisfaction of a specific demand, to serve a useful purpose, but may none the less be a work of art. But suppose a poet were making up verses as he walked; suddenly finding a line in his head, and then another, and then dissatisfied with them and altering them until he had got them to his liking: what is the plan which he is executing? He may have had a vague idea that if he went for a walk he would be able to compose poetry; but what were, so to speak, the measurements and specifications of the poem he planned to compose? He may, no doubt, have been hoping to compose a sonnet on a particular subject specified by the editor of a review; but the point is that he may not, and that he is none the less a poet for composing without having any definite plan in his head. Or suppose a sculptor were not making a Madonna and child, three feet high, in Hoptonwood stone, guaranteed to placate the chancellor of the diocese and obtain a faculty for placing it in the vacant niche over a certain church door; but were simply playing about with clay, and found the clay under his fingers turning into a little dancing man: is this not a work of art because it was done without being planned in advance?

All this is very familiar. There would be no need to insist upon it, but that the technical theory of art relies on our forgetting it. While we are thinking of it, let us note the importance of not over-emphasizing it. Art as such does not imply the distinction between

planning and execution. But (*a*) this is a merely negative characteristic, not a positive one. We must not erect the absence of plan into a positive force and call it inspiration, or the unconscious, or the like. (*b*) It is a permissible characteristic of art, not a compulsory one. If unplanned works of art are possible, it does not follow that no planned work is a work of art. That is the logical fallacy[1] that underlies one, or some, of the various things called romanticism. It may very well be true that the only works of art which can be made altogether without a plan are trifling ones, and that the greatest and most serious ones always contain an element of planning and therefore an element of craft. But that would not justify the technical theory of art.

(3) If neither means and end nor planning and execution can be distinguished in art proper, there obviously can be no reversal of order as between means and end, in planning and execution respectively.

(4) We next come to the distinction between raw material and finished product. Does this exist in art proper? If so, a poem is made out of certain raw material. What is the raw material out of which Ben Jonson made *Queene and Huntresse, chaste, and faire*? Words, perhaps. Well, what words? A smith makes a horseshoe not out of all the iron there is, but out of a certain piece of iron, cut off a certain bar that he keeps in the corner of the smithy. If Ben Jonson did anything at all like that, he said: 'I want to make a nice little hymn to open Act v, Scene vi of *Cynthia's Revels*. Here is the English language, or as much of it as I know; I will use *thy* five times, *to* four times, *and, bright, excellently*, and *goddesse* three times each, and so on.' He did nothing like this. The words which occur in the poem were never before his mind as a whole in an order different from

that of the poem, out of which he shuffled them till the poem, as we have it, appeared. I do not deny that by sorting out the words, or the vowel sounds, or the consonant sounds, in a poem like this, we can make interesting and (I believe) important discoveries about the way in which Ben Jonson's mind worked when he made the poem; and I am willing to allow that the technical theory of art is doing good service if it leads people to explore these matters; but if it can only express what it is trying to do by calling these words or sounds the materials out of which the poem is made, it is talking nonsense.

But perhaps there is a raw material of another kind: a feeling or emotion, for example, which is present to the poet's mind at the commencement of his labour, and which that labour converts into the poem. 'Aus meinem grossen Schmerzen mach' ich die kleinen Lieder', said Heine; and he was doubtless right; the poet's labour can be justly described as converting emotions into poems. But this conversion is a very different kind of thing from the conversion of iron into horseshoes. If the two kinds of conversion were the same, a blacksmith could make horseshoes out of his desire to pay the rent. The something more, over and above that desire, which he must have in order to make horseshoes out of it, is the iron which is their raw material. In the poet's case that something more does not exist.

(5) In every work of art there is something which, in some sense of the word, may be called form. There is, to be rather more precise, something in the nature of rhythm, pattern, organization, design, or structure. But it does not follow that there is a distinction between form and matter. Where that distinction does exist, namely, in the artifacts, the matter was there in the shape of raw material before the form was imposed upon it, and the form was there in the shape of a preconceived plan before being imposed upon the matter; and as the two coexist in the finished product we can see how the matter might have accepted a different form, or the form have been imposed upon a different matter. None of these statements applies to a work of art. Something was no doubt there before a poem came into being; there was, for example, a confused excitement in the poet's mind; but, as we have seen,

1. It is an example of what I have elsewhere called the fallacy of precarious margins. Because art and craft overlap, the essence of art is sought not in the positive characteristics of all art, but in the characteristics of those works of art which are not works of craft. Thus the only things which are allowed to be works of art are those marginal examples which lie outside the overlap of art and craft. This is a precarious margin because further study may at any moment reveal the characteristics of craft in some of these examples. See *Essay on Philosophical Method*.

this was not the raw material of the poem. There was also, no doubt, the impulse to write; but this impulse was not the form of the unwritten poem. And when the poem is written, there is nothing in it of which we can say, 'this is a matter which might have taken on a different form', or 'this is a form which might have been realized in a different matter'.

When people have spoken of matter and form in connexion with art, or of that strange hybrid distinction, form and content, they have in fact been doing one of two things, or both confusedly at once. Either they have been assimilating a work of art to an artifact, and the artist's work to the craftsman's; or else they have been using these terms in a vaguely metaphorical way as means of referring to distinctions which really do exist in art, but are of a different kind. There is always in art a distinction between what is expressed and that which expresses it; there is a distinction between the initial impulse to write or paint or compose and the finished poem or picture or music; there is a distinction between an emotional element in the artist's experience and what may be called an intellectual element. All these deserve investigation; but none of them is a case of the distinction between form and matter.

(6) Finally, there is in art nothing which resembles the hierarchy of crafts, each dictating ends to the one below it, and providing either means or raw materials or parts to the one above. When a poet writes verses for a musician to set; these verses are not means to the musician's end, for they are incorporated in the song which is the musician's finished product, and it is characteristic of means, as we saw, to be left behind. But neither are they raw materials. The musician does not transform them into music; he sets them to music; and if the music which he writes for them had a raw material (which it has not), that raw material could not consist of verses. What happens is rather that the poet and musician collaborate to produce a work of art which owes something to each of them; and this is true even if in the poet's case there was no intention of collaborating.

Aristotle extracted from the notion of a hierarchy of crafts the notion of a supreme craft, upon which all hierarchical series converged, so that the various 'goods' which all crafts produce played their part, in one way or another, in preparing for the work of this supreme craft, whose product could, therefore, be called the 'supreme good'.[2] At first sight, one might fancy an echo of this in Wagner's theory of opera as the supreme art, supreme because it combines the beauties of music and poetry and drama, the arts of time and the arts of space, into a single whole. But, quite apart from the question of whether Wagner's opinion of opera as the greatest of the arts is justified, this opinion does not really rest on the idea of a hierarchy of arts. Words, gestures, music, scenery are not means to opera, nor yet raw materials of it, but parts of it; the hierarchies of means and materials may therefore be ruled out, and only that of parts remains. But even this does not apply. Wagner thought himself a supremely great artist because he wrote not only music but his words, designed his scenery, and acted as his own producer. This is the exact opposite of a system like that by which motorcars are made, which owes its hierarchical character to the fact that the various parts are all made by different firms, each specializing in work of one kind.

§ 4. *Technique*

As soon as we take the notion of craft seriously, it is perfectly obvious that art proper cannot be any kind of craft. Most people who write about art today seem to think that it is some kind of craft; and this is the main error against which a modern aesthetic theory must fight. Even those who do not openly embrace the error itself, embrace doctrines implying it. One such doctrine is that of artistic technique.

The doctrine may be stated as follows. The artist must have a certain specialized form of skill, which is called technique. He acquires his skill just as a craftsman does, partly through personal experience and partly sharing in the experience of others who thus become his teachers. The technical skill which he thus acquires does not by itself make him an artist; for a technician is made, but an artist is born. Great artistic powers may produce fine works of art

2. *Nicomachen Ethics*, beginning: 1094 a1-b10.

even though technique is defective; and even the most finished technique will not produce the finest sort of work in their absence; but all the same, no work of art whatever can be produced without some degree of technical skill, and, other things being equal, the better technique the better will be the work of art. The greatest artistic powers, for their due and proper display, demand a technique as good in its kind as they are in their own.

All this, properly understood, is very true; and, as a criticism of the sentimental notion that works of art can be produced by any one, however little trouble he has take to learn his job, provided his heart is in the right place, very salutary. And since a writer on art is for the most part addressing himself not to artists, but to amateurs of art, he does well to insist on what every artist knows, but most amateurs do not: the vast amount of intelligent and purposeful labour, the painful and conscientious self-discipline, that has gone to the making of a man who can write a line as Pope writes it, or knock a single chip off a single stone like Michelangelo. It is no less than true, and no less important, that the skill here displayed (allowing the word skill to pass for the moment unchallenged), though a necessary condition of the best art, is not by itself sufficient to produce it. A high degree of such skill is shown in Ben Jonson's poem; and a critic might, not unfruitfully, display this skill by analysing the intricate and ingenious patterns of rhythm and rhyme, alliteration, assonance, and dissonance, which the poem contains. But what makes Ben Jonson a poet, and a great one, is not his skill to construct such patterns but his imaginative vision of the goddess and her attendants, for whose expression it was worth his while to use that skill, and for whose enjoyment it is worth our while to study the patterns he has constructed. Miss Edith Sitwell, whose distinction both as poet and critic needs no commendation, and whose analyses of sound-pattern in poetry are as brilliant as her own verse, has analysed in this way the patterns constructed by Mr. T. S. Eliot, and has written warmly of the skill they exemplify; but when she wishes conclusively to compare his greatness with the littleness of certain other poets who are sometimes ridiculously fancied his equals, she ceases to praise his

technique, and writes, 'here we have a man who has talked with fiery angels, and with angels of a clear light and holy peace, and who has "walked amongst the lowest of the dead".'[3] It is this experience, she would have us understand, that is the heart of his poetry; it is the 'enlargement of our experience' by his own (a favourite phrase of hers, and one never used without illumination to her readers) that tells us he is a true poet; and however necessary it may be that a poet should have technical skill, he is a poet only in so far as this skill is not identified with art, but with something used in the service of art.

This is not the old Greco-Roman theory of poet-craft, but a modified and restricted version of it. When we examine it, however, we shall find that although it has moved away from the old poet-craft theory in order to avoid its errors, it has not moved far enough.

When the poet is described as possessing technical skill, this means that he possesses something of the same nature as what goes by that name in the case of a technician proper or craftsman. It implies that the thing so called in the case of a poet stands to the production of his poem as the skill of a joiner stands to the production of a table. If it does not mean this, the words are being used in some obscure sense; either an esoteric sense which people who use them are deliberately concealing from their readers, or (more probably) a sense which remains obscure even to themselves. We will assume that the people who use this language take it seriously, and wish to abide by its implications.

The craftsman's skill is his knowledge of the means necessary to realize a given end, and his mastery of these means. A joiner making a table shows his skill by knowing what materials and what tools are needed to make it, and being able to use these in such a way as to produce the table exactly as specified.

The theory of poetic technique implies that in the first place a poet has certain experiences which demand expression; then he conceives the possibility of a poem in which they might be expressed; then this poem, as an unachieved end, demands for its

3. *Aspects of Modern Poetry*, ch. v and p. 251.

realization the exercise of certain powers or forms of skill, and these constitute the poet's technique. There is an element of truth in this. It is true that the making of a poem begins in the poet's having an experience which demands expression in the form of a poem. But the description of the unwritten poem as an end to which his technique is means is false; it implies that before he has written his poem he knows, and could state, the specification of it in the kind of way in which a joiner knows the specification of a table he is about to make. This is always true of a craftsman; it is therefore true of an artist in those cases where the work of art is also a work of craft. But it is wholly untrue of the artist in those cases where the work of art is not a work of craft; the poet extemporizing his verses, the sculptor playing with his clay, and so forth. In these cases (which after all are cases of art, even though possibly of art at a relatively humble level) the artist has no idea what the experience is which demands expression until he has expressed it. What he wants to say is not present to him as an end towards which means have to be devised; it becomes clear to him only as the poem takes shape in his mind, or the clay in his fingers.

Some relic of this condition survives even in the most elaborate, most reflective, most highly planned works of art. That is a problem to which we must return in another chapter: the problem of reconciling the unreflective spontaneity of art in its simplest forms with the massive intellectual burden that is carried by great works of art such as the *Agamemnon* or the *Divina Commedia*. For the present, we are dealing with a simpler problem. We are confronted with what professes to be a theory of art in general. To prove it false we need only show that there are admitted examples of art to which it does not apply.

In describing the power by which an artist constructs patterns in words or notes or brush-marks by the name of technique, therefore, this theory is misdescribing it by assimilating it to the skill by which a craftsman constructs appropriate means to a preconceived end. The patterns are no doubt real; the power by which the artist constructs them is no doubt a thing worthy of our attention; but we are only frustrating our study of it in advance if we approach it in

the determination to treat it as if it were the conscious working-out of means to the achievement of a conscious purpose, or in other words technique.

§ 5. *Art as a Psychological Stimulus*

The modern conception of artistic technique, as stated or implied in the writings of critics, may be unsuccessful; but it is a serious attempt to overcome the weaknesses of the old poet-craft theory, by admitting that a work of art as such is not an artifact, because its creation involves elements which cannot be subsumed under the conception of craft; while yet maintaining that there is a grain of truth in that theory, because among the elements involved in the creation of a work of art there is one which can be thus subsumed, namely, the artist's technique. We have seen that this will not do; but at least the people who put it forward have been working at the subject.

The same cannot be said about another attempt to rehabilitate the technical theory of art, namely, that of a very large school of modern psychologists, and of critics who adopt their way of speaking. Here the entire work of art is conceived as an artifact, designed (when a sufficient degree of skill is present to justify the word) as means to the realization of an end beyond it, namely, a state of mind in the artist's audience. In order to affect his audience in a certain way, the artist addresses them in a certain manner, by placing before them a certain work of art. In so far as he is a competent artist, one condition at least is fulfilled: the work of art does affect them as he intends it should. There is a second condition which may be fulfilled: the state of mind thus aroused in them may be in one way or another a valuable state of mind; one that enriches their lives, and thus gives him a claim not only on their admiration but also on their gratitude.

The first thing to notice about this stimulus-and-reaction theory of art is that it is not new. It is the theory of the tenth book of Plato's *Republic*, of Aristotle's *Poetics*, and of Horace's *Ars Poetica*. The psychologists who make use of it have, knowingly or unknowingly, taken over the poet-craft doctrine bodily, with no suspicion of the devastating criticism it has received at the hands of aestheticians in the last few centuries.

This is not because their views have been based on a study of Plato and Aristotle, to the neglect of more modern authors. It is because, like good inductive scientists, they have kept their eye on the facts, but (a disaster against which inductive methods afford no protection) the wrong facts. Their theory of art is based on a study of art falsely so called.

There are numerous cases in which somebody claiming the title of artist deliberately sets himself to arouse certain states of mind in his audience. The funny man who lays himself out to get a laugh has at his command a number of well-tried methods for getting it; the purveyor of sob-stuff is in a similar case; the political or religious orator has a definite end before him and adopts definite means for achieving it, and so on. We might even attempt a rough classification of these ends.[4] First, the 'artist's' purpose may be to arouse a certain kind of emotion. The emotion may be of almost any kind; a more important distinction emerges according as it is aroused simply for its own sake, as an enjoyable experience, or for the sake of its value in the affairs of practical life. The funny man and the sob-stuff monger fall on one side in this division, the political and religious orator on the other. Secondly, the purpose may be to stimulate certain intellectual activities. These again may be of very various kinds, but they may be stimulated with either of two motives: either because the objects upon which they are directed are thought of as worth understanding, or because the activities themselves are thought of as worth pursuing, even though they lead to nothing in the way of knowledge that is of importance. Thirdly, the purpose may be to stimulate a certain kind of action; here again with two kinds of motive: either because the action is conceived as expedient, or because it is conceived as right.

Here are six kinds of art falsely so called; called by that name because they are kinds of craft in which the practitioner can by the use of his skill evoke a desired psychological reaction in his audience, and hence they come under the obsolete, but not yet dead and buried, conception of poet-craft, painter-craft, and so forth; falsely so called, because the distinction of means and end, upon which every one of them rests, does not belong to art proper.

Let us give the six their right names. Where an emotion is aroused for its own sake, as an enjoyable experience, the craft of arousing it is amusement; where for the sake of its practical value, magic (the meaning of that word will be explained in chapter IV). Where intellectual faculties are stimulated for the mere sake of their exercise, the work designed to stimulate them is a puzzle; where for the sake of knowing this or that thing, it is instruction. Where a certain practical activity is stimulated as expedient, that which stimulates it is advertisement or (in the current modern sense, not the old sense) propaganda; where it is stimulated as right, exhortation.

These six between them, singly or in combination, pretty well exhaust the function of whatever in the modern world wrongfully usurps the name of art. None of them has anything to do with art proper. This is not because (as Oscar Wilde said, with his curious talent for just missing a truth and then giving himself a prize for hitting it) 'all art is quite useless', for it is not; a work of art may very well amuse, instruct, puzzle, exhort, and so forth, without ceasing to be art, and in these ways it may be very useful indeed. It is because, as Oscar Wilde perhaps meant to say, what makes it art is not the same as what makes it useful. Deciding what psychological reaction a so-called work of art produces (for example, asking yourself how a certain poem 'makes you feel') has nothing whatever to do with deciding whether it is a real work of art or not. Equally irrelevant is the question what psychological reaction is meant to produce.

The classification of psychological reactions produced by poems, pictures, music, or the like is thus not a classification of kinds of art. It is a classification of kinds of pseudo-art. But the term 'pseudo-art' means something that is not art but is mistaken for art; and something that is not art can be mistaken for it only if there is some ground for the mistake: if

4. The reason why I call it a rough classification is because you cannot really 'stimulate intellectual activities', or 'stimulate certain kinds of action', in a man. Anybody who says you can, has not thought about the conditions under which alone these things can arise. Foremost among these conditions is this: that they must be absolutely spontaneous. Consequently they cannot be responses to stimulus.

the thing mistaken for art is akin to art in such a way that the mistake easily arises. What must this kinship be? We have already seen in the last chapter that there may be a combination of, for example, art with religion, of such a kind that the artistic motive, though genuinely present, is subordinated to the religious. To call the result of such a combination art, *tout court*, would be to invite the reply, 'it is not art but religion'; that is, the accusation that what is simply religion is being mistaken for art. But such a mistake could never in fact be made. What happens is that a combination of art and religion is elliptically called art, and then characteristics which it possesses not as art but as religion are mistakenly supposed to belong to it as art.

So here. These various kinds of pseudo-art are in reality various kinds of use to which art may be put. In order that any of these purposes may be realized, there must first be art, and then a subordination of art to some utilitarian end. Unless a man can write, he cannot write propaganda. Unless he can draw, he cannot become a comic draughtsman or an advertisement artist. These activities have in every case developed through a process having two phases. First, there is writing or drawing or whatever it may be, pursued as an art for its own sake, going its own way and developing its own proper nature, caring for none of these things. Then this independent and self-sufficient art is broken, as it were, to the plough, forced aside from its own original nature and enslaved to the service of an end not its own. Here lies the peculiar tragedy of the artist's position in the modern world. He is heir to a tradition from which he has learnt what art should be; or at least, what it cannot be. He has heard its call and devoted himself to its service. And then, when the time comes for him to demand of society that it should support him in return for his devotion to a purpose which, after all, is not his private purpose but one among the purposes of modern civilization, he finds that his living is guaranteed only on condition that he renounces his calling and uses the art which he has acquired in a way which negates its fundamental nature, by turning journalist or advertisement artist or the like; a degradation far more frightful than the prostitution or enslavement of the mere body.

Even in this denatured condition the arts are never mere means to the ends imposed upon them. For means rightly so called are devised in relation to the end aimed at; but here, there must first be literature, drawing, and so forth, before they can be turned to the purposes described. Hence it is a fundamental and fatal error to conceive art itself as a means to any of these ends, even when it is broken to their service. It is an error much encouraged by modern tendencies in psychology, and influentially taught at the present day by persons in a position of academic authority; but after all, it is only a new version, tricked out in the borrowed plumage of modern science, of the ancient fallacy that the arts are kinds of craft.

If it can deceive even its own advocates, that is only because they waver from one horn of a dilemma to the other. Their theory admits of two alternatives. Either the stimulation of certain reactions in its audience is the essence of art, or it is a consequence arising out of its essence in certain circumstances. Take the first alternative. If art is art only so far as it stimulates certain reactions, the artist as such is simply a purveyor of drugs, noxious or wholesome; what we call works of art are nothing but a section of the Pharmacopoeia.[5] If we ask on what principle that branch can be distinguished from others, there can be no answer.

This is not a theory of art. It is not an aesthetic but an anti-aesthetic. If it is presented as a true account of its advocates' experience, we must accept it as such; but with the implication that its advocates have no aesthetic experience whatever, or at least none so robust as to leave a mark on their minds deep enough to be discernible when they turn their eyes inward and try to recognize its main features.[6] It is, of course, quite possible to look at pictures, listen to music, and read poetry without getting any aesthetic experience from these things; and the exposition of this psychological theory of art may

5. Cf. D. G. James, *Scepticism and Poetry* (1937).

6. Dr. I. A. Richards is at present the most distinguished advocate of the theory I am attacking. I should never say of him that he has no aesthetic experience. But in his writings he does not discuss it; he only reveals it from time to time by things he lets slip.

be illustrated by a great deal of talk about particular works of art; but if this is really connected with the theory, it is no more to be called art-criticism or aesthetic theory than the annual strictures in *The Tailor and Cutter* on the ways in which Academy portrait-painters represent coats and trousers. If it attempts to develop itself as a method of art-criticism, it can only (except when it forgets its own principles) rely on anti-aesthetic standards, as when it tries to estimate the objective merits of a given poem by tabulating the 'reactions' to it of persons from whom the poet's name has been concealed, irrespective of their skill or experience in the difficult business of criticizing poetry; or by the number of emotions, separately capable of being recorded by the psychologist and severally regarded by him as valuable, which it evokes in a single hearer.

On this horn of the dilemma art disappears altogether. The alternative possibility is that the stimulating of certain reactions should be regarded not as the essence of art but as a consequence arising in certain conditions our of the nature of that essence. In that case, art survives the analysis, but only at the cost of making it irrelevant, as a pharmacologist's account of the effect of a hitherto unanalysed drug would be irrelevant to the question of its chemical composition. Granted that works of art in certain conditions do stimulate certain reactions in their audience, which is a fact; and granted that they do so not because of something other than their nature as works of art, but because of that nature itself, which is an error; it will even so not follow that light is thrown on that nature itself by the study of these reactions.

Psychological science has in fact done nothing towards explaining the nature of art, however much it has done towards explaining the nature of certain elements of human experience with which it may from time to time be associated or confused. The contribution of psychology to pseudo-aesthetic is enormous; to aesthetic proper it is nil.

. . .

VI
ART PROPER: (1) AS EXPRESSION

§ 1. *The New Problem*

We have finished at last with the technical theory of art, and with the various kinds of art falsely so called to which it correctly applies. We shall return to it in the future only so far as it forces itself upon our notice and threatens to impede the development of our subject.

That subject is art proper. It is true that we have already been much concerned with this; but only in a negative way. We have been looking at it so far as was necessary in order to exclude from it the various things which falsely claimed inclusion in it. We must now turn to the positive side of this same business, and ask what kinds of things they are to which the name rightly belongs.

. . .

(1) This, then, is the first point we have learnt from our criticism: that there is in art proper a distinction resembling that between means and end, but not identical with it.

(2) The element which the technical theory calls the end is defined by it as the arousing of emotion. The idea of arousing (i.e. of bringing into existence, by determinate means, something whose existence is conceived in advance as possible and desirable) belongs to the philosophy of craft, and is obviously borrowed thence. But the same is not true of emotion. This, then, is our second point. Art has something to do with emotion; what it does with it has a certain resemblance to arousing it, but is not arousing it.

(3) What the technical theory calls the means is defined by it as the making of an artifact called a work of art. The making of this artifact is described according to the terms of the philosophy of craft: i.e. as the transformation of a given raw material by imposing on it a form preconceived as a plan in the maker's mind. To get the distortion out of this we must remove all these characteristics of craft, and thus we reach the third point. Art has something to do with making things, but these things are not material things, made by imposing form on matter, and

they are not made by skill. They are things of some other kind, and made in some other way.

We now have three riddles to answer. For the present, no attempt will be made to answer the first: we shall treat it merely as a hint that the second and third should be treated separately. In this chapter, accordingly, we shall inquire into the relation between art and emotion; in the next, the relation between art and making.

§ 2. *Expressing Emotion and Arousing Emotion*

Our first question is this. Since the artist proper has something to do with emotion, and what he does with it is not to arouse it, what is it that he does? It will be remembered that the kind of answer we expect to this question is an answer derived from what we all know and all habitually say; nothing original or recondite, but something entirely commonplace.

Nothing could be more entirely commonplace than to say he expresses them. The idea is familiar to every artist, and to every one else who has any acquaintance with arts. To state it is not to state a philosophical theory or definition of art; it is to state a fact or supposed fact about which, when we have sufficiently identified it, we shall have later to theorize philosophically. For the present it does not matter whether the fact that is alleged, when it is said that the artist expresses emotion, is really a fact or only supposed to be one. Whichever it is, we have to identify it, that is, to decide what it is that people are saying when they use the phrase. Later on, we shall have to see whether it will fit into a coherent theory.

They are referring to a situation, real or supposed, of a definite kind. When a man is said to express emotion, what is being said about him comes to this. At first, he is conscious of having an emotion, but not conscious of what this emotion is. All he is conscious of is a perturbation or excitement, which he feels going on within him, but of whose nature he is ignorant. While in this state, all he can say about his emotion is: 'I feel...I don't know what I feel.' From this helpless and oppressed condition he extricates himself by doing something which we call expressing himself. This is an activity which has something to do with the thing we call language: he expresses himself by speaking. It has also something to do with consciousness: the emotion expressed is an emotion of whose nature the person who feels it is no longer unconscious. It has also something to do with the way in which he feels the emotion. As unexpressed, he feels it in what we have called a helpless and oppressed way; as expressed, he feels it in a way from which this sense of oppression has vanished. His mind is somehow lightened and eased.

This lightening of emotions which is somehow connected with the expression of them has a certain resemblance to the 'catharsis' by which emotions are earthed through being discharged into a make-believe situation; but the two things are not the same. Suppose the emotion is one of anger. If it is effectively earthed, for example by fancying oneself kicking some one down stairs, it is thereafter no longer present in the mind as anger at all: we have worked it off and are rid of it. If it is expressed, for example by putting it into hot and bitter words, it does not disappear from the mind; we remain angry; but instead of the sense of oppression which accompanies an emotion of anger not yet recognized as such, we have that sense of alleviation which comes when we are conscious of our own emotion as anger, instead of being conscious of it only as an unidentified perturbation. This is what we refer to when we say that it 'does us good' to express our emotions.

The expression of an emotion by speech may be addressed to some one; but if so it is not done with the intention of arousing a like emotion in him. If there is any effect which we wish to produce in the hearer, it is only the effect which we call making him understand how we feel. But, as we have already seen, this is just the effect which expressing our emotions has on ourselves. It makes us, as well as the people to whom we talk, understand how we feel. A person arousing emotion sets out to affect his audience in a way in which he himself is not necessarily affected. He and his audience stand in quite different relations to the act, very much as physician and patient stand in quite different relations towards a drug administered by the one and taken by the other. A person expressing emotion, on the contrary, is treating himself and his audience in the same kind of way; he is making his emotions clear to

his audience, and that is what he is doing to himself.

It follows from this that the expression of emotion, simply as expression, is not addressed to any particular audience. It is addressed primarily to the speaker himself, and secondarily to any one who can understand. Here again, the speaker's attitude towards his audience is quite unlike that of a person desiring to arouse in his audience a certain emotion. If that is what he wishes to do, he must know the audience he is addressing. He must know what type of stimulus will produce the desired kind of reaction in people of that particular sort; and he must adapt his language to his audience in the sense of making sure that it contains stimuli appropriate to their peculiarities. If what he wishes to do is to express his emotions intelligibly, he has to express them in such a way as to be intelligible to himself; his audience is then in the position of persons who overhear[7] him doing this. Thus the stimulus-and-reaction terminology has no applicability to the situation.

The means-and-end, or technique, terminology too is inapplicable. Until a man has expressed his emotion, he does not yet know what emotion it is. The act of expressing it is therefore an exploration of his own emotions. He is trying to find out what these emotions are. There is certainly here a directed process: an effort, that is, directed upon a certain end; but the end is not something foreseen and preconceived, to which appropriate means can be thought out in the light of our knowledge of its special character. Expression is an activity of which there can be no technique.

§ 3. *Expression and Individualization*

Expressing an emotion is not the same thing as describing it. To say 'I am angry' is to describe one's emotion, not to express it. The words in which it is expressed need not contain any reference to anger as such at all. Indeed, so far as they simply and solely express it, they cannot contain any such reference. The curse of Ernulphus, as invoked by Dr. Slop on the unknown person who tied certain knots, is a classical and supreme expression of anger; but it

does not contain a single word descriptive of the emotion it expresses.

This is why, as literary critics well know, the use of epithets in poetry, or even in prose where expressiveness is aimed at, is a danger. If you want to express the terror which something causes, you must not give it an epithet like 'dreadful'. For that describes the emotion instead of expressing it, and your language becomes frigid, that is inexpressive, at once. A genuine poet, in his moments of genuine poetry, never mentions by name the emotions he is expressing.

Some people have thought that a poet who wishes to express a great variety of subtly differentiated emotions might be hampered by the lack of a vocabulary rich in words referring to the distinctions between them; and that psychology, by working out such a vocabulary, might render a valuable service to poetry. This is the opposite of the truth. The poet needs no such words at all; the existence or non-existence of a scientific terminology describing the emotions he wishes to express is to him a matter of perfect indifference. If such a terminology, where it exists, is allowed to affect his own use of language, it affects it for the worse.

The reason why description, so far from helping expression, actually damages it, is that description generalizes. To describe a thing is to call it a thing of such and such a kind: to bring it under a conception, to classify it. Expression, on the contrary, individualizes. The anger which I feel here and now, with a certain person, for a certain cause, is no doubt an instance of anger, and in describing it as anger one is telling truth about it; but it is much more than mere anger: it is a peculiar anger, not quite like any anger that I ever felt before, and probably not quite like any anger I shall ever feel again. To become fully conscious of it means becoming conscious of it not merely as an instance of anger, but as this quite peculiar anger. Expressing it, we saw, has something to do with becoming conscious of it; therefore, if being fully conscious of it means being conscious of all its peculiarities, fully expressing it means expressing all its peculiarities. The poet, therefore, in proportion as he understands his business, gets as far away as possible from merely labelling his emotions as instances of this or that general kind, and

7. Further development of the ideas expressed in this paragraph will make it necessary to qualify this word and assert a much more intimate relation between artist and audience.

takes enormous pains to individualize them by expressing them in terms which reveal their difference from any other emotion of the same sort.

This is a point in which art proper, as the expression of emotion, differs sharply and obviously from any craft whose aim it is to arouse emotion. The end which a craft sets out to realize is always conceived in general terms, never individualized. However accurately defined it may be, it is always defined as the production of a thing having characteristics that could be shared by other things. A joiner, making a table out of these pieces of wood and no others, makes it to measurements and specifications which, even if actually shared by no other table, might in principle be shared by other tables. A physician treating a patient for a certain complaint is trying to produce in him a condition which might be, and probably has been, often produced in others, namely, the condition of recovering from that complaint. So an 'artist' setting out to produce a certain emotion in his audience is setting out to produce not an individual emotion, but an emotion of a certain kind. It follows that the means appropriate to its production will be not individual means but means of a certain kind: that is to say, means which are always in principle replaceable by other similar means. As every good craftsman insists, there is always a 'right way' of performing any operation. A 'way' of acting is a general pattern to which various individual actions may conform. In order that the 'work of art' should produce its intended psychological effect, therefore, whether this effect be magical or merely amusing, what is necessary is that it should satisfy certain conditions, possess certain characteristics: in other words be, not this work and no other, but a work of this kind and of no other.

This explains the meaning of the generalization which Aristotle and others have ascribed to art. We have already seen that Aristotle's *Poetics* is concerned not with art proper but with representative art, and representative art of one definite kind. He is not analysing the religious drama of a hundred years before, he is analysing the amusement literature of the fourth century, and giving rules for its composition. The end being not individual but general (the production of an emotion of a certain kind)

the means too are general (the portrayal, not of this individual act, but of an act of this sort; not, as he himself puts it, what Alcibiades did, but what anybody of a certain kind would do). Sir Joshua Reynolds's idea of generalization is in principle the same; he expounds it in connexion with what he calls 'the grand style', which means a style intended to produce emotions of a certain type. He is quite right; if you want to produce a typical case of a certain emotion, the way to do it is to put before your audience a representation of the typical features belonging to the kind of thing that produces it: make your kings very royal, your soldiers very soldierly, your women very feminine, your cottages very cottagesque, your oak-trees very oakish, and so on.

Art proper, as expression of emotion, has nothing to do with all this. The artist proper is a person who, grappling with the problem of expressing a certain emotion, says, 'I want to get this clear.' It is no use to him to get something else clear, however like it this other thing may be. Nothing will serve as a substitute. He does not want a thing of a certain kind, he wants a certain thing. This is why the kind of person who takes his literature as psychology, saying 'How admirably this writer depicts the feelings of women, or bus-drivers, or homosexuals...', necessarily misunderstands every real work of art with which he comes into contact, and takes for good art, with infallible precision, what is not art at all.

§ 4. *Selection and Aesthetic Emotion*

It has sometimes been asked whether emotions can be divided into those suitable for expression by artists and those unsuitable. If by art one means art proper, and identifies this with expression, the only possible answer is that there can be no such distinction. Whatever is expressible is expressible. There may be ulterior motives in special cases which makes it desirable to express some emotions and not others; but only if by 'express' one means publicly, that is, allow people to overhear one expressing oneself. This is because one cannot possibly decide that a certain emotion is one which for some reason it would be undesirable to express thus publicly, unless one first becomes conscious of it; and doing this, as we saw, is somehow bound up with expressing it. If art

means the expression of emotion, the artist as such must be absolutely candid; his speech must be absolutely free. This is not a precept, it is a statement. It does not mean that the artist ought to be candid, it means that he is an artist only in so far as he is candid. Any kind of selection, any decision to express this emotion and not that, is inartistic not in the sense that it damages the perfect sincerity which distinguishes good art from bad, but in the sense that it represents a further process of a non-artistic kind, carried out when the work of expression proper is already complete. For until that work is complete one does not know what emotions one feels; and is therefore not in a position to pick and choose, and give one of them preferential treatment.

From these considerations a certain corollary follows about the division of art into distinct arts. Two such divisions are current: one according to the medium in which the artist works, into painting, poetry, music, and the like; the other according to the kind of emotion he expresses, into tragic, comic, and so forth. We are concerned with the second. If the difference between tragedy and comedy is a difference between the emotions they express, it is not a difference that can be present to the artist's mind when he is beginning his work; if it were, he would know what emotion he was going to express before he had expressed it. No artist, therefore, so far as he is an artist proper, can set out to write a comedy, a tragedy, an elegy, or the like. So far as he is an artist proper, he is just as likely to write any one of these as any other; which is the truth that Socrates was heard expounding towards the dawn, among the sleeping figures in Agathon's dining-room.[8] These distinctions, therefore, have only a very limited value. They can be properly used in two ways. (1) When a

work of art is complete, it can be labelled *ex post facto* as tragic, comic, or the like, according to the character of the emotions chiefly expressed in it. But understood in that sense the distinction is of no real importance. (2) If we are talking about representational art, the case is very different. Here the so-called artist knows in advance what kind of emotion he wishes to excite, and will construct works of different kinds according to the different kinds of effect they are to produce. In the case of representational art, therefore, distinctions of this kind are not only admissable as an *ex post facto* classification of things to which in their origin it is alien; they are present from the beginning as a determining factor in the so-called artist's plan of work.

The same considerations provide an answer to the question whether there is such a thing as a specific 'aesthetic emotion'. If it is said that there is such an emotion independently of its expression in art, and that the business of artists is to express it, we must answer that such a view is nonsense. It implies, first, that artist have emotions of various kinds, among which is this peculiar aesthetic emotion; secondly, that they select this aesthetic emotion for expression. If the first proposition were true, the second would have to be false. If artists only find out what their emotions are in the course of finding out how to express them, they cannot begin the work of expression by deciding what emotion to express.

In a different sense, however, it is true that there is a specific aesthetic emotion. As we have seen, an unexpressed emotion is accompanied by a feeling of oppression; when it is expressed and thus comes into consciousness the same emotion is accompanied by a new feeling of alleviation or easement, the sense that this oppression is removed. It resembles the feeling of relief that comes when a burdensome intellectual or moral problem has been solved. We may call it, if we like, the specific feeling of having successfully expressed ourselves; and there is no reason why it should not be called a specific aesthetic emotion. But it is not a specific kind of emotion pre-existing to the expression of it, and having the peculiarity that when it comes to be expressed it is expressed artistically. It is an emotional colouring which attends the expression of any emotion whatever.

8. Plato, *Symposium*, 223D. But if Aristodemus heard him correctly, Socrates was saying the right thing for the wrong reason. He is reported as arguing, not that a tragic writer as such is also a comic one, but that ὁ τέχνῃ τραγῳδοποιός [*hē technē tragōidopoios*] is also a comic writer. Emphasis on the word τέχνη [*technē*] is obviously implied; and this, with a reference to the doctrine (*Republic*, 333E-334A) that craft is what Aristotle was to call a potentiality of opposites, i.e. enables its possessor to do not one kind of thing only, but that kind and the opposite kind too, shows that what Socrates was doing was to assume the technical theory of art and draw from it the above conclusion.

§ 5. *The Artist and the Ordinary Man*

I have been speaking of 'the artist', in the present chapter, as if artists were persons of a special kind, differing somehow either in mental endowment or at least in the way they use their endowment from the ordinary persons who make up their audience. But this segregation of artists from ordinary human beings belongs to the conception of art as craft; it cannot be reconciled with the conception of art as expression. If art were a kind of craft, it would follow as a matter of course. Any craft is a specialized form of skill, and those who possess it are thereby marked out from the rest of mankind. If art is the skill to amuse people, or in general to arouse emotions in them, the amusers and the amused form two different classes, differing in their respectively active and passive relation to the craft of exciting determinate emotions; and this difference will be due, according to whether the artist is 'born' or 'made', either to a specific mental endowment in the artist, which in theories of this type has gone by the name of 'genius', or to a specific training.

If art is not a kind of craft, but the expression of emotion, this distinction of kind between artist and audience disappears. For the artist has an audience only in so far as people hear him expressing himself, and understand what they hear him saying. Now, if one person says something by way of expressing what is in his mind, and another hears and understands him, the hearer who understands him has that same thing in his mind. The question whether he would have had it if the first had not spoken need not here be raised; however it is answered, what has just been said is equally true. If some one says 'Twice two is four' in the hearing of some one incapable of carrying out the simplest arithmetical operation, he will be understood by himself, but not by his hearer. The hearer can understand only if he can add two and two in his own mind. Whether he could do it before he heard the speaker say those words makes no difference. What is here said of expressing thoughts is equally true of expressing emotions. If a poet expresses, for example, a certain kind of fear, the only hearers who can understand him are those who are capable of experiencing that kind of fear themselves. Hence, when some one reads and understands a poem, he is not merely understanding the poet's expression of his, the poet's, emotions, he is expressing emotions of his own in the poet's words, which have thus become his own words. As Coleridge put it, we know a man for a poet by the fact that he makes us poets. We know that he is expressing his emotions by the fact that he is enabling us to express ours.

Thus, if art is the activity of expressing emotions, the reader is an artist as well as the writer. There is no distinction of kind between artist and audience. This does not mean that there is no distinction at all. When Pope wrote that the poet's business was to say 'what all have felt but none so well express'd', we may interpret his words as meaning (whether or no Pope himself consciously meant this when he wrote them) that the poet's difference from his audience lies in the fact that, though both do exactly the same thing, namely express this particular emotion in these particular words, the poet is a man who can solve for himself the problem of expressing it, whereas the audience can express it only when the poet has shown them how. The poet is not singular either in his having that emotion or in his power of expressing it; he is singular in his ability to take the initiative in expressing what all feel, and all can express.

. . .

§ 7. *Expressing Emotion and Betraying Emotion*

Finally, the expressing of emotion must not be confused with what may be called the betraying of it, that is, exhibiting symptoms of it. When it is said that the artist in the proper sense of that word is a person who expresses his emotions, this does not mean that if he is afraid he turns pale and stammers; if he is angry he turns red and bellows; and so forth. These things are no doubt called expressions; but just as we distinguish proper and improper senses of the word 'art', so we must distinguish proper and improper senses of the word 'expression', and in the context of a discussion about art this sense of expression is an improper sense. The characteristic

mark of expression proper is lucidity or intelligibility; a person who expresses something thereby becomes conscious of what it is that he is expressing, and enables others to become conscious of it in himself and in them. Turning pale and stammering is a natural accompaniment of fear, but a person who in addition to being afraid also turns pale and stammers does not thereby become conscious of the precise quality of his emotion. About that he is as much in the dark as he would be if (were that possible) he could feel fear without also exhibiting these symptoms of it.

Confusion between these two senses of the word 'expression' may easily lead to false critical estimates, and so to false aesthetic theory. It is sometimes thought a merit in an actress that when she is acting a pathetic scene she can work herself up to such an extent as to weep real tears. There may be some ground for that opinion if acting is not an art but a craft, and if the actress's object in that scene is to produce grief in her audience; and even then the conclusion would follow only if it were true that grief cannot be produced in the audience unless symptoms of grief are exhibited by the performer. And no doubt this is how most people think of the actor's work. But if his business is not amusement but art, the object at which he is aiming is not to produce a preconceived emotional effect on his audience but by means of a system of expressions, or language, composed partly of speech and partly of gesture, to explore his own emotions: to discover emotions in himself of which he was unaware, and, by permitting the audience to witness the discovery, enable them to make a similar discovery about themselves. In that case it is not her ability to weep real tears that would mark out a good actress; it is her ability to make it clear to herself and her audience what the tears are about.

This applies to every kind of art. The artist never rants. A person who writes or paints or the like in order to blow off steam, using the traditional material of art as means for exhibiting the symptoms of emotion, may deserve praise as an exhibitionist, but loses for the moment all claim to the title of artist. Exhibitionists have their uses; they may serve as an amusement, or they may be doing magic. The second category will contain, for example, those young men who, learning in the torment of their own bodies and minds what war is like, have stammered their indignation in verses, and published them in the hopes of infecting others and causing them to abolish it. But these verses have nothing to do with poetry.

. . .

<h1 style="text-align:center">VIII</h1>

ART PROPER: (2) AS IMAGINATION

§ 1. *The Problem Defined*

The next question in the programme laid down at the beginning of the preceding chapter was put in this way: What is a work of art, granted that there is something in art proper (not only in art falsely so called) to which that name is applied, and that, since art is not craft, this thing is not an artifact? It is something made by the artist, but not made by transforming a given raw material, nor by carrying out a preconceived plan, nor by way of realizing the means to a preconceived end. What is this kind of making?

Here are two conditions which, however closely they are connected, we shall do well to consider separately. We had better begin with the artist, and put the second question first. I shall therefore begin by asking: What is the nature of this making which is not technical making, or, if we want a one-word name for it, not fabrication? It is important not to misunderstand the question. When we asked what expression was, in the preceding chapter, it was pointed out that the writer was not trying to construct an argument intended to convince the reader, nor to offer him information, but to remind him of what (if he is a person whose experience of the subject-matter has been sufficient to qualify him for reading books of this kind) he knows already. So here. We are not asking for theories but for facts. And the facts for which we are asking are not recondite facts. They are facts well known to the reader. The order of facts to which they belong may be indicated by saying that they are the ways in which all of us who are concerned with art habitually think about it, and the ways in which we habitually express our thoughts in ordinary speech.

By way of making this clearer, I will indicate the kind of way in which our question cannot be answered. A great many people who have put to themselves the question 'What is this making, characteristic of the artist, which is not a fabrication?' have sought an answer in some such way as the following: 'This non-technical making is plainly not an accidental making, for works of art could not be produced by accident.[9] Something must be in control. But if this is not the artist's skill, it cannot be his reason or will or consciousness. It must therefore be something else; either some controlling force outside the artist, in which case we may call it inspiration, or something inside him but other than his will and so forth. This must be either his body, in which case the production of a work of art is at bottom a physiological activity, or else it is something mental but unconscious, in which case the productive force is the artist's unconscious mind.'

Many imposing theories of art have been built on these foundations. The first alternative, that the artist's activity is controlled by some divine or at least spiritual being that uses him as its mouthpiece, is out of fashion to-day, but that is no reason why we should refuse it a hearing. It does at least fit the facts better than most of the theories of art nowadays current. The second alternative, that the artist's work is controlled by forces which, though part of himself and specifically part of his mind, are not voluntary and not conscious, but work in some mental cellar unseen and unbidden by the dwellers in the house above, is extremely popular; not among artists, but among psychologists and their numerous disciples, who handle the theory with a great deal of confidence and seem to believe that by its means the riddle of art has at last been solved.[10] The third alternative was popular with the physiological psychologists of the last century, and Grant Allen still remains its best exponent.

It would be waste of time to criticize these theories. The question about them is not whether they are good or bad, considered as examples of theorizing; but whether the problem which they are meant to solve is one that calls for theorizing in order to solve it. A person who cannot find his spectacles on the table may invent any number of theories to account for their absence. They may have been spirited away by a benevolent deity, to prevent him from over-working, or by a malicious demon, to interfere with his studies, or by a neighbouring mahatma, to convince him that such things can be done. He may have unconsciously made away with them himself, because they unconsciously remind him of his oculist, who unconsciously reminds him of his father, whom he unconsciously hates. Or he may have pushed them off the table while moving a book. But these theories, however ingenious and sublime, are premature if the spectacles should happen to be on his nose.

Theories professing to explain how works of art are constructed by means of hypotheses like these are based on recollecting that the spectacles are not on the table, and overlooking the fact that they are on the nose. Those who put them forward have not troubled to ask themselves whether we are in point of fact familiar with a kind of activity productive of results and under the agent's voluntary control, which has none of the special characteristics of craft. If they had asked the question, they must have answered it in the affirmative. We are perfectly familiar with activities of this kind; and our ordinary name for them is creation.

9. I am talking of quite sensible people. There are others; some of them have denied this proposition, pointing out that if a monkey played with a typewriter for long enough, rattling the keys at random, there is a calculable probability that within a certain time he would produce, purely by accident, the complete text of Shakespeare. Any reader who has nothing to do can amuse himself by calculating how long it would take for the probability to be worth betting on. But the interest of the suggestion lies in the revelation of the mental state of a person who can identify the 'works' of Shakespeare with the series of letters printed on the pages of a book bearing that phrase as its title; and thinks, if he can be said to think at all, that an archaeologist of 10,000 years hence, recovering a complete text of Shakespeare from the sands of Egypt but unable to read a single word of English, would possess Shakespeare's dramatic and poetic works.

10. Mr. Robert Graves (*Poetic Unreason*, 1925) is almost the only practicing man of letters or artist in this country who has come forward to back up the psychologists. Generally speaking, the judgement of literary men on the qualifications of the people who advocate this theory is sufficiently represented by Dr. I. A. Richards: 'To judge by the published work of Freud upon Leonardo da Vinci or of Jung upon Goethe (e.g. *The Psychology of the Unconscious*, p. 305) psycho-analysts tend to be peculiarly inept as critics' (*Principles of Literary Criticism*, ed. 5, 1934, pp. 29-30).

§ 2. *Making and Creating*

. . .

To create something means to make it non-technically, but yet consciously and voluntarily. Originally, *creare* means to generate, or make offspring, for which we still use its compound 'procreate,' and the Spaniards have *criatura*, for a child. The act of procreation is a voluntary act, and those who do it are responsible for what they are doing; but it is not done by any specialized form of skill. It need not be done (as it may be in the case of a royal marriage) as a means to any preconceived end. It need not be done (as it was by Mr. Shandy senior) according to any preconceived plan. It cannot be done (whatever Aristotle may say) by imposing a new form on any pre-existing matter. It is in this sense that we speak of creating a disturbance or a demand or a political system. The person who makes these things is acting voluntarily; he is acting responsibly; but he need not be acting in order to achieve any ulterior end; he need not be following a preconceived plan; and he is certainly not transforming anything that can properly be called a raw material. It is in the same sense that Christians asserted, and neo-Platonists denied, that God created the world.

This being the established meaning of the word, it should be clear that when we speak of an artist as making a poem, or a play, or a painting, or a piece of music, the kind of making to which we refer is the kind we call creating. For, as we already know, these things, in so far as they are works of art proper, are not made as means to an end; they are not made according to any preconceived plan; and they are not made by imposing an new form upon a given matter. Yet they are made deliberately and responsibly, by people who know what they are doing, even though they do not know in advance what is going to come out of it.

. . .

§ 3. *Creation and Imagination*

We must proceed to a further distinction. All the things taken above as examples of things created are what we ordinarily call real things. A work of art need not be what we should call a real thing. It may be what we call an imaginary thing. A disturbance, or a nuisance, or a navy, or the like, is not created at all until it is created as a thing having its place in the real world. But a work of art may be completely created when it has been created as a thing whose only place is in the artist's mind.

Here, I am afraid, it is the metaphysician who will take offence. He will remind me that the distinction between real things and things that only exist in our minds is one to which he and his fellow have given a great deal of attention. They have thought about it so long and so intently that it has lost all meaning. Some of them have decided that the things we call real are only in our minds; others that the things we describe as being in our minds are thereby implied to be just as real as anything else. These two sects, it appears, are engaged in a truceless war, and any one who butts in by using the words about which they are fighting will be set upon by both sides and torn to pieces.

I do not hope to placate these gentlemen. I can only cheer myself up by reflecting that even if I go on with what I was saying they cannot eat me. If an engineer has decided how to build a bridge, but has not made any drawings or specifications for it on paper, and has not discussed his plan with any one or taken any steps towards carrying it out, we are in the habit of saying that the bridge exists only in his mind, or (as we also say) in his head. When the bridge is built, we say that it exists not only in his head but in the real world. A bridge which 'exists only in the engineer's head' we also call an imaginary bridge; one which 'exists in the real world' we call a real bridge.

This may be a silly way of speaking; or it may be an unkind way of speaking, because of the agony it gives to metaphysicians; but it is a way in which ordinary people do speak, and ordinary people who speak in that way know quite well what kind of things they are referring to. The metaphysicians are right in thinking that difficult problems arise from talking in that way; and I shall spend the greater part of Book II in discussing these problems. Meanwhile, I shall go on 'speaking with the vulgar'; if metaphysicians do not like it they need not read it.

The same distinction applies to such things as music. If a man has made up a tune but has not written it down or sung it or played it or done anything which could make it public property, we say that the tune exists only in his mind, or only in his head, or is an imaginary tune. If he sings or plays it, thus making a series of audible noises, we call this series of noises a real tune as distinct from and imaginary one.

When we speak of making an artifact we mean making a real artifact. If an engineer said that he had made a bridge, and when questioned turned out to mean that he had only made it in his head, we should think him a liar or a fool. We should say that he had not made a bridge at all, but only a plan for one. If he said he had made a plan for a bridge and it turned out that he had put nothing on paper, we should not necessarily think he had deceived us. A plan is a kind of thing that can only exist in a person's mind. As a rule, an engineer making a plan in his mind is at the same time making notes and sketches on paper; but the plan does not consist of what we call the 'plans', that is, the pieces of paper with these notes and sketches on them. Even if he has put complete specifications and working drawings on paper, the paper with these specification and drawings on it is not the plan; it only serves to tell people (including himself, for memory is fallible) what the plan is. If the specifications and drawings are published, for example in a treatise on civil engineering, any one who reads the treatise intelligently will get the plan of that bridge into his head. The plan is therefore public property, although by calling it public we mean only that it can get into the heads of many people; as many as read intelligently the book in which the specifications and drawings are published.

In the case of the bridge there is a further stage. The plan may be 'executed' or carried out; that is to say, the bridge may be built. When that is done, the plan is said to be 'embodied' in the built bridge. It has begun to exist in a new way, not merely in people's heads but in stone or concrete. From being a mere plan existing in people's heads, it has become the form imposed on a certain matter. Looking back from that point of view, we can now say that the engineer's plan was the form of the bridge without its matter, or that when we describe him as having the plan in his mind we might equally have described him as having in mind the form of the finished bridge without its matter.

The making of the bridge is the imposing of this form on this matter. When we speak of the engineer as making the plan, we are using the word 'make' in its other sense, as equivalent to create. Making a plan for a bridge is not imposing a certain form on a certain matter; it is a making that is not a transforming, that is to say, it is a creation. It has the other characteristics, too, that distinguish creating from fabricating. It need not be done as means to an end, for a man can make plans (for example, to illustrate a text-book of engineering) with no intention of executing them. In such a case the making of the plan is not means to composing the text-book, it is part of composing the text-book. It is not means to anything. Again, a person making a plan need not be carrying out a plan to make that plan. He may be doing this; he may for instance have planned a text-book for which he needs an example of a reinforced concrete bridge with a single span of 150 feet, to carry a two-track railway with a roadway above it, and he may work out a plan for such a bridge in order that it may occupy that place in the book. But this is not a necessary condition of planning. People sometimes speak as if everybody had, or ought to have, a plan for his whole life, to which every other plan he makes is or ought to be subordinated; but no one can do that.

Making an artifact, or acting according to craft, thus consists of two stages. (1) Making the plan, which is creating. (2) Imposing that plan on certain matter, which is fabricating. Let us now consider a case of creating where what is created is not a work of art. A person creating a disturbance need not be, though of course he may be, creating it as means to some ulterior end, such as causing a government to resign. He cannot be transforming a pre-existing material, for there is nothing out of which a disturbance can be made; though he is able to create it only because he already stands, as a finite being always does stand, in a determinate situation; for example, at a political meeting. But what he creates cannot be something that exists only in his own mind.

A disturbance is something in the minds of the people disturbed.

Next, let us take the case of art. When a man makes up a tune, he may and very often does at the same time hum it or sing it or play it on an instrument. He may do none of these things, but write it on paper. Or he may both hum it or the like, and also write it on paper at the same time or afterwards. Also he may do these things in public, so that the tune at its very birth becomes public property, like the disturbance we have just considered. But all these things are accessories of the real work, though some of them are very likely useful accessories. The actual making of the tune is something that goes on in his head, and nowhere else.

I have already said that a thing which 'exists in a person's head' and nowhere else is alternatively called an imaginary thing. The actual making of the tune is therefore alternatively called the making of an imaginary tune. This is a case of creation, just as much as the making of a plan or a disturbance, and for the same reasons, which it would be tedious to repeat. Hence the making of a tune is an instance of imaginative creation. The same applies to the making of a poem, or a picture, or any other work of art.

The engineer, as we saw, when he made his plan in his own head, may proceed to do something else which we call 'making his plans'. His 'plans', here, are drawings and specifications on paper, and these are artifacts made to serve a certain purpose, namely to inform others or remind himself of the plan. The making of them is accordingly not imaginative creation; indeed, it is not creation at all. It is fabrication, and the ability to do it is a specialized form of skill, the craft of engineer's draughtmanship.

The artist, when he has made his tune, may go on to do something else which at first sight seems to resemble this: he may do what is called publishing it. He may sing or play it aloud, or write it down, and thus make it possible for others to get into their heads the same thing which he has in his. But what is written or printed on music-paper is not the tune. It is only something which when studied intelligently will enable others (or himself, when he has forgotten it) to construct the tune for themselves in their own heads.

The relation between making the tune in his head and putting it down on paper is thus quite different from the relation, in the case of the engineer, between making a plan for a bridge and executing that plan. The engineer's plan is embodied in the bridge: it is essentially a form that can be imposed on certain matter, and when the bridge is built the form is there, in the bridge, as the way in which the matter composing it is arranged. But the musician's tune is not there on the paper at all. What is on the paper is not music, it is only musical notation. The relation of the tune to the notation is not like the relation of the plan to the bridge; it is like the relation of the plan to the specifications and drawings; for these, too, do not embody the plan as the bridge embodies it, they are only a notation from which the abstract or as yet unembodied plan can be reconstructed in the mind of a person who studies them.

. . .

§ 5. *The Work of Art as Imaginary Object*

If the making of a tune is an instance of imaginative creation, a tune is an imaginary thing. And the same applies to a poem or a painting or any other work of art. This seems paradoxical; we are apt to think that a tune is not an imaginary thing but a real thing, a real collection of noises; that a painting is a real piece of canvas covered with real colours; and so on. I hope to show, if the reader will have patience, that there is no paradox here; that both these propositions express what we do as a matter of fact say about works of art; and that they do not contradict one another, because they are concerned with different things.

When, speaking of a work of art (tune, picture, &c.), we mean by art a specific craft, intended as a stimulus for producing specific emotional effects in an audience, we certainly mean to designate by the term 'work of art' something that we should call real. The artist as magician or purveyor of amusement is necessarily a craftsman making real things, and making them out of some material according to some plan. His works are as real as the works of an engineer, and for the same reason.

But it does not at all follow that the same is true of an artist proper. His business is not to produce an emotional effect in the audience, but, for example, to make a tune. This tune is already complete and perfect when it exists merely as a tune in his head, that is, an imaginary tune. Next, he may arrange for the tune to be played before an audience. Now there comes into existence a real tune, a collection of noises. But which of these two things is the work of art? Which of them is the music? The answer is implied in what we have already said: the music, the work of art, is not the collection of noises, it is the tune in the composer's head. The noises made by the performers, and heard by the audience, if they listen intelligently (not otherwise) can reconstruct for themselves the imaginary tune that existed in the composer's head.

. . .

The work of art proper is something not seen or heard, but something imagined. But what is it that we imagine? We have suggested that in music the work of art proper is an imagined tune. Let us begin by developing this idea.

Everybody must have noticed a certain discrepancy between what we actually see when looking at a picture or statue or play and what we see imaginatively; what we actually see when listening to music or speech and what we imaginatively hear. To take an obvious example: in watching a puppet-play we could (as we say) swear that we have seen the expression on the puppets' faces changing with their changing gestures and the puppet-man's changing words and tones of voice. Knowing that they are only puppets, we know that their facial expression cannot change; but that makes no difference; we continue to see imaginatively the expressions which we know that we do not see actually. The same thing happens in the case of masked actors like those of the Greek stage.

In listening to the pianoforte, again, we know from evidence of the same kind that we must be hearing every note begin with a *sforzando*, and fade away for the whole length of time that it continues to sound. But our imagination enables us to read into this experience something quite different. As we seem to see the puppets' features move, so we seem to hear a pianist producing a *sostenuto* tone, almost like that of a horn; and in fact notes of the horn and the pianoforte are easily mistaken one for the other. Still stranger, when we hear a violin and pianoforte playing together in the key, say, of G, the violin's F sharp is actually played a great deal sharper than the pianoforte's. Such a discrepancy would sound intolerably out of tune except to a person whose imagination was trained to focus itself on the key of G, and silently corrected every note of the equally tempered pianoforte to suit it. The corrections which imagination must thus carry out, in order that we should be able to listen to an entire orchestra, beggar description. When we listen to a speaker or singer, imagination is constantly supplying articulate sounds which actually our ears do not catch. In looking at a drawing in pen or pencil, we take a series of roughly parallel lines for the tint of a shadow. And so on.

Conversely, in all these cases imagination works negatively. We disimagine, if I may use the word, a great deal which actually we see and hear. The street noises at a concert, the noises made by our breathing and shuffling neighbours, and even some of the noises made by the performers, are thus shut out of the picture unless by their loudness or in some other way they are too obtrusive to be ignored. At the theatre, we are strangely able to ignore the silhouettes of the people sitting in front of us, and a good many things that happen on the stage. Looking at a picture, we do not notice the shadows that fall on it or, unless it is excessive, the light reflected from its varnish.

All this is commonplace. And the conclusion has already been stated by Shakespeare's Theseus: 'the best in this kind ['works of art', as things actually perceived by the senses] are but shadows, and the worst are no worse if imagination amend them.' The music to which we listen is not the heard sound, but that sound as amended in various ways by the listeners' imagination, and so with the other arts.

But this does not go nearly far enough. Reflection will show that the imagination with which we listen to music is something more, and more complex, than any inward ear; the imagination with which we

look at paintings is something more that 'the mind's eye'. Let us consider this in the case of painting.

§ 6. *The Total Imaginative Experience*

The change which came over painting at the close of the nineteenth century was nothing short of revolutionary. Every one in the course of that century had supposed that painting was 'a visual art'; that the painter was primarily a person who used his eyes, and used his hands only to record what the use of his eyes had revealed to him. Then came Cézanne, and began to paint like a blind man. His still-life studies, which enshrine the essence of his genius, are like groups of things that have been groped over with the hands; he uses colour not to reproduce what he sees in looking at them but to express almost in a kind of algebraic notation what in this groping he has felt. So with his interiors; the spectator finds himself bumping about those rooms, circumnavigating with caution those menacingly angular tables, coming up to the persons that so massively occupy those chairs and fending himself off them with his hands. It is the same when Cézanne takes us into the open air. His landscapes have lost almost every trace of visuality. Trees never looked like that; that is how they feel to a man who encounters them with his eyes shut, blundering against them blindly. A bridge is no longer a pattern of colour, as it is for Cotman; or a patch of colour so distorted as to arouse in the spectator the combined emotions of antiquarianism and vertigo, as it is for Mr. Frank Brangwyn; it is a perplexing mixture of projections and recessions, over and round which we find ourselves feeling our way as one can imagine an infant feeling its way, when it has barely begun to crawl, among the nursery furniture. And over the landscape broods the obsession of Mont Saint-Victoire, never looked at, but always felt, as a child feels the table over the back of its head.

Of course Cézanne was right. Painting can never be a visual art. A man paints with his hands, not with his eyes. The Impressionist doctrine that what one paints is light[11] was a pedantry which failed to

destroy the painters it enslaved only because they remained painters in defiance of the doctrine: men of their hands, men who did their work with fingers and wrist and arm, and even (as they walked about the studio) with their legs and toes. What one paints is what can be painted; no one can do more; and what can be painted must stand in some relation to the muscular activity of painting it. Cézanne's practice reminds one of Kant's theory that the painter's only use for his colours is to make shapes visible. But it is really quite different. Kant thought of the painter's shapes as two-dimensional shapes visibly traced on the canvass; Cézanne's shapes are never two-dimensional, and they are never traced on the canvass; they are solids, and we get at them through the canvass. In this new kind of painting the 'plane of the picture' disappears; it melts into nothing, and we go through it.[12]

Vernon Blake, who understood all this very well from the angle of the practising artist, and could explain himself in words like the Irishman he was, told draughtsmen that the plane of the picture was a mere superstition. Hold your pencil vertical to the paper, said he; don't stroke the paper, dig into it; think of it as if it were the surface of a slab of clay in which you were going to cut a relief, and of your pencil as a knife. Then you will find that you can draw something which is not a mere pattern on paper, but a solid thing lying inside or behind the paper.

In Mr. Berenson's hands the revolution became retrospective. He found that the great Italian painters yielded altogether new results when approached in this manner. He taught his pupils (and every one who takes any interest in Renaissance painting nowadays is Mr. Berenson's pupil) to look in paintings for what he called 'tactile values'; to thing of their muscles as they stood before a picture, and notice what happened in their fingers and elbows. He showed that Masaccio and Raphael, to take only two

11. Anticipated by Uvedale Price as long ago as 1808: 'I can imagine a man of the future, who may be born without the sense of feeling, being able to see nothing but light variously modified' (*Dialogue on the distinct characters of the Picturesque and Beautiful*).

12. The 'disappearance' of the picture-plane is the reason why, in modern artists who have learnt to accept Cézanne's principles and to carry their consequences a stage further than he carried them himself, perspective (to the great scandal of the man in the street, who clings to the picture-plane as unconsciously and as convulsively as a drowning man to a spar) has disappeared too. The man in the street thinks that this has happened because these modern fellows can't draw; which is like thinking that young men of the Royal Air Force career about in the sky because they can't walk.

outstanding instances, were painting as Cézanne painted, not at all as Monet or Sisley painted; not squirting light on a canvass, but exploring with arms and legs a world of solid things where Masaccio stalks giant-like on the ground and Raphael floats through serene air.

In order to understand the theoretical significance of these facts, we must look back at the ordinary theory of painting current in the nineteenth century. This was based on the conception of a 'work of art', with its implication that the artist is a kind of craftsman producing things of this or that kind, each with the characteristics proper to its kind, according to the difference between one kind of craft and another. The musician makes sounds; the sculptor makes solid shapes in stone or metal; the painter makes patterns of paint on canvass. What there is in these works depends, of course, on what kind of works they are; and what the spectator finds in them depends on what there is in them. The spectator in looking at a picture is simply seeing flat patterns of colour, and he can get nothing out of the picture except what can be contained in such patterns.

The forgotten truth about painting which was rediscovered by what may be called the Cézanne-Berenson approach to it was that the spectator's experience on looking at a picture is not a specifically visual experience at all. What he experiences does not consist of what he sees. It des not even consist of this as modified, supplemented, and expurgated by the work of the visual imagination. It does not belong to sight alone, it belongs also (and on some occasions even more essentially) to touch. We must be a little more accurate, however. When Mr. Berenson speaks of tactile values, he is not thinking of things like the texture of fur and cloth, the cool roughness of bard, the smoothness or grittiness of a stone, and other qualities which things exhibit to our sensitive finger-tips. As his own statements abundantly show, he is thinking, or thinking in the main, of distance and space and mass: not of touch sensations, but of motor sensations such as we experience by using our muscles and moving our limbs. But these are not actual motor sensations, they are imaginary motor sensations. In order to enjoy them when looking at a Masaccio we need not walk straight through the picture, or even stride about the gallery; what we are doing is to imagine ourselves as moving in these ways. In short: what we get from looking at a picture is not merely the experience of seeing, or even partly seeing and partly imagining, certain visible objects; it is also, and in Mr. Berenson's opinion more importantly, the imaginary experience of certain complicated muscular movements.

Persons especially interested in painting may have thought all this, when Mr. Berenson began saying it, something strange and new; but in the case of other arts the parallels were very familiar. It was well known that in listening to music we not only hear the noises of which the 'music', that is to say the sequences and combinations of audible sounds, actually consists; we also enjoy imaginary experiences which do not belong to the region of sound at all, notably visual and motor experiences. Everybody knew, too, that poetry has the power of bringing before us not only the sounds which constitute the audible fabric of the 'poem', but other sounds, and sights, and tactile and motor experiences, and at times even scents, all of which we possess, when we listen to poetry, in imagination.

This suggests that what we get out of a work of art is always divisible into two parts. (1) There is a specialized sensuous experience, an experience of seeing or hearing as the case may be. (2) There is also a non-specialized imaginative experience, involving not only elements homogeneous, after their imaginary fashion, with those which make up the specialized sensuous experience, but others heterogeneous with them. So remote is this imaginative experience from the specialism of its sensuous basis, that we may go so far as to call it an imaginative experience of total activity.

. . .

In the light of this discussion let us recapitulate and summarize our attempt to answer the question, what is a work of art? What, for example, is a piece of music?

(1) In the pseudo-aesthetic sense for which art is a kind of craft, a piece of music is a series of audible noises. The psychological and 'realistic' aestheticians,

as we can now see, have not got beyond this pseudo-aesthetic conception.

(2) If 'work of art' means work of art proper, a piece of music is not something audible, but something which may exist solely in the musician's head.

(3) To some extent it must exist solely in the musician's head (including, of course, the audience as well as the composer under that name), for his imagination is always supplementing, correcting, and expurgating what he actually hears.

(4) The music which he actually enjoys as a work of art is thus never sensuously or 'actually' heard at all. It is something imagined.

(5) But it is not imagined sound (in the case of painting, it is not imagined colour-patterns, & c.). It is an imagined experience of total activity.

(6) Thus a work of art proper is a total activity which the person enjoying it apprehends, or is conscious of, by the use of his imagination.

Putting together the conclusions of this chapter and the last, we get the following result.

By creating for ourselves an imaginary experience or activity, we express our emotions; and this is what we call art.

John Dewey (1859-1952)

Selections from
Art as Experience

THE LIVE CREATURE

By one of the ironic perversities that often attend the course of affairs, the existence of the works of art upon which formation of an esthetic theory depends has become an obstruction to theory about them. For one reason, these works are products that exist externally and physically. In common conception, the work of art is often identified with the building, book, painting, or statue in its existence apart from human experience. Since the actual work of art is what the product does with and in experience, the result is not favorable to understanding. In addition, the very perfection of some of these products, the prestige they possess because of a long history of unquestioned admiration, creates conventions that get in the way of fresh insight. When an art product once attains classic status, it somehow becomes isolated from the human conditions under which it wa brought into being and from the human consequences it engenders in actual life-experience.

When artistic objects are separated from both conditions of origin and operation in experience, a wall is built around them that renders almost opaque their general significance, with which esthetic theory deals. Art is remitted to a separate realm, where it is cut off from that association with the materials and aims of every other form of human effort, undergoing, and achievement. A primary task is thus imposed upon one who undertakes to write upon the philosophy of the fine arts. This task is to restore continuity between the refined and intensified forms of experience that are works of art and the everday events, doings, and sufferings that are universally recognized to constitute experience. Mountain peaks do not float unsupported; they do not even just rest upon the earth. They *are* the earth in one of its manifest operations. It is the business of those who are concerned with the theory of the earth, geographers and geologists, to make this fact evident in its various implications. The theorist who would deal philosophically with fine art has a like tast to accomplish.

If one is willing to grant this position, even if only by way of temporary experiment, he will see that there follows a conclusion at first sight surprising. In order to understand the meaning of artistic products, we have to forget them for a time, to turn aside from them and have recourse to the ordinary forces and conditions of experience that we do not usually regard as esthetic. We must arrive at the theory of art by means of a detour. For theory is concerned with understanding, insight, not without exclamations of admiration, and stimulation of that emotional outburst often called appreciation. It is quite possible to enjoy flowers in their colored form and delicate fragrance without knowing anything about plants theoretically. But if one sets out to *understand* the flowering of plants, he is committed to finding out something about the interactions of soil, air, water and sunlight that condition the growth of plants.

By common consent, the Parthenon is a great work of art. Yet it has esthetic standing only as the work becomes an experience for a human being. And, if one is to go beyond personal enjoyment into the formation of a theory about that large republic of art of which the building is one member, one has to be willing at some point in his reflections to turn from it to the bustling, arguing, acutely sensitive Athenian citizens, with civic sense identified with a civic religion, of whose experience the temple was

an expression, and who built it not as a work of art but as a civic commemoration. The turning to them is as human beings who had needs that were a demand for the building and that were carried to fulfillment in it; it is not an examination such as might be carried on by a sociologist in search for material relevant to his purpose. The one who sets out to theorize about the esthetic experience embodied in the Parthenon must realize in thought what the people into whose lives it entered had in common, as creators and as those who were satisfied with it, with people in our own homes and on our own streets.

In order to *understand* the esthetic in its ultimate and approved forms, one must begin with it in the raw; in the events and scenes that hold the attentive eye and ear of man, arousing his interest and affording him enjoyment as he looks and listens: the sights that hold the crowd—the fire-engine rushing by; the machines excavating enormous holes in the earth; the human-fly climbing the steeple-side; the men perched high in air on girders, throwing and catching red-hot bolts. The sources of art in human experience will be learned by him who sees how the tense grace of the ball-player infects the onlooking crowd; who notes the delight of the housewife in tending her plants, and the intent interest of her goodman in tending the patch of green in front of the house; the zest of the spectator in poking the wood burning on the hearth and in watching the darting flames and crumbling coals. These people, if questioned as to the reason for their actions, would doubtless return reasonable answers. The man who poked the sticks of burning wood would say he did it to make the fire burn better; but he is none the less fascinated by the colorful drama of change enacted before his eyes and imaginatively partakes in it. He does not remain a cold spectator. What Coleridge said of the reader of poetry is true in its way of all who are happily absorbed in their activities of mind and body: "The reader should be carried forward, not merely or chiefly by the mechanical impulse of curiosity, not by a restless desire to arrive at the final solution, but by the pleasurable activity of the journey itself."

The intelligent mechanic engaged in his job, interested in doing well and finding satisfaction in his handiwork, caring for his materials and tools with genuine affection, is artistically engaged. The difference between such a worker and the inept and careless bungler is as great in the shop as it is in the studio. Oftentimes the product may not appeal to the esthetic sense of those who use the product. The fault, however, is oftentimes not so much with the worker as with the conditions of the market for which his product is designed. Were conditions and opportunities different, things as significant to the eye as those produced by earlier craftsmen would be made.

So extensive and subtly pervasive are the ideas that set Art upon a remote pedestal, that many a person would be repelled rather than pleased if told that he enjoyed his casual recreations, in part at least, because of their esthetic quality. The arts which today have most vitality for the average person are things he does not take to be arts: for instance, the movie, jazzed music, the comic strip, and, too frequently, newspaper accounts of love-nests, murders, and exploits of bandits. For, when what he knows as art is relegated to the museum and gallery, the unconquerable impulse towards experiences enjoyable in themselves finds such outlet as the daily environment provides. Many a person who protests against the museum conception of art, still shares the fallacy from which that conception springs. For the popular notion comes from a separation of art from the objects and scenes of ordinary experience that many theorists and critics pride themselves upon holding and even elaborating. The times when select and distinguished objects are closely connected with the products of usual vocations are the times when appreciation of the former is most rife and most keen. When, because of their remoteness, the objects acknowledged by the cultivated to be works of fine art seem anemic to the mass of people, esthetic hunger is likely to seek the cheap and the vulgar.

The factors that have glorified fine art by setting it upon a far-off pedestal did not arise within the realm of art nor is their influence confined to the arts. For many persons an aura of mingled awe and unreality encompasses the "spiritual" and the "ideal" while "matter" has become by contrast a term of depreciation, something to be explained away or

apologized for. The forces at work are those that have removed religion as well as fine art from the scope of the common or community life. The forces have historically produced so many of the dislocations and divisions of modern life and thought that art could not escape their influence. We do not have to travel to the ends of the earth nor return many millennia in time to find peoples for whom everything that intensifies the sense of immediate living is an object of intense admiration. Bodily scarification, waving feathers, gaudy robes, shining ornaments of gold and silver, of emerald and jade, formed the contents of esthetic arts, and, presumably, without the vulgarity of class exhibitionism that attends their analogues today. Domestic utensils, furnishings of tent and house, rugs, mats, jars, pots, bows, spears, were wrought with such delighted care that today we hunt them out and give them places of honor in our art museums. Yet in their own time and place, such things were enhancements of the processes of everyday life. Instead of being elevated to a niche apart, they belonged to display of prowess, the manifestation of group and clan membership, worship of gods, feasting and fasting, fighting, hunting, and all the rhythmic crises that punctuate the stream of living.

Dancing and pantomime, the sources of the art of the theater, flourished as part of religious rites and celebrations. Musical art abounded in the fingering of the stretched string, the beating of the taut skin, the blowing with reeds. Even in the caves, human habitations were adorned with colored pictures that kept alive to the senses experiences with the animals that were so closely bound with the lives of humans. Structures that housed their gods and the instrumentalities that facilitated commerce with the higher powers were wrought with especial fineness. But the arts of the drama, music, painting, and architecture thus exemplified had no peculiar connection with theaters, galleries, museums. They were part of the significant life of an organized community.

The collective life that was manifested in war, worship, the forum, knew no division between what was characteristic of these places and operations, and the arts that brought color, grace, and dignity, into them. Painting and sculpture were organically one with architecture, as that was one with the social purpose that buildings served. Music and song were intimate parts of the rites and ceremonies in which the meaning of group life was consummated. Drama was a vital reënactment of the legends and history of group life. Not even in Athens can such arts be torn loose from this setting in direct experience and yet retain their significant character. Athletic sports, as well as drama, celebrated and enforced traditions of race and group, instructing the people, commemorating glories, and strengthening their civic pride.

Under such conditions, it is not surprising that the Athenian Greeks, when they came to reflect upon art, formed the idea that it is an act of reproduction, or imitation. There are many objections to this conception. But the vogue of the theory is testimony to the close connection of the fine arts with daily life; the idea would not have occurred to any one had art been remote from the interests of life. For the doctrine did not signify that art was a literal copying of objects, but that it reflected the emotions and ideas that are associated with the chief institutions of social life. Plato felt this connection so strongly that it led him to his idea of the necessity of censorship of poets, dramatists, and musicians. Perhaps he exaggerated when he said that a change from the Doric to the Lydian mode in music would be the sure precursor of civic degeneration. But no contemporary would have doubted that music was an integral part of the ethos and the institutions of the community. The idea of "art for art's sake" would not have been even understood.

There must then be historic reasons for the rise of the compartmental conception of fine art. Our present museums and galleries to which works of fine art are removed and stored illustrate some of the causes that have operated to segregate art instead of finding it an attendant of temple, forum, and other forms of associated life. An instructive history of modern art could be written in terms of the formation of the distinctively modern institutions of museum and exhibition gallery. I may point to a few outstanding facts. Most European museums are, among other things, memorials of the rise of nationalism and imperialism. Every capital must have its own museum of painting, sculpture, etc., devoted in

part to exhibiting the greatness of its artistic past, and, in other part, to exhibiting the loot gathered by its monarchs in conquest of other nations; for instance, the accumulations of the spoils of Napoleon that are in the Louvre. They testify to the connection between the modern segregation of art and nationalism and militarism.

. . .

HAVING AN EXPERIENCE

Experience occurs continuously, because the interaction of live creature and environing conditions is involved in the very process of living. Under conditions of resistance and conflict, aspects and elements of the self and the world that are implicated in this interaction qualify experience with emotions and ideas so that conscious intent emerges. Oftentimes, however, the experience had is inchoate. Things are experienced but not in such a way that they are composed into *an* experience. There is distraction and dispersion; what we observe and what we think, what we desire and what we get, are at odds with each other. We put our hands to the plow and turn back; we start and then we stop, not because the experience has reached the end for the sake of which it was initiated but because of extraneous interruptions or of inner lethargy.

In contrast with such experience, we have *an* experience when the material experienced runs its course to fulfillment. Then and then only is it integrated within and demarcated in the general stream of experience from other experiences. A piece of work is finished in a way that is satisfactory; a problem receives its solution; a game is played through; a situation, whether that of eating a meal, playing a game of chess, carrying on a conversation, writing a book, or taking part in a political campaign, is so rounded out that its close is a consummation and not a cessation. Such an experience is a whole and carries with it its own individualizing quality and self-sufficiency. It is *an* experience.

Philosophers, even empirical philosophers, have spoken for the most part of experience at large. Idiomatic speech, however, refers to experiences each of which is singular, having its own beginning and end. For life is no uniform uninterrupted march or flow. It is a thing of histories, each with its own plot, its own inception and movement toward its close, each having its own particular rhythmic movement; each with its own unrepeated quality pervading it throughout. A flight of stairs, mechanical as it is, proceeds by individualized steps, not by undifferentiated progression, and an inclined plane is at least marked off from other things by abrupt discreteness.

Experience in this vital sense is defined by those situations and episodes that we spontaneously refer to as being "real experiences"; those things of which we say in recalling them, "that *was* an experience." It may have been something of tremendous importance—a quarrel with one who was once an intimate, a catastrophe finally averted by a hair's breadth. Or it may have been something that in comparison was slight—and which perhaps because of its very slightness illustrates all the better what is to be an experience. There is that meal in a Paris restaurant of which one says "that *was* an experience." It stands out as an enduring memorial of what food may be. Then there is that storm one went through in crossing the Atlantic—the storm that seemed in its fury, as it was experienced, to sum up in itself all that a storm can be, complete in itself, standing out because marked out from what went before and what came after.

In such experiences, every successive part flows freely, without seam and without unfilled blanks, into what ensues. At the same time there is no sacrifice of the self-identity of the parts. A river, as distinct from a pond, flows. But its flow gives a definiteness and interest to its successsive portions greater than exist in the homogenous portions of a pond. In an experience, flow is from something to something. As one part leads into another and as one part carries on what went before, each gains distinctness in itself. The enduring whole is diversified by successive phases that are emphases of its varied colors.

Because of continuous merging, there are no holes, mechanical junctions, and dead centers when we have *an* experience. There are pauses, places of rest, but they punctuate and define the quality of movement. They sum up what has been undergone and prevent its dissipation and idle evaporation.

Continued acceleration is breathless and prevents parts from gaining distinction. In a work of art, different acts, episodes, occurrences melt and fuse into unity, and yet do not disappear and lose their own character as they do so—just as in a genial conversation there is a continuous interchange and blending, and yet each speaker not only retains his own character but manifests it more clearly than is his wont.

An experience has a unity that gives it its name, *that* meal, that storm, that rupture of friendship. The existence of this unity is constituted by a single *quality* that pervades the entire experience in spite of the variation of its consituent parts. This unity is neither emotional, practical, nor intellectual, for these terms name distinctions that reflection can make within it. In discourse *about* an experience, we must make use of these adjectives of interpretation. In going over an experience in mind *after* its occurrence, we may find that one property rather than another was sufficiently dominant so that it characterizes the experience as a whole. There are absorbing inquiries and speculations which a scientific man and philosopher will recall as "experiences" in the emphatic sense. In final import they are intellectual. But in their actual occurrence they were emotional as well; they were purposive and volitional. Yet the experience was not a sum of these different characters; they were lost in it as distinctive traits. No thinker can ply his occupation save as he is lured and rewarded by total integral experiences that are intrinsically worth while. Without them he would never know what it is really to think and would be completely at a loss in distinguishing real thought from the spurious article. Thinking goes on in trains of ideas, but the ideas form a train only because they are much more than what an analytic psychology calls ideas. They are phases, emotionally and practically distinguished, of a developing underlying quality; they are its moving variations, not separate and independent like Locke's and Hume's so-called ideas and impressions, but are subtle shadings of a pervading and developing hue.

We say of an experience of thinking that we reach or draw a conclusion. Theoretical formulation of the process is often made in such terms as to conceal effectually the similarity of "conclusion" to the consummating phase of every developing integral experience. These formulations apparently take their cue from the separate propositions that are premises and the proposition that is the conclusion as they appear on the printed page. The impression is derived that there are first two independent and ready-made entities that are then manipulated so as to give rise to a third. In fact, in an experience of thinking, premises emerge only as a conclusion becomes manifest. The experience, like that of watching a storm reach its height and gradually subside, is one of continuous movement of subject-matters. Like the ocean in the storm, there are a series of waves; suggestions reaching out and being broken in a clash, or being carried onwards by a coöperative wave. If a conclusion is reached, it is that of a movement of anticipation and cumulation, one that finally comes to completion. A "conclusion" is no separate and independent thing; it is the consummation of a movement.

Hence *an* experience of thinking has its own esthetic quality. It differs from those experiences that are acknowledged to be esthetic, but only in its materials. The material of the fine arts consists of qualities; that of experience having intellectual conclusion are signs or symbols having no intrinsic quality of their own, but standing for things that may in another experience be qualitatively experienced. The difference is enormous. It is one reason why the strictly intellectual art will never be popular as music is popular. Nevertheless, the experience itself has a satisfying emotional quality because it possesses internal integration and fulfillment reached through ordered and organized movement. This artistic structure may be immediately felt. In so far, it is esthetic. What is even more important is that not only is this quality a significant motive in undertaking intellectual inquiry and in keeping it honest, but that no intellectual activity is an integral event (is *an* experience), unless it is rounded out with this quality. Without it, thinking is inconclusive. In short, esthetic cannot be sharply marked off from intellectual experience since the latter must bear an esthetic stamp to be itself complete.

The same statement holds good of a course of action that is dominantly practical, that is, one that

consists of overt doings. It is possible to be efficient in action and yet not have a conscious experience. The activity is too automatic to permit of a sense of what it is about and where it is going. It comes to an end but not to a close or consummation in consciousness. Obstacles are overcome by shrewd skill, but they do not feed experience. There are also those who are wavering in action, uncertain, and inconclusive like the shades in classic literature. Between the poles of aimlessness and mechanical efficiency, there lie those courses of action in which through successive deeds there runs a sense of growing meaning conserved and accumulating toward an end that is felt as accomplishment of a process. Successful politicians and generals who turn statesmen like Caesar and Napoleon have something of the showman about them. This of itself is not art, but it is, I think, a sign that interest is not exclusively, perhaps not mainly, held by the result taken by itself (as it is in the case of a mere efficiency), but by it as the outcome of a process. There is interest in completing an experience. The experience may be one that is harmful to the world and its consummation undesirable. But it has esthetic quality.

The Greek identification of good conduct with conduct having proportion, grace, and harmony, the *kalon-agathon*, is a more obvious example of distinctive esthetic quality in moral action. One great defect in what passes as morality is its anesthetic quality. Instead of exemplifying wholehearted action, it takes the form of grudging piecemeal concessions to the demands of duty. But illustrations may only obscure the fact that any practical activity will, provided that it is integrated and moves by its own urge to fulfillment, have esthetic quality.

A generalized illustration may be had if we imagine a stone, which is rolling down hill, to have an experience. The activity is surely sufficiently "practical." The stone starts from somewhere, and moves, as consistently as conditions permit, toward a place and state where it will be at rest—toward an end. Let us add, by imagination, to these external facts, the ideas that it looks forward with desire to the final outcome; that it is interested in the things it meets on its way, conditions that accelerate and retard its movement with respect to their bearing on the end; that it acts and feels toward them according to the hindering or helping function it attributes to them; and that the final coming to rest is related to all that went before as the culmination of a continuous movement. Then the stone would have an experience, and one with esthetic quality.

If we turn from this imaginary case to our own experience, we shall find much of it is nearer to what happens to the actual stone than it is to anything that fulfills the conditions fancy just laid down. For in much of our experience we are not concerned with the connection of one incident with what went before and what comes after. There is no interest that controls attentive rejection or selection of what shall be organized into the developing experience. Things happen, but they are neither definitely included nor decisively excluded; we drift. We yield according to external pressure, or evade and compromise. There are beginnings and cessations, but no genuine initiations and concludings. One thing replaces another, but does not absorb it and carry it on. There is experience, but so slack and discursive that it is not *an* experience. Needless to say, such experiences are anesthetic.

Thus the non-esthetic lies within two limits. At one pole is the loose succession that does not begin at any particular place and that ends—in the sense of ceasing—at no particular place. At the other pole is arrest, constriction, proceeding from parts having only a mechanical connection with one another. There exists so much of one and the other of these two kinds of experience that unconsciously they come to be taken as norms of all experience. Then, when the esthetic appears, it so sharply contrasts with the picture that has been formed of experience, that it is impossible to combine its special qualities with the features of the picture and the esthetic is given an outside place and status. The account that has been given of experience dominantly intellectual and practical is intended to show that there is no such contrast involved in having an experience; that, on the contrary, no experience of whatever sort is a unity unless it has esthetic quality.

The enemies of the esthetic are neither the practical nor the intellectual. They are the humdrum; slackness of loose ends; submission to convention

in practice and intellectual procedure. Rigid abstinence, coerced submission, tightness on one side and dissipation, incoherence and aimless indulgence on the other, are deviations in opposite directions from the unity of an experience. Some such considerations perhaps induced Aristotle to invoke the "mean proportional" as the proper designation of what is distinctive of both virtue and the esthetic. He was formally correct. "Mean" and "proportion" are, however, not self-explanatory, nor to be taken over in a prior mathematical sense, but are properties belonging to an experience that has a developing movement toward its own consummation.

. . .

THE ACT OF EXPRESSION

Every experience, of slight or tremendous import, begins with an impulsion, rather *as* an impulsion. I say "impulsion" rather than "impulse." An impulse is specialized and particular; it is, even when instinctive, simply a part of the mechanism involved in a more complete adaptation with the environment. "Impulsion" designates a movement outward and forward of the whole organism to which special impulses are auxiliary. It is the craving of the living creature for food as distinct from the reactions of tongue and lips that are involved in swallowing; the turning toward light of the body as a whole, like the heliotropism of plants, as distinct from the following of a particular light by the eyes.

Because it is the movement of the organism in its entirety, impulsion is the initial stage of any complete experience. Observation of children discovers many specialized reactions. But they are not, therefore, inceptive of complete experiences. They enter into the latter only as they are woven as strands into an activity that calls the whole self into play. Overlooking these generalized activities and paying attention only to the differentiations, the divisions of labor, which render them more efficient, are pretty much the source and cause of all further errors in the interpretation of experience.

Impulsions are the beginnings of complete experience because they proceed from need; from a hunger and demand that belongs to the organism as a whole and that can be supplied only by instituting definite relations (active relations, interactions) with the environment. The epidermis is only in the most superficial way an indication of where an organism ends and its environment begins. There are things inside the body that are foreign to it, and there are things outside of it that belong to it *de jure*, if not *de facto*; that must, that is, be taken possession of if life is to continue. On the lower scale, air and food materials are such things; on the higher, tools, whether the pen of the writer or the anvil of the blacksmith, utensils and furnishings, property, friends and institutions—all the supports and sustenances without which a civilized life cannot be. The need that is manifest in the urgent impulsions that demand completion through what the environment—and it alone—can supply, is a dynamic acknowledgment of this dependence of the self for wholeness upon its surroundings.

It is the fate of a living creature, however, that it cannot secure what belongs to it without an adventure in a world that as a whole it does not own and to which it has no native title. Whenever the organic impulse exceeds the limits of the body, it finds itself in a strange world and commits in some measure the fortune of the self to external circumstance. It cannot pick just what it wants and automatically leave the indifferent and adverse out of account. If, and as far as, the organism continues to develop, it is helped on as a favoring wind helps the runner. But the impulsion also meets many things on its outbound course that deflect and oppose it. In the process of converting these obstacles and neutral conditions into favoring agencies, the live creature becomes aware of the intent implicit in its impulsion. The self, whether it succeed or fail, does not merely restore itself to its former state. Blind surge has been changed into a purpose; instinctive tendencies are transformed into contrived undertakings. The attitudes of the self are informed with meaning.

An environment that was always and everywhere congenial to the straightaway execution of our impulsions would set a term to growth as surely as one always hostile would irritate and destroy. Impulsion forever boosted on its forward way would run its course thoughtless, and dead to emotion. For it

would not have to give an account of itself in terms of the things it encounters, and hence they would not become significant objects. The only way it can become aware of its nature and its goal is by obstacles surmounted and means employed; means which are only means from the very beginning are too much one with an impulsion, on a way smoothed and oiled in advance, to permit of consciousness of them. Nor without resistance from surroundings would the self become aware of itself; it would have neither feeling nor interest, neither fear nor hope, neither disappointment nor elation. Mere opposition that completely thwarts, creates irritation and rage. But resistance that calls out thought generates curiosity and solicitous care, and, when it is overcome and utilized, eventuates in elation.

That which merely discourages a child and one who lacks a matured background of relevant experiences is an incitement to intelligence to plan and convert emotion into interest, on the part of those who have previously had experiences of situations sufficiently akin to be drawn upon. Impulsion from need starts an experience that does not know where it is going; resistance and check bring about the conversion of direct forward action into re-flection; what is turned back upon is the relation of hindering conditions to what the self possesses as working capital in virtue of prior experiences. As the energies thus involved re-enforce the original impulsion, this operates more circumspectly with insight into end and method. Such is the outline of every experience that is clothed with meaning.

That tension calls out energy and that total lack of opposition does not favor normal development are familiar facts. In a general way, we all recognize that a balance between furthering and retarding conditions is the desirable state of affairs—provided that the adverse conditions bear intrinsic relation to what they obstruct instead of being arbitrary and extraneous. Yet what is evoked is not just quantitative, or just more energy, but is qualitative, a transformation of energy into thoughtful action, through assimilation of meanings from the background of past experiences. The junction of the new and old is not a mere composition of forces, but is a re-creation in which the present impulsion gets form and

solidity while the old, the "stored," material is literally revived, given new life and soul through having to meet a new situation.

It is this double change which converts an activity into an act of expression. Things in the environment that would otherwise be mere smooth channels or else blind obstructions become means, media. At the same time, things retained from past experience that would grow stale from routine or inert from lack of use, become coefficients in new adventures and put on a raiment of fresh meaning. Here are all the elements needed to define expression. The definition will gain force if the traits mentioned are made explicit by contrast with alternative situations. Not all outgoing activity is of the nature of expression. At one extreme, there are storms of passion that break through barriers and that sweep away whatever intervenes between a person and something he would destroy. There is activity, but not, from the standpoint of the one acting, expression. An onlooker may say "What a magnificent expression of rage!" But the enraged being is only raging, quite a different matter from *expressing* rage. Or, again, some spectator may say "How that man is expressing his own dominant character in what he is doing or saying." But the last thing the man in question is thinking of is to express his character; he is only giving way to a fit of passion. Again the cry or smile of an infant may be expressive to mother or nurse and yet not be an act of expression of the baby. To the onlooker it is an expression because it tells something about the state of the child. But the child is only engaged in doing something directly, no more expressive from his standpoint than is breathing or sneezing—activities that are also expressive to the observer of the infant's condition.

. . .

An act of discharge or mere exhibition lacks a medium. Instinctive crying and smiling no more require a medium than do sneezing and winking. They occur through some channel, but the means of outlet are not used as immanent means of an end. The act that *expresses* welcome uses the smile, the

outreached hand, the lighting up of the face as media, not consciously but because they have become organic means of communicating delight upon meeting a valued friend. Acts that were primitively spontaneous are converted into means that make human intercourse more rich and gracious—just as a painter converts pigment into means of expressing an imaginative experience. Dance and sport are activities in which acts once performed spontaneously in separation are assembled and converted from raw, crude material into works of expressive art. Only where material is employed as media is there expression and art. Savage taboos that look to the outsider like mere prohibitions and inhibitions externally imposed may be to those who experience them media of expressing social status, dignity, and honor. Everything depends upon the way in which material is used when it operates as medium.

The connection between a medium and the act of expression is intrinsic. An act of expression always employs natural material, though it may be natural in the sense of habitual as well as in that of primitive or native. It becomes a medium when it is employed in view of its place and rôle, in its relations, an inclusive situation—as tones become music when ordered in a melody. The same tones might be uttered in connection with an attitude of joy, surprise, or sadness, and be natural outlets of particular feelings. They are *expressive* of one of these emotions when other tones are the medium in which one of them occurs.

Etymologically, an act of expression is a squeezing out, a pressing forth. Juice is expressed when grapes are crushed in the wine press; to use a more prosaic comparison, lard and oil are rendered when certain fats are subjected to heat and pressure. Nothing is pressed forth except from original raw or natural material. But it is equally true that the mere issuing forth or discharge of raw material is not expression. Through interaction with something external to it, the wine press, or the treading foot of man, juice results. Skin and seeds are separated and retained; only when the apparatus is defective are they discharged. Even in the most mechanical modes of expression there is interaction and a consequent transformation of the primitive material which stands

as raw material for a product of art, in relation to what is actually pressed out. It takes the wine press as well as grapes to ex-press juice, and it takes environing and resisting objects as well as internal emotion and impulsion to constitute an *expression* of emotion.

...

THE EXPRESSIVE OBJECT

Expression, like construction, signifies both an action and its result. The last chapter considered it as an act. We are now concerned with the product, the object that is expressive, that says something to us. If the two meanings are separated, the object is viewed in isolation from the operation which produced it, and therefore apart from individuality of vision, since the act proceeds from an individual live creature. Theories which seize upon "expression," as if it denoted simply the object, always insist to the uttermost that the object of art is purely representative of other objects already in existence. They ignore the individual contribution which makes the object something new. They dwell upon its "universal" character, and upon its meaning—an ambiguous term, as we shall see. On the other hand, isolation of the act of expressing from the expressiveness possessed by the object leads to the notion that expression is merely a process of discharging personal emotion—the conception criticized in the last chapter.

The juice expressed by the wine press is what it is because of a prior act, and it is something new and distinctive. It does not merely represent other things. Yet it has something in common with other objects and it is made to appeal to other persons than the one who produced it. A poem and picture present material passed through the alembic of personal experience. They have no precedents in existence or in universal being. But, nonetheless, their material came from the public world and so has qualities in common with the material of other experiences, while the product awakens in other persons new perceptions of the meanings of the common world. The oppositions of individual and universal, of subjective and objective, of freedom and order, in which philosophers have reveled, have no place in the work

of art. Expression as personal act and as objective result are organically connected with each other.

It is not necessary, therefore, to go into these metaphysical questions. We may approach the matter directly. What does it mean to say that a work of art is representative, since it must be representative in some sense if it is expressive? To say in general that a work of art is or is not representative is meaningless. For the word has many meanings. An affirmation of representative quality may be false in one sense and true in another. If literal reproduction is signified by "representative" then the work of art is not of that nature, for such a view ignores the uniqueness of the work due to the personal medium through which scenes and events have passed. Matisse said that the camera was a great boon to painters, since it relieved them from any apparent necessity of copying objects. But representation may also mean that the work of art tells something to those who enjoy it about the nature of their own experience of the world: that it presents the world in a new experience which they undergo.

A similar ambiguity attends the question of meaning in a work of art. Words are symbols which represent objects and actions in the sense of standing for them; in that sense they have meaning. A signboard has meaning when it says so many miles to such and such a place, with an arrow pointing the direction. But meaning in these two cases has a purely external reference; it stands for something by pointing to it. Meaning does not belong to the word and signboard of its own intrinsic right. They have meaning in the sense in which an algebraic formula or a cipher code has it. But there are other meanings that present themselves directly as possessions of objects which are experienced. Here there is no need for a code or convention of interpretation; the meaning is as inherent in immediate experience as is that of a flower garden. Denial of meaning to a work of art thus has two radically different significations. It may signify that a work of art has not the kind of meaning that belongs to signs and symbols in mathematics—a contention that is just. Or it may signify that the work of art is without meaning as nonsense is without it. The work of art certainly does not have that which is had by flags when used to signal another ship. But it does have that possessed by flags when they are used to decorate the deck of a ship for a dance.

Since there are presumably none who intend to assert that works of art are without meaning in the sense of being senseless, it might seem as if they simply intended to exclude external meaning, meaning that resides outside the work of art itself. Unfortunately, however, the case is not so simple. The denial of meaning to art usually rests upon the assumption that the kind of value (and meaning) that a work of art possesses is so unique that it is without community or connection with the contents of other modes of experience than the esthetic. It is, in short, another way of upholding what I have called the esoteric idea of fine art. The conception implied in the treatment of esthetic experience set forth in the previous chapters is, indeed, that the work of art has a unique *quality*, but that it is that of clarifying and concentrating meanings contained in scattered and weakened ways in the material of other experiences.

The problem in hand may be approached by drawing a distinction between expression and statement. Science states meanings; art expresses them. It is possible that this remark will itself illustrate the difference I have in mind better than will any amount of explanatory comment. Yet I venture upon some degree of amplification. The instance of a signboard may help. It directs one's course to a place, say a city. It does not in any way supply experience of that city even in a vicarious way. What it does do is to set forth some of the conditions that must be fulfilled in order to procure that experience. What holds in this instance may be generalized. Statement sets forth the conditions under which an experience of an object or situation may be had. It is a good, that is, effective, statement in the degree in which these conditions are stated in such a way that they can be used as *directions* by which one may arrive at the experience. It is a bad statement, confused and false, if it sets forth these conditions in such a way that when they are used as directions, they mislead or take one to the object in wasteful way.

"Science" signifies just that mode of statement that is most helpful as direction. To take the old standard case—which science today seems bent upon

modifying—the statement that water is H_2O is primarily a statement of the conditions under which water comes into existence. But it is also for those who understand it a direction for producing pure water and for testing anything that is likely to be taken for water. It is a "better" statement than popular and pre-scientific ones just because in stating the conditions for the existence of water comprehensively and exactly, it sets them forth in a way that gives direction concerning generation of water. Such, however, is the newness of scientific statement and its present prestige (due ultimately to its directive efficacy) that scientific statement is often thought to possess more than a signboard function and to disclose or be "expressive" of the inner nature of things. If it did, it would come into competition with art, and we should have to take sides and decide which of the two promulgates the more genuine revelation.

The poetic as distinct from the prosaic, esthetic art as distinct from scientific, expression as distinct from statement, does something different from leading to an experience. It constitutes one. A traveler who follows the statement or direction of a signboard finds himself in the city that has been pointed towards. He then may *have* in his own experience some of the meaning which the city possesses. We may have it to such an extent that the city has expressed itself to him—as Tintern Abbey expressed itself to Wordsworth in and through his poem. The city might, indeed, be trying to express itself in a celebration attended with pageantry and all other resources that would render its history and spirit perceptible. Then there is, if the visitor has himself the experience that permits him to participate, an expressive object, as different from the statements of a gazetteer, however full and correct they might be, as Wordsworth's poem is different from the account of Tintern Abbey given by an antiquarian. The poem, or painting, does not operate in the dimension of correct descriptive statement but in that of experience itself. Poetry and prose, literal photograph and painting, operate in different media to distinct ends. Prose is set forth in propositions. The logic of poetry is super-propositional even when it uses what are, grammatically speaking, propositions.

The latter have intent; art is an immediate realization of intent.

. . .

THE CHALLENGE TO PHILOSOPHY

Esthetic experience is imaginative. This fact, in connection with a false idea of the nature of imagination, has obscured the larger fact that all *conscious* experience has of necessity some degree of imaginative quality. For while the roots of every experience are found in the interaction of a live creature with its environment, that experience becomes conscious, a matter of perception, only when meanings enter it that are derived from prior experiences. Imagination is the only gateway through which these meanings can find their way into a present interaction; or rather, as we have just seen, the conscious adjustment of the new and the old *is* imagination. Interaction of a living being with an environment is found in vegetative and animal life. But the experience enacted is human and conscious only as that which is given here and now is extended by meanings and values drawn from what is absent in fact and present only imaginatively.*

There is always a gap between the here and now of direct interaction and the past interactions whose funded result constitutes the meanings with which we grasp and understand what is now occurring. Because of this gap, all conscious perception involves a risk; it is a venture into the unknown, for as it assimilates the present to the past it also brings about some reconstruction of that past. When past and present fit exactly into one another, when there is only recurrence, complete uniformity, the resulting experience is routine and mechanical; it does not come to consciousness in perception. The inertia of habit overrides adaptation of the meaning of the here and now with that of experiences, without which there is no consciousness, the imaginative phase of experience.

*"Mind denotes a whole system of meanings as they are embodied in the workings of organic life.... Mind is a constant luminosity; consciousness is intermittent, a series of flashes of different intensities."—"Experience and Nature," p. 303.

Mind, that is the body of organized meanings by means of which events of the present have significance for us, does not always enter into the activities and undergoings that are going on here and now. Sometimes it is baffled and arrested. Then the stream of meanings aroused into activity by the present contact remain aloof. Then it forms the matter of reverie, of dream; ideas are floating, not anchored to any existence as its property, its possession of meanings. Emotions that are equally loose and floating cling to these ideas. The pleasure they afford is the reason why they are entertained and are allowed to occupy the scene; they are attached to existence only in a way that, as long as sanity abides, is felt to be only fanciful and unreal.

In every work of art, however, these meanings are actually embodied in a material which thereby becomes the medium for their expression. This fact constitutes the peculiarity of all experience that is definitely esthetic. Its imaginative quality dominates, because meanings and values that are wider and deeper than the particular here and now in which they are anchored are realized by way of *expressions* although not by way of an object that is physically efficacious in relation to other objects. Not even a useful object is produced except by the intervention of imagination. Some existent material was perceived in the light of relations and possibilities not hitherto realized when the steam engine was invented. But when the imagined possibilities were embodied in a new assemblage of natural materials, the steam engine took its place in nature as an object that has the same physical effects as those belonging to any other physical object. Steam did the physical work and produced the consequences that attend any expanding gas under definite physical conditions. The sole difference is that the conditions under which it operates have been arranged by human contrivance.

The work of art, however, unlike the machine, is not only the outcome of imagination, but operates imaginatively rather than in the realm of physical existences. What it does is to concentrate and enlarge an immediate experience. The formed matter of esthetic experience directly *expresses*, in other words, the meanings that are imaginatively evoked; it does not, like the material brought into new relations in a machine, merely provide *means* by which purposes over and beyond the existence of the object may be executed. And yet the meanings imaginatively summoned, assembled, and integrated are embodied in material existence that here and now interacts with the self. The work of art is thus a challenge to the performance of a like act of evocation and organization, through imagination, on the part of the one who experiences it. It is not just a stimulus to and means of an overt course of action.

This fact constitutes the uniqueness of esthetic experience, and this uniqueness is in turn a challenge to thought. It is particularly a challenge to that systematic thought called philosophy. For esthetic experience is experience in its integrity. Had not the term "pure" been so often abused in philosophic literature, had it not been so often employed to suggest that there is something alloyed, impure, in the very nature of experience and to denote something beyond experience, we might say that esthetic experience is pure experience. For it is experience freed from the forces that impede and confuse its development as experience; freed, that is, from factors that subordinate an experience as it is directly had to something beyond itself. To esthetic experience, then, the philosopher must go to understand what experience is.

. . .

Susanne Langer (1895-1985)

Expressiveness

Chapter 2 from *Problems of Art*

2 EXPRESSIVENESS

When we talk about "Art" with a capital "A"—that is, about any or all of the arts: painting, sculpture, architecture, the potter's and goldsmith's and other designers' arts, music, dance, poetry, and prose fiction, drama and film—it is a constant temptation to say things about "Art" in this general sense that are true only in one special domain, or to assume that what holds for one art must hold for another. For instance, the fact that music is made for performance, for presentation to the ear, and is simply not the same thing when it is given only to the tonal imagination of a reader silently perusing the score, has made some aestheticians pass straight to the conclusion that literature, too, must be physically heard to be fully experienced, because words are originally spoken, not written; an obvious parallel, but a careless and, I think, invalid one. It is dangerous to set up principles by analogy, and generalize from a single consideration.

But it is natural, and safe enough, to ask analogous questions: "What is the function of sound in music? What is the function of sound in poetry? What is the function of sound in prose composition? What is the function of sound in drama?" The answers may be quite heterogeneous; and that is itself an important fact, a guide to something more than a simple and sweeping theory. Such findings guide us to exact relations and abstract, variously exemplified basic principles.

At present, however, we are dealing with principles that have proven to be the same in all the arts, when each kind of art—plastic, musical, balletic, poetic, and each major mode, such as literary and dramatic writing, or painting, sculpturing, building plastic shapes—has been studied in its own terms.

Such candid study is more rewarding than the usual passionate declaration that all the arts are alike, only their materials differ, their principles are all the same, their techniques all analogous, etc. That is not only unsafe, but untrue. It is in pursuing the differences among them that one arrives, finally, at a point where no more differences appear; then one has found, not postulated, their unity. At that deep level there is only one concept exemplified in all the different arts, and that is the concept of Art.

The principles that obtain wholly and fundamentally in every kind of art are few, but decisive; they determine what is art, and what is not. Expressiveness, in one definite and appropriate sense, is the same in all art works of any kind. What is created is not the same in any two distinct arts—this is, in fact, what makes them distinct—but the principle of creation is the same. And "living form" means the same in all of them.

A work of art is an expressive form created for our perception through sense or imagination, and what it expresses is human feeling. The word "feeling" must be taken here in its broadest sense, meaning *everything that can be felt*, from physical sensation, pain and comfort, excitement and repose, to the most complex emotions, intellectual tensions, or the steady feeling-tones of a conscious human life. In stating what a work of art is, I have just used the words "form," "expressive," and "created"; these are key words. One at a time, they will keep us engaged.

Let us consider first what is meant, in this context, by a *form*. The word has many meanings, all equally legitimate for various purposes; even in connection with art it has several. It may, for instance—and often does—denote the familiar, characteristic

structures known as the sonnet form, the sestina, or the ballad form in poetry, the sonata form, the madrigal, or the symphony in music, the contredance or the classical ballet in choreography, and so on. This is not what I mean; or rather, it is only a very small part of what I mean. There is another sense in which artists speak of "form" when they say, for instance, "form follows function," or declare that the one quality shared by all good works of art is "significant form," or entitle a book *The Problem of Form in Painting and Sculpture*, or *The Life of Forms in Art*, or *Search for Form*. They are using "form" in a wider sense, which on the one hand is close to the commonest, popular meaning, namely just the *shape* of a thing, and on the other hand to the quite unpopular meaning it has in science and philosophy, where it designates something more abstract; "form" in its most abstract sense means structure, articulation, a whole resulting from the relation of mutually dependent factors, or more precisely, the way that whole is put together.

The abstract sense, which is sometimes called "logical form," is involved in the notion of expression, at least the kind of expression that characterizes art. That is why artists, when they speak of achieving "form," use the word with something of an abstract connotation, even when they are talking about a visible and tangible art object in which that form is embodied.

The more recondite concept of form is derived, of course, from the naive one, that is, material shape. Perhaps the easiest way to grasp the idea of "logical form" is to trace its derivation.

Let us consider the most obvious sort of form, the shape of an object, say a lampshade. In any department store you will find a wide choice of lampshades, mostly monstrosities, and what is monstrous is usually their shape. You select the least offensive one, maybe even a good one, but realize that the color, say violet, will not fit into your room; so you look about for another shade of the same shape but a different color, perhaps green. In recognizing this same shape in another object, possibly of another material as well as another color, you have quite naturally and easily abstracted the concept of this shape from your actual impression of the first lampshade.

Presently it may occur to you that this shade is too big for your lamp; you ask whether they have *this same shade* (meaning another one of this shape) in a smaller size. The clerk understands you.

But what is *the same* in the big violet shade and the little green one? Nothing but the interrelations among their respective various dimensions. They are not "the same" even in their spatial properties, for none of their actual measures are alike; but their shapes are congruent. Their respective spatial factors are put together in the same way, so they exemplify the same form.

It is really astounding what complicated abstractions we make in our ordinary dealing with forms—that is to say, through what twists and transformations we recognize the same logical form. Consider the similarity of your two hands. Put one on the table, palm down, superimpose the other, palm down, as you may have superimposed cut-out geometric shapes in school—they are not alike at all. But their shapes are *exact opposites*. Their respective shapes fit the same description, provided that the description is modified by a principle of application whereby the measures are read one way for one hand and the other way for the other—like a timetable in which the list of stations is marked: "Eastbound, read down; Westbound, read up."

As the two hands exemplify the same form with a principle of reversal understood, so the list of stations describes two ways of moving, indicated by the advice to "read down" for one and "read up" for the other. We can all abstract the common element in these two respective trips, which is called the *route*. With a return ticket we may return only by the same route. The same principle relates a mold to the form of the thing that is cast in it, and establishes their formal correspondence, or common logical form.

So far we have considered only objects—lampshades, hands, or regions of the earth—as having forms. These have fixed shapes; their parts remain in fairly stable relations to each other. But there are also substances that have no definite shapes, such as gases, mist, and water, which take the shape of any bounded space that contains them. The interesting thing about such amorphous fluids is that when they are put into violent motion they do exhibit visible

forms, not bounded by any container. Think of the momentary efflorescence of a bursting rocket, the mushroom cloud of an atomic bomb, the funnel of water or dust screwing upward in a whirlwind. The instant the motion stops, or even slows beyond a certain degree, those shapes collapse and the apparent "thing" disappears. They are not shapes of things at all, but forms of motions, or dynamic forms.

Some dynamic forms, however, have more permanent manifestations, because the stuff that moves and makes them visible is constantly replenished. A waterfall seems to hang from the cliff, waving streamers of foam. Actually, of course, nothing stays there in mid-air; the water is always passing; but there is more and more water taking the same paths, so we have a lasting shape made and maintained by its passage—a permanent dynamic form. A quiet river, too, has dynamic form; if it stopped flowing it would either go dry or become a lake. Some twenty-five hundred years ago, Heracleitos was struck by the fact that you cannot step twice into the same river at the same place—at least, if the river means the water, not its dynamic form, the flow.

When a river ceases to flow because the water is deflected or dried up, there remains the river bed, sometimes cut deeply in solid stone. That bed is shaped by the flow, and records as graven lines the currents that have ceased to exist. Its shape is static, but it *expresses* the dynamic form of the river. Again, we have two congruent forms, like a cast and its mold, but this time the congruence is more remarkable because it holds between a dynamic form and a static one. That relation is important; we shall be dealing with it again when we come to consider the meaning of "living form" in art.

The congruence of two given perceptible forms is not always evident upon simple inspection. The common *logical* form they both exhibit may become apparent only when you know the principle whereby to relate them, as you compare the shapes of your hands not by direct correspondence, but by correspondence of opposite parts. Where the two exemplifications of the single logical form are unlike in most other respects one needs a rule for matching up the relevant factors of one with the relevant factors of the other; that is to say, a *rule of translation*,

whereby one instance of the logical form is shown to correspond formally to the other.

The logical form itself is not another thing, but an abstract concept, or better an *abstractable* concept. We usually don't abstract it deliberately, but only use it, as we use our vocal cords in speech without first learning all about their operation and then applying our knowledge. Most people perceive intuitively the similarity of their two hands without thinking of them as conversely related; they can guess at the shape of the hollow inside a wooden shoe from the shape of a human foot, without any abstract study of topology. But the first time they see a map in the Mercator projection—with parallel lines of longitude, not meeting at the poles—they find it hard to believe that this corresponds logically to the circular map they used in school, where the meridians bulged apart toward the equator and met at both poles. The visible shapes of the continents are different on the two maps, and it takes abstract thinking to match up the two representations of the same earth. If, however, they have grown up with both maps, they will probably see the geographical relationships either way with equal ease, because these relationships are not *copied* by either map, but *expressed*, and expressed equally well by both; for the two maps are different *projections* of the same logical form, which the spherical earth exhibits in still another—that is, a spherical—projection.

An expressive form is any perceptible or imaginable whole that exhibits relationships of parts; or points, or even qualities or aspects within the whole, so that it may be taken to represent some other whole whose elements have analogous relations. The reason for using such a form as a symbol is usually that the thing it represents is not perceivable or readily imaginable. We cannot see the earth as an object. We let a map or a little globe express the relationships of places on the earth, and think about the earth by means of it. The understanding of one thing through another seems to be a deeply intuitive process in the human brain; it is so natural that we often have difficulty in distinguishing the symbolic expressive form from what it conveys. The symbol seems to be the thing itself, or contain it, or be contained in it. A child interested in a globe will not say: "This

means the earth," but: "Look, this is the earth." A similar identification of symbol and meaning underlies the widespread conception of holy names, of the physical efficacy of rites, and many other primitive but culturally persistent phenomena. It has a bearing on our perception of artistic import; that is why I mention it here.

The most astounding and developed symbolic device humanity has evolved is language. By means of language we can conceive the intangible, incorporeal things we call our *ideas*, and the equally inostensible elements of our perceptual world that we call *facts*. It is by virtue of language that we can think, remember, imagine, and finally conceive a universe of facts. We can describe things and represent their relations, express rules of their interactions, speculate and predict and carry on a long symbolizing process known as reasoning. And above all, we can communicate, by producing a serried array of audible or visible words, in a pattern commonly known, and readily understood to reflect our multifarious concepts and percepts and their interconnections. This use of language is *discourse*; and the pattern of discourse is known as *discursive form*. It is a highly versatile, amazingly powerful pattern. It has impressed itself on our tacit thinking, so that we call all systematic reflection "discursive thought." It has made, far more than most people know, the very frame of our sensory experience—the frame of objective facts in which we carry on the practical business of life.

Yet even the discursive pattern has its limits of usefulness. An expressive form can express any complex of conceptions that, via some rule of projection, appears congruent with it, that is, appears to be of that form. Whatever there is in experience that will not take the impress—directly or indirectly—of discursive form, is not discursively communicable or, in the strictest sense, logically thinkable. It is unspeakable, ineffable; according to practically all serious philosophical theories today, it is unknowable.

Yet there is a great deal of experience that is knowable, not only as immediate, formless, meaningless impact, but as one aspect of the intricate web of life, yet defies discursive formulation, and

therefore verbal expression: that is what we sometimes call the *subjective aspect* of experience, the direct feeling of it—what it is like to be waking and moving, to be drowsy, slowing down, or to be sociable, or to feel self-sufficient but alone; what it feels like to pursue an elusive thought or to have a big idea. All such directly felt experiences usually have no names—they are named, if at all, for the outward conditions that normally accompany their occurrence. Only the most striking ones have names like "anger," "hate," "love," "fear," and are collectively called "emotion." But we feel many things that never develop into any designable emotion. The ways we are moved are as various as the lights in a forest; and they may intersect, sometimes without cancelling each other, take shape and dissolve, conflict, explode into passion, or be transfigured. All these inseparable elements of subjective reality compose what we call the "inward life" of human beings. The usual factoring of that life-stream into mental, emotional, and sensory units is an arbitrary scheme of simplification that makes scientific treatment possible to a considerable extent; but we may already be close to the limit of its usefulness, that is, close to the point where its simplicity becomes an obstacle to further questioning and discovery instead of the revealing, ever-suitable logical projection it was expected to be.

Whatever resists projection into the discursive form of language is, indeed, hard to hold in conception, and perhaps impossible to communicate, in the proper and strict sense of the word "communicate." But fortunately our logical intuition, or form-perception, is really much more powerful than we commonly believe, and our knowledge—genuine knowledge, understanding—is considerably wider than our discourse. Even in the use of language, if we want to name something that is too new to have a name (e.g., a newly invented gadget or a newly discovered creature), or want to express a relationship for which there is no verb or other connective word, we resort to metaphor; we mention it or describe it as something else, something analogous. The principle of metaphor is simply the principle of saying one thing and meaning another, and expecting to be understood to mean the other. A metaphor is not language,

it is an idea expressed by language, an idea that in its turn functions as a symbol to express something. It is not discursive and therefore does not really make a statement of the idea it conveys; but it formulates a new conception for our direct imaginative grasp.

Sometimes our comprehension of a total experience is mediated by a metaphorical symbol because the experience is new, and language has words and phrases only for familiar notions. Then an extension of language will gradually follow the wordless insight, and discursive expression will supersede the non-discursive pristine symbol. This is, I think, the normal advance of human thought and language in that whole realm of knowledge where discourse is possible at all.

But the symbolic presentation of subjective reality for contemplation is not only tentatively beyond the reach of language—that is, not merely beyond the words we have; it is impossible in the essential frame of language. That is why those semanticists who recognize only discourse as a symbolic form must regard the whole life of feeling as formless, chaotic, capable only of symptomatic expression, typified in exclamations like "Ah!" "Ouch!" "My sainted aunt!" They usually do believe that art is an expression of feeling, but that "expression" in art is of this sort, indicating that the speaker has an emotion, a pain, or other personal experience, perhaps also giving us a clue to the general kind of experience it is—pleasant or unpleasant, violent or mild—but not setting that piece of inward life objectively before us so we may understand its intricacy, its rhythms and shifts of total appearance. The differences in feeling-tones or other elements of subjective experience are regarded as differences in quality, which must be felt to be appreciated. Furthermore, since we have no intellectual access to pure subjectivity, the only way to study it is to study the symptoms of the person who is having subjective experiences. This leads to physiological psychology—a very important and interesting field. But it tells us nothing about the phenomena of subjective life, and sometimes simplifies the problem by saying they don't exist.

Now, I believe the expression of feeling in a work of art—the function that makes the work an expressive form—is not symptomatic at all. An artist working on a tragedy need not be in personal despair or violent upheaval; nobody, indeed, could work in such a state of mind. His mind would be occupied with the causes of his emotional upset. Self-expression does not require composition and lucidity; a screaming baby gives his feeling far more release than any musician, but we don't go into a concert hall to hear a baby scream; in fact, if that baby is brought in we are likely to go out. We don't want self-expression.

A work of art presents feeling (in the broad sense I mentioned before, as everything that can be felt) for our contemplation, making it visible or audible or in some way perceivable through a symbol, not inferable from a symptom. Artistic form is congruent with the dynamic forms of our direct sensuous, mental, and emotional life; works of art are projections of "felt life," as Henry James called it, into spatial, temporal, and poetic structures. They are images of feeling, that formulate it for our cognition. What is artistically good is whatever articulates and presents feeling to our understanding.

Artistic forms are more complex than any other symbolic forms we know. They are, indeed, not abstractable from the works that exhibit them. We may abstract a shape from an object that has this shape, by disregarding color, weight and texture, even size; but to the total effect that is an artistic form, the color matters, the thickness of lines matters, and the appearance of texture and weight. A given triangle is the same in any position, but to an artistic form its location, balance, and surroundings are not indifferent. Form, in the sense in which artists speak of "significant form" or "expressive form," is not an abstracted structure, but an apparition; and the vital processes of sense and emotion that a good work of art expresses seem to the beholder to be directly contained in it, not symbolized but really presented. The congruence is so striking that symbol and meaning appear as one reality. Actually, as one psychologist who is also a musician has written, "Music sounds as feelings feel." And likewise, in good painting, sculpture, or building, balanced shapes and colors, lines and masses look as emotions, vital tensions and their resolutions feel.

An artist, then, expresses feeling, but not in the way a politician blows off steam or a baby laughs and cries. He formulates that elusive aspect of reality that is commonly taken to be amorphous and chaotic; that is, he objectifies the subjective realm. What he expresses is, therefore, not his own actual feelings, but what he knows about human feeling.

Once he is in possession of a rich symbolism, that knowledge may actually exceed his entire personal experience. A work of art expresses a conception of life, emotion, inward reality. But it is neither a confessional nor a frozen tantrum; it is a developed metaphor, a non-discursive symbol that articulates what is verbally ineffable—the logic of consciousness itself.

Stephen Pepper (1891-1972)

The Aesthetic Object and the Consummatory Field

Selections from *The Work of Art*

1
What is a Work of Art?

One of the surprising things in the history of aesthetics is the small amount of attention given to the aesthetic object, or the work of art. Attention has been mainly directed upon aesthetic value or upon aesthetic experience. But the object that has that value or produces that experience has been largely neglected. Only within the last decade do we find some attempts at a description of its nature.

I should like in this chapter to press this inquiry perhaps a little further, or at least to see where we stand on the problem at the present time.

The first step in clarification of the problem is to realize that we are not dealing in this area with one object but with a little nest of related objects. It helps a lot just to become aware of this fact. For, if we think there must be only one object of aesthetic interest and that this is *the* work of art, we shall find ourselves blocked at the start by the competition of the several aesthetic objects each of which is making its own vigorous and legitimate claim to the title.

Let us have in mind, to begin with, one of the simplest of these nests of objects to describe, some picture of unquestioned aesthetic worth. Suppose we take the same picture Ushenko uses in his excellent analysis in his *Dynamics of Art*—Breughel's *Winter*. This is the sort of thing we generally refer to with innocent confidence as a work of art. Until the complexity of the problem has been brought to our attention, it probably does not occur to any of us that there is a problem here at all. We just point to the picture and indicate what we mean. We mean that what we point at is the work of art, Breughel's *Winter*.

. . .

So what are we pointing at when we point at a work of art?

The problem begins to unfold. Let me distinguish three objects in this nest of objects. There is first what may be called the vehicle—that continuously existing object, generally physical in nature, which carries the aesthetic values, preserves them and controls them for perception. For Breughel's *Winter*—and now for a while we shall imagine we are before his original—the vehicle for this picture is the canvas covered with various oil pigments in the Vienna museum. As a physical object this picture, this vehicle, can be carried about, loaned to other museums, stored in a salt mine, sold as merchandise, cleaned, damaged, restored, etc. If carefully described, it would probably be described in physical and chemical terms. Few writers would consider the vehicle as literally an object of aesthetic worth. It is an instrument for the production, preservation, and control of the object of aesthetic worth.

Then, secondly, I wish to distinguish the object of immediate perception. This is the experience a spectator has at any one time when stimulated by the vehicle. This is the object we see and feel and fill with meaning. It has a date and a location. Many will set the location within our bodies. Definitely our bodies are much involved in the object of immediacy. Our sense organs, our eyes in this instance, give us the colors and the lines and the shape; and our brains presumably give us the meanings of the represented objects dependent on learning and memory; and our endocrine systems presumably contribute to our emotions. Our bodies are extensively involved in the perceptual response. Whether the content of the perception is limited to the activities

of our bodies, or only centered there, in either circumstance the locus of the object of immediacy is in the region of our bodily responses. And the duration of an object of immediacy is a certain spread of time, but actually no longer than the so-called specious present, the time that can be taken in intuitively at a single act of attention.

The object of immediacy is only a few seconds long, then. This brings out the fact that the aesthetic perception of a poem or a piece of music requires a series of perceptive immediacies. For the beginning of a melody has passed out of the span of immediacy before the end of it comes. We get the contour of the whole melody when it is completed, but not through the direct stimulation of its sounds from end to end of a single attention span. A single motive of the melody may be intuited that way, like a phrase of a sentence, but not the whole melody or the whole sentence, for the attention span is limited to a few seconds.

The need of a succession of perceptive immediacies to obtain one integral perception of a poem or a melody is here obvious enough. A bit of reflection will show that the same is true of a spatial work of art like a picture or a statue. A statue in the round clearly demands that the spectator see all sides of it for a single integral perception of the whole statue. A series of perceptive immediacies is required for a single complete perception of the statue just as for the poem or melody. Less obviously, but just as surely, a series of such immediacies is required for an integral perception of a picture like Breughel's *Winter*. At the first glance we perhaps see the men and the dogs, or the parallel verticals of the trees cutting a long diagonal. Then we are drawn to notice other details of the picture, and it requires some minutes to grasp and respond to even the main elements of composition and representation embedded in the picture.

So, just in a single perception of a work of art, we run into some unexpected complexities. What is usually called a single perception—say the first time one hears a musical composition or sees a picture—is already not one act of perceptual response but a succession of such acts. Yet somehow we obtain something of an integral perception of the work and of the series of perceptive immediacies.

Before we go any further let us be quite clear with ourselves concerning the object of immediacy. It is very often assumed in aesthetic discussions that this is the pivotal aesthetic object and that this is an object of direct sensory stimulation. Many who speak of an "aesthetic surface" appear to have these assumptions implicit. There is the suggestion that a pure aesthetic experience is a purely receptive one, discriminating the sensuous effects and the formal relations impressed upon a spectator by the stimulus object. The derivation of "aesthetic" from the Greek "aesthesis," meaning "sensuous," is often appealed to. Meanings, references, and synthetic activities of the mind are admitted into the aesthetic experience grudgingly. Even representation is questionably aesthetic, and social references even more so. The attraction to this view is mainly, I feel, its supposed intuitive ultimacy in the object of immediacy.

The object of sensuous immediacy is, of course, necessary and pivotal as the source of all aesthetic data, but it is not sufficient. It is not sufficient, as we have just seen, for even one integral perception of a work of art. A whole melody of usual length cannot possibly be a perceptual object of direct stimulation, because the initial sound stimuli are way out of the attention span when the terminal stimuli of the melody are being responded to. The earlier phrases of a melody have to be referred to or reached by some process of memory while the last phrase is being played, in order that the melody as a whole may be intuited. Even in the aesthetic perception of a single simple melody there must be a synthetic incorporation of past meanings into a present content. A term for this process, become current through Dewey's prestige, is "funding." Funding is the fusion of meanings from past experiences into a present experience. The earlier perceptions of a melody are thus funded into the later ones, and thence arises our capacity for getting the integral sense of a melody from a series of short-span perceptual immediacies.

The necessity of funding even for rather simple aesthetic perceptions shows up at once the inadequacy of any theory that tries to limit the aesthetic field to that of pure sensuous immediacy. There is practically no work of art—perhaps none—that does

not require some funding for its perception. The least that could be suggested is that the funding should be limited to the memories of earlier sensuous responses. But if sensuous funding is permissible, why not any other sorts of meaning so long as they can be relevantly embodied into an aesthetic perception?

This rather new concept of funding deserves some closer examination. It includes another concept, also rather new in aesthetic descriptions, the concept of fusion. As just pointed out, funding is fusion of memory elements into a present perception. We call memories funding when they give a tone or atmosphere to the content of direct sensuous stimulation. It is not funding if no memory elements are present in a perception. It is not funding if the memory is separately distinguishable from the direct sensuous material. Funding is something between the two. It is the fusion of memory with sensuous immediacy so as to give the effect of an enriched immediacy.

. . .

Now if we see what fusion of memories is within a present perception, we can show how it operates within the radius of a work of art. [. . .] We are interested in a certain cumulative effect of fusion towards the comprehension of a single stimulating object—towards a total funded perception of a single work of art.

Our problem is how it may be possible to obtain an adequate perception of a complex object like a work of art and on what grounds we may call one perception more adequate than another. The concept of funding goes a long way towards solving that problem.

The perception of a complex object like Breughel's *Winter* is necessarily selective and partial. No one in a single act of perception can experience the totality of that picture in all its discriminated detail. But through funding one can approach that ideal. The first perception of a work of art by an experienced spectator is necessarily very thin and inadequate. We can easily get the sense of this meagreness by looking at, or listening to, some most recent production of a school of art in some medium with which we are still unfamiliar. A few details catch our attention.

For the rest we are often much confused and suspect that we are pretty blind. Here the growing adequacy of successive perceptions with increasing discrimination is obvious enough. But even for the experienced beholder, it takes time and a multiplicity of perceptions to discriminate the relevant details. Now, as we said earlier, one pays attention to the large compositional effect; then to details of pattern, to contrasts, repetitions, echoes of themes; then to the space representation, the pattern on the picture plane, and the pattern in depth; then to the figures represented; then to the activities of the figures and their interrelationships—and so on. Familiar as one may be with Breughel's Winter and absorbed as one may be in its relevant traits, one's perceptions are still selective and concentrate now on certain features to delight in, now on others. How, then, ever to get the perceptions of the whole picture?

It is through funding that a person does it. When one is focusing his attention on the figures in the foreground, he is aware of the figures and hills in the background in the fringe of his vision and the memory of an attentive focusing upon them is funded into the perception of the figures in the foreground. So all the past perceptions of the picture are added to the present perception in the way of "hushed reverberations." Literally one can never see the whole picture in all its detail in focus at one time. But one can feel the whole picture in all its detail in a funded consciousness with certain details in clear focus and the rest fused into these as memories of their character and interrelationships.

When we come into a strange town, we can see only what is directly before our eyes. What happens up each street, and how the streets turn, and where the parks are and the river and the bridges, and where the stores are and the city hall and the residential area are all hidden to us. But when we have been in the town awhile, the perception of each street contains a feeling of its relations with every other street, and the tone of a street a block away from the freight yards has the clatter of the freight cars in it already, and the contrasting peace of the park beyond by the river and the swimming pool are right there in the very block we are moving along.

So it is in a work of art, in Breughel's picture. With familiarity we get to feel every detail funded into any detail we may be looking at. There is only this difference between the town and the picture, that we think of the town as an object primarily in terms of its practical physical relationships rather than in terms of its total perceivable character, whereas we think of the work of art and evaluate it primarily in terms of its total perceivable character rather than in terms of its physical vehicle.

Through funding—for this is the significant point we are stressing—the total character of a work of art is describably perceivable. This total character is definable and open to verification. Through funding previous perceptions of details here, here and here in the work of art can be interrelated and through memory fused into the subsequent perception of other details. Thus a progression of cumulative funding of perceptions can be described, leading to the ideal of a set of totally funded perceptions of the work. The object of aesthetic criticism is this ideal set of fully funded perceptions of all the relevant details stimulated by the physical vehicle of the work of art.

But I am getting a little ahead of my sequence. I showed the need of considering the thing we call a work of art as a nest of objects. I am in fact suggesting that it consists of three closely interrelated objects: First, the physical vehicle; second, the object of perceptual immediacy. These two objects within the nest of the total work of art we have so far been describing. The third which we now come to I shall call the object of criticism.

The physical vehicle is the continuous enduring control object which is the source of stimulation for the succession of fugitive objects of perceptual immediacy. The object of criticism is some sort of synthesis or evaluative goal of the sequence of perceptual immediacies. The first object, the vehicle, is as enduring as the physical and cultural materials of which it is composed. The third object, the object of criticism, is equally enduring because it is in the nature of a potentiality or dispositional property of the vehicle. It is the full potentiality of aesthetic perception available to the aesthetic vehicle. But what connects the two and actualizes both for aesthetic appreciation is the sequence of perceptual immediacies stimulated by the vehicle. The second object is the actual object of immediate aesthetic experience. This object, however, is fugitive. It lasts but a few moments and is gone. There may be a continuous succession of immediate perceptions, as in listening to a symphony or contemplating a painting for a long time. But the length of a single stretch of immediacy cannot exceed a specious present.

. . .

2
Judgment of Beauty

. . .

Within the compass of what is roughly called "the work of art," we found three interrelated objects, it will be recalled: First, there was the vehicle or control object such as the canvas for a picture, the printed page for a poem; second, there was the immediate fugitive perception stimulated by the vehicle; and, third, there was the object of criticism which is a dispositional property of the vehicle and refers to the funded perception or system of perceptions of a fully competent observer stimulated by the vehicle.

According to our analysis, a description of any one of these three objects would be in the nature of a declarative sentence, true or false. Likewise, a description of any discrepancies between the character of some person's reported perception of the vehicle and the character of the final funded system of relevant perceptions constituting the object of criticism, so far as ascertained, would be in the nature of a declarative sentence, true or false.

It follows in our view that there is at least one acceptable significance of the expression of "ought" which is declarative in form and may be true or false. This is an assertion to the effect that for a full appreciation of a work of art a man's immediate perceptions ought to approximate as closely as possible the character of the fully funded relevant perceptions constituting the object of criticism.

What is indicated in this view is something implicitly denied by the value-judgment theorists, namely, that under the guidance of the vehicle as a

control object there is a factually describable process of progressive discrimination and appreciation of the object of criticism, which is the goal of this process. The dynamics for the process lies in the impulses which attract the spectator to respond to the object in the beginning. Continued attraction to the object leads to continued response for the maximum value to be found in it, and this cumulative process tends to continue until all the relevant content is attained which, when attained, constitutes the object of criticism itself—the terminus and implicit goal of the whole process.

Such a process is what I should like to call a "selective system." The characteristic of a selective system is that a single dynamic element directs action at two levels at once, a long-range level, such as a goal, and a short-range level, such as a tentative attempt to attain the goal. The attempt has to be made if the goal is to be reached at all, and the motivation for the attempt is the very motivation that directs the organism to the goal. But if the goal is not known ahead, or if skills and causal relationships have to be learned to reach the goal, then the attempts on the way to the goal are necessarily liable to error. The error is a factual occurrence and can be truly described, and the fact that it *ought* not to have occurred (which is the common way of calling attention to it) can also be truly described by comparing it with the act that would have led to the goal and *ought* to have been performed. Through the dynamics of a selective system, the act that ought to be performed presently will be performed, since the dynamics of the system sees to it that the organism is continuously attracted towards the goal. The charge upon the goal is the factual sanction—the verifiable sanction—for the goal as a value criterion. A selective system is a factual process that operates on two levels and selects acts which it initiates and which it tries out on a subordinate level, testing how far they contribute towards the attainment of an act aimed for on a superordinate level.

An appetitive purposive structure such as the pursuit of food by a hungry animal, or the pursuit of knowledge by an inquisitive one, is a prime example of a selective system.

The dynamic process of the appreciation of a work of art is another such selective system. It has peculiarities of its own, however, which distinguish it from the working of an everyday practical purpose. The difference can by best summarized by saying that the dynamics of appreciation is consummatory, whereas that of a practical purpose is anticipatory. In developing the contrast between the two, many qualifications would need to be made. But at present it is more important to see that the appreciation of a work of art is a progressive selective process and to see how, in general, it differs from the process of a practical purpose, than to be minutely precise in the differentiation of the two.

A practical purpose, as we generally encounter it, is anticipatory. We have knowledge or foresight of the goal which we set before us as an end through the dynamics of some drive, and we proceed to seek out means for attaining the goal. We may not know the means and we may make errors along the way in our selection of means. Our acts in selecting the means are good or bad in proportion as these acts are, on the one hand, conducive to the attainment of the goal, or, on the other hand, mistaken and delaying. We speak of a mistaken act as an error and as one we *ought not* to have performed. The true instrumental act when discovered is the one, we say, we *ought* all along to have performed. Through the selective system of an appetitive purpose at least one sense of "ought" thus obtains a factual or declarative description.

How does it get this description? It gets it by the fact that a single dynamic agent, a purposive drive in this instance, is acting on two levels at the same time. It is driving the organism on a superordinate or upper level towards a goal, and in pursuance of this process it is also driving the organism on a subordinate or lower level towards a means. The very drive that impels the organism to the goal impels it to the means as an essential part of the same complex activity. A highly structured act is here unfolding through time. It is a *Gestalt*-like process. It is not a mere succession of bead-like acts, as though the terminal goal-seeking act only followed upon a means-seeking act, as though the goal-seeking act did not begin until after the means-seeking act was over. The goal-seeking act is going on at the same

time as the means-seeking act, and these two acts are upper and lower levels of the same structure and both are impelled, motivated, by the same drive. The drive that gives its emotional value to the goal gives its value simultaneously to the means, and the value of the goal is the norm; for, if the means fails to lead to the goal, the drive at once ceases to charge the means. The emotional value of the means is, in fact, relative to that of the end. That is the way this dynamic structure actually operates. By the very nature of a purposive structure the anticipatory thought of the goal charged by a drive selects pro or con a means charged by that same drive. Therefore, the means is good if it has the properties conducive to the attainment of the goal, bad if it doesn't. To state that the means is good is, thus, in a declarative sentence (true or false) to ascribe relational properties to that object just as much as to state that the object is heavy or above some other object in space. It is to attribute to the object the property of being wanted as a means and so of having causal relations leading to another object wanted as an end. All of this is factual, open to description, true or false.

I hope the reader will forgive me this expansion upon the obvious. But I must make it because I wish to point out for you clearly the analogous situation which holds in the process of a spectator's coming into the full appreciation of a work of art. The two processes have certain differences, but they are alike in this, which is crucial for the present issue regarding the declarative nature of judgments of beauty; namely, that both are selective systems and, as such, institute norms and selections of acts pro and con under those norms and by the very dynamics that institutes the norms. The process of a spectator's appreciation of a work of art is also a two-level selective process by which tentative acts are selected pro and con with reference to a potential terminus of the process set up by the dynamics of the process itself.

Let me take a very simple illustration. Think of yourself entering a gallery of an art museum. Suppose your eye catches a picture at the end of the room which attracts your attention and arouses your incipient admiration. Do you stop at the doorway and there relish the experience? No, pleasant as

the picture is at that distance, it would be tantalizing to be kept there at a distance. The very consummatory structure of the situation draws you into the room to a position neither too near nor too far, where the colors and shapes are to be seen at their best. If there is a glass over the picture, you will move so that all glare is eliminated. In short, in a consummatory field of activity a person is drawn to the optimum condition of consummatory response with respect to the object—and, when the object is a work of art, specifically with respect to the stimulating aesthetic vehicle. And all positions or conditions less than the optimum are by the dynamics of the field rejected as less good than the optimum to which the dynamics of the field draws the spectator.

And similarly with music. We seek a location neither too near nor too far, where the sounds come at a consummatory optimum. To hear good music in the distance is to be drawn towards it where it can be heard best. The Pied Piper in the fable drew the children after him by means of this principle. They followed him because to stay behind as he moved forward was to drop out of the area of optimum reception. And our manipulation of the volume and the tone of a phonograph has the same significance.

We may call this the consummatory principle. It is the tendency to make the most of the consummatory field. The dynamics of the field draws the agent to the optimum area of satisfaction.

Now, if we have grasped the principle, we see that it is a selective system like an appetitive drive. In fact, it is the terminal phase of a positive desire. For the structure of a purposive act motivated by an appetitive drive like hunger is such as to draw an organism as quickly as possible to the consummatory field where the drive can attain quiescence. Acts are selected as right or wrong in proportion as they conduce or fail to conduce to the attainment of the consummatory field. But, having attained that field, then (barring the pressure of a practical emergency) the principle of action changes to that of maximizing satisfaction in the field. Acts are selected as right or wrong in proportion as they increase or decrease the available satisfaction, in proportion as they approach to or recede from areas of optimum reception. That the principle of selection changes within

the consummatory field from what it was in the approach to this field can be seen by the fact that outside the field the quicker the activity is over the better, whereas within the field the longer the period of activity the better. The trend for the optimum of stimulation within the field has the effect of holding the organism there as long as possible. This is, of course, just a more detailed description of the well-recognized contrast between practical achievement and aesthetic contemplation. For practical achievement, the rule of the shortest path holds—the speedier the better. But for aesthetic enjoyment, the longer the better.

The point for us to note, however, is that the consummatory principle, which seeks to intensify and draw out enjoyment, is a selective principle. This point is often missed. Even in the very simple examples we have just offered the selective operation of the consummatory field emerges. The structure of he field causes a person who moves from a more to a less favorable position within the field to consider his movement an error and to correct it to a better position. And so from better to better positions the person moves until he finds the optimum position which actually has been operating all the time as the norm for the correctness and incorrectness of every move of the spectator within the field. It is a natural norm determined by the structure of the specific consummatory field and is describable in declarative sentences just as a physicist might describe a magnetic field.

The dynamics of this selective system, like that of a purposive structure relating means and end, is such that the impulse for the optimum is the same as that which motivates the error in the approach to the optimum. Just as the drive which charges the anticipation of the end is the very one that charges the incorrect choice of a means so that in the very dynamics of the system the means acknowledges its incorrectness by virtue of the end; so here the consummatory principle by which the organism seeks to maximize its enjoyment in the consummatory field determines both the optimum point and the points of lesser receptivity. In this way a movement into a less favorable position is acknowledged as an error by the same dynamics that leads the organism to correct its error and feel its way towards the optimum.

Let us note, too, that the point of optimum receptivity is not known to the organism ahead of his responses in the consummatory field, unless he has had previous experience and remembers. Where is the best point to see a picture, or to listen to a piano? One has to move around in the consummatory area and find out. Nevertheless, that point is settled by the very structure of the field. It is a dispositional property of the situation. For the organism moving about in the field it is the ideal and norm of correctness of all his actions in the field. It is the place where he *ought* to be. And this is a declarative statement concerning the structure of the field!

Now, I think you can see where all these preliminaries are heading. They point to the statement that the object of criticism is the terminal area of optimum receptivity for the vehicle of a work of art.

For consider what is sought in the fullness of contemplation of a picture like Breughel's *Winter*. To stand before it in the most favorable position under a favorable light is a beginning. But to perceive all the relevant details and to gather them up in successive discriminations and fundings of the content of the picture are parts of the same process. The balance and tensions of the forms, the linear design, the drama of the represented scene, and the attendant emotions are all in the consummatory field of the picture as truly as the point of most favorable visibility. The discriminative mind is drawn to find these in the consummatory field of this picture as compellingly as the body is attracted from the door at the end of the gallery to the optimum position a few feet in front of the picture. The search for this optimum consummatory area will be tentative and accompanied by many incorrect responses, just as a naive perceiver's search for the optimum position of visibility would be. The incorrect responses are the mistaking of irrelevant for relevant details in the object of criticism.

. . .

When a critic states that Breughel's *Winter* is beautiful, he is accordingly referring to a consummatory field and the operation of a selective system within that field. He is referring to an area of optimum receptivity and to the content of response obtainable in

that area. He may describe this content of the relevant characters of the fully appreciated picture in great detail. These characters will include emotions and feelings as well as colors, lines, and representational meanings. He is asserting in declarative terms that this is the response a person will get if he maximizes the relevant satisfactions in this consummatory area. His statement is of the "if-then" form and recognizes that most persons entering this consummatory field will have many inadequate perceptions of the picture on their way towards an optimum response. The ordinary way of expressing the discrepancy between the inadequate perceptions and the optimum response is that these perceptions are not what they ought to be, for they ought to be the perception of the optimum response. In making this normative statement the critic is not commanding other people to make their perceptions conform to his. On the contrary, he is showing these people the ultimate perception they themselves are trying to attain by their entrance into the consummatory field and by their attraction to this object. The critic is like the helpful guide who shows you just where you can get the best view of the object. Perhaps the object is a waterfall and you have to climb a thousand feet to the finest view of it. But the critic is not commanding you to climb. He is telling you a fact about your consummatory field, and if your drive is strong enough from your interest in the falls, it is a safe prediction you will find that observation point. You would, in fact, find it for yourself if your interest persisted, but if you follow the directions of the experienced guide it will save you some trouble and pains.

Now obviously this is not the end. It is only the beginning of the story of responsible aesthetic criticism. There are many things that need to be straightened out and amplified. Just what, in concrete detail, is the object of criticism? What, more precisely, constitutes relevancy? May there not be a considerable variance in the optimum response? May there not be alternative objects of criticism in response to a single aesthetic vehicle? Is the object of criticism ever exhaustively attained? Isn't it an extrapolated ideal towards which men's perceptions approach? To most of these questions I would with various qualifications give an affirmative answer.

But the big point to see is that in our description of the process of aesthetic criticism all such questions are open to intelligent treatment. They are questions of fact to be settled in terms of the evidence concerning the factual relations among the aesthetic vehicle, the successive perceptions of it, and the process of approaching aesthetic maximization in the object of criticism.

Roman Ingarden (1893-1970)

On the Phenomenological Formation of the Aesthetic Object

Selections from *Phenomenological Aesthetics: An Attempt at Defining its Range*

. . .

When in 1927 I began writing my first book on this subject it was quite clear to me that one cannot employ the method of empirical generalization in aesthetics, but that one must carry through an eidetic analysis of the idea of a literary work of art or a work of art in general.

. . .

From the start the work of art was assumed to be a purely intentional product of an artist's creative acts. At the same time, as a schematic entity having certain potential elements, it was contrasted with its "concretions". A work which for its inception required an author, but also the recreative receptive experiences of a reader or observer, so that right from the beginning, on account of its very nature and the mode of its existence, it pointed towards essentially different experiential histories, different mental subjects, as the necessary conditions of its existence and its mode of appearing (*Erscheinungsweise*), while in the annals of its existence (in its "life", as I used to say) it pointed to a whole community of such readers, observers, or listeners. And conversely, these experiences can come about only in such a way that by their very nature they refer to a certain object: the work of art. Moreover, it transpired at the same time that it requires for its existence not only these various experiences but additionally a certain physical object like a book, a piece of marble, a painted canvas, which must be suitably shaped by the artist and suitably perceived and apprehended by the consumer, in order that against this background the given work of art might appear and that, while remaining for a period of time unchanged, it should

assist its many consumers in identifying the work. In this manner, in addition to the bodily and conscious behaviour of various people and to the works of art themselves we have also drawn into the discussion certain real material objects as the physical ontological basis of a work of art.

. . .

When in the course of my enquiry the problem of aesthetic value began to press itself with growing force which I could not ignore, the internal unity of the whole range of problems began to appear to me with increasing clarity, and at the same time I became aware that it is necessary to discover such a concept of aesthetics as would guarantee such unity.

. . .

First of all, it has to be stressed that it is inappropriate to regard all the experiences and behaviour out of which a work of art flows as being active, while regarding those experiences and actions which terminate in aesthetic apprehension or cognition of a work of art as passive and purely receptive. In both situations there are phases of passivity and receptivity —of apprehension and acceptance—and phases of activity, of movement beyond what is already given, and to the production of something new which has not existed before and which is an honest product of the artist or of the observer. In the first instance the process does not exhaust itself in the productive experiencing by the artist: it discharges itself in a certain active bodily behaviour during which the physical ontological foundation of the work of art is shaped. This shaping is directed by the creative experience and by the work of art which

begins to outline itself and to shine through that experience, which is to be seemingly embodied in the work. This leads to results which are controlled by the artist and which must be subjected to such control if the artist is successfully to realize his intentions. From this several consequences follow.

Firstly, there are the specific phases in the shaping of the physical foundation, and this occurs on each occasion. Secondly, there is the developing structure of the work of art which dawns upon the artist in the course of this structuring of the foundation, the work being initially swathed in a protoplasmic state. And finally, the effectiveness coming into being during the shaping of the physical foundation, an effectiveness in performing the function of embodying and presenting the intended work of art in its immediacy. The artist controls and checks these results, this control taking place during the receptive experience which apprehends the properties of the object (the work of art). The painter, for instance, must see the products of the particular phases of his activity, of what is already painted on the canvas, and what artistic effectiveness it possesses. The composer in putting his work together, possibly noting it down in a score, has to hear how the particular parts sound, and for this purpose he often uses an instrument in order to be able to hear the particular fragments. It is this seeing or hearing that enables the artist to continue the work and shaping its physical foundation, leading the artist to make revisions or even to a complete recasting of the work. Only occasionally, in the case of poetry, do we get the poet composing "at one go" without having to read through his draft, and without any revisions or alterations. This is closely interwoven with the creative process and yet is itself an act of receptively, of aesthetic apprehension. We may say that in this case the artist becomes an observer of his own emerging work, but even then it is not completely passive apprehension but an active, receptive behaviour. On the other side, the observer too does not behave in a completely passive or receptive way, but being temporarily disposed to the reception and recreation of the work itself, is also not only active, but in a certain sense at least creative. From the initially receptive phases of his experience there emerge creative phases at the moment when the already apprehended and reconstructed work of art stimulates the consumer to pass from looking to that phase of aesthetic experience in which the apprehending subject moves beyond the schematic work of art itself and in a creative way completes it. He swathes the work in aesthetically significant qualities suggested by the work and then brings about the constitution of the work's aesthetic value. (This need not always be the case. Sometimes these qualities are imposed by the observer without any suggestion, or without sufficient suggestion from the work itself. Then the value of the constituted aesthetic object also does not have a sufficient basis in the work of art itself. It is in these various different situations that we find a basis for resolving the problem of the objectivity of value in each particular case.) This is creative behaviour, which is not only stimulated and guided by what has already been apprehended in a work of art, but also demands the observer's creative initiative, in order for him not only to guess with what aesthetically significant qualities a certain area of indeterminateness in the work of art is to be filled, but also to imagine in immediate perception how the aesthetically significant congruence which has arisen in the work concretized by that completion by those new elements as yet unembodied in the work itself will sound. Frequently this achievement of bringing the concretized work into immediate perception, saturated with aesthetically significant qualities, comes about with the aid of considerable activity on the observer's part, without which everything would be savourless and lifeless. This phase of aesthetic shaping and live manifestation of the aesthetic value leads in turn to the phase of the apprehension of the essence of the constituted valuable aesthetic object, while the shape of the object blossoming in this apprehension stimulates the observer into an active response towards the already apprehended value, and to an assessment of this value.

This process, be it (a) active-passive or receptive, or (b) active-creative, is not the product of man's purely conscious behaviour. It is the whole man endowed with defined mental and bodily powers, which during the process undergo certain characteristic changes which will differ, depending upon how the encounter is taking place and upon the shape of the work of art, or the relevant aesthetic object,

that is being created. If this process leads to the creation of a true and honest work of art, then both this process and the manifest face of the work leaves a permanent mark in the artist's soul. To some extent, the same happens when the observer encounters a great work of art, an encounter which produces the constitution of a highly valuable aesthetic object. He, too, then undergoes a permanent and significant change.

The various processes and changes in the artist or the observer are paralleled by appropriate changes taking place in the object. In the case of the work of art in the process of being created this is obvious: the work of art comes into being gradually. And during this period, which may be prolonged, the changes occur in the shape and the properties of the emerging work corresponding to the particular phases of its coming into being. Similarly, just as the way in which a work of art is being created may vary, so may the changes it undergoes. On the whole it would be very difficult to say whether and within what boundaries there exist certain norms governing the coming into being of a work of art. In specific cases it is very difficult to discover these changes and prove their existence, especially when we see the work in its finished state and it shows no signs of the history of its coming into being. There can however, be no doubt that these changes which a work of art undergoes as it comes into being do exist, and that they correspond to the process of its coming into being.

It is not easy to demonstrate that when the observer is apprehending a finished work of art there are similar changes to the ones just described. This process appears possible and understandable in the case where the observer's apprehension of the work goes astray and he comprehends it faultily, but generally we do demand and expect that during the process of apprehending a work of art there should be no deficiency, that it should be apprehended adequately and that it should stand before the observer's eyes in a faithful reconstruction. In such a case we could ascribe to the particular phases of the work's apprehension only the process of discovery of particular parts and characteristics of the work and of their emergence in immediate perception. We would then again be having two interwoven parallel

processes: on the one hand, the apprehension, and on the other, the revelation and the appearance in immediate perception of the work of art, which together would produce the phenomenon of the encounter (communion?) between the observer and the work. It is, however, rare for the encounter to take such a course as to produce exclusively in a pure reconstruction of the work of art, and were it to happen always in the case of a particular work of art, it would mean that as a work of art it is really dead, aesthetically inert, and therefore does not really perform its function. The process of apprehending the work which is better suited to its character does not appear until the time when apart from its pure reconstruction, an aesthetic concretion is achieved which bestows upon the naked scheme of the work of art a plenitude of aesthetic qualities and aesthetic values. This process shrouds the aesthetic object until the observer has achieved a certain type of final completion (*Vollendung*) and constitution resulting in a quiescence in his behaviour.

He himself now feels that the completion of the aesthetic object has been achieved and that he has accomplished the task of constituting the object. Now he only has to respond properly to the already constituted value of the aesthetic object in order to do justice to it. The task of performing an evaluation of the aesthetically concretized work of art, consonant with a response to value, may possibly arise and must be solved in such a way that nothing is altered or disturbed in the already concretized object, so that the process of evaluation should not produce any further change in the object. For it to be just and to preserve the untouchability of the evaluated object this evaluation must not be active. One may of course speculate whether this is always possible, but it is the essential meaning and function of evaluation.

And once again I must stress that the process of the concretion and the constitution of a valuable aesthetic object may run very differently in the case of one and the same work of art because the very constitutive experience and the circumstances in which it takes place may be different. This diversity is increased further due to the fact that works of art are quite different in their individuality and in the essentials of their kind. So they may influence the

observer variously with their artistic activity and may arouse in him occasionally to quite disparate aesthetic experience when he apprehends the work. There are thus considerable difficulties in describing these changes. For the time being we are only concerned to state that there is a "correlativity" and a mutual dependence between two parallel processes: in the experiencing subject and in the object which reveals itself to the observer and at the same time comes into being through this manifestation. These processes cannot be separated and neither can be studied in complete isolation from the other. This is the basic postulate of an aesthetics which has realized that the fundamental fact, with the elucidation of which it ought to start its investigation, is the encounter between man and an external object different from him and for the time being independent of him.

This object, thing, process, or event may be something purely physical, or a certain fact in the life, and experience of the observer, or a musical motif, a snatch of a melody, or a harmony of sounds, a colour contrast, or a particular metaphysical quality. All this comes from the outside and puts a particular pressure on the artist in the unfolding of an extremely rare intuition, even though it is only an intuition of the imagination. The role of this "object" is to move the artist in a particular way: it forces him out of a natural quotidian attitude and puts him into a completely new disposition.

This "object" may be a particularly eyecatching quality of some thing, as for instance, of a pigment both saturated and "shining", or a specific shape. It must however be a quality which draws our attention to itself because it excites in us an emotionally coloured experience and an atmosphere of a certain surprise at its particularity and its wonderfully penetrating character. The German word *reizend* describes this quality. It may be of such a kind that one's drawing towards it may change into a "savouring" of its specificity and it may satisfy through its very presence the spectator's or listener's awakening desire to be in communion with it. Should the quality fully succeed in this, it then creates a certain primitive, simple aesthetic object. The experiencing observer's encounter with this quality gives rise to a certain kind of surprise, interest, delight, and later even happiness in the immediate communion with that specific quality.

This quality may, however, be seemingly qualitatively incomplete, heteronymous. It may consequently demand completion and through its embryonic manifestation it makes the observer aware of a certain lack which may at times become very unpleasant. This lack persuades the observer to seek other qualities that would complement that first quality and would bring the whole phenomenon to a saturation or final completion (*Vollendung*), thereby removing that unpleasant lack. Thus, the observer may find himself undergoing a lengthy process lasting until he is able to find that complementing quality, which would not only forge a connection with that first quality, but would also possess a synthetic overtone acting as a "shape" which envelopes the whole phenomenon. This search constitutes the beginning of the creative process which depends not only on discovering this overtone, but which also creates the qualitative entity in which that shape finds its ontological base and upon which it concretely manifests itself.

This entity, say a certain combination of sounds, a three-dimensional structure, or a certain linguistic whole consisting of sentences, must be suitably shaped in order that upon it (or in it) that synthetic shape may manifest itself in immediate perception. We call this shape the work of art. It is seemingly created by the artist on top of that aesthetically significant synthetic overtone which as yet is not fully manifest. Naturally, the work of art is in itself qualitatively determined. If that aesthetically active shape is to manifest itself, this can only come about through a "harmony", a congruence between the shape and the work's qualitative definition, so that the whole which comes about in this way is self-sufficient and brings about a complete self-presentation of that aesthetically active synthetic shape. It may also happen that the already composed whole leads to an immediately perceived presence of one or more completely new aesthetically active qualities not initially envisaged by the artist, although he is far from indifferent to them. The process of shaping the work of art then moves no further. If however the newly created whole can fulfill the artist's longing and desire to achieve a direct communion and a delight in the

self-present whole ultimately emerging from the process, this brings him satisfaction and peace. The restless search and creation turns into a wholly peaceful observation and contemplation. That which brings fulfillment and peace has the character of something valuable, but not because it is something which we try to reach but, on the contrary, because it is in itself complete and perfect.

This new intentionally produced object may for the time be only "painted" in the imagination. It therefore does not achieve complete self-presence and does not bring about either an honest fulfillment of desires or peace. On the contrary, it rouses one's desire to "see" it in reality. What is more, the purely intentional object conceived in imagination quickly passes together with the image itself, and one should perhaps perform a new act of imagination before one can commune with the same work again, even in imagination. One does not often succeed in repeating this kind of creative vision without the object undergoing significant changes. Hence arises the thought that the created work must somehow be "fixed" in a comparatively durable material. The artist is therefore concerned with bringing about changes in the surrounding material world, be that in some thing, or be that in order to start the unfolding of a certain process so as to make possible an almost perceptible presence of the work and a certain kind of embodiment on the basis of, for example, a suitably carved stone, as well as the self-presentation of the aesthetically significant qualities manifesting themselves upon it. The artist therefore tries to shape his creative experience in a way enabling it to discharge itself in a certain mental and bodily behaviour or activity which brings about the formation of a thing or a process due to serve as the physical basis of the existence of the work of art.

If he is a painter he covers a canvas with paints, if he is an architect he builds a house, and if he is a poet he writes a poem. In this he is motivated by the structure of the properties of a work of art which at first appear only in imagination or, more likely, by means of a certain fragment of leaven. Then the painting or poem in the process of being created helps him to finish the details of a work which originally appeared to him rather sketchily and had only the capacity to suggest a vision of an aesthetically valuable shape. Although the pigmented canvas or the carved stone never, as we frequently say, fully "realize" the work of art, embody it in themselves or constitute the sufficient condition for the visible manifestation on their basis of the work of art, nevertheless they do provide a certain kind of support for the intentional feigning or recreation of, for instance, a painting or a musical work. And given a suitable behaviour by the artist or observer, they impose upon the concretion of the work a liveliness and fullness of an almost perceptible manifestation, thereby making possible the self-presence of aesthetically valuable qualities. If for example in the case of an already shaped literary text, our reading a certain poem silently—assuming of course that the poem is already "written"—is not enough to call forth that self-presentation of the aesthetically valuable qualities, we then resort to reading aloud, recitation, or in the case of a dramatic work, to a presentation on the stage which possesses a higher level of liveliness and effectiveness in affecting the spectator. We then frequently talk of the "realization" of the drama on stage or on film. But we must not forget that there are works, lyrics, for instance, in the case of which recitation, especially an unduly "realistic" or "vivid" recitation, interferes with the self-presentation of emotionally coloured subtle aesthetically valuable qualities. In their case it is enough for them to appear in the imaginative intuition in order to manifest themselves in their delicate subtlety and thus move us most profoundly. But this is probably true only of literature, for could it also be true of unpainted paintings or effectively unplayed symphonies?

It may happen that when an artist is creating the physical ontological foundation of his work of art, and has not finished composing his work in his imagination but only has a certain outline which, however, moves him aesthetically, he has a particularly vivid idea of some of its features. He is then also sometimes aware that some of them tend, if anything, to interfere with the presentation of aesthetically significant qualities or that through a different shaping of the physical foundation of the work, and thereby the work itself, he would succeed in getting better artistic effects. The artist then changes the composition of his work, perfects it, and sometimes,

discouraged, abandons it altogether. But not in every case does he then have to reject the, as we say, intrinsic "idea", that is, be persuaded that the aesthetically valuable shape which originally germinated in the imagination is valueless. On the contrary, despite everything, he affirms its value and continues to expect that, should he be able to present it against a background of a differently composed object (a work of art), it would than be properly "realized" and embodied, and would manifest itself in the fullness of its value. So once more he constructs an object: a painting, a cathedral, a symphony, or a literary work, or completely changes the material of the ontological foundation of the work. For instance, instead of bronze he now employs Carrara marble, instead of one range of pigments a different range with the same aesthetically valuable overtones. In the course of these various changes and operations it transpires that neither during the shaping of the physical foundation of the work nor during the development of the initial conception and the working out of the various details of the work does the artist behave in a purely creative way. Rather, during many phases of his activity he assumes the position of an observer of already educed details of the physical foundation and of the various parts and traits of the work itself appearing against this background.

The variety of the basic structures of works in the different arts, which I had once demonstrated, leads to the conclusion that the process of the creative composition of works of art, which in their properties are to constitute the basis for the aesthetically valuable qualities and the formation of the physical foundation of the work, runs very differently. Each of these two factors introduces different difficulties to be overcome.

On the one hand, it can be the resistance of the physical materials or the aesthetic ineffectiveness of the artistic entity itself which demands from the author various skills and activities to control a variety of techniques or to find completely new techniques, the latter the more difficult to perfect. On the other hand, in this technical battle with the material the artist needs the ability not to lose the basic intuition of the aesthetically active synthetic shape which directs him in his "realization" of his work. The genius of the original intuition and the toil of hard labour have to go hand in hand, and when their harmonization fails to occur, we get a technically abortive entity, which nevertheless allows us to guess at what it was meant to manifest. Or the fundamental intuition gets lost and, for all the excellent techniques, there is now nothing in the complete work of the aesthetically valuable quality inspired by that intuition: the entity may be perfect in its "workmanship" and yet inert, having nothing to tell us. But despite all these varieties of creative behaviour on the artist's part the work nevertheless has in each case the same basic structure which belongs to the work's essence.

I trust that some details of this structure are becoming obvious from what I am trying to say, but I must refrain from a more detailed analysis, which perhaps is not in any case required. For I am here concerned only with the thesis that it is a process which often undergoes several phases, in which there is a constant contact and encounter between the acting experiencing artist and a certain object, or rather two objects: the work of art in course of creation and the physical foundation undergoing change through his influence. Moreover, both these elements undergo correlative mutually dependent changes. It is not a collision of dead matter but a living encounter full of activity.

In order to make my central thesis clearer it may be worthwhile characterizing briefly the behaviour of an observer of a work of art, both in his perceptual (receptive) experiences and in certain of his bodily actions. It is customary to talk of the "aesthetic experience" and to mean by it a momentary and homogeneous experience: there are many such theories in twentieth-century aesthetics. I had once attempted to show that it consists of many various rationally connected elements and occupies many phases. Here I would only add that this could occur in two different ways. The experience starts either with a sense-perception of a certain physical foundation of a work of art (a painted surface, a lump of stone, and so on) whose certain details enable the observer to "read" the shape of the work—whereupon the work comes to be constituted in his receptive experience—or, alternatively, the observer instantaneously perceives the work of art itself, that is, he sees a picture or a sculpture representing someone.

While in subsequent phases of the process the perceived painting now begins to work aesthetically upon the observer who, passing on into an aesthetic attitude, actualizes the aesthetically valuable qualities which the work of art has suggested to him and so brings about the constitution of the aesthetic value of the whole. In order to highlight this difference in the manner of the observer's behaviour when he apprehends the work of art I shall consider his behaviour through the example of his communion with an Impressionist painting.

In the first instance the observer sees for the time being an area of canvas or paper covered with coloured patches. Some of these flow into each other, others stand out in sharper contrast. In stopping to consider these patches more closely the observer behaves in the way that we do today when we observe a purely abstract painting where the collection of these patches of paint appears to us self-sufficient. Soon however some of these patches, either in their in their disposition or through their colour, begin to work upon the observer, rousing him to adopt an aesthetic attitude: he now begins to sense rather than see certain aesthetically significant qualities suggested by the disposition, colour, and shape of the patches. At a certain moment he focuses his attention upon them, apprehends them in full focus and delights in them. Finally, he reacts towards them with either a positive or a negative emotion which represents his response to their aesthetically valuable disposition of contrasting colours. But it may also happen that perceiving a certain variety of coloured patches which appear to him completely devoid of any interconnection produces in him a shock arising from his incomprehension. This leads him to ask: "What is this supposed to be?" or "What does this represent?" This state of disquietude, of incomprehension, may pass into an attempt at understanding what precisely the painting is all about. And then suddenly the observer realizes that he is looking at the painting faultily, regarding the coloured patches as objective determinations, as the properties of the canvas or wood which has been painted over for no apparent reason, whereas he should make use of the coloured patches to receive a certain quantity of experiential data which, seemingly of their own accord, arrange themselves into a certain aspect of an object seen from a certain point of view under certain lighting conditions.

The observer allows himself to be drawn and then suddenly everything becomes "comprehensible". From the multiplicity of coloured patches a human face emerges: for instance the face of a girl reading a book, as in Renoir's *La liseuse*, or a collection of many coloured objects illuminated by a lively light, as in Sisley's *Le brouillard* or Pissarro's *Femme dans un clos* and his *Arbres en fleur*. Now, on the one hand, the look of the painting changes. Only now does it begin to appear as a painting which "represents" something, in which objects and people appear illuminated by a certain light in very vibrating, glistening, unstable aspects, while the variety of coloured patches which lie at the basis of this painting do not quite disappear from the field of vision, although they are not that which we see and upon which our interest rests.

But, on the other hand, the observer's behaviour also undergoes change. He now accomplishes an act of "seeing" which is almost like that of normal visual perception, of things presented "in the picture". In Claude Monet's *Regattes à Argenteuil* he sees sailing boats on the Seine and reflections of their sails in the waves. At the same time, upon the basis of that "seeing", he performs an act of comprehension of what is to be presented in the painting, what is to manifest itself as though present when he sees the painting in a proper way. An it is inappropriate to say that we look "upon" the picture or that we "see" it. For although we in fact do look "at the picture", we perceive in the picture just the objects we have already mentioned, which are manifested to us through our apprehension of multicoloured patches of whose disposition on the canvas we are not at that moment aware. For had we been aware of these dispositions we would be seeing a smeared or blotched canvas, or an abstract painting, and we would not be seeing either the sailing boats or the wavy reflections of their white sails on the rippling blue waters of the river.

But something else occurs which is peculiar, and of whose peculiarity we are not normally aware, precisely because we have experienced it so frequently as something completely "natural" and far from surprising, namely that looking upon a human face

emerging from a play of patches and light we perceive something more: a friendly smile, satisfaction, joyfulness, or deep sorrow. We say, and this goes for spectators as well as for painters themselves or the so-called critics, that a certain "expression" of the person presented in the painting imposes itself upon us. This occurs chiefly in good portraits like those by Rembrandt or Van Gogh. Here the term "expression" may mean two different, although related things: a certain actual mood, emotion or mental state, or a certain defined trait of the character of the presented person, of psychological maturity or kindheartedness such as we can see in certain self-portraits by the older Rembrandt, in, for instance, his portrait in the New York Frick Gallery. These two elements do not appear in all portraits with equal clarity. The observer's apprehension of this type of features in a painting brings about a change in the painting's aspects or looks. The element of the mental and of the mental states brought in by the perceptual content livens up the whole painting in a specific way, often giving it a character of depth and subtlety because it reveals that part of the human soul which is normally hidden or difficult to reach. But this leads to a change in the observer's behaviour. He now understands the sense of the "facial expression" of the person presented or, conversely, in other instances, he stumbles upon something incomprehensible or puzzling in that expression (and this too is a certain positive phenomenon) and is unable to formulate an opinion as to what, as we sometimes say, lies hidden behind this incomprehensible smile or look. But while in the first instance this leads to a positive reaction, in the second instance he may find himself more or less hurt or put in a weird mood. When the observer comes to understand the psychological element of the painting, this frequently produces an emotional reaction in him: kindliness calls forth a state of kindliness, while hostility or a trait of malice apparent in someone's face produces a rather negative attitude in the spectator.

But these are seemingly extra-aesthetic elements in the observer's experience. Of greater importance is what in this experience has consequences for aesthetics. If for instance an expression of a mental state or a trait of character is manifested in the painting in a sharp, imposing, and unambiguous manner, so that the presented person appears to the spectator as though "alive", the spectator undergoes a different experience. This is a feeling of admiration for the mastery of the painter who succeeded through purely painterly means, through a certain disposition and shape, through differently coloured patches, in bringing about the manifestation of something as different from the pigments as the joy or the maturity of the presented person. The spectator asks how was it possible that, for instance, a character trait of the presented person should become visible by these means; what is more, that something should impose itself upon him with considerable force, so that he is unable to free himself from, as we sometimes say, this "sensation". What dispositions of colours and lines are required to manifest a look full of love or kindliness with which a person views another person? The spectator who puts this question to himself and who looks for an answer in a further examination of the picture, changes—and here his behaviour alters radically—from a "naive" spectator who simply communes emotionally with people presented in the painting and reacts to their behaviour with his own behaviour in the way that this occurs in ordinary life in interpersonal relationships, into a person who treats the given painting *as a work of art*, as a peculiar entity which fulfills special functions. He now investigates its specific strata: what is represented and the means of representation. He critically examines their functions and evaluates their artistic effectiveness or ineffectiveness. Finally he arrives either at a high valuation of the work or rejects it and condemns it as kitsch.

In this new attitude he begins to understand the given work quite differently. This understanding now concerns not what is being expressed of the mental life of the presented person, but rather considers what the individual strata of the painting contribute to its whole, what they effect, what is the "calculation" behind the whole painting, what is most important in it artistically and aesthetically, and what is merely the means to achieve this goal, what is a mannerism acquired from others (an intolerable mannerism, we sometimes say), and what is a new technical achievement or a new discovery, either in the realm of the presented world or in the field of aesthetically significant qualities and the ultimate

overtones of aesthetic value. By behaving in this way the spectator becomes a "connoisseur" of painterly art, of its various effects and artistic and aesthetic achievements. This behaviour on the part of the spectator endows the observed picture with a new character: it now stands before him as, for instance, a masterpiece, and also as a work of a master, testifying to his ability and his spirit, to his mode of evaluation and to the world of values with which he is in communion; values which he tries to make manifest to his spectators and through his work to enable the spectators to share these values. All this brings it about that on the one hand justice is rendered to the given work of art as a work of art, that it is grasped and understood in its proper function and in the values realized in it, while on the other hand, that between the observer and the artist, the master, there arises a specific *rapprochement*, even a certain kind of spiritual communion, although the master is absent and may well be long since dead.

This sketchy account of the observer's communion with a painting must of course be checked against many other examples, enriched with new details and deepened. Its primary purpose is to justify and to give a firmer foundation to my main thesis regarding the encounter of the artist or observer with a work of art. If this thesis is true and adequately substantiated, then it may serve as a principle of demarcation of aesthetic enquiry, endowing it with a certain unity which is not provided by either the so-called "subjectivist" or the "objectivist" aesthetics. This thesis points to a certain fundamental fact from the analysis of which in its collective totality it is possible to move further in two directions.

(1) Towards an analysis of the emerging or the already finished work of art and (2) towards the investigation of the activity of the artist-creator and the behaviour of the spectator, the recreator, and the critic. So, in an analytical structural enquiry into the work of art we shall not forget that works of art arise out of defined creative acts by an artist, and that they are therefore shaped in a certain purposeful manner, namely in the intention of realizing a certain artistic or aesthetic project and achievement; that they are also the products of a behaviour in which the basic and essential role is played by conscious intentional experiences and that, in their capacity as such products, these experiences may acquire only a certain particular mode of existence and, derivatively, of acting in various human communities. Because of their mode of existence they must, when they are being contemplated by the spectator, be brought by him to a phenomenal immediate perception, to a concretion and a self-presentation of aesthetically significant qualities, and of the aesthetic value resting upon them. In our investigation of the creative acts by the artist we shall never forget what their aim is and what they can achieve. In investigating the behaviour of the spectator or of the observer in general, we shall remember what it is that he as an observer of a work of art must emphasize, in what way he can do justice to the work of art, how the work's value or lack of it may be revealed and made manifest to other people, how he can and ought to carry out their evaluation, and lastly, what he does not do and ought not to do as a consumer and observer of a work of art, rather than as an ideologue or as a public-spirited citizen.

In pointing to a close connection between the two sides—the works of art and the people who are in communion with them or produce them—I am not altering my existing conviction which I have tried to develop and justify in many of my works. It is that works of art, although they are only purely intentional objects—admittedly resting on physical ontological foundations—after all form a special sphere of being whose peculiarity and specific endowment ought to be preserved in any investigation. It must not be violated by postulates which are foreign to it. Works of art have a right to expect to be properly apprehended by observers who are in communion with them and to have their special value justly treated.

Monroe C. Beardsley (1915-1985)

The Aesthetic Point of View

I

There has been a persistent effort to discover the uniquely aesthetic component, aspect, or ingredient in whatever is or is experienced. Unlike some other philosophical quarries, the object of this chase has not proved as elusive as the snark, the Holy Grail, or Judge Crater—the hunters have returned not empty-handed, but overburdened. For they have found a rich array of candidates for the basically and essentially aesthetic:

aesthetic experience	aesthetic objects
aesthetic value	aesthetic concepts
aesthetic enjoyment	aesthetic situations
aesthetic satisfaction	

Confronted with such trophies, we cannot easily doubt that there *is* something peculiarly aesthetic to be found in the world of our experience; yet its exact location and its categorial status remain in question. This is my justification for conducting yet another raid on the ineffable with the help of a different concept, one in the contemporary philosophical style.

II

When the conservationist and the attorney for Con Edison argue their conflicting cases before a state commission that is deciding whether a nuclear power plant shall be built beside the Hudson River, we can say they do not merely disagree; they regard that power plant from different points of view. When the head of the Histadrut Publishing House refused to publish the novel *Exodus* in Israel, he said: "If it is to be read as history, it is inaccurate. If it is to be read as literature, it is vulgar."[1]

And Maxim Gorky reports a remark that Lenin once made to him:

"I know nothing that is greater than [Beethoven's] *Appassionata*. I would like to listen to it every day.

A marvellous, super-human music. I always say with pride—a naive pride perhaps: What miracles human beings can perform!" Then screwing his eyes [Lenin] added, smiling sadly, "But I can't listen to music too often; it affects your nerves. One wants to say stupid nice things and stroke on the head the people who can create such beauty while living in this vile hell. And now you must not stroke anyone on the head: you'll have your hands beaten of. You have to hit them on the head without mercy, though our ideal is not to use violence against anyone. Hmm, hmm,—an infernally cruel job we have."[2]

In each of these examples, it seems plausible to say that one of the conflicting points of view is a peculiarly aesthetic one: that of the conservationist troubled by threats to the Hudson's scenic beauty; that of the publisher who refers to reading *Exodus* "as literature"; that of Lenin, who appears to hold

1. *New Republic*, January 16, 1961, p. 23. Compare Brendan Gill, in *The New Yorker*, March 5, 1966:

 It is a lot easier to recommend attendance at "The Gospel According to St. Matthew" as an act of penitential piety during the Lenten season than it is to praise the movie as a movie. Whether or not the life and death of Our Lord is the greatest story ever told, it is so far from being merely a story that we cannot deal with it in literary terms (if we could, I think we would have to begin by saying that in respect to construction and motivation it leaves much to be desired); our difficulty is enormously increased when we try to pass judgment on the story itself once it has been turned into a screenplay.

2. From Gorky's essay on Lenin, in his *Collected Works* (Moscow, 1950), 17:39-40. My colleague Olga Lang called my attention to this passage and translated it for me. Compare Gorky, *Days with Lenin* (New York, 1932), p. 52. *Time* (April 30, 1965, p. 50) reported that the Chinese Communists had forbidden the performance of Beethoven's works because they "paralyze one's revolutionary fighting will." A Chinese bacteriologist, in a letter to a Peking newspaper, wrote that after listening to Beethoven, he "began to have strange illusions about a world filled with friendly love."

that we ought to adopt the political (rather than the aesthetic) point of view toward Beethoven's sonata, because of the unfortunate political consequences of adopting the aesthetic point of view.

If the notion of the aesthetic point of view can be made clear, it should be useful from the philosophical point of view. The first philosophical use is in mediating certain kinds of dispute. To understand a particular point of view, we must envision its alternatives. Unless there can be more than one point of view toward something, the concept breaks down. Consider, for example, the case of architecture. The classic criteria of Vitruvius were stated tersely by Sir Henry Wotton in these words: "Well-building hath three conditions: Commodity, Firmness, and Delight." Commodity is function: that it makes a good church or house or school. Firmness is construction: that the building holds itself up. Suppose we were comparing a number of buildings to see how well built they are, according to these "conditions." We would find some that are functionally effective, structurally sound, and visually attractive. We would find others—old worn-out buildings or new suburban shacks—that are pretty poor in each of these departments. But also we would find that the characteristics vary independently over a wide range; that some extremely solid old bank buildings have Firmness (they are knocked down at great cost) without much Commodity or Delight, that some highly delightful buildings are functionally hopeless, that some convenient bridges collapse.

Now suppose we are faced with one of these mixed structures, and invited to say whether it is a good building, or how good it is. Someone might say the bank is very well built, because it is strong; another might reply that nevertheless its ugliness and inconvenience make it a very poor building. Someone might say that the bridge couldn't have been much good if it collapsed; but another might reply that it was a most excellent bridge, while it lasted—that encomium cannot be taken from it merely because it did not last long.

Such disputes may well make us wonder—as Geoffrey Scott wonders in his book *The Architecture of Humanism*[3]—whether these "conditions" belong

in the same discussion. Scott says that to lump them together is confusing: it is to "force on architecture an unreal unity of aim," since they are "incommensurable virtues." For clarity in architectural discussion, then, we might separate the three criteria, and say that they arise in connection with three different points of view—the practical, the engineering, and the aesthetic. In this way, the notion of a point of view is introduced to break up a dispute into segments that seem likely to be more manageable. Instead of asking one question—whether this is a good building—we divide it into three. Considering the building from the aesthetic point of view, we ask whether it is a good work of architecture; from the engineering point of view, whether it is a good structure; and from the practical point of view, whether it is a good machine for living.

Thus one way of clarifying the notion of a point of view would be in terms of the notion, of being *good of a kind*.[4] We might say that to adopt the aesthetic point of view toward a building is to classify it as belonging to a species of aesthetic objects—namely, works of architecture—and then to take an interest in whether or not it is a *good* work of architecture. Of course, when an object belongs to one obvious and notable kind, and we judge it in relation to that kind, the "point of view" terminology is unnecessary. We wouldn't ordinarily speak of considering music from a musical point of view, because it wouldn't occur to us that someone might regard it from a political point of view. In the same way, it would be natural to speak of considering whiskey from a medical point of view but not of considering penicillin from a medical point of view. This shows that the "point of view" terminology is implicitly rejective: it is a device for setting aside considerations

3. (New York, 1954), p. 15, where he quotes Wotton.

4. In this discussion, I have been stimulated by an unpublished paper by J. O. Urmson, "Good of a Kind and Good from a Point of View," which I saw in manuscript in 1961 and which was later published as Chapter 9 of *The Emotive Theory of Ethics* (New York, 1968). I should also like to thank him for comments on a earlier version of his paper. Compare his note added to "What Makes a Situation Aesthetic?" in *Philosophy Looks at the Arts*, ed. Joseph Margolis (New York, 1962), p. 26. I also note that John Hospers has some interesting remarks on the aesthetic point of view in "The Ideal Aesthetic Observer," *British Journal of Aesthetics* 2 (1962): 99-111.

advanced by others (such as that the bridge will fall) in order to focus attention on the set of considerations that *we* wish to emphasize (such as that the sweep and soar of the bridge are a joy to behold).

The "point of view" terminology, however, is more elastic than the "good of its kind" terminology. To consider a bridge or music or sculpture as an aesthetic object is to consider it from the aesthetic point of view. But what about a mountain, a sea shell, or a tiger? These are neither musical compositions, paintings, poems, nor sculptures. A sea shell cannot be *good* sculpture if it is not sculpture at all. But evidently we can adopt the aesthetic point of view toward these things. In fact, some aesthetic athletes (or athletic aesthetes) have claimed the ability to adopt the aesthetic point of view toward anything at all—toward *The Story of O* (this is what Elliot Fremont-Smith has called "beyond pornography"), toward a garbage dump, toward the murders of three civil-rights workers in Philadelphia, Mississippi. (This claim has been put to a severe test by some of our more far-out sculptors.) Perhaps even more remarkable is the feat recently performed by those who viewed the solemn installation of an "invisible sculpture" behind the Metropolitan Museum of Art. The installation consisted in digging a grave-size hole and filling it in again. "It is really an underground sculpture," said its conceiver, Claes Oldenburg. "I think of it as the dirt being loosened from the sides in a certain section of Central Park."[5] The city's architectural consultant, Sam Green, commented on the proceedings: "This is a conceptual work of art and is as much valid as something you can actually see. Everything is art if it is chosen by the artist to be art. You can say it is good art or bad art, but you can't say it isn't art. Just because you can't see a statue doesn't mean that it isn't there." This, of course, is but one of the countless examples of the current tendency to stretch the boundaries of the concept of "art."

The second philosophical use of the notion of the aesthetic point of view is to provide a broad concept of art that might be helpful for certain purposes. We might say: "A work of art (in the broad sense) is any perceptual or intentional object that is deliberately

regarded from the aesthetic point of view."[6] Here, "regarding" would have to include looking, listening, reading, and similar acts of attention, and also what I call "exhibiting"—picking up an object and placing it where it readily permits such attention, or presenting the object to persons acting as spectators.

III

What, then, is the aesthetic point of view? I propose the following: To adopt the aesthetic point of view with regard to X is to take an interest in whatever aesthetic value X may possess.

I ask myself what I am doing in adopting a particular point of view, and acting toward an object in a way that is appropriate to that point of view; and, so far as I can see, it consists in searching out a corresponding value in the object, to discover whether any of it is present. Sometimes it is to go farther: to cash in on that value, to realize it, to avail myself of it. All this searching, seeking, and, if possible, realizing I subsume under the general phrase "taking an interest in." To listen to Beethoven's *Appasionata* with pleasure and a sense that it is "marvelous, superhuman music" is to seek—and find—aesthetic value in it. To read the novel *Exodus* "as literature," and be repelled because it is "vulgar," is (I take it) to seek aesthetic value in it but not find very much of it. And when Geoffrey Scott makes his distinction between different ways of regarding a building, and between that "constructive integrity in fact" which belongs under Firmness and that "constructive vividness in appearance" which is a source of architectural Delight, he adds that "their value in the building is of a wholly disparate kind";[7] in short,

5. *New York Times*, October 2, 1967, p. 55.

6. Compare my "Comments" on Stanley Cavell's paper in *Art, Mind, and Religion*, ed. W. H. Capitan and D. D. Merril (Pittsburgh, 1967), esp. pp. 107-9.

7. Scott, *Architecture of Humanism*, p. 89; compare pp. 90-91, 95. In case it may be thought that architects who have the highest respect for their materials might repudiate my distinction, I quote Pier Luigi Nervi (in his Charles Eliot Norton lectures): "There does not exist, either in the past or in the present, a work of architecture which is accepted and recognized as excellent from the aesthetic point of view which is not also excellent from a technical point of view" (from *Aesthetics and Technology in Building* [Cambridge, Mass., 1965], p. 2). Though arguing that one kind of value is a necessary (but not a sufficient) condition of the other, Nervi clearly assumes that there is a distinguishable aesthetic point of view.

the two points of view, the engineering and the aesthetic, involve two kinds of value.

This proposed definition of "aesthetic point of view" will not, as it stands, fit all of the ordinary uses of this phrase. There is a further complication. I am thinking of a remark by John Hightower, Executive Director of the New York State Council on the Arts, about the Council's aim to "encourage some sort of aesthetic standards." He said, "There are lots of laws that unconsciously inhibit the arts. Architecture is the most dramatic example. Nobody has looked at the laws from an aesthetic point of view."[8] And I am thinking of a statement in the *Yale Alumni Magazine*[9] that the Yale City Planning Department was undertaking "a pioneering two-year research project to study highway environment from an aesthetic point of view." I suppose the attention in these cases was not on the supposed aesthetic value of the laws or of the present "highway environment," but rather on the aesthetic value that might be achieved by changes in these things. Perhaps that is why these examples speak of "*an* aesthetic point of view" rather than "*the* aesthetic point of view." And we could, if we wished, make use of this verbal distinction in a broadened definition: To adopt *an* aesthetic point of view with regard to X is to take an interest in whatever aesthetic value that X may possess or *that is obtainable by means of X.*

I have allowed the phrase "adopting the aesthetic point of view" to cover a variety of activities. One of them is judging: To judge X from the aesthetic point of view is to estimate the aesthetic value of X. Those who are familiar with Paul Taylor's treatment of points of view in his book *Normative Discourse* will note how the order I find in these concepts differs from the one he finds. His account applies only to judging, and is therefore too narrow to suit me. It also has, I think, another flaw. He holds that "taking a certain point of view is nothing but adopting certain canons of reasoning as the framework within which value judgments are to be justified; the canons of reasoning define the point of view.... We have already said that a value judgment is a moral judgment if it is made from the moral point of view."[10]

Thus we could ask of Taylor: What is an aesthetic value judgment? He would reply: It is one made from the aesthetic point of view. And which are those? They are the ones justified by appeal to certain "canons of reasoning," and more particularly the "rules of relevance." But which are the aesthetic rules of relevance? These are the rules "implicitly or explicitly followed by people" in using the aesthetic value-language—that is, in making judgments of aesthetic value. Perhaps I have misunderstood Taylor's line of thought here, but the path it seems to trace is circular. I hope to escape this trap by breaking into the chain at a different point.

I define "aesthetic point of view" in terms of "aesthetic value." And while I think this step is by no means a trivial one, it is not very enlightening unless it is accompanied by some account of aesthetic value. I don't propose to present a detailed theory on this occasion, but I shall extend my chain of definitions to a few more links, and provide some defense against suspected weaknesses. What, then, is aesthetic value? The aesthetic value of an object is the value it possesses in virtue of its capacity to provide aesthetic gratification.

There are three points about this definition that require some attention. First, it will be noted that this is not a definition of "value." It purports to distinguish *aesthetic* value form other kinds of value in terms of a particular capacity. It says that in judging the total value of an object we must include that part of its value which is due to its capacity to provide aesthetic gratification.

The second point concerns "aesthetic gratification." My earliest version of this capacity-definition of "aesthetic value" employed the concept of aesthetic experience.[11] I am still not persuaded that this concept must be abandoned as hopeless, but it needs further elaboration in the face of criticism by George Dickie, whose relentless attack on unnecessarily multiplied entities in aesthetics has led him to skepticism about whether there is such a thing as aesthetic experience.[12] I have tried working with the

8. *New York Times*, April 2, 1967, p. 94.

9. December 1966, p. 20.

10. Paul Taylor, *Normative Discourse* (Englewood Cliffs, N. J., 1961), p. 109.

11. See my *Aesthetics: Problems in the Philosophy of Criticism* (New York, 1958), chap. 11.

12. See "Beardsley's Phantom Aesthetic Experience," *Journal of Philosophy* 62 (1965): 129-36; and my "Aesthetic Experience Regained," *Journal of Aesthetics and Art Criticism* 28 (1969): 3-11.

concept of aesthetic enjoyment instead,[13] and that may be on the right track. For the present, I have chosen a term that I think is somewhat broader in scope, and perhaps therefore slightly less misleading.

Again, however, the term "aesthetic gratification" is not self-explanatory. It seems clear that one kind of gratification can be distinguished from another only in terms of its intentional object: that is, of the properties that the pleasure is taken *in*, or the enjoyment is enjoyment *of*. To discriminate aesthetic gratification—and consequently aesthetic value and the aesthetic point of view—we must specify what it is obtained from. I offer the following: Gratification is aesthetic when it is obtained primarily from attention to the formal unity and/or the regional qualities of a complex whole, and when its magnitude is a function of the degree of formal unity and/or the intensity of regional quality.

The defense of such a proposal would have to answer two questions. First, is there such a type of gratification? I think there is, and I think that it can be distinguished from other types of gratification, though it is often commingled with them. Second, what is the justification for calling this type of gratification "aesthetic"? The answer to this question is more complicated. Essentially, I would argue that there are certain clear-cut exemplary cases of works of art—that is, poems, plays, musical compositions, and so forth—that must be counted as works of art if anything is. There is a type of gratification characteristically and preeminently provided by such works, and this type of gratification is the type I have distinguished above. Finally, this type of gratification (once distinguished) has a paramount claim to be denominated "aesthetic"—even though there are many other things that works of art can do to you, such as inspire you, startle you, or give you a headache.

If this line of argument can be made convincing, we find ourselves with what might be called primary *marks* of the aesthetic: it is the presence in the object of some notable degree of unity and/or the presence of some notable intensity of regional quality that indicate that the enjoyments or satisfactions it affords are aesthetic—insofar as those enjoyments or satisfactions are afforded by these properties. I shall return to these marks a little later, and show the sort of use I think can be made of them.

IV

But before we come to that, we must consider the third point about the capacity-definition of "aesthetic value"—and this is the most troublesome of them all.

The term "capacity" has been chosen with care. My view is that the aesthetic value of an object is not a function of the actual degree of gratification obtained from it. It is not an average, or the mean degree of gratification obtained from it by various perceivers. It is not a sum, or the total gratification obtained from it in the course of its existence. All these things depend in part on external considerations, including the qualifications of those who happen to resort to libraries, museums, and concerts, and the circumstances of their visits. I am thinking in terms of particular exposures to the work—a particular experience of the music, of the poem, of the painting—and of the degree of aesthetic gratification obtained on each occasion. Aesthetic value depends on the highest degree obtainable under optimal circumstances. Thus my last definition should be supplemented by another one: The amount of aesthetic value possessed by an object is a function of the degree of aesthetic gratification it is capable of providing in a particular experience of it.

My reason for holding this view is that I want to say that a critical evaluation is a judgment of aesthetic value, and it seems clear to me that estimating capacities is both the least and the most we can ask of the critical evaluator. I take it that when a literary critic, for example, judges the goodness of a poem (from the aesthetic point of view) and is prepared to back up his judgment with reasons, he must be saying something about the relationship of the poem to the experiences of actual or potential readers. The question is: What is this relationship? When a critic says that a poem is good, he is hardly ever in a position to predict the gratification that particular readers or groups of readers will receive from it. Moreover, he is usually not in a position to generalize about tendencies—to say, for instance, that readers of such-and-such propensities, preferences,

13. "The Discrimination of Aesthetic Enjoyment," *British Journal of Aesthetics* 3 (1963): 291-300.

or preparations will probably be delighted by the poem. If the critic has at his disposal the information required to support such statements, he is of course at liberty to say such things as: "This would have appealed to President Kennedy," or "This is an ideal Christmas gift for your friends who love mountain climbing." But when he simply says, "This is a good poem," we must interpret him as saying something weaker (though still significant) about the capacity of the work to provide a notable degree of aesthetic gratification. For *that* is a judgment he should be able to support, if he understands the poem.

The question, however, is whether the capacity-definition of "aesthetic value" is too weak, as a report of what actually happens in art criticism. I can think of three difficulties that have been or could be raised. They might be called (1) the unrecognized masterpiece problem, (2) the LSD problem, and (3) the Edgar Rice Burroughs problem. Or, to give them more abstract names, they are (1) the problem of falsification, (2) the problem of illusion, and (3) the problem of devaluation.

1. Some people are troubled by one consequence of the capacity-definition—that objects can possess aesthetic value that never has been and never will be realized: "Full many a gem of purest ray serene / The dark unfathomed caves of ocean bear." This ought not to trouble us, I think. It is no real paradox that many objects worth looking at can never be looked at. But there is another kind of aesthetic inaccessibility in the highly complicated and obscure work that no critic can find substantial value in, thought it may still be there. In Balzac's short story "Le chef-d'oeuvre inconnu," the master painter works in solitude for years, striving for the perfection of his greatest work; but in his dedication and delusion he overlays the canvas with so many brush strokes that the work is ruined. When his fellow artists finally see the painting, they are appalled by it. But how can they be sure that the painting doesn't have aesthetic value, merely because they have not found any? The capacity to provide aesthetic gratification of a high order may still be there, though they are not sharp or sensitive enough to take advantage of it.

If my proposed definition entailed that negative judgments of aesthetic value cannot even in principle be justified, then we would naturally mistrust it. But of course this consequence is not necessary. What does follow is that there is a certain asymmetry between negative and affirmative judgments, with respect to their degree of confirmation; but this is so between negative and affirmative existential statements in general. The experienced critic may have good reason in many cases not only for confessing that he finds little value in a painting, but for adding that very probably no one ever will find great value in it.

2. If aesthetic value involves a capacity, then its presence can no doubt be sufficiently attested by a single realization. What a work *does* provide, it clearly *can* provide. And if my definition simply refers to the capacity, without qualification, then it makes no difference under what conditions that realization occurs. Now take any object you like, no matter how plain or ugly—say a heap of street sweepings awaiting the return of the street cleaner. Certainly we want to say that it is lacking in aesthetic value. But suppose someone whose consciousness is rapidly expanding under the influence of LSD or some other hallucinogenic drug happens to look at this heap and it gives him exquisite aesthetic gratification. Then it has the capacity to do so, and so it has high aesthetic value. But then perhaps every visual object has high aesthetic value, and all to about the same degree—if the reports may be trusted.

I cannot speak authoritatively of the LSD experience, but I gather that when a trip is successful, the object, however humble, may glow with unwonted intensity of color and its shapes assume an unexpected order and harmony. In short, the experience is illusory. This is certainly suggested by the most recent report I have run across.[14] Dr. Lloyd A. Grumbles, a Philadelphia psychiatrist, said that while listening to Beethoven's *Eroica*, particularly the third movement, he felt simultaneously "insatiable longing and total gratification." Dr. Grumbles said he also looked at prints of Picasso and Renoir paintings and realized for the first time that "they were

14. In the *Delaware County Daily Times* (Chester, Pa.), February 10, 1967.

striving for the same goal." Now you *know* he was under the influence of *something*.

This example suggests a modification of the definition given earlier: The aesthetic value of X is the value that X possesses in virtue of its capacity to provide aesthetic gratification when correctly experienced.

3. The problem of devaluation can perhaps be regarded as a generalization of the LSD problem.[15] When I was young I was for a time an avid reader of the Martian novels of Edgar Rice Burroughs. Recently when I bought the Dover paperback edition and looked at them again, I found that I could hardly read them. Their style alone is enough to repel you, if you really pay attention to it.

The problem is this: if on Monday I enjoy a novel very much, and thus know that it has the capacity to provide gratification, then how can I ever reverse that judgment and say the novel lacks that capacity? If the judgment that the novel is a good one is a capacity-judgment, it would seem that downward reevaluations (that is, devaluations) are always false—assuming that the original higher judgment was based on direct experience. There is no problem about upward reevaluations: when I say on Tuesday that the novel is better than I thought on Monday, this means that I have discovered the novel to have a greater capacity than I had realized. But how can we explain the lowering of an aesthetic evaluation and still maintain that these evaluations are capacity-judgments?

Some cases of devaluation can no doubt be taken care of without modifying the definition of "aesthetic value." The devaluation may be due to a shift in our value grades caused by enlargement of our range of experience. I might think that *Gone with the Wind* is a great novel, because it is the best I have read, but later I might take away that encomium and give it to *War and Peace*. Or the devaluation may be due to the belated recognition that my previous satisfaction in the work was a response to extra-aesthetic features. I now realize that my earlier enjoyment of detective stories was probably caused only in small part by their literary qualities, and was much more of a game-type pleasure.

15. It was discussed briefly in my *Aesthetics*, pp. 534-35, but has since been called to my attention more sharply and forcefully by Thomas Regan.

But setting these cases aside, there remain cases where on perfectly sound and legitimate grounds I decide that the work, though it has provided a certain level of aesthetic gratification, is in fact not really that good. I have overestimated it. Evidently the definition of "aesthetic value" must be modified again. One thing we might do is insert a stipulation that the work be a reliable or dependable source of gratification: flukes don't count. We need not change the judgment into a straight tendency-statement. But we might insist that the enjoyment of the novel must at least be a repeatable experience. Something like this notion seems to underlie the frequent claim that our first reactions to a new work of art are not wholly to be trusted, that we should wait awhile and try it again; that we should see whether we can find at least one other person to corroborate our judgment; or that only posterity will be in a position to know whether the work is great.

I grant that all these precautions are helpful—indeed, they enable us to avoid the two sources of error mentioned a moment ago: having an inadequately formulated set of grading terms, and confusing aesthetic with nonaesthetic gratification. But I think it ought to be possible for a person, after a single experience of a work, to have excellent grounds for thinking it good and for commending it to others. And I think he would be justified in pointing out that he has found a potential source of aesthetic gratification that lies ready to be taken advantage of—even though he does not yet know how readily, how easily, how conveniently, or how frequently recourse may be had to it. Thus my escape from the difficulty is to revise the definition of "aesthetic value" again so as to stipulate that it is the value of the whole work that is in question: The aesthetic value of X is the value that X possesses in virtue of its capacity to provide aesthetic gratification *when correctly and completely experienced*.

The youth who was carried away by the adventures of Thuvia and the green men of Mars and the other denizens of that strange planet may well have gotten greater aesthetic gratification than the elderly person who returned to them after so many years. For the youth was fairly oblivious to the faults of style, and he filled in the flat characterizations

with his own imagination, giving himself up unself-consciously to the dramatic events and exotic scenery. But, though he was lucky in a way, his judgment of the *whole* work was not to be trusted.

V

We saw earlier that the notion of a point of view plays a particular role in focusing or forwarding certain disputes by limiting the range of relevant considerations. We invoke the aesthetic point of view when we want to set aside certain considerations that others have advanced—as that a poem is pornographic, or that a painting is a forgery—or that (as Jacques Maritain remarks) "a splendid house without a door is not a good work of architecture."[16] But the person whose considerations are thus rejected may feel that the decision is arbitrary, and enter an appeal, in the hope that a higher philosophical tribunal will rule that the lower court erred in its exclusions. How do we know whether being pornographic or being a forgery or lacking a door is irrelevant from the aesthetic point of view? I propose this answer: A consideration about an object is relevant to the aesthetic point of view if and only if it is a fact about the object that affects the degree to which the marks of aesthetic gratification (formal unity and intensity of regional quality) are present in the object.

Thus: Is the fact that a painting is a forgery relevant to a judgment of it from the aesthetic point of view? No, because it has no bearing on its form or quality. Is the fact that a painting is a seascape relevant? Sometimes. It is when the subject contributes to or detracts from its degree of unity or its qualitative intensity. Is the biography of the composer relevant? According to a writer in *The Music Review*, "it is a well-known fact that knowledge of the circumstances surrounding the composition of a work enhances the audience's appreciation.... It is because of this that programme notes, radio comments, and music appreciation courses are in such demand. To secure such knowledge is one of the important tasks of musical research."[17] Now, I'm not

sure that this "well-known fact" is really a fact, but let us assume that it is. Does it follow that information about the circumstances of composition is relevant to consideration of the work from an aesthetic point of view? We can imagine this sort of thing:

> It was a cold rainy day in Vienna, and Schubert was down to his last crust of bread. As he looked about his dingy garret, listening to the rain that beat down, he reflected that he could not even afford to feed his mice. He recalled a sad poem by Goethe, and suddenly a melody sprang into his head. He seized an old piece of paper and began to write feverishly. Thus was "Death and the Maiden" born.

Now even if everyone, or nearly everyone, who reads this program note finds that it increases his appreciation of the song, a condition of appreciation is not necessarily a condition of value. From this information—say, that it was raining—nothing can be inferred about the specifically aesthetic character of the song. (It is relevant, of course, that the words and music match each other in certain ways; however, we know that not by biographical investigation but by listening to the song itself.)

Here is one more example. In a very interesting article, "On the Aesthetic Attitude in Romanesque Art," Meyer Schapiro has argued:

> Contrary to the general belief that in the Middle Ages the work of art was considered mainly as a vehicle of religious teaching or as a piece of craftsmanship serving a useful end, and that beauty of form and color was no object of contemplation in itself, these texts abound in aesthetic judgments and in statements about the qualities and structure of the work. They speak of the fascination of the image, its marvelous likeness to physical reality, and the artist's wonderful skill, often in complete abstraction from the content of the object of art.[18]

Schapiro is inquiring whether medieval people were capable of taking the aesthetic point of view in some independence of the religious and technological points of view. He studies various texts in which aesthetic objects are described and praised, to elicit the grounds on which this admiration is based, and to discover whether these grounds are relevant to

16. *L'intuition créatrice dans l'art et dans la poésie* (Paris, 1966), p. 53.

17. Hans Tischler, "The Aesthetic Experience," *Music Review* 17 (1956): 200.

18. In *Art and Thought*, ed. K. Bharatha Iyer (London, 1947), p. 138. I thank my colleague John Williams for calling my attention to this essay.

the aesthetic point of view. Form and color, for example, are clearly relevant, and so to praise a work for its form or color is to adopt the aesthetic point of view. And I should think the same can be said for "the fascination of the image"—by which Schapiro refers to the extraordinary interest in the grotesque figures freely carved by the stonecutters in Romanesque buildings. These centaurs, chimeras, two-headed animals, creatures with feet and the tail of a serpent, and so forth, are the images deplored by St. Bernard with an ambivalence like that in Lenin's remark about Beethoven: "In the cloister, under the eyes of the brethren who read there, what profit is there in those ridiculous monsters, in that marvelous and deformed beauty, in that beautiful deformity?"[19]

But what of Schapiro's other points—the image's "marvelous likeness to physical reality, and the artist's wonderful skill"? If a person admires skill in depiction, he is certainly not taking a religious point of view—but is he taking the aesthetic point of view? I should think not. No doubt when he notices the accuracy of depiction, reflects on the skill required to achieve it, and thus admires the artist, he may be placed in a more favorable psychological posture toward the work itself. But this contributes to the conditions of the experience; it does not enter into the experience directly, as does the perception of form and color, or the recognition of the represented objects as saints or serpents. So I would say that the fact that the medieval writer admired the skill in depiction is *not* evidence that he took the aesthetic point of view, though it is evidence that he took *an* aesthetic pont of view, since skill was involved in the production of the work.

VI

There is one final problem that may be worth raising and commenting on briefly, although it is not at all clear to me how the problem should even be formulated. It concerns the justification of adopting the aesthetic point of view and its potential conflicts with other points of view. On the one hand, it is interesting to note that much effort has been spent (especially during recent decades) in getting people to adopt the aesthetic point of view much more firmly and continuously than has been common in our country. The conversationists are trying to arouse us to concern for the preservation of natural beauties, instead of automatically assuming that they have a lower priority than any other interest that happens to come up—such as installing power lines or slaughtering deer or advertising beer. And those who are concerned with "education of the eye," or "visual education," are always developing new methods of teaching the theory and practice of good design, with the aim of producing people who are aware of the growing hideousness of our cities and towns, and who are troubled enough to work for changes.

But the effort to broaden the adoption of the aesthetic point of view sometimes takes another form. According to its leading theoretician, the "Camp sensibility" is characterized by the great range of material to which it can respond: "Camp is the consistently aesthetic experience of the world," writes Susan Sontag. "It incarnates a victory of style over content, of aesthetics over morality, or irony over tragedy."[20]

Here is an extreme consequence of trying to increase the amount of aesthetic value of which we can take advantage. But it also gives rise to an interesting problem, which might be called 'the dilemma of aesthetic education." The problem is pointed up by a cartoon I saw not long ago (by David Gerard), showing the proprietor of a junkyard named "Sam's Salvage" standing by a huge pile of junked cars and saying to two other men: "Whattya mean it's an ugly eyesore? If I'd paid Picasso to pile it up, you'd call it a work of art."

The central task of aesthetic education, as traditionally conceived, is the improvement of taste, involving the development of two dispositions: (1) the capacity to obtain aesthetic gratification from increasingly subtle and complex aesthetic objects that are characterized by various forms of unity—in short, the response to beauty in one main sense—and (2) an increasing dependence on objects beautiful in this way (having harmony, order, balance, proportion) as sources of aesthetic satisfaction. It is this impulse

19. Ibid., p. 133.

20. Susan Sontag, "Notes on Camp," *Partisan Review* 31 (1964): 526.

that is behind the usual concept of "beautification"—shielding the highways from junkyards and billboards, and providing more trees and flowers and grass. As long as the individual's aesthetic development in this sense is accompanied by increasing access to beautiful sights and sounds, it is all to the good. His taste improves; his aesthetic pleasures are keener; and when he encounters avoidable ugliness, he may be moved to eliminate it by labor or by law. On the other hand, suppose he finds that his environment grows uglier as the economy progresses, and that the ugliness becomes harder to escape. Second, suppose he comes to enjoy another kind of aesthetic value, one that derives from intensity of regional quality more than formal fitness. And third, suppose he comes to realize that his aesthetic gratification is affected by the demands he makes on an object—especially because the intensity of its regional qualities partly depends on its symbolic import. For example, the plain ordinary object may be seen as a kind of symbol, and become expressive (that is, assume a noteworthy quality) if the individual attends to it in a way that invites these features to emerge. Suddenly, a whole new field of aesthetic gratification opens up. Trivial objects, the accidental, the neglected, the meretricious and vulgar, all take on new excitement. The automobile graveyard and the weed-filled garden are seen to have their own wild and grotesque expressiveness as well as symbolic import. The kewpie doll, the Christmas card, the Tiffany lampshade can be enjoyed aesthetically, not for their beauty but for their bizarre qualities and their implicit reflection of social attitudes. This is a way of transfiguring reality, and though not everything can be transfigured, perhaps, it turns out that much can.

What I mean by the dilemma of aesthetic education is this: that we are torn between conflicting ways of redirecting taste. One is the way of love of beauty, which is limited in its range of enjoyment but is reformist by implication, since it seeks a world that conforms to its ideal. The other is the way of aestheticizing everything—of taking the aesthetic point of view wherever possible—which widens enjoyment but is defeatist, since instead of eliminating the junkyard and the slum, it tries to see them as expressive and symbolic. The conflict here is analogous to that between the social gospel and personal salvation in some of our churches—though no doubt its consequences are not equally momentous. I don't suppose this dilemma is ultimately unresolvable, though I cannot consider it further at the moment. I point it out as one of the implications of the tendency (which I have been briefly exploring) to extend the aesthetic point of view as widely as possible.

But there is another weighty tradition opposed to this expansion. Lenin and St. Bernard stand witness to the possibility that there may be situations in which it is morally objectionable to adopt the aesthetic point of view. A man who had escaped from Auschwitz commented on Rolf Hochmuth's play: "*The Deputy* should not be considered as a historical work or even as a work of art, but as a moral lesson."[21] Perhaps he only meant that looking for historical truth or artistic merit in *The Deputy* is a waste of time. But he may also have meant that there is something blameworthy in contemplating those terrible events from a purely historical or purely aesthetic point of view. Renata Adler, reporting in *The New Yorker*[22] on the New Politics convention that took place in Chicago on Labor Day weekend, 1967, listed various types of self-styled revolutionaries who attended, including "the aesthetic-analogy revolutionaries, who discussed riots as though they were folk songs or pieces of local theatre, subject to appraisal in literary terms ('authentic,' 'beautiful')." That is carrying the aesthetic point of view pretty far.

This possibility has not gone unnoticed by imaginative writers, notably Henry James and Henrik Ibsen.[23] The tragedy of Mrs. Gereth, in *The Spoils of Poynton*, is that of a woman who could not escape the aesthetic point of view. She had a "passion for the exquisite" that made her prone "to be rendered unhappy by the presence of the dreadful [and] she was condemned to wince whenever she turned." In fact, the things that troubled her most—and she encountered them everywhere, but nowhere in more

21. *New York Times*, May 4, 1966.

22. September 23, 1967.

23. I set aside the verse by W. H. Auden called "The Aesthetic Point of View."

abundance than in the country house known as Waterbath—were just the campy items featured by Miss Sontag: "trumpery ornament and scrapbook art, with strange excrescences and bunchy draperies, with gimcracks that might have been keepsakes for maid-servants [and even] a souvenir from some centennial or other Exhibition." The tragedy of the sculptor Professor Rubek in *When We Dead Awaken* is that he so ably aestheticized the woman who loved him and who was his model that she was not a person to him. As she says, "The work of art first— then the human being." It may even be—and I say this with the utmost hesitation, since I have no wish to sink in these muddy waters—that this is the theme of Antonioni's film *Blow-up*: the emptiness that comes from utter absorption in an aesthetic point of view of a photographer to whom every person and every event seems to represent only the possibility of a new photographic image. In that respect, Antonioni's photographer is certainly worse than Professor Rubek.

The mere confrontation of these two vague and general social philosophies of art will not, of course, take us very far toward understanding the possibilites and the limitations of the aesthetic point of view. I leave matters unresolved, with questions hanging in the air. Whatever resolution we ultimately find, however, will surely incorporate two observations that may serve as a pair of conclusions.

First, there are occasions on which it would be wrong to adopt the aesthetic point of view, because there is a conflict of values and the values that are in peril are, in that particular case, clearly higher.

Once in a while you see a striking photograph or film sequence in which someone is (for example) lying in the street after an accident, in need of immediate attention. And it is a shock to think suddenly that the photographer must have been on hand. I don't want to argue the ethics of news photography, but if someone, out of the highest aesthetic motives, withheld first aid to a bleeding accident victim in order to record the scene, with careful attention to lighting and camera speed, then it is doubtful that that picture could be so splendid a work of art as to justify neglecting so stringent a moral obligation.

The second conclusion is that there is nothing— no object or event—that is per se wrong to consider from the aesthetic point of view. This, I think, is part of the truth in the art-for-art's-sake doctrine. To adopt the aesthetic point of view is simply to seek out a source of value. And it can never be a moral error to realize value—barring conflict with other values. Some people seem to fear that a serious and persistent aesthetic interest will become an enervating hyperaestheticism, a paralysis of the will like that reported in advanced cases of psychedelic dependence. But the objects of aesthetic interest—such as harmonious design, good proportions, intense expressiveness—are not drugs, but part of the breath of life. Their cumulative effect is increased sensitization, fuller awareness, a closer touch with the environment and concern for what it is and might be. It seems to me very doubtful that we could have too much of these good things, or that they have inherent defects that prevent them from being an integral part of a good life.

Mary Mothersill (1923-)

The Judgement of Taste

Selected from *Beauty Restored*

> *How are the judgements of taste possible?... This problem of the* Critique
> of Judgement...*is part of the general problem of transcendental
> philosophy: How are synthetic* a priori *judgements possible?*[1]

Although the solution that Kant offers may not be altogether satisfactory, he is right, it seems to me, in locating the central issue of aesthetics; the vagaries of the anti-theorists and their opponents are best understood as the outcome of a failure to face the issue squarely. In what follows, I borrow some terms from Kant, but put off exegetical questions until later. Thus, for example 'judgement of taste' and 'principle of taste' are defined by stipulation. Both were commonplaces of eighteenth-century critical theory, and although he preserves a continuity, Kant transforms them into technical terms fitted out with explanations that suit his theoretical purposes. I want, as it were, to cancel both the Addisonian and the Kantian associations and begin *de novo*. (It may seem cumbersome but the alternatives are no better: neologisms are hard to remember and usually ugly.) In setting out the rules for the use of key terms, I will explain as fully as possible what the point of my various restrictions is supposed to be. The major hazard in this troubled area is covert question-begging, and it is worth a certain amount of tedium to ensure that well-marked barriers are in place.

By 'judgement of taste' I understand either a sentence of a particular form or a speech act that involves uttering such a sentence. (Where the distinction matters it can be drawn, but often in the interests of economy the ambiguity can be left dormant.) The form of a judgement of taste is '*O* is beautiful (has artistic, literary, musical...merit)'. '*O*' is to be understood not as a variable but as a dummy, replaceable by a name, such as 'Chartres Cathedral', or by a description, such as 'the earliest Anglo-Saxon

epic'. The awkward disjunctive predicate is an anti-question-begging device that provides a way for different views to be stated without prejudice. If it should turn out that there is a generic aesthetic property, then we will need an appropriate predicate, and 'x is beautiful' is sanctioned by tradition. If there is no such property, then the predicate can be shelved or reassigned; in the meantime, it is available (like the title for a novel that may never be completed). '*X* has artistic, literary, musical...merit' is designed first for those who believe that art in general has a value that marks it off from anything discoverable in the contemplation of sunsets or seashells, and second for those who hold that each of the fine arts has its own proper excellence and that there need be no common denominator.[2]

The judgement of taste is singular, categorical, and affirmative. A few words about each: (i) *the judgement of taste is singular*. The singularity needs to be emphasized to keep the line clear between judgements and lawlike generalizations. The name or description that replaces '*O*' must name or describe an individual. Criteria for individuality will vary with different sets of ontological assumptions, and there may be alternatives that are equally plausible. I will assume that an individual must have identity conditions, must have properties, and must be eligible to play a role in causal relations. My requirements are satisfied unproblematically by objects, persons, and events. As for 'abstract entities',

1. Kant. *Critique of Judgement*. Trans. Meredith. Oxford: Clarendon Press, 1973: 144.

2. As, e.g., Paul Ziff in "The Task of Defining a Work of Art." *Philosophical Review* 42.1 (1953).

like poems, musical compositions, mathematical proofs, and so forth, their claims to individuality need to be defended. If they can be explained in such a way as to show that they meet the conditions, they will be individuals; if they meet some but not all of the conditions, then their status will be in doubt. Grammatical plurals may figure as subject terms in a judgement of taste only if the generalizations are clearly enumerative, i.e. equivalent to a finite conjunction of singular judgements. Thus, 'All the roses in my garden are beautiful' is allowable, but not 'Roses in general are beautiful'.

(ii) *The judgement of taste is categorical.* In formal criticism, judgements of taste, as flat assertion, occur rather rarely. It is only if, like T. S. Eliot, you think that *Hamlet* is *not*, without qualification, a good play, that it is thought necessary to say so. Comparative judgements are, on the other hand, quite common, and there is an argument, first aired in the *Hippias Major*,[3] that attempts to establish that since beauty is relative—the standards for maidens are different from the standards for goddesses—the comparative form is basic. This claim cannot, on reflection, be true: if O^1 is more beautiful than O^2 then it is true of each that it is beautiful; hence the categorical takes precedence. As for conditional judgements, such as 'O would have been beautiful if the violist's intonation had been better', it seems clear that a satisfactory analysis presupposes an understanding of the consequent.

(iii) *The judgement of taste is affirmative.* Why confine attention to judgements of taste that are affirmative? To add a negation sign is to alter truth value (or whatever valence is appropriate) but not to change the content of a sentence. The justification I offer for the time being is that in surveying the range of traditional conceptions of the beautiful, one gets the impression that although there are differences about what it means to say that something is beautiful, they are less radical than divergent views about what it is that is properly opposed to beauty. What I have in mind is differences of the following sort: Socrates at times speaks of the beautiful and the ugly in the way he speaks of pleasure and pain, namely as directional change along a

single axis; thus if O is more beautiful than O^1, O^1 must be uglier than O. G. E. Moore, by contrast, conceives of the ugly as the polar opposite of the beautiful and maintains that 'an enjoyment or admiring contemplation of things which are themselves ugly or evil' is the first of the greatest positive evils'.[4] Moore also contends that the goodness of beauty and the evil of ugliness are 'absolute' in the sense that the contrast survives the assumption that there is no one and never will be anyone to make the comparison. Thus he asks us to imagine a world that is 'exceedingly beautiful' and then to

> imagine the ugliest world you can possibly conceive. Imagine it simply one heap of filth, containing everything that is most disgusting to us, for whatever reason, and the whole, as far as may be, without redeeming feature. Such a pair of worlds we are entitled to compare...Supposing them quite apart from any possible contemplation by human beings...is it irrational to hold that it is better that the beautiful world should exist than the one which is ugly? Would it not be well, in any case, to do what we could to produce it rather than the other? I certainly cannot help thinking that it would.[5]

Others, again, have held that the lower limit of the beautiful is not the ugly but what is mediocre or drab, and that genuine ugliness is not an aesthetic but a moral offense. Santayana distinguishes the moral sphere, where practical reason and the authority of conscience are set in opposition to wrongdoing and the inevitable evils of life, from the aesthetic sphere—our 'holiday life', the 'reign of freedom', the 'dispensation of grace'[6]—and observes that here

> The values...with which we deal are positive; they were negative in the sphere of morality. The ugly is hardly an exception because it is not the cause of any real pain. In itself it is rather the source of amusement. If its suggestions are vitally repulsive, its presence becomes a real evil towards which we assume a practical and moral attitude.[7]

Yet another view is endorsed by Dewey, who writes:

3. Plato, *Hippias Major*, 289.

4. G. E. Moore. *Principia Ethica*. Cambridge: Cambridge University Press, 1903: 208.

5. *Ibid*, p. 83.

6. George Santayana. *The Sense of Beauty*. New York: Scribners, 1896: 21.

7. *Ibid*.

the non-aesthetic lies within two limits. At one pole is the loose succession that does not begin at any particular place and that ends—in the sense of ceasing—a no particular place. At the other pole is arrest, constriction, proceeding from parts having only a mechanical connection with one another... The enemies of the aesthetic are neither the practical nor the intellectual. They are the humdrum; slackness of loose ends; submission to convention in practice and intellectual procedure. Rigid abstinence, coerced submission, tightness on one side and dissipation, incoherence and aimless indulgence on the other, are deviations from the unity of an experience.[8]

My hunch is that it will be easier to find an account of beauty on which Socrates, Moore, Dewey, and Santayana might concur than to try to resolve their differences about the proper complement of beauty. There is the further point that since beauty is a good, an analysis of beauty is inherently *interesting* in a sense in which the 'humdrum', 'coerced submission', or the *totally* ugly universe are not. Hence for present purposes, the judgement of taste is affirmative.

So much for the requirements. Let us consider where and when they are satisfied. Although not so described by their authors, judgements of taste figure substantially in informal conversations. What do people talk about? Someone who read philosophy but did not go to parties might come to think of 'unstudied utterance' as consisting mainly of factual assertion or ethical debate. Observation would teach him that (except in the most austere circles) people exchange gossip, talk about their jobs, recount adventures and exploits and swap opinions about the merits of current movies, books, fashions, styles of domestic architecture, and so forth. It might be objected that not every casual commendation merits the title of 'judgement of taste' and that if someone says that *M* 'is a good movie', it doesn't follow that he is making an *aesthetic* evaluation. This is true enough, but note the following: (i) if it is a question of providing an explicit definition of the aesthetic predicate (or predicates), then that is something one hopes for as an *outcome* of a theory. In the meantime we depend on our intuitions while recognizing that they often falter. (ii) Though in matters of taste,

as elsewhere, there is a difference between honest, considered opinion and mere chatter, there is no *principle* that will enable us to draw the distinction in practice. Neither topic nor manner of speech affords a reliable clue: serious things are said lightly and witless banality pronounced in a solemn tone. One who is meticulous in judging the cut of a jacket may have nothing but the most perfunctory impressions of a master work. Furthermore, we are often unclear in our own minds about the authenticity and the grounds of our own judgements. One reason that people like to air their views is that in the course of articulating an impression, thereby opening it to objections, one may come to see the matter in a different light. The effort it takes to defend a judgement of taste will sometimes reveal unsuspected sentimentalities and folly.

Explicit judgements of taste, as noted earlier, occur rather rarely in academic criticism or critical theory, since with respect at least to canonical works, a community of taste can be assumed. Critics are therefore free to address themselves to detailed questions of interpretation or to defend one or another variant 'reading'. A better place to look for examples is in the reviews of current goings-on which appear in the popular press. Unlike scholarly critics, reviewers have deadlines to meet and a limited amount of space: they have to arrive at a verdict which, though it may be qualified, will give the reader some clues as to whether a particular book or opera or gallery show is worth the expenditure of time, attention, and money. If there is such a thing as what aestheticians describe as a 'logic or critical reasoning', then it is to the journeymen rather than to the pontiffs that we should look for examples.

Assuming that with native wit as our only guide we hit on what we take to be some central cases, what can we say about them? That they are 'value judgements'? True but unhelpful. 'Normative', perhaps. The 'normative—non-normative' distinction is none too clear, but perhaps in the present case all the better for that: 'normative', ranging as it does over commands, prescriptions, commendations, suitably characterizations, seems just right in keeping open the questions that need to be kept open.

Philosophers whose views are sharply opposed

8. John Dewey. *Art as Experience*. New York: Putnam, 1934: 40.

can agree that the judgement of taste has a normative 'aspect': the question that divides them is the question of how seriously to take that aspect. Consider two extremes, Santayana and Kant: Santayana acknowledges that the normative aspect of the judgement of taste needs to be explained. His account, in summary form, is as follows: a judgement of taste (sentence) is neither true nor false until, by figuring as the content of a particular speech act, it can be assigned to a particular speaker at a particular time. Specification is necessary because the judgement of taste belongs to the genre of confession in that its truth is assured given that the speaker in question is sincere. Why, then, its characteristically non-first-personal form? A mixture, on Santayana's view, of logical confusion and timidity: we allow ourselves to imagine that we can lay down the law although reflection would assure us that 'it is unmeaning to say that what is beautiful to one man *ought* to be beautiful to another',[9] and we do so because most of us are too supine and wedded to conformity to stand up for our own personal preferences:

> the frailty and superficiality of our own judgements cannot brook contradiction. We abhor another man's doubt when we cannot tell him why we ourselves believe.[10]

> If we were sure of our ground, we should be willing to acquiesce in the naturally different feelings and ways of others, as the man who is conscious of speaking his language with the accent of the capital confesses its arbitrariness with gaiety and is pleased and interested in the variations of it he observes in provincials; but the provincial is always zealous to show that he has reason and ancient authority to justify his oddities.[11]

The judgement of taste is, in other words, what Austin calls a 'masquerader': but the disguise is only a disguise and might be doffed:

> If we appealed more often to our actual feelings, our judgements would be more diverse, but they would be more legitimate and instructive.[12]

Thus, in Santayana's view, '*O* is beautiful' (speech act) informs us that the speaker finds *O* a source of pleasure: the connotations are defensive bluster like the pompousness of a minor civil servant.

Kant, on the other hand, views the normative aspect of the judgement of taste not as a sign of human frailty but as signalling the claims of a *kind* of judgement that resists assimilation to first-personal predilections. I may, on Kant's view, preserve my equanimity in the face of the discovery that others do not like the canary wine as much as I do, but when it is a question of whether some particular item is *beautiful*,

> The judgement of taste exacts agreement from every one; and a person who describes something as beautiful insists that every one ought to give the object in question his approval and follow suit in describing it as beautiful.[13]

> To say: This flower is beautiful is tantamount to repeating its own proper claim to the delight of every one.[14]

> In all judgements by which we describe anything as beautiful, we tolerate no one else as being of a different opinion, and in taking up this position we do not rest our judgement upon concepts but only on our own feeling. Accordingly we introduce this fundamental feeling not as a private feeling, but as a public sense.[15]

Both philosophers, if I may put it this way, acknowledge the facts of the matter, namely that the judgement of taste is understood as making a claim on others, that it has what I have called a normative aspect. To discover such an aspect is to take a stand on the question of the meaning or use of the aesthetic predicate, and that is to go beyond what my definitional sketch requires. The judgement of taste is a declarative sentence with a singular subject; nothing in its form distinguishes it from (Kant's example) 'Here is a piece of rock crystal with a movable drop of water in it'. To claim, as both Kant and Santayana claim, that to call something beautiful is to say what ought to be the case is, in this sense, already an interpretation of 'the facts'. '*O* is beautiful' does

9. Santayana, *The Sense of Beauty,* 33.

10. *Ibid.*

11. *Ibid.*

12. *Ibid.*

13. Kant, *Critique of Judgement*: § 23, this volume.

14. *Ibid.*, p. 136.

15. *Ibid.*, § 23, this volume.

not *look* like a command; nor indeed does it look like a confession. On Santayana's view, it is a confused—because logically impossible—command; on Kant's view it is a paradoxical command, one which, if legitimate, stands in need of a transcendental deduction. Each doctrine needs to be set out in detail if it is to be fairly criticized. On the other hand no harm can come from asking oneself at each stage, 'How does it sound so far?' Let us pause, then, in order to make an interim comparative assessment of the two views.

The grounds of Santayana's views are partly conceptual and partly contingent or factual. Suppose we grant the former and agree that 'it is unmeaning to say that what is beautiful to one man *ought* to be beautiful to another'.[16] Let us consider his diagnostic hypothesis which is to the effect that failure to recognize the solecism stems not so much from stupidity, not knowing one's own language and so forth, but from fearfulness about expressing a feeling that may not be shared by the 'authorities'. The timid snobs will thus be divided from the sturdy souls; the latter will be recognized by the fact that either they do not use the term 'beautiful' (or its disjunctive extensions) at all lest they be misunderstood or else when they do use it, they add something on the order of 'Of course all I mean is that *O*, as it happens, pleases me'. The sturdy souls are all, in short, clear-headed 'subjectivists'. Let us suppose that Santayana's claim is testable and not trivially circular. Is it true? My observation suggests that it is not and that one could make a good case for the contrary claim. 'Of course that's only my opinion' is a badge of timidity, not strength. When, in Santayana's words, 'we are sure of our ground', we do not (or anyway need not) 'confess its arbitrariness with gaiety'; we do 'lay claim to universal assent', just as Kant says, and think that a failure to find beauty where we find it betokens lack of sensibility or understanding.

But Kant's view as so far sketched also has its difficulties: let us suspend our assent from Santayana's first claim—after all there is a great variety of 'ought' constructions, and it may be that one of these would give us an interpretation that is not 'unmeaning' of the normative aspects of the judgement of taste. But

much of what Kant says suggests that what he finds in the judgement of taste is a genuine, though implicit *command*, in respect of its generality or scope the counterpart of the categorical imperative. (The grounds, of course, are different; the categorical imperative involves a concept, namely the concept of the good, and is linked with interest, whereas what is beautiful 'pleases without a concept' and is independent of interest.)[17] But what is it that Kant takes to be commanded? It cannot be merely assent (everyone saying 'Yes indeed!') but at least *sincere* assent. '*O* is beautiful' (speech act) is sincere, let us assume, only if the speaker actually takes *O* to be beautiful. So sincere assent on the part of *B* to *A*'s judging *O* to be beautiful requires that *B* find *O* beautiful. To find something beautiful is to appreciate it, and appreciation, as suggested above, comprises affective response. Such response does not seem to be something one could intelligibly *require* of another person, still less could it be the topic of a command. (Kant himself is clear on this point when, in the *Foundations of the Metaphysicians of Morals*, he observes that the term 'love' in the Christian commandment cannot be construed as referring to a feeling since feelings are not subject to command.)[18] There appears, then, to be one clear sense in which Santayana is right: no one can be placed under an obligation to find something beautiful.

Since the general point is admitted by Kant, he must have had something else in mind. What could it be? Appreciation, as has often been said, is not pure passivity; works of art, in particular, are often complex and present a challenge to the understanding. Thus, though it is possible to immerse oneself in serious music as one would in a warm bath, we are sometimes told that it is 'wrong' to do so. Perhaps then, what the judgement of taste requires is that we attend to the object in question, that, as Ziff puts it, we 'contemplate, study and observe'. There is, however, the following difficulty: I do not myself resent advice even if it is unasked, but if I were told that I ought to attend, study, contemplate, or observe some item, I would want to know why: life is

16. Santayana, *The Sense of Beauty*, p. 33.

17. Kant, *Critique of Judgement*, § 4, this volume.

18. Kant. *Foundations of the Metaphysics of Morals*. Translated T.K. Abbot. London: Longman, Green, 1909: First Section.

short. But if attention is what the judgement of taste enjoins, it seems also to offer a rationale: it is because it is *beautiful* that O is worth attending to. Nothing more need be promised.

Perhaps, still looking for a way to understand Kant's idea of an implied injunction, we should think of the judgement of taste as being, like the categorical imperative itself, unconditional. What is commanded is not attention but respect. There is something to be said for this suggestion: works of art do command respect, and if it is hard to say exactly what it means to treat, say, a sonata as 'an end in itself', it is hard also in the case of persons. In the former case, as in the latter, it is fairly clear what is proscribed: one ought not to use a Giacometti for a coatrack or Verdi's *Requiem* as background music for the cocktail hour. But suppose someone says, 'Why not?' Here we have two choices: we can say, 'Because it is beautiful'—which lands us back at square one—or we can take the following line: 'Verdi, Giacometti (whoever) are not only artists but fellow human beings; their work, what they offer to you, is their best and most serious effort; treat it with respect.' But now the difficulty is that we have come, as it were, too *close* to the moral imperative: I agree with Cavell in thinking that we treat works of art in ways in which we ordinarily treat persons (see sect. 2) and also in thinking that this phenomenon is in need of explanation. Of course works of art are not persons but mere objects or events (or abstract entities). But their connection with their authors is peculiarly intimate. Perhaps one should think of them as relicts. Corpses (although the analogy is inept) are relicts and, though mere objects, must be treated in a special way. Many people who were glad that Mussolini was dead and thought he deserved to be killed, were appalled—thought it not just disgusting but wrong—that his body should have been strung up for public display.

In a way it is unmysterious: a work of art is the outcome of someone's intentional, considered, deliberate action, and what could be more personal? (That is why the institutional theorists like to speak of works of art as 'gestures' or 'statements'.) 'Outcome of intentional action' is, however, a description that fits many items—footprints in the snow,

aerosol sprays, the New York subway system, polluted rivers—which are not taken to be works of art. Perhaps what is common to works of art is that they are accepted as gifts and properly received with gratitude. Such gifts don't call for favors in return: the donors may be long dead, anonymous, invisible. (A nonbeliever might feel grateful for natural beauties.) But however vague our focus on the beneficent source or author, to feel gratitude is to feel pleasure. In thinking about the opposition of Kant's views to Santayana's it is important to remember that both take for granted the conceptual connection between taking something to be beautiful and finding it a source of pleasure. And this suggests that though we have yet to find an adequate rendering of the normative aspect of the judgement of taste, there is a common denominator.

Let me use the term 'avowal' to refer to sentences of the form, 'O gives me pleasure', and consider how judgements of taste are related to avowals. Although Santayana's reductionist hypothesis is, as I have argued, *prima facie* false, it is true that to claim that O is beautiful is taken to indicate that one is pleased by O. Is this just a Humean connection based on the observation that in general people turn out to be pleased by what they allege to be beautiful? It would appear not, since any account in which reference to pleasure is suppressed strikes us not as unusual but as parodic and weird. So, if we had pushed the possibility that what the judgement of taste commands is 'respect', we would have had to entertain, in parallel to the moral case of the conscientious misanthrope, the situation of someone acting from a sense of pure aesthetic obligation who sits grimly through hours of music that he loathes or, through an effort of will, forces himself to read three poems a day. Not impossible, perhaps, but certainly not standard, and if the subject were to insist that the works to which he subjected himself were beautiful, we would be at a loss to understand him. But although the connection seems not to be contingent, it is not formal either, or at least, at this stage, we are in no position to speak of 'entailments'. Paul Grices's notion of 'implicature' might serve us here:[19] to the extent that it pretends to be rational,

19. H. P. Grice. "Logic and Conversation." In D. Davidson and G. Harman, Eds. *The Logic of Grammar*. Encino, California: Dickinson, 1975: 65.

conversation is conducted in accord with unwritten rules and conventions that underwrite ellipsis, and on occasion sanction such claims as that a particular speaker 'said that' (for example) the cat is on the mat, even though the words he uttered did not comprise either that sentence or its equivalent. Let us say, then, that the judgement of taste 'implicates' and 'avowal'. '*O* is beautiful' (speech act) implicates '*O* pleases me'. In acknowledgement of its (as yet unanalyzed) normative aspect, we can say that the judgement of taste also 'implicates' a verdict. The legalistic overtones will have to be, for some examples, suppressed: to remark on the beauty of, say, a snowdrift one need not empanel a jury. But artistic merit, which we have been allowing to occupy center stage, *is* contested, often in a somewhat formal way, so perhaps the term will serve.

The anti-theorists, as I have suggested, trade on a thesis which is true and important, namely that there are no principles of taste. No one, except Hampshire, makes the thesis quite explicit; none offers any argument; and when it comes to describing the critical process, they all tacitly adopt a view inconsistent with their best insight. For convenience, I shall refer to the insight as the *First Thesis* (*FT*). Kant, I believe, was the first to state the thesis in a clear and uncompromising way and to recognize it as a cornerstone of philosophical aesthetics. Thus he writes:

> A principle of taste would mean a fundamental premise under the condition of which one might subsume the concept of an object, and then, by a syllogism, draw the inference that it is beautiful. That, however, is absolutely impossible.[20]

What is 'absolutely impossible' is what entails a contradiction, and Kant evidently thinks that *FT* is established by a *reductio* argument. The idea would be that anyone who has caught on to the concept of taste (or of the exercise of taste) will simply *see* that the notion of a principle of taste is an absurdity. What Kant assumes is that the central concept has been adequately analyzed, is in sharp focus, and that there is not likely to be any serious disagreement about how and where boundaries are to be drawn. Of course, not everyone sees the matter in that light,

and Kant's *reductio* argument will not cut any ice with those whose conceptions differ from his or who think that taste is a confused concept or not a concept at all. My own instinct is that Kant is right but that he is not entitled to present his claim as a simple *aperçu*. The first part of the *Third Critique* is famous for the obliquity of its arguments and its apparently haphazard mode of exposition: it is often hard to distinguish premises from conclusions, to know what is to be assumed and what is supposed to have been proved. No doubt some of the exegetical problems are soluble, but I do not think that acceptance of *FT* needs to await their solution. Let us see whether there is not a shorter route.

Such an exercise, it might be argued, is pointless since everyone takes *FT* for granted: no serious aesthetician of today believes in principle of taste. But that, as I argued earlier, is not true: the *term*, indeed, is out of fashion, but Kant's definition is satisfied by the conception of 'good reasons' that provide support for critical verdicts. This conception is openly endorsed by the pro-theorists and, because they do not have *FT* in clear enough focus to appreciate its consequences, allowed by the anti-theorists as well. As a first step toward establishing the truth of *FT*, we have to discover what makes its denial attractive. No one that I know of has actually undertaken to *refute* Kant's claim or even to say explicitly that Kant was mistaken. It *is*, however, argued by the pro-theorists and assumed by the anti-theorists that there *are* principles of taste, and if that is true, then *FT* is false and Kant mistaken. My hope is that in understanding how philosophers are led to this view we shall see that it is untenable, that *FT* is true and Kant correct.

A 'principle of taste', I shall assume, would be a generalization that, if valid, would provide deductive support for a verdict, that is, for the judgement of taste under its normative aspect. Such a generalization would have the form, 'Whatever has property ø is *pro tanto* beautiful (has artistic, musical...merit)'. For stylistic reasons—'principle of taste' suggests outworn dogmas—aestheticians of today prefer to speak of 'critical features', i.e. values for ø. But no feature could be 'critical' unless (in my terminology) some principle of taste were valid. There are differences:

20. Kant, *Critique of Judgement*, p. 141.

Kant speaks of a 'fundamental premise', which suggests complete generality. Current theorists are eager to insist that criteria, to be meaningful, must be relativized to media, genres, art forms, *oeuvres*. Thus the author of 'The Dreariness of Aesthetics' urges a 'ruthlessness in making distinctions'; to discover criteria for 'good literature' we must distinguish literature form history, for example. Gibbon's *Decline and Fall* is not literature; 'the works of Ethel M. Dell' are literature but not 'good literature'. *Alice in Wonderland* is not good literature either:

> this should not be read as condemnation. *Alice* is charming, amusing, a better companion than Dostoyevsky on a desert island, a work of genius, etc., but *Alice* has not the properties possessed by *King Lear, The Brothers Karamazov, The Love Song of J. Alfred Prufrock, Ulysses*, the properties in terms of which we estimate the work of Mauriac, of Graham Greene, of Maxwell Anderson, of Jane Austen, or Priestley, and of Ethel M. Dell, properties regularly referred to by the ordinary critic of films, poetry, drama, and the novel, properties which have clearly been in the mind of those literary theorists from Aristotle on, who have not been content to lose themselves in mystification. If such properties are discoverable, and I think they are, it will not be merely arbitrary to describe as 'good literature' the works that possess these properties.[21]

In similar vein Helen Knight (1949) does better: Passmore does not say what the 'properties' of literature, still less good literature, actually are—which, given his examples, is perhaps not surprising.

> One picture is good for one sort of thing, and another for something quite different...We praise the brightness and clarity of an Impressionist painting, but do not condemn a Rembrandt for lacking these qualities...Suppose we are considering the work of a colourist, a member, let us say, of the Venetian school. We praise it for its subtle nuances of colour and for atmospheric unity, the kind that obscures the contours of things. And if it fails in these respects we condemn it. But of course we do not condemn a fresco painting of the fifteenth century because it has none of these qualities...These examples show that there are a great many alternative standards. To a large extent these are set by the artist or school. We have seen that different pictures are good for different reasons.[22]

Knight's point was reiterated by later writers, such as Kennick:

> we feel no constraint in praising one novel for its verisimilitude, another for its humor, and still another for its plot and characterization.[23]

Pro-theorists are no less eager to stress the diversity of standards. Thus Monroe Beardsley:

> deep space is a good thing in some paintings, while flat space is a good thing in others; different qualities depend for their intensity upon each other. Exactness of perspective in the size-distance relations of figures is needed in a Piero della Francesca or in a Rembrandt etching, where the violation of it in one part of the work would introduce a disturbing disunity; but its violation in a Cézanne still life...is a merit because of the qualities that are obtained in this way. Sometimes the critic can see these things at once, and with a confident perceptiveness. Yet an adequate justification for saying that any feature is a defect or a merit in any work would include an explanation in terms of some general principle about the value-contributions of that feature alone or in combination with others.[24]

The consensus would appear to be that though there may be no criteria that hold across the board and none that are decisive—and in that sense no principles of taste—nonetheless there are and must be, as it were, *little* principles of taste, specified for particular kinds of works of art, festooned with *ceteris paribus* clauses, and to be applied judiciously and not in a merely 'mechanical' way. But if Kant is right, as I think he is, then modesty of scope and recommendations of tact are not to the point: if there are no principles of taste, then there are no 'critical features', and one idea of how to validate judgements of taste must simply be scratched.

On what do the pro-theorists base their claims to the contrary? They offer one simple, unconvincing

21. J. A. Passmore. "The Dreariness of Aesthetics." In William Elton, ed. *Aesthetics and Language*. Oxford: Blackwell, 1954: 46.

22. Helen Knight. "The Use of 'Good' in Aesthetic Judgments." In William Elton, ed. *Aesthetics and Language*. Oxford: Blackwell, 1954: 155.

23. W. E. Kennick. "Does Traditional Aesthetics Rest on a Mistake?" In F. J. Coleman, ed. *Contemporary Studies in Aesthetics*. New York: McGraw-Hill, 1968: 415.

24. Monroe Beardsley. *Aesthetics: Problems in the Philosophy of Criticism*. New York: Harcourt, Brace, 1958: 465.

argument, but what seems to sustain their position is a conception of the relation between criteria and causes which, though not very clear, is interesting and deserves analysis. To begin with the argument: in its simplest form it is to the effect that critical verdicts can be justified only by reference to principles, and that what warrants the claim that, for example, x is a good novel is the true ascription to x of a feature acknowledged as 'criterial'. The alternative is skepticism (or 'subjectivism'), and since that is found unacceptable, it is said to follow that there are principles of taste. The pro-theorists offer no argument in support of the assumption that justification depends on a deductive inference, and this, I believe, is because they take a much more general thesis to be true, namely that to say anything at all about a work of art is to commit oneself to a principle. The general thesis seems to combine two notions; first, that anyone who asserts that x is ø must think that ø is an important feature of x (this I take to be false), and, second, that no predication is secure unless backed by definitional criteria; this prejudice—Peter Geach calls it 'the Socratic fallacy'[25]—apparently still survives. Francis Sparshott, for example, writes:

> One cannot describe a work of art without showing what one thinks important in it. Thus, even a description presupposes a system of evaluation, and such a system when articulated and defended is an aesthetic theory.

> Even if a critic were to confine himself to saying what was good or bad, these assertions would be pointless unless they were based on some principles of judgement. If the critic had no other criterion than the likes or dislikes he found himself happening to have, his use of them as criteria would show that he had a theory about art: the theory that no artistic standards are in principle capable of formulation. And this is a debatable proposition.

> It seems, then, that critical activities of all kinds presuppose theories, in the sense that they are reasonable things to do only if certain theories are true. A critic may be too busy or lazy or stupid, to find out what these presupposed theories are; but that is no reason for him to despise those who are prepared to take the trouble.[26]

Sparshott's claims rely heavily on the unanalyzed relation of presupposition and on an exceedingly loose sense of 'theory'. There is a tiresome pedagogical gambit designed to impress students with the *inescapability* of philosophy: if you can distinguish truth from falsehood, then your distinction 'presupposes' a theory of philosophical logic, even though you may be 'too busy or lazy or stupid' to find out what the theory is. As for 'critical activities' as 'reasonable...only if certain theories are true', consider the critical writings of Henry James, and let Sparshott tell us what the theory is such that, were it shown to be false, James's criticism would thereby be exposed as 'unreasonable'.

A more sophisticated version of the argument appears in Maurice Mandelbaum's 'Family Resemblances and Generalizations concerning the Arts' (1965).[27] Mandelbaum was the first to recognize in print the flimsiness of the anti-theorist position in general and to raise a number of questions about the Wittgensteinian doctrines on which it depends. In commenting on the paper by Paul Ziff, discussed above, Mandelbaum notes that in listing the characteristics of the Poussin, proposed as sufficient to establish something as 'a pictorial work of art', Ziff has been selective; for example, he has included 'has a complex formal structure' but not 'weighs x pounds' or 'has x insurable value'. Hence, according to Mandelbaum, 'Professor Ziff's characterization of the Poussin contains an implicit theory of the nature of the work of art':

> the implicit theory must be assumed to be a theory which is general in import, and not confined to how we should look at this one painting only. Were this not so, the sort of description of the Poussin painting given...would not have helped to establish a clear-cut case of what is to be designated as a work of art.[28]

Here Mandelbaum is not being fair to Ziff: Ziff had attempted to arrive at a 'partial definition' by studying what he took to be a 'central case' and listing the features that seemed to him to *make* it a clear case. Although his paper, as we have seen, has its difficulties, he is surely working in the right direction:

25. Peter Geach. "Plato's *Euthyphro*, an Analysis and Commentary." *The Monist* 50 (1996).

26. Francis Sparshott. *The Structure of Aesthetics*. London: Routledge and Kegan Paul, 1963: 13.

27. Maurice Mandlebaum. "Family Resemblances and Generalizations Concerning the Arts." In Morris Weitz, ed. *Problems in Aesthetics* 2nd ed. New York: Macmillan, 1970: 190.

28. *Ibid.*

he begins with a paradigm and discovers by reflection that its 'complex formal structure' is a salient object of interest; it is tendentious to argue, as Mandelbaum does, that what is offered as a discovery is in fact evidence of prior commitment to a *theory*. Furthermore, granting the vagueness of the term, it seems to me an infelicitous usage that permits a 'theory' to be 'implicit', particularly in cases where one is unable to say, except trivially, what the implied theory *is*.

There is a second and more interesting source from which the pro-theorists draw sustenance: it is the ancient notion that principles of taste are grounded on inductively established 'laws of taste'. A plausible presentation might begin with the distinction sketched above between normative and non-normative aspects of the judgement of taste, between verdicts and avowals. Verdicts call for justification, and one, though not, as claimed, the only possible method of justification would be via principles of taste. Principles of taste, if they were to serve their function, would have to be normative in whatever sense verdicts are normative. Since avowals, if sincere, are true, they do not call for justification nor, as such, for explanation. That someone who is pleased by a work of art or nature should say so, whether in so many words or by way of implicature, is nonsurprising. It may happen however, that a subject *S* finds *O* a cause or pleasure and that *O* being what it is and given what we know about *S*, we find the fact of *S*'s pleasure to need explanation.

Again, if some works of art are found, in Dr. Johnson's phrase, 'to please many and to please long', if people whose interests, sympathies, and commitments are everywhere at odds nonetheless find a particular painting or poem a source of pleasure, such a convergence needs to be explained. A generalization which, if true, would provide a basis for explanation in either of these situations, I would call a 'law of taste'. Such a law would tell us what features of items in a specified class will be *pro tanto* a cause of pleasure to subjects suitably qualified and under standard conditions. (The restrictions are designed to accommodate the interests of aestheticians—a twenty-dollar bill found on the street is something they would want to exclude—and also the requirements of common sense: no item will be pleasing to someone in a deep depression or in the throes of seasickness.)

Given the restrictions, the idea is not on the face of it implausible: Hume (for one) took it very seriously. If 'the same Homer, who is pleased at Athens and Rome two thousand years ago, is still admired at Paris and London',[29] then as between the *Iliad* and its audience, there must be 'a certain conformity or relation between the object and the organs and faculties of the mind'[30] and the basis of that conformity merits investigation: there must be some features of the poem such that given 'the nature of the human frame', it is reasonable to predict that the *Iliad* will continue to be a source of pleasure.

Monroe Beardsley believes that there are laws of taste—he speaks of 'specific canons' for each of the art forms—and 'general canons' that subsume the specific canons.[31] Philosophers who are more cautious incline to the view endorsed by C. I. Lewis, namely that there are laws but they have yet to be discovered.[32] Suppose that Beardsley is right or that some laws are discovered; what would be the consequence with respect to principles of taste? Since principles are invoked to support verdicts, the answer depends on how the force of the verdicts is understood. On the strongest reading of Kant's view, in pronouncing *O* to be beautiful, I prescribe, command, or require the agreement of others, and so the presumptive laws of taste will make little difference. Commands are otiose where compliance is assured. If *O* has ø and if pleasure is the standard response to ø, then I (the judge) can relax and let nature take its course. But suppose that the object I pronounce beautiful is *not* covered by a law of taste; then we would have to imagine the hypothetical principle of taste as having some extrapsychological sanction (which is how Kant conceives the verdict itself). Our supposition would narrow the gap between moral and aesthetic imperatives: although Kant does not, as far as I know, actually say that there are psychological laws connecting desired ends with appropriate actions, the supposition is consistent with

29. Hume, "Of the Standard of Taste," reprinted in this volume.

30. *Ibid*.

31. Beardsley, *Aesthetics*, pp. 464 ff.

32. C. I. Lewis. *An Analysis of Knowledge and Valuation*. La Salle: Open Court, 1946: 469.

his general view of causality in the phenomenal world. But since such connections, if they exist, are 'merely empirical', they have no bearing on the demands of practical reason. The categorical imperative is unconditioned, and despite the fact that, as I have argued earlier, the notion of an 'aesthetic imperative' seems paradoxical, perhaps Kant has a point that could be retrieved.

On the other hand, if, like Santayana, you believe that the verdictive aspect of the judgement of taste is mere window-dressing, then there will be no room for principles of taste (except factitious ones) and the sole theoretical task will be to discover, in Santayana's words, 'what conditions an object must fulfill to be beautiful, what elements of our nature makes us sensible of beauty, and what the relation is between the constitution of the object and the excitement of our susceptibilities'.[33] Santayana, to be sure, evinces no interest in the conception of 'law of taste' which I have described. Not that it was unfamiliar to him—he knew the work of Gustav Fechner and his associates who believed that they had established laws of aesthetic preference on a strictly experimental basis.[34] Santayana's psychology is phenomenological, introspective, and poetic: when he classifies the causes of aesthetic pleasure under the headings of 'matter', 'form', and 'expression', he does not suppose himself to be preparing the way for an exact science that would predict who would be pleased by what under specifiable conditions. But *The Sense of Beauty*, and nothing supersedes it, appeared in 1904. How do things stand today?

Since we lack (as it seems to me) a satisfactory analysis of the general aesthetic predicate (or predicates), we have no clear picture of the relation between verdict and avowal, and hence incline to fudge the distinction—in principle clear enough—between justifying a verdict and explaining a response. We find that outright psychologism (with or without laws) is vulnerable to the open-question test; we think it in order to ask of a novel but not of vanilla ice cream, 'Yes, it is liked by almost everybody, but is it any *good*?' In reply to the obvious next question we mention 'critical features'; if asked to name some, we say that it depends on the class of comparison and that 'different works of art are good for different reasons'. As to what constitutes in general a 'reason', we tend to slip back into a causal or quasi-causal idiom and say that certain properties have been found by induction to be conducive to that special pleasure associated with artistic goodness. The elision of causal and conceptual connections invites an easy answer to the question of relevance. A 'consideration' is relevant if it supports a critical verdict, and to do that it must involve reference to a property that has proved in the past to be a virtue, that is, to contribute to the goodness or artistic merit of works of art. Relevance is thereby tied to principles of taste and principles of taste to laws of taste. A flimsy structure—and if, as I shall argue, there are neither laws nor principles, then the question of relevance will have to be recast or else abandoned.

33. Santayana, *The Sense of Beauty*, p. 13.

34. See K. E. Gilbert and H. Kuhn. *A History of Aesthetics*. Bloomington, Indiana: Indiana University Press: Chapter 18.

Christine Battersby (1946-)

Situating the Aesthetic: a Feminist Defence

For many philosophers writing in the analytic tradition, David Hume, the eighteenth-century Scot, was the father of philosophy. Analogies have been made between his gently ironic account of the psychological origins of metaphysical 'ideas' and Ludwig Wittgenstein's more playful (more modern) scepticism towards metaphysical language and metaphysical problems. But Hume—at least the narrowed-down, tidied-up Hume of the analytic philosophers—was at his least exciting when writing about matters of taste. For this Hume believed that all knowledge derives from experience, and then reduced all questions about a 'standard of taste' to questions about a consensus: in effect, advocating a kind of opinion poll of properly educated connoisseurs with sensibilities fine enough (but not *over*-refined) to be able to respond accurately and adequately to qualities inherent in the object or art-work assessed. Hume compared aesthetic taste to wine-tasting: 'good' and 'bad', 'beautiful' and 'sublime' qualities in objects were discriminated by a highly-trained élite who articulated the preferences of the common man.

Given such an account of aesthetic taste, the radical move into an attack on such a notion is obvious. For who are these connoisseurs? What are their class allegiances? And to what sex and race do they belong? Rejecting notions of objectivity along with those of impartiality, analytic philosophers on the British left have tended to stress that the notion of an aesthetic quality is itself an ideological construct. At its most extreme, this position is transmuted into one that insists that the very category of 'art' is itself oppressive of the working classes. Wittgensteinian notions of language-games and 'forms of life' have been used to buttress reductive claims which are greatly at odds with Wittgenstein's own comments on aesthetic worth.

Wittgenstein countered twentieth-century (German) notions of 'culture'; but without fundamentally disrupting the language of cultural and aesthetic value. By contrast, the British analytic philosopher, Roger Taylor, used Wittgensteinian conceptual analysis to argue that it is a mistake:

> to say, as has been said in the history of aesthetics, that one's society's art is only the art of the upper classes, and that real art is something else... Art is nothing over and above what has been socially established as art. What is called art in our society is art regardless of what future societies call art and, therefore, the supposition ... that our society might have got the art-list wrong assumes, wrongly, that there is something to get right or wrong. The only mistake that can be made is one of not knowing the conventions of the society (i.e. not knowing what society calls art).[1]

In this passage from *Art, An Enemy of the People* (1978), Taylor is implicitly attacking Marx's own notion of aesthetic worth. For Marx (along with most continental Marxists) believed that aesthetic taste can itself be subject to revolution; that there is more to artistic appreciation than the consensus of a majority or an élite; that, indeed, revolutionising attitudes to art can itself be an important instrument of social change. For Marx all art was very far from always being an 'enemy of the people'. Taylor distances himself Marxism. But his polemic is significant, for it demonstrates neatly how the empiricist and analytic approach that is characteristic of British philosophy can so easily reduce all questions of artistic value to ones about the sociology of taste. More-Marxist-than-Marx, all notions of artistic progress are analogously flattened into a polemic about the need to sweep away the very category of art itself.

1. Roger L. Taylor, *Art, An Enemy of the People* (Hassocks, Sussex: Harvester, 1978), pp. 49-50.

It seems to me that philosophers working within this British tradition must bear part of the responsibility for the fact that in English-speaking cultures the question of what might or might not be a part of a radical aesthetic has been rather a side issue in leftist politics. Thus, in post-war Britain philosophical aesthetics increasingly became an area left open to the traditionalists: to right-wing thinkers, such as Roger Scruton, or to those who saw themselves as apolitical—but who did nothing to disturb the political *status quo*.[2] Terry Eagleton's recent book, *The Ideology of the Aesthetic*, reveals that such a position is, at last, changing. In ways that often irritate—but which are nevertheless important as indicators of a social trend—Eagleton has attempted to reposition his own left-wing attitudes towards 'the aesthetic' against a background of aesthetic theory that has reached down to the present from Kant, through German idealism, through Hegel, through Marx and the Frankfurt School.[3]

Given Eagleton's efforts, it might perhaps be considered otiose to spend time criticising Taylor's rather dated form of reductive aesthetics...except for the fact that some of the most sophisticated and influential feminist theorists of the arts can still sound as crude as Taylor when the subject of aesthetic value comes into play. In this paper I will defend the traditional subject matter of aesthetics against those Marxist and socialist feminists who think that they need to take a position 'beyond' or counter to feminist aesthetics. But my defence of aesthetics will be undertaken with a radical end in view. For I believe that feminists need to work towards a fundamental revaluing of all aesthetic values. And I thus advocate a *revision* of notions of aesthetic worth that is at odds with the *excision* of

such categories advocated, for example, by Griselda Pollock.

Pollock's importance to feminist art theory (including my own) can hardly be overstated. She makes theoretical distinctions far in advance of those of Taylor, and would scorn his use of Wittgensteinian techniques of linguistic analysis. Nevertheless, in her essay on feminist art histories and Marxism in *Vision and Difference*, Pollock adopts a stance towards 'Literary appreciation and art-history-as-appreciation' as dismissive as Taylor's attitude to art itself. For her the concern 'with quality—i.e. positive and negative evaluations of artefacts'—condemns both these disciplines out of hand. Pointing out that art by women has historically been assessed as poor quality art, Pollock remarks:

> ...feminists are easily tempted to respond by trying to assert that women's art is just as good as men's; it has merely to be judged by yet another set of criteria. But this only creates an alternative method of appreciation—another way of consuming art. They attribute to women's art other qualities, claiming that it expresses a feminine essence, or interpret it by saying it tends to a central 'core' type of imagery derived from the form of the female genitals and from female bodily experience. All too familiar formal psychologistic or stylistic criteria are marshalled to estimate women's art. The effect is to leave intact that very notion of evaluating art, and of course the normative standards by which it is done...
> I am arguing that feminist art history has to reject all this evaluative criticism and stop merely juggling the aesthetic criteria for appreciating art. Instead it should concentrate on historical forms of explanation of women's artistic *production*.[4]

Although feminists have evaluated art-works and whole art-genres from either moral, prudential or straightforwardly political perspectives, within feminist art and literary history there has been no sustained attempt to develop a feminist theory of aesthetic value. Indeed, the whole topic has been neglected ... apart from a certain seepage from French theoreticians whose projects are often equated with 'feminist aesthetics'. This conflation is (rightly) one

2. Roger Scruton's *Art and Imagination: A Study in the Philosophy of Mind* (London: Methuen, 1974) ends with the phrase 'ethics and aesthetics are one'. But the space that Scruton thus makes for a political dimension in aesthetics is not left-wing.

3. Terry Eagleton's *The Ideology of the Aesthetic* (Oxford: Blackwell, 1990) is uneven in detail and conception. The book does, however, have merits—particularly in signalling a new openness to the aesthetic (that comes not just from Eagleton, but from the prestigious list of professional philosophers consulted by Eagleton, and acknowledged in his introduction).

4. Griselda Pollock, *Vision and Difference: Femininity, Feminism and Histories of Art* (London: Routledge, 1988) p. 26-27.

of the targets of Rita Felski's attack in *Beyond Feminist Aesthetics*, since the most influential of these writers (Kristeva and Cixous) are concerned with describing a *féminin* attitude which has more to do with culturally constructed notions of 'the feminine' than with being either female or feminist.[5] Thus Cixous notes that, in the past, it was more likely to be male authors than female authors whose works fall into the approved category of the *féminin*.[6]

Luce Irigaray, whose work can be more sensibly read as working towards a feminist aesthetics, has been less influential. Too easily heard as a philosophical essentialist, her project of speaking *as a woman* has to be understood in terms of her rejection of such philosophical 'masters' as Plato, Kant, Freud and Derrida.[7] But in English-language cultures—cut off from the philosophical traditions out of which Irigaray emerges—the notion that an aesthetic evaluation might be feminist (and not be simply a sociological report or a moral or political judgement) is found somewhat baffling. Thus in the above-quoted passage Pollock presents the feminist aesthetician with a false dichotomy: she must *either* eschew all aesthetic value judgements, *or* lapse into essentialism and formalism.

But why must any feminist revaluation of the notion of aesthetic value treat female bodies and experience in a biological way and/or adopt the old values of patriarchal art? Why does Felski (illegitimately) entitle her (legitimate) attack on essentialist and formalistic tendencies in feminist literary criticism *Beyond Feminist Aesthetics*? Why has 'aesthetics' become a dirty word to those on the left in

English-language cultures? Radical responses appear to have been based on non-radical readings of the history of philosophy. There are other ways of understanding that history which will help us begin to disentangle those elements of past aesthetics which need to be preserved, and those which must be either abandoned or transformed for the purposes of a feminist aesthetics.

In its original (eighteenth-century) meaning, the subject-matter of aesthetics was the 'science of the senses'. The word 'aesthetics' comes to us from the German theorists (particularly Baumgarten and—most influentially—Immanuel Kant), rather than from empiricists like Hume who did not believe a 'science of taste' was possible. The German inventors of this branch of philosophy were not concerned to discover how it might be possible to reach universal conclusions (valid for all persons) on the basis of individual, immediate (= passive and unconceptualised) sense experience. I think the hostility that feminists (and Marxists) often feel towards the notion of aesthetic evaluation comes, in part, from a confusion of 'aesthetics' with 'aestheticism'. But it is only contingently—via the Kantian system—that aesthetics became allied with an aestheticist attitude towards the world.

As Kant explains in the *Critique of Judgement* (1790), a purely aesthetic judgement has eight characteristics. Firstly, it is made up from feelings of pleasure and pain. Secondly, it is immediate. In other words, although it is possible to rationalise aesthetic judgements after the fact, the judgements themselves are not based on a reasoning process. Thirdly, such a judgement is particular; it involves an individual experiencing subject responding to a unique object. Fourthly, the judgement is non-conceptual. Aesthetic response is said to be imaginative, and not based on the understanding of rules. Fifthly, aesthetic judgements are subjective—despite the fact that they also appear to have universal validity, and to apply not only to oneself, but to all experiencing human subjects.

According to Kant—and this is the sixth point—this universality is possible because the purely aesthetic response abstracts from the merely contingent features of the experience (from that which is

5. Rita Felski, *Beyond Feminist Aesthetics: Feminist Literature and Social Change* (London: Hutchinson Radius, 1989).

6. Hélène Cixous, *Writing Differences: Readings from the Seminar of Hélène Cixous*, ed. Susan Sellers (Oxford University Press, 1988), p. 25. For more on this topic see my *Gender and Genius: Towards a Feminist Aesthetics* (London: The Women's Press, 1989; Indiana University Press, 1990).

7. Diana Fuss, *Essentially Speaking: Feminism, Nature and Difference* (London: Routledge, 1990) usefully defends Irigaray from such a reading. Fuss and Whitford (whose *Luce Irigaray: Philosophy in the Feminine* and *Irigaray Reader* will be appearing shortly) have persuaded me that I should have placed more emphasis in *Gender and Genius* on the differences between Irigaray's position and those of Cixous and Kristeva.

historically variable and accidental). The purely aesthetic response transcends all emotion and all 'charm' or 'attraction' exerted by the object on the observer. Indeed, in its purest form even the existence of the object was seen as irrelevant to the aesthetic attitude. There could be no question of taking into account the object's use-value or its material value. Kant calls this transcendent attitude 'disinterested'.[8]

The seventh point is that for Kant it is the 'formal' features of the object that provide the focus of the aesthetic attitude. And, as always in Kant, form—that which makes a thing what it is and not something else—is explicated in terms of the space-time characteristics of the world. These characteristics are not straightforwardly 'out there', but are read onto the world by man's productive imagination. Finally, as an eighth point, it should be pointed out that for Kant the purest kind of aesthetic response—the pleasure in the 'beautiful'—is based on a 'disinterested' appreciation of the harmony that is implicit in the form of an object. It is a response to that which makes an object a whole and not simply a multiplicity of parts. But since form is itself a product of the human imagination, what man is in effect taking pleasure in is the mind's power over nature.

I should add as an important addendum to this that Kant also registers that there are other less pure forms of aesthetic pleasure. His key example is that of the 'sublime', which involves a response to the terrifying (to gaunt mountains, thunder, storm-ridden seas, earthquakes, etc.). Here the pleasure comes from the overcoming of threat and of pain: of registering that the world is constructed by the imagination as an unknowable infinity which, at any moment, threatens to overwhelm the ego and reveal to the self its limits. But since the sublime involves registering this threat and transcending this threat, the enjoyment of the sublime is itself also an enjoyment of power over nature.

From a feminist point of view there are many aspects of Kant's analysis that require criticism, since the ties that Kant makes between aesthetic pleasure and power are gendered through and through.[9] But it is, I believe, his notion of a 'disinterested' withdrawal from all material and use-value that has done most to bring the notion of the aesthetic into disrepute. For, during the nineteenth century, the aesthetic movement developed this notion of Kant's to an extreme. The aesthetic was equated with a particular attitude of mind: with a blanking out of moral, social and political considerations...and with an indifference to bodily dictates and needs. But disinterest is not integral to the notion of the aesthetic in its original meaning of a 'science of taste', and is a mode of artistic evaluation that feminists can and must revise and resist. For it by no means follows that to deny that aesthetic judgements are disinterested is to deny that there are no evaluative standards that can be developed to discriminate between adequate and inadequate responses to art-works...or good and bad art-works.

Aesthetic evaluation comes in many forms. There is, for example, the type of evaluation that I analysed in *Gender and Genius*: that of deciding which artists deserve to be counted 'great', 'important' or even 'geniuses'. I argued there that present-day women artists will suffer unless we recognise how gendered the standards are that are used to determine which artists are 'great', and unless feminists develop some alternative standards for aesthetic discrimination. Since these ideas have been developed much more fully elsewhere, I want here to focus on other, more pervasive, modes of aesthetic evaluation, starting with the evaluative element that is built into the *descriptions* of particular qualities of an art-work. Thus, claims about an art-work's 'authenticity', 'originality', 'delicacy', 'forcefulness' or 'subtlety' are not purely 'factual' statements that can be straightforwardly verified or falsified. All

8. This is where Kant's mature position in the *Critique of Judgement* (1790) diverges from that of his early essay 'Observations on the Feeling of the Beautiful and Sublime' (1764). In the early work all beauty has a fundamental grounding in attraction (especially sexual attraction), and women are the paradigm examples of the beautiful. In the late work women are still positioned as beautiful. But the link is much more problematical, since an appreciation of them as sexual objects has to transcend all charm and sexual appeal.

9. *Gender and Genius* begins this task. But there I concentrated primarily on the continuities, rather than on the differences, between Kant's early and late positions: i.e. that in both women are excluded from the production and pleasures of the sublime.

these terms fuse factual and descriptive elements in ways that make interpretation—and even apparently neutral descriptions—evaluative through and through.

There is, of course, *some* descriptive element in the use of a word like 'authentic'. To say that a blues song is authentic is not simply to say that one approves of it or that other people approve of it. 'Authenticity' is not just a quality in a musical composition that can be heard in an immediate way by a listener with suitably trained ears—although it is of course true that this is a judgement that is often made fairly instantaneously. 'Authenticity' involves situating the musical composition or performance in terms of a variety of *traditions* which are themselves evaluated as expressions of uncontrived emotion and/or character. We are dealing here with a highly complex value judgement of an aesthetic type which involves reference to standards; and I would thus reject Kant's notion that aesthetic judgements must be 'immediate', must abstract from all sensual appeal, and concentrate (in an utterly 'disinterested' way) on the 'form' of an object.

Since I accept neither 'immediacy' not 'disinterestedness' as integral aspects of aesthetic judgement, it might be felt that I have moved so far away from traditional notions of 'aesthetic value' as to make my own position anti-aesthetical. But I would resist such a conclusion. Indeed, I would wish to go so far as to say that there is no way of escaping the necessity of judging aesthetically, and that there is no value-neutral critical space from which feminists can speak. Even to give priority to political, ethical or utilitarian value judgements over aesthetic judgements is, in effect, to opt for a particular variety of aesthetic value.

For me aesthetic evaluation takes place in the context of certain evoked *traditions* which bring along with them *standards* for discriminating particular qualities and features of art objects. I certainly would not want to move back to a form of pre-Kantian empiricism in which judgements of taste are simply represented as passive responses to pre-given 'objective' qualities which cause either like or dislike... and in which the only role for the artistic critic would be to either discover or refine the social consensus.

This is because to evaluate a painting favourably is not simply to say that one likes it, that others like it, or that an élite of critics like it. An evaluation is not a report (either about external properties or about the state of mind of the observer). There is no contradiction in English in saying, 'I think Bacon is a great painter of the nude, but I can't stand him.'

To evaluate is not to describe what one *does* like or think, but what one *ought* to like or think. It is to set up an ideal observer as a standard of comparison; against which one's own (and others') likes and dislikes are to be judged. Sociologists of taste who seek to establish an equivalence between aesthetic judgements and records of social consensus have to refuse this crucial distinction between the ideal and the real. Hence Pierre Bourdieu's complaint that Kant's *Critique of Judgement* remains grammatically locked 'in the register of *Sollen*, "ought"'.[10] In his *Distinction: A Social Critique of the Judgement of Taste* (1979), Bordieu uses questionnaire techniques in an attempt to reduce Kantian aesthetic preferences to factual claims about the attitudes and judgements of the French high-bourgeoisie.

Aesthetic judgements are not expressions of like or dislike by actual, historical individuals. They are expressions of approval or disapproval by *ideal* individuals by reference to standards derived from *traditions* (which are not simply there as 'historical givens', but which have to be constructed by the observers). Feminist art and literary critics have shown that there are traditions of female art that run alongside (and between) the dominant traditions of art selected by the high-bourgeoisie. These matrilineal lines of influence and pattern need to be made visible, so that productions by women can be made more comprehensible and be better assessed by 'ideal observers' who judge the art-work in viewing conditions that are as-near-as-possible ideal, and in terms of a range of knowledge, experience, sensitivity and emotion that are appropriate for the art-work under observation. It is against these norms that all one's responses to the art-work have to be judged.

I am not claiming that these ideal observers actually exist, nor that for all art there is only one ideal

10. Pierre Bourdieu, *Distinction: A Social Critique of the Judgement of Taste* (1979), trans. Richard Nice (London: Routledge, 1986), p. 488.

observer (with only one range of experience, of sensitivity, of emotions and knowledge). It seems highly implausible to suppose that the ideal observer of a building by Le Corbusier would require the same qualities of mind and of knowledge as the ideal observer of a portrait by Angelica Kauffman. Whether each art-work has only *one* ideal observer (i.e. whether aesthetic evaluations are universals) is a matter for debate. Personally, I would want to say that there is more than one valid response to each art-work (which is not to say, of course, that all responses are equally valid). But, as a feminist, I would also want to say that my ideal observers are not 'gentlemanly connoisseurs'. Instead, my own ideal posits observers with experiences and life-histories that have led them to empathise with art produced at the margins, and in opposition to the prevailing rhetorics of exclusion. An engagement with feminist theory and practice might produce such an openness of response; but so, too, might poverty or an involvement with the issues of 'black' and 'third-world' peoples.

There is also no reason whatsoever why an 'ideal' observer should be theorised in a Kantian fashion as transcending or lacking emotion or sexual appetite—or as solely rational. To make such moves would be to downgrade matter, emotionality and the 'feminine' in ways that require a feminist analysis and a feminist critique. But neither, I would wish to insist, can a feminist aesthetics be simply equated with a reversal of the old hierarchies that placed (masculine) form and rationality over (feminine) emotion and matter. I haven't time to provide a full critique of such notions here; I would simply point to the arguments in *Gender and Genius* where I show that, in the field of aesthetics, 'feminine' characteristics were long ago appropriated by male artists in ways that disadvantaged female artists in the history of culture.

I can't close this paper, however, without mentioning a further way in which evaluation creeps into the most apparently value-neutral descriptions of art; and that is via the notion of an 'Artist'. Gombrich opened his best-seller, *The Story of Art*, by suggesting that there is really no such thing as 'Art', only a series of artists. Against him I argue that there really is no

such thing as an artist, only a series of art-works that critics hold together via the notion of an *oeuvre*. Not everything that is produced by those working in the arts gets counted into an *oeuvre*. Sketches for paintings sometimes count; but graffiti, doodles and marginalia are usually excluded. And so is the entire output of some individuals whose work is explained in terms of certain already-established traditions: 'Schools', 'Circles', 'Tendencies' or 'Movements' or 'Genres'. For the concept of an *oeuvre* is itself an evaluative category which looks to the notion of an individual's life, development and maturation to explicate the phenomenon of *unity through change*.

It is the notion of unity through change which we need to focus on to understand this difficult notion of an *oeuvre*. For an artist to have an *oeuvre* implies that there is some shape to his life, and that there are historical, geographical and social explications that can explain why this individual remains the same individual despite the myriad changes, pieces and contradictions which mark his or her work. An artist who is not credited with an *oeuvre* is one whose art-works have been treated in isolation (not as fragments of a fully individual, psychically rich self), or whose art-works have been treated as the product of non-individual collectives. It is not that an *oeuvre* is not located in terms of tradition, but that the *oeuvre* is considered as non-reducible to the traditions which the artist adapted or employed. Indeed, the great artist is precisely the one who is seen to mark the tradition in ways that determine the boundary between the old and the new. In Kant's famous phrase: 'The genius gives the rule to art.'

There have been sex-differential erasures from the history of the arts. The *oeuvres* of women artists and authors have disintegrated, since they have been seen to lack form: that which shapes matter, binds the accidents together into a unity, and makes a thing what it is and not something else. Women's works have been scattered and dispersed to a much greater extent than those of (white) males. The concept '*oeuvre*' has been used in gender-discriminatory ways. Nor is this simply because of the material disadvantages under which women produced their art. Inherent in the notion of an *oeuvre*—and hence built

into the notion of an 'artist'—is a value judgement: a notion of a significant, important or (at least) interesting expression of a fully-human self. But since our ways of judging human maturation take the male personality as both norm and ideal, women have had to struggle to get their art-works interpreted in such generous ways.

As a philosopher I will not be happy until feminist critics register the centrality of aesthetic value judgements at every level of discussion and response to cultural production. For I see it as an urgent task to work out ways of theorising aesthetic value so as to benefit women in the arts. But as a feminist I will not be happy until philosophers recognise the deep level at which aesthetic value judgements are gendered. Amongst the humanities subjects in Britain philosophy has been perhaps the slowest to open itself up to feminist transformations; and of the various fields of feminist philosophy in other English-language cultures, feminist aesthetics is amongst the least developed. But feminist philosophers have an important role to play in exposing the many ways in which gender issues disturb and pervert what in our culture gets categorised as 'Art' and who gets seen as 'an Artist'.

My own task then as both a philosopher and a feminist is to reform our notion of 'aesthetic value' in such a way as to benefit women. And that means that I am fundamentally opposed to Roger Taylor's idea that all art is an enemy of the people; to Griselda Pollock's claim that feminists must reject all forms of aesthetic value; and to any suggestion that the way ahead lies 'beyond' feminist aesthetics. As both a feminist and a philosopher I am, therefore, not ashamed to situate myself in a tradition of theorising the arts that reaches back to Immanuel Kant. Indeed, I believe that this is what must be done if we are to discover how feminists can (collectively) transform our notion of aesthetic values.

Obviously, this is a large task; and it is not one that any one person can do alone—especially since we lack most of the basic historical scholarship that would reveal gender bias in the history of our aesthetic vocabulary. Terms like 'universal', 'rational', 'abstract', 'form', 'structure', 'matter', 'organic', 'natural', 'functional', 'imaginative', 'beautiful', 'sublime' are commonly used in art criticism; but all require a feminist analysis of the type that I have elsewhere supplied for 'genius'. And so do such apparently innocuous terms as *oeuvre*. I am therefore glad to have had a chance to signal the scale of the tasks ahead. Feminist aesthetics must fracture the ideal of one universal, historically-timeless canon of 'great art' discoverable by any 'disinterested' observer...and must also resist the rhetoric of one universally constant, unchanging 'feminine essence' governing art by women. But holding these resistances in tandem is not contradictory. To assert both these things together does not mean that we must conclude that feminist aesthetics cannot exist.

The Task of Definition

Part 3: The Task of Definition

Introduction

The eight selections in this section deal with the problem of defining art. Whereas Collingwood thought that a theory of art needed to define art in terms of a set of necessary and sufficient conditions, many philosophers today think that the subject matter of art is too diverse for any definition. It may be argued that 'art' is an open concept in the sense that it can be extended to new contexts of use, rather than be explicitly defined. In addition, much contemporary art appears to be aimed at transcending limits and breaking boundaries. Thus for any claim that art must possess some particular set of characteristics one can imagine a body of art works which explicitly aim to refute that claim. Because a number of contemporary analytic philosophers ground their objections to definition in Wittgenstein's 'family resemblance' account of concepts, the first selection consists of two sections from his *Philosophical Investigations*.

The Austrian logician and philosopher Ludwig Wittgenstein (1889-1951), one of the most charismatic and powerful figures in twentieth century philosophy, introduces the notion of family resemblance as part of a sustained attack on the assumption that language has a universal form. There is no common element to the various forms of language in virtue of which they are instances of language. Wittgenstein makes this claim by way of the analogy of game play, but his text reads as successfully if one substitutes 'art' for 'game'. Do not assume, he argues, that there is something common to all games in virtue of which they are games. Instead look and see. What you will find is an 'overlapping and crisscrossing', a set of resemblances of the sort you would find amongst the members of a family. In the second piece from *Philosophical Investigations*, Wittgenstein discusses a kind of seeing of central importance in aesthetics, aspectual seeing. When I notice an aspect of a thing, it comes to look quite different than it did before, though in a sense it is unchanged; when I come to see a figure in a painting as a person the painting is transformed; it is changed still more if I see the person as someone known to me. Drawings and texts are aspectually multi-stable. Some, like Necker cubes and the duck-rabbit can be seen in several radically different ways; similarly, sentences like "they were visiting doctors" (which can mean that doctors were visiting someone or that some people had gone to see doctors) are grammatically multi-stable. But multi-stability is much more pervasive than this: a sentence meant ironically conveys the opposite meaning of the same sentence meant non-ironically; we hear notes as melody, and so on. Perceptual multi-stability involves seeing a structure supervene on the perceived parts. The perception of structure in a perceptible is central to aesthetic judgement. Seeing-as and family resemblance are closely related phenomena, since seeing the resemblance is an instance of seeing-as.

The second selection, from Stanley Cavell's *The Claim of Reason*, is a subtle reflection on the role of these Wittgensteinian concepts on the learning of language and on extending the use of terms into new contexts. Stanley Cavell (1926-), a philosopher of language, literature and film at Harvard University, argues that we take too much for granted about language learning when we think of it as being taught the names of things. As a child's linguistic capacities grow, her world grows as well: she learns not only the names of things but what things there are, not only how to express a wish, but what a wish is, what love is, and so on. As a child follows her teachers into language she is initiated into the forms of life held in language. Language is not determined everywhere by rules: there are always new contexts, new needs, and new possibilities for self-expression. After we have been initiated into language and gained mastery of this form of disclosure of what is, language remains open, tolerant of new projections. It is not, says Cavell, completely open: the things disclosed by a word have a family resemblance, and although there is no closure on what can count as such a resemblance, not just anything will count. As our language is open to new forms of disclosure, so is our world, and through language in its revelatory or poetic uses, our world—or we ourselves—are enlarged.

Arthur Danto (1924-), philosopher and art critic, is professor emeritus at Columbia University and a strong proponent of the philosophical importance of contemporary art. The selection here, "Artworks and Real Things", is one of several pieces by Danto which have become classics in the area of pushing back the boundaries of art. Danto challenges the philosophical distinction between art and reality, arguing that much recent art cannot be understood as a representation or imitation of antecedently existing real objects, but must instead be seen as the creation of new ones. Such works are real objects which are separated from the non-artistic not by any presentable aesthetic property but by their intentional inclusion in the 'artworld' of artworks. Warhol's brillo boxes, although made of wood, could hold brillo pads; Duchamp's *Fountain* could be used as a urinal (after all, it *is* a urinal). *Fountain* differs from any other urinal only in having been given a title and selected for exhibition by an artist; in its place in the gallery it makes a statement which no other urinal does, but not because of its aesthetic properties. What features does a work need to possess to enter the artworld? By means of a series of examples, Danto suggests that for a thing to be a work, an artist must make a statement by means of it, and the possibility of that will depend upon not only the artist but the history of art at that point. Art history must be ready to enfranchise the work. Danto uses these observations to distinguish art from copies, fakes and imitations. When something becomes a work it becomes subject to an interpretation. That interpretation depends upon the state of art theory, competent observers, and an art-historical location for it. The claim to being art, like other entitlements, can be defeated. A fake, like the quotation of a statement, fails to say what the work it copies does, even if photographically identical to it. Like the sounds "I love you" issuing from a parrot, it fails to stand in the right relations to the artworld and is mere noise.

Danto's provocative pieces stimulated much theoretical response, including the next two selections. The first, "The Art Object", by Barbara Savedoff (1956-), a philosopher at Baruch College of the City University of New York, criticises theorists like Danto for their over-emphasis on the role of theory in the identification of works as

art, to the neglect of the object itself. Through of a discussion of concrete examples, Savedoff argues that the aesthetic properties of a work are generally an essential element in that work's ability to sustain one interpretation instead of another. She argues that while Danto is correct in taking the interpretation of a work to be determined by its art-historical context, the properties of the piece help determine the role of that context. Savedoff does not reject the claim that the aesthetic properties of the work are sometimes irrelevant, but argues that over-emphasis on theory is destructive of good art criticism. When works become merely opportunities for presenting theories, they cease to function as art.

George Dickie (1926-), a philosopher at the University of Illinois at Chicago, has made many important contributions to contemporary analytic aesthetics, including his critique of the aesthetic attitude and his institutional theory of art, here presented in "The New Institutional Theory of Art". Like Danto, Dickie tries to give a definition of art the essential properties of which do not include the presentational features of the work. The feature he focuses on is that of having been created to be presented to an artworld public. Works, both of the representational kind and the more problematic kind which Danto has discussed, are artifacts. Furthermore, they have a place in the art-historical world. An artist makes the artifact for presentation to a public and for presentation as art. The institutional theory thus gives a special place to the intentions of the artist: art is an artifact created with certain intentions. Dickie's institutional theory does not fall prey to counterexamples in the way traditional content-based theories do. Indeed, it is tailor-made to avoid defeat by works like Duchamp's *Fountain*. On the other hand, the theory says little about artworks themselves, and thus says little to explain what artworks are for and why we should care about them. Many philosophers will prefer a theory with more explanatory power and pay the price of failing to capture everything which is called art.

In "On Defining and Interpreting Art Intentionalistically", Susan Feagin (1948-), an aesthetician at the University of Missouri, Kansas City, discusses an argument that an artist's having certain intentions is a necessary condition for a given interpretation of a work, which she calls the argument from definition and value. We value artworks because they are intentional creations made by human beings for reasons; unless we were interested in intentional behaviour we would have no interest in art, which is after all the product of human endeavour to achieve some goal. This view of art is persuasive and valuable but it doesn't capture everything we care about in art; the public character of artworks and the privacy of intentions ensures that other factors will compete with the artist's intentions. The institutional and intentional aspects of art are in considerable tension. The presence of an art institution has precisely the effect of defeating the necessity of the artist having any particular intention, since the work will be evaluated by institutional conventions whether the artist wants it to or not. Feagin argues that we need a clearer concept of the intentional description of an action, and distinguishes between two different classes of intentional description: some actions can only be done intentionally, such as telephoning; others intentionally or unintentionally, such as offending. For example, I can offend you unintentionally (or, of course, intentionally) by phoning you in the evening. This suggests that an artist couldn't have made a work without having some intentions for the work, but could have failed to have others; an artist could, for example,

write a poem without satiric intent but have it so interpreted. Accordingly, Feagin argues that one can have an institutionally sensitive theory of art without it falling prey to danger of systematic interpretive ambiguity. And this suggests that the institutional theory can be extended in ways which will help to explain why we care about art.

Jerrold Levinson (1948-), a professor of aesthetics at the University of Maryland, has written widely on aesthetics, especially the aesthetics of music. All his work is informed by a concern for the historical dimension of art. In "Defining Art Historically"(1979), he offers a kind of institutional theory of art which explicitly connects art works to the history of the artworld. He argues that an artwork is an artifact made with the intention of being regarded in ways in which previous works have standardly been regarded. Like Feagin, Levinson is distressed by problematic features of the institutional analysis, particularly its failure to link membership in the artworld with the intentions the artist has for the ways in which the artwork is to be regarded. Levinson argues that the values we find in art and the regard we take to be appropriate to it are backward-looking in the sense that past works provide exemplars of what people have found valuable and worthy of regard. By giving a definition for what it is to be a work of art at a certain time with reference to standard works at prior times, Levinson hopes to preserve the value content of art in his definition, without denying the open character of art and its potential to offer new and unexpected forms.

In "Style and Personality in the Literary Work", Jenefer Robinson (1945-), professor of philosophy at the University of Cincinnati, discusses the question of the artist's intentions in connection with the notion of literary style. Although I have placed the piece here, it could be read equally profitably together with the Hirsch, Ricoeur and Barthes selections in the section on *Hermeneutics and Interpretation*. Robinson's first thesis is that style is essentially a way of doing something, and is thus expressive of personality. The way we do things is partly a matter of conscious choice, but it is also partly involuntary. Literary style is a complex of ways of performing artistic acts (of describing, portraying character, manipulating plot, etc.), and the artist's personality is embodied in her style and works which exhibit that style. Many novels are written from the point of view of one of the characters, and whether or not this is so, the point of view of the novel is not generally the author's own. Robinson identifies this feature in her second thesis, which is that the style of a work is not typically expressive of the writer's actual personality but of the 'implied author', the author as she seems to be from the evidence of the work. After developing this thesis, she turns to a number of objections to it. She concludes with a sketch of the potential richness of her claim in explaining features of literary criticism. If Robinson is right, the artist's personality is much more intimately connected with our understanding of a work than most contemporary criticism allows. These issues are taken up at length in the section on *Hermeneutics and Interpretation*.

Ludwig Wittgenstein (1889-1951)

On Family Resemblance and On Seeing As

Selections from *Philosophical Investigations*

Translated by G. E. M. Anscombe

65. Here we come up against the great question that lies behind all these considerations.—For someone might object against me: "You take the easy way out! You talk about all sorts of language-games, but have nowhere said what the essence of a language-game, and hence of language, is: what is common to all these activities, and what makes them into language or parts of language. So you let yourself off the very part of the investigation that once gave you yourself most headache, the part about the *general form of propositions* and of language."

And this is true.—Instead of producing something common to all that we call language, I am saying that these phenomena have no one thing in common which makes us use the same word for all,—but that they are *related* to one another in many different ways. And it is because of this relationship, or these relationships, that we call them all "language". I will try to explain this.

66. Consider for example the proceedings that we call "games". I mean board-games, card-games, ball-games, Olympic games, and so on. What is common to them all?—Don't say: "There *must* be something common, or they would not be called 'games'"—but *look and see* whether there is anything common to all.—For if you look at them you will not see something that is common to *all*, but similarities, relationships, and a whole series of them at that. To repeat: don't think, but look!—Look for example at board-games, with their multifarious relationships. Now pass to card-games; here you find many correspondences with the first group, but many common features drop out, and others appear. When we pass next to ball-games, much that is common is retained, but much is lost.—Are they all 'amusing'? Compare chess with noughts and crosses. Or is there always winning and losing, or competition between players? Think of patience. In ball games there is winning and losing; but when a child throws his ball at the wall and catches it again, this feature has disappeared. Look at the parts played by skill and luck; and at the difference between skill in chess and skill in tennis. Think now of games like ring-a-ring-a-roses; here is the element of amusement, but how many other characteristic features have disappeared! And we can go through the many, many other groups of games in the same way; can see how similarities crop up and disappear.

And the result of this examination is: we see a complicated network of similarities overlapping and criss-crossing: sometimes overall similarities, sometimes similarities of detail.

67. I can think of no better expression to characterize these similarities than "family resemblances"; for the various resemblances between members of a family: build, features, colour of eyes, gait, temperament, etc. etc. overlap and criss-cross in the same way.—And I shall say: 'games' form a family.

And for instance the kinds of number form a family in the same way. Why do we call something a "number"? Well, perhaps because it has a—direct—relationship with several things that have hitherto been called number; and this can be said to give it an indirect relationship to other things we call the same name. And we extend our concept of number as in spinning a thread we twist fibre on fibre. And

the strength of the thread does not reside in the fact that some one fibre runs through its whole length, but in the overlapping of many fibres.

But if someone wished to say: "This is something common to all these constructions—namely the disjunction of all their common properties"—I should reply: Now you are only playing with words. One might as well say: "Something runs through the whole thread—namely the continuous overlapping of those fibres".

68. "All right; the concept of number is defined for you as the logical sum of these individual interrelated concepts: cardinal numbers, rational numbers, real numbers, etc.; and in the same way the concept of a game as the logical sum of a corresponding set of sub-concepts."—It need not be so. For I *can* give the concept 'number' rigid limits in this way, that is, use the word "number" for a rigidly limited concept, but I can also use it so that the extension of the concept is *not* closed by a frontier. And this is how we do use the word "game". For how is the concept of a game bounded? What still counts as a game and what no longer does? Can you give the boundary? No. You can *draw* one; for none has so far been drawn. (But that never troubled you before when you used the word "game".)

"But then the use of the word is unregulated, the 'game' we play with it is unregulated"—It is not everywhere circumscribed by rules; but no more are there any rules for how high one throws the ball in tennis, or how hard; yet tennis is a game for all that and has rules too.

69. How should we explain to someone what a game is? I imagine that we should describe *games* to him, and we might add: "This *and similar things* are called 'games'". And do we know any more about it ourselves? Is it only other people whom we cannot tell exactly what a game is?—But this is not ignorance. We do not know the boundaries because none have been drawn. To repeat, we can draw a boundary—for a special purpose. Does it take that to make the concept usable? Not at all! (Except for that special purpose.) No more than it took the definition: 1 pace = 75 cm. to make the measure of length 'one pace' usable. And if you want to say "But still, before that it wasn't an exact measure", then I reply: very well, it was an inexact one.—Though you still owe me a definition of exactness.

70. "But if the concept 'game' is uncircumscribed like that, you don't really know what you mean by a 'game'."—When I give the description: "The ground was quite covered with plants"—do you want to say I don't know what I am talking about until I can give a definition of a plant?

My meaning would be explained by, say, a drawing and the words "The ground looked roughly like this". Perhaps I even say "it looked *exactly* like this."—Then were just *this* grass and *these* leaves there, arranged just like this? No, that is not what it means. And I should not accept any picture as exact in *this* sense.

Someone says to me: "Shew the children a game." I teach them gaming with dice, and the other says "I didn't mean that sort of game." Must the exclusion of the game with dice have come before his mind when he gave me the order?

71. One might say that the concept 'game' is a concept with blurred edges.—"But is a blurred concept a concept at all? Is it even always an advantage to replace an indistinct picture by a sharp one? Isn't the indistinct one often exactly what we need?

Frege compares a concept to an area and says that an area with vague boundaries cannot be called an area at all. This presumably means that we cannot do anything with it.—But is it senseless to say: "Stand roughly there"? Suppose that I were standing with someone in a city square and said that. As I say it I do not draw any kind of boundary, but perhaps point with my hand—as if I were indicating a particular *spot*. And this is just how one might explain to someone what a game is. One gives examples and intends them to be taken in a particular way.—I do not, however, mean by this that he is supposed to see in those examples that common thing which I—for some reason—was unable to express; but that he is now to *employ* those examples in a particular way. Here giving examples is not an *indirect* means of explaining—in default of a better. For any general definition can be misunderstood too. The point is that *this* is how we play the game. (I mean the language-game with the word 'game'.)

. . .

xi

Two uses of the word "see".

The one: "What do you see there?"—"I see *this*" (and then a description, a drawing, a copy). The other: "I see a likeness between these two faces"— let the man I tell this to be seeing the faces as clearly as I do myself.

The importance of this is the difference of category between the two 'objects' of sight.

The one man might make an accurate drawing of the two faces, and the other notice in the drawing the likeness which the former did not see.

I contemplate a face, and then suddenly notice its likeness to another. I *see* that it has not changed; and yet I see it differently. I call this experience "noticing an aspect".

Its *causes* are of interest to psychologists.

We are interested in the concept and its place among the concepts of experience.

You could imagine the illustration

appearing in several places in a book, a text-book for instance. In the relevant text something different is in question every time: here glass cube, there an inverted open box, there a wire frame of that shape, there three boards forming a solid angle. Each time the text supplies the interpretation of the illustration.

But we can also *see* the illustration now as one thing now as another.—So we interpret it, and *see* it as we *interpret* it.

Here perhaps we should like to reply: The description of what is got immediately, i.e. of the visual experience, by means of an interpretation—is an indirect description. "I see the figure as a box" means: I have a particular visual experience which I have found that I always have when I interpret the figure as a box or when I look at a box. But if it

meant this I ought to know it. I ought to be able to refer to the experience directly, and not only indirectly. (As I can speak of red without calling it the colour of blood.)

I shall call the following figure, derived from Jastrow[1], the duck-rabbit. It can be seen as a rabbit's head or as a duck's.

And I must distinguish between the 'continuous seeing' of an aspect and the 'dawning' of an aspect.

The picture might have been shewn me, and I never have seen anything but a rabbit in it.

Hence it is useful to introduce the idea of a picture-object. For instance

would be a 'picture-face'.

In some respects I stand towards it as I do towards a human face. I can study its expression, can react to it as to the expression of the human face. A child can talk to picture-men or picture-animals, can treat them as it treats dolls.

I may, then, have seen the duck-rabbit simply as a picture-rabbit from the first. That is to say, if asked "What's that?" or "What do you see here?" I should have replied: "A picture-rabbit". If I had further been asked what that was, I should have explained by pointing to all sorts of pictures of rabbits, should perhaps have pointed to real rabbits, talked about their habits, or given an imitation of them.

I should not have answered the question, "What do you see here?" by saying: "Now I am seeing it as a picture-rabbit". I should simply have described my perception: just as if I had said "I see a red circle over there."—

1. *Fact and Fable in Psychology.*

ON FAMILY RESEMBLANCE and ON SEEING AS

Nevertheless someone else could have said of me: "He is seeing the figure as a picture-rabbit."

It would have made as little sense for me to say "Now I am seeing it as..." as to say at the sight of a knife and fork "Now I am seeing this as a knife and fork". This expression would not be understood.— Any more than: "Now it's a fork" or "It can be a fork too".

One doesn't 'take' what one knows as the cutlery at a meal for cutlery; any more than one ordinarily tries to move one's mouth as one eats, or aims at moving it.

If you say "Now it's a face for me:, we can ask: "What change are you alluding to?"

I see two pictures, with the duck-rabbit surrounded by rabbits in one, by ducks in the other. I do not notice that they are the same. Does it follow from this that I see something different in the two cases?—It gives us a reason for using this expression here.

"I saw it quite differently, I should never have recognized it!" Now, that is an exclamation. And there is also a justification for it.

I should never have thought of superimposing the heads like that, of making this comparison between them. For they suggest a different mode of comparison.

Nor has the head seen like this the slightest similarity to the head seen like this—although they are congruent.

I am shewn a picture-rabbit and asked what it is; I say "It's a rabbit". Not "Now it's a rabbit". I am reporting my perception.—I am shewn the duck-rabbit and asked what it is; I may say "It's a duck-rabbit." But I may also react to the question quite differently.—The answer that it is a duck-rabbit is again the report of a perception; the answer "Now it's a rabbit" is not. Had I replied "It's a rabbit", the ambiguity would have escaped me, and I should have been reporting my perception.

The change of aspect. "But surely you would say that the picture is altogether different now!"

But what is different: my impression? my point of view?—Can I say? I describe the alteration like a perception; quite as if the object had altered before my eyes.

"Now I am seeing this", I might say (pointing to another picture, for example). This has the form of a report of a new perception.

The expression of a change of aspect is the expression of a new perception and at the same time of the perception's being unchanged.

I suddenly see the solution of a puzzle-picture. Before, there were branches there; now there is a human shape. My visual impression has changed and now I recognize that it has not only shape and colour but also a quite particular 'organization'.— My visual impression has changed;—what was it like before and what is it like now?—If I represent it by means of an exact copy—and isn't that a good representation of it?—no change is shewn.

And above all do not say "After all my visual impression isn't the drawing; it is this—which I can't shew to anyone."—Of course it is not the drawing, but neither is it anything of the same category, which I carry within myself.

The concept of the 'inner picture' is misleading, for this concept uses the 'outer picture' as a model; and yet the uses of the words for these concepts are no more like one another that the uses of 'numeral' and 'number'. (And if one chose to call numbers 'ideal numerals', one might produce a similar confusion.)

If you put the 'organization' of a visual impression on a level with colours and shapes, you are proceeding from the idea of the visual impression as an inner object. Of course this makes this object into a chimera; a queerly shifting construction. For the similarity to a picture is now impaired.

If I know that the schematic cube has various aspects and I want to find out what someone else sees, I can get him to make a model of what he sees, in addition to a copy, or to point to such a model; even though he has no idea of my purpose in demanding two accounts.

But when we have a changing aspect the case is altered. Now the only possible expression of our experience is what before perhaps seemed, or even was, a useless specification when once we had the copy.

And this by itself wrecks the comparison of 'organization' with colour and shape in visual impressions.

If I saw the duck-rabbit as a rabbit, then I saw: these shapes and colours (I give them in detail)—and I saw besides something like this: and here I point to a number of different pictures of rabbits.—This shews the difference between the concepts.

'Seeing as...' is not part of perception. And for that reason it is like seeing and again not like.

I look at an animal and am asked: "What do you see?" I answer: "A rabbit".—I see a landscape; suddenly a rabbit runs past. I exclaim "A rabbit!"

Both things, both the report and the explanation, are expressions of perception and of visual experience. But the exclamation is so in a different sense from the report: it is forced from us.—It is related to the experience as a cry is to pain.

But since it is the description of a perception, it can also be called the expression of thought.—If you are looking at the object, you need not think of it; but if you are having the visual experience expressed by the exclamation, you are also *thinking* of what you see.

Hence the flashing of an aspect on us seems half visual experience, half thought.

Someone suddenly sees an appearance which he does not recognize (it may be a familiar object, but in an unusual position or lighting); the lack of recognition perhaps lasts only a few seconds. Is it correct to say he has a different visual experience from someone who knew the object at once?

For might not someone be able to describe an unfamiliar shape that appeared before him just as *accurately* as I, to whom it is familiar? And isn't that the answer?—Of course it will not generally be so. And his description will run quite differently. (I say, for example, "The animal had long ears"—he: "There were two long appendages", and then he draws them.)

I meet someone whom I have not seen for years; I see him clearly, but fail to know him. Suddenly I know him, I see the old face in the altered one. I believe that I should do a different portrait of him now if I could paint.

Now, when I know my acquaintance in a crowd, perhaps after looking in his direction for quite a while,—is this a special sort of seeing? Is it a case of both seeing and thinking? or an amalgam of the two, as I should almost like to say?

The question is: *why* does one want to say this?

The very expression which is also a report of what is seen, is here a cry of recognition.

What is the criterion of the visual experience?—The criterion? What do you suppose?

The representation of 'what is seen'.

The concept of a representation of what is seen, like that of a copy, is very elastic, and so *together with it* is the concept of what is seen. The two are intimately connected. (Which is *not* to say that they are alike.)

How does one tell that human beings *see* three-dimensionally?—I ask someone about the lie of the land (over there) of which he has a view. "Is it like *this*?" (I shew him with my hand)—"Yes."—"How do you know?"—"It's not misty, I see it quite clear."—He does not give reasons for the surmise. The only thing that is natural to us is to represent what we see three-dimensionally; special practice and training are needed for two-dimensional representation whether in drawing or in words. (The queerness of children's drawings.)

If someone sees a smile and does not know it for a smile, does not understand it as such, does he see it differently from someone who understands it?—He mimics it differently, for instance.

Hold the drawing of a face upside down and you can't recognize the expression of the face. Perhaps you can see that it is smiling, but not exactly what *kind* of smile it is. You cannot imitate the smile or describe it more exactly.

And yet the picture which you have turned round may be a most exact representation of a person's face.

The figure (a) ⬡ is the reverse of the figure (b) ⬡

As (c) *ǝɹnsɐǝlԀ* is the reverse of (d) *Pleasure*

But—I should like to say—there is a difference between my impressions of (c) and (d) and between those of (a) and (b). (d), for example, looks neater than (c). (Compare a remark of Lewis Carroll's.) (d) is easy, (c) hard to copy.

Imagine the duck-rabbit hidden in a tangle of lines. Now I suddenly notice it in the picture, and notice it simply as the head of a rabbit. At some later time I look at the same picture and notice the same figure, but see it as the duck, without necessarily realizing that it was the same figure both times.—If I later see the aspect change—can I say that the duck and rabbit aspects are now seen quite differently from when I recognized them separately in the tangle of lines? No.

But the change produces a surprise not produced by the recognition.

If you search in a figure (1) for another figure (2), and then find it, you see (1) in a new way. Not only can you give a new kind of description of it, but noticing the second figure was a new visual experience.

But you would not necessarily want to say "Figure (1) looks quite different now; it isn't even in the least like the figure I saw before, though they are congruent!"

There are here hugely many interrelated phenomena and possible concepts.

Then is the copy of the figure an *incomplete* description of my visual experience? No.—But the circumstances decide whether, and what, more detailed specifications are necessary.—It *may* be an incomplete description; if there is still something to ask.

Of course we can say: There are certain things which fall equally under the concept 'picture-rabbit' and under the concept 'picture-duck.' And a picture, a drawing, is such a thing.—But the *impression* is not simultaneously of a picture-duck and a picture-rabbit.

"What I really *see* must surely be what is produced in me by the influence of the object"—Then what is produced in me is a sort of copy, something that in its turn can be looked at, can be before one; almost something like a *materialization*.

And this materialization is something spatial and it must be possible to describe it in purely spatial terms. For instance (if it is a face) it can smile; the concept of friendliness, however, has no place in an account of it, but is *foreign* to such an account (even though it may subserve it).

If you ask me what I saw, perhaps I shall be able to make a sketch which shews you; but I shall mostly have no recollection of the way my glance shifted in looking at it.

The concept of 'seeing' makes a tangled impression. Well, it is tangled.—I look at the landscape, my gaze ranges over it, I see all sorts of distinct and indistinct movement; *this* impresses itself sharply on me, *that* is quite hazy. After all, how completely ragged what we see can appear! And now look at all that can be meant by "description of what is seen".—But this just is what is called description of what is seen. There is not *one genuine* proper case of such description—the rest being just vague, something which awaits clarification, or which must just be swept aside as rubbish.

Stanley Cavell (1926-)

Selections from

Excursus on Wittgenstein's Vision of Language

. . .

What I wish to say at this point can be taken as glossing Wittgenstein's remark that "we learn words in *certain* contexts" (e.g., *Blue Book*, p. 9). This means, I take it, both that we do not learn words in *all* the contexts in which they could be used (what, indeed, would that mean?) and that not every context in which a word is used is one in which the word *can* be learned (e.g., contexts in which the word is used metaphorically). And after a while we are expected to know when the words are appropriately used in further contexts. This is obvious enough, and philosophers have always asked for an explanation of it: "How do words acquire that generality upon which thought depends?" As Locke put it:

> All things that exist being particulars, it may perhaps be thought reasonable that words, which ought to be conformed to things, should be so too, I mean in their signification: but yet we find quite the contrary. The far greatest part of words that make all languages are general terms; which has not been the effect of neglect or chance, but of reason and necessity.... The next thing to be considered is, how general words come to be made. For since all things that exist are only particulars, how come we by general terms, or where find we those general natures they are supposed to stand for? [*An Essay Concerning Human Understanding*, Book III; Chapter III; Sections I and VI]

This is only one of the questions to which philosophers have given the answer, "Because there are universals"; and the "problem of universals" has been one of assigning, or denying, an ontological status to such things and of explaining, or denying, our knowledge of them. What Wittgenstein wishes us to see, if I understand, is that no such answers could provide an explanation of the questions which lead to them.

"We learn words in certain contexts and after a while we are expected to know when they are appropriately used in (= can appropriately be projected into) further contexts" (and, of course, our ability to project appropriately is a criterion for our having learned a word). Now I want to ask: (1) What is (do we call) "learning a word", and in particular (to keep to the simplest case) "learning the general name of something"?; and (2) what makes a projection an appropriate or correct one? (Again, traditionally, the answer to (1) is: "Grasping a universal", and to (2): "The recognition of another instance of the same universal", or "the fact that the new object is *similar* to the old".)

Learning a Word

Suppose we ask: "When a child learns the name of something (e.g., 'cat', 'star', 'pumpkin'), obviously he doesn't learn merely that *this* (particular) sound goes with *that* (particular) object; so what does he learn?" We might answer: "He learns that sounds *like* this name objects *like* that." We can quickly become very dissatisfied with that answer. Suppose we reflected that that answer seems to describe more exactly a situation in which learning that "cat" is the name of *that* means learning that "rat" (a sound *like* "cat") is the name of *that* (an object *like* a cat). That obviously is not what we meant to say (because that obviously is not what happens?). How is what we meant to say different? We might try: "He learns that sounds *exactly* similar to this name objects *exactly* similar to that." But that is either false or obviously empty. For what does it mean to say that one cat is exactly similar to another cat? We do not want to mean that you can not tell them apart (for that obviously would not explain what we are trying to explain). What we *want* to say is that the child learns

that a sound that *is* (counts as) this *word* names objects which *are* cats. But isn't that just what we thought we needed, and were trying to give, an *explanation* for?

Suppose we change the point of view of the question and ask: What do we teach or tell a child when we point to a pumpkin and say, "Pumpkin"? Do we tell him what a pumpkin is or what the word "pumpkin" means? I was surprised to find that my first response to this question was, "You can say either". (Cf. "Must We Mean What We Say?", p. 21.) And that led me to appreciate, and to want to investigate, how much a matter knowing what something *is* is a matter of knowing what something is *called*; and to recognize how limited or special a truth is expressed in the motto, "We may change the names of things, but their nature and their operation on the understanding never change" (Hume, *Treatise*, Book II, Part III, Section I).

At the moment I will say just this: That response ("You can say either") is true, at best, only for those who have already mastered a language. In the case of a child still coming to a mastery of its language it may be (fully) true *neither* that what we teach them is (the meaning of) a word *nor* that we tell them what a thing is. It looks very like one or the other, so of course it is very natural to say that it is one or the other; but so does malicious gossip often look like honesty, and so we very often call it honesty.

How might saying "Pumpkin" and pointing to a pumpkin not be "telling the child what a word means"? There are many sorts of answers to that. One might be: it takes two to *tell* someone something; you can't give someone a piece of information unless he knows how to *ask* for that (or comparable) information. (Cf. *Investigations*, §31.) And this is no more true of learning language than it is true of learning any of the forms of life which grow language. You can't tell a child what a word means when the child has yet to learn what "asking for a meaning" is (i.e., how to ask for a meaning), in the way you can't lend a rattle to a child who has yet to learn what "being lent (or borrowing) something" means. Grownups like to think of children (especially their own) as small grownups, midgets. So they say to their child, "Let Sister use your shovel", and then nudge the child over towards Sister, wrest the

shovel from the child's hand, and are later impatient and disappointed when the child beats Sister with a pail and Sister rages not to "return" the shovel. We learn from suffering.

Nor, in saying "Pumpkin" to the child, are we telling the child what a pumpkin is, i.e., the child does not then know what a pumpkin is. For to "know what a pumpkin is" is to know, e.g., that it is a kind of fruit; that it is used to make pies; that it has many forms and sizes and colors; that this one is misshapen and old; that inside every tame pumpkin there is a wild man named Jack, screaming to get out.

So what are we telling the child if we are telling him neither what a word means nor what a thing is? We might feel: "If you can't tell a child a simple thing like what a pumpkin is or what the word 'pumpkin' means, then how does learning ever *begin*?" But why assume we are telling him anything at all? Why assume that we are *teaching* him anything? Well, because obviously he has learned something. But perhaps we are too quick to suppose we know what it is in such situations that makes us say the child is learning something. In particular, too quick to suppose we know what the child is learning. To say we are teaching them language obscures both how different what they learn may be from anything we think we are teaching, or mean to be teaching; and how vastly more they learn than the thing we should say we had "taught". Different and more, not because we are bad or good teachers, but because "learning" is not as academic a matter as academics are apt to suppose.

First, reconsider the obvious fact that there is not the *clear* difference between learning and maturation that we sometimes suppose there is. Take this example: Suppose my daughter now knows two dozen words. (Books on child development must say things like: At age 15 months the average child *will have a vocabulary of* so many words.) One of the words she knows, as her Baby Book will testify, is "kitty". What does it mean to say she "knows the word"? What does it mean to say she "learned it"? Take the day on which, after I said "Kitty" and pointed to a kitty, she repeated the word and pointed to the kitty. What does "repeating the word" mean here? and what did she point to? All I know is (and does she know more?) that she made the sound I

made and then pointed to what I pointed at. Or rather, I know less (and more) than that. For what is "her making the sound I made"? She produced a sound (imitated me?) which *I accepted, responded to* (with smiles, hugs, words of encouragement, etc.) *what I had said*. The next time a cat came by, on the prowl or in a picture book, she did it again. A new entry for the Baby Book under "Vocabulary".

Now take the day, some weeks later, when she smiled at a fur piece, stroked it, and said "kitty". My first reaction was surprise, and, I suppose, disappointment: she doesn't really know what "kitty" means. But my second reaction was happier: she means by "kitty" what I mean by "fur". Or was it what I mean by "soft", or perhaps "nice to stroke"? Or perhaps she didn't mean at all what in my syntax would be recorded as "That is an X". After all, when she sees real kittens she not only utters her allophonic version of "kitty", she usually squeals the word over and over, squats down near it, stretches out her arm towards it and opens and closes her fingers (an allomorphic version of "petting the kitten"?), purses her lips, and squints with pleasure. All she did with the fur piece was, smiling, to say "kitty" once and stroke it. Perhaps the syntax of that performance should be transcribed as "This is like a kitty", or "Look at the funny kitty", or "Aren't soft things nice?", or "See, I remembered how pleased you are when I say 'kitty'", or "I like to be petted". Can we decide this? Is it a *choice* between these definite alternatives? In each case her word was produced about a soft, warm, furry object of a certain size, shape, and weight. What did she learn in order to do that? *What did she learn from having done it?* If she had never made such leaps she would never have walked into speech. Having made it, meadows of communication can grow for us. Where you can leap to depends on where you stand. When, later, she picks up a gas bill and says "Here's a letter", or when, hearing a piece of music we've listened to together many times, she asks "Who's Beethoven?", or when she points to the television coverage of the Democratic National Convention and asks "What are you watching?", I may realize we are not ready to walk certain places together.

But although I didn't tell her, and she didn't learn, either what the word "kitty" means or what a kitty is, if she keeps leaping and I keep looking and smiling, she will learn both. I have wanted to say: Kittens—what we call "kittens"—do not exist in her world yet, she has not acquired the forms of life which contain them. They do not exist in something like the way cities and mayors will not exist in her world until long after pumpkins and kittens do; or like the way God or love or responsibility do not exist in our world; we have not mastered, or we have forgotten, or we have distorted, or learned through fragmented models, the forms of life which could make utterances like "God exists" or "God is dead" or "I love you" or "I cannot do otherwise" or "Beauty is but the beginning of terror" bear all the weight they could carry, express all they could take from us. We do not know the meaning of the words. We look away and leap around.

"Why be so difficult?" Why perversely deny that the child has learned a word, and insist, with what must be calculated provocativeness, that your objects are 'not in her world'? Anyone will grant that she can't do everything we do with the word, nor know everything we do about kitties—I mean kittens; but when she says 'Kitty nice' and evinces the appropriate behavior, then she's learned the name of an object, learned to name an object, and the *same* object we name. The differences are between what she does and what you do obvious, and any sensible person will take them for granted.

What I am afraid of is that we take too much for granted about what the learning and the sharing of language implies. What's *wrong* with thinking of learning language as being taught or told the names of things? Why did Wittgenstein call sharp attention to Augustine's having said or implied that it is, and speak of a particular "picture" of language underlying it, as though Augustine was writing from a particular, arbitrary perspective, and that the judgment was snap?

There is more than one "picture" Wittgenstein wishes to develop: one of them concerns the idea that all words are names, a second concerns the idea that learning a name (or any word) is being told what it means, a third is the idea that learning a language is a matter of learning (new) words. The first of these ideas, and Wittgenstein's criticism of it, has, I believe, received wider attention than the other two, which are the ones which concern us here. (The

ideas are obviously related to one another, and I may say that I find the second two to give the best sense of what Wittgenstein finds "wrong" with the first. It isn't as I think it is usually taken, merely that "language has many functions" besides naming things; it is also that the ways philosophers account for naming makes it incomprehensible how language can so much as perform *that* function.)

Against the dominant idea of the dominant Empiricism, that what is basic to language (basic to the way it joins the world, basic to its supply of meaning, basic to the way it is taught and learned) are basic *words*, words which can (only) be learned and taught through "ostensive definitions", Wittgenstein says, among other things, that to be *told* what a word means (e.g., to know that when someone forms a sound and moves his arm he is *pointing to* something and *saying its name*, and to know *what* he is pointing to) we have to be able to ask what it means (*what* it refers to); and he says further: "One has already to know (or be able to do) something in order to be capable of asking a thing's name. But what does one have to know?" (*Investigations*, §30). I want to bring out two facts about this question of Wittgenstein's: that it is not because naming and asking are peculiarly mental or linguistic phenomena that a problem is created; and that the question is not an experimental but a conceptual one, or as one might put it, that the question "What do we call 'learning or asking for a name'?" had better be clear before we start experimenting to find out "how" "it" is done.

It will help to ask: Can a child attach a label to a thing? (Wittgentstein says that giving a thing a name is like attaching a label to something (§15). Other philosophers have said that too, and taken that as imagining the essential function of language. But what I take Wittgenstein to be suggesting is: Take the label analogy seriously; and then you'll see how *little* of language is like that. Let us see.) We might reply: "One already has to know (or be able to do) something in order to be capable of attaching a label to a thing. But what does one have to know?" Well, for example, one has to know what the thing in question is; what a label is; what the point of attaching a label to a thing is. Would we say that the child is attaching a label to a thing if he was pasting (the *way* a child pastes) bits of paper on various objects? Suppose, even, that he can say: "These are my labels" (i.e., that he says <xyzir may leybils>). (Here one begins to sense the force of a question like: What makes "These are labels" *say that* these are labels?) And that he says: "I am putting labels on my jars." *Is* he?

Mightn't we wish to say *either* Yes or No? Is it a matter of *deciding* which to say? What is it a decision about? Should we say, "Yes and No"? But what makes us want to say this? Or suppose we ask: In what sense does a child *pay* for something (cp. say something) (e.g., for groceries, or tickets to a puppet show)? Suppose he says "Let me pay" (and takes the money, handing it to the clerk (putting it on the counter?)). *What* did he do?

Perhaps we can say this: If you say "No, he is not putting labels on things, paying money (repeating names)", you are thinking: He doesn't know the significance of his behaviors; or, he doesn't know what labels or money or names are; or, he isn't intending to do these things, and you can't do them without intending to (but is that true?); anyway, he doesn't know what doing those things really would be (and what would be "doing them really"? Is he only pretending to?). If you say "Yes, he is pasting labels on", etc., then won't you want to follow this with: "only not the way *we* do that"? But how is it different?

Maybe you feel: "What else would you say he's doing? It's not wrong to say 'He's pasting labels, paying money, learning names', even though everyone knows that he isn't quite or fully *doing* those things. You see the sense in which that is meant." But what has begun to emerge is how far from clear that "sense" is, how little any of the ways we *express* that sense really satisfy us when we articulate them.

That the justifications and explanations we give of our language and conduct, that our ways of trying to intellectualize our lives, do not really satisfy us, is what, as I read him, Wittgenstein wishes us above all to grasp. This is what his "methods" are designed to get us to see. What directly falls under his criticism are not the results of philosophical argument but those unnoticed turns of mind, casts of phrase, which comprise what intellectual historians call "climates of opinion", or "cultural style", and which, unnoticed and therefore unassessed, defend conclusions

from direct access—fragments, as it were, of our critical super-egos which one generation passes to the next along with, perhaps as the price of, its positive and permanent achievements: such fragments as "To be clear about our meaning we must define our terms", "The meaning of a word is the experience or behavior it causes", "We may change the names of things but their operation on the understanding never changes", "Language is merely conventional", "Belief is a (particular) feeling", "Belief is a disposition caused by words (or signs)", "If what I say proves false then I didn't (don't?) know it", "We know our own minds directly", "Moral judgments express approval or disapproval", "Moral judgments are meant to get others to *do* something, or to change their attitudes", "All rationally settleable questions of language are questions of fact", "Knowledge is increased only by reasoning or by collecting evidence", "Taste is relative, and people might like, or get pleasure from anything"...If philosophy is the criticism a culture produces of itself, and proceeds essentially by criticizing past efforts at this criticism, then Wittgenstein's originality lies in having developed modes of criticism that are not moralistic, that is, that do not leave the critic imagining himself free of the faults he sees around him, and which proceed not by trying to argue a given statement false or wrong, but by showing that the person making an assertion does not really know what he means, has not really said what he wished. But since self-scrutiny, the full examination and defense of one's own position, has always been part of the impulse to philosophy, Wittgenstein's originality lies not in the creation of the impulse, but in finding ways to prevent it from defeating itself so easily, ways to make it methodical. That is Freud's advance over the insights of his predecessors at self-knowledge, e.g., Kierkegaard, Nietzsche, and the poets and novelists he said anticipated him.

Now let me respond, in two ways, to the statement: "It's not *wrong* to say the child is pasting labels, repeating names; everyone *sees the sense* in which that is meant."

First of all, it is not true that everybody knew that he wasn't quite "learning a thing's name" when Augustine said that in learning language he learned the names of things, and that we all "knew the sense" in which he meant what he said. (We do picture in the mind as having inexplicable powers, without really knowing what these powers are, what we expect of them, nor in *what* sense they are inexplicable.)

Again, neither Wittgenstein nor I said it was *wrong to say* the child was "learning the names of things", or "paying for the tickets", or "pasting labels on her jars". One thing we have heard Wittgenstein say about "learning names" was: "...Augustine describes the learning of human language as if the child came into a strange country and did not understand the language of the country; that is, as if it already had a language, only not this one" (§32). And, in the same spirit, we could say: To describe the child as "pasting labels on his jars" or "paying for the tickets" is to describe the child as if he were an adult (or anyway, master of the adult activity). That is, we say about a child "She is pasting labels on jars" or "He paid for the tickets", when we should also "She's a mommy" or "He was Uncle Croesus today". No one will say it's wrong (because untrue?) to say *those* things. And here we do begin more clearly to see the "sense" in which they are meant. You *and* the child know that you are really playing—which does not mean that what you are doing isn't serious. Nothing is more serious business for a child than knowing it will be an adult—and *wanting* to be, i.e., *wanting to do the things we do*—and knowing that it can't really do them yet. What is wrong is to say what a child is doing as though the child were an adult, and not recognize that he is still a child playing, above all growing. About "putting on labels", "playing school", "cooking supper", "sending out invitations", etc., that is, perhaps, easy to see. But elsewhere perhaps not.

Consider an older child, one ignorant of, but ripe for a pumpkin (knows how to ask for a name, what a fruit is, etc.). When you say "That is a pumpkin" we can comfortably say that this child learns what the word "pumpkin" means and what a pumpkin is. There may still be something different about the pumpkins in his world; they may, for example, have some unknown relation to pumps (the contrivance or the kind of shoe) and some intimate association with Mr. Popkin (who lives next door), since he obviously has the same name they do. But that probably won't lead to trouble, and one day the person that was this child may, for some reason, remember

that he believed these things, had these associations, when he was a child. (And does he, then, stop believing or having them?)

And we can also say: When you say "I love my love" the child learns the meaning of the word "love" and what love is. *That* (*what you do*) will *be* love in the child's world; and if it is mixed with resentment and intimidation, then love is a mixture of resentment and intimidation, and when love is sought *that* will be sought. When you say "I'll take you tomorrow, I promise", the child begins to learn what temporal durations are, and what *trust* is, and what you do will show what trust is worth. When you say "Put on your sweater", the child learns what commands are and what *authority* is, and if giving orders is something that creates anxiety for you, then authorities are anxious, authority itself uncertain.

Of course the person, growing, will learn other things about these concepts and "objects" also. They will grow gradually as the child's world grows. But all he or she knows about them is what he or she has learned, and *all* they have learned will be part of what they are. And what will the day be like when the person "realizes" what he "believed" about what love and trust and authority are? And how will he stop believing it? What we learn is not just what we have studied; and what we have been taught is not just what we were intended to learn. What we have in our memories is not just what we have memorized.

What is important in failing to recognize "the spirit" in which we say "The child, in learning language, is learning the names of things" is that we imagine that we have explained the nature of language when we have only avoided a recognition of its nature; and we fail to recognize how (what it really means to say that) children learn language *from* us.

To summarize what has been said about this: In "learning language" you learn not merely what the names of things are, but what a name is; not merely what the form of expression is for expressing a wish, but what expressing a wish is; not merely what the word for "father" is, but what a father is; not merely what the word for "love" is, but what love is. In learning language, you do not merely learn the pronunciation of sounds, and their grammatical orders, but the "forms of life" which make those sounds the

words they are, do what they do—e.g., name, call, point, express a wish or affection, indicate a choice or an aversion, etc. And Wittgenstein sees the relation among *these* forms as 'grammatical' also.

Instead, then, of saying either that we *tell* beginners what words mean, or that we *teach* them what objects are, I will say: We initiate them, into the relevant forms of life held in language and gathered around the objects and persons of our world. For that to be possible, we must make ourselves exemplary and take responsibility for that assumption of authority; and the initiate must be able to follow us, in however rudimentary a way, *naturally* (look where our finger points, laugh at what we laugh at, comfort what we comfort, notice what we notice, find alike or remarkable or ordinary what we find alike or remarkable or ordinary, feel pain at what we feel pain at, enjoy the weather or the notion we enjoy, make the sounds we make); and he must *want* to follow us (care about our approval, like a smile better than a frown, a croon better than a croak, a pat better than a slap). "Teaching" here would mean something like "showing them what we say and do", and "accepting what they say and do as what we say and do", etc.; and this will be more than we know, or can say.

In what sense is the child's ability to "follow" us, his caring what we do, and his knowing when we have and have not accepted the identity of his words and deeds, *learned*? If I say that all of this is natural, I mean it is nothing more than natural. Most people do descend from apes into authorities, but it is not inevitable. There is no reason why they don't continue crawling, or walk on all fours, or slide their feet instead of lifting them; no reason why they don't laugh where they (most) now cry; no reason why they make (or "try" to make) the sounds and gestures we make; no reason why they see, if they do, a curving lake as like a carousel; no reason why, having learned to use the phrase "turn down the light" they will accept the phrase "turn down the phonograph" to mean what it means, recognizing that the factor "turn down" is the same, or almost the same, in both; and then accept the phrases "turn down the bed" and "turn down the awning" and "turn down the offer" to mean what they mean, while recognizing that the

common factor has less, if any, relation to its former occurrences. If they couldn't do these things they would not grow into our world; but is the avoidance of that consequence the *reason* they do them?

We begin to feel, or ought to, terrified that maybe language (and understanding, and knowledge) rests upon very shaky foundations—a thin net over an abyss. (No doubt that it is part of the reason philosophers offer absolute "explanations" for it.) Suppose the child doesn't grasp what we mean? Suppose he doesn't respond differently to a shout and a song, so that what *we* "call" disapproval *encourages* him? Is it an accident that this doesn't normally happen? Perhaps we feel the foundations of language to be shaky when we look for, and miss, foundations of a particular sort, and look upon our shared commitments and responses—as moral philosophers in our liberal tradition have come to do—as more like particular agreements than they are. Such an idea can give us a sense that whether our words will go on meaning what they do depends on whether other people find it worth their while to continue to understand us—that, seeing a better bargain elsewhere they might decide that we are no longer of their world; as though our sanity depended upon their approval of us, finding us to their liking.

. . .

Projecting a Word

. . .

If what can be said in a language is not everywhere determined by rules, not its understanding anywhere secured through universals, and if there are always new contexts to be met, new breeds, new relationships, new objects, new perceptions to be recorded and shared, then perhaps it is as true of a master of a language as of his apprentice that though "in a sense" we learn the meaning of words and what objects are, the learning is never over, and we keep finding new potencies in words and new ways in which objects are disclosed. The "routes of initiation" are never closed. But *who* is the authority when all are masters? Who initiates us into new projections? Why haven't we arranged to *limit* words to *certain* contexts, and then coin new ones for new eventualities? The fact that we do not behave this way must be at the root of the fierce ambiguity of ordinary language, and that we won't behave this way means that for real precision we are going to have to get words *pinned* to a meaning through explicit definition and limitation of context. Anyway, for *some* sorts of precision, for some purposes, we will need definitions. But maybe the very ambiguity of ordinary language, though sometimes, some places, a liability, is just what gives it the power, of illumination, of enriching perception, its partisans are partial to. Besides, to say that a word "is" ambiguous may only be to say that it "can" mean various things, can, like a knife, be used in various ways; it doesn't mean that on any given occasion it *is* being used in various ways, nor that on the whole we have trouble in knowing which way it is being used. And in that case, the *more* uses words "can" have, then the *more* precise, or exact, that very possibility might allow us to be, as occasion arises. But let's move closer.

We learn the use of "feed the kitty", "feed the lion", "feed the swans", and one day one of us says "feed the meter", or "feed in the film", or "feed the machine", or "feed his pride", or "feed wire", and we understand, we are not troubled. Of course we could, in most of these cases, use a different word, not attempt to project or transfer "feed" from contexts like "feed the monkey" into contexts like "feed the machine". But what should be gained if we did? And what would be lost?

What are our choices? We could use a more general verb, like "put", and say merely "Put the money in the meter", "Put new material into the machine", "Put film into the camera", etc. But first, that merely deprives us of a way of speaking which can discriminate differences which, in some instances, will be of importance; e.g., it does not discriminate between putting a flow of material into a machine and putting a part made of some new material into the construction of the machine. And it would begin to deprive us of the concept we have of the emotions. Is the idea of feeding pride or hope or anxiety any more metaphorical, any less essential to the concept of an emotion, than the idea that pride and hope, etc., grow

and, moreover, grow on certain circumstances? Knowing what sorts of circumstances these are and what the consequences and marks of over-feeding are, is part of knowing what pride is. And what other way is there of knowing? Experiments? But those are the very concepts an experiment would itself be constructed from.

Second, to use a more general verb does not reduce the range of transfer or projection, but increases it. For in order that "put" be a relevant candidate for this function, it must be the same word we use in contexts like "Put the cup on the saucer", "Put your hands over your head", "Put our the cat", "Put on your best armor", "Put on your best manner", "Put our the light and then put our the light".

We could, alternatively, use a more specific verb than "feed". There would be two ways of doing this, either (a) to use a word already in use elsewhere, or (b) to use a new word. In (a) we have the same case as before. In (b) we might "feed eels", "fod lions", "fawd swans", "fide pride", "fad machines"....Suppose we find a culture which in fact does "change the verb" in this way. Won't we want to ask: *Why* are these forms different in the different cases? What differences are these people seeing and attaching importance to, in the way these things are (as we say, but they cannot say) "fed"? (I leave open the question whether the "f–d" form is morphemic; I assume merely that we have gathered from the contexts in which it is used that it can always be translated by *our* word "feed".) We could try to answer that by seeing what else the natives would and would not accept as "feeding", "fodding", "fawding", etc. What other animals or things or abstractions they would say they were "fiding" or "fadding"....(I am also assuming that we can tell there is no reason in superficial grammar why the forms are as they are, e.g., no agreement in number, gender, etc.) Could we imagine that there were no other contexts in which these forms were used; that for *every* case in which we have to translate their verb as "feed" they use a different form of (the "morpheme") "f — d"? This would be a language in which forms were perfectly intolerant of projection, one in which the natives would simply look puzzled if we asked whether you could feed a lion or fod an eel. What would we have to assume about them, their forms of life, in

order to "imagine" that? Presumably, that they saw no connection between giving food to eels, to lions, and to swans, that these were just different actions, as different as feeding an eel, hunting it, killing it, eating it. If we had to assume that, that might indeed be enough to make us call them "primitive". And wouldn't we, in addition, have to assume, not only that they saw them as different, but that these activities *were* markedly different; and not different in the way it is different for *us* to feed swans and lions (we don't hold bread crumbs to a lion's mouth, we don't spear whole loaves with a pitchfork and shovel them at swans) but different in some regularized way, e.g., in the preparations gone through in gathering the "food", in the clothes worn for the occasion, in the time of day at which it was done, in the songs sung on each occasion...? And then don't we have to imagine that these preparations, clothes, times, songs are never used for other purposes, or if they are, that no connection between *these* activities and those of "feeding" are noticed or noted in the language? And hence further imagine that the way these clothes, times, songs are used are simply different again, different the way wearing clothes is from washing them or rending or mending them? Can everything be just different?

But though language—what we call language—is tolerant, allows projection, not just any projection will be acceptable, i.e., will communicate. Language is equally, definitively, intolerant—as love is tolerant and intolerant of differences, as materials or organisms are of stress, as communities are of deviation, as arts or sciences are of variation.

While it is true that we must use the same word in, project a word into, various contexts (must be *willing* to call some contexts the *same*), it is equally true that what will *count* as a legitimate projection is deeply controlled. You can "feed peanuts to a monkey" and "feed pennies to a meter", but you cannot feed a monkey by stuffing pennies in its mouth, and if you mash peanuts into a coin slot you won't *be* feeding the meter. Would you be feeding a lion if you put a bushel of carrots in his cage? That he in fact does not eat them would not be enough to show that you weren't; he *may* not eat his *meat*. But in the latter case "may not eat" means "isn't hungry then" or "refuses to eat it". And not every case of

"not eating" is "refusing food". The swan who glides past the Easter egg on the shore, or over a school of minnows, or under the pitchfork of meat the keeper is carrying for the lion cage, is not refusing to eat the egg, the fish, or the meat. What will be, or count as, "being fed" is related to what will count as "refusing to eat", and thence related to "refusing mate", "refusing to obey", etc. What can a lion or a swan refuse? Well, what can they be offered? (If we say "The battery refuses to respond" are we thinking of the battery as stubborn?)

I might say: An object or activity or event onto or into which a concept is projected, must *invite* or *allow* that projection; in the way in which, for an object to be (called) an art object, it must allow or invite the experience and behavior which are appropriate or necessary to our concepts of the appreciation or contemplation or absorption...of an art object. What kind of object will allow or invite or be fit for that contemplation, etc., is no more accidental or arbitrary than what kind of object will be fit to serve as (what we call) a "shoe". Of course there are variations possible; because there are various ways, and purposes, for being shod. On a given occasion one may fail to recognize a given object as a shoe—perhaps all we see is a twist of leather thong, or several blocks of wood. But what kind of failure is this? It may help to say: What we fail to see here is not *that* the object in question is a shoe (that would be the case where, say, we failed to notice what it was the hostess shoved under the sofa, or where we had been distracted from our inventory of the objects in a painting and later seem to remember a cat's being where you say a shoe lies on its side), but rather we fail to see *how* the object in question is a shoe (how it would be donned, and worn, and for what kind of activities or occasions).

The question "How do we use the word 'shoe' (or 'see' or 'voluntary' or 'anger' or 'feed' or 'imagine' or 'language')?" is like the question a child once asked me, looking up from the paper on which she was drawing and handing me her crayon, "How do you make trees?"; and perhaps she also asked, "How do you make a house or people or people smiling or walking or dancing or the sun or a ship or the waves...?". Each of these questions can be answered in two or three strokes, as the former questions can

each be answered in two or three examples. Answered, that is, for the moment, for that question then. We haven't said or shown everything about making trees or using the expression "But now imagine...". But then there is no "everything" to be said. For we haven't been asked, or asked ourselves, *everything* either; nor *could* we, however often we wish that were possible.

That there are no explanations which are, as it were, complete in themselves, is part of what Wittgenstein means when he says, "In giving explanations I already have to use language full-blown...; this by itself shows that I can adduce only exterior facts about language" (*Investigations*, §120). And what goes for explaining my words goes for giving directions and for citing rules in a game and for justifying my behavior or excusing my child's or for making requests...or for the thousands of things I do in talking. You cannot use words to do what we do with them until you are initiate of the forms of life which give those words the point and shape they have in our lives. When I give you directions, I can adduce only exterior facts about directions, e.g., I can say, "Not that road, the other, the one passing the clapboard houses; and be sure to bear left at the railroad crossing". But I cannot *say* what directions *are* in order to get you to go the way I am pointing, nor *say* what my direction *is*, if that means saying something which is not a further *specification* of my direction, but as it were, cuts below the actual pointing to something which makes my pointing finger point. When I cite or teach you a rule, I can adduce only exterior facts about rules, e.g., say that it applies only when such-and-such is the case, or that it is inoperative when another rule applies, etc. But I cannot *say* what following rules is *überhaupt*, nor say how to obey a rule in a way which doesn't presuppose that you already know what it is to follow them.

For our strokes or examples to be the explanations we proffer, to serve the need we see expressed, the child must, we may say, see *how* those few strokes are a tree or a house ("There is the door, there is the window, there's the chimney with smoke coming out...."); the person must see how the object is a shoe ("There is the sole, that's for the toe..."); how the action was—why you call it one, say it was—done in anger ("He was angry at...", "He knew that would

hurt", "That gesture was no accident", "He doesn't usually speak sharply to his cat"...). Those strokes are not the only way to make a house (that is not the only instance of what we call a shoe; that is not the only kind of action we call an affront, or one performed voluntarily) but if you didn't see that and how they made a house, you probably wouldn't find or recognize any other ways. "How much do we have to imagine?" is like the question, "How many strokes do we have to use?"; and mustn't the answer be, "It depends"? "How do we know these ten strokes make a house?" is like the question, "How do we know that those ten words make that question?". It is at this level that the answer "Because we know the grammar of visual or verbal representation" is meant to operate.

Things, and things imagined, are not on a par. Six imagined rabbits plus one real rabbit in your hat do not total either seven imagined or seven real rabbits. But the very ability to draw a rabbit, like the ability to imagine one, or to imagine what we would feel or do or say in certain circumstances, depends upon the mastery of a form of representation (e.g., knowing what "That is a pumpkin" says) *and* on the general knowledge of the thing represented (e.g., knowing what a pumpkin is). That language can be represented in language is a discovery about language, one which shows the kind of stability language has (viz., the kind of stability an art has, the kind of stability a continuing culture has) and the kind of general knowledge we have about the expressions we use (viz., the kind we have about houses, faces, battles, visitations, colors, examples...) in order to represent or plan or use or explain them. To know how to use the word "anger" is to know what *anger* is. ("The world is my representation.")

I am trying to bring out, and keep in balance, two fundamental facts about human forms of life, and about the concepts formed in those forms: that any form of life and every concept integral to it has an indefinite number of instances and directions of projection; and that this variation is not arbitrary. *Both* the "outer" variance and the "inner" consistency are necessary if a concept is to accomplish its tasks—of meaning, understanding, communicating, etc., and in general, guiding us through the world, and relating thought and action and feeling to the world.

. . .

I might summarize the vision I have been trying to convey of the tempering of speech—the simultaneous tolerance and intolerance of words—by remarking that when Wittgenstein says "*Essence* is expressed by grammar" (§371), he is not denying the importance, or significance, of the concept of essence, but retrieving it. The need for essence is satisfied by grammar, if we see our real need. Yet at an early critical juncture of the *Investigations*, the point at which Wittgenstein raises the "great question that lies behind all these considerations" (§65), he imagines someone complaining that he has "nowhere said what the essence of a language-game, and hence of language, is: what is common to all these activities, and what makes them into language..."; and he replies: "...this is true. —Instead of producing something common to all that we call language, I am saying that these phenomena have no one thing in common which makes us use the same word for all." He then goes on to discuss the notion of "what is common" to all things called by the same name, obviously alluding to one familiar candidate philosophers have made to bear the name "universal" or "essence"; and he enjoins us, instead of saying "there *must* be something in common"—which would betray our possession by a philosophical "picture"—to "*look and see*" whether there is. He says that what we will actually find will be "a complicated network of similarities overlapping and criss-crossing: sometimes overall similarities, sometimes similarities of detail.... I can think of no better expression to characterize these similarities than 'family resemblances'" (§66, §67); and it looks as if he is here offering the notion of "family resemblances" as an alternative to the idea of "essence". But if this is so, his idea is empty, it explains nothing. For a philosopher who feels the need of universals to explain meaning or naming will certainly still feel their need to explain the notion of "family resemblance". That idea would counter the idea of universals only if it had been shown that family resemblance is all we need to explain the fact of naming *and* that objects may bear a family resemblance to one another and may have *nothing* in common; which is either false or trivial. It is false if it is

supposed to mean that, asked if these brothers have anything in common and we cannot say what, we will say "Nothing at all". (We may not be able to *say* very well what it is, but we needn't, as Wittgenstein imagines to be our alternative, merely "play with words" and say "There is something common to all...—namely the disjunction of all their common properties" (§67). For that would not even *seem* to say, if we see something in common among them, what we see. We might come up with, "They all have that unmistakeable Karamazov quality". That may not tell you what they have in common, but only because you don't know the Karamazovs; haven't grasped their essence, as it were.) Or else it is trivial, carries no obvious philosophical implication; for "They have nothing in common" has as specific and ordinary a use as "They have something in common" and just as Wittgenstein goes on to show ordinary uses of "what is common" which do not lead us to the idea of universals (cf. §72), so we can show ordinary uses of "there is nothing common to all" (which we *may* say about a set of triplets) which will equally not lead us *away* from the idea of universals.

But I think that all that the idea of "family resemblances" is meant to do, or need do, is to make us dissatisfied with the idea of universals as explanations of language, of how a word can refer to this and that and that other thing, to suggest that it fails to meet "our real need". Once we see that the expression "what is common" *has* ordinary uses, and that these are different from what universals are meant to cover; and, more importantly, see that concepts do not usually have, and do not need "rigid limits", so that universals are neither necessary nor even useful in explaining how words and concepts apply to different things (cf. §68); and again, see that the grasping of a universal cannot perform the function it is imagined to have, for a new application of a word or concept will still have to be *made out*, *explained*, in the particular case, and then the explanations themselves will be sufficient to explain the projection; and see, finally, that I *know* no more about the application of a word or concept than the explanations I can give, so that no universal or definition would, as it were, *represent* my knowledge (cf. §73)—once we see all this, the idea of a universal no longer has its *obvious* appeal, it no longer carries a *sense* of explaining something profound. (Obviously the drive to universals has more behind it than the sense that the generality of words must be explained. Another source of its power is the familiar fact that subjects and predicates function differently. Another is the idea that all we can know of an object is its intersection of essences.)

I think that what Wittgenstein ultimately wishes to show is that it *makes no sense* at all to give a general explanation for the generality of language, because it makes no sense at all to suppose words in general might *not* recur, that we might possess a name for a thing (say "chair" or "feeding") and yet be willing to call *nothing* (else) "the same thing". And even if you say, with Berkeley, that "an idea [or word] which considered in itself is particular, becomes general by being made to represent or stand for all other particular ideas of the same sort" (*Principles*, Introduction, section 12) you still haven't explained *how* this word gets used for these various "particulars", nor what the significance is if they don't. This suggests that the effort to explain the generality of words is initiated by a prior step which produces the idea of a word as a "particular", a step of "considering it in itself". And what *is* that like? We learn words in certain contexts.... What are we to take as the "particular" present here? Being willing to call other ideas (or objects) "the same sort" and being willing to use "the same word" for them is one and the same thing. The former does not explain the latter.

There is a Karamazov essence, but you will not find it if you look for *a* quality (look, that is, with the wrong "picture" of a quality in mind); you will find it by learning the grammar of "Karamazov": it is part of its grammar that *that* is what "an intellectual Karamazov" is, and *that* is what "a spiritual Karamazov" is, and *that* is what "Karamazov authority" is, ...Each is too much, and irresistible.

Arthur C. Danto (1924-)

Artworks and Real Things

To the memory of Rudolph Wittkower

> *The children imitating the cormorants,*
> *Are more wonderful*
> *Than the real cormorants.*
>
> > Issa

> *Painting relates to both art and life ...*
> *(I try to work in that gap between the two).*
>
> > Rauschenberg

From philosophers bred to expect a certain stylistic austerity, I beg indulgence for what may strike them as an intolerable wildness in the following paper. It is a philosophical reflection on New York painting from circa 1961 to circa 1969, and a certain wildness in the subject may explain the wildness I apologize for in its treatment. Explain but not excuse, I will be told: the properties of the subject treated of need never penetrate the treatment itself; Freud's papers on sexuality are exemplarily unarousing, papers in logic are not logical *merely* in consequence of their subject. But in a way the paper is part of its own subject, since it becomes an artwork at the end. Perhaps the final creation in the period it treats of. Perhaps the final artwork in the history of art!

I

Rauschenberg's self-consciously characterized activity exemplifies an ancient task imposed generically upon artists in consequence of an alienating criticism by Plato of art as such. Art allegedly stands at a certain invidious remove from reality, so that in

This paper was read in an earlier version at a conference on the philosophy of art at the University of Illinois at Chicago Circle. I am grateful to Professor George Dickie for having invited it. For prodromal reflections on much the same topic, see my paper "The Artworld," in *Journal of Philosophy*, vol. 61 (1964), pp. 571-584.

fabricating those entities whose production defines their essence, artists are contaminated at the outset with a kind of ontological inferiority. They bear, as well, the stigma of a moral reprobation, for with their productions they charm the souls of artlovers with shadows of shadows. Finally, speaking as a precocious therapist as well as a true philistine, Plato insinuates that art is a sort of perversion, a substitute, deflected, compensatory activity engaged in by those who are impotent to *be* what as a *pis-aller* they *imitate*. Stunned by this triple indictment into a quest for redemption, artists have sought a way towards ontological promotion, which means of course collapsing the space between reality and art. That there should, by Rauschenberg's testimony, still remain an insulating vacuity between the two which even *he* has failed to drain of emptiness, stimulates a question regarding the philosophical suitability of the task.

To treat as a defect exactly what makes a certain thing or activity possible and valuable is almost a formula for generating platonic philosophy, and in the case of art an argument may be mounted to show that its possibility and value is logically tied up with putting reality at a distance. It was, for example, an astonishing discovery that representations of barbaric rites need *themselves* no more be barbaric than representations of any *x* whatever need have the properties of *x*-hood. By *imitating* practices it was

horrifying to engage in (Nietzsche), the Greeks spontaneously put such practices at a distance and invented civilization in the process; for civilization consists in the awareness of media as media and hence of reality as reality. So just those who gave birth to tragedy defeated an insupportable reality by putting between themselves and it a spiritualizing distance it is typical of Plato to find demeaning. It may be granted that this achievement creates the major problem of representational art, which is sufficiently to resemble the realities it denotes that identification of it as a representation of the latter is possible, while remaining sufficiently different that confusion of the two is difficult. Aristotle, who explains the pleasure men take in art through the pleasure they take in imitations, is clearly aware that the pleasure in question (which is intellectual) logically presupposes the knowledge that it *is* an imitation and not the real thing it resembles and denotes. We may take (a minor) pleasure in a man imitating a crow-call of a sort we do not commonly take in crow-calls themselves, but this pleasure is rooted in cognition: we must know enough of crow-calls to know that these are what the man is imitating (and not, say, giraffe-calls), and must know that he and not crows is the provenance of the caws. One further condition for pleasure is this, that the man *is* imitating and not just an unfortunate crow-boy, afflicted from birth with a crowish pharynx. These crucial asymmetries need not be purchased at the price of decreased verisimilitude, and it is not unreasonable to insist upon a perfect acoustical indiscernibility between true and sham crow-calls, so that the uninformed in matters of art might—like an overhearing crow, in fact—be deluded and adopt attitudes appropriate to the reality of crows. The knowledge upon which artistic pleasure (in contrast with *aesthetic* pleasure) depends is thus external to and at right angles to the sounds themselves, since they concern the causes and conditions of the sounds and their relation to the real world. So the option is always available to the mimetic artist to rub away all differences between artworks and real things providing he is assured that the audience has a clear grasp of the distances.

It was in the exercise of this option, for example, that Euripides undertook the abolition of the chorus, inasmuch as *real* confrontation, *real* frenzies of jealousy commonly transpire without benefit of the ubiquitous, nosy, and largely disapproving chorus inexplicably (to *him*) deemed necessary for the action to get on by his predecessors. And in a similar spirit of realism, the stony edifying heroes of the past are replaced by plain folks, and their cosmic suffering with the commonplace heartpains of such (for example) as us. So there *was* some basis for the wonder of his contemporary, Socrates (who many, considering his Egyptolatry in the *Laws*, have been disapproving not so much of art as of *realistic* art in the *Republic*), as to what the *point* of drama any longer could be: if we have the real thing, of what service is an idle iteration of it? And so he created a dilemma by looking inversely at the cognitive relations Aristotle subsequently rectified: either there is going be a discrepancy, and mimesis fails, or art succeeds in erasing the discrepancy, in which case it just *is* reality, a roundabout way of getting what we already *have*. And, as one of his successors has elegantly phrased it: "one of the damned things is enough." Art fails if it is indiscernible from reality, and it equally if oppositely fails if it is not.

We are all familiar enough with one attempt to escape this dilemma, which consists in locating art in whatever makes for the discrepancies between reality and imitations of it. Euripides, it is argued, went in just the wrong direction. Let us instead make objects which are *insistently* art by virtue of the fact that no one can mistake them for reality. So the disfiguring conventions abolished in the name of reality become reintroduced in the name of art, and one settles for perhaps a self-conscious woodenness, a deliberate archaism, an operatic falseness so marked and underscored that it must be apparent to any audience that illusion could never have been our intent. *Non*-imitativeness becomes the criterion of art, the more artificial and less imitative in consequence, the purer the art in question. But a fresh dilemma awaits at the other end of the inevitable route, namely that non-imitativeness is *also* the criterion of reality, so the more purely art things become, the closer they verge on reality, and *pure* art collapses into pure *reality*. Well, this may after all be the route to ontological promotion, but the other side of the dilemma asks what makes us want to call

art what by common consent is reality? So in order to preserve a distinction, we reverse directions, hardly with a light heart since the same dilemma, we recall, awaits us at the other end. And there seems, on the face of it, only one available way to escape the unedifying shuttle from dilemma to dilemma, which is to make non-imitations which are radically distinct from all heretofore existing real things. Like Rauschenberg's stuffed goat garlanded with a tire! It is with such unentrenched objects, like combines and emerubies, that the abysses between life and art are to be filled!

There remains then only the nagging question of whether all unentrenched objects are to be reckoned artworks, e.g., consider the first can-opener. *I* know of an object indiscernible from what happen to be our routine can-openers, which *is* an artwork:

> The single starkness of its short, ugly, ominous blade-like extremity, embodying aggressiveness and masculinity, contrast formally as well as symbolically with the frivolous diminishing helix, which swings freely (but upon a fixed enslaving axis!) and is pure, helpless femininity. The two motifs are symbiotically sustained in single, powerful composition, no less universal and hopeful for its miniature scale and commonplace material.
> [*Gazette des beaux arts*, vol. 14, no. 6, pp. 430-431. My translation]

As an artwork, of course, it has the elusive defining properties of artworks, significant form *compris*. In virtue of its indiscernibility from the domestic utensil, then, one might think it uncouth if not unintelligible to withhold predication of significant form to the latter, merely on the grounds of conspicuous *Zunhandenheit* (one *could* open cans with the work the critic of the *Gazette* was so stirred by) or large numbers. For it would be startling that two things should have the same shape and yet one have and the other lack significant form. Or it would be were we to forget for an inadvertent moment the existence of a Polynesian language in which the sentence "Beans are high in protein," indiscernible acoustically from the English sentence "Beans are high in protein" actually means, in its own language, what "Motherhood is sacred" means in English. And it induces profound filial sentiments when audited by native speakers though hardly that with us. So perhaps significant form is supervenient upon a semantical reading, itself a weak function of language affiliation which mere inscriptional congruity happens to underdetermine? The question is suitably rhetorical at this point, for my concern is that the logical intersection of the non-imitative and the non-entrenched may as easily be peopled with artworks as by real things, and *may* in fact have pairs of indiscernible objects, one an artwork and one not. In view of this possibility, we must avert our eyes from the objects themselves in a counter-phenomenological turn—*Von den Sachen selbst!*—and see whatever it is, which clearly does not meet the eye, which keeps art and reality from leaking hopelessly into one another's territory. Only so can we escape the dilemma of Socrates, which has generated so much art-history through the misunderstandings it epitomizes and encourages.

II

Borges merits credit for, amongst other things, having discovered the Pierre Menard Phenomenon: two art-objects, in this instance two fragments of the *Quixote*, which though verbally indiscriminable have radically non-overlapping and incompatible *artistic* properties. The art-works in question stand to their common physical embodiment in something like the relationship in which a set of isomers may stand to a common molecular formula, which then underdetermines and hence fails to explain the differences in their chemical reactions. The difference, of course, is given by the way the elements recorded in the formula are put together. Of the two *Quixotes*, for example, one is "more subtle" and the other "more clumsy" than its counterpart. That of Cervantes is the more coarse: it "opposes to the fiction of chivalry the tawdry provincial reality of his country." Menard's ("On the other hand...") selects for *its* reality "the land of Carmen during the century of Lepanto and Lope de Vega." Menard's work is an oblique condemnation of *Salammbô*, which Cervantes' could hardly have been. Though visibly identical, one is almost incomparably richer than the other and, Borges writes, "The contrast in style is also vivid. The archaic style of Menard—quite foreign, after all —suffers from a certain affectation. Not so that of his forerunner, who handles with ease the current

Spanish of his time." Menard, were he to have *completed* his *Quixote*, would have had the task of creating at least one character in excess of Cervantes': the author of the (so-called in Menard's but *not* so-called in Cervantes') "Autobiographical Fragment." And so on. Menard's work was *his*, not a copy nor an accidentally congruent achievement of the sort involved in the discovery that the painters of Jupiter are making (there being no question here of cultural diffusion) flat works using the primary colors and staggeringly like Mondrians, but rather a fresh, in its own way remarkable creation. A mere copy would have no *literary* value at all, but would be merely an exercise in facsimilation, and a *forgery* of so well known a work would be a fiasco. It is a precondition for the Menard phenomenon that author and audience alike know (not the original but) the *other* Quixote. But Menard's is not a quotation either, as it were, for quotations in this sense *merely* resemble the expressions they denote without having *any* of the artistically relevant properties of the latter: *quotations* cannot be scintillating, original, profound, searching, or whatever what is quoted may be. There are, indeed, theories of quotation according to which they lack *any* semantical structure, which their originals seldom lack. So a *quotation* of the Quixote (*either* Quixote) would be artistically null though quite superimposable upon its original. Quotations, in fact, are striking examples of objects indiscernible from originals which are not artworks though the latter are. Copies (in general) lack the properties of the originals they denote and resemble. A copy of a cow is not a cow, a copy of an artwork is not an artwork.

Quotations are entities difficult to locate ontologically, like reflections and shadows, being neither artworks nor real things, inasmuch as they are parasitic upon reality, and have in particular that degree of derivedness assigned by Plato to artworks as class. So though a copy—or quotation—of an artwork is logically excluded from the class of artworks, it raises too many special questions to be taken as our specific example of an entity indiscernible from an artwork though not one. But it is not difficult to generate less intricate examples. Consider, for the moment, *neckties*, which have begun to work their way into the artworld, e.g., Jim Dine's *Universal Ties*,

John Duff's *Tie Piece*, etc. Suppose Picasso exhibits now a tie, painted uniform blue in order to reject any touch of *le peinture* as decisively as the Strozzi altarpiece rejects, as an act of artistic will, giottesque perspective. One says: my child could do *that*. Well, true enough, there is nothing beyond infantile capability here: so let a child, with his stilted deliberateness, color one of his father's ties an all over blue, no brush-strokes 'to make it nice.' I would hesitate to predict a magnificent future in art for this child on the basis of his having caused the existence of something indistinguishable from something created by the greatest master of modern times. I would go further, and say that he has not produced an artwork. For something prevents *his* object from entering the artworld, as it prevents from entering that world those confections by a would-be van Meegeren of Montmartre who sees at once the Picasso tie as a chance for clever forgery. Three such objects would give rise to one of those marvelous Shakespearean plots, of confused twins and mistaken identities, a possibility not a joking one for Kahnwieler (or was it Kootz?) who takes all the necessary precautions. *In spite of which*, let us suppose, the ties get mixed up, and the child's tie hangs to this very day in the Museum of the Municipality of Talloir. Picasso, of course, disputes its authenticity, and refuses to sign it (in fact he signs the forgery). The original was confiscated by the Ministry of Counterfacts. I look forward to the time when a doctoral candidate under Professor Theodore Reff straightens out the attributions by counting threads, though the status of a forgery with an authentic signature remains for philosophers of art to settle. Professor Goodman has an intriguing argument that sooner or later differences are bound to turn up, that what looks identically similar today will look artistically so diverse tomorrow that men will wonder how the case I have described would ever have arisen. Well, sufficient unto the day may be the similarities thereof: tomorrow's differentiations would appear *whichever* of the three ties were to hang in the museum, and I am inclined to feel that any seen differences will ultimately be used to reinforce the attribution, right or wrong, which is the accepted one. But that leaves still unsettled the ontological questions, besides generating a kind of absurdity of connoisseurship by

bringing into the aesthetics of this order of object the refined peering appropriate, say, to Poussin or Morandi or Cézanne. None of whom, though clearly not for reasons of artistic ineptitude, would have been able to make an artwork out of a painted tie. So it isn't just that Picasso happens to be an *artist* that makes the difference in the cases at hand. But the further reasons are interesting.

For one thing, there would have been no room in the artworld of Cézanne's time for a painted necktie. Not everything can be an artwork at every time: the artworld must be ready for it. Much as not every line which is *witty* in a given context can be witty in all. Pliny tells of a contest between rival painters, the first drawing a straight line; the second drawing, in a different color, a line *within* that line; the first drawing an ultimately fine line within this. One does not ordinarily think of lines as having sides, but with each inscribed line, a space exists between its edges and the edges of the containing line, so that the result would be like five very thin strips of color. Nested lines, each making space where none was believed possible, shows remarkable steadiness of hand and eye, and bears witness to the singular prowess of Parahesios and his rival here. And the object was a wonder in its time. But not an artwork! No more than the famous free-hand circle of Giotto. But I could see exactly such an object turning up on Madison Avenue today, a synthesis, perhaps, of Barnett Newman and Frank Stella. Such an object in the time of Parahesios would have *merely* been a set-piece of draughtsmanly control. So it is not even as though, on the Berkeleyan assumption that only artworks can anticipate artworks, Parahesios were a predecessor of the contemporary painter of fine stripes. Parahesios could not have modified his perception of art, nor that of his times, to accommodate his *tour de main* as an artistic achievement. But Picasso's artworld was ready to receive, at Picasso's hand, a necktie: for he had made a chimpanzee out of a toy, a bull out of a bicycle seat, a goat out of a basket, a venus out of a gas-jet: so why not a *tie out of a tie*? It had room not only in the artworld, but in the corpus of the artist, in a way in which the identical object, from the hands of Cézanne, would have had room for neither. Cézanne could only have made a mountain out of paint, in the received and traditional manner of such transformations. He did not have the option even of making paint out of paint, in the later manner of the Abstract Expressionists.

But while these considerations serve to show that the identical object could, in one art-historical context be an artwork and in another one not, the problem remains of moving from *posse ad esse*. What, apart from the possibility, makes it actually a work of art in the context of late Picasso? And what makes then the differences between what Picasso did and his contemporaries, the child and the forger, did? Only when the world was ready for "Necktie" could the comedy of mistaken identities have transpired, and while it is easy to see how, given the sharp and exact resemblances, an artwork which was a necktie should have been confused with a necktie which was not an artwork, the task of explicating the differences remains.

One way to see the matter is this: Picasso *used* the necktie to *make a statement*, the forger employed the necktie to copy what Picasso made a statement with, but made *no* statement by means of his. And this would be true even were he inspired by van Meegeren to invent, say, a rose-colored necktie to fill a gap in Picasso's development. The child and Cézanne are simply making noise. Their objects have no location in the history of art. Part at least of what Picasso's statement is about is art, and art had not developed appropriately by the time of Cézanne for such a statement to have been intelligible, nor can the child in question have sufficiently internalized the history and theory of art to make a statement, much less *this* statement, by means of the painted necktie. At least the right relations hold between the four objects to enable a distinction structurally of a piece with that between statement, echo, and noise to be made. And though a real enough object—a hand-painted tie!—Picasso's work stands at just the right remove from reality for it to *be* a statement, indeed a statement in part about reality and art sufficiently penetrating to enable its own enfranchisement into the world of art. It enters at a phase of art-history when the consciousness of the difference between reality and art is part of what makes the difference between art and reality.

III

Testamorabida is a playwright who deals in Found Drama. Disgusted with theatricality, he has run through the tiresome post-Pirandello devices for washing the boundaries away between life and art, and has sickened of the contrived atmospheres of happenings. Nothing is going to be real enough save reality. So he declares his latest play to have been everything that happened in the life of a family in Astoria between last Saturday and tonight, the family in question having been picked by throwing a dart at the map of the town. How natural are the actors! They have no need to overcome the distance from their roles by stanislaviskyian exercise, since they *are* what they play. Or 'play.' The author 'ends' the play by fiat at eleven-ten (curtain) and has the after-theater party with friends at the West End Bar. No reviews, there was no audience, there was just one 'performance.' For all the 'actors' know, it was an ordinary evening, pizza and television, hair put up in rollers, a wrong number and a tooth-ache. All that makes this slice of life an artwork is the declaration that it is so, plus the meta-artistic vocabulary: 'actor,' 'dialogue,' 'natural,' 'beginning,' 'end.' And perhaps the title, which may be as descriptive as you please, viz., "What a Family in Astoria Did...".

Titles are borne by artworks, interestingly enough, though not by things indiscernible from them which are *not* artworks, e.g., another period in the life of that or any other family in Astoria or anywhere. Even 'Untitled' is a kind of title: non-artworks are not entitled even to be untitled. Cézanne's hand-painted necktie may bear a label, say at the Cézanne House, along with other memorabilia, but 'Cézanne's Necktie' is not its title ('Cézanne's Necktie' could be the title of Picasso's tie if it were painted in just the color of the Louvre's *Vase Bleu*). Noblemen have titles too. 'Title' has the ring of status, of something which can be conferred. It has, indeed, enough of the ring of legality to suggest that 'artwork'—perhaps like 'person!'—is after all an ascriptive term rather than a descriptive—or exclusively descriptive—one.

Ascriptively, as I understand it, is a property of predicates when they attach to objects in the light of certain conventions, and which apply less on the basis of certain necessary and sufficient conditions than of certain defeating conditions not holding. 'Person' is defeasible, for example, through such avenues as minority, subcompetence, disenfranchisement, financial responsibility and liability, and the like. A corporation can consist of a single person, who is not identical with the corporation in question, and the distinction between that person and the corporation he belongs to is perhaps enough like the distinction between an artwork and the physical object it consists in but is not identical with that we can think of artworks in terms of privileges, exemptions, rights, and the like. Thus artworks, which happen to contain neckties, are entitled to hang in museums, in a way in which neckties indiscernible from the former are not. They have, again, a certain peer-group which their indiscernible but plebeian counterparts do not. The blue necktie which is an artwork belongs with the Cowper-Niccolini Madonna and the Cathedral of Laon, while the necktie just like it which is not an artwork belongs just with the collars and cufflinks of banal haberdashery, somewhat *abîmé* by blue-paint. The blue necktie, indeed, is in the museum and in the collection, but its counterparts, though they can be geometrically in the museum, are there only in the way sofas and palm-trees typically are. There is, in fact, a kind of *In-der-Pinakothek-sein* not so awfully different from the *In-der-Welt-sein* which pertains to persons in contrast with things. A necktie which is an artwork differs from one which is not like a person differs from a body: metaphysically, it takes two sets of predicates amazingly similar to the P- and M-predicates which *persons* take on a well-known theory of P. F. Strawson's: no accident, perhaps, if 'person' too is an ascriptive predicate. The blue necktie, thus, which is an artwork, is *by* Picasso, whereas its counterpart is not *by* Cézanne even though he put the paint on it. And so forth. So let us try this out for a moment, stressing here the defeating conditions, less to strike a blow against Testamorbida than to see what kind of thing it is that can be subject to defeat of this order. I shall mention only two defeating conditions as enough for our purposes, though hardly exhausting the list. Indeed, were art to evolve, new defeating conditions would emerge.

(1) *Fakes*. If illusion were the aim after all of art,

then there would be just exactly the same triumph in getting Stendhal to swoon at a fake Guido Reni as causing birds to peck at painted grapes. There is, I believe, no stigma attached to painting pictures of pictures: Burliuk once told me that, since artists paint the things they love and since *he* loved *pictures*, he saw no obstacle to painting pictures of pictures, viz., of Hogarth's *Shrimp Girl*. It happens that Burliuk remained himself, his picture of the *Shrimp Girl* deviating from the *Shrimp Girl* roughly as he differed from Hogarth. He was not, on the other hand, pretending the *Shrimp Girl* was *his* any more than he was pretending that Westhampton, which he also and in the same spirit painted pictures of, was *his*: what was *his* was the painting, a statement in paint which denoted the *Shrimp Girl* as his seascapes denoted glimpses of Westhampton: so we are distanced as much from the one motif as from the other, admiring in both cases the vehicle. Well, a man might love his own paintings as much as he loves those of others, so what was to have prevented Burliuk from painting, say, his *Portrait of Leda*? This is not a case of *copying* the latter, so that we have two copies of the same painting: it is explicitly a painting *of* a painting, a different thing altogether, though it might exactly enough resemble a copy. A copy is defective, for example, insofar as it deviates from the original, but the question of deviation is simply irrelevant if it is a painting of a painting: much as we do not expect the artist to use chlorophyll in depicting trees. Now, if deviation is irrelevant, so is non-deviation. A copy is, indeed, just like a quotation, showing what we are to respond to rather than being what we are to respond to: whereas a painting of a painting is something *to* which we respond. Artists who repeat themselves, the Pierre Menard phenomenon notwithstanding, raise some remarkable questions. Schumann's last composition was based on a theme he claimed was dictated to him by angels in his sleep, but was *in fact* the slow movement of his own recently published Violin Concerto. (Is it an accident that Schumann was working on a book of quotations at the time of his *Zusammenbruch*?) Robert Desnos's *Dernier Poème à Youki* ("*J'ai tant rêvé de toi que to perds ta réalité...*") is simply, according to Mary Ann Caws, "a retranslation into French of the rough and truncated translation into Czech" of his earlier and famous poem addressed to the actress Yvonne George: but was Desnos delirious when he addressed this poem, at his death, to Youki (or did he confuse Youki and Yvonne) or think it was a new poem or what? (I mention Schumann and Desnos in case someone thinks Goodman's distinction of one- and two-stage arts has any bearing). Repetitions are maddening.

A fake pretends to be a statement but is not one. It lacks the required relation to the artist. That we should mistake a fake for a real work (or *vice versa*) does not matter. Once we discover that it is a fake, it loses its stature as an artwork because it loses its structure as a statement. It at best retains a certain interest as a decorative object. Insofar as being a fake is a defeating condition, it is analytical to the concept of an artwork that it be "original". Which does not entail that it need or cannot be derivative, imitative, influenced, 'in the manner of,' or whatever. We are not required to invent a language in order to make a statement. Being an original means that the work must in a deep sense originate with the artist we believe to have done it.

(2) *Non-artistic provenance.* It is analytically true that artworks can only be *by* artists, so that an object, however much (or exactly) it may resemble an artwork is not *by* whoever is responsible for its existence, unless he is an artist. But "artist" is as ascriptive a term as "artwork," and in fact "by" is as ascriptive as either. Since, after all, not everything whose existence we owe to artists are *by* him. Consider the customs inspector who bears the stings of past and recent *gaffes* by his peers and decides to take no chances: a certain piece of polished brass— in fact the bushing for a submarine—is declared an artwork. But *his* so calling it that no more makes it an artwork than someone in the same métier calling an object near of morphic kin to it *not* an artwork made the latter *not* be one. What injustice, then, if an artist decides to exhibit the bushing as a found object.

Douaniers, children, chimpanzees, counterfeiters: tracing an object to any of these defeats it as an artwork, demotes it to the status of a mere real object. Hence the logical irrelevance if the claim that a child, a chimpanzee, a forger, or, *à la rigeur*, a customs inspector could *do* any of them. The mere object perhaps does not lie outside their powers. But as an

artwork it does. Much in the way in which not everyone who can say the words "I pronounce you man and wife" can marry people, nor who can pronounce the words "Thirty days or thirty dollars" can *sentence* a man. So the question of whether an object is *by* someone, and how one is qualified to make artworks out of real things, are of a piece with the question of whether it is an artwork.

The moment something is considered an artwork, it becomes subject to an *interpretation*. It owes its existence as an artwork to this, and when its claim to art is defeated, it loses its interpretation and becomes a mere thing. The interpretation is in some measure a function of the artistic context of the work: it means something different depending upon its art-historical location, its antecedents, and the like. And as an artwork, finally, it acquires a structure which an object photographically similar to it is simply disqualified from sustaining if it is a real thing. Art exists in an atmosphere of interpretation and an artwork is thus a vehicle of interpretation. The space between art and reality is like the space between language and reality partly because art *is* a language of sorts, in the sense at least that an artwork says something, and so presupposes a body of sayers and interpreters who are in position, who define what being in position is, to interpret an object. There is not art without those who speak the language of the artworld, and who know enough of the difference between artworks and real things to recognize that calling an artwork a real thing *is* an interpretation of it, and one which depends for its point and appreciation on the contrast between the artworld and the real-world. And it is exactly with reference to this that the defeating conditions for ascription of "artwork" are to be understood. If this is so, then ontological promotion of art is hardly to be looked for. It is a logical impossibility. Or nearly so: for there is one further move to reckon with.

IV

Much as philosophy has come to be increasingly its own subject, has turned reflexively inward onto itself, so art has done, having become increasing its own (and only) subject: like the Absolute of Hegel, which finally achieved congruence with itself by becoming self-contemplative in the respect that *what* it contemplates is itself in contemplation. Rosenberg thus reads the canvas as an arena in which a real action occurs when an artistic (but *nota bene*: *only* when an *artist*) makes a wipe of paint upon it: a stroke. To appreciate that the boundaries have been crossed, we must read the stroke as saying, in effect, about itself, that it *is* a stroke and not a representation of anything. Which the indiscernible strokes made by housepainters cannot *begin* to say, though it is true that they are strokes and not representations. In perhaps the subtlest suite of paintings in our time, such strokes—fat, ropy, expressionist—have been read with a deadly literalness of their makers' or the latter's ideologues intention as (mere) real things, and made the subject of paintings as much as if they were apples, by Roy Lichtenstein. These are paintings *of* brush strokes. And Lichtenstein's paintings say, about themselves, at least this: that they *are* not but only represent brush strokes, and yet they are art. The boundaries between reality and art as much inform these works as they did the initial impulses of the Abstract Expressionists they impale. The boundaries between art and reality, indeed, become *internal* to art itself. And this is a revolution. For when one is able to bring within oneself what separates oneself from the world, viz., as when Berkeley brings the brain into the mind, the distinction between mind and brain now standing as a distinction within the mind itself, everything is profoundly altered. And in a curious way, the Platonic challenge has been met. Not by promoting art but by demoting reality, conquering it in the sense that when a line is engulfed, what lies on both sides of that line is engulfed as well. To incorporate one's own boundaries in an act of spiritual topology is to transcend those boundaries, like turning oneself inside out and taking one's external environment in as now part of oneself.

I would like briefly to note two consequences of this. The first is that it has been a profoundly disorienting maneuver, increasingly felt as the categories which pertain to art suddenly pertain to what we always believed contrasted essentially with art. Politics becomes a form of theater, clothing a kind of costume, human relations a kind of role, life a

game. We interpret ourselves and our gestures as we once interpreted artworks. We look for meanings and unities, we become players in a play.

The other consequence is more interesting. The relationship between reality and art has traditionally been the province of philosophy, since the latter is analytically concerned with relations between the world and its representations, the space between representation and life. By bringing within itself what it had traditionally been regarded as logically apart from, art transforms itself into philosophy, in effect. The distinction between philosophy of art and art itself is no longer tenable, and by a curious, astounding magic we have been made over into contributors to a field we had always believed it our task merely to analyze from without.

Barbara Savedoff (1956-)

The Art Object

Art is the product of an etiquette, and to neglect its conceptual framework and reduce it to its physical data is an act of barbarism.[1]

Art theorists, critics and philosophers alike, currently emphasize the dependence of the art object on theory for its status and identity as art. We see an object as a work of art because of the ideas surrounding it, and these ideas also determine the direction our interpretation of the work will take. The critic Harold Rosenberg describes this dependence in his essay 'Art and Words'. It is a background of theory which keeps us from seeing a Kenneth Noland striped painting as a fabric design, and 'which places a [Barnett Newman painting] in the perspective of Abstract Expressionism rather than of Bauhaus design or mathematical abstraction'.[2]

Philosophers, in illustrating the same point, have favoured examples from Dada and Pop Art of identical art/non-art pairs.[3] Since an art work can look exactly like something which is not art, art status cannot be a matter of physical properties. Thus Arthur Danto calls on an 'atmosphere of art theory' to explain why Warhol's piles of Brillo boxes are art and those of the supermarket stockboy are not,[4] while Timothy Binkley refers to the procedure of indexing with reference to the conventions of art to explain the art status of Dada Readymades that are identical to their non-art counterparts.[5]

We can add that this atmosphere, these conventions, do more than confer art status—they are responsible for our distinguishing the Pop *Brillo Boxes* from Dada Readymades, and for our distinguishing the forms of interpretation appropriate to each.

With this recognition that the art work cannot be identified simply with a physical object, there has been an emphasis on the importance of theory, context, and convention and a corresponding de-emphasis of the importance of the physical object for the identification of a work. In the hurry to abandon the object and to adopt theory as the means of identifying the art work, the importance of the object in that identification has sometimes been underestimated.

For example, even though a title may be important in giving us a clue to the ideas surrounding a painting, it doesn't give us everything we have to know in order to interpret a painting and identify it elements. At most, it is the way the title plays off the titled object which will determine the interpretation—we have to know how the painting looks in order to determine how the title might affect interpretation. This may seem uncontroversial, but it is a fact which Danto overlooks in his discussion of examples, both in "The Artworld" and in *The Transfiguration of the Commonplace*.

Though the object is thus central to the interpretation of works in traditional media, such as painting and sculpture, it might seem that conceptual art[6] presents an exception, since the role of the object is reduced to that of communicating ideas. It would seem that all the critically relevant information about the work is contained in the communicated ideas.

1. Harold Rosenberg, 'Art and Words', in G. Battcock, ed. *Idea Art* (New York: Dutton, 1973), p. 154.

2. Ibid., p. 151.

3. In this paper, I shall call two objects identical when they look exactly the same.

4. Arthur Danto, 'The Artworld', *Journal of Philosophy*, Vol. LXI, No. 19 (15 Oct. 1964).

5. Timothy Binkley, 'Piece: Contra Aesthetics', *Journal of Aesthetics and Art Criticism*, Vol. XXXV, No. 3 (Spring, 1977).

6. I use the term 'conceptual art' in a broad sense to refer to art concerned primarily with ideas. So the term encompasses much of Dada and Pop, as well as Conceptual art proper.

Acquaintance with the object and its particular physical properties would therefore be unnecessary. But even for conceptual art, acquaintance with the object and its properties is often essential to the full interpretation of a work. This is overlooked by Binkley in his discussion of the interpretation of various Dada and Conceptual works in his essay 'Piece: Contra Aesthetics'.

Both Danto and Binkley neglect the art object in their interpretations of particular works, much to the detriment of those interpretations. But this neglect is not confined to the writings of philosophers of art. It can be found in the writings of art critics as well. Too often, interpretations are only weakly supported, or not supported at all, by the objects under consideration.

In this paper, I will show how attention to the art object is essential to the proper interpretation of the works which Danto and Binkley discuss. I will then briefly note the way in which the lack of attention to the object has undermined some recent art criticism. If we are to have criticism which actually illuminates the work it discusses, the central role the object plays in interpretation must be recognized.

I

One of the key examples in both 'The Artworld' and *The Transfiguration of the Commonplace* is that of the hypothetical identical pair of murals *Newton's First Law* and *Newton's Third Law*. Each is a painted white vertical rectangle divided through the middle by a horizontal black line, but since for Danto a title 'is more than a name or label; it is a *direction* for the interpretation',[7] the differently entitled murals allow of very different interpretations. *Newton's First Law* is described as representing the path through space of an isolated particle. *Newton's Third Law* is described as 'a mass pressing downward met by a mass pressing upward'.[8] There are other ways we could identify these objects as paintings, all having to do with our reading of the horizontal line as above, below, or in a white surface. Danto says that these 'different identifications are incompatible with one another...and each might be said to make a different artwork, even though each artwork contains the identical real objects as part of itself'.[9] In other words, different titles of identical objects give us different identifications, and different identifications give us different works. Or do they? This description of the situation ignores actual art critical practice as well as the distinction between painting and making diagrams; it also points to some dangers of using hypothetical examples.

Rather than describe different works, Danto has only presented us with different possible readings of the objects under consideration. His analysis is an accurate account of how our interpretation of two diagrams might differ depending on their title or caption. Identical diagrams may be used to illustrate many different things. But *Newton's First Law* and *Newton's Third Law* are not supposed to be diagrams; they are supposed to be painted murals.

A diagram is a diagram *of* something. What this 'something' is is usually indicated by a caption or by labels within the diagram. A diagram of the unemployment rate shows the number of people unemployed over a certain period of time. We could see it as showing the inflation rate or as representing a mountain range, but either of these would be misinterpretations of a diagram of the unemployment rate. A particular diagram can be seen as representing any of a variety of things; its caption tells us what is actually being represented.

Consider, then, a diagram consisting of a rectangle horizontally divided by a straight line. It may be seen as many different things, but its caption 'Newton's First Law' or 'The Path of an Isolated Particle through Space', tells us how it is to be understood. To read a diagram, so captioned, as representing two masses pressing against each other with equal and opposing force, or as representing a flat horizon, would be to misinterpret the diagram. The captioned diagram allows of one correct reading, one correct interpretation.

Now consider a painting which consists of a white surface horizontally divided by a black line. This description allows for several possibilities. For example, the white may be painted flat, so that we are

7. Arthur Danto, *The Transfiguration of the Commonplace* (Cambridge, Mass.: Harvard U. P., 1981), p. 119.

8. Danto (1964), p. 577.

9. Danto (1964), p. 578.

forced to read the painting as presenting two surfaces which abut at the central line, or the white may be painted in such a way as to create an illusion of deep space behind the black line. Then again, the white may be so painted as to be ambiguous between these two readings—we might think here of Brice Marden paintings which hover between flatness and illusionistic space. The differences in the possible readings of the imagined painting will depend on differences in the object. How the painting looks will determine the range of allowable readings.

Suppose then that the painting is ambiguous between two readings. Though incompatible, each reading belongs to a full understanding of the painting. To ignore one in favour of the other would be to ignore a part of the painting. To identify a Brice Marden painting as flat surface, and to disallow other identifications, would be to fail to fully comprehend the painting.

The identity of the elements of a diagram is determined by its text, and all other possible identifications are irrelevant to its functioning as a diagram. Not so for painting. In order to understand a painting, we need not find unambiguous identifications for each of its elements. In fact, such a reductive procedure would represent a failure to treat the work as art. Art works allow of ambiguity.

Given this, how might the title of the painting determine its identity? Calling the painting 'Newton's Third Law', or more explicitly, 'Two Masses', will not rid the painting of its spatial ambiguity—that ambiguity is there to be seen. Nor will the title render the spatial interpretation irrelevant to the analysis or criticism of the painting. To allow the title this priority would be to confuse painting with diagramming.

If a painting is ambiguous between two readings, illusionistic and flat, giving it the title 'Newton's Third Law' would not serve to produce a work fully and accurately described as presenting 'a mass pressing downward met by a mass pressing upward'. The painter would have to paint an unambiguously flat painting if the title were to produce the desired unambiguous identification and art work.

This is not to say that titles never determine the identification of art works. To give a patently illusionistic version of the painting the title 'Two Surfaces' would be to add a layer of meaning absent from the untitled work. For example, we could see the title, and therefore the painting, as an ironic comment on the inevitable illusionism of painting and on the misguided attempts of those who seek absolute flatness. The title does not force us to read the elements of the painting differently, but it forces us to place the reading in a new context—thus producing a new interpretation and a new work. The title doesn't have the power to dictate one supportable reading over another. At most, it adds another element to the interpretation.

This effect on interpretation only occurs when the context is such that we deem it appropriate to include the title as part of the work. For example, Robert Rauschenberg erased a de Kooning drawing and entitled it 'Erased de Kooning'. *Erased de Kooning* admits of an entirely different interpretation than the one its untitled identical counterpart would require. Instead of forcing us to consider the ramifications of creating one work of art by destroying another, the untitled work would most likely leave us to contemplate the subtle markings left by the erasure. Similarly for Duchamp's *L.H.O.O.Q. Shaved* and its identical untitled counterpart. The untitled work would refer us to the *Mona Lisa*, while the titled work refers us to Duchamp's *L.H.O.O.Q.* In these cases, the titles make for different works.

It's doubtful, though, whether Whistler's painting *Arrangement in Gray and Black* would have been identified as a different work had it been entitled 'The Artist's Mother'. The title 'Arrangement in Gray and Black' serves to indicate Whistler's concern with formal qualities, and he might have hoped that it would serve to direct the viewers' attention to the formal aspects of the painting they were in the habit of ignoring. But the title doesn't force viewers to ignore the representational element of the work in a proper analysis.

The titles of Frank Stella's Indian Bird series, or of Mel Bochner's wall paintings are of even more doubtful interpretative relevance. It would be beside the point to seek in them a guide for our interpretation. More likely than not, such an effort would set us on the wrong track, diverting our attention

from what was interesting and significant about those works. Often a title just names the object.

Danto is right in asserting that the interpretation of a work is determined by the context in which it is presented. The age, community, conditions of presentation, and history of an object determine the theory by which we identify it and by which we would distinguish it from an identical object with a different context. A title, on the other hand, is one element among others at the artist's disposal in the creation of a work. An artist might sometimes be able to make different works of identical objects by entitling them differently, but usually the context of the work won't allow the title that significance. In any case, the title of the work cannot override the visual data, dictating how they are to be read. At most, the title places the data, the object, in a new context.

II

Let us now turn to Timothy Binkley's claim that the increase in the role of theory in certain movements of twentieth-century art has led to the creation of art works which are not about the look of the object, art works for which the object is altogether superfluous. Binkley contends that there are cases where the title and description of a work constitute the work, and so serve to acquaint us completely with the work. This claim is trivially true of conceptual works such as those of Lawrence Wiener, which consist solely in a description. But where the work involves an object, as in Dada and Pop Art, we should not too hastily proclaim the irrelevance of the object or its look.

Binkley tells us that 'the first version of *L.H.O.O.Q.* was executed by Picabia on Duchamp's instructions', while the version with which we are familiar was executed by Duchamp himself. Binkley claims that 'it would be an idle curiosity to speculate whose version is better or more interesting on the basis of how each looks',[10] for the artistically relevant features are not aesthetic ones.

Is it true that the look is entirely irrelevant, that we can fully know *L.H.O.O.Q.* just by having it described to us? The look is irrelevant if by that we

just mean that we don't look for aesthetic values, such as the beauty of the line, in the Duchamp work. But this does not commit us to the view that we know the work by description, for the execution of the work can affect its interpretation. Differences in look are important to the extent that they create differences in meaning. To know whether differences in the look of each version of *L.H.O.O.Q.* would produce differences in our interpretation of each, we would have to see them both. Perhaps we would find no significant difference in our interpretations of the two versions, based on appearance, but we could not know this before seeing them both.

L.H.O.O.Q. is a postcard of the *Mona Lisa* with a moustache and goatee drawn on her. Does it make no difference what the moustache and goatee look like? The meaning of the work may be affected by whether the moustache is of a type sported by artists or businessmen, labourers or professionals. Differences such as these will determine differences in allowable readings and interpretations.

For instance, if the moustache is typical of those worn by businessmen of the time, it could be appropriate to see the work as addressing the commercialization of art. If, on the other hand, it's a moustache typical of bohemians, such an interpretation becomes less plausible. And if we were to discover that the moustache and goatee were exactly like those worn by Duchamp, a whole new range of interpretative possibilities would be opened by Duchamp's imposing of himself on a masterpiece of painting. We need to know what the moustache and goatee look like in order to discover which interpretations are plausible.

Binkley could claim that I've only shown the possible need for a fuller description; but the limitation to any description would of necessity cut down on possible interpretations. If we limit ourselves to a description of a work, we must be sure that the description mentions all the facts that might possibly be relevant to its interpretation. We can be sure of this only if we can be sure that we know everything there is to know about the meaning of the work, that is, only if we discount the possibility of discovering new meanings.

Furthermore, there are aspects of the work which could not be captured by a description, no matter

10. Binkley, p. 273.

how complete. For example, without seeing the work, we don't see its possible reference to transsexuality. And without seeing the work, we don't see the way in which the disrespectful title changes the meaning of Mona Lisa's enigmatic expression. The re-interpretation of the smile as sexually suggestive requires seeing the work.

Seeing the work is also important if we are to understand its tone. The moustache and goatee of *L.H.O.O.Q.* are very careful, neat and relatively unobtrusive. Would the work be unchanged had the moustache and goatee been crudely dashed off with a thick black crayon? Could not subtle changes in meaning result? The look of the moustache might determine whether we perceive the work as comic or mocking, affectionate or contemptuous, mischievous or defiant, or some combination of these. The tone of the work is best known through viewing the object itself and the manner in which the moustache and goatee are drawn.

It may be true that the main thrust of *L.H.O.O.Q.*, the humiliation of the *Mona Lisa*, remains the same however the work is executed. Still, the nature of that humiliation differs with variations in the execution. For this reason we cannot say that the object is superfluous.

One final point—even supposing that a description would provide us with adequate knowledge of a work such as *L.H.O.O.Q.*, the object would not be expendable. *L.H.O.O.Q.*, the plan, would not have the same meaning that *L.H.O.O.Q.*, embodied, does. Suppose Duchamp had just written and submitted for our contemplation the direction: 'Draw a moustache and goatee on a postcard of the *Mona Lisa* and entitle it "*L.H.O.O.Q.*"'. It is unlikely that the plan would have the same impact or ultimate meaning as the executed idea. The plan lacks the significance we find in the actual presentation of such an object as a work of art.

This point is all the more clearly illustrated by *Erased de Kooning*. The idea of erasing a de Kooning drawing has only a fraction of the impact and audacity of the actual erasure. Though it may well be that the work can be fully known by description alone, the object is still necessary.

I do not claim to have proved with these examples that the object is always important for or necessary to the art work, or that the object is equally important in different types of works. But I hope I have shown that it is often important in cases where at first glance it appears to be unnecessary. Even in cases where the work is of mainly conceptual interest, the object can play in important non-aesthetic role.

III

The examples discussed in this paper show that the object has a more central role in the interpretation and identification of art works than is allowed by either Danto or Binkley. There is no question that the importance of theory and convention in determining the identity of art works must be recognized, but this recognition must not blind us to the equal importance of the object. It must not lead us to treat art works as diagrams or illustrations for ideas.

Binkley assumes that a description can full encompass a non-aesthetic art work's artistically relevant features. Danto, on the other hand, assumes that in seeing an object as an art work, we reduce it to one of its possible descriptions. Neither view allows for the complexity of the art work, for its many artistically relevant aspects which cannot be fully known by description and which are all part of an adequate interpretation. Unfortunately, this inattention to the object can often be found in contemporary art criticism, where an exclusive focus on the ideas surrounding the work leads the critic farther and farther away from an attention to the work itself. This leads to a situation in which weak works may gain undue prominence by being surrounded by theories and interpretations which proclaim significances which aren't there. This is the basis of Rosenberg's attack on Helen Frankenthaler's work which, rightly or wrongly, he characterizes as 'weak visual matter in an envelope of aggressive critical language'[11] and as 'decorative bombast sustained by dubious art theory'.[12]

But the neglect of the object can also lead to reductive interpretations which prevent a full appreciation of the art under consideration. Such a reduction impoverishes, and can be used to dismiss a

11. Rosenberg, p. 161.

12. Rosenberg, p. 162.

work unfairly. We can see this impoverishment and dismissal in Danto's analysis of *Newton's Third Law*. The role of the mural is reduced to that of illustrating a particular scientific law. It is then judged by its success in filling that role, and found wanting. 'Too weak by far for the subject, writes the critic'.[13] But it is far from clear that the work must only be judged by its adequacy in illustrating that particular subject.

This reduction, and a subsequent undervaluation, is also evident in Carter Ratcliff's article, 'Frank Stella: Portrait of the Artist as Image Administrator'.[14] Ratcliff attempts to dismiss Stella's work by (1) attacking the formalist criticism surrounding it and by (2) giving reductive descriptions of the paintings, and on the basis of these *descriptions*, complaining of the emptiness of the *paintings*. Neither line of argument pays attention to the paintings themselves.

Such reductive criticism may result from an inability to come to terms with visual art, and more particularly, with abstract art. It is easier to talk about representational content than about visual features. And since abstract paintings cannot be seen as representing objects, they must be seen, by those with a continuing need for verbal content and representation, as illustrating theories. This way of viewing art seems to gain credence from the contemporary emphasis on the importance of the theory surrounding the work. But I've argued that this importance does not eclipse, but only balances, that of the object.

Interpretation is not a matter of dumb looking, of pre-theoretic viewing. But when art works become merely occasions for presenting theories, when they become the imperfect illustrations of ideas, they cease to function as art. If the reduction of art to its physical data is an act of barbarism, so too is the reduction of art to its theory.

13. Arthur Danto (1981), p. 122.

14. Carter Ratcliff, 'Frank Stella: Portrait of the Artist as Image Administrator', *Art in America*, Vol. 73, No. 2 (February, 1985).

George Dickie (1926-)

The New Institutional Theory of Art

The version of the institutional theory that I worked out in 1974 in *Art and the Aesthetic*[1] was defective in several respects, but the institutional approach is, I think, still viable. By an instutional approach I mean the idea that works of art are art as the result of the position they occupy within an institutional framework or context. I have tried in a forthcoming book, *The Art Circle*, to work out a revised version of the theory. In this paper, I shall attempt to give a summary account of the new institutional theory of art.

It should be made clear here at the beginning that the theory of art I am trying to work out is a classificatory one. Some theories of art have assumed that a work of art is necessarily a good thing, but this assumption would leave unaccounted for all the mediocre, bad, and worthless art. It is the wider class of objects which contains the worthless, the indifferent, the mediocre, the good, and the masterpieces about which I am concerned to theorize.

Traditional theories of art place works of art within simple and narrowly-focused networks of relations. The imitation theory, for example, suspends the work of art in a three-place-network between artist and subject matter, and the expression theory places the work of art in a two-place network of artist and work. The institutional theory attempts to place the work of art within a multi-placed network of greater complexity than anything envisaged by the various traditional theories. The networks or contexts of the traditional theories are too "thin" to be sufficient. The institutional theory attempts to provide a context which is "thick" enough to do the job. The network of relations or context within which a theory places works of art I shall call "the framework" of that theory.

Despite my reservations about the traditional theories of art, they were, I believe, on the right track about the group of objects they focus on. All of the traditional theories assume that works of art are artifacts, although they differ about the nature of the artifacts. There is, then, a sense in which the institutional approach is a return to the traditional way of theorizing about art for it too maintains that works of art are artifacts. By the way, what is meant by "artifact" here is the ordinary dictionary definition: "an object made by man, especially with a view to subsequent use." Furthermore, although many are, an artifact need not be a physical object: for example, a poem is not a physical object, but it is, nevertheless, an artifact. Still further, things such as performances, for example, improvised dances, are also "made by man" and are, therefore, artifacts.

In the 1950s, first Paul Ziff and then Morris Weitz challenged the assumption of artifactuality, claiming that being an artifact is not a necessary condition of art. Although Ziff's and Weitz's views differ somewhat, they have in common the claim that there is no necessary condition for something's being art, not even artifactuality. Their common view can be called "the new conception of art." This new view conceives of the members of the class of works of art as having no common feature of any theoretical significance. The members of the classes are related only be means of similarities: work of art A resembles work of art B and work of art B resembles work of art C, but A does not have to resemble C. According to the new view, an object becomes a work of art by sufficiently resembling a prior-established work of art.

1. Dickie, G., *Art and the Aesthetic* (Ithaca and London 1974).

The new conception speaks of sufficient resemblance as the only way that a work of art can come into being. An examination of the new view reveals, however, that it entails that there must be another way than sufficient resemblance to a prior-established work of art for a work of art to come into being. That two ways of becoming art are required by the new conception of art can be shown in the following way. Suppose that work of art A had become art by sufficiently resembling prior-established work of art B. Work of art B would have had to become art by sufficiently resembling an earlier prior-established work of art, call it C. If resemblance to a prior-established work of art is the only way of becoming art, then the way back in time from work of art A to work of art B to work of art C generates an infinite regress of works of art receding into the past. If resemblance to a prior-established work of art were the only way of becoming art, there could be not first work of art and, consequently, there could not be any art at all. Some way of becoming art other than resemblance to a prior-established work is required for resemblance to a prior-established work to function as a way of becoming art. Works of art which become art by sufficiently resembling prior-established works of art may be called "similarity art." In order for there to be similarity art there must be at least one work of art which did not become art in virtue to its similarity to a prior-established work of art. Consequently, the new conception of art really requires two ways of becoming art: the similarity way and some nonsimilarity way. The new conception is an unacknowledged "double" theory of art.

What is the nature of the nonsimilarity art required by the new conception? Since neither Ziff nor Weitz was aware that their view requires nonsimilarity art, it is not surprising that they said nothing about it. The nature of nonsimilarity art will have to be inferred from the stated theory. First, nonsimilarity art is primary within the theory—there could not be similarity art unless there is first nonsimilarity art. Second, the class of works of art, according to the new conception, consists of two distinct subsets of which one (nonsimilarity art) is more basic than the other (similarity art). Finally, there is nothing in the new conception of art or outside of it which requires nonsimilarity art to be a one-time sort of thing the only function of which is to block the regress and get the art process going. Although nothing in the new conception entails that it is, the only plausible account of the nature of nonsimilarity art that I can think of is that it is art which is art as the result of someone's creating an artifact. This, of course, does not prove that nonsimilarity art is to be identified with what may be called "artifactual art," but artifactual art seems to be the only real contender. The new conception of art involves two distinct kinds of art—artifactual art and similarity art—with the former being primary. Artifactual art is clearly not confined to the beginning of the art process, because such art is being created at the present and has been created throughout the history of art.

Ziff and Weitz demand that if one is to theorize about art, one must produce a theory which encompasses all members of the class of works of art. And according to their view, the members of the class have no common feature or features. Consequently, they claim that one cannot theorize about art in the traditional manner of discovering necessary and sufficient features. The closest they can come to theorizing about art is to say that there is a class of objects to which the terms "art" and "work of art" meaningfully apply and that this class cannot be theoretically characterized further.

The earlier examination of the new conception of art has shown that the class of objects to which the terms "art" and "work of art" meaningfully apply divides into two distinct subclasses of art. This division shows that the class can be theoretically characterized further. The first thing to be noted about the subclasses is that the two activities which generate the two subclasses are very different. Artifactual art is generated by the human activity of making. Similarity art is generated by the human activity of noticing similarities. The strikingly different activities which generate the two subclasses suggest that the two classes are not literally subclasses of a single class. The two classes seem more like a class picked out by the literal uses of a term and a derivative class picked out by the metaphorical uses of the same term. I will not, however, pursue this point here.

Even if one were to agree with Ziff and Weitz that artifactual art and similarity art are both literally art, why should this persuade philosophers to abandon their traditional concern with theorizing about what is in effect artifactual art? From Plato's time forward, philosophers of art have been concerned to theorize about the class of objects which is generated by a particular kind of human making. Philosophers have been interested in these objects precisely because they are human artifacts. The fact that there is another class of objects which is in some way derivative by means of similarities from the class of objects they have traditionally been interested in is not surprising and is no reason to divert philosophers of art from their traditional activity. That traditional activity is the attempt to describe correctly the nature of the making of artifactual art and, consequently, the nature of the objects made. Artifactuality is, in effect, a "built-in" characteristic of the interest of philosophers in works of art.

On the surface anyway, there is no mystery about the making of the great bulk of works of artifactual art; they are crafted in various traditional ways—painted, sculpted, and the like. (Later, I will attempt to go below the surface a bit.) There is, however, a puzzle about the artifactuality of some relatively recent works of art: Duchamp's readymades, found art, and the like. Some deny that such things are art because, they claim, they are not artifacts made by artists. It can, I think, be shown that they are the artifacts of artists. (In *Art and the Aesthetic* I claimed, I now think mistakenly, that artifactuality is *conferred* on things such as Duchamp's *Fountain* and found art, but I will not discuss this here.)

Typically an artifact is produced by altering some preexisting material: by joining two pieces of material, by cutting some material, by sharpening some material, and so on. This is typically done so that the altered material can be used to do something. When materials are so altered, one has clear cases which neatly fit the dictionary definition of "artifact"—"An object made by man, especially with a view to subsequent use." There are other cases which are less clear-cut. Suppose one picks up a piece of driftwood and without altering it in any way digs a hole or brandishes it at a threatening dog.

The unaltered driftwood has been *made* into a digging tool or a weapon by the use to which it is put. These two cases do not conform to the nonnecessary clause of the definition "especially with a view to subsequent use" because they are pressed into service on the spot. There does seem to be a sense in which something is made in these cases, but what is it that has been made if the driftwood is unaltered? In the clear cases in which material is altered, a complex object is produced: the original material is for present purposes a simple object and its being altered produces the complex object—altered material. In the two less clear-cut cases, complex objects have also been made—the wood used as a digging tool and the wood used as a weapon. In neither of the two less clear-cut cases is the driftwood alone the artifact; the artifact in both cases is the driftwood manipulated and used in a certain way. The two cases in question are exactly like the sort of thing that anthropologists have in mind when they speak of unaltered stones found in conjunction with human or human-like fossils as artifacts. The anthropologists assume that the stones were used in some way. The anthropologists have in mind the same notion of a complex object made by the use of a simple (i.e., unaltered) object.

A piece of driftwood may be used in a similar way within the context of the artworld, i.e., picked up and displayed in the way that a painting or a sculpture is displayed. Such a piece of driftwood would be being used as an artistic medium and thereby would become part of the more complex object—the-driftwood-used-as-an-artistic-medium. This complex object would be an artifact of an artworld system. Duchamp's *Fountain* can be understood along the same lines. The urinal (the simple object) is being used as an artistic medium to make *Fountain* (the complex object) which is an artifact within the artworld—Duchamp's artifact. The driftwood would be being used and the urinal was used as artistic media in the way that pigments, marble, and the like are used to make more conventional works of art.

Thus far, I have talked of artifactuality as a necessary condition of art, but this discussion does not distinguish the institutional theory from the traditional

theories, as the latter have assumed or implied that being an artifact is a necessary condition of art. In the last paragraph, however, I introduced without explanation the notion of the *artworld*, and it is now time to turn to a discussion of the artworld, for it is this notion which lies at the heart of the institutional theory.

Perhaps the best way to begin a discussion of the artworld is to quote the now-abandoned definition of "work of art" from the earlier version of the institutional theory. "A work of art in the classificatory sense is (1) an artifact (2) a set of the aspects of which has had conferred upon it the status of candidate for appreciation by some person or persons acting on behalf of a certain social institution (the artworld)."[2] Monroe Beardsley has observed that in the discussion which surrounds the definition in the earlier version of the theory I characterized the artworld as an "established practice" which is to say, an informal kind of activity. He then goes on to point out that the quoted definition makes use of such phrases as "conferred status" and "acting on behalf of". Such phrases typically have application within formal institutions such as states, corporations, universities, and the like. Beardsley correctly notes that it is a mistake to use the language of formal institutions to try to describe an informal institution as I conceive the artworld to be. Beardsley queries, "...does it make sense to speak of acting on behalf of a practice? Status-awarding authority can center in [a formal institution], but practices, as such, seem to lack the requisite source of authority."[3]

Accepting Beardsley's criticism, I have abandoned as too formal the notions of *status conferral* and *acting on behalf of* as well as those aspects of the earlier version which connect up with these notions. Being a work of art is a status all right, that is, it is the occupying of a position within the human activity of the artworld. Being a work of art is not, however, a status which is conferred but is rather a status which is achieved as the result of creating an artifact within or against the background of the artworld.

2. Ibid, p. 34.

3. "Is Art Essentially Institutional?", in: *Culture and Art*, Lars Aagaard-Mogensen (ed.) (Atlantic Highlands, N. J. 1976), p. 202.

The claim is then that works of art are art as the result of the position or place they occupy within an established practice, namely, the artworld. There are two crucial questions about the claim. (1) Is the claim true and (2) if the claim is true, how is the artworld to be described?

The claim is a claim about the existence of a human institution, and the test of its truth is the same as for any other claim about human organization—the test of observation. "Seeing" the artworld and the works of art embedded in its structures, however, is not as easy as "seeing" some of the other human institutions which we are more accustomed to thinking about.

Arthur Danto has invented an argument which helps somewhat in "seeing" the structure in which works of art are embedded. (I must note, however, that what Danto himself "sees" with the use of his argument is quite different from what I "see", but I will not here attempt to rebut Danto's theory.) My version of Danto's argument runs as follows. Consider a painting and another object which looks exactly like it but which was produced accidentally and is, therefore, not a work of art. Or consider *Fountain* and a urinal which is its twin but is not a work of art. Here are two pairs of objects with visually indistinguishable elements, but the first element in each pair is a work of art and the second element is not. The fact that the first element of each pair is a work of art and the second element is not although the elements of each pair are visually indistinguishable shows that the first object in each pair must be enmeshed in some sort of framework or network of relations in which the second element is not. It is the first element's being enmeshed in the framework which accounts for its being a work of art, and it is the second element's not being enmeshed in the framework which accounts for its not being a work of art. The framework in question is not, of course, visible to the eye in the way that the colors of the two objects are.

Some will argue that the *Fountain*/urinal pair does not show anything because *Fountain* is not a work of art. Fortunately, the other hypothetical pair is sufficient to get the argument off the ground. The *Fountain*/urinal pair, however, can also be shown to suffice

even if *Fountain* is not a work of art. *Fountain* does not actually have to be a work of art to show the necessity of a context or framework. It is sufficient for the argument that at some time some person mistakenly thought *Fountain* to be a work of art. The framework within which *Fountain* apparently had a place would in this case explain the mistake. And, some persons have though *Fountain* to be a work of art.

Danto's argument shows that works of art exist within a context or framework, but it does not reveal the nature of the elements which make up the framework. Moreover, many different frameworks are possible. Each of the traditional theories of art, for example, implies its own particular framework. For one example, Susanne Langer's view that "Art is the creation of forms symbolic of human feeling" implies a framework of artist (one who creates) and a specific kind of subject matter (human feeling). And as I noted at the beginning of the paper, the imitation theory and the expression theory each implies a particular framework. Langer's theory and the other traditional theories, however, fall easy prey to counterexamples, and, consequently, none of the frameworks they imply can be the right one. The reason that the traditional theories are easy prey for counterexamples is that the frameworks implied by the theories are too narrowly focused on the artist and various different of the more obvious characteristics which works of art may have rather than on *all* the framework elements which surround works of art. The result is that it is all too easy to find works of art which lack the properties seized upon by a particular traditional theory as universal and defining.

The frameworks of the traditional theories do lead in the right direction in one respect. Each of the traditional theories conceives of the making of art as a human practice, as an established way of behaving. The framework of each of these theories is conceived of, then, as a cultural phenomenon which persists through time and is repeatable. The persistence of a framework as a cultural practice is enough, I think, to make the traditional theories themselves quasi-institutional. That is to say, each of the traditional theories purports to describe an established cultural practice. In every one of the traditional theories, however, there is only one established role envisioned and that is the role of the artist or the maker of artifacts. And in every case, the artist is seen as the creator of an artifact with a property such as being representative, being symbolic, or being an expression. For the traditional theories the artist's role is envisaged as simply that of producing representations, producing symbolic forms, producing expressions, or some such thing. It is this narrow conception of the artist's role which is responsible for the ease with which counterexamples can be produced. Since the traditional theories are inadequate, there must be more to the artist's role than the producing of any, or even all, of these kinds of things which the traditional theorists envisage. What an artist understands and does when he creates a work of art far exceeds the simple understanding and doing entailed by the traditional theories.

Whenever art is created there is, then, an artist who creates it, but an artist always creates for a *public* of some sort. Consequently, the framework must include a role for a *public* to whom art is presented. Of course, for a variety of reasons many works of art are never in fact presented to any public. Some works just never reach their public although their makers intended for them to do so. Some works are withheld from their public by their creators because they judge them to be in some way inferior and unworthy of presentation. The fact that artists withhold some of their works because they judge them unworthy of presentation shows that the works are things of a *kind* to be presented, otherwise, it would be pointless to judge them unworthy of presentation. Thus, even art not intended for public presentation presupposes a public, for not only is it possible to present it to a public (as sometimes happens), it is a thing of a type which has as a goal presentation to a public. The notion of a public hovers always in the background, even when a given artist refuses to present his work. In those cases in which works of art are withheld from a public, there is what might be called a "double intention"—there is an intention to create a thing of a kind which is presented, but there is also an intention not to actually present it.

But what is an artworld public? Such a public is not just a collection of people. The members of an artworld public are such because they know how to fulfill a role which requires knowledge and understanding similar in many respects to that required of an artist. There are as many different publics as there are different arts, and the knowledge required for one public is different from that required by another public. An example of one bit of knowledge required of the public of stage plays is the understanding of what it is for someone to act a part. Any given member of a public would have a great many such bits of information.

The artist and public roles are the minimum framework for the creation of art, and the two roles in relation may be called "the presentation group". The role of artist has two central aspects: first, a general aspect characteristic of all artists, namely, the awareness that what is created for presentation is art, and, second, the ability to use one or more of a wide variety of art techniques which enable one to create art of a particular kind. Likewise, the role of a public has two central aspects: first, a general aspect characteristic of all publics, namely, the awareness that what is presented to it is art and, second, the abilities and sensitivities which enable one to perceive and understand the particular kind of art with which one is presented.

In almost every actual society which has an institution of art-making, in addition to the roles of artist and public, there will be a number of supplementary artworld roles such as those of critic, art teacher, director, curator, conductor, and many more. The presentation group, i.e., the roles of artist and public in relation, however, constitutes the essential framework for art-making.

Among the more frequent criticisms of *Art and the Aesthetic* was that it failed to show that art-making is institutional because it failed to show that art-making is rule-governed. The underlying assumption of the criticism is that it is rule-governedness which distinguishes institutional practices such as, say, promising from noninstitutional ones such as, say, dog-walking. And it is true that *Art and the Aesthetic* did not bring out the rule-governedness of art-making and this requires correcting. There are

rules implicit in the theory developed in the earlier book, but unfortunately I failed to make them explicit. There is no point in discussing the rules governing art-making implicit in the earlier theory, but those of the present revised theory can be stated. Earlier in this paper I argued that artifactuality is a necessary condition for being a work of art. This claim of necessity implies one rule of art-making: if one wishes to make a work of art, one must do so by creating an artifact. Also earlier in this paper I claimed that being a thing of a kind which is presented to an artworld public is a necessary condition for being a work of art. This claim of necessity implies another rule of art-making: if one wishes to create a work of art, one must do so by creating a thing of a kind which is presented to an artworld public. These two rules are jointly sufficient for making works of art.

The question naturally arises as to why the framework described as the institutional one is the correct essential framework rather than some other framework. The frameworks of the traditional theories are clearly inadequate, but their inadequacy does not prove the correctness of the framework of the present version of the institutional theory. Proving that a theory is true is notoriously difficult to do, although proving that a theory is false is sometimes easy to do. It can be said of the present version of the institutional theory that it is a conception of a framework in which works of art are clearly embedded and that no other plausible framework is in the offing. For lack of a more conclusive argument that the institutional theory's framework is the right one, I shall have to rely on the description of it I have given to function as an argument as to its rightness. If the description is correct, or approximately so, then it should evoke a "that's right" experience in the listener. In the remainder of the paper I shall, in effect, continue my description of the essential framework for the creation of art.

In *Art and the Aesthetic* I talked a great deal about conventions and how they are involved in the institution of art. In that book, I tried to distinguish between what I called "the primary convention" and the other "secondary conventions" which are involved in the creation and presentation of art. One

example of the so-called secondary conventions discussed there is the Western theatrical convention of concealing stagehands behind the scenery. This Western convention was there contrasted with that of classical Chinese theater in which the stagehand (called the property man) appears on stage during the action of the play and rearranges props and scenery. These two different theatrical solutions for the same task, namely, the employment of stagehands, brings out an essential feature of conventions. Any conventional way of doing something could have been done in a different way.

The failure to realize that things of the kind just discussed are conventions can result in confused theory. For example, it is another convention of Western theater that spectators do not participate in the action of a play. Certain aesthetic-attitude theorists failed to realize that this particular convention is a convention and concluded that the nonparticipation of spectators is a rule derived from aesthetic consciousness and that the rule must not be violated. Such theorists are horrified by Peter Pan's request for the members of the audience to applaud to save Tinkerbell's life. The request, however, merely amounts to the introduction of a new convention which small children, but not some aestheticians, catch on to right away.

There are innumerable conventions involved in the creation and presentation of art, but there is not, as I claimed in my earlier book, a *primary* convention to which all the other conventions are secondary. In effect, in *Art and the Aesthetic* I claimed that not only are there many conventions involved in the creation and presentation of art, but that at bottom the whole activity is completely conventional. But theater, painting, sculpting, and the like, are not ways of doing something which could be done in another way, and, therefore, they are not conventional. If, however, there is no *primary* convention, there is a primary *something* within which the unnumerable conventions that there are have a place. What is primary is the understanding shared by all involved that they are engaged in an established activity or practice within which there is a variety of roles: artist roles, public roles, critic roles, director roles, curator roles, and so on. Our artworld consists of the totality of such roles with the roles of artist and public at its core. Described in a somewhat more structured way, the artworld consists of a set of individual artworld systems, each of which contains its own specific artist and public roles plus other roles. For example, painting is one artworld system, theater is another, and so on.

The institution of art, then, involves rules of very different kinds. There are conventional rules which derive from the various conventions employed in presenting and creating art. These rules are subject to change. There are more basic rules which govern the engaging in an activity, and these rules are not conventional. The artifact rule—if one wishes to make a work of art, one must do so by creating an artifact—is not a conventional rule, it states a condition for engaging in a certain kind of practice.

As I remarked earlier, the artifact rule and the other nonconventional rule are sufficient for the creating of art. And, as each rule is necessary, they can be used to formulate a definition of "work of art".

A work of art is an artifact of a kind created to be presented to an artworld public.

This definition explicitly contains the terms "artworld" and "public", both of which have been discussed but not defined in this paper. The definition also involves the notions of *artist* and *artworld system*, both of which have been discussed but not definitionally characterized in this paper. I shall not attempt to define either "artist", "public", "artworld", or "artworld system" here, as I do in my book manuscript, but the definition of "work of art" given here and the definitions of these other four central terms provide the leanest possible description of the institutional theory of art.

To forestall an objection to the definition, let me acknowledge that there are artifacts which are created for presentation to the artworld publics which are not works of art: for example, playbills. Such things are, however, parasitic or secondary to works of art. Work of art are artifacts of a primary kind in this domain, and playbills and the like which are dependent on works of art are artifacts of a secondary kind within this domain. The word "artifact" in

the definition should be understood to be referring to artifacts of primary kind.

The definition of "work of art" given in *Art and the Aesthetic* was, as I affirmed there, circular, although not viciously so. The definition of "work of art" just given is also circular, although again not viciously so. In fact, the definitions of the five central terms constitute a logically circular set of terms.

There is an ideal of noncircular definition which assumes that the meaning of terms used in a definition ought not to lead back to the term originally defined, but rather ought to be or lead to terms which are more basic. The ideal of noncircular definition also assumes that we ought to be able to arrive at terms which are primitive in the sense that they can be known in some nondefinitional way, say, by direct sensory experience or by rational intuition. There may be some sets of definitions which satisfy this ideal, but the definitions of the five central terms of the institutional theory do not. Does this mean that the institutional theory involves a vicious circularity? The circularity of the definitions shows the interdependency of the central notions. These central notions are *inflected*, that is, they bend in on, presuppose, and support one another. What the definitions reveal is that art-making involves an intricate, co-relative structure which cannot be described in the straight-forward, linear way envisaged by the ideal of noncircular definition. The inflected nature of art is reflected in the way we learn about art. This learning is sometimes approached through being taught how to be an artist—learning how to draw pictures which can be displayed, for example. This learning is sometimes approached through being taught how to be a member of an artworld public—learning how to look at pictures which are presented as the intentional products of artists. Both approaches teach us about artists, works, and publics all at the same time, for these notions are not independent of one another. I suspect that many areas within the cultural domain also have the same kind of inflected nature that the institution of art has. For example, the area which involves the notions of *law*, *legislature*, *executive*, and *judiciary*.

The ideal of noncircular definition holds also that sets of circular definitions cannot be informative. This may be true of some sets of definitions, but it is not, I think, true of the definitions of the institutional theory. For these definitions just mirror the mutually dependent items which constitute the art enterprise, and, thereby, informs us of its inflected nature.

Susan L. Feagin

On Defining and Interpreting Art Intentionalistically

I would like here to consider an argument which has recently been offered in favour of the view that an artist's having certain intentions is a necessary condition for a given interpretation of a work of art. I shall refer to it as the argument from definition and value.[1] It is a strong and intuitively compelling argument, capturing the attitudes of many who are inclined towards intentionalism. The argument as I describe it here is an extrapolation from often cryptic and even vague formulations by numerous writers in aesthetics. I have expanded and elaborated it in order to present it in its most appealing form. I have also rendered it more precise. A failing of many discussions of artists' intentions is that their logical role is left unspecific: intentions are spoken of as relevant or irrelevant; and as criteria or standards, without its being specified whether they are necessary or sufficient conditions for a given interpretation, or are one relevant consideration among many others, or always count in favour of a given interpretation and never against, and so on. I myself, as will become apparent, find the argument from definition and value to be quite persuasive in so far as it argues generally for the importance of considering artists' intentions, although I think it fails to establish that the presence of the appropriate intentions is a *necessary* condition for an interpretation of a work of art in any given case.

The argument from definition and value connects, quite properly, the question how to interpret art with how we define it and what we value about it. We value works of art because they are human creations, and not just the products of natural forces. What distinguishes art as human creation is precisely the presence of intentions, goals, or purposes to be achieved. Communication, originality, and the display and exercise of skill are all descriptions of values which require there to be specific intentions on the part of the artist. We would not have the concept 'art' or 'work of art' unless we were interested in intentional behaviour as opposed to unintentional behaviour and the results of human behaviour, and hence art is defined as the product of the human endeavour to achieve some goal such as communication, the display of skill, etc. Interpretations applied to a work presuppose the presence of certain intentions of the artist, since interpretation is carried out in light of the nature and values of works of art. Why define art as a product of human endeavour if we are not interested in what the human beings who created it were endeavouring to do? At least one writer, Stein Haugom Olsen, has carried this idea to its logical extreme by seeing *every* element of the work in terms of how the artist intended it to function in producing his or her intended aim or goal.[2] Hence, the presence of certain intentions of the artist's is a necessary condition for the application

1. Among those who have hinted at such an argument (in addition to those who are discussed in more detail below) are Michael Steig, 'The Intentional Phallus: Determining Verbal Meaning in Literature', *Journal of Aesthetics and Art Criticism* (Fall, 1977), Vol. XXXVI, No. i, p. 51; Colin Radford, 'Fakes', *Mind*, Vol. LXXVII, No. 345 (Jan. 1978), p. 71 and p. 76. Frank Cioffi seems to have something like this in mind in 'Intention and Interpretation in Criticism' in Cyril Barrett, ed., *Collected Papers in Aesthetics* (Oxford, 1965), p. 174, when he concludes 'The notion of the author's intention is logically tied to the interpretation we give to his work.' It is interesting to note that he says this in spite of his earlier claim that 'What any general thesis about the relevance of intentions to interpretation overlooks is the heterogeneity of the contexts in which questions of interpretation arise' (p. 165).

2. 'Interpretation and Intention', *British Journal of Aesthetics*, Vol. 17, No. 3 (Summer, 1977), p. 215.

of interpretative concepts to the work: its very nature and importance are owing to the presence of human intentions. Descriptions of a work as: satirizing x, a political statement, the culmination of a particular style, a moral allegory, or a serious exercise in a given genre, presuppose the presence of certain intentions of the artist.

A recent article by Mary Sirridge has shown some, again plausible, implications of this view. She states that intentions, in some cases at least, provide the standard for 'determining whether we are faced with irony, sympathy, or simply illustration'.[3] In the absence of such a standard there is 'universal interpretative ambiguity', since any given work of art *can* support, on the basis of its observed qualities, literally myriads of interpretations. On this view, intentions are a necessary condition for interpretations since the absence of the requisite intentions serves to eliminate possible interpretations of the work.

The argument from definition and value concludes that an artist's having a certain specifiable (although unspecified) intention is a necessary condition for a given interpretation of a work of art, and it is important to examine these unspecified intentions before going on to discuss the argument proper. Although examples are often given of the interpretative concepts in question—satire, a serious exercise in a genre, parody, etc.—there is a notable lack of examples of what specific intentions must be present for those interpretative concepts to apply. Perhaps one might say it is obvious what intentions are necessary: e.g., in order for something to be a satire its author must intend it to be a satire. But such simplicity is deceptive. Satires are always satires of something, so I suppose that the simple view would hold that if the work is a satire of x its author must intend it to be a satire of x. But what if x and y are two different descriptions of the same object or event, and the author intended to satirize y—is the work then a satire of x? Are all and only those aspects of the work which the author intended

to be satirical actually satirical? What if the notion of a satire never entered the author's head, but rather his or her intent was to poke fun at x? Is the intention to poke fun at the same as the intention to write a satire? If so, how is it determined that the intentions are identical? If they are not, then what rule of inference allows us to conclude that x is a satire when the author intends to poke fun? (Could this be part of what Wimsatt and Beardsley were getting at in their much maligned remark that artists' intentions are unavailable?) Perhaps there is no single intention which an author must have in order for the work to be, say, a satire, but rather there is a range of intentions, at least one of which the author must have in order for the work to be a satire. If so, what delimits this range? Is it finite and discoverable?

Questions such as these show the need for more discussion of how to identify and individuate intentions.[4] It is dangerous to put off such work in the expectation that it can be handled to the satisfaction of aesthetics by the philosophy of mind and/or action theory, since, as some possibilities explored above show, how one distinguishes one intention from another can affect the logical role of intentions in determining the interpretation of a work of art. For example, to repeat, there may be no single intention which must be present in order to apply a given interpretative concept correctly to a work of art, but it may be true that an artist must have at least one intention within a certain range of possibilities.

The complexities these questions introduce are important, but an investigation of how to deal with them must wait until another time. Instead, I shall consider the argument from definition and value, as have its exponents, independently of these difficulties

3. 'Artistic Intention and Critical Prerogative', *British Journal of Aesthetics*, Vol. 18, No. 2 (Spring, 1978), p. 150. She uses the word 'motivation' rather than 'intention', but stresses that she uses it in a non-technical sense. Cioffi, op. cit., p. 168, also holds intentions serve an eliminative function, but nowhere claims they are the only criterion which could do so.

4. Attempts to develop a 'logic of intentional action' are more common than attempts to develop a 'logic of intentions'. This is fairly clearly a residue of the fear of positing the existence of 'ghostly entities', and, what is worse, to make it appear as though these were causes. Along this line, in an early work, 'Toward a Theory of Interpretation and Preciseness' in Leonard Linsky, ed., *Semantics and the Philosophy of Language* (Urbana, 1952), Arne Naess explores some of the difficulties for interpretation of *sentences* (not works of art) when one's intentions are indefinite. See esp. p. 257. More recently, see the answers to *Analysis* Problem No. 16, Vol. 38, No. 3 (June 1978).

which, I shall suppose, can be dealt with satisfactorily. This is a significant, perhaps even unwarranted, presupposition and the very fact that it is being presupposed should not be overlooked.

The argument from definition and value is persuasive because it does capture part of the truth about our dealings with art, but is deficient because it captures only part. We would not have the concept of art—or satire, parody, allegory, and other interpretive concepts—if we were not interested in the intentional products of human activity. But other values and conventions have developed concerning the creation and appreciation of art in social contexts apart form the original intentions of the artist. As long as art is public, observable and experienced by those not privy to the aims of the artist, the imposition on the public object of values and interests of the public, whose values and interests may not be those of the artist, is always possible. The effect of these is to compete with and perhaps to override the importance of the intentions of the artist.[5]

Curiously, the importance of social values is recognized by Olsen who supports the logical extreme of the 'intentions as necessary condition' view. Art, he says, is not merely an intentional concept but also an institutional one, i.e., one defined by social roles and conventions. As such, the requirement that an artist should have a given intention can be suspended as long as there is 'an institution comprising conventions and categories which must be fulfilled for someone to identify something as a [work of art]'.[6] This caveat is echoed by Sirridge's observation that if there is a traditional iconography which fits the work, the work is to be interpreted in accord with that, regardless of the artist's intentions.[7]

Saying 'art' and interpretative concepts are 'intentional' *and* 'institutional' comes dangerously close to having it in both of two incompatible ways. I say 'dangerously close' because it is unclear exactly how we are to define 'intentional concept' and 'institutional concept'. An intentional concept can naturally be though of as one which requires for its application that a given individual (or set of individuals), standing in a specified relation to that to which the concept applies, has certain intentions. This is more stringent than it could be: the requirement could merely be that the individual(s) concerned have some intentions or other, but not any specifiable intention. 'Artefact' would be an intentional concept under this construal. Finally, a still weaker rendering would be to require that the individual(s) concerned should be of such a nature as to have intentions, without requiring that there have been any intentions on the occasion or with regard to the object in question. (Most writers are careful to deny that the presence of intentions is sufficient for the application of the concept.) 'Institutional concept' is even more difficult to define. By analogy with 'intentional concept' it may be construed as one which requires the presence of some specific institution as a necessary condition for its application. On the other hand, and somewhat more plausibly, the institution may be seen as something which makes the application of the concept possible, a kind of background context within which institutional concepts are used.

George Dickie, in his much discussed definition of art as an institutional concept, seems to view 'art' as an institutional concept in this latter sense, specifying in addition to the presence of the institution (the artworld) two individually necessary and jointly

5. Something similar to this view is argued by A.J. Ellis, 'Intention and Interpretation in Literature', *British Journal of Aesthetics*, Vol. 14 (Autumn, 1974). These points are also stressed by so-called 'institutional' definitions of art. For an opposing view, see Anthony Savile, 'The Place of Intention in the Concept of Art', *Proceedings of the Aristotelian Society*, LXIX, 1968-9, reprinted in Harold Osborne, *Aesthetics* (London: Oxford University Press, 1972). Savile argues that the artist's intentions are relevant to the determination of 'the complete text' of the work, i.e., to individuating the work of art, but he still maintains that correct interpretation is logically independent of the artist's intended meaning (Osborne, p. 173). Clearly, then, he *does* limit correct interpretations of the work to what makes the work 'appropriate in the intersubjectively identifiable circumstances' of its production (p. 170). This would limit correct interpretations to what could have been (at least chronologically) intended, even though Savile denies that they must be in accord with the artist's intention.

6. Olsen, op. cit., p. 213. He is speaking specifically of literature, whereas I have generalized the argument to apply to art in general. Indeed, there is nothing within the argument which would warrant its application to one medium while restricting its application to others.

7. Sirridge, p. 149.

sufficient conditions for something's being a work of art—namely artifactuality and the status having been conferred of candidate for appreciation.[8] The latter condition, at least, can be met only within the context of the institution of the artworld. Being a member of the artworld puts one in the position to confer this status.[9] But Dickie also says that intentions are also necessarily involved in identifying something as a work of art.[10] There is the usual problem of what intentions must be involved—and Dickie might say there are no *particular* intentions which must be present since it depends on the conventions of the relevant artistic institution—yet one apparently cannot *un*intentionally confer the status of candidate for appreciation. Three points of tension subsequently arise when Dickie relates his definition of *art* as an institutional concept (which also necessarily involves intentions) to his analysis of the *aesthetic object*, or those *aspects* of the work of art with respect to which the status of candidate for appreciation is conferred. First, consistent with his institutional analysis, he states that 'the aspects of a work of art which belong to the aesthetic object of that work of art are determined by the conventions governing the presentation of the work'.[11] However, consistent with his claim that human intentionality is also involved he says '...the aesthetic object is the aspect of the work for the sake of which the art is created'.[12] 'For the sake of which' is, or is ordinarily, a clear reference to intentions, designs, or purposes. Moreover, the above quotations represent the institution and the intentions respectively as *sufficient* determining conditions for the identification of the aesthetic object. Differing sets of sufficient conditions (such as beheading and disembowelling as sufficient for death) do not ordinarily provide logical difficulties, but in this case there may be a conflict between the intentions and the conventional practice. An artist may claim features of an art work

to be aesthetically relevant which are not aesthetically relevant according to the conventions and practices of the artworld, and vice versa. If the artist's merely so proclaiming *makes them* conventions and practices of the artworld this would render a very peculiar understanding of 'conventions' and 'practices' and lead to vicious circularity, something which Dickie is sensitive to and in general carefully avoids. But then a second point of tension arises: an artist's intentions may in fact alter future conventions and practices of the artworld, showing that among the conventions of the artworld is a recognition of some important status with respect to at least some of an artist's intentions. And, finally, Dickie suggests that intentions are necessary but not sufficient for something to be a work of art, and also that an aesthetic object is a sub-class of the properties (i.e., only the aesthetically relevant properties) of the work of art.[13] Yet, he also suggests that intentions are *sufficient* to identify the aesthetic object. But then the intentions can determine the aesthetic object, which must be part of the work of art, but are *not* sufficient to identify the work of art, so that it looks as if the aesthetic object could be something other than the work of art. Of course, the existence of the work of art may be a 'background condition', logically prior to a determination of the aesthetic object, so that *different* intentions on the part of the artist are involved in making something a work of art as opposed to an aesthetic object, but I do not think Dickie makes his position on this point clear. Greater clarity with respect to the particular intentions concerned and the relationship between the intentionality and institutionality of 'art' and 'aesthetic object' would have alleviated some of these tensions.

Although Dickie's discussion of art as intentional and institutional leads only to tension, Olsen's discussion leads to contradiction. At one point, in explaining that art is an intentional concept, he states, 'one cannot avoid appealing to intentions and this "cannot" is logical'.[14] But in explaining that the concept of

8. George Dickie, *Art and the Aesthetic: An Institutional Analysis* (Ithaca, 1974), p. 27.

9. Dickie, p. 80.

10. Dickie, p. 46, 'Art is a concept which necessarily involves human intentionality'.

11. Dickie, p. 147.

12. Dickie, p. 181.

13. This in spite of the fact that Dickie—inadvertently?—collapses the distinction between 'aesthetic object' and 'work of art' in the definition he gives of 'art' on p. 179, where the work of art is identified with those aspects of the artefact which constitute the aesthetic object.

14. Olsen, p. 215.

art is institutional he says '...the requirement that the author intended it as a literary work can be suspended' as long as there is 'an institution comprising conventions and categories which must be fulfilled for someone to identify something as a [work of art]'.[15] There is an inconsistency here. Olsen apparently thinks he has harmonized the two views that art is intentional and that it is institutional when he states, 'The concept of a literary work is an intentional concept. It gives no meaning to talk about literary works apart from the practices and purposes of authors and readers....'[16] Although the practices and purposes of readers allow works to fit neatly into the category of 'institutional concept', if such practices alone are sufficient for something to be called 'art' this certainly conflicts with the claim which Olsen makes that 'art' is an intentional concept. For the practices and purposes of readers are not, and may even conflict with, the intentions—'practices and purposes'—of the author.

Some conclusions can be drawn from the discussion of the argument from definition and value so far. I argued initially that an endorsement of 'intentionalism' in any form should be preceded by a careful analysis of what intentions one is concerned with and in what sense they are conditions for the application of a concept. Confusion over the nature of categories of concepts such as 'intentional' and 'institutional' is the result of the failure to carry out such an analysis. In Olsen's case, it has even led to inconsistency. In any case, it raises questions about what the logical role of intentions *is* supposed to be, in spite of *apparently* clear statements that intentions are necessary conditions for the application of 'art' and interpretative concepts. Credibility is covertly gained at the expense of clarity, and inconsistency risked at the loss of precision.

Like the view that 'art' and various interpretative concepts are 'intentional concepts', there is an insight which is captured by calling them 'institutional concepts'. Descriptions of art, like the descriptions of other activities and events, may originally be given only because we wish to describe them in a way which takes note of their intentional character, since the description 'art' as well as various interpretative descriptions would not even have been introduced except for the interest in intentional as opposed to unintentional (other goal-directed or non-goal-directed) activity. But these descriptions can become extended to apply to unintentional activities, and the products of those activities, simply because they bear similarities to the intentional ones. These further things then become identified as art or as falling under a given interpretative description not because one presupposes certain intentions on the part of the artist, but because of these objects' perceivable similarities to those things which *are* produced with the requisite intent.[17] The class of objects to which the description applies is thus an 'extendable class'. In the case of objects which fall under a given interpretative description which is extended in this way, the focus of interest cannot be related to the works' being intentional, since it is not intentional but, rather other aspects of it which can be appreciated regardless of the artist's intentions. The concepts of art, allegory, etc., become institutional concepts, defined according to the similarities they bear to the intentional instances, and in relation to interests which arise because of these similarities, rather than because of the presence of certain intentions of the artist. From the supposition that we would not have a given concept *C* unless we were interested in intentional, as opposed to unintentional, actions (and

15. Olsen, p. 213.

16. Olsen, p. 211.

17. A couple of terms which may be used in critical discourse serve to illustrate nicely how a critical vocabulary can be extended in this way. 'Farce' is defined first by the *Oxford Dictionary* as 'A dramatic work intended only to excite laughter', but secondly as 'anything fit only to laugh at'. And the development of the definitions of 'joke' is nicely recorded: 1670, 'something said or done to excite laughter or amusement' (note the presence of an intention, 'something done to...'); 1726, 'something not serious or earnest' (one might say intent is implied here, but not made explicit); and finally 1791, 'a laughingstock'. This last is described as a transference from the 1670 definition, and requires no intention, but only that the object in question be treated as an object of fun.

Dickie might say that the concept is extended to a new object because it is treated like the core cases (status is conferred...) but one might then ask *why* it is so treated. In this context a discussion of perceivable similarities seems more explanatory than how something is treated, and he himself seems to endorse as much in his discussion of the secondary or derivative sense of 'art'.

products or results of those actions), we cannot correctly conclude that the artist's having the appropriate intention is a necessary condition for the application of *C*. What the artist has done may be determined by the conventions of the medium, symbolism, and the social situation, whether the artist is aware of those conventions or not. The effect of the presence of an institution is precisely to defeat the necessity of there being any particular intention that the artist may have had.

Since the argument from definition and value of art does contain part of the truth about the rationale for defining art and interpreting it as we do, one should see what can be salvaged from it to establish the relevance of artist's intentions to an interpretation. Some comments by Professor Anscombe in her complex and stimulating work *Intention* indicate how the argument might be salvaged by restricting its scope. She points out that descriptions of actions which occur in the form of description of intentional actions can often be applied even though those actions are done unintentionally.[18] She then divides some descriptions (in the form of descriptions of intentional actions) of actions into two columns: those in one column can be applied only to intentional actions, and those in the other may be applied to intentional or unintentional actions, that is, actions which figure in an extendable class. Examples of the former are telephoning, calling, buying, selling, signalling, contracting, and examples of the latter are intruding, offending, abandoning, and arranging. We may be assured that the presence of

particular descriptions of actions in one column or the other is material ripe for dispute. 'Buying', for example, is in the 'intentionally only' column, which ignores the fact that under special circumstances, such as an auction, one can have bought something without intending to. The same is true that, when conventions exist of which one is not aware, one may signal or send for something quite unintentionally. And even more difficult is the case of contracting: although one may plausibly argue that it is impossible to make a contract unless one does so intentionally, one certainly may contract for specific goods or services of which one is unaware, or contract for them under circumstances which one does not even understand, much less intend.

These disputes about where individual descriptions of human activities belong point out the need for an elucidation of what determines which list any given description must go onto. Some interpretative concepts seem to fall fairly clearly into one column or the other: 'art' itself seems to fall into the extendable class and 'satire' into the non-extendable class. But what about 'allegory' or 'parable', or even 'expressive of human kindness'? For those desiring to make use of the argument from definition and value, it is incumbent upon them to state the criteria for distinguishing these two classes, so that it is possible, at least in theory, to determine which concepts must retain as a necessary condition for their application the presence of artist's intentions and which do not. The possibility of salvaging something from the argument from definition and value is hinted at by the observation that there are these two classes of 'forms of descriptions of intentional actions', but this is *only* a hint, for we have no rationale or explanation for the division. What are the differing characteristics of these two kinds of concepts (or characteristics of those things to which the concepts refer?) which allow them to be so divided? The crucial task is to discover which concepts *may* be extended to apply to non-intentional cases, and which may *not*. Linguistic intuitions, useful for an initial sorting, provide no rationale for the division and hence no grounds for settling disputes which arise about that division And disputes are likely, since one's intuitions which govern the initial sorting

18. G. E. M. Anscombe, *Intention* (Ithaca, N.Y., 1969), pp. 84-5 (Sec. 47). All the examples I shall discuss are from these two pages. Concerning the phrase 'descriptions of actions which occur in the form of description of intentional actions', which I, at least, find somewhat cumbersome and obscure, she has in mind, if I understand her properly, the following idea. The quoted phrase refers to descriptions which would not exist unless the question 'why did you do that?' existed, and an action is intentional if it is appropriate to ask 'why?' (in the appropriate sense). The form of description 'intentional actions' is revealed by our answers to 'why?' Yet, 'we can speak of the form of description "intentional actions", and of the descriptions which can occur in this form, and note that some are and some are not dependent on the existence of this form for their own sense' (p. 85). Hence, some of the descriptions in this form can apply to actions which are in fact unintentional.

are likely to echo one's position on whether intentions are a necessary condition for any given interpretation of a work of art.

To forestall a possible objection: it will not defend the argument from definition and value to point out that when the concepts become extended in the way I have suggested they do we have simply 'changed their meaning'. This may or not be true, depending on one's views about 'meanings', a rather notorious concept to appeal to these days. The same is true for the claim that this constitutes a new 'use'. On what grounds does one distinguish uses? Does naming the extended uses—descriptive, evaluative, etc.—ensure their irrelevance to the issue? Even if true, however, it is irrelevant. The issue is *why* we should restrict the meaning or use to the intentionalistic one, and to state that our initial interests, or even *primary* interests, lie in distinguishing intentional from unintentional cases does not explain why we should preserve meanings, definitions, or extensions of concepts to this interest at the expense of any new ones that arise. The values that are introduced by extending the concept reflect back on its original use, colouring our appreciation of what was originally identified as art. To say that artist's intentions are necessary to support any given interpretation of the work is to embrace blind conservatism—blind because of the disregard of any possible new values and ways of experiencing a work of art, and hence rationale for interpreting it, that may be introduced in the future.

Two major conclusions can be drawn from this discussion. First, given the lack of a rationale for dividing interpretative concepts (and the concept 'art' itself) into the extendable and the non-extendable categories, it is left undetermined *for any given case* whether an artist having a given intention is a necessary condition for a given interpretation of a work of art (with the possible exception of those few concepts which fall uncontroversially into the non-extendable class). It may be true that we would not be interested in art as the skilful product of human creation if we were not interested in what artists have done intentionally, but this is not to say that in *every* particular case we are interested in what the artist did intentionally, or only interested in that, or at least that.

Therefore, although it seems reasonable *in general* to use the absence of artist's intentions to rule out proliferating interpretations, there may be individual cases where it is most reasonable to base an interpretation on factors independent of the intent of the artist. Intentions cannot be cited as providing the only criterion for deciding between a multiplicity of interpretations, since we have not yet established how to determine what interpretative concepts can be extended to apply independently of the artist's intentions. Hence, although we may be convinced, as I am, that a consideration of an artist's intentions represents something fundamental concerning our dealing with art, one *cannot* appeal to this fact to defend one's appeal to intentions to support an interpretation of a work *in any given case*, since there may be other values and considerations which override the importance of the artist's intention in *that* case, and which one should grant are the basis for interpreting that particular work in that way. Some proliferation of interpretations is, after all, permissible: there are alternatives besides puritanism and promiscuity.

The second conclusion to be drawn is that even though 'universal interpretative ambiguity' can be avoided, one need not avoid it by applying the same 'standard' for deciding between interpretations in every case. One may consider an artist's intention to be a necessary condition for the application of a given interpretative concept to one work, but a social or artistic convention may be appealed to in another. Different conditions of the artist, the perceiver, and variations in historical precedents and cultural milieu as well as variations among a work's potential for affording various kinds of experiences may all figure in determining what in that particular case will determine the applicability of a given interpretation. What considerations should be determinate in each case, and why those considerations in those cases, is something *far* beyond the scope of this paper, but presumably still within the province of the philosophy of art.

Though I would not like to commit myself here to a view of what ensures specific criteria are appropriate in any given case, perhaps some explanation is needed to avoid the charge that this variation

among standards for the application of interpretative concepts is a sign of arbitrariness. Human interests in art (qua art) are multiple. Interests in art include historical ones—special skills the artist displays, innovations, insights, advances on predecessors, utilizations of iconography or symbols. They also include emotional and cognitive ones—new perspectives on people and the world that I can derive from a work, ideas it inspires, the feelings it evokes; and they include what might be called 'purely aesthetic' ones—the play of themes in a Bach fugue, intricacy of marquetry, vivid colours, sensuous shapes, rhythms, and rhymes. Interpretation of art takes place in the context of these (and perhaps other) interests in art, and the criteria for the application of interpretative concepts naturally *reflect* our interests in art. In cases where there is a multiplicity of interests it is conceivable that they will sometimes conflict so that not all can be satisfied at once. The multiplicity of our interests is *partly* revealed by the presence of a variety of non-extendable concepts whose criteria for application are guided by *one* of these interests: 'original' and 'satire' are guided pretty clearly by the first 'historical' type of interest, 'captivating' and 'trivial' most plausibly by the second, and 'intricate' and 'delicate' by the third. But our multiplicity of interests is also *partly* revealed by the existence of different criteria for the application of the same concept to different works of art, concepts which apply to objects in extendable classes. Some works, for example, may be identified as satisfying a particular interpretative concept because of the presence of an artist's intention, others are identified as satisfying that concept because of their perceivable similarities to the first group, and still others are identified as satisfying the concept because of their functional similarities (as opposed to their perceivable similarities, e.g., the capacity to afford a particular kind of emotional experience) to the first and/or the second group. Allegories, for example, may be initially identified by considerations of intentions, and the concept later applied to works which (reflecting the second type of interests, cognitive or emotional interests, alluded to above) can support an allegorical interpretation. This would presumably be because of their functional similarities to the originally identified cases. Considering a work as an allegory may even bring out structural or formal relationships within the construction of a story or painting, relationships which may even be obscured by (or which do not even emerge under) interpretations which do not include a recognition of its allegorical status.[19] Thus, both cognitive and 'purely aesthetic' interests in art may be satisfied by interpreting a work as an allegory, because of similarities to the traditional cases of allegory, even when it does not meet the standards for what was, *ex hypothesi*, traditionally a necessary condition for the identification of a work as an allegory. Thus one has grounds for extending the concept beyond the original kinds of cases. Whether there is a restricted range or permissible priorities among interests in art qua art, and consequently whether *multiple* interpretations of the same work based on different priorities may be equally permissible, is an issue I cannot begin to deal with here, but which would have to be dealt with if a fuller explanation is to be given of how different criteria are appropriately used to determine the application of particular interpretative concepts.

To grant that the conditions for the application of a given interpretative description may vary is not merely an endorsement of a plurality of critical approaches on the basis of the variety which exists in critical practice.[20] It is true (but very crudely put), that some critics are intentionalists and some are formalists. It is not this plurality which I am endorsing, but rather the propriety of the same critic's setting different standards in different cases, considering intentions in one case and not in another, on the basis of differing interests, all of which are appropriate to, but perhaps weighted differently with respect to, different works of art. These interests

19. For example (though not an allegorical one), it is within the conventions of the classical symphony that one will recognize the 'surprise' in the second movement of Haydn's 'Surprise' Symphony (No. 94).

20. In that respect the view here advanced should be distinguished from that of Richard Shusterman, 'The Logic of Interpretation', *The Philosophical Quarterly* Vol. 28, No. 113 (Oct. 1978). His theory accepts the fact that there is a plurality of practice as sufficient reason for sanctioning it within his theoretical framework.

determine what values are to be recognized in art, in light of which art works are to be interpreted. *This* variation in practice can in principle be justified by an appeal to what values of art should be emphasized in particular works. Actual variation among critics does not itself justify the theory which endorses those practices, but must be justified in the theory by an explanation of what values are to be sought in different works of art. Those values do not all centre around art as the intentional product of human creation, as we can see by the extension of 'art' as well as the extension of various interpretative concepts to apply to works which were not produced with the proposed intentions.[21]

21. I thank the editor [of the *British Journal of Aesthetics*] for helpful comments on this paper.

Jerrold Levinson (1948-)
Defining Art Historically

The question of what makes something art is probably the most venerable in aesthetics. What is the artness of an art work? Wherein does it reside? We would certainly like to know. We would certainly be interested to learn what ties together Dickens's *Oliver Twist*, Tallis's *Spem in alium*, Flavin's *Pink and Gold*, Balanchine's *Variations for a Door and a Sigh*, Wilson-Glass's *Einstein on the Beach*, the Parthenon, and countless other unknown and unsung objects under the common banner of art. After rejecting the many proposals made by philosophers from Plato to the present on grounds of narrowness, tendentiousness, inflexibility, vagueness or circularity, one would appear to be left with no answer to the question at all, and perhaps a suspicion that it is unanswerable. Nevertheless, the question has been taken up in recent years and given a new sort of answer: the institutional theory of art, announced by Arthur Danto and propounded explicitly by George Dickie. In short, the theory is that art works are art works because they occupy a certain place, which they must be given, in a certain institution, that of Art.[1]

I

In this paper I would like to begin to develop an alternative to the institutional theory of art, albeit one that is clearly inspired by it. What I will retain from that theory is the crucial idea that artworkhood is not an intrinsic exhibited property of a thing, but rather a matter of being related in the right way to human activity and thought. However, I propose to construe this relation solely in terms of the *intention* of an *independent individual* (or individuals)—as opposed to an overt *act* (that of conferring the status of a candidate for appreciation) performed in an *institutional setting* constituted by many individuals—where the intention makes reference (either transparently or opaquely) to the *history of art* (what art has been) as opposed to that murky and somewhat exclusive institution, the *artworld*. The core of my proposal will be an account of what it is to regard-as-a-work-of-art, an account which gives this an essential historicity.[2] It is this which will do the work in my theory which the notion of artworld is supposed to do in the institutional theory. That art is necessarily backward-looking (though in some cases not consciously so) is a fact which the definition of art must recognize. To ignore it is to miss the only satisfying explanation of the unity of art across time and of its inherently continuous evolution—the manner in which art of a given moment must *involve*, as opposed merely to *follow*, that which has preceded it.

II

Before sketching my view in some detail, I want to remark on two major difficulties with the institutional theory. (I pass over the often-made charges that the theory is *uninformative*, and that the key

1. Dickie's definition of art runs as follows: 'A work of art in the classificatory sense is (1) an artifact (2) a set of the aspects of which has had conferred upon it the status of candidate for appreciation by some person or persons acting on behalf of a certain social institution (the artworld)' *Art and the Aesthetic* (Cornell University Press, 1974), p. 34.

2. The suggestions that regarding-as-a-work-of-art may be a primary notion and that the nature of art must be located in its historical development can be found in Richard Wollheim's marvellous book *Art and Its Objects* (Harper & Row, 1971), sections 40 and 60-3, respectively. It is those remarks which first prompted me to work out the view I am trying to present. I might add here that I use 'regard' in this paper as a broad term covering whatever is done in relation to an object so as to experience or interact with it.

notions of 'artworld' and 'conferral of status' are *vague* and *artificial*.[3]) The first problem is the implication that art-making must involve a certain *cultural performance*, a ceremony or quasi-ceremony, a kind of hand-waving which draws into the fold. One must do something outwardly, and one must do it in relation to a certain social institution. On the contrary, I would urge that there can be private, isolated art which is constituted as art in the mind of the artist—and on no one's behalf but his own and that of *potential* experiencers of it. (I assume that *just that* is not enough to make the artworld, or else the notion becomes trivial and otiose.) Although in my scheme an art-maker will *typically* have art and an existing society of art consumers in mind when producing an art object, this is not necessary. In no case *must* one invoke or accord with the shadowy infrastructure of the artworld to make what one makes into art. Consider the farmer's wife at a country fair in Nebraska, who sets an assemblage of egg shells and white glue down on the corner of a table for folks to look at. Isn't it possible that she has created art? Yet she and the artworld exist in perfect mutual oblivion. Consider a solitary Indian along the Amazon, who steals off from his non-artistic tribe to arrange coloured stones in a clearing, not outwardly investing them with special position in the world. Might not this also be art (and, note, before any future curator decides that it is)? The institutional theory comes close to conflating art and *self-conscious* art, art and *socially situated* art, art and *declared* art.

The second and main problem I find with the institutional theory is that the artworld must do all the work in specifying the *way* in which an object has to be presented or treated in order for it to be a work of art, whereas the notion of *appreciation* (the point of the enterprise) is not specified at all or only in the most general terms.[4] That is to say, we are not told enough about what the art-maker must envisage must be done with his object by potential spectators. It seems, though, that some kind of specification of this must be essayed if making art is to be distinguished from making non-art. I believe the key to an adequate and revealing definition of art is to specify what the art object must be *intended for*, what sort of *regard* the spectator must be asked to extend to the object—rather than designate an *institution* on behalf of which some such request can be made. The trick, of course, is to do so without describing an intended way of regard given by fixed characteristics (*e.g.* with full attention, contemplatively, giving special notice to appearance, with emotional openness). It has been sufficiently shown that *that* sort of definition is doomed to failure, given the impossibility of locating a single unitary aesthetic attitude or regard common to all the ways we approach and have approached works of art, and given the ways unthought of in which we will undoubtedly be approaching some works in the future. The definition I will offer does not hamstring the kinds of regard that may eventually be given to art works, yet gives the art-making intention the content it sorely needs.

III

The above-mentioned content is to be found in the actual historical development of art. My idea is roughly this: *a work of art is a thing intended for regard-as-a-work-of-art*: regard in any of the ways *works of art existing prior to it have been correctly regarded.* In the absence of any identifiable 'aesthetic attitude', how else can 'regard-as-a-work-of-art' be understood? Obviously, in adopting this proposal we are not analysing art completely in non-art terms. Rather, what we are doing is explicating what it is for an object to be art at a given time with reference to the body of past art taken as unproblematic. But

3. For useful criticism of the institutional theory see R. Sclafani, 'Art as a Social Institution: Dickie's New Definitions', *Journal of Aesthetics and Art Criticism*, Vol. 32, 1973; R. Sclafani, 'Art Works, Art Theory, and the Artworld', *Theoria*, Vol. 39, 1973; T. Cohen, 'The Possibility of Art: Remarks on a Proposal by Dickie', *Philosophical Review*, Vol. 82, 1973; A. Silvers, 'The Artworld Discarded', *Journal of Aesthetics and Art Criticism*, Vol. 34, 1976; K. Walton, 'Review: Dickie: *Art and the Aesthetic*', *Philosophical Review*, Jan. 1977; M. Beardsley, 'Is Art Essentially Institutional?' in *Culture and Art*, L. Aagaard-Mogensen (ed.), Humanities Press, 1976. I share many of the misgivings expressed by these authors.

4. Which even then may be subject to counterexamples, as well as being unilluminating in any case (cf. Cohen, *op. cit.*). Dickie's extremely general suggestion for the meaning of 'appreciation' is: 'in experiencing the qualities of a thing one finds them worthy or valuable' (Dickie, *op. cit.*, pp. 40-1).

what it is for a thing to be art at any time can eventually be exhibited in this manner, by starting with the present and working backwards. New art is art because of this relation to past art, art of the recent past is art because of this relation to art of the not-so-recent-past, art of the not-so-recent-past is art because of this relation to art of the distant past...until one arrives presumably at the *ur*-arts of our tradition—those to which the mantle of *art* can be initially attached, but which are art *not* in virtue of any relation to preceding objects. (I will return to the *ur*-arts in section VII.) Before stating a more careful definition, let me further attempt to explain the motives for its introduction.

The concept of art work is unlike that of other sorts of things that surround us, *e.g.* cars, chairs, persons. *Art work* seems to lack antecedently defined limits in terms of intrinsic features, even flexible ones—as opposed to car, chair, person. There is no question of determining in all cases that something is art by weighing it against some archetype or other. The *only* clue one has is the particular, concrete, and multifarious population which art has acquired at any point (that is, assuming, as I do, the nebulousness and/or inessentiality of that institution, the artworld). It appears almost obvious, then, that for a prospective object to count as art must be for it to be related in some way to those objects that have already been decided or determined. For a thing to be art it must be linked by its creator to the repository of art existing at the time, as opposed to being aligned by him with some abstracted template of required characteristics. What I am saying is that ultimately the concept of art has no content beyond what art *has been*. It is this content which must figure in a successful definition.

Let me focus on the central case of art-aware art-makers. In such cases making an art work is a conscious act involving a conception of art. But what conception of art can all such art-makers, existing at different times and places, have in common? It seems the only possibility is a conception of art tantamount to all or anything that has been art until now—a concrete conception not equivalent to any abstract principle or generalization drawn from a survey of art's past. The art-aware art-maker is thus

one who connects his creation to such a conception, and in so doing, makes it art. If he does not do this—if his activity involves no reference whatsoever to the body of art works preceding him—then I think we fail to understand in what sense he is consciously or knowingly producing art. Given the abandonment of special aesthetic attitudes and/or artistic purposes, some connection of some sort between current art works and earlier ones must logically be demanded of the putative art-maker. It looks as if there are three likely ways in which the connection might be established: (i) by making something which will be externally similar to previous art works; (ii) by making something which is intended to afford the same kind of pleasure/experience which previous art works have afforded; (iii) by making something which is intended for regard or treatment as previous art works have been regarded or treated.

The first suggestion, while the simplest, clearly will not do. It is useless unless respects of similarity are indicated, since just about anything would be externally similar to some past art work in some respect. But aside from that, art works are just not to any great extent bound together by external similarity. For example, certain welded iron sculptures resemble portions of junkyards more closely than they do the sculptures which were their predecessors. External similarity to art works is neither necessary nor sufficient for being an art work. The second suggestion is more promising, but it fails too. There are two reasons for this: (1) the pleasures/experiences derived from art are not necessarily unique to art; (2) it is the *manner* in which art works afford their pleasures/experiences, the *ways* in which one approaches or engages them *so that* they give those pleasures/experiences, which characterize them as art. To illustrate these points, imagine a drug which when ingested, or a Martian stone which when rubbed, would provide a pleasure/experience akin to what one can have by listening intently to Beethoven's Quartet in C# minor, Op. 131. Such a drug or stone would not thereby be an art work, although it would be handy thing to have around. Furthermore, to focus on the pleasures derived from art works is to emphasize the passive and resultant in the situation, as opposed to the active and causative,

i.e. the way of taking the object. It is more reasonable to hold that an artist directing an object toward potential spectators is concerned intentionally with what is to be *done* with the object, as opposed to what might be *got* out of it, since the spectator can only *directly* adjust himself or behave with respect to the former. So I think we are left with the third suggestion as the only one around with which to build an account of what it is to be art.

IV

A definition which preserves my basic idea, but adds certain qualifications, is the following:

(1) X is an art work=df X is an object which a person or persons, having the appropriate proprietary right over X, non-passingly intends for regard-as-a-work-of-art, *i.e.* regard in any way (or ways) in which prior art works are or were correctly (or standardly) regarded.

Several comments on this initial definition are in order. First, there is the phrase 'intends for'. This is to be understood as short for 'makes, appropriates or conceives for the purpose of', so as to comprehend fashioned, found, and conceptual art. Second, there is the notion that the intent must be fairly stable ('non-passing'), as opposed to merely transient. In other words, it is not enough to turn an object into art that one momentarily considers it for regard-as-a-work-of-art. Third, I have construed regard-as-a-work-of-art as equivalent to ways of regarding past art only in so far as they are or were *correct* (or *standard*) ways. If one omits this qualification, or appeals instead to *common* ways of regard, or even *rewarding* ways of regard, the definition will go awry. The following case will illustrate this point.

Italian Renaissance portraits are presumably art works. Suppose that they come to be regarded in a new and unprecedented way, *viz.* they begin to be used as thermal insulation, and are found to be quite suitable for this. And suppose, through an amazing decline in taste or an unparalleled need for insulation, this manner of regard becomes the rule. If we omit 'correctly' from our definition, or replace it by 'commonly' or 'rewardingly', then given the case as described, it follows from our definition that anything subsequently intended by its maker for use as insulation (*e.g.* a sheet of fibreglass) would be an art work. Why? Because Renaissance portraits are past art works which are regarded, are commonly regarded, and are rewardingly regarded as insulation. This must be wrong. It can't be possible to turn all tomorrow's fibreglass production into art simply through general misuse today of a certain class of portraits. To avoid this unwanted consequence, we *must* appeal to some notion of *correct* regarding for art works.[5] Using Renaissance portraits as insulation is manifestly not a correct way of regarding them, no matter how widespread or satisfactory such a use might be. And so on our definition nothing can become art through intentional reference to such a prior way of regarding art works.

Fourth, the definition includes a proprietary-right condition. What this amounts to is basically *ownership*—you cannot 'artify' what you do not own and thus have no right to dispose of. All your intentions will not avail in such a case, because another person's intention, that of the owner, has priority over yours. (Of course, if he is not opposed to your intention, he can grant you permission to make his possession into an art work.) One standardly attains the right in question by creating an object, but notice that this will not always suffice—for example, if the object is created under contract during working hours while in the employ of a metal tubing company. (On the other hand, neither is it necessary to create something in order to have the right to

5. The notion of correct regard for an art work is a difficult one to make out, but surely relevant to it are the following considerations: (1) how the artist *intended* his work to be regarded; (2) what manner of regarding the work is *most* rewarding; (3) the kinds of regard *similar* objects have enjoyed; (4) what way of regarding the work is optimum for realizing the *ends* (*e.g.* certain pleasures, moods, awarenesses) which the artist envisaged in connection with appreciation; (5) what way of regarding the work makes for the most satisfying or coherent picture of its place in the *development* of art. (For an illuminating discussion of some of these factors, see Walton, 'Categories of Art', *Philosophical Review*, Vol. 79, 1970.) Nothing in the present paper depends on the exact analysis of 'correct regard', however. To understand my account of art one only has to grant that *there are* correct ways of regarding past art works, whatever that might amount to.

'artify' it, as witnessed by found art.) It might be thought that the proprietary-right condition would rule out varieties of conceptual art, but this is not so. One must just avoid the mistake of taking the art object in such cases to be simply and solely what the artist has described or pointed to (*e.g.* Marilyn Monroe, the Empire State Building, a slice of the life of a family in Queens—things which the artist clearly has no proprietary right over), rather than a directed complex of the description and the object.

Given a proprietary-right condition, it is somewhat problematic whether curators, promoters, exhibitors can turn non-art objects of the past into art objects of the present as blithely as is usually allowed. Imagine an art museum having mounted for regard-as-a-work-of-art a strange ornate receptacle whose original purpose is unknown. The object comes from an ancient Mexican culture thought to have died out. However, a well-documented descendant of the tribe, armed with full knowledge of its customs and practices, appears and successfully demands the removal of the receptacle from public view (it is apparently a sacred ritual object, used for nocturnal royal baptisms, and not in any sense for appreciation). I maintain that the object in question does not just revert to being non-art—it never was art at all, because our present art establishment unknowingly lacked the right to make it such. This sort of case may be more prevalent than is generally imagined.

It will be useful to distinguish three kinds of intention which can realize the condition expressed in the definition: *intending for regard-as-a-work-of-art*. The first would be the *specific art-conscious* intention: intending for regard in the specific way or ways some particular past art works (or class of art works) have been correctly regarded. An example of this would be intending for regard in the way wire sculptures are to be regarded. The second is the *non-specific art-conscious* intention: intending for regard in whatever ways any past art works have been correctly regarded, having no particular ones in mind. The third is the *art-unconscious* intention: intending for regard in some specific way ϕ characterized in terms of intrinsic features, where ϕ is *in fact* a way in which some past art works have been correctly regarded, though this fact is not known to the intender. An example of this might be intending for listening to with attention to timbre.

The first and second kinds realize *intending for regard-as-a-work-of-art* on a *de dicto* (or opaque) interpretation of the notion, whereas the third kind satisfies a *de re* (or transparent) interpretation of it. Given the notion as readable in both modes, my definition thus allows (via the art-unconscious intention) for an art-maker ignorant of all art works, all art activities, and all institutions of art. Such a person can be seen to make art if he intends his object for regard in a way which *happens to be*, unbeknown to him, in the repertory of aesthetic regards established at that time. In such a case there is the requisite link to the prior history of art, but it is one the art-maker is unaware of, though he has in fact forged it.

So cases of naïve activity can be cases of art-making if they accord with the development of art at that point in the manner sketched. And I would insist that a theory must account for these cases. From where we stand such persons (*e.g.* the Amazon Indian mentioned before) are clearly making art—and it is not our recognition which makes it so.

V

The definition presented in the preceding section conveys in a fairly perspicuous fashion what I believe it now means for something to be an art work. However, at the expense of some perspicuity but in the name of greater precision and flexibility, I offer a second definition which makes explicit the time-dependence of the status of 'art work', clarifies the interpretation of 'prior art works', and indicates more exactly what sort of definition of art I am giving.

(I_1) X is an art work at t=df X is an object of which it is true at t that some person or persons having the appropriate proprietary right over X, non-passingly intends (or intended) X for regard-as-a-work-of-art, *i.e.* regard in any way (or ways) in which art works existing prior to t are or were correctly (or standardly) regarded.

An object can be an art work at one time and not another. This definition recognizes that an object may not be an art work from the moment of its physical creation, but may only become an art work at some *later* date. It also allows for an object which becomes an art work even subsequent to its creator's intending it for a certain regard, and even subsequent to the death of its creator.[6]

The first sort of case is relatively common. Any piece of found art serves as an example. The snow shovel involved in Duchamp's *Snow Shovel*, or the bottle rack in his *Bottle Rack*, became works of art at a certain time owing to Duchamp's appropriating them with a certain intention, whereas they existed but were not works of art before that time. The same goes for driftwood mounted and displayed in someone's living room, or potsherds and door handles touched by curatorial intent in a museum of primitive art. Another kind of example would be a canvas which is undertaken and completed merely as a technical exercise but which after a few days' reflection is then viewed by its creator as for regarding-as-a-work-of-art. These things are art only *after* a certain intentional act has taken place. Definition I_t makes this plain.

The second sort of case is less common, but I think a completely adequate definition of art must be capable of handling it. An example would be the following: A naïve or art-unaware creator makes an object Z at t, which he intends for a kind of treatment or regard which is not a correct way of regarding any art works existing prior to t_1. However, it is a kind of treatment or regard which *will be* correct for certain art works 0 existing 200 years after t_1. I think we want to say that the naïve creator's work is art beginning around $t_2(=t_1+200)$ but not before.

That is to say, Z becomes art 200 years after its intentioned creation, when the history of art, so to speak, catches up with what Z's creator was engaged in. It would be hard to deny at t_2 that Z was art; for after all, it was created and intended for just the sort of treatment that 0's, which are recognized art works at t_2, are correctly accorded. Z is art at t_2 because it was intended for a kind of regard which (unbeknown to its creator) turns out to be in the stock of standard regards for art works at t_2. Z at t_2 can be seen as projected for a kind of appreciative activity which had become part of artistic tradition. However, before t_2 this cannot be seen. There is no plausible ground for considering Z to be art prior to t_2. Something cannot be art from the outset *just* in virtue of its future redemption by the evolution of art—only actual redemption will turn the trick then and there.

Definition I_t handles this case as desired. Z is an art work at t_2 (and thereafter) because it is an object of which it is true at t_2 that someone rightfully and non-passingly intended it (at t_1) for regard in a way in which some art works existing prior to t_2 are correctly regarded. However, Z is *not*, according to I_t, an art work at t_1.

So what sort of definition of art have we given? In short, a definition which explains what it is to be art at a given time in terms of what is art at previous times. To be art at t is to be intentionally related in the required way to something which is art prior to t. The present state of art shows us that certainly nothing more can be required. On the other hand, nothing less than this can be required if we are to locate a conception of art which will cover equally Donatello's *David* and Carl Andre's *Lever*, Mozart's 'Jupiter' Symphony and Stockhausen's *Momente*, Shelley's 'Ode to the West Wind' and John Berryman's *Dream Songs*. If there is now a univocal sense of 'art' in which all six items count as art, and count as such from the time of their creation, then I believe this sense is given (more or less) by definition I_t.

I can almost see the reader shake his head at this point and ask: but does this definition *really tell* me what art is? Doesn't it seem that I have to *know* what art is in order to use it? In fact, isn't the definition simply *circular*, in that it defines art in terms of art? This response is perfectly understandable,

6. There are three times of importance that should be distinguished if we are to get clear on this issue. One is the time of physical creation of the object, t_p. A second is the time of intentioned-object creation, t_1, *i.e.* the time at which the brute object is structured or transformed by a certain intention concerning it. Every art work is, strictly speaking, an intentioned object. A third is the time of art-becoming, t_a. In the typical or normal case of art production $t_p=t_1=t_a$; in the case of found art, t_p is earlier than t_1, and $t_1=t_a$; in the case of the naïve creator ahead of his time (discussed below), $t_p=t_1$, and t_a is later than t_1.

but it is none the less mistaken. True, there is something reflexive about the definition, in that it exhibits art as essentially referring to itself. But to eliminate this reflexiveness would be to eviscerate the term 'art' of the only universal content which it now retains. If art works at one time are essentially intentionally related to art works at an earlier time, then on the assumption that definitions attempt to give essences, how could a definition of art fail to explicate art works—to put it bluntly—in terms of art works? Thus the *appearance* of circularity.

But, strictly speaking, I_t is *not* circular. What it does is define the *concept*: *being art at a given time* by reference to the *actual body of things* that are art prior to that time. True, one cannot tell what counts as art at t without its being granted what things count as art prior to t—but this is in fact just the way art itself works. Furthermore, and this also conforms to the reality of art, to the extent that it is unclear which objects *prior to t* are art works, it will be equally unclear which objects *at* t count as art. True, one cannot use the definition to tell, all at once, what has, does, and will count as art at all times, but this is because the applicability of 'art' at any stage is always tied to its concrete, historical realization at that stage. That the definition is not circular if properly understood, can be seen by reflecting that one doesn't have to know what 'art work at t' *means* in order for I_t to *tell* you; one only has to grant that there is a set of things which are art works prior to t—*whatever* they are and *whatever* that (*viz.* 'art work') might mean.

The last point suggests another way of expressing the analysis of art that I offer, a way I think that removes any lingering suspicion of circularity. Basically, what I have proposed is that the *meaning* of 'art now' involves the extension of 'art previously'— that the *meaning* of 'art at t' is to be given in terms of the *extension* of 'art prior to t'. Formulating a variant of I_t to make this explicit, we have:

(I_t') X is an art work at t=df X is an object of which it is true at t that some person or persons, having the appropriate proprietary right over X, non-passingly intends (or intended) X for regard-as-a-work-of-art, *i.e.* regard in any way (or ways) in which objects in the extension of 'art work' prior to t are or were correctly (or standardly) regarded.[7]

It is clear that the *meaning* of 'art work' is not involved in the right hand side of this definition, but only its past *extension* at some point. Thus, I maintain that I_t' or I_t captures our present concept of art—and without presupposing that concept in doing so.

VI

On the view I have presented, which makes art a necessarily backward-looking affair, it may be wondered how the revolutionary aspect of art can be accommodated. Surely, one might say, if art is continually looking to the rear, how can it change or advance? Won't it always remain the same? To begin to answer this let me first distinguish revolutionary from merely new or original art. A new art work is simply one non-identical to any previously existing art work. An original art work is a new one significantly different in structural or aesthetic properties from any previously existing art work. The production of original art could continue indefinitely without there being any additions to the stock of ways in which art works are regarded. But by a revolutionary art work I will mean one for which any of the past ways of approaching art seems inadequate, inappropriate, pointless or impossible; a revolutionary art work appears to be ultimately calling for a kind of regard which is totally *unprecedented*. It is plainly only revolutionary art that poses any difficulty for my analysis.[8]

7. Note in this definition that when I speak of the extension of the term 'art work' at a time t this means the extension of the term at t as it is understood *now*—*i.e.* in its *current* usage.

8. Most movements in art are revolutionary in a weak sense, in that they ask for or involve *some* specific new ways of taking art objects, but few such movements (perhaps none before Dadaism) deny the applicability of *all* past ways of taking art objects. For example, Impressionist paintings certainly are and were to be approached in specific ways (*e.g.* synoptic vision from a distance) which were not in practice for previous paintings (*e.g.* those of the Neo-classicists). But there clearly remained ways in common in which they were to be regarded. Thus, weakly revolutionary art does not challenge the historicity of the art-making intention.

Art which is revolutionary because it demands or requires a new approach to yield up its fruits to spectators is not *per se* a problem. A problem only arises for art works, *e.g.* Dadaist ones, which are *intended* as revolutionary by their artists, that is to say, intended for treatment in a manner completely distinct from what has gone before. (Whether all intentionally revolutionary art is thereby revolutionary *simpliciter* is a complicated question I cannot go into here.) Two strategies suggest themselves for reconciling my proposal to this important and characteristic mode of art-making. One is to maintain that although the consciously revolutionary artist desires that eventually his objects will be dealt with in unprecedented ways, to make them *art* he must initially direct his audience to take them (or try taking them) in some way that art *has* been taken—otherwise, what can we make of the claim that he has given us *art*, as opposed to something else? The art-making intention of the consciously revolutionary artist may thus have to be a covertly disingenuous one, somewhat along these lines: 'My object is for regarding in any way art works have been regarded in the past (but with the expectation that this will prove frustrating or unrewarding, thus prodding the spectator to adopt some other point of view—this being my real intention).' The secondary intention embodies the true *aim* of such art, but the primary intention must be present to make it *art* at all.

A second strategy for dealing with this issue perhaps does less violence to the outward stance of the consciously revolutionary artist. This requires a liberalization of what regard-as-a-work-of-art amounts to. Instead of construing it as restricted to past correct ways of regarding art works, broaden it to include completely unheralded types of regard so long as one is directed to adopt such regards in conscious opposition to those past correct ways. The liberalized version of regard-as-a-work-of-art then reads as follows: regard in any way (or ways) in which prior art works are or were correctly (or standardly) regarded, or *in some other way in contrast to and against the* background of those ways. (Call this 'regard-as-a-work-of-art*'.) If this second strategy is adopted, one simply substitutes 'regard-as-a-work-of-art*' for 'regard-as-a-work-of-art' in I, I_t, and I_t' to get definitions adequate to revolutionary art.

Whereas the idea of the first strategy was that the self-aware revolutionary artist must on one level intend the existing correct art regards, freeing him to intend on another level some entirely new regard, the present strategy does not insist that he should directly intend the existing ways at all, but only that he should project the new way *in relation* (albeit antagonistic relation) to its predecessors. If he fails to do even that, I think there are no grounds on which one could deny that he fails to make art. Of course it is open at that point for some other member of the art community, assuming he has the proprietary right, to appropriate the would-be artist's work at a later date with the right intention, and so bring it into the sphere of art. The point is, to get a revolutionary mode of activity to *be* art it is necessary that its creator (or his subsequent proxy) should consciously nod in the direction of past artistic activity.

Which of the two strategies is ultimately preferable as a way of accommodating the historical definition of art to revolutionary art-making is a question I will not attempt to settle here. However, for the sake of simplifying succeeding discussion, I will assume for the remainder of the paper the workability of the first strategy and tentatively adopt it. This means that definitions I, I_t, I_t', properly understood, will be viewed as adequate to revolutionary (as well as evolutionary) art.

VII

The view presented so far suggested the following picture of art's evolution. Art works are objects projected for regard, at least in part, in ways past art works have been standardly regarded. These art works, if at all original, will differ from those of the past more or less markedly, and will therefore optimally call for ways of regard (which the artist has usually envisaged) somewhat different from ones already in practice. But then *those* ways will become part of the tradition of art appreciation, allowing for newer works to be constituted as art by reference to *them*, and so on. There is thus a deeper continuity in the development of art than is generally noted. Art works of a given period do more than *follow* their predecessors. They are even more than casually *descended* from them, more even than testimonies of the influence of style, medium, and

subject matter. Rather, those predecessors are *necessarily involved* (via the ways in which they have been regarded) in the intentional structure which determines their successors as art. What art becomes depends conceptually, not just causally, on what art has been.

Definition I_t analyses being art at a given time in terms of what is art prior to that time. The definition can be applied to the present time, and then at as many times back into the past as one chooses, until one at last reaches the origins of art[9] itself (*i.e.* the *ur*-arts). Having reached that terminus, however, we could then use it as the starting-point of another kind of definition of art, one which begins with the hypothesized origins of art, and yields serially all that has sprung from it up to the present. This would be a recursive definition and would reveal art as a recursive domain. Before giving one, let me tell a somewhat over-simplified tale.

The time predates the beginning of art. Certain societies are thriving in which various activities are going on. In some of these activities objects (including events) are produced and then treated in a certain manner. These activities can be identified retrospectively as the *ur*-arts of our tradition. At some point, new activities arise wherein objects of a different sort are produced which are intended for treatment as objects of some *ur*-art are. The new activity then becomes associated with that of the *ur*-art, under a wider category, that of *art*. At this stage, an activity of object-making can only become art by relating itself to the purposes of some (or possibly more than one) *ur*-art; the objects of the activity can only be art works by being thought of in connection with the ends towards which the objects of some *ur*-art were directed. Once a new activity and its objects are established as art, *further* activities and objects now enter the realm of art through intentional connection with *them*. Eventually one arrives at art as we find it today.[10] Let me state the definition suggested by this tale:

(II) Initial Step: Objects of the *ur*-arts are art works at t_0 (and thereafter).[11]

Recursive Step: If X is an art work prior to t, then Y is an art work at t if it is true at t that some person or persons, having the appropriate proprietary right over Y, non-passingly intends (or intended) Y for regard in any way (or ways) in which X is or was correctly regarded.

I believe this definition very nearly generates all and only those things which have been, are, or could be art works, given the concept of art we presently have.[12] And yet, it is easy to understand how the definition might strike one as inoperative or incomplete. For recursion depends upon the initial step, the initial step speaks of the *ur*-arts—but one has not been told what the *ur*-arts *are*! I would be happy to supply their description if I know what they were, but I don't. Nor does anyone. Is there, then, a way to save II from this charge of having merely programmatic status?

that the story is told from the point of view of art as the production of art works for appreciation by spectators, and not from the point of view of art as the release of psychic energy or the expression of artistic impulses by creators. As should be apparent, it is only the former idea of art that this paper is concerned to elucidate.

11. Let t_0 be the time roughly at which the *ur*-arts begin spawning non-*ur*-art art works.

12. Wollheim, in section 60 of *Art and Its Objects*, mentions the possibility of a general *method* of identifying all works of art which would be recursive in form. He concludes that as a method of identification it would not work, the reason being the inability to formulate rules of transformation (taking art at a given point into its successors) adequate to the concrete evolution of art in the distant and also the recent past. He has in mind rules that would operate on given structures or styles and spew out altered ones indicating the direction taken by art at that juncture. The problem is especially acute for the modern period: 'whereas earlier changes in art affected only the more or less detailed properties of a work of art, e.g. painterly vs. linear, in the art of our day one work of art generates another by the supersession of its most general properties...e.g. hard-edge painting as the successor of abstract expressionism' (*op. cit.*, p. 126). Granted that Wollheim is right about this, I think the possibility of a definition such as I propose is unaffected. The definition does not depend on rules of stylistic change but, rather, simply on the rule I have argued for as constraining the intention which makes something art. The definition, unlike Wollheim's projected method, does not of course generate all works of art in terms of their intrinsic observable features, but only in terms of certain external intentional relations they bear to other objects.

9. That is, art as understood in Western culture—I am theorizing about nothing else.

10. The story I tell here is consonant with a remark made in passing by Walton, 'Review: Dickie...', *op. cit.*, concerning the historical development of art. I should also emphasize

I think there is. Our explanation of the *idea* of an *ur*-art given earlier in this section can be turned to provide a method in principle for *actually identifying* the *ur*-arts. Basically, one just has to ask, of objects at points successively farther into the past, and until the questioning process terminates, 'What makes this count as art?' More formally, and relying on definition I for simplicity of exposition, the procedure would be as follows: Begin with a group of related recent art works, A. Then by I, A consists of objects which were *intended* for regard R, where R is the manner of regard *in fact* standardly accorded certain earlier art works, A'. Now focus on A'. By I, A' consists of objects which were intended for regard R', R' being the regard in fact standardly given an even earlier set of art works, A''. A, A', A''...thus form a backward reaching series of art works whose principle of continuation should be clear. Eventually one arrives at a set of objects A_0 which are such that objects succeeding them are intended for regard as A_0's are standardly regarded, but there are no objects X preceding A_0 such that A_0's were intended to be regarded as X's in fact standardly were. A_0 is then one set of *ur*-art works. Of course to put this method into practice would be exceedingly difficult. It would require a great deal of knowledge of artists' intentions and actual appreciative practices of societies to perform successfully the backward trace on an initial sample. And one would have to do this for many such samples in order to unearth all the *ur*-arts of Western culture. However, *if* one did carry out this procedure for a wide, well-chosen variety of current paradigm art works, one would have pretty good reason to be confident that all of the *ur*-arts had been ferreted out from their historical hiding places. At that point, if one liked, one could substitute for the place-holder '*ur*-arts' in II a specification in *intrinsic* terms of the activities that archaeological investigation had revealed to be *in fact* the roots of Western Art. This would in effect 'complete' the recursive definition of art.

It is important to note that while the basic definition (I_t) is put forward as capturing the general concept of art which we now employ, the recursive definition aims only at displaying in a revealing way the

extension of that concept. The basic definition explains the shared sense in which Donatello's David is art in 1420, Shelley's 'Ode to the West Wind' is art in 1820, and Stockhausen's *Momente* is art in 1970. The recursive definition, though, does *not* explain the sense of 'art work'. It would be implausible to maintain that our conception of art work entails that all such things have ultimate ancestors of the sort that the *ur*-arts are. Surely the notion of *ur*-arts, whether characterized positionally or intrinsically, is no part of the content of a judgement that something is an art work. What the recursive definition does, though, is to generate all art works by a method that closely parallels and illuminates the actual historical process of the evolution of art.[13]

VIII

Having spelled out the theory I have to offer, in which the concrete history of art replaces the institutional network of art at centre stage, I wish to remark further on certain issues over which my theory and the reigning institutional one differ. In particular, two issues that can be put in the form of questions: (1) Is art-making in essence an *internal* (intention) or *external* (conferral) matter? (2) Need a

13. The recursive definition justifies perhaps more strongly than the basic definition my titular claim to be 'defining art historically'. Of course, I am not defining art simply as that which has a history; just about any activity has a history. But neither am I defining it simply as that activity whose historical source is the *ur*-arts. For some of the ultimate ancestors of art (viz. the ur-arts) may in fact also be ultimate ancestors of activities other than art. If that is so, does our recursive definition unwantedly generate those non-art activities as well as that of art? No, because in order to be art something must not only have an ur-art as ancestor but must also be descended from it in a particular fashion—namely, via intentional relations invoking previous standard regards. It is a good bet that even if there are other activities which have ur-arts as ultimate ancestors, they do not exhibit that principle of descent.

Now that we have concluded our discussion of the ur-arts as they figure in the recursive definition, it might be observed that objects of the ur-arts are art works which do not conform to our basic definition of the meaning of 'art work', namely I_t (or I_t'). (This was first pointed out to me by Terence Horgan.) For there are no art works and correct regards prior to the ur-arts. I_t (or I_t') thus strictly speaking only tell one what it means for any thing apart from an ur-art object to be an art work. Objects of the ur-arts are, by contrast, simply stipulated to be art works.

person have a special *position* in the artworld to create certain sorts of art works? I will consider these briefly in turn.

(1) Z is an object made by an artist, and intended for regard-as-a-work-of-art, but not offered, not placed, not mounted, not circumscribed, advertised, or sold—in short, not 'done with' in any way. Isn't Z still an art work? The institutionalist might argue that having the intention *just is* conferring a certain status, and no other 'action' is necessary. But if having the intention is always *thereby* conferring status, while any overt conferring must *anyway* include the requisite intention (or else it is mere sham, 'playing the artist'), then this seems to me tantamount to admitting that intention is really all that is essential to art-making. This is not to say that an art-maker is very *likely* to *just* intend an object of regard-as-a-work-of-art. It is highly unlikely that he will fail to act so as to draw attention to his work. Artists naturally try to increase the chances of their works getting the regard they intend (both for their benefit and for ours).

On the other hand, the fear that taking everything outward away from the essentials of art-making would mean a world pullulating with art works of the unfashioned kind, generated at every turn of thought—that fear is groundless. It is relatively easy, natural, and common to summon the requisite nonpassing intention in connection with an object one has made, but difficult, unnatural, and rare to form such an intention in connection with an object one has not made—it takes a certain courage and occasionally perversity to convince oneself of the right or point of so appropriating what nature or another person has already fashioned. Only if one overlooks the fact that these intentions are not going to arise in many people will one suppose the need for an art-maker to perform an action on behalf of the artworld, in order to account for the observation that not one man in a hundred has transformed his kitchen stove into a work of art.

(2) Arthur Danto gives an answer to this question in speaking of 'the making of artworks out of real things', *i.e.* the appropriation/minimal-fashioning mode of art. "It is analytically true that art works can only be *by* artists, so that an object, however much (or exactly) it may resemble an artwork is not *by* whoever is responsible for its existence, unless he is an artist. The mere object [*e.g.* a brass bushing] perhaps does not lie outside their [*viz.* non artists'] powers. But as an artwork it does."[14] If 'artist' in these remarks meant only 'person who at some time makes an art work' then I would have no trouble agreeing that an art work can be brought into being by nobody other than an artist. However, the context makes it clear that 'artist' means there something more like 'person with an established position in the artworld, one of whose main concerns is the making of art works' (call this 'artist*'). Danto believes that tracing a 'real thing' to someone who is not an artist* defeats any claim it might have to be art. I cannot accept this. I do not believe the 'conventions of ascribing'[15] the predicate 'is art' are like that at all. The only reason I see why one would maintain they are is based on confusing *established* or *professional* art with *all* art. I am willing to admit that commanding a special position or having a certain background may be relevant to making brass bushings into *recognized* art, or making them into *significant* art, or into art works which will affect the *development* of art—but not to making them into art, *simpliciter*. The wittiest riposte of the season is presumably utterable *only* by a member of high society; art *per se* no more operates on this level than philosophy does.

IX

The concept of art has certainly changed over time. There is no doubt of that. It is thus worth emphasizing in this final section that my analysis is aimed just at capturing what the concept of art is *at present*—that is, what it *now* means for an object created *at any time* (past, present, or future) to count as art at that time, rather than what it meant at the time of the object's creation.[16] Claiming that the analysis indicates what it means, say, for something

14. A. Danto, 'Artworks and Real Things', *Theoria*, Vol. 39, 1973, p. 14.

15. *Ibid.*, p. 12.

16. This is the distinction, difficult to grasp firmly, between: (i) what it *means at present* for something to *be art at the time of its creation*, and (ii) what it *meant at the time of its creation* for something to *be art at that time*.

created in 1777 to be an art work thus does not entail or require that that the concept-of-art$_{1977}$ is identical with concept-of-art$_{1777}$. Presumably these two concepts would classify the field of objects into art and non-art somewhat differently. And calling Rembrandt's *The Night Watch* a work of art in 1777 undoubtedly meant something different from what is meant by calling it that in 1977. However, given my analysis of it, I think the only part of concept-of-art$_{1977}$ that could unarguably be held to have been *missing* from concept-of-art$_{1777}$ is the permissibility of objects as art which are unfashioned or only minimally fashioned by their creators.[17] Whereas concept-of-art$_{1977}$ associates *The Night Watch* with former stainless steel bars, coat racks, cardboard cartons, and goats' heads, concept-of-art$_{1777}$ served in part to differentiate *The Night Watch* from such things. This major conceptual changeover occurred, as we know, around 1920 as a result of the Dadaist movement.

I have already noted that the historical definition of art provides a powerful and direct explanation of the inherent unity and continuity of the development of art. In short, for something to be an art work at any time is for it to be intentionally related to art works that precede it—no more and no less. And the historical definition, if accepted, helps to dispel the lingering effects of the so-called 'intentional fallacy' understood as a claim about the irrelevance of artists' intentions to correct or full appreciation of their works. For if artists' intentions are recognized as central to the difference between art and non-art, they are not so likely to be offhandedly declared irrelevant to an understanding of art works once seen as so constituted. In particular, the historical definition indicates the overwhelming importance for appreciation of those past art works/genres/ways of regard/modes of treatment which an artist connects to his current production through his art-making intention.

The historical definition of art also casts a useful light on the fact that in art anything goes, but not everything works. The reason anything goes is that there are no clear limits to the sorts of things people may seriously intend us to regard-as-a-work-of-art. The reason not everything works is that regarding-something-as-a-work-of-art necessarily involves bringing the past of art to bear on what is being offered as art in the present. That the present object and past regards will mesh is not guaranteed.[18] The interaction of the two sometimes satisfies immediately, sometimes only after an interval. Sometimes we are shocked and unsettled, but recover and are illuminated. Sometimes we are forcibly impelled to adopt new modes of regard, leaving old ones aside. But sometimes we are simply bewildered, bored, bothered—or all three—and in a manner which is never transcended. In such cases we have art works, all right, but such works don't work.

In conclusion, let me say that I do not mean to deny that there is a common practice of art, and a group of people bound together under that umbrella, nor do I deny that art works need to be understood in relation to their cultural situation. What I do deny is that the institutions of art in a society are essential to art, and that an analysis of arthood must therefore involve them. The making of art is primary; the social frameworks and conventions that grow up around it are not. While the sociology of art is of great interest, the essence of art does not lie there but instead in art's relation to its contingent history. The theory I offer sketches in its main outlines what this relation is.[19]

17. On the other hand, it seems clear that there was much in the concept-of-art$_{1777}$ that is missing from the concept-of-art$_{1977}$. Concept-of-art$_{1777}$ was surely more restrictive than its 1977 counterpart; one could reasonably maintain that it included specification of structural features, technical requirements, purposes, ends, and even minimum aesthetic effectiveness. Thus, to get from concept-of-art$_{1777}$ to concept-of-art$_{1977}$ one must delete all such artistic specifications, while broadening the sphere of creation beyond that of fashioning; what is retained throughout is the common thread of reference by art at any time to the sort of treatment earlier art was accorded.

18. Thus it is clear that the historical theory of art leaves room for the sense of 'conceptual strain' accompanying some works of art (e.g. Bottlerack) that Anita Silvers (op. cit.) accuses the institutional theory of eliminating. The strain arises from the clash between the nature of the object and the kinds of regard typically accorded earlier art works, which regards had to be invoked in making the object in question art.

19. I would like to acknowledge criticism, comments, and suggestions form Kendall Walton, John Bennett, and John Brown, which were helpful in improving this paper.

Jenefer M. Robinson (1945-)

Style and Personality in the Literary Work

Introduction

In this paper I want to describe and defend a certain conception of literary style. If we look at literary style in the way I shall suggest, it will explain many of the problems that surround this elusive concept such as why something can be an element of style in the work of one author and not in another, what the difference is between individual style and general style, and how style differs from "signature." The ordinary conception of style is that it consists of nothing but a set of verbal elements such as a certain kind of vocabulary, imagery, sentence structure and so on. On my conception, however, a literary style is rather a way of *doing* certain things, such as describing characters, commenting on the action and manipulating the plot. I shall claim that an author's way of doing things is an expression of her personality, or, more accurately, of the personality she seems to have. The verbal elements of style gain their stylistic significance by contributing to the expression of this personality, and they cannot be identified as *stylistic* elements independently of the personality they help to express.

Many theorists and critics have written as if style were an expression of personality. A good recent example is an essay on the first paragraph of Henry James' novel *The Ambassadors*, in which the writer, Ian Watt, claims that

> the most obvious and demonstrable features of James' prose style, its vocabulary and syntax, are direct reflections of his attitude to life and his conception of the novel...[1]

Watt lists some of the most notable elements in James' style: the preference for "non-transitive"

verbs, the widespread use of abstract nouns, the prevalence of the word "that," the presence of "elegant variation" in the way in which something is referred to, and the predominance of negatives and near-negatives. Then Watt proceeds to show how these stylistic elements are expressive of James' *interest* in the abstract, his *preoccupation* with what is going on in the consciousness of his characters and his *attitude* of humorous compassion for them.

This essay is an attempt to explain and justify the assumption of Watt and others like him that style is essentially an expression of qualities of mind, attitudes, interests and personality traits which appear to be the author's own. My thesis is a thesis about what Richard Wollheim calls "individual style" and not about the style of periods or of groups of writers within a period.[2] I do not want to suggest that the unity of period or group styles, such as the Augustan style, can be explained in terms of the "personality" of a group or period. One other point should be mentioned. I believe that my remarks apply equally well to the non-literary arts, but for reasons of space I shall not attempt to justify this claim here.

I
Style As The Expression of Personality

In this first section I shall argue that style is essentially a way of doing something and that it is expressive of personality. Further, I shall suggest that what count as the verbal elements of style are precisely those elements which contribute to the expression of personality.

1. Ian Watt, "The first paragraph of *The Ambassadors*: an explication," reprinted in *Henry James* ed. Tony Tanner (London: Macmillan, 1968), p. 301.

2. See Richard Wollheim, "Pictorial Style: Two Views" in *The Concept of Style* ed. Berel Lang (Philadelphia: University of Pennsylvania Press, 1979), pp. 129-145. My chief debt in this paper is to Wollheim, whose remark that style has "psychological reality" provided its initial stimulus.

Intuitively, my style of dress, work, speech, decision-making and so on is the mode or manner or way in which I dress, work, speak and make decisions. In short it is the way I *do* these things. In ordinary contexts, then, a style is always a way of *doing* something. No less intuitively, my style of dressing, working, speaking and making decisions is typically an *expression* of (some features of) my personality, character, mind or sensibility. Thus my vulgar way of dressing is likely to be an expression of my vulgar sensibility, my witty, intellectual way of speaking an expression of my witty, intellectual mind, and my uncompromisingly courageous character.

In saying that a person's way of doing things is an *expression* of that person's traits of mind, character or personality, I am saying (1) that the person's way of doing things exhibits or manifests these traits, and (2) that it is these traits which cause the person to do things in the way they do. Thus these traits leave a matching imprint or trace upon the actions which express them. If my timid way of behaving at parties is an expression of my timid character, then (1) my behavior exhibits or manifests timidity—I behave in a manifestly timid fashion, blushing, refusing to talk to strangers, hiding in the washrooms, etc.—and (2) my timid behavior is caused by my timid character, i.e., it is not due to the fact that (say) I am pretending to be timid, imitating a timid person or acting the part of a timid person in a play, nor is it the result of secret arrogance and contempt for parties. In general, if a person's actions are an expression of her personality, then those actions have the character that they have—compassionate, timid, courageous or whatever—in virtue of the fact that they are caused by the corresponding trait of mind or character in that person, compassion, timidity or courage. In expression, as the word itself suggests, an "inner" state is expressed or forced out into "outer" behavior. An "inner" quality of mind, character or personality causes the "outer" behavior to be the way it is, and also leaves its "trace" upon that behavior. A timid or compassionate character leaves a "trace" of timidity or compassion upon the actions which express it.[3]

3. See especially Richard Wollheim, "Expression," in Royal Institute of Philosophy Lectures, Vol. I, 1966-67, *The Human Agent* (New York: St. Martin's Press, 1968), and *Art and its Objects* (2nd edition; Cambridge: Cambridge University Press, 1980), sections 15-19. See also Guy Sircello, *Mind and Art* (Princeton: Princeton University Press, 1972).

Just as a person's style of dressing, working, and speaking is the mode or manner or way in which she dresses, works and speaks, so an author's style of description, character delineation and treatment of a theme is the mode or manner or way in which she describes things, delineates character and treats her theme. In other words, it is her way of *doing* certain things, such as describing or characterizing a setting, delineating character, treating or presenting a theme, and commenting on the action. Moreover, the writer's way of describing, delineating, commenting and so on is typically an *expression* of (some features of) her personality, character, mind or sensibility. Thus James' humorous yet compassionate way of describing Strether's bewilderment expresses the writer's own humorous yet compassionate attitude. Jane Austen's ironic way of describing social pretension expresses her ironic attitude to social pretension.

Now, a style is not simply a way of doing something. We do not say that a person has a *style* of doing so-and-so unless that person does so-and-so in a relatively consistent fashion. Thus we say I have a vulgar and flamboyant *style* of dressing only if I consistently dress in a vulgar and flamboyant way. It may be, of course, that my way of dressing differs considerably from one day to the next: yesterday I wore a purple silk pyjama suit, today I am wearing a frilly scarlet mini-dress and tomorrow it will be leather dungarees and a transparent blouse. Despite these differences, however, we still say that I have a consistent way of dressing, because all my outfits are consistently vulgar and flamboyant. Moreover, my style of dressing is expressive of a particular feature of my personality, namely vulgarity and flamboyance. In an exactly similar way, we say that Jane Austen has a *style* of describing social pretension because she consistently describes social pretension in an *ironic* way and the way she describes social pretension is expressive of a particular feature of her outlook, namely her irony.

So far I have talked only about a person's style of doing a particular thing, such as dressing. By contrast, when we say that a person has "a style," we normally mean that he or she has the same style of doing a number of different things. Thus when we accuse John of having a vulgar and flamboyant style, we may be referring to the vulgar and flamboyant way in which John not only dresses but also talks

and entertains his dinner guests. Again, in characterizing Mary's style as generous, open, casual and easy-going, we may mean that Mary is generous, open, casual and easy-going in almost everything that she does. In this case Mary's style is expressive not of a single trait but of a number of traits which together 'sum up' Mary's personality.

In just the same way, a person's literary style is their style of performing a wide range of (literary) activities. Thus, clearly, Jane Austen's style is not simply her style of doing any one thing, such as describing social pretension, but rather her style of doing a number of things, such as *describing, portraying* and *treating* her characters, theme and social setting, *commenting* on the action, *presenting* various points of view, and so on. In short, to borrow a concept from Guy Sircello, it is the way in which she performs the various "artistic acts"[4] which constitute the writing of a literary work. Now, a style of doing a wide range of things is just like a style of doing a particular thing in that it consistently expresses certain features of the mind, personality, etc., of the agent. We say that Mary has "a style" in virtue of the consistently generous, open, casual and easy-going way in which she does a number of different things. Similarly, a writer has a literary style in virtue of the fact that her style of performing a wide variety of artistic acts expresses the same qualities of (her) mind and temperament. For example, James' style of *treating* Strether, of *portraying* the difference between what Strether thinks of Waymarsh and what he thinks he thinks, of *emphasizing* the abstract and the timeless, of *commenting* on Strether's bewilderment and so on together constitute what we call "James's style." And this style owes its coherence to the fact that all these artistic acts express the same set of attitudes, interests and qualities of mind.

Of course, not every artistic act of a writer in a particular work expresses exactly the same qualities of mind, character or personality. In *Emma*, for example, Jane Austen portrays Mrs. Elton in a quite different way from Jane Fairfax. This is because Jane Austen's attitude toward Mrs. Elton is quite different attitude toward Jane Fairfax. In the one portrayal she expresses (among other things) her love of the ridiculous, and in the other she expresses (among other things) her compassion for suffering sensibility. But Jane Austen's way of portraying Mrs. Elton and her way of portraying the other characters in the novel, her way of describing their personal relationships, her way of developing the plot, and all the other innumerable artistic acts which go into writing the novel *Emma* together add up to the style in which *Emma* is written, a style which expresses all those attitudes that together form the personality of the author of *Emma*.

If a writer has an individual style, then the way she writes has a certain consistency: the same traits of mind, character and personality are expressed throughout her work. Now, at a particular point in a novel, the writer may seem to express anxiety about, anger at or contempt towards a particular character, event, or idea, although the writer does not seem to be a chronically anxious, angry or contemptuous sort of person. However, such "occasional" properties should not be thought of as properties of style. Only those properties which are "standing" or long-term properties can be considered stylistic. Thus stylistic qualities are likely to be qualities of mind, moral qualities and deep-seated character traits, rather than mood or emotional qualities of such as "angry," "joyful," and "afraid." In the same way, we do not treat every angry, joyful or fearful action performed in real life as an expression of basic character or personality; it is only when someone consistently acts in a choleric or a cheerful way, that we infer to her essentially choleric or cheerful nature.

I have argued that a literary style is a way of performing "artistic acts," describing a setting, portraying character, manipulating plot and so on, and it is the writer's way of performing these acts which is expressive of all those standing traits, attitudes, qualities of mind and so on that together form her personality. What, then, is the relation between the performance of these acts and what have traditionally been thought of as the verbal elements of style, such as a certain vocabulary, imagery and sentence structure? When a writer describes a setting and

4. Guy Sircello, *Mind and Art* (Princeton: Princeton University Press, 1972), Chapter 1. I am not sure whether Sircello would approve of the use to which I put the concept of artistic acts.

portrays a character, she uses words, and the kind of word she uses, the sort of sentence structure she forms and so on together constitute the elements of verbal style. If a writer manipulates his theme from the point of view of one whose main interest is in thought and the development of consciousness (James) or if she portrays her characters with a judicious mixture of irony and compassion (Austen), then he or she does so by using language in certain ways.

Obviously the presence of certain verbal elements does not *entail* that a particular personality is being expressed.[5] If, however, (on a reasonable interpretation) those verbal elements are being used by a writer to perform artistic acts in a particular way, then we can infer from the way the acts are performed to characteristics of the writer's mind, character and personality. For example, Henry James uses negatives, abstract nouns, etc., in order to describe Strether's state of consciousness, to comment on Strether's bewilderment and to characterize Strether's attitude to Waymarsh, and he thereby expresses qualities of his own mind and personality.

Moreover, negatives, abstract nouns, non-transitive verbs, elegant variation and so on are verbal elements which at first sight seem to have nothing in common. What links them all together, however, as elements of "James' style" is their use in the artistic acts James performs: they are all elements of his style because they all contribute to the expression of his personality and attitudes. For example, using these particular verbal elements, James thereby describes Strether's state of consciousness in a particular judicious, abstractive, expository way and thereby expresses his own "subjective and abstractive tendency,"[6] his interest in the relations between minds (Strether's, the narrator's, the reader's), his moral sensitivity and his cool and judicious intellect.

II
The Personality of the Implied Author

So far in this essay I have written as if the personality expressed by the style of a work were that of the writer herself. I have suggested that we infer from the way in which the writer performs the artistic acts in a work to the presence of personality traits and so on *in the writer* which cause her to perform those acts in the way that she does. But this is an oversimplification. What is more typically expressed by the style of a work is not the personality of the actual author, but of what, following Wayne Booth, we might call the "implied author,"[7] that is, the author as she seems to be from the evidence of the work. Thus however querulous and intolerant the actual Tolstoy may have been in real life, the implied author of *Anna Karenin* is full of compassionate understanding.

Because the way in which people act typically expresses features of their minds, attitudes and personalities, we are justified in making inferences from the way in which people perform actions to the presence in them of certain character or personality traits. If we see Mary constantly acting in a generous and compassionate way, then, barring any evidence to the contrary, it is reasonable to infer that Mary has a generous and compassionate nature which is responsible for her generous and compassionate actions.[8] The situation is more complicated, however, when we are considering acts performed by an author in the composition of a literary work. Although it may sometimes be legitimate to infer from the way these acts are performed to personality traits in the actual author, it is normally the case that the personality expressed by the style of a literary work is not that of the actual author but that of the implied author.

This might sound as if the author were trying to mislead us. After all if in real life it turns out that

5. See Frank Sibley, "Aesthetic Concepts," in *Philosophy Looks at the Arts*, ed. Joseph Margolis (New York: Scribner, 1962), and a large subsequent literature.

6. Watt, "The first paragraph of *The Ambassadors*," p. 291.

7. Wayne Booth, *The Rhetoric of Fiction* (Chicago: University of Chicago Press, 1961), especially pp. 70-77. Kendall Walton has developed the related, but more general notion of an "apparent artist" in his paper "Points of View in Narrative and Depictive Representation", *Nôus* 10 (1976), pp 49-61, and elsewhere. Walton's own theory of style, in which the idea of the "apparent artist" plays an important role, is to be found in "Style and the Products and Processes of Art," in *The Concept of Style* ed. Berel Lang (Philadelphia: University of Pennsylvania Press, 1979).

8. What "having a compassionate nature" means is a large question: presumably at the least it involves having certain beliefs and desires and being prone to certain kinds of behavior. For a discussion of compassion, see Lawrence Blum, "Compassion" in *Explaining Emotions* ed. Amelie Rorty (Berkeley: University of California Press, 1980).

Mary's generous and compassionate actions are entirely due to her desire to impress John, then we might well accuse her of deceiving us—or at least John—about her true nature. She seems to be a generous and compassionate person but in fact is not. However, the situation is significantly different in the literary case. It is, after all, a commonplace convention of fiction-writing that the author more or less consciously "puts on" or "adopts" a person to tell "her" story, but normally at any rate the author is not thereby trying to deceive us into believing that this assumed persona or personality is her own.[9] When we make inferences from the way the artistic acts in a work are performed to the personality of this implied author, the "person" who seems to be performing these acts, we are aware that the personality which leaves its "trace" on the way those acts are performed is a personality created and adopted by the author and which may be different from that of the author herself.[10] Thus, as Booth points out, even the implied author of *Emma* does not have all her qualities in common with the real Jane Austen. Both are wise, witty, unsentimental and so on, but the implied author of *Emma* has a moral perfection beyond the scope of the real Jane Austen.[11]

Some literary works deliberately exploit a number of different styles. A good example is James Joyce's *Ulysses*. In this case the style of at least some of the different episodes of the book should be identified with the style not of the implied author "James Joyce" but of the narrator of that episode. The personality expressed by the style of the Cyclops episode, for example, is not the personality which the author seems to have; the coarse and unpleasant personality expressed belongs only to the nameless narrator of the episode. Notice, however, that this kind of case is parasitic upon the normal case: it is because a style is normally an expression of the personality of the writer that we infer from the style of the Cyclops episode to the presence of a coarse and unpleasant person writing or narrating it.[12]

Does it make sense to talk about "the style" of *Ulysses*? In a way it does not, because *Ulysses* contains so many different styles (some of which are not even "individual" styles).[13] Nevertheless, we can identify an implied author of *Ulysses* and detect the way in which he appears to *manipulate* the narrative point of view, *treat* the *Ulysses* theme, *characterize* Molly Bloom, etc. The way these artistic acts are performed is part of *the style of Ulysses*. For example, the presence of many different narrators with different styles is itself a feature of *Joyce's* style and it is expressive of certain traits that Joyce seems to have, such as a boisterous creativity, a delight in the expressive capacities of language and an interest in the way reality can be viewed and reported from so many different points of view.[14]

One of the ways in which we identify "Joyce's style" is by looking at Joyce's ouevre as a whole. Thus we may be inclined to see the style of the early Stephen episodes in *Ulysses* (as opposed to, say, the Cylcops episode) as in "Joyce's style" partly because they are in somewhat the same style as other works by Joyce, notably *A Portrait of the Artist*. The style of an oeuvre, just like the style of an individual work, is an expression of the personality of the implied

9. It is not appropriate for me to argue here for any general thesis about the correct way to interpret literary texts, but it is interesting to notice that my view that style is the expression of personality fits very nicely with a plausible theory of critical interpretation recently defended by Alexander Nehamas ("The Postulated Author: Critical Monism as a Regulative Ideal", *Critical Inquiry* 8 (Autumn, 1981), pp. 133-149. In his words,

> To interpret a text is to consider it as its author's production. Literary texts are produced by agents and must be understood as such.... And since texts are products of expressive actions, understanding them is inseparably tied to understanding their agents.

Here Nehamas uses the word "author" to mean "implied author." His claim is that a text must be read as an expression of the attitudes and so on of the implied author. Of course it could turn out that Nehamas is wrong and the correct way to read literary texts is as the expression of attitudes in the actual author. My thesis can accommodate either view.

10. Compare the way in which actors "adopt" the personality which they express.

11. See Booth, *The Rhetoric of Fiction*, p. 265.

12. Compare *Tristram Shandy* which is written in Tristram's (the narrator's) style. The implied author seems to have a personality much like that of Tristram, but he is distinct from Tristram and appears from time to time to correct Tristram's opinions in helpful footnotes.

13. See, for example, *The Oxen of the Sun* episode.

14. Notice that plays can have individual style despite the fact that they contain many different "voices."

author of that oeuvre. Just as we sometimes find a variety of styles in a single work (like *Ulysses*), so it is possible to find in a single oeuvre a variety of styles corresponding to radically different implied authors. But in the normal case the implied author of different works in a single oeuvre is recognizably the "same person." Of course no two works do or even can express exactly the same personality, but there will normally be striking similarities. Typically, the personality expressed by an author's style matures over time. Thus the implied author of Jane Austen's books becomes less acerbic in her wit, more compassionate and tender;[15] the implied author of Henry James' works becomes ever more complex, subtle and abstract in his thinking and moralizing. A style grows and matures with the personality it expresses.

III
An Objection Considered

My thesis has been that the defining feature of a literary work which has an individual style is that the work is an expression of the personality of the implied author,[16] and what links the diverse verbal elements of style together into a coherent whole is that they all contribute to the expression of this particular personality. One objection to this thesis is that there are many qualities of a work which *prima facie* are qualities of its style but which do not seem to express any qualities of mind or personality in the implied author. In particular, there are formal qualities (euphonious, Latinate, colloquial, ornate) and expressive qualities (dramatic, heroic, violent) which may be attributed to the style of a work but which are not (or need not be) qualities of the implied author's mind or personality.

In this section of the paper I shall argue that such formal and expressive qualities are not always qualities of the individual style of a work, and that when

15. However, the implied author of the late fragment *The Watsons* may seem less mature than the implied author of *Persuasion*.

16. From now on I shall write as if the personality expressed by the style of a work were that of the implied author, because typically this is the case. However the implied author may sometimes have all his or her properties in common with the actual author. Moreover, as I have already noticed, in some cases the personality expressed is that of the narrator.

they are it is only because they contribute to the expression qualities of mind, personality, etc. in the implied author. Among works which possess striking formal or expressive qualities (euphony, violence, etc.), I distinguish three sorts of case: (1) works which have such properties but lack style altogether, (2) works which have such properties and also belong to a general style category but which lack individual style, and (3) works which have such properties and which also possess individual style.

(1) Intuitively, there could be a piece of characterless prose which nevertheless happens to be *euphonious*, i.e., the words it contains make a pleasing musical sound. Imagine, for example, an incompetent Freshman English paper in which the ideas are unclearly expressed, the sentence structure confused and the choice of words unimaginative. No one reading the paper would attribute to it an individual style. Yet, quite by chance, the ill-chosen words are euphonious: l's, m's and n's predominate, there are only a few plosives or fricatives, and the vowel sounds fit together in a melodious way. To say that this work is in a "euphonious style," however, is at best misleading, since intuitively it is not in a style at all. The possession of just one striking formal quality, such as euphony, is not normally sufficient to endow a work with style. Indeed even a string of nonsense syllables may be euphonious, although presumably they cannot be in a style. Hence euphony does not always contribute to individual style, just because it may be a quality of a work that lacks style altogether. On my view, of course, a euphonious work that lacks individual style is a euphonious work which fails to express any individual personality in the implied author.

(2) A more interesting situation arises when a work is in a "euphonious style" in the sense that it belongs to what Wollheim calls a "general" style category, although it does not possess *individual* style. General style categories, such as period or school styles, group together writers, painters or other artists who seem to the critic and historian to have important characteristics in common, for example, the Elizabethan pastoral lyric style or the style of the school of Donne (the Metaphysical style). To belong to a general category of literary style often

involves obeying certain conventions and using certain techniques. Thus the style of Elizabethan pastoral love lyrics demands a certain stylized way or referring to the lover and the beloved, of describing their surroundings and so on. The imagery and the poetic forms employed all fall within a fairly narrow and predictable range. More importantly for my present argument, membership in a particular general style category often requires a work to have certain formal and expressive qualities. Thus the style of an Elizabethan pastoral love lyric is supposed to be charming and euphonious, the Metaphysical style colloquial and dramatic, and the Miltonic epic style (i.e., the style of works which imitate *Paradise Lost*) Latinate and heroic.

Now, intuitively, there is a distinction between merely belonging to a general style category and having formed individual style. For example, although a poem must be (somewhat) colloquial and (somewhat) dramatic in order to count as a Metaphysical poem at all, it does not follow that every minor lyric by Carew or Suckling has an individual style. Indeed we may often be hard-pressed to distinguish between the lesser works of Carew and Suckling, just because they do lack "individuality." Similarly, many of the poems in the collection *England's Helicon* obey all the requirements of the Elizabethan pastoral lyric style and yet remain "characterless." They are charming and euphonious but they have an anonymous air about them: they do not seem to have been written by anyone in particular. In short, a work which belongs to a general style category may have certain striking formal or expressive qualities even though it lacks individual style. An Elizabethan love lyric may be euphonious, a Metaphysical poem dramatic, a Miltonic epic Latinate without necessarily being in an individual style.

One of the merits of my theory of style is that it allows us to define and explain this intuitive distinction between individual and general style. On my view, the crucial difference is that whereas having an individual style necessarily involves the expression of personality in the implied author, belonging to a general style category has no such implications. Elsewhere[17] I have argued for this position in much

greater detail than is either possible or appropriate here. If I am right, however, it follows that there can be works belonging to a general style category which possess the formal and expressive qualities characteristic of that style but which do not express any individual personality in the implied author. Hence these formal and expressive qualities, although qualities of general style, do not contribute to the expression of an individual personality in the implied author of the work.

(3) Finally, formal and expressive qualities such as "Latinate," "euphonious" and "dramatic" may be qualities that are present in works of individual style and which do not contribute to the expression of personality in those works. It does not follow, however, that the implied author is Latinate, euphonious or dramatic sort of fellow. These qualities in themselves do not express any particular trait in the implied author. Rather they can help to express many diverse traits, depending upon the artistic acts to which they contribute. In a similar way, Henry James' fondness for negatives does not in itself express any feature of "his" personality; it is the way the negatives are used in the performance of artistic acts, such as describing Strether's state of mind, which gives this feature of James' work its stylistic significance.

The quality of euphony, for example, may indeed contribute to individual style, but it does so by contributing to the expression of individual personality in a work. Consequently the contribution it makes is very different in different works. Both Swinburne's "Garden of Prosperpine" and large passages of Milton's "Paradise Lost" can be described as euphonious, but the personalities expressed in the individual style of these two works are very different. In the Swinburne poem the gentle, musical sounds help to

17. General and Individual Style in Literature," *The Journal of Aesthetics and Art Criticism*, 43 (1984), I argue there that if a work belongs to a general style category, such as a school or period style, then it obeys certain rules and observes certain conventions, some of which undoubtedly foster certain kinds of formal and expressive properties. However, it is possible to write works which belong to a general style category and succeed to some extent in achieving the formal and expressive goals of that category without thereby expressing an individual personality in the implied author.

express the implied author's sense of world-weariness, melancholy and resignation,[18] whereas the famous Miltonic melody generally serves to help express the implied author's sense of the dignity and grandeur of his theme. To say that both works are in a "euphonious style" means simply that euphony is a formal quality of both works, which in both cases contributes to individual style. The way it contributes, however, is quite different in the two cases. Similarly it could be argued that both Jane Austen and Donne have *dramatic* styles, but clearly the dramatic qualities in each help to express quite different personalities and hence contribute quite differently to the styles of each.[19]

In summary then, the formal and expressive qualities I have been discussing are not always qualities of the individual style of a work: they may be present in works lacking any style at all or in works which belong to a general style category but do not have individual style. Moreover, even when such qualities contribute to the individual style of a work, they do so in very different ways. The 'same' quality in two different works may contribute to the expression of quite traits of mind and personality in the implied authors of those works.

There are two interesting corollaries of my discussion. First, it would seem to follow that no verbal element or formal or expressive quality in a work is always and inevitably an element or quality of individual style. Even such qualities as "euphonious"

and "Latinate" do not contribute to individual style wherever they appear, and even when they do contribute to individual style, they do so in virtue of how they are used in the artistic acts in the work. Secondly, it would also seem to follow that *any* verbal element or formal or expressive quality in a work *can* be an element or quality of individual style, provided it contributes in the appropriate way to the expression of personality in the implied author.

In short, if my thesis is correct, then there is no "taxonomy" or checklist of style elements, that is, elements which contribute to individual style wherever they appear.[20] Euphony, Latinate diction, and the presence of many negatives are elements of individual style only if they are used in such a way as to contribute to the expression of traits of mind and personality in the implied author.

We cannot, therefore, identify the elements of individual style merely as the most striking or salient features of a work. On the one hand there are striking features which do not invariably contribute to individual style. I have argued that euphony, for example, may be a striking feature of works which lack individual style. Again, it would be a striking feature of a work if all the proper names in it began with the letter 'X', yet intuitively this would not be a feature of its *style* (although it could be if, for example, it were used to express the implied author's sense of fun).

On the other hand, moreover, there are many elements which are not particularly salient but which contribute to individual style. Thus a certain writer who has a formed individual style may have a preference for the indefinite article over the definite which contributes in a small way to the expression of her generalizing imagination and tendency to abstraction. Again, any careful, sensitive reader of *The Ambassadors* can tell that James tends to "interpolate" elements in his sentences, but we may not notice that the interpolations typically occur between verb or adjective and complement, or between auxiliary and main verb, and that they cluster towards

18. There go the loves that wither,
 The old loves with wearier wings;
 And all dead years draw thither,
 And all disastrous things;...

19. Sometimes a writer performs the artistic act of "expressing" some quality in the external world, as when she, for example, "expresses" the violence of a battle or the fragility of an elf. Again, however, it is not the violence or fragility themselves which contribute to the style, but the way in which violence or fragility is "expressed" (in this sense) by the writer. Thus one woman may "express" the violence of a battle with gusto, thereby expressing "her" enjoyment of fast-moving action and enthusiasm for heroic exploits, whereas another may "express" the violence with cool detachment, thereby expressing "her" ironic awareness of human folly. For further discussion of this issue, see Guy Sircello, *Mind and Art*, Chapter 4, and my "Expressing the Way the World Is," *Journal of Aesthetic Education* 13 (1979), pp. 29-44.

20. cf. Richard Wollheim, "Pictorial Style: Two Views." It is possible that there are taxonomies for *general* style categories, unlike individual style.

the center of a sentence.[21] Yet it is non-salient elements such as these which contribute significantly to James' style, because they all help to express "James'" characteristic attitudes, interests and qualities of mind and personality.

IV
Some Problems Resolved

I have argued that if a literary work has an individual style, the artistic acts in the work are performed in such a way as to express qualities of mind, attitudes, personality traits, etc., which make up the individual personality of the implied author's work. The verbal elements of (individual) style are those elements which contribute to the expression of this personality. There is no "checklist" of elements or qualities which inherently or intrinsically contribute to individual style, no matter where they appear.

So far I have merely tried to make my thesis seem reasonable and to forestall some possible objections to it. In this final section I should like to make some more positive remarks in its favor. The best reason for accepting my theory is that it answers an array of difficult questions surrounding the concept of style.

(1) First, my theory explains why a correct description of a writer's style mentions some of its verbal characteristics but not others. On my view, what count as the elements of style are precisely those verbal elements which contribute to the expression of the implied author's personality. In Henry James, for example, the relevant verbal elements include the recurrent use of non-transitive verbs, abstract nouns, negatives and the word 'that'. These all help contribute to the expression of "James'" personality. But we could, no doubt, if we searched for them, discover many recurrent elements in James' work which are not stylistically significant. Thus perhaps it would turn out that James had a penchant for

nouns beginning with the letter 'f' or that his sentences invariably had an even number of words in them. A description of James' style would not mention these elements, however, precisely because they do not contribute to the expression of the personality of the implied author. In short, many quite diverse and seemingly unrelated verbal elements belong to the same style in virtue of the fact that they all contribute to the expression of the same personality. It is only if the frequent use of nouns beginning with the letter 'f' can be shown to contribute to this personality that this particular verbal characteristic would be an element of style.

(2) For similar reasons, my theory explains why it is that the same verbal element may have stylistic significance in one work or author and no stylistic significance, or a different significance, in another work or author. For the same stylistic element may play no expressive role in the one case and an important role in the other. Alternatively, it may simply play different expressive roles in the two cases. Suppose, for example, that two writers tend to use the indefinite article rather than the definite. In one writer, who has a formed individual style, this may contribute to the expression of her generalizing imagination and tendency to abstraction. In the other writer, it may be an accident and it may have no expressive effect in the work, or perhaps it indicates a lack of strength and precision in the style. In the first writer we have located the presence of a stylistic element; in the second writer the same element has no stylistic significance or a different one. If we were to view a person's style as consisting of a set of elements which we can check off on a checklist, then it would make no sense to say that a particular element is sometimes stylistic and sometimes not. But if we view style as a function of the literary personality expressed by a work in the way I have suggested, then the problem dissolves.

(3) It is commonly believed that if a writer or a work has an individual style, this implies that the various stylistic elements have a certain unity. Yet there are no intrinsic connections among the features of James' style, for example: why should negatives, abstract nouns, and 'elegant variation' go together to form a unified style? My theory explains in a clear

21. See Seymour Chatman, *The Later Style of Henry James* (Oxford: Blackwell 1972), pp. 126-127. Chatman's book contains many more examples of non-salient (as well as salient) verbal features that are important to James' style. In his comparison between a successful parody of James' style (by Max Beerbohm) and a rather unsuccessful one (by W. H. D. Rouse), Chatman shows how Beerbohm incorporates into his parody many features of James' style which were obviously not salient to Rouse.

way what stylistic unity amounts to: a style has a unity because it is the expression of the personality of the implied author. Just as we see the way a person performs the various actions of daily life as expressive of different facets of her personality, so we see the way in which a writer seems to perform the various artistic acts in a literary work as expressive of different facets of "her" personality. The many disparate elements of verbal style fit together only because they are being used to express the "same" personality: the writer uses the elements of verbal style to describe her characters, treat her theme, etc., thereby seeming to reveal a set of personality traits, qualities of mind, attitudes and so forth which "makes sense" out of (unifies) this multitude of artistic acts.

The question arises as to whether this set of "standing" traits forms a coherent personality. The concept of a "unified" or coherent personality is admittedly somewhat vague, since the most disparate and apparently inconsistent psychological traits seem capable of coexisting in normal, rational people.[22] All I need to insist on, however, is that if a work has an individual style then the different traits expressed by the various artistic acts in the work (portraying Jane Fairfax, characterizing Emma's treatment of her father, etc.) coexist in a way which is consistent with our knowledge of persons and human nature. Moreover, the same traits must be consistently expressed throughout a work. Thus the implied author of *Le Rouge et le Noir* both admires and despises the aristocratic world to which Julien Sorel aspires, but because he does so consistently and because the conflict in his attitudes is one which we recognize as possible in a basically rational person, his admiration and scorn are both part of the personality expressed by the style of the work.[23] If however, a work expresses no individual personality at all or if the personality expressed is a confusion of different traits which do not fit together in an intelligible way, then it follows from my thesis that the work in question lacks individual style.[24]

(4) It used to be a commonplace of literary theory that the subject-matter of a text is *what* the writer writes about, whereas the style is *how* she writes about it. This distinction has recently been questioned by several writers, including Nelson Goodman who argues that

> some differences in style consist entirely of differences in what is said. Suppose one historian writes in terms of military conflicts, another in terms of social changes; or suppose one biographer stresses public careers, another personalities.[25]

The theory of style which I have outlined in this essay accounts for the intuition that sometimes features of subject-matter may be stylistic features and explains which features of subject-matter will count as stylistic and why. Briefly, a feature of subject-matter is of stylistic relevance just in case it is expressive of the implied author's personality. Thus it is reasonable to construe the subject-matter of *The Ambassadors* as the development of Strether's consciousness. In this case the choice of subject-matter is clearly of stylistic relevance. Again the differences in the histories and biographies envisioned by Goodman are clearly differences in the personalities of the implied authors of these works.

(5) My theory also has a satisfying explanation for the difference between what Goodman calls "style" and "signature." A "signature" is anything which identifies a work as being by a particular author, school, or whatever, such as an actual signature. A "signature," however, may have no stylistic significance. Goodman says:

> Although a style is metaphorically a signature, a literal signature is no feature of style.[26]

22. See the work on emotions by Amelie Rorty, "Explaining Emotions" and Patricia Greenspan, "A Case of Mixed Feelings: Ambivalence and the Logic of Emotion" both in Rorty ed., *Explaining Emotions*.

23. Lee Brown brought this example to my attention.

24. If for example, *for no apparent reason*, an author describes a certain character with unqualified approval in chapters 1, 3 and 5 and with a certain kind of qualified disapproval in chapters 2, 4 and 6, then it might be that the implied author is schizophrenic or, more likely, simply a confused creation.

25. Nelson Goodman, "The Status of Style," *Critical Inquiry* 1 (1975), p. 801. Goodman's explanation for this fact is different from mine, however.

26. Goodman, "The Status of Style," p. 807.

It is true that a style, like a "signature," may *identify* a work or an author, but the way it performs the identification is quite different. A "signature" may have nothing to do with the qualities of the implied author expressed by a work. Perhaps it is an actual signature or perhaps some other convention is used: a writer might be uniquely identifiable by the particular Latin tag which appears at the head of all her books, regardless of their subject-matter or style (if any). A style, on the other hand, identifies a work or an author because it is an expression of a set of attitudes, qualities of mind, character traits and so on which are unique to the implied author of that work or oeuvre.

(6) Finally, as I have already remarked, one of the virtues of my theory is that it allows me to clarify the distinction between general and individual style.[27]

If a work belongs to a general style category, then, although it may have formal and expressive qualities that are distinctive of that style, it may nevertheless remain "characterless": no personality "informs" the work. Alternatively, there may be personality traits expressed but they do not seem to belong to any particular individual. The work has an "anonymous" air about it, because the artistic acts are performed in a way which is common to a large number of different writers.[28] By contrast, as I have argued throughout this paper, the defining quality of an individual style is that it expresses a coherent set of attitudes, qualities of mind and so on which seem to belong to the individual writer of the work: a work which has an individual style expresses the personality of the implied author of that work.[29]

27. See also my "General and Individual Style in Literature."

28. There are some general style categories such as the heroic epic, in which individual style is rarely found and might even be deemed inappropriate. The Homeric epics, however, do not seem to contain passages that have individual style. It is interesting to note that the argument over the authorship of the *Iliad* is partly an argument about style and personality in the work. Those parts of the *Iliad* which have individual style provide a strong argument for scholars who wish to argue that there was one central author of the *Iliad* (call him "Homer") even though parts of it had been handed down by an oral tradition. By contrast, scholars who argue that there were a number of bards who contributed impor-

tantly to the creation of the *Iliad* point to the fact that there is no individual style to the *Iliad* as a whole. Interestingly, both sets of experts seem implicitly to grant the connection between individual style and an individual personality which is expressed in the style. For an introduction to the problem of multiple authorship in the *Iliad*, see E. R. Dodds, "Homer" in *The Language and Background of Homer* ed. G. S. Kirk (Cambridge: Cambridge University Press, 1964), pp. 1-21.

29. Many people have helped to improve this paper. I am particularly indebted to Lee Brown, Ann Clark, John Martin, Francis Sparshott, Kendall Walton, Richard Wollheim, and the editors and referees of *The Philosophical Review*. I am also grateful to Berel Lang whose NEH Seminar on the Concept of Style aroused my interest in this topic.

Part 4

Psychology and Interpretation

Part 4: Psychology and Interpretation

Introduction

Sigmund Freud (1856-1939) was the founder of psychoanalysis. It is hard to overestimate the importance his work and psychoanalytic thought have had on our culture. Indeed, his influence on cultural studies is out of all proportion to the present importance of psychoanalytic thought in psychology. Like Nietzsche, for whom culture was the projection of subterranean forces of desire and the will to power, and who thus saw the explanation of cultural phenomena as requiring an archeological explanation (a digging up of what is buried and hidden), Freud saw culture as the product of unconscious forces. To understand his importance for cultural studies, it is important to see that his work, like Nietzsche's, is continuous with the Romantics' mythologising of the will which it critiques and redescribes. The influence of Freud's inversion of the Romantic emphasis on genius and the imagination is visible in a number of the selections found later in this anthology.

In "The Relation of the Poet to Day-Dreaming" (1908), Freud argues that to understand artistic creativity we should look at children's play. When they play, children create imaginative worlds of their own—or more accurately, rearrange the things in this world in an order which better pleases them. As they mature, people replace play with fantasy and day-dreaming. Fantasies are driven by unfulfilled erotic and self-exalting wishes, and we conceal, and are ashamed, of them. The writer fantasizes in words and allows us to fantasize through those words. The aesthetic pleasure the reader finds in the language of the work is a kind of bribe, a kind of foreplay which allows us surreptitiously to identify with the hero of the fantasy and thus release unconscious tensions from our minds.

In "Psychology and Literature", the Swiss psychoanalyst Carl Gustav Jung (1875-1961) criticises the reductionism of Freud's account of artistic vision and offers a view of vision in art as the true symbolic expression of something existent in its own right. Jung attempts to account for artistic spirit in terms of archetypes in the collective unconscious, which is the great reservoir of meaning from which the empirical self is formed. Both Freud and Jung, in their very different accounts of the formation of the self out of unconscious resources, show the extent to which Romantic ideas about creativity and spiritual value permeate psychoanalytic thinking.

This section concludes with two pieces by Usula K. Le Guin (1929-), noted novelist and essayist. The first, "The Child and the Shadow", offers a Jungian view of the power of archetypes in fairytales and myth, arguing that the great fantasies "speak *from* the unconscious *to* the unconscious in the *language* of the unconscious—symbol and archetype" and that their moral and spiritual effect depends upon their genuineness. In the second selection, "Some Thoughts on Narrative", Le Guin discusses the narrative structure of storytelling, beginning with Aristotle's account of a good plot. She argues that narrative is a normal and central function of language. It is not at its root an art form, but rather a fundamental operation of the mind: "To learn to speak is to learn to tell a story". Using dream narrative as counterpoint, she argues that narrative is an active engagement with the environment which operates by means of posing options and alternatives. Narrative is an augmentation of the reality which is given in merely present experience; it connects the present moment to the past and future by the pathways of possible actions. Le Guin offers an important reason that we care about stories: it is by way of stories that we experience our lives and are able to understand our own and others' actions.

Sigmund Freud (1856-1939)

The Relation of the Poet to Day-Dreaming[1]

Translated by I. F. Grant Duff

We laymen have always wondered greatly—like the cardinal who put the question to Ariosto—how that strange being, the poet, comes by his material. What makes him able to carry us with him in such a way and to arouse emotions in us of which we thought ourselves perhaps not even capable? Our interest in the problem is only stimulated by the circumstance that if we ask poets themselves they give us no explanation of the matter, or at least no satisfactory explanation. The knowledge that not even the clearest insight into the factors conditioning the choice of imaginative material, or into the nature of the ability to fashion that material, will ever make writers of us does not in any way detract from our interest.

If we could only find some activity in ourselves, or in people like ourselves, which was in any way akin to the writing of imaginative works! If we could do so, then examination of it would give us a hope of obtaining some insight into the creative process of imaginative writers. And indeed, there is some prospect of achieving this—writers themselves always try to lessen the distance between their kind and ordinary human beings; they so often assure us that every man is at heart a poet, and that the last poet will not die until the last human being does.

We ought surely to look in the child for the first traces of imaginative activity. The child's best loved and most absorbing occupation is play. Perhaps we may say that every child at play behaves like an imaginative writer, in that he creates a world of his own or, more truly, he rearranges the things of his world and orders it in a new way that pleases him

better. It would be incorrect to think that he does not take this world seriously; on the contrary, he takes his play very seriously and expends a great deal of emotion on it. The opposite of play is not serious occupation but—reality. Notwithstanding the large affective cathexis of his play-world, the child distinguishes it perfectly from reality; only he likes to borrow the objects and circumstances that he imagines from the tangible and visible things of the real world. It is only this linking of it to reality that still distinguishes a child's 'play' from 'day-dreaming'.

Now the writer does the same as the child at play; he creates a world of phantasy which he takes very seriously; that is, he invests it with a great deal of affect, while separating it sharply from reality. Language has preserved this relationship between children's play and poetic creation. It designates certain kinds of imaginative creation, concerned with tangible objects and capable of representation, as 'plays'; the people who present them are called 'players'. The unreality of this poetical world of imagination, however, has very important consequences for literary technique; for many things which if they happened in real life could produce no pleasure can nevertheless give enjoyment in a play—many emotions which are essentially painful may become a source of enjoyment to the spectators and hearers of a poet's work.

There is another consideration relating to the contrast between reality and play on which we will dwell for a moment. Long after a child has grown up and stopped playing, after he has for decades attempted to grasp the realities of life with all seriousness, he may one day come to a state of mind in which the contrast between play and reality is again

1. First published in *Neue Revue*, I., 1908; reprinted in *Sammlung*, Zweite Folge.

abrogated. The adult can remember with what intense seriousness he carried on his childish play; then by comparing his would-be serious occupations with his childhood's play, he manages to throw off the heavy burden of life and obtain the great pleasure of humour.

As they grow up, people cease to play, and appear to give up the pleasure they derived from play. But anyone who knows anything of the mental life of human beings is aware that hardly anything is more difficult to them than to give up a pleasure they have once tasted. Really we never can relinquish anything; we only exchange one thing for something else. When we appear to give something up, all we really do is to adopt a substitute. So when the human being grows up and ceases to play he only gives up the connection with real objects; instead of playing he then begins to create phantasy. He builds castles in the air and creates what are called daydreams. I believe that the greater number of human beings create phantasies at times as long as they live. This is a fact which has been overlooked for a long time, and its importance has therefore not been properly appreciated.

The phantasies of human beings are less easy to observe than the play of children. Children do, it is true, play alone, or form with other children a closed world in their minds for the purposes of play; but a child does not conceal his play from adults, even though his playing is quite unconcerned with them. The adult, on the other hand, is ashamed of his daydreams and conceals them from other people; he cherishes them as his most intimate possessions and as a rule he would rather confess all his misdeeds than tell his day-dreams. For this reason he may believe that he is the only person who makes up such phantasies, without having any idea that everybody else tells themselves stories of the same kind. Daydreaming is a continuation of play, nevertheless, and the motives which lie behind these two activities contain a very good reason for this different behaviour in the child at play and in the day-dreaming adult.

The play of children is determined by their wishes—really by the child's *one* wish, which is to be grown-up, the wish that helps to 'bring him up'. He always plays at being grown-up; in play he imitates what is known to him of the lives of adults. Now he has no reason to conceal this wish. With the adult it is otherwise; on the other hand, he knows that he is expected not to play any longer or to day-dream, but to be making his way in a real world. On the other hand, some of the wishes from which his phantasies spring are such as have to be entirely hidden; therefore he is ashamed of his phantasies as being childish and as something prohibited.

If they are concealed with so much secretiveness, you will ask, how do we know so much about the human propensity to create phantasies? Now there is a certain class of human beings upon whom not a god, indeed, but a stern goddess—Necessity—has laid the task of giving an account of what they suffer and what they enjoy. These people are the neurotics; among other things they have to confess their phantasies to the physician to whom they go in the hope of recovering through mental treatment. This is our best source of knowledge, and we have later found good reason to suppose that our patients tell us about themselves nothing that we could not also hear from healthy people.

Let us try to learn some of the characteristics of day-dreaming. We can begin by saying that happy people never make phantasies, only unsatisfied ones. Unsatisfied wishes are the driving power behind phantasies; every separate phantasy contains the fulfilment of a wish, and improves on unsatisfactory reality. The impelling wishes vary according to the sex, character and circumstance of the creator; they may be easily divided, however, into two principal groups. Either they are ambitious wishes, serving to exalt the person creating them, or they are erotic. In young women erotic wishes dominate the phantasies almost exclusively, for their ambition is generally comprised in their erotic longings; in young men egoistic and ambitious wishes assert themselves plainly enough alongside their erotic desires. But we will not lay stress on the distinction between these two trends; we prefer to emphasize the fact that that they are often united. In many altar-pieces the portrait of the donor is to be found in one corner of the picture; and in the greater number of ambitious day-dreams, too, we can discover a woman in some corner, for

whom the dreamer performs there all his heroic deeds and at whose feet all his triumphs are to be laid. Here you see we have strong enough motives for concealment; a well-brought-up woman is, indeed, credited with only a minimum of erotic desire, while a young man has to learn to suppress the overweening self-regard he acquires in the indulgent atmosphere surrounding his childhood, so that he may find his proper place in a society that is full of other persons making similar claims.

We must not imagine that the various products of this impulse towards phantasy, castles in the air or day-dreams, are stereotyped or unchangeable. On the contrary, they fit themselves into the changing impressions of life, alter with the vicissitudes of life; every deep new impression gives them what might be called a 'date-stamp'. The relation of phantasies to time is altogether of great importance. One may say that a phantasy at one and the same moment hovers between three periods of time—the three periods of our ideation. The activity of phantasy in the mind is linked up with some current impression, occasioned by some event in the present, which had the power to rouse an intense desire. From there it wanders back to the memory of an early experience, generally belonging to infancy, in which this wish was fulfilled. Then it creates for itself a situation which is to emerge in the future, representing the fulfilment of the wish—this is the day-dream or phantasy, which now carries in it traces both of the occasion which engendered it and of some past memory. So past, present and future are threaded, as it were, on the string of the wish that runs through them all.

A very ordinary example may serve to make my statement clearer. Take the case of a poor orphan lad, to whom you have given the address of some employer where he may perhaps get work. On the way there he falls into a day-dream suitable to the situation from which it springs. The content of the phantasy will be somewhat as follows: He is taken on and pleases his new employer, makes himself indispensable in the business, is taken into the family of the employer, and marries the charming daughter of the house. Then he comes to conduct the business, first as a partner, and then as successor to his father-in-law. In this way the dreamer regains what he had in his happy childhood, the protecting house, his loving parents and the first objects of his affection. You will see from such an example how the wish employs some event in the present to plan a future on the pattern of the past.

Much more could be said about phantasies, but I will only allude as briefly as possible to certain points. If phantasies become over-luxuriant and over-powerful, the necessary conditions for an outbreak of neurosis or psychosis are constituted; phantasies are also the first preliminary stage in the mind of the symptoms of illness of which our patients complain. A broad bypath here branches off into pathology.

I cannot pass over the relation of phantasies to dreams. Our nocturnal dreams are nothing but such phantasies, as we can make clear by interpreting them.[2] Language, in its unrivalled wisdom, long ago decided the question of the essential nature of dreams by giving the name of 'day-dreams' to the airy creations of phantasy. If the meaning of our dreams usually remains obscure in spite of this clue, it is because of the circumstance that at night wishes of which we are ashamed also become active in us, wishes which we have to hide from ourselves, which were consequently repressed and pushed back into the unconscious. Such repressed wishes and their derivatives can therefore achieve expression only when almost completely disguised. When scientific work had succeeded in elucidating the distortion in dreams, it was no longer difficult to recognize that nocturnal dreams are fulfilments of desires in exactly the same way as day-dreams are—those phantasies with which we are all so familiar.

So much for day-dreaming; now for the poet! Shall we dare really to compare an imaginative writer with 'one who dreams in broad daylight', and his creations with day-dreams? Here, surely, a first distinction is forced upon us; we must distinguish between poets who, like the bygone creators of epics and tragedies, take over their material ready-made, and those who seem to create their material spontaneously. Let us keep to the latter, and let us also not choose for our comparison those writers who are most highly esteemed by critics. We will choose

2. Cf. Freud, *Die Traumdeutung.*

the less pretentious writers of romances, novels and stories, who are read all the same by the widest circles of men and women. There is one very marked characteristic in the productions of these writers which must strike us all: they all have a hero who is in the centre of interest, for whom the author tries to win our sympathy by every possible means, and whom he places under the protection of a special providence. If at the end of one chapter the hero is left unconscious and bleeding from severe wounds, I am sure to find him at the beginning of the next being carefully tended and on the way to recovery; if the first volume ends in the hero being shipwrecked in a storm at sea, I am certain to hear at the beginning of the next his hairbreadth escape—otherwise, indeed, the story could not continue. The feeling of security with which I follow the hero through his dangerous adventures is the same as that with which a real hero throws himself into the water to save a drowning man, or expose himself to the fire of the enemy while storming a battery. It is this very feeling of being a hero which one of our best authors has well expressed in the famous phrase, '*Es kann dir nix g'schehen!*'[3] It seems to me, however, that this significant mark of invulnerability very clearly betrays—His Majesty the Ego, the hero of all daydreams and all novels.

The same relationship is hinted at in yet other characteristics of these egocentric stories. When all the women in a novel invariably fall in love with the hero, this can hardly be looked upon as a description of reality, but it is easily understood as an essential constituent of a day-dream. The same thing holds good when the other people in the story are sharply divided into good and bad, with complete disregard of the manifold variety in the traits of real human beings; the 'good' ones are those who help the ego in its character of hero, while the 'bad' are his enemies and rivals.

We do not in any way fail to recognize that many imaginative productions have travelled far from the original naïve day-dream, but I cannot suppress the surmise that even the most extreme variations could be brought into relationship with this model by an uninterrupted series of transitions. It has struck me in many so-called psychological novels, too, that only one person—once again the hero—is described from within; the author dwells in his soul and looks upon the other people from outside. The psychological novel in general probably owes its peculiarities to the tendency of modern writers to split up their egos by self-observation into many component-egos, and in this way to personify the conflicting trends in their own mental life in many heroes. There are certain novels, which might be called 'eccentric', that seem to stand in marked contradiction to the typical daydream; in these the person introduced as the hero plays the least active part of anyone, and seems instead to let the actions and sufferings of other people pass him by like a spectator. Many of the later novels of Zola belong to this class. But I must say that the psychological analysis of people who are not writers, and who deviate in many things from the so-called norm, has shown us analogous variations in their day-dreams in which the ego contents itself with the rôle of spectator.

If our comparison of the imaginative writer with the day-dreamer, and of poetic production with the day-dream, is to be of any value, it must show itself fruitful in some way or other. Let us try, for instance, to examine the works of writers in reference to the idea propounded above, the relation of the phantasy to the wish that runs through it and to the three periods of time; and with its help let us study the connection between the life of the writer and his productions. Hitherto it has not been known what preliminary ideas would constitute an approach to this problem; very often this relation has been regarded as much simpler than it is; but the insight gained from phantasies leads us to expect the following state of things. Some actual experience which made a strong impression on the writer had stirred up a memory of an earlier experience, generally belonging to childhood, which then arouses a wish that finds a fulfilment in the work in question, and in which elements of the recent event and the old memory should be discernible.

Do not be alarmed at the complexity of this formula; I myself expect that in reality it will prove itself to be too schematic, but that possibly it may

3. Anzengruber. [The phrase means 'Nothing can happen to *me*!'—Trans.]

contain a first means of approach to the true state of affairs. From some attempts I have made I think that this way of approaching works of imagination might not be unfruitful. You will not forget that the stress laid on the writer's memories of his childhood, which perhaps seems so strange, is ultimately derived from the hypothesis that imaginative creation, like day-dreaming, is a continuation of and substitute for the play of childhood.

We will not neglect to refer also to that class of imaginative work which must be recognized not as spontaneous production, but as a re-fashioning of ready-make material. Here, too, the writer retains a certain amount of independence, which can express itself in the choice of material and in changes in the material chosen, which are often considerable. As far as it goes, this material is derived from the racial treasure-house of myths, legends and fairytales. The study of these creations of racial psychology is in no way complete, but it seems extremely probable that myths, for example, are distorted vestiges of the wish-phantasies of whole nations—the age-long dreams of young humanity.

You will say that, although writers came first in the title of this paper, I have told you far less about them than about phantasy. I am aware of that, and will try to excuse myself by pointing to the present state of our knowledge. I could only throw out suggestions and bring up interesting points which arise from the study of phantasies, and which pass beyond them to the problem of the choice of literary material. We have not touched on the other problem at all, *i.e.* what are the means which writers use to achieve those emotional reactions in us that are roused by their productions. But I would at least point out to you the path which leads from our discussion of day-dreams to the problems of the effect produced on us by imaginative works.

You will remember that we said the day-dreamer hid his phantasies carefully from other people because he had reason to be ashamed of them. I may now add that even if he were to communicate them to us, he would give us no pleasure by his disclosures. When we hear such phantasies they repel us, or at least leave us cold. But when a man of literary talent presents his plays, or relates what we take to be his personal day-dreams, we experience great pleasure arising probably from many sources. How the writer accomplishes this is his innermost secret; the essential *ars poetica* lies in the technique by which our feeling of repulsion is overcome, and this has certainly to do with those barriers erected between every individual being and all others. We can guess at two methods used in this technique. The writer softens the egotistical character of the day-dream by changes and disguises, and he bribes us by the offer of a purely formal, that is, aesthetic, pleasure in the presentation of his phantasies. The increment of pleasure which is offered us in order to release yet greater pleasure arising from deeper sources in the mind is called an 'incitement premium' or technically, 'fore-pleasure'. I am of opinion that all the aesthetic pleasure we gain from the works of imaginative writers is of the same type as this 'fore-pleasure', and that the true enjoyment of literature proceeds from the release of tensions in our minds. Perhaps much that brings about this result consists in the writer's putting us into a position in which we can enjoy our own day-dreams without reproach or shame. Here we reach a path leading into novel, interesting and complicated researches, but we also, at least for the present, arrive at the end of the present discussion.

Carl Gustav Jung (1875-1961)

Psychology and Literature

Translated by W. S. Dell and Cary F. Baynes

It is obvious enough that psychology, being the study of psychic processes, can be brought to bear upon the study of literature, for the human psyche is the womb of all the sciences and arts. We may expect psychological research, on the one hand, to explain the formation of a work of art, and on the other to reveal the factors that make a person artistically creative. The psychologist is thus faced with two separate and distinct tasks, and must approach them in radically different ways.

In the case of the work of art we have to deal with a product of complicated psychic activities—but a product that is apparently intentional and consciously shaped. In the case of the artist we must deal with the psychic apparatus itself. In the first instance we must attempt the psychological analysis of a definitely circumscribed and concrete artistic achievement, while in the second we must analyse the living and creative human being as a unique personality. Although these two undertakings are closely related and even interdependent, neither of them can yield the explanations that are sought by the other. It is of course possible to draw inferences about the artist from the work of art, and *vice versa*, but these inferences are never conclusive. At best they are probable surmises or lucky guesses. A knowledge of Goethe's particular relation to his mother throws some light upon Faust's exclamation: "The mothers—mothers—how very strange it sounds!" But it does not enable us to see how the attachment to his mother could produce the Faust drama itself, however unmistakably we sense in the man Goethe a deep connection between the two. Nor are we more successful in reasoning in the reverse direction. There is nothing in *The Ring of the Nibelungs* that would enable us to recognize or definitely infer the fact that Wagner occasionally liked to wear womanish clothes, though hidden connections exist between the heroic masculine world of the Nibelungs and a certain pathological effeminacy in the man Wagner.

The present state of development of psychology does not allow us to establish those rigorous causal connections which we expect of a science. It is only in the realm of the psycho-physiological instincts and reflexes that we can confidently operate with the idea of causality. From the point where psychic life begins—that is, at a level of greater complexity—the psychologist must content himself with more or less widely ranging descriptions of happenings and with the vivid portrayal of the warp and weft of the mind in all its amazing intricacy. In doing this, he must refrain from designating any one psychic process, taken by itself, as "necessary." Were this not the state of affairs, and could the psychologist be relied upon to uncover the causal connections within a work of art and in the process of artistic creation, he would leave the study of art no ground to stand on and would reduce it to a special branch of his own science. The psychologist, to be sure, may never abandon his claim to investigate and establish causal relations in complicated psychic events. To do so would be to deny psychology the right to exist. Yet he can never make good this claim in the fullest sense, because the creative aspect of life which finds its clearest expression in art baffles all attempts at rational formulation. Any reaction to stimulus may be causally explained; but the creative act, which is the absolute antithesis of mere reaction, will for ever elude the human understanding. It can only be described

in its manifestations; it can be obscurely sensed, but never wholly grasped. Psychology and the study of art will always have to turn to one another for help, and the one will not invalidate the other. It is an important principle of psychology that psychic events are derivable. It is a principle in the study of art that a psychic product is something in and for itself whether the work of art or the artist himself is in question. Both principles are valid in spite of their relativity.

I. *The Work of Art*

There is a fundamental difference of approach between the psychologist's examination of a literary work, and that of the literary critic. What is of decisive importance and value for the latter may be quite irrelevant for the former. Literary products of highly dubious merit are often of the greatest interest to the psychologist. For instance, the so-called "psychological novel" is by no means as rewarding for the psychologist as the literary-minded suppose. Considered as a whole, such a novel explains itself. It has done its own work of psychological interpretation, and the psychologist can at most criticize or enlarge upon this. The important question as to how a particular author came to write a particular novel is of course left unanswered, but I wish to reserve this general problem for the second part of my essay.

The novels which are most fruitful for the psychologist are those in which the author has not already given a psychological interpretation of his characters, and which therefore leave room for analysis and explanation, or even invite it by their mode of presentation. Good examples of this kind of writing are the novels of Benoît, and English fiction in the manner of Rider Haggard, including the vein exploited by Conan Doyle which yields that most cherished article of mass-production, the detective story. Melville's *Moby Dick*, which I consider the greatest American novel, also comes within this class of writings. An exciting narrative that is apparently quite devoid of psychological exposition is just what interests the psychologist most of all. Such a tale is built upon a groundwork of implicit psychological assumptions, and, in the measure that the author is unconscious of them, they reveal themselves, pure and unalloyed, to the critical discernment. In the psychological novel, on the other hand, the author himself attempts to reshape his material so as to raise it from the level of crude contingency to that of psychological exposition and illumination—a procedure which all too often clouds the psychological significance of the work or hides it from view. It is precisely to novels of this sort that the layman goes for "psychology"; while it is novels of the other kind that challenge the psychologist, for he alone can give them deeper meaning.

I have been speaking in terms of the novel, but I am dealing with a psychological fact which is not restricted to this particular form of literary art. We meet with it in the works of poets as well, and are confronted with it when we compare the first and second parts of the Faust drama. The love-tragedy of Gretchen explains itself; there is nothing that the psychologist can add to it that the poet has not already said in better words. The second part, on the other hand, calls for explanation. The prodigious richness of the imaginative material has so overtaxed the poet's formative powers that nothing is self-explanatory and every verse adds to the reader's need of an interpretation. The two parts of *Faust* illustrate by way of extremes this psychological distinction between works of literature.

In order to emphasize the distinction, I will call the one mode of artistic creation *psychological*, and the other *visionary*. The psychological mode deals with materials drawn from the realm of human consciousness—for instance, with the lessons of life, with emotional shocks, the experience of passion and the crises of human destiny in general—all of which go to make up the conscious life of man, and his feeling life in particular. This material is psychically assimilated by the poet, raised from the commonplace to the level of poetic experience, and given an expression which forces the reader to greater clarity and depth of human insight by bringing fully into his consciousness what he ordinarily evades and overlooks or senses only with a feeling of dull discomfort. The poet's work is an interpretation and illumination of the contents of consciousness, of the ineluctable experiences of human life with its eternally recurrent sorrow and joy. He leaves nothing

over for the psychologist, unless, indeed, we expect the latter to expound the reasons for which Faust falls in love with Gretchen, or which drive Gretchen to murder her child! Such themes go to make up the lot of human-kind; they repeat themselves millions of times and are responsible for the monotony of the police-court and of the penal code. No obscurity whatever surrounds them, for they fully explain themselves.

Countless literary works belong to this class: the many novels dealing with love, the environment, the family, crime and society, as well as didactic poetry, the larger number of lyrics, and the drama, both tragic and comic. Whatever its particular form may be, the psychological work of art always takes its materials from the vast realm of conscious human experience—from the vivid foreground of life, we might say. I have called this mode of artistic creation psychological because in its activity it nowhere transcends the bounds of psychological intelligibility. Everything that it embraces—the experience as well as its artistic expression—belongs to the realm of the understandable. Even the basic experiences themselves, though non-rational, have nothing strange about them; on the contrary, they are that which has been known from the beginning of time—passion and its fated outcome, man's subjection to the turns of destiny, eternal nature with its beauty and its horror.

The profound difference between the first and second parts of *Faust* marks the difference between the psychological and the visionary modes of artistic creation. The latter reverses all the conditions of the former. The experience that furnishes the material for artistic expression is no longer familiar. It is a strange something that derives its existence from the hinterland of man's mind—that suggests the abyss of time separating us from pre-human ages, or evokes a super-human world of contrasting light and darkness. It is a primordial experience which surpasses man's understanding, and to which he is therefore in danger of succumbing. The value and the force of the experience are given by its enormity. It arises from timeless depths; it is foreign and cold, many-sided, demonic and grotesque. A grimly ridiculous sample of the eternal chaos—a

crimen laesae majestatis humanae, to use Nietzsche's words—it bursts asunder our human standards of value and of aesthetic form. The disturbing vision of monstrous and meaningless happenings that in every way exceed the grasp of human feeling and comprehension makes quite other demands upon the powers of the artist than do the experiences of the foreground of life. These never rend the curtain that veils the cosmos; they never transcend the bounds of the humanly possible, and for this reason are readily shaped to the demands of art, no matter how great a shock to the individual they may be. But the primordial experiences rend from top to bottom the curtain upon which is painted the picture of an ordered world, and allow a glimpse into the unfathomed abyss of what has not yet become. Is it a vision of other worlds, or of the obscuration of the spirit, or of the beginning of things before the age of man, or of the unborn generations of the future? We cannot say that it is any or none of these.

Shaping—re-shaping—
The eternal spirit's eternal pastime.[1]

We find such vision in *The Shepherd of Hermas*, in Dante, in the second part of *Faust*, in Nietzsche's Dionysian exuberance, in Wagner's *Nibelungenring*, in Spitteler's *Olympischer Frühling*, in the poetry of William Blake, in the *Ipnerotomachia* of the monk Francesco Colonna, and in Jacob Boehme's philosophic and poetic stammerings. In a more restricted and specific way, the primordial experience furnishes material for Rider Haggard in the fiction-cycle that turns upon *She*, and it does the same for Benoît, chiefly in *L'Atlantide*, for Kubin in *Die Andere Seite*, for Meyrink in *Das Grüne Gesicht*—a book whose importance we should not undervalue—for Goetz in *Das Reich ohne Raum*, and for Barlach in *Der Tote Tag*. This list might be greatly extended.

In dealing with the psychological mode of artistic creation, we never need ask ourselves what the material consists of or what it means. But this question forces itself upon us as soon as we come to the visionary mode of creation. We are astonished, taken aback, confused, put on our guard or even disgusted—and we demand commentaries and explanations. We

1. *Gestaltung, Umgestaltung,*
 Des ew'gen Sinnes ew'ge Unterhaltung. (Goethe.)

are reminded in nothing of everyday, human life, but rather of dreams, night-time fears and the dark recesses of the mind that we sometimes sense with misgiving. The reading public for the most part repudiates this kind of writing—unless, indeed, it is coarsely sensational—and even the literary critic feels embarrassed by it. It is true that Dante and Wagner have smoothed the approach to it. The visionary experience is cloaked, in Dante's case, by the introduction of historical facts, and, in that of Wagner, by mythological events so that history and mythology are sometimes taken to be the materials with which these poets worked. But with neither of them does the moving force and the deeper significance lie there. For both it is contained in the visionary experience. Rider Haggard, pardonably enough, is generally held to be a mere inventor of fiction. Yet even with him the story is primarily a means of giving expression to significant material. However much the tale may seem to overgrow the content, the latter outweighs the former in importance.

The obscurity as to the sources of the material in visionary creation is very strange, and the exact opposite of what we find in the psychological mode of creation. We are even led to suspect that this obscurity is not unintentional. We are naturally inclined to suppose—and Freudian psychology encourages us to do so—that some highly personal experience underlies this grotesque darkness. We hope thus to explain these strange glimpses of chaos and to understand why it sometimes seems as though the poet had intentionally concealed his basic experience from us. It is only a step from this way of looking at the matter to the statement that we are here dealing with a pathological and neurotic art—a step which is justified in so far as the material of the visionary creator shows certain traits that we find in the fantasies of the insane. The converse also is true; we often discover in the mental output of psychotic persons a wealth of meaning that we should expect rather from the works of a genius. The psychologist who follows Freud will of course be inclined to take the writings in question as a problem in pathology. On the assumption that an intimate, personal experience underlies what I call the "primordial vision"—an experience, that is to say, which

cannot be accepted by the conscious outlook—he will try to account for the curious images of the vision by calling them cover-figures and by supposing that they represent an attempted concealment of the basic experience. This, according to his view, might be an experience in love which is morally or aesthetically incompatible with the personality as a whole or at least with certain fictions of the conscious mind. In order that the poet, through his ego, might repress this experience and make it unrecognizable (unconscious), the whole arsenal of a pathological fantasy was brought into action. Moreover, this attempt to replace reality by fiction, being unsatisfactory, must be repeated in a long series of creative embodiments. This would explain the proliferation of imaginative forms, all monstrous, demonic, grotesque and perverse. On the one hand they are substitutes for the unacceptable experience, and on the other they help to conceal it.

Although a discussion of the poet's personality and psychic disposition belongs strictly to the second part of my essay, I cannot avoid taking up in the present connection this Freudian view of the visionary work of art. For one thing, it has aroused considerable attention. And then it is the only well-known attempt that has been made to give a "scientific" explanation of the sources of the visionary material or to formulate a theory of the psychic processes that underlie this curious mode of artistic creation. I assume that my own view of the question is not well known or generally understood. With this preliminary remark, I will now try to present it briefly.

If we insist on deriving the vision from a personal experience, we must treat the former as something secondary—as a mere substitution for reality. The result is that we strip the vision of its primordial quality and take it as nothing but a symptom. The pregnant chaos then shrinks to the proportions of a psychic disturbance. With this account of the matter we feel reassured and turn again to our picture of a well-ordered cosmos. Since we are practical and reasonable, we do not expect the cosmos to be perfect; we accept these unavoidable imperfections which we call abnormalities and diseases, and we take it for granted that human nature is not exempt

from them. The frightening revelation of abysses that defy the human understanding is dismissed as illusion, and the poet is regarded as a victim and perpetrator of deception. Even to the poet, his primordial experience was "human—all too human," to such a degree that he could not face its meaning but had to conceal it from himself.

We shall do well, I think, to make fully explicit all the implications of that way of accounting for artistic creation which consists in reducing it to personal factors. We should see clearly where it leads. The truth is that it takes us away from the psychological study of the work of art, and confronts us with the psychic disposition of the poet himself. That the latter presents an important problem is not to be denied, but the work of art is something in its own right, and may not be conjured away. The question of the significance to the poet of his own creative work—of his regarding it as a trifle, as a screen, as a source of suffering or as an achievement—does not concern us at the moment, our task being to interpret the work of art psychologically. For this undertaking it is essential that we give serious consideration to the basic experience that underlies it—namely, to the vision. We must take it at least as seriously as we do the experiences that underlie the psychological mode of artistic creation, and no one doubts that they are both real and serious. It looks, indeed, as if the visionary experience were something quite apart from the ordinary lot of man, and for this reason we have difficulty in believing that it is real. It has about it an unfortunate suggestion of obscure metaphysics and of occultism, so that we feel called upon to intervene in the name of a well-intentioned reasonableness. Our conclusion is that it would be better not to take such things too seriously, lest the world revert again to a benighted superstition. We may, of course, have a predilection for the occult; but ordinarily we dismiss the visionary experience as the outcome of a rich fantasy or of a poetic mood—that is to say, as a kind of poetic licence psychologically understood. Certain of the poets encourage this interpretation in order to put a wholesome distance between themselves and their work. Spitteler, for example, stoutly maintained that it was one and the same whether the poet sang of an Olympian Spring or to the theme: "May is here!" The truth is that poets are human beings, and that what a poet has to say about his work is often far from being the most illuminating word on the subject. What is required of us, then, is nothing less than to defend the importance of the visionary experience against the poet himself.

It cannot be denied that we catch the reverberations of an initial love-experience in *The Shepherd of Hermas*, in the *Divine Comedy* and in the *Faust* drama—an experience which is completed and fulfilled by the vision. There is no ground for the assumption that the second part of *Faust* repudiates or conceals the normal, human experience of the first part, nor are we justified in supposing that Goethe was normal at the time when he wrote *Part I*, but in a neurotic state of mind when he composed *Part II*. *Hermas*, Dante and Goethe can be taken as three steps in a sequence covering nearly two thousand years of human development, and in each of them we find the personal love-episode not only connected with the weightier visionary experience, but frankly subordinated to it. On the strength of this evidence which is furnished by the work of art itself and which throws out of court the question of the poet's particular psychic disposition, we must admit that the vision represents a deeper and more impressive experience than human passion. In works of art of this nature—and we must never confuse them with the artist as a person—we cannot doubt that the vision is a genuine, primordial experience, regardless of what reason-mongers may say. The vision is not something derived or secondary, and it is not a symptom of something else. It is true symbolic expression—that is, the expression of something existent in its own right, but imperfectly known. The love-episode is a real experience really suffered, and the same statement applies to the vision. We need not try to determine whether the content of the vision is of a physical, psychic or metaphysical nature In itself it has psychic reality, and this is no less real than physical reality. Human passion falls within the sphere of conscious experience, while the subject of the vision lies beyond it. Through our feelings we experience the known, but our intuitions point to things that are unknown and hidden—that

by their very nature are secret. If ever they become conscious, they are intentionally kept back and concealed, for which reason they have been regarded from earliest times as mysterious, uncanny and deceptive. They are hidden from the scrutiny of man, and he also hides himself from them out of *deisidaemonia*. He protects himself with the shield of science and the armour of reason. His enlightenment is born of fear; in the day-time he believes in an ordered cosmos, and he tries to maintain this faith against the fear of chaos that besets him by night. What if there were some living force whose sphere of action lies beyond our world of every day? Are there human needs that are dangerous and unavoidable? Is there something more purposeful than electrons? Do we delude ourselves in thinking that we possess and command our own souls? And is that which science calls the "psyche" not merely a question-mark arbitrarily confined within the skull, but rather a door that opens upon the human world from a world beyond, now and again allowing strange and unseizable potencies to act upon man and to remove him, as if upon the wings of the night, from the level of common humanity to that of a more than personal vocation? When we consider the visionary mode of artistic creation, it even seems as if the love-episode had served as a mere release—as if the personal experience were nothing but the prelude to the all-important "divine comedy."

It is not alone the creator of this kind of art who is in touch with the night-side of life, but the seers, prophets, leaders and enlighteners also. However dark this nocturnal world may be, it is not wholly unfamiliar. Man has known of it from time immemorial—here, there, and everywhere; for primitive man today it is an unquestionable part of his picture of the cosmos. It is only we who have repudiated it because of our fear of superstition and metaphysics, and because we strive to construct a conscious world that is safe and manageable in that natural law holds in it the place of statute law in a commonwealth. Yet, even in our midst, the poet now and then catches sight of the figures that people the night-world—the spirits, demons and gods. He knows that a purposiveness out-reaching human ends is the life-giving secret for man; he has a presentiment of

incomprehensible happenings in the pleroma. In short, he sees something of that psychic world that strikes terror into the savage and the barbarian.

From the very first beginnings of human society onward man's efforts to give his vague intimations a binding form have left their traces. Even in the Rhodesian cliff-drawings of the Old Stone Age there appears, side by side with the most amazingly life-like representations of animals, an abstract pattern— a double cross contained in a circle. This design has turned up in every cultural region, more or less, and we find it today not only in Christian churches, but in Tibetan monasteries as well. It is the so-called sun-wheel, and as it dates from a time when no one had thought of wheels as a mechanical device, it cannot have had its source in any experience of the external world. It is rather a symbol that stands for a psychic happening; it covers an experience of the inner world, and is no doubt as lifelike a representation as the famous rhinoceros with the tick-birds on its back. There has never been a primitive culture that did not possess a system of secret teaching, and in many cultures this system is highly developed. The men's councils and the totem-clans preserve this teaching about hidden things that lie apart from man's daytime existence—things which, from primeval times, have always constituted his most vital experiences. Knowledge about them is handed on to younger men in the rites of initiation. The mysteries of the Græco-Roman world performed the same office, and the rich mythology of antiquity is a relic of such experiences in the earliest stages of human development.

It is therefore to be expected of the poet that he will resort to mythology in order to give his experience its most fitting expression. It would be a serious mistake to suppose that he works with materials received at second-hand. The primordial experience is the source of his creativeness; it cannot be fathomed, and therefore requires mythological imagery to give it form. In itself it offers no words or images, for it is a vision seen "as in a glass, darkly." It is merely a deep presentiment that strives to find expression. It is like a whirlwind that seizes everything within reach and, by carrying it aloft, assumes a visible shape. Since the particular expression can

never exhaust the possibilities of the vision, but falls far short of it in richness of content, the poet must have at his disposal a huge store of materials if he is to communicate even a few of his intimations. What is more, he must resort to an imagery that is difficult to handle and full of contradictions in order to express the weird paradoxicality of his vision. Dante's presentiments are clothed in images that run the gamut of Heaven and Hell; Goethe must bring in the Blocksberg and the infernal regions of Greek antiquity; Wagner needs the whole body of Nordic myth; Nietzsche returns to the hieratic style and recreates the legendary seer of prehistoric times; Blake invents for himself indescribable figures, and Spitteler borrows old names for new creatures of the imagination. And no intermediate step is missing in the whole range from the ineffably sublime to the perversely grotesque.

Psychology can do nothing towards the elucidation of this colourful imagery except bring together materials for comparison and offer a terminology for its discussion. According to this terminology, that which appears in the vision is the collective unconscious. We mean by collective unconscious, a certain psychic disposition shaped by the forces of heredity; from it consciousness has developed. In the physical structure of the body we find traces of earlier stages of evolution, and we may expect the human psyche also to conform in its make-up to the law of phylogeny. It is a fact that in eclipses of consciousness—in dreams, narcotic states and cases of insanity—there come to the surface psychic products or contents that show all the traits of primitive levels of psychic development. The images themselves are sometimes of such a primitive character that we might suppose them derived from ancient, esoteric teaching. Mythological themes clothed in modern dress also frequently appear. What is of particular importance for the study of literature in these manifestations of the collective unconscious is that they are compensatory to the conscious attitude. This is to say that they can bring a one-sided, abnormal, or dangerous state of consciousness into equilibrium in an apparently purposive way. In dreams we can see this process very clearly in its positive aspect. In cases of insanity the compensatory process is often perfectly obvious, but takes a negative form. There are persons, for instance, who have anxiously shut themselves off from all the world only to discover one day that their most intimate secrets are known and talked about by everyone.[2]

If we consider Goethe's *Faust*, and leave aside the possibility that it is compensatory to his own conscious attitude, the question that we must answer is this: In what relation does it stand to the conscious outlook of his time? Great poetry draws its strength from the life of mankind, and we completely miss its meaning if we try to derive it from personal factors. Whenever the collective unconscious becomes a living experience and is brought to bear upon the conscious outlook of an age, this event is a creative act which is of importance to everyone living in that age. A work of art is produced that contains what may truthfully be called a message to the generations of men. So *Faust* touches something in the soul of every German. So also Dante's fame is immortal, while *The Shepherd of Hermas* just failed of inclusion in the New Testament canon. Every period has its bias, its particular prejudice and its psychic ailment. An epoch is like an individual; it has its own limitations of conscious outlook, and therefore requires a compensatory adjustment. This is effected by the collective unconscious in that a poet, a seer or a leader allows himself to be guided by the unexpressed desire of his times and shows the way, by word or deed, to the attainment of that which everyone blindly craves and expects—whether this attainment results in good or evil, the healing of an epoch or its destruction.

It is always dangerous to speak of one's own times, because what is at stake in the present is too vast for comprehension. A few hints must therefore suffice. Francesco Colonna's book is cast in the form of a dream, and is the apotheosis of natural love taken as a human relation; without countenancing a wild indulgence of the senses, he leaves completely aside the Christian sacrament of marriage. The book was written in 1453. Rider Haggard, whose life coincides with the flowering-time of the Victorian era, takes up this subject and deals with it in his own

2. See my article: "Mind and the Earth," in *Contributions to Analytical Psychology* (New York: Harcourt, Brace, 1928).

way; he does not cast it in the form of a dream, but allows us to feel the tension of moral conflict. Goethe weaves the theme of Gretchen-Helen-Mater-Gloriosa like a red thread into the colourful tapestry of Faust. Nietzsche proclaims the death of God, and Spitteler transforms the waxing and waning of the gods into a myth of the seasons. Whatever his importance, each of these poets speaks with the voice of thousands and ten thousands, foretelling changes in the conscious outlook of his time.

II. *The Poet*

Creativeness, like the freedom of the will, contains a secret. The psychologist can describe both these manifestations as processes, but he can find no solution of the philosophical problems they offer. Creative man is a riddle that we may try to answer in various ways, but always in vain, a truth that has not prevented modern psychology from turning now and again to the question of the artist and his art. Freud thought that he had found a key in his procedure of deriving the work of art from the personal experiences of the artist.[3] It is true that certain possibilities lay in this direction, for it was conceivable that a work of art, no less than a neurosis, may be traced back to those knots in psychic life that we call the complexes. It was Freud's great discovery that neuroses have a causal origin in the psychic realm—that they take their rise from emotional states and from real or imagined childhood experiences. Certain of his followers, like Rank and Stekel, have taken up related lines of enquiry and have achieved important results. It is undeniable that the poet's psychic disposition permeates his work root and branch. Nor is there anything new in the statement that personal factors largely influence the poet's choice and use of his materials. Credit, however, must certainly be given to the Freudian school for showing how far-reaching this influence is and in what curious way it comes to expression.

Freud takes the neurosis as a substitute for a direct means of gratification. He therefore regards it as something inappropriate—a mistake, a dodge, an excuse, a voluntary blindness. To him it is essentially a

shortcoming that should never have been. Since a neurosis, to all appearances, is nothing but a disturbance that is all the more irritating because it is without sense or meaning, few people will venture to say a good word for it. And a work of art is brought into questionable proximity with the neurosis when it is taken as something which can be analysed in terms of the poet's repressions. In a sense it finds itself in good company, for religion and philosophy are regarded in the same light by Freudian psychology. No objection can be raised if it is admitted that this approach amounts to nothing more than the elucidation of those personal determinants without which a work of art is unthinkable. But should the claim be made that such an analysis accounts for the work of art itself, then a categorical denial is called for. The personal idiosyncrasies that creep into a work of art are not essential; in fact, the more we have to cope with these peculiarities, the less it is a question of art. What is essential in a work of art is that it should rise far above the realm of personal life and speak from the spirit and heart of the poet as man to the spirit and heart of mankind. The personal aspect is a limitation—and even a sin—in the realm of art. When a form of "art" is primarily personal it deserves to be treated as if it were a neurosis. There may be some validity in the idea held by the Freudian school that artists without exception are narcissistic—by which is meant that they are undeveloped persons with infantile and auto-erotic traits. Their statement is only valid, however, for the artist as a person, and has nothing to do with the man as an artist. In his capacity of artist he is neither autoerotic, nor hereto-erotic, nor erotic in any sense. He is objective and impersonal—even inhuman—for as an artist he is his work, and not a human being.

Every creative person is a duality or a synthesis of contradictory aptitudes. On the one side he is a human being with a personal life, while on the other side he is an impersonal, creative process. Since as a human being he may be sound or morbid, we must look at his psychic make-up to find the determinants of his personality. But we can only understand him in his capacity of artist by looking at his creative achievement. We should make a sad mistake if we tried to explain the mode of life of an English gentleman, a

3. See Freud's essy on Jensen's *Gradiva* and on Leonardo da Vinci.

Prussian officer, or a cardinal in terms of personal factors. The gentleman, the officer and the cleric function as such in an impersonal rôle, and their psychic make-up is qualified by a peculiar objectivity. We must grant that the artist does not function in an official capacity—the very opposite is nearer the truth. He nevertheless resembles the types I have named in one respect, for the specifically artistic disposition involves an overweight of collective psychic life as against the personal. Art is a kind of innate drive that seizes a human being and makes him its instrument. The artist is not a person endowed with free will who seeks his own ends, but one who allows art to realize its purposes through him. As a human being he may have moods and a will and personal aims, but as an artist he is "man" in a higher sense—he is "collective man"—one who carries and shapes the unconscious, psychic life of mankind. To perform this difficult office it is sometimes necessary for him to sacrifice happiness and everything that makes life worth living for the ordinary human being.

All this being so, it is not strange that the artist is an especially interesting case for the psychologist who uses an analytical method. The artist's life cannot be otherwise than full of conflicts, for two forces are at war within him—on the one hand the common human longing for happiness, satisfaction and security in life, and on the other a ruthless passion for creation which may go so far as to override every personal desire. The lives of artists are as a rule so highly unsatisfactory—not to say tragic—because of their inferiority on the human and personal side, and not because of a sinister dispensation. There are hardly any exceptions to the rule that a person must pay dearly for the divine gift of the creative fire. It is as though each of us were endowed at birth with a certain capital of energy. The strongest force in our make-up will seize and all but monopolize this energy, leaving so little over that nothing of value can come of it. In this way the creative force can drain the human impulses to such a degree that the personal ego must develop all sorts of bad qualities—ruthlessness, selfishness and vanity (so-called "auto-erotism")—and even every kind of vice, in order to maintain the spark of life and to keep itself from

being wholly bereft. The auto-erotism of artists resembles that of illegitimate or neglected children who from their tenderest years must protect themselves from the destructive influence of people who have no love to give them—who develop bad qualities for that very purpose and later maintain an invincible egocentrism by remaining all their lives infantile and helpless or by actively offending against the moral code or the law. How can we doubt that it is his art that explains the artist, and not the insufficiencies and conflicts of his personal life? These are nothing but the regrettable results of the fact that he is an artist—that is to say, a man who from his very birth has been called to a greater task than the ordinary mortal. A special ability means a heavy expenditure of energy in a particular direction, with a consequent drain from some other side of life.

It makes no difference whether the poet knows that his work is begotten, grows and matures with him, or whether he supposes that by taking thought he produces it out of the void. His opinion of the matter does not change the fact that his own work outgrows him as a child its mother. The creative process has feminine quality, and the creative work arises from unconscious depths—we might say, from the realm of the mothers. Whenever the creative force predominates, human life is ruled and moulded by the unconscious as against the active will, and the conscious ego is swept along on a subterranean current, being nothing more than a helpless observer of events. The work in process becomes the poet's fate and determines his psychic development. It is not Goethe who creates *Faust*, but *Faust* which creates Goethe. And what is *Faust* but a symbol? By this I do not mean an allegory that points to something all too familiar, but an expression that stands for something not clearly known and yet profoundly alive. Here it is something that lives in the soul of every German, and that Goethe has helped to bring to birth. Could we conceive of anyone but a German writing *Faust* or *Also sprach Zarathustra*? Both play upon something that reverberates in the German soul—a "primordial image," as Jacob Burckhardt once called it—the figure of a physician or teacher of mankind. The archetypal image of the wise man, the saviour or redeemer, lies buried and dormant in

man's unconscious since the dawn of culture; it is awakened whenever the times are out of joint and a human society is committed to a serious error. When people go astray they feel the need of a guide or teacher or even of the physician. These primordial images are numerous, but do not appear in the dreams of individuals or in works of art until they are called into being by the waywardness of the general outlook. When conscious life is characterized by one-sidedness and by a false attitude, then they are activated—one might say, "instinctively"—and come to light in the dreams of individuals and the visions of artists and seers, thus restoring the psychic equilibrium of the epoch.

In this way the work of the poet comes to meet the spiritual need of the society in which he lives, and for this reason his work means more to him than his personal fate, whether he is aware of this or not. Being essentially the instrument for his work, he is subordinate to it, and we have no reason for expecting him to interpret it for us. He has done the best that in him lies in giving it form, and he must leave the interpretation to others and to the future. A great work of art is like a dream; for all its apparent obviousness it does not explain itself and is never unequivocal. A dream never says: "You ought," or: "This is the truth." It presents an image in much the same way as nature allows a plant to grow, and we must draw our own conclusions. If a person has a nightmare, it means either that he is too much given to fear, or else that he is too exempt from it; and if he dreams of the old wise man it may mean that he is too pedagogical, as also that he stands in need of a teacher. In a subtle way both meanings come to the same thing, as we perceive when we are able to let the work of art act upon us as it acted upon the artist. To grasp its meaning, we must allow it to shape us as it once shaped him. Then we understand the nature of his experience. We see that he has drawn upon the healing and redeeming forces of the collective psyche that underlies consciousness with its isolation and its painful errors; that he has penetrated to that matrix of life in which all men are embedded, which imparts a common rhythm to all human existence, and allows the individual to communicate his feeling and his striving to mankind as a whole.

The secret of artistic creation and of the effectiveness of art is to be found in a return to the state of *participation mystique*—to that level of experience at which it is man who lives, and not the individual, and at which the weal or woe of the single human does not count, but only human existence. This is why every great work of art is objective and impersonal, but none the less profoundly moves us each and all. And this is also why the personal life of the poet cannot be held essential to his art—but at most a help or a hindrance to his creative task. He may go the way of a Philistine, a good citizen, a neurotic, a fool or a criminal. His personal career may be inevitable and interesting, but it does not explain the poet.

Ursula K. LeGuin (1929-)

The Child and the Shadow

Once upon a time, says Hans Christian Andersen, there was a kind, shy, learned young man from the North, who came south to visit the hot countries, where the sun shines fiercely and all shadows are very black.

Now across the street from the young man's window is a house, where he once glimpses a beautiful girl tending beautiful flowers on the balcony. The young man longs to go speak to her, but he's too shy. One night, while his candle is burning behind him, casting his shadow onto the balcony across the way, he "jokingly" tells his shadow to go ahead, go on into that house. And it does. It enters the house across the street and leaves him.

The young man's a bit surprised, naturally, but he doesn't do anything about it. He presently grows a new shadow and goes back home. And he grows older, and more learned; but he's not a success. He talks about beauty and goodness, but nobody listens to him.

Then one day when he's a middle-aged man, his shadow comes back to him—very thin and rather swarthy, but elegantly dressed. "Did you go into the house across the street?" the man asks him, first thing; and the shadow says, "Oh yes, certainly." He claims that he saw everything, but he's just boasting. The man knows what to ask. "Were the rooms like the starry sky when one stands on the mountaintops?" he asks, and all the shadow can say is, "Oh, yes, everything was there." He doesn't know how to answer. He never got in any farther than the anteroom, being, after all, only a shadow. "I should have been annihilated by that flood of light had I penetrated into the room where the maiden lived," he says.

He is, however, good at blackmail and such arts; he is a strong, unscrupulous fellow, and he dominates the man completely. They go traveling, the shadow as master and the man as servant. They meet a princess who suffers "because she sees too clearly." She sees that the shadow casts no shadow and distrusts him, until he explains that the man is really his shadow, which he allows to walk about by itself. A peculiar arrangement, but logical; the princess accepts it. When she and the shadow engage to marry, the man rebels at last. He tries to tell the princess the truth, but the shadow gets there first, with explanations: "The poor fellow is crazy, he thinks he's a man and I'm his shadow!"— "How dreadful," says the princess. A mercy killing is definitely in order. And while the shadow and the princess get married, the man is executed.

Now that is an extraordinarily cruel story. A story about insanity, ending in humiliation and death.

Is it a story for children? Yes, it is. It's a story for anybody who's listening.

If you listen, what do you hear?

The house across the street is the House of Beauty, and the maiden is the Muse of Poetry; the shadow tells us that straight out. And that the princess who sees too clearly is pure, cold reason, is plain enough. But who are the man and the shadow? That's not so plain. They aren't allegorical figures. They are symbolic or archetypal figures, like those in a dream. Their significance is multiple, inexhaustible. I can only hint at the little I'm able to see of it.

The man is all that is civilized—learned, kindly, idealistic, decent. The shadow is all that gets suppressed in the process of becoming a decent, civilized adult. The shadow is the man's thwarted

selfishness, his unadmitted desires, the swearwords he never spoke, the murders he didn't commit. The shadow is the dark side of his soul, the unadmitted, the inadmissible.

And what Andersen is saying is that this monster is an integral part of the man and cannot be denied—not if the man wants to enter the House of Poetry.

The man's mistake is in not following his shadow. It goes ahead of him, as he sits there at his window, and he cuts it off from himself, telling it, "jokingly," to go on without him. And it does. It goes on into the House of Poetry, the source of all creativity—leaving him outside, on the surface of reality.

So, good and learned as he is, he can't do any good, can't act, because he has cut himself off at the roots. And the shadow is equally helpless; it can't get past the shadowy anteroom to the light. Neither of them, without the other, can approach the truth.

When the shadow returns to the man in middle life, he has a second chance. But he misses it, too. He confronts his dark self at last, but instead of asserting equality or mastery, he lets it master him. He gives in. He does, in fact, become the shadow's shadow, and his fate then is inevitable. The Princess Reason is cruel in having him executed, and yet she is just.

Part of Andersen's cruelty is the cruelty of reason—of psychological realism, radical honesty, the willingness to see and accept the consequences of an act or a failure to act. There is a sadistic, depressive streak in Andersen also, which is his own shadow; it's there, it's part of him, but not all of him, nor is he ruled by it. His strength, his subtlety, his creative genius, come precisely from his acceptance of and cooperation with the dark side of his own soul. That's why Andersen the fabulist is one of the great realists of literature.

Now I stand here, like the princess herself, and tell you what the story of the shadow means to me at age forty-five. But what did it mean to me when I first read it, at age ten or eleven? What does it mean to children? Do they "understand" it? Is it "good" for them—this bitter, complex study of a moral failure?

I don't know. I hated it when I was a kid. I hated all the Andersen stories with unhappy endings. That didn't stop me from reading them, and rereading them. Or from remembering them...so that after a gap of over thirty years, when I was pondering this talk, a little voice suddenly said inside my left ear, "You'd better dig out that Andersen story, you know, about the shadow."

At age ten I certainly wouldn't have gone on about reason and repression and all that. I had no critical equipment, no detachment, and even less power of sustained thought than I have now. I had somewhat less conscious mind than I have now. But I had as much, or more, of an unconscious mind, and was perhaps in better touch with it than I am now. And it was to that, to the unknown depths in me, that the story spoke; and it was the depths which responded to it and, nonverbally, irrationally, understood it, and learned from it.

The great fantasies, myths, and tales are indeed like dreams: they speak *from* the unconscious *to* the unconscious, in the *language* of the unconscious—symbol and archetype. Though they use words, they work the way music does: they short-circuit verbal reasoning, and go straight to the thoughts that lie too deep to utter. They cannot be translated fully into the language of reason, but only a Logical Positivist, who also finds Beethoven's Ninth Symphony meaningless, would claim that they are therefore meaningless. They are profoundly meaningful, and usable—practical—in terms of ethics; of insight; of growth.

Reduced to the language of daylight, Andersen's story says that a man who will not confront and accept his shadow is a lost soul. It also says something specifically about itself, about art. It says that if you want to enter the House of Poetry, you have to enter it in the flesh, the solid, imperfect, unwieldy body, which has corns and colds and greeds and passions, the body that casts a shadow. It says that if the artist tries to ignore evil, he will never enter into the House of Light.

That's what one great artist said to me about shadows. Now if I may move our candle and throw the shadows in a different direction, I'd like to interrogate a great psychologist on the same subject. Art has spoken, let's hear what science has to say. Since art is the subject, let it be the psychologist whose ideas on art are the most meaningful to most artists, Carl Gustav Jung.

Jung's terminology is notoriously difficult, as he kept changing meanings the way a growing tree changes leaves. I will try to define a few of the key terms in an amateurish way without totally misrepresenting them. Very roughly, then, Jung saw the ego, what we usually call the self, as only a part of the Self, the part of it which we are consciously aware of. The ego "revolves around the Self as the earth around the Sun," he says. The Self is transcendent, much larger than the ego; it is not a private possession, but collective—that is, we share it with all other human beings, and perhaps with all beings. It may indeed be our link with what is called God. Now this sounds mystical, and it is, but it's also exact and practical. All Jung is saying is that we are fundamentally alike; we all have the same general tendencies and configurations in our psyche, just as we all have the same general kind of lungs and bones in our body. Human beings all look roughly alike; they also think and feel alike. And they are all part of the universe.

The ego, the little private individual consciousness, knows this, and it knows that if it's not to be trapped in the hopeless silence of autism it must identify with something outside itself, beyond itself, larger than itself. If it's weak, or if it's offered nothing better, what it does is identify with the "collective consciousness." That is Jung's term for a kind of lowest common denominator of all the little egos added together, the mass mind, which consists of such things as cults, creeds, fads, fashions, status-seeking, conventions, received beliefs, advertising, popcult, all the isms, all the ideologies, all the hollow forms of communication and "togetherness" that lack real communion or real sharing. The ego, accepting these empty forms, becomes a member of the "lonely crowd." To avoid this, to attain real community, it must turn inward, away from the crowd, to the source: it must identify with *its own* deeper regions, the great unexplored regions of the Self. These regions of the psyche Jung calls the "collective unconscious," and it is in them, where we all meet, that he sees the source of true community; of felt religion; of art, grace, spontaneity, and love.

How do you get there? How do you find your own private entrance to the collective unconscious? Well, the first step is often the most important, and

Jung says that the first step is to turn around and follow your own shadow.

Jung saw the psyche as populated with a group of fascinating figures, much livelier than Freud's grim trio of Id, Ego, Superego; they're all worth meeting. The one we're concerned with is the shadow.

The shadow is on the other side of our psyche, the dark brother of the conscious mind. It is Vergil who guided Dante through hell, Gilgamesh's friend Enkidu, Frodo's enemy Gollum. It is the Doppelgänger. It is Mowgli's Grey Brother; the werewolf; the wolf, the bear, the tiger of a thousand folktales; it is the serpent, Lucifer. The shadow stands on the threshold between the conscious and the unconscious mind, and we meet it in our dreams, as sister, brother, friend, beast, monster, enemy, guide. It is all we don't want to, can't, admit into our conscious self, all the qualities and tendencies within us which have been repressed, denied, or not used. In describing Jung's psychology, Jolande Jacobi wrote that "the development of the shadow runs parallel to that of the ego; qualities which the ego does not need or cannot make use of are set aside or repressed, and thus they play little or no part in the conscious life of the individual. Accordingly, a child has no real shadow, but his shadow becomes more pronounced as his ego grows in stability and range."[1] Jung himself said, "Everyone carries a shadow, and the less it is embodied in the individual's conscious life, the blacker and denser it is."[2] The less you look at it, in other words, the stronger it grows, until it can become a menace, an intolerable load, a threat within the soul.

Unadmitted to consciousness, the shadow is projected outward, onto others. There's nothing wrong with me—it's *them*. I'm not a monster, other people are monsters. All foreigners are evil. All communists are evil. All capitalists are evil. It was the cat that made me kick him, Mummy.

If the individual wants to live in the real world, he must withdraw his projections; he must admit that the hateful, the evil, exists within himself. This isn't

1. Jolande Jacobi, *The Psychology of C. G. Jung* (New Haven: Yale University Press, 1962), p. 107.

2. Carl Gustav Jung, *Psychology and Religion: West and East*, Bollingen Series XX, *The Collected Works of C. G. Jung*, vol. 11 (New York: Pantheon Books, 1958), p. 76.

easy. It is very hard not to be able to blame anybody else. But it may be worth it. Jung says, "If he only learns to deal with his own shadow he has done something real for the world. He has succeeded in shouldering at least an infinitesimal part of the gigantic, unsolved social problems of our day."[3]

Moreover, he has grown toward true community, and self-knowledge, and creativity. For the shadow stands on the threshold. We can let it bar the way to the creative depths of the unconscious, or we can let it lead us to them. For the shadow is not simply evil. It is inferior, primitive, awkward, animallike, childlike; powerful, vital, spontaneous. It's not weak and decent, like the learned young man from the North; it's dark and hairy and unseemly; but, without it, the person is nothing. What is a body that casts no shadow? Nothing, a formlessness, two-dimensional, a comic-strip character. The person who denies his own profound relationship with evil denies his own reality. He cannot do, or make; he can only undo, unmake.

Jung was especially interested in the second half of life, when this conscious confrontation with a shadow that's been growing for thirty or forty years can become imperative—as it did for the poor fellow in the Andersen story. As Jung says, the child's ego and shadow are both still ill defined; a child is likely to find his ego in a ladybug, and his shadow lurking horribly under his bed. But I think that when in pre-adolescence and adolescence the conscious sense of self emerges, often quite overwhelmingly, the shadow darkens right with it. The normal adolescent ceases to project so blithely as the little child did; he realizes that you can't blame everything on the bad guys with the black Stetsons. He begins to take responsibility for his acts and feelings. And with it he often shoulders a terrible load of guilt. He sees his shadow as much blacker, more wholly evil, than it is. The only way for a youngster to get past the paralyzing self-blame and self-disgust of this stage is really to look at that shadow, to face it, warts and fangs and pimples and claws and all—and to accept it as himself—as *part* of himself. The ugliest part, but not the weakest. For the shadow is the guide. The guide inward and out again; downward

and up again; there, as Bilbo the Hobbit said, and back again. The guide of the journey to self-knowledge, to adulthood, to the light.

"Lucifer" means the one who carries the light.

It seems to me that Jung described, as the individual's imperative need and duty, that journey which Andersen's learned young man failed to make.

It also seems to me that most of the great works of fantasy are about that journey; and that fantasy is the medium best suited to a description of that journey, its perils and rewards. The events of a voyage into the unconscious are not describable in the language of rational daily life: only the symbolic language of the deeper psyche will fit them without trivializing them.

Moreover, the journey seems to be not only a psychic one, but a moral one. Most great fantasies contain a very strong, striking moral dialectic, often expressed as a struggle between the Darkness and the Light. But that makes it sound simple, and the ethics of the unconscious—of the dream, the fantasy, the fairy tale—are not simple at all. They are, indeed, very strange.

Take the ethics of the fairy tale, where the shadow figure is often played by an animal—horse, wolf, bear, snake, raven, fish. In her article "The Problem of Evil in Fairytales," Marie Louise von Franz—a Jungian—points out the real strangeness of morality in folktales. There *is no right way* to act when you're the hero or heroine of a fairy tale. There is no system of conduct, there are no standards of what a nice prince does and what a good little girl doesn't do. I mean, do good little girls usually push old ladies into baking ovens, and get rewarded for it? Not in what we call "real life," they don't. But in dreams and fairy tales they do. And to judge Gretel by the standards of conscious, daylight virtue is a complete and ridiculous mistake.

In the fairy tale, though there is no "right" and "wrong," there is a different standard, which is perhaps best called "appropriateness." Under no conditions can we say that it is morally right and ethically virtuous to push an old lady into a baking oven. But, under the conditions of fairy tale, in the language of the archetypes, we can say with perfect conviction that it may be *appropriate* to do so. Because, in those

3. Jung, *Psychology and Religion*, p. 83.

terms, the witch is not an old lady, nor is Gretel a little girl. Both are psychic factors, elements of the complex soul. Gretel is the archaic child-soul, innocent, defenseless; the witch is the archaic crone, the possessor and destroyer, the mother who feeds you cookies and who must be destroyed before she eats you like a cookie, so that you can grow up and be a mother too. And so on and so on. All explanations are partial. The archetype is inexhaustible. And children understand it as fully and surely as adults do—often more fully, because they haven't got minds stuffed full of the one-sided, shadowless half-truths and conventional moralities of the collective consciousness.

Evil, then, appears in the fairy tale not as something diametrically opposed to good, but as inextricably involved with it, as in the yang-yin symbol. Neither is greater than the other, nor can human reason and virtue separate one from the other and choose between them. The hero or heroine is the one who sees what is appropriate to be done, because he or she sees the *whole*, which is greater than either evil or good. Their heroism is, in fact, their certainty. They do not act by rules; they simply know the way to go.

In this labyrinth where it seems one must trust to blind instinct, there is, von Franz points out, one—only one—consistent rule or "ethic": "Anyone who earns the gratitude of animals, or whom they help for any reason, invariably wins out. This is the only unfailing rule that I have been able to find."

Our instinct, in other words, is not blind. The animal does not reason, but it sees. And it acts with certainty; it acts "rightly," appropriately. That is why all animals are beautiful. It is the animal who knows the way, the way home. It is the animal within us, the primitive, the dark brother, the shadow soul, who is the guide.

There is often a queer twist to this in folktales, a kind of final secret. The helpful animal, often a horse or a wolf, says to the hero, "When you have done such-and-so with my help, then you must kill me, cut off my head." And the hero must trust his animal guide so wholly that he is willing to do so. Apparently the meaning of this is that when you have followed the animal instincts far enough, then they

must be sacrificed, so that the true self, the whole person, may step forth from the body of the animal, reborn. That is von Franz's explanation, and it sounds fair enough; I am glad to have any explanation of that strange episode in so many tales, which has always shocked me. But I doubt that that's all there is to it—or that any Jungian would pretend it was. Neither rational thought nor rational ethics can "explain" these deep strange levels of the imagining mind. Even in merely reading a fairy tale, we must let go our daylight convictions and trust ourselves to be guided by dark figures, in silence; and when we come back, it may be very hard to describe where we have been.

In many fantasy tales of the nineteenth and twentieth centuries the tension between good and evil, light and dark, is drawn absolutely clearly, as a battle, the good guys on one side and the bad guys on the other, cops and robbers, Christians and heathens, heroes and villains. In such fantasies I believe the author has tried to force reason to lead him where reason cannot go, and has abandoned the faithful and frightening guide he should have followed, the shadow. These are false fantasies, rationalized fantasies. They are not the real thing. Let me, by way of exhibiting the real thing, which is always much more interesting than the fake one, discuss *The Lord of the Rings* for a minute.

Critics have been hard on Tolkien for his "simplisticness," his division of the inhabitants of Middle Earth into the good people and the evil people. And indeed he does this, and his good people tend to be entirely good, though with endearing frailties, while his Orcs and other villains are altogether nasty. But all this is a judgment by daylight ethics, by conventional standards of virtue and vice. When you look at the story as a psychic journey, you see something quite different, and very strange. You see then a group of bright figures, each one with its black shadow. Against the elves the Orcs. Against Aragorn, the Black Rider. Against Gandalf, Saruman. And above all, against Frodo, Gollum. Against him—and with him.

It is truly complex, because both figures are already doubled. Sam is, in part, Frodo's shadow, his inferior part. Gollum is two people, too, in a more

direct, schizophrenic sense; he's always talking to himself, Slinker talking to Stinker, Sam calls it. Sam understands Gollum very well, though he won't admit it and won't accept Gollum as Frodo does, letting Gollum be their guide, trusting him. Frodo and Gollum are not only both hobbits; they are the same person—and Frodo knows it. Frodo and Sam are the bright side, Smeagol-Gollum the shadow side. In the end Sam and Smeagol, the lesser figures, drop away, and all that is left is Frodo and Gollum, at the end of the long quest. And it is Frodo the good who fails, who at the last moment claims the Ring of Power for himself; and it is Gollum the evil who achieves the quest, destroying the Ring, and himself with it. The Ring, the archetype of the Integrative Function, the creative-destructive, returns to the volcano, the eternal source of creation and destruction, the primal fire. When you look at it that way, can you call it a simple story? I suppose so. *Oedipus Rex* is a fairly simple story, too. But it is not simplistic. It is the kind of story that can be told only by one who has turned and faced his shadow and looked into the dark.

That it is told in the language of fantasy is not an accident, or because Tolkien was an escapist, or because he was writing for children. It is a fantasy because fantasy is the natural, the appropriate, language for the recounting of the spiritual journey and the struggle of good and evil in the soul.

That has been said before—by Tolkien himself, for one—but it needs repeating. It needs lots of repeating, because there is still, in this country, a deep puritanical distrust of fantasy, which comes out often among people truly and seriously concerned about the ethical education of children. Fantasy, to them, is escapism. They see no difference between the Batmen and Supermen of the commercial dope-factories and the timeless archetypes of the collective unconscious. They confuse fantasy, which in the psychological sense is a universal and essential faculty of the human mind, with infantilism and pathological regression. They seem to think that shadows are something that we can simply do away with, if we can only turn on enough electric lights. And so they see the irrationality and cruelty and strange amoralities of fairy tale, and they say: "But

this is very bad for children, we must teach children right from wrong, with realistic books, books that are true to life!"

I agree that children need to be—and usually want very much to be—taught right from wrong. But I believe that realistic fiction for children is one of the very hardest media in which to do it. It's hard not to get entangled in the superficialities of the collective consciousness, in simplistic moralism, in projections of various kinds, so that you end up with the baddies and the goodies all over again. Or you get that business about "there's a little bit of bad in the best of us and a little bit of good in the worst of us," a dangerous banalization of the fact, which is that there is incredible potential for good and for evil in every one of us. Or writers are encouraged to merely capitalize on sensationalism, upsetting the child reader without themselves being really involved in the violence of the story, which is shameful. Or you get the "problem books." The problem of drugs, of divorce, of race prejudice, of unmarried pregnancy, and so on—as if evil were a problem, something that can be solved, that has an answer, like a problem in fifth grade arithmetic. If you want the answer, you just look in the back of the book.

That is escapism, that posing evil as a "problem," instead of what it is: all the pain and suffering and waste and loss and injustice we will meet all our lives long, and must face and cope with over and over and over, and admit, and live with, in order to live human lives at all.

But what, then, is the naturalistic writer for children to do? Can he present the child with evil as an *insoluble* problem—something neither the child nor any adult can do anything about at all? To give the child a picture of the gas chambers of Dachau, or the famines of India, or the cruelties of a psychotic parent, and say, "Well, baby, this is how it is, what are you going to make of it?"—that is surely unethical. If you suggest that there is a "solution" to these monstrous facts, you are lying to the child. If you insist that there isn't, you are overwhelming him with a load he's not strong enough yet to carry.

The young creature does need protection and shelter. But it also needs the truth. And it seems to me that the way you can speak absolutely honestly

and factually to a child about both good and evil is to talk about himself. Himself, his inner self, his deep, the deepest Self. That is something he can cope with; indeed, his job in growing up is to become himself. He can't do this if he feels the task is hopeless, nor can he if he's led to think there isn't any task. A child's growth will be stunted and perverted if he is forced to despair or if he is encouraged in false hope, if he is terrified or if he is coddled. What he needs to grow up is reality, the wholeness which exceeds all our virtue and all our vice. He needs knowledge; he needs self-knowledge. He needs to see himself and the shadow he casts. That is something he can face, his own shadow; and he can learn to control it and to be guided by it. So that,

when he grows up into his strength and responsibility as an adult in society, he will be less inclined, perhaps, either to give up in despair or to deny what he sees, when he must face the evil that is done in the world, and the injustices and grief and suffering that we all must bear, and the final shadow at the end of all.

Fantasy is the language of the inner self. I will claim no more for fantasy than to say that I personally find it the appropriate language in which to tell stories to children—and others. But I say that with some confidence, having behind me the authority of a very great poet, who put it much more boldly. "The great instrument of moral good," Shelley said, "is the imagination."

Some Thoughts On Narrative (1980)

This paper incorporates parts of the Nina Mae Kellogg Lecture given at Portland State University in the spring of 1980.

Recently, at a three-day-long symposium on narrative, I learned that it's unsafe to say anything much about narrative, because if a poststructuralist doesn't get you a deconstructionist will. This is a pity, because the subject is an interesting one to those outside the armed camps of literary theory. As one who spends a good deal of her time telling stories, I should like to know, in the first place, why I tell stories, and in the second place, why you listen to them; and vice versa.

Through long practice I know how to tell a story, but I'm not sure I know what a story is; and I have not found much patience with the question among those better qualified to answer it. To literary theorists it is evidently too primitive, to linguists it is not primitive enough; and among psychologists I know of only one, Simon Lesser, who has tried seriously to explain narration as a psychic process. There is, however, always Aristotle.

Aristotle says that the essential element of drama and epic is "the arrangement of the incidents." And he goes on to make the famous and endearing remark that this narrative or plotly element consists of a beginning, a middle, and an end:

> A beginning is that which is not itself necessarily after anything else, and which has naturally something else after it; an end, that which is naturally after something else, either as its necessary or usual consequent, and with nothing else after it; and a middle, that which is by nature after one thing and has also another after it.

According to Aristotle, then, narrative connects events, "arranges incidents," in a directional temporal order analogous to a directional spatial order. Causality is implied but not exactly stated (in the word "consequent," which could mean "result" or merely "what follows"); the principal linkage as I understand it is temporal (E. M. Forster's story

sequence, "and then...and then...and then..."). So narrative is language used to connect events in time. The connection, whether conceived as a closed pattern, beginning-middle-end, or an open one, past-present-future, whether seen as lineal or spiral or recursive, involves a movement "through" time for which spatial metaphor is adequate. Narrative makes a journey. It goes from A to Z, from then to then-prime.

This might be why narrative does not normally use the present tense except for special effect or out of affectation. It locates itself in the past (whether the real or an imagined, fictional past) in order to allow itself forward movement. The present not only competes against the story with a vastly superior weight of reality, but limits it to the pace of watch hand or heartbeat. Only by locating itself in the "other country" of the past is the narrative free to move towards its future, the present.

The present tense, which some writers of narrative fiction currently employ because it is supposed to make the telling "more actual," actually distances the story (and some very sophisticated writers of narrative fiction use it for that purpose). The present tense takes the story out of time. Anthropological reports concerning people who died decades ago, whose societies no longer exist, are written in the present tense; this paper is written in the present tense. Physics is normally written in the present tense, in part because it *generalizes*, as I am doing now, but also because it deals so much with nondirectional time.

Time for a physicist is quite likely to be reversible. It doesn't matter whether you read an equation forwards or backwards—unlike a sentence. On the subatomic level directionality is altogether lost. You cannot write the history of a photon; narration is irrelevant; all you can say of it is that it might be, or, otherwise stated, if you can say where it is you can't say when and if you can say when it is you can't say where.

Even of an entity relatively so immense and biologically so complex as a gene, the little packet of instructions that tells us what to be, there is no story to be told; because the gene, barring accident, is immortal. All you can say of it is that it is, and it is,

and it is. No beginning, no end. All middle.

The past and future tenses become useful to science when it gets involved in irreversible events, when beginning, middle, and end will run only in that order. What happened two seconds after the Big Bang? What happened when Male Beta took Male Alpha's banana? What will happen if I add this hydrochloric acid? These are events that made, or will make, a difference. The existence of a future—a time different from now, a then-prime—depends on the irreversibility of time; in human terms, upon mortality. In Eternity there is nothing novel, and there are no novels.

So when the storyteller by the hearth starts out, "Once upon a time, a long way from here, lived a king who had three sons," that story will be telling us that things change; that events have consequences; that choices are to be made; that the king does not live forever.

Narrative is a stratagem of mortality. It is a means, a way of living. It does not seek immortality; it does not seek to triumph over or escape from time (as lyric poetry does). It asserts, affirms, participates in directional time, time experienced, time as meaningful. If the human mind had a temporal spectrum, the nirvana of the physicist or the mystic would be way over in the ultraviolet, and at the opposite end, in the infrared, would be *Wuthering Heights*.

To put it another way: Narrative is a central function of language. Not, in origin, an artifact of culture, an art, but a fundamental operation of the normal mind functioning in society. To learn to speak is to learn to tell a story.

I would guess that preverbal narration takes place almost continuously on the unconscious level, but pre- or nonverbal mental operations are very hard to talk about. Dreams might help.

It has been found that during REM (rapid eye movement) sleep, the recurrent phase of sleep during which we dream abundantly, the movement of the eyes is intermittent. If you wake the dreamer while the eyes are flickering, the dreams reported are disconnected, jumbled, snatches and flashes of imagery; but, awakened during a quiet-eye period,

the dreamer reports a "proper dream," a *story*. Researchers call the image-jumble "primary visual experience" and the other "secondary cognitive elaboration."

Concerning this, Liam Hudson wrote (in the *Times Literary Supplement* of January 25, 1980):

> While asleep, then, we experience arbitrary images, and we also tell ourselves stories. The likelihood is that we weave the second around the first, embedding images that we perceive as bizarre in a fabric that seems to us more reasonable. If I confront myself, while asleep, with the image of a crocodile on the roof of a German *Schloss*, and then, while still fast asleep, create for myself some plausible account of how this implausible event has occurred, I am engaged in the manoeuvre of rationalisation— of rendering sensible-seeming something that is not sensible in the least. In the course of this manoeuvre, the character of the original image is falsified....
>
> The thinking we do without thinking about it consists in the translation of our experience to narrative, irrespective of whether our experience fits the narrative form or not.... Asleep and awake it is just the same: we are telling ourselves stories all the time,... tidier stories than the evidence warrants.

Mr. Hudson's summary of the material is elegant, and his interpretation of it is, I take it, Freudian. Dreamwork is *rationalization*, therefore it is *falsification*: a cover-up. The mind is an endless Watergate. Some primitive "reality" or "truth" is forever being distorted, lied about, tidied up.

But what if we have no means of access to this truth or reality except through he process of "lying," except through the narrative? Where are we supposed to be standing in order to judge what "the evidence warrants"?

Take Mr. Hudson's crocodile on the roof of a German castle (it is certainly more interesting than what I dreamed last night). We can all make that image into a story. Some of us will protest, No no I can't, I can't tell stories, etc., having been terrorized by our civilization into believing that we are, or have to be, "rational." But all of us can make that image into some kind of story, and if it came into our head while we were asleep, no doubt we would do so without a qualm, without giving it a second thought. As

I have methodically practiced irrational behavior for many years, I can turn it into a story almost as easily waking as asleep. What has happened is that Prince Metternich was keeping a crocodile to frighten his aunt with, and the crocodile has escaped through a skylight onto the curious, steep, leaden roofs of the castle, and is clambering, in the present tense because it is a dream and outside time, towards a machicolated nook in which lies, in a stork's nest, but the stork is in Africa, an egg, a wonderful, magical Easter egg of sugar containing a tiny window through which you look and you see— But the dreamer is awakened here. And if there is any "message" to the dream, the dreamer is not aware of it; the dream with its "message" has gone from the unconscious to the unconscious, like most dreams, without any processing describable as "rationalization," and without ever being verbalized (unless and until the dreamer, in some kind of therapy, has leaned laboriously to retrieve and hold and verbalize dreams). In this case all the dreamer—we need a name for this character, let us call her Edith Driemer—all Edith remembers, fleetingly, is something about a roof, a crocodile, Germany, Easter, and while thinking dimly about her great-aunt Esther in Munich, she is presented with further "primary visual (or sensory) experiences" running in this temporal sequence: A loud ringing in the left ear. Blinding light. The smell of an exotic herb. A toilet. A pair of used shoes. A disembodied voice screaming in Parsee. A kiss. A sea of shining clouds. Terror. Twilight in the branches of a tree outside the window of a strange room in an unknown city...

Are these the "primary experiences" experienced while her eyes move rapidly, furnishing material for the next dream? They could well be; but by following Aristotle's directions and making purely temporal connections between them, we can make of them a quite realistic narration of the day Edith woke up and turned off the alarm clock, got up and got dressed, had breakfast listening to the radio news, kissed Mr. Driemer goodbye, and took a plane to Cincinnati in order to attend a meeting of market analysts.

I submit that though this network of "secondary elaboration" may be more rationally controlled than

that of the pretended dream, the primary material on which it must work can be considered inherently as bizarre, as absurd, as the crocodile on the roof, and that the factual account of Edith Driemer's day is no more and no less than the dream-story a "manoeuvre," "rendering sensible-seeming something that is not sensible in the least."

Dream narrative differs from conscious narrative in using sensory symbol more than language. In dream the sense of the directionality of time is often replaced by spatial metaphor, or may be lowered, or reversed, or vanish. The connections dream makes between events are most often unsatisfactory to the rational intellect and the aesthetic mind. Dreams tend to flout Aristotle's rules of plausibility and muddle up his instructions concerning plot. Yet they are undeniably narrative: they connect events, fit things together in an order or a pattern that makes, to some portion of our mind, sense.

Looked at as a "primary visual (sensory) experience," in isolation, without connection to any context or event, each of our experiences is equally plausible or implausible, authentic or inauthentic, meaningful or absurd. But living creatures go to considerable pains to escape equality, to evade entropy, chaos, and old night. They arrange things. They make sense, literally. Molecule by molecule. In the cell. The cells arrange themselves. The body is an arrangement in spacetime, a patterning, a process; the mind is a process of the body, an organ, doing what organs do: organize. Order, pattern, connect. Do we have any better way to organize such wildly disparate experiences as a half-remembered crocodile, a dead great-aunt, the smell of coffee, a scream from Iran, a bumpy landing, and a hotel room in Cincinnati, than the narrative?—an immensely flexible technology, or life strategy, which if used with skill and resourcefulness presents each of us with that most fascinating of all serials, The Story of My Life.

I have read of a kind of dream that is symptomatic of one form of schizophrenia. The dream presents an object, a chair perhaps, or a coat, or a stump. Nothing happens, and there is nothing else in the dream.

Seen thus in spatial and temporal isolation, the primary experience or image can be the image of despair itself (like Sartre's tree root). Beckett's work yearns toward this condition. In the other direction, Rilke's celebration of "Things"—a chair, a coat, a stump—offers connection: a piece of furniture is part of the pattern of the room, of the life, a bed is a table in a swoon (in one of his French poems), forests are in the stump, the pitcher is also the river, and the hand, and the cup, and the thirst.

Whether the technique is narrative or not, the primary experience has to be connected with and fitted into the rest of experience to be useful, probably even to be available, to the mind. This may hold even for mystical perception. All mystics say that what they have experienced in vision cannot be fitted into ordinary time and space, but they try— they have to try. The vision is ineffable, but the story begins, "In the middle of the road of our life..."

It may be that an inability to fit events together in an order that at least seems to make sense, to make the narrative connection, is a radical incompetence at being human. So seen, stupidity could be defined as a failure to make enough connections, and insanity as severe repeated error in making connections— in telling The Story of My Life.

But nobody does it right all the time, or even most of the time. Even without identifying narration with falsification, one must admit that a vast amount of our life narration is fictional—how much, we cannot tell.

But if narration is a life stratagem, a survival skill, how can I get away, asleep and awake, with mistaking and distorting and omitting data, through wishful thinking, ignorance, laziness, and haste? If the ghostwriter in my head writing The Story of My Life is forgetful, careless, mendacious, a hack who doesn't care what happens so long as it makes some kind of story, why don't I get punished? Radical errors in interpreting and reacting to the environment aren't let off lightly, in either the species or the individual.

Is the truthfulness of the story, then, the all-important value; or is the quality of the fiction important too? Is it possible that we all keep going in very much the same way as Queen Dido or Don Quixote

keeps going—by virtue of being almost entirely fictional characters?

Anyone who knows J. T. Fraser's work, such as his book *Of Time, Passion, and Knowledge,* and that of George Steiner, will have perceived my debt to them in trying to think about the uses of narrative. I am not always able to follow Mr. Steiner; but when he discusses the importance of the future tense, suggesting that statements about what does not exist and may never exist are central to the use of language, I follow him cheering and waving pompoms. When he makes his well-known statement "Language is the main instrument of man's refusal to accept the world as it is,' I continue to follow, though with lowered pompoms. The proposition as stated worries me. Man's refusal to accept the world as it is? Do women also refuse? What about science, which tries so hard to see the world as it is? What about art, which not only accepts the dreadful world as it is but praises it for being so? "Isn't life a terrible thing, thank God!" says the lady with the backyard full of washing and babies in *Under Milk Wood,* and the sweet song says, "Nobody knows the trouble I seen, Glory, Hallelujah!" I agree with them. All grand refusals, especially when made by Man, are deeply suspect.

So, caviling all the way, I follow Mr. Steiner. If the use of language were to describe accurately what exists, what, in fact, would we want it for?

Surely the primary, survival-effective uses of language involve stating alternatives and hypotheses. We don't, we never did, go about making statements of fact to other people, or in our internal discourse with ourselves. We talk about what may be, or what we'd like to do, or what you ought to do, or what might have happened: warnings, suppositions, propositions, invitations, ambiguities, analogies, hints, lists, anxieties, hearsay, old wives' tales, leaps and cross-links and spiderwebs between here and there, between than and now, between now and sometime, a continual weaving and restructuring of the remembered and the perceived and the imagined, including a great deal of wishful thinking and a variable quantity of deliberate or non-deliberate fictionalizing, to reassure ourselves or for the pleasure of it, and also some deliberate or semi-deliberate falsification in order to mislead a rival or persuade a friend or escape despair; and no sooner have we made one of these patterns of words than we may, like Shelley's cloud, laugh, and arise, and unbuild it again.

In recent centuries we speakers of this lovely language have reduced the English verb almost entirely to the indicative mood. But beneath that specious and arrogant assumption of certainty all the ancient, cloudy, moody powers and options of the subjunctive remain in force. The indicative points its bony finger at primary experiences, at the Things; but it is the subjunctive that joins them, with the bonds of analogy, possibility, probability, contingency, contiguity, memory, desire, fear, and hope: the narrative connection. As J. T. Fraser puts it, moral choice, which is to say human freedom, is made possible "by language, which permits us to give accounts of possible and impossible worlds in the past, in the future, or in a faraway land."

Fiction in particular, narration in general, may be seen not as a disguise or falsification of what is given but as an active encounter with the environment by means of posing options and alternatives, and an enlargement of present reality by connecting it to the unverifiable past and the unpredictable future. A totally factual narrative, were there such a thing, would be passive: a mirror reflecting all without distortion. Stendhal sentimentalized about the novel as such a mirror, but fiction does not reflect, nor is the narrator's eye that of a camera. The historian manipulates, arranges, and connects, and the storyteller does all that as well as intervening and inventing. Fiction connects possibilities, using the aesthetic sense of time's directionality defined by Aristotle as plot; and by doing so it is useful to us. If we cannot see our acts and being under the aspect of fiction, as "making sense," we cannot act as if we were free.

To describe narrative as "rationalization" of the given or of events is a blind alley. In the telling of a story, reason is only a support system. It can provide causal connections; it can extrapolate; it can judge what is likely, plausible, possible. All this is

crucial to the invention of a good story, a sane fantasy, a sound piece of fiction. But reason by itself cannot get from the crocodile to Cincinnati. It cannot see that Elizabeth is, in fact, going to marry Darcy, and why. It may not even ever quite understand who it was, exactly, that Oedipus did marry. We cannot ask reason to take us across the gulfs of the absurd.

Only the imagination can get us out of the bind of the eternal present, inventing or hypothesizing or pretending or discovering a way that reason can then follow into the infinity of options, a clue through the labyrinths of choice, a golden string, the story, leading us to the freedom that is properly human, the freedom open to those whose minds can accept unreality.

Part 5

Hermeneutics and Interpretation

Part 5: Hermeneutics and Interpretation

Introduction

Problems in hermeneutics, or the methodology of textual interpretation, have dominated much of European philosophy since the demonstration by Heidegger that to the extent that understanding itself is historical and interpretive, the hermeneutic circle is unavoidable. Every attempt to understand, as an interrogative act, is grounded in assumptions and presuppositions that structure what is asked. Understanding is an event in which interpreter and text mutually determine each other. There is a back and forth movement between partial understandings and a sense of the whole; we seek to comprehend the whole on the basis of what we already understand. Those partial understandings are transformed in response to resistances originating in the text and what we know of the subject matter. Talk of the objective meaning of the text prior to interpretation is illusory, but that makes it hard to see how it is possible to decide that one interpretation is better than another.

Martin Heidegger (1889-1976) is surely the most prominent twentieth-century German philosopher. His book *Being and Time* changed the face of European philosophy. Heidegger argued that the hermeneutic circle is not merely a matter of interpretive procedure, but refers to the fundamental mode of human being in the world. *Dasein*, Heidegger's word for the kind of beings that humans are, is that being whose nature it is to interrogate things in their being. Things are primordially in the openness where they come into Dasein's presence. The things which are closest to us phenomenologically are what we may call 'equipment'—that is, the implements for living with which we are attuned and by means of which our life in the world is mediated. The first part of the selection by Heidegger, "the Being of Beings Encountered in the Surrounding World", is from *Being and Time*, and is an analysis of the artifacts which are the products of those forms of making and taking care which the Greeks called *technē*. Heidegger argues that Dasein's dealings with the equipment of ordinary living is an attunement forming a clearing or open space, in which human habitation takes place and the truth of things happens. Dasein's mode of being alongside the entities within the world is concern, and concern is a form of being which discloses things in their importance to Dasein. Dasein as a being is thus primordially in the truth. But the clearing in which things are for us has boundaries beyond which we cannot see, and thus it is simultaneously a revealing and a concealing. Human understanding is both temporal and finite.

The second part of the selection, taken from Heidegger's influential essay "On the

Origin of the Work of Art", deals with the way truth happens in the work of art; how art reveals without pretending to offer total unconcealment. It looks at the way in which an artwork can disclose the truth of the equipmental being of equipment. This disclosure in turn shows something about art: what is at work is the disclosure of a particular being in its being. Both equipment and works are artifacts, but they are of fundamentally different kinds. The createdness of equipment disappears into its usefulness in such a way that when it is at its most useful it is least prominent. But in the artwork createdness is an event which calls for recognition and preservation; it is a happening of truth which is formative of a culture. Thus, for Heidegger, art is understood as the happening of truth in the work, a happening which opens us to the clearing in which things are in truth. For Heidegger, like Nietzsche, art is central to the formation of culture.

The second selection is by the German phenomenologist Hans-Georg Gadamer (1900-). The account of textual understanding in Gadamer's book *Truth and Method* made philosophical hermeneutics a position of central importance in twentieth-century philosophy. Our selection is his 1966 essay "The Universality of the Hermeneutical Problem". Gadamer offers an account of hermeneutics by way of the experience of alienation. Language is the fundamental mode of being-in-the-world, and it is a way of understanding through alienation. Gadamer expresses this provocatively by saying "it is not so much our judgements as it is our prejudices that constitute our being." Our prejudices constitute the initial directedness of our openness to the world. They determine the questions that we propose to the text by reading it, and the assertions of the text are initially understood as answers to those questions. Inquiry has the logic of question and answer, and understanding includes coming to see which questions the assertions of the text are answers to. For Gadamer, the inquirer's initial situation loses it status as a privileged position for understanding and becomes instead merely a *moment* of understanding which, while it is productive and discloses meaning, will be overcome and fused with future horizons of understanding. Understanding is an event. It is the formation of a comprehensive perspective in which the limited horizons of text and inquirer are fused into a common view of the subject matter with which both are concerned. Understanding is thus essentially the "fusion of horizons" of inquiry.

Paul Ricoeur (1913-), French philosopher, theologian and literary critic, has written widely on hermeneutical problems. Like Gadamer and Heidegger, he writes from within a horizon of human finitude, arguing that human existence can be apprehended only in the mirror of its external manifestations; there is no direct unmediated consciousness of the human, but only the "long detour of signs of humanity deposited in cultural works". The selection by Ricoeur, "The Hermeneutical Function of Distanciation", takes as its beginning the tension between alienating distance and appropriating immediacy, which is at the heart of Gadamer's account of the historicity of human experience, and attempts to overcome it by means of his own analysis of how we understand a text. It is not writing which gives rise to the hermeneutical problem, as Gadamer believes, but the dialectic between speaking and writing. Indeed even

this dialectic is based on a more fundamental form of alienation ineliminable even in speech, namely the transcendence of what is meant in what is said.

The passing of speech into writing shelters the event of discourse from destruction, but it also emancipates the references of the discourse, which in speech are fixed by various indexical devices, from the intentions of the writer. This means that distanciation is not a product of an alienating methodology, but is constitutive of the text as writing. What happens to reference when discourse becomes a text? Ricoeur answers that a text offers a proposed world to the reader as a medium of self-understanding. The reader who appropriates the text gives herself over to the play of the text and receives back from it an enlarged self. The identity that we possess as literate selves is a product of cultural history; our apprehension of the human condition as we find it in ourselves is inseparable from the texts and artworks which make up our culture.

The next two selections take up the problem of the autonomy of the text (known by the slogan "the death of the author") from opposite sides. The first selection is the opening chapter of *Validity in Interpretation* by E.D. Hirsch (1928-), an American literary theorist and professor of English at the University of Virginia, who is deeply critical of, but much influenced by, Gadamer's hermeneutical position. In "In Defence of the Author", Hirsch argues for the "sensible belief that a text means what its author meant" and he does so by critiquing four common arguments aimed at banishing the author. These arguments threaten the very idea of validity in interpretation, for they threaten the idea of a meaning to be found in the work. Hirsch argues that meanings must be publicly verifiable affairs of human consciousness. The arguments directed against our access to the author's meaning are self-refuting because they are inconsistent with the possibility of public interpretation, and such interpretation evidently exists.

The selection by the French literary theorist Roland Barthes (1915-1980), "The Death of the Author," argues for a view of writing as "the destruction of every voice, every point of origin". The idea of the author is an artifact of modernity, and just one more holdover from the enlightenment: commitment to the cult of the individual. Writing has, in fact, no need of the author but only of the resources of language itself. A text is not a sequence of words that delivers a single meaning, but a space of borrowings and quotations, a clashing of signifiers indefinitely open to new possibilities. To impose an author on this space is to smother the reader. The freedom of the reader requires the death of the author.

The next selection, "Poststructuralism and the Paraliterary," is from *The Originality of the Avant-Garde and Other Modernist Myths* by Columbia University art critic and historian Rosalind Krauss (1940-). In it she extends the argument offered by Barthes, suggesting that in his work and in the writings of Derrida we find an intentional blurring of the boundaries of literature and criticism. Such work occupies a 'paraliterary' space which is deeply hostile to traditional criticism and cannot be understood by means of the techniques of established literary criticism, which depends upon the validation of a privileged point of view.

The last selection, "Reinterpreting Interpretation", is by Joseph Margolis (1924-), a philosopher and prolific writer on aesthetics and the theory of culture at Temple University. In it he asks what an adequate theory of interpretation needs to include, offering a definition that he tests against the claims of Rosalind Krauss and Roland Barthes. After a very detailed and critical discussion of their criticisms of traditional accounts of interpretation, he concludes that their accounts cannot meet the minimal requirements of a theory of interpretation. Any candidate for an adequate theory of interpretation must both be able to explain how we can individuate artworks for interpretation without distorting them and how artworks are internally constituted so that they sustain interpretative investigation. Such a theory must also explain how the interpretation of texts can alter them without destroying their identity over time. These are large and difficult demands to meet, and none of the theories canvassed succeed. Cultural theory, concludes Margolis, still has a future.

Martin Heidegger (1889-1976)

Selections from

Being and Time

Translated by John Macquarrie and Edward Robinson

. . .

¶ 15. The Being of the Entities Encountered in the Environment

The Being of those entities which we encounter as closest to us can be exhibited phenomenologically if we take as our clue our everyday Being-in-the-world, which we also call our "*dealings*"[1] *in* the world and *with* entities within-the-world. Such dealings have already dispersed themselves into manifold ways of concern.[2] The kind of dealing which is closest to us is as we have shown, not a bare perceptual cognition, but rather that kind of concern which manipulates things and puts them to use; and this has its own kind of 'knowledge'. The phenomenological question applies in the first instance to the Being of those entities which we encounter in such concern. To assure the kind of seeing which is here required, we must first make a remark about method.

In the disclosure and explication of Being, entities are in every case our preliminary and our accompanying theme [das Vor-und-Mitthematische]; but our real theme is Being. In the domain of the present analysis, the entities we shall take as our preliminary theme are those which show themselves in our concern with the environment. Such entities are not thereby objects for knowing the 'world' theoretically; they are simply what gets used, what gets produced, and so forth. As entities so encountered,

they become the preliminary theme for the purview of a 'knowing' which, as phenomenological, looks primarily towards Being, and which, in thus taking Being as its theme, takes these entities as its accompanying theme. This phenomenological interpretation is accordingly not a way of knowing those characteristics of entities which themselves are [seiender Beschaffenheiten des Seienden]; it is rather a determination of the structure of the Being which entities possess. But as an investigation of Being, it brings to completion, autonomously and explicitly, that understanding of Being which belongs already to Dasein and which 'comes alive' in any of its dealings with entities. Those entities which serve phenomenologically as our preliminary theme—in this case, those which are used or which are to be found in the course of production—become accessible when we put ourselves into the position of concerning ourselves with them in some such way. Taken strictly, this talk about "putting ourselves into such a position" [Sichversetzen] is misleading; for the kind of Being which belongs to such concernful dealings is not one into which we need to put ourselves first. This is the way in which everyday Dasein always *is*: when I open the door, for instance, I use the latch. The achieving of phenomenological access to the entities which we encounter, consists rather in thrusting aside our interpretative tendencies, which keep thrusting themselves upon us and running along with us, and which conceal not only the phenomenon of such 'concern', but even more those entities themselves *as* encountered of their own accord *in* our concern with them. These entangling errors become plain if in the course of our investigation we now ask which entities shall be taken as our preliminary

1. 'Umgang'. This word means literally a 'going around' or 'going about', in a sense not too far removed from what we have in mind when we say that someone is 'going about his business'. 'Dealings' is by no means an accurate translation, but is perhaps as convenient as any. 'Intercourse' and 'trafficking' are also possible translations.

2. See above, H. 57, n. 1, p. 83. Note: all "H" references are to the German version of the text.

theme and established as the pre-phenomenal basis for our study.

One may answer: "Things." But with this obvious answer we have perhaps already missed the pre-phenomenal basis we are seeking. For in addressing these entities as 'Things' (*res*), we have tacitly anticipated their ontological character. When analysis starts with such entities and goes on to inquire about Being, what it meets is Thinghood and Reality. Ontological explication discovers, as it proceeds, such characteristics of Being as substantiality, materiality, extendedness, side-by-side-ness, and so forth. But even pre-ontologically, in such Being as this, the entities which we encounter in concern are proximally hidden. When one designates Things as the entities that are 'proximally given', one goes ontologically astray, even though ontologically one has something else in mind. What one really has in mind remains undetermined. But suppose one characterizes these 'Things' as Things 'invested with value'? What does "value" mean ontologically? How are we to categorize this 'investing' and Being-invested? Disregarding the obscurity of this structure of investiture with value, have we thus met that phenomenal characteristic of Being which belongs to what we encounter in our concernful dealings?

The Greeks had an appropriate term for 'Things': πραγματα [*pragmata*]—that is to say, that which one has to do with in one's concernful dealings (πραξισ [*praxis*]). But ontologically, the specifically 'pragmatic' character of the πραγματα is just what the Greeks left in obscurity; they thought of these 'proximally' as 'mere Things'. We shall call those entities which we encounter in concern "equipment".[3] In our dealings we come across equipment for writing, sewing, working, transportation, measurement. The kind of Being which equipment possesses must be exhibited. The clue for doing this lies in our first defining what makes an item of equipment—namely, its equipmentality.

Taken strictly, there 'is' no such thing as *an* equipment. To the Being of any equipment there always belongs a totality of equipment, in which it can be this equipment that it is. Equipment is essentially 'something in-order-to...' ["etwas um-zu..."]. A totality of equipment is constituted by various ways of the 'in-order-to', such as serviceability, conducivenenss, usability, manipulability.

In the 'in-order-to' as a structure there lies an *assignment* or *reference* of something to something.[4] Only in the analyses which are to follow can the phenomenon which this term 'assignment' indicates be made visible in its ontological genesis. Provisionally, it is enough to take a look phenomenally at a manifold of such assignments. Equipment—in accordance with its equipmentality—always *in terms of* [*aus*] its belonging to other equipment: ink-stand, pen, ink, paper, blotting pad, table, lamp, furniture, windows, doors, room. These 'Things' never show themselves proximally as they are for themselves,

3. 'das *Zeug*'. The word 'Zeug' has no precise English equivalent. While it may mean any implement, instrument, or tool, Heidegger uses it for the most part as a collective noun which is analogous to our relatively specific 'gear' (as in 'gear for fishing') or the more elaborate 'paraphernalia', or still more general 'equipment', which we shall employ throughout this translation. In this collective sense 'Zeug' can sometimes be used in a way which is comparable to the use of 'stuff' in such sentences as 'there is plenty of stuff lying around'. (See section 16.) In general, however, this pejorative connotation is lacking. For the most part Heidegger uses the term as a collective noun, so that he can say that there is no such thing as '*an* equipment'; but still he uses it occasionally with an indefinite article to refer to some specific tool or instrument—some item or bit of equipment.

4. 'In der Struktur "Um-zu" liegt eine *Verweisung* von etwas auf etwas.' There is no close English equivalent for the word 'Verweisung', which occurs many times in this chapter. The basic metaphor seems to be that of *turning* something away towards something else, or *pointing* it away, as when one 'refers' or 'commits' or 'relegates' or 'assigns' something to something else, whether one 'refers' a symbol to what it symbolizes, 'refers' a beggar to a welfare agency, 'commits' a person for trial, 'relegates' or 'banishes' him to Siberia, or even 'assigns' equipment to a purpose for which it is to be used. 'Verweisung' thus does some of the work of 'reference', 'commitment', 'assignment', 'relegation', 'banishment'; but it does not do *all* the work of any of these expressions. For a businessman to 'refer' to a letter, for a symbol to 'refer' to what it symbolizes, for a man to 'commit larceny or murder' or merely to 'commit himself' to certain partisan views, for a teacher to give a pupil a long 'assignment', or even for a journalist to receive an 'assignment' to the Vatican, we would have to find some other verb than 'verweisen'. We shall, however, use the verbs 'assign' and 'refer' and their derivatives as perhaps the least misleading substitutes, employing whichever seems the more appropriate in the context, and occasionally using a hendiadys as in the present passage. See Section 17 for further discussion. (When other words such as 'anweisen' or 'zuweisen' are translated as 'assign', we shall usually subjoin the German in brackets.)

so as to add up to a sum of *realia* and fill up a room. What we encounter as closest to us (though not as something taken as a theme) is the room; and we encounter it not as something 'between four walls' in a geometrical spatial sense, but as equipment for residing. Out of this the 'arrangement' emerges, and it is in this that any 'individual' item of equipment shows itself. *Before* it does so, a totality of equipment has already been discovered.

Equipment can genuinely show itself only in dealings cut to its own measure (hammering with a hammer, for example); but in such dealings an entity of this kind is not *grasped* thematically as an occurring Thing, nor is the equipment-structure known as such even in the using. The hammering does not simply have knowledge about [um] the hammer's character as equipment, but it has appropriated this equipment in a way which could not possibly be more suitable. In dealings such as this, where something is put to use, our concern subordinates itself to the "in-order-to" which is constitutive for the equipment we are employing at the time; the less we just stare at the hammer-Thing, and the more we seize hold of it and use it, the more primordial does our relationship to it become, and the more unveiledly is it encountered as that which it is—as equipment. The hammering itself uncovers the specific 'manipulability' ["Handlichkeit"] of the hammer. The kind of Being which equipment possesses—in which it manifests itself in its own right—we call *"readiness-to-hand"* [*Zuhandenheit*].[5] Only because equipment has *this* 'Being-in-itself' and does not merely occur, is it manipulable in the broadest sense and at our disposal. No matter how sharply we just *look* [Nur-noch-*hinsehen*] at the 'outward appearance' ["Aussehen"] of Things in whatever form this takes, we cannot discover anything ready-to-hand. If we look at Things just 'theoretically', we can get along without understanding readiness-to-hand. But when we deal with them by using them and manipulating them, this activity is not a blind one; it has its own kind of sight, by which our manipulation is guided and from which it acquires its specific Thingly character. Dealings with equipment subordinate themselves to the manifold assignments of the 'in-order-

to'. And the sight with which they thus accommodate themselves is circumspection.[6]

'Practical' behaviour is not 'atheoretical' in the sense of "sightlessness".[7] The way it differs from theoretical behaviour does not lie simply in the fact that in theoretical behaviour one observes, while in practical behaviour one *acts* [*gehandelt* wird], and that action must employ theoretical cognition if it is not to remain blind; for the fact that observation is a kind of concern is just as primordial as the fact that action has *its own* kind of sight. Theoretical behaviour is just looking, without circumspection. But the fact that this looking is non-circumspective does not mean that it follows no rules: it constructs a canon for itself in the form of *method*.

The ready-to-hand is not grasped theoretically at all, nor is it itself the sort of thing that circumspection takes proximally as a circumspective theme. The peculiarity of what is proximally ready-to-hand is that, in its readiness-to-hand, it must, as it were, withdraw [zurückzuziehen] in order to be ready-to-hand quite authentically. That with which our everyday dealings proximally dwell is not the tools themselves [die Werkzeuge selbst]. On the contrary, that with which we concern ourselves primarily is the work—that which is to be produced at the time; and this is accordingly ready-to-hand too. The work

5. Italics only in earlier editions.

6. The word 'Umsicht', which we translate by 'circumspection', is here presented as standing for a special kind of 'Sicht' ('sight'). Here, as elsewhere, Heidegger is taking advantage of the fact that the prefix *'um'* may mean either 'around' or 'in order to'. *'Umsicht'* may accordingly be thought of as meaning 'looking around' or 'looking around for something' or 'looking around for a way to get something done'. In ordinary German usage, 'Umsicht' seems to have much the same connotation as our 'circumspection'—a kind of awareness in which one looks around before one decides just what one ought to do next. But Heidegger seems to be generalizing this notion as well as calling attention to the extent to which circumspection in the narrower sense occurs in our every-day living. (The distinction between 'sight' ('Sicht') and 'seeing' ('Sehen') will be developed further in Sections 31 and 36 below.)

7. '...im Sinne der Sichtlosigkeit...' The point of this sentence will be clear to the reader who recalls that the Greek verb θεωρειν [*theōrein*], from which the words 'theoretical' and 'atheoretical' are derived, originally meant 'to see'. Heidegger is pointing out that this is not what we have in mind in the traditional contrast between the 'theoretical' and the 'practical'.

bears with it that referential totality within which the equipment is encountered.[8]

The work to be produced, as the *"towards-which"* of such things as the hammer, the plane, and the needle, likewise has the kind of Being that belongs to equipment. The shoe which is to be produced is for wearing (footgear) [Schuhzeug]; the clock is manufactured for telling the time. The work which we chiefly encounter in our concernful dealings— the work that is to be found when one is "at work" on something [das in Arbeit befindliche]—has a usability which belongs to it essentially; in this usability it lets us encounter already the "towards-which" for which *it* is usable. A work that someone has ordered [das bestellte Werk] is only by reason of its use and the assignment-context of entities which is discovered in using it.

But the work to be produced is not merely usable for something. The production itself is a using *of* something for something. In the work there is also a reference or assignment to 'materials': the work is dependent on [angewiesen auf] leather, thread, needles, and the like. Leather, moreover is produced from hides. These are taken from animals, which someone else has raised. Animals also occur within the world without having been raised at all; and, in a way, these entities still produce themselves even when they have been raised. So in the environment certain entities become accessible which are always ready-to-hand, but which, in themselves, do not need to be produced. Hammer, tongs, and needle, refer in themselves to steel, iron, metal, mineral, wood, in that they consist of these. In equipment that is used, 'Nature' is discovered along with it by that use—the 'Nature' we find in natural products.

Here, however, "Nature" is not to be understood as that which is just present-at-hand, nor as the *power of Nature*. The wood is a forest of timber, the mountain a quarry of rock; the river is water-power, the wind is wind 'in the sails'. As the 'environment' is discovered, the 'Nature' thus discovered is encountered too. If its kind of Being as ready-to-hand is disregarded, this 'Nature' itself can be discovered and defined simply in its pure presence-at-hand. But when this happens, the Nature which 'stirs and strives', which assails us and enthralls us as landscape, remains hidden. The botanist's plants are not the flowers of the hedgerow; the 'source' which the geographer establishes for a river is not the 'springhead in the dale'.

The work produced refers not only to the "towards-which" of its usability and the "whereof" of which it consists: under the simple craft conditions it also has an assignment to the person who is to use it or wear it. The work is cut to his figure; he 'is' there along with it as the work emerges. Even when goods are produced by the dozen, this constitutive assignment is by no means lacking; it is merely indefinite, and points to the random, the average. Thus along with the work, we encounter not only entities ready-to-hand but also entities with Dasein's kind of Being—entities for which, in their concern, the product becomes ready-to-hand; and together with these we encounter the world in which wearers and users live, which is at the same time ours. Any work with which one concerns oneself is ready-to-hand not only in the domestic world of the workshop but also in the *public world*. Along with the public world, the *environing Nature* [*die Umweltnatur*] is discovered and is accessible to everyone. In roads, streets, bridges, buildings, our concern discovers Nature as having some definite direction. A covered railway platform takes account of bad weather; an installation for public lighting takes account of the darkness, or rather of specific changes in the presence or absence of daylight—the 'position of the sun'. In a clock, account is taken of some definite constellation in the world-system. When we look at the clock, we tacitly make use of the 'sun's position', in accordance with which the measurement of time gets regulated in the official astronomical manner. When we make use of the clock-equipment, which is proximally and inconspicuously ready-to-hand, the environing Nature is ready-to-hand along with it. Our concernful absorption in whatever work-world

8. 'Das Werk trägt die Verweisungsganzheit, innerhalb derer das Zeug begegnet.' In this chapter the word 'Werk' ('work') usually refers to the product achieved by working rather than to the process of working as such. We shall as a rule translate 'Verweisungsganzheit' as 'referential totality', though sometimes the clumsier 'totality of assignments' may convey the idea more effectively. (The older editions read 'deren' rather than 'derer'.)

lies closest to us, has a function of discovering; and it is essential to this function that, depending upon the way in which we are absorbed, those entities within-the-world which are brought along [beigebrachte] in the work and with it (that is to say, in the assignments or references which are constitutive for it) remain discoverable in varying degrees of explicitness and with a varying circumspective penetration.

The kind of Being which belongs to these entities is readiness-to-hand. But this characteristic is not to be understood as merely a way of taking them, as if we were talking such 'aspects' into the 'entities' which we proximally encounter, or as if some world-stuff which is proximally present-at-hand in itself[9] were 'given subjective colouring' in this way. Such an Interpretation would overlook the fact that in this case these entities would have to be understood and discovered beforehand as something purely present-at-hand, and must have priority and take the lead in the sequence of those dealings with the 'world' in which something is discovered and made one's own. But this already runs counter to the ontological meaning of cognition, which we have exhibited as a *founded* mode of Being-in-the-world.[10] To lay bare what is just present-at-hand and no more, cognition must first penetrate *beyond* what is ready-to-hand in our concern. *Readiness-to-hand is the way in which entities as they are 'in themselves' are defined ontologico-categorically*. Yet only by reason of something present-at-hand, 'is there' anything ready-to-hand. Does it follow, however, granting this thesis for the nonce, that readiness-to-hand is ontologically founded upon presence-at-hand?

But even if, as our ontological Interpretation proceeds further, readiness-to-hand should prove itself to be the kind of Being characteristic of those entities which are proximally discovered within-the-world, and even if its primordiality as compared with pure presence-at-hand can be demonstrated, have all these explications been of the slightest help towards understanding the phenomenon of the world ontologically? In Interpreting these entities within-the-world, however, we have always 'presupposed' the world. Even if we join them together, we still do not get anything like the 'world' as their sum. If, then, we start with the Being of these entities, is there any avenue that will lead us to exhibiting the phenomenon of the world?

¶ *16. How the Worldly Character of the Environment Announces itself in Entities Within-the-world*[11]

The world itself is not an entity within-the-world; and yet it is so determinative for such entities that only in so far as 'there is' a world can they be encountered and show themselves, in their Being, as entities which have been discovered. But in what way 'is there' a world? If Dasein is ontically constituted by Being-in-the-World, and if an understanding of the Being of its Self belongs just as essentially to its Being, no matter how indefinite that understanding may be, then does not Dasein have an understanding of the world—a pre-ontological understanding, which indeed can and does get along without explicit ontological insights? With those entities which are encountered within-the-world—that is to say, with their character as within-the-world—does not something like the world show itself for concernful Being-in-the-world? Do we not have a pre-phenomenological glimpse of this phenomenon? Do we not always have such a glimpse of it, without having to take it as a theme for ontological Interpretation? Has Dasein itself, in the range of its concernful absorption in equipment ready-to-hand, a possibility of Being in which the worldhood of those entities within-the-world with which it is concerned is, in a certain way, lit up for it, *along with* those entities themselves?

If such possibilities of Being for Dasein can be exhibited within its concernful dealings, then the way lies open for studying the phenomenon which is thus lit up, and for attempting to 'hold it at bay', as it were, and to interrogate it as to those structures which show themselves therein.

To the everydayness of Being-in-the-world there belong certain modes of concern. These permit the entities with which we concern ourselves to be

9. '...ein zünächst an sich vorhandener Weltstoff...' The earlier editions have '...zunächst ein an sich vorhandener Weltstoff...'.

10. See H. 61 above.

11. '*Die am innerweltlich Seienden sich meldende Weltmässigkeit der Umwelt.*'

encountered in such a way that the worldly character of what is within-the-world comes to the fore. When we concern ourselves with something, the entities which are most closely ready-to-hand may be met as something unusable, not properly adapted for the use we have decided upon. The tool turns out to be damaged, or the material unsuitable. In each of these cases *equipment* is here, ready-to-hand. We discover its unusability, however, not by looking at it and establishing its properties, but rather by the circumspection of the dealings in which we use it. When its unusability is thus discovered, equipment becomes conspicuous. This *conspicuousness* presents the ready-to-hand equipment as in a certain un-readiness-to-hand. But this implies that what cannot be used just lies there; it shows itself as an equipmental Thing which looks so and so, and which, in its readiness-to-hand as looking that way, has constantly been present-at-hand too. Pure presence-at-hand announces itself in such equipment, but only to withdraw to the readiness-to-hand of something with which one concerns oneself—that is to say, of the sort of thing we find when we put it back into repair. This presence-at-hand of something that cannot be used is still not devoid of all readiness-to-hand whatsoever; equipment which is present-at-hand *in this way* is still not just a Thing which occurs somewhere. The damage to the equipment is still not a mere alteration of a Thing—not a change of properties which just occurs in something present-at-hand.

In our concernful dealings, however, we not only come up against unusable things *within* what is ready-to-hand already: we also find things which are missing—which not only are not 'handy' ["handlich"] but are not 'to hand' ["zur Hand"] at all. Again, to miss something in this way amounts to coming across something un-ready-to-hand. When we notice what is un-ready-to-hand, that which is ready-to-hand enters the mode of *obtrusiveness*. The more urgently [Je dringlicher] we need what is missing, and the more authentically it is encountered in its un-readiness-to-hand, all the more obtrusive [um so aufdringlicher] does that which is ready-to-hand become—so much so, indeed, that it seems to lose its character of readiness-to-hand. It reveals itself

as something just present-at-hand and no more, which cannot be budged without the thing that is missing. The helpless way in which we stand before it is a deficient mode of concern, and as such it uncovers the Being-just-present-at-hand-and-no-more of something ready-to-hand.

In our dealings with the world[12] of our concern, the un-ready-to-hand can be encountered not only in the sense of that which is unusable or simply missing, but as something un-ready-to-hand which is *not* missing at all and *not* unusable, but which 'stands in the way' of our concern. That to which our concern refuses to turn, that for which it has 'no time', is something *un*-ready-to-hand in the manner of what does not belong here, of what has not as yet been attended to. Anything which is un-ready-to-hand in this way is disturbing to us, and enables us to see the *obstinacy* of that with which we must concern ourselves in the first instance before we do anything else. With this obstinacy, the presence-at-hand of the ready-to-hand makes itself known in a new way as the Being of that which still lies before us and calls for our attending to it.[13]

The modes of conspicuousness, obtrusiveness, and obstinacy all have the function of bringing to

12. In the earlier editions 'Welt' appears with quotation marks. These are omitted in the later editions.

13. Heidegger's distinction between 'conspicuousness' ('Auffälligkeit'), 'obtrusiveness' ('Aufdringlichkeit'), and 'obstinacy' ('Aufsässigkeit') is hard to present unambiguously in translation. He seems to have in mind three rather similar situations. In each of these we are confronted by a number of articles which are ready-to-hand. In the first situation we wish to use one of these articles for some purpose, but we find that it cannot be used for that purpose. It then becomes 'conspicuous' or 'striking', and *in a way* 'un-ready-to-hand'— in that we are not able to use it. In the second situation we may have precisely the same articles before us, but we want one which is not there. In this case the missing article too is 'un-ready-to-hand', but in another way—in that it is not there to be used. This is annoying, and the articles which are still ready-to-hand before us, thrust themselves upon us in such a way that they become 'obtrusive' or even 'obnoxious'. In the third situation, some of the articles which are ready-to-hand before us are experienced as *obstacles* to the achievement of some purpose; as obstacles they are 'obstinate', 'recalcitrant', 'refractory', and we have to attend to them or dispose of them in some way before we can finish what we want to do. Here again the obstinate objects are un-ready-to-hand, but simply in the way of being obstinate.

the fore the characteristic of presence-at-hand in what is ready-to-hand. But the ready-to-hand is not thereby just observed and stared at as something present-at-hand; the presence-at-hand which makes itself known is still bound up in the readiness-to-hand of equipment. Such equipment still does not veil itself in the guise of mere Things. It becomes 'equipment' in the sense of something which one would like to shove out of the way.[14] But in such a Tendency to shove things aside, the ready-to-hand shows itself as still ready-to-hand in its unswerving presence-at-hand.

Now that we have suggested, however, that the ready-to-hand is thus encountered under modifications in which its presence-at-hand is revealed, how far does this clarify the *phenomenon of the world*? Even in analysing these modifications we have not gone beyond the Being of what is within-the-world, and we have come no closer to the world-phenomenon than before. But though we have not as yet grasped it, we have brought ourselves to a point where we can bring it into view.

In conspicuousness, obtrusiveness, and obstinacy, that which is ready-to-hand loses its readiness-to-hand in a certain way. But in our dealings with what is ready-to-hand, this readiness-to-hand is itself understood, though not thematically. It does not vanish simply, but takes its farewell, as it were, in the conspicuousness of the unusable. Readiness-to-hand still shows itself, and it is precisely here that the worldly character of the ready-to-hand shows itself too.

The structure of the Being of what is ready-to-hand as equipment is determined by references or assignments. In a peculiar and obvious manner, the 'Things' which are closest to us are 'in themselves' ["Ansich"]; and they are encountered as 'in themselves' in the concern which makes use of them without noticing them explicitly—the concern which can come up against something unusable. When equipment cannot be used, this implies that the constitutive assignment of the "in-order-to" to a "towards-

this" has been disturbed. The assignments themselves are not observed; they are rather 'there' when we concernfully submit ourselves to them [Sichstellen unter sie]. But *when an assignment has been disturbed*—when something is unusable for some purpose—then the assignment becomes explicit. Even now, of course, it has not become explicit as an ontological structure; but it has become explicit ontically for the circumspection which comes up against the damaging of the tool. When an assignment to some particular "towards-this" has been thus circumspectively aroused, we catch sight of the "towards-this" itself, and along with it everything connected with the work—the whole 'work-shop'—as that wherein concern always dwells. The context of equipment is lit up, not as something never seen before, but as a totality constantly sighted beforehand in circumspection. With this totality, however, the world announces itself.

Similarly, when something ready-to-hand is found missing, though its everyday presence [Zugegensein] has been so obvious that we have never taken any notice of it, this makes a *break* in those referential contexts which circumspection discovers. Our circumspection comes up against emptiness, and now sees for the first time *what* the missing article was ready-to-hand *with*, and *what* it was ready-to-hand *for*. The environment announces itself afresh. What is thus lit up is not itself just one thing ready-to-hand among others; still less is it something *present-at-hand* upon which equipment ready-to-hand is somehow founded: it is in the 'there' before anyone has observed or ascertained it. It is itself inaccessible to circumspection, so far as circumspection is always directed towards entities; but in each case it has already been disclosed for circumspection. 'Disclose' and 'disclosedness' will be used as technical terms in the passages that follow, and shall signify 'to lay open' and 'the character of having been laid open.' Thus 'to disclose' never means anything like 'to obtain indirectly by inference'.[15]

That the world does not 'consist' of the ready-to-

14. Here 'Zeug' is used in the pejorative sense of 'stuff'. See note 3 above.

15. In ordinary German usage, the verb 'erschliessen' may mean not only to 'disclose' but also—in certain constructions—to 'infer' or 'conclude' in the sense in which one 'infers' a conclusion from premises. Heidegger is deliberately ruling out this latter interpretation, though on a very few occasions he may use the word in this sense. He explains his

own meaning by the cognate verb 'aufschliessen', to 'lay open'. To say that something has been 'disclosed' or 'laid open' in Heidegger's sense, does not mean that one has any detailed awareness of the contents which are thus 'disclosed', but rather that they have been 'laid open' to us as implicit in what is given, so that they may be made explicit to our awareness by further analysis or discrimination of the given, rather than by any inference from it.

hand shows itself in the fact (among others) that whenever the world is lit up in the modes of concern which we have been Interpreting, the ready-to-hand becomes deprived of its worldhood so that Being-just-present-at-hand comes to the fore. If, in our everyday concern with the 'environment', it is to be possible for equipment ready-to-hand to be encountered in its 'Being-in-itself' [in seinem "An-sich-sein"], then those assignments and referential totalities in which our circumspection 'is absorbed' cannot become a theme for that circumspection any more than they can for grasping things 'thematically' but non-circumspectively. If it is to be possible for the ready-to-hand not to emerge from its inconspicuousness, the world *must not announce itself*. And it is in this that the Being-in-itself of entities which are ready-to-hand has its phenomenal structure constituted.

In such private expressions as "inconspicuousness", "unobtrusiveness", and "non-obstinacy", what we have in view is a positive phenomenal character of the Being of that which is proximally ready-to-hand. With these negative prefixes we have in view the character of the ready-to-hand as "holding itself in"; this is what we have our eye upon in the "Being-in-itself" of something,[16] though 'proximally' we ascribe it to the present-at-hand—to the present-at-hand as that which can be thematically ascertained. As long as we take our orientation primarily and exclusively from the present-at-hand, the 'in-itself' can by no means be ontologically clarified. If, however, this talk about the 'in-itself' has any ontological importance, some interpretation must be called for. This "in-itself" of Being is something which gets invoked with considerable emphasis, mostly in an ontical way, and rightly so from a phenomenal standpoint. But if some *ontological* assertion is supposed to be given when this is *ontically* invoked, its claims are not fulfilled by such a procedure. As the foregoing analysis has already made clear, only on the basis of the phenomenon of the world can the Being-in-itself of entities within-the-world be grasped ontologically.

But if the world can, in a way, be lit up, it must assuredly be disclosed. And it has already been disclosed beforehand whenever what is ready-to-hand within-the-world is accessible for circumspective concern. The world is therefore something 'wherein' Dasein as an entity already *was*, and if in any manner it explicitly comes away from anything, it can never do more than come back to the world.

Being-in-the-world, according to our Interpretation hitherto, amounts to a non-thematic circumspective absorption in references or assignments constitutive for the readiness-to-hand of a totality of equipment. Any concern is already as it is, because of some familiarity with the world. In this familiarity Dasein can lose itself in what it encounters within-the-world and be fascinated with it. What is it that Dasein is familiar with? Why can the worldly character of what is within-the-world be lit up? The presence-at-hand[17] of entities is thrust to the fore by the possible breaks in that referential totality in which circumspection 'operates'; how are we to get a closer understanding of this totality?

. . .

¶ 44. Dasein, Disclosedness, and Truth

. . .

Our earlier analysis of the worldhood of the world and of entities within-the-world has shown, however, that the uncoveredness of entities within-the-world is *grounded* in the world's disclosedness. But disclosedness is that basic character of Dasein according to which it *is* its "there". Disclosedness is constituted by state-of-mind, understanding, and discourse, and pertains equiprimordially to the world, to Being-in, and to the Self. In its very structure, care is *ahead of itself*—Being already in a world—as Being alongside entities within-the-world; and in this structure the disclosedness of Dasein lies hidden. *With* and *through* it is uncoveredness;[18]

16. 'Diese "Un" meinen den Charakter des Ansichhaltens des Zuhandenen, das, was wir mit dem An-sich-sein im Auge haben...' The point seems to be that when we speak of something 'as it is "in itself" or "in its own right"', we think of it as 'holding itself in' or 'holding itself back'—not 'stepping forth' or doing something 'out of character'.

17. Here the older editions have 'Zuhandenheit' where the newer ones have 'Vorhandenheit'.

18. '*Mit* und *durch* sie ist Entdecktheit...' Our version reflects the ambiguity of the German, which leaves the grammatical function of the pronoun 'sie' obscure and permits it to refer either to 'the disclosedness of Dasein', to 'care', or—perhaps most likely—to 'the structure of care'.

hence only with Dasein's *disclosedness* is the *most primordial* phenomenon of truth attained. What we have pointed our earlier with regard to the existential Constitution of the "there" and in relation to the everyday Being of the "there", pertains to the most primordial phenomenon of truth, nothing less. In so far as Dasein is its disclosedness essentially, and discloses and uncovers as something disclosed to this extent it is essentially 'true'. *Dasein is 'in the truth'.* This assertion has meaning ontologically. It does not purport to say that ontically Dasein is introduced 'to all the truth' either always or just in every case, but rather that the disclosedness of its ownmost Being belongs to its existential constitution.

If we accept the results we have obtained earlier, the full existential meaning of the principle that 'Dasein is in the truth' can be restored by the following considerations:

(1) To Dasein's state of Being, *disclosedness in general* essentially belongs. It embraces the whole of that structure-of-Being which has become explicit through the phenomenon of care. To care belongs not only Being-in-the-world but also Being alongside entities within-the-world. The uncoveredness of such entities is equiprimordial with the Being of Dasein and its disclosedness.

(2) To Dasein's state of Being belongs *thrownness*; indeed it is constitutive for Dasein's disclosedness. In thrownness is revealed that in each case Dasein, as my Dasein and this Dasein, is already in a definite world and alongside a definite range of definite entities within-the-world.[19] Disclosedness is essentially factical.

(3) To Dasein's state of Being belongs *projection*—disclosive Being towards its potentiality-for-Being. As something that understands, Dasein *can* understand *itself* in terms of the 'world' and Others or in terms of its ownmost potentiality-for-Being.[20] The

possibility just mentioned means that Dasein discloses itself to itself in and as its ownmost potentiality-for-Being. This *authentic* disclosedness shows the phenomenon of the most primordial truth in the mode of authenticity. The most primordial, and indeed the most authentic, disclosedness in which Dasein, as a potentiality-for-Being, can be, is the *truth of existence*. This becomes existentially and ontologically definite only in connection with the analysis of Dasein's authenticity.

(4) To Dasein's state of Being belongs *falling*. Proximally and for the most part Dasein is lost in its 'world'. Its understanding, as a projection upon possibilities of Being, has diverted itself thither. Its absorption in the "they" signifies that it is dominated by the way things are publicly interpreted. That which has been uncovered and disclosed stands in a mode in which it has been disguised and closed off by idle talk, curiosity, and ambiguity. Being towards entities has not been extinguished, but it has been uprooted. Entities have not been completely hidden; they are precisely the sort of thing that has been uncovered, but at the same time they have been disguised. They show themselves, but in the mode of semblance. Likewise what has formerly been uncovered sinks back again, hidden and disguised. *Because Dasein is essentially falling, its state of Being is such that it is in 'untruth'.* This term, like the expression 'falling', is here used ontologically. If we are to use it in existential analysis, we must avoid giving it any ontically negative 'evaluation'. To be closed off and covered up belongs to Dasein's *facticity*. In its full existential-ontological meaning, the proposition that 'Dasein is in the truth' states equiprimordially that 'Dasein is in untruth'. But only in so far as Dasein has been disclosed has it also been closed off; and only in so far as entities within-the-world have been uncovered along with Dasein, have such entities, as possibly encounterable within-the-world, been covered up (hidden) or disguised.

It is therefore essential that Dasein should explicitly appropriate what has already been uncovered, defend it *against* semblance and disguise, and assure itself of its uncoveredness again and again. The uncovering of anything new is never done on the basis of having something completely hidden, but takes its departure rather from uncoveredness in the

19. 'In ihr enthüllt sich, dass Dasein je schon als meines und dieses in einer bestimmten Welt und bei einem bestimmten Umkreis von bestimmten innerweltlichen Seienden ist.'

20. '...der Entwurf: das erschliessende Sein zu seinem Seinkönnen. Dasein *kann sich* als verstehendes aus der "Welt" und den Anderen her verstehen oder aus seinem eigensten Seinkönnen.' The earlier editions have a full stop after '*Entwurf*' rather than a colon, and introduce 'das' with a capital. The grammatical function of 'als verstehendes' seems ambiguous.

mode of semblance. Entities look as if... That is, they have, in a certain way, been uncovered already, and yet they are still disguised.

Truth (uncoveredness) is something that must always first be wrested from entities. Entities get snatched our of their hiddenness. The factical uncoveredness of anything is always, as it were, a kind of *robbery*.

. . .

Our being alongside entities within-the-world is concern, and this is Being which uncovers. To Dasein's disclosedness, however, discourse belongs essentially. Dasein expresses itself [spricht sich aus]: it expresses *itself* as a Being-towards entities—a Being-towards which uncovers. And in assertion it expresses itself as such about entities which have been uncovered. Assertion communicates entities in the "how" of their uncoveredness. When Dasein is aware of the communication, it brings itself in its awareness into an uncovering Being-towards the entities discussed. The assertion which is expressed is about something, and in what it is about [in ihrem Worüber] it contains the uncoveredness of these entities. This uncoveredness is preserved in what is expressed. What is expressed becomes, as it were, something ready-to-hand within-the-world which can be taken up and spoken again.[21] Because the uncoveredness has been preserved, that which is expressed (which thus is ready-to-hand) has in itself a relation to any entities about which it is, an assertion. Any uncoveredness is an uncoveredness of something. Even when Dasein speaks over again what someone else has said, it comes into a Being-towards the very entities which have been discussed.[22] But it has been exempted from having to uncover them again, primordially, and it holds that it has thus been exempted.

Dasein need not bring itself face to face with entities themselves in an 'original' experience; but it nevertheless remains in a Being-towards these entities. In a large measure uncoveredness gets appropriated not by one's own uncovering, but rather by hearsay of something that has been said. Absorption in something that has been said belongs to the kind of Being which the "they" possesses. That which has been expressed as such takes over Being-towards those entities which have been uncovered in the assertion. If, however, these entities are to be appropriated explicitly with regard to their uncoveredness, this amounts to saying that the assertion is to be demonstrated as one that uncovers. But the assertion expressed is something ready-to-hand, and indeed in such a way that, as something by which uncoveredness is preserved, it has in itself a relation to the entities uncovered. Now to demonstrate that it is something which uncovers [ihres Entdeckend-seins] means to demonstrate how the assertion by which the uncoveredness is preserved is related *to* these entities. The assertion is something ready-to-hand. The entities to which it is related as something that uncovers, are either ready-to-hand or present-at-hand within-the-world. The relation itself presents itself thus, as one that is present-at-hand. But this relation lies in the fact that the uncoveredness preserved in the assertion is in each case an uncoveredness of something. The judgment 'contains something which holds for the objects' (Kant). But the relation itself now acquires the character of presence-at-hand by getting switched over to a relationship between things which are present-at-hand. The uncoveredness of something becomes the present-at-hand conformity of one thing which is present-at-hand—the assertion expressed—*to* something else which is present-at-hand—the entity under discussion. And if this conformity is seen only as a relationship between things which are present-at-hand—that is, if the kind of Being which belongs to the terms of this relationship has not been discriminated and is understood as something merely present-at-hand—then the relation shows itself as an agreement of two things which are present-at-hand, an agreement which is present-at-hand itself.

When the assertion has been expressed, the

21. 'Das Ausgesprochene wird gleichsam zu einem innerweltlich Zuhandenen, das aufgenommen und weitergesprochen werden kann.' While we have followed our ususal policy in translating 'das Ausgesprochene' as 'what is expressed', it might perhaps be translated as 'that which is spoken out', 'the utternace', or even 'the pronouncement'.

22. "Auch im Nachsprechen kommt das nachsprechende Dasein in ein Sein zum besprochenen Seienden selbst.'

uncoveredness of the entity moves into the kind of Being of that which is ready-to-hand within-the-world.[23] *But now to the extent that in this uncoveredness,* as an uncoveredness of something, *a relationship to something present-at-hand persists, the uncoveredness (truth) becomes, for its part, a relationship between things which are present-at-hand (intellectus and res)—a relationship that is present-at-hand itself.*

Though it is founded upon Dasein's disclosedness, the existential phenomenon of uncoveredness becomes a property which is present-at-hand but in which there still lurks a relational character; and as such a property, it gets broken asunder into a relationship which is present-at-hand. Truth as disclosedness and as a Being-towards uncovered entities—a Being which itself uncovers—has become truth as agreement between things which are present-at-hand within-the-world. And thus we have pointed out the ontologically derivative character of the traditional conception of truth.

. . .

Dasein, as constituted by disclosedness, is essentially in the truth. Disclosedness is a kind of Being which is essential to Dasein. *'There is' truth only in so far as Dasein is and so long as Dasein is.* Entities are uncovered only *when* Dasein *is*; and only as long as Dasein *is*, are they disclosed. Newton's laws, the principle of contradiction, any truth whatever—these are true only as long as Dasein *is*. Before there was any Dasein, there was no truth; nor will there be any after Dasein is no more. For in such a case truth as disclosedness, uncovering, and uncoveredness, *cannot* be. Before Newton's laws were discovered, they were not 'true'; it does not follow that they were false, or even that they would become false if ontically no discoveredness were any longer possible. Just as little does this 'restriction' imply that the Being-true of 'truths' has in any way been diminished.

To say that before Newton his laws were neither true nor false, cannot signify that before him there were no such entities as have been uncovered and

pointed out by those laws. Through Newton the laws became true; and with them, entities became accessible in themselves to Dasein. Once entities have been uncovered, they show themselves precisely as entities which beforehand already were. Such uncovering is the kind of Being which belongs to 'truth'.

That there are 'eternal truths' will not be adequately proved until someone has succeeded in demonstrating that Dasein has been and will be for all eternity. As long as such a proof is still outstanding, this principle remains a fanciful contention which does not gain in legitimacy from having philosophers commonly 'believe' it.

Because the kind of Being that is essential to truth is of the character of Dasein, all truth is relative to Dasein's Being. Does this relativity signify that all truth is 'subjective'? If one Interprets 'subjective' as 'left to the subject's discretion', then it certainly does not. For uncovering, in the sense which is most its own, takes asserting out of the province of 'subjective' discretion, and brings the uncovering Dasein face to face with the entities themselves. And only *because* 'truth', as uncovering, *is a kind of Being which belongs to Dasein*, can it be taken out of the province of *Dasein's* discretion. Even the 'universal validity' of truth is rooted solely in the fact that Dasein can uncover entities in themselves and free them. Only so can these entities in themselves be binding for every possible assertion—that is, for every way of pointing them out.[24] If truth has been correctly understood, is it in the least impaired by the fact that it is ontically possible only in the 'subject' and that it stands and falls with the Being of that 'subject'?

Now that we have an existential conception of the kind of Being that belongs to truth, the meaning of "presupposing the truth" also becomes intelligible. *Why must we presuppose that there is truth?* What is 'presupposing'? What do we have in mind with the 'must' and the 'we'? What does it mean to say 'there is truth'? 'We' presuppose truth because 'we', being in the kind of Being which Dasein possesses, *are* 'in

23. '*Die Entdecktheit des Seienden rückt mit der Ausgesprochenheit der Aussage in die Seinsart des innerweltlich Zuhandenen.*'

24. 'Auch die "Allgemeingültigkeit" der Wahrheit ist lediglich verwurzelt, dass das Dasein Seiendes an ihm selbst entdecken und freigeben kann. Nur so vermag dieses Seiende an ihm selbst jede mögliche Aussage, das heisst Aufzeigung seiner, zu binden.'

the truth'. We do not presuppose it as something 'outside' us and 'above' us, towards which, along with other 'values', we comport ourselves. It is not we who presuppose 'truth'; but it is *'truth'* that makes it at all possible ontologically for us to be able to be such that we 'presuppose' anything at all. Truth is what first *makes possible* anything like presupposing.

What does it mean to 'presuppose'? It is to understand something as the ground for Being of some other entity. Such understanding of an entity in its interconnections of Being, is possible only on the ground of disclosedness—that is, on the ground of Dasein's Being something which uncovers. Thus to presuppose 'truth' means to understand it as something for the sake of which Dasein is. But Dasein is already ahead of itself in each case; this is implied in its state-of-Being as care. It is an entity for which, in its Being, its ownmost potentiality-for-Being is an issue. To Dasein's Being and its potentiality-for-Being as Being-in-the-world, disclosedness and uncovering belong essentially. To Dasein its potentiality-for-Being-in-the-world is an issue, and this includes[25] concerning itself with entities within-the-world and uncovering them circumspectively. In Dasein's state-of-Being as care, in Being-ahead-of-itself, lies the most primordial 'presupposing'. *Because this presupposing of itself belongs to Dasein's Being, 'we' must also presuppose 'ourselves' as having the attribute of disclosedness.* There are also entities with a character other than that of Dasein, but the 'presupposing' which lies in Dasein's Being does not relate itself to these; it relates itself solely to Dasein itself. The truth which has been presupposed, or the 'there is' by which its Being is to be defined, has that kind of Being—or meaning of Being—which belongs to Dasein itself. We must 'make' the presupposition of truth because it *is* one that has been 'made' already with the Being of the 'we'.

We *must* presuppose the truth. Dasein itself, as in each case my Dasein and this Dasein, *must* be; and in the same way the truth, as Dasein's disclosedness, *must be*. This belongs to Dasein's essential thrownness into the world. *Has Dasein as itself ever decided freely whether it wants to come into 'Dasein' or not, and will it ever be able to make such a decision?* 'In itself' it is quite incomprehensible why entities are to be *uncovered*, why *truth* and *Dasein* must be. The usual refutation of that scepticism which denies either the Being of 'truth' or its cognizability, stops half way. What it shows, as a formal argument, is simply that if anything gets judged, truth has been presupposed. This suggests that 'truth' belongs to assertion—that pointing something out is, by its very meaning, an uncovering. But when one says this, *one has to clarify* why that in which there lies the ontological ground for this necessary connection between assertion and truth as regards their Being, must be as it is. The kind of Being which belongs to truth is likewise left completely obscure, and so is the meaning of presupposing, and that of its ontological foundation in Dasein itself. Moreover, one here fails to recognize that even when nobody *judges*, truth already gets presupposed in so far as Dasein is at all.

A sceptic can no more be refuted than the Being of truth can be 'proved'. And if any sceptic of the kind who denies the truth, factically *is*, he does not even need to be refuted. In so far as he *is*, and has understood himself in this Being, he has obliterated Dasein in the desperation of suicide; and in doing so, he has also obliterated truth. Because Dasein, for its own part, cannot first be subjected to proof, the necessity of truth cannot be proved either. It has no more been demonstrated that there ever has 'been' an 'actual' sceptic[26] (though this is what has at bottom been believed in the refutations of scepticism, in spite of what these undertake to do) than it has been demonstrated that there are any 'eternal truths'. But perhaps such sceptics have been more frequent than one would innocently like to have true when one tries to bowl over 'scepticism' by formal dialectics.

Thus with the question of the Being of truth and the necessity of presupposing it, just as with the question of the essence of knowledge, an 'ideal subject' has generally been posited. The motive for this, whether explicit or tacit, lies in the requirement that

25. Reading 'und darin' with the newer editions. The older editions have 'd.h. u.a.'

26. '...dass es je...einen "wirklichen" Skeptiker "gegeben" hat.' The older editions have 'nie' ('never') instead of 'je' ('ever').

philosophy should have the '*a priori*' as its theme, rather than 'empirical facts' as such. There is some justification for this requirement, though it still needs to be grounded ontologically. Yet is this requirement satisfied by positing an 'ideal subject'? Is not such a subject a *fanciful idealization*? With such a conception have we not missed precisely the *a priori* character of the factical subject, Dasein? Is it not an attribute of the *a priori* character of the factical subject (that is, an attribute of Dasein's facticity) that it is in the truth and in untruth equiprimordially?

The ideas of a 'pure "I"' and of a 'consciousness in general' are so far from including the *a priori* character of 'actual' subjectivity that the ontological characters of Dasein's facticity and its state of Being are either passed over or not seen at all. Rejection of a 'consciousness in general' does not signify that the *a priori* is negated, any more than the positing of an idealized subject guarantees that Dasein has an *a priori* character grounded upon fact.

Both the contention that there are 'eternal truths' and the jumbling together of Dasein's phenomenally grounded 'ideality' with an idealized absolute subject, belong to those residues of Christian theology within philosophical problematics which have not as yet been radically extruded.

The Being of truth is connected primordially with Dasein. And only because Dasein is as constituted by disclosedness (that is, by understanding), can anything like Being be understood; only so is it possible to understand Being.

Being (not entities) is something which 'there is' only in so far as truth is. And truth *is* only in so far as and as long as Dasein is. Being and truth 'are' equiprimordially. What does it signify that Being 'is', where Being is to be distinguished from every entity? One can ask this concretely only if the mean-ing of Being and the full scope of the understanding of Being have in general been clarified. Only then can one also analyse primordially what belongs to the concept of a science *of Being as such*, and to its possibilities and its variations. And in demarcating this research and its truth, the kind of research in which *entities* are uncovered, and its accompanying truth, must be defined ontologically.

The answer to the question of the meaning of Being has yet to be given [steht...aus]. What has our fundamental analysis of Dasein, as we have carried it out so far, contributed to working out this question? By laying bare the phenomenon of care, we have clarified the state of Being of that entity to whose Being something like an understanding of Being belongs. At the same time the Being of Dasein has thus been distinguished from modes of Being (readiness-to-hand, presence-at-hand, Reality) which characterize entities with a character other than that of Dasein. Understanding has itself been elucidated; and at the same time the methodological transparency of the procedure of Interpreting Being by understanding it and interpreting it, has thus been guaranteed.

If in care we have arrived at Dasein's primordial state of Being, then this must also be the basis for conceptualizing that understanding of Being which lies in care; that is to say, it must be possible to define the meaning of Being. But *is* the phenomenon of care one in which the most primordial existential-ontological state of Dasein is disclosed? And has the structural manifoldness which lies in this phenomenon, presented us with the most primordial totality of factical Dasein's Being? Has our investigation up to this point ever brought Dasein into view *as a whole*?

Selections from

The Origin of the Work of Art

Translated by Albert Hofstadter

Thing and Work

. . .

That the thingness of the thing is particularly difficult to express and only seldom expressible is infallibly documented by the history of its interpretation indicated above. This history coincides with the destiny in accordance with which Western thought has hitherto thought the Being of beings. However, not only do we now establish this point; at the same time we discover a clue in this history. Is it an accident that in the interpretation of the thing the view that takes matter and form as guide attains to special dominance? This definition of the thing derives from an interpretation of the equipmental being of equipment. And equipment, having come into being through human making, is particularly familiar to human thinking. At the same time, this familiar being has a peculiar intermediate position between thing and work. We shall follow this clue and search first for the equipmental character of equipment. Perhaps this will suggest something to us about the thingly character of the thing and the workly character of the work. We must only avoid making thing and work prematurely into subspecies of equipment. We are disregarding the possibility, however, that differences relating to the history of Being may yet also be present in the way equipment *is*.

But what path leads to the equipmental quality of equipment? How shall we discover what a piece of equipment truly is? The procedure necessary at present must plainly avoid any attempts that again immediately entail the encroachments of the usual interpretations. We are most easily insured against this if we simply describe some equipment without any philosophical theory.

We choose as example a common sort of equipment—a pair of peasant shoes. We do not even need to exhibit actual pieces of this sort of useful article in order to describe them. Everyone is acquainted with them. But since it is a matter here of direct description, it may be well to facilitate the visual realization of them. For this purpose a pictorial representation suffices. We shall choose a well-known painting by Van Gogh, who painted such shoes several times. But what is there to see here? Everyone knows what shoes consist of. If they are not wooden or bast shoes, there will be leather soles and uppers, joined together by thread and nails. Such gear serves to clothe the feet. Depending on the use to which the shoes are to be put, whether for work in the field or for dancing, matter and form will differ.

Such statements, no doubt correct, only explicate what we already know. The equipmental quality of equipment consists in its usefulness. But what about this usefulness itself? In conceiving it, do we already conceive along with it the equipmental character of equipment? In order to succeed in doing this, must we not look out for useful equipment in its use? The peasant woman wears her shoes in the field. Only here are they what they are. They are all the more genuinely so, the less the peasant woman thinks about the shoes while she is at work, or looks at them at all, or is even aware of them. She stands and walks in them. That is how shoes actually serve. It is in this process of the use of equipment that we must actually encounter the character of equipment.

As long as we only imagine a pair of shoes in general, or simply look at the empty, unused shoes as they merely stand there in the picture, we shall never discover what the equipmental being of the equipment in truth is. From Van Gogh's painting we cannot even tell where these shoes stand. There is nothing

surrounding this pair of peasant shoes in or to which they might belong—only an undefined space. There are not even clods of soil from the field or the field-path sticking to them, which would at least hint at their use. A pair of peasant shoes and nothing more. And yet—

From the dark opening of the worn insides of the shoes the toilsome tread of the worker stares forth. In the stiffly rugged heaviness of the shoes there is the accumulated tenacity of her slow trudge through the far-spreading and ever-uniform furrows of the field swept by a raw wind. On the leather lie the dampness and richness of the soil. Under the soles slides the lonliness of the field-path as evening falls. In the shoes vibrates the silent call of the earth, its quiet gift of the ripening grain and its unexplained self-refusal in the fallow desolation of the wintry field. This equipment is pervaded by uncomplaining anxiety as to the certainty of bread, the wordless joy of having once more withstood want, the trembling before the impending childbed and shivering at the surrounding menace of death. This equipment belongs to the *earth*, and it is protected in the *world* of the peasant woman. From out of this protected belonging the equipment itself rises to its resting-within-itself.

But perhaps it is only in the picture that we notice all this about the shoes. The peasant woman, on the other hand, simply wears them. If only this simple wearing were so simple. When she takes off her shoes late in the evening, in deep but healthy fatigue, and reaches out for them again in the still dim dawn, or passes them by on the day of rest, she knows all this without noticing or reflecting. The equipmental quality of the equipment consists indeed in its usefulness. But this usefulness itself rests in the abundance of an essential being of the equipment. We call it reliability. By virtue of this reliability the peasant woman is made privy to the silent call of the earth; by virtue of the reliability of the equipment she is sure of her world. World and earth exist for her, and for those who are with her in her mode of being, only thus—in the equipment. We say "only" and therewith fall into error; for the reliability of the equipment first gives to the simple world its security and assures to the earth the freedom of its steady thrust.

The equipmental being of equipment, reliability, keeps gathered within itself all things according to their manner and extent. The usefulness of equipment is nevertheless only the essential consequence of reliability. The former vibrates in the latter and would be nothing without it. A single piece of equipment is worn out and used up; but at the same time the use itself also falls into disuse, wears away, and becomes usual. Thus equipmentality wastes away, sinks deeper into mere stuff. In such wasting, reliability vanishes. This dwindling, however, to which use-things owe their boringly obtrusive usualness, is only one more testimony to the original nature of equipmental being. The worn-out usualness of the equipment then obtrudes itself as the sole mode of being, apparently peculiar to it exclusively. Only blank usefulness now remains visible. It awakens the impression that the origin of equipment lies in a mere fabrication that impresses a form upon some matter. Nevertheless, in its genuinely equipmental being, equipment stems from a more distant source. Matter and form and their distinction have a deeper origin.

The repose of equipment resting within itself consists in its reliability. Only in this reliability do we discern what equipment in truth is. But we still know nothing of what we first sought: the thing's thingly character. And we know nothing at all of what we really and solely seek: the workly character of the work in the sense of the work of art.

Or have we already learned something unwittingly, in passing so to speak, about the work-being of the work?

The equipmental quality of equipment was discovered. But how? Not by a description and explanation of a pair of shoes actually present; not by a report about the process of making shoes; and also not by the observation of the actual use of shoes occurring here and there; but only by bringing ourselves before Van Gogh's painting. This painting spoke. In the vicinity of the work we were suddenly somewhere else than we usually tend to be.

The art work lets us know what shoes are in truth. It would be the worst self-decption to think that our description, as a subjective action, had first depicted everything thus and then projected it into the painting. If anything is questionable here, it is rather

that we experienced too little in the neighbourhood of the work and that we expressed the experience too crudely and too literally. But above all, the work did not, as it might seem at first, serve merely for a better visualizing of what a piece of equipment is. Rather, the equipmentality of equipment first genuinely arrives at its appearance through the work and only in the work.

What happens here? What is at work in the work? Van Gogh's painting is the disclosure of what the equipment, the pair of peasant shoes, *is* in truth. This entity emerges into the unconcealedness of its being. The Greeks called the unconcealedness of beings *aletheia*. We say "truth" and think little enough in using this word. If there occurs in the work a disclosure of a particular being, disclosing what and how it is, then there is here an occurring, a happening of truth at work.

In the work of art the truth of an entity has set itself to work. "To set" means here: to bring to a stand. Some particular entity, a pair of peasant shoes, comes in the work to stand in the light of its being. The being of the being comes into the steadiness of its shining.

The nature of art would then be this: the truth of beings setting itself to work. But until now art presumably has had to do with the beautiful and beauty, and not with truth. The arts that produce such works are called the beautiful or fine arts, in contrast with the applied or industrial arts that manufacture equipment. In fine art the art itself is not beautiful, but is called so because it produces the beautiful. Truth, in contrast, belongs to logic. Beauty, however, is reserved for aesthetics.

But perhaps the proposition that art is truth setting itself to work intends to revive the fortunately obsolete view that art is an imitation and depiction of reality? The reproduction of what exists requires, to be sure, agreement with the actual being, adaptation to it; the Middle Ages called it *adaequatio*; Aristotle already spoke of *homoiosis*. Agreement with what *is* has long been taken to be the essence of truth. But then, is it our opinion that this painting by Van Gogh depicts a pair of actually existing peasant shoes, and is a work of art because it does so successfully? Is it our opinion that the painting draws a likeness

from something actual and transposes it into a product of artistic—production? By no means.

The work, therefore, is not the reproduction of some particular entity that happens to be present at any given time; it is, on the contrary, the reproduction of the thing's general essence. But then where and how is this general essence, so that art works are able to agree with it? With what nature of what thing should a Greek temple agree? Who could maintain the impossible view that the Idea of Temple is represented in the building? And yet, truth is set to work in such a work, if it is a work. Or let us think of Hölderlin's hymn, "The Rhine." What is pregiven to the poet, and how is it given, so that it can then be regiven in the poem? And if in the case of this hymn and similar poems the idea of a copy-relation between something already actual and the art work clearly fails, the view that the work is a copy is confirmed in the best possible way by a work of the kind presented in C. F. Meyer's poem "Roman Fountain."

> *Roman Fountain*
> The jet ascends and falling fills
> The marble basin circling round;
> This, veiling itself over, spills
> Into a second basin's ground.
> The second in such plenty lives,
> Its bubbling flood a third invests,
> And each at once receives and gives
> And streams and rests.

This is neither a poetic painting of a fountain actually present nor a reproduction of the general essence of a Roman fountain. Yet truth is put into the work. What truth is happening in the work? Can truth happen at all and thus be historical? Yet truth, people say, is something timeless and supertemporal.

We seek the reality of the art work in order to find there the art prevailing within it. The thingly substructure is what proved to be the most immediate reality in the work. But to comprehend this thingly feature the traditional thing-concepts are not adequate; for they themselves fail to grasp the nature of the thing. The currently predominant thing-concept, thing as formed matter, is not even derived from the nature of the thing but from the nature of equipment. It also

turned out that equipmental being generally has long since occupied a peculiar preeminence in the interpretation of beings. This preeminence of equipmentality, which however did not actually come to mind, suggested that we pose the question of equipment anew while avoiding the current interpretations.

We allowed a work to tell us what equipment is. By this means, almost clandestinely, it came to light what is at work in the work: the disclosure of the particular being in its being, the happening of truth. If, however, the reality of the work can be defined solely by means of what is at work in the work, then what about our intention to seek out the real art work in its reality? As long as we supposed that the reality of the work lay primarily in its thingly substructure we were going astray. We are now confronted by a remarkable result of our considerations—if if still deserves to be called a result at all. Two points become clear:

First: the dominant thing-concepts are inadequate as means of grasping the thingly aspect of the work.

Second: what we tried to treat as the most immediate reality of the work, its thingly substructure, does not belong to the work in that way at all.

As soon as we look for such a thingly substructure in the work, we have unwittingly taken the work as equipment, to which we then also ascribe a superstructure supposed to contain its artistic quality. But the work is not a piece of equipment that is fitted out in addition with an aesthetic value that adheres to it. The work is no more anything of the kind than the bare thing is a piece of equipment that merely lacks the specific equipmental characteristics of usefulness and being made.

Our formulation of the question of the work has been shaken because we asked, not about the work but half about a thing and half about equipment. Still, this formulation of the question was not first developed by us. It is the formulation native to aesthetics. The way in which aesthetics views the art work from the outset is dominated by the traditional interpretation of all beings. But the shaking of this accustomed formulation is not the essential point. What matters is a first opening of our vision to the fact that what is workly in the work, equipmental in

equipment, and thingly in the thing comes closer to us only when we think the Being of beings. To this end it is necessary beforehand that the barriers of our preconceptions fall away and that the current pseudo concepts be set aside. That is why we had to take this detour. But it brings us directly to a road that may lead to a determination of the thingly feature in the work. The thingly feature in the work should not be denied; but if it belongs admittedly to the work-being of the work, it must be conceived by way of the work's workly nature. If this is so, then the road toward the determination of the thingly reality of the work leads not from thing to work but from work to thing.

The art opens up in its own way the Being of beings. This opening up, i.e., this deconcealing, i.e., the truth of beings, happens in the work. In the art work, the truth of what is has set itself to work. Art is truth setting itself to work. What is truth itself, that it sometimes comes to pass as art? What is this setting-itself-to-work?

The Work and Truth

. . .

Truth happens in Van Gogh's painting. This does not mean that something is correctly protrayed, but rather that in the revelation of the equipmental being of the shoes, that which is as a whole—world and earth in their counterplay—attains to unconcealedness.

Thus in the work it is truth, not only something true, that is at work. The picture that shows the peasant shoes, the poem that says the Roman fountain, do not just make manifest what this isolated being as such is—if indeed they manifest anything at all; rather, they make unconcealedness as such happen in regard to what is as a whole. The more simply and authentically the shoes are engrossed in their nature, the more plainly and purely the fountain is engrossed in their nature—the more directly and engagingly do all beings attain to a greater degree of being along with them. That is how self-concealing being is illuminated. Light of this kind joins its shining to and into the work. This shining, joined in the work, is the beautiful. *Beauty is one way in which truth occurs as unconcealedness.*

We now, indeed, grasp the nature of truth more clearly in certain respects. What is at work in the work may accordingly have become more clear. But the work's now visible work-being still does not tell us anything about the work's closest and most obtrusive reality, about the thingly aspect of the work. Indeed it almost seems as though, in pursuing the exclusive aim of grasping the work's independence as purely as possible, we had completely overlooked the one thing, that a work is always a work, which means that it is something worked out, brought about, effected. If there is anything that distinguishes the work as work, it is that the work has been created. Since the work is created, and creation requires a medium out of which and in which it creates, the thingly element, too, enters the work. This is incontestable. Still the question remains: how does being created belong to the work? This can be elucidated only if two points are cleared up:

1. What do being created and creation mean here in distinction from making and being made?

2. What is the inmost nature of the work itself, from which alone can be gauged how far createdness belongs to the work and how far it determines the work-being o the work?

Creation is here always thought of in reference to the work. To the nature of the work there belongs the happening of truth. From the outset we define the nature of creating by its relation to the nature of truth as the unconcealedness of beings. The pertinence of createdness to the work can be elucidated only by way of a more fundamental clarification of the nature of truth. The question of truth and its nature returns again.

We must raise that question once more, if the proposition that truth is at work in the work is not to remain a mere assertion.

We must now first ask in a more essential way: how does the impulse toward such a thing as a work lie in the nature of truth? Of what nature is truth, that it can be set into work, or even under certain conditions must be set into work, in order to be *as* truth? But we defined the setting-into-a-work of truth as the nature of art. Hence our last question becomes:

What is truth, that it can happen as, or even must happen as, art? How is it that art exists at all?

Truth and Art

Art is the origin of the art work and of the artist. Origin is the source of the nature in which the being of an entity is present. What is art? We seek its nature in the actual work. The actual reality of the work has been defined by that which is at work in the work, by the happening of truth. This happening we think of as the fighting of the conflict between world and earth. Repose occurs in the concentrated agitation of this conflict. The independence or self-composure of the work is grounded here.

In the work, the happening of truth is at work. But what is thus at work, is so *in* the work. This means that the actual work is here already presupposed as the bearer of this happening. At once the problem of the thingly feature of the given work confronts us again. One thing thus finally becomes clear: however zealously we inquire into the work's self-sufficiency, we shall still fail to find its actuality as long as we do not also agree to take the work as something worked, effected. To take it thus lies closest at hand, for in the word "work" we hear what is worked. The workly character of the work consists in its having been created by the artist. It may seem curious that this most obvious and all-clarifying definition of the work is mentioned only now.

The work's createdness, however, can obviously be grasped only in terms of the process of creation. Thus, constrained by the facts, we must consent after all to go into the activity of the artist in order to arrive at the origin of the work of art. The attempt to define the work-being of the work purely in terms of the work itself proves to be unfeasible.

In turning away now from the work to examine the nature of the creative process, we should like nevertheless to keep in mind what was said first of the picture of the peasant shoes and later of the Greek temple.

We think of creation as a bringing forth. But the making of equipment, too, is a bringing forth. Handicraft—a remarkable play of language—does not, to be sure, create works, not even when we contrast, as we must, the handmade with the factory product. But what is it that distinguishes bringing forth as creation from bringing forth in the mode of making? It is as difficult to track down the essential features

of the creation of works and the making of equipment as it is easy to distinguish verbally between the two modes of bringing forth. Going along with the first appearances we find the same procedure in the activity of potter and sculptor, of joiner and painter. The creation of a work requires craftmanship. Great artists prize craftmanship most highly. They are the first to call for its painstaking cultivation, based on complete mastery. They above all others constantly strive to educate themselves ever anew in thorough craftmanship. It has often been pointed out that the Greeks, who knew quite a bit about works of art, use the same word *techne* for craft and art and call the craftsman and the artist by the same name: *technites*.

It thus seems advisable to define the nature of creative work in terms of its craft aspect. But reference to the linguistic usage of the Greeks, with their experience of the facts, must give us pause. However usual and convincing the reference may be to the Greek practice of naming craft and art by the same name, *techne*, it nevertheless remains oblique and superficial; for *techne* signifies neither craft not art, and not at all the technical in our present-day sense; it never means a kind of practical performance.

The word *techne* denotes rather a mode of knowing. To know means to have seen, in the widest sense of seeing, which means to apprehend what is present, as such. For Greek thought the nature of knowing consists in *aletheia*, that is, the uncovering of beings. It supports and guides all comportment toward beings. *Techne*, as knowledge experienced in the Greek manner, is a bringing forth of beings in that it *brings forth* present beings as such beings *out of* concealedness and specifically *into* the unconcealedness of their appearance; *techne* never signifies the action of making.

The artist is a *technites* not because he is also a craftsman, but because both the setting forth of works and the setting forth of equipment occur in a bringing forth and presenting that causes beings in the first place to come forward and be present in assuming an appearance. Yet all this happens in the midst of the being that grows out of its own accord, *phusis*. Calling art *techne* does not at all imply that the artist's action is seen in the light of craft. What looks like craft in the creation of a work is of a different sort. This doing is determined and pervaded by the nature of creation, and indeed remains contained within that creating.

What then, if not craft, is to guide our thinking about the nature of creation? What else than a view of what is to be created: the work? Although it becomes actual only as the creative act is performed, and thus depends for its reality upon this act, the nature of creation is determined by the nature of the work. Even though the work's createdness has a relation to creation, nevertheless both createdness and creation must be defined in terms of the work-being of the work. And now it can no longer seem strange that we first and at length dealt with the work alone, to bring its createdness into view only at the end. If createdness belongs to the work as essentially as the word "work" makes it sound, then we must try to understand even more essentially what so far could be defined as the work-being of the work.

In the light of the definition of the work we have reached at this point, according to which the happening of truth is at work in the work, we are able to characterize creation as follows: to create is to cause something to emerge as a thing that has been brought forth. The work's becoming a work is a way in which truth becomes and happens. It all rests on the nature of truth. But what is truth, that it has to happen in such a thing as something created? How does truth have an impulse toward a work grounded in its very nature? Is this intelligible in terms of the nature of truth as thus far elucidated?

. . .

The readiness of equipment and the createdness of the work agree in this, that in each case something is produced. But in contrast to all other modes of production, the work is distinguished by being created so that its createdness is part of the created work. But does not this hold true for everything brought forth, indeed for anything that has in any way come to be? Everything brought forth surely has this endowment of having been brought forth, if it has any endowment at all. Certainly. But in the work, createdness is expressly created into the created

being, so that it stands out from it, from the being thus brought forth, in an expressly particular way. If this is how matters stand, then we must also be able to discover and experience the createdness explicitly in the work.

The emergence of createdness from the work does not mean that the work is to give the impression of having been made by a great artist. The point is not that the created being be certified as the performance of a capable person, so that the producer is thereby brought to public notice. It is not the "N. N. fecit" that is to be made known. Rather, the simple "factum est" is to be held forth into the Open by the work: namely this, that unconcealedness of what is happened here, and that as this happening it happens here for the first time; or, that such a work *is* at all rather than is not. The thrust that the work as this work is, and the uninterruptedness of this plain thrust, constitute the steadfastness of the work's self-subsistence. Precisely where the artist and the process and the circumstances of the genesis of the work remain unknown, this thrust, this "*that* it is" of createdness, emerges into view most purely from the work.

To be sure, "that" it is made is a property also of all equipment that is available and in use. But this "that" does not become prominent in the equipment; it disappears in usefulness. The more handy a piece of equipment is, the more inconspicuous it remains that, for example, such a hammer is and the more exclusively does the equipment keep itself in its equipmentality. In general, of everything present to us, we can note that it *is*; but this also, if it is noted at all, is noted only soon to fall into oblivion, as is the wont of everything commonplace. And what is more commonplace than this, that a being is? In a work, by contrast, this fact, that it *is* as a work, is just what is unusual. The event of its being created does not simply reverberate through the work; rather, the work casts before itself the eventful fact that the work is as this work, and it has constantly this fact about itself. The more essentially the work opens itself, the more luminous becomes the uniqueness of the fact that it is rather than is not. The more essentially this thrust comes into the Open, the stronger and more solitary the work becomes. In the bring-

ing forth of the work there lies this offering "that it be."

The question of the work's createdness ought to have brought us nearer to its workly character and therewith to its reality. Createdness revealed itself as the conflict's being fixed in place in the figure by means of the rift. Createdness here is itself expressly created into the work and stands as the silent thrust into the Open of the "that." But the work's reality does not exhaust itself even in createdness. However, this view of the nature of the work's createdness now enables us to take the step toward which everything thus far said tends.

The more solitarily the work, fixed in the figure, stands on its own and the more cleanly it seems to cut all ties to human beings, the more simply does the thrust come into the Open that such a work *is*, and the more essentially is the extraordinary thrust to the surface and the long-familiar thrust down. But this multiple thrusting is nothing violent, for the more purely the work is itself transported into the openness of beings—an openness opened by itself—the more simply does it transport us into this openness and thus at the same time transport us out of the realm of the ordinary. To submit to this displacement means: to transform our accustomed ties to world and to earth and henceforth to restrain all usual doing and prizing, knowing and looking, in order to stay within the truth that is happening in the work. Only the restraint of this staying lets what is created be the work that it is. This letting the work be a work we call the preserving of the work. It is only for such preserving that the work yields itself in its createdness as actual, i.e., now: present in the manner of a work.

Just as a work cannot be without being created but is essentially in need of creators, so what is created cannot itself come into being without those who preserve it.

However, if a work does not find preservers, does not at once find them such as respond to the truth happening in the work, this does not at all mean that the work may also be a work without preservers. Being a work, it always remains tied to preservers, even and particularly when it is still only waiting for preservers and only pleads and waits for them to

enter into its truth. Even the oblivion into which the work can sink is not nothing; it is still a preservation. It feeds on the work. Preserving the work means: standing within the openness of beings that happens in the work. This "standing-within" of preservation, however, is a knowing. Yet knowing does not consist in mere information and notions about something. He who truly knows what is, knows what he wills to do in the midst of what is.

The willing here referred to, which neither merely applies knowledge nor decides beforehand, is thought of in terms of the basic experience of thinking in *Being and Time*. Knowing that remains a willing, and willing that remains a knowing, is the existing human being's entrance into and compliance with the unconcealedness of Being. The resoluteness intended in *Being and Time* is not the deliberate action of a subject, but the opening up of human being, out of its captivity in that which is, to the openness of Being.[1] However, in existence, man does not proceed from some inside to some outside; rather, the nature of *Existenz* is out-standing standing-within the essential sunderance of the clearing of beings. Neither in the creation mentioned before nor in the willing mentioned now do we think of the performance or act of a subject striving toward himself as his self-set goal.

Willing is the sober resolution of that existential self-transcendence which exposes itself to the openness of beings as it is set into the work. In this way, standing-within is brought under law. Preserving the work, as knowing, is a sober standing-within the extraordinary awesomeness of the truth that is happening in the work.

This knowledge, which as a willing makes its home in the work's truth and only thus remains a knowing, does not deprive the work of its independence, does not drag it into the sphere of mere experience, and does not degrade it to the role of a stimulator of experience. Preserving the work does not reduce people to their private experiences, but brings them into affiliation with the truth happening in the work. Thus it grounds being for and with one another as the historical standing-out of human existence in reference to unconcealedness. Most of all, knowledge in the manner of preserving is far removed from that merely aestheticizing connoisseurship of work's formal aspects, its qualities and charms. Knowing as having seen is a being resolved; it is standing within the conflict that the work has fitted into the rift.

The proper way to preserve the work is cocreated and prescribed only and exclusively by the work. Preserving occurs at different levels of knowledge, with always differing degrees of scope, constancy, and lucidity. When works are offered for merely artistic enjoyment, this does not yet prove that they stand in preservation as works.

As soon as the thrust into the extraordinary is parried and captured by the sphere of familiarity and connoisseurship, the art business has begun. Even a painstaking handing on of works to posterity, all scientific efforts to regain them, no longer reach the work's own being, but only a recollection of it. But even this recollection may still offer to the work a place from which it joins in shaping history. The work's own peculiar reality, on the other hand, is brought to bear only where the work is preserved in the truth that happens by the work itself.

The work's reality is determined in its basic features by the nature of the work's being. We can now return to our opening question: how do matters stand with the work's thingly feature that is to guarantee its immediate reality? They stand so that now we no longer raise this question about the work's thingly element; for as long as we ask it, we take the work directly and as a foregone conclusion, as an object that is simply there. In that way we never question in terms of the work, but in our own terms. In our terms—we, who then do not let the work be a work but view it as an object that is supposed to produce this or that state of mind in us.

But what looks like the thingly element, in the sense of our usual thing-concepts, in the work taken as object, is, seen from the perspective of the work, its earthy character. The earth juts up within the work because the work exists as something in which truth is at work and because truth occurs only by installing itself within a particular being. In the earth, however, as essentially self-closing, the openness of the Open finds the greatest resistance (to the Open)

1. The word for resoluteness, *Entschlossenheit*, if taken literally, would mean "unclosedness."—Tr.

and thereby the site of the Open's constant stand, where the figure must be fixed in place.

Was it then superfluous, after all, to enter into the question of the thingly character of the thing? By no means. To be sure, the work's work-character cannot be defined in terms of its thingly character, but as against that the question about the thing's thingly character can be brought into the right course by way of a knowledge of the work's work-character. This is no small matter, if we recollect that those ancient, traditional modes of thought attack the thing's thingly character and make it subject to an interpretation of what is as a whole, which remains unfit to apprehend the nature of equipment and of the work, and which makes us equally blind to the original nature of truth.

To determine the thing's thingness neither consideration of the bearer of properties is adequate, nor that of the manifold of sense data in their unity, and least of all that of the matter-form structure regarded by itself, which is derived from equipment. Anticipating a meaningful and weighty interpretation of the thingly character of things, we must aim at the thing's belonging to the earth. The nature of the earth, in its free and unhurried bearing and self-closure, reveals itself, however, only in the earth's jutting into a world, in the opposition of the two. This conflict is fixed in place in the figure of the work and becomes manifest by it. What holds true of equipment—namely that we come to know its equipmental character specifically only through the work itself—also holds of the thingly character of the thing. The fact that we never know thingness directly, and if we know it at all, then only vaguely and thus require the work—this fact proves indirectly that in the work's work-being the happening of truth, the opening up or disclosure of what is, is at work.

But, we might finally object, if the work is indeed to bring thingness cogently into the Open, must it not then itself—and indeed before its own creation and for the sake of its creation—have been brought into a relation with the things of earth, with nature? Someone who was bound to know what he was talking about, Albrecht Dürer, did after all make the well-known remark: "For in truth, art lies hidden within nature; he who can wrest it from her, has it."

"Wrest" here means to draw out the rift and to draw the design with the drawing-pen on the drawing-board.[2] But we at once raise the counterquestion: how can the rift-design be drawn out if it is not brought into the Open by the creative sketch as a rift, which is to say, brought out beforehand as a conflict of measure and unmeasure? True, there lies hidden in nature a rift-design, a measure and a boundary and, tied to it, a capacity for bringing forth—that is, art. But it is equally certain that this art hidden in nature becomes manifest only through the work, because it lies originally in the work.

The trouble we are taking over the reality of the work is intended as spadework for discovering art and the nature of art in the actual work. The question concerning the nature of art, the way toward knowledge of it, is first to be placed on a firm ground again. The answer to the question, like every genuine answer, is only the final result of the last step in a long series of questions. Each answer remains in force as an answer only as long as it is rooted in questioning.

The reality of the work has become not only clearer for us in the light of its work-being, but also essentially richer. The preservers of a work belong to its createdness with an essentiality equal to that of the creators. But it is the work that makes the creators possible in their nature, and that by its own nature is in need of preservers. If art is the origin of the work, this means that art lets those who naturally belong together at work, the creator and the preserver, originate, each in his own nature. What, however, is art itself that we call it rightly an origin?

In the work, the happening of truth is at work and, indeed, at work according to the manner of a work. Accordingly the nature of art was defined to begin with as the setting-into-work of truth. Yet this definition is intentionally ambiguous. It says on the one hand: art is the fixing in place of a self-establishing truth in the figure. This happens in creation as the bringing forth of the unconcealedness of what is. Setting-into-work, however, also means: the bringing of work-being into movement and happening. This happens as preservation. Thus art is: the

2. "Reissen heisst hier Herausholen des Risses und den Riss reissen mit der Reissfeder auf dem Reissbrett."

creative preserving of truth in the work. *Art then is the becoming and happening of truth*. Does truth, then, arise out of nothing? It does indeed if by nothing is meant the mere not of that which is, and if we here think of that which is as an object present in the ordinary way, which thereafter comes to light and is challenged by the existence of the work as only presumptively a true being. Truth is never gathered from objects that are present and ordinary. Rather, the opening up of the Open, and the clearing of what is, happens only as the openness is projected, sketched out, that makes its advent in thrownness.[3]

. . .

3. Thrownness, *Geworfenheit*, is understood in *Being and Time* as an existential characteristic of *Dasein*, human being, its thatness, its "that it is," and it refers to the facticity of human being's being handed over to itself, its being on its own responsibility; as long as human being is what it is, it is thrown, cast, "*im Wurf.*" Projection, *Entwurf*, on the other hand, is a second existential character of human being, referring to its driving forward toward its own possibility of being. It takes the form of understanding, which the author speaks of as the mode of human bieng in which being *is* in its possibilities *as* possibilities. It is not the mere having of a preconceived plan, but is the projecting of possibility in human being that occurs antecedently to all plans and makes planning possible. Human being is both thrown and projected; it is thrown project, factical directedness toward possibilities of being.—Tr.

Hans-Georg Gadamer (1900-)

The Universality of the Hermeneutical Problem

Translated by David E. Linge

Why has the problem of language come to occupy the same central position in current philosophical discussions that the concept of thought, or "thought thinking itself," held in philosophy a century and a half ago? By answering this question, I shall try to give an answer indirectly to the central question of the modern age—a question posed for us by the existence of modern science. It is the question of how our natural view of the world—the experience of the world that we have as we simply live out our lives—is related to the unassailable and anonymous authority that confronts us in the pronouncements of science. Since the seventeenth century, the real task of philosophy has been to mediate this new employment of man's cognitive and constructive capacities with the totality of our experience of life. This task has found expression in a variety of ways, including our own generation's attempt to bring the topic of language to the center of philosophical concern. Language is the fundamental mode of operation of our being-in-the-world and the all-embracing form of the constitution of the world. Hence we always have in view the pronouncements of the sciences, which are fixed in nonverbal signs. And our task is to reconnect the objective world of technology, which the sciences place at our disposal and discretion, with those fundamental orders of our being that are neither arbitrary nor manipulable by us, but rather simply demand our respect.

I want to elucidate several phenomena in which the universality of this question becomes evident. I have called the point of view involved in this theme "hermeneutical," a term developed by Heidegger. Heidegger was continuing a perspective stemming originally from Protestant theology and transmitted into our own century by Wilhelm Dilthey.

What is hermeneutics? I would like to start from two experiences of alienation that we encounter in our concrete existence: the experience of alienation of the aesthetic consciousness and the experience of alienation of the historical consciousness. In both cases what I mean can be stated in a few words. The aesthetic consciousness realizes a possibility that as such we can neither deny nor diminish in its value, namely, that we relate ourselves, either negatively or affirmatively, to the quality of an artistic form. This statement means we are related in such a way that the judgement we make decides in the end regarding the expressive power and validity of what we judge. What we reject has nothing to say to us— or we reject it because it has nothing to say to us. This characterizes our relation to art in the broadest sense of the word, a sense that, as Hegel has shown, includes the entire religious world of the ancient Greeks, whose religion of beauty experienced the divine in concrete works of art that man creates in response to the gods. When it loses its original and unquestioned authority, this whole world of experience becomes alienated into an object of aesthetic judgment. At the same time, however, we must admit that the world of artistic tradition—the splendid contemporaneousness that we gain through art with so many human worlds—is more than a mere object of our free acceptance or rejection. Is it not true that when a work of art has seized us it no longer leaves us the freedom to push it away from us once again and to accept or reject it on our own terms? And is it not also true that these artistic creations, which come down through the millennia, were not created for such aesthetic acceptance or rejection? No artist of the religiously vital cultures of the past ever produced his work of art with any other intention than that his creation

should be received in terms of what it says and presents and that it should have its place in the world where men live together. The consciousness of art—the aesthetic consciousness—is always secondary to the immediate truth-claim that proceeds from the work of art itself. To this extent, when we judge a work of art on the basis of its aesthetic quality, something that is really much more intimately familiar to us is alienated. This alienation into aesthetic judgment always takes place when we have withdrawn ourselves and are no longer open to the immediate claim of that which grasps us. Thus one point of departure for my reflections in *Truth and Method* was that the aesthetic sovereignty that claims its rights in the experience of art represents an alienation when compared to the authentic experience that confronts us in the form of art itself.

About thirty years ago, this problem cropped up in a particularly distorted form when National Socialist politics of art, as a means to its own ends, tried to criticize formalism by arguing that art is bound to a people. Despite its misuse by the National Socialists, we cannot deny that the idea of art being bound to a people involves a real insight. A genuine artistic creation stands within a particular community, and such a community is always distinguishable from the cultured society that is informed and terrorized by art criticism.

The second mode of the experience of alienation is the historical consciousness—the noble and slowly perfected art of holding ourselves at a critical distance in dealing with witnesses to past life. Ranke's celebrated description of this idea as the extinguishing of the individual provided a popular formula for the ideal of historical thinking: the historical consciousness has the task of understanding all the witnesses of a past time out of the spirit of that time, of extricating them from the preoccupations of our own present life, and of knowing, without moral smugness, the past as a human phenomenon. In his well-known essay *The Use and Abuse of History*, Nietzsche formulated the contradiction between this historical distancing and the immediate will to shape things that always cleaves to the present. And at the same time he exposed many of the consequences of what he called the "Alexandrian," weakened form of the will, which is found in modern historical science. We might recall his indictment of the weakness of evaluation that has befallen the modern mind because it has become so accustomed to considering things in ever different and changing lights that it is blinded and incapable of arriving at an opinion of its own regarding the objects it studies. It is unable to determine its own position vis-à-vis what confronts it. Nietzsche traces the value-blindness of historical objectivism back to the conflict between the alienated historical world and the life-powers of the present.

To be sure, Nietzsche is an ecstatic witness. But our actual experience of the historical consciousness in the last one hundred years has taught us most emphatically that there are serious difficulties involved in its claim to historical objectivity. Even in those masterworks of historical scholarship that seem to be the very consummation of the extinguishing of the individual demanded by Ranke, it is still an unquestioned principle of our scientific experience that we can classify these works with unfailing accuracy in terms of the political tendencies of the time in which they were written. When we read Mommsen's *History of Rome*, we know who alone could have written it, that is, we can identify the political situation in which this historian organized the voices of the past in a meaningful way. We know it too in the case of Treitschke or of Sybel, to choose only a few prominent names from Prussian historiography. This clearly means, first of all, that the whole reality of historical experience does not find expression in the mastery of historical method. No one disputes the fact that controlling the prejudices of our own present to such an extent that we do not misunderstand the witnesses of the past is a valid aim, but obviously such control does not completely fulfill the task of understanding the past and its transmissions. Indeed, it could very well be that only *insignificant* things in historical scholarship permit us to approximate this ideal of totally extinguishing individuality, while the great productive achievements of scholarship always preserve something of the splendid magic of immediately mirroring the present in the past and the past in the present. Historical science, the second experience from which I begin, expresses only one part of our actual experience—our actual encounter with historical tradition—and it knows

only an alienated form of this historical tradition.

We can contrast the hermeneutical consciousness with these examples of alienation as a more comprehensive possibility that we must develop. But, in the case of this hermeneutical consciousness also, our initial task must be to overcome the epistemological truncation by which the traditional "science of hermeneutics" has been absorbed into the idea of modern science. If we consider Schleiermacher's hermeneutics, for instance, we find his view of this discipline peculiarly restricted by the modern idea of science. Schleiermacher's hermeneutics shows him to be a leading voice of historical romanticism. But at the same time, he kept the concern of the Christian theologian clearly in mind, intending his hermeneutics, as a general doctrine of the art of understanding, to be of value in the special work of interpreting Scripture. Schleiermacher defined hermeneutics as the art of avoiding misunderstanding. To exclude by controlled, methodical consideration whatever is alien and leads to misunderstanding—misunderstanding suggested to us by distance in time, change in linguistic usages, or in the meanings of words and modes of thinking—that is certainly far from an absurd description of the hermeneutical endeavor. But the question also arises as to whether the phenomenon of understanding is defined appropriately when we say that to understand is to avoid misunderstanding. Is it not, in fact, the case that every misunderstanding presupposes a "deep common accord"?

I am trying to call attention here to a common experience. We say, for instance, that understanding and misunderstanding take place between I and thou. But the formulation "I and thou" already betrays an enormous alienation. There is nothing like an "I and thou" at all—there is neither the I nor the thou as isolated, substantial realities. I may say "thou" and I may refer to myself over against a thou, but a common understanding [Verständigung] always precedes these situations. We all know that to say "thou" to someone presupposes a deep common accord [tiefes Einverständnis]. Something endured is already present when this word is spoken. When we try to reach agreement on a matter on which we have different opinions, this deeper factor always comes into play, even if we are seldom aware of it.

Now the science of hermeneutics would have us believe that the opinion we have to understand is something alien that seeks to lure us into misunderstanding, and our task is to exclude every element through which a misunderstanding can creep in. We accomplish this task by a controlled procedure of historical training, by historical criticism, and by a controllable method in connection with powers of psychological empathy. It seems to me that this description is valid in one respect, but yet it is only a partial description of a comprehensive life-phenomenon that constitutes the "we" that we all are. Our task, it seems to me, is to transcend the prejudices that underlie the aesthetic consciousness, the historical consciousness, and the hermeneutical consciousness that has been restricted to a technique for avoiding misunderstandings and to overcome the alienations present in them all.

What is it, then, in these three experiences that seemed to us to have been left out, and what makes us so sensitive to the distinctiveness of these experiences? What is the *aesthetic* consciousness when compared to the fullness of what has already addressed us—what we call "classical" in art? Is it not always already determined in this way what will be expressive for us and what we will find significant? Whenever we say with an instinctive, even if perhaps erroneous, certainty (but a certainty that is initially valid for our consciousness) "this is classical; it will endure," what we are speaking of has already performed our possibility for aesthetic judgment. There are no purely formal criteria that can claim to judge and sanction the formative level simply on the basis of its artistic virtuosity. Rather, our sensitive-spiritual existence is an aesthetic resonance chamber that resonates with the voices that are constantly reaching us, preceding all explicit aesthetic judgment.

The situation is similar with the historical consciousness. Here, too, we must certainly admit that there are innumerable tasks of historical scholarship that have no relation to our own present and to the depths of its historical consciousness. But it seems to me there can be no doubt that the great horizon of the past, out of which our culture and our present live, influences us in everything we want, hope for, or fear in the future. History is only present

to us in the light of our futurity. Here we have all learned from Heidegger, for he exhibited precisely the primacy of futurity for our possible recollection and retention, and for the whole of our history.

Heidegger worked out this primacy in his doctrine of the productivity of the hermeneutical circle. I have given the following formulation to this insight: It is not so much our judgments as it is our prejudices that constitute our being.[1] This is a provocative formulation, for I am using it to restore to its rightful place a positive concept of prejudice that was driven out of our linguistic usage by the French and the English Enlightenment. It can be shown that the concept prejudice did not originally have the meaning we have attached to it. Prejudices are not necessarily unjustified and erroneous, so that they inevitably distort the truth. In fact, the historicity of our existence entails that prejudices, in the literal sense of the word, constitute the initial directedness of our whole ability to experience. Prejudices are biases of our openness to the world. They are simply conditions whereby we experience something—whereby what we encounter says something to us. This formulation certainly does not mean that we are enclosed within a wall of prejudices and only let through the narrow portals those things that can produce a pass saying, "Nothing new will be said here." Instead we welcome just that guest who promises something new to our curiosity. But how do we know the guest whom we admit is one who has something *new* to say to us? Is not our expectation and our readiness to hear the new also necessarily determined by the old that has already taken possession of us? The concept of prejudice is closely connected to the concept of authority, and the above image makes it clear that it is in need of hermeneutical rehabilitation. Like every image, however, this one too is misleading. The nature of the hermeneutical experience is not that something is outside and desires admission. Rather, we are possessed by something and precisely by means of it we are opened up for the new, the different, the true. Plato made this clear in his beautiful comparison of bodily foods with spiritual nourishment: while we can refuse the former (e.g., on the advice of a physician),

we have always taken the latter into ourselves already.

But now the question arises as to how we can legitimate this hermeneutical conditionedness of our being in the face of modern science, which stands or falls with the principle of being unbiased and prejudiceless. We will certainly not accomplish this legitimation by making prescriptions for science and recommending that it toe the line—quite aside from the fact that such pronouncements always have something comical about them. Science will not always do us this favor. It will continue along its own path with an inner necessity beyond its control, and it will produce more and more breathtaking knowledge and controlling power. It can be no other way. It is senseless, for instance, to hinder a genetic researcher because such research threatens to breed a superman. Hence the problem cannot appear as one in which our human consciousness ranges itself over against the world of science and presumes to develop a kind of antiscience. Nevertheless, we cannot avoid the question of whether what we are aware of in such apparently harmless examples as the aesthetic consciousness and the historical consciousness does not represent a problem that is also present in modern natural science and our technological attitude toward the world. If modern science enables us to erect a new world of technological purposes that transforms everything around us, we are not thereby suggesting that the researcher who gained the knowledge decisive for this state of affairs even considered technical applications. The genuine researcher is motivated by a desire for knowledge and by nothing else. And yet, over against the whole of our civilization that is founded on modern science, we must ask repeatedly if something has not been omitted. If the presuppositions of these possibilities for knowing and making remain half in the dark, cannot the result be that the hand applying this knowledge will be destructive?

The problem is really universal. The hermeneutical question, as I have characterized it, is not restricted to the areas from which I began in my own investigations. My only concern there was to secure a theoretical basis that would enable us to deal with the basic factor of contemporary culture, namely,

1. Cf. [Hans-Georg Gadamer, *Wahreit und Methode.* Türbingen: Mohr, 1960] p. 261.

science and its industrial, technological utilization. Statistics provide us with a useful example of how the hermeneutical dimension encompasses the entire procedure of science. It is an extreme example, but it shows us that science always stands under definite conditions of methodological abstraction and that the successes of modern sciences rest on the fact that other possibilities for questioning are concealed by abstraction. This fact comes out clearly in the case of statistics, for the anticipatory character of the questions statistics answer make it particularly suitable for propaganda purposes. Indeed, effective propaganda must always try to influence initially the judgment of the person addressed and to restrict his possibilities of judgment. Thus what is established by statistics seems to be a language of facts, but which questions these facts answer and which facts would begin to speak if other questions were asked are hermeneutical questions. Only a hermeneutical inquiry would legitimate the meaning of these facts and thus the consequences that follow from them.

But I am anticipating, and have inadvertently used the phrase, "which answers to which questions fit the facts." This phrase is in fact the hermeneutical *Urphänomen*: No assertion is possible that cannot be understood as an answer to a question, and assertions can only be understood in this way. It does not impair the impressive methodology of modern science in the least. Whoever wants to learn science has to learn to master its methodology. But we also know that methodology as such does not guarantee in any way the productivity of its application. Any experience of life can confirm the fact that there is such a thing as methodological sterility, that is, the application of a method to something not really worth knowing, to something that has not been made an object of investigation on the basis of a genuine question.

The methodological self-consciousness of modern science certainly stands in opposition to this argument. A historian, for example, will say in reply: It is all very nice to talk about the historical tradition in which alone the voices of the past gain their meaning and through which the prejudices that determine the present are inspired. But the situation is completely different in questions of serious historical research. How could one seriously mean, for example, that the clarification of the taxation practices of fifteenth-century cities or of the marital customs of Eskimos somehow first receive their meaning from the consciousness of the present and its anticipations? These are questions of historical knowledge that we take up as tasks quite independently of any relation to the present.

In answering to this objection, one can say that the extremity of this point of view would be similar to what we find in certain large industrial research facilities, above all in America and Russia. I mean the so-called random experiment in which one simply covers the material without concern for waste or cost, taking the chance that some day one measurement among the thousands of measurements will finally yield an interesting finding; that is, it will turn out to be the answer to a question from which someone can progress. No doubt modern research in the humanities also works this way to some extent. One thinks, for instance, of the great editions and especially of the ever more perfect indexes. It must remain an open question, of course, whether by such procedures modern historical research increases the chances of actually noticing the interesting fact and thus gaining from it the corresponding enrichment of our knowledge. But even if they do, one might ask: Is this an ideal, that countless research projects (i.e., determinations of the connection of facts) are extracted from a thousand historians, so that the 1001st historian can find something interesting? Of course I am drawing a caricature of genuine scholarship. But in every caricature there is an element of truth, and this one contains an indirect answer to the question of what it is that really makes the productive scholar. That he has learned the methods? The person who never produces anything new has also done that. It is imagination [*Phantasie*] that is the decisive function of the scholar. Imagination naturally has a hermeneutical function and serves the sense for what is questionable. It serves the ability to expose real, productive questions, something in which, generally speaking, only he who masters all the methods of his sciences succeeds.

As a student of Plato, I particularly love those

scenes in which Socrates gets into a dispute with the Sophist virtuosi and drives them to despair by his questions. Eventually they can endure his questions no longer and claim for themselves the apparently preferable role of the questioner. And what happens? They can think of nothing at all to ask. Nothing at all occurs to them that is worth while going into and trying to answer.

I draw the following inference from this observation. The real power of hermeneutical consciousness is our ability to see what is questionable. Now if what we have before our eyes is not only the artistic tradition of a people, or historical tradition, or the principle of modern science in its hermeneutical preconditions but rather the whole of our experience, then we have succeeded, I think, in joining the experience of science to our own universal and human experience of life. For we have now reached the fundamental level that we can call (with Johannes Lohmann) the "linguistic constitution of the world."[2] It presents itself as the consciousness that is effected by history [wirkungsgeschichtliches Bewusstsein] and that provides an initial schematization for all our possibilities of knowing. I leave out of account the fact that the scholar—even the natural scientist—is perhaps not completely free of custom and society and from all possible factors in his environment. What I mean is that precisely *within* his scientific experience it is not so much the "laws of ironclad inference" (Helmholz) that present fruitful ideas to him, but rather unforeseen constellations that kindle the spark of scientific inspiration (e.g., Newton's falling apple or some other incidental observation).

The consciousness that is effected by history has its fulfillment in what is linguistic. We can learn from the sensitive student of language that language, in its life and occurrence, must not be thought of as merely changing, but rather as something that has a teleology operating within it. This means that the words that are formed, the means of expression that appear in a language in order to say certain things, are not accidentally fixed, since they do not once again fall altogether into disuse. Instead, a definite articulation of the world is built up—a process that

works as if guided and one that we can always observe in children who are learning to speak.

We can illustrate this by considering a passage in Aristotle's *Posterior Analytics* that ingeniously describes one definite aspect of language formation.[3] The passage treats what Aristotle calls the *epagoge*, that is, the formation of the universal. How does one arrive at a universal? In philosophy we say: how do we arrive at a general concept, but even words in this sense are obviously general. How does it happen that they are "words," that is, that they have a general meaning? In his first apperception, a sensuously equipped being finds himself in a surging sea of stimuli, and finally one day he begins, as we say, to know something. Clearly we do not mean that he was previously blind. Rather, when we say "to know" [erkennen] we mean "to recognize" [wiedererkennen], that is, to pick something out [herauserkennen] of the stream of images flowing past as being identical. What is picked out in this fashion is clearly retained. But how? When does a child know its mother for the first time? When it sees her for the first time? No. Then when? How does it take place? Can we really say at all that there is a single event in which a first knowing extricates the child from the darkness of not knowing? It seems obvious to me that we cannot. Aristotle has described this wonderfully. He says it is the same as when an army is in flight, driven by panic, until at last someone stops and looks around to see whether the foe is still dangerously close behind. We cannot say that the army stops when one soldier has stopped. But then another stops. The army does not stop by virtue of the fact that two soldiers stop. When does it actually stop, then? Suddenly it stands its ground again. Suddenly it obeys the command once again. A subtle pun is involved in Aristotle's description, for in Greek "command" means *arche*, that is, *principium*. When is the principle present as a principle? Through what capacity? This question is in fact the question of the occurrence of the universal.

If I have not misunderstood Johannes Lohmann's exposition, precisely this same technology operates constantly in the life of language. When Lohmann speaks of linguistic tendencies as the real agents of

2. Cf. Johannes Lohmann, *Philosophie und Sprachwissenschaft* (Berlin: Duncker & Humbolt, 1963).

3. Aristotle, *Posterior Analytics*, 100a 11-13.

history in which specific forms expand, he knows of course that it occurs in these forms of realization, of "coming to a stand" [*Zum-Stehen-Kommen*], as the beautiful German word says. What is manifest here, I contend, is the real mode of operation of our whole human experience of the world. Learning to speak is surely a phase of special productivity, and in the course of time we have all transformed the genius of the three-year-old into a poor and meager talent. But in the utilization of the linguistic interpretation of the world that finally comes about, something of the productivity of our beginnings remains alive. We are all acquainted with this, for instance, in the attempt to translate, in practical life or in literature or wherever; that is, we are familiar with the strange, uncomfortable, and tortuous feeling we have as long as we do not have the right word. When we have found the right expression (it need not always be one word), when we are certain that we have it, then it "stands," then something has come to a "stand." Once again we have a halt in the midst of the rush of the foreign language, whose endless variation makes us lose our orientation. What I am describing is the mode of the whole human experience of the world. I call this experience hermeneutical, for the process we are describing is repeated continually throughout our familiar experience. There is always a world already interpreted, already organized in its basic relations, into which experience steps as something new, upsetting what has led our expectations and undergoing reorganization itself in the upheaval. Misunderstanding and strangeness are not the first factors, so that avoiding misunderstanding can be regarded as the specific task of hermeneutics. Just the reverse is the case. Only the support of familiar and common understanding makes possible the venture into the alien, the lifting up of something out of the alien, and thus the broadening and enrichment of our own experience of the world.

This discussion shows how the claim to universality that is appropriate to the hermeneutical dimension is to be understood. Understanding is language-bound. But this assertion does not lead us into any kind of linguistic relativism. It is indeed true that we live within a language, but language is not a system of signals that we send off with the aid of a telegraphic key when we enter the office or transmission station. That is not speaking, for it does not have the infinity of the act that is linguistically creative and world experiencing. While we live wholly within a language, the fact that we do so does not constitute linguistic relativism because there is absolutely no captivity within a language—not even within our native language. We all experience this when we learn a foreign language, especially on journeys insofar as we master the foreign language to some extent. To master the foreign language means precisely that when we engage in speaking it in the foreign land, we do not constantly consult inwardly our own world and its vocabulary. The better we know the language, the less such a side glance at our native language is perceptible, and only because we never know foreign languages well enough do we always have something of this feeling. But it is nevertheless already speaking, even if perhaps a stammering speaking, for stammering is the obstruction of a desire to speak and is thus opened into the infinite realm of possible expression. Any language in which we live is infinite in this sense, and it is completely mistaken to infer that reason is fragmented because there are various languages. Just the opposite is the case. Precisely through our finitude, the particularity of our being, which is evident even in the variety of languages, the infinite dialogue is opened in the direction of the truth that we are.

If this is correct, then the relation of our modern industrial world, founded by science, which we described at the outset, is mirrored above all on the level of language. We live in an epoch in which an increasing leveling of all life-forms is taking place— that is the rationally necessary requirement for maintaining life on our planet. The food problem of mankind, for example, can only be overcome by the surrender of the lavish wastefulness that has covered the earth. Unavoidably, the mechanical, industrial world is expanding within the life of the individual as a sort of sphere of technical perfection. When we hear modern lovers talking to each other, we often wonder if they are communicating with words or with advertising labels and technical terms from the sign language of the modern industrial world. It

is inevitable that the leveled life-forms of the industrial age also affect language, and in fact the impoverishment of the vocabulary of language is making enormous progress, thus bringing about an approximation of language to a technical sign-system. Leveling tendencies of this kind are irresistible. Yet in spite of them the simultaneous building up of our own world in language still persists whenever we want to say something to each other. The result is the actual relationship of men to each other. Each one is at first a kind of linguistic circle, and these linguistic circles come into contact with each other, merging more and more. Language occurs once again, in vocabulary and grammar as always, and never without the inner infinity of the dialogue that is in progress between every speaker and his partner. That is the fundamental dimension of hermeneutics. Genuine speaking, which has something to say and hence does not give prearranged signals, but rather seeks words through which one reaches the other person, is the universal human task —but it is a special task for the theologian, to whom is commissioned the saying-further (*Weitersagen*) of a message that stands written.

Paul Ricoeur (1913-)

The Hermeneutical Function of Distanciation

Translated by John B. Thompson

In previous studies, I have described the background against which I shall try to elaborate the hermeneutical problem in a way that will be significant for the dialogue between hermeneutics and the semiological and exegetical disciplines. The description has led us to an antinomy which seems to me to be the mainspring of Gadamer's work, namely the opposition between alienating distanciation and belonging. This opposition is an antinomy because it establishes an untenable alternative: on the one hand, alienating distanciation is the attitude that renders possible the objectification which reigns in the human sciences; but on the other hand, this distanciation, which is the condition of the scientific status of the sciences, is at the same time the fall that destroys the fundamental and primordial relation whereby we belong to and participate in the historical reality which we claim to construct as an object. Whence the alternative underlying the very title of Gadamer's work *Truth and Method*: either we adopt the methodological attitude and lose the ontological density of the reality we study, or we adopt the attitude of truth and must then renounce the objectivity of the human sciences.

My own reflection stems from a rejection of this alternative and an attempt to overcome it. The first expression of this attempt consists in the choice of a dominant problematic which seems to me to escape from the alternative between alienating distanciation and participatory belonging. The dominant problematic is that of the text, which reintroduces a positive and, if I may say so, productive notion of distanciation. In my view, the text is much more than a particular case of intersubjective communication: it is the paradigm of distanciation in communication. As such, it displays a fundamental characteristic of the very

historicity of human experience, namely that it is communication in and through distance.

In what follows, I shall elaborate the notion of the text in view of that to which it testifies, the positive and productive function of distanciation at the heart of the historicity of human experience. I propose to organise this problematic around five themes: (1) the realisation of language as *discourse*; (2) the realisation of discourse as a *structured work*; (3) the relation of *speaking to writing* in discourse and in the works of discourse; (4) the work of discourse as the *projection of a world*; (5) discourse and the work of discourse as the *mediation of self-understanding*. Taken together, these features constitute the criteria of textuality.

We shall see that the question of writing, when placed at the centre of this network of criteria, in no way constitutes the unique problematic of the text. The text cannot, therefore, be purely and simply identified with writing. There are several reasons for this. First, it is not writing as such which gives rise to the hermeneutical problem, but the dialectic of speaking and writing. Second, this dialectic is constructed upon a dialectic of distanciation which is more primitive than the opposition of writing to speaking and which is already part of oral discourse *qua* discourse; we must therefore search in discourse itself for the roots of all subsequent dialectics. Finally, between the realisation of language as discourse and the dialectic of speaking and writing, it seems necessary to insert the fundamental notion of the realisation of discourse as a structured work. It seems to me that the objectification of language in works of discourse constitutes the proximate condition of the inscription of discourse in writing; literature consists of written works, hence above all of

works. But that is not all: the triad discourse-work-writing still only constitutes the tripod which supports the decisive problematic, that of the projection of a world, which I shall call the world of the work, and where I see the centre of gravity of the hermeneutical question. The whole preliminary discussion will serve only to prepare the way for the displacement of the problem of the text towards that of the *world* which it opens up. At the same time, the question of self-understanding, which had occupied the foreground in Romantic hermeneutics, is postponed until the end, appearing as a terminal point and not as an introductory theme or even less as the centre of gravity.

I. The realisation of language as discourse

Discourse, even in an oral form, displays a primitive type of distanciation which is the condition of possibility of all the characteristics we shall consider later. This primitive type of distanciation can be discussed under the heading of the dialectic of event and meaning.

Discourse is given as an event: something happens when someone speaks. The notion of discourse as event is essential when we take into consideration the passage from a linguistics of language or codes to a linguistics of discourse or messages. The distinction comes, as we know, from Ferdinand de Saussure[1] and Louis Hjelmslev;[2] the first distinguished 'language' [*langue*] and 'speech' [*parole*], the second 'schema' and 'use'. The theory of discourse draws all the epistemological consequences of this duality. Whereas structural linguistics simply places speech and use in parentheses, the theory of discourse removes the parentheses and proclaims the existence of two linguistics resting upon different principles. The French linguist Emile Benveniste[3]

has gone the furthest in this direction. For him, the linguistics of discourse and the linguistics of language are constructed upon different units. If the 'sign' (phonological and lexical) is the basic unit of language, the 'sentence' is the basic unit of discourse. The linguistics of the sentence underlies the dialectic of event and meaning, which forms the starting point for our theory of the text.

What are we to understand by 'event'? To say that discourse is an event is to say, first, that discourse is realised temporally and in the present, whereas the system of language is virtual and outside of time. In this sense, we can speak with Benveniste of the 'instance of discourse', in order to designate the emergence of discourse itself as an event. Moreover, whereas language has no subject insofar as the question 'who speaks?' does not apply at this level, discourse refers back to its speaker by means of a complex set of indicators, such as personal pronouns. We can say, in this sense, that the instance of discourse is self-referential. The eventful character is now linked to the person who speaks; the event consists in the fact that someone speaks, someone expresses himself in taking up speech. Discourse is an event in yet a third way: the signs of language refer only to other signs in the interior of the same system so that language no more has a world than it has a time and a subject, whereas discourse is always about something. Discourse refers to a world which it claims to describe, express or represent. The event, in this third sense, is the advent of a world in language [*langage*] by means of a discourse. Finally, while language is only a prior condition of communication for which it provides the codes, it is in discourse that all messages are exchanged. So discourse not only has a world, but it has an other, another person, an interlocutor to whom it is addressed. The event, in this last sense, is the temporal phenomenon of exchange, the establishment of a dialogue which can be started, continued or interrupted. All of these features, taken together, constitute discourse as an event. It is notable that they appear only in the realisation of language in discourse, in the actualisation of our linguistic competence in performance.

However, in thus accentuating the eventful character of discourse, we have brought out only one of

1. Ferdinande de Saussure, *Cours de linguistique générale* (Paris: Edition critique T. de Mauro, 1973), pp. 30ff., 36ff., 112, 227 [English translation: *Course in General Linguistics*, translated by Wade Baskin (London: Fontana/Collins, 1974), pp. 13ff., 16ff., 77, 165].

2. Louis Hjelmslev, *Essais linguistiques* (Copenhague: Cercle linguistique de Copenhague, 1959).

3. Emile Benveniste, *Problèmes de linguistique générale* (Paris: Gallimard, 1966) [English translation: *Problems in General Linguistics*, translated by Mary Elizabeth Meek (Florida: University of Miami Press, 1971)].

the two constitutive poles of discourse. Now we must clarify the second pole, that of meaning, For it is the tension between the two poles which gives rise to the production of discourse as a work, the dialectic of speaking and writing, and all the other features of the text which enrich the notion of distanciation.

In order to introduce the dialectic of event and meaning, I propose to say that, if all discourse is realised as an event, all discourse is understood as meaning. What we wish to understand is not the fleeting event, but rather the meaning which endures. This point demands the greatest clarification, for it may seem that we are reverting from the linguistics of discourse to the linguistics of language. But that is not so; it is in the linguistics of discourse that event and meaning are articulated. This articulation is the core of the whole hermeneutical problem. Just as language, by being actualised in discourse, surpasses itself as system and realises itself as event, so too discourse, by entering the process of understanding, surpasses itself as event and becomes meaning. The surpassing of the event by the meaning is characteristic of discourse as such. It attests to the very intentionality of language, to the relation within the latter of the *noema* and the *noesis*. If language is a meinen, a meaningful intention, it is precisely in virtue of the surpassing of the event by the meaning. The very first distanciation is thus the distanciation of the saying in the said.

But what is said? To clarify more completely this problem, hermeneutics must appeal not only to linguistics—even when this is understood as the linguistics of discourse as opposed to the linguistic of language—but also to the theory of *speech-acts*, as found in the work of Austin[4] and Searle.[5] According to these authors, the act of discourse is constituted by a hierarchy of subordinate acts distributed on three levels: (1) the level of the locutionary or propositional act, the act of saying; (2) the level of the illocutionary act (or force), what we do in saying; (3) the level of the perlocutionary act, what we do

by the fact that we speak. If I tell you to close the door, I do three things. First, I relate the action predicate (to close) to two variables (you and the door): this is the act of saying. Second, I tell you this with the force of an order rather than a statement, wish or promise: this is the illocutionary act. Finally, I can provoke certain consequences, such as fear, by the fact that I give you an order; hence discourse is a sort of stimulus which produces certain results: this is the perlocutionary act.

What are the implications of these distinctions for our problem of the intentional exteriorisation by which the event is surpassed in the meaning? The locutionary act is exteriorised in the sentence *qua* proposition. For it is as such and such proposition that the sentence can be identified and reidentified as the *same*. A sentence thus appears as an utterance (*Aus-sage*), capable of being conveyed to others with such and such a meaning. What is identified is the predicative structure itself, as the above example reveals. An action sentence can be identified, therefore, by its specific predicate (the action) and by its two variables (the agent and the object). The illocutionary act can also be exteriorised by means of grammatical paradigms (the moods: indicative, imperative, etc.) and other procedures which 'mark' the illocutionary force of a sentence and thus enable it to be identified and reidentified. It is true that, in oral discourse, the illocutionary force can be identified by gestures and gesticulations as well as by properly linguistic features; it is also true that the least articulated aspects of discourse, the aspects we call prosody, provide the most compelling indices. Nevertheless, the properly syntactic marks constitute a system of inscription which makes possible in principle the fixation by writing of these indications of illocutionary force. It must be conceded that the perlocutionary act, being primarily a characteristic of oral discourse, is the least inscribable element. But the perlocutionary action is also the least discursive aspect of discourse: it is discourse *qua* stimulus. Here discourse operates, not through the recognition of my intention by the interlocutor, but in an energetic mode, as it were, by direct influence upon the emotions and affective attitudes of the interlocutor. Thus the propositional

4. J. L. Austin, *How to do Things with Words* (Oxford: Oxford University Press, 1962).

5. John R. Searle, *Speech Acts: An Essay in the Philosophy of Language* (Cambridge: Cambridge University Press, 1969).

act, the illocutionary force and the perlocutionary action are susceptible, in decreasing degrees, to the intentional exteriorisation which renders inscription by writing possible.

Thus, by the meaning of the act of discourse, or the *noema* of the *saying*, we must understand not only the correlate of the sentence, in the narrow sense of the propositional act, but also the correlate of the illocutionary force and even that of the perlocutionary action, insofar as these three aspects of the act of discourse are codified and regulated according to paradigms, and hence insofar as they can be identified and reidentified as having the same meaning. I therefore give the word 'meaning' a very broad connotation that covers all the aspects and levels of the *intentional exteriorisation* which, in turn, renders possible the exteriorisation of discourse in writing and in the work.

II. Discourse as a work

I shall propose three distinctive features of the notion of a work. First, a work is a sequence longer than the sentence; it raises a new problem of understanding, relative to the finite and closed totality which constitutes the work as such. Second, the work is submitted to a form of codification which is applied to the composition itself, and which transforms discourse into a story, a poem, an essay, etc. This codification is known as a literary genre; a work, in other words, is characteristically subsumed to a literary genre. Finally, a work is given a unique configuration which likens it to an individual and which may be called its style.

Composition, belonging to a genre and individual style characterise discourse as a work. The very word 'work' reveals the nature of these new categories; they are categories of production and of labour. To impose a form upon material, to submit production to genres, to produce an individual: these are so many ways of treating language as a material to be worked upon and formed. Discourse thereby becomes the object of a *praxis* and a *techne*. In this respect, there is not a sharp opposition between mental and manual labour. We may recall what Aristotle says about practice and production: 'All practice and all production concern the individual.

For it is not man that medicine cures, except by accident; rather it is Callias or Socrates or some other individual, thus designated, who at the same time happens to be a man' (*Metaphysics* A, 91a, a15). In a similar vein, G.-G. Granger writes in his *Essai d'une philosophie du style*: 'Practice is activity considered together with its complex context and in particular with the social conditions which give it meaning in a world actually experienced.'[6] Labour is thus one, if not the principal, structure of practice; it is 'practical activity objectifying itself in works'.[7] In the same way, the literary work is the result of a labour which organises language. In labouring upon discourse, man effects the practical determination of a category of individuals: the works of discourse. Here the notion of meaning receives a new specification, linking it to the level of the individual work. There is thus a problem of the interpretation of works, a problem irreducible to the step by step understanding of sentences. The phenomenon of the work globally signifying qua work is underlined by the fact of style. The problem of literature can then be situated within a general stylistics, conceived as a 'meditation on human works'[8] and specified by the notion of labour, for which it seeks the conditions of possibility: 'To investigate the most general conditions of inserting structures in individual practices would be the task of a stylistics.'[9]

In the light of these principles, what happens to the features of discourse outlined at the beginning of this study? Let us recall the initial paradox of event and meaning: discourse, we said, is realised as event but understood as meaning. How does the notion of work fit into this paradox? By introducing the categories of production and labour into the dimension of discourse, the notion of work appears as a practical mediation between the irrationality of the event and the rationality of meaning. The event is stylisation itself, but this stylisation is in dialectical relation with a complex, concrete situation presenting conflictual tendencies. Stylisation occurs at the

6. G.-G Granger, *Essai d'une philosophie du style* (Paris: A. Colin, 1968), p. 6.

7. Ibid.

8. Ibid., p. 11.

9. Ibid., p. 12.

heart of an experience which is already structured but which is nevertheless characterised by openings, possibilities, indeterminacies. To grasp a work as an event is to grasp the relation between the situation and the project in the process of restructuration. The work of stylisation takes the peculiar form of an interplay between an anterior situation which appears suddenly undone, unresolved, open, and a conduct or strategy which reorganises the residues left over from the anterior structuration. At the same time, the paradox of the fleeting event and the identifiable and repeatable meaning, which is at the origin of our meditation on distanciation in discourse, finds a remarkable mediation in the notion of work. The two aspects of event and meaning are drawn together by the notion of style. Style, we said, is expressed temporally as an individual work and in this respect concerns the irrational moment of taking a stand [*parti pris*], but its inscription in the materials of language give it the appearance of a sensible idea, a concrete universal, as W.K. Wimsatt says in *The Verbal Icon*.[10] A style is the promotion of a particular standpoint in a work which, by its singularity, illustrates and exalts the eventful character of discourse; but this event is not to be sought elsewhere than in the very form of the work. If the individual work cannot be grasped theoretically, it can be recognised as the singularity of a process, a construction, in response to a determinate situation.

The concept of the subject of discourse receives a new status when discourse becomes a work. The notion of style permits a new approach to the question of the subject of the literary work. The key is in the categories of production and labour; in this respect, the model of the artisan is particularly instructive (the stamp on furniture in the eighteenth century, the signature of the artist, etc.). For the concept of author, which qualifies that of the speaking subject on this level, appears as the correlate of the individuality of the work. The most striking proof is provided by the example which is least literary, namely the style of the construction of the mathematical object such as Granger describes it in the first part of his *Essai d'une philosophie du style*. Even

the construction of an abstract model of phenomena, insofar as it is a practical activity immanent in a process of structuration, bears a proper name. A given mode of structuration necessarily appears to be chosen instead of some other mode. Since style is labour which individuates, that is, which produces an individual, so it designates retroactively its author. Thus the word 'author' belongs to stylistics. Author says more than speaker: the author is the artisan of a work of language. But the category of author is equally a category of interpretation, in the sense that it is contemporaneous with the meaning of the work as a whole. The singular configuration of the work and the singular configuration of the author are strictly correlative. Man individuates himself in producing individual works. The signature is the mark of this relation.

The most important consequence of introducing the category of work pertains to the notion of composition. For the work of discourse presents the characteristics of organisation and structure which enable structural methods to be applied to discourse itself, methods which were first successfully applied to linguistic entities shorter than the sentence in phonology and semantics. The objectification of discourse in the work and the structural character of composition, to which we shall add distanciation by writing, compel us to place in question the Diltheyan opposition between 'understanding' and 'explanation'. A new phase of hermeneutics is opened by the success of structural analysis; henceforth explanation is the obligatory path of understanding. This does not mean, I hasten to say, that explanation can eliminate understanding. The objectification of discourse in a structured work does not abolish the first and fundamental feature of discourse, namely that it is constituted by a series of sentences whereby someone says something to someone about something. Hermeneutics, I shall say, remains the art of discerning the discourse in the work; but this discourse is only given in and through the structures of the work. Thus interpretation is the reply to the fundamental distanciation constituted by the objectification of man in works of discourse, an objectification comparable to that expressed in the products of his labour and his art.

10. W. K. Wimsatt, *The Verbal Icon: Studies in the Meaning of Poetry* (Kentucky, University of Kentucky Press, 1954).

III. The relation of speaking and writing

What happens to discourse when it passes from speaking to writing? At first sight, writing seems only to introduce a purely external and material factor: fixation, which shelters the event of discourse from destruction. In fact, fixation is only the external appearance of a problem which is much more important, and which affects all the properties of discourse that we have enumerated above. To begin with, writing renders the text autonomous with respect to the intention of the author. What the text signifies no longer coincides with what the author meant; henceforth, textual meaning and psychological meaning have different destinies.

This first modality of autonomy encourages us to recognise a positive significance in *Verfremdung*, a significance which cannot be reduced to the nuance of decline which Gadamer tends to give to it. The autonomy of the text already contains the possibility that what Gadamer calls the 'matter' of the text may escape from the finite intentional horizon of its author; in other words, thanks to writing, the 'world' of the *text* may explode the world of the *author*.

What is true of the psychological conditions holds also for the sociological conditions of the production of the text. An essential characteristic of a literary work, and of a work of art in general, is that it transcends its own psycho-sociological conditions of production and thereby opens itself to an unlimited series of readings, themselves situated in different socio-cultural conditions. In short, the text must be able, from the sociological as well as the psychological point of view, to 'decontextualise' itself in such a way that it can be 'recontextualised' in a new situation —as accomplished, precisely, by the act of reading.

The emancipation with respect to the author has a parallel on the side of those who receive the text. In contrast to the dialogical situation, where the *vis-à-vis* is determined by the very situation of discourse, written discourse creates an audience which extends in principle to anyone who can read. The freeing of the written material with respect to the dialogical condition of discourse is the most significant effect of writing. It implies that the relation between writing and reading is no longer a particular case of the relation between speaking and hearing.

The first important hermeneutical consequence of the autonomy of the text is this: distanciation is not the product of methodology and hence something superfluous and parasitical; rather it is constitutive of the phenomenon of the text as writing. At the same time, it is the condition of interpretation; *Verfremdung* is not only what understanding must overcome, but also what conditions it. We are thus prepared to discover a relation between *objectification* and *interpretation* which is much less dichotomous, and consequently much more complementary, than that established by the Romantic tradition. The passage from speaking to writing affects discourse in several other ways. In particular, the functioning of reference is profoundly altered when it is no longer possible to identify the thing spoken about as part of the common situation of the interlocutors. We shall offer a separate analysis of this phenomenon under the title of 'the world of the text'.

IV. The world of the text

The feature which we have placed under this title is going to lead us further from the position of Romantic hermeneutics, including the work of Dilthey, as well as towards the antipodes of structuralism, which I confront here as the simple contrary of Romanticism.

We may recall that Romantic hermeneutics placed the emphasis on the expression of genius; to liken oneself to this genius, to render it contemporary, such was the task of hermeneutics. Dilthey, still close in this sense to Romantic hermeneutics, based his concept of interpretation on that of 'understanding', that is, on grasping an alien life which expresses itself through the objectifications of writing. Whence the psychologising and historicising character of Romantic and Diltheyan hermeneutics. This route is no longer open to us, once we take distanciation by writing and objectification by structure seriously. But is this to say that, renouncing any attempt to grasp the soul of an author, we shall restrict ourselves to reconstructing the structure of a work?

The answer to this question distances us as much from structuralism as from Romanticism. The principal task of hermeneutics eludes the alternative of genius or structure; I shall link it to the notion of

'the world of the text'. This notion extends what we earlier called the reference or denotation of discourse. Following Frege, we can distinguish between the sense and the reference of any proposition.[11] The sense is the ideal object which the proposition intends, and hence is purely immanent in discourse. The reference is the truth value of the proposition, its claim to reach reality. Reference thus distinguishes discourse from language [langue]; the latter has no relation with reality, its words returning to other words in the endless circle of the dictionary. Only discourse, we shall say, intends things, applies itself to reality, expresses the world.

The new question which arises is this: what happens to reference when discourse becomes a text? Here we find that writing, and above all the structure of the work, modify reference to the point of rendering it entirely problematic. In oral discourse, the problem is ultimately resolved by the ostensive function of discourse; in other words, reference is determined by the ability to point to a reality common to the interlocutors. If we cannot point to the thing about which we speak, at least we can situate it in relation to the unique spatio-temporal network which is shared by the interlocutors. It is the 'here' and 'now', determined by the situation of discourse, which provides the ultimate reference of all discourse. With writing, things already begin to change. For there is no longer a situation common to the writer and the reader, and the concrete conditions of the act of pointing no longer exist. This abolition of the ostensive character of reference is no doubt what makes possible the phenomenon we call 'literature', which may abolish all reference to a given reality. However, the abolition of ostensive reference is taken to its most extreme conditions only with the appearance of certain literary genres, which are generally linked to but not necessarily dependent upon writing. The role of most of our literature is, it seems, to destroy the world. That is true of fictional literature—folktales, myths, novels, plays— but also of all literature which could be called poetic, where language seems to glorify itself at the expense of the referential function of ordinary discourse.

Nevertheless, there is no discourse so fictional that it does not connect up with reality. But such discourse refers to another level, more fundamental than that attained by the descriptive, constative, didactic discourse which we call ordinary language. My thesis here is that the abolition of a first order reference, an abolition effected by fiction and poetry, is the condition of possibility for the freeing of a second order reference, which reaches the world not only at the level of manipulable objects, but at the level that Husserl designated by the expression *Lebenswelt* [life-world] and Heidegger by the expression 'being-in-the-world'.

The unique referential dimension of the work of fiction and poetry raises, in my view, the most fundamental hermeneutical problem. If we can no longer define hermeneutics in terms of the search for the psychological intentions of another person which are concealed *behind* the text, and if we do not want to reduce interpretation to the dismantling of structures, then what remains to be interpreted? I shall say: to interpret is to explicate the type of being-in-the-world unfolded *in front of* the text.

Here we rejoin one of Heidegger's suggestions concerning the notion of *Verstehen*. Recall that, in *Being and Time*, the theory of 'understanding' is no longer tied to the understanding of others, but becomes a structure of being-in-the-world. More precisely, it is a structure which is explored after the examination of *Befindlichkeit* [state-of-mind]. The moment of 'understanding' corresponds dialectically to being in a situation: it is the projection of our ownmost possibilities at the very heart of the situations in which we find ourselves. I want to retain from this analysis the idea of 'the projection of our ownmost possibilities', applying it to the theory of the text. For what must be interpreted in a text is a *proposed world* which I could inhabit and wherein I could project one of my ownmost possibilities. That is what I call the world of the text, the world proper to *this* unique text.

The world of the text is therefore not the world of everyday language. In this sense, it constitutes a new sort of distanciation which could be called a distanciation of the real from itself. It is this

11. G. Grege, 'On sense and reference' in *Translations from the Philosophical Writings of Gottlob Frege*, edited by Peter Geach and Max Black (Oxford: Basil Blackwell, 1960).

distanciation which fiction introduces into our apprehension of reality. We said that narratives, folktales and poems are not without a referent; but this referent is discontinuous with that of everyday language. Through fiction and poetry, new possibilities of being-in-the-world are opened up within everyday reality. Fiction and poetry intend being, not under the modality of being-given, but under the modality of power-to-be. Everyday reality is thereby metamorphised by what could be called the imaginative variations which literature carries out on the real.

I have shown elsewhere, with the example of metaphorical language,[12] that fiction is the privileged path for the redescription of reality; and that poetic language is *par excellence* that which effects what Aristotle, reflecting on tragedy, called the *mimesis* of reality. For tragedy imitates reality only because it recreates it by means of a *mythos*, a 'fable', which reaches the profoundest essence of reality.

Such is the third sort of *distanciation* which the hermeneutic experience must incorporate.

V. Self-understanding in front of the work

I should like to consider a fourth and final dimension of the notion of the text. I announced it in the introduction by saying that the text is the medium through which we understand ourselves. This fourth theme marks the appearance of the subjectivity of the reader. It extends the fundamental characteristic of all discourse whereby the latter is addressed to someone. But in contrast to dialogue, this *vis-à-vis* is not given in the situation of discourse; it is, if I may say so, created or instituted by the work itself. A work opens up its readers and thus creates its own subjective *vis-à-vis*.

It may be said that this problem is well known in traditional hermeneutics: it is the problem of the appropriation (*Aneignung*) of the text, its application (*Anwendung*) to the present situation of the reader. Indeed, I also understand it in this way; but I should like to underline how this theme is transformed when it is introduced *after* the preceding points.

To begin with, appropriation is dialectically linked

to the distanciation characteristic of *writing*. Distanciation is not abolished by appropriation, but is rather the counterpart of it. Thanks to distanciation by writing, appropriation no longer has any trace of affective affinity with the intention of an author. Appropriation is quite the contrary of contemporaneousness and congeniality: it is understanding at and through distance.

In the second place, appropriation is dialectically linked to the objectification characteristic of the *work*. It is mediated by all the structural objectifications of the text; insofar as appropriation does not respond to the author, it responds to the sense. Perhaps it is at this level that the mediation effected by the text can be best understood. In contrast to the tradition of the *cogito* and to the pretension of the subject to know itself by immediate intuition, it must be said that we understand ourselves only by the long detour of the signs of humanity deposited in cultural works. What would we know of love and hate, of moral feelings and, in general, of all that we call the *self*, if these had not been brought to language and articulated by literature? Thus what seems most contrary to subjectivity, and what structural analysis discloses as the texture of the text, is the very *medium* within which we can understand ourselves.

Above all, the *vis-à-vis* of appropriation is what Gadamer calls 'the matter of the text' and what I call here 'the world of the work'. Ultimately, what I appropriate is a proposed world. The latter is not *behind* the text, as a hidden intention would be, but *in front of* it, as that which the work unfolds, discovers, reveals. Henceforth, *to understand is to understand oneself in front of the text*. It is not a question of imposing upon the text our finite capacity of understanding, but of exposing ourselves to the text and receiving from it an enlarged self, which would be the proposed existence corresponding in the most suitable way to the world proposed. So understanding is quite different from a constitution of which the subject would possess the key. In this respect, it would be more correct to say that the *self* is constituted by the 'matter' of the text.

It is undoubtedly necessary to go still further: just as the world of the text is real only insofar as it is imaginary, so too it must be said that the subjectivity

12. See 'Metaphor and the central problem of hermeneutics', in [*Hermeneutics and the Human Sciences* by Paul Ricoeur, Cambridge University Press, 1981].

of the reader comes to itself only insofar as it is placed in suspense, unrealised, potentialised. In other words, if fiction is a fundamental dimension of the reference of the text, it is no less a fundamental dimension of the subjectivity of the reader. As reader, I find myself only by losing myself. Reading introduces me into the imaginative variations of the *ego*. The metamorphosis of the world in play is also the playful metamorphosis of the *ego*.

If that is true, then the concept of 'appropriation', to the extent that it is directed against *Verfremdung*, demands an internal critique. For the metamorphosis of the *ego*, of which we have just spoken, implies a moment of distanciation in the relation of self to itself; hence understanding is as much disappropriation as appropriation. A critique of the illusions of the subject, in a Marxist or Freudian manner, therefore can and must be incorporated into self-understanding. The consequence for hermeneutics is important: we can no longer oppose hermeneutics and the critique of ideology. The critique of ideology is the necessary detour which self-understanding must take, if the latter is to be formed by the matter of the text and not by the prejudices of the reader.

Thus we must place at the very heart of self-understanding that dialectic of objectification and understanding which we first perceived at the level of the text, its structures, its sense and its reference. At all these levels of analysis, distanciation is the condition of understanding.

E. D. Hirsch, Jr. (1928-)

In Defense of the Author

It has been said of Boehme that his books are like a picnic to which the author brings the words and the reader the meaning. The remark may have been intended as a sneer at Boehme, but it is an exact description of all works of literary art without exception.

Northrop Frye

A. BANISHMENT OF THE AUTHOR

It is a task for the historian of culture to explain why there has been in the past four decades a heavy and largely victorious assault on the sensible belief that a text means what its author meant. In the earliest and most decisive wave of the attack (launched by Eliot, Pound, and their associates) the battleground was literary: the proposition that textual meaning is independent of the author's control was associated with the literary doctrine that the best poetry is impersonal, objective, and autonomous; that it leads an afterlife of its own, totally cut off from the life of its author.[1] This programmatic notion of what poetry should be became subtly identified with a notion of what all poetry and indeed all forms of literature necessarily must be. It was not simply desirable that literature should detach itself from the subjective realm of the author's personal thoughts and feelings; it was, rather, an indubitable fact that all written language remains independent of that subjective realm. At a slightly later period, and for different reasons, this same notion of semantic autonomy was advanced by Heidegger and his followers.[2] The idea also has been advocated by writers who believe with Jung that individual expressions may quite unwittingly express archetypal, communal meanings. In some branches of linguistics, particularly in so-called information theory, the semantic autonomy of language has been a working assumption. The theory has formed another home in the work of non-Jungians who have interested themselves (as Eliot did earlier) in symbolism, though Cassirer, whose name is sometimes invoked by such writers, did not believe in the semantic autonomy of language.[3] As I said, it is the job of the cultural historian to explain why this doctrine should have gained currency in recent times, but it is the theorist's job to determine how far the theory of semantic autonomy deserves acceptance.

Literary scholars have often contended that the theory of authorial irrelevance was entirely beneficial to literary criticism and scholarship because it shifted the focus of discussion from the author to his work. Made confident by the theory, the modern critic has faithfully and closely examined the text to ferret out its independent meaning instead of its supposed significance to the author's life. That this shift toward exegesis has been desirable most critics would agree, whether or not they adhere to the theory of semantic autonomy. But the theory accompanied the exegetical movement for historical not logical reasons, since no logical necessity compels a critic to banish an author in order to analyze

1. The classic statement is in T. S. Eliot, "Tradition and the Individual Talent," *Selected Essays* (New York, 1932).

2. See, for example, Martin Heidegger, *Unterwegs zur Sprache* (Pfullingen, 1959).

3. See Ernst Cassirer, *The Philosophy of Symbolic Forms*: Vol. 1, *Language*, trans. R. Manheim (New Haven, 1953), particularly pp. 69, 178, 213, 249-50, and passim.

his text. Nevertheless, through its historical association with close exegesis, the theory has liberated much subtlety and intelligence. Unfortunately, it has also frequently encouraged willful arbitrariness and extravagance in academic criticism and has been one very important cause of the prevailing skepticism which calls into doubt the possibility of objectively valid interpretation. These disadvantages would be tolerable, of course, if the theory were true. In intellectual affairs skepticism is preferable to illusion.

The disadvantages of the theory could not have been easily predicted in the exciting days when the old order of academic criticism was being overthrown. At that time such naïvetés as the positivistic biases of literary history, the casting about for influences and other causal patterns, and the post-romantic fascination with the habits, feelings, and experiences surrounding the act of composition were very justly brought under attack. It became increasingly obvious that the theoretical foundations of the old criticism were weak and inadequate. It cannot be said, therefore, that the theory of authorial irrelevance was inferior to the theories or quasi-theories it replaced, nor can it be doubted that the immediate effect of banishing the author was wholly beneficial and invigorating. Now, at a distance of several decades, the difficulties that attend the theory of semantic autonomy have clearly emerged and are responsible for that uneasiness which persists in the academies, although the theory has long been victorious.

That this state of academic skepticism and disarray results largely from the theory of authorial irrelevance is, I think, a fact of our recent intellectual history. For, once the author had been ruthlessly banished as the determiner of his text's meaning, it very gradually appeared that no adequate principle existed for judging the validity of an interpretation. By an inner necessity the study of "what a text says" became the study of what it says to an individual critic. It became fashionable to talk about a critic's "reading" of a text, and this word began to appear in the titles of scholarly works. The word seemed to imply that if the author had been banished, the critic still remained, and his new, original, urbane, ingenious, or relevant "reading" carried its own interest.

What had not been noticed in the earliest enthusiasm for going back to "what the text says" was that the text had to represent *somebody's* meaning—if not the author's, then the critic's. It is true that a theory was erected under which the meaning of the text was equated with everything it could plausibly be taken to mean. (I have described in Appendix I the fallacies of this and other descriptions of meaning that were contrived to escape the difficulties of authorial irrelevance.[4]) The theory of semantic autonomy forced itself into such unsatisfactory, ad hoc formulations because in its zeal to banish the author it ignored the fact that meaning is an affair of consciousness not of words. Almost any word sequence can, under the conventions of language, legitimately represent more than one complex of meaning.[5] A word sequence means nothing in particularly until somebody either means something by it or understands something from it. There is no magic land of meanings outside human consciousness. Whenever meaning is connected to words, a person is making the connection, and the particular meanings he lends to them are never the only legitimate ones under the norms and conventions of his language.

One proof that the conventions of language can sponsor different meanings from the same sequence of words resides in the fact that interpreters can and do disagree. When these disagreements occur, how are they to be resolved? Under the theory of semantic autonomy they cannot be resolved, since the meaning is not what the author meant, but "what the poem means to different sensitive readers."[6] One interpretation is as valid as another, so long as it is "sensitive" or "plausible." Yet the teacher of literature who adheres to Eliot's theory is also by profession the preserver of a heritage and the conveyor of knowledge. On what ground does he claim that his "reading" is more valid than that of any pupil? On

4. See particularly pp. 224-35.

5. The random example that I use later in the book is the sentence: "I am going to town today." Different senses can be lent to the sentence by the simple device of placing a strong emphasis on any of the six different words.

6. The phrase is from T. S. Eliot, *On Poetry and Poets* (New York, 1957), p. 126.

no very firm ground. This impasse is a principal cause of the loss of bearings sometimes felt though not often confessed by academic critics.

One ad hoc theory has been advanced to circumvent this chaotic democracy of "readings" deserves special mention here because it involves the problem of value, a problem that preoccupies some modern literary theorists. The most valid reading of a text is the "best" reading.[7] But even if we assumed that a critic did have access to the divine criteria by which he could determine the best reading, he would still be left with two equally compelling normative ideals—the best meaning and the author's meaning. Moreover, if the best meaning were not the author's, then it would have to be the critic's—in which case the critic would be the author of the best meaning. Whenever meaning is attached to a sequence of words it is impossible to escape an author.

Thus, when critics deliberately banished the original author, they themselves usurped his place, and this led unerringly to some of our present-day theoretical confusions. Where before there had been but one author, there now arose a multiplicity of them, each carrying as much authority as the next. To banish the original author as the determiner of meaning was to reject the only compelling normative principle that could lend validity to an interpretation. On the other hand, it might be the case that there does not really exist a viable normative ideal that governs the interpretation of texts. This would follow if any of the various arguments brought against the author were to hold. For if the meaning of a text is not the author's, then no interpretation can possible correspond to *the* meaning of the text, since the text can have no determinate or determinable meaning. My demonstration of this point will be found in Appendix I and in the sections on determinacy in Chapter 2.[8] If a theorist wants to

save the ideal of validity, he has to save the author as well, and, in the present-day context, his first task will be to show that the prevailing arguments against the author are questionable and vulnerable.

B. "THE MEANING OF A TEXT CHANGES—EVEN FOR THE AUTHOR"

A doctrine widely accepted at the present time is that the meaning of a text changes.[9] According to the radical historicistic view, textual meaning changes from era to era; according to the psychologistic view, it changes from reading to reading. Since the putative changes of meaning experienced by the author himself must be limited to a rather brief historical span, only the psychologistic view need concern us here. Of course, if any theory of semantic mutability were true, it would legitimately banish the author's meaning as a normative principle in interpretation, for if textual meaning could change in any respect there could be no principle for distinguishing a valid interpretation from a false one. But that is yet another problem that will be dealt with in a suitable place.[10] Here I need not discuss the general (and insoluble) normative problems that would be raised by a meaning which could change, but only the conditions that have caused critics to accuse authors of such fickleness.

Everyone who has written knows that his opinion of his own work changes and that his responses to his own text vary from reading to reading. Frequently an author may realize that he no longer agrees with his earlier meaning or expression and will revise his own text. Our problem, of course, has nothing to do with revision or even with the fact that an author may explain his meaning differently at different times, since the authors are sometimes inept explainers of their meanings, as Plato observed.

7. It would be invidious to name any individual critic as the begetter of this widespread and imprecise notion. By the "best" reading, of course, some critics mean the most valid reading, but the idea of bestness is widely used to embrace indiscriminately both the idea of validity and of such aesthetic values as richness, inclusiveness, tension, or complexity—as though validity and aesthetic excellence must somehow be identical.

8. See pp. 44-48, 225-30.

9. See René Wellek and Austin Warren, *Theory of Literature* (New York, 1948), Chap. 12.

10. I have discussed it in Appendix I, pp. 212-16. For the sake of clarity I should, however, quickly indicate to the reader that verbal meaning can be the same for different interpreters by virtue of the fact that verbal meaning has the character of a type. A type covers a range of actualizations (one example would be a phoneme) and yet in each actualization remains (like a phoneme) the identical type. This last point is explained in Chap. 2, Sec. D, and in Appendix III, pp. 266-70.

Even the puzzling case of the author who no longer understands his own text at all is irrelevant to our problem, since his predicament is due to the fact that an author, like anyone else, can forget what he meant. We all know that sometimes a person remembers correctly and sometimes not, and that sometimes a person recognizes his mistakes of memory and corrects them. None of this has any theoretical interest whatever.

When critics assert that the author's understanding of his text changes, they refer to the experience that everybody has when he rereads his own work. His response to it is different. This is a phenomenon that certainly does have theoretical importance—though not of the sort sometimes allotted to it. The phenomenon of changing authorial responses is important because it illustrates the difference between textual meaning and what is loosely termed a "response" to the text.

Probably the most extreme examples of this phenomenon are cases of authorial self-repudiation, such as Arnold's public attack on his masterpiece, *Empedocles on Etna*, or Schelling's rejection of all the philosophy he had written before 1809. In these cases there cannot be the slightest doubt that the author's later response to his work was quite different from his original response. Instead of seeming beautiful, profound, or brilliant, the work seemed misguided, trivial, and false, and its meaning was no longer one that the author wished to convey. However, these examples do not show that the meaning of the work had changed, but precisely the opposite. If the work's meaning had changed (instead of the author himself and his attitudes), then the author would not have needed to repudiate his meaning and could have spared himself the discomfort of a public recantation. No doubt the *significance* of the work to the author had changed a great deal, but its meaning had not changed at all.

This is the crux of the matter in all those cases of authorial mutability with which I am familiar. It is not the meaning of the text which changes, but its significance to the author. This distinction is too often ignored. *Meaning* is that which is represented by a text; it is what the signs represent. *Significance*, on the other hand, names a relationship between that meaning and a person, or a conception, or a

situation, or indeed anything imaginable. Authors, who like everyone else change their attitudes, feelings, opinions, and value criteria in the course of time, will obviously in the course of time tend to view their own work in different contexts. Clearly what changes for them is not the meaning of the work, but rather their relationship to that meaning. Significance always implies a relationship, and one constant, unchanging pole of that relationship is what the text means. Failure to consider this simple and essential distinction has been the source of enormous confusion in hermeneutic theory.

If we really believed that the meaning of a text had changed for its author, there could be only one way that we could know it: he would have to tell us. How else could we know that his understanding has changed—understanding being a silent and private phenomenon? Even if an author reported that his understanding of his meaning had changed, we should not be put off by the implausibility of the statement but should follow out its implications in a spirit of calm inquiry. The author would have to report something like this: "By these words I meant so and so, but now I observe that I really meant something different," or, "By these words I meant so and so, but I insist that from now on they shall mean something different." Such an event is unlikely because authors who feel this way usually undertake a revision of their text in order to convey their new meaning more effectively. Nevertheless, it is an event that *could* occur, and its very possibility shows once again that the same sequence of linguistic signs can represent more than one complex of meaning.

Yet, even though the author has indeed changed his mind about the meaning he wants to convey by his words, he has not managed to change his earlier meaning. This is very easily proved by his own report. He could report a change in his understanding only if he were able to compare his earlier construction of his meaning with his later construction. That is the only way he could know that there is a difference: he holds both meanings before his mind and rejects the earlier one. But his earlier meaning is not thereby changed in any way. Such a report from an author would simply force a choice on the interpreter, who would have to decide which of the

author's two meanings he is going to concern himself with. He would have to decide which "text" he wanted to interpret at the moment. The critic is destined to fall into puzzlement if he confuses one text with the other or if he assumes that the author's will is entirely irrelevant to his task.

This example is, as I said, quite improbable. I do not know of a single instance where an author has been so eccentric as to report without any intention to deceive that he now means by his text what he did not mean. (Deliberate lies are, of course, another matter; they have no more theoretical interest than failures of memory.) I was forced into this improbable example by the improbability of the original thesis, namely that an author's meaning changes for himself. What the example showed on the contrary was that an author's original meaning *cannot* change—even for himself, though it can certainly be repudiated. When critics speak of changes in meaning, they are usually referring to changes in significance. Such changes are, of course, predictable and inevitable, and since the primary object of criticism, as distinct from interpretation, is significance, I shall have more to say about this distinction later, particularly in Chapter 4. For the moment, enough has been said to show that the author's revaluation of his text's significance does not change its meaning and, further, that arguments which rely on such examples are not effective weapons for attacking either the stability or the normative authority of the author's original meaning.

C. "IT DOES NOT MATTER WHAT AN AUTHOR MEANS—ONLY WHAT HIS TEXT SAYS"

As I pointed out in section A, this central tenet in the doctrine of semantic autonomy is crucial to the problem of validity. If the tenet were true, then any reading of a text would be "valid," since any reading would correspond to what the text "says"—for that reader. It is useless to introduce normative concepts like "sensitive," "plausible," "rich," and "interesting," since what the text "says" might not, after all, be any of those things. Validity of interpretation is not the same as inventiveness of interpretation. Validity implies the correspondence of an interpretation to a meaning which is represented by the text,

and none of the above criteria for discriminating among interpretations would apply to a text which is dull, simple, insensitive, implausible, or uninteresting. Such a text might not be worth interpreting, but a criterion of validity which cannot cope with such a text is not worth crediting.

The proponents of semantic autonomy in England and America can almost always be relied on to point to the example of T. S. Eliot, who more than once refused to comment on the meanings of his own texts. Eliot's refusals were based on his view that the author has no control over the words he has loosed upon the world and no special privileges as an interpreter of them. It would have been quite inconsistent with this view if Eliot had complained when someone misinterpreted his writings, and, so far as I know, Eliot with stoical consistency never did complain. But Eliot never went so far as to assert that he did not mean anything in particular by his writings. Presumably he did mean something by them, and it is a permissible task to attempt to discover what he meant. Such a task has a determinate object and therefore could be accomplished correctly or incorrectly. However, the task of finding out what a text says has no determinate object, since the text can say different things to different readers. One reading is as valid or as invalid as another. However, the decisive objection to the theory of semantic autonomy is not that it inconveniently fails to provide an adequate criterion of validity. The decisive objection must be sought within the theory itself and in the faultiness of the arguments used to support it.

One now-famous argument is based on the distinction between a mere intention to do something and the concrete accomplishment of that intention. The author's desire to communicate a particular meaning is not necessarily the same as his success in doing so. Since his actual performance is presented in his text, any special attempt to divine his intention would falsely equate his private wish with his public accomplishment. Textual meaning is a public affair. The wide dissemination of this argument and its acceptance as an axiom of recent literary criticism can be traced to the influence of a vigorous essay, "The Intentional Fallacy," written by W. K. Wimsatt

and Munroe Beardsley and first published in 1946.[11] The critic of the arguments in that essay is faced with the problem of distinguishing between the essay itself and the popular use that has been made of it, for what is widely taken for granted as established truth was not argued and could not have been successfully argued in the essay. Although Wimsatt and Beardsley carefully distinguished between three types of intentional evidence, acknowledging that two of them are proper and admissible, their careful distinctions and qualifications have now vanished in the popular version which consists in the false and facile dogma that what an author intended is irrelevant to the meaning of his text.

The best way to indicate what is fallacious in this popular version is to discuss first the dimension in which it is perfectly valid—evaluation. It would be absurd to evaluate the stylistic felicity of a text without distinguishing between the author's intention to convey a meaning and, on the other hand, his effectiveness in conveying it. It would be similarly absurd to judge the profundity of a treatise on morality without distinguishing between the author's intention to be profound and his success in being so. Evaluation is constantly distinguishing between intention and accomplishment. Take this example: A poet intends a four-line poem to convey a sense of desolation, but what he manages to convey to some readers is a sense that the sea is wet, to others that twilight is approaching. Obviously his intention to convey desolation is not identical with his stylistic effectiveness in doing so, and the anti-intentionalists quite justly point this out. But the intentional fallacy is properly applicable *only* to artistic success and to other normative criteria like profundity, consistency, and so on. The anti-intentionalist quite properly defends the right and duty of the critic to judge freely on his own criteria and to expose discrepancies between wish and deed. However, the intentional fallacy has no proper application whatever to verbal meaning. In the above example the only universally valid meaning of the poem is the sense of desolation. If the critic has not understood that point, he will not even reach an accurate judgment—namely, that the meaning was ineptly expressed and perhaps was not worth expressing in the first place.[12]

Beneath the so-called intentional fallacy and, more generally, the doctrine of semantic autonomy lies an assumption which if true would at least render plausible the view that the meaning of a text is independent of its author's intention. I refer to the concept of a public consensus. If a poet intended his poem to convey desolation, and if to every component reader his poem conveyed only a sense that twilight is approaching, then such public unanimity would make a very strong case (in this particular instance) for the practical irrelevance of the author's intention. But when has such unanimity occurred? If it existed generally, there would not be any problems of interpretation.

The myth of the public consensus has been decisive in gaining wide acceptance for the doctrine that the author's intention is irrelevant to what the text says. That myth permits the confident belief that the "saying" of the text is a public fact firmly governed by public norms. But if this public meaning exists, why is it that we, who are the public, disagree? Is there one group of us that constitutes the true public, while the rest are heretics and outsiders? By what standard is it judged that a correct insight into public norms is lacking in all those readers who are (except for the text at hand) competent readers of texts? The idea of a public meaning sponsored not by the author's intention but by a public consensus is based upon a fundamental error of observation and logic. It is an empirical fact that the consensus does not exist, and it is a logical error to erect a stable normative concept (i.e. *the* public meaning) out of an unstable descriptive one. The public meaning of a text is nothing more or less than those meanings which the public happens to construe from the text. Any meaning which two or more members of the public construe is ipso facto within the public norms that govern language and its interpretation. Vox populi: vox populi.

If a text means what it says, then it means nothing in particular. Its saying has no determinate existence but must be the saying of the author or a

11. *Sewanee Review*, 54 (1946). Reprinted in William K. Wimsatt, Jr., *The Verbal Icon: Studies in the Meaning of Poetry* (Lexington, Ky., 1954).

12. For a definition of verbal meaning see Chap. 2, Sec. A.

reader. The text does not exist even as a sequence of words until it is construed; until then, it is merely a sequence of signs. For sometimes words can have homonyms (just as, by analogy, entire texts can), and sometimes the same word can be quite a different word. For example, when we read in Wordsworth's *Intimations Ode* the phrase "most worthy to be blessed," are we to understand "most" as a superlative or merely an intensifier like "very"? Even on this primitive level, signs can be variously construed, and until they are construed the text "says" nothing at all.

D. "THE AUTHOR'S MEANING IS INACCESSIBLE"

Since we are all different from the author, we cannot reproduce his intended meaning in ourselves, and even if by some accident we could, we still would not be certain that we had done so. Why concern ourselves, therefore, with an inherently impossible task when we can better employ our energies in useful occupations such as making the text relevant to our present concerns or judging its conformity to high standards of excellence? The goal of reproducing an inaccessible and private past is to be dismissed as a futile enterprise. Of course, it is essential to understand some of the public facts of language and history in order not to miss allusions or mistake the contemporary senses of words, but these preliminary tasks remain squarely in the public domain and do not concern a private world beyond the reach of written language.

Before touching on the key issue in this argument—namely, that the author's intended meaning cannot be known—I would like to make an observation about the subsidiary argument respecting the public and private dimensions of textual meaning. According to this argument, it would be a mistake to confuse a public fact—namely, language—with a private fact—namely, the author's mind. But I have never encountered an interpretation that inferred truly private meanings from a text. An interpreter might, of course, infer meanings which according to our judgment could not possibly under any circumstances be implied by the author's words, but in that case, we would reject the interpretation not because

it is private but because it is probably wrong. That meaning, we say, cannot be implied by those words. If our skepticism were shared by all readers of the interpretation, then it would be reasonable to say that the interpretation is private. However, it is a rare interpretation that does not have at least a few adherents, and if it has any at all, then the meaning is not private; it is at worst improbable.

Whenever an interpretation manages to convince another person, that in itself proves beyond doubt that the author's words *can* publicly imply such a meaning. Since the interpreted meaning *was* conveyed to another person, indeed to at least two other persons, the only significant interpretive question is, "Did the author really intend that public meaning by his words?" To object that such a meaning is highly personal and ought not to have been intended is a legitimate aesthetic or moral judgment, but is irrelevant to the question of meaning. That meaning—if the author did mean it—has proved itself to be public, and if the interpreter manages to do his job convincingly, the meaning can become available to a very large public. It is simply a self-contradiction for a member of the public to say, "Yes, I see that the author did mean that, but it is a private not a public meaning."

The impulse that underlies this self-contradictory sort of argument is sound insight that deserves to be couched in terms more suitable than "public" and "private." The issue is first of all a moral and aesthetic one. It is proper to demand of authors that they show consideration for their readers, that they use their linguistic inheritance with some regard for the generality of men and not just for a chose few. Yet many new usages are bound to elude the generality of men until readers become habituated to them. The risk of resorting to semi-private implications—available at first only to a few—is very often worth taking, particularly if the new usage does finally become widely understood. The language expands by virtue of such risky innovations. However, the soundest objection to so-called private meanings does not relate to moral and aesthetic judgment but to the practice of interpretation. Those interpreters who look for personal implications in such formalized utterances as poems very often disregard

genre conventions and limitations of which the author was very well aware. When an author composes a poem, he usually intends it as an utterance whose implications are not obscurely autobiographical. There may be exceptions to this rule of thumb, and poetic kinds are too various to warrant any unqualified generalizations about the conventions of poetry and the intentions of authors, but too many interpreters in the past have sought autobiographical meanings where none were meant. Such interpreters have been insensitive to the proprieties observed by the author and to his intentions. The fallacy in such interpretations is not that the inferred meanings are private, but that they are probably not the author's meanings. Whether a meaning is autobiographical is a neutral and by itself irrelevant issue in interpretation. The only thing that counts is whether the interpretation is probably right.

The genuine distinction between public and private meaning resides in the first part of the argument, where it is asserted that the author's intended meaning cannot be known. Since we cannot get inside the author's head, it is useless to fret about an intention that cannot be observed, and equally useless to try to reproduce a private meaning experience that cannot be reproduced. Now the assertions that the author's meaning cannot be reproduced presupposes the same psychologistic theory of meaning which underlies the notion that an author's meaning changes even for himself. Not even the author can reproduce his original meaning because nothing can bring back his original meaning experience. But as I suggested, the irreproducibility of meaning experience does not equate with the nonexistence of meanings. The psychologistic identification of textual meaning with a meaning experience is inadmissible. Meaning experiences *are* private, but they are not meanings.[13]

The most important argument to consider here is the one which states that the author's intended meaning cannot be *certainly* known. This argument cannot be successfully met because it is self-evidently true. I can never know another person's intended meaning with certainty because I cannot get inside his head to compare the meaning he intends with the meaning I understand, and only by such direct comparison could I be certain that his meaning and my own are identical. But this obvious fact should not be allowed to sanction the overly hasty conclusion that the author's intended meaning is inaccessible and is therefore a useless object of interpretation. It is a logical mistake to confuse the impossibility of certainty in understanding with the impossibility of understanding. It is a similar, though more subtle, mistake to identify knowledge with certainty. A good many disciplines do not pretend to certainty, and the more sophisticated the methodology of the discipline, the less likely that its goal will be defined as certainty of knowledge. Since genuine certainty in interpretation is impossible, the aim of the discipline must be to reach a consensus, on the basis of what is known, that correct understanding has *probably* been achieved. The issue is not whether certainty is accessible to the interpreter but whether the author's intended meaning is accessible to him. Is correct understanding possible? That is the question raised by the thesis under examination.

Most of us would answer that the author's meaning is only partially accessible to an interpreter. We cannot know all the meanings the author entertained when he wrote down his text, as we infer from two familiar kinds of evidence. Whenever I speak I am usually attending to ("have in mind") meanings that are outside my subject of discourse. Furthermore, I am always aware that the meanings I can convey through discourse are more limited than the meanings I can entertain. I cannot, for example, adequately convey through words many of my visual perceptions—though these perceptions are meanings, which is to say, objects of consciousness. It is altogether likely that no text can ever convey all the meanings an author had in mind as he wrote.

But this obvious fact is not decisive. Why should anyone with common sense wish to equate an author's textual meaning with all the meanings he happened to entertain when he wrote? Some of these he had no intention of conveying by his words. Any author knows that written verbal utterances can convey only verbal meanings—that is to say, meanings which can be conveyed to others by the words he uses. The interpretation of texts is concerned exclusively with sharable meanings, and not everything I am

13. See Chap. 2, Sec. B, and Chap. 4, Sec. A and B.

thinking of when I write can be shared with others by means of my words. Conversely, many of my sharable meanings are meanings which I am not directly thinking of at all. They are so-called unconscious meanings.[14] It betrays a totally inadequate conception of verbal meaning to equate it with what the author "has in mind." The only question that can relevantly be at issue is whether the *verbal* meaning which an author intends is accessible to the interpreter of his text.

Most authors believe in the accessibility of their verbal meaning, for otherwise most of them would not write. However, no one could unanswerably defend this universal faith. Neither the author nor the interpreter can ever be certain that communication has occurred or that it can occur. But again, certainty is not the point at issue. It is far more likely that an author and an interpreter can entertain identical meanings than that they cannot. The faith that speakers have in the possibility of communication has been built up in the very process of learning a language, particularly in those instances when the actions of the interpreter have confirmed to the author that he has been understood. These primitive confirmations are the foundation for our faith in far less primitive modes of communication. The inaccessibility of verbal meaning is a doctrine that experience suggests to be false, though neither experience nor argument can prove its falsity. But since the skeptical doctrine of inaccessibility is highly improbable, it should be rejected as a working assumption of interpretation.

Of course, it is quite reasonable to take a skeptical position that is less sweeping than the thesis under examination: certain texts might, because of their character or age, represent authorial meanings which are now inaccessible. No one would, I think, deny this reasonable form of skepticism. However, similar versions of such skepticism are far less acceptable, particularly in those theories which deny the accessibility of the author's meaning whenever the text descends from an earlier cultural era or whenever the text happens to be literary. These views are endemic respectively to radical historicism and to the theory that literary texts are ontologically distinct from non-literary ones. Both of these theories are challenged in subsequent chapters. However, even if these theories were acceptable, they could not uphold the thesis that an author's verbal meaning is inaccessible, for that is an empirical generalization which neither theory nor experience can decisively confirm or deny. Nevertheless, with a high degree of probability, that generalization is false, and it is impossible and quite unnecessary to go beyond this conclusion.

E. "THE AUTHOR OFTEN DOES NOT KNOW WHAT HE MEANS"

Ever since Plato's Socrates talked to the poets and asked them with quite unsatisfactory results to explain "some of the most elaborate passages in their own writings," it has been a commonplace that an author often does not really know what he means.[15] Kant insisted that not even Plato knew what he meant, and that he, Kant, could understand some of Plato's writings better than Plato did himself.[16] Such examples of authorial ignorance are, no doubt, among the most damaging weapons in the attack on the author. If it can be shown (as it apparently can) that in some cases the author does not really know what he means, then it seems to follow that the author's meaning cannot constitute a general principle or norm for determining the meaning of a text, and it is precisely such a general normative principle that is required in defining the concept of validity.

Not all cases of authorial ignorance are of the same type. Plato, for instance, no doubt knew very well what he meant by his theory of Ideas, but it may have been, as Kant believed, that the theory of Ideas had different and more general implications than those Plato enunciated in his dialogues. Though Kant called this a case of understanding the

14. See Chap. 2, Secs. D and E.

15. Plato, *Apology*, 22b-c.

16. Immanuel Kant, *Critique of Pure Reason*, trans. N. K. Smith (London, 1933), A 314, B 370, p. 310: "I shall not engage here in any literary enquiry into the meaning which this illustrious author attached to the expression. I need only remark that it is by no means unusual, upon comparing the thoughts which an author has expressed in regard to his subject, whether in ordinary conversation or in writing, to find that we understand him better than he has understood himself."

author better than the author understood himself, his phrasing was inexact, for it was not Plato's meaning that Kant understood better than Plato, but rather the subject matter that Plato was attempting to analyze. The notion that Kant's understanding of the Ideas was superior to Plato's implies that there is a subject matter to which Plato's meaning was inadequate. If we do not make this distinction between subject matter and meaning, we have no basis for judging that Kant's understanding is better than Plato's.[17] Kant's statement would have been more precise if he had said that he understood Plato's meaning better than Plato. If we do not make and preserve the distinction between a man's meaning and his subject matter, we cannot distinguish between true and false, better and worse meanings.

This example illustrates one of the two main types of authorial ignorance. It has greatest importance in those genres of writing that aspire to tell the truth about a particular subject matter. The other principal type of authorial ignorance pertains not to the subject matter but to the author's meaning itself, and can be illustrated whenever casual conversation is subjected to stylistic analysis:

"Did you know that those last two sentences of yours had parallel constructions which emphasized their similarity of meaning?"

"No! How clever of me! I suppose I really did want to emphasize the similarity, though I wasn't aware of that, and I had no idea I was using rhetorical devices to do it."

What this example illustrates is that there are usually components of an author's intended meaning that he is not conscious of. It is precisely here, where an interpreter makes these intended but unconscious meanings explicit, that he can rightfully claim to understand the author better than the author himself. But here again a clarification is required. The interpreter's right to such a claim exists only when he carefully avoids confusing meaning with subject matter, as in the example of Plato and Kant. The interpreter may believe that he is

drawing out implications that are "necessary" accompaniments to the author's meaning, but such necessary accompaniments are rarely avoidable components of someone's *meaning*. They become necessary associations only within a given *subject matter*.[18] For example, although the concept "two" necessarily implies a whole array of concepts including those of succession, integer, set, and so on, these may not be implied in a given usage of the word, since that usage could be inadequate or misconceived with respect to the subject matter in which "two" falls. Only within that subject matter does there subsist necessity of implication. Thus, by claiming to perceive implications of which the author was not conscious, we may sometimes distort and falsify the meaning of which he was conscious, which is not "better understanding" but simply misunderstanding of the author's meaning.

But let us assume that such misunderstanding has been avoided and that the interpreter really has made explicit certain aspects of an author's undoubted meaning of which the author was unconscious—as in stylistic analysis of casual conversation. The further question then arises: How can an author mean something he did not mean? The answer to that question is simple. It is not possible to mean what one does not mean, though it is very possible to mean what one is not conscious of meaning. That is the entire issue in the argument based on authorial ignorance. That a man may not be conscious of all that he means is no more remarkable than that he may not be conscious of all that he does. There is a difference between meaning and consciousness of meaning, and since meaning is an affair of consciousness, one can say more precisely that there is a difference between consciousness and self-consciousness. Indeed, when an author's meaning is complicated, he cannot possibly at a given moment be paying attention to all its complexities. But the distinction between attended and unattended meanings is not the same as the distinction between what

17. The distinction between meaning and subject matter is discussed in Chap. 2, Sec. F, and is one foundation for my objections to Gadamer's identification of meaning with *Sache*. See Appendix II, pp. 247-49.

18. This distinction was not observed in the interesting essay by O. Bollknow, "Was heisst es einen Verfasser zu verstehen besser als er sich selber verstanden hat?" in *Das Verstehen, Drei Aufsätze zur Theorie des Geisteswissenschaften* (Mainz, 1949).

an author means and what he does not mean. [19] No example of the author's ignorance with respect to his meaning could legitimately show that his intended meaning and the meaning of his text are two different things.

Other varieties of authorial ignorance are therefore of little theoretical interest. When Plato observed that poets could not *explain* what they meant, he intimated that poets were ineffectual, weak-minded, and vague—particularly with respect to their "most elaborate passages." But he would not have contended that a vague, uncertain, cloudy, and pretentious meaning is not a meaning, or that it is not the poet's meaning.[20] Even when a poet declares that his poem means whatever it is taken to mean (as in the case of some modern writers who believe in the current theory of public meaning and authorial irrelevance), then, no doubt, his poem may not mean anything in particular. Yet even in such a limiting case it is still the author who "determines" the meaning.

One final illustration of authorial ignorance, a favorite among literary critics, is based on an examination of an author's early drafts, which often indicate that what the author apparently intended when he began writing is frequently quite different from what his final work means. Such examples show how considerations of style, genre, and local texture may play a larger part in his final meaning than that played by his original intention, but these interesting observations have hardly any theoretical significance. If a poet in his first draft means something different than he means in his last, it does not imply that somebody other than the poet is doing the meaning. If the poet capitalizes on a local effect which he had not originally intended, so much the better if it makes a better poem. All this surely does not imply that an author does not mean what he means, or that his text does not mean what he intends to convey.

If there is a single moral to the analyses of this chapter, it is that meaning is an affair of consciousness and not of physical signs or things. Consciousness is, in turn, an affair of persons, and in textual interpretation the persons involved are an author and a reader. The meanings that are actualized by the reader are either shared with the author or belong to the reader alone. While this statement of the issue may affront our deeply ingrained sense that language carries its own autonomous meanings, it in no way calls into question the power of language. On the contrary, it takes for granted that all meaning communicated by texts is to some extent language-bound, that no textual meaning can transcend the meaning possibilities and the control of the language in which it is expressed. What has been denied here is that linguistic signs can somehow speak their own meaning—a mystical idea that has never been persuasively defended.

19. For a discussion of so-called conscious and unconscious meanings see Chap. 2, Sec. D and E.

20. Or at least that of the muse who temporarily possesses him—the muse being, in those unseemly cases, the real author.

Roland Barthes (1915-1980)

The Death of the Author

Translated by Stephen Heath

In his story *Sarrasine* Balzac, describing a castrato disguised as a woman, writes the following sentence: '*This was woman herself, with her sudden fears, her irrational whims, her instinctive worries, her impetuous boldness, her fussings, and her delicious sensibility.*' Who is speaking thus? Is it the hero of the story bent on remaining ignorant of the castrato hidden beneath the woman? Is it Balzac the individual, furnished by his personal experience with a philosophy of Woman? Is it Balzac the author professing 'literary' ideas on femininity? Is it universal wisdom? Romantic psychology? We shall never know, for the good reason that writing is the destruction of every voice, of every point of origin. Writing is that neutral, composite, oblique space where our subject slips away, the negative where all identity is lost, starting with the very identity of the body writing.

No doubt it has always been that way. As soon as a fact is *narrated* no longer with a view to acting directly on reality but intransitively, that is to say, finally outside of any function other than that of the very practice of the symbol itself, this disconnection occurs, the voice loses its origin, the author enters into his own death, writing begins. The sense of this phenomenon, however, has varied; in ethnographic societies the responsibility for a narrative is never assumed by a person but by a mediator, shaman or relator whose 'performance'—the mastery of the narrative code—may possibly be admired but never his 'genius'. The author is a modern figure, a product of our society insofar as, emerging from the Middle Ages with English empiricism, French rationalism and the personal faith of the Reformation, it discovered the prestige of the individual, of, as it is

more nobly put, the 'human person'. It is thus logical that in literature it should be this positivism, the epitome and culmination of capitalist ideology, which has attached the greatest importance to the 'person' of the author. The *author* still reigns in histories of literature, biographies of writers, interviews, magazines, as in the very consciousness of men of letters anxious to unite their person and their work through diaries and memoirs. The image of literature to be found in ordinary culture is tyrannically centred on the author, his person, his life, his tastes, his passions, while criticism still consists for the most part in saying that Baudelaire's work is the failure of Baudelaire the man, Van Gogh's his madness, Tchaikovsky's his vice. The *explanation* of a work is always sought in the man or woman who produced it, as if it were always in the end, through the more or less transparent allegory of the fiction, the voice of a single person, the *author* 'confiding' in us.

Though the sway of the Author remains powerful (the new criticism has often done no more than consolidate it), it goes without saying that certain writers have long since attempted to loosen it. In France, Mallarmé was doubtless the first to see and to foresee in its full extent the necessity to substitute language itself for the person who until then had been supposed to be its owner. For him, for us too, it is language which speaks, not the author; to write is, through a prerequisite impersonality (not at all to be confused with the castrating objectivity of the realist novelist), to reach that point where only language acts, 'performs', and not 'me'. Mallarmé's entire poetics consists in suppressing the author in the interests of writing (which is, as will be seen, to

restore the place of the reader). Valéry, encumbered by a psychology of the Ego, considerably diluted Mallarmé's theory but, his taste for classicism leading him to turn to the lessons of rhetoric, he never stopped calling into question and deriding the Author; he stressed the linguistic and, as it were, 'hazardous' nature of his activity, and throughout his prose works he militated in favour of the essentially verbal condition of literature, in the face of which all recourse to the writer's interiority seemed to him pure superstition. Proust himself, despite the apparently psychological character of what are called his *analyses*, was visibly concerned with the task of inexorably blurring, by an extreme subtilization, the relation between the writer and his characters; by making of the narrator not he who has seen and felt nor even he who is writing, but he who *is going to write* (the young man in the novel—but, in fact, how old is he and who is he?—wants to write but cannot; the novel ends when writing at last becomes possible), Proust gave modern writing its epic. By a radical reversal, instead of putting his life into his novel, as is so often maintained, he made of his very life a work for which his own book was the model; so that it is clear to us that Charlus does not imitate Montesquiou but that Montesquiou—in his anecdotal, historical reality—is no more than a secondary fragment, derived from Charlus. Lastly, to go no further than this prehistory of modernity, Surrealism, though unable to accord language a supreme place (language being system and the aim of the movement being, romantically, a direct subversion of codes—itself moreover illusory: a code cannot be destroyed, only 'played off'), contributed to the desacrilization of the image of the Author by ceaselessly recommending the abrupt disappointment of expectations of meaning (the famous surrealist 'jolt'), by entrusting the hand with the task of writing as quickly as possible what the head itself is unaware of (automatic writing), by accepting the principle and the experience of several people writing together. Leaving aside literature itself (such distinctions really becoming invalid), linguistics has recently provided the destruction of the Author with a valuable analytical tool by showing that the whole of the enunciation is an empty process, functioning perfectly without there being any need for it to be filled with the person of the interlocutors. Linguistically, the author is never more than the instance writing, just as *I* is nothing other than the instance saying *I*: language knows a 'subject', not a 'person', and this subject, empty outside of the very enunciation which defines it, suffices to make language 'hold together', suffices, that is to say, to exhaust it.

The removal of the Author (one could talk here with Brecht of a veritable 'distancing', the Author diminishing like a figurine at the far end of the literary stage) is not merely an historical fact or an act of writing; it utterly transforms the modern text (or—which is the same thing—the text is henceforth made and read in such a way that at all its levels the author is absent). The temporality is different. The Author, when believed in, is always conceived of as the past of his own book: book and author stand automatically on a single line divided into a *before* and an *after*. The Author is thought to *nourish* the book, which is to say that he exists before it, thinks, suffers, lives for it, is in the same relation of antecedence to his work as a father to his child. In complete contrast, the modern scriptor is born simultaneously with the text, is in no way equipped with a being preceding or exceeding the writing, is not the subject with the book as predicate; there is no other time than that of the enunciation and every text is eternally written *here and now*. The fact is (or, it follows) that *writing* can no longer designate an operation of recording, notation, representation, 'depiction' (as the Classics would say); rather, it designates exactly what linguists, referring to Oxford philosophy, call a performative, a rare verbal form (exclusively given in the first person and in the present tense) in which the enunciation has no other content (contains no other proposition) than the act by which it is uttered—something like the *I declare* of kings or the *I sing* of very ancient poets. Having buried the Author, the modern scriptor can thus no longer believe, as according to the pathetic view of his predecessors, that this hand is too slow for his thought or passion and that consequently, making a law of necessity, he must emphasize this delay and indefinitely 'polish' his form. For him, on the contrary, the hand, cut off from any voice, borne by a

pure gesture of inscription (and not of expression), traces a field without origin—or which, at least, has no other origin than language itself, language which ceaselessly calls into question all origins.

We know now that a text is not a line of words releasing a single 'theological' meaning (the 'message' of the Author-god) but a multi-dimensional space in which a variety of writings, none of them original, blend and clash. The text is a tissue of quotations drawn from the innumerable centres of culture. Similar to Bouvard and Pécuchet, those eternal copyists, at once sublime and comic and whose profound ridiculousness indicates precisely the truth of writing, the writer can only imitate a gesture that is always anterior, never original. His only power is to mix writings, to counter the ones with the others, in such a way as never to rest on any one of them. Did he wish to *express himself*, he ought at least to know that the inner 'thing' he thinks to 'translate' is itself only a ready-formed dictionary, its words only explainable through other words, and so on indefinitely; something experiences in exemplary fashion by the young Thomas de Quincey, he who was so good at Greek that in order to translate absolutely modern ideas and images into that dead language, he had, so Baudelaire tells us (in *Paradis Artificiels*), 'created for himself an unfailing dictionary, vastly more extensive and complex than those resulting from the ordinary patience of purely literary themes'. Succeeding the Author, the scriptor no longer bears within him passions, humours, feelings, impressions, but rather this immense dictionary from which he draws a writing that can know no halt: life never does more than imitate the book, and the book itself is only a tissue of signs, an imitation that is lost, infinitely deferred.

Once the Author is removed, the claim to decipher a text becomes quite futile. To give a text an Author is to impose a limit on that text, to furnish it with a final signified, to close the writing. Such a conception suits criticism very well, the latter then allotting itself the important task of discovering the Author (or its hypostases: society, history, psyché, liberty) beneath the work: when the Author has been found, the text is 'explained'—victory to the critic.

Hence there is no surprise in the fact that, historically, the reign of the Author has also been that of the Critic, nor again in the fact that criticism (be it new) is today undermined along with the Author. In the multiplicity of writing, everything is to be *disentangled*, nothing *deciphered*; the structure can be followed, 'run' (like the thread of a stocking) at every point and at every level, but there is nothing beneath: the space of writing is to be ranged over, not pierced; writing ceaselessly posits meaning ceaselessly to evaporate it, carrying out a systematic exemption of meaning. In precisely this way literature (it would be better from now on to say *writing*), by refusing to assign a 'secret', an ultimate meaning, to the text (and to the world as text), liberates what may be called an anti-theological activity, an activity that is truly revolutionary since to refuse to fix meaning is, in the end, to refuse God and his hypostases—reason, science, law.

Let us come back to the Balzac sentence. No one, no 'person', says it: its source, its voice, is not the true place of the writing, which is reading. Another—very precise—example will help to make this clear: recent research (J.-P. Vernant[1]) has demonstrated the constitutively ambiguous nature of Greek tragedy, its texts being woven from words with double meanings that each character understands unilaterally (this perpetual misunderstanding is exactly the 'tragic'); there is, however, someone who understands each word in its duplicity and who, in addition, hears the very deafness of the characters speaking in front of him—this someone being precisely the reader (or here, the listener). Thus is revealed the total existence of writing: a text is made of multiple writings, drawn from many cultures and entering into mutual relations of dialogue, parody, contestation, but there is one place where this multiplicity is focused and that place is the reader, not, as was hitherto said, the author. The reader is the space on which all the quotations that make up a writing are inscribed without any of them being lost; a text's unity lies not in its origin but in its destination. Yet

1. [Cf. Jean-Pierre Vernant (with Pierre Vidal-Naquet), *Mythe et tragédie en Grèce ancienne*, Paris 1972, esp. pp. 19-40, 99-131.]

this destination cannot any longer be personal: the reader is without history, biography, psychology; he is simply that *someone* who holds together in a single field all the traces by which the written text is constituted. Which is why it is derisory to condemn the new writing in the name of a humanism hypocritically turned champion of the reader's rights. Classic criticism has never paid any attention to the reader; for it, the writer is the only person in literature. We are now beginning to let ourselves be fooled no longer by the arrogant antiphrastical recriminations of good society in favour of the very thing it sets aside, ignores, smothers, or destroys; we know that to give writing its future, it is necessary to overthrow the myth: the birth of the reader must be at the cost of the death of the Author.

Rosalind Krauss (1940-)

Poststructuralism and the Paraliterary

Last fall [1980] Partisan Review *conducted a two-day symposium under the general title "The State of Criticism." Although various sessions were designed to treat a variety of topics, most presentations were dominated by one continuing theme: structuralist and poststructuralist critical theory and the threat that it somehow poses for literature. My own role in these proceedings was limited to that of discussant; I was to comment on the main paper, written by Morris Dickstein and delivered as the substance of a session dedicated to the influence of recent critical theory on the vehicles of mass culture. As will become obvious, Dickstein's paper was yet another statement of the general sense that literary criticism (understood as an academic discipline) had fallen hostage to an invading force, that this force was undermining critical practice (understood as close reading) and, through that corrosive effect, was eating away at our concept of literature itself.*

My comments had, then, a very particular point of origin. But the views against which those comments were directed are extremely widespread within the literary establishment—both inside and outside the academy—where a sense of the pernicious nature of poststructuralism has led to more recent projects devoted to "How to Rescue Literature."[1] Thus, despite the specific occasion that gave rise to my discussion of the "paraliterary," I believe this is of much wider conceptual interest. I therefore reproduce in full my remarks.

The title of this morning's session—"The Effects of Critical Theories on Practical Criticism, Cultural Journalism, and Reviewing"—suggests that what is

at issue is the dissemination, or integration, of certain theoretical perspectives into an apparatus of critical practice that reaches well beyond the graduate departments of English or Comp. Lit. at Harvard, Yale, Cornell, and Johns Hopkins. The subject appears to be the effect of theory on what Mr. Dickstein describes as "the mediating force between an increasingly difficult literature and an increasingly diverse audience," a mediating force represented in this country by a long list of magazines and journals, headed, undoubtedly, by *The New York Review of Books*. Now this is a subject on which Mr. Dickstein's paper—obsessed by what he sees as the deepening technocratization of graduate studies—does not touch. If by this omission he means to imply that he thinks that advanced critical theory has had *no* effect whatsoever on that wider critical apparatus, then he and I are in complete agreement.

But the question would seem to be—Mr. Dickstein's laments aside—*why* has there been no such effect? In order to broach that subject I would like to recall briefly two lectures I attended by two of the technocrats in Mr. Dickstein's account: Jacques Derrida and Roland Barthes. Derrida's lecture was the presentation of part of an essay called "Restitutions," which, in examining the claims Heidegger makes in "The Origin of the Work of Art," focuses on a painting by Van Gogh commonly thought to be the depiction of a pair of shoes. In that lecture, Derrida placed special emphasis on the role of a voice that continually interrupted the flow of his own more formal discourse as it spun out the terms of philosophical debate. Enacted in a slight falsetto, this voice was, Derrida explained, that of a woman who repeatedly breaks into the measured order of the exposition with questions that are slightly hysterical, very exasperated, and above all *short*. "What pair?" she keeps insisting, "Who said they were a *pair* of shoes?" Now this voice, cast as a woman's, is

1. Two particularly vociferous attacks on poststructuralism have appeared recently in *The New York Review of Books*: Roger Shattuck, "How to Rescue Literature," *NYR*, XXVI, 6 (April 17, 1980), 29-35; and Denis Donoghue "Deconstructing Deconstruction," *NYR*, XXVII, 10 (June 12, 1980), 37-41.

of course Derrida's own, and it functions to telegraph in a charged and somewhat disguised way the central argument which for other reasons must proceed at a more professorial pace. But aside from its rather terroristic reductiveness, this voice functions to open and theatricalize the space of Derrida's writing, alerting us to the dramatic interplay of levels and styles and speakers that had formerly been the prerogative of literature but not of critical or philosophical discourse.

This arrogation of certain terms and ruses of literature leads me to the lecture by Roland Barthes entitled "*Longtemps je me suis couché de bonne heure*" in which, by analogizing his own career to that of Proust, Barthes more explicitly pointed to an intention to blur the distinction between literature and criticism. Indeed, much of Barthes's recent work—I am thinking of *The Pleasure of the Text, A Lover's Discourse*, and *Roland Barthes by Roland Barthes*—simply cannot be called criticism, but it cannot, for that matter, be called not-criticism either. Rather, criticism finds itself caught in a dramatic web of many voices, citations, asides, divagations. And what is created, as in the case of much of Derrida, is a kind of paraliterature. Since Barthes's and Derrida's projects are extremely different, it is perhaps only in this matter of inaugurating a paraliterary genre that their work can be juxtaposed.

The paraliterary space is the space of debate, quotation, partisanship, betrayal, reconciliation; but it is not the space of unity, coherence, or resolution that we think of as constituting the work of literature. For both Barthes and Derrida have a deep enmity towards that notion of the literary work. What is left is drama without the Play, voices without the Author, criticism without the Argument. It is no wonder that this country's critical establishment—outside the university, that is—remains unaffected by this work, simply cannot use it. Because the paraliterary cannot be a model for the systematic unpacking of the meanings of a work of art that criticism's task is thought to be.

The creation of the paraliterary in the more recent work of these men is, of course, the result of theory—their own theories in operation, so to speak. These theories run exactly counter to the notion that there is a work, x, behind which there stands a group of meanings, a, b, or c, which the hermeneutic task of the critic unpacks, reveals, by breaking through, peeling back the literal surface of the work. By claiming that there is not, *behind* the literal surface, a set of meanings to which it points or models to which it refers, a set of originary terms onto which it opens and from which it derives its own authenticity, this theory is not prolonging the life of formalism and saying what Mr. Dickstein claims "we all know"— that writing is about writing. For in that formula a different object is substituted for the term "about"; instead of a work's being "about" the July Monarchy or death and money, it is "about" its own strategies of construction, its own linguistic operations, its own revelation of convention, its own surface. In this formulation it is the Author or Literature rather than the World or Truth that is the source of the text's authenticity.

Mr. Dickstein's view of this theory is that it is a jazzed-up, technocratized version of formalism, that its message is that writing is about writing, and that in a work like *S/Z*, "Barthes's purpose is to preserve and extract the multiplicity of the text's meanings." Here we arrive not only at the point where there is no agreement whatsoever between us, but also at the second reason why this theory has left the wider critical establishment of this country in such virginal condition. For where that establishment has not been largely ignorant of the work of Barthes or Derrida or Lacan, it has misconceived or misconstrued it. To use the example that Mr. Dickstein has provided, *S/Z* is precisely not the preservation and extraction of "the multiplicity of the text's meanings." Nor is it what the jacket copywriter for the American edition claims: the semantic dissection of a Balzac novella, "in order to uncover layers of unsuspected meanings and connotations." For both these notions—"extraction" and "dissection"—presuppose an activity that is not Barthes's own, just as they arise from a view of the literary object that Barthes wishes not so much to attack as to dispel. For *extract* and *dissect* assume a certain relation between denotation and connotation as they function within the literary text; they assume, that is, the primacy of the denotative, the literal utterance, beyond which lies the rich vein of connotation or association or meaning. Common sense conspires to tell

us that this should be so. But Barthes—for whom common sense is the enemy, due to its unshakable habit of fashioning everything on the model of nature—demonstrates the opposite: that denotation is the effect of connotation, the last block to be put in place. *S/Z* is a demonstration of the way that systems of connotation, stereotype, cliché, gnomic utterance—in short, the always already-known, already-experienced, already-given-within-a-culture—concatenate to produce a text. Further, he claims that it is not only this connotational system that writes the text, but that it is, literally, what we read when we read the literary work. Nothing is buried that must be "extracted"; it is all part of the surface of the text.

Thus, in introducing the three women who surround the narrator of *Sarrasine*, Balzac describes Marianina as "a girl of sixteen whose beauty embodied the fabled imaginings of the Eastern poets! Like the sultan's daughter, in the story of the Magic Lamp, she should have been kept veiled." To this description Barthes responds, "This is a vast commonplace of literature: the Woman copies the Book. In other words, every body is a citation: of the 'already-written.' The origin of desire is the statue, the painting, the book." Then Marianina's mother is introduced with the question, "Have you ever encountered one of those women whose striking beauty defies the inroads of age?" To which Barthes's response is: "Mme de Lanty's body is drawn [with the words *one of those women*] from another Book: the Book of Life." Again, after the opening description of Mme de Rochefide as a woman "delicately formed, with one of those faces as fresh as that of a child," Barthes pounces again on the term "one of those faces": "The body is a duplicate of the Book: the young woman originates in the Book of Life, the plural refers to a total of stored-up and recorded experiences." The text's invocation of those books, those vast storehouses of cliché, creates what Barthes refers to as the "stereographic space of writing," as well as the illusion that there is a denotational object—Marianina, or Mme de Lanty—that precedes the connotational system signaled by "one of those faces." But if writing sets up the pretense that denotation is the first meaning, for Barthes denotation is "no more than the last of the connotations

(the one which seems both to establish and to close the reading)." Identifying these connotational systems as codes, Barthes writes, "To depict is to unroll the carpet of the codes, to refer not from a language to a referent, but from one code to another. Thus, realism consists not in copying the real but in copying a (depicted) copy of the real.... This is why realism cannot be designated a 'copier' but rather a 'pasticheur' (through secondary mimesis, it copies what is already a copy)."

The painstaking, almost hallucinatory slowness with which Barthes proceeds through the text of *Sarrasine* provides an extraordinary demonstration of this chattering of voices which is that of the codes at work. If Barthes has a purpose, it is to isolate these codes by applying a kind of spotlight to each instance of them, to expose them "as so many fragments of something that has always been already read, seen, done, experienced." It is also to make them heard as voices "whose origin," he says, "is lost in the vast perspective of the already-written" and whose interweaving acts to "de-originate the utterance." It is as impossible to reconcile this project with formalism as it is to revive within it the heartbeat of humanism. To take the demonstration of the de-originated utterance seriously would obviously put a large segment of the critical establishment out of business; it is thus no wonder that poststructuralist theory should have had so little effect in that quarter.

There is however another place where this work has met with a rather different reception: in graduate schools where students, whatever their other concerns might be, are interested in reading. These students, having experienced the collapse of modernist literature, have turned to the literary products of postmodernism, among the most powerful examples of which are the paraliterary works of Barthes and Derrida. If one of the tenets of modernist literature had been the creation of a work that would force reflection on the conditions of its own construction, that would insist on reading as a much more consciously *critical* act, then it is not surprising that the medium of a *post*modernist literature should be the critical text wrought into a paraliterary form. And what is clear is that Barthes and Derrida are the *writers*, not the critics, that students now read.

Joseph Margolis (1924-)

Reinterpreting Interpretation

Give or take a little in the way of precision, there are at least three bits of advice that ought not to be ignored in constructing a theory of interpretation of any size. First, it is impossible to disjoin the account of the nature or logic of interpretation from one's theory of the nature of what it is that may or must be submitted to interpretation. Second, there are only two sorts of pertinent theories of interpretation. One holds that interpretation is practiced *on* relatively stable, antecedently specifiable referents of some sort, and that the requisite account identifies the practice by which distributed claims about them are responsibly assigned truth-like values of some sort; the other holds that interpretation is a productive practice by which an entire "world" or what may be distributively referred to in that world is or are actually and aptly first constituted *for* certain sorts of further claim or use, possibly for interpretation in the first sense. These are not yet theories in their own right, but they are remarkably economical directives about what to explore. The first sort of theory identifies the traditional genus of interpretation; the second is notably, even peculiarly, fashionable in our own time and is sometimes thought to disallow theories of the first sort. The latter move cannot possibly be right, for the simple reason that there is no socially sustained discourse that is not at least constative or enunciative in the sense of facilitating (in the sense of the French cognate verbs) orderly reference and predication. Since that is so, the familiar contemporary worry about statement, assertion, judgment, claim and the like on the grounds of the need to avoid any and all forms of cognitive privilege or transparency is a conceptually suicidal defense that misses the point of the ineliminability of the constative. One cannot do without reference, predication, description, interpretation, explanation, analysis, evaluation; although saying that disallows nothing in the way of arguable views about *what* may be described or interpreted or *how* description and interpretation actually proceed. The point would be entirely trivial except for the annoying fact that it is no longer unusual to hear it denied or implicitly rejected. In any case, the first sort of theory is the classical one. It admits the complexity of *what* we interpret, but it does not extend the notion of interpretation to include the very constitution of *that*. In contemporary theories, on the other hand, the cognitive intransparency of the world obliges us to make room for theories of the second sort. Characteristically, the work of such theories is thought to be inseparable from the work of theories of the first sort. You can appreciate, therefore, that the barest beginning of an account of interpretation plunges us at once into a conceptual swamp. For how can we interpret what has yet to be constituted and how can anything be constituted by way of interpretation? Still, there are no interesting theories of interpretation in our own time that do not—*or will not*—combine both senses of "interpret."

The third bit of advice reminds us that, whatever the slackness of linguistic usage, what are interpreted in either of the senses given are distinctly cultural phenomena or cultural entities of some sort, are interpretable in fact just in virtue of their having cultural features or because they are treated as having such features or because they have features sufficiently like cultural features to warrant being similarly treated.

These are all, of course, deliberately elusive but quite safe initial pronouncements that convey an air of imminent system and scope and a promise of detail

that a street-wise audience is likely to be polite and patient enough about while awaiting full delivery from the vendor. Also, it is not likely to be ignored that, regarding all three bits of advice taken together, the first sort of theory of interpretation identifies referents conceptually apt in some antecedent sense *for* interpretation; whereas the second sort of theory treats interpretation as a process of actually constituting things *by* interpretation, by a constructive activity by which certain phenomena or entities are first and merely posited. This second usage enjoys a certain vogue at present, though, thus featured, it also has an odd ring. In any case, there is no incompatibility or equivalence between these two sorts of theory; also, it is worth considering that an adequate account of interpretation may need to incorporate elements of both sorts of theory. The kind of contribution the first might make can hardly be supposed to be entailed or precluded by the work of the second; and the point of the second would be entirely lost if it did not accommodate some generically constative discourse that could or actually would include interpretative discourse of the first sort.

Let us say that the first sort of theory is meant to be *adequational*, that is, to assign (for the purpose of interpretive constatation) a nature or features to the referents of our discourse such that *they* would be conceptually adequated to our making and supporting the kind of claim about them that we take interpretation to provide. Given the warning already collected, there is no reason to suppose that there is anything illicitly privileged in merely attempting to formulate an adequational theory. This is not to say that there is no metaphysical or epistemological bite to such a theory, only that it cannot reasonably be supposed that every metaphysics or epistemology necessarily violates the common injunction against privilege. Otherwise, since constative discourse cannot be avoided and since it cannot proceed without a stable practice of reference and predication, it appears that it could not fail to yield metaphysical and epistemological findings, privileged or not. Relativize such findings, however, to the mere saliencies or *Erscheinungen* of our shared world: one could then reject all the tricks of cognitive privilege

without giving up the benefits of an adequational theory. The point is modest enough, though enormously potent. Indeed, it is almost universally ignored. What it signifies is that the admission of reference and predication is the logical or formal admission of a need *for* the processes of description and interpretation: it is the admission that a world apt for interpretation must be stable enough to support such processes. It is a complete *non sequitur*, therefore, to suppose that admitting that much is tantamount to admitting some further metaphysical or epistemological privilege. Correspondingly, we may characterize the second sort of theory as *constructive*, in the sense that we and the things of our cultural world may be taken to be constituted somehow, possibly serially reconstituted, as what they are, or thereby become, as a result of some initial interpretive act.

Interpretation in the adequational sense must be referentially reliable though it hardly requires, for that reason, that referents have fixed or unchanging natures; and interpretation in the second sense specifically admits an initial production or a constitutive change in the nature of certain things by virtue of some as yet unspecified activity. Clearly, there is no reason to suppose that there is a univocal sense of "interpret" that usefully serves both theories at once. But if a reasonable account of interpretation could be fashioned for both sorts of theory—which seems both promising and generous—then it would be a considerable convenience to be able to identify by the same term the referents addressed in the first sense of "interpret" and whatever may be constituted in the second sense. Call such referents *texts*. Recapitulating the above: texts and interpretation in the first sense must be adequated to one another; the ways in which texts are constituted yield referents apt for interpretation in the first sense; and texts are constituted as such by some suitable cultural activity, by interpretation in the second sense.

This is all very general but still noticeably tighter than our first intuitions. We may perhaps add one further preliminary distinction to save a little time later. The only other general constraints we should impose on what we mean to take texts to be—in order to accommodate interpretive discourse of a suitably

comprehensive sort—are these: first, that texts must be taken to be sufficiently *unitary*, in a logical sense, that is, individuatable and reidentifiable numerically, though this hardly settles the question of *how unified* in a substantive way, how fixed or unchanging their internal natures must be; and second, that, however unified, variable, alterable, even enlarged or affected they may be or become as a result *of* interpretive activity, their nature must intrinsically include attributes of a suitably cultural sort that render them apt for interpretation in the first sense and that account for their peculiar alterability and openness in the second sense. They could not be unitary without *some* internal unity: so our warning about the distinction between a metaphysics and epistemology of privilege and a metaphysics and epistemology of salience is well taken. But equally, they could not be texts adequated for interpretation if they did not intrinsically possess linguistic, language-like, semiotic, symbolic, representational, expressive, rhetorical, intentional or similar properties: these are indeed just the sorts of property interpretive theories of the first sort and metaphysical theories of the second take for granted. Let us, for later convenience, say that texts intrinsically possess *Intentional* properties. A theory of interpretation is, then, a theory that: (i) accounts for originally constituting or reconstituting texts as such by constituting would-be referents possessing intrinsically Intentional natures; and (ii) accounts for the interpretation of such texts in virtue of which pertinent claims about them may be assigned truth-like values and may be duly supported in an evidentiary way. It is a matter of considerable importance that texts may, on an opposed theory, be said to be produced by some sort of socially pertinent labor (*poesis*) that is *not* originally interpretive itself—for instance, on the mimetic theory. In that case—classically, of course—only the adequational and constative notion of interpretation is needed. In our own time, because the world's transparency has been so radically denied, actually constituting *what* we can address by intelligent act or inquiry requires an original mixing of labor with the physical world or the repeated reclaiming of such a mixed world by further mixing of the same sort. In speaking of that

process as interpretive, we anticipate (if only by way of a myth) the second, the constructive, sense of interpretation.

Once again, speaking in this way is no more than setting the stage for a suitable theory. Those already engaged in the advanced argument will find these remarks little more than a postponement of the essential issue. Still, it cannot be denied that the point of managing things thus is to suggest very strongly that *any* alternative option is either defective, incomplete, inadequate, untenable, unresponsive, unconvincing, not pertinent—or worse. Much hangs on the presumption, of course, but we could never get started on an actual theory if we stopped here to examine with due care all the arguments that might lead us in other directions. There is a hubris in the undertaking. We may, therefore, anticipate an unavoidable barrage of puzzles that we may not actually address in selecting what is narrowly required for our topic.

I

So much for preliminaries. Now for a little scaffolding. Consider two very popular claims drawn from recent theoretically-minded views of texts (or, more narrowly, artworks). For one, Rosalind Krauss, pressing into service what (reflecting on the views of Roland Barthes and Jacques Derrida) she takes to be the postmodernist intention to "blur the distinction between literature and criticism," she speaks of "a kind of paraliterature," that is, a literature that is now neither criticism nor non-criticism but a sort of analogue of what criticism would have been for the modernist (preeminently, for Clement Greenburg) now that the distinction between artworks or texts and criticism has been blurred:

> The paraliterary space is the space of debate, quotation, partisanship, betrayal, reconciliation; but it is not the space of unity, coherence, or resolution that we think of as constituting the work of literature. For both Barthes and Derrida have a deep enmity towards that notion of the literary work. What is left is drama without the Play, voices without the Author, criticism without the Argument. It is no wonder that this country's critical establishment—outside the university, that is—remains unaffected by this work, simply cannot use it. Because

the paraliterary cannot be a model for the systematic unpacking of the meanings of a work of art that criticism's task is thought to be... there is not, *behind* the literal surface, a set of meanings to which [the paraliterary] points or models to which it refers, a set of originary terms onto which it opens and from which it derives its own authenticity.[1]

Clearly, in opposing the views of theorists like Greenburg, Krauss means to dismantle altogether (not merely to reverse) the high modernist thesis in all of its forms—for instance, as it appears in T. S. Eliot's famous remark, that a work of art "is autotelic" and that "criticism by definition is *about* something other than itself" (a notation Eliot considerably changed in due course);[2] or to oppose what might be called the premodernist thesis of New Criticism—for instance, a it appears in Monroe Beardsley's so-called Principles of Independence and Autonomy: "that literary works exist as individuals and can be distinguished from other things" and "that literary works are self-sufficient entities whose properties are decisive in checking interpretations and judgments."[3] Krauss's thesis is at least a first specimen of what we have called the constructive or second sense of interpretation, although to admit that much is neither to support her particular thesis nor to suggest particular weaknesses in the second sort of theory as a result of weaknesses in her own version of that theory.

What is easy to miss, what Krauss misses, is that (a) the rejection of the fixed disjunction between criticism or interpretation and text or (b) the rejection of the fixed nature or fixedly bounded nature of texts independent of particular judgments or interpretation is not at all tantamount or equivalent to (c) the rejection of any functional (or logical) disjunction between criticism and texts. This may not be obvious. Roughly put: the paraliterary need not—indeed cannot logically—disallow, at any moment at which it is pertinently intruded, that last disjunction (c). The very nature of constative discourse forbids it. Krauss risks—the evidence of her extended discussions indicate that she more than risks, she actually loses—the point of the paraliterary insertion itself. When she says that what is "left" is "drama without the Play, voices without the Author, criticism without the Argument," we may understand that she thereby opposes the pertinence or adequacy of modernist (or premodernist) theories of the would-be referents of criticism—the object of distinctions (a) and (b); but in dismissing them, she *must* hold (so must we all) to some version of (c), the logical distinction of paraliterary comments (criticism or interpretation, if you like), *if*, as she obviously does, she means to speak (and does speak) of the work of Duchamp and Pollock and Stella and Serra and LeWitt and others. This is the reason, reviewing a variety of postmodernist work, she speaks of the "index," the "shifter," "traces, imprints, and clues" and similarly attenuated referential devices.[4] She shows by her discourse that she cannot—she is hardly disposed to—abandon the devices of reference (captions and titles included); but her dialectical maneuvers against modernists are intended to leave the impression (there is some reason to think she herself is convinced by the argument) that she *has* actually abandoned the logical referent we call "the play," in abandoning the high, complex, modernist entity "the Play"—as well as authors and criticism and the rest. Put as simply as we can: the logical distinction and pairing between interpretive discourse and interpreted referent is both entirely different in purpose from and perfectly compatible with the so-called postmodernist insistence on denying an unbridgeable disjunction between criticism and text or artwork.

What Krauss fails to notice (or to acknowledge) is that the constative constraints of discourse, whether paraliterary or highly critical, must retain an effective reference to what is sufficiently *unitary* (individuatable in a logical sense) to make such discourse pertinent; also, that it makes no difference at all what we suppose to be the internal *unity* or the

1. Rosalind E. Krauss, "Postmodernism and the Paraliterary," in *The Originality of the Avant-Garde and Other Myths* (MIT Press, 1983), pp. 292-293.

2. T. S. Eliot, "The Function of Criticism," in *Selected Essays 1917-1932* (London: Faber and Faber, 1932), p. 19.

3. Monroe C. Beardsley, "The Authority of the Text," in *The Possibility of Criticism* (Wayne State University Press, 1970), p. 16.

4. See Krauss, "Notes on the Index: Part 1" and "Notes on the Index: Part 2," in *The Originality of the Avant-Garde*.

order that remains when art departs from the high unity modernist or premodernist usage presumes, so long as our theory (and practice) permit reference and predication to continue to succeed. What postmodernists of Krauss's stripe merely confuse—which is not equivalent to an accusation against ether Barthes or Derrida—is the difference between merely judging or interpreting artworks and trashing modernism, or the difference between formulating the difference between modernist and postmodernist art and judging or interpreting works of either sort, or even the difference between favoring or opposing, for cause, particular theories about art of either sort.

Fussy as it may appear, the quarrel being addressed is a more strategic one. Krauss's obvious intent—an objective she somewhat garbles in collecting Barthes's very interesting notion, which she means to apply in the visual artworld—is to reject the fixed demarcation between criticism or interpretation and text or artwork. The idea is that *what* in the paraliterary manner is said about a would-be artwork at time *t* may *need* to differ from *what* may be said about that "same" artwork at *t´* later than *t*, *as a result of already having defensibly interpreted (or commented on) the work at t.*

There are really two mistakes that Krauss commits here. First of all, she wrongly supposes, in rejecting what a critic offers in "a reading [of a particular painting] *by* proper names," that she is also somehow committed to rejecting the need *for* proper names or other referential devices in critically discussing that painting or its details. For example, she shows, regarding Picasso's *La Vie*, a 1904 Blue Period portrait of Picasso's friend Casagemas, which was modeled on an earlier self-portrait of Picasso himself, that a standard, somewhat psychoanalytic interpretation of the "meaning" of the work pretty well trades on what she herself wishes to avoid and rightly condemns as "the art history of the proper name." In context, she actually mentions and briefly discusses the principal philosophical theories of proper names and links them to what she terms disapprovingly "an aesthetics of extension."[5] But she

thereby confuses the requirements of constatation with the presumptions of privilege; she slights the minima of unicity in her reasonable suspicions about modernist notions of unity. We *do not* settle the nature, essence, or boundaries of artworks merely by ensuring that we can identify and refer to them.

The truth is that the extensional function of proper names and referential devices may function within quite complex intentional contexts (for instance, as in the fragmenting of *Beaujolais* in a Juan Gris collage—which counts against modernist simplification); and where, as with titles or captions, it functions to individuate an artwork, we need not suppose that the very nature, structure, intentional detail or unity of the work is fixed or bounded by, or somehow determinately specified or specifiable in accord with, or unalterable with regard to, or unalterably linked to, that extensional function. The extensional function of proper names (naming *La Vie*, for instance) is not the same thing as the extension of what the name names (whatever we may suppose that to be, the "painting," say); and the extension of a name (whatever that is) is not the same thing as, and does not determine, the Intentional complexities of what the name names (for example, what one or many nonconverging interpretations of *La Vie* may reasonably impute, synchronically or diachronically, to *La Vie*).[6] This is precisely what is meant to be accommodated by distinguishing between the unicity and the unity of an artwork, where what "unity" designates may be contested, say, by modernist and postmodernist theorists of art, all the while *some* referential fixity regarding the bare logical "unicity" of a work enables that contest to be actually and first joined. It is entirely possible that the purely referential function be achieved by paying attention to reliable markings that are not even part, in any pertinent sense, of the painting in question. In a word, criticism and interpretation require referentially successful discourse; but providing for that says absolutely nothing about, and sets no significant constraints on (though it does require constraints on), the intrinsic nature of artworks and other cultural entities.

5. Krauss, "In the Name of Picasso," in *The Originality of the Avant-Garde*, pp. 28, 30, 32; italics added.

6. See Margolis, *Texts without Referents; Reconciling Science and Narrative* (Oxford: Blackwell, 1988) chs. 7, 8.

A theory of how to interpret the Picasso, eschewing a literal-minded "art history of the proper name" applied to the representational content of the painting, however, goes no distance at all toward demonstrating that the use of referential devices *for* fixing the painting's identity, or even for fixing certain of its details, commits us to the doctrine that paintings have or must have fixed natures. No, that is an utter *non sequitur* that draws us on to Krauss's second mistake, namely, her supposing that the play of paraliterary criticism in what she sketches as Barthes's spirit is, in its own turn, also incompatible with the mere referential fixity of the artwork itself. The truth is that many have been wrongly persuaded *that the extensional function of reference somehow fixes once and for all the substantive or Intentional complexities (the nature) of whatever are thus only logically individuated*—if, indeed, they actually are the sort of entity that possess such properties (as, of course, cultural phenomena all do).

The referential fixity of a text or artwork is a matter quite distinct from the substantive fixity of what may be referentially fixed. The two are doubtlessly closely linked, in the sense that nothing could be referentially fixed that did not exhibit a certain stability of nature; but how alterable (or by what means altered) the life of a person or the restored *Last Supper* or the oft interpreted *Hamlet* or the theoretically intriguing *Fountain* or the marvelously elastic *Sarrasine* may be is *not* a matter that can be decided, or that is actually determined merely, by fixing such texts or artworks *as* the reidentifiable referents that are. Modernism and premodernism do indeed appear to have been too naive or too conservative about the conceptual link between these two notions, and postmodernism may have liberated us in that respect; but, for its own part, postmodernism has failed (in Krauss at least) to acknowledge an *ontic* conservatism implied in referential success insofar as the possibility of such success affects the very nature of texts *apt for reference*—which of course (sadly perhaps) the modernists were never even tempted to disown. Unicity and unity are yoked concepts all right; but they need not, running in tandem, ever be taken for the same horse. By the same argument, to say that interpretation (in the sense of the first sort of theory we introduced) presupposes description is *not* to say that description must, to be valid or true, be timelessly fixed or unchangeable or designate the fixed or unchangeable properties of whatever we go on to interpret. That would depend on the particular *nature* of what we meant to describe or interpret—for whatever we describe or interpret must have a "nature" of some sort. Admitting description—or, better, describability—is, first, a purely logical concession to the minima of discourse; it is only secondarily, beyond that, disputatiously, a further—a hardly entailed—concession to modernism or to some other privileged metaphysics of art.[7] If so, then the requirement of the first sense of "interpret" the constative distinction, *cannot* be denied; and the modernist or premodernist thesis is at least not entailed by that concession. We may collect all this quite simply by acknowledging that the apparent formal fixities of discourse, the fixities of reference and prediction, have nothing as such to do with deciding *what* the intrinsic nature of texts or particular texts may or must be—except for the fact (the hardly negligible fact) that whatever we say *is* the nature of a text must be compatible with so saying and with the interpretive discourse it is meant to support. Interpreted texts must have somewhat stable properties but they need not have altogether fixed natures. So we must go beyond Krauss.

7. I confess that, in *The Language of Art and Art Criticism* (Wayne State University, 1965) and *Art and Philosophy* (Atlantic Highlands, N.J.: Humanities Press, 1980), I had not fully appreciated these complexities. I see that I was drawn, in effect, to allow more than I specifically wished to commit myself to. This essay is part of an attempt to make good my full escape—and, at the same time, to recover what is recoverable from those earlier accounts. I have, here, been very much influenced by the entire development of Continental European philosophy moving through Husserl and Heidegger and Gadamer and Derrida and Barthes and Foucault. But I am pleased to acknowledge the fairness of a criticism of the apparent force of my previously published position, in Richard Shusterman, "Interpretation, Intention, and Truth," in *Journal of Aesthetics and Art Criticism* 46 (1988): 399-411. I do believe that Shusterman himself fails to distinguish the logical and substantive issues, which gives a somewhat false impression of my earlier views. But that, doubtless, is due to my own former innocence; and, in any case, I should not protest too strenuously. See Joseph Margolis, *Texts without Referents*, part II.

II

Consider, now, a second claim, this time from Barthes's well-known essay, "From Work to Text," which is as close to a canonical formulation of what Krauss originally wished to borrow as one could possibly find:

> In opposition to the notion of the *work* of art or literature there now arises a need for a new object, one obtained by the displacement or overturning of previous categories. This object is the Text. ... The Text must not be thought of as a defined object. It would be useless to attempt a material separation of works and texts. ... A very ancient work can contain "some text," while many products of contemporary literature are not texts at all. The difference is as follows: the work is concrete, occupying a portion of book-space (in a library, for example); the Text, on the other hand, is a methodological field.[8]

Two distinctions need to be made: first, there is no doubt that Barthes *never* means to abandon a constative reliance on referential facilities, all the while he clearly intends to subvert conventional views about reading a text (for instance, views somewhat like Beardsley's New Critical view of interpretative reading); second, there is no doubt that Barthes does mean *to constitute*, by a certain sort of reading and serial rereading, *that* "object" that thereby becomes (what he calls) the Text. The notion of the Text, for Barthes, therefore, is *not* the notion of an antecedent referent to which interpretation is directed but rather the notion of what is productively yielded by interpretively addressing "something else" that, in the ongoing process of reading and rereading, *is* uniquely affected by that very process.

It is impossible to pursue the theme without citing Barthes's famous distinction between the readerly and the writerly (the *lisible* and *scriptible*) offered at the very opening of *S/Z*, which is close in spirit (and even language) to the paper just mentioned:

> Why is the writerly our value? Because of the goal of literary work (of literature as work) is to make the reader no longer a consumer, but a producer of the text. Our literature is characterized by the pitiless divorce which the literary institution maintains between the producer of the text and its user, between its owner and its customer, between its author and its reader. This reader is thereby plunged into a kind of idleness—he is intransitive; he is, in short, *serious*: instead of functioning himself, instead of gaining access to the magic of the signifier, to the pleasure of writing, he is left with no more than the poor freedom either to accept or reject the text: reading is nothing more than a *referendum*. Opposite the writerly text, then, is the countervalue, its negative, reactive value: what can be read, but not written: the *readerly*. We call any readerly text a classic text.[9]

Of course, Balzac's *Sarrasine* is the classic readerly text that Barthes marvelously shows us how to read as a writerly Text. In doing that, Barthes confirms: (i) that writerly reading does not eliminate readerly reading or its eligibility and contribution; (ii) that reading of either sort presupposes a referent—the point of mentioning the "signifier," necessary for both readerly and writerly reading; (iii) that the readerly text may have been, at some earlier time, a writerly Text in its own right but is now no longer such, is now a fixed or bounded text, the unity of which in the modernist or premodernist sense has become a function of its particular interpretive history; alternatively, its being reread now (as a readerly

8. Roland Barthes, "From Work to Text," in *Textual Strategies; Perspectives in Post-Structuralist Criticism*, trans. and ed. Josué V. Harari (Cornell University Press, 1979), p. 74.

9. Roland Barthes, *S/Z*, trans. Richard Miller (New York: Hill and Wang, 1974), p. 4. The closest English-language equivalent of Barthes's conception of "texts"—approached, however, from an entirely different point of view, one more disposed to the semantic than to the syntactic, though equally freewheeling in its attitude to codes or rules—is, of course, the one favored by Harold Bloom. The following brief passage from Harold Bloom, *A Map of Misreading* (Oxford University Press, 1975), "Introduction: A Meditation upon Misreading," makes this quite clear: "Reading... is a belated and all-but-impossible act, and if strong is always a misreading. Literary meaning tends to become more underdetermined even as literary language becomes more over-determined. ...Influence, as I conceive it, means that there are *no* texts, but only relationships *between* texts. These relationships depend upon a critical act, a misreading or misinterpretation, that one poet performs upon another, and that does not differ in kind from the necessary critical acts performed by every strong reader upon every text he encounters. The influence-relation governs reading as it governs writing, and reading is therefore a miswriting just as writing is a misreading. As literary history lengthens, all poetry necessarily becomes verse-criticism, just as all criticism becomes prose-poetry." (p. 3).

thing) commits us canonically to recovering what constitutes it as a properly fixed text; hence (iv) that even a readerly text is constituted (in our second sense) by interpreting something *else*—the "signifier," in Barthes's Saussurean usage; (v) that, for Barthes, the "Text," taken as the internal accusative of reading, is not an actual referent for further writerly reading (though the signifier is) but is collapsed into such a fixed referent only for readerly reading; and (vi) that reading in the writerly way is not in the least incompatible with admitting readerly texts; in fact, it may be practiced on such texts.

A great deal of nonsense has been spread abroad maligning Barthes's intelligence, when what is wanted is a careful understanding of the remarkable thesis Barthes has bequeathed us. As it happens, it affords the best clue we are likely to find regarding the second sort of theory of interpretation. In any case, in his terribly freewheeling way, Barthes shows us how to *entertain* the idea that a text (in our sense, not quite in his, though congruently enough with his own notion), need not be presumed to have a fixed nature throughout a responsible reading (that is, *in* what we—once again, not Barthes—are calling interpretation) in spite of the fact that, however that nature may change, it remains a changing or changeable nature *assignable to this or that text* (as *we* are prepared to say) or "signifier" (in Barthes's usage). What shall we make of that?

Barthes actually does speak of interpretation but only to dismiss it or to use the notion in what he calls "the Nietzschean sense of the word."[10] What he means is that ordinary interpretation (interpretation in our first sense) is addressed only to readerly texts, to texts construed as "products," referents with fixed natures; whereas writerly texts invite interpretation only in the "Nietzschean" sense (in something close to our second sense), in a sense applied to "production without product, structuration without structure":

> To interpret a text is not to give it a (more or less justified, more or less free) meaning, but on the contrary to appreciate what *plural* constitutes it. ... This text is a galaxy of signifiers, not a structure of signifieds; it has no beginning; it is reversible; we

gain access to it by several entrances, none of which can be authoritatively declared to be the main one; the codes it mobilized extend as far *as the eye can reach*; they are interminable ... their number is never closed, based as it is on the infinity of language.[11]

Barthes himself is most exact here: "as nothing exists outside the text [this remark follows Derrida's by about three years[12]], there is never a *whole* of the text [that is,] for the plural text, there cannot be a [fixed] narrative structure, a grammar, or a logic."[13] His meaning is plainly designed to preserve an adequacy of reference ("a galaxy of signifiers") but to disallow a complete fixity of predictable nature ("a structure of signifieds").

Interpretation in the "Nietzschean" sense subtends a responsive reading all right, but it is a reading that employs (as Barthes's own reading of *S/Z* shows) a *selection* from the codes of reading that obtain (somehow) in the life of our society—that do not and cannot lead to closure, to hierarchical preference, to correctness by way of reference to an antecedently closed textual nature. There is no longer an *explication de texte*: there is only a reading of the signifiers that thereby constitutes, reconstitutes, leaves infinitely or "plurally" open to endless further reconstitution, the signifiers that acquire *that very* history. This is the meaning of that otherwise impenetrable remark (playfully Rousseauesque): "narrative is both merchandise and the relation of the contract of which it is the object."[14] So seen, *Sarrasine* is not a standard story or a two-part story that contains a story within a story inviting explanation; it *is* a story "of a contract of a force (the narrative) and the action of this force on the very contract controlling it": we are invited (in effect, *by* the writerly contract) to invent, by applying *to certain signifiers* the codes of reading *of our world*, whatever equivalences of structure may be imaginatively produced in an exchange of readings applied *to* the admitted structures of *Sarrasine* (the apparently "nested

10. Barthes, *S/Z*, p. 5.

11. Ibid., pp. 5-6.

12. See Jacques Derrida, *Of Grammatology*, trans. Gayatri Chakravorty Spivak (Johns Hopkins Press, 1976), pp. 158, 161.

13. Barthes, *S/Z*, p. 6.

14. Ibid., p. 90.



narratives").[15] It would be wrong, therefore, to deny that Barthes's sort of playful interpretation abandons reference *or* predication *or* a disciplined reading: it merely abandons *the full fixity of texts favored in readerly readings*, in standard modernist and premodernist accounts, and shifts reference from finished text to enabling signifier.

There are two pressure points in Barthes's theory of Texts pertinent to our second sense of interpretation. First, there *is* literally nothing that could be interpreted—*in the first sense* of "interpret"—until after the Text is "constituted" (Barthes's term) by work that is interpretive in the second sense; secondly, constituting a Text in that sense does not simply yield a "product," a specific fixed text in the ordinary sense, that could be further interpreted—in the first sense of "interpret." Remember—the point is regularly neglected by the would-be anarchists and irrationalists of interpretation—that Barthes never disallows the validity or disciplined option of readerly interpretation practiced on a textual product that is managed in accord with the first sense of "interpret." Barthes's thesis is only that the two sorts of reading arise together within the same societal practices and may even be regarded as sequentially ordered phases of reading (or interpretation) within the practice of an increasingly normalized use of particular texts (or "galaxies of signifiers"). Barthes's own emphasis is on the *jouissance* of preferring the writerly over the readerly, not the ineligibility of the latter.[16] Liberty with texts or signifiers does not escape the normal constraints of discourse—only the presumptions of *jejune* literary theory.

Consider the following observation (or, confession):

> Reading a text cited by Stendhal (but not written by him) I find Proust in the minute detail. The Bishop of Lescars refers to the niece of his vicar-general in a series of affected apostrophes (*My little niece, my little friend, my lovely brunette, ah, delicious little morsel!*) which remind me of the way the two post girls at the Grand Hotel at Balbec, Marie Geneste and Celeste Albaret, address the narrator (*Oh, the little black-haired devil, oh, tricky little devil! Ah, youth! Ah, lovely skin!*). Elsewhere, but in the same way, in Flaubert, it is the blossoming apple trees of Normandy which I read *according to* Proust...this does not mean that I am in any way a Proust "specialist": Proust is what comes to me, not what I summon up; not an "authority," simply a *circular memory* [that is, a memory that "circles" or stalks a text]. Which is what the inter-text is: the impossibility of living outside the infinite text—whether this text be Proust or the daily newspaper or the television screen: the book creates the meaning, the meaning creates life.[17]

Reading in the writerly manner is a form of living, not a form of research; it involves know-how (*savoir-aller*, not *savoir*, at least not frontally). But it is disciplined, in at least the sense that it involves a form of play interesting to others (for instance, as in *S/Z*) only if the reader is really civilized and witty and inventive. *We*, then, can retrace the *play* of *S/Z* in order to become similarly motivated and (perhaps as) skillful. But reading in that way resists the "bifurcation" of the reader/read text—in order to allow that distinction to be made again in a freer way. There is no "explaining" that Text (Barthes's "Text") and there is no "knowledge" of the meaning of that Text: because, of course, there *is* (then) no definitive text and no one way of motivating readings "which would be definitive" of any meaning.[18] Nevertheless, there *are* "galaxies of signifiers," socially habituated practices, disciplined options of reading, and above all the customary meanings of sentences and sedimented readerly texts. One sees at once Krauss's mistake—as well as the mistake of such heavyhanded postmodernists as Jean-François Lyotard.[19] For, *savoir-faire* or *savoir-lire* presupposes *savoir*—at least distributively; similarly, writerly reading presupposes readerly reading—again at least distributively.

Barthes effectively acknowledges the point: it is the only possible condition on which a complete

15. Ibid.

16. See Roland Barthes, *The Pleasure of the Text*, trans. Richard Miller (New York: Hill and Wang, 1975).

17. Ibid., pp. 34-36.

18. Ibid., p. 34.

19. See Jean-François Lyotard, *The Postmodern Condition: A Report on Knowledge*, trans. Geoff Bennington and Brian Massumi (University of Minnesota Press, 1984), for instance, section 6.

chaos of reading (or of cultural life in general) can be avoided. It is in part at least what Wittgenstein means by "forms of life," what Bourdieu means by "*habitus*," what Marx means by "*praxis*" and "modes of production," what Hegel means by "*Sitten*," what Gadamer means by "*wirkungsgeschichtliches Bewusstsein*," what Husserl means by plural "*Lebensformen*," what Foucault means by "*epistemes*." It is no more than the acknowledgement of the preformative historical practices by which culturally apt individuals first become apt. Their world is already culturally performed *for them*: that is the reason they may be said to learn their native language and their native culture; that is the reason they can specify the "signifiers," the culturally (already) prepared materials, that, by interpreting (in the productive sense), they first constitute texts or artworks as such—what thereupon prove to be usable as referents apt for interpretation (in the adequational sense). Barthes's emphasis, of course, is on the initial process of doing just that. On the evidence (on his view), the process has been forgotten or ignored or misconstrued. Our own emphasis, for the moment at least, is focused rather on the option of continuing a critical discourse about whatever is thereby so constituted—without in the least reneging on Barthes's fine lesson. On the argument, we preserve both themes merely by distinguishing with care the logical requirements of unicity or individuation from the prejudice of certain substantive (premodernist or modernist) presumptions of unity or fixity of nature.

The constraints of reference and predication are not violated by Barthes, only displaced from produced texts to interpretable signifiers (in the second sense of "interpret"). Barthes himself does not tarry long enough to give us a theory of the social habituation of the practices of reading that support the distinctive discipline of readerly and writerly reading. He presupposes such a theory—or such theories—but he moves on only to offer examples of what he recommends. For our own part, we could easily pause to construct a theory of social practice—from Hegel or Marx, or Nietzsche or Foucault, or Weber or Lukács, or Husserl or Heidegger, or Adorno or Benjamin, or Lévi-Strauss or Althusser, or Wittgenstein or Bourdieu, or Gadamer or Kuhn.

The point remains quite constant, however: the waiving of texts in a sense suited to the first sort of interpretation does not eliminate constative discourse elsewhere (for readerly texts, say), does not preclude referential and predicative discipline within the *writerly* reading recommended (as in the identification of relevant signifiers, the identification of other readerly-and-writerly-read texts, a certain civilized familiarity with the details of one's culture), and it does not even preclude a rapprochement between readerly and writerly reading *before and after* the play of a particularly agile exercise of the latter sort (the charm of *S/Z*, say). In short, Barthes's preference of the writerly is not even a denial of the ontology of texts—or, of the likely dawning of gradually normalized texts for which such an ontology could be retrospectively constructed (if we wished); *and* it does not itself supply an adequate analysis of what a signifier is, or a practice of reading, or even a human being capable of reading in either the readerly or writerly way. It is one thing to grasp the fresh discovery Barthes bequeaths us; it is quite another to make a shambles of every effort to understand interpretation. After all, the "bifurcation" of the signifier and the would-be reader remains, *after* the provisional "bifurcation" of the readerly text and the reader is first disallowed—and *then* (of course) civilly permitted to be recovered once again in Barthes's educated sense.

Barthes offers an instance (in *S/Z*)—*after* the fact of a readerly deposit of *Sarrasine* in the canon of conventional texts—*of* what it would be like *before* such a reading to read in the writerly way. The "galaxy of signifiers" itself lacks fixed meaning; but, as the competent readers we are, we do possess the know-how for grasping what may be taken to be their meaning. Barthes suppresses this hermeneutic or praxical or habituative dimension of reading—but it is surely there. The semantic and semiotic potentialities of signifiers are already built in to the minima of any socialized habit of reading and using language. Nevertheless, Saussure, whom Barthes had taken his original departure from (but now supercedes), had never successfully explained the "original" relationship between writing and speech or writing and thought that he insisted on; and without that

"originary" source—or the effective replacement for it more perspicuously advanced by Wittgenstein and Gadamer, say—there remains a critical lacuna in Barthes's own account. (Saussure's failing, of course, is just what Derrida had so mercilessly exposed in *Of Grammatology*.[20]) But the deeper theme, missing also in Derrida, is this: that the deconstructive or poststructuralist or antimodernist rejection of the bifurcation of reader and text itself entails a competent practice or activity *on the part of readers vis-à-vis something else* (signifiers, say) within a preformed or habituated cultural space in which (and by using the processes of which) what Barthes calls the "plural" or "infinite" Text *is first constituted*. In a sense, "the deconstruction of hermeneutics" is therefore reversed and aced by being shown to require and presuppose a "hermeneutics of deconstruction."[21] It is not, however, itself thereby disallowed or repudiated. What the argument shows is that the rejection of a cultural world bifurcated between inquiring subjects and subjects inquired into—or between such subjects and what they do or produce (texts, in the idiom we have adopted)—is itself the work of subjects active *in* such a bifurcated world. In short, *we* theorize in a critical moment about a preformative condition *we* cannot originally fathom (that Saussure thought he could fathom, that Husserl also thought he could fathom) within which the bifurcation of world and word (or text) and reader first arises. Barthes's splendid game of writerly-reading readerly texts, therefore, serves a double purpose: for one thing, it affords a miniature exemplar of the impossibility of radically disjoining the double function of subjects as observer and observed (in much the same sense in which one cannot beat oneself at chess); and, for another, it subverts the fixities of privilege, of readerly reading, of the metaphysics of presence, of all the bugaboos of failing to remember *that* the steady structures of our now bifurcated world depend impenetrably on whatever *we* critically and mythically postulate as the preformed world within which our own salient world arises.

So seen, Barthes's invention is an attractive toy—no more than a toy, no more than a toy for Barthes himself: for we *could* easily (and would need to) interpose a conception of numbered, reidentifiable texts that could support interpretation in the first *and* second senses and that would, at the same time, subvert a metaphysics of privilege (the notion of fixed and bounded texts) just because—for reading purposes at least—texts do and must remain referentially accessible. Barthes's conceit of the infinite Text (that is not itself a referent) is, then, merely the deliberately posed extravagance of a disappearing limit *for* the more modestly interposed texts we are now recommending. Barthes nearly says as much:

> The Text (if only because of its frequent "unreadability") decants the work from its consumption and gathers it up as play, task, production, and activity. This means that the Text requires an attempt to abolish (or at least to lessen) the distance between writing and reading, not by intensifying the reader's projection into the work, but by linking the two together in a single signifying process.[22]

The point is, a theory of texts adequate for interpretation at the present time must collect Barthes's double lesson—but must do so in an ampler and more systematic way than Barthes actually does. We must: (1) detach the full theory of the nature of texts (literary, visual, musical) from the mere constative constraints of discourse about them, so that all notions of fixity, essence, analogy with physical particulars are attenuated as far as possible or challenged as much as necessary; and (2) we must develop a positive theory of texts, of how texts (or culturally emergent phenomena and entities in general[23]) are actually constituted—first, from precultural physical materials and, second, from culturally prepared materials. (1) trades on the lesson drawn from Krauss and Barthes: that unity and unicity are distinct though not altogether separable notions; (2) requires an entirely fresh start and cannot fail to center on

20. Derrida, *Of Grammatology*, pt. I, ch. 2.

21. I am pleased to take this phrasing from John D. Caputo, *Radical Hermeneutics; Repetition, Deconstruction, and the Hermeneutic Project* (Indiana University Press, 1987), p. 187.

22. Barthes, "From Work to Text," p. 79.

23. This is, of course, a theme I have pursued in a great number of places. See Joseph Margolis, *Art and Philosophy*, Part One; *Culture and Cultural Entities* (Dordrecht: D. Reidel, 1984), ch. 1; *Texts without Referents*, ch. 6.

the peculiarities of Intentional properties and their incarnated relation to material properties.[24]

III

This has been a strenuous exercise. For one thing, it is always difficult to depend on the florid French. And for another, our thesis has its distinctly threatening side. But we may collect our findings now a little more lightly. An adequate theory of interpretation will seek to explain: (1) how it is that we can referentially fix, identify, or individuate artworks or texts for interpretation without at the same time insisting that their nature, their collected properties, their essential boundaries must also be supposed to be fixed, determined, changeless, or at least unaffected by merely interpreting them or commenting on them in the normal critical way; (2) how it is that artworks or texts are first constituted as such, so that they become the relatively stable referents of subsequent interpretive discourse; and (3) how it is that discursive interpretation *can* alter the natures of individuated texts and artworks and, in doing that, reconstitute their natures or properties without disorganizing their numerical identity and (of course) without inviting total chaos.

What we have at least shown is the sheer coherence of our intended answer to these questions: *the bare unicity of referents accommodates the absence of any fixed unity or fixed nature of the particulars thus identified*. In the biological world, for instance, we capture the limits of our tolerance for changing natures and fixed reference by adjusting our notions of natural kinds: spatio-temporal continuities, as Hume more or less admits, aid us in allowing fixity of identity to range over the shifting sequences of instantiated properties. In contemporary physics, among the quantum-mechanical puzzles of reconciling particle/wave anomalies, we exploit (with Heisenburg, for instance) punctual identification for the sake of descriptive control and then permit identification to become as story-relative as can be tolerated at a theoretical level at which such punctual identification would be altogether disallowed. In the cultural world, both with regard to persons and artworks, we borrow whatever similar conveniences we can; we maintain, for instance, wherever we may, "one person/one body," or "one sculpture/one block of marble," or "one poem/one inscription from a set of possible inscriptions." But texts and artworks do not form natural kinds and cannot be identified merely physically or as physical bodies. They differ essentially from natural objects in possessing Intentional properties. It is, in fact, just in virtue of that, paradigmatically, that texts *are subject to interpretation* in the two senses supplied *and* that those two senses are interrelated in the manner sketched.

Quite obviously, we have now come to the most strenuous part of the theory needed. Since we cannot possibly attempt here a full account of the ontology of artworks or cultural phenomena in general, we may as well be candid about the upshot of what such an account would yield.[25] It would make it possible to concede, *without endangering* the rigors of numerical identity *or* of the critical testing of particular claims *or* of coherent discourse in general, that texts may in principle be assigned infinitely many interpretations, that they may enter into infinitely many histories, and that interpretations and histories assigned them at t' later than t may well be affected by interpretations and histories assigned them at t. This *is* what accommodating Barthes's notion would require.

The fascinating thing is that it is entirely possible to make such a notion coherent, manageable, even quite plausible and disciplined. It would require quite a number of substantial concessions regarding the logic of general discourse that would not be narrowly occupied with the theory of art or interpretation. (These have elsewhere been shown to be entirely viable.) They could not fail to include at least: (i) abandoning as fixed principles the principles of excluded middle and *tertium non datur*; (ii) admitting the adequacy of, and the impossibility of exceeding the limitations of, story-relative reference; (iii) admitting the viability of relativistic truth-values and the compatibility of distributively employing such values together with the distributed use of bivalent

24. For a fuller account of intentionality, intensionality, Intentionality, see Joseph Margolis, *Science without Unity: Reconciling the Human and Natural Sciences* (Oxford: Blackwell, 1987), chs. 7, 9.

25. In *Texts without Referents*, chs. 6, 8, there appears the most compendious account of the matter I have been able to fashion to date.

or bipolar values where wanted; and (iv) challenging, if not repudiating, the adequacy of extensional canons for regimenting all languages descriptive of the real world. It would also require quite a number of substantial concessions of an ontological sort reconciled with the adjusted logic of discourse. For instance, it would require: (v) denying the adequacy of all physicalisms (as opposed to materialisms), whether reductive or not, in order to accommodate the reality of the artworld and the world of human culture in general; (vi) admitting cultural emergence, as distinct from physical emergence, as a process that yields indissolubly complex embodied or incarnated phenomena or properties; (vii) admitting that what distinguishes artworks, texts, and other cultural entities from natural entities depends essentially on the complex incarnation of Intentional properties; and (viii) admitting, in addition, that Intentional properties are such that they can be constituted, altered, affected, generated by the processes of critical discourse or interpretation applied to given texts or cultural referents, without adversely affecting the numerical fixity of such referents.

In a word, *if* physicalism and extensionalism are philosophically correct, or at least adequate (in real-time terms) for all discourse about the cultural world,

then *everything* so far said is entirely pointless. That must be conceded straight off. But *if* they are neither correct nor demonstrated to be correct nor demonstrably correct nor even demonstrably adequate (in real-time terms), then we are left with a world for which theses (i)-(viii) are peculiarly apt, possibly even minimally required. It is certainly true that attacks on physicalism and extensionalism are widely and honorably resisted. But it is entirely fair to say that there is no known demonstration showing that opposition to those doctrines is as such incoherent, irresponsible, unfruitful, or calamitous. That is as honorable a stand as the other—probably a more resourceful one at least at the present time.[26] In any case, the admission of (i)-(viii) leads us directly to the startling finding that artworks or texts may be assigned infinitely many interpretations and may enter into infinitely many histories.[27] This is just what Barthes was getting at when, notoriously, he affirmed that "the Text...practices the infinite deferral of the signified."[28]

It is also, however, what a theorist like Gadamer means, speaking from the altogether different vantage of a hermeneutic ontology, when he declares that

to understand a text always means to apply it to ourselves and to know that, even if it must always

26. Two specimen claims may be mentioned. In one, Daniel C. Dennett provocatively remarks: "Intentionality is not a mark that divides phenomena from phenomena, but sentences from sentences. ... Intentional objects are not any kind of objects at all. [The tendency to treat them as distinct objects rests on] the dependence of Intentional objects on particular descriptions [that is, on the thesis that] to change the description is to change the object. What sort of thing is a different thing under different descriptions? Not any object. Can we not do without the objects altogether and talk most of descriptions? ... Intentional sentences are *intensional* (non-extensional) sentences," Daniel C. Dennett, *Content and Consciousness* (London: Routledge and Kegan Paul, 1969), pp. 28-29. But this, though quite characteristic of a certain analytic stance, is remarkably weak. First of all, even with respect to ordinary descriptive contexts, it is not true that the intentionality thesis holds that things are altered by altering descriptions; it holds, rather, that, under differing descriptions, we cannot always tell *whether* we are dealing with the same thing or not. Secondly, in the context of *texts*, which Dennett nowhere considers, it may be claimed that, because texts possess Intentional properties inherently, they *are* interpretable and, *qua* interpretable, their properties may actually be changed or affected by *interpretation* but not in a way that would also change their merely physical features or change them for that reason alone. In a second claim, Donald

Davidson, speaking of what he terms "radical interpretation"—effectively, understanding what another says, either intra-linguistically or inter-linguistically—flatly and without the least argument (here or anywhere) affirms that, since it is true enough that "interpretable speeches are nothing but (that is, identical with) actions performed with assorted non-linguistic intentions (to warn, control, amuse, distract, insult), and these actions are in turn nothing but (identical with) intentional movements of the lips and larynx, ... [these] non-linguistic goings-on must supply the evidential base for interpretation" (regardless of the fact that saying so "provides no clues as to how the evidence is related to what it surely is evident for"), Donald Davidson, "Radical Interpretation," in *Inquiries into Truth and Interpretation* (Oxford University Press, 1984), pp. 126-127. But Davidson has never managed to show how to determine prior "non-linguistic" intentions or how to distinguish them from linguistically expressed intentions or how to construe them in extensionally compliant physicalist terms or how to construe linguistically expressed intentions in extensionally compliant terms. Failure to achieve such results must effectively count as the failure of the doctrine actually advanced.

27. Theses (i)-(viii) are, in effect, defended in the trilogy that includes *Pragmatism without Foundations, Science without Unity, Texts without Referents*.

28. Barthes, "From Work to Text," p. 76.

be understood in different ways, it is still the same text presenting itself to us in these different ways.... The linguistic explicitness that the process of understanding gains through interpretation does not create a second sense apart from that which is understood and interpreted. The interpretative concepts are not, as such, thematic in understanding. Rather, it is their nature to disappear behind what they bring, in interpretation, into speech. Paradoxically, an interpretation is right when it is capable of disappearing in this way. The possibility of understanding is dependent on the possibility of this kind of mediating interpretation...interpretation is contained potentially in the understanding process. It simply makes the understanding explicit. Thus interpretation is not a means through which understanding is achieved, but it has passed into the content of what is understood.[29]

Notice that, unlike Barthes, Gadamer insists on the reidentification of one and the same text under plural, potentially infinite, interpretation and reinterpretation. The infinite openness of texts—in both an interpretive and historical sense (ultimately the same sense)—is ensured by the notion of reflexive application: the Intentional import *of* a text essentially incorporates into *its* developing, endlessly reconstituted meaning what its recovery for our own historical experience and prejudice can make it out to be. Its meaning is heuristically schematized in the intersection between *our* present power of reading and what, from that evolving perspective, we posit as *its* collected past. In this regard, our logical proposal about interpretable texts is closer to Gadamer's usage than to Barthes's. Quite unaccountably, however, Gadamer is, at every step, much more reluctant than he ought to be to accommodate a frank relativism—he is quite arbitrary about the point; and so, in this regard, our substantive proposal about interpretation is closer to Barthes's vision than to Gadamer's.

Still, it *is* Gadamer rather than Barthes who attempts to answer the third of the three questions we posed just a moment ago, namely, how it is that discursive interpretation can alter the nature of individuated texts without affecting their numerical

identity and without producing conceptual chaos. Gadamer's answer depends, as is well known, on repudiating the Romantic recoverability of authorial intent, on reclaiming the historicity of human existence and cultural texts, on admitting the intransparency and preformative forces of the human world in which, in a Heideggerean sense, we are "thrown," and (most important) on featuring the natural or perspectival "prejudice" of all understanding and interpretation—in a word, on the function of "the fusion of horizons" (*Horizontverschmelzung*). Thus Gadamer maintains: "It is part of real understanding...that we regain the concepts of an historical past [understand or interpret a text] in such a way that they also include our own comprehension of them. [This is what is meant by] 'the fusion of horizons'."[30] The meaning *of* a text is the "fusion" of its perceived past and its perceived present application to ourselves; but it is *we* who monitor both elements of the effort.

The upshot is: (1) that it is in virtue of the Intentional nature of texts that they require interpretation in order to be understood; (2) that since interpretable texts and textual interpreters exist historically, preformatively, intransparently, there cannot be a

29. Hans-Georg Gadamer, *Truth and Method*, 2d ed., trans. Garrett Barden and Robert Cumming (New York: Seabury Press, 1975), p. 359.

30. Ibid., p. 337. The entire argument is effectively collected in second part, part II, including Gadamer's resistance to relativism. It must be said as well, however, that, although Barthes clearly slights, and means to slight, the historical dimension of interpretation in his antimodernist (if not postmodernist) proposal, restoring that historical consideration—as with Gadamer—does *not* redeem the reliability of authorial intent *or* (against Gadamer) the reliability of a tradition's intent. The deeper puzzle involved here has somewhat eluded Alasdair MacIntyre's recent—and justified—critique of Barthes. So MacIntyre observes, against Barthes's "postmodernism" (Roland Barthes *Critique et verité* [Paris: Seuil, 1966], particularly p. 56): "The understanding of the text is not controlled by authorial intention or by any relationship to an audience with specific shared beliefs, for it is outside context except the context of interpretation," Alasdair MacIntyre, *Whose Justice? Which Rationality?* (University of Notre Dame, 1988), p. 386. What MacIntyre fails to demonstrate—though his criticism of Barthes stands—is that the *recovery of tradition* itself entails, within any tradition, a historicized openendedness of the sort Barthes explores, even if it is the case that Barthes himself, always suspicious of reliable histories, exaggerates the arbitrariness of writerly reading. It's reasonably clear that Barthes's own practice belies the rhetoric favored and that MacIntyre's corrective is committed to traditionalism.

uniquely correct or uniquely convergent reading or interpretation of a given text; and (3) that since interpretation and understanding require the historicized recovery of the Intentional import of a given text, it is quite impossible to fix that recovery except in terms of the salient or convincing fusion of—or what, from the perspective of present interpreters, is posited as the shared or continuous or intersecting—horizons of the past and the present. This resolution of our third question, rather along Gadamer's lines, reconciles the ontology of texts and the methodology of their interpretation.

Gadamer, however, without the least defense (as already remarked), affirms that there *is* a "universal" or "classical" tradition that can always be historically recovered—indeed, that must be recovered—for a successful resolution of the hermeneutic task.[31] Naturally, we reject his claim. But, more amiably for our present purpose, we may content ourselves with the knowledge that the conceptual strategy here adopted draws in its wake a large number of further questions we have not yet answered, having to do with claims of objectivity, supporting evidence, relativistic tolerance and the universality of cognitive claims, the specific ontology of art, the relationship of Intentional and physical attributes, and the like; and the strategy still accommodates in a dialectical way all the recent modernist/postmodernist quarrels, all the complexities of historicity and intransparency, Gadamer's own closet essentialism, and even such more daring conjectures as Michel Foucault for instance advances. For, puzzling over Velásquez's problem in representing pictorial representation within the Classical canon (in *Las Meninas*), Foucault remarks: "Before the end of the eighteenth century, *man* did not exist... He is a quite recent creature, which the demiurge of knowledge fabricated with its own hands less than two hundred years ago. [Before that time] there was no epistemological consciousness of man as such. The Classical *episteme* is articulated along lines that do not isolate, in any way, a specific domain proper to man."[32] The meaning of Foucault's remarkably apt perception (even if we should disagree with his interpretation of *Las Meninas*) is that the historical past, which is both real and *not* the same as the physical past in which it is incarnate, can be retroactively affected (without violating physical time or physical causality) by future sensibilities that could not have been recognized as potentiated in a particular past present. Merely to mention the complication is to appreciate the task of a seriously contemporary theory of interpretation.

Notions of historicity, therefore, as variable as Krauss's, Barthes's, Gadamer's, and Foucault's strongly favor the need for, and the plausibility of, a theory rather like the one here offered. The canonical view—what we have called interpretation restricted in the first sense—does not permit these subtle questions to be even honored or perceived; and interpretation in the sense here championed—that unites the first and second senses given—secures the stability of texts and interpretation by way of the salient habits of life of a society rather than by way of a privileged discovery of independently fixed entities. Without such a grounding, without the sheer conservative contingencies of life itself, human history would be an utter chaos; the disorder of critical interpretation would be instantly matched by the loss of science and rational prudence. That admission alone is much more than the recovery of a pragmatist aesthetics, but it is at least that.[33]

31. Ibid., pp. 253-258, 316-325.

32. Michel Foucault, *The Order of Things; An Archaeology of the Human Sciences*, trans. (New York: Vintage Books, 1973), pp. 308-309.

33. Presidential Address, 46th Annual Meeting of the American Society of Aesthetics, October 28, 1988, Vancouver, British Columbia.

Part 6

Marxist Theory

Part 6: Marxist Theory

Introduction

The fruitfulness of Marxist analysis of art and popular culture derives from its identification of these things as components of the ideological superstructure of society. An ideology is the condition of alienation that affects the members of a society. As Marx learned from Hegel, people living in a given society mistake their own alienated creations for independent realities. The ideological beliefs that the members of a society embrace will both reflect the arrangement of productive forces at that time and motivate people's behaviour; such beliefs serve the interests of the ruling class by rationalizing the arrangements from which it derives its privileges. The ideas and values constituting people's social identity are thus a partial reflection of the structures which both alienate people from their genuine interests and fit them to the social arrangements which serve the power structure of the day.

The first selection, "Alienated Labour" by Karl Marx (1818-1883), is from the *Economic and Philosophical Manuscripts of 1844*. In this early work, Marx extends and grounds Hegel's conception of alienation as self-creation through a dialectical process of alienation and de-alienation. Human beings make *themselves* through the production of objects which then form a powerful set of conditions upon which they become dependent. But people not only alienate their products from themselves, they alienate the very activity through which these objects are produced. Alienated labour transforms free self-directed activity into a means, and our species-life into the mere means of physical existence, alienating people from each other.

One of the most important developments in twentieth-century cultural studies was the emergence of the critical theory of the Frankfurt school, centred at the Institute for Social Research in the 1920s and 30s. Its leading representatives, Max Horkheimer, Theodor Adorno, Walter Benjamin and Herbert Marcuse, extended the Marxist concept of alienation into a general critique of the psychosocial mechanisms of domination and control, especially in the cultural sphere. The second selection is taken from the famous piece "The Work of Art in the Age of Mechanical Reproduction" by German philosopher and cultural critic Walter Benjamin (1892-1940). In it Benjamin argues that the industrial conditions underlying mechanical reproducibility have radically changed the nature of art in the modern world, destroying what he called the traditional aura of the work (that character of uniqueness and authenticity which separated the work from daily life),

making a mass culture of conformity available as a means of social control to the ruling class. Although written long before the advent of television, Benjamin's insights into the technological ground of photography and cinema are suggestive of the massive influence that television and advertising have in the shaping of personal identity through popular culture.

The next selection is "Theory of the Avant-Garde and Critical Literary Science" from *Theory of the Avant-Garde* by Peter Bürger, a professor of French and comparative literature at the University of Bremen. In it, Bürger argues that aesthetic theory must have a proper historical ground, and that the modern concept of art needs to be understood against the nineteenth-century background of aestheticism to which the avant-garde movements responded. The avant-garde was to make artistic means visible in their generality, stripping them of their dependence of style and artistic content. It is only with the avant-garde that art as an emerging institution enters the stage of self-criticism. Realism no longer appears as the principle of artistic creation but as the product of certain procedures. After having placed the role of the avant-garde, Bürger devotes the remainder of the selection to a criticism of Benjamin's theory of art as an inadequate characterization of the emergence of the modern art system.

The final selection in this section is chapter one of *The Aesthetic Dimension: Towards a Critique of Marxist Aesthetics*, by Herbert Marcuse (1989-1979). This work is a polemical tract against orthodoxy in Marxist aesthetics, arguing for the relative independence of art from given social relations. The selection proceeds by criticising six orthodoxies that imply that the social relations of production must be represented in the literary work. Marxist aesthetics has devalued subjectivity because it has had an inadequate analysis of its relation to social conditions. Introducing the psychoanalytic concept of sublimation, Marcuse argues that the truth of art lies in its power to break the monopoly of established reality through aesthetic sublimation. The utopian vision of a better world found in art is a repository for the demands and rebellions which cannot be met in reality, so art is simultaneously a mode of adjustment to established conditions and a refusal of those conditions. The indictment of established reality through the invocation of a beautiful realm is the basis for the radical potential of art. Marcuse's heady mix of psychoanalysis and class analysis was extremely influential to the political and artistic experimentation of the sixties. The influence of Marcuse and other Frankfurt school thinkers is visible in later selections, particularly those by Habermas, Lyotard, and Huyssen.

Karl Marx (1818-1883)

Alienated Labour

Translated by T. B. Bottomore

[XXII] We have begun from the presuppositions of political economy. We have accepted its terminology and its laws. We presupposed private property; the separation of labour, capital and land, as also of wages, profit and rent; the division of labour; competition; the concept of exchange value, etc. From political economy itself, in its own words, we have shown that the worker sinks to the level of a commodity, and to a most miserable commodity; that the misery of the worker increases with the power and volume of his production; that the necessary result of competition is the accumulation of capital in a few hands, and thus a restoration of monopoly in a more terrible form; and finally that the distinction between capitalist and landlord, and between agricultural labourer and industrial worker, must disappear, and the whole of society divide into the two classes of property *owners* and *propertyless* workers.

Political economy begins with the fact of private property; it does not explain it. It conceives the *material* process of private property, as this occurs in reality, in general and abstract formulas which then serve it as laws. It does not *comprehend* these laws; that is, it does not show how they arise out of the nature of private property. Political economy provides no explanation of the basis for the distinction of labour from capital, of capital from land. When, for example, the relation of wages to profits is defined, this is explained in terms of the interests of capitalists; in other words, what should be explained is assumed. Similarly, competition is referred to at every point and is explained in terms of external conditions. Political economy tells us nothing about the extent to which these external and apparently accidental conditions are simply the expression of a necessary development. We have seen how exchange itself seems an accidental fact. The only motive forces which political economy recognizes are *avarice* and the *war between the avaricious, competition*.

Just because political economy fails to understand the interconnexions within this movement it was possible to oppose the doctrine of competition to that of monopoly, the doctrine of freedom of the crafts to that of the guilds, the doctrine of division of landed property to that of the great estates; for competition, freedom of crafts, and the division of landed property were conceived only as accidental consequences brought about by will and force, rather than as necessary, inevitable and natural consequences of monopoly, the guild system and feudal property.

Thus we have now to grasp the real connexion between this whole system of alienation—private property, acquisitiveness, the separation of labour, capital and land, exchange and competition, value and the devaluation of man, monopoly and competition—and the system of *money*.

Let us not begin our explanation, as does the economist, from a legendary primordial condition. Such a primordial condition does not explain anything; it merely removes the question into a grey and nebulous distance. It asserts as a fact or event what it should deduce, names, the necessary relation between two things; for example, between the division of labour and exchange. In the same way theology explains the origin of evil by the fall of man;

that is, it asserts as a historical fact what it should explain.

We shall begin from a *contemporary* economic fact. The worker becomes poorer the more wealth he produces and the more his production increases in power and extent. The worker becomes an even cheaper commodity the more goods he creates. The *devaluation* of the human world increases in direct relation with the *increase in value* of the world of things. Labour does not only create goods; it also produces itself and the worker as a *commodity*, and indeed in the same proportion as it produces goods.

This fact simply implies that the object produced by labour, its product, now stands opposed to it as an *alien being*, as a *power independent* of the producer. The product of labour is labour which has been embodied in an object and turned into a physical thing; this product is an *objectification* of labour. The performance of work is at the same time its objectification. The performance of work appears in the sphere of political economy as a *vitiation* of the worker, objectification as a *loss* and as *servitude to the object*, and appropriation as *alienation*.

So much does the performance of work appear as vitiation that the worker is vitiated to the point of starvation. So much does the objectification appear as loss of the object that the worker is deprived of the most essential things not only of life but also of work. Labour itself becomes an object which he can acquire only by the greatest effort and with unpredictable interruptions. So much does the appropriation of the object appear as alienation that the more objects the worker produces the fewer he can possess and the more he falls under the domination of his product, of capital.

All these consequences follow from the fact that the worker is related to the *product of his labour* as to an *alien* object. For it is clear on this presupposition that the more the worker expends himself in work the more powerful becomes the world of objects which he creates in the face of himself, the poorer he becomes in his inner life, and the less he belongs to himself. It is just the same as in religion. The more of himself man attributes to God the less he has left in himself. The worker puts his life into the object, and his life then belongs no longer to himself but to the object. The greater his activity, therefore, the less he possesses. What is embodied in the product is no longer his own. The greater this product is, therefore, the more he is diminished. The *alienation* of the worker in his product means not only that his labour becomes an object, assumes an *external* existence, but that it exists independently, *outside himself*, and alien to him, and that it stands opposed to him as an autonomous power. The life which he has given to the object sets itself against him as an alien and hostile force.

[XXIII] Let us now examine more closely the phenomenon of *objectification*; the worker's production and the *alienation* and *loss* of the object it produces, which is involved in it. The worker can create nothing without *nature*, without the *sensuous external world*. The latter is the material in which his labour is realized, in which it is active, out of which and through which it produces things.

But just as nature affords the *means of existence* of labour, in the sense that labour cannot *live* without objects upon which it can be exercised, so it also provides the *means of existence* in a narrower sense; namely the means of physical existence for the *worker* himself. Thus, the more the worker *appropriates* the external world of sensuous nature by his labour the more he deprives himself of *means of existence*, in two respects: first, that the sensuous external world becomes progressively less an object belonging to his labour or a means of existence in his labour, and secondly, that it becomes progressively less a means of existence in the direct sense, a means for the physical subsistence of the worker.

In both respects, therefore, the worker becomes a slave of the object; first, in that he receives an *object of work*, i.e. receives *work*, and secondly, in that he receives *means of subsistence*. Thus the object enables him to exist, first as a *worker* and secondly, as a *physical subject*. The culmination of this enslavement is that he can only maintain himself as a *physical subject* so far as he is a *worker*, and that it is only as a *physical subject* that he is a worker.

(The alienation of the worker in his object is expressed as follows in the laws of political economy: the more the worker produces the less he has to consume; the more value he creates the more worthless

he becomes; the more refined his product the more crude and misshapen the worker; the more civilized the product the more barbarous the worker; the more powerful the work the more feeble the worker; the more the work manifests intelligence the more the worker declines in intelligence and becomes a slave of nature.)

Political economy conceals the alienation in the nature of labour in so far as it does not examine the direct relationship between the worker (work) and production. Labour certainly produces marvels for the rich but it produces privation for the worker. It produces palaces, but hovels for the worker. It produces beauty, but deformity for the worker. It replaces labour by machinery, but it casts some of the workers back into a barbarous kind of work and turns the others into machines. It produces intelligence, but also stupidity and cretinism for the workers.

The direct relationship of labour to its products is the relationship of the worker to the objects of his production. The relationship of property owners to the objects of production and to production itself is merely a *consequence* of this first relationship and confirms it. We shall consider this second aspect later.

Thus, when we ask what is the important relationship of labour, we are concerned with the relationship of the *worker* to production.

So far we have considered the alienation of the worker only from one aspect; namely, *his relationship with the product of his labour.* However, alienation appears not merely in the result but also in the *process* of *production,* within *productive activity* itself. How could the worker stand in an alien relationship to the product of his activity if he did not alienate himself in the act of production itself? The product is indeed only the *résumé* of activity, of production. Consequently, if the product of labour is alienation, production itself must be the activity of alienation—the alienation of activity and the activity of alienation. The alienation of the object of labour merely summarizes the alienation in the work activity itself.

What constitutes the alienation of labour? First, that the work is *external* to the worker, that it is not part of his nature; and that, consequently, he does not fulfil himself in his work but denies himself, has a feeling of misery rather than well-being, does not develop freely his mental and physical energies but is physically exhausted and mentally debased. The worker, therefore, feels himself at home only during his leisure time, whereas at work he feels homeless. His work is not voluntary but imposed, *forced labour.* It is not the satisfaction of a need, but only a *means* for satisfying other needs. Its alien character is clearly shown by the fact that as soon as there is no physical or other compulsion it is avoided like the plague. External labour, labour in which man alienates himself, is a labour of self-sacrifice, of mortification. Finally, the external character of work for the worker is shown by the fact that it is not his own work but work for someone else, that in work he does not belong to himself but to another person.

Just as in religion the spontaneous activity of human fantasy, of the human brain and heart, reacts independently as an alien activity of gods or devils upon the individual, so the activity of the worker is not his own spontaneous activity. It is another's activity and a loss of his own spontaneity.

We arrive at the result that man (the worker) feels himself to be freely active only in his animal functions—eating, drinking and procreating, or at most also in his dwelling and in personal adornment—while in his human functions he is reduced to an animal. The animal becomes human and the human becomes animal.

Eating, drinking and procreating are of course also genuine human functions. But abstractly considered, apart from the environment of human activities, and turned into final and sole ends, they are animal functions.

We have now considered the act of alienation of practical human activity, labour, from two aspects: (1) the relationship of the worker to the *product of labour* as an alien object which dominates him. This relationship is at the same time the relationship to the sensuous external world, to natural objects, as an alien and hostile world; (2) the relationship of labour to the *act of production* within *labour.* This is the relationship of the worker to his own activity as something alien and not belonging to him, activity

as suffering (passivity), strength as powerlessness, creation as emasculation, the *personal* physical and mental energy of the worker, his personal life (for what is life but activity?), as an activity which is directed against himself, independent of him and not belonging to him. This is *self-alienation* as against the above-mentioned alienation of the *thing*.

[XXIV] We have now to infer a third characteristic of *alienated labour* from the two we have considered.

Man is a species-being not only in the sense that he makes the community (his own as well as those of other things) his object both practically and theoretically, but also (and this is simply another expression for the same thing) in the sense that he treats himself as the present, living species, as a *universal* and consequently free being.[1]

Species-life, for man as for animals, has its physical basis in the fact that man (like animals) lives from inorganic nature, and since man is more universal than an animal so the range of inorganic nature from which he lives is more universal. Plants, animals, minerals, air, light, etc. constitute, from the theoretical aspect, a part of human consciousness as objects of natural science and art; they are man's spiritual inorganic nature, his intellectual means of life, which he must first prepare for enjoyment and perpetuation. So also, from the practical aspect, they form a part of human life and activity. In practice man lives only from these natural products, whether in the form of food, heating, clothing, housing, etc. The universality of man appears in practice in the universality which makes the whole of nature into his inorganic body: (1) as a direct means of life; and equally (2) as the material object and instrument of his life activity. Nature is the inorganic body of man; that is to say nature, excluding the human body itself. To say that man *lives* from nature means that nature is his *body* with which he must remain in a continuous interchange in order not to die. The statement that the physical and mental life of man, and nature, are interdependent means simply that nature is interdependent with itself, for man is a part of nature.

1. In this passage Marx reproduces Feuerbach's argument in *Das Wesen des Christentums*. [*Editor's note.*]

Since alienated labour: (1) alienates nature from man; and (2) alienates man from himself, from his own active function, his life activity; so it alienates him from the species. It makes *species-life* into a means of individual life. In the first place it alienates species-life and individual life, and secondly, it turns the latter, as an abstraction, into the purpose of the former, also in its abstract and alienated form.

For labour, *life activity*, *productive life*, now appear to man only as *means* for the satisfaction of a need, the need to maintain his physical existence. Productive life is, however, species-life. It is life creating life. In the type of life activity resides the whole character of a species, its species-character; and free, conscious activity is the species-character of human beings. Life itself appears only as a *means of life*.

The animal is one with its life activity. It does not distinguish the activity from itself. It is *its activity*. But man makes his life activity itself an object of his will and consciousness. He has a conscious life activity. It is not a determination with which he is completely identified. Conscious life activity distinguishes man from the life activity of animals. Only for this reason is he a species-being. Or rather, he is only a self-conscious being, i.e. his own life is an object for him, because he is a species-being. Only for this reason is his activity free activity. Alienated labour reverses the relationship, in that man because he is a self-conscious being makes his life activity, his *being*, only a means for his *existence*.

The practical construction of an *objective world*, the *manipulation* of inorganic nature, is the confirmation of man as a conscious species-being, i.e. a being who treats the species as his own being or himself as a species-being. Of course, animals also produce. They construct nests, dwellings, as in the case of bees, beavers, ants, etc. But they only produce what is strictly necessary for themselves and their young. They produce only in a single direction, while man produces universally. They produce only under the compulsion of direct physical needs, while man produces when he is free from physical need and only truly produces in freedom from such need. Animals produce only themselves, while man reproduces the whole of nature. The products of animal production belong directly to their physical bodies,

while man is free in face of his product. Animals construct only in accordance with the standards and needs of the species to which they belong, while man knows how to produce in accordance with the standards of every species and knows how to apply the appropriate standard to the object. Thus man constructs also in accordance with the laws of beauty.

It is just in his work upon the objective world that man really proves himself as a *species-being*. This production is his active species-life. By means of it nature appears as *his* work and his reality. The object of labour is, therefore, the *objectification of man's species-life*; for he no longer reproduces himself merely intellectually, as in consciousness, but actively and in a real sense, and he sees his own reflection in a world which he has constructed. While, therefore, alienated labour takes away the object of production from man, it also takes away his *species-life*, his real objectivity as a species-being, and changes his advantage over animals into a disadvantage in so far as his inorganic body, nature, is taken from him.

Just as alienated labour transforms free and self-directed activity into a means, so it transforms the species-life of man into a means of physical existence.

Consciousness, which man has from his species, is transformed through alienation so that species-life becomes only a means for him. (3) Thus alienated labour turns the *species-life of man*, and also nature as his mental species-property, into an *alien* being and into a *means* for his *individual existence*. It alienates from man his own body, external nature, his mental life and his *human* life. (4) A direct consequence of the alienation of man from the product of his labour, from his life activity and from his species-life, is that *man* is *alienated* from other *men*. When man confronts himself he also confronts *other* men. What is true of man's relationship to his work, to the product of his work and to himself, is also true of his relationship to other men, to their labour and to the objects of their labour.

In general, the statement that man is alienated from his species-life means that each man is alienated from others, and that each of the others is likewise alienated from human life.

Human alienation, and above all the relation of man to himself, is first realized and expressed in the relationship between each man and other men. Thus in the relationship of alienated labour every man regards other men according to the standards and relationships in which he finds himself placed as a worker.

[XXV] We began with an economic fact, the alienation of the worker and his production. We have expressed this fact in conceptual terms as *alienated labour*, and in analysing the concept we have merely analysed an economic fact.

Let us now examine further how this concept of alienated labour must express and reveal itself in reality. If the product of labour is alien to me and confronts me as an alien power, to whom does it belong? If my own activity does not belong to me but is an alien, forced activity, to whom does it belong? To a being *other* than myself. And who is this being? The *gods*? It is apparent in the earliest stages of advanced production, e.g. temple building, etc. in Egypt, India, Mexico, and in the service rendered to gods, that the product belonged to the gods. But the gods alone were never the lords of labour. And no more was *nature*. What a contradiction it would be if the more man subjugates nature by his labour, and the more the marvels of the gods are rendered superfluous by the marvels of industry, the more he should abstain from his joy in producing and his enjoyment of the product for love of these powers.

The *alien* being to whom labour and the product of labour belong, to whose service labour is devoted, and to whose enjoyment the product of labour goes, can only be *man* himself. If the product of labour does not belong to the worker, but confronts him as an alien power, this can only be because it belongs to *a man other than the worker*. If his activity as a torment to him it must be a source of *enjoyment* and pleasure to another. Not the gods, nor nature, but only man himself can be this alien power over men.

Consider the earlier statement that the relation of man to himself is first *realized*, *objectified*, through his relation to other men. If he is related to the product of his labour, his objectified labour, as to an *alien*, hostile, powerful and independent object, he is related in such a way that another alien, hostile,

powerful and independent man is the lord of this object. If he is related to his own activity as to unfree activity, then he is related to it as activity in the service, and under the domination, coercion and yoke, of another man.

Every self-alienation of man, from himself and from nature, appears in the relation which he postulates between other men and himself and nature. Thus religious self-alienation is necessarily exemplified in the relation between laity and priest, or, since it is here a question of the spiritual world, between the laity and a mediator. In the real world of practice this self-alienation can only be expressed in the real, practical relation of man to his fellow men. The medium through which alienation occurs is itself a *practical* one. Through alienated labour, therefore, man not only produces his relation to the object and to the process of production to alien and hostile men; he also produces the relation of other men to his production and his product, and the relation between himself and other men. Just as he creates his own production as a vitiation, a punishment, and his own product as a loss, as a product which does not belong to him, so he creates the domination of the non-producer over production and its product. As he alienates his own activity, so he bestows upon the stranger an activity which is not his own.

We have so far considered this relation only from the side of the worker, and later on we shall consider it also from the side of the non-worker.

Thus, through alienated labour the worker creates the relation of another man, who does not work and is outside the work process, to this labour. The relation of the worker to work also produces the relation of the capitalist (or whatever one likes to call the lord of labour) to work. *Private property* is, therefore, the product, the necessary result, of *alienated labour*, of the external relation of the worker to nature and to himself.

Private property is thus derived from the analysis of the concept of *alienated labour*; that is, alienated man, alienated labour, alienated life, and estranged man.

We have, of course, derived the concept of *alienated labour* (*alienated life*) from political economy, from an analysis of the *movement of private property*. But the analysis of this concept shows that although private property appears to be the basis and cause of alienated labour, it is rather a consequence of the latter, just as the goods are *fundamentally* not the cause but the product of confusions of human reason. At a later stage, however, there is a reciprocal influence.

Only in the final stage of the development of private property is its secret revealed, namely, that it is on one hand the *product* of alienated labour, and on the other hand the *means* by which labour is alienated, *the realization of this alienation*.

This elucidation throws light upon several unresolved controversies—

1. Political economy begins with labour as the real soul of production and then goes on to attribute nothing to labour and everything to property. Proudhon, faced by this contradiction, has decided in favour of labour against private property. We perceive, however, that this apparent contradiction is the contradiction of *alienated labour* with itself and that political economy has merely formulated the laws of alienated labour.

We also observe, therefore, that *wages* and *private property* are identical, for wages, like the product or object of labour, labour itself remunerated, are only a necessary consequence of the alienation of labour. In the wage system labour appears not as an end in itself but as the servant of wages. We shall develop this point later on and here only bring out some of the [XXVI] consequences.

An enforced *increase in wages* (disregarding the other difficulties, and especially that such an anomaly could only be maintained by force) would be nothing more than a *better remuneration of slaves*, and would not restore, either to the worker or to the work, their human significance and worth.

Even the *equality of incomes* which Proudhon demands would only change the relation of the present-day worker to his work into a relation of all men to work. Society would then be conceived as an abstract capitalist.

2. From the relation of alienated labour to private property it also follows that the emancipation of society from private property, from servitude, takes the political form of the *emancipation of the workers*; not in the sense that only the latter's emancipation is involved, but because this emancipation includes the emancipation of humanity as a whole. For all human servitude is involved in the relation of the worker to production, and all the types of servitude are only modifications or consequences of this relation.

As we have discovered the concept of *private property* by an *analysis* of the concept of *alienated labour*, so with the aid of these two factors we can evolve all the *categories* of political economy, and in every category, e.g. trade, competition, capital, money, we shall discover only a particular and developed expression of these fundamental elements.

However, before considering this structure let us attempt to solve two problems.

1. To determine the general nature of *private property* as it has resulted from alienated labour, in its relation to *genuine human and social property*.

2. We have taken as a fact and analysed the *alienation of labour*. How does it happen, we may ask, that *man alienates his labour*? How is this alienation founded in the nature of human development? We have already done much to solve the problem in so far as we have *transformed* the question concerning the *origin of private property* into a question about the relation between *alienated labour* and the process of development of mankind. For in speaking of private property one believes oneself to be dealing with something external to mankind. But in speaking of labour one deals directly with mankind itself. This new formulation of the problem already contains its solution.

AD (1) *The general nature of private property and its relation to genuine human property*.

We have resolved alienated labour into two parts, which mutually determine each other, or rather, which constitute two different expressions of one and the same relation. *Appropriation* appears as *alienation* and *alienation* as *appropriation*, alienation as genuine acceptance in the community.

We have considered one aspect, *alienated* labour, in its bearing upon the *worker* himself, i.e. *the relation of alienated labour to itself*. And we have found as the necessary consequence of this relation the *property relation* of the *non-worker* to the *worker* and to labour. *Private property* as the material, summarized expression of alienated labour includes both relations; *the relation of the worker to labour, to the product of his labour and to the non-worker*, and the relation of the *non-worker to the worker and to the product of the latter's labour*.

We have already seen that in relation to the worker, who *appropriates* nature by his labour, appropriation appears as alienation, self-activity as activity for another and of another, living as the sacrifice of life, and production of the object as loss of the object to an alien power, an alien man. Let us now consider the relation of this *alien* man to the worker, to labour, and to the object of labour.

It should be noted first that everything which appears to the worker as an *activity of alienation*, appears to the non-worker as a *condition of alienation*. Secondly, the *real, practical* attitude (as a state of mind) of the worker in production and to the product appears to the non-worker who confronts him as a *theoretical* attitude.

[XXVII] Thirdly, the non-worker does everything against the worker which the latter does against himself, but he does not do against himself what he does against the worker.

Let us examine these three relationships more closely.[2]

2. The manuscript breaks off unfinished at this point. [*Editor's note*.]

Walter Benjamin (1892-1940)

Selections from

The Work of Art in the Age of Mechanical Reproduction

Translated by Harry Zohn

"Our fine arts were developed, their types and uses were established, in times very different from the present, by men whose power of action upon things was insignificant in comparison with ours. But the amazing growth of our techniques, the adaptability and precision they have attained, the ideas and habits they are creating, make it a certainty that profound changes are impending in the ancient craft of the Beautiful. In all the arts there is a physical component which can no longer be considered or treated as it used to be, which cannot remain unaffected by our modern knowledge and power. For the last twenty years neither matter nor space nor time has been what it was from time immemorial. We must expect great innovations to transform the entire technique of the arts, thereby affecting artistic invention itself and perhaps even bringing about an amazing change in our very notion of art."[1]

—Paul Valéry, PIÈCES SUR L'ART, "La Conquête de l'ubiquité," Paris.

Preface

When Marx undertook his critique of the capitalistic mode of production, this mode was in its infancy. Marx directed his efforts in such a way as to give them prognostic value. He went back to the basic conditions underlying capitalistic production and through his presentation showed what could be expected of capitalism in the future. The result was that one could expect it not only to exploit the proletariat with increasing intensity, but ultimately to create conditions which would make it possible to abolish capitalism itself.

The transformation of the superstructure, which takes place far more slowly than that of the substructure, has taken more than half a century to manifest in all areas of culture the change in the conditions of production. Only today can it be indicated what form this has taken. Certain prognostic requirements should be met by these statements. However, theses about the art of the proletariat after its assumption of power or about the art of a classless society would have less bearing on these demands than theses about the developmental tendencies of art under present conditions of production. Their dialectic is no less noticeable in the superstructure than in the economy. It would therefore be wrong to underestimate the value of such theses as a weapon. They brush aside a number of outmoded concepts, such as creativity and genius, eternal value and mystery—concepts whose uncontrolled (and at present almost uncontrollable) application would lead to a processing of data in the Fascist sense. The concepts which are introduced into the theory of art in what follows differ from the more familiar terms in that they are completely useless for the purposes of Fascism. They

1. Quoted from Paul Valéry, *Aesthetics*, "The Conquest of Ubiquity," translated by Ralph Manheim, p. 225. Pantheon Books, Bollingen Series, New York, 1964.

are, on the other hand, useful for the formulation of revolutionary demands in the politics of art.

I

In principle a work of art has always been reproducible. Manmade artifacts could always be imitated by men. Replicas were made by pupils in practice of their craft, by masters for diffusing their works, and, finally, by third parties in the pursuit of gain. Mechanical reproduction of a work of art, however, represents something new. Historically, it advanced intermittently and in leaps at long intervals, but with accelerated intensity. The Greeks knew only two procedures of technically reproducing works of art: founding and stamping. Bronzes, terra cottas, and coins were the only art works which they could produce in quantity. All others were unique and could not be mechanically reproduced. With the woodcut graphic art became mechanically reproducible for the first time, long before script became reproducible by print. The enormous changes which printing, the mechanical reproduction of writing, has brought about in literature are a familiar story. However, within the phenomenon which we are here examining from the perspective of world history, print is merely a special, though particularly important, case. During the Middle Ages engraving and etching were added to the woodcut; at the beginning of the nineteenth century lithography made its appearance.

With lithography the technique of reproduction reached an essentially new stage. This much more direct process was distinguished by the tracing of the design on a stone rather than its incision on a block of wood or its etching on a copperplate and permitted graphic art for the first time to put its products on the market, not only in large numbers as hitherto, but also in daily changing forms. Lithography enabled graphic art to illustrate everyday life, and it began to keep pace with printing. But only a few decades after its invention, lithography was surpassed by photography. For the first time in the process of pictorial reproduction, photography freed the hand of the most important artistic functions which henceforth devolved only upon the eye looking into a lens. Since the eye perceives more swiftly than the hand can draw, the process of pictorial reproduction was accelerated so enormously that it could keep pace with speech. A film operator shooting a scene in the studio captures the images at the speed of an actor's speech. Just as lithography virtually implied the illustrated newspaper, so did photography foreshadow the sound film. The technical reproduction of sound was tackled at the end of the last century. These convergent endeavors made predictable a situation which Paul Valéry pointed up in this sentence: "Just as water, gas, and electricity are brought into our houses from far off to satisfy our needs in response to a minimal effort, so we shall be supplied with visual or auditory images, which will appear and disappear at a simple movement of the hand, hardly more than a sign" (*op. cit.*, p. 226). Around 1900 technical reproduction had reached a standard that not only permitted it to reproduce all transmitted works of art and thus to cause the most profound change in their impact upon the public; it also had captured a place of its own among the artistic processes. For the study of this standard nothing is more revealing than the nature of the repercussions that these two different manifestations— the reproduction of works of art and the art of the film—have had on art in its traditional form.

II

Even the most perfect reproduction of a work of art is lacking in one element: its presence in time and space, its unique existence at the place where it happens to be. This unique existence of the work of art determined the history to which it was subject throughout the time of its existence. This includes the changes which it may have suffered in physical condition over the years as well as the various changes in its ownership.[2] The traces of the first can be revealed only by chemical or physical analyses which it is impossible to perform on a reproduction; changes of ownership are subject to a tradition which must be traced from the situation of the original.

2. Of course, the history of a work of art encompasses more than this. The history of the "Mona Lisa," for instance, encompasses the kind and number of its copies made in the 17th, 18th, and 19th centuries.

The presence of the original is the prerequisite to the concept of authenticity. Chemical analyses of the patina of a bronze can help to establish this, as does the proof that a given manuscript of the Middle Ages stems from an archive of the fifteenth century. The whole sphere of authenticity is outside technical—and, of course, not only technical—reproducibility.[3] Confronted with its manual reproduction, which was usually branded as a forgery, the original preserved all its authority; not so *vis à vis* technical reproduction. The reason is twofold. First, process reproduction is more independent of the original than manual reproduction. For example, in photography, process reproduction can bring out those aspects of the original that are unattainable to the naked eye yet accessible to the lens, which is adjustable and chooses its angle at will. And photographic reproduction, with the aid of certain processes, such as enlargement or slow motion, can capture images which escape natural vision. Secondly, technical reproduction can put the copy of the original into situations which would be out of reach for the original itself. Above all, it enables the original to meet the beholder halfway, be it in the form of a photograph or a phonograph record. The cathedral leaves its locale to be received in the studio of a lover of art; the choral production, performed in an auditorium or in the open air, resounds in the drawing room.

The situations into which the product of mechanical reproduction can be brought may not touch the actual work of art, yet the quality of its presence is always depreciated. This holds not only for the art work but also, for instance, for a landscape which passes in review before the spectator in a movie. In the case of the art object, a most sensitive nucleus—namely, its authenticity—is interfered with whereas no natural object is vulnerable on that score. The authenticity of a thing is the essence of all that is transmissible from its beginning, ranging from its substantive duration to its testimony to the history which it has experienced. Since the historical testimony rests on the authenticity, the former, too, is jeopardized by reproduction when substantive duration ceases to matter. And what is really jeopardized when the historical testimony is affected is the authority of the object.[4]

One might subsume the eliminated element in the term "aura" and go on to say: that which withers in the age of mechanical reproduction is the aura of the work of art. This is a symptomatic process whose significance points beyond the realm of art. One might generalize by saying: the technique of reproduction detaches the reproduced object from the domain of tradition. By making many reproductions it substitutes a plurality of copies for a unique existence. And in permitting the reproduction to meet the beholder or listener in his own particular situation, it reactivates the object reproduced. These two processes lead to a tremendous shattering of tradition which is the obverse of the contemporary crisis and renewal of mankind. Both processes are intimately connected with the contemporary mass movements. Their most powerful agent is the film. Its social significance, particularly in its most positive form, is inconceivable without its destructive, cathartic aspect, that is, the liquidation of the traditional value of the cultural heritage. This phenomenon is most palpable in the great historical films. It extends to ever new positions. In 1927 Abel Gance exclaimed enthusiastically: "Shakespeare, Rembrandt, Beethoven will make films...all legends, all mythologies and all myths, all founders of religion, and the very religions...await their exposed resurrection, and the heroes crowd each other at the gate."[5] Presumably

3. Precisely because authenticity is not reproducible, the intensive penetration of certain (mechanical) processes of reproduction was instrumental in differentiating and grading authenticity. To develop such differentiations was an important function of the trade in works of art. The invention of the woodcut may be said to have struck at the root of the quality of authenticity even before its late flowering. To be sure, at the time of its origin a medieval picture of the Madonna could not yet be said to be "authentic." It became "authentic" only during the succeeding centuries and perhaps most strikingly so during the last one.

4. The poorest provincial staging of *Faustus* is superior to a Faust film in that, ideally, it competes with the first performance at Weimar. Before the screen it is unprofitable to remember traditional contents which might come to mind before the stage—for instance, that Goethe's friend Johann Heinrich Merck is hidden in Mephisto, and the like.

5. Abel Gance, "Le Temps de l'image est venu," *L'Art cinématographique,* Vol. 2, pp. 94 f, Paris, 1927.

without intending it, he issued an invitation to a far-reaching liquidation.

III

During long periods of history, the mode of human sense perception changes with humanity's entire mode of existence. The manner in which human sense perception is organized, the medium in which it is accomplished, is determined not only by nature but by historical circumstances as well. The fifth century, with its great shifts of population, saw the birth of the late Roman art industry and the Vienna Genesis, and there developed not only an art different from that of antiquity but also a new kind of perception. The scholars of the Viennese school, Riegl and Wickhoff, who resisted the weight of classical tradition under which these later art forms had been buried, were the first to draw conclusions from them concerning the organization of perception at the time. However far-reaching their insight, these scholars limited themselves to showing the significant, formal hallmark which characterized perception in late Roman times. They did not attempt—and, perhaps, saw no way—to show the social transformations expressed by these changes of perception. The conditions for an analogous insight are more favorable in the present. And if changes in the medium of contemporary perception can be comprehended as decay of the aura, it is possible to show its social causes.

The concept of aura which was proposed above with reference to historical objects may usefully be illustrated with reference to the aura of natural ones. We define the aura of the latter as the unique phenomenon of a distance, however close it may be. If, while resting on a summer afternoon, you follow with your eyes a mountain range on the horizon or a branch which casts its shadow over you, you experience the aura of those mountains, of that branch. This image makes it easy to comprehend the social bases of the contemporary decay of the aura. It rests on two circumstances, both of which are related to the increasing significance of the masses in contemporary life. Namely, the desire of contemporary masses to bring things "closer" spatially and humanly, which is just as ardent as their bent toward overcoming the uniqueness of every reality by accepting its reproduction.[6] Every day the urge grows stronger to get hold of an object at very close range by way of its likeness, its reproduction. Unmistakably, reproduction as offered by picture magazines and newsreels differs from the image seen by the unarmed eye. Uniqueness and permanence are as closely linked in the latter as are transitoriness and reproducibility in the former. To pry an object from its shell, to destroy its aura, is the mark of a perception whose "sense of the universal equality of things" has increased to such a degree that it extracts it even from a unique object by means of reproduction. Thus is manifested in the field of perception what in the theoretical sphere is noticeable in the increasing importance of statistics. The adjustment of reality to the masses and of the masses to reality is a process of unlimited scope, as much for thinking as for perception.

IV

The uniqueness of a work of art is inseparable from its being imbedded in the fabric of tradition. This tradition itself is thoroughly alive and extremely changeable. An ancient statue of Venus, for example, stood in a different traditional context with the Greeks, who made it an object of veneration, than with the clerics of the Middle Ages, who viewed it as an ominous idol. Both of them, however, were equally confronted with its uniqueness, that is, its aura. Originally the contextual integration of art in tradition found its expression in the cult. We know that the earliest art works originated in the service of a ritual—first the magical, then the religious kind. It is significant that the existence of the work of art with reference to its aura is never entirely separated

6. To satisfy the human interest of the masses may mean to have one's social function removed from the field of vision. Nothing guarantees that a portraitist of today, when painting a famous surgeon at the breakfast table in the midst of his family, depicts his social function more precisely than a painter of the 17th century who portrayed his medical doctors as representing this profession, like Rembrandt in his "Anatomy Lesson."

from its ritual function.[7] In other words, the unique value of the "authentic" work of art has its basis in ritual, the location of its original use value. This ritualistic basis, however remote, is still recognizable as secularized ritual even in the most profane forms of the cult of beauty.[8] The secular cult of beauty, developed during the Renaissance and prevailing for three centuries, clearly showed that ritualistic basis in its decline and the first deep crisis which befell it. With the advent of the first truly revolutionary means of reproduction, photography, simultaneously with the rise of socialism, art sensed the approaching crisis which has become evident a century later. At the time, art reacted with the doctrine of *l'art pour l'art*, that is, with a theology of art. This gave rise to what might be called a negative theology in the form of the idea of "pure" art, which not only denied any social function of art but also any categorizing by subject matter. (In poetry, Mallarmé was the first to take this position.)

An analysis of art in the age of mechanical reproduction must do justice to these relationships, for they lead us to an all-important insight: for the first time in world history, mechanical reproduction emancipates the work of art from its parasitical dependence on ritual. To an ever greater degree the work of art reproduced becomes the work of art designed for reproducibility.[9] From a photographic negative, for example, one can make any number of prints; to ask for the "authentic" print makes no sense. But the instant the criterion of authenticity ceases to be applicable to artistic production, the total function of art is reversed. Instead of being based on ritual, it begins to be based on another practice—politics.

V

Works of art are received and valued on different planes. Two polar types stand out: with one, the accent is on the cult value; with the other, on the exhibition value of the work.[10] Artistic production

7. The definition of the aura as a "unique phenomenon of a distance however close it may be" represents nothing but the formulation of the cult value of the work of art in categories of space and time perception. Distance is the opposite of closeness. The essentially distant object is the unapproachable one. Unapproachability is indeed a major quality of the cult image. True to its nature, it remains "distant, however close it may be." The closeness which one may gain from its subject matter does not impair the distance which it retains in its appearance.

8. To the extent to which the cult value of the painting is secularized the ideas of its fundamental uniqueness lose distinctness. In the imagination of the beholder the uniqueness of the phenomena which hold sway in the cult image is more and more displaced by the empirical uniqueness of the creator or of his creative achievement. To be sure, never completely so; the concept of authenticity always transcends mere genuineness. (This is particularly apparent in the collector who always retains some traces of the fetishist and who, by owning the work of art, shares in its ritual power.) Nevertheless, the function of the concept of authenticity remains determinate in the evaluation of art; with the secularization of art, authenticity displaces the cult value of the work.

9. In the case of films, mechanical reproduction is not, as with literature and painting, an external condition for mass distribution. Mechanical reproduction is inherent in the very technique of film production. This technique not only permits in the most direct way but virtually causes mass distribution. It enforces distribution because the production of a film is so expensive than an individual who, for instance, might afford to buy a painting no longer can afford to buy a film. In 1927 it was calculated that a major film, in order to pay its way, had to reach an audience of nine million. With the sound film, to be sure, a setback in its international distribution occurred at first: audiences became limited by language barriers. This coincided with the Fascist emphasis on national interests. It is more important to focus on this connection with Fascism than on this setback, which was soon minimized by synchronization. The simultaneity of both phenomena is attributable to the depression. The same disturbances which, on a larger scale, led to an attempt to maintain the existing property structure by sheer force led the endangered film capital to speed up the development of the sound film. The introduction of the sound film brought about a temporary relief, not only because it again brought the masses into the theaters but also because it merged new capital from the electrical industry with that of the film industry. Thus, viewed from the outside, the sound film promoted national interests, but seen from the inside it helped to internationalize film production even more than previously.

10. This polarity cannot come into its own in the aesthetics of Idealism. Its idea of beauty compromises these polar opposites without differentiating between them and consequently excludes their polarity. Yet in Hegel this polarity announces itself as clearly as possible within the limits of Idealism. We quote from his *Philosophy of History*: "Images were known of old. Piety at an early time required them for worship, but it could do without beautiful images. These might even be disturbing. In every beautiful painting there is also something nonspiritual, merely external, but its spirit speaks to man through its

begins with ceremonial objects destined to serve in a cult. One may assume that what mattered was their existence, not their being on view. The elk portrayed by the man of the Stone Age on the walls of his cave was an instrument of magic. He did expose it to his fellow men, but in the main it was meant for the spirits. Today the cult value would seem to demand that the work of art remain hidden. Certain statues of gods are accessible only to the priest in the cella; certain Madonnas remain covered nearly all year round; certain sculptures on medieval cathedrals are invisible to the spectator on ground

beauty. Worshipping, conversely, is concerned with the work as an object, for it is but a spiritless stupor of the soul.... Fine art has arisen...in the church..., although it has already gone beyond its principle as art."

Likewise, the following passage from *The Philosophy of Fine Art* indicates that Hegel sensed a problem here.

"We are beyond the stage of reverence for works of art as divine and objects deserving our worship. The impression they produce is one of a more reflective kind, and the emotions they arouse require a higher test...."—G. W. F. Hegel, *The Philosophy of Fine Art*, trans., with notes, by F. P. B. Osmaston, Vol. 1, p. 12, London, 1920.

The transition from the first kind of artistic reception to the second characterizes the history of artistic reception in general. Apart from that, a certain oscillation between these two polar modes of reception can be demonstrated for each work of art. Take the Sistine Madonna. Since Hubert Grimme's research it has been known that the Madonna originally was painted for the purpose of exhibition. Grimme's research was inspired by the question: What is the purpose of the molding in the foreground of the painting which the two cupids lean upon? How, Grimme asked further, did Raphael come to furnish the sky with two draperies? Research proved that the Madonna had been commissioned for the public lying-in-state of Pope Sixtus. The Popes lay in state in a certain side chapel of St. Peter's. On that occasion Raphael's picture had been fastened in a nichelike background of the chapel, supported by the coffin. In this picture Raphael portrays the Madonna approaching the papal coffin in clouds from the background of the niche, which was demarcated by green drapes. At the obsequies of Sixtus a pre-eminent exhibition value of Raphael's picture was taken advantage of. Some time later it was placed on the high altar in the church of the Black Friars at Piacenza. The reason for this exile is to be found in the Roman rites which forbid the use of painting exhibited at obsequies as cult objects on the high altar. This regulation devalued Raphael's picture to some degree. In order to obtain an adequate price nevertheless, the Papal See resolved to add to the bargain the tacit toleration of the picture above the high altar. To avoid attention the picture was given to the monks of the far-off provincial town.

level. With the emancipation of the various art practices from ritual go increasing opportunities for the exhibition of their products. It is easier to exhibit a portrait bust that can be sent here and there than to exhibit the statue of a divinity that has its fixed place in the interior of a temple. The same holds for the painting as against the mosaic or fresco that preceded it. And even though the public presentability of a mass originally may have been just as great as that of a symphony, the latter originated at the moment when its public presentability promised to surpass that of the mass.

With the different methods of technical reproduction of a work of art, its fitness for exhibition increased to such an extent that the quantitative shift between its two poles turned into a qualitative transformation of its nature. This is comparable to the situation of the work of art in prehistoric times when, by the absolute emphasis on its cult value, it was, first and foremost, an instrument of magic. Only later did it come to be recognized as a work of art. In the same way today, by the absolute emphases on its exhibition value the work of art becomes a creation with entirely new functions, among which the one we are conscious of, the artistic function, later may be recognized as incidental.[11] This much is certain: today photography and the film are the most serviceable exemplifications of this new function.

VI

In photography, exhibition value begins to displace cult value all along the line. But cult value does not give way without resistance. It retires into an ultimate retrenchment: the human countenance. It is no accident that the portrait was the focal point of early photography. The cult of remembrance of

11. Bertolt Brecht, on a different level, engaged in analogous reflections: "If the concept of 'work of art' can no longer be applied to the thing that emerges once the work is transformed into a commodity, we have to eliminate this concept with cautious care but without fear, lest we liquidate the function of the very thing as well. For it has to go through this phase without mental reservation, and not as noncommittal deviation from the straight path; rather, what happens here with the work of art will change it fundamentally and erase its past to such an extent that should the old concept be taken up again—and it will, why not?—it will no longer stir any memory of the thing it once designated."

loved ones, absent or dead, offers a last refuge for the cult value of the picture. For the last time the aura emanates from the early photographs in the fleeting expression of a human face. This is what constitutes their melancholy, incomparable beauty. But as man withdraws from the photographic image, the exhibition value for the first time shows its superiority to the ritual value. To have pinpointed this new stage constitutes the incomparable significance of Atget, who, around 1900, took photographs of deserted Paris streets. It has quite justly been said of him that he photographed them like scenes of crime. The scene of a crime, too, is deserted; it is photographed for the purpose of establishing evidence. With Atget, photographs become standard evidence for historical occurrences, and acquire a hidden political significance. They demand a specific kind of approach; free-floating contemplation is not appropriate to them. They stir the viewer; he feels challenged by them in a new way. At the same time picture magazines begin to put up signposts for him, right ones or wrong ones, no matter. For the first time, captions have become obligatory. And it is clear that they have an altogether different character than the title of a painting. The directives which the captions give to those looking at pictures in illustrated magazines soon become even more explicit and more imperative in the film where the meaning of each single picture appears to be prescribed by the sequence of all preceding ones.

VII

The nineteenth-century dispute as to the artistic value of painting versus photography today seems devious and confused. This does not diminish its importance, however; if anything, it underlines it. The dispute was in fact the symptom of a historical transformation the universal impact of which was not realized by either of the rivals. When the age of mechanical reproduction separated art from its basis in cult, the semblance of its autonomy disappeared forever. The resulting change in the function of art transcended the perspective of the century; for a long time it even escaped that of the twentieth century, which experienced the development of the film.

Earlier much futile thought had been devoted to the question of whether photography is an art. The primary question—whether the very invention of photography had not transformed the entire nature of art—was not raised. Soon the film theoreticians asked the same ill-considered question with regard to the film. But the difficulties which photography caused traditional aesthetics were mere child's play as compared to those raised by the film.

. . .

IX

For the film, what matters primarily is that the actor represents himself to the public before the camera, rather than representing someone else. One of the first to sense the actor's metamorphosis by this form of testing was Pirandello. Though his remarks on the subject in his novel *Si Gira* were limited to the negative aspects of the question and to the silent film only, this hardly impairs their validity. For in this respect, the sound film did not change anything essential. What matters is that the part is acted not for an audience but for a mechanical contrivance—in the case of the sound film, for two of them. "The film actor," wrote Pirandello, "feels as if in exile—exiled not only from the stage but also from himself. With a vague sense of discomfort he feels inexplicable emptiness: his body loses its corporeality, it evaporates, it is deprived of reality, life, voice, and the noises caused by his moving about, in order to be changed into a mute image, flickering an instant on the screen, then vanishing into silence.... The projector will play with his shadow before the public, and he himself must be content to play before the camera."[12] This situation might also be characterized as follows: for the first time— and this is the effect of the film—man has to operate with his whole living person, yet forgoing its aura. For aura is tied to his presence; there can be no replica of it. The aura which, on the stage, emanates from Macbeth, cannot be separated for the spectators from that of the actor. However, the singularity of

12. Luigi Pirandello, *Si Gira*, quoted by Léon Pierre-Quint, "Signification du cinéma," *L'Art cinématographique*, op. cit., pp. 14-15.

the shot in the studio is that the camera is substituted for the public. Consequently, the aura that envelops the actor vanishes, and with it the aura of the figure he portrays.

It is not surprising that it should be a dramatist such as Pirandello who, in characterizing the film, inadvertently touches on the very crisis in which we see the theater. Any thorough study proves that there is indeed no greater contrast than that of the stage play to a work of art that is completely subject to or, like the film, founded in, mechanical reproduction. Experts have long recognized that in the film "the greatest effects are almost always obtained by 'acting' as little as possible...." In 1932 Rudolf Arnheim saw "the latest trend...in treating the actor as a stage prop chosen for its characteristics and... inserted at the proper place."[13] With this idea something else is closely connected. The stage actor identifies himself with the character of his role. The film actor very often is denied this opportunity. His creation is by no means all of a piece; it is composed of many separate performances. Besides certain fortuitous considerations, such as cost of studio, availability of fellow players, décor, etc., there are elementary necessities of equipment that split the actor's work into a series of mountable episodes. In particular, lighting and its installation require the presentation of an event that, on the screen, unfolds as a rapid and unified scene, in a sequence of separate shootings which may take hours at the studio; not to mention more obvious montage. Thus a jump from the window can be shot in the studio as a jump from a scaffold, and the ensuing flight, if need be, can be shot weeks later when outdoor scenes are taken. Far more paradoxical cases can easily be construed. Let us assume that an actor is supposed to be startled by a knock at the door. If his reaction is not satisfactory, the director can resort to an expedient: when the actor happens to be at the studio again he has a shot fired behind him without his being forewarned of it. The frightened reaction can be shot now and be cut into the screen version. Nothing more strikingly shows that art has left the realm of the "beautiful semblance" which, so far, had been taken to be the only sphere where art could thrive.

X

The feeling of strangeness that overcomes the actor before the camera, as Pirandello describes it, is basically of the same kind as the estrangement felt before one's own image in the mirror. But now the reflected image has become separable, transportable. And where is it transported? Before the public.[14] Never for a moment does the screen actor cease to be conscious of this fact. While facing the camera

13. Rudolf Arnheim, *Film als Kunst*, Berlin, 1932, pp. 176 f. In this context certain seemingly unimportant details in which the film director deviates from stage practices gain in interest. Such is the attempt to let the actor play without make-up, as made among others by Dreyer in his *Jeanne d'Arc*. Dreyer spent months seeking the forty actors who constitute the Inquisitors' tribunal. The search for these actors resembled that for stage properties that are hard to come by. Dreyer made every effort to avoid resemblances of age, build, and physiognomy. If the actor thus becomes a stage property, this latter, on the other hand, frequently functions as actor. At least it is not unusual for the film to assign a role to the stage property. Instead of choosing at random from a great wealth of examples, let us concentrate on a particularly convincing one. A clock that is working will always be a disturbance on the stage. There it cannot be permitted its function of measuring time. Even in a naturalistic play, astronomical time would clash with theatrical time. Under these circumstances it is highly revealing that the film can, whenever appropriate, use time as measured by a clock. From this more than from many other touches it may clearly be recognized that under certain circumstances each and every prop in a film may assume important functions. From here it is but one step to Pudovkin's statement that "the playing of an actor which is connected with an object and is built around it...is always one of the strongest methods of cinematic construction." (W. Pudovkin, *Filmregie und Filmmanuskript*, Berlin, 1928, p. 126.) The film is the first art form capable of demonstrating how matter plays tricks on man. Hence, films can be an excellent means of materialistic representation.

14. The change noted here in the method of exhibition caused by mechanical reproduction applies to politics as well. The present crisis of the bourgeois democracies comprises a crisis of the conditions which determine the public presentation of the rulers. Democracies exhibit a member of government directly and personally before the nation's representatives. Parliament is his public. Since the innovations of camera and recording equipment make it possible for the orator to become audible and visible to an unlimited number of persons, the presentation of the man of politics before camera and recording equipment becomes paramount. Parliaments, as much as theaters, are deserted. Radio and film not only affect the function of the professional actor but likewise the function of those who also exhibit themselves before this mechanical equipment, those who govern. Though their tasks may be different, the change affects equally the actor and the ruler. The trend is toward establishing controllable and transferrable skills under certain social conditions. This results in a new selection, a selection before the equipment from which the star and the dictator emerge victorious.

he knows that ultimately he will face the public, the consumers who constitute the market. This market, where he offers not only his labor but also his whole self, his heart and soul, is beyond his reach. During the shooting he has as little contact with it as any article made in a factory. This may contribute to that oppression, that new anxiety which, according to Pirandello, grips the actor before the camera. The film responds to the shriveling of the aura with an artificial build-up of the "personality" outside the studio. The cult of the movie star, fostered by the money of the film industry, preserves not the unique aura of the person but the "spell of the personality," the phony spell of a commodity. So long as the movie-makers' capital sets the fashion, as a rule no other revolutionary merit can be accredited to today's film than the promotion of a revolutionary criticism of traditional concepts of art. We do not deny that in some cases today's films can also promote revolutionary criticism of social conditions, even of the distribution of property. However, our present study is no more specifically concerned with this than is the film production of Western Europe.

It is inherent in the technique of the film as well as that of sports that everybody who witnesses its accomplishments is somewhat of an expert. This is obvious to anyone listening to a group of newspaper boys leaning on their bicycles and discussing the outcome of a bicycle race. It is not for nothing that newspaper publishers arrange races for their delivery boys. These arouse great interest among the participants, for the victor has an opportunity to rise from delivery boy to professional racer. Similarly,

the newsreel offers everyone the opportunity to rise from passer-by to movie extra. In this way any man might even find himself part of a work of art, as witness Vertoff's *Three Songs About Lenin* or Ivens' *Borinage*. Any man today can lay claim to being filmed. This claim can best be elucidated by a comparative look at the historical situation of contemporary literature.

For centuries a small number of writers were confronted by many thousands of readers. This changed toward the end of the last century. With the increasing extension of the press, which kept placing new political, religious, scientific, professional, and local organs before the readers, an increasing number of readers became writers—at first, occasional ones. It began with the daily press opening to its readers space for "letters to the editor." And today there is hardly a gainfully employed European who could not, in principle, find an opportunity to publish somewhere or other comments on his work, grievances, documentary reports, or that sort of thing. Thus, the distinction between author and public is about to lose its basic character. The difference becomes merely functional; it may vary from case to case. At any moment the reader is ready to turn into a writer. As expert, which he had to become willy-nilly in an extremely specialized work process, even if only in some minor respect, the reader gains access to authorship. In the Soviet Union work itself is given a voice. To present it verbally is part of a man's ability to perform the work. Literary license is now founded on polytechnic rather than specialized training and thus becomes common property.[15]

15. The privileged character of the respective techniques is lost. Aldous Huxley writes:

" Advances in technology have led...to vulgarity.... Process reproduction and the rotary press have made possible the indefinite multiplication of writing and pictures. Universal education and relatively high wages have created an enormous public who know how to read and can afford to buy reading and pictorial matter. A great industry has been called into existence in order to supply these commodities. Now, artistic talent is a very rare phenomenon; whence it follows...that, at every epoch and in all countries, most art has been bad. But the proportion of trash in the total artistic output is greater now than at any other period. That it must be so is a matter of simple arithmetic. The population of Western Europe has a little more than doubled during the last century. But the amount of reading—and seeing—matter has increased, I should imagine, at least twenty and possibly fifty or even a hundred times. If there were n men of talent in a population of x millions, there will presumably be 2n men of talent among 2x millions. The situation may be summed up thus. For every page of print and pictures published a century ago, twenty or perhaps even a hundred

pages are published today. But for every man of talent then living, there are now only two men of talent. It may be of course that, thanks to universal education, many potential talents which in the past would have been stillborn are now enabled to realize themselves. Let us assume, then, that there are now three or even four men of talent to every one of earlier times. It still remains true to say that the consumption of reading—and seeing—matter has far outstripped the natural production of gifted writers and draughtsmen. It is the same with hearing-matter. Prosperity, the gramophone and the radio have created an audience of hearers who consume an amount of hearing-matter that has increased out of all proportion to the increase of population and the consequent natural increase of talented musicians. It follows from all this that in all the arts the output of trash is both absolutely and relatively greater than it was in the past; and that it must remain greater for just so long as the world continues to consume the present inordinate quantities of reading-matter, seeing-matter, and hearing-matter."—Aldous Huxley, *Beyond the Mexique Bay. A Traveller's Journal*, London, 1949, pp. 274ff. First published in 1934.

This mode of observation is obviously not progressive.

All this can easily be applied to the film, where transitions that in literature took centuries have come about in a decade. In cinematic practice, particularly in Russia, this change-over has partially become established reality. Some of the players whom we meet in Russian films are not actors in our sense but people who portray *themselves*—and primarily in their own work process. In Western Europe the capitalistic exploitation of the film denies consideration to modern man's legitimate claim to being reproduced. Under these circumstances the film industry is trying hard to spur the interest of the masses through illusion-promoting spectacles and dubious speculations.

XI

The shooting of a film, especially of a sound film, affords a spectacle unimaginable anywhere at any time before this. It presents a process in which it is impossible to assign to a spectator a viewpoint which would exclude from the actual scene such extraneous accessories as camera equipment, lighting machinery, staff assistants, etc.—unless his eye were on a line parallel with the lens. This circumstance, more than any other, renders superficial and insignificant any possible similarity between a scene in the studio and one on the stage. In the theater one is well aware of the place from which the play cannot immediately be detected as illusionary. There is no such place for the movie scene that is being shot. Its illusionary nature is that of the second degree, the result of cutting. That is to say, in the studio the mechanical equipment has penetrated so deeply into reality that its pure aspect freed from the foreign substance of equipment is the result of a special procedure, namely, the shooting by the specially adjusted camera and the mounting of the shot together with other similar ones. The equipment-free aspect of reality here has become the height of artifice; the sight of immediate reality has become an orchid in the land of technology.

Even more revealing is the comparison of these circumstances, which differ so much from those of the theater, with the situation in painting. Here the question is: How does the cameraman compare with the painter? To answer this we take recourse to an analogy with a surgical operation. The surgeon represents the polar opposite of the magician. The magician heals a sick person by the laying on of hands; the surgeon cuts into the patient's body. The magician maintains the natural distance between the patient and himself; though he reduces it very slightly by the laying on of hands, he greatly increases it by virtue of his authority. The surgeon does exactly the reverse; he greatly diminishes the distance between himself and the patient by penetrating into the patient's body, and increases it but little by the caution with which his hand moves among the organs. In short, in contrast to the magician—who is still hidden in the medical practitioner—the surgeon at the decisive moment abstains from facing the patient man to man; rather, it is through the operation that he penetrates into him.

Magician and surgeon compare to painter and cameraman. The painter maintains in his work a natural distance from reality, the cameraman penetrates deeply into its web.[16] There is a tremendous difference between the pictures they obtain. That of the painter is a total one, that of the cameraman consists of multiple fragments which are assembled under a new law. Thus, for contemporary man the representation of reality by the film is incomparably more significant than that of the painter, since it offers, precisely because of the thoroughgoing permeation of reality with mechanical equipment, an aspect of reality which is free of all equipment. And that is what one is entitled to ask from a work of art.

16. The boldness of the cameraman is indeed comparable to that of the surgeon. Luc Durtain lists among specific technical sleights of hand those "which are required in surgery in the case of certain difficult operations. I choose as an example a case from oto-rhino-laryngology; ...the so-called endonasal perspective procedure; or I refer to the acrobatic tricks of larynx surgery which have to be performed following the reversed picture in the laryngoscope. I might also speak of ear surgery which suggests the precision work of watchmakers. What range of the most subtle muscular acrobatics is required from the man who wants to repair or save the human body! We have only to think of the couching of a cataract where there is virtually a debate of steel with nearly fluid tissue, or of the major abdominal operations (laparotomy)."—Luc Durtain, *op. cit.*

XII

Mechanical reproduction of art changes the reaction of the masses toward art. The reactionary attitude toward a Picasso painting changes into the progressive reaction toward a Chaplin movie. The progressive reaction is characterized by the direct, intimate fusion of visual and emotional enjoyment with the orientation of the expert. Such fusion is of great social significance. The greater the decrease in the social significance of an art form, the sharper the distinction between criticism and enjoyment by the public. The conventional is uncritically enjoyed, and the truly new is criticized with aversion. With regard to the screen, the critical and the receptive attitudes of the public coincide. The decisive reason for this is that individual reactions are predetermined by the mass audience response they are about to produce, and this is nowhere more pronounced than in the film. The moment these responses become manifest they control each other. Again, the comparison with painting is fruitful. A painting has always had an excellent chance to be viewed by one person or by a few. The simultaneous contemplation of paintings by a large public, such as developed in the nineteenth century, is an early symptom of the crisis of painting, a crisis which was by no means occasioned exclusively by photography but rather in a relatively independent manner by the appeal of art works to the masses.

Painting simply is in no position to present an object for simultaneous collective experience, as it was possible for architecture at all times, for the epic poem in the past, and for the movie today. Although this circumstance in itself should not lead one to conclusions about the social role of painting, it does constitute a serious threat as soon as painting, under special conditions and, as it were, against its nature, is confronted directly by the masses. In the churches and monasteries of the Middle Ages and at the princely courts up to the end of the eighteenth century, a collective reception of paintings did not occur simultaneously, but by graduated and hierarchized mediation. The change that has come about is an expression of the particular conflict in which painting was implicated by the mechanical reproducibility of paintings. Although paintings began to be publicly exhibited in galleries and salons, there was no way for the masses to organize and control themselves in their reception.[17] Thus the same public which responds in a progressive manner toward a grotesque film is bound to respond in a reactionary manner to surrealism.

XIII

The characteristics of the film lie not only in the manner in which man presents himself to mechanical equipment but also in the manner in which, by means of this apparatus, man can represent his environment. A glance at occupational psychology illustrates the testing capacity of the equipment. Psychoanalysis illustrates it in a different perspective. The film has enriched our field of perception with methods which can be illustrated by those of Freudian theory. Fifty years ago, a slip of the tongue passed more or less unnoticed. Only exceptionally may such a slip have revealed dimensions of depth in a conversation which had seemed to be taking its course on the surface. Since the *Psychopathology of Everyday Life* things have changed. This book isolated and made analyzable things which had heretofore floated along unnoticed in the broad stream of perception. For the entire spectrum of optical, and now also acoustical, perception the film has brought about a similar deepening of apperception. It is only an obverse of this fact that behavior items shown in a movie can be analyzed much more precisely and from more points of view than those presented on paintings or on the stage. As compared with painting, filmed behavior lends itself more readily to analysis because of its incomparably more precise statements of the situation. In comparison with the stage scene, the filmed behavior item lends itself more readily to analysis because it can be isolated more easily. This circumstance derives its chief importance

17. This mode of observation may seem crude, but as the great theoretician Leonardo has shown, crude modes of observation may at times be usefully adduced. Leonardo compares painting and music as follows: "Painting is superior to music because, unlike unfortunate music, it does not have to die as soon as it is born.... Music which is consumed in the very act of its birth is inferior to painting which the use of varnish has rendered eternal." (Trattato I, 29.)

from its tendency to promote the mutual penetration of art and science. Actually, of a screened behavior item which is neatly brought out in a certain situation, like a muscle of a body, it is difficult to say which is more fascinating, its artistic value or its value for science. To demonstrate the identity of the artistic and scientific uses of photography which heretofore usually were separated will be one of the revolutionary functions of the film.[18]

By close-ups of the things around us, by focusing on hidden details of familiar objects, by exploring commonplace milieus under the ingenious guidance of the camera, the film, on the one hand, extends our comprehension of the necessities which rule our lives; on the other hand, it manages to assure us of an immense and unexpected field of action. Our taverns and our metropolitan streets, our offices and furnished rooms, our railroad stations and our factories appeared to have us locked up hopelessly. Then came the film and burst this prison-world asunder by the dynamite of the tenth of a second, so that now, in the midst of its far-flung ruins and debris, we calmly and adventurously go traveling. With the close-up, space expands; with slow motion, movement is extended. The enlargement of a snapshot does not simply render more precise what in any case was visible, though unclear: it reveals entirely new structural formations of the subject. So, too, slow motion not only presents familiar qualities of movement but reveals in them entirely unknown ones "which, far from looking like retarded rapid movements, give the effect of singularly gliding, floating, supernatural motions."[19] Evidently a different nature opens itself to the camera than opens to the naked eye—if only because an unconsciously penetrated space is substituted for a space consciously explored by man. Even if one has a general knowledge of the way people walk, one knows nothing of a person's posture during the fractional second of a stride. The act of reaching for a lighter or a spoon is a familiar routine, yet we hardly know what really goes on between hand and metal, not to mention how this fluctuates with our moods. Here the camera intervenes with the resources of its lowerings and liftings, its interruptions and isolations, its extensions and accelerations, its enlargements and reductions. The camera introduces us to unconscious optics as does psychoanalysis to unconscious impulses.

XIV

One of the foremost tasks of art has always been the creation of a demand which could be fully satisfied only later.[20] The history of every art form shows

18. Renaissance painting offers a revealing analogy to this situation. The incomparable development of this art and its significance rested not least on the integration of a number of new sciences, or at least of new scientific data. Renaissance painting made use of anatomy and perspective, of mathematics, meteorology, and chromatology. Valéry writes: "What could be further from us than the strange claim of a Leonardo to whom painting was a supreme goal and the ultimate demonstration of knowledge? Leonardo was convinced that painting demanded universal knowledge, and he did not even shrink from a theoretical analysis which to us is stunning because of its very depth and precision...."—Paul Valéry, *Pièces sur l'art*, "Autour de Corot," Paris, p. 191.

19. Rudolf Arnheim, *loc. cit.*, p. 138.

20. "The work of art," says André Breton, "is valuable only in so far as it is vibrated by the reflexes of the future." Indeed, every developed art form intersects three lines of development. Technology works toward a certain form of art. Before the advent of the film there were photo booklets with pictures which flitted by the onlooker upon pressure of the thumb, thus portraying a boxing bout or a tennis match. Then there were the slot machines in bazaars; their picture sequences were produced by the turning of a crank.

Secondly, the traditional art forms in certain phases of their development strenuously work toward effects which later are effortlessly attained by the new ones. Before the rise of the movie the Dadaist's performances tried to create an audience reaction which Chaplin later evoked in a more natural way.

Thirdly, unspectacular social changes often promote a change in receptivity which will benefit the new art form. Before the movie had begun to create its public, pictures that were no longer immobile captivated an assembled audience in the so-called *Kaiserpanorama*. Here the public assembled before a screen into which stereoscopes were mounted, one to each beholder. By a mechanical process individual pictures appeared briefly before the stereoscopes, then made way for others. Edison still had to use similar devices in presenting the first movie strip before the film screen and projection were known. This strip was presented to a small public which stared into the apparatus in which the succession of pictures was reeling off. Incidentally, the institution of the *Kaiserpanorama* shows very clearly a dialectic of the development. Shortly before the movie turned the reception of pictures into a collective one, the individual viewing of pictures in these swiftly outmoded establishments came into play once more with an intensity comparable to that of the ancient priest beholding the statue of a divinity in the cella.

critical epochs in which a certain art form aspires to effects which could be fully obtained only with a changed technical standard, that is to say, in a new art form. The extravagances and crudities of art which thus appear, particularly in the so-called decadent epochs, actually arise from the nucleus of its riches historical energies. In recent years, such barbarisms were abundant in Dadaism. It is only now that its impulse becomes discernible: Dadaism attempted to create by pictorial—and literary—means the effects which the public today seeks in the film.

Every fundamentally new, pioneering creation of demands will carry beyond its goal. Dadaism did so to the extent that it sacrificed the market values which are so characteristic of the film in favor of higher ambitions—though of course it was not conscious of such intentions as here described. The Dadaists attached much less importance to the sales value of their work than to its uselessness for contemplative immersion. The studied degradation of their material was not the least of their means to achieve this uselessness. Their poems are "word salad" containing obscenities and every imaginable waste product of language. The same is true of their paintings, on which they mounted buttons and tickets. What they intended and achieved was a relentless destruction of the aura of their creations, which they branded as reproductions with the very means of production. Before a painting of Arp's or a poem by August Stramm it is impossible to take time for contemplation and evaluation as one would before a canvas of Derain's or a poem by Rilke. In the decline of middle-class society, contemplation became a school for asocial behavior; it was countered by distraction as a variant of social conduct.[21] Dadaistic activities actually assured a rather vehement distraction by making works of art the center of scandal. One requirement was foremost: to outrage the public.

From an alluring appearance or persuasive structure of sound the work of art of the Dadaists became an instrument of ballistics. It hit the spectator like a bullet, it happened to him, thus acquiring a tactile quality. It promoted a demand for the film, the distracting element of which is also primarily tactile, being based on changes of place and focus which periodically assail the spectator. Let us compare the screen on which a film unfolds with the canvas of a painting. The painting invites the spectator to contemplation; before it the spectator can abandon himself to his associations. Before the movie frame he cannot do so. No sooner has his eye grasped a scene than it is already changed. It cannot be arrested. Duhamel, who detests the film and knows nothing of its significance, though something of its structure, notes this circumstance as follows: "I can no longer think what I want to think. My thoughts have been replaced by moving images."[22] The spectator's process of association in view of these images is indeed interrupted by their constant, sudden change. This constitutes the shock effect of the film, which, like all shocks, should be cushioned by heightened presence of mind.[23] By means of its technical structure, the film has taken the physical shock effect out of the wrappers in which Dadaism had, as it were, kept it inside the moral shock effect.[24]

. . .

Epilogue

The growing proletarianization of modern man and the increasing formation of masses are two aspects of the same process. Fascism attempts to organize the newly created proletarian masses without affecting

21. The theological archetype of this contemplation is the awareness of being alone with one's God. Such awareness, in the heyday of the bourgeoisie, went to strengthen the freedom to shake off clerical tutelage. During the decline of the bourgeoisie this awareness had to take into account the hidden tendency to withdraw from public affairs those forces which the individual draws upon in his communion with God.

22. Georges Duhamel, *Scènes de la vie future*, Paris, 1930, p. 52.

23. The film is the art form that is in keeping with the increased threat to his life which modern man has to face. Man's need to expose himself to shock effects is his adjustment to the dangers threatening him. The film corresponds to profound changes in the apperceptive apparatus—changes that are experienced on an individual scale by the man in the street in big-city traffic, on a historical scale by every present-day citizen.

24. As for Dadaism, insights important for Cubism and Futurism are to be gained from the movie. Both appear as deficient attempts of art to accommodate the pervasion of reality by the apparatus. In contrast to the film, these schools did not try to use the apparatus as such for the artistic presentation of reality, but aimed at some sort of alloy in the joint presentation of reality and apparatus. In Cubism, the premonition that this apparatus will be structurally based on optics plays a dominant part; in Futurism, it is the premonition of the effects of this apparatus which are brought out by the rapid sequence of the film strip.

the property structure which the masses strive to eliminate. Fascism sees its salvation in giving these masses not their right, but instead a chance to express themselves.[25] The masses have a right to change property relations; Fascism seeks to give them an expression while preserving property. The logical result of Fascism is the introduction of aesthetics into political life. The violation of the masses, whom Fascism, with its *Führer* cult, forces to their knees, has its counterpart in the violation of an apparatus which is pressed into the production of ritual values.

All efforts to render politics aesthetic culminate in one thing: war. War and war only can set a goal for mass movements on the largest scale while respecting the traditional property system. This is the political formula for the situation. The technological formula may be stated as follows: Only war makes it possible to mobilize all of today's technical resources while maintaining the property system. It goes without saying that the Fascist apotheosis of war does not employ such arguments. Still, Marinetti says in his manifesto on the Ethiopian colonial war: "For twenty-seven years we Futurists have rebelled against the branding of war as antiaesthetic.... Accordingly we state: ...War is beautiful because it establishes man's dominion over the subjugated machinery by means of gas masks, terrifying megaphones, flame throwers, and small tanks. War is beautiful because it initiates the dreamt-of metalization of the human body. War is beautiful because it enriches a flowering meadow with the fiery orchids of machine guns. War is beautiful because it combines the gunfire,

the cannonades, the cease-fire, the scents, and the stench of putrefaction into a symphony. War is beautiful because it creates new architecture, like that of the big tanks, the geometrical formation flights, the smoke spirals from burning villages, and many others.... Poets and artists of Futurism!...remember these principles of an aesthetics of war so that your struggle for a new literature and a new graphic art...may be illumined by them!"

This manifesto has the virtue of clarity. Its formulations deserve to be accepted by dialecticians. To the latter, the aesthetics of today's war appears as follows: If the natural utilization of productive forces is impeded by the property system, the increase in technical devices, in speed, and in the sources of energy will press for an unnatural utilization, and this is found in war. The destructiveness of war furnishes proof that society has not been mature enough to incorporate technology as its organ, that technology has not been sufficiently developed to cope with the elemental forces of society. The horrible features of imperialistic warfare are attributable to the discrepancy between the tremendous means of production and their inadequate utilization in the process of production—in other words, to unemployment and the lack of markets. Imperialistic war is a rebellion of technology which collects, in the form of "human material," the claims to which society has denied its natural material. Instead of draining rivers, society directs a human stream into a bed of trenches; instead of dropping seeds from airplanes, it drops incendiary bombs over cities; and through gas warfare the aura is abolished in a new way.

"*Fiat ars—pereat mundus*," says Fascism, and, as Marinetti admits, expects war to supply the artistic gratification of a sense perception that has been changed by technology. This is evidently the consummation of "*l'art pour l'art*." Mankind, which in Homer's time was an object of contemplation for the Olympian gods, now is one for itself. Its self-alienation has reached such a degree that it can experience its own destruction as an aesthetic pleasure of the first order. This is the situation of politics which Fascism is rendering aesthetic. Communism responds by politicizing art.

25. One technical feature is significant here, especially with regard to newsreels, the propagandist importance of which can hardly be overestimated. Mass reproduction is aided especially by the reproduction of masses. In big parades and monster rallies, in sports events, and in war, all of which nowadays are captured by camera and sound recording, the masses are brought face to face with themselves. This process, whose significance need not be stressed, is intimately connected with the development of the techniques of reproduction and photography. Mass movements are usually discerned more clearly by a camera than by the naked eye. A bird's-eye view best captures gatherings of hundreds of thousands. And even though such a view may be as accessible to the human eye as it is to the camera, the image received by the eye cannot be enlarged the way a negative is enlarged. This means that mass movements, including war, constitute a form of human behavior which particularly favors mechanical equipment.

Peter Bürger

Theory of the Avant-Garde and Critical Literary Science

Translated by Michael Shaw

History is inherent in esthetic theory. Its categories are radically historical (Adorno).[1]

1. The Historicity of Aesthetic Categories

Aesthetic theories may strenuously strive for metahistorical knowledge, but that they bear the clear stamp of the period of their origin can usually be seen afterward, and with relative ease. But if aesthetic theories are historical, a critical theory of art that attempts to elucidate what it does must grasp that it is itself historical. Differently expressed, it must historicized aesthetic theory.

It will first have to be made clear what historicizing a theory may mean. It cannot mean the application to present-day aesthetic theorizing of the historicist perspective, which understands all the phenomena of a period wholly as expressions of that period and then creates an ideal contemporaneity among the individual periods (Ranke's "equally close to God"). The false objectivism of the historicist approach has been justly criticized. To propose bringing it back to life in a discussion of theories would be absurd.[2] But neither can historicizing mean that one views all previous theories as nothing more than steps leading up to one's own. In such an undertaking, fragments of earlier theories are detached from their original context and fitted into a new one but the change in function and meaning which that fragment undergoes is not adequately reflected. In spite of its progressiveness, the construction of history as the prehistory of the present, a construction that upward-moving classes characteristically engage in, is one-sided in the Hegelian sense, for it grasps only one aspect of the historical process, whose other aspect historicism lays hold of in a false objectivism. In the present context, historicizing a theory will have a different meaning, that is, the insight into the nexus between the unfolding of an object and the categories of a discipline or science. Understood in this fashion, the historicity of a theory is not grounded in its being the expression of a *Zeitgeist* (the historicist view) nor in the circumstance that it incorporates earlier theories (history as prehistory of the present) but in the fact that the unfolding of object and the elaboration of categories are connected. Historicizing a theory means grasping this connection.

It might be objected that such an enterprise cannot but lay claim to a position outside history, so that historicizing simultaneously and necessarily becomes a dehistoricizing or, differently expressed, that the determination of the historicity of the language of a science presupposes a meta level from which this determination can be made, and that this meta level is necessarily metahistorical (which would then require the historicizing of this meta level, etc.). Not in the sense of a separation of various levels of

1. Th. W. Adorno, *Äesthetische Theorie*, ed. Gretel Adorno and R. Tiedemann (Frankfurt: Suhrkamo, 1970), p. 532.

2. On the critique of historicism, see H.-G. Gadamer: "The naivité of so-called historicism consists in the fact that it does not undertake this reflection and in trusting to its own methodological approach forgets its own historically." *Truth and Method*, p. 266-67. See also the analysis of Ranke by H. R. Jauss, "Geschichte der Kunst und Histoire," in Jauss, *Literaturgeschichte als Provokation* (Frankfurt: Suhrkamp, 1970), p. 222-26. (A translation of this essay appears as chapt. 2 in H. R. Jauss, *Toward an Aesthetic of Reception*, trans. T. Bahti, intro. Paul de Man [Minneapolis: Univ. of Minnesota Press, 1982].)

the language of science did we introduce the concept of historicization here, but in that of reflection, which grasps in the medium of *one* language the historicity of its own speech. What is meant here can best be explained by some fundamental methodological insights that Marx formulated in the introduction to the *Grundrisse der Kritik der politischen Ökonomie*: "The example of labor," Marx writes, "shows strikingly how even the most abstract categories, despite their validity—precisely because of their abstractness—for all epochs, are nevertheless, in the specific character of this abstraction, themselves likewise a product of historic relations, and possess their full validity only for and within these relations."[3] The idea is difficult to grasp because Marx maintains on the one hand that certain simple categories are always valid, yet also states that their generality is due to specific historical conditions. The decisive distinction here is between "validity for all epochs" and the *perception* of this general validity (in Marx's terms, "the specific character of this abstraction"). It is Marx's contention that conditions must have unfolded historically for that perception to become possible. In the monetary system, he says, wealth is still interpreted to be money, which means that the connection between labor and wealth is not seen. Only in the theory of the physiocrats is labor discovered to be the source of wealth, though it is not labor in general but only a particular form of it, namely, agriculture. In classical English economics, in Adam Smith, it is no longer a particular kind of labor but labor in general that is recognized as the source of wealth. For Marx, this development is not merely one in economic theory. Rather, he feels that the possibility of a progress in knowledge is a function of the development of the object toward which insight directs itself. When the physiocrats developed their theory (in France, during the second half of the eighteenth century), agriculture was still the economically dominant sector on which all others depended. Only in the economically much more advanced England, where the industrial revolution had already set in and where the dominance of agriculture over all other sectors of social production would therefore be eventually

eliminated, was Smith's insight possible—that it was not a specific form of labor but labor as such that created wealth. "The indifference toward a specific form of labor presupposes a highly developed totality of actual forms of labor none of which is any longer the dominant one" (*Grundrisse*, p. 25)

It is my thesis that the connection between the insight into the general validity of a category and the actual historical development of the field to which this category pertains and which Marx demonstrated through the example of the category of labor also applies to objectifications in the arts. Here also, the full unfolding of the constituent elements of a field is the condition for the possibility of an adequate cognition of that field. In bourgeois society, it is only with aestheticism that the full unfolding of the phenomenon of art became a fact, and it is to aestheticism that the historical avant-garde movements respond.[4]

3. K. Marx, *Grundrisse*, trans. Martin Nicolaus (New York: Random House 1973), p. 105.

4. The concept of the historical avant-garde movements used here applies primarily to Dadaism and early Surrealism but also and equally to the Russian avant-garde after the October revolution. Partly significant differences between them notwithstanding, a common feature of all these movements is that they do not reject individual artistic techniques and procedures of earlier art but reject that art in its entirety, thus bringing about a radical break with tradition. In their most extreme manifestations, their primary target is art as an institution such as it has developed in bourgeois society. With certain limitations that would have to be determined through concrete analysis, this is also true of Italian Futurism and German Expressionism.

Although cubism does not pursue the same intent, it calls into question the system of representation with its linear perspective that had prevailed since the Renaissance. For this reason, it is part of the historic avant-garde movements, although it does not share their basic tendency (sublation of art in the praxis of life).

The concept 'historic avant-garde movements' distinguishes these from all those neo-avant-gardiste attempts that are characteristic for Western Europe and the United States during the fifties and sixties. Although the neo-avant-gardes proclaim the same goals as the representatives of the historic avant-garde movements to some extent, the demand that art be reintegrated in the praxis of life within the existing society can no longer be seriously made after the failure of avant-gardiste intentions. If an artist sends a stove pipe to an exhibit today, he will never attain the intensity of protest of Duchamp's Ready-Mades. On the contrary, whereas Duchamp's *Urinoir* is meant to destroy art as an institution (including its specific organizational forms such as museums and exhibits), the finder of the stove pipe asks that his "work" be accepted by the museum. But this means that the avant-gardiste protest has turned into its opposite.

The central category of "artistic means" or "procedures" can serve to illuminate this thesis. Through it, the artistic process of creation can be reconstructed as a process of rational choice between various techniques, the choice being made with reference to the effect that is to be attained. Such a reconstruction of artistic production not only presupposes a relatively high degree of rationality in artistic production; it also presupposes that means are freely available, i.e., no longer part of a system of stylistic norms where, albeit in mediated form, social norms express themselves. That Molière's comedy uses artistic means just as Beckett does goes without saying. But that they were not recognized as such during Molière's time can be demonstrated by a glance at Boileau's criticism. Aesthetic criticism here is still criticism of the stylistic means of the crudely comic that the ruling social class found unacceptable. In the feudal, absolutist society of seventeenth century France, art is still largely integrated into the life-style of the ruling class. Although the bourgeois aesthetics that developed in the eighteenth century freed itself of the stylistic norms that had linked the art of feudal absolutism and the ruling class of that society, art nonetheless continued to obey the "imitatio naturae" principle. The stylistic means therefore do not yet have the generality of means whose single purpose is their effect on the recipient but are subordinated to a (historically changing) stylistic principle. Artistic means is undoubtedly the most general category by which works of art can be described. But that the various techniques and procedures can be *recognized* as artistic means has been possible only since the historical avant-garde movements. For it is in the historical avant-garde movements that the totality or artistic means becomes available as means. Up to this period in the development of art, the use of artistic means had been limited by the period style, an already existing canon of permissible procedures, an infringement of which was acceptable only within certain bounds. But during the dominance of a style, the category 'artistic means' as a general one cannot be seen for what it is because, *realiter*, it occurs only as a particular one. It is, on the other hand, a distinguishing feature of the historical avant-garde

movements that they did not develop a style. There is no such thing as a dadaist or a surrealist style. What did happen is that these movements liquidated the possibility of a period style when they raised to a principle the availability of the artistic means of past periods. Nor until there is universal availability does the category of artistic means become a general one.

If the Russian formalists view 'defamiliarization' as *the* artistic technique,[5] recognition that this category is a general one is made possible by the circumstance that in the historical avant-garde movements, shocking the recipient becomes the dominant principle of artistic intent. Because defamiliarization thereby does in fact become the dominant artistic technique, it can be discovered as a general category. This is not to say that the Russian formalists demonstrated defamiliarization principally in avant-gardiste art (on the contrary, Shklovsky's preferred demonstration objects are *Don Quixote* and *Tristram Shandy*). What is claimed is no more than a connection—though a necessary one—between the principle of shock in avant-gardiste art and the recognition that defamiliarization is a category of general validity. This nexus can be posited as necessary because it is only the full unfolding of the thing (here, the radicalization of defamiliarization in shock) that makes recognizable the general validity of the category. This is not to say that the act of cognition is transferred to reality itself, that the subject that produces the insight is negated. What is acknowledged is simply that the possibilities of cognition are limited by the real (historical) unfolding of the object.[6]

5. See, among others, Victor Shklovsky, "Art as Technique" (1916), in *Russian Formalistic Criticism. Four Essays*, trans. Lee T. Lemon and Marion J. Reis (Lincoln: Univ. of Nebraska Press, 1965).

6. Reference to and comments on the historical connection between Formalism and avant-garde (more precisely, Russian Futurism) in V. Ehrlich, *Russian Formalism* (Gravenhage, Mouton, 1955). On Shklovsky, see Renate Lachmann, "Die 'Verfremdung' und das 'neue Sehen' bei Viktor Sklovskij," in *Poetica 3* (1970), pp. 226-49. But K. Chvatik's interesting remark that there exists "an inner reason for the close connection between structuralism and avant-garde, a *methodolgical* and *theoretical* reason" (*Strukturalismus und Avantgarde* [München: Hanser, 1970], p. 21) is not developed in the book. Krystyna Pomorska, *Russian Formalist Theory and its Poetic Ambiance* (The Hague/Paris: Mouton Slavistic Printings and Reprintings, 82, 1968) contents herself with a listing of elements Futurism and Formalism have in common.

It is my thesis that certain general categories of the work of art were first made recognizable in their generality by the avant-garde, that it is consequently from the standpoint of the avant-garde that the preceding phases in the development of art as a phenomenon in bourgeois society can be understood, and that it is an error to proceed inversely, by approaching the avant-garde via the earlier phases of art. This thesis does not mean that it is only in avant-gardiste art that *all* categories of the work of art reach their full elaboration. On the contrary, we will note that certain categories essential to the description of pre-avant-gardiste art (such as organicity, subordination of the parts to the whole) are in fact negated in the avant-gardiste work. One should not assume, therefore, that all categories (and what they comprehend) pass through an even development. Such an evolutionist view would eradicate what is contradictory in historical processes and replace it with the idea that development is linear progress. In contrast to such a view, it is essential to insist that the historical development of society as a whole as well as that within subsystems can only be grasped as the result of the frequently contrariant evolutions that categories undergo.[7]

The above thesis needs refining in one further respect. Only the avant-garde, it was said, made artistic means recognizable in their generality because it no longer chooses means according to a stylistic principle, but avails itself of them as *means*. It was not ex nihilo, of course, that avant-garde practice created the possibility of recognizing categories of the work of art in their general validity. Rather, that possibility has its historical presupposition in the development of art in bourgeois society. Since the middle of the nineteenth century, that is, subsequent to the consolidation of political rule by the bourgeoisie, this development has taken a particular turn: the form-content dialectic of artistic structures has increasingly shifted in favor of form. The content of the work of art, its "statement," recedes ever more as compared with its formal aspect, which defines itself as the aesthetic in the narrower sense. From the point of view of production aesthetics, this dominance of form in art since about the middle of the nineteenth century can be understood as command over means; from the point of view of reception aesthetics, as a tendency toward the sensitizing of the recipient. It is important to see the unity of the process: means become available as the category "content" withers.[8]

From this perspective, one of the central theses of Adorno's aesthetics, "the key to any and every content (*Gehalt*) of art lies in its technique" becomes clear.[9] Only because during the last one hundred years, the relation between the formal (technical) elements of the work and its content (those elements which make statements) changed and form became in fact predominant can this thesis be formulated at all. Once again, the connection between the historical unfolding of a subject and of the categories that grasp that subject area becomes apparent. Yet Adorno's formulation has a problematical aspect and that is its claim to universal validity. If it is true that Adorno's theorem could be formulated only because art since Baudelaire took the course it did, the claim that the theorem applies also to earlier periods of art becomes questionable. In the methodological reflection quoted earlier, Marx addresses this question. He states specifically that even the most abstract categories have "full validity" only for and within those conditions whose products they are. Unless one wants to see a covert historicism in this formulation, there arises the problem of whether it is possible to have a knowledge of the past that does not fall victim to the historicist illusion of a presuppositionless understanding of the past nor simply grasp that past in categories that are the product of a later period.

7. On this, see the important comments by Althusser in Louis Althusser and Etienne Balibar, *Reading Capital,* trans. Ben Brewster (New York: Pantheon Books, 1970), which have hardly been discussed as yet in the German Federal Republic. On the problem of the nonsynchrony of individual categories, see chapter 2, section 3, below.

8. See also H. Plessner, "Über die gesellschaftlichen Bedingungen der modernen Malerei," in Plessner, *Diesseits der Utopie. Ausgewählte Beiträge zur Kultursoziologie* (Frankfurt: Suhrkamp, 1974), pp. 107, 118.

9. Th. W. Adorno, *Versuch über Wagner* (München/Zürich: Knaur, 1964), p. 135.

2. The Avant-garde as the Self-Criticism of Art in Bourgeois Society

In the introduction to the *Grundrisse*, Marx formulates another idea of considerable methodological scope. It also concerns the possibility of understanding past social formulations or past social subsystems. The historicist position that assumes it can understand past social formations without reference to the present of the researcher is not even considered by Marx, who has no doubt about the nexus between the development of the thing and that of the categories (and thus the historicity of cognition). What he criticizes is not the historicist illusion of the possibility of historical knowledge without a historical reference point, but the progressive construction of history as the prehistory of the present. "The so-called historical presentation of development is founded, as a rule, on the fact that the latest form regards the previous ones as steps leading up to itself, and, since it is only rarely and only under quite specific conditions able to criticize itself—leaving aside, of course, the historical periods which appear to themselves as times of decadence—it always conceives them one-sidedly" (*Grundrisse*, p. 106). The concept of "one-sided" is used here in a strictly theoretical sense. It means that a contradictory whole is not being understood dialectically (in its contradictions) but that only one side of the contradiction is being fastened on. The past is certainly to be constructed as the prehistory of the present, but this construction grasps only one side of the contradictory process of historical development. To take hold of the process in its entirety, it is necessary to go beyond the present that first makes knowledge possible. Marx takes this step not by introducing the dimension of the future but by introducing the concept of the self-criticism of the present. "The Christian religion was able to be of assistance in reaching an objective understanding of earlier mythologies only when its own self-criticism had been accomplished to a certain degree.... Likewise, bourgeois economics arrived at an understanding of feudal, ancient, oriental economics only after the self-criticism of bourgeois society had begun" (*Grundrisse*, p. 106). Marx speaks of "objective understanding"

here but he certainly does not fall victim to the objectivist self-deception of historicism, for he never doubts that historical knowledge relates to the present. His sole concern is to overcome dialectically the necessary "one-sidedness" of the construction of the past as prehistory of the present, and to do so by using the concept of the self-criticism of the present.

If one wishes to use self-criticism as a historiographic category as one describes a certain stage of development of a social formation or of a social subsystem, its meaning will first have to be precisely defined. Marx makes a distinction between self-criticism and another type, such as the "critique Christianity leveled against paganism, or also that of Protestantism against Catholicism" (*Grundrisse*, p. 106). We will refer to this type as system-immanent criticism. Its characteristic is that it functions within a social institution. To stick to Marx's example: system-immanent criticism within the institution of religion is criticism of specific religious ideas in the name of other ideas. In contrast to this form, self-criticism presupposes distance from mutually hostile religious ideas. This distance, however, is merely the result of a fundamentally more radical criticism, and that is the criticism of religion as an institution.

The difference between system-immanent criticism and self-criticism can be transferred to the sphere of art. Examples of system-immanent criticism would be the criticism the theoreticians of French classicism directed against Baroque drama, or Lessing's of the German imitations of classical French tragedy. Criticism here functions within an institution, the theater. Varying concepts of tragedy that are grounded (if by multiple mediations) in social positions confront each other. There is another kind of criticism and that is the self-criticism of art: it addresses itself to art as an institution and must be distinguished from the former type. The methodological significance of the category 'self-criticism' is that for social subsystems also, it indicates the condition of the possibility of 'objective understanding' of past stages of development. Applied to art, this means that only when art enters the stage of self-criticism does the 'objective understanding' of past periods of the development of art become

possible. 'Objective understanding' here does not mean an understanding that is independent of the place in the present of the cognizing individual; it merely means insight into the overall process insofar as this process has come to a conclusion in the present of the cognizing individual, however provisional that conclusion may be.

My second thesis is this: with the historical avant-garde movements, the social subsystem that is art enters the stage of self-criticism. Dadaism, the most radical movement within the European avant-garde, no longer criticizes schools that preceded it, but criticizes art as an institution, and the course of its development took in bourgeois society. The concept 'art as an institution' as used here refers to the productive and distributive apparatus and also to the ideas about art that prevail at a given time and that determine the reception of works. The avant-garde turns against both—the distribution apparatus on which the work of art depends, and the status of art in bourgeois society as defined by the concept of autonomy. Only after art, in nineteenth-century Aestheticism, has altogether detached itself from the praxis of life can the aesthetic develop "purely." But the other side of autonomy, art's lack of social impact, also becomes recognizable. The avant-gardiste protest, whose aim it is to reintegrate art into the praxis of life, reveals the nexus between autonomy and the absence of any consequences. The self-criticism of the social subsystem, art, which now sets in, makes possible the 'objective understanding' of past phases of development. Whereas during the period of realism, for example, the development of art was felt to lie in a growing closeness of representation to reality, the one-sidedness of this construction could now be recognized. Realism no longer appears as *the* principle of artistic creation but becomes understandable as the sum of certain period procedures. The totality of the developmental process of art becomes clear only in the stage of self-criticism. Only after art has in fact wholly detached itself from everything that is the praxis of life can two things be seen to make up the principle of development of art in bourgeois society: the progressive detachment of art from real life contexts, and the correlative crystallization of a distinctive sphere of experience, i.e., the aesthetic.

The Marx text gives no direct answer to the question concerning the historical conditions of the possibility of self-criticism. From Marx's text, one can only abstract the general observation that self-criticism presupposes that the social formation or social subsystem to which that criticism directs itself have fully evolved its own, unique characteristics. If this general theorem is transferred to the sphere of history, the result is as follows: for the self-criticism of bourgeois society, the proletariat must first have come into existence. For the coming into being of the proletariat makes it possible to recognize liberalism as an ideology. The precondition for the self-criticism of the social subsystem 'religion' is the loss of the legitimating function of religious world pictures. These lose their social function as feudalism ends, bourgeois society comes into being, and the world pictures that legitimate dominion (and the religious world pictures belong into this category) are replaced by the basic ideology of the fair exchange. "Because the *social power* of the capitalist is institutionalized as an exchange relation in the form of the private labor contract and the siphoning off of privately available surplus value has replaced *political dependency*, the market assumes, together with its cybernetic function, an ideological function. The class relationship can assume the anonymous, unpolitical form of wage dependency."[10] Since the central ideology of bourgeois society is one of the base, dominion-legitimating world pictures lose their function. Religion becomes a private affair and, at the same time, the critique of religion as an institution becomes possible.

We now go on to ask what may be the historical conditions for the possibility of the self-criticism of the social subsystem that is art? As one attempts to answer this question, it is most important to guard against a hasty construction of relationships (of the sort, crisis of art, crisis of bourgeois society[11]). If

10. J. Habermas, *Legitimation Crisis* (Boston: Beacon Press, 1975), pp. 25-26.

11. F. Tomberg's "Negation affirmativ. Zur ideologischen Funktion der modernen Kunst im Unterricht," in Tomberg, *Politische Ästhetik. Vorträge und Aufsätze* (Darmstadt/Neuwied: Luchterhand, 1973) may be considered a hasty attempt to create a tie-in between the development of art and that of society, for it is not backed by analyses of the subject. Tomberg constructs a connection between the "worldwide

one takes seriously the idea of the relative autonomy of social subsystems vis-à-vis the development of society as a whole, one cannot assert that crises that affect society as a whole will necessarily also manifest themselves as crises within subsystems, or vice versa. To grasp the conditions for the possibility of the self-criticism of the subsystem 'art,' it is necessary to construct the history of the subsystem. But this cannot be done by making the history of bourgeois society the basis from which the history of art is to be developed. If one proceeded in this fashion, one would do no more than relate the artistic objectifications to the stages of development of bourgeois society, presupposing these latter to be already known. Knowledge cannot be produced in this fashion, since what is being looked for (the history of art and its social effect) is assumed to be known already. The history of society as a whole would then appear to be the meaning of the subsystems, as it were. In contrast to this idea, the nonsynchronism in the development of individual subsystems must be insisted on; which means that the history of bourgeois society can be written only as the synthesis of the nonsynchronisms in the development of the various subsystems. The difficulties that beset such an undertaking are manifest. They are alluded to simply to make clear why the subsystem 'art' is seen here as having a history of its own.

If the history of the subsystem 'art' is to be constructed, I feel it is necessary to distinguish between art as an institution (which functions according to the principle of autonomy) and the content of individual works. For it is only this distinction that permits one to understand the history of art in bourgeois society as a history in whose course the divergence between institution and content is eliminated. In bourgeois society (and already before the bourgeoisie also seized political power in the French Revolution), art occupies a special status that is most succinctly referred to as autonomy. "Autonomous art only establishes itself as bourgeois society develops, the economic and political systems become detached from the cultural one, and the traditionalist world pictures which have been undermined by the basis ideology of fair exchange release the arts from their ritual use."[12] Autonomy here defines the functional mode of the social subsystem 'art': its (relative) independence in the face of demands that it be socially useful.[13] But it must be remembered that the detachment of art from the praxis of life and the accompanying crystallization of a special sphere of experience (i.e., the aesthetic) is not a straight-line development (there are significant counter-trends), and that it cannot be interpreted undialectically (as the coming into its own of art, for example). Rather, the autonomy status of art within bourgeois society is by no means undisputed but is the precarious product of overall social development. That status can always be called into question by society (more precisely, society's rulers) when it seems useful to harness art once more. Not only the extreme example of the fascist politics of art that liquidates the autonomy status, but the large number of legal proceedings against artists for offenses against morality, testify to that fact.[14] A distinction is to be made here between such attacks on the autonomy status by social authorities, and the force that emanates from the substance of individual works as it manifests itself

rebellion against the intellectually limited bourgeois master" whose "most characteristic symptom" is the resistance of the Vietnamese people against "northamerican imperialism," and the end of "modern art." "This means the end of the period of so-called modern art as an art of creative subjectivity and the total negation of social reality. Where it continues to go on, it must turn into farce. Art can be credible today only if it engages itself in the present revolutionary process—even though this may temporarily be at the price of a loss of form" (ibid., p. 59 f.). The end of modern art here is merely a moral postulate; it is not derived from its development. If, in the same essay, an ideological function is ascribed to commerce with modern art (since it comes out of the experience of "the unchangeability of the social structure," commerce with it promotes this illusion [ibid., p. 58]), this contradicts the claim that we have come to the end of the "period of modern art so-called." In another essay in the same volume, the thesis of the loss of function of art is affirmed, and we read this conclusion: "The beautiful world which must now be created is not the reflected world but society as it really is," (Über den gesellschaftlichen Gehalt ästhetischer Kategorien," ibid., p. 89).

12. J. Habermas, "Bewusstmachende oder rettende Kritik—die Aktualität Walter Benjamins," in S. Unseld, ed., *Zur Aktualität Walter Benjamins* (Frankfurt: Suhrkamp, 1972), p. 190.

13. Habermas defines autonomy as "independence of works of art vis-à-vis demands for their use outside art" (p. 190). I prefer to speak of social demands for this avoids having the definition enter the definition.

14. On this, see K. Heitmann, *Der Immoralismuse-Prozess gegen die französische Literatur im 19. Jahrhundert* (Bad Homburg: Anthenäum, 1970).

in the form-content totality and that aims at eradicating the distance between work and the praxis of life. Art in bourgeois society lives off the tension between the institutional framework (releasing art from the demand that it fulfill a social function) and the possible political content (*Gehalt*) of individual works. This tension, however, is not stable but subject to a historical dynamic that tends toward its abolition, as we will see.

Habermas has attempted to define these contents as they characterize all art in bourgeois society: "Art is a sanctuary for the—perhaps merely cerebral—satisfaction of those needs which become quasi illegal in the material life process of bourgeois society" (*"Bewusstmachende oder rettende Kritik*," p. 192). Among these needs, he counts the "mimetic commerce with nature," "solidary living with others," and the "happiness of a communicative experience which is not subject to the imperatives of means-ends rationality and allows as much scope to the imagination as to the spontaneity of behavior" (p. 192 f.). Such a perspective has its justification within the framework of a general definition of the function of art in bourgeois society that Habermas means to provide, but it would be problematic in our context because it does not permit us to grasp the historical development of the contents expressed in works. I believe it is necessary to distinguish between the institutional status of art in bourgeois society (apartness of the work of art from the praxis of life) and the contents realized in works of art (these may but need not be residual needs in Habermas's sense). This differentiation permits one to discover the period in which the self-criticism of art is possible. Only with the aid of this distinction can our question concerning the historical conditions for the possibility of the self-criticism of art be answered.

Someone may raise the following objection to the attempt to distinguish between the formal determinacy of art[15] (status of autonomy) and the determinacy of its content (*Gehalt*) of individual

works: the autonomy status itself must be understood as content; apartness from the purposive, rational organization of bourgeois society already implies the claim to a happiness society does not permit. There is undoubtedly some justice in such a view. Formal determinacy is not something external to content; independence vis-à-vis the direct demand that purposes be served also accrues to the work whose explicit content is conservative. But precisely this fact should prompt the scholar to distinguish between the status of autonomy that governs the functioning of the individual work on the one hand, and the import of individual works (or groups of works) on the other. Both Voltaire's *contes* and Mallarmé's poems are autonomous works of art. But in varying social contexts and for definable historical and social reasons, different uses are made of the scope that the status of autonomy confers on the work of art. As the example of Voltaire shows, the autonomy status certainly does not preclude the artist's adoption of a political position; what it does limit is the chance of effectiveness.

The proposed distinction between art as an institution (whose functional mode is autonomy) and the import of works makes it possible to sketch an answer to the question concerning the conditions for the possibility of the self-criticism of the social subsystem "art." As regards the difficult question concerning the historical crystallization of art as an institution, it suffices if we observe in this context that this process came to a conclusion at about the same time as the struggle of the bourgeoisie for its emancipation. The insights formulated in Kant's and Schiller's aesthetic writings presuppose the completed evolution of art as a sphere that is detached from the praxis of life. We can therefore take it as our point of departure that at the end of the eighteenth century at the latest, art as an institution is already fully developed in the sense specified above. Yet this does not mean that the self-criticism of art has also set in. The Hegelian idea of an end of the period of art was not adopted by the young Hegelians. Habermas explains this by the "special position which art occupies among the forms of the absolute spirit in the sense that unlike subjectified religion and scientific philosophy, it does not take

15. The concept "formal determinacy" (*Formbestimmtheit*) does not mean here that form is a component of the statement but the determination by the institutional frame within which works of art function. The concept is thus used in the same sense as when Marx speaks of the determination of goods by the commodity form.

on tasks in the economic and political system but satisfies residual need which cannot be met in bourgeois society" (*Bewusstmachende oder rettende Kritik.*" p. 193 f.). I believe that there are historical reasons why the self-criticism of art cannot occur *as yet*. It is true that the institution of autonomous art is fully developed, but within this institution, there still function contents (*Gehalte*) that are of a thoroughly political character and thus militate against the autonomy principle of the institution. The self-criticism of the social subsystem that is art can become possible only when the contents also lose their political character, and art wants to be nothing other than art. This stage is reached at the end of the nineteenth century, in Aestheticism.[16]

16. G. Mattenklott sketches a political critique of the primacy of the formal in Aestheticism: "form is the fetish which has been transplanted into the political sphere. The total indeterminacy of its contents leaves open the door to any and all ideological accretion" (*Bilderdienst. Ästhetische Opposition bei Beardsley und George* [München, 1970], p. 227). This critique contains the correct insight into the political problematic of Aestheticism. What it fails to see is that it is in Aestheticism that art in bourgeois society becomes conscious of itself. Adorno did see this: "But there is something liberating in the consciousness of self which bourgeois art finally attains of itself as bourgeois, the moment it takes itself seriously, as does the reality which it is not" ("Der Artist als Statthalter," in Adorno, *Noten zur Literatur I* [Bibliothek Suhrkamp 47], p. 188. On the problem of Aestheticism, also see H. C. Seeba, *Kritik des ästhetischen Menschen. Hermeneutik und Moral in Hofmannsthals 'Der Tor und der Tod.'* (Bad Homburg/Berlin/Zürich, 1970). For Seeba, the relevance of Aestheticism is to be found in the circumstance that "the actual 'aesthetic' principle of fictional patterns which are intended to facilitate the understanding of reality but make more difficult its direct, imageless experience leads to that loss of reality from which Claudio already suffers" (ibid., p. 180). The shortcoming of this ingenious critique of Aestheticism is that in opposing the "principle of fictional patterns" (which can surely function as an instrument of cognition of reality), it resorts to a "direct, imageless experience" that is itself rooted in Aestheticism. So that one element of Aestheticism is being criticized here by another! If one listens to authors such as Hofmannsthal, it will be impossible to understand the loss of reality as a result of an addiction to images. Rather, that loss will have to be seen as the socially conditioned cause of that addiction. In other words, Seeba's critique of Aestheticism remains largely rooted in what it proposes to criticize. Further, P. Bürger, "Zur ästhetisierended Wirklichkeitsdarstellung bei Proust, Valéry und Sartre," in P. Bürger, ed., *Vom Ästhetizismus zum Nouveau Roman. Versuche kritischer Literaturwissenschaft* (Frankfurt, 1974).

For reasons connected with the development of the bourgeoisie after its seizure of political power, the tension between the institutional frame and the content of individual works tends to disappear in the second half of the nineteenth century. The apartness from the praxis of life that had always constituted the institutional status of art in bourgeois society now becomes the content of works. Institutional frame and content coincide. The realistic novel of the nineteenth century still serves the self-understanding of the bourgeois. Fiction is the medium of a reflection about the relationship between individual and society. In Aestheticism, this thematics is overshadowed by the ever-increasing concentration the makers of art bring to the medium itself. The failure of Mallarmé's principal literary project, Valéry's almost total lack of productivity over two decades, and Hofmannsthal's Lord Chandos letter are symptoms of a crisis of art.[17] At the moment it has shed all that is alien to it, art necessarily becomes problematic for itself. As institution and content coincide, social ineffectuality stands revealed as the essence of art in bourgeois society, and thus provokes the self-criticism of art. It is to the credit of the historical avant-garde movements that they supplied this self-criticism.

3. Regarding the Discussion of Benjamin's Theory of Art

In his essay, "The work of art in the age of technical reproduction,"[18] Walter Benjamin uses the concept, *the loss of aura*, to describe the decisive changes art underwent in the first quarter of the twentieth century, and attempts to account for that loss by changes in techniques of reproduction. Since up to this point we have derived the conditions for the

17. On this, see W. Jens, *Statt einer Literaturgeschichte* (Pfullingen, 1962), the chapter "Der Mensch und die Dinge. Die Revolution der deutschen Prosa," pp. 109-33.

18. In W. Benjamin, "The work of art in the age of mechanical reproduction," in *Illuminations* (New York: Schocken Books, 1969), pp. 217-51. Adorno's letter to Benjamin, dated March 18, 1936 (reprinted in Th. W. Adorno, *Über Walter Benjamin*, ed. R. Tiedemann [Frankfurt: Suhrkamp, 1970], pp. 126-34 is especially important in the critique of Benjamin's theses. R. Tiedemann, *Studien zur Philosophie Walter Benjamins* (Frankfurt: 1965), p. 87 ff., argues from a position close to Adorno's.

possibility of the self-criticism of art from the historical unfolding of art (institution and content of works), we need to discuss the suitability of Benjamin's thesis, which explains these conditions as the direct result of changes in the sphere of productive forces.

Benjamin's point of departure is a certain type of relation between work and recipient, which he refers to as marked by the presence of an aura.[19] What Benjamin means by the concept of aura could probably most easily be rendered as unapproachability: the "unique phenomenon of a distance however close it may be" (*Illuminations*, p. 222). The aura has its origin in cultic ritual, but for Benjamin, the mode of reception marked by the presence of aura remains characteristic also of the no longer sacral art that has developed since the Renaissance. It is not the break between the sacral art of the Middle Ages and the secular art of the Renaissance that Benjamin judges decisive in the history of art; rather, it is that break that results from the loss of aura. Benjamin traces this break to the change in techniques of reproduction. According to him, reception characterized by the presence of aura requires categories such as uniqueness and authenticity. But these become irrelevant to an art (such as the film, for example) whose very design entails reproduction. It is Benjamin's decisive idea that a change in reproduction techniques brings with it a change in the forms of perception and that this will result in a change in the "character of art as a whole." The contemplative reception of the bourgeois individual is to be supplanted by what is the simultaneously distracted and rationally testing reception of the masses. Instead of being based on ritual, art will now be based on politics.

We will first consider Benjamin's construction of the development of art, then the materialistic explanatory scheme he proposed. The period of sacral art during which it is an integral part of ecclesiastical ritual, and the period of autonomous art that develops along with bourgeois society and that detaches itself from ritual, creating a specific type of perception (the aesthetic), are summarized by Benjamin in the concept of art with an aura. But the periodization of art he proposes is problematic for several reasons. For Benjamin, art with an aura and individual reception (absorption in the object) go hand in hand. But this characterization applies only to autonomous art, certainly not to the sacral art of the Middle Ages (the reception of the sculpture on medieval cathedrals and the mystery plays was collective). Benjamin's construction of history omits the emancipation of art from the sacral, which was the work of the bourgeoisie. One of the reasons for this omission may be that with the *l'art pour l'art* movement and aestheticism, something like a resacralization (or reritualization) of art did in fact occur. But there is no similarity between this reversion and the original sacral function of art. Art here is not an element in an ecclesiastical ritual within which a use value is conferred on it. Instead, art generates a ritual. Instead of taking its place within the sacral sphere, art supplants religion. The resacralization of art that occurred in aestheticism thus presupposes art's total emancipation from the sacral and must under no circumstances be equated with the sacral character of medieval art.

To judge Benjamin's materialist explanation of the change in modes of reception as a result of changes in reproduction techniques, it is important to realize that he sketches a second explanation, which may prove to have greater explanatory efficacy. The artist of the avant-garde, especially the dadaists, he writes, had already, before film was discovered, attempted to created filmlike effects by the means used in painting. "The Dadaists attached much less importance to the sales [exchange] value of their work than to its uselessness for contemplative immersion.... Their poems are a 'word salad' containing obscenities and every imaginable waste product of language. The same is true of their paintings, on which they mounted buttons and tickets. What they intended and achieved was a relentless destruction of the aura of their creation which they branded as reproductions with the very means of production" (*Illuminations*, pp. 237-38). Here, the loss of aura is not traced to a change in reproduction techniques but to an intent on the part of the makers of art.

19. See B. Linder, "'Natur-Geschichte'—Geschichtsphilosophie und Welterfahrung in Benjamins Schriften," in *Text + Kritik*, nos. 31/32 (October 1971), pp. 41-58.

The change in the "overall character of art" is no longer the result of technological innovation but mediated by the conscious acts of a generation of artists. To the dadaists, Benjamin ascribes only the role of precursors; they create a "demand" that only the new technical medium can satisfy. But there is a problem here: how is one to explain this pioneering? Differently expressed, the explanation of the change in the mode of reception by the change in reproduction techniques acquires a different place value. It can no longer lay claim to explaining a historical process, but at most to being a hypothesis for the possible *diffusion* of a mode of reception that the dadaists were the first to have intended. One cannot wholly resist the impression that Benjamin wanted to provide an ex post facto materialist foundation for a discovery he owed to his commerce with avant-gardiste art, the discovery of the loss of aura. But such an undertaking is problematic for the decisive break in the development of art, which Benjamin fully grasps in its historical significance would then be the result of technological change. A direct link is established here between emancipation or emancipatory expectation, and industrial technique.[20] But although emancipation is a process that can certainly provide a field of new possibilities for the satisfaction of human needs, it cannot be conceived of as independent of human consciousness. An emancipation that occurs naturally would be the opposite of emancipation.

At bottom, Benjamin is attempting to transfer, from society as a whole to the partial sphere that is art, the Marxist theorem according to which the development of the productive forces "shatters" the production relations.[21] The question arises whether this transfer does not ultimately remain mere analogy. In Marx, the concept 'productive forces' refers to the technological level of development of a given society and includes both the means of production as objectified in machines, and the workers' capacities to use these means. It is questionable whether a concept of artistic productive forces can be derived from this idea, because in artistic production, it would be difficult to subsume under one concept the capacities and abilities of the producer and the stage of development of the material productive and reproductive techniques. So far, artistic production has been a type of simple commodity production (even in late-capitalist society), where the material means of production have a relatively minor bearing on the quality of the product. They do, however, have significance as regards its distribution and effectiveness. That, since the invention of film, distribution techniques have affected production in turn cannot be doubted. The quasi-industrial techniques whose dominance in certain areas is a result of this fact have proved anything but "shattering," however.[22] What has occurred is the total subordination of work contents to profit motives, and a fading of the critical potencies of works in favor of a training in consumer attitudes (which extends to the most intimate interhuman relations).[23]

Brecht, in whose *Threepenny Lawsuit* we hear echoes of Benjamin's theorem concerning the destruction of art and its aura by new reproduction techniques, formulates more cautiously than Benjamin: "This apparatus *can be used* better than almost anything else to supersede the old kind of untechnical, anti-technical 'glowing' art, with its religious links."[24]

20. Here, we see Benjamin in the context of an enthusiasm for technique that was characteristic during the twenties of both liberal intellectuals (some references on this in H. Lethen, *Neue Sachlichkeit 1924-1932* [Stuttgart: Metzler, 1970], p. 58 ff.) and the revolutionary Russian avant-garde (an example is B. Arvatov, *Kunst und Produktion*, ed., trans. H. Günther and Karla Hielscher (München: Hanser, 1972).

21. This explains why Benjamin's theses were interpreted as a revolutionary theory of art by the extreme Left. See H. Lethen, "Walter Benjamins Thesen zu einer 'materialistischen Kunsttheorie,'" in Lethen, *Neue Sachlichkeit*, pp. 127-39.

22. Pulp literature is produced by teams of authors, as is well known. There is a division of labor and the work is put out according to criteria that are dictated by the tastes of groups of addressees.

23. This is also the point at which Adorno's critique of Benjamin sets in. See his essay "Über den Fetischcharakter in der Musik und die Regression des Hörens," in Adorno, *Dissonanzen. Muzik in der verwalteten Welt* (Göttingen: Vadenhoeck 29/29a, 1969), pp. 9-45, which is an answer to Benjamin's essay. See also Christa Bürger, *Textanalyse als Ideologiekritik. Zur Rezeption zeitgenössischer Unterhaltungsliteratur* (Frankfurt: Athenäum, 1973), chap. 1, 2.

24. B. Brecht, *The Threepenny Lawsuit* (1931), in John Willett, ed., trans., *Brecht on Theatre. The development of an aesthetic*, (New York: Hill and Wang, 1966), p. 48.

In contrast to Benjamin, who tends to ascribe emancipatory quality to the new technical means (film) as such, Brecht emphasizes that certain possibilities inhere in the technical means; but he suggests that the development of such possibilities depends on the way they are used.

If, for the reasons mentioned, it is a problematical undertaking to transfer the concept of productive forces from the sphere of overall social analysis to that of art, the same holds true of the concept of production relations, if only because in Marx, it unambiguously refers to the totality of social relations that govern work and the distribution of the products of work. But with art as an institution, we have previously introduced a concept that refers to the conditions under which art is produced, distributed, and received. In bourgeois society, the salient characteristic of this institution is that the products that function within it remain (relatively) free from any pressure that they serve social purposes. It is Benjamin's achievement to have defined, by the concept of aura, the type of relation between work and recipient that evolves in the institution of art in bourgeois society. Two essential insights come together here: first, that it is not in and of themselves that works of art have their effect but rather that this effect is decisively determined by the institution within which the works function; second, that modes of reception must be based in social history: the perception of aura, for example, in the bourgeois individual. What Benjamin discovers is form as a determinant in art (*Formbestimmtheit*, in the sense Marx uses the concept); here, we also have what is materialist in his approach. But the theorem according to which reproduction techniques destroy art that has an aura is a pseudomaterialist explanatory model.

A final comment regarding the matter of periodization in the development of art: Above, we criticized Benjamin's periodization because he blurs the break between medieval-sacral and modern, secular art. Given the break between art with and without aura as elaborated by Benjamin, one arrives at the methodologically important insight that periodization in the development of art must be looked for in the sphere of art as institution, not in the sphere of the transformation of the content of individual works. This implies that periodization in the history of art cannot simply follow the periodization in the history of social formations and their phases of development but that it must be the task of a science of culture (*Kulturwissenschaft*) to bring into view the large-scale changes in the development of its subject. Only in this way can cultural science make an authentic contribution to the investigation of the history of bourgeois society. But where that history is taken as an already known reference system and used as such in the historical investigation of partial social spheres, cultural science degenerates into a procedure of establishing correspondences. The cognitive value of such an enterprise must be rated as small.

To summarize: the historical conditions for the possibility of self-criticism of the social subsystem 'art' cannot be elucidated with the aid of Benjamin's theorem; instead, these conditions must be derived from the disappearance of that tension that is constitutive for art in bourgeois society, the tension between art as institution (autonomy status) and the contents of individual works. In this effort, it is important not to contrast art and society as two mutually exclusive spheres. For both the (relative) insulation of art from demands that it serve purposes, and the development of contents are social phenomena (determined by the development of society as a whole).

If we criticize Benjamin's thesis according to which the technical reproducibility of the work of art imposes a different mode of reception (one marked by the absence of aura), this does not mean that we deny the importance the development of techniques of reproduction has. But two points must be made: technical development must not be understood as an independent variable, for it is itself dependent on overall social development. Second, the decisive turn in the development of art in bourgeois society must not be traced monocausally to the development of technical reproduction techniques. With these two provisos, one may summarize the importance that technical development has for the evolution of the fine arts in these terms: because the advent of photography makes possible the

precise mechanical reproduction of reality, the mimetic function of the fine arts withers.[25] But the limits of this explanatory model become clear when one calls to mind that it cannot be transferred to literature. For in literature, there is no technical innovation that could have produced an effect comparable to that of photography in the fine arts. When Benjamin understands the rise of l'art pour l'art as a reaction to the advent of photography,[26] the explanatory model is surely being strained. L'art pour l'art theory is not simply the reaction to a new means of reproduction (however substantially it may have promoted the tendency toward the independence of the fine arts) but is the answer to the tendency in fully evolved bourgeois society for works of art to lose their social function (we characterized this development as the loss of the political content of individual works). There is no intent to deny the significance that changed techniques of reproduction had for the development of art; but the latter cannot be derived from the former. The evolution of art as a distinct subsystem that began with l'art pour l'art was carried to its conclusion in Aestheticism must be seen in connection with the tendency toward the division of labor underway in bourgeois society. The fully evolved, distinct subsystem 'art' is simultaneously one whose individual products tend to no longer take on any social function.

By way of a general formulation, it is probably impossible to safely go further than this: the process by which the social subsystem 'art' evolves into a wholly distinct entity is part and parcel of the developmental logic of bourgeois society. As the division of labor becomes more general, the artist also turns into a specialist. This trend, which reaches its apogee in Aestheticism, has been most adequately reflected by Valéry. Within the general tendency toward ever-increasing specialization, it may be assumed that various subsystems impinge on each other. The development of photography, for example, affects painting (withering of the mimetic function). But such reciprocal influences among social subsystems should not be given excessive weight. Although important, especially in explaining nonsynchronies in the evolution of the various arts, they cannot be made the "cause" of that process in which the various arts generate what is specifically theirs. That process is a function of the overall social development to which it belongs and cannot be adequately understood by a cause-effect scheme.[27]

The self-criticism of the social subsystem 'art' to which the avant-garde movements attained has been seen so far primarily in connection with the tendency toward the progressing division of labor that is so characteristic of the development of bourgeois society. The overall social tendency toward the articulation of subsystems and a concurrent specialization of function are being understood as the developmental law to which the sphere of art is also subject. This completes the sketch of the objective aspect of the process. But how the evolution of distinct subsystems is reflected by the subjects must still be inquired into. It seems to me that the concept of a shrinkage of experience can aid us here. If experience is defined as a bundle of perceptions and reflections that have been worked through, it becomes

25. This is the reason for the difficulties encountered by attempts to ground an aesthetic theory today in the concept of reflection. Such attempts are historically conditioned also by the development of art in bourgeois society, more precisely, by the 'withering' of the mimetic function of art that sets in with the avant-garde. The attempt to provide a sociological explanation of modern painting is undertaken by A. Gehlen, *Zeit-Bilder. Zur Soziologie und Ästhetik der modernen Malerei* (Frankfurt/Bonn, 1960). But the social conditions of the development of modern painting as listed by Gehlen remain rather general. In addition to the invention of photography, he mentions the enlargement of living space and the end of the nexus between painting and the natural sciences (ibid., p. 40 ff.).

26. "With the advent of the first truly revolutionary means of reproduction, photography, simultaneously with the rise of socialism, art sensed the approaching crisis which has become evident a century later. At the time, art reacted with the doctrine of *l'art pour l'art*, that is, with a theology of art" ("The work of art in the age of mechanical reproduciton," p. 224).

27. See P. Francastel, who summarizes his investigations on art and technique as follows: 1. "There is no contradiction between the development of certain forms of contemporary art and the forms scientific and technical activity takes in contemporary society"; 2. "the development of the arts in the present obeys a specific esthetic developmental principle" (*Art et technique aux XIXe et Xxe siecles* [Bibl. Meditations 16, 1964], p. 221 f.

possible to characterize the effect of the crystallization of subsystems resulting from the progressing division of labor as a shrinking of experience. Such shrinkage does not mean that the subject who has now become specialist in a subsystem no longer perceives or reflects. In the sense proposed here, the concept means that 'experiences' the specialist has in his partial sphere can no longer be translated back into the praxis of life. The aesthetic experience as a specific experience, such as aestheticism developed it, would in its pure form be the mode in which the shrinking of experience as defined above expresses itself in the sphere of art. Differently formulated: aesthetic experience is the positive side of that process by which the social subsystem 'art' defines itself as a distinct sphere. Its negative side is the artist's loss of any social function.

As long as art interprets reality or provides satisfaction of residual needs only in the imagination, it is, though detached from the praxis of life, still related to it. It is only in Aestheticism that the tie to society still existent up to this moment is severed. The break with society (it is the society of Imperialism) constitutes the center of the works of Aestheticism. Here lies the reason for Adorno's repeated attempts to vindicate it.[28]

28. See Th. W. Adorno, "George und Hofmannsthal. Zum Briefwechsel: 1891-1906 in *Prismen. Kulturkritik und Gesellschaft* (München: dtv 159, 1963), pp. 190-231; and Adorno, "Der Artist als Statthalter," in *Noten zur Literatur I*, pp. 173-93.

Herbert Marcuse (1898-1979)

Chapter One from
The Aesthetic Dimension

Translated by Herbert Marcuse and Erica Sherover

In a situation where the miserable reality can be changed only through radical political praxis, the concern with aesthetics demands justification. It would be senseless to deny the element of despair inherent in this concern: the retreat into a world of fiction where existing conditions are changed and overcome only in the realm of the imagination. However, this purely ideological conception of art is being questioned with increasing intensity. It seems that art as art expresses a truth, an experience, a necessity which, although not in the domain of radical praxis, are nevertheless essential components of revolution. With this insight, the basic conception of Marxist aesthetics, that is its treatment of art as ideology, and the emphasis on the class character of art, become again the topic of critical reexamination.[1]

This discussion is directed to the following theses of Marxist aesthetics:

1. There is a definite connection between art and the material base, between art and the totality of the relations of production. With the change in production relations, art itself is transformed as part of the superstructure, although, like other ideologies, it can lag behind or anticipate social change.

2. There is a definite connection between art and social class. The only authentic, true, progressive art is the art of an ascending class. It expresses the consciousness of this class.

3. Consequently, the political and the aesthetic, the revolutionary content and the artistic quality tend to coincide.

4. The writer has an obligation to articulate and express the interests and needs of the ascending class. (In capitalism, this would be the proletariat.)

5. A declining class or its representatives are unable to produce anything but "decadent" art.

6. Realism (in various senses) is considered as the art form which corresponds most adequately to the social relationships, and thus is the "correct" art form.

Each of these implies that the social relations of production must be represented in the literary work—not imposed upon the work externally, but a part of its inner logic and the logic of the material.

This aesthetic imperative follows from the base-superstructure conception. In contrast to the rather dialectical formulations of Marx and Engels, the conception has been made into a rigid schema, a schematization that has had devastating consequences for aesthetics. The schema implies a normative notion of the material base as the true reality and a political devaluation of nonmaterial forces particularly of the individual consciousness and subconscious and their political function. This function can

1. Especially among the authors of the periodicals *Kursbuch* (Frankfurt: Suhrkamp, later Rotbuch Verlag), *Argument* (Berlin), *Literaturmagazin* (Reinbik: Rowohlt). In the center of this discussion is the idea of an autonomous art in confrontation with the capitalist art industry on the one hand, and the radical propaganda art on the other. See especially the excellent articles by Nicolas Born, H. C. Buch, Wolfgang Harich, Hermann Peter Piwitt, and Michael Schneider in volumes I and II of the *Literaturmagazin*, the volume *Autonomie der Kunst* (Frankfurt: Suhrkamp, 1972) and Peter Bürger, *Theorie der Avantgarde* (Frankfurt: Suhrkamp, 1974).

be either regressive or emancipatory. In both cases, it can become a material force. If historical materialism does not account for this role of subjectivity, it takes on the coloring of vulgar materialism.

Ideology becomes mere ideology, in spite of Engels's emphatic qualifications, and a devaluation of the entire realm of subjectivity takes place, a devaluation not only of the subject as *ego cogito*, the rational subject, but also of inwardness, emotions, and imagination. The subjectivity of individuals, their own consciousness and unconsciousness tends to be dissolved into class consciousness. Thereby, a major prerequisite of revolution is minimized, namely, the fact that the need for radical change must be rooted in the subjectivity of individuals themselves, in their intelligence and their passions, their drives and their goals. Marxist theory succumbed to that very reification which it had exposed and combated in society as a whole. Subjectivity became an atom of objectivity; even in its rebellious form it was surrendered to a collective consciousness. The deterministic component of Marxist theory does not lie in its concept of the relationship between social existence and consciousness, but in the reductionistic concept of consciousness which brackets the particular content of individual consciousness and, with it, the subjective potential for revolution.

This development was furthered by the interpretation of subjectivity as a "bourgeois" notion. Historically, this is questionable.[2] But even in bourgeois society, insistence on the truth and right of inwardness is not really a bourgeois value. With the affirmation of the inwardness of subjectivity, the individual steps out of the network of exchange relationships and exchange values, withdraws from the reality of bourgeois society, and enters another dimension of existence. Indeed, this escape from reality led to an experience which could (and did) become a powerful force in *invalidating* the actually prevailing bourgeois values, namely, by shifting the locus of the individual's realization from the domain of the performance principle and the profit motive

to that of the inner resources of the human being: passion, imagination, conscience. Moreover, withdrawal and retreat were not the last position. Subjectivity strove to break out of its inwardness into the material and intellectual culture. And today, in the totalitarian period, it has become a political value as a counterforce against aggressive and exploitative socialization.

Liberating subjectivity constitutes itself in the inner history of the individuals—their own history, which is not identical with their social existence. It is the particular history of their encounters, their passions, joys, and sorrows—experiences which are not necessarily grounded in their class situation, and which are not even comprehensible from this perspective. To be sure, the actual manifestations of their history are determined by their class situation, but this situation is not the ground of their fate—of that which happens to them. Especially in its nonmaterial aspects it explodes the class framework. It is all too easy to relegate love and hate, joy and sorrow, hope and despair to the domain of psychology, thereby removing them from the concerns of radical praxis. Indeed, in terms of political economy they may not be "forces of production," but for every human being they are decisive, they constitute reality.

Even in its most distinguished representatives Marxist aesthetics has shared in the devaluation of subjectivity. Hence the preference for realism as the model of progressive art; the denigration of romanticism as simply reactionary; the denunciation of "decadent" art—in general, the embarrassment when confronted with the task of evaluating the aesthetic qualities of a work in terms other than class ideologies.

I shall submit the following thesis: the radical qualities of art, that is to say, its indictment of the established reality and its invocation of the established reality and its invocation of the beautiful image (*schöner Schein*) of liberation are grounded precisely in the dimensions where art *transcends* its social determination and emancipates itself from the given universe of discourse and behavior while preserving its overwhelming presence. Thereby art creates the realm in which the subversion of experience

2. See Erich Köhler, *Ideal und Wirklichkeit in Höfishen Epik* (Tübingen, Niemeyer, 1956: second edition 1970), especially chapter V, for a discussion of this in relation to the courtly epic.

proper to art becomes possible: the world formed by art is recognized as a reality which is supposed and distorted in the given reality. This experience culminates in extreme situations (of love and death, guilt and failure, but also joy, happiness, and fulfillment) which explode the given reality in the name of a truth normally denied or even unheard. The inner logic of the work of art terminates in the emergence of another reason, another sensibility, which defy the rationality and sensibility incorporated in the dominant social institutions.

Under the law of the aesthetic form, the given reality is necessarily *sublimated*: the immediate content is stylized, the "data" are reshaped and reordered in accordance with the demands of the art form, which requires that even the representation of death and destruction invoke the need for hope— a need rooted in the new consciousness embodied in the work of art.

Aesthetic sublimation makes for the affirmative, reconciling component of art,[3] though it is at the same time a vehicle for the critical, negating function of art. The transcendence of immediate reality shatters the reified objectivity of established social relations and opens a new dimension of experience: rebirth of the rebellious subjectivity. Thus, on the basis of aesthetic sublimation, a *desublimation* takes place in the perception of individuals—in their feelings, judgments, thoughts; an invalidation of dominant norms, needs, and values. With all its affirmative-ideological features, art remains a dissenting force.

We can tentatively define "aesthetic form" as the result of the transformation of a given content (actual or historical, personal or social fact) into a self-contained whole: a poem, play, novel, etc.[4] The work is thus "taken out" of the constant process of reality and assumes a significance and truth of its own. The aesthetic transformation is achieved through a reshaping of language, perception, and understanding so that they reveal the essence of reality in its appearance: the repressed potentialities of man and nature. The work of art thus re-presents reality while accusing it.[5]

The critical function of art, its contribution to the struggle for liberation, resides in the aesthetic form. A work of art is authentic or true not by virtue of its content (i.e., the "correct" representation of social conditions), nor by its "pure" form, but by the content having become form.

True, the aesthetic form removes art from the actuality of the class struggle—from actuality pure and simple. The aesthetic form constitutes the autonomy of art vis à vis "the given." However, this dissociation does not produce "false consciousness" or mere illusion but rather a counter-consciousness: negation of the realistic-conformist mind.

Aesthetic form, autonomy, and truth are interrelated. Each is a socio-historical phenomenon, and each *transcends* the socio-historical arena. While the latter limits the autonomy of art it does so without invalidating the *trans*historical truths expressed in the work. The truth of art lies in its power to break the monopoly of established reality (i.e., of those who established it) to *define* what is *real*. In this rupture, which is the achievement of the aesthetic form, the fictitious world of art appears as true reality.

Art is committed to that perception of the world which alienates individuals from their functional existence and performance in society—it is committed to an emancipation of sensibility, imagination, and reason in all spheres of subjectivity and objectivity. The aesthetic transformation becomes a vehicle of recognition and indictment. But this achievement presupposes a degree of autonomy which withdraws art from the mystifying power of the given and frees it for the expression of its own truth. Inasmuch as man and nature are constituted by an unfree society, their repressed and distorted potentialities can be represented only in an *estranging* form.

3. See pp. 55f.

4. See my *Counterrevolution and Revolt* (Boston: Beacon Press, 1972), p. 81.

5. Ernst Fischer in *Auf den Spuren der Wirklichkeit: sechs Essays* (Reinbeck: Rowholt, 1968) recognizes in the "will to form" (*Wille zur Gestalt*) the will to transcend the actual: negation of that which is, and presentiment (*Ahnung*) of a freer and purer existence. In this sense, art is the "irreconcilable, the resistance of the human being to its vanishing in the [established] order and systems" (67).

The world of art is that of another *Reality Principle*, of estrangement—and only as estrangement does art fulfill a *cognitive* function: it communicates truths not communicable in any other language; it contradicts.

However, the strong affirmative tendencies toward reconciliation with the established reality coexist with the rebellious ones. I shall try to show that they are not due to the specific class determination of art but rather to the redeeming character of the *catharsis*. The catharsis itself is grounded in the power of aesthetic form to call fate by its name, to demystify its force, to give the word to the victims—the power of recognition which gives the individual a modicum of freedom and fulfillment in the realm of unfreedom. The interplay between the affirmation and the indictment of that which is, between ideology and truth, pertains to the very structure of art.[6] But in the authentic works, the affirmation does not cancel the indictment: reconciliation and hope still preserve the memory of things past.

The affirmative character of art has yet another source: it is in the commitment of art to Eros, the deep affirmation of the Life Instincts in their fight against instinctual and social oppression. The permanence of art, its historical immortality throughout the millennia of destruction, bears witness to this commitment.

Art stands under the law of the given, while transgressing this law. The concept of art as an essentially autonomous and negating productive force contradicts the notion which sees art as performing an essentially dependent, affirmative-ideological function, that is to say, glorifying and absolving the existing society.[7] Even the militant bourgeois literature of the eighteenth century remains ideological: the struggle of the ascending class with the nobility is primarily over issues of bourgeois morality. The lower classes play only a marginal role, if any. With a few notable exceptions, this literature is not one of class struggle. According to this point of view, the ideological character of art can be remedied today only by grounding art in revolutionary praxis and in the *Weltanschauung* of the proletariat.

It has often been pointed out that this interpretation of art does not do justice to the views of Marx and Engels.[8] To be sure, even this interpretation admits that art aims at representing the essence of a given reality and not merely its appearance. Reality is taken to be the totality of social relations and its essence is defined as the laws determining these relations in the "complex of social causality."[9] This view demands that the protagonist in a work of art represent individuals as "types" who in turn exemplify "objective tendencies of social development, indeed of humanity as a whole."[10]

Such formulations provoke the question whether literature is not hereby assigned a function which could only be fulfilled in the medium of theory. The representation of the social totality requires a conceptual

6. "Two antagonistic attitudes towards the powers that be are prevalent in literature: resistance and submission. Literature is certainly not mere ideology and does not merely express a social consciousness that invokes the illusion of harmony, assuring the individuals that everything is as it ought to be, and that nobody has the right to expect fate to give him more than he receives. To be sure, literature has again and again justified established social relationships; nevertheless, it has always kept alive that human yearning which cannot find gratification in the existing society. Grief and sorrow are essential elements of bourgeois literature" (Leo Lowenthal, *Das Bild des Menschen in der Literatur* [Neuwied: Luchterhand, 1966] pp. 14f.). (Published in English as *Literature and the Image of Man* [Boston: Beacon Press, 1957].)

7. See my essay "The Affirmative Character of Cuture" in *Negations* (Boston Beacon Press, 1968).

8. In his book *Marxistische Ideologie und allgemeine Kunsttheorie* (Tübingen: Mohr: 1970), Hans-Dietrich Sander presents a thorough analyses of Marx's and Engels' contribution to a theory of art. The provocative conclusion: most of Marxist aesthetics is not only a gross vulgarization—Marx's and Engles' views are also turned into their opposite! He writes: Marx and Engels saw "the essence of a work of art precisely not in its political or social relevance" (p. 174). They are closer to Kant, Fichte, and Schelling than to Hegel (p. 171). Sander's documentation for this thesis may well be too selective and minimize statements by Marx and Engels which contradict Sander's interpretation. However, his analysis does show clearly the difficulty of Marxist aesthetics in coming to grips with the problems of the theory of art.

9. Bertolt Brecht, "Volkstümlichkeit und Realismus" in *Gesammelte Werke* (Frankfurt: Suhrkamp, 1967), volume VIII, p. 323.

10. Georg Lukács, "Es geht um den Realismus," in *Marxismus und Literatur*, edited by Fritz J. Raddatz (Reinbek: Rowholt, 1969) volume II, p. 77.

analysis, which can hardly be transposed into the medium of sensibility. During the great debate on Marxist aesthetics in the early thirties, Lu Märten suggested that Marxist theory possesses a theoretical form of its own which militates against any attempt to give it an aesthetic form.[11]

But if the work of art cannot be comprehended in terms of social theory, neither can it be comprehended in terms of philosophy. In his discussion with Adorno, Lucien Goldmann rejects Adorno's claim that in order to understand a literary work "one has to transcend it towards philosophy, philosophical culture and critical knowledge." Against Adorno, Goldmann insists on the concreteness immanent in the work which makes it into an (aesthetic) totality in its own right: "The work of art is a universe of colors, sounds and words, and concrete characters. There is no death, there is only Phaedra dying."[12]

The reification of Marxist aesthetics depreciates and distorts the truths expressed in this universe— it minimizes the cognitive function of art as ideology. For the radical potential of art lies precisely in its ideological character, in its transcendent relation to the "basis." Ideology is not always *mere* ideology, false consciousness. The consciousness and the representation of truths which appear as abstract in relation to the established process of production are also ideological functions. Art presents one of these truths. As ideology, it opposes the given society. The autonomy of art contains the categorical imperative: "things must change." If the liberation of human beings and nature is to be possible at all, then the social nexus of destruction and submission must be broken. This does not mean that the revolution becomes thematic; on the contrary, in the aesthetically most perfect works, it does not. It seems that in these works the necessity of revolution is presupposed, as the *a priori* of art. But the revolution is also as it were surpassed and questioned as to how far it responds to the anguish of the human being, as to how far it achieves a rupture with the past.

11. In *Die Linkskurve* III, 5 (Berlin: May 1931, reprinted 1970), p. 17.

12. *Collogue international sur la sociologie de la littéature* (Bruxelles: Institut de la Sociologie, 1974), p. 40.

Compared with the often one-dimensional optimism of propaganda, art is permeated with pessimism, not seldom intertwined with comedy. Its "liberating laughter" recalls the danger and the evil that have passed—this time! But the pessimism of art is not counterrevolutionary. It serves to warn against the "happy consciousness" of radical praxis: as if all of that which art invokes and indicts could be settled through the class struggle. Such pessimism permeates even the literature in which the revolution itself is affirmed, and becomes thematic; Büchner's play, *The Death of Danton* is a classic example.

Marxist aesthetics assumes that all art is *somehow* conditioned by the relations of production, class position, and so on. Its first task (but only its first) is the specific analysis of this "somehow," that is to say, of the limits and modes of this conditioning. The question as to whether there are qualities of art which transcend specific social conditions and how these qualities are related to the particular social conditions remains open. Marxist aesthetics has yet to ask: What are the qualities of art which transcend the specific social content and form and give art its universality? Marxist aesthetics must explain why Greek tragedy and the medieval epic, for example, can still be experienced today as "great," "authentic" literature, even though they pertain to ancient slave society and feudalism respectively. Marx's remark at the end of *The Introduction to the Critique of Political Economy* is hardly persuasive; one simply cannot explain the attraction of Greek art for us today as our rejoicing in the unfolding of the social "childhood of humanity."

However correctly one has analyzed a poem, play, or novel in terms of its social content, the questions as to whether the particular work is good, beautiful, and true are still unanswered. But the answers to these questions cannot again be given in terms of the specific relations of production which constitute the historical context of the respective work. The circularity of this method is obvious. In addition it falls victim to an easy relativism which is contradicted clearly enough by the permanence of certain qualities of art through all changes of style and historical periods (transcendence, estrangement, aesthetic order, manifestations of the beautiful).

The fact that a work truly represents the interests or the outlook of the proletariat or of the bourgeoisie does not yet make it an authentic work of art. This "material" quality may facilitate its reception, may lend it greater concreteness, but it is in no way constitutive. The universality of art cannot be grounded in the world and world outlook of a particular class, for art envisions a concrete universal, humanity (*Menschlichkeit*), which no particular class can incorporate, not even the proletariat, Marx's "universal class." The inexorable entanglement of joy and sorrow, celebration and despair, Eros and Thanatos cannot be dissolved into problems of class struggle. History is also grounded in nature. And Marxist theory has the least justification to ignore the metabolism between the human being and nature, and to denounce the insistence on this natural soil of society as a regressive ideological conception.

The emergence of human beings as "species beings"—men and women capable of living in that community of freedom which is the potential of the species—this is the subjective basis of a classless society. Its realization presupposes a radical transformation of the drives and needs of the individuals: an organic development within the socio-historical. Solidarity would be on weak grounds were it not rooted in the instinctual structure of individuals. In this dimension, men and women are confronted with psycho-physical forces which they have to make their own without being able to overcome the naturalness of these forces. This is the domain of the primary drives: of libidinal and destructive energy. Solidarity and community have their basis in the subordination of destructive and aggressive energy to the social emancipation of the life instincts.

Marxism has too long neglected the radical political potential of this dimension, though the revolutionizing of the instinctual structure is a prerequisite for a change in the system of needs, the mark of a socialist society as qualitative difference. Class society knows only the appearance, the image of the qualitative difference; this image, divorced from praxis, has been preserved in the realm of art. In the aesthetic form, the autonomy of art constitutes itself. It was forced upon art through the separation of mental and material labor, as a result of the prevailing relations of domination. Dissociation from the process of production became a refuge and a vantage point from which to denounce the reality established through domination.

Nevertheless society remains present in the autonomous realm of art in several ways: first of all as the "stuff" for the aesthetic representation which, past and present, is transformed in this representation. This is the historicity of the conceptual, linguistic, and imaginable material which the tradition transmits to the artists and with or against which they have to work; secondly, as the scope of the actually available possibilities of struggle and liberation; thirdly as the specific position of art in the social division of labor, especially in the separation of intellectual and manual labor through which artistic activity, and to a great extent also its reception, become the privilege of an "elite" removed from the material process of production.

The class character of art consists only in these objective limitations of its autonomy. The fact that the artist belongs to a privileged group negates neither the truth nor the aesthetic quality of his work. What is true of "the classics of socialism" is true also of the great artists: they break through the class limitations of their family, background, environment. Marxist theory is not family research. The progressive character of art, its contribution to the struggle for liberation cannot be measured by the artists' origins nor by the ideological horizon of their class. Neither can it be determined by the presence (or absence) of the oppressed class in their works. The criteria for the progressive character of art are given only in the work itself as a whole: in what it says and how it says it.

In this sense art is "art for art's sake" inasmuch as the aesthetic form reveals tabooed and repressed dimensions of reality: aspects of liberation. The poetry of Mallarmé is an extreme example; his poems conjure up modes of perception, imagination, gestures—a feast of sensuousness which shatters everyday experience and anticipates a different reality principle.

The degree to which the distance and estrangement from praxis constitute the emancipatory value of art becomes particularly clear in those works of

literature which seem to close themselves rigidly against such praxis. Walter Benjamin has traced this in the works of Poe, Baudelaire, Proust, and Valéry. They express a "consciousness of crisis" (*Krisenbewusstsein*): a pleasure in decay, in destruction, in the beauty of evil; a celebration of the asocial, of the anomic—the secret rebellion of the bourgeois against his own class. Benjamin writes about Baudelaire:

> It seems of little value to give his work a position on the most advanced ramparts of the human struggle for liberation. From the beginning, it appears much more promising to follow him in his machinations where he is without doubt at home: in the enemy camp. These machinations are a blessing for the enemy only in the rarest cases. Baudelaire was a secret agent, an agent of the secret discontent of his class with its own rule. One who confronts Baudelaire with this class gets more out of him than one who rejects him as uninteresting from a proletarian standpoint.[13]

The "secret" protest of this esoteric literature lies in the ingression of the primary erotic-destructive forces which explode the normal universe of communication and behavior. They are asocial in their very nature, a subterranean rebellion against the social order. Inasmuch as this literature reveals the dominion of Eros and Thanatos beyond all social control, it invokes needs and gratifications which are essentially destructive. In terms of political praxis, this literature remains elitist and decadent. It does nothing in the struggle for liberation—except to open the tabooed zones of nature and society in which even death and the devil are enlisted as allies in the refusal to abide by the law and order of repression. This literature is one of the historical forms of critical aesthetic transcendence. Art cannot abolish the social division of labor which makes for its esoteric character, but neither can art "popularize" itself without weakening its emancipatory impact.

13. Walter Benjamin, "Fragment über Methodenfrage einer Marxistischen Literatur-Analyse," in *Kursbuch* 20 (Frankfurt: Surkamp, 1970), p. 3.

Part 7

(Post) Modernism

Part 7: (Post) Modernism

Introduction

Few terms in aesthetics are more contested than *modernism* and *postmodernism*. There are good reasons for this fact. On the one hand, there is little disagreement about the fact that modern art corresponds with a period of experimentation in technique begun by the impressionists and carried forward by various movements toward abstraction; that modern architecture coincides with the heroic period inaugurated by the Bauhaus movement's emphasis on ergonomic design; or that the modern novel and modern music were characterised by difficulty and experimentation in technique, a distancing both from the simpler stylistic structures of earlier high culture and from the banal contamination of popular culture. But the various movements in the different arts responded to different pressures. Modernism in architecture, for example, was fuelled by an almost religious faith in the power of industrialisation to produce a well-designed environment for mass democracy, whereas modernism in literature had no such humanist democratic mandate. Modernist culture maintained its lofty position through self-conscious strategies that distanced it from the increasingly pervasive popular culture, for example, through the demand for aesthetic autonomy and art for art's sake. However, many of the experimental wings of the movement aimed themselves directly against this attempt to separate art from popular culture, by means either political or parodic attacks. The idea of the aesthetic avant-garde itself points ambiguously toward the heights of aesthetic purification and toward a sustainable social order. So modernism from the beginning was shadowed by the artistic vitality of its popular culture opposite.

The selections in this section represent different influential formulations of modernism and/or postmodernism. They should be read in conjunction with the selections from the preceding section as well as the last section on culture, gender and difference; for example the selection by Andreas Huyssen, "Mass Culture as Woman: Modernism's Other", offers a formulation of the distinction between postmodernism and modernism.

The first selection, "Modernist Painting", by the influential New York art critic Clement Greenberg (1908-1994) defines modernism using the Kantian notion of internal criticism. Each of the disciplines needs to formulate its own critique in terms

of its own characteristic methods to justify itself. The great danger for the arts is that if they could not demonstrate that they provided a species of experience that was valuable in its own right, they would be reduced to entertainment or therapy. This demonstration, performed by artistic experimentation in each art form, lay in the formal properties available in a given medium. Greenberg's account of modernism thus categorically separates it from popular culture.

The second selection, "Modernity as an Incomplete Project", is by German philosopher and sociologist, Jürgen Habermas (1929-), the foremost contemporary representative of the Frankfurt school. Like Greenberg, Habermas approaches modernism through the Enlightenment notion of internal critique. The project of the Enlightenment, modernism consisted in the efforts to develop an autonomous natural science, universal system of law and autonomous art each according to their own inner logic, with the expectation of promoting the expansion of truth, justice and beauty for social good. This optimism was unfounded: the separation of the disciplinary spheres has come to mean a society of specialists. But what follows from this? Habermas's concern in the essay is with conservative political demands for a rejection of Enlightenment humanism, arguing that they misidentify the real sources of the failures of modernism, and that they prescribe false solutions under the banner of postmodernism.

The next selection, "Answering the Question: What is Postmodernism?" is written at least in part in response to Habermas's challenge. Its author, Jean-François Lyotard (1925-), is Professor of Philosophy at the University of Paris at Vincennes and one of France's most innovative and creative thinkers. How are we to understand the modernist aim to unify the disparate parts of experience into an aesthetic whole? Lyotard examines the various demands to cease artistic experimentation put forward in the name of realism. But an aesthetic of realism is no longer possible except as propaganda. Lyotard agrees with the analysis of the Frankfurt School that capitalism is inherently derealising in its effects and produces a mass culture industry that delivers only fantasies of realism. The function of these fantasies is to shape identities supportive of the culture with which people can easily identify and thereby preserve their consciousness from doubt. Given this reality, if artists do not wish to become supporters of the mass culture of conformism they must refuse to lend their art to such therapeutic or therapeutic or 'pornographic' uses.

Lyotard argues that the technological criterion—the subordination of cognitive statements to the best possible performance—is unavoidable in capitalism, and with it comes a shattering of belief and the destruction of the aura of reality. Appropriating Kant's notion of the sublime, Lyotard defines modern art as the art that devotes its technique to presenting the fact that the unpresentable exists. It is in this context that Lyotard answers the question, "What is the postmodern?": "The postmodern would be that which, in the modern, puts forward the unpresentable in presentation itself." Clearly, for Lyotard both modernism and postmodernism stand opposed to the conservative cultural criticism identified by Habermas.

The next selection is from *The Politics of Postmodernism*, by University of Toronto English Professor Linda Hutcheon (1947-). In this selection Hutcheon navigates the various meanings of the terms of postmodernism, arguing that the debate between

Lyotard and Habermas contains a slippage between the social condition properly called postmodernity and the cultural product of postmodernity which is postmodernism. Insufficient attention has been paid to the artistic vitality and independence of popular culture (a complaint echoed in the selection by Huyssen in Part 8).

The last selection is "The 'Culture of Postmodernism" by Ihab Hassan, Vilas Research Professor of English and Comparative Literature at the University of Wisconsin in Milwaukee, literary critic and early proponent of postmodernism. Hassan's ambitious review of the meanings and sources of postmodernism begins with a historical reflection on the origin of the term and then delineates ten conceptual problems which help to constitute and also obscure postmodernism. He then proposes a provisional scheme that distinguishes three strains of artistic experimentation: the avant-garde, the modern, and the postmodern, which have conspired to create the "tradition of the new". The avant-garde—which assaulted the bourgeoisie with attacks and absurdities—has all but vanished, leaving the field to aloof olympian modernist experiments in formalism and the playful kitschy irreverencies of postmodernism. Hassan then offers a table of contrasts between modernism and postmodernism, summarising postmodern tendencies under the heading of the neologism 'indetermanence'. Using the conservative postmodernism of Daniel Bell and the radical pronouncements of Jean-François Lyotard as a focus, Hassan discusses these tendencies in terms of the interplay between artistic and philosophic impulses toward indeterminacy and immanence, which he sees everywhere in contemporary cultural life.

Clement Greenberg (1908-1994)

Modernist Painting

Modernism includes more than just art and litera-
ture. By now it includes almost the whole of what is
truly alive in our culture. It happens, also, to be
very much of a historical novelty. Western civiliza-
tion is not the first to turn around and question its
own foundations, but it is the civilization that has
gone furthest in doing so. I identify Modernism with
the intensification, almost the exacerbation of this
self-critical tendency that began with the philoso-
pher Kant. Because he was the first to criticize the
means itself of criticism, I conceive of Kant as the
first real Modernist.

The essence of Modernism lies, as I see it, in the
use of the characteristic methods of a discipline to
criticize the discipline itself—not in order to sub-
vert it, but to entrench it more firmly in its area of
competence. Kant used logic to establish the limits
of logic, and while he withdrew much from its old
jurisdiction, logic was left in all the more secure
possession of what remained to it.

The self-criticism of Modernism grows out of but
is not the same thing as the criticism of the Enlight-
enment. The Enlightenment criticized from the
outside, the way criticism in its more accepted sense
does; Modernism criticizes from the inside, through
the procedures themselves of that which is being
criticized. It seems natural that this new kind of criti-
cism should have appeared first in philosophy, which
is critical by definition, but as the nineteenth cen-
tury wore on it made itself felt in many other fields.
A more rational justification had begun to be de-
manded of every formal social activity, and
"Kantian" self-criticism was called on eventually to
meet and interpret this demand in areas that lay far
from philosophy.

We know what has happened to an activity like
religion that has not been able to avail itself of
"Kantian" immanent criticism in order to justify it-
self. At first glance the arts might seem to have been
in a situation like religion's. Having been denied by
the Enlightenment all tasks they could take seriously,
they looked as though they were going to be assimi-
lated to entertainment pure and simple, and enter-
tainment itself looked as though it were going to be
assimilated, like religion, to therapy. The arts could
save themselves from this leveling down only by dem-
onstrating that the kind of experience they provided
was valuable in its own right and not to be obtained
from any other kind of activity.

Each art, it turned out, had to effect this demon-
stration on its own account. What had to be exhib-
ited and made explicit was that which was unique
and irreducible not only in art in general, but also in
each particular art. Each art had to determine,
through the operations peculiar to itself, the effects
peculiar and exclusive to itself. By doing this each
art would, to be sure, narrow its area of competence,
but at the same time it would make its possession of
this area all the more secure.

It quickly emerged that the unique and proper
area of competence of each art coincided with all
that was unique to the nature of its medium. The
task of self-criticism became to eliminate from the
effects of each art any and every effect that might
conceivably be borrowed from or by the medium of
any other art. Thereby each art would be rendered
"pure," and in its "purity" find the guarantee of its
standards of quality as well as of its independence.
"Purity" meant self-definition, and the enterprise of
self-criticism in the arts became one of self-definition
with a vengeance.

Realistic, illusionist art had dissembled the me-
dium, using art to conceal art. Modernism used art to
call attention to art. The limitations that constitute

the medium of painting—the flat surface, the shape of the support, the properties of pigment—were treated by the Old Masters as negative factors that could be acknowledged only implicitly or indirectly. Modernist painting has come to regard these same limitations as positive factors that are to be acknowledged openly. Manet's paintings became the first Modernist ones by virtue of the frankness with which they declared the surfaces on which they were painted. The Impressionists, in Manet's wake, abjured underpainting and glazing, to leave the eye under no doubt as to the fact that the colors used were made of real paint that came from pots or tubes. Cézanne sacrificed verisimilitude, or correctness, in order to fit drawing and design more explicitly to the rectangular shape of the canvas.

It was the stressing, however, of the ineluctable flatness of the support that remained most fundamental in the processes by which pictorial art criticized and defined itself under Modernism. Flatness alone was unique and exclusive to that art. The inclosing shape of the support was a limiting condition, or norm, that was shared with the art of the theater; color was a norm or means shared with sculpture as well as the theater. Flatness, two-dimensionality, was the only condition painting shared with no other art, and so Modernist painting oriented itself to flatness as it did to nothing else.

The Old Masters had sensed that it was necessary to preserve what is called the integrity of the picture plane: that is, to signify the enduring presence of flatness under the most vivid illusion of three-dimensional space. The apparent contradiction involved—the dialectical tension, to use a fashionable but apt phrase—was essential to the success of their art, as it is indeed to the success of all pictorial art. The Modernists have neither avoided nor resolved this contradiction; rather, they have reversed its terms. One is made aware of the flatness of their pictures before, instead of after, being made aware of what the flatness contains. Whereas one tends to see what is *in* an Old Master before seeing it as a picture, one sees a Modernist painting as a picture first. This is, of course, the best way of seeing any kind of picture, Old Master or Modernist, but Modernism imposes it as the only and necessary way, and Modernism's success in doing so is a success of self-criticism.

It is not in principle that Modernist painting in its latest phase has abandoned the representation of recognizable objects. What it has abandoned in principle is the representation of the kind of space that recognizable, three-dimensional objects can inhabit. Abstractness, or the nonfigurative, has in itself still not proved to be an altogether necessary moment in the self-criticism of pictorial art, even though artists as eminent as Kandinsky and Mondrian have thought so. Representation, or illustration, as such does not abate the uniqueness of pictorial art; what does so are the associations of the things represented. All recognizable entities (including pictures themselves) exist in three-dimensional space, and the barest suggestion of a recognizable entity suffices to call up associations of that kind of space. The fragmentary silhouette of a human figure, or of a teacup, will do so, and by doing so alienate pictorial space from the two-dimensionality which is the guarantee of painting's independence as an art. Three-dimensionality is the province of sculpture, and for the sake of its own autonomy painting has had above all to divest itself of everything it might share with sculpture. And it is in the course of its effort to do this, and not so much—I repeat—to exclude the representational or the "literary," that painting has made itself abstract.

At the same time Modernist painting demonstrates precisely in its resistance to the sculptural, that it continues tradition and the themes of tradition, despite all appearances to the contrary. For the resistance to the sculptural begins long before the advent of Modernism. Western painting, insofar as it strives for realistic illusion, owes an enormous debt to sculpture, which taught it in the beginning how to shade and model towards an illusion of relief, and even how to dispose that illusion in a complementary illusion of deep space. Yet some of the greatest feats of Western painting came as part of the effort it has made in the last four centuries to suppress and dispel the sculptural. Starting in Venice in the sixteenth century and continuing in Spain, Belgium, and Holland in the seventeenth, that effort was carried on at first in the name of color. When David, in the eighteenth century, sought to revive sculptural painting, it was in part to save pictorial art from the decorative flattening-out that the

emphasis on color seemed to induce. Nevertheless, the strength of David's own best pictures (which are predominantly portraits) often lies as much in their color as in anything else. And Ingres, his pupil, though subordinating color far less consistently, executed pictures that were among the flattest, least sculptural done in the West by a sophisticated artist since the fourteenth century. Thus by the middle of the nineteenth century all ambitious tendencies in painting were converging (beneath their differences) in an anti-sculptural direction.

Modernism, in continuing this direction, made it more conscious of itself. With Manet and the Impressionists, the question ceased to be defined as one of color versus drawing, and became instead a question of purely optical experience as against optical experience modified or revised by tactile associations. It was in the name of the purely and literally optical, not in that of color, that the Impressionists set themselves to undermining shading and modeling and everything else that seemed to connote the sculptural. And in a way like that in which David had reacted against Fragonard in the name of the sculptural, Cézanne, and the Cubists after him, reacted against Impressionism. But once again, just as David's and Ingres' reaction had culminated in a kind of painting even less sculptural than before, so the Cubist counter-revolution eventuated in a kind of painting flatter than anything Western art had seen since before Cimabue—so flat indeed that it could hardly contain recognizable images.

In the meantime the other cardinal norms of the art of painting were undergoing an equally searching inquiry, though the results may not have been equally conspicuous. It would take me more space than is at my disposal to tell how the norm of the picture's inclosing shape or frame was loosened, then tightened, then loosened once again, and then isolated and tightened once more by successive generations of Modernist painters; or how the norms of finish, of paint texture, and of value and color contrast, were tested and retested. Risks have been taken with all these, not only for the sake of new expression, but also in order to exhibit them more clearly as norms. By being exhibited and made explicit they are tested for their indispensability. This testing is by no means finished, and the fact that it becomes more searching as it proceeds accounts for the radical simplifications, as well as radical complications, in which the very latest abstract art abounds.

Neither the simplifications nor the complications are matters of license. On the contrary, the more closely and essentially the norms of a discipline become defined the less apt they are to permit liberties (*liberation* has become a much abused word in connection with avant-garde and Modernist art). The essential norms or conventions of painting are also the limiting conditions with which a marked-up surface must comply in order to be experienced as a picture. Modernism has found that these limiting conditions can be pushed back indefinitely before a picture stops being a picture and turns into an arbitrary object; but it has also found that the further back these limits are pushed the more explicitly they have to be observed. The interesting black lines and colored rectangles of a Mondrian may seem hardly enough to make a picture out of, yet by echoing the picture's inclosing shape so self-evidently they impose that shape as a regulating norm with a new force and new completeness. Far from incurring the danger of arbitrariness in the absence of a model in nature, Mondrian's art proves, with the passing of time, almost too disciplined, too convention-bound in certain respects; once we have gotten used to its utter abstractness we realize that it is more traditional in its color, as well as in its subservience to the frame, than the last paintings of Monet are.

It is understood, I hope, that in plotting the rationale of Modernist art I have had to simplify and exaggerate. The flatness towards which Modernist painting orients itself can never be an utter flatness. The heightened sensitivity of the picture plane may no longer permit sculptural illusion, or trompe-l'oeil, but it does and must permit optical illusion. The first mark made on a surface destroys its virtual flatness, and the configurations of a Mondrian still suggest a kind of illusion of a kind of third dimension. Only now it is a strictly pictorial, strictly optical third dimension. Where the Old Masters created an illusion of space into which one could imagine oneself walking, the illusion created by a Modernist is one into which one can only look, can travel through only with the eye.

One begins to realize that the Neo-Impressionists were not altogether misguided when they flirted with science. Kantian self-criticism finds its perfect expression in science rather than in philosophy, and when this kind of self-criticism was applied in art the latter was brought closer in spirit to scientific method than ever before—closer than in the early Renaissance. That visual art should confine itself exclusively to what is given in visual experience, and make no reference to anything given in other orders of experience, is a notion whose only justification lies, notionally, in scientific consistency. Scientific method alone asks that a situation be resolved in exactly the same kind of terms as that in which it is presented—a problem in physiology is solved in terms of physiology, not in those of psychology; to be solved in terms of psychology, it has to be presented in, or translated into, these terms first. Analogously, Modernist painting asks that a literary theme be translated into strictly optical, two-dimensional terms before becoming the subject of pictorial art—which means its being translated in such a way that it entirely loses its literary character. Actually, such consistency promises nothing in the way of esthetic quality or esthetic results, and the fact that the best art of the past seventy or eighty years increasingly approaches such consistency does not change this; now as before, the only consistency that counts in art is esthetic consistency, which shows itself only in results and never in methods or means. From the point of view of art itself its convergence of spirit with science happens to be a mere accident, and neither art nor science gives or assures the other of anything more than it ever did. What their convergence does show, however, is the degree to which Modernist art belongs to the same historical and cultural tendency as modern science.

It should also be understood that the self-criticism of Modernist art has never been carried on in any but a spontaneous and subliminal way. It has been altogether a question of practice, immanent to practice and never a topic of theory. Much has been heard about programs in connection with Modernist art, but there has really been far less of the programmatic in Modernist art than in Renaissance or Academic art. With a few untypical exceptions, the masters of Modernism have betrayed no more of an appetite for fixed ideas about art than Corot did. Certain inclinations and emphases, certain refusals and abstinences seem to become necessary simply because the way to stronger, more expressive art seems to lie through them. The immediate aims of Modernist artists remain individual before anything else, and the truth and success of their work is individual before it is anything else. To the extent that it succeeds as art Modernist art partakes in no way of the character of a demonstration. It has needed the accumulation over decades of a good deal of individual achievement to reveal the self-critical tendency of Modernist painting. No one artist was, or is yet, consciously aware of this tendency, nor could any artist work successfully in conscious awareness of it. To this extent—which is by far the largest—art gets carried on under Modernism in the same way as before.

And I cannot insist enough that Modernism has never meant anything like a break with the past. It may mean a devolution, an unraveling of anterior tradition, but it also means its continuation. Modernist art develops out of the past without gap or break, and wherever it ends up it will never stop being intelligible in terms of the continuity of art. The making of pictures has been governed, since pictures first began to be made, by all the norms I have mentioned. The Paleolithic painter or engraver could disregard the norm of the frame and treat the surface in both a literally and a virtually sculptural way because he made images rather than pictures, and worked on a support whose limits could be disregarded because (except in the case of small objects like a bone or horn) nature gave them to the artist in an unmanageable way. But the making of pictures, as against images in the flat, means the deliberate choice and creation of limits. This deliberateness is what Modernism harps on: that is, spells out the fact that the limiting conditions or art have to be made altogether human limits.

I repeat that Modernist art does not offer theoretical demonstrations. It could be said, rather, that it converts all theoretical possibilities into empirical ones, and in doing so tests, inadvertently, all theories about art for their relevance to the actual practice and experience of art. Modernism is subversive in this respect alone. Ever so many factors thought to

be essential to the making and experiencing of art have been shown not to be so by the fact that Modernist art has been able to dispense with them and yet continue to provide the experience of art in all its essentials. That this "demonstration" has left most of our old value judgements intact only makes it the more conclusive. Modernism may have had something to do with the revival of the reputations of Uccello, Piero, El Greco, Georges de la Tour, and even Vermeer, and it certainly confirmed if it did not start other revivals like that of Giotto; but Modernism has not lowered thereby the standing of Leonardo, Raphael, Titian, Rubens, Rembrandt or Watteau. What Modernism has made clear is that, though the past did appreciate masters like these justly, it often gave wrong or irrelevant reasons for doing so.

Still, in some ways this situation has hardly changed. Art criticism lags behind Modernist as it lagged behind pre-Modernist art. Most of the things that get written about contemporary art belong to journalism rather than criticism properly speaking.

It belongs to journalism—and to the millennial complex from which so many journalists suffer in our day—that each new phase of Modernism should be hailed as the start of a whole new epoch of art making a decisive break with all the customs and conventions of the past. Each time, a kind of art is expected that will be unlike previous kinds of art, and so "liberated" from norms of practice or taste, that everybody, regardless of how informed or uninformed, will be able to have his say about it. And each time, this expectation is disappointed, as the phase of Modernism in question takes its place, finally, in the intelligible continuity of taste and tradition, and as it becomes clear that the same demands as before are made on artist and spectator.

Nothing could be further from the authentic art of our times than the idea of a rupture of continuity. Art is, among many other things, continuity. Without the past of art, and without the need and compulsion to maintain past standards of excellence, such a thing as Modernist art would be impossible.

Jürgen Habermas (1929-)

Modernity—An Incomplete Project

Translated by Seyla Ben-Habib

In 1980, architects were admitted to the Biennial in Venice, following painters and filmmakers. The note sounded at this first Architecture Biennial was one of disappointment. I would describe it by saying that those who exhibited in Venice formed an avant-garde of reversed fronts. I mean that they sacrificed the tradition of modernity in order to make room for a new historicism. Upon this occasion, a critic of the German newspaper, *Frankfurter Allgemeine Zeitung*, advanced a thesis whose significance reaches beyond this particular event; it is a diagnosis of our times: "Postmodernity definitely presents itself as Antimodernity." This statement describes an emotional current of our times which has penetrated all spheres of intellectual life. It has placed on the agenda theories of postenlightenment, postmodernity, even of posthistory.

From history we know the phrase, "The Ancients and the Moderns." Let me begin by defining these concepts. The term "modern" has a long history, one which has been investigated by Hans Robert Jauss.[1] The word "modern" in its Latin form "modernus" was used for the first time in the late 5th century in order to distinguish the present, which had become officially Christian, from the Roman and pagan past. With varying content, the term "modern" again and again expresses the consciousness of an epoch that relates itself to the past of antiquity,

in order to view itself as the result of a transition from the old to the new.

Some writers restrict this concept of "modernity" to the Renaissance, but this is historically too narrow. People considered themselves very modern during the period of Charles the Great in the 12th century, as well as in France of the late 17th century at the time of the famous "Querelle des Anciens et des Modernes." That is to say, the term "modern" appeared and reappeared exactly during those periods in Europe when the consciousness of a new epoch formed itself through a renewed relationship to the ancients—whenever, moreover, antiquity was considered a model to be recovered through some kind of imitation.

The spell which the classics of the ancient world cast upon the spirit of later times was first dissolved with the ideals of the French Enlightenment. Specifically, the idea of being "modern" by looking back to the ancients changed with the belief, inspired by modern science, in the infinite progress of knowledge and in the infinite advance towards social and moral betterment. Another form of modernist consciousness was formed in the wake of this change. The romantic modernist sought to oppose the antique ideals of the classicists; he looked for a new historical epoch and found it in the idealized Middle Ages. However, this new ideal age, established early in the 19th century, did not remain a fixed ideal. In the course of the 19th century, there emerged out of this romantic spirit that radicalized consciousness of modernity which freed itself from all specific historical ties. This most recent modernism simply makes an abstract opposition between tradition and the present; and we are, in a way, still the contemporaries of that kind of aesthetic modernity which

1. Jauss is a prominent German literary historian and critic involved in "the aesthetics of reception," a type of criticism related to reader-response criticism in this country. For a discussion of "modern" see Jauss, *Asthetische Normen und geschichtliche Reflexion in der Querelle des Anciens et des Modernes* (Munich, 1964). For a reference in English see Jauss, "History of Art and Pragmatic History," *Toward an Aesthetic of Reception*, trans. Timothy Bahti (Minneapolis: University of Minnesota Press, 1982), pp. 46-8. [Ed.]

first appeared in the midst of the 19th century. Since then, the distinguishing mark of works which count as modern is "the new" which will be overcome and made obsolete through the novelty of the next style. But, while that which is merely "stylish" will soon become outmoded, that which is modern preserves a secret tie to the classical. Of course, whatever can survive time has always been considered to be a classic. But the emphatically modern document no longer borrows this power of being a classic from the authority of a past epoch; instead, a modern work becomes a classic because it has once been authentically modern. Our sense of modernity creates its own self-enclosed canons of being classic. In this sense we speak, e.g., in view of the history of modern art, of classical modernity. The relation between "modern" and "classical" has definitely lost a fixed historical reference.

The Discipline of Aesthetic Modernity

The spirit and discipline of aesthetic modernity assumed clear contours in the work of Baudelaire. Modernity then unfolded in various avant-garde movements and finally reached its climax in the Café Voltaire of the dadaists and in surrealism. Aesthetic modernity is characterized by attitudes which find a common focus in a changed consciousness of time. This time consciousness expresses itself through metaphors of the vanguard and the avant-garde. The avant-garde understands itself as invading unknown territory, exposing itself to the dangers of sudden, shocking encounters, conquering an as yet unoccupied future. The avant-garde must find a direction in a landscape into which no one seems to have yet ventured.

But these forward gropings, this anticipation of an undefined future and the cult of the new mean in fact the exaltation of the present. The new time consciousness, which enters philosophy in the writings of Bergson, does more than express the experience of mobility in society, of acceleration in history, of discontinuity in everyday life. The new value placed on the transitory, the elusive and the ephemeral, the very celebration of dynamism, discloses a longing for an undefiled, immaculate and stable present.

This explains the rather abstract language in which the modernist temper has spoken of the "past." Individual epochs lose their distinct forces. Historical memory is replaced by the heroic affinity of the present with the extremes of history—a sense of time wherein decadence immediately recognizes itself in the barbaric, the wild and the primitive. We observe the anarchistic intention of blowing up the continuum of history, and we can account for it in terms of the subversive force of this new aesthetic consciousness. Modernity revolts against the normalizing functions of tradition; modernity lives on the experience of rebelling against all that is normative. This revolt is one way to neutralize the standards of both morality and utility. This aesthetic consciousness continuously stages a dialectical play between secrecy and public scandal; it is addicted to a fascination with that horror which accompanies the act of profaning, and yet is always in flight from the trivial results of profanation.

On the other hand, the time consciousness articulated in avant-garde art is not simply ahistorical; it is directed against what might be called a false normativity in history. The modern, avant-garde spirit has sought to use the past in a different way; it disposes those pasts which have been made available by the objectifying scholarship of historicism, but it opposes at the same time a neutralized history which is locked up in the museum of historicism.

Drawing upon the spirit of surrealism, Walter Benjamin constructs the relationship of modernity to history in what I would call a posthistoricist attitude. He reminds us of the self-understanding of the French Revolution: "The Revolution cited ancient Rome, just as fashion cites an antiquated dress. Fashion has a scent for what is current, whenever this moves within the thicket of what was once." This is Benjamin's concept of the *Jetztzeit*, of the present as a moment of revelation; a time in which splinters of a messianic presence are enmeshed. In this sense, for Robespierre, the antique Rome was a past laden with momentary revelations.[2]

Now, this spirit of aesthetic modernity has recently begun to age. It has been recited once more in the

2. See Benjamin, "Theses on the Philosophy of History," *Illuminations*, trans. Harry Zohn (New York: Schocken, 1969), p. 261. [Ed.]

1960s; after the 1970s, however, we must admit to ourselves that this modernism arouses a much fainter response today than it did fifteen years ago. Octavio Paz, a fellow-traveller of modernity, noted already in the middle of the 1960s that "the avant-garde of 1967 repeats the deeds and gestures of those of 1917. We are experiencing the end of the idea of modern art." The work of Peter Bürger has since taught us to speak of "post-avant-garde" art; this term is chosen to indicate the failure of the surrealist rebellion.[3] But what is the meaning of this failure? Does it signal a farewell to modernity? Thinking more generally, does the existence of a post-avant-garde mean there is a transition to that broader phenomenon called postmodernity?

This is in fact how Daniel Bell, the most brilliant of the American neoconservatives, interprets matters. In his book, *The Cultural Contradictions of Capitalism*, Bell argues that the crisis of the developed societies of the West are to be traced back to a split between culture and society. Modernist culture has come to penetrate the values of everyday life; the life-world is infected by modernism. Because of the forces of modernism, the principle of unlimited self-realization, the demand for authentic self-experience and the subjectivism of a hyperstimulated sensitivity have come to be dominant. This temperament unleashes hedonistic motives irreconcilable with the discipline of professional life in society, Bell says. Moreover, modernist culture is altogether incompatible with the moral basis of a purposive, rational conduct of life. In this manner, Bell places the burden of responsibility for the dissolution of the Protestant ethic (a phenomenon which had already disturbed Max Weber) on the "adversary culture." Culture in its modern form stirs up hatred against the conventions and virtues of everyday life, which has become rationalized under the pressures of economic and administrative imperatives.

I would call your attention to a complex wrinkle in this view. The impulse of modernity, we are told on the other hand, is exhausted; anyone who considers himself avant-garde can read his own death warrant. Although the avant-garde is still considered to be expanding, it is supposedly no longer creative. Modernism is dominant but dead. For the neoconservative the question then arises: how can norms arise in society which will limit libertinism, reestablish the ethic of discipline and work? What new norms will put a brake on the levelling caused by the social welfare state so that the virtues of individual competition for achievement can again dominate? Bell sees a religious revival to be the only solution. Religious faith tied to a faith in tradition will provide individuals with clearly defined identities and existential security.

Cultural Modernity and Societal Modernization

One can certainly not conjure up by magic the compelling beliefs which command authority. Analyses like Bell's, therefore, only result in an attitude which is spreading in Germany no less than in the States: an intellectual and political confrontation with the carriers of cultural modernity. I cite Peter Steinfels, an observer of the new style which the neoconservatives have imposed upon the intellectual scene in the 1970s:

> The struggle takes the form of exposing every manifestation of what could be considered an oppositionist mentality and tracing its "logic" so as to link it to various forms of extremism: drawing the connection between modernism and nihilism...between government regulation and totalitarianism, between criticism of arms expenditures and subservience to communism, between Women's liberation or homosexual rights and the destruction of the family...between the Left generally and terrorism, anti-semitism, and fascism....[4]

The *ad hominem* approach and the bitterness of these intellectual accusations have also been trumpeted loudly in Germany. They should not be explained so much in terms of the psychology of neoconservative writers; rather, they are rooted in the analytical weaknesses of neoconservative doctrine itself.

3. For Paz on the avant-garde see in particular *Children of the Mire: Modern Poetry from Romanticism to the Avant-Garde* (Cambridge: Harvard University Press, 1974), pp. 148-64. For Bürger see *Theory of the Avant-Garde* (Minneapolis: University of Minnesota Press, Fall 1983). [Ed.]

4. Peter Steinfels, *The Neoconservatives* (New York: Simon and Schuster, 1979), p. 65.

Neoconservatism shifts onto cultural modernism the uncomfortable burdens of a more or less successful capitalist modernization of the economy and society. The neoconservative doctrine blurs the relationship between the welcomed process of societal modernization on the one hand, and the lamented cultural development on the other. The neoconservative does not uncover the economic and social causes for the altered attitudes towards work, consumption, achievement and leisure. Consequently, he attributes all of the following—hedonism, the lack of social identification, the lack of obedience, narcissism, the withdrawal from status and achievement competition—to the domain of "culture." In fact, however, culture is intervening in the creation of all these problems in only a very indirect and mediated fashion.

In the neoconservative view, those intellectuals who still feel themselves committed to the project of modernity are then presented as taking the place of those unanalyzed causes. The mood which feeds neoconservatism today in no way originates from discontent about the antinomian consequences of a culture breaking from the museums into the stream of ordinary life. This discontent has not been called into life by modernist intellectuals. It is rooted in deep-seated reactions against the process of *societal* modernization. Under the pressures of the dynamics of economic growth and the organizational accomplishments of the state, this social modernization penetrates deeper and deeper into previous forms of human existence. I would describe this subordination of the life-worlds under the system's imperatives as a matter of disturbing the communicative infrastructure of everyday life.

Thus, for example, neopopulist protests only express in pointed fashion a widespread fear regarding the destruction of the urban and natural environment and of forms of human sociability. There is a certain irony about these protests in terms of neoconservatism. The tasks of passing on a cultural tradition, of social integration and of socialization require adherence to what I call communicative rationality. But the occasions for protest and discontent originate precisely when spheres of communicative action, centered on the reproduction and transmission of values and norms, are penetrated

by a form of modernization guided by standards of economic and administrative rationality—in other words, by standards of rationalization quite different from those of communicative rationality on which those spheres depend. But neoconservative doctrines turn our attention precisely away from such societal processes: they project the causes, which they do not bring to light, onto the plane of a subversive culture and its advocates.

To be sure, cultural modernity generates its own aporias as well. Independently from the consequences of *societal* modernization and within the perspective of *cultural* development itself, there originate motives for doubting the project of modernity. Having dealt with a feeble kind of criticism of modernity—that of neoconservatism—let me now move our discussion of modernity and its discontents into a different domain that touches on these aporias of cultural modernity—issues that often serve only as a pretense for those positions which either call for a postmodernity, recommend a return to some form of premodernity, or throw modernity radically overboard.

The Project of Enlightenment

The idea of modernity is intimately tied to the development of European art, but what I call "the project of modernity" comes only into focus when we dispense with the usual concentration upon art. Let me start a different analysis by recalling an idea from Max Weber. He characterized cultural modernity as the separation of the substantive reason expressed in religion and metaphysics into three autonomous spheres. They are: science, morality and art. These came to be differentiated because the unified world-views of religion and metaphysics fell apart. Since the 18th century, the problems inherited from these older world-views could be arranged so as to fall under specific aspects of validity: truth, normative rightness, authenticity and beauty. They could then be handled as questions of knowledge, or of justice and morality, or of taste. Scientific discourse, theories of morality, jurisprudence, and the production and criticism of art could in turn be institutionalized. Each domain of culture could be made to correspond to cultural professions

in which problems could be dealt with as the concern of special experts. This professionalized treatment of the cultural tradition brings to the fore the intrinsic structures of each of the three dimensions of culture. There appear the structures of cognitive-instrumental, of moral-practical and of aesthetic-expressive rationality, each of these under the control of specialists who seem more adept at being logical in these particular ways than other people are. As a result, the distance grows between the culture of the experts and that of the larger public. What accrues to culture through specialized treatment and reflection does not immediately and necessarily become the property of everyday praxis. With cultural rationalization of this sort, the threat increases that the life-world, whose traditional substance has already been devalued, will become more and more impoverished.

The project of modernity formulated in the 18th century by the philosophers of the Enlightenment consisted in their efforts to develop objective science, universal morality and law, and autonomous art according to their inner logic. At the same time, this project intended to release the cognitive potentials of each of these domains from their esoteric forms. The Enlightenment philosophers wanted to utilize this accumulation of specialized culture for the enrichment of everyday life—that is to say, for the rational organization of everyday social life.

Enlightenment thinkers of the cast of mind of Condorcet still had the extravagant expectation that the arts and sciences would promote not only the control of natural forces but also understanding of the world and of the self, moral progress, the justice of institutions and even the happiness of human beings. The 20th century has shattered this optimism. The differentiation of science, morality and art has come to mean the autonomy of the segments treated by the specialist and their separation from the hermeneutics of everyday communication. This splitting off is the problem that has given rise to efforts to "negate" the culture of expertise. But the problem won't go away: should we try to hold on to the *intentions* of the Enlightenment, feeble as they may be, or should we declare the entire project of modernity a lost cause? I now want to return to the problem of artistic culture, having explained why, historically, aesthetic modernity is only a part of cultural modernity in general.

The False Programs of the Negation of Culture

Greatly oversimplifying, I would say that in the history of modern art one can detect a trend towards ever greater autonomy in the definition and practice of art. The category of "beauty" and the domain of beautiful objects were first constituted in the Renaissance. In the course of the 18th century, literature, the fine arts and music were institutionalized as activities independent from sacred and courtly life. Finally, around the middle of the 19th century an aestheticist conception of art emerged, which encouraged the artist to produce his work according to the distinct consciousness of art for art's sake. The autonomy of the aesthetic sphere could then become a deliberate project: the talented artist could lend authentic expression to those experiences he had in encountering his own de-centered subjectivity, detached from the constraints of routinized cognition and everyday action.

In the mid-19th century, in painting and literature, a movement began which Octavio Paz finds epitomized already in the art criticism of Baudelaire. Color, lines, sounds and movement ceased to serve primarily the cause of representation; the media of expression and the techniques of production themselves became the aesthetic object. Theodor W. Adorno could therefore begin his *Aesthetic Theory* with the following sentence: "It is now taken for granted that nothing which concerns art can be taken for granted any more: neither art itself, nor art in its relationship to the whole, nor even the right of art to exist." And this is what surrealism then denied: *das Existenzrecht der Kunst als Kunst*. To be sure, surrealism would not have challenged the right of art to exist, if modern art no longer had advanced a promise of happiness concerning its own relationship "to the whole" of life. For Schiller, such a promise was delivered by aesthetic intuition, but not fulfilled by it. Schiller's *Letters on the Aesthetic Education of Man* speaks to us of a utopia reaching beyond art itself. But by the time of Baudelaire, who

repeated this *promesse de bonheur* via art, the utopia of reconciliation with society had gone sour. A relation of opposites had come into being; art had become a critical mirror, showing the irreconcilable nature of the aesthetic and the social worlds. This modernist transformation was all the more painfully realized, the more art alienated itself from life and withdrew into the untouchableness of complete autonomy. Out of such emotional currents finally gathered those explosive energies which unloaded in the surrealist attempt to blow up the autarkical sphere of art and to force a reconciliation of art and life.

But all those attempts to level art and life, fiction and praxis, appearance and reality to one plane; the attempts to remove the distinction between artifact and object of use, between conscious staging and spontaneous excitement; the attempts to declare everything to be art and everyone to be an artist, to retract all criteria and to equate aesthetic judgment with the expression of subjective experiences—all these undertakings have proved themselves to be sort of nonsense experiments. These experiments have served to bring back to life, and to illuminate all the more glaringly, exactly those structures of art which they were meant to dissolve. They gave a new legitimacy, as ends in themselves, to appearance as the medium of fiction, to the transcendence of the artwork over society, to the concentrated and planned character of artistic production as well as to the special cognitive status of judgements of taste. The radical attempt to negate art has ended up ironically by giving due exactly to these categories through which Enlightenment aesthetics had circumscribed its object domain. The surrealists waged the most extreme warfare, but two mistakes in particular destroyed their revolt. First, when the containers of an autonomously developed cultural sphere are shattered, the contents get dispersed. Nothing remains from a desublimated meaning or a destructured form; and emancipatory effect does not follow.

Their second mistake has more important consequences. In everyday communication, cognitive meanings, moral expectations, subjective expressions and evaluations must relate to one another. Communication processes need a cultural tradition covering all spheres—cognitive, moral-practical and

expressive. A rationalized everyday life, therefore, could hardly be saved from cultural impoverishment through breaking open a single cultural sphere—art—and so providing access to just one of the specialized knowledge complexes. The surrealist revolt would have replaced only one abstraction.

In the spheres of theoretical knowledge and morality, there are parallels to this failed attempt of what we might call the false negation of culture. Only they are less pronounced. Since the days of the Young Hegelians, there has been talk about the negation of philosophy. Since Marx, the question of the relationship of theory and practice has been posed. However, Marxist intellectuals joined a social movement; and only at its peripheries were there sectarian attempts to carry out a program of the negation of philosophy similar to the surrealist program to negate art. A parallel to the surrealist mistakes becomes visible in these programs when one observes the consequences of dogmatism and of moral rigorism.

A reified everyday praxis can be cured only by creating unconstrained interaction of the cognitive with the moral-practical and the aesthetic-expressive elements. Reification cannot be overcome by forcing just one of those highly stylized cultural spheres to open up and become more accessible. Instead, we see under certain circumstances a relationship emerge between terroristic activities and the over-extension of any one of these spheres into other domains: examples would be tendencies to aestheticize politics, or to replace politics by moral rigorism or to submit it to the dogmatism of a doctrine. These phenomena should not lead us, however, into denouncing the intentions of the surviving Enlightenment tradition as intentions rooted in a "terroristic reason."[5] Those who lump together the very project of modernity with the state of consciousness and the spectacular action of the individual terrorist are no less short-sighted than those who

5. The phrase "to aestheticize politics" echoes Benjamin's famous formulation of the false social program of the fascists in "The Work of Art in the Age of Mechanical Reproduction." Habermas's criticism here of Enlightenment critics seems directed less at Adorno and Max Horkheimer than at the contemporary *nouveaux philosophes* (Bernard-Henri Lèvy, etc.) and their German and American counterparts. [Ed.]

would claim that the incomparably more persistent and extensive bureaucratic terror practiced in the dark, in the cellars of the military and secret police, and in camps and institutions, is the raison d'être of the modern state, only because this kind of administrative terror makes use of the coercive means of modern bureaucracies.

Alternatives

I think that instead of giving up modernity and its project as a lost cause, we should learn from the mistakes of those extravagant programs which have tried to negate modernity. Perhaps the types of reception of art may offer an example which at least indicates the direction of a way out.

Bourgeois art had two expectations at once from its audiences. On the one hand, the layman who enjoyed art should educate himself to become an expert. On the other hand, he should also behave as a competent consumer who uses art and relates aesthetic experiences to his own life problems. This second, and seemingly harmless, manner of experiencing art has lost its radical implications exactly because it had a confused relation to the attitude of being expert and professional.

To be sure, artistic production would dry up, if it were not carried out in the form of a specialized treatment of autonomous problems and if it were to cease to be the concern of experts who do not pay so much attention to exoteric questions. Both artists and critics accept thereby the fact that such problems fall under the spell of what I earlier called the "inner logic" of a cultural domain. But this sharp delineation, this exclusive concentration on one aspect of validity alone and the exclusion of aspects of truth and justice, break down as soon as aesthetic experience is drawn into an individual life history and is absorbed into ordinary life. The reception of art by the layman, or by the "everyday expert," goes in a rather different direction than the reception of art by the professional critic.

Albrecht Wellmer has drawn my attention to one way that an aesthetic experience which is not framed around the experts' critical judgments of taste can have its significance altered: as soon as such an experience is used to illuminate a life-historical situation and is related to life problems, it enters into a language game which is no longer that of the aesthetic critic. The aesthetic experience then not only renews the interpretation of our needs in whose light we perceive the world. it permeates as well our cognitive significations and our normative expectations and changes the manner in which all these moments refer to one another. Let me give an example of this process.

This manner of receiving and relating to art is suggested in the first volume of the work *The Aesthetics of Resistance* by the German-Swedish writer Peter Weiss. Weiss describes the process of reappropriating art by presenting a group of politically motivated, knowledge-hungry workers in 1937 in Berlin.[6] These were young people who, through an evening highschool education, acquired the intellectual means to fathom the general and social history of European art. Out of the resilient edifice of this objective mind, embodied in works of art which they saw again and again in the museums in Berlin, they started removing their own chips of stone, which they gathered together and reassembled in the context of their own milieu. This milieu was far removed from that of traditional education as well as from the then existing regime. These young workers went back and forth between the edifice of European art and their own milieu until they were able to illuminate both.

In examples like this which illustrate the reappropriation of the expert's culture from the standpoint of the life-world, we can discern an element which does justice to the intentions of the hopeless surrealist revolts, perhaps even more to Brecht's and Benjamin's interests in how art works, which having lost their aura, could yet be received in illuminating ways. In sum, the project of modernity has not yet been fulfilled. And the reception of art is only one of at least three of its aspects. The project aims at a differentiated relinking of modern culture with an

6. The reference is the novel *Die Asthetik des Widerstands* (1975-8) by the author perhaps best known here for his 1964 play Marat/Sade. The work of art "reappropriated" by the workers is the Pergamon altar, emblem of power, classicism and rationality. [Ed.]

everyday praxis that still depends on vital heritages, but would be impoverished through mere traditionalism. This new connection, however, can only be established under the condition that societal modernization will also be steered in a different direction. The life-world has to become able to develop institutions out of itself which set limits to the internal dynamics and imperatives of an almost autonomous economic system and its administrative complements.

If I am not mistaken, the chances for this today are not very good. More or less in the entire Western world a climate has developed that furthers capitalist modernization processes as well as trends critical of cultural modernism. The disillusionment with the very failures of those programs that called for the negation of art and philosophy has come to serve as a pretense for conservative positions. Let me briefly distinguish the antimodernism of the "young conservatives" from the premodernism of the "old conservatives" and from the postmodernism of the neoconservatives.

The "young conservatives" recapitulate the basic experience of aesthetic modernity. They claim as their own the revelations of a decentered subjectivity, emancipated from the imperatives of work and usefulness, and with this experience they step outside the modern world. On the basis of modernistic attitudes they justify an irreconcilable antimodernism. They remove into the sphere of the far-away and the archaic the spontaneous powers of imagination, self-experience and emotion. To instrumental reason they juxtapose in Manichean fashion a principle only accessible through evocation, be it the will to power or sovereignty, Being or the Dionysiac force of the poetical. In France this line leads from Georges Bataille via Michel Foucault to Jacques Derrida.

The "old conservatives" do not allow themselves to be contaminated by cultural modernism. They observe the decline of substantive reason, the merely procedural rationality, with sadness and recommend a withdrawal to a position *anterior* to modernity. Neo-Aristotelianism, in particular, enjoys a certain success today. In view of the problematic of ecology, it allows itself to call for a cosmological ethic. (As belonging to this school, which originates itself with Leo Strauss, one can count the interesting works of Hans Jonas and Robert Spaemann.)

Finally, the neoconservatives welcome the development of modern science, as long as this only goes beyond its sphere to carry forward technical progress, capitalist growth and rational administration. Moreover, they recommend a politics of defusing the explosive content of cultural modernity. According to one thesis, science, when properly understood, has become irrevocably meaningless for the orientation of the life-world. A further thesis is that politics must be kept as far aloof as possible from the demands of moral-practical justification. And a third thesis asserts the pure immanence of art, disputes that it has a utopian content, and points to its illusory character in order to limit the aesthetic experience to privacy. (One could name here the early Wittgenstein, Carl Schmitt of the middle period, and Gottfried Benn of the late period.) But with the decisive confinement of science, morality and art to autonomous spheres separated from the life-world and administered by experts, what remains from the project of cultural modernity is only what we would have if we were to give up the project of modernity altogether. As a replacement one points to traditions which, however, are held to be immune to demands of (normative) justification and validation.

This typology is like any other, of course, a simplification, but it may not prove totally useless for the analysis of contemporary intellectual and political confrontations. I fear that the ideas of antimodernity, together with an additional touch of premodernity, are becoming popular in the circles of alternative culture. When one observes the transformations of consciousness within political parties in Germany, a new ideological shift (*Tendenzwende*) becomes visible. And this is the alliance of postmodernists with premodernists. It seems to me that there is no party in particular that monopolizes the abuse of intellectuals and the position of neoconservatism. I therefore have good reason to be thankful for the liberal spirit in which the city of Frankfurt offers me a prize bearing the name of Theodor Adorno, a most significant son of this city, who as philosopher and writer has stamped the image of the intellectual in our country in incomparable fashion, who, even more, has become the very image of emulation for the intellectual.

Jean-François Lyotard (1925-)

Answering the Question: What is Postmodernism?

Translated by Régis Durand

A Demand

There is a period of slackening—I refer to the color of the times. From every direction we are being urged to put an end to experimentation, in the arts and elsewhere. I have read an art historian who extols realism and is militant for the advent of a new subjectivity. I have read an art critic who packages and sells "Transavantgardism" in the marketplace of painting. I have read that under the name of postmodernism, architects are getting rid of the Bauhaus project, throwing out the baby of experimentation with the bathwater of functionalism. I have read that a new philosopher is discovering what he drolly calls Judaeo-Christianism, and intends by it to put an end to the impiety which we are supposed to have spread. I have read in a French weekly that some are displeased with *Mille Plateaux* [by Deleuze and Guattari] because they expect, especially when reading a work of philosophy, to be gratified with a little sense. I have read from the pen of a reputable historian that writers and thinkers of the 1960 and 1970 avant-gardes spread a reign of terror in the use of language, and that the conditions for a fruitful exchange must be restored by imposing on the intellectuals a common way of speaking, that of the historians. I have been reading a young philosopher of language who complains that Continental thinking, under the challenge of speaking machines, has surrendered to the machines the concern for reality, that it has substituted for the referential paradigm that of "adlinguisticity" (one speaks about speech, writes about writing, intertextuality), and who thinks that the time has now come to restore a solid anchorage of language in the referent. I

have read a talented theatrologist for whom postmodernism, with its games and fantasies, carries very little weight in front of political authority, especially when a worried public opinion encourages authority to a politics of totalitarian surveillance in the face of nuclear warfare threats.

I have read a thinker of repute who defends modernity against those he calls the neoconservatives. Under the banner of postmodernism, the latter would like, he believes, to get rid of the uncompleted project of modernism, that of the Enlightenment. Even the last advocates of *Aufklärung*, such as Popper or Adorno, were only able, according to him, to defend the project in a few particular spheres of life—that of politics for the author of *The Open Society*, and that of art for the author of *Ästhetische Theorie*. Jürgen Habermas (everyone had recognized him) thinks that if modernity has failed, it is in allowing the totality of life to be splintered into independent specialties which are left to the narrow competence of experts, while the concrete individual experiences "desublimated meaning" and "deconstructed form," not as a liberation but in the mode of that immense ennui which Baudelaire described over a century ago.

Following a prescription of Albrecht Wellmer, Habermas considers that the remedy for this splintering of culture and its separation from life can only come from "changing the status of aesthetic experience when it is no longer primarily expressed in judgments of taste," but when it is "used to explore a living historical situation," that is, when "it is put in relation with problems of existence." For this experience

then "becomes a part of a language game which is no longer that of aesthetic criticism"; it takes part "in cognitive processes and normative expectations"; "it alters the manner in which those different moments *refer* to one another." What Habermas requires from the arts and the experiences they provide is, in short, to bridge the gap between cognitive, ethical, and political discourses, thus opening the way to a unity of experience.

My question is to determine what sort of unity Habermas has in mind. Is the aim of the project of modernity the constitution of sociocultural unity within which all the elements of daily life and of thought would take their places as in an organic whole? Or does the passage that has to be charted between heterogeneous language games—those of cognition, of ethics, of politics—belong to a different order from that? And if so, would it be capable of effecting a real synthesis between them?

The first hypothesis, of a Hegelian inspiration, does not challenge the notion of a dialectically totalizing *experience*; the second is closer to the spirit of Kant's *Critique of Judgment*; but must be submitted, like the *Critique*, to that severe reexamination which postmodernity imposes on the thought of the Enlightenment, on the idea of a unitary end of history and of a subject. It is this critique which not only Wittgenstein and Adorno have initiated, but also a few other thinkers (French or other) who do not have the honor to be read by Professor Habermas—which at least saves them from getting a poor grade for their neoconservatism.

Realism

The demands I began by citing are not all equivalent. They can even be contradictory. Some are made in the name of postmodernism, others in order to combat it. It is not necessarily the same thing to formulate a demand for some referent (and objective reality), for some sense (and credible transcendence), for an addressee (and audience), or an addressor (and subjective expressiveness) or for some communicational consensus (and a general code of exchanges, such as the genre of historical discourse). But in the diverse invitations to suspend artistic experimentation, there is an identical call for order, a desire for unity, for identity, for security, or popularity (in the sense of *Öffentlichkeit*, of "finding a public"). Artists and writers must be brought back into the bosom of the community, or at least, if the latter is considered to be ill, they must be assigned the task of healing it.

There is an irrefutable sign of this common disposition: it is that for all those writers nothing is more urgent than to liquidate the heritage of the avant-gardes. Such is the case, in particular, of the so-called transavantgardism. The answers given by Achille Bonito Oliva to the questions asked by Bernard Lamarche-Vadel and Michel Enric leave no room for doubt about this. By putting the avant-gardes through a mixing process, the artist and critic feel more confident that they can suppress them than by launching a frontal attack. For they can pass off the most cynical eclecticism as a way of going beyond the fragmentary character of the preceding experiments; whereas if they openly turned their backs on them, they would run the risk of appearing ridiculously neoacademic. The *Salons* and the *Académies*, at the same time when the bourgeoisie was establishing itself in history, were able to function as purgation and to grant awards for good plastic and literary conduct under the cover of realism. But capitalism inherently possesses the power to derealize familiar objects, social roles, and institutions to such a degree that the so-called realistic representations can no longer evoke reality except as nostalgia or mockery, as an occasion for suffering rather than for satisfaction. Classicism seems to be ruled out in a world in which reality is so destabilized that it offers no occasion for experience but one for ratings and experimentation.

This theme is familiar to all readers of Walter Benjamin. But it is necessary to assess its exact reach. Photography did not appear as a challenge to painting from the outside, any more than industrial cinema did to narrative literature. The former was only putting the final touch to the program of ordering the visible elaborated by the quattrocento; while the latter was the last step in rounding off diachronies as organic wholes, which had been the ideal of the great novels of education since the eighteenth century. That

the mechanical and the industrial should appear as substitutes for hand or craft was not in itself a disaster—except if one believes that art is in its essence the expression of an individuality of genius assisted by an elite craftsmanship.

The challenge lay essentially in that photographic and cinematographic processes can accomplish better, faster, and with a circulation a hundred thousand times larger than narrative or pictorial realism, the task which academicism had assigned to realism: to preserve various consciousnesses from doubt. Industrial photography and cinema will be superior to painting and the novel whenever the objective is to stabilize the referent, to arrange it according to a point of view which endows it with a recognizable meaning, to reproduce the syntax and vocabulary which enable the addressee to decipher images and sequences quickly, and so to arrive easily at the consciousness of his own identity as well as the approval which he thereby receives from others—since structures of images and sequences constitute a communication code among all of them. This is the way the effects of reality, or if one prefers, the fantasies of realism, multiply.

If they too do not wish to become supporters (of minor importance at that) of what exists, the painter and novelist must refuse to lend themselves to such therapeutic uses. They must question the rules of the art of painting or of narrative as they have learned and received them from their predecessors. Soon those rules must appear to them as a means to deceive, to seduce, and to reassure, which makes it impossible for them to be "true." Under the common name of painting and literature, an unprecedented split is taking place. Those who refuse to reexamine the rules of art pursue successful careers in mass conformism by communicating, by means of the "correct rules," the endemic desire for reality with objects and situations capable of gratifying it. Pornography is the use of photography and film to such an end. It is becoming a general model for the visual or narrative arts which have not met the challenge of the mass media.

As for the artists and writers who question the rules of plastic and narrative arts and possibly share their suspicions by circulating their work, they are destined to have little credibility in the eyes of those concerned with "reality" and "identity"; they have no guarantee of an audience. Thus it is possible to ascribe the dialectics of the avant-gardes to the challenge posed by the realisms of industry and mass communication to painting and the narrative arts. Duchamp's "ready made" does nothing but actively and parodistically signify this constant process of dispossession of the craft of painting or even of being an artist. As Thierry de Duve penetratingly observes, the modern aesthetic question is not "What is beautiful?" but "What can be said to be art (and literature)?"

Realism, whose only definition is that it intends to avoid the question of reality implicated in that of art, always stands somewhere between academicism and kitsch. When power assumes the name of a party, realism and its neoclassical complement triumph over the experimental avant-garde by slandering and banning it—that is, provided the "correct" images, the "correct" narratives, the "correct" forms which the party requests, selects, and propagates can find a public to desire them as the appropriate remedy for the anxiety and depression that public experiences. The demand for reality—that is, for unity, simplicity, communicability, etc.—did not have the same intensity not the same continuity in German society between the two world wars and in Russion society after the Revolution: this provides a basis for a distinction between Nazi and Stalinist realism.

What is clear, however, is that when it is launched by the political apparatus, the attack on artistic experimentation is specifically reactionary: aesthetic judgment would only be required to decide whether such or such a work is in conformity with the established rules of the beautiful. Instead of the work of art having to investigate what makes it an art object and whether it will be able to find an audience, political academicism possesses and imposes a priori criteria of the beautiful, which designate some works and a public at a stroke and forever. The use of categories in aesthetic judgment would thus be of the same nature as in cognitive judgment. To speak like Kant, both would be determining judgments: the expression is "well formed" first in the understanding,

then the only cases retained in experience are those which can be subsumed under this expression.

When power is that of capital and not that of a party, the "transavantgardist" or "postmodern" (in Jencks's sense) solution proves to be better adapted than the antimodern solution. Eclecticism is the degree zero of contemporary general culture: one listens to reggae, watches a western, eats McDonald's food for lunch and local cuisine for dinner, wears Paris perfume in Tokyo and "retro" clothes in Hong Kong; knowledge is a matter for TV games. It is easy to find a public for eclectic works. By becoming kitsch, art panders to the confusion which reigns in the "taste" of the patrons. Artists, gallery owners, critics, and public wallow together in the "anything goes," and the epoch is one of slackening. But this realism of the "anything goes" is in fact that of money; in the absence of aesthetic criteria, it remains possible and useful to assess the value of works of art according to the profits they yield. Such realism accommodates all tendencies, just as capital accommodates all "needs," providing that the tendencies and needs have purchasing power. As for taste, there is no need to be delicate when one speculates or entertains oneself.

Artistic and literary research is doubly threatened, once by the "cultural policy" and once by the art and book market. What is advised, sometimes through one channel, sometimes through the other, is to offer works which, first, are relative to subjects which exist in the eyes of the public they address, and second, works so made ("well made") that the public will recognize what they are about, will understand what is signified, will be able to give or refuse its approval knowingly, and if possible, even to derive from such work a certain amount of comfort.

The interpretation which has just been given of the contact between the industrial and mechanical arts, and literature and the fine arts is correct in its outline, but it remains narrowly sociologizing and historicizing—in other words, one-sided. Stepping over Benjamin's and Adorno's reticences, it must be recalled that science and industry are no more free of the suspicion which concerns reality than are art and writing. To believe otherwise would be to entertain an excessively humanistic notion of the mephistophelian functionalism of sciences and technologies. There is no denying the dominant existence today of techno-science, that is, the massive subordination of cognitive statements to the finality of the best possible performance, which is the technological criterion. But the mechanical and the industrial, especially when they enter fields traditionally reserved for artists, are carrying with them much more than power effects. The objects and the thoughts which originate in scientific knowledge and the capitalist economy convey with them one of the rules which supports their possibility: the rule that there is no reality unless testified by a consensus between partners over a certain knowledge and certain commitments.

This rule is of no little consequence. It is the imprint left on the politics of the scientist and the trustee of capital by a kind of flight of reality out of the metaphysical, religious, and political certainties that the mind believed it held. This withdrawal is absolutely necessary to the emergence of science and capitalism. No industry is possible without a suspicion of the Aristotelian theory of motion, no industry without a refutation of corporatism, of mercantilism, and of physiocracy. Modernity, in whatever age it appears, cannot exist without a shattering of belief and without discovery of the "lack of reality" of reality, together with the invention of other realities.

What does this "lack of reality" signify if one tries to free it from a narrowly historicized interpretation? The phrase is of course akin to what Nietzsche calls nihilism. But I see a much earlier modulation of Nietzschean perspectivism in the Kantian theme of the sublime. I think in particular that it is in the aesthetic of the sublime that modern art (including literature) finds its impetus and the logic of avant-gardes finds its axioms.

The sublime sentiment, which is also the sentiment of the sublime, is, according to Kant, a strong and equivocal emotion: it carries with it both pleasure and pain. Better still, in it pleasure derives from pain. Within the tradition of the subject, which comes from Augustine and Descartes and which Kant does not radically challenge, this contradiction,

which some would call neurosis or masochism, develops as a conflict between the faculties of a subject, the faculty to conceive of something and the faculty to "present" something. Knowledge exists if, first, the statement is intelligible, and second, if "cases" can be derived from the experience which "corresponds" to it. Beauty exists if a certain "case" (the work of art), given first by the sensibility without any conceptual determination, the sentiment of pleasure independent of any interest the work may elicit, appeals to the principle of a universal consensus (which may never be attained).

Taste, therefore, testifies that between the capacity to conceive and the capacity to present an object corresponding to the concept, an undetermined agreement, without rules, giving rise to a judgment which Kant calls reflective, may be experienced as pleasure. The sublime is a different sentiment. It takes place, on the contrary, when the imagination fails to present an object which might, if only in principle, come to match a concept. We have the Idea of the world (the totality of what is), but we do not have the capacity to show an example of it. We have the Idea of the simple (that which cannot be broken down, decomposed), but we cannot illustrate it with a sensible object which would be a "case" of it. We can conceive the infinitely great, the infinitely powerful, but every presentation of an object destined to "make visible" this absolute greatness or power appears to us painfully inadequate. Those are Ideas of which no presentation is possible. Therefore, they impart no knowledge about reality (experience); they also prevent the free union of the faculties which gives rise to the sentiment of the beautiful; and they prevent the formation and the stabilization of taste. They can be said to be unpresentable.

I shall call modern the art which devotes its "little technical expertise" (son "petit technique"), as Diderot used to say, to present the fact that the unpresentable exists. To make visible that there is something which can be conceived and which can neither be seen nor made visible: this is what is at stake in modern painting. But how to make visible that there is something which cannot be seen? Kant himself shows the way when he names "formlessness, the absence of form," as a possible index to the unpresentable. He also says of the empty "abstraction" which the imagination experiences when in search for a presentation of the infinite (another unpresentable): this abstraction itself is like a presentation of the infinite, its "negative presentation." He cites the commandment, "Thou shalt not make graven images" (Exodus), as the most sublime passage in the Bible in that it forbids all presentation of the Absolute. Little needs to be added to those observations to outline an aesthetic of sublime paintings. As painting, it will of course "present" something though negatively; it will therefore avoid figuration or representation. It will be "white" like the ones of Malevitch's squares; it will enable us to see only by making it impossible to see; it will please only by causing pain. One recognizes in those instructions the axioms of avant-gardes in painting, inasmuch as they devote themselves to making an allusion to the unpresentable by means of visible presentations. The systems in the name of which, or with which, this task has been able to support or to justify itself deserve the greatest attention; but they can originate only in the vocation of the sublime in order to legitimize it, that is, to conceal it. They remain inexplicable without the incommensurability of reality to concept which is implied in the Kantian philosophy of the sublime.

It is not my intention to analyze here in detail the manner in which the various avant-gardes have, so to speak, humbled and disqualified reality by examining the pictorial techniques which are so many devices to make us believe in it. Local tone, drawing, the mixing of colors, linear perspective, the nature of the support and that of the instrument, the treatment, the display, the museum: the avant-gardes are perpetually flushing out artifices of presentation which make it possible to subordinate thought to the gaze and to turn it away from the unpresentable. If Habermas, like Marcuse, understands this task of derealization as an aspect of the (repressive) "desublimation" which characterizes the avant-garde, it is because he confuses the Kantian sublime with Freudian sublimation, and because aesthetics has remained for him that of the beautiful.

The Postmodern

What, then, is the postmodern? What place does it or does it not occupy in the vertiginous work of the questions hurled at the rules of image and narration? It is undoubtedly a part of the modern. All that has been received, if only yesterday (*modo, modo*, Petronius used to say), must be suspected. What space does Cézanne challenge? The Impressionists'. What object do Picasso and Braque attack? Cézanne's. What presupposition does Duchamp break with in 1912? That which says one must make a painting, be it cubist. And Buren questions that other presupposition which he believes had survived untouched by the work of Duchamp: the place of presentation of the work. In an amazing acceleration, the generations precipitate themselves. A work can become modern only if it is first postmodern. Postmodernism thus understood is not modernism at its end but in the nascent state, and this state is constant.

Yet I would like not to remain with this slightly mechanistic meaning of the word. If it is true that modernity takes place in the withdrawal of the real and according to the sublime relation between the presentable and the conceivable, it is possible, within this relation, to distinguish two modes (to use the musician's language). The emphasis can be placed on the powerlessness of the faculty of presentation, on the nostalgia for presence felt by the human subject, on the obscure and futile will which inhabits him in spite of everything. The emphasis can be placed, rather, on the power of the faculty to conceive, on its "inhumanity" so to speak (it was the quality Apollinaire demanded of modern artists), since it is not the business of our understanding whether or not human sensibility or imagination can match what it conceives. The emphasis can also be placed on the increase of being and the jubilation which result from the invention of new rules of the game, be it pictorial, artistic, or any other. What I have in mind will become clear if we dispose very schematically a few names on the chessboard of the history of avant-gardes: on the side of melancholia, the German Expressionists, and on the side of *novatio*, Braque and Picasso, on the former Malevitch and on the latter Lissitsky, on the one

Chirico and on the other Duchamp. The nuance which distinguishes these two modes may be infinitesimal; and yet they testify to a difference (*un différend*) on which the fate of thought depends and will depend for a long time, between regret and assay.

The work of Proust and that of Joyce both allude to something which does not allow itself to be made present. Allusion, to which Paolo Fabbri recently called my attention, is perhaps a form of expression indispensable to the works which belong to an aesthetic of the sublime. In Proust, what is being eluded as the price to pay for this allusion is the identity of consciousness, a victim to the excess of time (*au trop de temps*). But in Joyce, it is the identity of writing which is the victim of an excess of the book (*au trop de livre*) or of literature.

Proust calls forth the unpresentable by means of a language unaltered in its syntax and vocabulary and of a writing which in many of its operators still belongs to the genre of novelistic narration. The literary institution, as Proust inherits it from Balzac and Flaubert, is admittedly subverted in that the hero is no longer a character but the inner consciousness of time, and in that the diegetic diachrony, already damaged by Flaubert, is here put in question because of the narrative voice. Nevertheless, the unity of the book, the odyssey of that consciousness, even if it is deferred from chapter to chapter, is not seriously challenged: the identity of the writing with itself throughout the labyrinth of the interminable narration is enough to connote such unity, which has been compared to that of *The Phenomenology of Mind*.

Joyce allows the unpresentable to become perceptible in his writing itself, in the signifier. The whole range of available narrative and even stylistic operators is put into play without concern for the unity of the whole, and new operators are tried. The grammar and vocabulary of literary language are no longer accepted as given; rather, they appear as academic forms, as rituals originating in piety (as Nietzsche said) which prevent the unpresentable from being put forward.

Here, then, lies the difference: modern aesthetics is an aesthetic of the sublime, though a nostalgic one. It allows the unpresentable to be put forward only

as the missing contents; but the form, because of its recognizable consistency, continues to offer to the reader or viewer matter for solace and pleasure. Yet these sentiments do not constitute the real sublime sentiment, which is in an intrinsic combination of pleasure and pain: the pleasure that reason should exceed all presentation, the pain that imagination or sensibility should not be equal to the concept.

The postmodern would be that which, in the modern, puts forward the unpresentable in presentation itself; that which denies itself the solace of good forms, the consensus of a taste which would make it possible to share collectively the nostalgia for the unattainable; that which searches for new presentations, not in order to enjoy them but in order to impart a stronger sense of the unpresentable. A postmodern artist or writer is in the position of a philosopher: the text he writes, the work he produces are not in principle governed by preestablished rules, and they cannot be judged according to a determining judgment, by applying familiar categories to the text or to the work. Those rules and categories are what the work of art itself is looking for. The artist and the writer, then, are working without rules in order to formulate the rules of what *will have been done*. Hence the fact that work and text have the characters of an *event*; hence also, they always come too late for their author, or, what amounts to the same thing, their being put into work, their realization (*mise en oeuvre*) always begin too soon. *Post modern* would have to be understood according to the paradox of the future (*post*) anterior (*modo*).

It seems to me that the essay (Montaigne) is postmodern, while the fragment (*The Athaeneum*) is modern.

Finally, it must be clear that it is our business not to supply reality but to invent allusions to the conceivable which cannot be presented. And it is not to be expected that this task will effect the last reconciliation between language games (which, under the name of faculties, Kant knew to be separated by a chasm), and that only the transcendental illusion (that of Hegel) can hope to totalize them into a real unity. But Kant also knew that the price to pay for such an illusion is terror. The nineteenth and twentieth centuries have given us as much terror as we can take. We have paid a high enough price for the nostalgia of the whole and the one, for the reconciliation of the concept and the sensible, of the transparent and the communicable experience. Under the general demand for slackening and for appeasement, we can hear the mutterings of the desire for a return of terror, for the realization of the fantasy to seize reality. The answer is: Let us wage a war on totality; let us be witnesses to the unpresentable; let us activate the differences and save the honor of the name.

Linda Hutcheon (1947-)

Representing the Postmodern

Selected from *The Politics of Postmodernism*

What is postmodernism?

Few words are more used and abused in discussions of contemporary culture than the word 'postmodernism.' As a result, any attempt to define the word will necessarily and simultaneously have both positive and negative dimensions. It will aim to say what postmodernism is but at the same time it will have to say what it is not. Perhaps this is an appropriate condition, for postmodernism is a phenomenon whose mode is resolutely contradictory as well as unavoidably political.

Postmodernism manifests itself in many fields of cultural endeavor—architecture, literature, photography, film, painting, video, dance, music, and elsewhere. In general terms it takes the form of self-conscious, self-contradictory, self-undermining statement. It is rather like saying something whilst at the same time putting inverted commas around what is being said. The effect is to highlight, or 'highlight,' and to subvert, or 'subvert,' and the mode is therefore a 'knowing' and an ironic—even 'ironic'—one. Postmodernism's distinctive character lies in this kind of wholesale 'nudging' commitment to doubleness, or duplicity. In many ways it is an even-handed process because postmodernism ultimately manages to install and reinforce as much as undermine and subvert the conventions and presuppositions it appears to challenge. Nevertheless, it seems reasonable to say that the postmodernism's initial concern is to de-naturalize some of the dominant features of our way of life; to point out that those entities that we unthinkingly experience as 'natural' (they might even include capitalism, patriarchy, liberal humanism) are in fact 'cultural'; made by us, not given to us. Even nature, postmodernism might point out, doesn't grow on trees.

This kind of definition may seem to run counter to the majority of those discussed in the opening chapter of this book. But its roots lie in the sphere in which the term 'postmodern' first found general usage: architecture. And there we find a further contradiction. It is one which juxtaposes and gives equal value to the self-reflexive and the historically grounded: to that which is inward-directed and belongs to the world of art (such as parody) and that which is outward-directed and belongs to 'real life' (such as history). The tension between these apparent opposites finally defines the paradoxically worldly texts of postmodernism. And it sparks, just as powerfully, their no less real, if ultimately compromised politics. Indeed it is their compromised stance which makes those politics recognizable and familiar to us. After all, their mode—that of complicitous critique—is for the most part our own.

Representation and its politics

A decade or so ago a German writer stated: 'I cannot keep politics out of the question of postmodernism.' Nor should he. The intervening years have shown that politics and postmodernism have made curious, if inevitable, bedfellows. For one thing, the debates on the definition and evaluation of the postmodern have been conducted largely in political—and negative—terms: primarily neoconservative and neoMarxist. Others on the left have seen, instead, its radical political *potential*, if not actuality, while feminist artists and theorists have resisted the incorporation of their work into postmodernism for

fear of recuperation and the attendant de-fusing of their own political agendas.

While these debates will not be the main focus of this study, they do form its unavoidable background. This is not so much a book about the representation of politics as an investigation of what postmodern theorist and photographer Victor Burgin calls the 'politics of representation.' Roland Barthes once claimed that it is impossible to represent the political, for it resists all mimetic copying. Rather, he said, 'where politics begins is where imitation ceases.' And this is where the self-reflexive, parodic art of the postmodern comes in, underlining in its ironic way the realization that all cultural forms of representation—literary, visual, aural—in high art or the mass media are ideologically grounded, that they cannot avoid involvement with social and political relations and apparatuses.

In saying this, I realize that I am going against a dominant trend in contemporary criticism that asserts that the postmodern is disqualified from political involvement because of its narcissistic and ironic appropriation of existing images and stories and its seemingly limited accessibility—to those who recognize the sources of parodic appropriation and understand the theory that motivates it. But, what this study of the forms and politics of postmodern representation aims to show is that such a stand is probably politically naive and, in fact, quite impossible to take in the light of the actual art of postmodernism. Postmodern art cannot but be political, at least in the sense that its representations—its images and stories—are anything but neutral, however 'aestheticized' they may appear to be in their parodic self-reflexivity. While the postmodern has no effective theory of agency that enables a move into political *action*, it does work to turn its inevitable ideological grounding into a site of de-naturalizing critique. To adapt Barthe's general notion of the 'doxa' as public opinion or the 'Voice of Nature' and consensus, postmodernism works to 'de-oxify' our cultural representations and their undeniable political import.

Umberto Eco has written that he considers postmodern 'the orientation of anyone who has learned the lesson of Foucault, i.e., that power is not something unitary that exists outside us.' He might well have added to this, as others have, the lessons learned from Derrida about textuality and deferral, or from Vattimo and Lyotard about intellectual mastery and its limits. In other words, it is difficult to separate the 'de-oxifying' impulse of postmodern art and culture from the deconstructing impulse of what we have labelled poststructuralist theory. A symptom of this inseparability can be seen in the way in which postmodern artists and critics speak about their 'discourses'—by which they mean to signal the inescapably political contexts in which they speak and work. When discourse is defined as the 'system of relations between parties engaged in communicative activity,' it points to politically uninnocent things—like the expectation of shared meaning—and it does so within a dynamic social context that acknowledges the inevitability of the existence of power relations in any social relations. As one postmodern theorist has put it: "Postmodern aesthetic experimentation should be viewed as having an irreducible political dimension. It is inextricably bound up with a critique of domination."

. . .

Postmodernity, postmodernism, and modernism

Much of the confusion surrounding the usage of the term postmodernism is due to the conflation of the cultural notion of postmodern*ism* (and its inherent relationship to modernism) and postmodern*ity* as the designation of a social and philosophical period or 'condition.' The latter has been variously defined in terms of the relationship between intellectual and state discourses; as a condition determined by universal, diffuse cynicism, by a panic sense of the hyperreal and the simulacrum. The manifest contradictions between some of these designations of postmodernity will not surprise anyone who enjoys generalizations about the present age. Nevertheless many do see postmodernity as involving a critique of humanism and positivism, and an investigation of the relation of both to our notions of subjectivity.

In philosophical circles, postmodernity has been the term used to situate theoretical positions as apparently diverse as Derrida's challenges to the western metaphysics of presence; Foucault's investigations of the complicities of discourse, knowledge, and power; Vattimo's paradoxically potent 'weak thought'; and Lyotard's questioning of the validity of the metanarratives of legitimation and emancipation. In the broadest of terms, these all share a view of discourse as problematic and of ordering systems as suspect (and as humanly constructed). The debate about postmodernity—and the confusion with postmodernism—seems to have begun with the exchange on the topic of modernity between Jürgen Habermas and Jean-François Lyotard. Both agreed that modernity could not be separated from notions of unity and universality or what Lyotard dubbed 'metanarratives.' Habermas argued that the project of modernity, rooted in the context of Enlightenment rationality, was still unfinished and required completion; Lyotard countered with the view that modernity has actually been liquidated by history, a history whose tragic paradigm was the Nazi concentration camp and whose ultimate delegitimizing force was that of capitalist 'technoscience' which has changed for ever our concepts of knowledge. Therefore, for Lyotard, postmodernity is characterized by no grand totalizing narrative, but by smaller and multiple narratives which seek no universalizing stabilization or legitimation. Fredric Jameson has pointed out that both Lyotard and Habermas are clearly working from different, though equally strong, legitimating 'narrative archetypes'—one French and (1789) Revolutionary in inspiration, the other Germanic and Hegelian; one valuing commitment, the other consensus. Richard Rorty has offered a trenchant critique of both positions, ironically noting that what they share is an almost overblown sense of the role of philosophy today. Attempting a more modest role that is ultimately postmodern—that of accepting the complicity of knowledge with power—Rorty's neopragmatism has been seen as bravely trying to bridge the seeming opposites.!

In a very real sense, though, such oppositions cannot be bridged quite so easily. Part of the difficulty is a matter of history: modernity in Habermas's Germany could be said to have been cut short by Nazism and thus indeed to be 'incomplete.' It would seem to be for this reason that Habermas opposes what he sees as postmodern historicism: for him, the 'radicalized consciousness of modernity' was able to free itself from history and therein lay its glory and its explosive content. In the specifically German context of this revolutionary view of modernity, the postmodern might well look neoconservative, as Habermas has claimed. But many have objected to Habermas's extension of his critique of local forces of anti-modernity outside that specific German context to include all postmodernity and postmodernism.

Lyotard's challenge to Habermas's definition of the postmodern has also come under serious scrutiny. In his introductory remarks to the English translation of *La Condition Postmoderne*, Jameson makes an attempt to rescue the notion of metanarrative from Lyotard's Habermas-inspired attack, partly because his own notion of postmodernity is itself a metanarrative one, based on Mandel's cultural periodization: in its simplest terms, market capitalism begat realism; monopoly capitalism begat modernism; and therefore multinational capitalism begets postmodernism. The slippage from postmodern*ity* to postmodern*ism* is constant and deliberate in Jameson's work: for him postmodernism *is* the 'cultural logic of late capitalism.' It replicates, reinforces, and intensifies the 'deplorable and reprehensible' socio-economic effects of postmodernity. Perhaps. But I want to argue that it also critiques those effects, while never pretending to be able to operate outside them.

The slippage to postmodern*ism* from postmodern*ity* is replicated in the very title of Jameson's influential 1984 article, 'Postmodernism, or the cultural logic of late capitalism.' Yet what is confusing is that Jameson retains the word postmodern*ism* for both the socio-economic periodization and the cultural designation. In his more recent work, he is adamant about defining postmodernism as both 'a whole set of aesthetic and cultural features and procedures' and 'the socioeconomic organization of our society commonly called late capitalism.' While the two are no doubt inextricably related, I would want to argue for their separation in the context of discourse. The verbal similarity of the terms postmodernity and

postmodernism signals their relationship overtly enough without either confusing the issue by using the same word to denote both or evading the issue by conflating the two in some sort of transparent causality. The relationship must be *argued*, not *assumed* by some verbal sleight of hand. My exhortation to keep the two separate is conditioned by my desire to show that critique is as important as complicity in the response of cultural postmodernism to the philosophical and socio-economic realities of postmodernity: postmodernism here is not so much what Jameson sees as a systemic form of capitalism as the name given to cultural practices which acknowledge their inevitable implication in capitalism, without relinquishing the power or will to intervene critically in it.

Habermas, Lyotard, and Jameson, from their very different perspectives, have all raised the important issue of the socio-economic and philosophical grounding of postmodernism in postmodernity. But to assume an equation of the culture and its ground, rather than allowing for at least the possibility of a relation of contestation and subversion, is to forget the lesson of postmodernism's complex relation to modernism: its retention of modernism's initial oppositional impulses, both ideological and aesthetic, and its equally strong rejection of its founding notion of formalist autonomy.

Much serious scholarly work has already been done on the complexity of the relationship between postmodernism and modernism. Certainly many of the attacks on the postmodern come from the implicit or explicit vantage point of what Walter Moser once wittily called 'a relapsarian modernism.' Others—less negatively—want to root postmodernism historically in the oppositionality of the modernist avant-garde. For the Marxist critic, the attraction of modernism lies in what Jameson calls its 'Utopian compensation' and its 'commitments to radical change.' While the postmodern has indeed no such impulse, it is none the less fundamentally demystifying and critical, and among the things of which it is critical are modernism's elitist and sometimes almost totalitarian modes of effecting that 'radical change'—from those of Mies van der Rohe to those of Pound and Eliot, not to mention Céline. The oppositional politics to which modernism laid claim were not always leftist, as defenders like Eagleton

and Jameson appear to suggest. We must not forget, as Andreas Huyssen has put it, that modernism has also been 'chided by the left as the elitist, arrogant and mystifying master-code of bourgeois culture while demonized by the right as the Agent Orange of natural social cohesion.' Huyssen goes on to explain that the historical (or modernist) avant-garde too was, in its turn, condemned by both the right (as a threat to the bourgeois desire for cultural legitimation) and the left (by the Second International's and by Lukác's valorizing of classical bourgeois realism).

Among the crypto-modernist anti-postmodernists, there is a strong sense that postmodernism somehow represents a lowering of standards or that it is the lamentable consequence of the institutionalization and acculturation of the radical potential of modernism. In other words, it would seem to be difficult to discuss postmodernism without somehow engaging in a debate about the value and even identity of modernism. Jameson has claimed that there are four possible positions: pro-postmodernist and anti-modernist; pro-postmodernist and pro-modernist; anti-postmodernist and anti-modernist; and anti-postmodernist and pro-modernist. But however you break down the positions, there is still an even more basic underlying opposition between those who believe postmodernism represents a break from modernism, and those who see it in a relation of continuity. The latter position stresses what the two share: their self-consciousness or their reliance, however ironic, on tradition. Contrary to the tendency of some critics to label as typically postmodern both American surfiction and the French texts of *Tel Quel*, I would see these as extensions of modernist notions of autonomy and auto-referentiality and thus as 'late modernist.' These formalist extremes are precisely what are called into question by the historical and social grounding of postmodern fiction and photography. To use Stanley Trachtenberg's terms, the postmodern is not (or perhaps not only) an 'intransitive art, which constitutes an act in itself'; it is also 'transitive or purposive'.

From those committed to a model of rupture rather than continuity between the modernist and the postmodernist come arguments based on any number of fundamental differences: in socio-economic

organization; in the aesthetic and moral position of the artist; in the concept of knowledge and its relation to power; in philosophical orientation; in the notion of where meaning inheres in art; in the relation of message to addressee/addresser. For some critics, the modernist and the postmodernist can in fact be opposed point by point. But one of the most contentious of these points seems to be that of the relation of mass culture to both modernism and postmodernism. The Marxist attacks on the postmodern are often in terms of its conflation of high art and mass culture, a conflation modernism rejected with great firmness. It is precisely this rejection that Andreas Huyssen addresses so cogently in his *After the Great Divide* (1986), arguing that modernism defined itself through the exclusion of mass culture and was driven, by its fear of contamination by the consumer culture burgeoning around it, into an elitist and exclusive view of aesthetic formalism and the autonomy of art. It is certainly the historical avant-garde that prepares the way for postmodernism's renegotiation of the different possible relations (of complicity and critique) between high and popular forms of culture. Huyssen does much to upset the view (presented by Jameson and Eagleton, among others) of mass culture as, in his words, 'the homogeneously sinister background on which the achievements of modernism can shine in their glory.' It is not that the modernist exclusion was not historically understandable in the context of, say, fascist spectacle, but Huyssen claims that this is now a 'historically superseded protest' which needs rethinking precisely in the context of late capitalism.

Much influential work has been done on high/popular cultural oppositions and their interactions in order to show that the crossing of such borders does not necessarily mean the destruction of all order or the intrinsic devaluation of all received ideas, as Charles Newman thinks, or an increasing dehumanization of life, as Jameson seems to believe. There is still a tendency to see ethnic, local, or generally popular forms of art as 'subcultural' and it is for this reason that I have deliberately chosen to focus on those two most consistently onmipresent and problematic forms of postmodern representation—still photography and narrative fiction. Between them they constitute a statistically significant number of the representations of both mass culture and high art today. The photography of postmodernism challenges the ideological underpinnings of both the high-art photography of modernism and the mass- (advertising, newspapers, magazines) and popular- (snapshots) cultural photographic forms. It moves out of the hermeticism and narcissism that is always possible in self-referentiality and into the cultural and social world, a world bombarded daily with photographic images. And it manages to point at once to the contingency of art and to the primacy of social codes, making the invisible visible, 'de-oxifying' the doxa—be it either modernist/formalist or realist/documentary. In postmodern fiction, too, the documentary impulse of realism meets the problematizing of reference seen earlier in self-reflexive modernism. Postmodern narrative is filtered through the history of both. And this is where the question of representation and its politics enters.

Ihab Hassan

The Culture of Postmodernism

As if modernism did not offer its share of queries, quandaries, and inconclusions, I bring further vexations in the name of postmodernism, a term that some have threatened to inscribe on my tombstone. Yet the term has become a current trope of tendencies in theater, dance, music, art, and architecture; in literature and criticism; in philosophy, psychoanalysis, and historiography; in cybernetic technologies; and even in the sciences, which are making "new alliances" with humanistic thought.

In the last two decades, the word postmodernism has shifted from awkward neologism to derelict cliché without ever attaining to the dignity of concept. Some want to theorize that concept now. And why should they be denied their theories? The effort to understand our historical presence, to perceive the interactions of language, knowledge, and power in our epoch, to valorize the living categories of our existence—surely that effort deserves our wakeful respect. More concretely, the central nisus of literary history in our time—namely, to problematize periodization, to apprehend history as theory, theory as literature, and literature as both history and theory—that nisus, I think, depends on our self-conceptions, to which postmodernism is crux.

Our concern, I have not forgotten, is with modernisms in all their versions, supplements, traces, and tergiversations; our concern, that is, centers on the enigmas of literary change. But literary change, like history itself, remains an engorged abstraction, another god that failed—unless grounded in some apprehension both personal and universal. That apprehension we call death, to which I now—I trust only abstractly—must briefly turn.

Death takes the measure of every change and inspires its metaphors. Suddenly, the body refuses its long intimacy with the will, giving itself to emptiness. Men lived, it seems, millennia without conscious knowledge of their deaths; nor do infants today possess such knowledge until they enter late childhood. Yet we all surrender nightly to dreamless sleep; and our civilization rests on burial mounds and cairns. As individuals of a secular society, we now refuse mythic time and religious consolation, and so feel death all the more acutely as rupture, cessation. No rebirth for us; no immortality or metempsychosis; no Heraclitean fire or Brunist transmutation, nor Hölderlin's "*aus dem Bunde der Wesen Schwindet der Tod.*"

Ernest Becker believed that the human body represents the "curse of fate," and that culture stands on repression, not only of sexuality, as Freud thought, but also of mortality, "because man [is]...primarily an avoider of death."[1] We need not concur with this somber view to perceive that every creative act is also a small exercise in dying. For the new is an aspect of the unknown, "the undiscovered county from whose bourn / No traveler returns." Innovation/renovation, creation/recreation: such terms conspire deeply against our quotidian being.

Consider two familiar views of change, equally partial, perhaps equally true: one, surpassing even Heraclitus, asserts that "you can't step into the same stream once" (Cratylus); the other claims that "nothing is ever new under the sun" (Ecclesiastes). One favors change and difference, the other repetition

1. Ernest Becker, *The Denial of Death* (New York: The Free Press, 1975), 96.

and sameness. The first, disjunctive, preserves the gap between concrete phenomena; the second, conjunctive, fills gaps by its abstract narratives or metalanguages. We may need both, the first to perceive the New, the second to comprehend it. Yet each whispers to us of human mortality. For the discontinuous vision invokes perpetual rebirth, the phoenix rising from its ashes, while the vision of continuity yearns for retrospective immortality, the sphinx's anamnesis. Thus mortality may make cowards of us all, making politics the art of self-avoidance, making history a rehearsal of desires. Is there no way out of these deadly gyres?

Roland Barthes believed that "the New is not a fashion but a value" upon which we found our existence. "To escape from the alienation of present society, there is only one way: escape forward," he said.[2] But which way, in our day, is "forward"? Which "forward" evades mortality? The questions, though communal, return us to the languages of the self. From Lacan we know that the symbolic subject, the self in language, constitutes itself in a *béance* or abysm; and so "no being is ever evoked by...[the subject] except among the shadows of death."[3] And from Foucault we learn that death serves as a cognitive principle in "the anonymous flow of speech," continually displacing the present; "to die" is an infinitive we can never complete.[4]

In short, more than an existential metaphor, more than an ontology of the new or a politics of innovation, death enters the very languages by which we try to understand change. It may also act, Heidegger thought, as the principle of any "authentic history," which finds its weight not in the "past" nor in the "today" but in the *Geschehen* or process of Existence, originating from the future, the "Being-toward-death."[5]

But it is time to abandon these morbid reflections and approach the problem at hand. History, I have suggested, moves in measures both continuous and discontinuous. Thus the prevalence of postmodernism today does not suggest that ideas or institutions of the past cease to shape the present. Rather, traditions develop, and even types suffer a sea-change. Certainly, the powerful cultural assumptions generated by, say, Darwin, Marx, Baudelaire, Nietzsche, Cézanne, Debussy, Freud and Einstein, in their various fields, still pervade the Western mind. Certainly, those assumptions have been reconceived, not once but many times—else history would repeat itself, forever same. In this perspective, postmodernism may appear as a significant revision, if not an original *épistémè*, of twentieth-century *Western* societies.

Whence the term postmodernism? Its origin remains uncertain, though we know that Frederico de Onís used the word *postmodernismo* in his *Antología de la poesía española e hispanoamericana* (1882-1932), published in Madrid in 1934; and Dudley Fitts picked it up again in his *Anthology of Contemporary Latin American Poetry* of 1942.[6] Both meant thus to indicate a minor reaction to modernism already latent within it, reverting to the early twentieth century. The term also appeared in Arnold Toynbee's *A Study of History* as early as D. C. Somervell's first-volume abridgement of 1947. For Toynbee, "Post-Modernism" designated a new historical cycle in Western civilization, starting around 1875, which we now scarcely begin to discern. Somewhat later, during the fifties, Charles Olson often spoke of postmodernism with more sweep than lapidary definition.

But prophets and poets enjoy an ample sense of time, which few literary scholars seem to afford. In

2. Roland Barthes, *The Pleasure of the Text*, trans. Richard Howard (New York: Hill & Wang, 1975), 40.

3. Jacques Lacan, *The Language of the Self*, trans. Anthony Wilden (Baltimore, Md.: Johns Hopkins Univ. Press, 1968), 85.

4. Michel Foucault, *Language, Counter-Memory, Practice*, trans. Donald F. Bouchard and Sherry Simon (Ithaca, N.Y.: Cornell Univ. Press, 1977), 174f.

5. Martin Heidegger, *Existence and Being* (Chicago: Henry Regnery, 1949), 92.

6. For the best history of the term "postmodernism," see Michael Köhler, "'Postmodernismus': Ein begriffsgeschichtlicher überblick," *Amerikastudien* 22, no. 1 (1977): 8-18. That same issue contains other excellent discussions and bibliographies of the term; see particularly Gerhard Hoffmann, Alfred Hornung, and Rüdiger Kunow, "'Modern,' 'Postmodern,' and 'Contemporary' as Criteria for the Analysis of Twentieth-Century Literature," 19-46.

1959 and 1960, Irving Howe and Harry Levin wrote of postmodernism rather disconsolately as a falling-off from the great modernist movement.[7] It remained for Leslie Fiedler and myself, among others, to employ the term during the sixties with premature approbation, and even with a touch of bravado.[8] Fiedler had it in mind to challenge the elitism of the high modernist tradition in the name of popular culture; I wanted to explore that impulse of self-unmaking which is part of the literary tradition of silence. Pop and silence, or mass culture and deconstruction, or Superman and Godot—or, as I shall later argue, immanence and indeterminacy—may all be aspects of the postmodern universe. But all this must wait upon more patient analysis, longer history.

Yet the history of literary terms serves only to confirm the irrational genius of language. We come closer to the question of postmodernism itself by acknowledging the psychopolitics, if not the psychopathology, of academic life. Let us admit it: there is a will to power in nomenclature, as well as in people or texts. A new term opens for its proponents a space in language. A critical concept of system is a "poor" poem of the intellectual imagination. The battle of the books is also an ontic battle against death. That may be why Max Planck believed that one never manages to convince one's opponents—not even in theoretical physics!—one simply tries to outlive them. William James described the process with more cheer: novations, he said, are first repudiated as nonsense, then declared obvious, then appropriated by former adversaries as their own discoveries.

In an age of frantic intellectual fashions, values can be too recklessly voided, and tomorrow can quickly preempt today and yesteryear. The sense of supervention may express some cultural urgency that partakes less of hope than of fear. This much we recall: Lionel Trilling entitled one of his most thoughtful works *Beyond Culture* (1965); Kenneth Boulding argued that "postcivilization" is an essential part of *The Meaning of the Twentieth Century* (1964); and George Steiner could have subtitled his essay, *In Bluebeard's Castle* (1971), "Notes Toward the Definition of Postculture." Before them, Roderick Seidenberg had published his *Post-Historic Man* exactly in midcentury; and most recently, I have myself speculated, in *The Right Promethean Fire* (1980), about the advent of a post-humanist era. As Daniel Bell put it: "It used to be that the great literary modifier was the word *beyond*…. But we seem to have exhausted the beyond, and today the sociological modifier is *post*."[9]

My point here is double: in the question of postmodernism, there is a will and counter-will to intellectual power, an imperial desire of the mind, but this will and this desire are themselves caught in a historical moment of supervention, if not exactly of obsolescence. The reception or denial of postmodernism thus remains contingent on the psychopolitics of academic life—including the various dispositions of people and power in our universities, of critical factions and personal frictions, or boundaries that arbitrarily include or exclude—no less than on the imperatives of the culture at large. This much, reflexivity seems to demand from us at the start.

But reflection demands also that we address a number of conceptual problems that both conceal and constitute postmodernism itself. I shall try to isolate ten of these, commencing with the simpler, moving toward the more intractable.

1. The word postmodernism sounds not only awkward, uncouth, it evokes what it wishes to surpass or suppress, modernism itself. The term thus contains

7. Irving Howe, "Mass Society and Postmodern Fiction," *Partisan Review* 26, no. 3 (Summer 1959), reprinted in his *Decline of the New* (New York: Harcourt, Brace, 1970), 190-207; Harry Levin, "What was Modernism?" *Massachusetts Review* 1, no. 4 (Aug. 1960), reprinted in *Refractions* (New York: Oxford Univ. Press, 1966), 271-95.

8. Leslie Fiedler, "The New Mutants," *Partisan Review* 32, no. 4 (Fall 1965), reprinted in his *Collected Essays* (New York: Stein & Day, 1971), 2: 379-400; and Ihab Hassen, "Frontiers of Criticism: Metaphors of Silence," *Virginia Quarterly* 46, no. 1 (Winter 1970). In earlier essays, I had also used the term "anti-literature" and "the literature of silence" in a proximate sense; see, for instance, Ihab Hassan, "The Literature of Silence," *Encounter 28*, no. 1 (Jan. 1967).

9. Daniel Bell, *The Coming of Post-Industrial Society* (New York: Basic Books, 1973), 53.

its enemy within, as the terms romanticism and classicism, baroque and rococo, do not. Moreover, it denotes temporal linearity and connotes belatedness, even decadence, to which no postmodernist would admit. But what better name have we to give this curious age? The atomic, or Space, or Television Age? These technological tags lack theoretical definition. Or shall we call it the Age of Indetermanence (indeterminacy and immanence) as I have half-antically proposed?[10]

2. Like other categorical terms—say post-structuralism, or modernism, or romanticism, for that matter—postmodernism suffers from a certain *semantic* instability: that is, no clear consensus about its meaning exists among scholars. The general difficulty is compounded in this case by two factors, namely the relative youth, indeed brash adolescence, of the term postmodernism, and its semantic kinship with more current terms, themselves equally unstable. Thus some critics mean by postmodernism what others call avant-gardism or even neo-avantgardism, while still others would call the same phenomenon simply modernism. This can make for inspired debates.[11]

3. A related difficulty concerns the *historical* instability of many literary concepts, their openness to change. Who, in this epoch of fierce misprisions, would dare to claim that romanticism is apprehended by Coleridge, Pater, Lovejoy, Peckham, and Bloom in quite the same way? There is already some evidence that postmodernism, and modernism even more, are beginning to slip and slide in time, threatening to make any diacritical distinction between them desperate.[12] But perhaps the phenomenon, akin to Hubble's "red shift" in astronomy, may someday serve to measure the historical velocity of literary concepts.

4. Modernism and postmodernism are not separated by an Iron Curtain or Chinese Wall; for history is a palimpsest, and culture is permeable in time past, time present, and time future. We are all, I suspect, a little Victorian, Modern, and Postmodern, at once. And an author may, in his or her own lifetime, easily write both a modernist and a postmodernism work. (Contrast Joyce's *Portrait of the Artist as a Young Man* with his *Finnegans Wake*.) More generally, on a certain level of narrative abstraction, modernism itself may be rightly assimilated to romanticism, romanticism related to the Enlightenment, the latter to the Renaissance, and so back, if not to the Olduvai Gorge, then certainly to ancient Greece.

5. This means that a "period," as I have already intimated, must be perceived in terms *both* of continuity *and* discontinuity, the two perspectives being complementary and partial. The Apollonian view, rangy and abstract, discerns only historical conjunctions; the Dionysian feeling, sensuous though nearly purblind, touches only the disjunctive moment. Thus postmodernism, by invoking two divinities at once, engages a double view. Sameness and difference, unity and rupture, filiation and revolt, all must be honored if we are to attend to history, apprehend (perceive, understand) change both as a spatial, mental structure and as a temporal, physical process, both as pattern and unique event.

10. See Ihab Hassan, "Culture, Indeterminacy, and Immanence: Margins of the (Postmodern) Age," *Humanities in Society* 1, no. 1 (Winter 1978); reprinted in *The Right Promethean Fire: Imagination, Science, and Cultural Change* (Urbana: Univ. of Illinois Press, 1980), ch. 3.

11. Matei Calinescu, for instance, tends to assimilate "postmodern" to "neo-avant-garde" and sometimes to "avant-garde," in *Faces of Modernity: Avant-Garde, Decadence, Kitsch* (Bloomington: Indiana Univ. Press, 1977), though later he discriminates among these terms thoughtfully, in "Avant-Garde, Neo-Avant-Garde, and Postmodernism," in *Perspectives on the Avant-Garde*, ed. Rudolf Kuenzli and Stephen Foster (Iowa City: Univ. of Iowa Press, forthcoming). Miklos Szabolcsi would identify "modern" with "avant-garde" and call "postmodernism" the "neo-avant-garde," in "Avant-Garde, Neo-Avant-Garde, Modernism: Questions and Suggestions," *New Literary History* 3, no. 1 (Autumn 1971): 49-70, while Paul de Man would call "modern" the innovative element, the perpetual "moment of crisis" in the literature of every period, in "Literary History and Literary Modernity," in *Blindness and Insight* (New York: Oxford Univ. Press, 1971), ch. 8; in a similar vein, William V. Spanos employs the term "postmodernism" to indicate "not fundamentally a chronological event, but rather a permanent mode of human understanding," in "Deconstruction and the Question of Postmodern Literature: Towards a Definition," *Par Rapport* 2, no. 2 (Summer 1979): 107. And even John Barth, as inward as any writer with postmodernism, now argues that postmodernism is a synthesis yet to come, and that what we had assumed to be postmodernism all along was only later modernism, in "The Literature of Replenishment: Postmodernism Fiction," *Atlantic Monthly* 245, no. 1 (Jan. 1980): 65-70.

12. In my own earlier and later essays on the subject I can discern such a slight shift; see "POSTmodernISM: A Paracritical Bibliography," *New Literary History* 3, no. 1 (Autumn 1971), reprinted in my *Paracriticisms: Seven Speculations of the Times* (Urbana: Univ. of Illinois Press, 1975), ch. 2; "Joyce, Beckett, and the Postmodern Imagination," *Triquaterly* 34 (Fall 1975): 179-200; and "Culture, Indeterminacy, and Immanence."

6. Thus a "period" is generally not a period at all; it is rather both a diachronic and synchronic construct. Postmodernism is no exception; it requires *both* historical *and* theoretical definition. We cannot seriously claim an inaugural "date" for it as Virginia Woolf pertly did for modernism, which she said began "in or about December, 1910"—though we may sometimes woefully imagine that postmodernism began "in or about September, 1939." Thus we continually discover "antecedents" of postmodernism—in Sterne, Sade, Blake, Lautréamont, Rimbaud, Jarry, Tzara, Hofmannsthal, Stein, the later Joyce, the later Pound, Duchamp, Artaud, Roussel, Bataille, Broch, Queneau, and Kafka. What this really indicates is that we have created in our minds a model of postmodernism, a particular typology of culture and imagination, and have proceeded to "rediscover" the affinities of various authors and different moments with that model. We have, that is, reinvented our ancestors—and always shall. Consequently, "older" authors can be postmodern—Kafka, Beckett, Borges, Nabakov, Gombrowicz—while "younger" authors need not be—Styron, Updike, Capote, Irving, Doctorow, Gardner.

7. As we have seen, any definition of postmodernism calls upon a fourfold vision of complementarities, embracing continuity and discontinuity, diachrony and synchrony. But a definition of the concept also requires a dialectical vision; for defining traits are often antithetical. Defining traits are dialectical and also plural; to elect a single trait as an absolute criterion of postmodern grace is to make of all other writers preterites.[13] Thus we cannot simply rest—as I have sometimes done—on the assumption that postmodernism is antiformal, anarchic, or decreative; for though it is indeed all these, and despite its fanatic will to unmaking, it also contains the need to discover a "unitary sensibility" (Sontag), to "cross the border and close the gap"

(Fiedler), and to attain, as I have suggested, an immanence of discourse, an expanded noetic intervention, a "neo-gnostic im-mediacy of mind."[14]

8. All this leads to the prior problem of periodization itself, which is also that of literary history conceived as a particular apprehension of change. Indeed, the concept of postmodernism implies some theory of innovation, renovation, novation, or simple change. But which one? Heraclitean? Viconian? Darwinian? Marxist? Freudian? Kuhnian? Derridean? Eclectic?[15] Or is a "theory of change" itself an oxymoron best suited to ideologues intolerant of the ambiguities of time? Should postmodernism, then, be left—at least for the moment—unconceptualized, a kind of literary-historical "difference" or "trace"?[16]

9. Postmodernism can expand into a still larger problem: is it only an artistic tendency or also a social phenomenon, perhaps even a mutation in Western humanism? If so, how are the various aspects of this phenomenon—psychological, philosophical, economic, political—joined or disjoined? In short, can we understand postmodernism in literature without some attempt to perceive the lineaments of a postmodern society, a Toynbeean postmodernity, or

13. Though some critics have argued that postmodernism is primarily "temporal," and others that it is mainly "spatial," it is in the particular relation between these single categories that postmodernism probably reveals itself. See the two seemingly contradictory views of William V. Spanos, "The Detective at the Boundary," in *Existentialism 2*, ed. William V. Spanos (New York: Thomas Y. Crowell, 1976), 163-89; and Jürgen Peper, "Postmodernismus: Unitary Sensibility," *Amerikastudien* 22, no. 1 (1977): 65-89.

14. Susan Sontag, "One Culture and the New Sensibility," in *Against Interpretation* (New York: Farrar, Straus & Giroux, 1967), 293-304; Leslie Fiedler, "Cross the Border—Close the Gap," in *Collected Essays*, 2: 461-85; and Ihab Hassan, "The New Gnosticism," *Paracriticisms*, ch. 6.

15. For some views of this, see Ihab and Sally Hassan, eds., *Innovation/Renovation: New Perspectives on the Humanities* (Madison: Univ. of Wisconsin Press, 1983).

16. At stake here is the idea of literary periodicity, challenged by current French thought. For other views of literary and historical change, including "hierarchic organization" of time, see Leonard Meyer, *Music, the Arts, and Ideas* (Chicago: Univ. of Chicago Press, 1967), 93, 102; Calinescu, *Faces of Modernity*, 147ff.; Ralph Cohen, "Innovation and Variation: Literary Change and Georgic Poetry," in *Literature and History*, ed. Ralph Cohen and Murray Krieger, (Berkeley and Los Angeles: Univ. of California Press, 1974); and my *Paracriticisms*, ch. 7. A harder question is one Geoffrey Hartman asks: "With so much historical knowledge, how can we avoid historicism, or the staging of history as a drama in which epiphanic raptures are replaced by epistemic ruptures?" Or, again, how can we "formulate a theory of reading that would be historical rather than historicist"? *Saving the Text: Literature/Derrida/Philosophy* (Baltimore, Md.: Johns Hopkins Univ. Press, 1981), xx.

future Foucauldian *épistémè*, of which the literary tendency I have been discussing is but a single, elitist strain?[17]

10. Finally, though not least vexing, is postmodernism an honorific term, used insidiously to valorize writers, however disparate, whom we otherwise esteem, to hail trends, however discordant, which we somehow approve? Or is it, on the contrary a term of opprobrium and objurgation? In short, is postmodernism an evaluative or normative, as well as descriptive, category of literary thought? Or does it belong, as Charles Altieri suggests, to that category of "essentially contested concepts" in philosophy which never wholly exhaust their constitutive confusions?[18]

No doubt other conceptual problems lurk in the matter of postmodernism. Such problems, however, cannot finally inhibit the desire to apprehend our historical presence in noetic constructs that reveal our being to ourselves. I move, therefore, to propose a provisional scheme that a strain in Western literature, from Sade to Beckett, seems to embody, and to do so by distinguishing, tentatively, among three modes of artistic change in the last hundred years. I call these avant-garde, modern, and postmodern, though I realize that all three have conspired together to create that "tradition of the new" which, since Baudelaire, brought "into being an art whose history, regardless of the credos of its practitioners, has consisted of leaps from vanguard to vanguard, and political mass movements whose aim has been the total renovation not only of social institutions but of man himself."[19]

By avant-garde, I mean those movements that agitated the earlier part of our century, including pataphysics, cubism, futurism, dadaism, surrealism, suprematism, constructivism, Merzism, de Stijl, and so on. Anarchic and disjunctive, these assaulted the bourgeoisie with their art, their manifestos, their antics. But their activism could also turn inward, becoming suicidal. Once full of brio and bravura, these movements have all but vanished now, leaving only their story, at once fugacious and exemplary.[20] Modernism, however, proved more stable, aloof, hieratic, like the French symbolism from which it derived; even its experiments now seem olympian. Enacted by such "individual talents" as Valéry, Proust, and Gide, the early Joyce, Yeats, and Lawrence, Rilke, Mann, and Musil, the early Pound, Eliot, and Faulkner, it commanded high authority, leading Delmore Schwartz to chant in *Shenandoah*: "Let us consider where the great men are / who still obsess the child when he can read."[21] But if much of modernism appears hieratic, hypotactical, and formalist, postmodernism strikes us by contrast as playful, paratactical, and deconstructionist. In this, it

17. Writers as different as Marshall McLuhan and Leslie Fiedler have explored the media and pop aspects of postmodernism for two decades, though their efforts are now out of fashion in some critical circles. The difference between postmodernism, as a contemporary artistic tendency, and postmodernity, as a cultural phenomenon, perhaps even an era of history, is discussed by Richard E. Palmer in "Postmodernity and Hermeneutics," *Boundary* 2, vol. 5, no. 2 (Winter 1977).

18. Charles Altieri, "Postmodernism: A Question of Definition," *Par Rapport* 2, no. 2 (Summer 1979): 90. This leads Altieri to conclude that "the best one can do who believes himself post-modern...is to articulate spaces of mind in which the confusions can not paralyze because one enjoys the energies and glimpses of our condition which they produce" (99).

19. Harold Rosenberg, *The Tradition of the New* (New York: Grove Press, 1961), 9. See also Ihab Hassan, *The Dismemberment of Orpheus*, 2nd rev. ed. (Madison: Univ. of Wisconsin Press, 1982), for further elaboration of these modes.

20. See especially Roger Shattuck, *The Banquet Years* (New York: Vintage, 1968); Renato Poggioli, *Theory of the Avant-Garde*, trans. Gerald Fitzgerald (Cambridge: Harvard Univ. Press, 1968); Peter Bürger, *Theorie der Avant-Garde* (Frankfurt am Main: Suhrkamp Verlag, 1974); Calinescu, *Faces of Modernity*; and *Les Avant-gardes littéraires au XXe siècle*, ed. Jean Weisgerber, 2 vols. (Paris: Didier, 1980). The last two works contain useful bibliographies of the avant-gardes.

21. Delmore Schwartz, *Shenandoah* (Norfolk, Conn.: New Directions, 1941), 20. Works that address modernism include Edmund Wilson, *Axel's Castle* (New York: Charles Scribner's Sons, 1931); José Ortega y Gasset, *The Modern Theme*, trans. Helene Weyl (Princeton, N.J.: Princeton Univ. Press, 1948); Lionel Trilling, *Beyond Culture* (New York: Viking, 1965); Ihab Hassan, *The Dismemberment of Orpheus*; Hugh Kenner, *The Pound Era* (Berkeley and Los Angeles: Univ. of California Press, 1971); Malcolm Bradbury and James McFarlane, eds., *Modernism* (New York: Penguin, 1976); and Calinescu, *Faces of Modernity*. The last two works contain extensive bibliographies of modernism as well as postmodernism.

recalls the irreverent spirit of the avant-garde, and so carries sometimes the label of neo-avant-garde.[22] Yet postmodernism remains "cooler," in McLuhan's sense, than older vanguards—cooler, less cliquish, and far less aversive to the pop, electronic society of which postmodernism is a part, and thus hospitable to kitsch.[23]

Can we distinguish postmodernism from modernism further? Perhaps certain schematic differences will provide a start:

MODERNISM	POSTMODERNISM
Romanticism / Symbolism	Pataphysics / Dadaism
Form (conjunctive, closed)	Antiform (disjunctive, open)
Purpose	Play
Design	Chance
Hierarchy	Anarchy
Mastery / Logos	Exhaustion / Silence
Art Object / Finished Work	Process / Performance / Happening
Distance	Participation
Creation / Totalization / Synthesis	Decreation / Deconstruction / Antithesis
Presence	Absence
Centering	Dispersal
Genre / Boundary	Text / Intertext
Semantics	Rhetoric
Paradigm	Syntagm
Hypotaxis	Parataxis
Metaphor	Metonymy
Selection	Combination
Root / Depth	Rhizome / Surface
Interpretation / Reading	Against Interpretation / Misreading
Signified	Signifier
Lisible (Readerly)	Scriptible (Writerly)
Narrative / Grande Histoire	Anti-narrative / Petite Histoire
Master Code	Idiolect
Symptom	Desire
Type	Mutant
Genital / Phallic	Polymorphous / Androgynous
Paranoia	Schizophrenia
Origin / Cause	Difference-Differance / Trace
God the Father	The Holy Ghost
Metaphysics	Irony
Determinacy	Indeterminacy
Transcendence	Immanence

The preceding table draws on ideas in many fields—rhetoric, linguistics, literary theory, philosophy, anthropology, psychoanalysis, political science, even theology—and draws on many authors—European and American—aligned with diverse movements, groups, and views. Yet the dichotomies this table represents remain insecure, equivocal. For differences shift, defer, even collapse; concepts in any one vertical column are not all equivalent; and inversions and exceptions, in both modernism and postmodernism, abound. Still, I would submit that rubrics in the right column point to the postmodern tendency, the tendency of indetermanence, and so may bring us closer to its historical and theoretical definition.

The time has come, however, to explain a little that neologism, "indetermanence," and to address the culture of postmodernism which the neologism attempts to describe. I commence with some views of Daniel Bell, who thinks that "we are coming to a watershed in Western society: we are witnessing the end of the bourgeois idea—that view of human action and social relations, particularly of economic change—which has molded the modern era for the last 200 years. And I believe that we have reached the end of the creative impulse and ideological sway of modernism, which, as a cultural movement, has dominated all the arts, and shaped our symbolic expressions, for the past 125 years."[24] Disjuctions between the realms of economy, polity,

relevant works by Leslie Fiedler, Richard Poirier, Susan Sontag, and George Steiner); Raymond Federman, ed., *Surfiction* (Chicago: Swallow Press, 1975); Charles Russell, ed., *The Advant-Garde Today* (Urbana: Univ. of Illinois Press, 1981); Mas'ud Zavarzadeh, *The Mythopoeic Reality* (Urbana: Univ. of Illinois Press, 1976); and *Amerikastudien* 22, no. 1 (1977). Again, the last two works offer lengthy bibliographies.

23. This is a point that Hans Magnus Enzensberger mistakes in his otherwise witty and perceptive essay, "The Aporias of the Avant-Garde," *The Consciousness Industry* (New York: Seabury, 1974). I believe Daniel Bell comes here nearer the mark: "What is most striking about postmodernism is that what was once maintained as esoteric is now proclaimed as ideology, and what was once the property of an aristocracy of the spirit is now turned into the democratic property of the mass." *The Cultural Contradictions of Capitalism* (New York: Basic Books, 1976), 52.

24. Bell, 7.

and culture; the crisis of the Protestant ethic, of middle-class values in general; the advent, beyond rising expectations, of a politics of entitlement or envy; syncretism and the jumbling of styles of culture; the increasing permeability of all society to novelty, without discrimination or resistance; the confusions of fact and fantasy in public as in private life; the enervation of the postmodern self, nourished on hedonism, consumption, febrile affluence—all these, Bell argues, have undermined the Western "order of things." But Bell goes on still further to identify not only technology but also culture (by which he means the entire symbolic universe, managed more and more by postmodern vanguards) as the culprit. For the "postmodernist temper demands that what was previously played out in fantasy and imagination must be acted out in life as well.... Anything permitted in art is permitted in life."[25] Thus cultural vanguards come to assume primacy "in the fields of manners, morals, and, ultimately, politics."[26] Bell exaggerates the triumph of these movements; and though he writes with acumen, he writes as a conservative sociologist, who finds it lamentable that the contemporary imagination should serve to disconfirm our policy. (I wonder if he has read much in the classic American literature or sensed its powers of darkness.)

Jean-François Lyotard, however, rejoices in the very same evidence of disconfirmation. *La Condition postmoderne* both corroborates *The Cultural Contradictions of Capitalism* and profoundly challenges its values. Lyotard's central theme is the desuetude of the "great narratives" and "metanarratives" which once organized bourgeois society. The radical crisis, then, is one of "*légitimation*"—compare with Habermas's "legitimation crisis" in *Legitimations Probleme in Spät Kapitalismus*—in every cognitive and social endeavor where a multitude of languages now reign. I translate freely Lyotard's theme:

> The postmodern condition is a stranger to disenchantment as to the blind positivity of delegitimation. Where can legitimacy reside after the dissolution of metanarratives? The criterion of functionality is merely technological; it cannot apply to judgments of truth and justice. The consensus obtained by discussion, as Habermas thinks? That criterion violates the heterogeneity of language games. And inventions are always made in dissent. Postmodern knowledge is not only the instrument of power. It refines our sensibilities, awakens them to differences, and strengthens our capacities to bear the incommensurable. It does not find its reason in the homologies of experts but in the paralogies of inventors.
>
> The open question, then, is this: can a legitimation of social relations, can a just society, be made practicable in accordance with a paradox analogous to that of current scientific activity? And of what would such a paradox consist?[27]

Lyotard thus ushers us, somewhat utopically, into the postmodern era of "*les petites histoires*": paratactical, paradoxical, paralogical narratives meant to open the structures of knowledge, as of politics, to language games, to imaginative reconstitutions that permit us either a new breakthrough or a change in the rules of the game itself.[28] He concludes: "A politics is taking shape in which the desires for both justice and the unknown are equally respected."[29] This ignores that "human justice," alas, can sanction bloody terror, and that "the unknown" can provoke intolerant reactions, provoke new quests for certainty or authority.

Still, it is of some interest that two thinkers, one conservative and the other radical, respond to a phenomenon that both call by the same name (though Bell protests against postmodernism by hyphenating the word, which both Lyotard and I find unnecessary). But the initial question remains: what is

25. Ibid., 53f. Carl Friedrich von Weizsäcker makes the more serious point about the predominance of pleasure in any society: "Und dann sage ich schon in diesem ganz einfachen Sinne von Glück—Erreichen von Angenehmem oder Erwünschtem, Vermeiden von Unangehenmem oder unerwünschtem Schmerzhaftem: die Orientierung and diesem Kriterium als Fundamentalorientierung einer Gesellschaft ist die Garantie des untergangs dieser Gesellschaft." *Wachstum und Lebenssinn*—Alternative Rationalitäten? Bergedorfer Gesprachskreis, Protokoll-Nr. 61 (1978): 8.

26. Ibid., 34.

27. Jean-François Lyotard, *La Condition postmoderne* (Paris: Editions de Minuit, 1979), 8f.

28. Ibid., 85f., 97f., 107.

29. Ibid., 108. Unlike Jürgen Habermas, Lyotard doubts the final value of *Diskurs*, consensus. For a critique of Habermas based on a confrontation between the latter and French thought, especially Derrida, see Dominick LaCapra, "Habermas and the Grounding of Critical Theory," *History and Theory* 16, no. 3 (Oct. 1977).

indetermanence? Or put another way: what useful scheme of postmodern transformations can we devise? The scheme I would propose proves to be less a scheme than a complex double tendency. The two tendencies are not dialectical; for they are not exactly antithetical, nor do they lead to any synthesis. Furthermore, each tendency generates its own contradictions, and contains as well elements of the other tendency. The two tendencies, then, interplay, their actions, ludic and deadly serious, suggesting the pattern of an ambilectic that now modulates important changes in nearly every domain of Western culture in the last half-century.

The *first* of these tendencies I have elsewhere called Indeterminacy.[30] But the tendency is really compounded of subtendencies evoked by the following words: openness, heterodoxy, pluralism, eclecticism, randomness, revolt, deformation. The latter alone subsumes a dozen current terms of unmaking: decreation, difference, discontinuity, disjunction, disappearance, decomposition, dedefinition, demystification, detotalization, delegitimation—let alone more technical and rhetorical terms, such as chiasmus, lapsus, schism, hiatus, diremption, suture, transumption, idiolect, heteromorph, and so on. Through all these signs moves a vast will to unmaking, affecting the body politic, the body cognitive, the erotic body, the psyche of each individual—affecting, in short, the entire realm of human discourse in the West. We may then call that tendency *Indeterminacies*, thus recognizing its plural character, which nonetheless reopens or revokes our familiar modes of thought and being.

I scarcely know where I might begin to document so pervasive, so perverse, a trend. In literature alone, our ideas of author, audience, reading, writing, book, genre, critical theory, and literature itself have all suddenly become questionable.[31] We now speak of intertextuality and semioclasty (Julia Kristeva), of a hermeneutics of suspicion (Paul Ricoeur), or a criticism of bliss and a pedagogy of unlearning (Roland Barthes). We propose schizo-analysis (Gilles Deleuze and Félix Guattari), a humanism of disappearance

(Michel Foucault), a grammatology of differences (Jacques Derrida), a politics of delegitimation (Jean-François Lyotard). These philosophies blanches truly abound: ideologies of fracture, metaphysics of absence, theologies of the supplement, mystiques of the trace.[32] But Gaul is not the only home of epistemological Gaullism, Gallic *ratures*, and borrowed *unheimlichkeit*. Others near at hand speak of paracriticism and parabiography (Ihab Hassan), freaks and mutants (Leslie Fiedler), dialogy and the imagination of doubt (Matei Calinescu), surfiction and playgiarism (Raymond Federman), a third-phase psychoanalysis of intimacy and incompleteness (Norman Holland), a theater of impossibility, brought to the vanishing point (Herbert Blau).[33] In so speaking, they testify variously to the indeterminate, or decreative, or antinomian impulse of our moment, a moment that reaches back half a century to Heisenberg's Principle of Uncertainty in physics and Gödel's Proof of Incompleteness (or Undecidability) in all logical systems. (The two theories, though logically unrelated, express the same spirit of limitation or ambiguity, which leads Douglas Hofstadter to

30. Ihab Hassan, "Culture, Indeterminacy, and Immanence," in *The Right Promethean Fire*. This chapter, as well as another entitled "The Re-Vision of Literature," contains material relevant to this discussion.

31. Ibid., 49-52; but see also pp. 109-14.

32. For good introductions to current French literary thought, see Jonathan Culler, *Structuralist Poetics* (Ithaca, N.Y.: Cornell Univ. Press, 1975) and *The Pursuit of Signs* (Ithaca, N.Y.: Cornell Univ. Press, 1981); Edward Said, *Beginnings* (New York: Basic Books, 1975); and Josué V. Harari, ed., *Textual Strategies* (Ithaca, N.Y.: Cornell Univ. Press, 1979); and for a thoughtful assessment of their impact, see Geoffrey H. Hartman, *Criticism in the Wilderness* (New Haven, Conn.: Yale Univ. Press, 1980). Note also that though postmodernism and poststructuralism cannot be identified, they clearly reveal many affinities. Thus in the course of one brief essay, for instance, Julia Kristeva comments on both immanence and indeterminacy in terms of her own: "Postmodernism is that literature which writes itself with the more or less conscious intention of expanding the signifiable, and thus human, realm"; and again: "At this degree of singularity, we are faced with idiolects, proliferating uncontrollably." See Julia Kristeva, "Postmodernism?" in Harry R. Garvin, ed., *Romanticism, Modernism, Postmodernism* (Lewisburg, Penn.: Bucknell Univ. Press, 1980), 137-41.

33. In addition, see such recent attempts to reconceive various disciplines as Norman O. Brown, *Closing Time* (New York: Random House, 1973); David L. Miller, *The New Polytheism* (New York: Harper & Row, 1975); Paul Feyerabend, *Against Method* (London: NLB, 1975); Charles Jencks, *The Language of Post-Modern Architecture* (New York: Rizzoli, 1977); Hayden White, *Tropics of Discourse* (Baltimore, Md.: John Hopkins Univ. Press, 1978); and Harold Bloom, et al., *Deconstruction and Criticism* (New York: Seabury Press, 1979).

remark that "provability is a weaker notion than truth, no matter what axiomatic system is involved."[34] Yet in the end the epistemic factor proves to be only one of many. The force of the antinomian and indeterminate tendency derives from larger dispositions in society: a rising standard of living in the West, the disruption of institutional values, freed desires, liberation movements of every kind, schism and secession around the globe, terrorism rampant—in short, the Many asserting their primacy over the One.

We may now challenge the totalizing will, from Pharaoh or Moses through Louis XIV ("*L'état c'est moi!*") and Charlie Wilson ("What's good for General Motors is good for the country") to Stalin, Hitler, Mao, and Castro. But we may not overlook a *second* major tendency of the postmodern world, dispersing of the will of the One. I call that tendency *Immanences*, a term I employ without religious echo, and by which I mean the capacity of mind to generalize itself in the world, to act upon both self and world, and so become more and more, immediately, its own environment. Various thinkers have reflected variously upon this tendency, speaking of etherialization (Arnold Toynbee), ephemeralization (Buckminster Fuller), conceptualization (Erwin Laszlo), dematerialization (Paolo Soleri), of nature historicized (Karl Marx) and the earth hominized (Teilhard de Chardin), and of a new technological and scientific gnosis (Ihab Hassan).[35] The tendency—evoked also by such sundry words as dispersal, diffusion, dissemination, diffraction, pulsion, integration, ecumenism, communication, interplay, interdependence, and interpenetration—depends, above all, on the emergence of man as a language animal, *homo pictor* or *homo significans*, a creature constituting himself, and increasingly his universe, by symbols of his own making. Is "this not the sign that the whole of this [classic] configuration is about to topple, and that man is in the process of perishing as the being of language continues to shine ever brighter upon our horizon?" Foucault asks.[36]

More than Foucault, however, Lyotard considers the role of media (*l'informatique*) in shaping the languages of self and society in advanced capitalist states; tomorrow's encyclopedias, he suggests, may be data banks which could become "nature" itself for postmodern man.[37] Media, of course, may derealize history even as they disseminate it around the world, often as kitsch or entertainment. But media also project mind to the edge of the universe or into the ghostly interstices of matter, and so abet another type of immanence, which scientists since Heisenberg have recognized as human participation or intervention in nature. Daniel Bell perceives this as the emergent stage of cultural development, implicating human beings in the recreation of reality, and confronting post-Kantian epistemologies with the enigma of artificial intelligence.[38] "Beyond this is a larger dream," Bell writes. "Just as Pascal sought to throw dice with God...so the decision theorists, and the new intellectual technology, seek their own *tableau entier*—the compass of rationality itself."[39] Yet both Lyotard's "*informatique*" and Bell's "*tableau entier*" have already created disquieting constraints in postmodern societies, constraints demanding from us stringent moral and political critiques.

Still other factors further the immanences of which I speak. The explosion of human populations increases the intellectual density of the earth, the possibilities of mental no less than physical interactions. (As everyone knows, a room holding one or two people differs radically from the same space

34. See Jeremy Bernstein, *Experiencing Science* (New York: Basic Books, 1978) and Douglas R. Hofstadter, *Gödel, Escher, Bach: An Eternal Golden Braid* (New York: Basic Books, 1979), 19. Both authors explain abstruse problems in such lucid and joyful prose as might put some literary critics to shame.

35. See Hassan, "The New Gnosticism," *Paracriticisms*, and "The Gnosis of Science," *The Right Promethean Fire*, for discussions of this trend.

36. Michel Foucault, *The Order of Things* (New York: Pantheon, 1970), 386.

37. *La Condition postmoderne*, 84f.; see also 16, 30f., and 63.

38. Daniel Bell, "Technology, Nature, and Society," in *Technology and the Frontiers of Knowledge* (Garden City, N.Y.: Doubleday, 1975), 34-42.

39. Ibid., 52f. But see also Hubert L. Dreyfus, *What Computers Can't Do* (New York: Harper & Row, 1979), for a skeptical counterstatement, which challenges Bell and possibly Lyotard (see n. 60). Dreyfus insists that the human mind proceeds by quantum leaps and tropes, creating whole configurations that no digital computer can simulate. The issue of Artificial Intelligence, however, remains far from settled.

containing seven, or again seventy, more.) Such intense interaction, Bell believes, augments both differences in the social structure (indeterminacies?) and syncretism in the culture (immanences?).[40] "In principle, much of this is not new," Bell adds. "What is distinctive is the change of scale.... All that we once knew played out on the scale of the Greek polis is now played out in the dimensions of the entire world. Scale creates two effects: one, it extends the range of control from a center of power. (What is Stalin, an unknown wit remarked, if not Genghis Khan with a telephone?) And two, when linear extensions reach certain thresholds, unsettling changes ensue."[41] Such immanences we may learn to rue. Still, though one immanence may become totalitarian, complex immanences of language and indeterminacies of theories or praxis diffract power, and so force us to reconceive the relation between wholes and parts.

This leads toward my didactic inconclusion. For the problem of postmodernism does finally engage crucial moral and political questions. These allude, as pre-Socratics used to say, to the play of the One and the Many: that is, to the essential unity of existence and its perceived diversity, its underlying sameness and visible difference—or, as we might nowadays say: to ecumenism and sectarianism, federalism and secession, centering and dispersal, presence and deferral. In our own divisive, diffusive, destructuring age, the tension between these terms threatens to snap. Yet we cannot afford to choose between the One and the Many, any more than we can accept *either* totalitarianism *or* terror.

The point is pertinent to teachers of the humanities, who have become inured to ambiguity, undecidability, dissemination, and deconstruction of the arts and theories they teach. Such ambiguity is liberating; it restores us to the multiplicity of creation; and it enhances our tolerance for differences of every kind. But such ambiguity must also imply some nexus of assent, some active context of value and power—in short, some Authority, the very authority which both limits and enables our shifting freedoms.

Truly, the question of authority is cardinal to current social, artistic, or epistemic debates. The authority can be as bland as the convention that permits me now to speak without interruptions from the audience; or it can be far more subtle and subversive, complex and coercive. In any case, authority—to which value is always attached—is what prevents human beings, if not from reverting to the state of nature, then from facing anew—each year, every hour—"the elementary problems of human living together" as Hannah Arendt put it.[42]

Who judges? why judge? how judge? whom or what judge? These are some of the renitent questions that postmodernism finally summons before us, and that authority must mediate. I cannot answer these queries myself, though I suspect that they are partially answered in the asking, and so must be asked again and again. Speaking for myself, in this time and this place, I know that in searching for an answer I am more likely to turn to Emerson than Nietzsche, and to Nietzsche more than Marx, turn, that is, to an integrative yet dialogical faculty like Imagination, in which discord and concord coexist, rather that to an analytic, monological faculty, including Demystification, which becomes finally sterile.

In the end, I repeat, we cannot , must not, choose between the One and the Many, Clarity and Ambiguity, Classicism and Modernism, Community and Dissemination. We can only open such terms to constant negotiations, perpetual transactions of desire, freedom, and justice, mediated by authorities that we need as much to reestablish as to reinvent. Indeed, despite all the conflicts, all the aporias, which constitute our world, is not our discourse here itself exemplary of a hermeneutic community of provisional trust? Heterodox, heteromorph, heteroclite, and indeterminate withal, we live in one human universe and astonish each other with our assents. On this, the culture of postmodernism still depends.[43]

40. Ibid., 54f.

41. Ibid., 56.

42. Hannah Arendt, *Between Past and Future* (New York: Viking, 1968), 141.

43. Portions of this text have appeared in Ihab Hassan, *The Dismemberment of Orpheus: Toward a Postmodern Literature*, 2d rev. ed. (Madison: Univ. of Wisconsin Press, 1982), and in *Innovation/Renovation: New Perspectives on the Humanities*, ed. Ihab Hassan and Sally Hassan (Madison: Univ. of Wisconsin Press, 1983.)

Part 8

Culture, Gender, and Difference

Part 8: Culture, Gender, and Difference

Introduction

The Enlightenment dream of a universal culture—in which the various spheres of human life come together in an organic unified whole—was thwarted by colonialism and the social divisions of race, sex and class. Ironically, these divisions were themselves products of—or at least exacerbated by—the Enlightenment revolution in knowledge that transformed Europe into a world power. To the extent that the great forces unleashed by the scientific and industrial revolutions produced a *world* culture, it was (and largely remains) a culture unified by the techniques of domination and control, rather than persuasion or consensus by way of some legitimating metanarrative. In opposition to images of the grand march of democracy, the artistic hero, or the voyages of discovery, stands the reality of *difference*: different cultures, different canons, forms of oppression, strategies of resistance. That there might be *several* cultures or *several* canons is threatening; the legitimating narratives forming our cultural identity lose their grip as we recognise the legitimacy of other ways of being. The resultant loosening of the boundaries of the self can be exhilarating, but it can also be profoundly disorienting as it jeopardises our sense of order and place. In the introduction to his book *The Postmodern Condition*, Lyotard defined the *postmodern* as incredulity toward metanarratives. The selections in this section on difference, gender, and culture are therefore continuous in theme with those of the past two sections. The scope of the essays is necessarily wider than art proper, extending to the whole of culture. Art as a vehicle for expressing and creating cultural identity is thus implicated in the political consequences of cultural domination.

The first selection is "Mass Culture as Woman", by Andreas Huyssen (1942-), Professor of German at Columbia University and a founding editor of *New German Critique*. This selection is an examination of both modernism from the point of view of mass culture and of the persistent gendering of mass culture as feminine and inferior to the "genuine" culture of high art. Huyssen suggests that the modernist aesthetic looks more like a *reaction* than a heroic *opposition* to the lures of popular culture, offering a discussion of the theories of Greenberg and Adorno in these terms. Huyssen argues that postmodernism in the arts, not only embraces mass culture but is a recognition of plurality which depends upon feminism's radical critique of patriarchal structures of high art.

"Women's Knowledge and Women's Art" by British sociologist of culture Janet Wolff rhetorically asks, "Can there be such a thing as 'women's writing?'" Wolff argues that the emergence of places for women's voices in culture is the result of feminist work in art criticism devoted to understanding the ways in which art not only represents gender identities or reproduces existing ideologies of the feminine, but also participates in the construction of those identities. To understand the pervasiveness of women's exclusion from culture we need to grasp what is meant by the maleness of knowledge, and to identify the practices that silence women. In short, we need to understand how knowledge as a male affair is institutionalised, and to this end Wolff discusses the feminist critique of knowledge-formation in science, and illuminates alternative paths to women's experience. Rejecting the project of building a women-centred culture totally outside the dominant culture as doomed, she argues for a strategy of destabilisation which exposes the ideological limitations of the dominant culture while working within the enabling spaces it offers.

Christine Battersby's book *Gender and Genius* is a richly delineated history of the concept of genius and its identification with maleness, particularly in post-Kantian romantic and modernist aesthetics. She explores the dilemmas posed to feminist aesthetics by the traditional invisibility and exclusion of women's aesthetic interests in the construction of culture. In the selection here, she discusses first the prospects for a psychoanalytic basis of a feminine aesthetics and then the opportunities for feminist scholarship accorded by postmodern thought. She examines the attractions of Lacan's psychoanalytic theory for feminism, arguing that it contains the same romantic myths we find in Freud, and that it essentialises women by mystifying the distinction between two kinds of marginality: that of others and that of outsiders. She concludes that Lacanian psychoanalysis does not offer adequate ground for a productive women-centred art. Battersby is equally suspicious of the opportunities afforded women's art by postmodernism. In its attacks on authorship and tradition, postmodernism looks superficially feminist-friendly, but Battersby argues that women artists do not stand in the same relation to tradition that male artists do. The change of perspective involved in the feminisation of aesthetic discourse in postmodernism is defined in terms of the difference it makes for the male author. Accordingly, it offers male artists something in addition to their maleness, whereas it is unclear what it offers women artists. In fact, the woman artist has been forced to adopt a double perspective in viewing herself "as a person confronting the paradigms of male individuality and female Otherness, defining herself in terms of those paradigms...and resisting them." Battersby argues that postmodernism only deflects women artists from the task of constructing an aesthetics that values women's art.

The next selection, "The Body Politic/The Impolitic Body/Bodily Politics" by Naomi Scheman (1946-), professor of Philosophy and Women's Studies at the University of Minnesota, is from her recent book *Engenderings*. In it Scheman argues for a responsible postmodernist feminism. The empowerment of the individual that resulted from the emergence of modern bourgeois liberalism produced an epistemology of sameness at odds with the differences of our bodies. It is our bodies that make us different, and those with different bodies have found themselves disempowered. According to the

norms of the Western tradition that identify women with the bodily, women's difference from men is essential: women are their bodies. Scheman argues that postmodernism is at root a revolt against social structures that have held in place the unified subject and the world of facts characterising bourgeois privilege. While that revolt can be merely playful or pluralistic without being politically responsible, it can also be grounded in genuine experience of disadvantage. The political need to say *we* remains, in spite of the justifiable suspicion that women and people of colour feel toward the assumption of such privilege. Scheman concludes with an appeal for an image of self in community— a locus of idiosyncrasy—as a starting point for a politically responsible postmodernism.

The selection by James Clifford (1945-), anthropologist and professor in the History of Consciousness Program at the University of California at Santa Cruz, is composed of two parts that contemplate the quandaries of living concurrently inside, between, and after cultures. A proponent of the new ethnography in anthropology—which is deeply influenced by postmodern literary theory—Clifford attempts to offer suggestions for ethnographic representation that allow the others being studied to speak in a voice unmediated by the ethnographer. The first part—from "On Ethnographic Allegory"— discusses the power of narrative and ethnographic allegory from a postmodern perspective. The ethnographer's narrative makes sense of the exotic and culturally distant other by mapping elements of the alien story onto what is familiar, in effect offering an ethical and redemptive allegory. But if cultural groups are always already inscribing themselves in interpretive narrative, then in what ways are the ethnographer's inscriptions privileged? Are they more than fables of the losses of authenticity in the emergence of Western hegemony? The second part—from "On Collecting Art and Culture"—discusses collecting as a form of Western subjectivity, and the fate of tribal artifacts and cultural objects once they are relocated into museums and scientific collections. It also raises the question of how (and why) we distinguish between scientific and artistic collections, and what role the artistic canon as represented in such collections plays in the redemptive metanarrative of modernity.

Clifford's selection is followed by a critical piece by Frances E. Mascia-Lees (1953-), Patricia Sharpe (1943-), and Colleen Ballerino Cohen (1947-). Mascia-Lees and Sharpe are co-directors of Women's Studies at Simon's Rock College of Bard, and Cohen is professor of Anthropology and Women's Studies at Vassar. They argue that Anthropology specifically and the social sciences in general would do better in its recognition of difference by adopting feminist theory—rather than postmodern trends in epistemology and literary theory—as models. For one thing, feminism knows its politics, while postmodernism, although also making the political visible, is too multiform to have a politics of its own. A central aim of the new ethnography is to apprehend and inscribe voices representing cultural difference without denying or distorting their autonomy and subjectivity. It is therefore curious that it ignores the vast experience that feminist scholarship has with this very problem. Mascia-Lees, Sharpe and Cohen offer a number of reasons for this neglect, suggesting that by failing to identify the power relations involved in the task of collecting information, postmodern ethnography offers ways to preserve the ethnographer's voice as authoritative, and thus to avoid the genuine political problems of intercultural research and action. In addition, the

unmitigated relativism of a view that denies any voice priority over others decentres the claims that indigenous people make in their attempts to recover the history of their exploitation, and thus denies legitimacy to their efforts at self-representation. Feminism—in particular feminist literary theory—offers a better model for interpreting the other, as it has a rich experience in framing research questions collaboratively and reworking traditional canons so that the voices of the oppressed have a legitimate place.

The two concluding selections constitute a closing summary and debate about the meaning of the defaillancy, or failure, of modernity. The first, "Universal History and Cultural Differences" by Jean-François Lyotard (1925-) is a meditation on this failure of modernity. He examines the question, "Can we continue today to organize the multitude of events that come to us from the world, both the human and non-human world, by subsuming them beneath the idea of a universal history of humanity?", subjecting it to a series of clarificatory investigations. The first-person narrative genre in which the question is framed is, he suggests, the mode of confession inaugurated by Descartes, in which the speaker is emancipated from error and bondage through the power of knowledge. The assumption of a "we" in the modernist tradition reflects the movement towards liberation in which third parties become part of the community of speakers, become one of us. The idea of a universal community of speakers is however no longer valid: too much horror has been carried out in the name of emancipation for any of the metanarratives of modernity to be credible. In the context of the failure of the modern subject, and the resulting irrelevance of the modern intellectual, there remains no alternative to a return to the local legitimating function of the narrative mechanism itself or to mere (and no longer 'heroic') resistance to the vast powers of industrial capital to organise fantasies of identity and membership by way of the culture-industry.

The final selection, "Cosmopolitanism Without Emancipation: A Response to Jean-François Lyotard", is by Richard Rorty (1931-), University Professor of the Humanities at The University of Virginia. Written directly as a response to the Lyotard selection, it argues for a Deweyan model of social narratives that undercuts Lyotard's apocalyptic radicalism. Rorty's claim is that all we need to sustain a progressive cosmopolitan ideal is a clear sense of how by our lights things might be better and an acknowledgement that our views may change in the future. This admitted ethnocentrism, suggests Rorty, is neither avoidable nor objectionable. The "we" we need in order to tell stories of progress is simply that of the historically contingent selves we take ourselves to be; we need make no assumptions about our superiority nor resort to terror in our communications with other groups. Difference is bridgeable—not once and for all nor perfectly—but piecemeal through attempts to achieve enough consensus to develop common projects. Lyotard's account of the failure of modernism depends on our failure to find a "single grand commensurating discourse," but that failure shows nothing about the impossibility of peaceful social progress. Rorty's response to the failure of the grand metaphysical projects of modernity is relief; the value of Enlightenment ideals lies in the democratic institutions and practices that we have inherited, and these are valuable just to the extent that they help us design ever more inclusive ways of living.

Andreas Huyssen (1942-)

Mass Culture as Woman: Modernism's Other

Selected from *After the Great Divide*

I

One of the founding texts of modernism, if there ever was one, is Flaubert's *Madame Bovary*. Emma Bovary, whose temperament was, in the narrator's words, "more sentimental than artistic," loved to read romances.[1] In his detached, ironic style, Flaubert describes Emma's reading matter: "They [the novels] were full of love and lovers, persecuted damsels swooning in deserted pavilions, postillions slaughtered at every turn, horses ridden to death on every page, gloomy forests, romantic intrigue, vows, sobs, embraces and tears, moonlit crossings, nightingales in woodland groves, noblemen brave as lions, gentle as lambs, impossibly virtuous, always well dressed, and who wept like fountains on all occasions."[2] Of course, it is well known that Flaubert himself was caught by the craze for romantic novels during his student days in the Collège at Rouen, and Emma Bovary's readings at the convent have to be read against this backdrop of Flaubert's life history— a point which critics rarely fail to make. However, there is ample reason to wonder if the adolescent Flaubert read these novels in the same way Emma Bovary would have, had she actually lived—or, for that matter, as real women at the time read them. Perhaps the answer to such a query will have to remain speculative. What is beyond speculation, however, is the fact that Emma Bovary became known, among other things, as the female reader caught between the delusions of the trivial romantic narrative and the realities of French provincial life during the

July monarchy, a woman who tried to live the illusions of aristocratic sensual romance and was shipwrecked on the banality of bourgeois everyday life. Flaubert, on the other hand, came to be known as one of the fathers of modernism, one of the paradigmatic master voices of an aesthetic based on the uncompromising repudiation of what Emma Bovary loved to read.

As to Flaubert's famous claim: "Madame Bovary, c'est moi," we can assume that he knew what he was saying, and critics have gone to great lengths to show what Flaubert had in common with Emma Bovary— mostly in order to show how he transcended aesthetically the dilemma on which she foundered in "real life." In such arguments the question of gender usually remains submerged, thereby asserting itself all the more powerfully. Sartre, however, in his monumental *L'Idiot de la Famille*, has analyzed the social and familial conditions of Flaubert's "objective neurosis" underlying his fantasy of himself as woman. Sartre has indeed succeeded in showing how Flaubert fetishized his own imaginary femininity while simultaneously sharing his period's hostility toward real women, participating in a pattern of the imagination and of behavior all too common in the history of modernism.[3]

That such masculine identification with woman, such imaginary femininity in the male writer, is itself historically determined is clear enough. Apart

1. Gustave Flaubert, *Madame Bovary*, trans. Merloyd Lawrence (Boston: Houghton Mifflin, 1969), p. 29.

2. Flaubert, p. 30.

3. Cf. Gertrud Koch, "Zwitter-Schwestern: Weiblichkeitswahn und Frauenhass—Jean-Paul Sartres Thesen von der androgynen Kunst," in *Sartres Flaubert lesen: Essays zu Der Idiot der Familie*, ed. Traugott König (Rowohlt: Reinbek, 1980), pp. 44-59.

from the subjective conditions of neurosis in Flaubert's case, the phenomenon has a lot to do with the increasingly marginal position of literature and the arts in a society in which masculinity is identified with action, enterprise, and progress—with the realms of business, industry, science, and law. At the same time, it has also become clear that the imaginary femininity of male authors, which often grounds their oppositional stance vis-à-vis bourgeois society, can easily go hand in hand with the exclusion of real women from the literary enterprise and with the misogyny of bourgeois patriarchy itself. Against the paradigmatic "Madame Bovary, c'est moi," we therefore have to insist that there is a difference. Christa Wolf, in her critical and fictional reflections on the question "who was Cassandra before anyone wrote about her?," put it this way:

> "We have admired this remark [Flaubert's 'Madame Bovary, c'est moi'] for more than a hundred years. We also admire the tears Flaubert shed when he had to let Madame Bovary die, and the crystal-clear calculation of his wonderful novel, which he was able to write despite his tears; and we should not and will not stop admiring him. But Flaubert was not Madame Bovary; we cannot completely ignore that fact in the end, despite all our good will and what we know of the secret relationship between an author and a figure created by art."[4]

One aspect of the difference that is important to my argument about the gender inscriptions in the mass culture debate is that woman (Madame Bovary) is positioned as reader of inferior literature—subjective, emotional and passive—while man (Flaubert) emerges as writer of genuine, authentic literature—objective, ironic, and in control of his aesthetic means. Of course, such positioning of woman as avid consumer of pulp, which I take to be paradigmatic, also affects the woman writer who has the same kind of ambition as the "great (male) modernist." Wolf cites Ingeborg Bachmann's tortured novel trilogy *Todesarten* (Ways of Dying) as a counterexample to Flaubert: "Ingeborg Bachmann *is* that nameless woman in *Malina*, she *is* the woman Franza in the novel fragment *The Franza Case* who

simply cannot get a grip on her life, cannot give it a form; who simply cannot manage to make her experience into a presentable story, cannot produce it out of herself as an artistic product."[5]

In one of her own novels, *The Quest for Christa T*, Wolf herself foregrounded the "difficulty of saying I" for the woman who writes. The problematic nature of saying "I" in the literary text—more often than not held to be a lapse into subjectivity or kitsch—is of course one of the central difficulties of the postromantic, modernist writer. Having first created the determining conditions for a certain historically specific type of subjectivity (the Cartesian cogito and the epistemological subject in Kant, as well as the bourgeois entrepreneur and the modern scientist), modernity itself has increasingly hollowed out such subjectivity and rendered its articulation highly problematic. Most modern artists, male or female, know that. But we only need to think of the striking contrast between Flaubert's confident personal confession, "Madame Bovary, c'est moi," and the famed "impassibilité" of the novel's style to know that there is a difference. Given the fundamentally differing social and psychological constitution and validation of male and female subjectivity in modern bourgeois society, the difficulty of saying "I" must of necessity be different for a woman writer, who may not find "impassibilité" and the concomitant reification of self in the aesthetic product quite as attractive and compelling an ideal as the male writer. The male, after all, can easily deny his own subjectivity for the benefit of a higher aesthetic goal, as long as he can take it for granted on an experimental level in everyday life. Thus Christa Wolf concludes, with some hesitation and yet forcefully enough: "Aesthetics, I say, like philosophy and science, is invited not so much to enable us to get closer to reality as for the purpose of warding it off, of protecting against it."[6] Warding something off, protecting against something out there seems indeed to be a basic gesture of the modernist aesthetic, from Flaubert to Roland Barthes and some other poststructuralists. What Christa Wolf calls reality would certainly have to include Emma

4. Christa Wolf, *Cassandra: A Novel and Four Essays* (New York: Farrar, Straus, Giroux, 1984), p. 300f.

5. Wolf, *Cassandra*, p. 301.

6. Wolf, *Cassandra*, p. 300.

Bovary's romances (the books *and* the love affairs), for the repudiation of *Trivialliteratur* has always been one of the constitutive features of a modernist aesthetic intent on distancing itself and its products from the trivialities and banalities of everyday life. Contrary to the claims of champions of the autonomy of art, contrary also to the ideologists of textuality, the realities of modern life and the ominous expansion of mass culture throughout the social realm are always already inscribed into the articulation of aesthetic modernism. Mass culture has always been the hidden subtext of the modernist project.

II

What especially interests me here is the notion which gained ground during the 19th century that mass culture is somehow associated with woman while real, authentic culture remains the prerogative of men. The tradition of women's exclusion from the realm of "high art" does not of course originate in the 19th century, but it does take on new connotations in the age of the industrial revolution and cultural modernization. Stuart Hall is perfectly right to point out that the hidden subject of the mass culture debate is precisely "the masses"—their political and cultural aspirations, their struggles and their pacification via cultural institutions.[7] But when the 19th and early 20th centuries conjured up the threat of the masses "rattling at the gate," to quote Hall, and lamented the concomitant decline of culture and civilization (which mass culture was invariably accused of causing), there was yet another hidden subject. In the age of nascent socialism *and* the first major women's movement in Europe, the masses knocking at the gate were also women, knocking at the gate of a male-dominated culture. It is indeed striking to observe how the political, psychological, and aesthetic discourse around the turn of the century consistently and obsessively genders mass culture and the masses as feminine, while high culture, whether traditional or modern, clearly remains the privileged realm of male activities.

To be sure, a number of critics have since abandoned the notion of *mass* culture in order to "exclude

from the outset the interpretation agreeable to its advocates: that is a matter of something like a culture that arises spontaneously from the masses themselves, the contemporary form of popular art."[8] Thus Adorno and Horkheimer coined the term culture industry; Enzensberger gave it another twist by calling it the consciousness industry; in the United States, Herbert Schiller speaks of mind managers, and Michael Real uses the term mass-mediated culture. The critical intention behind these changes in terminology is clear: they all mean to suggest that modern mass culture is administered and imposed from above and that the threat it represents resides not in the masses but in those who run the industry. While such an interpretation may serve as a welcome corrective to the naive notion that mass culture is identical with traditional forms of popular art, rising spontaneously from the masses, it nevertheless erases a whole web of gender connotations which, as I shall show, the older terminology "mass culture" carried with it—i.e., connotations of mass culture as essentially feminine which were clearly also "imposed from above," in a gender-specific sense, and which remain central to understanding the historical and rhetorical determinations of the modernism/mass culture dichotomy.

It might be argued that the terminological shift away from the term "mass culture" actually reflects changes in critical thinking about "the masses." Indeed, mass culture theories since the 1920s—for instance, those of the Frankfurt School—have by and large abandoned the explicit gendering of mass culture as feminine. Instead they emphasize features of mass culture such as streamlining, technological reproduction, administration, and Sachlichkeit—features which popular psychology would ascribe to the realm of masculinity rather than femininity. Yet the older mode of thinking surfaces time and again in the language, if not in the argument. Thus Adorno and Horkheimer argue that mass culture "cannot renounce the threat of castration,"[9] and they feminize it explicitly, as the evil queen of the fairy

7. Stuart Hall, paper given at the conference on mass culture at the Center for Twentieth Century Studies, Spring 1984.

8. Theodor W. Adorno, "Culture Industry Reconsidered," *New German Critique*, 6 (Fall 1975), 12.

9. Max Horkheimer and Theodor W. Adorno, *Dialectic of Enlightenment* (New York: Continuum, 1982), p. 141.

tale when they claim that "mass culture, in her mirror, is always the most beautiful in the land."[10] Similarly, Siegfried Kracauer, in his seminal essay on the mass ornament, begins his discussion by bringing the legs of the Tiller Girls into the reader's view, even though the argument then focuses primarily on aspects of rationalization and standardization.[11] Examples such as these show that the inscription of the feminine on the notion of mass culture, which seems to have its primary place in the late 19th century, did not relinquish its hold, even among those critics who did much to overcome the 19th century mystification of mass culture as woman.

The recovery of such gender stereotypes in the theorizing of mass culture may also have some bearing on the current debate about the alleged femininity of modernist/avant-gardist writing. Thus the observation that, in some basic register, the traditional mass culture/modernism dichotomy has been gendered since the mid-19th century as female/male would seem to make recent attempts by French critics to claim the space of modernist and avant-garde writing as predominantly feminine highly questionable. Of course this approach, which is perhaps best embodied in Kristeva's work, focuses on the Mallarmé-Lautréamont-Joyce axis of modernism rather than, say, on the Flaubert-Thomas Mann-Eliot axis which I emphasize in my argument here. Nevertheless, its claims remain problematic even there. Apart from the fact that such a view would threaten to render invisible a whole tradition of women's writing, its main theoretical assumption— "that 'the feminine' is what cannot be inscribed in common language"[12]—remains problematically close to that whole history of an imaginary male femininity which has become prominent in literature since the late 18th century.[13] This view becomes possible only if Madame Bovary's "natural" association with pulp—i.e., the discourse that persistently associated women with mass culture—is simply ignored, and if a paragon of male misogyny like Nietzsche is said to be speaking from the position of a woman. Teresa de Lauretis has recently criticized this Derridean appropriation of the feminine by arguing that the position of woman from which Nietzsche and Derrida speak is vacant in the first place, and cannot be claimed by women.[14] Indeed, more than a hundred years after Flaubert and Nietzsche, we are facing yet another version of an imaginary male femininity, and it is no coincidence that the advocates of such theories (who also include major women theoreticians) take great pains to distance themselves from any form of political feminism. Even though the French readings of modernism's "feminine" side have opened up fascinating questions about gender and sexuality which can be turned critically against more dominant accounts of modernism, it seems fairly obvious that the wholesale theorization of modernist writing as feminine simply ignores the powerful masculinist and misogynist current within the trajectory of modernism, a current which time and again openly states its contempt for women and for the masses and which had Nietzsche as its most eloquent and influential representative.

Here, then, some remarks about the history of the perception of mass culture as feminine. Time and again documents from the late 19th century ascribe pejorative feminine characteristics to mass culture—and by mass culture here I mean serialized feuilleton novels, popular and family magazines, the stuff of lending libraries, fictional bestsellers and the like—not, however, working-class culture or residual forms of older popular or folk cultures. A few examples will have to suffice. In the preface to their novel *Germinie Lacerteux* (1865), which is usually regarded as the first naturalist manifesto, the Goncourt brothers attack what they call the false novel. They describe it as those "spicy little works, memoirs of street-walkers, bedroom confessions, erotic smuttiness, scandals that hitch up their skirts

10. Max Horkheimer and Theodor W. Adorno, "Das Schema der Massenkultur," in Adorno, *Gesammelte Schriften*, 3 (Frankfurt am Main: Suhrkamp, 1981), p. 305.

11. Siegfried Kracauer, "The Mass Ornament," *New German Critique*, 5 (Spring 1975), pp. 67-76.

12. Sandra M. Gilbert and Susan Gubar, "Sexual Linguistics: Gender, Language, Sexuality," *New Literary History*, 16, no. 3 (Spring 1985), 516.

13. For an excellent study of male images of femininity since the 18th century see Silvia Bovenschen, *Die imaginierte Weiblichkeit* (Frankfurt am Main: Suhrkamp, 1979).

14. Teresa de Lauretis, "The Violence of Rhetoric: Considerations on Representation and Gender," *Semiotica* (Spring, 1985), special issue on the Rhetoric of Violence.

in pictures in bookshop windows." The true novel (*le roman vrai*) by contrast is called "severe and pure." It is said to be characterized by its scientificity, and rather than sentiment it offers what the authors call "a clinical picture of love" (*une clinique de l'amour*).[15] Twenty years later, in the editorial of the first issue of Michael Georg Conrad's journal *Die Gesellschaft* (1885), which marks the beginning of "die Moderne" in Germany, the editor states his intention to emancipate literature and criticism from the "tyranny of well-bred debutantes and old wives of both sexes," and from the empty and pompous rhetoric of "old wives criticism." And he goes on to polemicize against the then popular literary family magazines: "The literary and artistic kitchen personnel has achieved absolute mastery in the art of economizing and imitating the famous potato banquet.... It consists of twelve courses each of which offers the potato in a different guise."[16] Once the kitchen has been described metaphorically as the site of mass cultural production, we are not surprised to hear Conrad call for the reestablishment of an "*arg gefährdete Mannhaftigkeit*" (seriously threatened manliness) and for the restoration of bravery and courage (*Tapferkeit*) in thought, poetry, and criticism.

It is easy to see how such statements rely on the traditional notion that women's aesthetic and artistic abilities are inferior to those of men. Women as providers of inspiration for the artist, yes, but otherwise *Berufsverbot* for the muses,[17] unless of course they content themselves with the lower genres (painting flowers and animals) and the decorative arts. At any rate, the gendering of an inferior mass culture as feminine goes hand in hand with the emergence of a male mystique in modernism (especially in painting), which has been documented thoroughly by feminist scholarship.[18] What is interesting in the second half of the 19th century, however, is a certain chain effect of signification: from the obsessively argued inferiority of woman as artist (classically argued by Karl Scheffler in *Die Frau und die Kunst*, 1908) to the association of woman with mass culture (witness Hawthorne's "the damned mob of scribbling women") to the identification of woman with the masses as political threat.

This line of argument invariably leads back to Nietzsche. Significantly, Nietzsche's ascription of feminine characteristics to the masses is always tied to his aesthetic vision of the artist-philosopher-hero, the suffering loner who stands in irreconcilable opposition to modern democracy and its inauthentic culture. Fairly typical examples of this nexus can be found in Nietzsche's polemic against Wagner, who becomes for him the paradigm of the decline of genuine culture in the dawning age of the masses and the feminization of culture: "The danger for artists, for geniuses...is woman: adoring women confront them with corruption. Hardly any of them have character enough not to be corrupted—or 'redeemed'—when they find themselves treated like gods: soon they condescend to the level of the women."[19] Wagner, it is implied, has succumbed to the adoring women by transforming music into mere spectacle, theater, delusion:

> "I have explained where Wagner belongs—not in the history of music. What does he signify nevertheless in that history? The emergence of the actor in music.... One can grasp it with one's very hands: great success, success with the masses no longer sides with those who are authentic—one has to be an actor to achieve that. Victor Hugo and Richard Wagner—they signify the same thing: in declining cultures, wherever the decision comes to rest with the masses, authenticity becomes superfluous, disadvantageous, a liability. Only the actor still arouses great enthusiasm."[20]

And then Wagner, the theater, the mass, woman—all become a web of signification outside of, and in opposition to, true art: "No one brings along the finest senses of his art to the theater, least of all the artist who works for the theater—solitude is lacking;

15. Edmond and Jules de Goncourt, *Germinie Lacerteux*, trans. Leonard Tancock (Harmondsworth: Penguin, 1984), p. 15.

16. *Die Gesellschaft*, 1, no. 1 (January 1885).

17. Cf. Cäcilia Rentmeister, "Berufsverbot für Musen," *Ästhetik und Kommunikation*, 25 (September 1976), 92-113.

18. Cf., for instance, the essays by Carol Duncan and Norma Broude in *Feminism and Art History*, ed. Norma Broude and Mary D. Garrard (New York: Harper & Row, 1982) or the documentation of relevant quotes by Valerie Jaudon and Joyce Kozloff, "'Art Hysterical Notions' of Progress and Culture," *Heresies*, 1, no. 4 (Winter 1978), 38-42.

19. Friedrich Nietzsche, *The Case of Wagner*, in *The Birth of Tragedy and the Case of Wagner*, trans. Walter Kaufmann (New York: Random House, 1967), p. 161.

20. Nietzsche, *The Case of Wagner*, p. 179.

whatever is perfect suffers no witnesses. In the theater one becomes people, herd, female, pharisee, voting cattle, patron, idiot—*Wagnerian*."[21] What Nietzsche articulates here is of course not an attack on the drama or the tragedy, which to him remain some of the highest manifestations of culture. When Nietzsche calls theater a "revolt of the masses,"[22] he anticipates what the situationists would later elaborate as the society of the spectacle, and what Baudrillard chastises as the simulacrum. At the same time, it is no coincidence that the philosopher blames theatricality for the decline of culture. After all, the theater in bourgeois society was one of the few spaces which allowed women a prime place in the arts, precisely because acting was see as imitative and reproductive, rather than original and productive. Thus, in Nietzsche's attack on what he perceives as Wagner's feminization of music, his "infinite melody"—"one walks into the sea, gradually loses one's secure footing, and finally surrenders oneself to the elements without reservation"[23]—an extremely perceptive critique of the mechanisms of bourgeois culture goes hand in hand with an exhibition of that culture's sexist biases and prejudices.

III

The fact that the identification of woman with mass has major political implications is easily recognized. Thus Mallarmé's quip about *"reportage universal"* (i.e., mass culture), with its not so subtle allusion to *"suffrage universel,"* is more than just a clever pun. The problem goes far beyond questions of art and literature. In the late 19th century, a specific traditional male image of woman served as a receptacle for all kinds of projections, displaced fears, and anxieties (both personal and political), which were brought about by modernization and the new social conflicts, as well as by specific historical events such as the 1848 revolution, the 1870 Commune, and the rise of reactionary mass movements which, as in Austria, threatened the liberal order.[24] An examination of the magazines and the newspapers of the period will show that the proletarian and petit-bourgeois masses were persistently described in terms of a feminine threat. Images of the raging mob as hysterical, of the engulfing floods of revolt and revolution, of the swamp of big city life, of the spreading ooze of massification, of the figure of the red whore at the barricades—all of these pervade the writing of the mainstream media, as well as that of right-wing ideologues of the late 19th and early 20th centuries whose social psychology Klaus Theweleit has perceptively analyzed in his study *Male Phantasies*.[25] The fear of the masses in this age of declining liberalism is always also a fear of woman, a fear of nature out of control, a fear of the unconscious, of sexuality, of the loss of identity and stable ego boundaries in the mass.

This kind of thinking is exemplified by Gustave Le Bon's enormously influential *The Crowd* (*La Psychologie des foules*, 1895), which as Freud observed in his own *Mass Psychology and Ego Analysis* (1921) merely summarizes arguments pervasive in Europe at the time. In Le Bon's study, the male fear of woman and the bourgeois fear of the masses become indistinguishable: "Crowds are everywhere distinguished by feminine characteristics."[26] And: "The simplicity and exaggeration of the sentiments of crowds have for result that a throng knows neither doubt nor uncertainty. Like women, it goes at once to extremes.... A commencement of antipathy or disapprobation, which in the case of an isolated individual would not gain strength, becomes at once furious hatred in the case of an individual in a crowd."[27] And then he summarizes his fears with a reference to that icon which perhaps more than any

21. Friedrich Nietzsche, *Nietzsche Contra Wagner*, in *The Portable Nietzsche*, ed. and trans. Walter Kaufmann (Harmondworth and New York: Random House, 1976), p. 665f.

22. Nietzsche, *The Case of Wagner*, p. 183.

23. Friedrich Nietzsche, *Nietzsche Contra Wagner*, p. 666.

24. For a recent discussion of semantic shifts in the political and sociological discourse of masses, elites, and leaders from the late 19th century to fascism see Helmuth Berking, "Mythos und Politik: Zur historischen Semantik des Massenbegriffs," *Ästhetik und Kommunikation*, 56 (November 1984), 35-42.

25. An English translation of the two-volume work will soon be published by the University of Minnesota Press.

26. Gustave Le Bon, *The Crowd* (Harmondworth and New York: Penguin, 1981), p. 39.

27. Le Bon, p. 50.

other in the 19th century—more even than the Judiths and Salomés so often portrayed on symbolist canvases—stood for the feminine threat to civilization: "Crowds are somewhat like the sphinx of ancient fable: it is necessary to arrive at a solution of the problems offered by their psychology or to resign ourselves to being devoured by them."[28] Male fears of an engulfing femininity are here projected onto the metropolitan masses, who did indeed represent a threat to the rational bourgeois order. The haunting specter of a loss of power combines with fear of losing one's fortified and stable ego boundaries, which represent the *sine qua non* of male psychology in that bourgeois order. We may want to relate Le Bon's social psychology of the masses back to modernism's own fears of being sphinxed. Thus the nightmare of being devoured by mass culture through co-option, commodification, and the "wrong" kind of success is the constant fear of the modernist artist, who tries to stake out inauthentic mass culture. Again, the problem is not the desire to differentiate between forms of high art and depraved forms of mass culture and its co-options. The problem is rather the persistent gendering as feminine of that which is devalued.

IV

Seen in relation to this kind of paranoid view of mass culture and the masses, the modernist aesthetic itself—at least in one of its basic registers—begins to look more and more like a reaction formulation, rather than like the heroic feat steeled in the fibres of the modern experience. At the risk of oversimplifying, I would suggest that one can identify something like a core of the modernist aesthetic which has held sway over many decades, which manifests itself (with variations due to respective media) in literature, music, architecture, and the visual arts, and which has had an enormous impact on the history of criticism and cultural ideology. If we were to construct an ideal type notion of what the modernist art work has become as a result of successive canonizations—and I will exclude here the poststructuralist archeology of modernism which has shifted the

grounds of the debate—it would probably look somewhat like this:

—The work is autonomous and totally separate from the realms of mass culture and everyday life.

—It is self-referential, self-conscious, frequently ironic, ambiguous, and rigorously experimental.

—It is the expression of a purely individual consciousness rather than of a Zeitgeist or a collective state of mind.

—Its experimental nature makes it analogous to science, and like science it produces and carries knowledge.

—Modernist literature since Flaubert is a persistent exploration of and encounter with language. Modernist painting since Manet is an equally persistent elaboration of the medium itself: the flatness of the canvas, the structuring of notation, paint and brushwork, the problem of the frame.

—The major premise of the modernist art work is the rejection of all classical systems of representation, the effacement of "content," the erasure of subjectivity and authorial voice, the repudiation of likeness and verisimilitude, the exorcism of any demand for realism of whatever kind.

—Only by fortifying its boundaries, by maintaining its purity and autonomy, and by avoiding any contamination with mass culture and with the signifying systems of everyday life can the art work maintain its adversary to mass culture and entertainment which are seen as the primary forms of bourgeois cultural articulation.

One of the first examples of this aesthetic would be Flaubert's famous "impassibilité" and his desire to write "a book about nothing, a book without external attachments which would hold together by itself through the internal force of its style." Flaubert can be said to ground modernism in literature, both for its champions (from Nietzsche to Roland Barthes) and for its detractors (such as Georg Lukács). Other historical forms of this modernist aesthetic would be the clinical, dissecting gaze of the naturalist;[29] the doctrine of art for art's sake in its various classicist or romantic guises since the late 19th century; the insistence of the art-life dichotomy so frequently found at the turn of the century, with

28. Le Bon, p. 102.

29. Naturalism is not always included in the history of modernism because of its close relationship to realistic description, but it clearly belongs to this context as Georg Lukács never ceased to point out.

its inscription of art on the side of death and masculinity and its evaluation of life as inferior and feminine; and finally the absolutist claims of abstraction, from Kandinsky to the New York School.

But it was only in the 1940s and 1950s that the modernism gospel and the concomitant condemnation of kitsch became something like the equivalent of the one-party state in the realm of aesthetics. And it is still an open question to what extent current poststructuralist notions of language and writing and of sexuality and the unconscious are a postmodern departure toward entirely new cultural horizons; or whether, despite their powerful critique of older notions of modernism, they do not rather represent another mutation of modernism itself.

My point here is not to reduce the complex history of modernism to an abstraction. Obviously, the various layers and components of the ideal modernist work would have to be read in and through specific works in specific historical and cultural constellations. The notion of autonomy, for instance, has quite different historical determinations for Kant, who first articulated it in his *Kritik der Urteilskraft*, than for Flaubert in the 1850s, for Adorno during World War II, or again for Frank Stella today. My point is rather that the champions of modernism themselves were the ones who made that complex history into a schematic paradigm, the main purpose of which often seemed to be the justification of current aesthetic practice, rather than the richest possible reading of the past in relation to the present.

My point is not to say that there is only one, male, sexual politics to modernism, against which women would have to find their own voices, their own language, their own feminine aesthetic. What I am saying is that the powerful masculinist mystique which is explicit in modernists such as Marinetti, Jünger, Benn, Wyndham Lewis, Céline et al. (not to speak of Marx, Nietzsche, and Freud), and implicit in many others, has to be somehow related to the persistent gendering of mass culture as feminine and inferior—even if, as a result, the heroism of the moderns won't look quite as heroic any more. The autonomy of the modernist art work, after all, is always the result of a resistance, an abstention, and a suppression—resistance to the seductive lure of mass culture, abstention

from the pleasure of trying to please a larger audience, suppression of everything that might be threatening to the rigorous demands of being modern and at the edge of time. There seem to be fairly obvious homologies between this modernist insistence on purity and autonomy in art, Freud's privileging of the ego over the id and his insistence on stable, if flexible, ego boundaries, and Marx's privileging of production over consumption. The lure of mass culture, after all, has traditionally been described as the threat of losing oneself in dreams and delusions and of merely consuming rather than producing.[30] Thus, despite its undeniable adversary stance toward bourgeois society, the modernist aesthetic and its rigorous work ethic as described here seem in some fundamental way to be located also on the side of that society's reality principle, rather than on that of the pleasure principle. It is to this fact that we owe some of the greatest works of modernism, but the greatness of these works cannot be separated from the often one-dimensional gender inscriptions inherent in their very constitution as autonomous masterworks of modernity.

V

The deeper problem at stake here pertains to the relationship of modernism to the matrix of modernization which gave birth to it and nurtured it through its various stages. In less suggestive terms, the question is why, despite the obvious heterogeneity of the modernist project, a certain universalizing account of the modern has been able to hold sway for so long in literary and art criticism, and why even today it is far from having been decisively displaced from its position of hegemony in cultural institutions. What has to be put in question is the presumably adversary relationship of the modernist aesthetic to the myth and ideology of modernization and progress, which it ostensibly rejects in its fixation upon the eternal and timeless power of the poetic word. From the vantage point of our postmodern age, which has

30. On the relationship of the production/consumption paradigm to the mass culture debate see Tania Modleski, "Femininity as Mas(s)querade: A Feminist Approach to Mass Culture," forthcoming in Colin MacCabe, ed., *High Theory, Low Culture*, University of Manchester Press.

begun in a variety of discourses to question seriously the belief in unhampered progress and in the blessings of modernity, it becomes clear how modernism, even in its most adversary, anti-bourgeois manifestations, is deeply implicated in the process and pressures of the same mundane modernization it so ostensibly repudiates. It is especially in light of the ecological and environmental critique of industrial and postindustrial capitalism, and of the different yet concomitant feminist critique of bourgeois patriarchy, that the subterranean collusion of modernism with the myth of modernization becomes visible.

I want to show this briefly for two of the most influential and by now classical accounts of the historical trajectory of modernism—the accounts of Clement Greenberg in painting and of Theodor W. Adorno in music and literature. For both critics, mass culture remains the other of modernism, the specter that haunts it, the threat against which high art has to shore up its terrain. And even though mass culture is no longer imagined as primarily feminine, both critics remain under the sway of the old paradigm in their conceptualization of modernism.

Indeed, both Greenberg and Adorno are often taken to be the last ditch defenders of the purity of the modernist aesthetic, and they have become known since the late 1930s as uncompromising enemies of modern mass culture. (Mass culture had by then of course become an effective tool of totalitarian denomination of a number of countries, which all banished modernism as degenerate or decadent.) While there are major differences between the two men, both in temperament and in the scope of their analyses, they both share a notion of the inevitability of the evolution of modern art. To put it bluntly, they believe in progress—if not in society, then certainly in art. The metaphors of linear evolution and of a teleology of art are conspicuous in their work. I quote Greenberg: "It has been in search of the absolute that the avant-garde has arrived at 'abstract' or 'nonobjective' art—and poetry, too."[31] It is well known how Greenberg constructs the story of modernist painting as a single-minded trajectory, from the first

French modernist avant-garde of the 1860s to the New York School of abstract expressionism—his moment of truth.

Similarly, Adorno sees a historical work in the move from late romantic music to Wagner and ultimately to Schönberg and the second school of Vienna, which represent *his* moment of truth. To be sure, both critics acknowledge retarding elements in these trajectories—Stravinsky in Adorno's account, surrealism in Greenberg's—but the logic of history, or rather the logic of aesthetic evolution, prevails, giving a certain rigidity to Greenberg's and Adorno's theorizing. Obstacles and detours, it seems, only highlight the dramatic and inevitable path of modernism toward its telos, whether this telos is described as triumph as in Greenberg or as pure negativity as in Adorno. In the work of both critics, the theory of modernism appears as a theory of modernization displaced to the aesthetic realm; this is precisely its historical strength, and what makes it different from the mere academic formalization of which it is so often accused. Adorno and Greenberg further share a notion of decline that they see as following on the climax of development in high modernism. Adorno wrote about "Das Altern der Neuen Musik," and Greenberg unleashed his wrath on the reappearance of representation in painting since the advent of Pop Art.

At the same time, both Adorno and Greenberg were quite aware of the costs of modernization, and they both understood that it was the ever increasing pace of commodification and colonization of cultural space which actually propelled modernism forward, or, better, pushed it toward the outer margins of the cultural terrain. Adorno especially never lost sight of the fact that, ever since their simultaneous emergence in the mid-19th century, modernism and mass culture have been engaged in a compulsive *pas de deux*. To him, autonomy was a rational phenomenon, not a mechanism to justify formalist amnesia. His analysis of the transition in music from Wagner to Schönberg makes it clear that Adorno never saw modernism as anything other than a reaction formation to mass culture and commodification, a reaction formation which operated on the level of form and artistic material. The same awareness that mass

31. Clement Greenberg, "Avant-Garde and Kitsch," in *Art and Culture: Critical Essays* (Boston: Beacon Press, 1961), p. 5f.

culture, on some basic level, determined the shape and course of modernism is pervasive in Clement Greenberg's essays of the late 1930s. To a large extent, it is by the distance we have traveled from this "great divide" between mass culture and modernism that we can measure our own cultural postmodernity. And yet, I still know of no better aphorism about the imaginary adversaries, modernism and mass culture, than that which Adorno articulated in a letter to Walter Benjamin: "Both [modernist and mass culture] bear the scars of capitalism, both contain elements of change. Both are torn halves of freedom to which, however, they do not add up."[32]

But the discussion cannot end here. The postmodern crisis of high modernism and its classical accounts has to be seen as a crisis both of capitalist modernization itself and of the deeply patriarchal structures that support it. The traditional dichotomy, in which mass culture appears as monolithic, engulfing, totalitarian, and on the side of regression and the feminine ("Totalitarianism appeals to the desire to return to the womb," said T. S. Eliot[33]) and modernism appears as progressive, dynamic, and indicative of male superiority in culture, has been challenged empirically and theoretically in a variety of ways in the past twenty years or so. New versions of the history of modern culture, the nature of language, and artistic autonomy have been elaborated, and new theoretical questions have been brought to bear on mass culture and modernism; most of us would probably share the sense that the ideology of modernism, as I have sketched it here, is a thing of the past, even if it still occupies major bastions in cultural institutions such as the museum or the academy. The attacks on high modernism, waged in the name of the postmodern since the late 1950s, have left their mark on our culture, and we are still trying to figure out the gains and the losses which this shift has brought about.

32. Letter of March 18, 1936, in Walter Benjamin, *Gesammelte Schriften*, 1, 3 (Frankfurt am Main: Suhrkamp, 1974), p. 1003.

33. T. S. Eliot, *Notes towards the Definition of Culture*, published with *The Idea of a Christian Society as Christianity and Culture* (New York: Harcourt, Brace, 1968), p. 142.

VI

What then of the relationship of postmodernism to mass culture, and what of its gender inscriptions? What of postmodernism's relationship to the myth of modernization? After all, if the masculinist inscriptions in the modernist aesthetic are somehow subliminally linked to the history of modernization, with its insistence on instrumental rationality, teleological progress, fortified ego boundaries, discipline, and self-control; if, furthermore, both modernism and modernization are ever more emphatically subjected to critique in the name of the postmodern—then we must ask to what extent postmodernism offers possibilities for genuine cultural change, or to what extent the postmodern raiders of a lost past produce only simulacra, a fast-image culture that makes the latest thrust of modernization more palatable by covering up its economic and social dislocations. I think that postmodernism does both, but I will focus here only on some of the signs of promising cultural change.

A few somewhat tentative reflections will have to suffice, as the amorphous and politically volatile nature of postmodernism makes the phenomenon itself remarkably elusive, and the definition of its boundaries exceedingly difficult, if not per se impossible. Furthermore, one critic's postmodernism is another critic's modernism (or variant thereof), while certain vigorously new forms of contemporary culture (such as the emergence into a broader public's view of distinct minority cultures and of a wide variety of feminist work in literature and the arts) have so far rarely been discussed *as* postmodern, even though these phenomena have manifestly affected both the culture at large and the ways in which we approach the politics of the aesthetic today. In some sense it is the very existence of these phenomena which challenges the traditional belief in the necessary advances of modernism and the avant-garde. If postmodernism is to be more than just another revolt of the modern against itself, then it would certainly have to be defined in terms of this challenge to the constitutive forward thrust of avant-gardism.

I do not intend here to add yet another definition of what the postmodern *really* is, but it seems clear

to me that both mass culture and women's (feminist) art are emphatically implicated in any attempt to map the specificity of contemporary culture and thus to gauge this culture's distance from high modernism. Whether one uses the term "postmodernism" or not, there cannot be any question about the fact that the position of women in contemporary culture and society, and their effect on that culture, is fundamentally different from what it used to be in the period of high modernism and the historical avant-garde. It also seems clear that the uses high art makes of certain forms of mass culture (and vice versa) have increasingly blurred the boundaries between the two; where modernism's great wall once kept the barbarians out and safeguarded the culture within, there is now only slippery ground which may prove fertile for some and treacherous for others.

At stake in this debate about the postmodern is the great divide between modern art and mass culture, which the art movements of the 1960s intentionally began to dismantle in their practical critique of the high modernist canon and which the cultural neo-conservatives are trying to re-erect today.[34] One of the few widely agreed upon features of postmodernism is its attempt to negotiate forms of high art with certain forms and genres of mass culture and the culture of everyday life.[35] I suspect that it is probably no coincidence that such merger attempts occurred more or less simultaneously with the emergence of feminism and women as major forces in the arts, and with the concomitant reevaluation of formerly devalued forms and genres of cultural expression (e.g., the decorative arts, autobiographical texts, letters, etc.). However, the original impetus to merge high art and popular culture—for example, say in Pop Art in the early 1960s—did not yet have anything to do with the later

feminist critique of modernism. It was, rather, indebted to the historical avant-garde—art movements such as Dada, constructivism, and surrealism—which had aimed, unsuccessfully, at freeing art from its aestheticist ghetto and reintegrating art and life.[36] Indeed, the early American postmodernists' attempts to open up the realm of high art to the imagery of everyday life and American mass culture are in some ways reminiscent of the historical avant-garde's attempt to work in the interstices of high art and mass culture. In retrospect, it thus seems quite significant that major artists of the 1920s used precisely the then wide-spread "Americanism" (associated with jazz, sports, cars, technology, movies, and photography) in order to overcome bourgeois aestheticism and its separateness from "life." Brecht is the paradigmatic example here, and he was in turn strongly influenced by the post-revolutionary Russian avant-garde and its daydream of creating a revolutionary avant-garde culture for the masses. It seems that the European Americanism of the 1920s then returned to America in the 1960s, fueling the fight of the early postmodernists against the high-culture doctrines of Anglo-American modernism. The difference is that the historical avant-garde—even where it rejected Leninist vanguard politics as oppressive to the artist—always negotiated its political *Selbstverständnis* in relation to the revolutionary claims for a new society which would be the *sine qua non* of the new art. Between 1916—the "outbreak" of Dada in Zurich—and 1933/34—the liquidation of the historical avant-garde by German fascism and Stalinism—many major artists took the claim inherent in the avant-garde's name very seriously: namely, to lead the whole of society toward new horizons of culture, and to create an avant-garde art for the masses. This ethos of a symbiosis between revolutionary art and revolutionary politics certainly vanished after World War II; not just because of McCarthyism, but even more because of what Stalin's henchmen had done to the left aesthetic avant-garde of the 1920s. Yet the attempt by the American postmodernists of the 1960s to renegotiate the

34. For a discussion of the neo-conservatives' hostility toward postmodernism see the essay "Mapping the Postmodern."

35. While critics seem to agree on this point in theory, there is a dearth of specific readings of texts or art works in which such a merger has been attempted. Much more concrete analysis has to be done to assess the results of this new constellation. There is no doubt in my mind that there are as many failures as there are successful attempts by artists, and sometimes success and failure reside side by side in the work of one and the same artist.

36. On this distinction between late 19th-century modernism and the historical avant-garde see Peter Bürger, *Theory of the Avant-Garde* (Minneapolis: University of Minnesota Press, 1984).

relationship between high art and mass culture gained its own political momentum in the context of the emerging new social movements of those years—among which feminism has perhaps had the most lasting effects on our culture, as it cuts across class, race, and gender.

In relation to gender and sexuality, though, the historical avant-garde was by and large as patriarchal, misogynist, and masculinist as the major trends of modernism. One needs only to look at the metaphors in Marinetti's "Futurist Manifesto," or to read Marie Luise Fleisser's trenchant description of her relationship to Bertolt Brecht in a prose text entitled "Avantgarde"—in which the gullible, literarily ambitious young woman from the Bavarian province becomes a guinea pig in the machinations of the notorious metropolitan author. Or, again, one may think of how the Russian avant-garde fetishized production, machines, and science, and of how the writings and paintings of the French surrealists treated women primarily as objects of male phantasy and desire.

There is not much evidence that things were very different with the American postmodernists of the late 1050s and early 1960s. However, the avant-garde's attack on the autonomy aesthetic, its politically motivated critique of the highness of high art, and its urge to validate other, formerly neglected or ostracized forms of cultural expression created an aesthetic climate in which the political aesthetic of feminism could thrive and develop its critique of patriarchal gazing and penmanship. The aesthetic transgressions of the happenings, actions, and performances of the 1960s were clearly inspired by Dada, Informel, and action painting; and with few exceptions—the work of Valie Export, Charlotte Moorman, and Carolee Schneemann—these forms did not transport feminist sensibilities or experiences. But it seems historically significant that women artists increasingly used these forms in order to give voice to their experiences.[37] The road from the avant-garde's experiments to contemporary women's art seems to have been shorter, less

tortuous, and ultimately more productive than the less frequently traveled road from high modernism. Looking at the contemporary art scene, one may well want to ask the hypothetical question whether performance and "body art" would have remained so dominant during the 1970s had it not been for the vitality of feminism in the arts and the ways in which women artists articulated experiences of the body and of performance in gender-specific terms. I only mention the work of Yvonne Rainer and Laurie Anderson. Similarly, in literature the reemergence of the concern with perception and identification, with sensual experience and subjectivity in relation to gender and sexuality would hardly have gained the foreground in aesthetic debates (against even the powerful poststructuralist argument about the death of the subject and the Derridean expropriation of the feminine) had it not been for the social and political presence of a women's movement and women's insistence that male notions of perception and subjectivity (or the lack thereof) did not really apply to them. Thus the turn toward problems of "subjectivity" in the German prose of the 1970s was initiated not just by Peter Schneider's *Lenz* (1973), as is so often claimed, but even more so by Karin Struck's *Klassenliebe* (also 1973) and, in retrospect, by Ingeborg Bachmann's *Malina* (1971).

However one answers the question of the extent to which women's art and literature have affected the course of postmodernism, it seems clear that feminism's radical questioning of patriarchal structures in society and in the various discourses of art, literature, science, and philosophy must be one of the measures by which we gauge the specificity of contemporary culture as well as its distance from modernism and its mystique of mass culture as feminine. Mass culture and the masses as feminine threat—such notions belong to another age, Jean Baudrillard's recent ascription of femininity to the masses notwithstanding. Of course, Baudrillard gives the old dichotomy a new twist by applauding the femininity of the masses rather than denigrating it, but his move may be no more than yet another Nietzschean simulacrum.[38] After the feminist critique of the multilayered sexism in television, Hollywood, advertising,

37. Cf. Gislind Nabakowski, Helke Sander, and Peter Gorsen, *Frauen in der Kunst*, 2 volumes (Frankfurt am Main: Suhrkamp, 1980), especially the contributions by Valie Export and Gislind Nabakowski in volume 1.

38. I owe this critical reference to Baudrillard to Tania Modleski's essay "Femininity as Mas(s)querade."

and rock 'n' roll, the lure of the old rhetoric simply does not work any longer. The claim that the threats (or, for that matter, the benefits) of mass culture are somehow "feminine" has finally lost its persuasive power. If anything, a kind of reverse statement would make more sense: certain forms of mass culture, with their obsession with gendered violence are more of a threat to women than to men. After all, it has always been men rather than women who have had real control over the productions of mass culture.

In conclusion, then, it seems clear that the gendering of mass culture as feminine and inferior has its primary historical place in the late 19th century, even though the underlying dichotomy did not lose its power until quite recently. It also seems evident that the decline of this pattern of thought coincides historically with the decline of modernism itself. But I would submit that it is primarily the visible and public presence of women artists in *high* art, as well as the emergence of new kinds of women performers and producers in mass culture, which make the old gendering device obsolete. The universalizing ascription of femininity to mass culture always depended on the very real exclusion of women from high culture and its institutions. Such exclusions are, for the time being, a thing of the past. Thus, the old rhetoric has lost its persuasive power because the realities have changed.

Janet Wolff

Women's Knowledge and Women's Art

From *Feminine Sentences*

Can there be such a thing as 'women's writing'? More specifically, in a patriarchal culture, in which institution, language, and regimes of representation collude in the marginalization of women's experience and in the silencing of women's voice, is it possible for women to articulate the suppressed by new aesthetic strategies? Those feminists who propose the notion of *l'écriture féminine* argue that it is. This view has also had supporters in other traditions than contemporary French feminism. Virginia Woolf suggested that there is such a thing as a 'woman's sentence',[1] to be found in the work of women modernists like Dorothy Richardson.[2]

The idea that literary forms can be radically altered in order to accommodate and express women's experience is now well established in some areas of feminist criticism. 'Feminine writing' is rediscovered in the work of past authors, and created in contemporary experimental texts, influenced by Hélène Cixous's concept of 'writing from the body'[3] and by the work of other French feminist novelists and critics. Important in this development has been Julia Kristeva's analysis of what she has called 'the revolution in poetic language', in which she claims that certain avant-garde texts from the late nineteenth century explored the possibility of subverting the patriarchal order in representation by writing from the 'semiotic chora'—the pre-Oedipal (and

therefore, in Lacanian terms, the pre-Symbolic) moment.[4] The fact that the writers Kristeva discusses are men (Mallarmé and Lautréamont) is not the point, since what she is trying to do is to examine the origins, in modernist literature, of a type of writing which escapes the confines of the predominating patriarchal culture. Such writing would clearly be available for a feminist cultural politics.

The concept of 'feminine writing' has also been extended to the visual arts. Nancy Spero's work has recently been discussed as an example of *la peinture féminine*.[5] The idea that women can write, paint, and produce culture which is no longer constrained within forms alien to their experience has proved an attractive and a liberating one for many artists and critics. In this essay, I want to consider some of the more problematic issues raised by this work and this politics, in particular looking more closely at what is meant by 'women's art'. To the extent that this concept depends on certain ideas of 'women's knowledge' (that is, the assumption that women's and men's experience and knowledge is in some important sense *different*), it seems essential to discuss questions of aesthetics in relation to questions of epistemology. I shall therefore be looking at recent work on women and science and women and philosophy, in order to explore further the key concept of 'women's knowledge'.

The fact that the possibility of 'women's voice' in culture has been raised at all is in many ways the

1. Virginia Woolf, 'Women and Fiction', *Collected Essays*, vol. 1 (London, Hogarth Press, 1966).

2. Virginia Woolf, 'Dorothy Richardson', in *Collected Essays*. (See 'Feminism and Modernism' in this collection.)

3. Hélène Cixous, 'The Laugh of the Medusa', in Elaine Marks and Isabelle de Courtivron (eds.), *New French Feminisms* (New York, Schocken Books, 1981).

4. Julia Kristeva, *Revolution in Poetic Language* (New York, Columbia University Press, 1984).

5. Lisa Tickner, 'Nancy Spero: Images of Women and *la peinture féminine*', in *Nancy Spero* (London, Institute of Contemporary Arts, 1987).

culmination of fifteen or more years of feminist work in literary and art criticism. This work has systematically demonstrated the comprehensively patriarchal nature of culture—its institutions and ideologies of production and reception, its regimes of representation, and its formal and textual characteristics. First, feminists have addressed the question of why the history of art is almost entirely a history of men's work. (The same question can be asked of the history of music, the history of architecture, and of most other cultural forms. Even in the case of literature, where there have always been published women novelists, an examination of the processes of cultural production reveals an abundance of discriminatory practices which operate against women.) More recently, feminist art historians have turned from the earlier project of rediscovering 'lost' women artists, republishing 'lost' women authors (through feminist presses), and of rewriting the histories of art and literature. Instead, they have insisted on the importance of examining and exposing structural and ideological obstacles to women's success in the arts, both in the past and in the contemporary present.

Secondly, there has been a great deal of work on gender and representation, which has analysed the ways in which women have been depicted in literature and painting. This is not simply a question of exposing a narrow range of stereotypes, but more a recognition of the way in which the very category of 'woman' is constructed in representation. What becomes clear is the formal and conventional impossibility of a feminist heroine, of an ideologically subversive plot, or of a female body perceived without all the connotations and meanings of a patriarchal system of representation and of viewing.

Lastly, theories of reception have been mobilized to expose the denial to women of a subject position as reader. Jonathan Culler asks what it would be like to read the opening of Thomas Hardy's *The Mayor of Casterbridge* (which deals with a wife-sale) as a woman.[6] Just as art criticism and film criticism have demonstrated the ways in which texts constitute their readers/viewers as male, so feminist literary critics have identified that necessary process which has been called the 'immasculation of the reader'—that is, the need for women, if they are to be competent readers in our culture, to take on the point of view of men.[7]

In the face of this relentless exclusion of women from culture, feminists raise the question of what a *different* culture would be like. What is the possibility for women to write (or paint) from their own experience, no longer mediated by the culture and point of view of men? And where, if anywhere, are the spaces the dominant culture allows for this expression? The literary critic, Elaine Showalter, has proposed that the primary task of feminist criticism is the identification of the key characteristics of women's writing—an exercise which she calls *gynocritics*. This will deal with the 'history, styles, themes, genres, and structures of writing by women'.[8] To explore the basis of women's writing, Showalter employs the concept of the 'wild zone', borrowed from the anthropologist, Edwin Ardener. Ardener describes the way in which, in many cultures, areas of women's lives and experience are marginalized by the dominant culture. Where the experiences and perspectives of men and women overlap, then the dominant culture and language will be adequate to describe them. But since cultures are all patriarchal, those areas of experience which are specific to women are excluded, and cannot be articulated or shared within the available discourse.[9] This is the 'wild zone'.

In 1986 there was a report about the discovery of a secret script, apparently still use in China and dating from the Chang dynasty (1600 to 1100 BC).[10] The script, which used an inverted system of grammar and syntax very different from Chinese, and was

6. Jonathan Culler, *On Deconstruction: Theory and Criticism after Structuralism* (London, Routledge & Kegan Paul, 1983), ch. 1, Section 2: 'Reading as a Woman'.

7. Judith Fetterley, *The Resisting Reader* (Bloomington, Indiana University Press, 1978).

8. Elaine Showalter, 'Feminist Criticism in the Wilderness' in Elizabeth Abel (ed.), *Writing and Sexual Difference* (Brighton, Harvester Press, 1982), p. 14.

9. Edwin Ardener, 'Belief and the Problem of Women', in Shirley Ardener (ed.), *Perceiving Women* (London, J. M. Dent & Sons, 1975).

10. *Guardian* (19 May 1986), and *Spare Rib*, no. 168 (July 1986).

written with ink and brush and without punctuation, was said to have been used only by women, uniting them in 'an exclusive sisterhood'. This kind of anthropological evidence suggests the possibility for women of articulating the 'wild zone' of their own experience, outside the dominant culture and language of men.

Nevertheless, the notion of a 'wild zone', and the idea that we can somehow develop language outside culture, is problematic. As Showalter says, there is no way in which we can talk about the 'wild zone', the muted voice, the new language, outside the dominant structure.[11] We could add that there is no way in which those who are marginalized by the dominant culture can develop alternative cultural forms other than from their basis in that culture, for this is where they learn to speak, where they are socialized, and where they enter culture as gendered subjects with the ability to communicate. (Similar arguments have been made against Kristeva's suggestion that avant-garde writing emerges from the semiotic chora, for here too it must be stressed that *any* communication presupposes entry into the Symbolic.) Showalter concludes that women's writing is more a double-edged discourse than something entirely separate. It embodies the social, cultural, and literary heritage of both the muted and the dominant groups.

We need to look a little more closely at the assumption that women *are* excluded from culture, if this is to be more than a polemical claim. That is, we need to know what is meant by claiming that culture and knowledge are 'male'. We also need to be more specific about the argument that women are silenced by or excluded from the dominant culture. What are the mechanisms and practices through which this occurs? Lastly, we can then come back to the question of how it is possible for women to articulate their experience in language, in writing, and in art.

The institutional organization of knowledge operates to marginalize women, as well as to reinforce the gender inequalities in contemporary society. The historical development of the different disciplines, arbitrary as it has been from the point of view of our

actual experience in the world and in everyday life, reinforces the division of the sexes. We have come to study economics in isolation from history and from politics. We study philosophy in a way which detaches ideas from their origins and meanings in the social and material world. We study art and literature as totally separate from the political and social circumstances in which they are produced and consumed. This historical segregation of areas of investigation has other kinds of implication for knowledge, criticism, and power relations, apart from questions raised by feminism. But from the point of view of gender inequalities, it is clear that it is more or less impossible to address these issues within the framework of the mainstream academic tradition. To make any sense of the question of why there have been so few successful women artists we need to look at extra-aesthetic processes—the social, ideological, and economic situation of women, the institutions and practices of the arts in a particular period in terms of their social, financial, material organization, and so on. The question of why women are 'hidden from history' is not just a question about the discipline of history, though to answer it we will have to examine that discipline and its own specific kinds of formulation and exclusion. It is also a question about the *wider* context of historical events, which traditional historical method cannot perceive.

In short, a sociological perspective is essential in each of the disciplines, to make clear the circumstances which produce certain limited types of knowledge and certain particular gender imbalances. But even within the discipline of sociology itself these artificial divisions are visible. The sociology of industry, the sociology of politics, the sociology of education, and most of the other sub-areas within the discipline may be prepared to look at gender these days, observing women's disadvantaged position in each domain. But only an *integrated* sociological account could explain this, for women's position in the labour market (and, we could add, women's place in cultural production) is inextricably linked with two other things: the history of gender divisions and of the institutions in question, and the contemporary situation of men and women in the domestic sphere. Alongside the other areas of sociological

11. Showalter, 'Feminist Criticism in the Wilderness', p. 31.

study, the sociology of the family has a fairly long pedigree. But this approach to the domestic sphere as something separate merely compounds the separation of work and home, of public and private. It is only with the relatively recent rise of feminist sociology that it has become possible to relate the two areas rather than treating them as completely distinct.

The institutional organization of knowledge thus mirrors and produces the gender biases of the social world. The public is separated from the private in the dominant conceptualization, and because women have historically always been secondary in, or marginal to, the public sphere, they are similarly constructed as secondary in knowledge. Either they are totally invisible (as in the sociology of industry until recently), or at best secondary (filling less important roles);[12] or their own sphere of operation is completely ignored and absent from the literature. In fact, as feminist historians have pointed out,[13] it has never been correct to argue that from the nineteenth century men occupied the public sphere and women the private sphere. The interconnections are complex, and each sex has its own particular access to and involvement in both spheres. But only an intellectual approach which incorporates and explores the historical development of the public and the private and the relationship between them will be able to comprehend the real social relations of gender.

The fact that institutionalized knowledge reflects (and also produces) gender inequalities, giving priority to men's areas of knowledge and of social life, is connected to the development of the professions since the nineteenth century. The separation of new and distinct disciplines out of earlier more general areas of knowledge was itself the product of the increasing professionalization of work, including, in this case, of academic work. This coincided with the period in which the separation of spheres took on its most exaggerated form in western societies, as the centralization of production in larger units, outside the home, produced the physical conditions for this increasingly fragmented and compartmentalized way of life. This development was compounded by the growth of bureaucracies (another form of non-domestic, centralized work), and by the process of urbanization, notably the expansion of middle-class suburbs, which reinforced the separation of work and home. Feminist historians have documented this process, and also identified the role of the specific ideology of gender, domesticity, and male and female roles which accompanied and facilitated it.

The implications of this for the institutionalization of knowledge were twofold. In the first place, women were excluded from the production of knowledge, which was predominantly redefined as academic and professional thought. As with all other professions, whether they were new areas of work (like engineering and banking) or traditional areas, newly defined (and narrowed) as professions (such as medicine and education), the academy was a male preserve. Second, the subject-matter of the new disciplines was bound to reflect the interests of its practitioners—namely men. Thus, those areas of experience and knowledge which were specifically women's systematically failed to be represented in the 'knowledge' produced in the academy and in the institutions of intellectual life. The knowledge-producers were dealing with what they knew best, and they were also operating with the existing hierarchy of importance, in which the public (predominantly the male sphere) took precedence over the private (associated with women, and perceived as the female sphere). At the same time, women's 'public' existence (in factories, in offices, in the streets and in the department store) was ignored.

This issue can be related directly to the earlier discussion of women's exclusion from cultural production. For in this area too, the institutions (the Academies, the art schools, the journals, and so on) were run by men, and the ideologies of creativity were entirely male-defined. And those processes which in one way or another go back centuries, culminating in a particular division of labour after the Industrial Revolution, can be followed through to the present day. The ideology of domesticity and of

12. David Morgan, 'Men, Masculinity and the Process of Sociological Enquiry', in Helen Roberts (ed.), *Doing Feminist Research* (London, Routledge & Kegan Paul, 1981).

13. Leonore Davidoff and Catherine Hall, *Family Fortunes: Men and Women of the English Middle Class, 1780-1850* (London, Hutchinson, 1987), pp. 32-4.

women's role may be much transformed since the Victorian period, and women may have entered the labour market in large numbers. Nowadays they are not banned from Academy membership or barred from the life-class. Nevertheless, any look at major national and international exhibits confirms that men predominate in the visual arts. Women's work, across the arts, is given considerably less space in critical discussion. And the literary and art historical establishments for the most part remain very resistant to feminist work and to the necessary reconceptualization of the history and practice of the arts.

So far I have discussed various institutional obstacles to the equal expression of men's and women's experience, and I have suggested that both the development of the disciplines and the rise of the professions have tended to produce a knowledge that is partial and 'male'. Research on language has also suggested that a patriarchal culture silences women through the very concepts and linguistic practices which prevail. Descriptive linguistics has shown that women are often described relationally ('a man and his wife', for example), and that those supposedly generic terms 'man' and 'he' (as in 'a problem for the scientist of the twentieth century is that he...') *don't* in fact operate as neutral in respect to gender. Dale Spender demonstrates this with the telling comparison of the perfectly acceptable 'man is the only primate that commits rape' and the totally ridiculous statement 'man, unlike other mammals, has difficulties in giving birth'.[14] Vocabulary is also biased in terms of non-equivalents: for example, the very different connotations of 'master' and 'mistress' expose a whole history of meanings and of sexual inequalities. Descriptive linguistics also claims to have perceived significant differences in language use between men and women. Women are said to use 'tag questions' more often than men ('isn't it?', 'didn't they?'), registering a tentativeness far less common among male speakers. Men are said to speak more than women in a mixed forum, and to interrupt far more often. Contributions by women to a discussion are more likely to be ignored, while points made by men will be taken up by other speakers. Although some of the more simplistic of these claims about sexism in language have been contested, including by more sophisticated feminist studies and analyses,[15] there is no doubt that linguistic practices and language itself construct women and men differently, subordinating women and obstructing their equal participation in discourse and, hence, social life.

Kristeva's analysis of avant-garde writing, mentioned earlier, is the basis for a different kind of argument about the patriarchal nature of language (and also, as I indicated, for the possibility of a new, non-patriarchal speech). Starting from the Lacanian premise that for the child entry into language, into the Symbolic, is at the same time entry into patriarchy, Kristeva suggests that certain kinds of writing have been able to evade the apparently monolithic control of the Symbolic. Those texts which are produced from the rhythms and pulsions of the semiotic chora—the pre-linguistic, pre-Oedipal experience—and which are in this sense antecedent to representation, offer the possibility of a non-patriarchal expression. I have already referred to the difficulties with this argument. First, in that the writers Kristeva discusses are both male, there is nothing inherently 'feminine' about the use of the 'semiotic rhythm within language'.[16] Second, as Kristeva herself recognizes, in practice such a possibility only exists *within* the Symbolic.[17] Even the identification of patriarchy with entry into the Symbolic has been questioned, since the acquisition of language precedes the Oedipal phase in the child's development. But what is important about this feminist application of Lacanian theory is the acknowledgement of the crucial link between language and patriarchy, and of the linguistic constitution of the patriarchal regime.

14. Dale Spender, *Man Made Language* (London, Routlege & Kegan Paul, 1980), quoted by Maria Black and Rosalind Coward, 'Linguistic, Social and Sexual Relations: A Review of Dale Spender's Man-Made Language', *Screen Education*, no. 39 (Summer 1981), p. 76.

15. Black and Coward, ibid.; Deborah Cameron, *Feminism and Linguistics* (London, Macmillan, 1985).

16. Kristeva, *Revolution in Poetic Language*, p. 29.

17. Ibid., p. 68. See also discussion in 'Reinstating Corporeality: Feminism and Body Politics' in this collection.

A third area of gender bias in knowledge, after the institutional and the linguistic, is the methodological. Here I shall talk mainly about the social sciences, though it can equally be shown that research methods, systems of classification, conceptual frameworks, and theoretical models are partial and distorted in exactly the same way in other disciplines. The collection of statistics themselves has been shown to be biased.[18] For example social surveys on education, or social mobility, or poverty, generally take the family as the unit of analysis, and begin from the 'head of the household', usually the male head. Mobility studies notoriously trace sons of fathers. Not only does this research totally ignore what women do. It also obscures important intra-familial differences, which might well illuminate the material. (For example, where working-class men are married to middle-class women, educational success or longer-term upward mobility on the part of the child might be better explained.) There are, of course, real problems in taking smaller units of analysis (looking solely at individuals might hide the important dynamics of family power relations). But the fact is that mainstream social science operates with the uncritical categories of everyday life, which are biased in respect of gender.

Some feminist sociologists have claimed that even the sacred dogma of 'objectivity' is a sexist notion. Ann Oakley, for example, argues that the accepted orthodoxy on methods of interviewing is inappropriate for female social scientists interviewing other women.[19] The idea of the detached, impartial, controlling interviewer, whose own views and values are kept out of the dialogue, is one which is unacceptable for feminist research. Moreover, we could add, it is one which will fail to get at any real experience. Particularly in her work with mothers, Oakley found the ideal of distance and non-involvement was impossible to achieve, as well as undesirable to attempt. The hierarchical relationship it sets up and the manipulation of the subject were replaced by a co-operative, two-way relationship, in which her own experience and identity came into play in developing a connection which elicited the understanding she was looking for in her research.

It should be stressed that this does not mean either that only feminists should reject simplistic notions of objectivity and detachment (the implication is that *any* research will be better if it is based on dialogue); or that we must henceforth associate quantitative work with men and qualitative work with women. The latter is an assumption sometimes made. It is as well to bear in mind David Morgan's reminder that qualitative sociology has often consisted of brave males venturing out into areas of danger. 'Qualitative methodology and ethnography after all has its own brand of *machismo* with its image of the male sociologist bringing back news from the fringes of society, the lower depths, the mean streets, areas traditionally 'off limits' to women investigators.'[20] As I will argue in relation to feminist epistemology, however, an important part of the argument about method has to do with the congruence of officially prescribed techniques with male experience in our culture, and the associated incompatibility of these methods with women's lives and ways of communicating. Dorothy Smith has argued that sociology is also based on a kind of 'conceptual imperialism'.[21] In our culture women are assigned to the home (in ideology, if not necessarily always in practice). Men, on the other hand, are assigned to the world of work, and the abstract conceptual mode of knowledge that goes with this. Women's role is to mediate for men the relationship between the conceptual mode and the concrete forms in which it is realized. She argues for a woman-centred perspective, which will substitute for abstract concepts a new kind of knowledge, grounded in experience and doing justice to the complexity of human existence, not just the segregated and distorted perspective of men. In the rest of this essay I shall look at recent work in feminist epistemology which helps us to explore such questions and to examine the alleged male bias in knowledge and science.

18. Ann Oakley and Robin Oakley, 'Sexism in Official Statistics', in John Irvine et al. (eds), *Demystifying Social Statistics* (London, Pluto, 1979).

19. Ann Oakley, 'Interviewing Women: A Contradiction in Terms', in Roberts (ed.), *Doing Feminist Research*.

20. Morgan, 'Men, Masculinity and the Process of Sociological Enquiry', p. 86.

21. Dorothy Smith, 'Women's Perspective as a Radical Critique of Sociology', *Sociological Inquiry*, 44 (1974), p. 8.

The following is the starting point of a collection of feminist essays on epistemology, methodology, and science:

> What counts as knowledge must be grounded on experience. Human experience differs according to the kinds of activities and social relations in which humans engage. Women's experience systematically differs from the male experience upon which the knowledge claims have been grounded. Thus the experience on which prevailing claims to social and natural knowledge are founded is, first of all, only partially understood: namely, masculine experience as understood by men.[22]

By now it is no heresy to suggest that the acquisition of knowledge in the scientific process is a haphazard, accidental affair. Philosophers of science and sociologists of science have demonstrated the very *un*-scientific way in which hypotheses are formed, experiments devised, data gathered, and results written up. The direction of science itself is determined by the extra-scientific considerations of government policy and of the needs and preferences of funding agencies. The transformation of social science in Britain during the 1980s, increasingly in a direction of policy-oriented research, and at the expense of the survival of theoretically and critically inclined university departments, is a clear example of this process. It is useful, I think, to see the feminist intervention into the philosophy of science and knowledge as part of the critique of earlier naïve notions of science (social as well as natural science) as the pursuit of Truth, discovered in accordance with strict rules of Objectivity and Impartiality. Scientific knowledge, like any other kind of knowledge, is systematically related to human values and interests, and is necessarily a product of the limited and partial perspective of its practitioners. Inasmuch, therefore, as science is dominated by men, the scientific process is bound to produce a body of knowledge reflecting the lives and interests of men.

Hilary Rose, a sociologist of science, stresses the urgency of the feminist critique. In her view, 'the attitudes dominant within science and technology must be transformed, for their telos is nuclear annihilation'.[23] Her argument is that the destructive direction taken by science is a result of the fact that it is a very partial knowledge, produced by men and founded in the false separation of 'hand, brain and heart'. This separation she traces to the division of labour in society, and the denigration of reproduction and caring labour in western culture. In her view, it is only by transcending this division of labour that we will be able to develop a new scientific knowledge and technology which will 'enable humanity to live in harmony rather than in antagonism with nature'.[24] In this we have a critical theory of knowledge which relates the androcentric nature of science to the very different social roles and tasks of men and women in society. Like Dorothy Smith, Rose is proposing an experimental account of scientific practice, though one firmly located in the social relations in which experience is gained. (This sociological commitment rescues the account from any danger of essentialism, although some of the formulations of both Smith and Rose carry hints of sympathy for that feminism which subscribes to the existence of certain innate female characteristics. Hilary Rose's concluding sentence in this essay, invoking the 'baby socks, webs of wool, photos and flowers' which peace activists at Greenham Common thread through the wire fence round the military base, is unfortunate in carrying these connotations.)

This is an explanation of the distortion of science and knowledge in patriarchal culture in terms of the social relations and social roles of men and women. The argument is that science, dominated by men, manifests that kind of alienated, abstract nature which is characteristic of work in industrialized society. 'Objectivity' is a formal ideal which is in fact merely the representation of the way in which men have increasingly been obliged to live. The suggestion is that women, on the other hand, because of their continuing participation in 'caring labour', are likely to produce knowledge which is not based on the separation of subject and object and, hence, on

22. Sandra Harding and Merrill B. Hintikka (eds), *Discovering Reality: Feminist Perspectives on Epistemology, Metaphysics, Methodology, and Philosophy of Science* (Dordrecht, D. Reidel, 1983), p. x.

23. Hilary Rose, 'Hand, Brain, and Heart: A Feminist Epistemology for the Natural Sciences', *Signs*, 9 (1983), p. 73.

24. Ibid.

a misguided conception of the possibility of a detached, pure science.

The social historical account of knowledge-formation, and of the role of gender in this process, is crucial. But there is one important question which it does not answer, and that is *why* it is the case that men are confined to the abstract mode of reasoning and thought. To relate this to gender roles does not really get us any further, because we still have to explain, first, what the basis for such role differentiation is or was, and second the phenomenon of the advance of alienated labour itself. Childcare arrangements are no explanation, for as we know these vary enormously from one society to another, and from one period to another. Essentialist notions of intrinsically 'feminine' or 'masculine' work are unacceptable (since sociology and history make clear the social construction of these categories). Theories of industrialization and of the rise and development of capitalism deal with the structures and processes of contemporary industrial society (as well as its institutions and ideologies), without engaging with the alleged complicity between 'masculinity' and 'objectivity', between men and abstract thought, between patriarchy and the dominance of an ideology of neutral, disinterested science.

Recent works by feminists, particularly certain American philosophers of science, has addressed this issue in psychoanalytic terms. It is interesting that the most influential work here has been object-relations theory, and not, as is more the case in Europe, and in feminist literary and film studies, the Freudian and Lacanian branches of psychoanalytic theory. The work of Nancy Chodorow and Dorothy Dinnerstein has been particularly important here, although they have not written specifically on science and epistemology.[25] They have both argued that as a result of the Oedipal drama boys learn a greater sense of separateness and autonomy than girls. This is because, in a society in which women do the nurturing, boys have to separate clearly from the mother, in order to adopt the male identity. As Nancy Hartsock puts it 'male ego-formation necessarily requires repressing this first relation and negating the mother'.[26] For girls, on the other hand, the problem might be the *inability* to differentiate. (And indeed feminists have explained problems specific to women, such as eating disorders, in terms of this early childhood scenario, and the mother-daughter relationship. For girls, and women, the problem is often one of not having clearly enough defined ego boundaries.)

As a result of this wrench from the mother, this dramatic shift into autonomy, which breaks the pre-Oedipal attachment, males continue to repress ties to the other (because of a fear of reincorporation and engulfment), and are unable to experience themselves rationally. To quote Nancy Hartsock again: 'Girls, because of female parenting, are less differentiated from others than boys, more continuous with and related to the external object world.'[27]

The possible implications for theories of knowledge are clear. The commitment to objectivity is nothing other than a psychic need to retain distance. Invested in this is the man's very sense of gender identity, and in this light the fear of the female, and the fear of merging, make sense of a continuing way of being in the world founded on distance and differentiation. It is for this reason that Evelyn Fox Keller makes the connection with science: 'It would seem...appropriate to suggest that one possible outcome of these processes is that boys may be more inclined toward excessive and girls toward inadequate delineation—growing into men who have difficulty loving and women who retreat from science.' The result, she suggests, is 'a belief system which equates objectivity with masculinity, and a set of cultural values which simultaneously elevates what is defined as scientific and what is defined as masculine'.[28]

The real value of this approach is that it allows us to combine a social-historical analysis of gender

25. Nancy Chodorow, *The Reproduction of Mothering: Psychoanalysis and the Sociology of Gender* (Berkeley, University of California Press, 1978); Dorothy Dinnerstein, *The Mermaid and the Minotaur* (New York, Harper & Row, 1976).

26. Nancy Hartsock, 'The Feminist Standpoint: Developing the Ground for a Specifically Feminist Historical Materialism', in Harding and Hintikka (eds), *Discovering Reality*, p. 295.

27. Ibid.

28. Evelyn Fox Keller, 'Gender and Science', in Harding and Hintikka (eds), *Discovering Reality*, p. 199.

differences in the field of science with another level of understanding which exposes the psychic mechanisms of differential gender construction. With regard to science and knowledge in general, it offers an account which links the institutional fact of male dominance both with the social realities of men's and women's lives in our culture and with the psychological needs and tendencies that these produce. The scientific ideal of 'objectivity' appears now as the formal and theoretical equivalent of a deep and fundamental aspect of the male psyche in western society.

Does this mean that we can envisage a female science, which will be more comprehensive, less destructive, more appropriate to a non-alienated, relational existence? Within feminism, opinions differ about the possibility of a 'successor science'. Evelyn Fox Keller makes it clear that existing science is not to be jettisoned. Quoting with approval Mary Ellman's jibe at men, and their tendency to take refuge in science even in personal matters (Ellman says 'men always get impersonal. If you hurt their feelings they make Boyle's Law out of it'), Keller goes on to point out that we must not forget that Boyle's Law is not wrong. 'Any effective critique of science needs to take due account of the undeniable successes of science. Boyle's Law does give us a reliable description of the relation between pressure and volume in low density gases at high temperatures.' But, she continues, 'It is crucial to recognise that it is a statement about a particular set of phenomena, prescribed to meet particular interests and described in accordance with certain agreed-upon criteria of both reliability and utility.[29]

In other words, we must recognize the partial and perspectival nature of science and knowledge, without necessarily concluding that its discoveries are false or useless. Jane Flax points out that women's experience is not in itself an adequate ground for theory since it too is partial.[30]

There is a certain consensus among many feminist philosophers that the feminist critique of knowledge and science should not make the mistake of claiming to substitute a new, 'correct' knowledge. (More radical positions, however, do make this claim, arguing that masculine science is to be rejected altogether.) I think it is most useful to adopt the strategy of Sandra Harding, one of those who takes the more liberal view of the critique of knowledge. Arguing that there are 'no true stories', she recommends a feminist intervention which, in true postmodern terms, operates the destabilization of thought, recognizing at the same time 'the permanent partiality of feminist inquiry'.[31] Although there are certain difficulties with the implied relativism of this position,[32] it is the only honest and consistent one and, moreover, it is likely to be the most effective strategically.

Feminist analyses of science and knowledge-formulation have shown how it makes sense to describe the dominant culture and the dominant forms of knowledge as masculine and androcentric. They are masculine with regard to the social and power relations and the institutions in which knowledge is constructed. They are masculine in terms of the conceptual and linguistic apparatuses through which they are acquired and disseminated, and in terms of the selective nature of the subject-matter of the various disciplines of science and knowledge. And they are masculine in terms of the psychological orientation which produces a particular kind of knowledge, with its insistence on distance, objectivity, and non-relational characteristics. Can we proceed from this analysis to discuss the possibility of alternative forms of knowledge, which could be called women's knowledge? Here we are on more difficult ground.

We can certainly see that women's experience has been denied and marginalized by western culture and knowledge systems. It is the case, too, that work by feminists has begun to illuminate areas in the

29. Evelyn Fox Keller, *Reflections on Gender and Science* (New Haven, Conn., Yale University Press, 1985), pp. 10-11.

30. Jane Flax, 'Political Philosophy and the Patriarchal Unconscious: A Psychoanalytic Perspective on Epistemology and Metaphysics', in Harding and Hintikka (eds), *Discovering Reality*, p. 270.

31. Sandra Harding, *The Science Question in Feminism* (Ithaca, Cornell University Press, 1986), p. 194.

32. See Janet Wolff, 'The Critique of Reason and the Destruction of Reason', in Roy Landau (ed.), *The Relative and the Rational in the Architecture and Culture of the Present* (London, Architectural Association, forthcoming).

natural and social sciences which have been ignored so far (for example, work by medical scientists and biologists on women's health issues and by sociologists on women's paid work and women's domestic role). But these are corrective exercises rather than the result of a total reorganization of the field of knowledge. It is less easy to define the notion of 'women's knowledge' positively. One of the problems with such a notion is the risk, already referred to, of adopting an essentialist position—one which implies or even states that because of their particular characteristics (biological, reproductive, or cultural) women's world-view is different from (better than) that of men. Any such account must be posed historically, with regard to women's contemporary, socially constituted characteristics. A more serious difficulty with this kind of formulation is its invariable assumption that we can talk of the category of 'woman' or 'women'. As Sandra Harding points out, this category is problematic, because women vary greatly, depending on age, class, ethnic identity, sexual orientation, and so on.[33] If knowledge is the product of experience, we have to be absolutely clear that we cannot presume a unified experience, or set of experiences, across all women.

It is also problematic to undertake the task of articulating women's experience, silenced as it has traditionally been in patriarchal culture, in the categories, concepts, and language available. (This goes back to the problem with Kristeva's and others' argument about women speaking from the pre-Symbolic, discussed earlier.) The project of building a new, woman-centred knowledge totally outside the dominant culture seems to me to be a doomed one. For this reason, the strategy of 'destabilization', proposed by Sandra Harding, appears to be the most useful one at the moment. Such a deconstructive exercise, which operates by exposing the ideological limitations of male thought, begins to make space for women's voices and women's experience.

At this point we come back to questions of women's writing and women's art. We find a similar opposition here, between those feminists who want their work to present a positive celebration of women's lives and women's identities (the art of Judy Chicago and Nancy Spero and the writing of Monique Wittig, for example), and those feminists who employ the various media to deconstruct dominant meanings, problematizing issues of gender and opening up spaces for women to articulate their experiences (for example, the work of Mary Kelly, Silvia Kolbowski, Barbara Kruger). The celebratory work, which often revives traditional female crafts (embroidery, quilting, flower-painting), or uses the female body itself as the vehicle and subject-matter, is too often naïvely essentialist. Moreover, it misses the point that in a patriarchal culture it is not possible simply to declare a kind of unilateral independence. To go back to the vocabulary of feminist epistemology, we cannot just propose a 'successor art', which miraculously circumvents the dominant regime of representation. The guerrilla tactics of engaging with that regime and undermining it with 'destabilizing' strategies (collage, juxtaposition, reappropriation of the image, and so on) provide the most effective possibility for feminist art practice today. This is partly a matter of strategy (because celebratory art, which does not engage in this way, often remains separate and is easily marginalized by the art establishment); and partly a matter of analytic understanding (because it simply is *not* possible to operate outside language). As we have seen, psychoanalytic approaches sometimes have their own difficulty with this, proposing a feminist language which is in some sense 'outside' language and culture. It is clear that the only responsible and coherent strategies now are those based on the more limited objective of engaging with, and destabilizing, the images, ideologies, and systems of representation of patriarchal culture. Women's writing and women's art, like women's knowledge, begins to articulate the silenced voice of women, but it is obliged to do so in the context of a dominant, alien, but ultimately enabling culture.

33. Harding, *The Science Question in Feminism* p. 192.

Christine Battersby (1946-)

The Margins Within
Selected from *Gender and Genius*

Psychoanalytic hypotheses have been incorporated into the framework of research programmes in the empirical sciences. But all the classical psychoanalytic models made normal creativity an abnormal (but not pernicious) variety of maleness. Classical psychoanalysis thus, in effect, recycled the Romantics' account of the relationship between male sexual energies and cultural creation. The most influential of these models was, of course, that of Freud himself. For Freud artistic creativity involved sublimated sexual energy ('libido'). Although Freud did not make the maleness of libido an inevitable law of nature, 'Nevertheless the juxtaposition "feminine libido" is without any justification' [Freud, 1932, p. 131]. According to Freud, women are not *born* inferior, but they are socially conditioned into becoming intellectual, moral and creative subordinates. The adult woman's inferiority is not a *natural* deficiency, but is a *normal* consequence of the way that the young girl resolves the Oedipal drama—the triangle of jealousy and desire (Mummy/Daddy/Infant)—which Freud placed at the centre of family life. The only women to escape this fate are the 'masculine' women. [See Kofman, 1980, for a brilliant account of the details of the story.]

For Freud's 'feminine' woman the crisis of puberty that forces her to suppress her curiosity about the nature of her own sexuality also leads to the abandonment of her intellectual precocity. She is envious of the penis but represses knowledge of this. Without sexual curiosity there is no intellectual or creative curiosity. The 'feminine' woman sublimates her desire for a penis into a desire for a child (as penis-substitute) [Kofman, p. 203]. Normal femininity, neurosis and creativity comprise a three-dimensional figure. Normal femininity differs from neurosis only in virtue of the way and degree to which childhood sexuality is repressed. But the same is true of creativity:

> An artist is once more in rudiments an introvert, not far removed from neurosis. He is oppressed by excessively powerful instinctual needs. He desires to win honour, power, wealth, fame and the love of women (sic.); but he lacks the means of achieving these satisfactions. Consequently, like any other unsatisfied man, he turns away from reality and transfers all his interest, and his libido too, to the wishful constructions of his life of phantasy, whence the path might lead to neurosis. [Freud, 1916-17, p. 376]

How boringly familiar! Freud rationalises the schemata of Romantic aesthetics. Madness and 'genius' (a word often used) are once again twin brothers. To be creative a male genius has to avoid one false path that seems at first sight almost identical to the path of a genius: neurotic madness. A woman can only be creative by avoiding this route and also the 'feminine' route to her own development into mature sexuality. To what extent Freud believes 'femininity' to be not only *normal* for women, but *proper* for women, is a much-disputed question. What is clear, however, is that a woman can *either* be a truly feminine female or be a creative genius—she can't be both.

In recent years Freud has been re-read and re-interpreted by Jacques Lacan, and by feminists influenced by Lacanian ideas. Lacan disturbed the conventional understanding of Freudian theory and, in the process, undermined the idea that psychoanalysts should aim at establishing a strong, healthy (and paradigmatically male) ego. Despite this, it seems in some ways as if Lacan's theories are just another variation on an old Romantic theme. We are back with the great patriarchal 'I am' that

underlies the space-time reality within which we exist, except now it is not just an individual male psyche that creates our culture's conceptual scheme. Instead, this construction is (as with Nietzsche) the action of a masculine collective. Once again it is suggested that what we think of as 'reality' is a function of a language and a culture that privileges the male. But Lacan reached this conclusion not through a reading of Nietzsche, but by a *mélange* of Freud, surrealism and phenomenological and linguistic theory. He made the 'I am'—and the very notion of a self that persists through time—a construct of the unconscious, but then added that the unconscious is structured like a language, and that all language-systems express the divisions and hierarchies of the patriarchy.

According to Lacan, a child enters the (patriarchal) world of language reality as soon as s/he learns the difference between 'I' and 'you'. When a child is very tiny it is unaware of the boundaries of its self: the Other / the Mother is not really conceptualised as a separate being. The child and the universe are, in a sense, one. Gradually, the child loses this initial completeness of being which then haunts it all its life: the adult desires to be re-united with the (M)other—a desire that can be read in human agency and products. In a way highly reminiscent of Plato (and the myth of the androgyne) and de Meun (and the quest for the rose), Lacan made all desire an expression of hunger for an originary completeness of being. Except that in Lacan's world the individual no longer exists: 'I is another'. There is not a *self* that is looking for a complementary self; but a nexus of desires and wants reaching out to compensate for what is lacked. Language overlays this desire and directs it from 'subjects' towards 'objects', via 'causes'—all fictions of the patriarchal language-system.

Lacan posited three levels of psychic significance that cannot be mapped on to each other. These levels are explained in terms of the binary opposition: *'masculin'* / *'féminin'*. Lacan claimed—with Nietzsche—that 'woman' is but a fiction of a patriarchal language. But, since the French term *'féminin'* encompasses both the English words 'female' (a biological given) and 'feminine' (the culturally acquired characteristics associated with

womanhood), there are biologistic overtones to the vocabulary that Lacan employs.[1] The linguistic (or 'symbolic') order is the masculine domain that children enter as they use words to differentiate self from not-self. By 'language' Lacan means all systems of symbolic representation. Music, painting, mathematics: all are languages and all embody 'The Law of the Father' that governs possible relations between separate entities. In this world, the phallus symbolises both separation from the (M)other, and the desire to re-unite with the (M)other. Lacan thus makes the phallus the transcendental signifier—the paradigm 'I am'. Thus, despite Lacan's refusal to equate the 'phallus' with anything as mundane as a simple penis, 'The Law of the Father' turns out to be that hoary (and not very venerable) grandfather of European philosophy—the *logos spermatikos*.

The tedium of recognition increases as we examine Lacan's second order of psychic significance, that of the pre-linguistic (or 'imaginary') which is associated with the *féminin*. In this realm of the imaginary there are no fully-formed concepts, but images that originated prior to language in the pre-Oedipal stage of human development. The baby started out with the illusion that she was co-extensive with the universe. However, Lacan claims it was in the gaze of the (M)other's eyes that the child received the first inklings of the limits to its autonomy. The infant then constructed a false body *image* (the mirror image) to compensate for the disintegration of that original completeness. In Lacan's metaphysics, the *féminin* thus continues to be allied—as it was during the Renaissance—with seeing the world via the clouded mirror of a distorting consciousness. (See Chapter 3, *Gender and Genius*.) And, since Lacan explains psychosis by reference to entrapment in this presymbolic universe, he also carries on the tradition of gendering madness. Neurosis (seen by Freud as near to 'genius')

1. There is a French term *'femelle'*; but, since it is generally reserved for animals and plants, it has different connotations than the English language 'female'. This word is, consequently, avoided in most analyses of human sexuality. See Chapter 16 of *Gender and Genius* for some consequences of the fact that the French language tends to conflate the 'female' and the 'feminine' under the *'féminin'*, and for a complication to the apparently straightforward distinction between biological sex (male/female) and cultural norms (masculine/feminine) in the English language.

is associated with dysfunction with regard to the masculine order of symbols. Psychosis, by contrast, is allied to a *féminin* form of consciousness, and the failure to develop the fiction of an autonomous ego which marks entry into the symbolic realm.

Lacan's 'imaginary' realm is thus by no means an area of potential psychic freedom, (as it would become for feminists such as Hélène Cixous, Julia Kristeva or Toril Moi who adapted, or relayed, the Lacanian system in ways that would privilege the pre-linguistic or pre-symbolic *'féminin'*). According to Lacan himself, human development can only occur by breaking free of the illusions of the imaginary and into those of the symbolic. There is, however, also a positive side to femininity in Lacan's system. Indeed, he describes his own texts in terms of *jouissance*: the extremes of feminine (sexual and mystical) ecstasy that disrupt and expose the conceits of the male ego. This is Lacan's third order: that of 'the real'. And, as Jardine puts it,

> In Lacanian literature, the 'Real' designates that which is categorically unrepresentable, nonhuman, at the limits of the known; it is emptiness, the scream, the zero point of death, the proximity of jouissance. [1985, pp. 122-3]

In orgasm the self fragments into pleasure-centres: the boundaries between self and not-self collapse in ways reminiscent of the time when self and (M)other were one. This 'real' is revealed by language; but it is unrepresentable *by* language or *by* consciousness. To approach it at all, consciousness (and even unconsciousness) have to be caught off-guard: something that Lacan's (unorthodox) techniques of lecturing, writing and treating patients were designed to do. To this end Lacan acted out the part of a *féminin* psychotic. He turned himself into a mouthpiece for the not-self as a way of breaking down the (illusory) sense of the self of his audience and/or analysand.

In the 1970s Lacan became one of France's most popular cultural heroes. In *The Lives and Legends of Jacques Lacan* [1981], Catherine Clément describes his power as that of a 'shaman' who has allowed himself to be used as a mouthpiece for the unconscious. She even refers to him as a *'génie'*, a prophet, and as a male who had assumed *féminin* madness [pp. 49, 78ff., 85, 108ff.]. In other words,

Lacan was represented (and represented himself) in terms of the old stereotype of the Romantic genius-personality. And it seems to me that it is more than a simple irony of history that the man who denied the ego should have so promoted his own ego. [And see Turkle, 1978.] Lacan's techniques of *seeming* to let language (and hence the unconscious) speak through him—while manipulating it and his audience in a very deliberate way—should alert us to the sexual conservatism implicit in his stance.

Ecstatic surrender to that which is outside self; the Mother; Otherness; egolessness; hysteria; the *féminin*—these are concepts that cluster together in Lacanian thought, as they did in other post-Romantic philosophers such as Schopenhauer and Nietzsche. Through his practice, Lacan glorified a form of hysterical babble and of psychotic madness that has rendered women victims. Lacan could (safely) ally himself with a specifically *féminin* form of ecstasy, because he was perceived as a strong (male) ego that would not really fragment into psychosis (or get locked up in asylums) for parading his incoherence in public. Women who act like Lacan will have difficulty in being perceived in the same way as Lacan. For speaking *like a woman* is not at all the same things as speaking *as a woman*...Lacan relied on the values of a patriarchal culture for his classification as a psychic hero who has embraced madness and femininity *and remained sane*.

Lacan's psychoanalytic theory has, nevertheless, appealed to a number of feminists and women influenced by feminism.[2] It seemed that the pre-symbolic *féminin* order of the imaginary and the 'real' offered a means of eluding the privilege allotted to the male in the language of the unconscious. The British artist Mary Kelly, for example, glosses the theory behind her work with a document that invokes the 'feminine' and 'the unnameable, the unsaid',

2. There are terminological difficulties in describing those Frence women—like Hélène Cixous or Julia Kristeva—who have been so influential on feminist theory in Britain and the United States, but who shrug off (or loudly denounce) the label of 'feminist'. For a (somewhat partial) account of Cixous's celebrated distinction between the women's movement—a good thing (she supposes)—and feminism—a bad thing, in that feminists struggle for equal power and rights within a patriarchal world—see Toril Moi's *Sexual/Textual Politics* [1985], pp. 103ff.

adding that 'in so far as the feminine is said, or articulated in language, it is profoundly subversive' [1977, p. 310]. But, to my mind, Kelly is mistaken in supposing that a Lacanian 'feminine' can offer real-life women creators the theoretical back-up for their attempts to undermine the values of patriarchal culture. If the 'feminine' is genuinely excluded from language and all symbolic representation, how can it be subversive? If language is 'coincident with the patriarchy' (as Kelly claims) why isn't the notion of the 'feminine' simply a fiction of the patriarchy? And why is she so anxious to prove herself 'feminine'? One thing that the history of the concept of 'genius' reveals is that being a woman and being 'feminine' are radically different things. It is *women* who have been excluded from culture; not the 'feminine'. And women won't progress by embracing the mythology of the patriarchy that turns *female* Otherness into some kind of metaphysical metaphor for that which eludes consciousness and language.

If Lacan were correct about the relationship between patriarchy and culture, it seems to me that feminist creators might as well simply give up the political struggle and relax into *jouissance*. But *are* we as passive with respect to language as Lacanians make out? Is the feminist art historian, Griselda Pollock, right to claim that 'Learning to speak is learning to be spoken by the culture to which one is accessed by language' [1987, p. 92]? Although advertisers and image-makers work on the assumption that a person is just a collection of desires, drives and impulses, this myth of modern capitalism is as dangerous to women as the old myths that defined identity in terms of male individuality. Indeed, since in advanced industrial societies women are more important as consumers (as the targets of advertising campaigns) than as breeders or a class of domestics, I feel we should be doubly suspicious of any new theory of the self that suggests a special connection between the *féminin* and a bundle of free-floating desires. Otherwise, like the Romantic women, we may find ourselves humming just another variation on the old theme: female=egoless=manipulable =audience=non-producer.

To understand more fully why a feminist aesthetics cannot rest on Lacanian attempts to undermine the very notion of ego and individuality, it is necessary to make a distinction between two different kinds of marginality:

i *Others*—those who, because of our racist and sexist paradigms of normal humanity, get viewed as not-quite-human;

ii *Outsiders*—those who are viewed as fully-human but not-quite-normal. Under this category come 'feminine' males, genius males, degenerate males, shamanistic males...even pseudo-males (cf. Lombroso's 'the women of genius are men').

Of course, we no longer believe that the greatest cultural creators are feminine 'degenerates'; but in popular culture the great creators are still Outsider-figures. As Tom Gretton comments despairingly:

> Over the last century and a half concepts such as that of Bohemia have been much more successful in constituting the public persona 'artist' than the earnest attempts of a large number of painters and so forth over the same period to live 'bourgeois' lives, and to convince the world of the respectability, of the ordinariness of the profession. Painters and so forth are stereotyped as special people, as 'artists'. [1986, p. 66]

But the bohemian artist-figure is categorised as such in so far as he is outside the norms of the *male* personality. Some women might be treated as pseudo-males; but most are concealed by 'Otherness'. Thus, as we will see, this notion of the artist as the great Outsider serves to camouflage the achievements of creative women.

In *The Outsider* [1956] Colin Wilson traced the figure of the Outsider through modern literature, Romantic theory and existentialist philosophy. Wilson's book was an overnight success: the anti-hero observed so sharply by Dostoyevsky in the 1860s became the hero of the mid-twentieth century. The Outsider is a personality-type: one who sees himself as unlike other people, as estranged from conventional wisdom, morality and lifestyles, as misunderstood, alone and suffering. The Outsider feels forced to behave in ways that his own conscious mind finds irrational and evil. Beneath the skin and face of the normal human being, the Outsider discovers the mind of a wolf or a monster—a self which most men mask by a patina of civilised behaviour. His morality is to be true to himself (the Wolf in himself)—whatever the costs to other

people. So secretly he enjoys his suffering, his loneliness; and part of him finds the face of the monster that of perfect beauty.

We all know the type. It has been celebrated and explored in the lyrics of countless pop songs. But this Outsider is paradigmatically male, as Wilson's opening paragraphs make clear. Wilson uses Henri Barbusse's novel *L'Enfer* (*Inferno*) to establish the character of the Outsider. Wilson describes Barbusse's 'hole-in-the-corner man' who ventures out of his anonymous hotel room to loaf down city streets, stirred by 'desires' that 'separate him sharply from other people'. Barbusse's "pale and heavy-eyed" hero explains, "It is not a woman I want—it is *all* women, and I seek for them in those around me one by one...." Wilson makes sure we don't dismiss these male desires as simply banal. Barbusse's nameless hero follows women in the street, propositions them, and has sordid and casual sex with them. This is not "animal" need, but a metaphysical quest. The hero is not really a monster—certainly not an Other—he is a fully human (=fully-male) individual with wolf's eyes that help him see *"too deep and too much"* [Wilson, 1956, p. 21].

Wilson might have adopted a semi-ironic tone in describing the Outsider, but he was not ironic enough. The perverted male sexuality of this 'type' receives no comment in his 1956 study. Instead, the Outsider is presented as a compelling figure: a stage on the modern individual's way to becoming a truly fulfilled person. Although Barbusse's anti-hero had "no genius, no mission to fulfil, no remarkable feelings to bestow", his mentality had been shaped by the Romantic traditions of writing about the genius and the (male) artist [ibid., p. 22]. The tragedy of Wilson's Outsider is that he would like to be able to express himself and have the vivid perceptions of the artist; but he can neither do this, nor become balanced and normal [pp. 214-215].

Wilson's *The Outsider* has (deservedly) declined in popularity in comparison with those perennial favourites of sixth-formers and undergraduates that it sought to describe: Camus' *The Outsider* (*L'Étranger*); Sartre's *Nausea*; and Hermann Hesse's *Steppenwolf*. But the Outsider figures that they portray are very like Wilson's archetype. The obscure desires that drive these anti-heroes to be at odds with bourgeois society include male sexual urges. In all of them woman is Other, rather than Outsider. And this remains true of *The Misfits: A Study of Sexual Outsiders*, Wilson's 1988 follow-up to his study of the 'Outsider'. Here Wilson does comment (with pornographic relish) on the relationship between 'genius', the 'outsider' and sexual perversion. And although Wilson purports to develop a theory that will explain the psychic mechanisms driving both men and women, there *are* no women in his study. The theories of 'Dr Charlotte Bach' on the psychic bisexuality of cultural creators are considered in detail. But—despite being referred to as 'she' throughout Wilson's book—'Charlotte' turns out to be a transvestite male. Other females are sexual objects, disqualified by Wilson's account of 'human' sexuality from counting as 'human beings' at all— let alone successful human beings ('geniuses') or sexual perverts ('outsiders').

'Genius' is represented as the flip-side of sexual perversion: great art is made possible because 'The human (*sic*) sexual impulse has ceased to be a response to the smell of the female on heat' [p. 110]. Human evolution occurred not because women ceased to be purely instinctual animals (who come 'on heat'); but because

> Human beings have ceased to be dependent on the smell of oestrum (sic) to trigger sexual desire; it has been replaced by visual stimuli and imagination...
>
> Yet this is what all sexual perversion amounts to. Barbusse's 'outsider' is...attempting to achieve erection—not just of the penis, but of the reality function—through a kind of play-acting. [pp. 112-13]

Pornography (=male replacement of real sexual objects by fantasised sexual objects) shows how men (=males) have evolved above the animals. It is the imagination that makes man (=males) capable of the greatest—or most perverse—acts. Significantly, the metaphors for this greatness of 'human' imagination are as sexed as the account of 'human' sexuality itself:

> In sexual excitement, it is as if the spirit itself becomes erect, and becomes capable of penetrating the meaning of life. Normal consciousness is limp and flaccid; its attitude towards reality is defensive. [p. 45]

Women might feel relieved to find themselves excluded from this account of the origins of human art; but Wilson's soft-core mysticism is more than merely distasteful. It reveals how the personality (and sex drives) of the abnormal—and supernormal—male continues to blinker male vision...and reduce *women* to the status of Other. Less-than-fully-individual; less-than-fully-human: women are (smelly) absences...holes in the history of culture.

The Misfits evidently represents more than one kind of abyss in the still-popular notion that the genius-personality is a variant of the Outsider-personality! Even in the less philistine art criticism, however, there is a significant difference between the way male and female artists are described in terms of the Outsider/Other dichotomy. We can see an example of this if we look at the 1984 edition of John Rothenstein's *Modern English Painters, Hennell to Hockney*. Rothenstein's biographies of important recent artists include a married couple: Catherine Dean (1904-83) and Albert Houthuesen (1903-79). None of Dean's paintings are reproduced in the book, and only two locations are given for originals, so I find myself unable to form an independent judgement of her talents. My comments are not, therefore, ones about the quality of Dean's work as compared to Houthuesen's. Nor am I critical of Rothenstein's intentions—he obviously intends his chapter as a homage to a dead friend who is also a neglected woman artist. What I am arguing is that, even when art critics are struggling hard to be fair to women artists, 'Otherness' is a norm for female artists and 'Outsiderness' the norm for male artists. As a consequence, the relationship between individuality and tradition is constructed in very different ways on either side of the artistic gender divide. And this is a major factor in obscuring the presence of important women in the history of the arts.

Dean is presented almost entirely as a supplement to Houthuesen. Of the twelve pages on Dean, one is introductory (how her paintings came to Rothenstein's attention when he was visiting Houthuesen); seven are mainly about her engagement or marriage; and one a conclusion. Her most remarkable achievement

is negative, namely that her art was in no way affected by the intimate association of more than fifty years with an artist of rare and highly individual talent, and one whose work she always so deeply revered. Yet at no time was her own painting influenced by his. Her **Entombment** (1928)...does, indeed, closely resemble the treatment of the same subject in certain of Albert's, but anticipates it by a number of years; not that Catherine's painting ever remotely influenced Albert's... [p. 92]

We hear in passing about her frail health, her cancer, and a life devoted to managing Houthuesen's professional and business affairs during his long bouts of serious illnesses. We hear very little about her artistic influences, nothing about her philosophy of art, or even about the psychological set that led her to devote her own life to her family.

By itself, the biographical sketch of Catherine Dean would not be very surprising. After all, this might be the appropriate way of summing up a life of sacrifice. What is so extraordinary is the contrast in treatment to that of her husband. Houthuesen has the same amount of space devoted to him, but out of this there seem to be only four sentences on his marriage and engagement—including one that tells us that 'Life after leaving the College, in spite of the happiness of his marriage, was something of an anticlimax' [p. 60]. We learn about the dramas of his tragic childhood, his artistic father (murdered by his mother?), his artistic influences, his membership of artistic groups and his philosophy of art. Despite his fifty years of marriage to a woman painter who 'revered' his work, despite his links with artistic contemporaries and predecessors, Rothenstein concludes:

The painters who figure in these pages are, as painters, mostly solitaries, but none as solitary as Albert Houthuesen was: never a member of any group, or a participant in any 'movement', deeply grateful for what other artists taught him yet the disciple of none, going his own way, against the way of the world, the complex of ideas that dominated it. [p. 68]

If the male artist does not set himself up as the isolated and lonely Outsider, the art critic is likely to do it for him. The husband here is a fully developed individual, and can therefore be isolated and ignored even when supported by a devoted wife and situated in the context of artistic masters. The

wife, who seems artistically the more estranged from tradition (in that it is barely mentioned with regard to her work), lives her life as a half-person, and can never therefore be an Outsider. Only an Other. She is presented as outside artistic traditions: not influenced, and without the power to influence even the man she lived with for more than half a century. If this is really all there is to say about Dean, Rothenstein should have chosen someone else to eulogise. As I explained in the last chapter, to deserve the label 'significant' an artist has to be located in terms of a tradition. To be 'great' or a 'genius', the artist must be positioned by the critics at a point within the tradition that is viewed as the boundary between the old and the new ways. Artists like Catherine Dean have no chance of ever being viewed as 'geniuses'...or even as artistically important. She is not even represented as a fully-developed individual, let alone located within the (patrilineal) chains of influence and inheritance out of which 'culture' is constructed.

It is notable how many of the works and names of women painters and sculptors that have survived are of those who were married (or otherwise related) to male artists. Art critics have seemed unconcerned with adequately identifying the women who have shaped the contours of culture. Furthermore, the achievements of the women who *have* been identified are frequently underestimated, because their 'Otherness' means that they have been wrongly located in terms of *patrilineal* traditions of art and successions and groupings of *male* artists. From such a perspective a number of extremely important women seem mere hangers-on...and (eventually) disappear into invisibility. In *How to Suppress Women's Writings* [1983] Joanna Russ has shown how this process works with regard to the literary genres. But the situation is even more extreme in the fine arts.

To take one of many possible examples, Hannah Höch (1889-1978) is generally seen—if she is seen at all—as simply working in the field of collage and photomontage...although she was also a sculptor, a painter and a print- and doll-maker. Höch is also generally represented simply as a 'Dadaist'... although she firmly rejected this label as in any way adequate to characterise the last *fifty* years of her

working life. Höch has been frozen into a static moment in history (Berlin *c.* 1916-24): a caption to a face in a photo of an era that is dead. Although her works have obvious affinities with the later surrealists, the expressionists and the constructivists, some critics have looked and seen only stasis: unchanging Dada and photomontage. An alternative group of critics have looked and seen no constancy: only a kaleidoscope of changing alliances.

These critics have failed to find in Hannah Höch's work a unified *oeuvre* which has developed and matured in the same way as would that of a Picasso or an Ernst. Except for a few (mostly feminist) critics, Höch remains an Other: a fragmented egoless phenomenon. And, since the very concept of an *oeuvre* implies full individuality (*unity through change*), Otherness makes her disintegrate into insignificance. Her name is (still) standardly excluded from the summary histories of modern art—despite her role in inventing and developing the techniques of photomontage and collage. She is even (frequently) absent from the surveys of Dadaism itself—despite being one of the founder members of the Berlin group. It is, therefore, unsurprising that Höch is also missing in a number of the best-known of the English-language histories of women artists.

For an artist's achievements to be recognised, her work has to be read generously, as an expression of the psychic richness and unique individuality of a fully-human self. Even though, in Höch's case, there is enough information to be sure that we are dealing with a person whose contributions to art were neither insignificant nor sporadic, Höch has been treated as an Other, not as an Outsider. Her life's work has been diminished into uni-dimensional fragments. Höch's case is symptomatic of the problems facing women artists. To recognise the uniqueness of Höch's artistic achievement, we need to understand her own individual project for her life (a project that she might never have recognised herself). We need a narrative that can bind her output together into an *oeuvre*, and that narrative must be anchored by contextualising the artist's work adequately in terms of tradition and genre. And it is here that the difficulty lies for Hannah Höch, as for all the greatest female artists.

In order to make sense of the paradoxes of her art, Höch has to be fitted into a *female* tradition of art-production that cuts across patrilineal traditions of art and undermines them. This is symbolised by Höch's most famous collage: 'Cut with the Cake-Knife DADA through the last Weimar Beer Belly Cultural Epoch of Germany' (1919/20). At its centre is the head of Käthe Kollwitz (the famous woman painter) balanced on the body of Niddi Impekoven (the celebrated woman dancer). The distorted images of other well-known personages and technological 'inventions' erupt in paradoxical shifts of scale from a centre that focuses on the *female* contribution to art and anti-art. The dominating image in this collage might be that of Einstein—that *other* Other, the Jewish 'genius'—but the irreverent mockery of Höch's gaze has at its reference-point a *matrilineal* tradition of image-making that skews the whole concept of German '*Kultur*'.

I believe Höch knew how radical was her vision. In her writings and words she theorised the importance of presenting alternative sub-human and semi-human perspectives on reality. Her change of forename from Johanne to the more Jewish-sounding Hannah signals her allegiance with all Others within the German State. Symbolic also was the way Höch survived the Second World War: in a watchman's house on an abandoned air-strip in a remote suburb of Berlin. Much that now remains to us of Dada comes to us courtesy of Höch. Concealed in the cupboards of her house, and buried in her garden, was a treasure-trove of documents and art condemned by the Nazis as 'degenerate'. Although her name was on the Gestapo's blacklist of 'cultural bolshevists', and although (after reports from her neighbours) she was questioned and her house searched by the Nazis, the authorities did not know how to look—or how to listen to her voice. Not an 'Outsider'—only an 'Other' that disrupts *Kultur* from *the margins within*—she seemed insignificant. Neither Jew nor genius, this female Otherness allowed her to merge into the scenery...in much the same way as she later blended into the background in the histories of art.

Around 1915 (already in her mid-twenties and shortly before becoming a Dadaist) Hannah Höch immersed herself in reading philosophical and psychoanalytic theory. From that time on, her paintings and collages (and her weird marionette-dolls and half-human sculptures) would engage in a kind of mocking debate with the metaphysics of Romanticism that made the 'sublime' a saturnine (and melancholic) male and left the female a beautiful and monstrous Other. 'The Melancholic'; 'Alien Beauty' ('*Fremde Schönheit*'); 'Grotesque'; 'Woman and Saturn': the titles of her creations confirm the metaphysical (the anti-metaphysical) motives. Like the other Dadaists Höch was anti-Art; but even her attack on art could not altogether coincide with the males' rejection of the patrilineal traditions of art. (Hence the representation of Höch as somehow peripheral, or an insignificant presence in the Dadaist group.) Although not identifying herself as a feminist, her ironical gaze is always *female*...it accepts, and rejects, the 'Otherness' of women that has served to mask her own achievements. 'The Eternal Feminine' (1967) is a picture of a display-dummy in a fashion factory...and in the earliest photos of Höch with her Dada-dolls (1918) she poses in the same costume as the machine-like wooden puppets that she manufactured herself. The dummies and other grotesques enact her own treatment by the art historians, who could not register her as a fully individual artist because she bent the apparently straight lines of patrilineal art-tradition. Not an Other—but also not a brother—Höch demands reassessment in terms of those matrilineal zigzags that complicate the tracks of art and anti-art.

The fact that I (a non-specialist) know of the existence of Hannah Höch, and can begin to position her in terms of a *female* tradition of art, means, of course, that the complex task of re-thinking women's relation to culture is well under way.[3] But the practice of feminist art critics has been inadequately theorised. In recent years many Anglo-American feminists (both inside and outside the academies) have looked to the notion of an *écriture féminine* to provide a

3. For my acquaintance with the work of Hannah Höch I am indebted to an Exhibition— 'Hannah Höch 1889-1978: Collages'—that toured the UK in 1988, under the auspices of the Institute of Foreign Cultural Relations, Stuttgart. Deborah Sugg from the National Art Library, Victoria and Albert Museum, gave an outstanding lecture in conjunction

grounding for a 'woman-centred' perspective on art, literature and cultural history. This idea of a kind of feminine/female writing typical of feminine/female consciousness is taken from the texts of a number of key French female theoreticians who have developed out of the Lacanian and Derridean debates that marked psychoanalysis, linguistics, philosophy—and indeed feminism itself—during the 1970s.[4]

It might be thought that such a notion would offer the 'female tradition' in terms of which the words and works of women creators can be heard and appreciated. It is notable, however, that the examples given of *l'écriture féminine* are generally examples of *male* authors (James Joyce, Nietzsche, etc.) who are psychically *féminin*. Indeed, in *Writing Differences* [1988] Hélène Cixous complains that, with the notable exception of the Brazilian novelist, Clarice Lispector, in the past *female* authors have been too *masculin* [p. 25]. And this should not surprise us. What Cixous prizes as *féminin* is a type of self-projection that undermines the fiction of a stable and unitary ego.

Cixous values that which is resistant to conscious analysis, ecstatic, fluid, egoless, apparently incoherent and 'hysterical'. But an aesthetics based on this kind of 'femininity' actually discriminates against women in the histories of the arts. To be thought of as a great author exposing or *fictionalising* her fake ego, a woman must first be represented as a creator who has a body of work (an *oeuvre*) that is worth analysing. And this implies seeing the author or artist in terms of an ego. It also involves situating the artist's work in terms of traditions and genres, and registering her as individual but not unique; exceptional but not isolated, strange, freakish or simply crazy. Sadly, the mythologies of female Otherness still make it extremely difficult for critics (and women themselves) to see women in such ways. A male creator credited with an *oeuvre* that is *féminin* might retain his cultural significance while celebrating non-entity; but a female viewed as hysterical and ecstatic has to fight off a much more mundane kind of cultural non-entity. As the concept of genius has demonstrated, it is only in *great individuals* that madness has been valued...and women have been denied the same full individuality as genius-males.

Women creators still have to struggle (both socially and inwardly) against dispersing into the kind of Otherness now endorsed as 'feminine' by many of those who look to *l'écriture féminine*. To be seen as an individual—with an *oeuvre* that persists (coherently) through the (apparently incoherent) fragments that make it up—a woman creator has to be positioned within male *and* female traditions of art. But female traditions of art will not emerge via a revaluation of supposedly 'feminine' characteristics of mind or of body. Indeed, such traditions will remain concealed by those whose language (and textual practices) blur the distinctions between writing *like a woman* and writing *as a woman*. Being female involves not some collection of innate (or acquired) psychological or biological qualities. It is rather a matter of being consigned—on the basis of the way one's body is perceived—to a (non-privileged) position in a social nexus of power.

with that tour, and has since been generous with her time; with help in locating secondary material; and with her own (mostly unpublished) material on Höch. Sugg, like a number of the German feminist critics, treats Höch as a fully individual artist with an *oeuvre* that develops and matures. The same cannot be said of all the articles in the catalogue that accompanied the touring exhibition. However, I found Karin Thomas [1980] helpful...also an article by Dech [1980]—left out of the English catalogue, but included in that of the (much larger) German exhibition which provided the basis for the English catalogue.

4. Annie Leclerc seems to have triggered the initial interest in *l'écriture féminine*. But in America and Britain it is generally the work of Hélène Cixous, Luce Irigaray and (sometimes/some of) Julia Kristeva that is grouped together under this heading. Their stances are quite different; but for an introductory account of the underlying similarities see Ann Rosalind Jones [1981]. A much more detailed English-language overview (and summary) of the multifarious positions and debates within French feminism is in Gelfand and Hules [1985]: a text which gives an excellent feel for the sharp theoretical disagreements that have been engendered inside France around the concept of *l'écriture féminine*.

Post-modernism and the Female Author

Selected from *Gender and Genius*

Post-modernists have proclaimed the death of the author. But for an author to die, he must first have lived. In the last chapter I argued that female artists have disappeared from the histories of culture precisely because they were not granted the same kind of life—the same kind of individuality—as their brother artists. Although in theory post-modernism divorces a text from its author and should be gender-free, in practice post-modernism is parasitic on the canons of 'great texts' and 'great authors' established by Modernism (which was simply a development of Romanticism). Established authors and *oeuvres* are dismembered and decentred via a process of re-reading, reinterpretation and parody that fractures both *oeuvre* and tradition into discontinuity. The emphasis on debunking the subjective authority of an author, as well as all objective standards of artistic 'truth' or 'greatness', means that new authors and new traditions cannot get established. Thus, in practice, most post-modernist artists and critics carry on the patrilinear lines of tradition, which record only the occasional female presence.

We can see a confirmation of this in Richard Kearney's *The Wake of Imagination* [1988]. There are no female authors, artists or film-makers amongst the post-modernists analysed by Kearney in this text. Furthermore, even the definitions that Kearney provides of post-modernist art marginalise women's art—especially feminist art. Apparently, post-modernists have left behind such old-fashioned (Modernist) ideas as 'artistic progress' and 'innovation and change'. Not for the post-modernists the notion that an artist could be 'a precursor, a prophet of the future, a harbinger of new and better things to come' [pp. 21, 23]. Kearney carries on:

> What, if any, is the role of the creative imagination in a postmodern age apparently devoid of a project of emancipation? If the only future is one we look back to, what can we look forward to? Has the artist or intellectual any positive contribution to make to society? Has history anywhere to turn but inside out? Has art any role apart from self-parody? And where does all this leave imagination? [p. 25]

From a feminist perspective, this series of questions is extraordinarily interesting. The rhetoric suggests that political apathy (or at least paralysis) is integral to the 'post-modern age'. Could one guess from this description of art during the 1970s and '80s the influence that second-wave feminism has exerted (and continues to exert) on women in the arts? The very notion of a feminist art is represented as out of step with the times. To dream of changing society via the arts is an anachronism; even an awareness of a 'project of emancipation' jars with the mood of a male-dominated élite.

Kearney is himself critical of post-modernism. He wants to move on past post-modernism: to inject a political dimension back into aesthetic theory and practice. An extraordinary footnote describes his project as 'post-patriarchal' as well as 'post-centrist', 'post-egological', and 'post-logocentric' [pp. 460-61]. He will adopt 'a feminist-allied praxis attentive to the hitherto suppressed dimensions of alterity, difference, marginality' [loc. cit.]. Kearney, in other words, places himself on the side of the Other/the 'feminine'. He sees the way forward for art (post-post-modernism) to be through the re-writing of history, and showing the 'others' that history has excluded: 'the remembrance of things past may become "a motive power in the struggle for changing the world"' [p. 394]. Despite the footnote, however, it is notable that Kearney does not really appreciate what is involved in re-thinking *female* 'Otherness'. Indeed, his example of such an 'other' kind of history is limited to learning 'to appreciate what "other", non-Western cultures have to offer' [p. 392].

Kearney might think of himself as 'feminist-allied', but his own book continues to erase women from culture. The index of *The Wake of Imagination* contains the names of about eight women (counting 'The Nolan Sisters' as one), none of whom figure in his narrative in any significant way. Kearney does not even register that his 'new' type of history is precisely what feminist critics, historians and artists have been struggling to produce for the last two decades. Feminist scholarship does not impinge on his gaze, blinkered as it is by 'post-modernist' concerns. He provides us with a history of thinking and writing about creativity that is utterly blind to the way that imagination has been gendered in the history of Western thought. Since Kearney will found his new politics of the imagination on the historical analysis provided in this study, this omission is serious. Lacan's attack on the imaginary appears to Kearney, for example, to be breaking new ground. Whereas, from a feminist perspective, Lacan's refusal to celebrate the imagination of a 'feminine' subject fits into a long tradition of thinking biased towards the male.

In the gulf between Kearney's theory (open to feminine Otherness) and his practice (ignoring female Otherness) we can detect a process similar to that which occurred as Romanticism got under way. As the industrial society was born during the closing years of the eighteenth century, aspects of mind previously downgraded as 'feminine' were revalued and reassigned to the psyche of the genius-male. A similar process is occurring now as the industrial fades into the post-industrial age. 'Otherness', 'fragmentation', 'babble', 'marginality' have been revalued. The term 'feminist' itself has been depoliticised and appropriated within male (and female) fantasies that privilege the male even as the way forward is described in terms of a *post-patriarchal* culture. As the term 'post-patriarchal' suggests, post-modernism (and post-post-modernism) remains within the ambit of the patriarchal mythology that would retain all power, language and culture within the masculine domain. A feminist aesthetics should not be *post*-patriarchal; it should be *anti*-patriarchal. A feminist aesthetics cannot simply be an openness to Otherness; feminists have to concern themselves with what is involved in writing or creating *as a female*—as a subject positioned within the social and historical networks of power. It is, therefore, premature to announce the death of the female author.

There are two critical enterprises that are dangerously close to each other. One is the feminist task of exposing the fractures that must mark the selves and *oeuvres* of all female creators in our culture. The other critical exercise is the post-modern task: of fragmenting selves and *oeuvres* completely. The two critical activities need to be carefully distinguished. The post-modernist is a 'femininist'—concerned with psychic bisexuality... and with what it is to be a male (or pseudo-male) who writes *like a woman*. The *feminist* critic, by contrast, examines what is involved in writing *as a woman*: as a person confronting the paradigms of male individuality and female Otherness, defining herself in terms of those paradigms...and resisting them. In order to create at all, women have had to adopt a double perspective on themselves. But this fissured ego is by no means the same as the egolessness celebrated (in different, but disturbingly similar ways) by the later Romantics, the Lacanians and by other post-modernists.

We can see this *doubleness* of female vision in the present-day projects of Cixous, Irigaray and Kristeva (who both accept and reject the psychoanalytic perspective that represents the female as lacking in respect to the male). But, although Cixous claims that 'Until now women were not speaking out loud, were not writing, not creating their tongues—plural' —we can also see this doubleness of perspective (and of voice) in the writings of women in the past [Cixous, 1975, p. 137]. Mary Elizabeth Coleridge (1861-1907) is a useful example, since her poem 'In Dispraise of the Moon' (1896) barely disguises its author's distaste for her own femininity. The moon acts as a transparent metaphoric substitution for woman, with the sun standing for the male. From this point of view, woman lacks her own ego, energy and reason. She reflects male glories in a passive and dead kind of way:

I would not be the Moon, the sickly thing.
To summon owls and bats upon the wing;

For when the noble Sun is gone away,
She turns his night into a pallid day.

She hath no air, no radiance of her own,
That world unmusical of earth and stone.
She wakes her dim, uncoloured, voiceless hosts,
Ghost of the Sun, herself the sun of ghosts.

The mortal eyes that gaze too long on her
Of Reason's piercing ray defrauded are.
Light in itself doth feed the living brain;
That light, reflected, but makes darkness plain.
[Poems, 1954, p. 189]

Mary Elizabeth was only distantly related to Samuel Taylor Coleridge: her father's grandfather was Samuel Taylor's brother. But Mary's own poetic ambitions were utterly deadened by these patrilineal links. Although she published her novels and prose works without any kind of fuss, she refused to defile her surname by publishing her poetry (the part of her output that she most valued) under the name of 'Coleridge'. Indeed, her friends had to use Robert Bridges (later Poet Laureate) to trick and bully her into publishing any of her poems. Even then her verses only ever appeared during her lifetime under the male pseudonym 'Anodos' ('Wanderer'). If we detach this information and 'In Dispraise of the Moon' from the rest of her life and *oeuvre*, Mary is likely to seem the embodiment of a female who has completely internalised the perspective of lack.

We can only really work out the multiplicity of fractures within Coleridge's sense of self by reading her poetry again in the light of her novels, her short stories and the fragments of her notebooks and letters that have survived. We are likely to read 'In Dispraise of the Moon' differently, for example, when we know that she also wrote:

I am a different person every twelve hours. I go to bed as feminine as Ophelia, fiery, enthusiastic, ready to go to the stake for some righteous cause. I get up the very next morning, almost as masculine as Falstaff, grumbling at Family Prayers. [1910, p. 221]

Here (intriguingly) Mary lines up 'femininity' with positive values (fire, enthusiasm, courage) and 'masculinity' with 'grumbling' negative values. Despite going on (almost immediately) to refer to herself as 'Anodos'—and 'he'—Mary Coleridge retains a woman-centred perspective that sees femininity as both norm and ideal, and which judges masculinity a distortion (deficient or excessive). From seeming to occupy a central position in Mary's sense of self, 'In Dispraise of the Moon' shifts to become just one of a kaleidoscope of moods about being a female in a male-dominated world.

Until we recognise women's double perspective on themselves, we might be surprised that this poet—who seems so obviously contemptuous of female powers—should also have written 'The White Women' (1900). For this is a poem about an apparently matriarchal race of women. These women are also pale; but they are not described in terms of the conventional symbols of feminine moon circling male sun. These women are not pallid, sickly, or voiceless. They have never submitted to any kind of slavery, and are more powerful than the tiger, the falcon or the eagle—those conventional symbols of masculine daring.

Where dwell the lovely, wild white women folk,
 Mortal to man?
They never bowed their heads beneath the yoke,
They dwelt alone when the first morning broke
 And Time began.

Taller are they than man, and very fair,
 Their cheeks are pale,
At sight of them the tiger in his lair,
The falcon hanging in the azure air,
 The eagles quail.

The deadly shafts their nervous hands let fly
Are stronger than our strongest—in their form
Larger, more beauteous, carved amazingly,
And when they fight, the wild women cry
 The war-cry of the storm.

Their words are not as ours. If man might go
Among the waves of Ocean when they break
And hear them—hear the language of the snow
Falling on torrents—he might also know
 The tongue they speak.

Pure are they as the light; they never sinned,
 But when the rays of the eternal fire
Kindle the West, their tresses they unbind
And fling their girdles to the Western wind,
 Swept by desire.

Lo, maidens to the maidens then are born,
Strong children of the maidens and the breeze,
Dreams are not—in the glory of the morn,
Seen through the gates of ivory and horn—
 More fair than these.

And none may find their dwelling. In the shade
 Primeval of the forest oak they hide.
One of our race, lost in an awful glade,
Saw with his human eyes a wild white maid,
 And gazing, died.
[1954, pp. 212-13]

For not a few of her contemporaries Mary Coleridge embodied the ideal woman poet: 'a feminine of Blake more incandescent than burning' [Sichel, 1918, p. 135; and see Bridges, 1907, who compares her with Heine, as well as Blake]. Despite this, Mary has been reduced by patrilineal lines of tradition to the nerveless, voiceless, ineffectual female that she so dreaded...a pallid pre-Raphaelite wraith who has drifted out of all but a small percentage of works of feminist criticism.[1] But Coleridge's output demands reappraisal (and re-publication). Her *oeuvre* needs to be situated within the matrilineal traditions of writing. Walter de la Mare [1907] might have written of her, 'Once sure this heart beat beneath a man's cloak; and of how brilliant and youthful and Mercutio-like a man!'; but it's not clear that Mary would have liked this as an obituary. The poet of female lack refused to disown her sense of being distinctively female: 'If we do not retain sex I don't see how we can retain identity. Male and female we were created; and it is of the very essence of our nature' [1910, pp. 23-4].

In her novel *The Shadow on the Wall* [1904] Mary tried to work through the problems that face women who 'care most' for other women [p. 70], and who are also caught up with the values of the pre-Raphaelite 'brotherhood' of art:

1. It was in Gilbert and Gubar [1979] that I first encountered a poem by Coleridge. 'The Other Side of the Mirror' is quoted in full as 'central to the feminist aesthetics' constructed in *The Madwoman in the Attic* [pp. 15-16]. On reading it, I stopped in surprise. It is so strong. Wondering why I had never heard of her (and thinking that it was, perhaps, her only good poem), I went off to the library to look up her work. I found—to my astonishment—a richness of poetic vision, plus several novels, short stories and a biography (of Holman Hunt). Although individual poems by Coleridge have been reclaimed for feminist ends, her *oeuvre* has not. *Collected Poems* was last published in 1954, and most of the prose has yet to be reprinted. I could find no recent monographs on her work. Indeed, she is at present so obscure that her name is even missing from surveys of turn-of-the-century poetry in Britain.

'Genius is the best thing a man can have,'...
'It is what beautiful eyes are to a girl.'
'But if she knows she has beautiful eyes, at least, if she lets anyone see that she knows, that spoils it all directly.' [1904, p. 75]

Unsurprisingly, Mary's narrative fractures into complexity. It is the images that survive and haunt, not the ending. Alone, beneath the moon, her heroine dances, like some character in a (then unwritten) D. H. Lawrence novel. The hidden male watcher laughs out his shock at her 'animal' (and implicitly sexual) excess of energy [p. 91]. It was not only in an isolated poem that this unmarried spinster conjured up images of women 'Swept by desire'.

A man is allowed genius—and a great ego that knows its own genius—but a woman is not. Mary Coleridge's characters suggest (with irony) that to retain her power over a man a woman has to disguise her energy...and even learn to deceive herself every time she peers into her looking-glass. But although this seems to fit with de Beauvoir's claim in *The Second Sex* that a woman lives in bad faith, and is Other even to herself, Mary Coleridge also *resists* such a negative account of the female condition. This resistance is sited along the fracture-lines that the critic must use to unify her literary output into a distinctively female *oeuvre*.

A woman is presented with film-like images of herself (her Otherness) which are inconsistent and which therefore resist synthesis. Since a woman in our culture has to construct her self out of fragments, the work that she produces is likely to seem incoherent unless we fit it together into an overarching unity. This unity will not be seamless or monolithic. But we should not infer from this that we are not dealing with an *oeuvre*, or with a person who is not fully *individual*. It is disturbing that, at the historical moment that second-wave feminism has brought to the surface a rich hidden history of female authors and artists, the very concepts of 'individuality' and 'authorship' have come under attack by an élite group of critics who draw on recent French theories of writing and language. Here again, feminists have to keep separate two lines of argument that have become blurred. On the one hand, there is the track taken

by Roland Barthes, who would seem to want to kill off authors and eliminate selves and individuality completely [see Barthes, 1968, for example]. On the other hand, there are the theories of Jacques Derrida and (more importantly) Michel Foucault who do not prove—as some seem to suppose—that there is no such thing as a self or an author. They only show that these categories are by no means as simple and straightforward as they look. [See Derrida, 1984, p. 125; and Foucault, 1969.]

It is this latter position that is both more plausible and of more use to feminists seeking a basis for an aesthetics. The existence of fragments or fractures within a self or an *oeuvre* does not imply that there is no way of representing the pieces as a part of a whole. Indeed—as for the pathologist who must reconstruct a dead body after a crime—the existence of fracture-lines might be an important clue in assembling a model of the missing person. The analogy is useful since, as Foucault's analysis of authorship shows, an 'author' is not simply a flesh-and-blood person who scribbles, paints, sculpts, etc. We credit an author with an *oeuvre*; but it is the readers or art-consumers who decide what belongs in that *oeuvre*, and what should be cast aside as worthless. Thus, for example, an *oeuvre* often includes first-drafts, sketches and even letters; but it generally excludes doodles, memos and laundry lists. The face of an *individual* gradually emerges out of a jumble of fragments; but it is the audience that (collectively) creates the 'author' or 'artist' out of the facts at its disposal.

Imagine a child constructing a picture of a face out of a range of cut-out pieces. The child has first to decide whether she wants to construct a clown-face, a policeman-face or some other kind of face. Her choice will be determined by the game she happens to be playing, or the context that she finds herself in. Once this choice has been made, certain features will be selected as appropriate, and others discarded as inappropriate to her tastes and to her purposes. It would be odd to stick a big smiling, painted mouth on the neck of a policeman...unless,

of course, the child's purpose was to surprise or joke. It is 'tradition' that provides the context or 'game' within which the individual art critic sets out to construct the features of the artist. This analogy is not exact, since critics don't play these 'games' of tradition alone. Indeed, our knowledge of traditions is part of our cultural inheritance; and the 'traditions' are defined in part by the faces that fit into them. Furthermore, some of the fragments of 'facts' have been irretrievably destroyed, or temporarily mislaid by previous critics, biographers and historians working on the pieces. Nevertheless, the 'personality' of the author or artist that emerges out of this collective enterprise represents the values and projects of the audience in much the same way as does the face formed by the child.

Since the woman artist does not stand in the same relation to tradition as the male, her face can only emerge clearly by playing two separate games. She has to be positioned in two different, but overlapping patterns; the matrilineal and patrilineal lines of influence and response that swirl through (and across) the intricate network of relationships out of which we shape our past. A female creator needs to be slotted into the context of male traditions. But to understand what the artist is doing, and the merits or demerits of her work, she will also have to be located in a separate female pattern that, so to speak, runs through the first in a kind of contrapuntal way. Feminist cultural history offers us tricks of perspective as disturbing as those in a painting by Escher. Women are not just outside cultural traditions. They structure the spaces that lie between the bold lines picked out by previous generations of art critics and literary critics. Now after a lengthy period of sustained effort by feminist historians and critics, we are at last learning to see the depth of these spaces. We are gradually adopting the switch in perspective that allows us to appreciate the artistic achievements of many more women in the past. We cannot let post-modernist attacks on the notions of authorship, historical continuity and tradition deflect us from this task.

Notes

Barthes, Roland. "The Death of the Author." Trans. in *Image/Music/Text*. Stephen Heath, ed. London: Fontana, 1977: 142-8.

Bridges, Robert. "The Poems of Mary Coleridge." Reprinted in vol. vi of *Collected Essays, Papers, etc.* Oxford University Press, 1931.

Cixous, Hélène and Catherine Clément. *The Newly Born Woman.* Trans. Betsy Wing. Manchester University Press, 1986.

Clément, Catherine. *The Lives and Legends of Jacques Lacan.* Trans. Arthur Goldhammer. Columbia University Press, 1983.

Coleridge, Mary Elizabeth. *The Shadow on the Wall.* London: Edward Arnold, 1904.

Coleridge, Mary Elizabeth. *Gathered Leaves from the Prose of Mary E. Coleridge, with a Memoir by Edith Sichel.* London: Constable, 1910.

Coleridge, Mary Elizabeth. *Collected Poems.* Theresa Whistler, ed. London: Hart-Davis, 1954.

Dech, Jula. *"Marionette and Modepuppe, Maske und Maquillage—Beobachtungen am Frauenbild von Hannah Höch."* In Catalogue: *Hannah Höch: Fotomontagen, Gemälde, Aquarelle* (Exhibition in Tübingen). Götz Adriani, ed. Cologne: DuMont Buchverlag, 1980: 79-94.

Derrida, Jacques. "Deconstruction and the Other." *Dialogues with Contemporary Continental Thinkers: The Phenomenological Heritage.* Richard Kearney, ed. Manchester University Press, 1984.

Foucault, Michel. "What is an Author?" *The Foucault Reader.* Paul Rabinow, ed. Harmondsworth: Peregrine, 1986.

Freud, Sigmund. "Introductory Lectures on Psychoanalysis: Part III." *The Standard Edition of the Complete Psychological Works*, vol. xvi. James Strachey, ed. London: Hogarth Press, 1953-73.

Freud, Sigmund. "Femininity." *The Standard Edition of the Complete Psychological Works*, vol. xxii. James Strachey, ed. London: Hogarth Press, 1953-73.

Gelfand, Elissa D. and Virginia T. Hules, eds. *French Feminist Criticism: Women, Language and Literature, an Annotated Bibliography.* London, New York: Garland, 1985.

Gilbert, Sandra M. and Susan Gubar. *The Madwoman in the Attic: The Woman Writer and the Nineteenth-Century Literary Imagination.* Yale University Press, 1979.

Gretton, Tom. "New Lamps for Old." *The New Art History.* A. L. Rees and Frances Borzello, eds. London: Camden Press, 1986.

Jardine, Alice A. *Gynesis: Configurations of Woman and Modernity.* Cornell University Press, 1985.

Jones, Ann Rosalind. "Writing the Body: Toward an Understanding of *L'Écriture féminine*." Reprinted in *The New Feminist Criticism: Essays on Women, Literature and Theory.* Elaine Showalter, ed. London: Virago, 1986: 361-77.

Kearney, Richard. *The Wake of the Imagination: Ideas of Creativity in Western Culture.* London: Hutchinson, 1988.

Kelly, Mary. "On Sexual Politics and Art." Reprinted in Parker and Pollock: 303-312.

Kofman, Sarah. *The Enigma of Woman: Women in Freud's Writings.* Trans. Catherine Porter. Cornell University Press, 1985.

Moi, Toril. *Sexual/Textual Politics: Feminist Literary Theory*. London, New York: Methuen, 1985.

Parker, Rozsika and Griselda Pollock. *Old Mistresses: Women, Art and Ideology*. London: Routledge, 1981.

Rothenstein, John. *Modern English Painters* vol. iii, *Hennell to Hockney*. 3rd ed. London: Macdonald, 1984.

Russ, Joanna. *How to Suppress Women's Writings*. London: The Women's Press, 1984.

Sichel, Edith. *Letters, Verses and Other Writings*. Emily Marion Ritchie, ed. London: printed privately for friends, 1918.

Thomas, Karin. "Hannah Höch—the 'good girl who works hard': The Feminist Question-Mark." Trans. in catalogue: *Hannah Höch 1889-1978: Collages*. (Exhibition organised by the Institute of Foreign Cultural Relations, Stuttgart.) Stuttgart: Dr Cantz'sche Druckerei, 1985: 70-83.

Turkle, Sherry. *Psychoanalytic Politics: Freud's French Revolution*. London: Deutsch, Burnett Books, 1979.

Wilson, Colin. *The Outsider*. 2nd ed. London: Picador, 1978.

Wilson, Colin. *The Misfits: A Study of Sexual Outsiders*. London: Grafton Books, 1988.

Naomi Scheman (1946-)

The Body Politic / The Impolitic Body / Bodily Politics

From *Engenderings*

I am a philosopher, a woman, and a feminist. My identity as a philosopher is certified by training, diplomas, and a university appointment. My identity as a woman was not similarly earned: depending on the aspects you focus on, and how you think about them, it may be, among other things, a biological fact, or an always elusive goal, or an ineluctable liability to sexual assault. My identity as a feminist has come in large part from my attempts to make sense of those other two identities, particularly as they occur together—oxymoronically, I now think— as woman philosopher.

The main problem with being a woman philosopher is that according to our cultural norms philosophers have bodies only accidentally, and women have them essentially; women *are* our bodies. Even when the accident of corporeality is acknowledged to be universal, even necessary, and as permanent as one's identity, it still isn't essential that the philosopher have the precise body that he[1] has, and he's encouraged to regard it as a—perhaps indispensable —tool. Philosophers frequently fantasize body transfers, as they ponder the nature of personal identity. Women's bodies may be interchangeable, but not by us. Rather our bodies establish the terms under which *we*'ll be exchanged; they establish our worth, our identity.

The main problem with bodies, I have come to think, is that they are different, and the history of Western politics and epistemology[2] is the history of

attempts at denying difference. I want to sketch a simplified version of that history by distinguishing between premodern and modern attempts: the premodern involve the Body Politic, and the modern involve the Impolitic Body. Feminism—as a politically responsible form of postmodernism—is epistemologically radical insofar as it abandons those projects altogether, constructing knowledge based on women's differences—from men and from each other—and on bodily experiences. Feminism is Bodily Politics.

The Body Politic

One way of dealing with the problem of diversity, of the many, is by discovering, or postulating, the one. (*Why* diversity is a problem is another question, one I haven't an answer to. What's clear is that for Western epistemology and politics it has been a problem, perhaps *the* problem.) Individual knowers and political actors may be endlessly diverse, but premodern authority resides elsewhere—in a unitary realm of Forms, in God, or in the king. An individual's claim to knowledge rests on his ability to trace its origin to the unitary source. And that source is either literally bodily—see Foucault's account of the importance of the body of the king[3]— or with a barely sublimated body: consider the anxiety about graven images and sacrificial animals for the Hebrews and the "resolution" of both those anxieties in the incarnation of Christ, the visual splendor of cathedrals, the importance of religious art and music, the veneration of relics. The sublimated body, unlike the actual one, transcends any particularity—it is not different. But the residue of bodily presence ties authority to a patriarchal memory, makes it emotionally real, and encourages

1. I don't use 'he', 'his', etc. in their supposedly generic forms; the philosopher is normatively male, even if only honorifically.

2. In referring to "politics and epistemology" I mean to be stressing that knowledge is socially created, under historically specific conditions, and that there can be no valid epistemology that is inattentive to the conditions, in particular, to the institutionalized power inequalities—the politics—under which and in response to which knowledge is created and judged.

3. Michel Foucault, *Discipline and Punish: The Birth of the Prison*, trans. A. Sheridan (New York: Pantheon, 1977).

the belief that we are all part of one large body, all have our proper place in its constitution.

The premodern European world was, in the root sense of the word, patriarchal. From the *pater familias* to the king as father to God the Father, the many found their place and grounded their knowledge in relation to the one who gave and sustained their lives. The most prevalent theories of reproduction denied to the mother all but a nurturant role for the male seed; even parenthood had to be singular. The ways people knew their places in the world had to do with their bodies and the histories of those bodies, and when they violated the prescriptions for those places, their bodies were punished, often spectacularly. One's place in the body politic was as natural as the places of the organs in one's body, and political disorder, as unnatural as the shifting displacement of those organs. As Francis Barker puts it, in a discussion of *King Lear*, "Although disorder in the family, in the state and in the faculties of the soul—and, indeed, in cosmic nature—can act as metaphors for each other, their substantial interrelation is more profound than poetic artifice: they are all grounded at once in the same inner correspondence whose transgression risks the disarticulation of reality itself."[4]

The Impolitic Body

Against this unity of unities, the individualism of bourgeois subjectivity was genuinely liberatory. The modern self broke away from the defining bodies of the Church and of hereditary social, political, and economic power. The cost of making that break was a concurrent break with the subject's own body, a break that was characterized and experienced as fundamental to individual empowerment. As Foucault has argued most thoroughly, the modern body is disciplined, anatomized, medicalized, dissected, and surveyed by diffuse systems of power. (See also Barker, *The Tremulous Private Body*, 1984). These become internalized by a socially constituted self that is empowered by its success at objectifying and controlling its own body, that is, the body that it happens to inhabit and on which it is dependent,

4. Francis Barker, *The Tremulous Private Body: Essays on Subjection* (London: Methuen, 1984), p. 33.

and for which it therefore has to assume particular responsibility. Both our bodies and our dependence on them are embarrassments to the modern self. Even if they are regarded as indispensable, they are blamed for our failures, both epistemic and moral; they make us liable to illusions and to temptation.

Our bodies also make us different, and the authority of the bourgeois subject has resided in his sameness. So put, those claims are semantically odd: difference and sameness are relational terms—different from *what*? the same as *who*? Political logic doesn't always follow semantical, however, and sameness and difference have absolutely characterized those who do and do not fit the normative picture of the generic man—he who is authoritative because he has no characteristics that would make his point of view a partial or biased one. He is, for example, an author, not a Black or working class or homosexual or female or Third World author. The privileges of being white or middle class or heterosexual or male or European (or Euro-American) importantly include the privilege of being generic, of having one's identifying adjectives left off; they sound odd when put on.

Thus, ironically, the individualism of modern Western epistemology and politics are threatened by individuality. Without the One to forge unity from our diversity, without a stable body politic in which to find ourselves, we have to make a world from our own experiences and desires. And if those experiences and desires are diverse, we seem to have no guarantee that it will be one world that we will create. Anarchy (portrayed as the Hobbesian state of nature, a bourgeois nightmare), relativism, and scepticism are the quintessential political and epistemic anxieties of modernity (not to be confused with the real dangers, which are much more those of totalitarianism). Both science and the state require the positing of fundamental sameness among the enfranchised: difference must be merely epiphenomenal, trivialized by being relegated in political economy to the domain of consumption and in epistemology to the domain of the aesthetic. In those domains individuality is exalted, at the same time as even there it is channelled by the media and the art world, lest it get out of hand and disrupt the economy of the same.

The advances of liberalism since the seventeenth century have consisted largely in the expansion of the ranks of those who count as the same. Conversely, most of the horrors of modernity—slavery, colonialism, imperialism, the Holocaust, apartheid—have consisted largely in retrograde attempts to relegate some to the ranks of the different. Given the definition of full, exemplary humanness as sameness, the different are necessarily *less* than fully human, objects to the human subjects, and, typically, unlike the subjects, essentially embodied. The different are identified by their bodies—they are reputed not only to look different but to smell different and to have different capacities and tolerances—and it is obsessively their bodies that are mythologized, feared, loathed, exploited, tortured, or destroyed. Until relatively recently the struggles against these horrors have consisted in claims by the different to fundamental sameness—for example, Shylock's "do I not bleed?" The slogan of Black nationalism in the United States, "Black is beautiful," symbolizes the emergence of an alternative mode of struggle, one that challenges sameness as the basis of modern political and epistemic enfranchisement. That challenge is the reason why Third World nationalism has at least the potential to be both radical and progressive, unlike the earlier European and American versions, which, grounded in the epistemology of sameness, were ineradicably imperialist.

Bourgeois white women (usually, following the rules about who gets "adjectivized," referred to simply as 'women') have had a unique position in the modern scheme of things—different but supposedly not lesser. The pedestal is a place neither for a person nor for a devalued object: it is meant for an object that is cherished and cared for. Such women's alleged special virtues were meant to mark them as different, but as equal to or even—morally and aesthetically—superior to men. The arguments around women's suffrage in the United States in the late nineteenth and early twentieth centuries attest to the hold of this conception of womanhood on the imagination of even the proponents of suffrage, many of whom argued for it precisely because of the allegedly unique contribution of women's finer moral sensibilities. (The opponents of suffrage tended to believe rather that the corrupting atmosphere of politics would irreparably damage those fine, but delicate, sensibilities, rendering them unfit for the essential tasks of nurturing children and humanizing men.)

Sojourner Truth, a Black woman born a slave, responded to a litany about the sanctity of womanhood delivered by an opponent of women's suffrage, with a counter-litany of the differences of her life from the privileged, protected, pampered life "women" were said to lead. Her refrain was "Ain't I a woman?" The questions she was raising—who and what are women, who does the defining, how are women different from men and amongst ourselves, and what differences should those differences make—have defined the struggles of feminism for the last century. And, in conjunction with the analogous questions raised by the anti-imperialist struggles of the Third World, they point toward a revolution in political epistemology as radical as the one that marked the move into modernity. Also analogously with those struggles, feminism has to confront the definition of women in bodily terms against the backdrop of a culture that privileges the self defined as only accidentally embodied. The disciplines that control the impolitic body confer power and authority on those who master them: sublimation is the Freudian term for this process as applied to one's own(ed) body. Those who *are* their bodies are disciplined, mastered by others: they are those who lack the moral power of sublimation. Lacking authority, they do not make culture.

Bodily Politics

Postmodernism is, most profoundly, a revolt against the social, political, and economic structures that have held in place the unified subject and the correlative world of objective facts. Too often, however, the revolt is staged against the ideas of that subject and of that world, or against the supposed illusion that those structures are still in place. There is frequently no recognition of the need for concrete political struggle to effect the material changes that would actually make the unified subject of an anachronism, rather than just exposing it as historically conditioned. Postmodern epistemologies that are

political only negatively—only in their exposure of the emperor's new clothes, the revelation of the historicity of modernity—cannot provide a politically usable epistemology. The major strength of modern epistemology is that it is politically usable: it grounds both science and the liberal state. And it needs to be challenged by an epistemology that grounds and is grounded in an alternative set of political practices, that is, that bears a positive relation to some particular set of such practices. Subversive playfulness is not enough, nor is a noncritical pluralism.

Humberto Maturana's epistemology is, I think, such a noncritical pluralism.[5] To argue, as Maturana does, for the existence of a plurality of cognitive domains and for the absence of hierarchical relationships between them, is, I agree, to undercut one of the pillars of modern epistemology. Such an argument is a political move, and an important one, since that epistemology legitimates a wide range of strategies of domination. However, a noncritical pluralism like Maturana's sees as reactionary the attempts, or even the desire, to choose in more than a situational way between competing epistemologies. Figuring out how to explicate and guide such choices is, I want to urge, the task of any politically responsible postmodern epistemology. (If 'politically responsible' and 'postmodern' sound contradictory, that's part of the problem.)

Another way of posing this problem is as the problem of when and how to say *we*. The epistemology of sameness had an answer: insofar as I have thought myself out of my own particularity, including out of my body (a move that Kant, for example, equates with the attainment of autonomy), I can say *we*, confident that only those who cannot or have not so abstracted themselves will disagree. A claim to objectivity is a claim to speak for all whose voices count; it is a license not to listen. (I may, of course, need to listen in order to *achieve* objectivity; others may be helpful in pointing out my biases and may provide me with information I lack. But ultimately one voice will do, the one that speaks the truth.)

Women have become justifiably suspicious of this *we*: men have spoken for us (or for all mankind, which may or may not have included us), and we have known or discovered that what they have said is not what we would have said, had anybody asked or listened. The initial exhilaration of the wave of American feminism that started in the '60s lay largely in the discovery and evocation of a new *we*, the different voice that women spoke, the different world that we inhabited. It subsequently came as quite a shock to have it pointed out to us—mainly middle class white women by mainly women of color—that we had been spuriously generalizing from our own experience, committing precisely the epistemological and political sin we had been attacking in masculinist thought. The case against saying *we* seems overwhelming: politically as a piece of imperialist presumption, and epistemologically as a fiction that equates autonomy with universality.

The epistemological and political need to say *we* remains, however. Neither a theory nor a politics of irreducible singularity seems very promising. The very political activism that led to the problem—the need to build a theory that would further the fight against the various forms of oppression of *all* women—requires its nonsceptical solution. It is not surprising that feminists are charged—in particular by French poststructuralists—with remaining in thrall to the bourgeois conception of the subject, as well as to such concomitant liberal ideals as rights and autonomy. It is not even surprising that sometimes (though not as often as it is made) such a charge is justified. Those who have always been denied the status of *the same* are less likely to be attracted by the rebellious thrill of spurning its privileges, and it is extraordinarily difficult to do without the fundamentals of one epistemology in the absence of a developed alternative—not, that is, unless one has the privilege of being able to afford a cheerful nihilism (and only men get to play at being naughty boys).

One of the standard ways in which the quest for the same has engaged philosophy is essentialism—the idea that the properties of objects are distinguishable into the essential and the merely accidental, and that it is the former that make something the sort of thing

5. Humberto R. Maturana, "Elemente einer Ontologie des Beobachtens," in *Materialität der Kommunikation*, ed. Hans Ulrich Gumbrecht and K. Ludwig Pfeiffer (Frankfurt: Suhrkamp, 1988).

that it is, those properties that it has in common with all others of its kind. It has come to seem, even to those who would mean to repudiate essentialism, that one cannot meaningfully theorize about—or politically organize—a group of people one cannot *define*: how, we are asked, can there be a movement for women's liberation if we cannot define what is meant by 'woman', if we cannot tell who is and who is not one? With respect to women (and at least many other oppressed groups) the situation is complicated by the centrality of the body to the oppressor's definition. That is, something which in modernity is relegated to an accidental feature of being human, and is the responsibility of all the accidental, individuating features of particular people, becomes, with respect to oppressed groups, the locus of generic definition rather than of individuality.

If the problem with the bodies of middle class white men is that they get in the way of those men's claims to objectivity by making them liable to bias and partiality, the problem with the bodies of the rest of us is that they define us as interchangeable with others in our group, exchangeable as workers or as sex objects. For the privileged the body expresses the anarchic play of individual differences, which threaten one's authority unless one has the power to channel and control them. For the oppressed the body expresses the stereotyped difference that defines—in the oppressor's terms— group membership; the possibilities of individuality seem to lie in a retreat from the body. Since, paradoxically, the privileges that attend membership in the fellowship of the same lie that way too, the incentives are strong for the oppressed also to regard their bodies as merely accidental.

There are two sorts of problems with succumbing to those incentives. The hope for individuality if one can escape being defined by one's body is illusory, since, given currently available escape routes, the likeliest escape is into the realm of privilege, where the body is tamed in the name of sameness. And the politics of such escapes is necessarily elitist: one escapes precisely by breaking the perceptions of one's ties to others in one's oppressed group; one becomes the exceptional one. What is needed is rather a conception of individuality that is compatible with a historically specific *we* of

political identity and alliance. Such a *we* must be collectively articulated and situationally flexible: it must be *usable*.

The question of constructing such a *we* is of more than academic interest: for example, transsexual men claim really to be women, trapped in a male body that they frequently choose to have surgically altered to correspond better with their sense of their own gender identity. Are they women? Who is to decide? What does the question mean? Why does it matter? Particularly for groups, who have been defined by their oppressors, the need for *self*-definition can seem particularly acute. There are, for example, deep controversies among Jews and lesbians about how membership in those groups is to be internally defined, and what relation there should be between the internal definition and the definitions that target some people for anti-Semitic or homophobic violence. Such collective self-definitions need to be grounded not in some timeless essentialism, but in sensitivity to the actual political circumstances, to the needs for alliance building and empowerment. That is, the conceptual work that has typically been done by a politics of oppression masquerading as a metaphysics of bodily essences needs to be done by an explicit politics grounded in the complex interrelationships between individuality and group identity, both of them culturally encoded, and hence lived, as bodily.

Just as group definitions have been a part of the politics of oppression, the definitions of the normative self have been part of the politics of dominance and privilege. At least since Descartes, the Western normative self has been not only disembodied, but, as I have argued, consequently stripped of individuality. It has also, in a political economy based on private property, been obsessively concerned with boundaries, with where it leaves off and the not-self begins. The reconstitution of community among atomized selves has been a central task of philosophy and political theory: sociality, along with the body, has become metaphysically inessential to modern man. If we take both the body and sociality rather to be essential, we need a rethinking of the nature of the self: Descartes's *res cogitans* will no longer do. The defensiveness of the well-bounded self, sure of its borders (since nothing

else distinguishes it from all the other atoms), needs to give way to an image of the self in community and uniquely valuable, that is, as an essentially embedded *locus of idiosyncrasy*, a place from which one acts and interacts, in that style which is distinctively—*differently*—one's own, oneself. Boundaries—like group membership—become not definitive but situational and flexible.

Such a conception of the self—as a locus of idiosyncrasy—is, I think, a starting point for an epistemology that avoids the apolitical nihilism that so frequently seems to follow the postmodern undermining of the foundations of modernity. By putting flesh back on our bones, it would allow us to be responsible while acknowledging that there is nothing beyond ourselves to be responsible to.

James Clifford (1945-)

On Ethnographic Allegory

1. a story in which people, things and happenings have another meaning, as in a fable or parable: allegories are used for teaching or explaining.

2. the presentation of ideas by means of such stories....[1]

In a recent essay on narrative Victor Turner argues that social performances enact powerful stories—mythic and commonsensical—that provide the social process "with a rhetoric, a mode of emplotment, and a meaning" (1980:153). In what follows I treat ethnography itself as a performance emplotted by powerful stories. Embodied in written reports, these stories simultaneously describe real cultural events and make additional, moral, ideological, and even cosmological statements. Ethnographic writing is allegorical at the level both of its content (what it says about cultures and their histories) and of its form (what is implied by its mode of textualization).

An apparently simple example will introduce my approach. Marjorie Shostak begins her book *Nisa: The Life and Words of a !Kung Woman* with a story of childbirth the !Kung way—outside the village, alone. Here are some excerpts:

> I lay there and felt the pains as they came, over and over again. Then I felt something wet, the beginning of the childbirth. I thought, "Eh hey, maybe it is the child." I got up, took a blanket and covered Tashay with it; he was still sleeping. Then I took another blanket and my smaller duiker skin covering and I left. Was I not the only one? The only other woman was Tashay's grandmother, and she was asleep in her hut. So, just as I was, I left. I walked a short distance from the village and sat down beside a tree.... After she was born, I sat there; I didn't know what to do. I had no sense. She lay there, moving her arms about, trying to suck her fingers. She started to cry. I just sat there, looking at her. I thought, "Is this my child? Who gave birth to this child?" Then I thought, "A big thing like that? How could it possibly have come out from my genitals?" I sat there and looked at her, looked and looked and looked. (1981:1-3)

The story has great immediacy. Nisa's voice is unmistakable, the experience sharply evoked: "She lay there, moving her arms about, trying to suck her fingers." But as readers we do more than register a unique event. The story's unfolding requires us, first, to imagine a different *cultural* norm (!Kung birth, alone in the bush) and then to recognize a common *human* experience (the quiet heroism of childbirth, feelings of postpartum wonder and doubt). The story of an occurrence somewhere in the Kalahari Desert cannot remain just that. It implies both local

1. *Webster's New Twentieth Century Dictionary*, 2nd ed. In literary studies definitions of allegory have ranged from Angus Fletcher's (1964:2) loose characterization ("In the simplest terms, allegory says one thing and means another") to Todorov's reassertion (1973:63) of a stricter sense: "First of all, allegory implies the existence of at least two meanings for the same words; according to some critics, the first meaning must disappear, while others require that the two be present together. Secondly, this double meaning is indicated in the work in an *explicit* fashion: it does not proceed from the reader's interpretation (whether arbitrary or not)." According to Quintillian, any continuous or extended metaphor develops into allegory; and as Northrop Frye (1971:91) observes, "Within the boundaries of literature we find a kind of sliding scale, ranging from the most explicitly allegorical, consistent with being literature at all, at one extreme, to the most elusive, anti-explicit and anti-allegorical at the other." The various "second meanings" of ethnographic allegory I shall be tracing here are all textually explicit. But ethnographies slide along Frye's scale, exhibiting strong allegorical features, usually without marking themselves as allegories.

cultural meanings and a general story of birth. A difference is posited and transcended. Moreover, Nisa's story tells us (how could it not?) something basic about woman's experience. Shostak's life of a !Kung individual inevitably becomes an allegory of (female) humanity.

I argue below that these kinds of transcendent meanings are not abstractions or interpretations "added" to the original "simple" account. Rather, they are the conditions of its meaningfulness. Ethnographic texts are inescapably allegorical, and a serious acceptance of this fact changes the ways they can be written and read. Using Shostak's experiment as a case study I examine a recent tendency to distinguish allegorical levels as specific "voices" within the text. I argue, finally, that the very activity of ethnographic *writing*—seen as inscription or textualization—enacts a redemptive Western allegory. This pervasive structure needs to be perceived and weighed against other possible emplotments for the performance of ethnography.

^^^

Literary description always opens onto another scene set, so to speak, "behind" the this-worldly things it purports to depict.
MICHEL BEAUJOUR, "Some Paradoxes of Description"

Allegory (Gr. *allos*, "other," and *agoreuein*, "to speak") usually denotes a practice in which a narrative fiction continuously refers to another pattern of ideas or events. It is a representation that "interprets" itself. I am using the term allegory in the expanded sense reclaimed for it by recent critical discussions, notably those of Angus Fletcher (1964) and Paul De Man (1979). Any story has a propensity to generate another story in the mind of its reader (or hearer), to repeat and displace some prior story. To focus on ethnographic allegory in preference, say, to ethnographic "ideology"—although the political dimensions are always present (Jameson 1981)—draws attention to aspects of cultural description that have until recently been minimized. A recognition of allegory emphasizes the fact that realistic portraits, to the extent that they are "convincing" or "rich," are extended metaphors, patterns of associations that point to coherent (theoretical,

esthetic, moral) additional meanings. Allegory (more strongly than "interpretation") calls to mind the poetic, traditional, cosmological nature of such writing processes.

Allegory draws special attention to the *narrative* character of cultural representations, to the stories built into the representational process itself. It also breaks down the seamless quality of cultural description by adding a temporal aspect to the process of reading. One level of meaning in a text will always generate other levels. Thus the rhetoric of presence that has prevailed in much post-romantic literature (and in much "symbolic anthropology") is interrupted. De Man's critique of the valorization of symbols over allegory in romantic esthetics also questions the project of realism (De Man 1969). The claim that nonallegorical description was possible—a position underlying both positivist literalism and realist synecdoche (the organic, functional, or "typical" relationship of parts to wholes)—was closely allied to the romantic search for unmediated meaning in the event. Positivism, realism, and romanticism—nineteenth-century ingredients of twentieth-century anthropology—all rejected the "false" artifice of rhetoric along with allegory's supposed abstractness. Allegory violated the canons both of empirical science and of artistic spontaneity (Ong 1971:6-9). It was too deductive, too much an open imposition of meaning on sensible evidence. The recent "revival" of rhetoric by a diverse group of literary and cultural theorists (Roland Barthes, Kenneth Burke, Gerard Genette, Michel de Certeau, Hayden White, Paul De Man, and Michel Beaujour among others) has thrown serious doubt on the positivist-romantic-realist consensus. In ethnography the current turn to rhetoric coincides with a period of political and epistemological reevaluation in which the constructed, imposed nature of representational authority has become unusually visible and contested. Allegory prompts us to say of any cultural description not "this represents, or symbolizes, that" but rather, "this is a (morally charged) *story* about that."[2]

2. An "allegorical anthropology" is suggested fairly explicitly in recent works by Boon (1977, 1982), Crapanzano (1980), Taussig (1984), and Tyler (1984a).

The specific accounts contained in ethnographies can never be limited to a project of scientific description so long as the guiding task of the work is to make the (often strange) behavior of a different way of life humanly comprehensible. To say that exotic behavior and symbols make sense either in "human" or "cultural" terms is to supply the same sorts of allegorical added meanings that appear in older narratives that saw actions as "spiritually" significant. Culturalist and humanist allegories stand behind the controlled fictions of difference and similitude that we call ethnographic accounts. What is maintained in these texts is a double attention to the descriptive surface and to more abstract, comparative, and explanatory levels of meaning. This twofold structure is set out by Coleridge in a classic definition.

> We may then safely define allegorical writing as the employment of one set of agents and images with actions and accompaniments correspondent, so as to convey, while in disguise, either moral qualities or conceptions of the mind that are not in themselves objects of the senses, or other images, agents, fortunes, and circumstances so that the difference is everywhere presented to the eye or imagination, while the likeness is suggested to the mind; and this connectedly, so that the parts combine to form a consistent whole. (1936:30)

What one *sees* in a coherent ethnographic account, the imaged construct of the other, is connected in a continuous double structure with what one *understands*. At times, the structure is too blatant: "During the ceramic manufacturing process, women converse gently, quietly, always without conflict, about ecosystem dynamics..." (Whitten 1978:847). Usually it is less obvious and thus more realistic. Adapting Coleridge's formula, what appears descriptively to the senses (and primarily, as he suggests, to the observing eye) seems to be "other," while what is suggested by the coherent series of perceptions is an underlying similitude. Strange behavior is portrayed as meaningful within a common network of symbols—a common ground of understandable activity valid for both observer and observed, and by implication for all human groups. Thus ethnography's narrative of specific

differences presupposes, and always refers to, an abstract plane of similarity.

It is worth noting, though I cannot pursue the theme here, that before the emergence of secular anthropology as a science of *human* and *cultural* phenomena, ethnographic accounts were connected to different allegorical referents. Father Lafitau's famous comparison (1724) of Native American customs with those of the ancient Hebrews and Egyptians exemplifies an earlier tendency to map descriptions of the other onto conceptions of the "*premiers temps*." More or less explicit biblical or classical allegories abound in the early descriptions of the New World. For as Johannes Fabian (1983) argues, there has been a pervasive tendency to prefigure others in a temporally distinct, but locatable, space (earlier) within an assumed progress of Western history. Cultural anthropology in the twentieth century has tended to replace (though never completely) these historical allegories with humanist allegories. It has eschewed a search for origins in favor of seeking human similarities and cultural differences. But the representational process itself has not essentially changed. Most descriptions of others continue to assume and refer to elemental or transcendent levels of truth.

This conclusion emerges clearly from the recent Mead-Freeman controversy.[3] Two competing portrayals of Samoan life are cast as scientific projects; but both configure the other as a morally charged alter ego. Mead claimed to be conducting a controlled "experiment" in the field, "testing" the universality of stressful adolescence by examining a counter instance empirically. But despite Boasian rhetoric about the "laboratory" of fieldwork, Mead's experiment produced a message of broad ethical and political significance. Like Ruth Benedict in *Patterns of Culture* (1934), she held a liberal, pluralist vision, responding to the dilemmas of a "complex" American society. The ethnographic stories Mead and Benedict told were manifestly linked to the situation of a culture struggling with diverse values, with an apparent breakdown of

3. Mead (1923), Freeman (1983). I have drawn on my review of Freeman in the *Times Literary Supplement*, May 13, 1983, 475-76, which explores the literary dimensions of the controversy. For another treatment in this vein, see Porter 1984.

established traditions, with utopian visions of human malleability and fears of disaggregation. Their ethnographies were "fables of identity," to adapt Northrop Frye's title (1963). Their openly allegorical purpose was not a kind of moral or expository frame for empirical descriptions, something added on in prefaces and conclusions. The entire project of inventing and representing "cultures" was, for Mead and Benedict, a pedagogical, ethical undertaking.

Mead's "experiment" in controlled cultural variation now looks less like science than allegory— a too sharply focused story of Samoa suggesting a possible America. Derek Freeman's critique ignores any properly literary dimensions in ethnographic work, however, and instead applies its own brand of scientism, inspired by recent developments in sociobiology. As Freeman sees it, Mead was simply wrong about Samoans. They are not the casual, permissive people she made famous, but are beset by all the usual human tensions. They are violent. They get ulcers. The main body of his critique is a massing of counterexamples drawn from the historical record and from his own fieldwork. In 170 pages of empirical overkill, he successfully shows what was already explicit for an alert reader of *Coming of Age in Samoa*: that Mead constructed a foreshortened picture, designed to propose moral, practical lessons for American society. But as Freeman heaps up instances of Samoan anxiety and violence, the allegorical frame for his own undertaking begins to emerge. Clearly something more is getting expressed than simply the "darker side," as Freeman puts it, of Samoan life. In a revealing final page he admits as much, countering Mead's "Apollonian" sense of cultural balance with biology's "Dionysian" human nature (essential, emotional, etc.). But what is the scientific status of a "refutation" that can be subsumed so neatly by a Western mythic opposition? One is left with a stark contrast: Mead's attractive, sexually liberated, calm Pacific world, and now Freeman's Samoa of seething tensions, strict controls, and violent outbursts. Indeed Mead and Freeman form a kind of diptych, whose opposing panels signify a recurrent Western ambivalence about the "primitive." One is reminded of Melville's *Typee*, a sensuous paradise woven through with dread, the threat of violence.

^^^

Le transfert de l'Empire de la Chine à l'Empire de soi-même est constant.
VICTOR SEGALEN

A scientific ethnography normally established a privileged allegorical register it identifies as "theory," "interpretation," or "explanation." But once *all* meaningful levels in a text, including theories and interpretations, are recognized as allegorical, it becomes difficult to view one of them as privileged, accounting for the rest. Once this anchor is dislodged, the staging and valuing of multiple allegorical registers, or "voices," becomes an important area of concern for ethnographic writers. Recently this has sometimes meant giving indigenous discourse a semi-independent status in the textual whole, interrupting the privileged monotone of "scientific" representation.[4] Much ethnography, taking its distance from totalizing anthropology, seeks to evoke multiple (but not limitless) allegories.

Marjorie Shostak's *Nisa* exemplifies, and wrestles with, the problem of presenting and mediating multiple stories.[5] I shall dwell on it at some length. Shostak explicitly stages three allegorical registers: (1) the representation of a coherent cultural subject as source of scientific knowledge (Nisa is a "!Kung woman"); (2) the construction of a gendered subject (Shostak asks: what is it to be a woman?); (3) the story of a mode of ethnographic production and relationship (an intimate dialogue). Nisa is the pseudonym of a fifty-year-old woman who has lived most of her life in semi-nomadic conditions. Marjorie Shostak belongs to a Harvard-based research group that has studied the !Kung San hunter-gatherers since the 1950s. The complex truths that emerge from this "life and words" are not limited to an individual or to her surrounding cultural world.

The book's three registers are in crucial respects discrepant. First, the autobiography, cross-checked against other !Kung women's lives, is inserted within

4. On the origins of this "monotone," see De Certeau 1983:128.

5. The rest of this section is an expanded version of my review of *Nisa* in the *Times Literary Supplement*, September 17, 1982, 994-95.

an ongoing cultural interpretation (to which it adds "depth"). Second, this shaped experience soon becomes a story of "women's" existence, a story that rhymes closely with many of the experiences and issues highlighted in feminist thought. Third, *Nisa* narrates an intercultural encounter in which two individuals collaborate to produce a specific domain of truth. The ethnographic encounter itself becomes, here, the subject of the book, a fable of communication, rapport, and, finally, a kind of fictional, but potent, kinship. *Nisa* is thus manifestly an allegory of scientific comprehension, operating at the levels both of cultural description and of a search for human origins. (Along with other students of gatherer-hunters, the Harvard project—Shostak included—tend to see in this longest stage of human cultural development a baseline for human nature.) *Nisa* is a Western feminist allegory, part of the reinvention of the general category "woman" in the 1970s and 80s. *Nisa* is an allegory of ethnography, of contact and comprehension.

A braided narrative, the book moves constantly, at times awkwardly, between its three meaningful registers. *Nisa* is like many works that portray common human experiences, conflicts, joys, work, and so on. But the text Shostak has made is original in the way it refuses to blend its three registers into a seamless, "full" representation. They remain separate, in dramatic tension. This polyvocality is appropriate to the book's predicament, that of many self-conscious ethnographic writers who find it difficult to speak of well-defined "others" from a stable, distanced position. Difference invades the text; it can no longer be represented; it must be enacted.

Nisa's first register, that of cultural science, holds its subject in firm relation to a social world. It explains Nisa's personality in terms of !Kung ways, and it uses her experience to nuance and correct generalizations about her group. If *Nisa* reveals intersubjective mechanisms in unusual depth, its polyvocal construction shows, too, that the transition to scientific knowledge is not smooth. The personal does not yield to the general without loss. Shostak's research was based on systemic interviews with more than a score of !Kung women. From these conversations she amassed a body of data large enough to reveal typical attitudes, activities, and experiences. But Shostak was dissatisfied by the lack of depth in her interviews, and this led her to seek out an informant able to provide a detailed personal narrative. Nisa was quite unusual in her ability to recall and explain her life; moreover there developed a strong resonance between her stories and Shostak's personal concerns. This posed a problem for the expectations of a generalizing social science.

At the end of her first sojourn in the field, Shostak was troubled by a suspicion that her interlocutor might be too idiosyncratic. Nisa had known severe pain; her life as she recalled it was often violent. Most previous accounts of the !Kung, like Elizabeth Marshall Thomas's *The Harmless People* (1959), had shown them to be peace-loving. "Did I really want to be the one to balance the picture?" (350). On a return trip to the Kalahari, Shostak found reassurance. Though Nisa still exerted a special fascination, she now appeared less unusual. And the ethnographer became "more sure than ever that our work together could and should move forward. The interviews I was conducting with other women were proving to me that Nisa was fundamentally similar to those around her. She was unusually articulate, and she had suffered greater than average loss, but in most other important respects she was a typical !Kung woman" (358).

Roland Barthes (1981) has written poignantly of an impossible science of the individual. An insistent tug toward the general is felt throughout *Nisa*, and it is not without pain that we find Nisa generalized, tied to "an interpretation of !Kung life" (350). The book's scientific discourse, tirelessly contextual, typifying, is braided through the other two voices, introducing each of the fifteen thematic sections of the life with a few pages of background. ("Once a marriage has survived a few years beyond the young wife's first menstruation, the relationship between the spouses becomes more equal" [169]. And so forth.) Indeed, one sometimes feels that the scientific discourse functions in the text as a kind of brake on the book's other voices, whose meanings are excessively personal and intersubjective. There is a real discrepancy. For at the same time that Nisa's story contributes to better generalizations about the !Kung, its very specificity, and the particular

circumstances of its making, create meanings that are resistant to the demands of a typifying science.

The book's second and third registers are sharply distinct from the first. Their structure is dialogical, and at times each seems to exist primarily in response to the other. Nisa's life has its own textual autonomy, as a distinct narrative spoken in characteristic, believable tones. But it is manifestly the product of a collaboration. This is particularly true of its overall shape, a full lifespan—fifteen chapters including "Earliest Memories," "Family Life," "Discovering Sex," "Trial Marriages," "Marriage," "Motherhood and Loss," "Women and Men," "Taking Lovers," "A Healing Ritual," "Growing Older." Although at the start of the interviews Nisa had mapped out her life, sketching the main areas to be covered, the thematic roster appears to be Shostak's. Indeed, by casting Nisa's discourse in the shape of a "life," Shostak addresses two rather different audiences. On one side, this intensely personal collection of memories is made suitable for scientific typification as a "life-history" or "life-cycle." On the other, Nisa's life brings into play a potent and pervasive mechanism for the production of meaning in the West—the exemplary, coherent self (or rather, the self pulling itself together in autobiography). There is nothing universal or natural about the fictional processes of biography and autobiography (Gusdorf 1956; Olney 1972; Lejeune 1975). Living does not easily organize itself into a continuous narrative. When Nisa says, as she often does, "We lived in that place, eating things. Then we left and went somewhere else," or simply, "we lived and lived" (69), the hum of unmarked, impersonal existence can be heard. From this blurred background, a narrative shape emerges in the occasion of speaking, simultaneously to oneself and another. Nisa tells her life, a process textually dramatized in Shostak's book.

As alter ego, provoker, and editor of the discourse, Shostak makes a number of significant interventions. A good deal of cutting and rearranging transforms overlapping stories into "a life" that does not repeat itself unduly and that develops by recognizable steps and passages. Nisa's distinct voice emerges. But Shostak has systematically removed her own interventions (though they can often be sensed in Nisa's response). She has also taken out a variety of narrative markers: her friend's habitual comments at the end of a story, "the wind has taken that away," or at the start, "I will break open the story and tell you what's there"; or in the middle, "What am I trying to do? Here I am sitting, talking about one story, and another turns right into my head and into my thoughts!" (40). Shostak has clearly thought carefully about the framing of her transcripts, and one cannot have everything—the performance with all its divigations, and also an easily understandable story. If Nisa's words were to be widely read, concessions had to be made to the requirements of biographical allegory, to a readership practiced in the ethical interpretation of selves. By these formal means the book's second discourse, Nisa's spoken life, is brought close to its readers, becoming a narration that makes eloquent "human" sense.

The book's third distinct register is Shostak's personal account of fieldwork. "Teach me what it is to be a !Kung woman" was the question she asked of her informants (349). If Nisa responded with peculiar aptness, her words also seemed to answer another question, "What is it to be a woman?" Shostak told her informants "that I wanted to learn what it meant to be a woman in their culture so I could better understand what it meant in my own." With Nisa, the relationship became, in !Kung terms, that of an aunt talking to a young niece, to "a girl-woman, recently married, struggling with the issues of love, marriage, sexuality, work and identity" (4). The younger woman ("niece," sometimes "daughter") is instructed by an experienced elder in the arts and pains of womanhood. The transforming relationship ends with an equality in affection and respect, and with a final word, potent in feminist meaning: "sister" (371). Nisa speaks, throughout, not as a neutral witness but as a person giving specific kinds of advice to someone of a particular age with manifest questions and desires. She is not an "informant" speaking *cultural* truths, as if to everyone and no one, providing information rather than circumstantial responses.

In her account, Shostak describes a search for personal knowledge, for something going beyond the usual ethnographic rapport. She hopes that intimacy with a !Kung woman will, somehow, enlarge or

deepen her sense of being a modern Western woman. Without drawing explicit lessons from Nisa's experience, she dramatizes through her own quest the way a narrated life makes sense, allegorically, *for another*. Nisa's story is revealed as a joint production, the outcome of an encounter that cannot be rewritten as a subject-object dichotomy. Something more than explaining or representing the life and words of another is going on—something more open-ended. The book is part of a new interest in revaluing subjective (more accurately, intersubjective) aspects of research. It emerges from a crucial moment of feminist politics and epistemology: consciousness raising and the sharing of experience by women. A commonality is produced that, by bringing separate lives together, empowers personal action, recognizes a common estate. This moment of recent feminist consciousness is allegorized in *Nisa*'s fable of its own relationality. (In other ethnographies, traditionally masculine stories of initiation and penetration differently stage the productive encounter of self and other.)[6] Shostak's explicit feminist allegory thus reflects a specific moment in which the construction of "women's" experience is given center stage. It is a moment of continuing importance; but it has been challenged by recent countercurrents within feminist theory. The assertion of common female qualities (and oppressions) across racial, ethnic, and class lines is newly problematic. And in some quarters "woman" is seen, not as a locus of experience, but as a shifting subjective position not reducible to any essence.[7]

Shostak's allegory seems to register these countercurrents in its occasionally complex accounts of the processes of play and transference, which produce the final inscription of commonality. For the book's intimate relationships are based on subtle, reciprocal movements of doubling, imagination, and desire, movements allegorized in one of the stories Shostak tells in counterpoint to Nisa's narrative—an incident turning on the value of a girl-woman's body.

6. On ethnography as an allegory of conquest and initiation, see Clifford 1983b.

7. On racial and class divisions within feminism, see the rethinking of Rich (1979), and the work of Hull, Scott, and Smith (1982), Hooks (1981), and Moraga (1983). Strong feminist critiques of essentialism may be found in Wittig (1981) and Haraway (1985).

One day I noticed a twelve-year old girl, whose breasts had just started to develop, looking into the small mirror beside the driver's window of our Land Rover. She looked intently at her face, then, on tiptoe, examined her breasts and as much of her body as she could see, then went to her face again. She stepped back to see more, moved in again for a closer look. She was a lovely girl, although not outstanding in any way except being in the full health and beauty of youth. She saw me watching. I teased in the !Kung manner I had by then thoroughly learned, "So ugly! How is such a young girl already so ugly?" She laughed. I asked, "You don't agree?" She beamed, "No, not at all. I'm beautiful!" She continued to look at herself. I said, "Beautiful? Perhaps my eyes have become broken with age that I can't see where it is?" She said, "Everywhere— my face, my body. There is no ugliness at all." These remarks were said easily, with a broad smile, but without arrogance. The pleasure she felt in her changing body was as evident as the absence of conflict about it.(270)

A great deal of the book is here: an old voice, a young voice, a mirror...talk of self-possession. Narcissism, a term of deviance applied to women of the West, is transfigured. We notice, too, that it is the ethnographer, assuming a voice of age, who has brought a mirror, just as Nisa provides an allegorical mirror when Shostak takes the role of youth. Ethnography gains subjective "depth" through the sorts of roles, reflections, and reversals dramatized here. The writer, and her readers, can be both young (learning) and old (knowing). They can simultaneously listen, and "give voice to," the other.[8] Nisa's readers follow—and prolong—the play of a desire. They imagine, in the mirror of the other, a guileless self-possession, an uncomplicated feeling of "attractiveness" that Shostak translates as "I have work," "I am productive," "I have worth" (270).

Anthropological fieldwork has been represented as both a scientific "laboratory" and a personal "rite

8. Ethnographies often present themselves as fictions of learning, the acquisition of knowledge, and finally of authority to understand and represent another culture. The researcher begins in a child's relationship to adult culture, and ends by speaking within the wisdom of experience. It is interesting to observe how, in the text, an author's enunciative modes may shift back and forth between learning from and speaking for the other. This fictional freedom is crucial to ethnography's allegorical appeal: the simultaneous reconstruction of a culture and a knowing self, a double "coming of age in Samoa."

of passage." The two metaphors capture nicely the discipline's impossible attempt to fuse objective and subjective practices. Until recently, this impossibility was masked by marginalizing the intersubjective foundations of fieldwork, by excluding them from serious ethnographic texts, relegating them to prefaces, memoirs, anecdotes, confessions, and so forth. Lately this set of disciplinary rules is giving way. The new tendency to name and quote informants more fully and to introduce personal elements into the text is altering ethnography's discursive strategy and mode of authority. Much of our knowledge about other cultures must now be seen as contingent, the problematic outcome of intersubjective dialogue, translation, and projection. This poses fundamental problems for any science that moves predominantly from the particular to the general, that can make use of personal truths only as examples of typical phenomena or as exceptions to collective patterns.

Once the ethnographic process is accorded its full complexity of historicized dialogical relations, what formerly seemed to be empirical/interpretative accounts of generalized cultural facts (statements and attributions concerning "the !Kung," the "Samoans," etc.) now appear as just one level of allegory. Such accounts may be complex and truthful; and they are, in principle, susceptible to refutation, assuming access to the same pool of cultural facts. But as written versions based on fieldwork, these accounts are clearly no longer *the* story, but a story among other stories. *Nisa*'s discordant allegorical registers—the book's three, never quite manageable, "voices"—reflect a troubled, inventive moment in the history of cross-cultural representation.

^^^

Welcome of Tears *is a beautiful book, combining the stories of a vanishing people and the growth of an anthropologist.*
Margaret Mead, blurb for the paperback edition of Charles Wagley's *Welcome of Tears*

Ethnographic texts are not only, or predominantly, allegories. Indeed, as we have seen, they struggle to limit the play of their "extra" meanings, subordinating them to mimetic, referential functions. This struggle (which often involves disputes over what will count as "scientific" theory and what as "literary" invention or "ideological" projection) maintains disciplinary and generic conventions. If ethnography as a tool for positive science is to be preserved, such conventions must mask, or direct, multiple allegorical processes. For may not every extended description, stylistic turn, story, or metaphor be read to mean something else? (Need we accept the three explicit levels of allegory in a book like *Nisa*? What about its photographs, which tell their own story?) Are not readings themselves undecidable? Critics like De Man (1979) rigorously adopt such a position, arguing that the choice of a dominant rhetoric, figure, or narrative mode in a text is always an imperfect attempt to impose a reading or range of readings on an interpretive process that is open-ended, a series of displaced "meanings" with no full stop. But whereas the free play of readings may in theory be infinite, there are, at any historical moment, a limited range of canonical and emergent allegories available to the competent reader (the reader whose interpretation will be deemed plausible by a specific community). These structures of meaning are historically bounded and coercive. There is, in practice, no "free play."

Within this historical predicament, the critique of stories and patterns that persistently inform cross-cultural accounts remains an important political as well as scientific task. In the remainder of this essay I explore a broad, orienting allegory (or more accurately, a pattern of possible allegories) that has recently emerged as a contested area—a structure of retrospection that may be called "ethnographic pastoral." Shostak's book and the Harvard hunter-gatherer studies, to the extent that they engage in a search for fundamental, desirable human traits, are enmeshed in this structure.

In a trenchant article, "The Use and Abuse of Anthropology: Reflections on Feminism and Cross-Cultural Understanding," Michelle Rosaldo has questioned a persistent tendency to appropriate ethnographic data in the form of a search for origins. Analyses of social "givens" such as gender and sexuality show an almost reflexive need for anthropological just-so-stories. Beginning with

Simone de Beauvoir's founding question, "What is a woman?" scholarly discussions "move...to a diagnosis of contemporary subordination and from then on to the queries 'Were things always as they are today?' and then 'When did "it" start?'" (1980: 391). Enter examples drawn from ethnography. In a practice not essentially different from that of Herbert Spencer, Henry Maine, Durkheim, Engels, or Freud, it is assumed that evidence from "simple" societies will illuminate the origins and structure of contemporary cultural patterns. Rosaldo notes that most scientific anthropologists have, since the early twentieth century, abandoned the evolutionary search for origins, but her essay suggests that the reflex is pervasive and enduring. Moreover, even scientific ethnographers cannot fully control the meanings—readings—provoked by their accounts. This is especially true of representations that have not historicized their objects, portraying exotic societies in an "ethnographic present" (which is always, in fact, a past). This synchronic suspension effectively textualizes the other, and gives the sense of a reality not in temporal flux, not in the same ambiguous, moving *historical* present that includes and situates the other, the ethnographer, and the reader. "Allochronic" representations, to use Johannes Fabian's term, have been pervasive in twentieth-century scientific ethnography. They invite allegorical appropriations in the mythologizing mode Rosaldo repudiates.

Even the most coolly analytic accounts may be built on this retrospective appropriation. E. E. Evans-Pritchard's *The Nuer* (1940) is a case in point, for it portrays an appealingly harmonious anarchy, a society uncorrupted by a Fall. Henrika Kuklick (1984) has analyzed *The Nuer* (in the context of a broad trend in British political anthropology concerned with acephalous "tribal" societies) as a political allegory reinscribing a recurrent "folk model" of Anglo-Saxon democracy. When Evans-Pritchard writes, "There is no master and no servant in their society, but only equals who regard themselves as God's noblest creation," it is not difficult to hear echoes of a long political tradition of nostalgia for "an egalitarian, contractual union" of free individuals. Edenic overtones are occasionally underscored, as always with Evans-Pritchard, dryly.

> Though I have spoken of time and units of time the Nuer have no expression equivalent to "time" in our language, and they cannot, therefore, as we can, speak of time as though it were something actual, which passes, can be wasted, can be saved, and so forth. I do not think that they ever experience the same feeling of fighting against time or of having to coordinate activities with an abstract passage of time, because their points of reference are mainly the activities themselves, which are generally of a leisurely character. Events follow a logical order, but they are not controlled by an abstract system, there being no autonomous points of reference to which activities have to conform with precision. Nuer are fortunate. (103)

For a readership caught up in the post-Darwinian bourgeois experience of time—a linear, relentless progress leading nowhere certain and permitting no pause or cyclic return, the cultural islands out of time (or "without history") described by many ethnographers have a persistent prelapsarian appeal. We note, however, the ironic structure (which need not imply an ironic tone) of such allegories. For they are presented through the detour of an ethnographic subjectivity whose attitude toward the other is one of participant-observation, or better perhaps, belief-skepticism (see Webster 1982:93). Nuer are fortunate. (We are unfortunate.) The appeal is fictional, the temporal ease and attractive anarchy of Nuer society are distant, irretrievable. They are lost qualities, textually recovered.

This ironic appeal belongs to a broad ideological pattern that has oriented much, perhaps most, twentieth century cross-cultural representation. "For us, primitive societies [*Naturvölker*] are ephemeral.... At the very instant they become known to us they are doomed." Thus, Adolph Bastian in 1881 (quoted in Fabian 1983:122). In 1921, Bronislaw Malinowski: "Ethnography is in the sadly ludicrous, not to say tragic position, that at the very moment when it begins to put its workshop in order, to forge its proper tools, to start ready for work on its appointed task, the material of its study melts away with hopeless rapidity" (1961:xv). Authentic Trobriand society, he implied, was not long for this world. Writing in the 1950s, Claude Lévi-Strauss

saw a global process of entropy. *Tristes Tropiques* sadly portrays differentiated social structures disintegrating into global homogeneity under the shock of contact with a potent monoculture. A Rousseauian quest for "elementary" forms of human collectivity leads Lévi-Strauss to the Nambikwara. But their world is falling apart. "I had been looking for a society reduced to its simplest expression. That of the Nambikwara was so truly simple that all I could find in it was individual human beings" (1975:317).

The theme of the vanishing primitive, of the end of traditional society (the very act of naming it "traditional" implies a rupture), is pervasive in ethnographic writing. It is, in Raymond William's phrase, a "structure of feeling" (1973:12). Undeniably, ways of life can, in a meaningful sense, "die"; populations are regularly violently disrupted, sometimes exterminated. Traditions are constantly being lost. But the persistent and repetitious "disappearance" of social forms at the moment of their ethnographic representation demands analysis as a narrative structure. A few years ago the *American Ethnologist* printed an article based on recent fieldwork among the Nambikwara—who are still something more than "individual human beings." And living Trobriand culture has been the object of recent field study (Weiner 1976). The now-familiar film *Trobriand Cricket* shows a very distinct way of life, reinventing itself under the conditions of colonialism and early nationhood.

Ethnography's disappearing object is, then, in significant degree, a rhetorical construct legitimating a representational practice: "salvage" ethnography in its widest sense. The other is lost, in disintegrating time and space, but saved in the text. The rationale for focusing one's attention on vanishing lore, for rescuing in writing the knowledge of old people, may be strong (though it depends on local circumstances and cannot any longer be generalized). I do not wish to deny specific cases of disappearing customs and languages, or to challenge the value of recording such phenomena. I do, however, question the assumption that with rapid change something essential ("culture"), a coherent differential identity, vanishes. And I question, too, the mode of scientific and moral authority associated with salvage, or redemptive, ethnography. It is assumed that the other society is weak and "needs" to be represented by an outsider (and that what matters in its life is its past, not present or future). The recorder and interpreter of fragile custom is custodian of an essence, unimpeachable witness to an authenticity. (Moreover, since the "true" culture has always vanished, the salvaged version cannot be easily refuted.)

Such attitudes, though they persist, are diminishing. Few anthropologists today would embrace the logic of ethnography in the terms in which it was enunciated in Franz Boas's time, as a last-chance rescue operation. But the allegory of salvage is deeply ingrained. Indeed, I shall argue in a moment that it is built into the conception and practice of ethnography as a process of writing, specifically of textualization. Every description or interpretation that conceives itself as "bringing a culture into writing," moving from oral-discursive experience (the "native's," the fieldworker's) to a written version of that experience (the ethnographic text) is enacting the structure of "salvage." To the extent that the ethnographic process is seen as inscription (rather than, for example, as transcription, or dialogue) the representation will continue to enact a potent, questionable, allegorical structure.

This structure is appropriately located within a long Western tradition of pastoral (a topic also developed by Renato Rosaldo in *Writing Culture*). Raymond Williams's *The Country and the City* (1973), while drawing on an established tradition of scholarship on pastoral (Empson 1950, Kermode 1952, Frye 1971, Poggioli 1975, among others) strains toward a global scope wide enough to accommodate ethnographic writing. He shows how a fundamental contrast between city and country aligns itself with other pervasive oppositions: civilized and primitive, West and "non-West," future and past. He analyzes a complex, inventive, strongly patterned set of responses to social dislocation and change, stretching from classical antiquity to the present. Williams traces the constant reemergence of a conventionalized pattern of retrospection that laments the loss of a "good" country, a place where authentic social and

natural contacts were once possible. He soon, however, notes an unsettling regression. For each time one finds a writer looking back to a happier place, to a lost, "organic" moment, one finds another writer of that earlier period lamenting a similar, previous disappearance. The ultimate referent is, of course, Eden (9-12).

Williams does not dismiss this structure as simply nostalgic, which it manifestly is; but rather follows out a very complex set of temporal, spatial, and moral positions. He notes that pastoral frequently involves a *critical nostalgia*, a way (as Diamond [1974] argues for a concept of the primitive) to break with the hegemonic, corrupt present by asserting the reality of a radical alternative. Edward Sapir's "Culture, Genuine and Spurious" (1966) recapitulates these critical pastoral values. And indeed every imagined authenticity presupposes, and is produced by, a present circumstance of felt inauthenticity. But Williams's treatment suggests that such projections need not be consistently located in the past; or, what amounts to the same thing, that the "genuine" elements of cultural life need not be repetitiously encoded as fragile, threatened, and transient. This sense of pervasive social fragmentation, of a constant disruption of "natural" relations, is characteristic of a subjectivity Williams loosely connects with city life and with romanticism. The self, cut loose from viable collective ties, is an identity in search of wholeness, having internalized loss and embarked on an endless search for authenticity. Wholeness by definition becomes a thing of the past (rural, primitive, childlike) accessible only as a fiction, grasped from a stance of incomplete involvement. George Eliot's novels epitomize this situation of participant-observation in a "common condition...a knowable community, belong[ing] ideally in the past." *Middlemarch*, for example, is projected a generation back from the time of its writing to 1830. And this is approximately the temporal distance that many conventional ethnographies assume when they describe a passing reality, "traditional" life, in the present tense. The fiction of a knowable community "can be recreated there for a widely ranging moral action. But the real step that has been taken is withdrawal from any full response to an existing

society. Value is in the past, as a general retrospective condition, and is in the present only as a particular and private sensibility, the individual moral action" (180).

In George Eliot we can see the development of a style of sociological writing that will describe whole cultures (knowable worlds) from a specific temporal distance and with a presumption of their transience. This will be accomplished from a loving, detailed, but ultimately disengaged, standpoint. Historical worlds will be salvaged as textual fabrications disconnected from ongoing lived milieux and suitable for moral, allegorical appropriation by individual readers. In properly *ethnographic* pastoral this textualizing structure is generalized beyond the dissociations of nineteenth-century England to a wider capitalist topography of Western/non-Western, city/country oppositions. "Primitive," nonliterate, underdeveloped, tribal societies are constantly yielding to progress, "losing" their traditions. "In the name of science, we anthropologists compose requiems," writes Robert Murphy (1984). But the most problematic, and politically charged, aspect of this "pastoral" encodation is its relentless placement of others in a present-becoming-past. What would it require, for example, consistently to associate the inventive, resilient, enormously varied societies of Melanesia with the cultural *future* of the planet? How might ethnographies be differently conceived if this standpoint could be seriously adopted? Pastoral allegories of cultural loss and textual rescue would, in any event, have to be transformed.[9]

Pervasive assumptions about ethnography as writing would also have to be altered. For allegories of salvage are implied by the very practice of

9. In my reading, the most powerful attempt to unthink this temporal setup, by means of an ethnographic invention of Melanesia, is the work of Roy Wagner (1979, 1980). He opposes, perhaps too sharply, Western "anticipations of the past" with Melanesian "anticipations of the future." The former are associated with the idea of culture as a structuring tradition (1979:162). Hugh Brody's *Maps and Dreams* (1982) offers a subtle and precise attempt to portray the hunting life of Beaver Indians in northwest Canada as they confront world-system forces, an oil pipeline, hunting for sport, etc. He presents his work as a political collaboration. And he is careful to keep the future open, uncertain, walking a fine line between narratives of "survival," "acculturation," and "impact."

textualization that is generally assumed to be at the core of cultural description. Whatever else an ethnography does, it translates experience into text. There are various ways of effecting this translation, ways that have significant ethical and political consequences. One can "write up" the results of an individual experience of research. This may generate a realistic account of the unwritten experience of another group or person. One can present this textualization as the outcome of observation, of interpretation, of dialogue. One can construct an ethnography composed of dialogues. One can feature multiple voices, or a single voice. One can portray the other as a stable, essential whole, or one can show it to be the product of a narrative of discovery, in specific historical circumstances. I have discussed some of these choices elsewhere (1983a). What is irreducible, in all of them, is the assumption that ethnography brings experience and discourse into writing.

Though this is manifestly the case, and indeed reflects a kind of common sense, it is not an innocent common sense. Since antiquity the story of a passage from the oral/aural into writing has been a complex and charged one. Every ethnography enacts such a movement, and this is one source of the peculiar authority that finds both rescue and irretrievable loss—a kind of death in life—in the making of texts from events and dialogues. Words and deeds are transient (and authentic), writing endures (as supplementarity and artifice). The text embalms the event as it extends its "meaning." Since Socrates' refusal to write, itself powerfully written by Plato, a profound ambivalence toward the passage from oral to literate has characterized Western thinking. And much of the power and pathos of ethnography derives from the fact that it has situated its practice within this crucial transition. The fieldworker presides over, and controls in some degree, the making of a text out of life. His or her descriptions and interpretations become part of the "consultable record of what man has said" (Geertz 1973:30). The text is a record of something enunciated, in a *past*. The structure, if not the thematic content, of pastoral is repeated.

A small parable may give a sense of why this allegory of ethnographic rescue and loss has recently become less self-evident. It is a true parable.[10] A student of African ethno-history is conducting field research in Gabon. He is concerned with the Mpongwé, a coastal group who, in the nineteenth century, were active in contacts with European traders and colonists. The "tribe" still exists, in the region of Libreville, and the ethno-historian has arranged to interview the current Mpongwé chief about traditional life, religious ritual, and so on. In preparation for his interview the researcher consults a compendium of local custom compiled in the early twentieth century by a Gabonese Christian and pioneering ethnographer, the Abbé Raponda-Walker. Before meeting with the Mpongwé chief the ethnographer copies out a list of religious terms, institutions and concepts, recorded and defined by Raponda-Walker. The interview will follow this list, checking whether the customs persist, and if so, with what innovations. At first things go smoothly, with the Mpongwé authority providing descriptions and interpretations of the terms suggested, or else noting that a practice has been abandoned. After a time, however, when the researcher asks about a particular word, the chief seems uncertain, knits his brows. "Just a moment," he says cheerfully, and disappears into his house to return with a copy of Raponda-Walker's compendium. For the rest of the interview the book lies open on his lap.

Versions of this story, in increasing numbers, are to be heard in the folklore of ethnography. Suddenly cultural data cease to move smoothly from oral performance into descriptive writing. Now data also move from text to text, inscription becomes transcription. Both informant and researcher are readers and re-*writers* of a cultural invention. this is not to say, as some might, that the interview has ended in a sterile short circuit. Nor need one, like Socrates in the *Phaedrus*, lament the erosion of memory by literacy. The interview has not, suddenly, become "inauthentic," the data merely imposed. Rather, what one must reckon with are new conditions of ethnographic production. First, it is no longer possible to act as if the outside researcher

10. My thanks to Henry Butcher for this true story. I have told it as a parable, both because it is one, and because I suspect he would tell it somewhat differently, having been there.

is the sole, or primary, bringer of the culture into writing. This has, in fact, seldom been the case. However, there has been a consistent tendency among fieldworkers to hide, discredit, or marginalize prior written accounts (by missionaries, travelers, administrators, local authorities, even other ethnographers). The fieldworker, typically, starts from scratch, from a research *experience*, rather than from reading or transcribing. The field is not conceived of as already filled with texts. Yet this intertextual predicament is more and more the case (Larcom 1983). Second, "informants" increasingly read and write. They interpret prior versions of their culture, as well as those being by ethnographic scholars. Work with texts—the process of inscription, rewriting, and so forth—is no longer (if it ever was) the exclusive domain of outside authorities. "Nonliterate" cultures are already textualized; there are few, if any, "virgin" lifeways to be violated and preserved by writing. Third, a very widespread, empowering distinction has been eroded: the division of the globe into literate and nonliterate peoples. This distinction is no longer widely accurate, as non-Western, "tribal" peoples become increasingly literate. But furthermore, once one begins to doubt the ethnographer's monopoly on the power to inscribe, one begins to see the "writing" activities that have always been pursued by native collaborators—from an Ambrym islander's sketch (in a famous gesture) of an intricate kinship system in the sand for A. B. Deacon to the Sioux George Sword's book-length cultural description found in the papers of James Walker. (See the introduction of *Writing Culture*.)

But the most subversive challenge to the allegory of textualization I have been discussing here is found in the work of Derrida (1974). Perhaps the most enduring effect of his revival of "grammatology" has been to expand what was conventionally thought of as writing. *Alphabetic* writing, he argues, is a restrictive definition that ties the broad range of marks, spatial articulations, gestures, and other inscriptions at work in human cultures too closely to the representation of speech, the oral/aural word. In opposing logocentric representation to *écriture*, he radically extends the definition of the "written,"

in effect smudging its clear distinction from the "spoken." There is no need here to pursue in detail a disorienting project that is by now well known. What matters for ethnography is the claim that *all* human groups write—if they articulate, classify, possess an "oral-literature," or inscribe their world in ritual acts. They repeatedly "textualize" meanings. Thus, in Derrida's epistemology, the writing of ethnography cannot be seen as a drastically new form of cultural inscription, as an exterior imposition on a "pure," unwritten oral/aural universe. The logos is not primary and the *gramme* its mere secondary representation.

Seen in this light, the processes of ethnographic writing appear more complex. If, as Derrida would say, the cultures studied by anthropologists are always already writing themselves, the special status of the fieldworker-scholar who "brings the culture into writing" is undercut. Who, in fact, writes a myth that is recited into a tape recorder, or copied down to become part of field notes? Who writes (in a sense going beyond transcription) an interpretation of custom produced through intense conversations with knowledgeable native collaborators? I have argued that such questions can, and should, generate a rethinking of ethnographic authority (Clifford 1983a). In the present context I want merely to underline the pervasive challenge, both historical and theoretical in origin, that presently confronts the allegory of ethnographic practice as textualization.

It is important to keep the allegorical dimensions in mind. For in the West the passage from oral to literate is a potent recurring *story*—of power, corruption, and loss. It replicates (and to an extent produces) the structure of pastoral that has been pervasive in twentieth-century ethnography. Logocentric writing is conventionally conceived to be a *representation* of authentic speech. Pre-literate (the phrase contains a story) societies are oral societies; writing comes to them from "outside," an intrusion from a wider world. Whether brought by missionary, trader, or ethnographer, writing is both empowering (a necessary, effective way of storing and manipulating knowledge) and corrupting (a loss of immediacy, of the face-to-face communication Socrates cherished, of the presence and intimacy of

speech). A complex and fertile recent debate has circled around the valorization, historical significance, and epistemological status of writing.[11] Whatever may or may not have been settled in the debate, there is no doubt of what has become unsettled: the sharp distinction of the world's cultures into literate and pre-literate; the notion that ethnographic textualization is a process that enacts a fundamental transition from oral experience to written representation; the assumption that something essential is lost when a culture becomes "ethnographic"; the strangely ambivalent authority of a practice that salvages as text a cultural life becoming past.

These components of what I have called ethnographic pastoral no longer appear as common sense. Reading and writing are generalized. If the ethnographer reads culture over the native's shoulder, the native also reads over the ethnographer's shoulder as he or she writes each cultural description. Fieldworkers are increasingly constrained in what they publish by the reactions of those previously classified as nonliterate. Novels by a Samoan (Alfred Wendt) can challenge the portrait of his people by a distinguished anthropologist. The notion that writing is a corruption, that something irretrievably pure is lost when a cultural world is textualized is, after Derrida, seen to be a pervasive, contestable, Western allegory. Walter Ong and others have shown that something is, indeed, lost with the generalization of writing. But authentic culture is not that something—to be gathered up in its fragile, final truth by an ethnographer or by anyone else.

Modern allegory, Walter Benjamin (1977) tells us, is based on a sense of the world as transient and fragmentary. "History" is grasped as a process, not of inventive life, but of "irresistible decay." The material analogue of allegory is thus the "ruin" (178), an always-disappearing structure that invites imaginative reconstruction. Benjamin observes that "appreciation of the transience of things, and the concern to redeem them for eternity, is one of the strongest impulses in allegory" (quoted by Wolin 1982:71). My account of ethnographic pastoral

suggest that this "impulse" is to be resisted, not by abandoning allegory—an impossible aim—but by opening ourselves to different histories.

<center>^^^</center>

Allegories are secured...by teaching people to read in certain ways.
 TALAL ASAD (comment on this essay at the Santa Fe seminar)

I have explored some important allegorical forms that express "cosmological" patterns of order and disorder, fables of personal (gendered) identity, and politicized models of temporality. The future of these forms is uncertain; they are being rewritten and criticized in current practice. A few conclusions, or at least assertions, may be drawn from this exploration.

There is no way definitely, surgically, to separate the factual from the allegorical in cultural accounts. The data of ethnography make sense only within patterned arrangements and narratives, and these are conventional, political, and meaningful in a more than referential sense. Cultural facts are not true and cultural allegories false. In the human sciences the relation of fact to allegory is a domain of struggle and institutional discipline.

The meanings of an ethnographic account are uncontrollable. Neither an author's intention, nor disciplinary training, nor the rules of the genre can limit the readings of a text that will emerge with new historical, scientific, or political projects. But if ethnographies are susceptible to multiple interpretations, these are not at any given moment infinite, or merely "subjective" (in the pejorative sense). Reading is indeterminate only to the extent that history itself is open-ended. If there is a common resistance to the recognition of allegory, a fear that it leads to a nihilism of reading, this is not a realistic fear. It confuses contests for meaning with disorder. And often it reflects a wish to preserve an "objective" rhetoric, refusing to locate its own mode of production within inventive culture and historical change.

A recognition of allegory inescapably poses the political and ethical dimensions of ethnographic writing. It suggests that these be manifested, not hidden. In this light, the open allegorizing of a Mead

11. The "debate" centers in the confrontation of Ong (1967, 1977, 1982) and Derrida (1973, 1974). Tyler (1978, 1984b) tries to work past the opposition. Goody (1977) and Eisenstein (1979) have made important recent contributions.

or a Benedict enacts a certain probity—properly exposing itself to the accusation of having *used* tribal societies for pedagogical purposes. (Let those free of such purposes cast the first stone!) One need not, of course, purvey heavy-handed "messages," or twist cultural facts (as presently known) to a political purpose. I would suggest as a model of allegorical tact Marcel Mauss's *The Gift*. No one would deny its scientific importance or scholarly commitment. Yet from the outset, and especially in its concluding chapter, the work's aim is patent: "to draw conclusions of a moral nature about some of the problems confronting us in our present economic crisis" (1967:2). The book was written in response to the breakdown of European reciprocity in World War I. The troubling proximity it shows between exchange and warfare, the image of the round table evoked at the end, these and other urgent resonances mark the work as a socialist-humanist allegory addressed to the political world of the twenties. This is not the work's only "content." The many readings *The Gift* has generated testify to its productivity as a text. It can even be read—in certain graduate seminars—as a classic comparative study of exchange, with admonitions to skim over the final chapter. This is a sad mistake. For it misses the opportunity to learn from an admirable example of science deploying itself *in* history.

A recognition of allegory complicates the writing and reading of ethnographies in potentially fruitful ways. A tendency emerges to specify and separate different allegorical registers within the text. The marking off of extended indigenous discourses shows the ethnography to be a hierarchical structure of powerful stories that translate, encounter, and recontextualize other powerful stories. It is a palimpsest (Owens 1980). Moreover, an awareness of allegory heightens awareness of the narratives, and other temporal setups, implicitly or explicitly at work. Is the redemptive structure of salvage-textualization being replaced? By what new allegories? Of conflict? Of emergence? Of syncretism?[12]

Finally, a recognition of allegory requires that as readers and writers of ethnographies, we struggle to confront and take responsibility for our systematic constructions of others and of ourselves through others. This recognition need not ultimately lead to an ironic position—though it must contend with profound ironies. If we are condemned to tell stories we cannot control, may we not, at least, tell stories we believe to be true.

12. For recent changes in these underlying stories, see note 9 above, and Bruner 1985. See also James Boon's 1983 exploration of anthropology's satiric dimensions. A partial way out can perhaps be envisioned in the pre-modern current that Harry Berger has called "strong" or "metapastoral"—a tradition he finds in the writing of Sidney, Spenser, Shakespeare, Cervantes, Milton, Marvell, and Pope. "Such pastoral constructs within itself an image of its generic traditions in order to criticize them and, in the process, performs a critique on the limits of its own enterprise even as it ironically displays its delight in the activity it criticizes" (1984:2). Modern ethnographic examples are rare, although much of Lévi-Strauss's *Tristes Tropiques* certainly qualifies.

On Collecting Art and Culture

From *The Predicament of Culture*

. . .

Collecting Ourselves

Entering
You will find yourself in a climate of nut castanets,
A musical whip
From the Torres Straits, from Mirzapur a sistrum
Called Jumka, "used by Aboriginal
Tribes to attract small game
On dark nights," coolie cigarettes
And mask of Saagga, the Devil Doctor,
The eyelids worked by strings.

James Fenton's poem "The Pitt Rivers Museum, Oxford" (1984:81-84), from which this stanza is taken, rediscovers a place of fascination in the ethnographic collection. For this visitor even the museum's descriptive labels seem to increase the wonder ("...attract small game / on dark nights") and the fear. Fenton is an adult-child exploring territories of danger and desire, for to be a child in this collection ("Please sir, where's the withered / Hand?") is to ignore the serious admonitions about human evolution and cultural diversity posted in the entrance hall. It is to be interested instead by the claw of a condor, the jaw of a dolphin, the hair of a witch, or "a jay's feather worn as a charm / in Buckinghamshire." Fenton's ethnographic museum is a world of intimate encounters with inexplicably fascinating objects: personal fetishes. Here collecting is inescapably tied to obsession, to recollection. Visitors "find the landscape of their childhood marked out / Here in the chaotic piles of souvenirs...boxroom of the forgotten or hardly possible."

Go
As a historian of ideas or a sex-offender,
For the primitive art,
As a dusty semiologist, equipped to unravel
The seven components of that witch's curse
Or the syntax of the mutilated teeth. Go
In groups to giggle at curious finds.

But do not step into the kingdom of your promises
To yourself, like a child entering the forbidden
Woods of his lonely playtime.

Do not step in this tabooed zone "laid with the snares of privacy and fiction / And the dangerous third wish." Do not encounter these objects except as *curiosities* to giggle at, *art* to be admired, or *evidence* to be understood scientifically. The tabooed way, followed by Fenton, is a path of too-intimate fantasy, recalling the dreams of the solitary child "who wrestled with eagles for their feathers" or the fearful vision of a young girl, her turbulent lover seen as a hound with "strange pretercanine eyes." This path through the Pitt Rivers Museum ends with what seems to be a scrap of autobiography, the vision of a personal "forbidden woods"—exotic, desired, savage, and governed by the (paternal) law:

He had known what tortures the savages had prepared
For him there, as he calmly pushed open the gate
And entered the wood near the placard: "TAKE NOTICE
MEN-TRAPS AND SPRING-GUNS ARE SET ON
THESE PREMISES."
For his father had protected his good estate.

Fenton's journey into otherness leads to a forbidden area of the self. His intimate way of engaging the exotic collection finds an area of desire, marked off and policed. The law is preoccupied with *property*.

C. B. Macpherson's classic analysis of Western "possessive individualism" (1962) traces the seventeenth-century emergence of an ideal self as owner: the individual surrounded by accumulated property and goods. The same ideal can hold true for collectivities making and remaking their cultural "selves." For example Richard Handler (1985) analyzes the making of a Québécois cultural "patrimoine," drawing on Macpherson to unravel the assumptions and paradoxes involved in "having

a culture," selecting and cherishing an authentic collective "property." His analysis suggests that this identity, whether cultural or personal, presupposes acts of collection, gathering up possessions in arbitrary systems of value and meaning. Such systems, always powerful and rule governed, change historically. One cannot escape them. At best, Fenton suggests, one can transgress ("poach" in their tabooed zones) or make their self-evident orders seem strange. In Handler's subtly perverse analysis a system of retrospection—revealed by a Historic Monuments Commission's selection of ten sorts of "cultural property"—appears as a taxonomy worthy of Borges' "Chinese encyclopedia": "(1) commemorative monuments; (2) churches and chapels; (3) forts of the French Regime; (4) windmills; (5) roadside crosses; (6) commemorative inscriptions and plaques; (7) devotional monuments; (8) old houses and manors; (9) old furniture; (10) 'les choses disparues'" (1985:199). In Handler's discussion the collection and preservation of an authentic domain of identity cannot be natural or innocent. It is tied up with nationalist politics, with restrictive law, and with contested encodings of past and future.

^^^

Some sort of "gathering" around the self and the group—the assemblage of a material "world," the marking-off of a subjective domain that is not "other"—is probably universal. All such collections embody hierarchies of value, exclusions, rule-governed territories of the self. But the notion that this gathering involves the accumulation of possessions, the idea that identity is a kind of wealth (of objects, knowledge, memories, experience), is surely not universal. The individualistic accumulation of Melanesian "big men" is not possessive in Macpherson's sense, for in Melanesia one accumulates not to hold objects as private goods but to give them away, to redistribute. In the West, however, collecting has long been a strategy for the deployment of a possessive self, culture, and authenticity.

Children's collections are revealing in this light: a boy's accumulation of miniature cars, a girl's dolls, a summer-vacation "nature museum" (with labeled stones and shells, a hummingbird in a bottle), a treasured bowl filled with the bright shavings of crayons. In these small rituals we observe the channelings of obsession, an exercise in how to make the world one's own, to gather things around oneself tastefully, appropriately. The inclusions in all collections reflect wider cultural rules—of rational taxonomy, of gender, of aesthetics. An excessive, sometimes even rapacious need to have is transformed into rule-governed, meaningful desire. Thus the self that must possess but cannot have it all learns to select, order, classify in hierarchies—to make "good" collections.[1]

Whether a child collects model dinosaurs or dolls, sooner or later she or he will be encouraged to keep the possessions on a shelf or in a special box or to set up a doll house. Personal treasures will be made public. If the passion is for Egyptian figurines, the collector will be expected to label them, to know their dynasty (it is not enough that they simply exude power or mystery), to tell "interesting" things about them, to distinguish copies from originals. The good collector (as opposed to the obsessive, the miser) is tasteful and reflective.[2] Accumulation unfolds in a

1. On collecting as a strategy of desire see the highly suggestive catalogue (Hainard and Kaehr 1982) of an exhibition entitled "Collections passion" at the Musée d'Ethnographie, Neuchâtel, June to December 1981. This analytic collection of collections was a tour de force of reflexive museology. On collecting and desire see also Donna Haraway's brilliant analysis (1985) of the American Museum of Natural History, American manhood, and the threat of decadence between 1908 and 1936. Her work suggests that the passion to collect, preserve, and display is articulated in gendered ways that are historically specific. Beaucage, Gomilia, and Vallée (1976) offer critical meditations on the ethnographer's complex experience of objects.

2. Walter Benjamin's essay "Unpacking My Library" (1969:59-68) provides the view of a reflective devotee. Collecting appears as an art of living intimately allied with memory, with obsession, with the salvaging of order from disorder. Benjamin sees (and takes a certain pleasure in) the precariousness of the subjective space attained by the collection. "Every passion borders on the chaotic, but the collector's passion borders on the chaos of memories. More than that: the chance, the fate, that suffuse the past before my eyes are conspicuously present in the accustomed confusion of these books. For what else is this collection but a disorder to which habit has accommodated itself to such an extent that it can appear as order? You have all heard of people whom the loss of their books has turned them into invalids, of those who in order to acquire them became criminals. These are the very areas in which any order is a balancing act of extreme precariousness." (p. 60)

pedagogical, edifying manner. The collection itself—its taxonomic, aesthetic structure—is valued, and any private fixation on single objects is negatively marked as fetishism. Indeed a "proper" relation with objects (rule-governed possession) presupposes a "savage" or deviant relation (idolatry or erotic fixation).[3] In Susan Stewart's gloss, "The boundary between collection and fetishism is mediated by classification and display in tension with accumulation and secrecy" (1964:163).

Stewart's wide-ranging study *On Longing* traces a "structure of desire" whose task is the repetitious and impossible one of closing the gap that separates language from the experience it encodes. She explores certain recurrent strategies pursued by Westerners since the sixteenth century. In her analysis the miniature, whether a portrait or doll's house, enacts a bourgeois longing for "inner" experience. She also explores the strategy of gigantism (from Rabelais and Gulliver to earthworks and the billboard), the souvenir, and the collection. She shows how collections, most notably museums—create the illusion of adequate representation of a world by first cutting objects out of specific contexts (whether cultural, historical, or intersubjective) and making them "stand for" abstract wholes—a "Bambara mask," for example, becoming an ethnographic metonym for Bambara culture. Next a scheme of classification is elaborated for storing or displaying the object so that the reality of the collection itself, its coherent order, overrides specific histories of the object's production and appropriation (pp. 162-165). Paralleling Marx's account of the fantastic objectification of commodities, Stewart argues that in the modern Western museum "an illusion of a relation between things takes the place of a social relation" (p. 165). The collector discovers, acquires, salvages objects. The objective world is given, not produced, and thus historical relations of power in the work of acquisition are occulted. The *making* of meaning in museum classification and display is mystified as adequate *representation*. The time and order of the collection erase the concrete social labor of its making.

· · ·

Culture Collecting

Found in *American Anthropologist*, n.s. 34 (1932): 740:

NOTE FROM NEW GUINEA
Aliatoa, Wiwiak District, New Guinea

April 21, 1932

We are just completing a culture of a mountain group here in the lower Torres Chelles. They have no name and we haven't decided what to call them yet. They are a very revealing people in spots, providing a final basic concept from which all the mother's brothers' curses and father's sisters' curses, etc. derive, and having articulate the attitude toward incest which Reo [Fortune] outlined as fundamental in his Encyclopedia article. They have taken the therapeutic measures which we recommended for Dobu and Manus—having a devil in addition to the neighbor sorcerer, and having got their dead out of the village and localized. But in other ways they are annoying: they have bits and snatches of all the rag tag and bob tail of magical and ghostly belief from the Pacific, and they are somewhat like the Plains in their receptivity to strange ideas. A picture of a local native reading the index to the *Golden Bough* just to see if they had missed anything, would be appropriate. They are very difficult to work, living all over the place with half a dozen garden houses, and never staying put for a week at a time. Of course this offered a new challenge in method which was interesting. The difficulties incident upon being two days over impossible mountains have been consuming and we are going to do a coastal people next.

Sincerely yours,
MARGARET MEAD

"Cultures" are ethnographic collections. Since Tylor's founding definition of 1871 the term has designated a rather vague "complex whole" including everything that is learned group behavior, from body techniques to symbolic orders. There have been recurring attempts to define culture more precisely (see Kroeber and Kluckhohn 1952) or, for example, to distinguish it from "social structure."

3. My understanding of the role of the fetish as a mark of otherness in Western intellectual history—from DeBrosses to Marx, Freud, and Deleuze—owes a great deal to the largely unpublished work of William Pietz; see "The Problem of the Fetish, I" (1985).

But the inclusive use persists. For there are times when we still need to be able to speak holistically of Japanese or Trobriand or Moroccan culture in the confidence that we are designating something real and differently coherent. It is increasingly clear, however, that the concrete activity of representing a culture, subculture, or indeed any coherent domain of collective activity is always strategic and selective. The world's societies are too systematically interconnected to permit any easy isolation of separate or independently functioning systems (Marcus 1986). The increased pace of historical change, the common recurrence of stress in the systems under study, forces a new self-consciousness about the way cultural wholes and boundaries are constructed and translated. The pioneering *élan* of Margaret Mead "completing a culture" in highland New Guinea, collecting a dispersed population, discovering its key customs, naming the result—in this case "the Mountain Arapesh"—is no longer possible.

To see ethnography as a form of culture collecting (not, of course, the *only* way to see it) highlights the ways that diverse experiences and facts are selected, gathered, detached from their original temporal occasions, and given enduring value in a new arrangement. Collecting—at least in the West, where time is generally thought to be linear and irreversible—implies a rescue of phenomena from inevitable historical decay or loss. The collection contains what "deserves" to be kept, remembered, and treasured. Artifacts and customs are saved out of time.[4] Anthropological culture collectors have

typically gathered what seems "traditional"—what by definition is opposed to modernity. From a complex historical reality (which includes current ethnographic encounters) they select what gives form, structure, and continuity to a world. What is hybrid or "historical" in an emergent sense has been less commonly collected and presented as a system of authenticity. For example in New Guinea Margaret Mead and Reo Fortune chose not to study groups that were, as Mead wrote in a letter, "badly missionized" (1977:123); and it had been self-evident to Malinowski in the Trobriands that what most deserved scientific attention was the circumscribed "culture" threatened by a host of modern "outside" influences. The experience of Melanesians becoming Christians for their own reasons—learning to play, and play with, the outsiders' games—did not seem worth salvaging.

Every appropriation of culture, whether by insiders or outsiders, implies a specific temporal position and form of historical narration. Gathering, owning, classifying, and valuing are certainly not restricted to the West; but elsewhere these activities need not be associated with accumulation (rather than redistribution) or with preservation (rather than natural or historical decay). The Western practice of culture collecting has its own local genealogy, enmeshed in distinct European notions of temporality and order. It is worth dwelling for a moment on this genealogy, for it organizes the assumptions being arduously unlearned by new theories of practice, process, and historicity (Bourdieu 1977, Giddens 1979, Ortner 1984, Sahlins 1985).

A crucial aspect of the recent history of the culture concept has been its alliance (and division of labor) with "art." Culture, even without a capital C, strains toward aesthetic form and autonomy. I have already suggested that modern culture ideas and art ideas function together in an "art-culture system." The inclusive twentieth-century culture category—one that does not privilege "high" or "low" culture—is plausible only within this system, for while in principle admitting all learned human behavior, this culture with a small c orders phenomena in ways that privilege the coherent, balanced, and "authentic"

4. An exhibition, "Temps perdu, temps retrouvé," held during 1985 at the Musée d'Ethnographie of Neuchâtel systematically interrogated the temporal predicament of the Western ethnographic museum. Its argument was condensed in the following text, each proposition of which was illustrated museographically: "Prestigious places for locking things up, museums give value to things that are outside of life: in this way they resemble cemeteries. Acquired by dint of dollars, the memory-objects participate in the group's changing identity, serve the powers that be, and accumulate into treasures, while personal memory fades. Faced with the aggressions of everyday life and the passing of phenomena, memory needs objects—always manipulated through aesthetics, selective emphasis, or the mixing of genres. From the perspective of the future, what from the present should be saved?" (Hainard and Kaehr 1986:33, also Hainard and Kaehr 1985.)

aspects of shared life. Since the mid-nineteenth century, ideas of culture have gathered up those elements that seem to give continuity and depth to collective existence, seeing it whole rather than disputed, torn, intertextual, or syncretic. Mead's almost postmodern image of "a local native reading the index to *The Golden Bough* just to see if they had missed anything" is not a vision of authenticity.

Mead found Arapesh receptivity to outside influences "annoying." *Their* culture collecting complicated hers. Historical developments would later force her to provide a revised picture of these difficult Melanesians. In a new preface to the 1971 reprint of her three-volume ethnography *The Mountain Arapesh* Mead devotes several pages to letters from Bernard Narokobi, an Arapesh then studying law in Syndey, Australia. The anthropologist readily admits her astonishment at hearing from him: "How was it that one of the Arapesh—a people who had had such a light hold on any form of collective style—should have come further than any individual among the Manus, who had moved as a group into the modern world in the years between our first study of them, in 1928, and the beginning of our restudy, in 1953?" (Mead 1971:ix). She goes on to explain that Narakobi, along with other Arapesh men studying in Australia, had "moved from one period in human culture to another" as "individuals." The Arapesh were "less tightly bound within a coherent culture" than Manus (pp. ix-x). Narakobi writes, however, as a member of his "tribe," speaking with pride of the values and accomplishments of his "clansfolk." (He uses the name Arapesh sparingly.) He articulates the possibility of a new multiterritorial "cultural" identity: "I feel now that I can feel proud of my tribe and at the same time feel I belong not only to Papua-New Guinea, a nation to be, but to the world community at large" (p. xiii). Is not this modern way of being "Arapesh" already prefigured in Mead's earlier image of a resourceful native paging through *The Golden Bough*? Why must such behavior be marginalized or classed as "individual" by the anthropological culture collector?

Expectations of wholeness, continuity, and essence have long been built into the linked Western ideas of culture and art. A few words of recent background must suffice, since to map the history of these concepts would lead us on a chase for origins back at least to the Greeks. Raymond Williams provides a starting point in the early nineteenth century—a moment of unprecedented historical and social disruption. In *Culture and Society* (1966), *Keywords* (1976), and elsewhere Williams has traced a parallel development in usage for the words *art* and *culture*. The changes reflect complex responses to industrialism, to the specter of "mass society," to accelerated social conflict and change.[5]

According to Williams in the eighteenth century the word *art* meant predominantly "skill." Cabinetmakers, criminals, and painters were each in their way artful. *Culture* designated a tendency to natural growth, its uses predominantly agricultural and personal: both plants and human individuals could be "cultured." Other meanings also present in the eighteenth century did not predominate until the nineteenth. By the 1820s *art* increasingly designated a special domain of creativity, spontaneity, and purity, a realm of refined sensibility and expressive "genius." The "artist" was set apart from, often against, society— whether "mass" or "bourgeois." The term *culture* followed a parallel course, coming to mean what was most elevated, sensitive, essential, and precious— most uncommon—in society. Like art, culture became a general category; Williams calls it a "final court of appeal" against threats of vulgarity and leveling. It existed in essential opposition to perceived "anarchy."

Art and culture emerged after 1800 as mutually reinforcing domains of human *value*, strategies for gathering, marking off, protecting the best and most interesting creations of "Man."[6] In the twentieth

5. Although William's analysis is limited to England, the general pattern applies elsewhere in Europe, where the timing of modernization differed or where other terms were used. In France, for example, the words *civilisation* or, for Durkheim, *société* stand in for *culture*. What is at issue are general qualitative assessments of collective life.

6. As Virginia Dominguez has argued, the emergence of this new subject implies a specific historicity closely tied to ethnology. Drawing on Foucault's *Order of Things* (1966) and writing of the scramble for ethnographic artifacts during the "Museum Age" of the late nineteenth century, she cites Douglas Cole's summation of the prevailing rationale: "It is necessary to use the time to collect before it is too late" (Cole

century the categories underwent a series of further developments. The plural, anthropological definition of culture (lower-case *c* with the possibility of a final *s*) emerged as a liberal alternative to racist classifications of human diversity. It was a sensitive means for understanding different and dispersed "whole ways of life" in a high colonial context of unprecedented global interconnection. *Culture* in its full evolutionary richness and authenticity, formerly reserved for the best creations of modern Europe, could now be extended to all the world's populations. In the anthropological version of Boas' generation "cultures" were of equal value. In their new plurality, however, the nineteenth-century definitions were not entirely transformed. If they became less elitist (distinctions between "high" and "low" culture were erased) and less Eurocentric (every human society was fully "cultural"), nevertheless a certain body of assumptions were carried over from the older definitions. George Stocking (1968:69-90) shows the complex interrelations of nineteenth-century humanist and emerging anthropological definitions of culture. He suggests that anthropology owes as much to Matthew Arnold as to its official founding father, E. B. Tylor. Indeed much of the vision embodied in *Culture and Anarchy* has been transferred directly into relativist anthropology. A powerful structure of feeling continues to see culture, wherever it is found, as a coherent body that lives and dies. Culture is enduring, traditional, structural (rather than contingent, syncretic, historical). Culture is a process of ordering, not of disruption. It changes and develops like a living organism. It does not normally "survive" abrupt alterations.

1985:50). "Too late for what?" Dominguez asks. "There is a historical consciousness here of a special sort. We hear an urgency in the voices of the collectors, a fear that we will no longer be able to get our hands on these objects, and that this would amount to an irretrievable loss of the means of preserving our own historicity. There is a twofold displacement here. Objects are collected no longer because of their intrinsic value but as metonyms for the people who produced them. And the people who produced them are the objects of examination not because of their intrinsic value but because of their perceived contribution to our understanding of our own historical trajectory. It is a certain view of 'man' and a certain view of 'history' that make this double displacement possible" (Dominguez 1986:548).

In the early twentieth century, as *culture* was being extended to all the world's functioning societies, an increasing number of exotic, primitive, or archaic objects came to be seen as "art." They were equal in aesthetic and moral value with the greatest Western masterpieces. By midcentury the new attitude toward "primitive art" had been accepted by large numbers of educated Europeans and Americans. Indeed from the standpoint of the late twentieth century it becomes clear that the parallel concepts of art and culture did successfully, albeit temporarily, comprehend and incorporate a plethora of non-Western artifacts and customs. This was accomplished through two strategies. First, objects reclassified as "primitive art" were admitted to the imaginary museum of human creativity and, though more slowly, to the actual fine arts museums of the West. Second, the discourse and institutions of modern anthropology constructed comparative and synthetic images of Man drawing evenhandedly from among the world's authentic ways of life, however strange in appearance or obscure in origin. Art and culture, categories for the best creations of Western humanism, were in principle extended to all the world's peoples.

. . .

Other Appropriations

To tell these other stories, local histories of cultural survival and emergence, we need to resist deep-seated habits of mind and systems of authenticity. We need to be suspicious of an almost-automatic tendency to relegate non-Western peoples and objects to the pasts of an increasingly homogeneous humanity. A few examples of current invention and contestation may suggest different chronotypes for art and culture collecting.

Anne Vitart-Fardoulis, a curator at the Musée de l'Homme, has published a sensitive account of the aesthetic, historical, and cultural discourses routinely used to explicate individual museum objects. She discusses a famous intricately painted animal skin (its present name: M.H.34.33.5), probably originating among the Fox Indians of North America. The skin turned up in Western collecting

systems some time ago in a "cabinet of curiosities"; it was used to educate aristocratic children and was much admired for its aesthetic qualities. Vitart-Fardoulis tells us that now the skin can be decoded ethnographically in terms of its combined "masculine" and "feminine" graphic styles and understood in the context of a probable role in specific ceremonies. But the meaningful contexts are not exhausted. The story takes a new turn:

> The grandson of one of the Indians who came to Paris with Buffalo Bill was searching for the [painted skin] tunic his grandfather had been forced to sell to pay his way back to the United States when the circus collapsed. I showed him all the tunics in our collection, and he paused before one of them. Controlling his emotion, he spoke. He told the meaning of this lock of hair, of that design, why this color had been used, the meaning of that feather... This garment, formerly beautiful and interesting but passive and indifferent, little by little became meaningful, active testimony to a living moment through the mediation of someone who did not observe and analyze but who lived the object and for whom the object lived. It scarcely matters whether the tunic is really his grandfather's. (Vitart-Fardoulis 1986:12)

Whatever is happening in this encounter, two things are clearly *not* happening. The grandson is not replacing the object in its original or "authentic" cultural context. That is long past. His encounter with the painted skin is part of a modern collection. And the painted tunic is not being appreciated as art, as an aesthetic object. The encounter is too specific, too enmeshed in family history and ethnic memory.[7] Some aspects of "cultural" and "aesthetic" appropriation are certainly at work, but they occur within a *current tribal history*, a different temporality from that governing the dominant systems I diagrammed earlier. In the context of a present-becoming-future the old painted tunic becomes newly, traditionally meaningful.

The currency of "tribal" artifacts is becoming more visible to non-Indians. Many new tribal recognition claims are pending at the Department of the Interior. And whether or not they are formally successful matters less than what they make manifest: the historical and political reality of Indian survival and resurgence, a force that impinges on Western art and culture collections. The "proper" place of many objects in museums is not subject to contest. The Zuni who prevented the loan of their war god to the Museum of Modern Art (see *Writing Culture* ch. 9) were challenging the dominant art-culture system, for in traditional Zuni belief war god figures are sacred and dangerous. They are not ethnographic artifacts, and they are certainly not "art." Zuni claims on these objects specifically reject their "promotion" (in all senses of the term) to the status of aesthetic or scientific treasures.

I would not claim that the only true home for the objects in question is in "the tribe"—a location that, in many cases, is far from obvious. My point is just that the dominant, interlocking contexts of art and anthropology are no longer self-evident and uncontested. There are other contexts, histories, and futures in which non-Western objects and cultural records may "belong." The rare Maori artifacts that in 1984-85 toured museums in the United States normally reside in New Zealand museums. But they are controlled by the traditional Maori authorities, whose permission was required for them to leave the country. Here and elsewhere the circulation of museum collections is significantly influenced by resurgent indigenous communities.

What is at stake is something more than

7. In his wide-ranging study "Ethnicity and the Post-Modern Arts of Memory" (1986) Michael Fischer identifies general processes of cultural reinvention, personal search, and future-oriented appropriations of tradition. The specifity of some Native American relations with collected "tribal" objects is revealed in a grant proposal to the National Endowment for the Humanities by the Oregon Art Institute (Monroe 1986). In preparation for a reinstallation of the Rasmussen Collection of Northwest Coast works at the Portland Art Museum a series of consultations is envisioned with the participation of Haida and Tlingit elders from Alaska. The proposal makes clear that great care must be given "to matching specific groups of objects in the collection to the clan membership and knowledge base of specific elders. Northwest Coast Natives belong to specific clans who have extensive oral traditions and histories over which they have ownership. Elders are responsible for representing their clans as well as their group" (Monroe 1986:8). The reinstallation "will present *both the academic interpretation of an object or objects and the interpretation of the same material as viewed and understood by Native elders and artists*" (p. 5; original emphasis).

conventional museum programs of community education and "outreach" (Alexander 1979:215). Current developments question the very status of museums as historical-cultural theaters of memory. Whose memory? For what purposes? The Provincial Museum of British Columbia has for some time encouraged Kwakiutl carvers to work from models in its collection. It has lent out old pieces and donated new ones for use in modern potlatches. Surveying these developments, Michael Ames, who directs the University of British Columbia Museum, observes that "Indians, traditionally treated by museums only as objects and clients, add now the role of patrons." He continues: "The next step has also occurred. Indian communities establish their own museums, seek their own National Museum grants, install their own curators, hire their own anthropologists on contract, and call for repatriation of their own collections" (Ames 1986:57). The Quadra Island Kwakiutl Museum located in Quathraski Cove, British Columbia, displays tribal work returned from the national collections in Ottawa. The objects are exhibited in glass cases, but arranged according to their original family ownership. In Alert Bay, British Columbia, the U'mista Cultural Centre displays repatriated artifacts in a traditional Kwakiutl "big house" arranged in the sequence of their appearance at the potlatch ceremony. The new institutions function both as public exhibits and as cultural centers linked to ongoing tribal traditions. Two Haida museums have also been established in the Queen Charlotte Islands, and the movement is growing elsewhere in Canada and the United States.

Resourceful Native American groups may yet appropriate the Western museum—as they have made their own another European institution, the "tribe." Old objects may again participate in a tribal present-becoming-future. Moreover, it is worth briefly noting that the same thing is possible for written artifacts collected by salvage ethnography. Some of these old texts (myths, linguistic samples, lore of all kinds) are now being recycled as local history and tribal "literature."[8] The objects of both art and culture collecting are susceptible to other appropriations.

. . .

8. The archives of James Walker, produced before 1910, have become relevant to the teaching of local history by Sioux on the Pine Ridge Reservation (see Chapter 1, n. 15, and Clifford 1986a:15-17). Also a corpus of translated and untranslated Tolowa tales and linguistic texts collected by A. L. Kroeber and P. E. Goddard are important evidence in a planned petition for tribal recognition. The texts were gathered as "salvage ethnography" to record the shreds of a purportedly vanishing culture. But in the context of Tolowa persistence, retranslated and interpreted by Tolowa elders and their Native American lawyer, the texts yield evidence of tribal history, territorial limits, group distinctness, and oral tradition. They are Tolowa "literature" (Slagle 1986).

Notes

On Ethnographic Allegory

Barthes, Roland. *Camera Lucinda.* New York: Hill and Wang, 1981.

Beaujour, Michel. "Some Paradoxes of Description." *Yale French Studies* 61 (1981): 27-59.

Benedict, Ruth. *Patterns of Culture.* New York: New American Library, 1934.

Benjamin, Walter. *The Origin of German Tragic Drama.* London: New Left Books, 1977.

Berger, Harry, Jr. "The Origins of Bucolic Representation: Disenchantment and Revision in Theocritus' Seventh *Idyll.*" *Classical Antiquity* 3 (1984) 1:1-39.

Boon, James. *From Symbolism to Structuralism: Lévi-Strauss in a Literary Tradition.* New York: Harper and Row, 1972.

_____. *The Anthropological Romance of Bali, 1597-1972.* Cambridge: Cambridge University Press, 1977.

_____. *Other Tribes Other Scribes.* Ithaca, N. Y.: Cornell University Press, 1982.

_____. "Folly, Bali, and Anthropology, or Satire Across Cultures." *Proceedings of the American Ethnological Society*: 156-77.

Brody, Hugh. *Maps and Dreams.* New York: Pantheon, 1982.

Bruner, Edward M. "Ethnography as Narrative." *The Anthropology of Experience.* Victor Turner and Edward M. Bruner, eds., 1985.

Clifford, James. Review of *Nisa: The Life and Words of a !Kung Woman,* by Marjorie Shostak. *Times Literary Supplement* (September 17, 1982).

_____. "On Ethnographic Authority." *Representations* 1.2: 118-146.

_____. "Power and Dialogue in Ethnography: Marcel Griaule's Initiation." *Observers Observed: Essays on Ethnographic Fieldwork.* George W. Stocking, Jr., ed. Madison: University of Wisconsin Press: 121-156.

Clifford, James and George F. Marcus. *Writing Culture.* Berkeley: University of California Press, 1988.

Coleridge, Samuel Taylor. *Miscellaneous Criticism.* T. M. Raysor, ed. London: Constable, 1936.

Crapanzano, Vincent. *Tuhami: Portrait of a Moroccan.* Chicago: University of Chicago Press, 1980.

De Certeau, Michel. "History: Ethics, Science, and Fiction." *Social Science as Moral Inquiry.* Norma Hahn et al, eds. New York: Columbia University Press, 1983: 173-209.

De Man, Paul. "The Rhetoric of Temporality." *Interpretation: Theory and Practice.* Charles Singleton, ed. Baltimore: Johns Hopkins University Press, 1969: 173-209.

_____. *Allegories of Reading.* New Haven: Yale University Press, 1979.

Derrida, Jacques. *Speech and Phenomena.* Evanston: Northwestern University Press, 1973.

_____. *Of Grammatology.* Baltimore: Johns Hopkins University Press, 1974.

Diamond, Stanley. *In Search of the Primitive: A Critique of Civilization.* New Brunswick, N. J.: E. P. Dutton, 1974.

Eisenstein, Elizabeth. *The Printing Press as an Agent of Change* vol. 2. Cambridge: Cambridge University Press, 1979.

Empson, William. *Some Versions of Pastoral*. Norfolk: New Directions, 1950.

Evans-Pritchard, Edward E. *The Nuer*. Oxford: Oxford University Press, 1940.

Fabian, Johannes. *Time and the Other: How Anthropology Makes Its Object*. New York: Columbia University Press, 1983.

Fletcher, Angus. *Allegory: The Theory of a Symbolic Mode*. Ithaca: Cornell University Press, 1964.

Freeman, Derek. *Margaret Mead and Samoa: The Making and Unmaking of an Anthropological Myth*. Cambridge: Harvard University Press, 1983.

Frye, Northrop. *Fables of Identity: Studies in Poetic Mythology*. New York: Harcourt Brace Jovanovich, 1963.

_____. *Anatomy of Criticism*. Princeton: Princeton University Press, 1971.

Geertz, Clifford. *The Interpretation of Cultures*. New York: Basic Books, 1973.

Goody, Jack. *The Domestication of the Savage Mind*. Cambridge: Cambridge University Press, 1977.

Gusdorf, Georges. "Conditions et limites de l'autobiographie." *Formen der Selbstdarstellung*. Günther Reichenkrom and Erich Haase, eds. Berlin: Duncker and Humblot, 1956.

Haraway, Donna. "A Manifesto for Cyborgs: Science, Technology, and Socialist Feminism in the 1980s." *Socialist Review* 15.2 (1985): 65-108.

Hooks, Bell. *Ain't I a Woman?* Boston: South End Press, 1981.

Hull, Gloria, Patricia Bell Scott, and Barbara Smith, eds. *All the Women are White, All the Men are Black, but Some of Us Are Brave: Black Women's Studies*. Old Westbury: Feminist Press, 1982.

Kermode, Frank. *English Pastoral Poetry: From the Beginnings to Marvell*. London: Harrap, 1952.

Kuklick, Henrika. "Tribal Exemplars: Images of Political Authority in British Anthropology, 1885-1945." *History of Anthropology* vol. 2. George Stocking, ed. Madison: University of Wisconsin Press, 1984: 59-82.

Lafitau, Joseph François. *Moeurs des sauvages ameriquains*. Paris: n.p., 1724.

Lejeune, Philippe. *Le Pacte autobiographique*. Paris: Seuil, 1975.

Lévi-Strauss, Claude. *Tristes Tropiques*. New York: Atheneum, 1975.

Malinowski, Bronislaw. *Argonauts of the Western Pacific*. New York: E. P. Dutton, 1961.

Mauss, Marcel. *The Gift: Forms and Functions of Exchange in Archaic Societies*. New York: Norton, 1967.

Mead, Margaret. *Coming of Age in Samoa*. New York: William Morrow, 1923.

Moraga, Cherrie. *Loving in the War Years*. Boston: South End Press, 1983.

Murphy, Robert. "Requiem for the Kayopo." *New York Times Book Review* (August 12, 1984): 34.

Olney, James. *Metaphors of Self: The Meaning of Autobiography*. Princeton: Princeton University Press, 1972.

Ong, Walter. *The Presence of the Word*. New Haven: Yale University Press, 1967.

_____. *Rhetoric, Romance, and Technology: Studies in the Interaction of Expression and Culture*. Ithaca: Cornell University Press, 1971.

_____. *Interfaces of the Word*. Ithaca: Cornell University Press, 1977.

_____. *Orality and Literacy*. London: Methuen, 1982.

Owens, Craig. "The Allegorical Impulse: Toward a Theory of Postmodernism (Part 2)." *October* 13 (1980): 59-80.

Pogglioli, Renato. *The Oaten Flute: Essays on Pastoral Poetry and the Pastoral*. Cambridge: Harvard University Press, 1975.

Porter, Denis. "Anthropological Tales: Unprofessional Thoughts on the Mead/Freeman Controversy." *Notebooks in Cultural Analysis* 1 (1984): 15-37.

Rich, Adrienne. "Disloyal to Civilization: Feminism, Racism, Gynephobia (1978)." *On Lies, Secrets, and Silence*. New York: Norton, 1979.

Rosaldo, Michele. "The Use and Abuse of Anthropology: Reflections on Feminism and Cross-Cultural Understanding." *Signs* 5.3 (1980): 389-417.

Sapir, Edward. "Culture, Genuine and Spurious" (1924). *Culture, Language, and Personality*. Berkeley and Los Angeles: University of California Press, 1966.

Segalen, Victor. *Essai sur l'exotisme: Une Esthétique du divers*. Montpellier: Editions Fata Morgana, 1978.

Shostak, Marjorie. *Nisa: The Life and Words of a !Kung Woman*. Cambridge: Harvard University Press, 1981.

Taussig, Michael. "History as Sorcery." *Representations* 7 (1984): 87-109.

Thomas, Elizabeth Marshall. *The Harmless People*. New York: Alfred A. Knopf, 1959.

Todorov, Tzvetan. *The Fantastic*. Cleveland and London: Case Western Reserve Press, 1973.

Turner, Victor. *Celebration: Studies in Festivity and Ritual*. Washington, D. C.: Smithsonian Institution, 1982.

Tyler, Stephen A. *The Said and the Unsaid*. New York: Academic Press, 1978.

_____. "Ethnography, Intertextuality, and the End of Description." *American Journal of Semiotics*. In press.

_____. "Postmodern Anthropology." *Proceedings of the Anthropological Society*. Phyllis Chock, ed. In press.

Wagley, Charles. *Welcome of Tears*. New York: Oxford University Press, 1977.

Wagner, Roy. "The Talk of Koriki: a Daribi Contact Cult." *Social Research* 46.1 (1979): 140-65.

Webster, Steven. "Dialogue and Fiction in Ethnography." *Dialectical Anthropology* 7.2 (1982): 91-114.

Weiner, Annette. *Women of Value, Men of Renown*. Austin: University of Texas Press, 1976.

Whitten, Norman E. "Ecological Imagery and Cultural Adaptability: The Canelos Quichua of Eastern Equador." *American Anthropologist* 80 (1978): 836-59.

Williams, Raymond. *The Country and the City*. New York: Oxford University Press, 1973.

Wittig, Monique. "One is Not Born a Woman." *Feminist Issues* Winter 1981: 47-54.

Wolin, Richard. *Walter Benjamin*. New York: Columbia University Press, 1982.

On Collecting Art and Culture

Alexander, Edward. *Museums in Motion: An Introduction to the History and Functions of Museums*. Nashville, KY: American Association for State and Local History, 1979.

Ames, Michael. *Museums, the Public, and Anthropology: A Study in the Anthropology of Anthropology*. Vancouver: University of British Columbia Press, 1986.

Beaucage, Pierre, Jacques Gomila, and Lionel Vallée. *L'experience anthropologique*. Montréal: Presses de l'Université de Montréal: 71-133.

Benjamin, Walter. *Illuminations*. Hannah Arendt, ed. New York: Schocken Books, 1969.

Bourdieu, Pierre. *Outline of a Theory of Practice*. Cambridge: Cambridge University Press, 1977.

Clifford, James. "Partial Truths." *Writing Culture*. James Clifford and George Marcus, eds. Berkeley: University of California Press, 1986.

Cole, Douglas. *Captured Heritage: The Scramble for Northwest Coast Artifacts*. Seattle: University of Washington Press, 1985.

Dominguez, Virginia. "The Marketing of Heritage." *American Ethnologist* 13.3 (1986); 546-555.

Fenton, James. *Children in Exile: Poems 1968-1984*. New York: Random House, 1984.

Fischer, Michael. "Ethnicity and the Post-Modern Arts of Memory." *Writing Culture: The Poetics and Politics of Ethnography*. James Clifford and George Marcus, eds. Berkeley: University of California Press, 1986: 194-233.

Foucault, Michel. *Les mots et les choses*. Trans as *The Order of Things*. New York: Random House, 1970.

Giddens, Anthony. *Central Problems in Social Theory: Action, Structure and Contradiction in Social Analysis*. Berkeley: University of California Press, 1979.

Hainard, Jacques, and Rolland Kaehr, eds. *Collections passion*. Neuchâtel: Musée d'Ethnographie, 1982.

_____. *Temps perdu, temps retrouvé: Voir les choses du passé au présent*. Neuchâtel: Musée d'Ethnographie, 1985.

_____. "Temps perdu, temps retrouvé. Du coté de l'ethno..." *Gradhiva* 1 (Autumn): 33-37.

Handler, Richard. "On Having a Culture: Nationalism and the Preservation of Quebec's *Patrimoine*." *History of Anthropology* vol. 3, *Objects and Others*. George Stocking, ed. Madison: University of Wisconsin Press, 1985: 192-217.

Haraway, Donna. "Teddy Bear Patriarchy: Taxidermy in the Garden of Eden, New York City, 1908-1936." *Social Text* (Winter 1985): 20-63.

Macpherson, C. B. *The Political Theory of Possessive Individualism*. Oxford: Oxford University Press, 1962.

Marcus, George. "Contemporary Problems of Ethnography in the Modern World System." *Writing Culture*. James Clifford and George Carcus, eds. Berkeley: University of California Press, 1986: 165-193.

Mead, Margaret. *The Mountain Arapesh* vol. 3. Garden City: Natural History Press, 1971.

_____. *Letters from the Field: 1925-1975*. New York: Harper and Row, 1977.

Monroe, Dan. "Northwest Coast Native American Art Reinstallation Planning Grant." Application for NEH funding on behalf of the Oregon Art Institute, Portland, Oregon, 1986.

Ortner, Sherry. "Theory in Anthropology Since the Sixties." *Comparative Studies in Society and History* 26 (1984): 126-166.

Pietz, William. "The Problem of the Fetish, 1." *Res* 9 (Spring 1985): 5-17.

Sahlins, Marshall. *Islands of History*. Chicago: University of Chicago Press, 1985.

Slagle, Logan. *Tribal Recognition and the Tolowa*. Lecture presented at conference on the Nature and Function of Minority Literature. University of California, Berkeley, May 25, 1986.

Stewart, Susan. *On Longing: Narratives of the Miniature, the Gigantic, the Souvenir, the Collection*. Baltimore: Johns Hopkins University Press, 1984.

Stocking, George. "Arnold, Tylor and the Uses of Invention." *Race, Culture and Evolution*. New York: The Free Press, 1968: 69-90.

Vitart-Fardoulis, Anne. "L'objet interrogé: Ou comment faire parler une collection d'ethnographie." *Gradhiva* 1 (Autumn): 9-12.

Williams, Raymond. *Culture and Society, 1780-1950*. New York: Harper and Row, 1966.

_____. *Keywords*. New York: Harper and Row, 1976.

Frances E. Mascia-Lees (1953-), Patricia Sharpe (1943-), & Colleen Ballerino Cohen (1947-)

The Postmodernist Turn in Anthropology: Cautions from a Feminist Perspective

At this profoundly self-reflexive moment in anthropology—a moment questioning traditional modes of representation in the discipline—practitioners seeking to write a genuinely new ethnography would do better to use feminist theory as a model than to draw on pstmodern trends in epistemology and literary criticism with which they have thus far claimed allegiance.[1] Unlike postmodernism, feminist theory is an intellectual system that knows its politics, a politics directed toward securing recognition that the feminine is as crucial an element of the human as the masculine, and thus a politics skeptical and critical of traditional "universal truths" concerning human behavior. Similarly, anthropology is grounded in a politics: it aims to secure a recognition that the non-Western is as crucial an element of the human as the Western and thus is skeptical and critical of Western claims to knowledge and understanding.

Anthropologists influenced by postmodernism have recognized the need to claim a politics in order to appeal to an anthropological audience. This is evident even in the titles of the two most influential explications of this reflexive moment: *Anthropology*

1. The term "new ethnography" is commonly used to refer to cultural accounts that are reflexive in a sense seldom seen in traditional ethnographic writing. This reflexivity can take the form of identification of the fieldworker as an actor in the ethnographic situation, as in Paul Rabinow's *Reflections on Fieldwork in Morocco* (Berkeley and Los Angeles: University of California Press, 1977); Barbara Myerhoff's *Number Our Days* (New York: Simon & Schuster, 1978); Paul Friedrich's *The Princes of Naranja: An Essay in Anthrohistorical Method* (Austin: University of Texas Press, 1986); Marianne Alverson's *Under African Sun* (Chicago and London: University of Chicago Press, 1987); J. Favret-Saada's *Deadly Words: Witchcraft in the Bocage* (Cambridge: Cambridge University Press, 1980); and Manda Cesara's *Reflections of a Woman Anthropologist: No Hiding Places* (New York: Academic Press, 1982). It can present a commentary on cultural difference through the highlighting of intersubjective interactions, as in Marjorie Shostak's *Nisa: The Life and Words of a !Kung Woman* (Cambridge, Mass.: Harvard University Press, 1981); Kevin Dwyer's *Moroccan Dialogues* (Baltimore: Johns Hopkins University Press, 1982); and Vincent Crapanzano's *Tuhami: Portrait of a Moroccan* (Chicago: University of Chicago Press, 1980). It can experiment with traditional ethnographic rhetorical forms, as in Edward Schieffelin's *The Sorrow of the Lonely and the Burning of the Dancers* (New York: St. Martin's Press, 1976); and Michelle Rosaldo's *Knowledge and Passion: Ilongot Notions of Self and Social Life* (New York: Cambridge

University Press, 1980); or it can offer a close scrutiny of global systems of domination through the examination of symbolic manifestations in the lives of individuals, as in Michael Taussig's *The Devil and Commodity Fetishism in South America* (Chapel Hill: University of North Carolina Press, 1980); June Nash's *We Eat the Mines and the Mines Eat Us: Dependency and Exploitation in Bolivian Tin Mines* (New York: Columbia University Press, 1979); and Gananath Obeyesekere's *Medusa's Hair: An Essay on Personal Symbols and Religious Experience* (Berkeley and Los Angeles: University of California Press, 1981). In addition, there is a recent movement to read traditional ethnographic texts, such as Bronislaw Malinowski's *Agronauts of the Western Pacific* (New York: Dutton, 1961); and E. E. Evans-Pritchard's *The Nuer* (Oxford: Oxford University Press, 1940), for their narrative structure or rhetorical style, as well as to claim early texts once presented as "mere fiction," such as Elenore Bowen's (pseudonym for Laura Bohannan) *Return to Laughter: An Anthropological Novel* (New York: Harper & Row, 1954); and Gregory Bateson's *Naven: A Survey of the Problems Suggested by a Composite Picture of a Culture of a New Guinea Tribe Drawn from Three Points of View* (Stanford, Calif.: Stanford University Press, 1936), as precursors to the "new ethnography." This list is not exhaustive or particularly selective; many of these ethnographies employ several reflexive strategies. Among people talking about the new ethnography there is only limited consensus on which works are exemplars of the trend.

as *Cultural Critique: An Experimental Moment in the Human Sciences* and *Writing Culture: The Poetics and Politics of Ethnography*.[2] Indeed, the popularity of these books may be due as much to their appeal to anthropologists' traditional moral imperative—that we must question and expand Western definitions of the human—as to the current concern with modes of expression. Postmodern in their attention to texture and form as well as in their emphasis on language, text, and the nature of representation, these two works seek to connect this focus with the politics inherent in the anthropological enterprise. George Marcus and Michael Fischer's *Anthropology as Cultural Critique*, for example, starts off with a restatement of anthropology's traditional goals: to salvage "distinct cultural forms of life from the processes of global Westernization" and to serve "as a form of cultural critique of ourselves."[3] In keeping with postmodernism's emphasis on style, the authors claim that it is through new types of experimental ethnographic writing that anthropology can best expose the global systems of power relations that are embedded in traditional representations of other societies.

Underlying the new ethnography are questions concerning anthropology's role in the maintenance of Western hegemony: how have anthropological writings constructed or perpetuated myths about the non-Western "other"? How have these constructed images served the interest of the West? Even when critiquing colonialism and questioning Western representations of other societies, anthropology cannot avoid proposing alternative constructions. This has led to the recognition that ethnography is "always caught up with the invention, not the representation, of cultures."[4] And, as James Clifford suggests, the resultant undermining of the truth claims of Western representations of the "other" has been reinforced by important theorizing about the limits of representation itself in diverse fields.[5]

Postmodernist anthropologists, with their focus on classic ethnographies as texts, wish to call attention to the constructed nature of cultural accounts. They also wish to explore new forms of writing that will reflect the newly problematized relationships among writer, reader, and subject matter in anthropology in an age when the native informant may read and contest the ethnographer's characterizations—indeed, may well have heard of Jacques Derrida and have a copy of the latest Banana Republic catalog.[6] Postmodernist anthropologists claim that the aim of experimentation with such forms as intertextuality, dialogue, and self-referentiality is to demystify the anthropologist's unitary authority and thus to include, and to structure the relationships among, the "many voices clamoring for expression"[7] in the ethnographic situation. However, these new ways of structuring are more subtle and enigmatic than traditional modes of anthropological writing: they may serve to make the new ethnographies more obscure and, thus, difficult for anyone but highly trained specialists to dispute.

The essays in James Clifford and George Marcus's *Writing Culture: The Poetics and Politics of Ethnography* are concerned with the explication of the relation between the ethnographic field situation and the style of the ethnographic text. In his introduction to the book, for example, Clifford explains the effects of the new ethnographers' use of dialogue: "It locates cultural interpretations in many sorts of reciprocal contexts, and it obliges

2. George E. Marcus and Michael M.J. Fischer, *Anthropology as Cultural Critique: An Experimental Moment in the Human Sciences* (Chicago and London: University of Chicago Press, 1986); James Clifford and George E. Marcus, eds., *Writing Culture: The Poetics and Politics of Ethnography* (Berkeley and Los Angeles: University of California Press, 1986).

3. Marcus and Fischer, esp. 1.

4. James Clifford, "Introduction," in Clifford and Marcus, eds., 1-26, esp. 2. See Roy Wagner, *The Invention of Culture* (Chicago: University of Chicago Press, 1975) for an elaboration of this idea.

5. Clifford, "Introduction," 10.

6. Marilyn Strathern, "Out of Context: The Persuasive Fictions of Anthropology," *Current Anthropology* 28, no. 3 (June 1987): 251-70, esp. 269; James Clifford, "On Ethnographic Allegory," in Clifford and Marcus, eds., 98-121, esp. 117; and Paul Stoller, "A Dialogue on Anthropology between a Songhay and an Inquirer" (paper presented at the eighty-seventh annual meeting of the American Anthropological Association, Phoenix, Ariz., November 16-20, 1988).

7. Clifford, "Introduction," 15.

writers to find diverse ways of rendering negotiated realities as multisubjective, power-laden, and incongruent. In this view, 'culture' is always relational, an inscription of communicative processes that exist, historically, *between* subjects in relation to power."[8]

Thus, Clifford argues that new ethnographers, those anthropologists who do not just theorize about textual production but who write cultural accounts, employ experimental writing techniques in an attempt to expose the power relations embedded in any ethnographic work and to produce a text that is less encumbered with Western assumptions and categories than traditional ethnographies have been. Michelle Rosaldo, for example, has attempted to make the initial cultural unintelligibility of the voice of an Ilongot headhunter persuasive not so much through argumentation or explication as through repetition.[9] In *Nisa: The Life and Words of a !Kung Woman*, Marjorie Shostak juxtaposes the voice of the "other" with the voice of the ethnographer to offer the reader the possibility of confronting the difference between two distinct modes of understanding.[10] In *Moroccan Dialogues*, Kevin Dwyer experiments with a dialogic mode of representation to emphasize that the ethnographic text is a collaborative endeavor between himself and a Moroccan farmer.[11] Other experimental works have concentrated on exposing how the observation, as well as the interpretation, of another culture is affected by a researcher's cultural identity and mode of expression. In *The Princes of Naranja: An Essay in Anthrohistorical Method*, for example, Paul Friedrich gives an extensive discussion of his own personal history, showing how his childhood farm experiences predisposed him to a study of agrarian life and how an almost unbelievable series of physical mishaps led him to reorganize his entire book. He also shows how this reordering and his choice of stylistic devices such as texturing and "historical holography" help convey a sense of Naranjan life as complex.[12]

However, what appear to be new and exciting insights to these new postmodernist anthropologists —that culture is composed of seriously contested codes of meaning, that language and politics are inseparable, and that constructing the "other" entails relations of domination[13]—are insights that have received repeated and rich exploration in feminist theory for the past forty years. Discussion of the female as "other" was the starting point of contemporary feminist theory. As early as 1949, Simone de Beauvoir's *The Second Sex* argued that it was by constructing the woman as "other" that men in Western culture have constituted themselves as subjects.[14] An early goal of this second wave of feminism was to recover women's experience and thereby to find ways that we as women could constitute ourselves—claim ourselves—as subjects. This early feminist theory does have similarities with traditional anthropology. Both were concerned with the relationship of the dominant and the "other," and with the need to expand and question definitions of the human. However, even in this early stage, a crucial difference existed between anthropological and feminist inquiries. While anthropology questioned the status of the participant-observer, it spoke from the position of the dominant and thus for the "other." Feminists speak from the position of the "other."

This is not to oversimplify. It was not possible for feminists to speak directly *as* "other." Women in consciousness-raising groups were not simply giving voice to already formulated but not yet articulated women's perspectives; they were creatively constructing them. In telling stories about their experiences, they were giving them new meanings, meanings other than those granted by patriarchy, which sees women only as seductresses or wives, as good or bad mothers. Similarly, feminist scholars sought to construct new theoretical interpretations of women. Yet, even when attempting to speak for women, and as women, feminist scholars wrote within a patriarchal discourse that does not accord subject status to the feminine. In this way feminists exposed the contradictions in a supposedly neutral and objective discourse that always proceeds

8. Ibid. (emphasis Clifford's).

9. Rosaldo (n. 1 above).

10. Shostak (n. 1 above).

11. Dwyer (n. 1 above).

12. Friedrich (n. 1 above).

13. Clifford, "Introduction," 2.

14. Simone de Beauvoir, *The Second Sex* (1949 in French; reprint, New York: Alfred Knopf, 1953).

from a gendered being and thereby questioned the adequacy of academic discourse. Thus, feminist theory, even in the 1970s, was concerned not simply with understanding women's experience of otherness but also with the inscription of women as "other" in language and discourse. This was particularly evident in feminist literary criticism, which moved from the cataloging of stereotypes[15] to the study of female authorship as resistance and reinscription.[16] French feminists, notably Hélène Cixous and Luce Irigaray, playfully exploited language's metaphoric and polysemic capacities to give voice to feminist reinterpretations of dominant myths about women.[17]

A fundamental goal of the new ethnography is similar: to apprehend and inscribe "others" in such a way as not to deny or diffuse their claims to subjecthood. As Marcus and Fischer put it, the new ethnography seeks to allow "the adequate representation of other voices or points of view across cultural boundaries."[18] Informed by the notion of culture as a collective and historically contingent construct, the new ethnography claims to be acutely sensitive to cultural differences and, within cultures, to the multiplicity of individual experience.

However, despite these similarities, when anthropologists look for a theory on which to ground the new ethnography, they turn to postmodernism, dismissing feminist theory as having little to teach that anthropology does not already know. For example, Marcus and Fischer claim, "The debate over gender differences stimulated by feminism... often [falls] into the same rhetorical strategies that once were used for playing off the dissatisfactions of civilized society against the virtues of the primitive."[19] By focusing exclusively on those feminists who valorize "essential" female characteristics like motherhood and peaceableness, Marcus and Fischer construe feminism as little more than the expression of women's dissatisfactions with a sinister patriarchy. Thus, their ignorance of the full spectrum of feminist theory may partly explain their dismissal of it.

Similarly, Clifford justifies the exclusion of feminist anthropologists from *Writing Culture: The Poetics and Politics of Ethnography* with a questionable characterization of the feminist enterprise in anthropology: "Feminist ethnography has focused either on setting the record straight about women or revising anthropological categories.... It has not produced either unconventional forms of writing or a developed reflection on ethnographic textuality as such."[20] Clifford nonetheless uses Margorie Shostak's *Nisa: The Life and Words of a !Kung Woman* as a primary example in his essay "On Ethnographic Allegory" in the same volume. In this essay, he calls Shostak's work at once "feminist" and "original in its polyvocality,...manifestly the product of a collaboration with the other," reflexive of "a troubled, inventive moment in the history of cross-cultural representation."[21] He therefore reveals not only that he clearly knows of at least one feminist ethnography that has employed "unconventional forms of writing," but also that he prefers to write about feminists rather than inviting them to write for themselves.

This contradiction makes sense in the context of Clifford's essay on ethnographic allegory. In it he seeks to demonstrate that the new ethnography is like traditional anthropological writings about the "other" in that both use allegory. He argues that all ethnography is inevitably allegorical since it at once presents us with a representation of a different reality and continuously refers to another pattern of ideas to make that difference comprehensible. It

15. See esp. Mary Ellmann, *Thinking about Women* (New York: Harcourt, Brace, Jovanovich, 1968); and Annis Pratt, *Archetypal Patterns in Women's Fiction* (Bloomington: Indiana University Press, 1982).

16. See esp. Sandra Gilbert and Susan Gubar, *The Madwoman in the Attic: The Woman Writer and the Nineteenth-Century Literary Imagination* (New Haven, Conn.: Yale University Press, 1980); Elaine Showalter, *A Literature of Their Own: British Women Novelists from Brontë to Lessing* (Princeton, N.J.: Princeton University Press, 1977); and Ellen Moers, *Literary Women* (New York: Doubleday, 1976).

17. Hélène Cixous, "The Laugh of the Medusa," trans. Keith Cohen and Paula Cohen, in *The Signs Reader: Women, Gender and Scholarship*, ed. Elizabeth Abel and Emily K. Abel (Chicago and London: University of Chicago Press, 1983), 279-97; and Luce Irigaray, "This Sex Which Is Not One," in *New French Feminisms*, ed. Elaine Marks and Isabelle de Courtivron (New York: Schocken, 1981), 99-106.

18. Marcus and Fischer (n. 2 above), 2.

19. Ibid., 135.

20. Clifford, "Introduction," 20-21.

21. Clifford, "On Ethnographic Allegory" (n. 6 above), 104-9.

is odd that Clifford uses a feminist ethnography as his only example of how new ethnography is allegorical since, in view of his statement about feminist ethnography's lack of experimentation in his introduction, he himself should suspect that Shostak's work is not representative of the new ethnography. Such a contradiction seems to betray Clifford's tendency to equate women with forces of cultural conservatism. In dismissing the novelty of feminist work in anthropology, Clifford seeks to validate *Writing Culture* as truly innovative: "The essays in this volume occupy a new space opened up by the disintegration of 'Man' as *telos* for a whole discipline."[22] Like European explorers discovering the New World, Clifford and his colleagues perceive a new and uninhabited space where, in fact, feminists have long been at work.

How can we understand this dismissal of feminism in favor of postmodernism, the dismissal of political engagement in favor of a view that "beholds the world blankly, with a knowingness that dissolves feeling and commitment into irony"?[23] Anthropologists should be uncomfortable with an aesthetic view of the world as a global shopping center and suspicious of an ideology that sustains the global economic system.[24] Of course, there are many postmodernisms, just as there are many feminisms, and within both movements definitions are contested.[25] While there is also considerable overlap, postmodernism is unlike feminism in its relationship to the ferment of the 1960s.[26] While contemporary feminism is an ongoing political movement with roots in the 1960s, "post-modernism is above all post-1960s; its keynote is cultural helplessness. It is post-Viet Nam, post-New Left, post-hippie, post-Watergate. History was ruptured, passions have been expended, belief has become difficult....The 1960s exploded our belief in progress....Old verities crumbled, but new ones have not settled in. Self-regarding irony and blankness are a way of staving off anxieties, rages, terrors, and hungers that have been kicked up but cannot find resolution."[27] The sense of helplessness that postmodernism expresses is broader, however, than the disillusionment of the 1960s' leftists; it is an experience of tremendous loss of mastery in traditionally dominant groups. In the postmodern period, theorists "stave off" their anxiety by questioning the basis of the truths that they are losing the privilege to define.

Political scientist Nancy Hartsock has made a similar observation; she finds it curious that the postmodern claim that verbal constructs do not correspond in a direct way to reality has arisen precisely when women and non-Western peoples have begun to speak for themselves and, indeed, to speak about global systems of power differentials.[28] In fact, Hartsock suggests that the postmodern view that truth and knowledge are contingent and multiple may be seen to act as a truth claim itself, a claim that undermines the ontological status of the subject at the very time when women and non-Western peoples have begun to claim themselves as subject. In a similar vein, Sarah Lennox has asserted that the postmodern despair associated with the recognition that truth is never entirely knowable is merely an inversion of Western arrogance.[29] When Western white males—who traditionally have controlled the production of knowledge—can no longer define the truth, she argues, their response is to conclude that there is not a truth to be discovered. Similarly, Sandra Harding claims that "historically,

22. Clifford, "Introduction," 4.

23. Todd Gitlin, "Hip-Deep in Post-Modernism," *New York Times Book Review* (November 6, 1988), 1, 35-36, esp. 35.

24. See Fredric Jameson, "Postmodernism and Consumer Society," in *The Anti-Aesthetic: Essays on Postmodern Culture*, ed. H. Foster (Port Townsend, Wash.: Bay Press, 1983), 111-25.

25. This point recently has been made by Daryl McGowan Tress, "Comment on Flax's 'Postmodernism and Gender Relations in Feminist Theory,'" *Signs: Journal of Women in Culture and Society* 14, no. 1 (Autumn 1988): 196-200.

26. See Jane Flax, "Postmodernism and Gender Relations in Feminist Theory," *Signs* 12, no. 4 (Summer 1987): 621-43; Craig Owens, "The Discourse of Others: Feminists and Postmodernism," in Foster, ed., 57-82. Nancy Fraser and Linda Nicholson, "Social Criticism without Philosophy: An Encounter between Feminism and Postmodernism," *Theory, Culture, and Society* 5 (June 1988): 373-94, was very helpful to us on this point.

27. Gitlin, 36.

28. Nancy Hartsock, "Rethinking Modernism," *Cultural Critique* 7 (Fall 1987): 187-206.

29. Sarah Lennox, "Anthropology and the Politics of Deconstruction" (paper presented at the ninth annual conference of the National Women's Studies Association, Atlanta, Ga., June 1987).

relativism appears as an intellectual possibility, and as a 'problem,' only for dominating groups at the point where the hegemony (the universality) of their views is being challenged. [Relativism] is fundamentally a sexist response that attempts to preserve the legitimacy of androcentric claims in the face of contrary evidence."[30] Perhaps most compelling for the new ethnography is the question Andreas Huyssen asks in "Mapping the Postmodern": "Isn't the death of the subject/author position tied by mere reversal to the very ideology that invariably glorifies the artist as genius?...Doesn't post-structuralism where it simply denies the subject altogether jettison the chance of challenging the ideology of the subject (as male, white, and middle-class) by developing alternative notions of subjectivity?"[31]

These analyses clearly raise questions about the experience of Western white males and how that experience is reflected in postmodern thought. To the extent that this dominant group has in recent years experienced a decentering as world politics and economic realities shift global power relations, postmodern theorizing can be understood as socially constructed itself, as a metaphor for the sense of the dominant that the ground has begun to shift under their feet. And this social construction, according to Hartsock, Lennox, Harding, and Huyssen, is one that potentially may work to preserve the privileged position of Western white males. If so, then the new ethnography, in its reliance on postmodernism, may run the risk of participating in an ideology blind to its own politics. More than that, it may help to preserve the dominant colonial and neocolonial relations from which anthropology, and especially the new ethnography, has been trying to extricate itself.

But to phrase this argument exclusively in these terms is to obscure the fact that the significant power relations for many of these new postmodernist anthropologists are not global but parochial, those that are played out in the halls of anthropology departments, those that are embedded in the patriarchal social order of the academy in which male and female scholars maneuver for status, tenure, and power. In a recent article in *Current Anthropology*, P. Steven Sangren argues that although post-modernist anthropologists call for a questioning of textually constituted authority, their efforts are actually a play for socially constituted authority and power.[32] He thus suggests that it is first and foremost academic politics that condition the production and reproduction of ethnographic texts. Moreover, according to him, "whatever 'authority' is created in a text has its most direct social effect not in the world of political and economic domination of the Third World by colonial and neocolonial powers, but rather in the academic institutions in which such authors participate."[33] While postmodernist anthropologists such as Clifford, Marcus, and Fischer may choose to think that they are trans-forming global power relations as well as the discipline of anthropology itself, they may also be establishing first claim in the new academic territory on which this decade's battles for intellectual supremacy and jobs will be waged.[34] The exclusion of feminist voices in Clifford and Marcus's influential volume and Clifford's defensive, convoluted, and contradictory explanation for it are strategies that preserve male supremacy in the academy. Clifford seems well aware of this when we read in the same introductory pages in which he presents his defense of excluding feminist writers his statement that "all constructed truths are made possible by powerful 'lies' of exclusion and rhetoric."[35]

30. Sandra Harding, "Introduction: Is There a Feminist Method?" in *Feminism and Methodology*, ed. Sandra Harding (Bloomington and Indianapolis: Indiana University Press, 1987), 1-14, esp. 10.

31. Andreas Huyssen's "Mapping the Postmodern," quoted in Nancy K. Miller, "Changing the Subject: Authorship, Writing and the Reader," in *Feminist Studies: Critical Studies*, ed. Teresa de Lauretis (Bloomington: Indiana University Press, 1986), 102-20, esp. 106-7.

32. P. Steven Sangren, "Rhetoric and the Authority of Ethnography," *Current Anthropology* 29, no. 3 (June 1988): 405-24, esp. 411.

33. Ibid., 412.

34. In their reply to Sangren, Michael Fischer and George Marcus (written with Stephen Tyler) call Sangren's concern an "*obsession* with academic power and status" (emphasis ours). See Michael M. J. Fischer, George E. Marcus, and Stephen A. Tyler, "Comments," *Current Anthropology* 29, no. 3 (1988): 426-27, esp. 426.

35. Clifford, "Introduction" (n. 4 above), 7.

The lie of excluding feminism has characterized most postmodernist writing by males, not simply that in anthropology. One notable exception, Craig Owens's "The Discourse of Others: Feminists and Postmodernism," demonstrates the richness of insight into cultural phenomena that the conjunction of feminist and postmodern perspectives offers. For anthropologists, his analysis of the message we humans transmit to possible extraterrestrials, the space-age "other," is particularly telling. Of the schematic image of the nude man and woman, the former's right arm raised in greeting, which was emblazoned on the Pioneer spacecraft, Owens observes, "Like all representations of sexual difference that our culture produces, this is an image not simply of anatomical difference but of the values assigned to it."[36] A small difference in morphology is marked or underscored by the erect right arm, a signal that speech is the privilege of the male. Owens notes that deconstructions of this privilege by male postmodernists is rare: "If one of the most salient aspects of our postmodern culture is the presence of an insistent feminist voice...theories of postmodernism have tended either to neglect or to repress that voice. The absence of discussions of sexual difference in writings about postmodernism, as well as the fact that few women have engaged in the modernism/postmodernism debate, suggest that postmodernism may be another masculine invention engineered to exclude women."[37]

While "engineered," with its suggestions of conscious agency, may grant academic males too much sinister awareness, Owens's observation of the evidence is accurate: "Men appear unwilling to address the issues placed on the critical agenda by women unless those issues have been first neut(e)ralized."[38] This suggests their fear of entering into a discourse where the "other" has privilege. Intellectual cross-dressing, like its physical counterpart, is less disruptive of traditional orders of privilege when performed by women than by men.[39] Fearing loss of authority

and masculinity, male critics have preferred to look on feminism as a limited and peripheral enterprise, not as one that challenges them to rethink their own positions in terms of gender.[40] "Although sympathetic male critics respect feminism (an old theme: respect for women)," Owens acknowledges that "they have in general declined to enter into the dialogue in which their female colleagues have been trying to engage them."[41]

The case of Paul Rabinow is illustrative. His is the one article in *Writing Culture* that appears to deal seriously with feminism. However, he concludes that feminism in not an intellectual position he personally can hold. Seeing himself as "excluded from direct participation in the feminist dialogue," he constructs an alternative "ethical" position for anthropologists:

woman assumes a masculine position; perhaps that is why femininity is frequently associated with masquerade, with false representation, with simulation and seduction" (ibid., esp. 59). See also Mary Russo's "Female Grotesques: Carnival and Theory," in de Lauretis, ed. (n. 31 above), esp. 213-29. For a broad discussion of the advantages of cross-dressing for women, see Susan Gubar's "Blessings in Disguise: Cross-Dressing as Re-Dressing for Female Modernists," *Massachusetts Review* 22, no. 3 (Autumn 1981): 477-508. A suspicious look at some male responses to feminist literary criticism in terms of current interest in male cross-dressing, as evidenced by the film *Tootsie*, is Elaine Showalter's "Critical Cross-Dressing: Male Feminists and the Woman of the Year," *Raritan* 3, no. 2 (Fall 1983): 130-49. Male anxiety about the implications of doing feminist criticism was voiced by Dominick LaCapra in a discussion of his "Death in Venice: An Allegory of Reading" (paper delivered at the Woodrow Wilson Institute's "Interpreting the Humanities," June 1986). When asked about gender issues in Mann's story, he replied: "I can't do transvestite criticism like Jonathan Culler," a reference to the chapter "Reading as a Woman" in Jonathan Culler, *On Deconstruction: Theory and Criticism After Structuralism* (Ithaca, N.Y.: Cornell University Press, 1982), esp. 43-64. Freud's similar fear of identification with the feminine is discussed in C. Bernheimer and Claire Kahane, eds., *Dora's Case: Freud-Hysteria-Feminism* (New York: Columbia University Press, 1985).

40. Evelyn Fox Keller has described the recurrent mistranslation of gender and science as women and science, showing how gender questions are considered to be of concern only to women in "Feminist Perspectives on Science Studies," *Barnard Occasional Papers on Women's Issues* 3 (Spring 1988): 10-36.

41. Owens, esp. 62. This observation, of course, is well known to feminists who have been consistently frustrated by the marginalization of feminist insights. See, e.g., Miller (n. 31 above).

36. Owens (n. 26 above), 61.

37. Ibid.

38. Ibid., 62.

39. Owens notes that writing for women requires intellectual cross-dressing: "In order to speak, to represent herself, a

critical cosmopolitanism. "This is an oppositional position," he argues, "one suspicious of sovereign powers, universal truths...but also wary of the tendency to essentialize difference." Ironically, however, Rabinow not only universalizes, stating "we are all cosmopolitans," but also essentializes difference when he excludes himself from feminist dialogue solely because he is male. Seeing himself as unable to participate in feminist and Third World discourses, he identifies with Greek Sophists, "cosmopolitan insider's outsiders of a particular historical and cultural world."[42] In thus constructing himself as just one more "other" among the rest, Rabinow risks the danger he ascribes to critics like James Clifford: "obliterating meaningful difference," obliterating and obscuring some of the privileges and power granted to him by race, nationality, and gender.[43] He describes his decision to study elite French male colonial officials as proceeding from this oppositional ethical stance: "By 'studying up' I find myself in a more comfortable position than I would be were I 'giving voice' on behalf of dominated or marginal groups." An exclusive focus on the elite, eschewing the dominated or marginal, is a dangerous, if comfortable, correction. Feminists have taught us the danger of analyses that focus exclusively on men: they have traditionally rendered gender differences irrelevant and reinforced the Western male as the norm. Rabinow's earlier Reflections on Fieldwork in Morocco relied exclusively on male informants, presenting women only marginally and as objects of his sexual desire, communicating through "the unambiguity of gesture."[44] Ironically, he claims his new work will broaden "considerations of power and representation" which were "too localized in my earlier work on Morocco," yet he focuses even more explicitly on

men. This can be defended only if Rabinow struggles with his earlier insensitivity to gender issues and, in this study of elite powerful males, undertakes that part of the feminist project particularly suited to male practitioners: deconstructing the patriarchy.[45]

Feminists' call for self-reflexivity in men is related to postmodernist anthropology's goal of self-critique; when anthropologists include themselves as characters in ethnographic texts instead of posing as objective controlling narrators, they expose their biases. This coincides with the goals of postmodernism as characterized by Jane Flax: "Postmodern discourses are all 'deconstructive' in that they seek to distance us from and make us skeptical about beliefs concerning truth, knowledge, power, the self, and language that are often taken for granted within and serve as legitimation for contemporary Western culture."[46] Yet interest in these questions in postmodernism is abstract and philosophical, paradoxically grounded in a search for a more accurate vision of truth. Feminist theory shares similar concerns to these postmodern ideas, as Flax notes, but feminist theory differs from postmodernism in that it acknowledges its grounding in politics.

The one theorist who has grappled with the problems that arise when feminism and anthropology are merged is Marilyn Strathern, who notes that "anthropology has interests parallel to those of feminist scholarship," which would lead us to "expect 'radical' anthropology to draw on its feminist counterpart."[47] She notes, however, that feminism has affected only the choice of subjects of study in social anthropology, not its scholarly practices: where social anthropological categories of analysis have changed, "it has been in response to internal criticism that has little to do with feminist

42. Paul Rabinow, "Representations Are Social Facts: Modernity and Post-Modernity in Anthropology," in Clifford and Marcus, eds. (n. 2 above), 234-61, esp. 257-59.

43. Deborah Gordon has noted recently that not only is the critical cosmopolitan "not clearly marked by any 'local' concerns such as gender, race, nationality, etc.," but also "the Greek sophists who are Rabinow's fictive figure for this position were European men," in "Writing Culture, Writing Feminism: The Poetics and Politics of Experimental Ethnography," *Inscriptions*, nos. 3/4 (1988), 7-24.

44. Rabinow (n. 1 above), esp. 67.

45. Lois Banner argued that this is the appropriate task for males who are sympathetic to feminism in her response to Peter Gabriel Filene's plenary address, "History and Men's History and What's the Difference," at the Conference on the New Gender Scholarship: Women's and Men's Studies, University of Southern California, Los Angeles, February 1987.

46. Flax (n. 26 above), 624.

47. Marilyn Strathern, "An Awkward Relationship: The Case of Feminism and Anthropology," *Signs* 12, no. 2 (Winter 1987): 276-92, esp. 277-80.

theory." Strathern seeks to explain why anthropology has failed to respond to feminism as a profound challenge by showing how the two endeavors are parallel, yet mock each other. Feminism mocks experimental anthropology's search for an ethnography that is a "collaborative production...a metaphor for an ideal ethical situation in which neither voice is submerged by the Other," while anthropology mocks feminists' pretensions to separate themselves from Western "cultural suppositions about the nature of personhood and of relationships...shared equally by the [male] Other."[48]

Stathern thus suggests that there can be no true merging of feminism and the new ethnography, but this contention is based on a problematic formulation. Even the brief quotations above indicate Strathern's disturbing use of the term "other" to refer to "'patriarchy,' the institutions and persons who represent male domination, often simply concretized as 'men.'" This, she believes, is the "other" of feminism, the "other" that feminists must remain in opposition to for "the construction of the feminist self."[49] This feminist need to remain distinct from a wrongheaded male "other" is at odds, she argues, with the new ethnography's desire to get close to and know the "other." But in this latter usage of the word "other," she refers to the traditional anthropological subject of study, non-Western peoples. In her awkward parallel usage, Strathern seems to ignore differential power relations, failing to acknowledge that one term in each pair is historically marked by privilege. She does not see that women are to men as natives are to anthropologists. And, thus, even if as feminists we remain in opposition to men to construct ourselves, it does not mean that we must fear getting to know the non-Western "other." We may, however, be cautious in our desire to do so. Feminists can teach new ethnographers that their ideal of collaboration "is a delusion, overlooking the crucial dimension of different social interests," Strathern suggests, wrongly attributing this insight to the oppositional position feminists strike in relation to the patriarchal "other."[50] Our

suspicion of the new ethnographers' desire for collaboration with the "other" stems not from any such refusal to enter into dialogue with that "other," but from our history and understanding of being appropriated and literally spoken for by the dominant, and from our consequent sympathetic identification with the subjects of anthropological study in this regard.

This leads to the questioning, voiced recently by Judith Stacey, of whether any ethnography of the "other" can be compatible with feminist politics. Stacey argues that despite the appearance of compatibility between feminist researchers seeking an "egalitarian research process characterized by authenticity, reciprocity, and intersubjectivity between the researcher and her 'subjects,'" and the face-to-face and personalized encounter of the ethnographic field experience, major contradictions exist. First, the highly personalized relationship between ethnographer and research subject, which masks actual differences in power, knowledge, and structural mobility, "places research subjects at grave risk of manipulation and betrayal by the ethnographer." Additionally, Stacey points to the contradiction between the desire for collaboration on the final research product and the fact that "the research product is ultimately that of the researcher, however modified or influenced by informants."[51] Stacey's response to these contradictions is to despair of a fully feminist ethnography. "There can be ethnographies that are partially feminist, accounts of culture enhanced by the application of feminist perspectives," she argues, and there can be "feminist research that is rigorously self-aware and therefore humble about the partiality of its ethnographic vision and its capacity to represent self and other."[52] But how are these goals to be realized? Has feminism nothing more to teach the new ethnography?

We have suggested that an important aspect of feminist scholarship is its relationship to a politics. Strathern notes that within feminist writing, "play with context [similar to that used by the new ethnographers] is creative because of the expressed

48. Ibid., 281, 290-91.

49. Ibid., 288.

50. Ibid., 290.

51. Judith Stacey, "Can There Be a Feminist Ethnography?" *Women's Studies International Forum* 11, no. 1 (1988): 21-27, esp. 22-23.

52. Ibid., 26.

continuity of purpose between feminists as scholars and feminists as activists."[53] Feminism teaches us to take up a particularly moral and sensitive attitude toward relationships by emphasizing the importance of community building to the feminist project, and it also demands scrutiny of our motivations for research. In their current experimentation, anthropologists need a renewed sensitivity to "the question of relationships involved in communication."[54] They need to learn the lessons of feminism and consider for whom they write.

Throughout her discussion of postmodernist anthropology, Strathern displays suspicions, like those that feminists have, of its claims to use free play and jumble, to present many voices in flattened, nonhierarchical, plural texts, to employ "heteroglossia (a utopia of plural endeavour that gives all collaborators the status of authors)." Irony, she argues, rather than jumble is the postmodern mode, and "irony involves not a scrambling but a deliberate juxtaposition of contexts, pastiche perhaps but not jumble."[55]

Strathern contrasts this illusion of free play in postmodernist anthropology with feminist writing: "Much feminist discourse is constructed in a plural way. Arguments are juxtaposed, many voices solicited....There are no central texts, no definitive techniques." Unlike postmodern writing, however, which masks its structuring oppositions under a myth of jumble, feminist scholarship has "a special set of social interests. Feminists argue with one another in their many voices because they also know themselves as an interest group."[56] Thus, although feminism originally may have discovered itself by becoming conscious of oppression, more recently feminists have focused on relations among women and the project of conceiving difference without binary opposition. Feminist politics provide an explicit structure that frames our research questions and moderates the interactions in which we engage with other women. Where there is no such explicit political structure, the danger of veiled agendas is great.

Anthropologists could benefit from an understanding of this feminist dialogue. Just as early feminist theory of the "other" is grounded in women's actual subordination to men, so more recent trends in feminist theorizing about difference are grounded in actual differences among women. For example, the recent focus in mainstream feminist theory upon the diversity of women's experiences bears relation to the postmodern deconstruction of the subject, but it stems from a very different source: the political confrontation between white feminists and women of color.[57] In response to accusations by women of color that the women's movement has been in actuality a white middle-class women's movement, Western white feminists, together with women of color, have had to reconsider theories of *the* woman and replace them with theories of multiplicity. In a similar vein, the need for building self-criticism into feminist theory has been expressed with the recognition that what once appeared to be theoretically appropriate mandates for change may have very different results for different populations of women. For example, some scholars claim that antirape activism has served to reinforce racial stereotypes (the rapist as black male), that pro-choice legislation has provided a rationale for forced sterilization and abortions among the poor and women of color, and that feminist-backed no-fault-divorce legislation has contributed to the feminization of poverty. The new ethnography draws on postmodernist epistemology to accomplish its political ends, but much feminism derives its theory from a practice based in the material conditions of women's lives.

Both postmodernist anthropology and feminism assume a self-consciously reflexive stance toward their subjects, but there are significant differences between them. For, as Sandra Harding has suggested, at the moment that feminist scholars begin to address themselves to women's experiences, their inquiry necessarily becomes concerned with questions of power and political struggle, and their research goals become defined by that struggle. This

53. Strathern, "Out of Context: The Persuasive Fictions of Anthropology" (n. 6 above), 268.

54. Ibid., 269.

55. Ibid., 266-67.

56. Ibid., 268.

57. See Maria C. Lugones and Elizabeth Spelman, "Have We Got a Theory for You! Feminist Theory, Cultural Imperialism and the Demand for 'The Woman's Voice,'" *Women's Studies International Forum* 6, no. 6 (1983): 573-81, for a compelling representation of this dialogue.

is because "the questions an oppressed group wants answered are rarely requests for so-called pure truth. Instead, they are questions about how to change its conditions; how its world is shaped by forces beyond it; how to win over, defeat or neutralize those forces arrayed against its emancipation, growth or development; and so forth."[58] The feminist researcher is led to design projects that, according to Harding, women want and need.

Indeed, in this sense, feminist research is more closely aligned with applied anthropology, whose practitioners also often derive their questions from and apply their methods to the solution of problems defined by the people being studied, than with new ethnographers.[59] Applied anthropologists frequently function as "power brokers," translating between the subordinate, disenfranchised group and the dominant class or power. To understand the difference in approach between the new ethnographer and the applied anthropologist, it is useful to look at Clifford's recent article on "Identity in Mashpee."[60]

The Mashpee are a group of Native Americans who in 1976 sued in federal court for possession of a large tract of land in Mashpee, Massachusetts. The case revolved around claims of cultural identity: if the individuals bringing suit could prove an uninterrupted historical identity as a tribe, then their claim for compensation would be upheld. In his article, Clifford makes use of trial transcripts, transcripts of interviews with witnesses for the defense, and snippets of information from the documents used in the case to reconstruct Mashpee history. As a new ethnographer, Clifford analyzes

these as commentaries on "the ways in which historical stories are told" and on "the alternative cultural models that have been applied to human groups."[61] Such readings as this can and do elucidate who speaks for cultural authenticity and how collective identity and difference are represented. Indeed, for the new ethnographer, the Mashpee trial emerges as a sort of natural laboratory in which multiple voices contributing to a collectively constituted cultural reality can be heard. It illustrates how the postmodernist emphasis on dialogue helps anthropologists to study native populations as they change and interact in response to the dominant culture rather than simply as representatives of a pure and dying past. However, Mascia-Lees, as someone who has worked with and for the Mashpee in their federal recognition appeal, would argue that it is highly doubtful whether Clifford's insights provide the Mashpee with explanations of social phenomena that they either want or need.

We must question whether the appearance of multiple voices in Clifford's text can act to counter the hegemonic forces that continue to deny the Mashpee access to their tribal lands. Who is the intended audience for this analysis: the Mashpee or other scholars in institutions under Western control? And whose interests does it serve? Following Harding's claim that feminist research seeks to use women's experiences "as the test of adequacy of the problems, concepts, hypotheses, research design, collection, and interpretation of data,"[62] we might even go so far as to ask whether Clifford's representation uses the Mashpee's experience as a test of the adequacy of his research. Clifford sees himself as rejecting the Western privileging of visualism in favor of a paradigm of the interplay of voices. Yet, perhaps dialogue, even the proliferating Bakhtinian dialogic processes Clifford favors, is saturated with Western assumptions. We need to ask whose experience of the world this focus on dialogue reflects: that of the ethnographer who yearns to speak with and know the "other," or that of Native Americans, many of whom have frequently refused dialogue with the

58. Harding, "Introduction: Is There a Feminist Method?" (n. 30 above), 8.

59. Applied anthropologists, like feminist scholars, also frequently participate in collaborative research projects, helping to undermine the traditional, and largely unjustified and false, notion of research and scholarship as the heroic quest by the lone scholar for "truth." Sandra Harding recently has made the point that this notion often obscures the contributions made by women to the scientific enterprise, since what they do, especially in the laboratory, can be dismissed as domestic work in the service of the male scientist. Sandra Harding, *The Science Question in Feminism* (Ithaca, N.Y.: Cornell University Press, 1986).

60. James Clifford, "Identity in Mashpee," in his *The Predicament of Culture: Twentieth-Century Ethnography, Literature, and Art* (Cambridge, Mass.: Harvard University Press, 1988), 277-346.

61. Ibid., 289

62. Harding, "Introduction: Is There a Feminist Method?" 11.

anthropologist whom they see as yet one more representative of the oppressive culture and for some of whom dialogue may be an alien mode?

This yearning to know the "other" can be traced to the romanticism so frequently associated with anthropologists' scholarly pursuits. Traditionally, this romantic component has been linked to the heroic quests, by the single anthropologist, for "his soul"[63] through confrontation with the exotic "other."[64] This particular avenue for self-exploration has been closed recently by the resistance of Third World peoples to serving in therapeutic roles for Westerners as well as by the sense on the part of anthropologists that twentieth-century "natives" may themselves be in need of therapy, "neutered, like the rest of us, by the dark forces of the world system."[65]

Yet the romantic tradition in anthropology is being sustained by the postmodernist mandate for self-reflection. For in turning inward, making himself, his motives, and his experience the thing to be confronted, the postmodernist anthropologist locates the "other" in himself. It is as if, finding the "exotic" closed off to him, the anthropologist constructs himself as the exotic.[66] This is clearly the case, for example, in *The Princes of Naranja*.[67] Here, Paul Friedrich's characterization of the salient features of his own life history connects in the reader's mind with images of the Tarascan princes who have appeared on earlier pages: home-bred fatalism, peer rivalry, and personal experiences with death and danger. Since Friedrich's self-reflection was written some thirty years after his initial fieldwork experience in Naranja, it seems likely, although Friedrich does not suggest it, that this inscription of his own childhood history may have been as much affected by his Naranja experience as vice versa. Ironically, Friedrich's book, which opens up the possibility of demystifying the "other," reveals that this process may lead to a mystification of the self. In this light, it is hardly surprising that Clifford's work is so popular. Clifford the historian has turned ethnographers into the natives to be understood and ethnography into virgin territory to be explored.

This current focus on self-reflexivity in postmodernist anthropology is expressed not only in works that make the ethnographer into a character in the ethnographic text but also in analyses of earlier ethnographic writing.[68] Of this process Marilyn Strathern comments, "Retrospectively to ask about the persuasive fictions of earlier epochs is to ask about how others (Frazer, Malinowski, and the rest) handled our moral problems of literary construction. In answering the question, we create historic shifts between past writers in terms persuasive to our own ears, thereby participating in a postmodern history, reading back into books the strategies of fictionalisation. To construct past works as quasi-intentional literary games is the new ethnocentrism. There is no evidence, after all, that 'we' have stopped attributing our problems to 'others.'"[69]

Furthermore, much of this historical analysis deals with colonialism, affording the contemporary anthropologist a field of study in which it is possible to hold a critical and ethical view. Paradoxically, however, it simultaneously replays a time in which

63. We have chosen to retain the masculine pronoun here and in subsequent parts of the text when referring to individuals steeped in traditional anthropological ideas and practices. As feminist anthropologists have shown, even though anthropology has traditionally included women as researchers, the field has been plagued with androcentric assumptions. See Sally Slocum's "Woman the Gatherer: Male Bias in Anthropology," in *Toward an Anthropology of Women*, ed. R. Rapp (New York and London: Monthly Review Press, 1975), esp. 36-50, for one of the earliest works to expose this bias.

64. Susan Sontag, "The Anthropologist as Hero," in her *Against Interpretation* (New York: Farrar, Straus, Giroux, 1966), esp. 69-81; Clifford Geertz, *Works and Lives: The Anthropologist as Author* (Stanford, Calif.: Stanford University Press, 1988), esp. 73-101.

65. Stephen A. Tyler, "Post-Modern Ethnography: From Document of the Occult to Occult Document," in Clifford and Marcus, eds. (n. 2 above), 122-140, esp. 128.

66. On the use of the generic he, see n. 63 above. Here we wish to highlight that postmodern ethnographers, like their traditional forebears, speak from the male/dominant position and have seen self-reflection, collaboration, and textual experimentation as "new" only when it has been practiced by men.

67. Friedrich (n. 1 above), 246-61.

68. Geertz; Clifford, *The Predicament of Culture* (n. 60 above), esp. 92-113, 117-151; and Strathern, "Out of Context: The Persuasive Fictions of Anthropology" (n. 6 above).

69. Strathern, "Out of Context: The Persuasive Fictions of Anthropology," 269.

Western white males were of supreme importance in the lives of the "other" just at this moment when the anthropologist fears his irrelevance.

Such paradoxes, which emerge from the wedding of postmodernism with anthropology, pose the most difficult questions for practitioners of the new ethnography at present: once one articulates an epistemology of free play in which there is no inevitable relationship between signifier and signified, how is it possible to write an ethnography that has descriptive force? Once one has no metanarratives into which the experience of difference can be translated, how is it possible to write any ethnography? Here, too, lessons from feminism may be helpful; since current feminist theory lives constantly with the paradoxical nature of its own endeavor, it offers postmodernism models for dealing with contradiction. As Nancy Cott suggests, feminism is paradoxical in that it "aims for individual freedoms by mobilizing sex solidarity. It acknowledges diversity among women while positing that women recognize their unity. It requires gender consciousness for its basis, yet calls for the elimination of prescribed gender roles." Postmodern thought has helped feminists to argue that women's inferior status is a product of cultural and historical constructions and to resist essentialist truth claims, but the danger for feminists is that "in deconstructing categories of meaning, we deconstruct not only patriarchal definitions of 'womanhood' and 'truth' but also the very categories of our own analysis— 'women' and 'feminism' and 'oppression.'"[70]

That feminist theory, with its recent emphasis on the diversity of women's experience, has not succumbed entirely to the seduction of postmodernism and the dangers inherent in a complete decentering of the historical and material is due in part to feminist theory's concern with women as the central category of analysis and with feminism's political goal of changing power relationships that underlie women's oppression. Feminists will not relinquish the claim to understanding women's gendered experience in the hierarchical world in which we continue to live.[71]

This situatedness affords feminists a ground for reclaiming objectivity for our enterprise while at the same time recognizing the partiality of truth claims. Recent works by feminist critics of science have challenged traditional definitions of objectivity as disinterestedness and have reappropriated the term for the situated truth that feminism seeks. This argument is well stated by Mary Hawkesworth: "In the absence of claims of universal validity, feminist accounts derive their justificatory force from their capacity to illuminate existing social relations, to demonstrate the deficiencies of alternative interpretations, to debunk opposing views. Precisely because feminists move beyond texts to confront the world, they can provide concrete reasons in specific contexts for the superiority of their accounts....At their best, feminist analyses engage both the critical intellect and the world; they surpass androcentric accounts because in their systematicity more is examined and less is assumed."[72] Truth can only emerge in particular circumstances; we must be wary of generalizations. Such a politics demands and enables feminists to examine for whom we write. Strathern is one anthropologist who has found this lesson of value: "In describing Melanesian marriage ceremonies, I must bear my Melanesian readers in mind. That in turn makes problematic the previously established distinction between writer and subject: I must know on whose behalf and to what end I write."[73]

Hidden power relations constitute problems not only for women and for feminist scholarship but also for men and for the dominant discourse whose claims to objectivity are marred by distortions and mystification. The very fictional forms that in postmodern epistemology are the ideal vehicles for uncovering these power relations actually may tempt the new ethnographer to write without deciding who the audience is. The new ethnography must embed

70. Nancy Cott, quoted in Joanne Frye, "The Politics of Reading: Feminism, the Novel and the Coercions of 'Truth'" (paper presented at the annual meeting of the Midwest Modern Language Association, Columbus, Ohio, November 1987), esp. 2.

71. Ibid.

72. Mary E. Hawkesworth, "Knowers, Knowing, Known: Feminist Theory and Claims of Truth," *Signs* 14, no. 3 (Spring 1989): 533-57, esp. 557.

73. Strathern, "Out of Context: The Persuasive Fictions of Anthropology," esp. 269.

its theory in a grounded politics rather than turning to a currently popular aesthetic without interrogating the way in which that thinking is potentially subversive of anthropology's own political agenda.

It is true that postmodernism, with its emphasis on the decentering of the Cartesian subject, can be invigorating to those traditionally excluded from discourse. Jane Flax has stressed this liberating potential, arguing that postmodern experimentation encourages us "to tolerate and interpret ambivalence, ambiguity, and multiplicity."[74] Similarly, historian Joan Scott has recently argued that the postmodern rejection of the notion that humanity can be embodied in any universal figure or norm to which the "other" is compared acts to decenter the Western white male.[75] In Craig Owens's words: "The postmodern work attempts to upset the reassuring stability of [the] mastering position [of the] subject of representation as absolutely centered, unitary, masculine."[76] Indeed, this seems to be the political motivation underlying the new ethnography, but actual postmodern writing may not serve these political ends. Rather, it may erase difference, implying that all stories are really about one experience: the decentering and fragmentation that is the current experience of Western white males.

Moreover, even if we grant that postmodernism's potential lies in its capacity to decenter experience, a number of questions still arise. Can we think of difference without putting it against a norm? Can we recognize difference, but not in terms of hierarchy?[77] Perhaps more to the point in terms of the new ethnography, what are the implications of polyvocality? If the postmodernist emphasis on multivocality leads to a denial of the continued existence of a hierarchy of discourse, the material and historical links between cultures can be ignored, with all voices becoming equal, each telling only an individualized story. Then the history of the colonial, for example, can be read as independent of that of the colonizer. Such readings ignore or obscure exploitation and power differentials and, therefore, offer no ground to fight oppression and effect change. Moreover, in light of the diversity of the experience that the new ethnography wishes to foreground, anthropologists need to consider what provisions will have to be made for interdiscursive unintelligibility or misinterpretation. The traditional ethnographer's translation of other cultures into the discourse of Western social science long has been recognized to be problematic. A text that subtly orchestrates the translation of that experience in the mind of each reader, an interpreter who may be able to draw only on commonsense categories saturated with the assumptions of the Western tradition, is certainly no less so. However brilliant the deconstruction of the text of culture, however eloquent the oral history of the informant, the "other" may still be reconstituted in the language of the dominant discourse if there in not an analysis that "regards every discourse as a result of a practice of production which is at once material, discursive, and complex."[78] Without a politically reflexive grounding, the "other" too easily can be reconstituted as an exotic in danger of being disempowered by that exoticism.

Furthermore, the new ethnography's shift from a scientific to a more literary discourse may constitute a masking and empowering of Western bias rather than a diffusing of it. When the new ethnography borrows from literary narrative in an effort to rid itself of a unitary, totalizing narrative voice, it turns understandably, if ironically, to modern fiction for its models. The disappearance of the omniscient, controlling narrative voice that comments on the lives of all characters and knows their inner secrets is crucial to the modernist transformation of fiction evident in the works of writers like Joseph Conrad, Henry James, Virginia Woolf, James Joyce, Gertrude Stein, and William Faulkner, a transformation that coincided with the breakdown of colonialism. As critics have pointed out, authors who experiment with point of view, presenting a seeming jumble of

74. Flax (n. 26 above), 643.

75. Joan Scott, "History and the Problem of Sexual Difference" (lecture presented at Simon's Rock of Bard College, Great Barrington, Mass., November 1987).

76. Owens (n. 26 above), 58.

77. Scott.

78. J. Henriques, W. Holloway, C. Urwin, C. Venn, and V. Walkerdine, *Changing the Subject* (London and New York: Methuen, 1984), esp. 106.

perspectives and subjectivities in a variety of voices, may well be writing no more open texts than classic works in which all action is mediated by a unitary narrative voice.[79] The literary techniques of fragmentation, metaphor, thematic and verbal echo, repetition, and juxtaposition, which the new ethnography borrows, are all devices through which an author manipulates understanding and response. They function to structure the reader's experience of the apparently discontinuous, illogical, and fragmentary text. Through them, and by refusing to speak his or her views and intentions directly, the author achieves a more complete mastery.[80] Anthropologists seeking to write new ethnography and borrowing this range of devices from literature may unknowingly in the process pick up literary emphasis on form and the aesthetic of wholeness, both of which constitute traps for the ethnographer. These aesthetic criteria invite the manipulation of narrative devices in polyvocal works, whose apparent cacophony mirrors the diversity and multiplicity of individual and cultural perspectives, subtly to resolve all elements into a coherent and pleasing whole. These narrative devices potentially structure and control as surely as does the narrator of classic works, whether literary, historical, or ethnographic.[81]

These cautions can, of course, be viewed as excessively formalist, as failing to see the new ethnography as more than stylistic innovation. Stephen Tyler, in his incantatory, wildly enthusiastic

—though, perhaps, self-contradictory—celebration of new ethnography, labels such a view a "modernist perversion."[82] To him, the new ethnographic writing is evocative rather than representational; like ritual or poetry "it makes available through absence what can be conceived but not represented."[83] Indeed, readers wishing to experience the self-congratulatory ideology underlying the new ethnography, unqualified by subtlety or academic caution, should read Tyler's unproblematized claims: that postmodernist ethnography emphasizes "the cooperative and collaborative nature of the fieldwork situation" and "the mutual dialogic production of discourse";[84] that in privileging discourse over text it is concerned "not …to make a better representation, but…to avoid representation";[85] that it is "the meditative vehicle for a transcendence of time and place."[86] Tyler says that "ethnographic discourse is not part of a project whose aim is to create universal knowledge,"[87] but rather the "consumed fragment" of an understanding that is only experienced in the text, the text which is evocative and participatory, bringing the joint work of ethnographer and his native partners together with the hermeneutic process of the reader.[88]

However, Jonathan Friedman, coming at this from a Marxist perspective, and Judith Stacey, from a feminist one, are highly skeptical of the claim that postmodernist revision of ethnographic practice is significantly more than a matter of style. Friedman calls for a dialogue that is intertextual, not merely intratextual, since "it is clearly the case that the single dialogic text may express the attempt to recapture and thus neutralize, once more, the relation between us and them by assuming that the anthropologist can represent the other's voice."[89] Stacey argues that "acknowledging partiality and taking responsibility for authorial construction" are not enough: "The

79. See Roland Barthes, *S/Z*, trans. Richard Miller (New York: Hill & Wang, 1974); and Wayne Booth, *The Rhetoric of Fiction* (Chicago: University of Chicago Press, 1961).

80. Shoshana Felman, "Turning the Screw of Interpretation," *Yale French Studies* 55/56 (1977): 94-208, esp. 203-7.

81. This has been acknowledged by Clifford in *The Predicament of Culture* (n. 60 above) as well as by Geertz (n. 64 above), and has been well described by Bruce Kapferer in his review of both books in "The Anthropologist as Hero: Three Exponents of Post-Modernist Anthropology," *Critique of Anthropology* 8, no. 2 (1988): 77-104, esp. 98. According to Kapferer, "Present attempts to give voice—edited texts of tape recorded interviews, for example—can be made into the vehicle for the ethnographer's own views. The ethnographer hides behind the mask of the other. This could be more insidious than in the less self-conscious ethnography of yore. It can be another mode by which the other in appropriated and controlled."

82. Tyler (n. 65 above), 129.

83. Ibid., 123.

84. Ibid., 126.

85. Ibid., 128.

86. Ibid., 129.

87. Ibid., 131.

88. Ibid., 129-30.

89. Jonathan Friedman, "Comment," *Current Anthropology* 29, no. 3 (June 1988): 426-27, esp.427.

postmodern strategy is an inadequate response to the ethical issues endemic to ethnographic process and product."[90] The new ethnography threatens to subsume the "other" either in a manipulative, totalizing form whose politics is masked, or in the historically contingent discourse of each reader's response. In their borrowing of techniques from fiction, new ethnographers do not claim to write purely imaginative works. They continue to make some truth claims: their use of dialogue is presented as reflecting their experience in the field, and the fragmentation of their texts is presented as mirroring their postmodern condition. As Tyler puts it, "We confirm in our ethnographies our consciousness of the fragmentary nature of the post-modern world, for nothing so well defines *our world* as the absence of a synthesizing allegory."[91]

This is not true for non-Western males or for all women. The supposed absence of all metanarratives —the experience of helplessness and fragmentation —is the new synthesizing allegory that is being projected onto white women and Third World peoples who only recently have been partially empowered. To the extent that the new ethnography's political strength lies in a social criticism based on the "sophisticated reflection by the anthropologist about herself and her own society that describing an alien culture engenders," as Marcus and Fischer have suggested, it is disheartening as anthropology.[92] It has lost its claim to describe the "other" and yet seems devoid of the capacity to empower anyone but the writer and the reader for whom it serves as academic collateral or therapy. Anthropology is potentially reduced to an identity ritual for the anthropologist. If the new ethnography is that, then it must be seen as a facet of postmodernism's ultimate defense of the privilege of the traditional subject, even as, paradoxically, it deconstructs subject status.

While postmodern thinking has indeed invigorated many academic disciplines, anthropology must reconsider the costs of embracing it. Those anthropologists sensitive to the power relations in the ethnographic enterprise who wish to discover ways of confronting them ethically would do better to turn to feminist theory and practice than to postmodernism. Ultimately, the postmodern focus on style and form, regardless of its sophistication, directs our attention away from the fact that ethnography is more than "writing it up." From women's position as "other" in a patriarchal culture and from feminists' dialogue and confrontation with diverse groups of women, we have learned to be suspicious of all attempts by members of a dominant group to speak for the oppressed, no matter how eloquently or experimentally. Politically sensitive anthropologists should not be satisfied with exposing power relations in the ethnographic text, if that is indeed what the new ethnography accomplishes, but rather should work to overcome these relations. By turning to postmodernism, they may instead be (unwittingly or not) reinforcing such power relations and preserving their status as anthropologists, as authoritative speakers. Anthropologists may be better able to overcome these power relations by framing research questions according to the desires of the oppressed group, by choosing to do work that "others" want and need, by being clear for whom they are writing, and by adopting a feminist political framework that is suspicious of relationships with "others" that do not include a close and honest scrutiny of the motivations for research.

Within Western culture, women's position has been paradoxical. Like a Third World person who has been educated at Oxbridge, we feminist scholars speak at once as the socially constituted "other" and as speakers within the dominant discourse, never able to place ourselves wholly or uncritically in either position. Similarly, although ethnographers are speakers of the dominant discourse, they know the experience of otherness, albeit a self-inflicted and temporally limited one, from their time in the field. They may be able to draw on their experiences as outsiders in that situation to help them clarify their political and personal goals and to set their research agendas. While it is complex and uncomfortable to speak from a position that is neither inside nor outside, it is this position that necessitates that we merge our scholarship with a clear politics to work against the forces of oppression.

90. Stacey (n. 51 above), 26.

91. Tyler, 132 (emphasis ours).

92. Marcus and Fischer (n.2 above), 4.

Jean-François Lyotard (1925-)

Universal History and Cultural Differences

Translated by David Macey

It is not advisable to grant the genre of narrative any absolute privilege over other discursive genres when we come to analyse human phenomena, and particularly the phenomenon of language (ideology); it is still less advisable to do so when we adopt a philosophical approach. Certain of my earlier reflections ('Présentations', 'Lessons in Paganism', and even *The Post-Modern Condition*) may have succumbed to this 'transcendental appearance'. It is, on the other hand, advisable to approach one of the great questions posed for us by the historical world as the end of the twentieth century (or the beginning of the twenty-first) by examining some 'stories' or 'histories'. For to declare the world to be historical, is to assume that is can be treated in narrative terms.

The question I am thinking of is as follows: can we continue today to organize the multitude of events that come to us from the world, both the human and the non-human world, by subsuming them beneath the idea of a universal history of humanity? I do not intend to discuss this question as a philosopher. Even so, the formulation calls for certain clarifications.

1 I begin by saying: 'can we *continue* to organize...?' The word implies that this was previously the case. I am in fact referring here to a tradition: that of modernity. Modernity is not an era in thought, but rather a mode (this is the Latin origin of the word) of thought, of utterances, of sensibility. Erich Auerbach saw its dawnings in the writing of Augustine's *Confessions*: the destruction of the syntactic architecture of classical discourse and the adoption of a paratactic arrangement of short sentences linked by the most elementary of conjunctions: and. Both

he and Bakhtin find the same mode in Rabelais and then in Montaigne.

For my own part, and without attempting to legitimate this view here, I see signs of this in the first-person narrative genre chosen by Descartes to expound his method. The *Discours* is another confession. But what it confesses is not that the ego (*moi*) has been dispossessed by God; it confesses to the ego's attempt to master every *datum*, including itself. The *and* that links the sequences expressed by his sentences leaves room for contingency, and Descartes attempts to graft on to it the finality of a series organized with a view to mastering and possessing 'nature'. (Whether or not he succeeds is another matter.) This modern mode of organizing time is deployed by the *Aufklärung* of the eighteenth century.

The thought and action of the nineteenth and twentieth centuries are governed by an Idea (I am using Idea in its Kantian sense). That idea is the idea of emancipation. What we call philosophies of history, the great narratives by means of which we attempt to order the multitude of events, certainly argue this idea in very different ways: a Christian narrative in which Adam's sin is redeemed through love; the *Aufklärer* narrative of emancipation from ignorance and servitude thanks to knowledge and egalitarianism; the speculative narrative of the realization of the universal idea through the dialectic of the concrete; the Marxist narrative of emancipation from exploitation and alienation through the socialization of labour; the capitalist narrative of emancipation from poverty through technical and industrial development. These various narratives provide grounds for contention, and even for disagreement. But they all situate the data supplied

by events within the course of a history whose end, even if it is out of reach, is called freedom.

2 Second clarification. When we say, 'Can we continue to organize…', we at least accept, even if the (implicit) answer is negative ('We cannot')…we at least accept that a *we* still exists, and thus it is capable of thinking or experiencing this continuity or discontinuity. And the same question also asks what this *we* consists of. As the first person plural pronoun indicates, it refers to a community of subjects: you and I or they and I, depending on whether the speaker is addressing other members of the community (you/I) or a third party (you/they and I) for whom the other members it represents are designated by the third person (they). The question then arises as to whether or not this *we* is independent of the Idea of a history of humanity.

Within the tradition of modernity, the movement towards emancipation is a movement whereby a third party, who is initially outside the *we* of the emancipating avant-garde, eventually becomes part of the community of real (first person) or potential (second person) speakers. Eventually, there will be only a *we* made up of *you* and *I*. Within this tradition, the position of the first person is in fact marked as being that of the mastery of speech and meaning; let the people have a political voice, the worker a social voice, the poor an economic voice, let the particular seize hold of the universal, let the last be first! Forgive me if I over-simplify.

It follows that, being torn between the present minority situation in which third parties count for a great deal and in which you and I count for little, and the future unanimity in which third parties will, by definition, be banished, the *we* of the question I am asking reproduces the very tension humanity must experience because of its vocation for emancipation, the tension between the singularity, contingency and opacity of its present, and the universality, self-determination and transparence of the future it is promised. If that is indeed the case, the *we* which asks the question 'Shall we continue to think and act on the basis of the Idea of a hstory of humanity' is at the same time raising the question of its own identity insofar as it has been established by the modern tradition. And if the answer to the question has to be no (no, human history as a universal history of emancipation is no longer credible), then the status of the *we* which asks the question must also be reviewed.

It seems that it is condemned (but it is only in the eyes of modernity that this is a condemnation) to remain particular, to remain (perhaps) *you* and *I*, and to exclude a lot of third parties. But as it has not (yet) forgotten that they were potentially first persons, and were even destined to become first persons, it must either mourn for unanimity and find another mode of thinking or acting, or to be plunged into incurable melancholia by the loss of an 'object' (or the impossibility of a subject): free humanity. In either event we are affected by a sort of sorrow. The work of mourning, Freud teaches us, consists of recovering from the loss of a love object by withdrawing libido from the lost object and restoring it to the subject, withdrawing it from them and restoring it to us.

This can be done in several ways. Secondary narcissism is one such way. Many observers say that this is now the hegemonic mode of thought and action in the most highly developed societies. I fear that it is simply a blind (compulsive) repetition of an earlier period of mourning, of the period in which we mourned God, of the very period which gave rise to the modern world and to its project of conquest. To pursue that conquest today would simply mean perpetuating the conquest of the moderns, the only difference being that the notion of reaching unanimity has been abandoned. Terror is no longer exercised in the name of freedom, but in the name of 'our' satisfaction, in the name of the satisfaction of a *we* which is definitely restricted to singularity. And if I judge this prospect intolerable, am I still being too modern? Its name is tyranny: the law which 'we' decree is not addressed to *you*, to you fellow-citizens or even to you subjects; it is applied to *them*, to third parties, to those outside, and it is simply not concerned with being legitimized in their eyes. I recall that Nazism was one such way of mourning emancipation and of exercising, for the first time in Europe since 1789, a terror whose reason was not in theory accessible to all and whose benefits were not shared by all.

Another way to mourn the universal emancipation promised by modernity might be to 'work through' (in Freud's sense) not only the loss of the object, but also the loss of the subject who was promised this future. This would not simply be a matter of recognizing that we are finite; it would be a way of working through the status of the *we* and the question of the subject. What I mean is this: avoiding both the unthinking dismissal of the modern subject, and its parodic or cynical repetition (tyranny). This working-through will, I believe, inevitably lead to the abandoning of the linguistic-communication structure (I/you/he/she) which, consciously or otherwise, the moderns endorsed as an ontological and political model.

3 My third clarification pertains to the words '*can we*' in the question 'Can we continue to organize events on the basis of the Idea of a universal history of humanity?' As Aristotle and linguists know, when it is applied to a notion (in the present case the notion of the pursuit of a universal history), the modality of *can* simultaneously entails the affirmation and the negation of that notion. That the pursuit is possible implies neither that it will take place nor that it will not take place, but it certainly implies that the fact of its taking place or not taking place will take place. The content or the *dictum* (the affirmation or negation of the motion) is uncertain; the subsequent *modus* is, *de facto*, necessary. We recognize here Aristotle's thesis about contingent futures. (But they still have to be dated.)

But the expression *we can* does not merely connote possibility; it also indicates capacity. Is it within our power, our strength or our competence to perpetuate the modern project? This question indicates that the project requires strength and competence if it is to be sustained, and perhaps that we may lack that strength and competence. This reading should inspire an inquiry, an inquiry into the defaillancy (*défaillance*) of the modern subject. And if we argue the case for its defaillancy, we must prove it, by referring to facts or at least to signs. Their interpretation may well give rise to controversy, but they must at least be subjected to the cognitive procedures used to establish facts or to the

speculative procedures used to validate signs. (I refer here without further explanation to the Kantian problematic of hypotoses, which plays a major role in Kant's politico-historical philosophy.)

Without wishing to decide immediataly whether we are dealing with facts or signs, it seems difficult to refute the available evidence of the defaillancy of the modern subject. No matter which genre it makes hegemonic, the very basis of each of the great narratives of emancipation has, so to speak, been invalidated over the last fifty years. All that is real is rational, all that is rational is real: 'Auschwitz' refutes speculative doctrine. At least that crime, which was real, was not rational. All that is proletarian is communist, all that is communist is proletarian: 'Berlin 1953, Budapest 1956, Czechoslovakia 1968, Poland 1980' (to mention only the obvious examples) refute the doctrine of historical materialism: the workers rise up against the Party. All that is democratic exists through and for the people, and vice versa: 'May 1968' refutes the doctrine of parliamentary liberalism. If left to themselcves, the laws of supply and demand will result in universal prosperity, and vice versa: 'the crises of 1911 and 1929' refute the doctrine of economic liberalism. And 'the 1974-9 crisis' refutes the post-Keynesian adjustments that have been made to that doctrine.

The enquirer finds in the names of these events so many signs of the defaillancy of modernity. The great narratives are now barely credible. And it is therefore tempting to lend credence to the great narrative of the decline of great narratives. But, as we know, the great narrative of decadence is there in the very beginnings of Western thought, in Hesiod and Plato. It dogs the narrative of emancipation like a shadow. And so nothing has changed, except that greater strength and competence are required if we are to face up to our current tasks. Many believe that this is the moment for religion, the moment to reconstruct a credible narration which will tell the story of how the *fin de siécle* was wounded, and of how its scars healed. They point out that myth is the original genre, that the thought of origins appears in myths in all its originary paradox, and that we must restore the ruins to which rational, demythologizing and positivist thought has reduced it.

This does not seem to me to be the right direction at all. In any case, it should be noted that in this brief description the term *can* has undergone a further modification, as is evident from the use I have just made of the word *right*. The answer to the question 'Can we perpetuate great narratives?' has become 'We *must* do this or that'. 'Can' also has the meaning of having the right, and in that sense the word introduces into thought the universe of deontology; it is as easy to move from right to duty as it is to move from permissable to obligatory. And what is at stake here is the contingency of what follows on from the situation I have described as the defaillancy of modernity. There are several possible ways to follow on, and we have to decide between them. Even if we decide nothing, we still decide. Even if we remain silent, we still speak. Politics depends entirely upon how we follow on from one sentence to the next. This is not a matter of the volume of discourse, nor of the importance of the speaker or the addressee. One of the sentences which are currently possible will become real, and the real question is: which? A description of defaillancy does not give us even the beginnings of an answer to that question. This is why the word *postmodernity* can refer simultaneously to the most disparate prospects. These few remarks are simply intended to indicate the antimythologizing manner in which we must 'work through' the loss of the modern we.

It is now time to turn to the subject indicated by the title of this exposé. I wonder if the defaillancy of modernity, in the shape of what Adorno called the collapse of metaphysics (which for him found its concentrated expression in the failure of the affirmative dialectic of Hegelian thought when confronted with the Kantian thesis of obligation or the event of the insensate annihilation known as Auschwitz)...I wonder if this defaillancy might not have to be related to resistance on the part of what I will term the multiplicity of worlds of names, on the part of the insurmountable diversity of cultures. I will end by approaching the question in these terms, by returning to and reformulating certain aspects which I have already touched upon, and which concern the universality of our great narratives, the status of the *we*, the reason for the defaillancy of modernity and, finally, the contemporary question of legitimation.

A child or an immigrant enters into a culture by learning proper names. He has to learn the names used to designate relatives, heroes (in the broad sense of the word), places, dates and, I would add, following Kripke, units of measure, of space, of time and of exchange-value. These names are 'rigid designators'; they signify nothing or can, at least, acquire different and debatable significations; they can be linked to sentences from totally heterogeneous regimes (descriptive, interrogative, ostensive, evaluative, prescriptive, etc.). Names are not learned in isolation; they are embedded in little stories. The advantage of a story is, I repeat, that it can contain within it a multiplicity of heterogeneous families of discourse, provided that it expands, so to speak. It arranges them into a sequence of events designated by the culture's proper names.

This organization has a high degree of coherence, and its coherence is further reinforced by the mode of the narrative's transmission, and that mode is particularly visible in what I will, for convenience, term 'primitive' societies. André Marcel d'Ans writes: 'Amongst the Cashinahua, any interpretation of a *miyoi* (myth, tale, legend or traditional piece of writing) begins with a set formula: "This is the story of ... as I have always heard it told. In my turn I will tell it to you. Listen to it." And the recitation invariably ends with another formula: "Here ends the story of ... He who told you it was ... (Cashinahua name), who is known to the whites as (Spanish or Portuguese name)." The ethnologist tells us whites how the Cashinahua story teller tells Cashinahua listeners the story of a Cashinahua hero. The ethnologist can do so because he himself is a (male) Cashinahua listener. He is a listener because he has a Cashinahua name. The import and recurrence of the stories is ritually determined by strict rules. All the sentences in a story are, so to speak, pinned to agencies which have been named or can be named in the Cashinahua language. Whatever its regime, each of the universes presented by each of these sentences refers to a world of names. The hero or heroes, places, the sender and the receiver are meticulously named.

In order to hear these stories, one must have been named (all males and prepubertal girls can listen). In order to tell them, one must have been named (only men can tell stories). In order to have a story told about one (to be a referent), one must have been named (stories can be told about any Cashinahua; there are no exceptions). By putting the names into stories, narration protects the rigid designators of a common identity from the events of the 'now', and from the dangers of what follows on from it. To be named is to be recounted. In two ways: every story, no matter how anecdotal it may seem, reactivates names and nominal relations. And by repeating that story, the community reassures itself as to the permanence and legitimacy of its world of names thanks to the recurrence of that world in its stories. And certain stories are explicitly about the giving of names.

If we raise the question of the origin of tradition or of authority amongst the Cashinahua in positive terms, we are faced with the usual paradox. A sentence is, one might think, authorized only if its sender enjoys a certain authority. What happens when the authority of the sender derives from the meaning of a sentence? By legitimizing the sender described by its universe, the sentence itself gains legitimacy in the eyes of the addressee. The Cashinahua narrator derives his authority from telling stories in his name. But his name is authorized by his stories, and especially by those which recount the genesis of names. This *circulus vitiosus* is common.

We see here the discursive workings of what might be called a 'very large scale integrated culture' [English in the original]. Identification reigns supreme. A self-enclosed culture eliminates scraps of stories and elements that cannot be integrated by making sacrifices, taking drugs (as amongst the Cashinahua), or by fighting wars on its borders.

Mutatis mutandis, the self-identification of a culture involves this same mechanism. Its dismemberment, in a situation of colonial, imperialist or servile dependency, signifies the destruction of its cultural identity. On the other hand, this mechanism is also the principal strength of guerrillas fighting for independence, as narrative and its transmission provides resistance with both legitimacy (right) and logistics (mode of transmission of messages, identification of places and moments, use of natural elements within a cultural tradition, etc.).

We have said that the power of the narrative mechanism confers legitimacy: it encompasses the multiplicity of families of sentences and of possible discursive genres; it could always be actualized, and still can be; being diachronic and parachronic, it ensures mastery over time, and therefore over life and death. Narrative is authority itself. It authorizes an unbeakable *we*, outside of which there can only be *they*.

Such an organization is in every respect the complete opposite of that of the great narratives of legitimation that characterize Western modernity. The latter are cosmopolitical, as Kant would put it. They are concerned of course with the 'transcendence' of particular cultural identities in favour of a universal civic identity. But how that transcendence takes place is far from obvious.

There is nothing in a savage society to lead it to dialecticalize itself into a society of citizens. To say that it is human and already prefigures a universality is to admit that the problem has been solved; the humanist presupposes the idea of a universal history and inscribes particular communities within it as moments within the universal development of human communities. This is also, *grosso modo*, the axiom of the great speculative narrative as applied to human history. But the real question is whether or not there is a human history. The epistemological version is the most prudent, but it is also the most disappointing; in accordance with the rules of the cognitive genre, anthropology describes savage narrations and their rules without pretending to establish any continuity between them and the rules of its own mode of discourse. In its Lévi-Straussean version, it may introduce a functional, or in other words 'structural' identity between the myth and its explanation, but it does so at the cost of abandoning any attempt to find an intelligible transition between the two. Identity, but no history.

We are familiar with all these difficulties, and they are trivial. I recall them simply because they may allow us to take better stock of the import of our contemporary defaillancy. It is as though the immense effort, signalled by the name of the

Declaration of Rights, that has been made to strip peoples of a narrative legitimacy which lies, so to speak, downstream in historical terms, and to make them adopt as their sole legitimacy the Idea of free citizenship, which lies upstream...it is as though an effort that has, in various ways, been going on for two hundred years, had ended in failure. We might even find a harbinger of its failure in the very designation of the author of a declaration with a universal import: 'We, the French people'.

The labour movement provides a particularly convincing example of this failure. Its theoretical internationalism meant of course that the class struggle did not derive its legitimacy from local popular or working-class traditions, but from an Idea that was to be realized: the idea of the worker emancipated from the proletarian condition. But we know that as soon as war broke out between France and Germany in 1870, the International broke up over the Alsace-Lorraine question, that in 1914 both French and German socialists voted war credits in their respective countries, and so on. By beginning the construction of socialism in one country and by abolishing Comintern, Stalinsim openly ratifies the superiority of national proper names over the universal name of 'soviets'. The rise of independence struggles after the Second World War and the recognition of new national names seem to indicate a strengthening of local legitimacies and the disappearance of any prospect of universal emancipation. Newly 'independent' governments enter the sphere of influence of either the capitalist market or the Stalinist-style political apparatus, and the 'leftists' who were fighting for universal emancipation are eliminated without mercy. As the current slogan of the far right in France has it: *French first* (which implies that freedom comes second).

It might be said that this retreat into local legitimacy is a reaction to and a form of resistance against the devastating effects imperialism and its crisis are having on particular cultures. This is true; it confirms the diagnosis, and makes it worse. For the rebuilding of the world market after the Second World War and the immense economic-financial battles now being waged by the multinational companies and banks, with support from national states, to win that market offers no cosmopolitan prospects. Even if the partners in this game could boast of having reached goals set by the economic liberalism or the Keynesianism of the modern age, it would be difficult to give them any credit, as it is perfectly clear that their game is doing nothing to reduce the inequality of wealth in the world, and is in fact increasing it, that it is not breaking down national barriers but using them for speculative economic and financial ends. The world market is not creating a universal history in modernity's sense of that term. Cultural differences are, moreover, being promoted as touristic and cultural commodities at every point on the scale.

And what, finally, is the '*we*' which tries to think this situation of defaillancy, if not the kernel, the minority, the avant-garde which prefigures today the free humanity of tomorrow? When we try to think that, do we simply condemn ourselves to being negative heroes? It is at least clear that one figure of the intellectual (Voltaire, Zola, Sartre) has disintegrated as a result of this defaillancy. That figure was once supported by the recognized legitimacy of the Idea of emancipation, and it was, for better or worse, part of the history of modernity. But the violence of the critique addressed to education in the 1960s, followed by the inexorable degradation of educational institutions in all modern countries, clearly shows that knowledge and its transmission have ceased to exercise the authority which once made people listen to the intellectuals when they moved from the professorial chair to the public platform. In a world in which success means saving time, thinking has only one disadvantage, but it is an irredeemable disadvantage: it makes you waste time.

Such, in simplified form, is the question I ask myself, or which has to be asked. I do not intend to answer it here, but merely to discuss it. Certain elements which I have not noted in this exposé may become more explicit in the course of the discussion. Now that the age of the intellectuals, and that of the parties, is over, it might, without wishing to be presumptuous, be useful, on both sides of the Atlantic, to begin to trace a line of resistance against our modern defaillancy.

Richard Rorty (1931-)

Cosmopolitan Without Emancipation: A Response to Jean-François Lyotard

From *Objectivity, Relativism and Truth*

In the form John Dewey gave it, pragmatism is a philosophy tailored to the needs of political liberalism, a way of making political liberalism look good to persons with philosophical tastes. It provides a rationale for nonideological, compromising, reformist muddling-through (what Dewey called "experimentalism"). It claims that categorical distinctions of the sort philosophers typically invoke are useful only so long as they facilitate conversation about what we should do next. Such distinctions, Dewey says, should be blurred or erased as soon as they begin to hinder conversation—to block the road of inquiry.

Dewey thinks that muddle, compromise, and blurry syntheses are usually less perilous, politically, than Cartesian clarity. That is one reason why his books are so often thought bland and boring. For he neither erects an exciting new binary opposition in terms of which to praise the good and damn the bad, nor does he distinguish between bad binary oppositions and some wonderful new form of discourse which will somehow avoid using any such oppositions. He just urges us to be on our guard against using intellectual tools which were useful in a certain sociocultural environment after that environment has changed, to be aware that we may have to invent new tools to cope with new situations.

Dewey spent half his time debunking the very idea of "human nature" and of "philosophical foundations" for social thought. But he spent the other half spinning a story about univeral history—a story of progress according to which contemporary movements for social reform within the liberal democracies are parts of the same overall movement as the overthrow of feudalism and the abolition of slavery. He offered a historical narrative in which American democracy is the embodiment of all the best features of the West, while at the same time making fun of what Jean-François Lyotard, in his *The Postmodern Condition*, has called "metanarratives."

Dewey thought that we could have a morally uplifting historical narrative without bothering to erect a metaphysical backdrop against which this narrative is played out, and without getting very specific about the goal toward which it tends. Followers of Dewey like myself would like to praise parliamentary democracy and the welfare state as very good things, but only on the basis of invidious comparisons with suggested concrete alternatives, not on the basis of claims that these institutions are truer to human nature, or more rational, or in better accord with the universal moral law, than feudalism or totalitarianism. Like Lyotard, we want to drop *meta*narratives. Unlike him, we keep on spinning edifying first-order narratives.

So the pragmatist answer to the question Lyotard raises in his "Universal history and cultural differences"—"Can we continue to organize the events which crowd in upon us from the human and nonhuman worlds with the help of the Idea of a universal history of humanity?"[1]—is that we can and should, as long as the point of doing so is to lift our spirits through utopian fantasy, rather than to gird

1. Jean-François Lyotard, "Histoire universelle et différences culturelles," *Critique* 41 (May 1985), p. 559. This issue of *Critique* includes a French translation of the original version of my response to Lyotard, as well as a paper by Vincent Descombes ("Les mots de la tribu") which comments on the exchange between us, as well as on my earlier paper "Habermas, Lyotard, and Post-Modernity," reprinted in volume 2 of these papers, *Essays on Heidegger and Others*. *Critique* 41 also includes the transcript of a brief conversational exchange between me and Lyotard.

our loins with metaphysical weapons. We Deweyans have a story to tell about the progress of our species, a story whose later episodes emphasize how things can have been getting better in the West during the last few centuries, and which concludes with some suggestions about how they might become better still in the next few. But when asked about cultural differences, about what our story has to do with the Chinese or the Cashinahua, we can only reply that, for all we know, intercourse with these people may help modify our Western ideas about what institutions can best embody the spirit of Western social democracy.

We look forward, in a vague way, to a time when the Cashinahua, the Chinese, and (if such there be) the planets which form the Galactic Empire will all be part of the same cosmopolitan social democratic community. This community will doubtless have different institutions than those to which we are presently accustomed, but we assume that these future institutions will incorporate and enlarge the sorts of reforms which we applaud our ancestors for having made. The Chinese, the Cashinahua, and the Galactics will doubtless have suggestions about what further reforms are needed, but we shall not be inclined to adopt these suggestions until we have managed to fit them in with our distinctively Western social democratic aspirations, through some sort of judicious give-and-take.

This sort of ethnocentrism is, we pragmatists think, inevitable and unobjectionable. It amounts to little more than the claim that people can rationally change their beliefs and desires only by holding most of those beliefs and desires constant— even though we can never say in advance just which are to be changed and which retained intact. ("Rationally" here means that one can give a retrospective account of why one changed—how one invoked old beliefs or desires in justification of the new ones—rather than having to say, helplessly, "it just happened; somehow I got converted.") We cannot leap outside our Western social democratic skins when we encounter another culture, and we should not try. All we should try to do is to get inside the inhabitants of that culture long enough to get some idea of how we look to them, and whether they

have any ideas we can use. That is also all they can be expected to do on encountering us. If members of the other culture protest that this expectation of tolerant reciprocity is a provincially Western one, we can only shrug our shoulders and reply that we have to work by our own lights, even as they do, for there is no supercultural observation platform to which we might repair. The only common ground on which we can get together is that defined by the overlap between their communal beliefs and desires and our own.

The pragmatist utopia is thus not one in which human nature has been unshackled, but one in which everybody has had a chance to suggest ways in which we might cobble together a world (or Galactic) society, and in which all such suggestions have been thrashed out in free and open encounters. We pragmatists do not think that there is a natural "moral kind" coextensive with our biological species, one which binds together the French, the Americans, and the Cashinahua. But we nevertheless feel free to use slogans like Tennyson's "the Parliament of Man, the Federation of the World!" For we want narratives of increasing cosmopolitanism, though not narratives of emancipation. For we think that there was nothing to emancipate, just as there was nothing which biological evolution emancipated as it moved along from the trilobites to the anthropoids. There is no human nature which was once, or still is, in chains.[2] Rather, our species has—ever since it developed language—been making up a nature for itself. This nature has been developed through ever-larger, richer, more muddled, and more painful syntheses of opposing values.

Lately our species has been making up a particularly

2. See Bernard Yack, *The Longing for Total Revolution: Philosophical Sources of Social Discontent from Rousseau to Marx and Nietzsche.* (Princeton: Princeton University Press, 1986). Yack describes a tradition to which, as I see it, Foucault and Lyotard belong, but Dewey does not. It never occurred to Dewey that there was something inherently "repressive" about society as such, or something wrong with using bio-power to create subjects. He took over from Hegel the idea that you have to be socialized to be human, and that the important question is how you can maximize both richness of socialization and tolerance for individual eccentricity and deviance. That is a question which can be answered only by designing and performing a lot of painful and difficult social experiments, a lot more than we have so far envisaged.

good nature for itself—that produced by the institutions of the liberal West. When we praise this development, we pragmatists drop the revolutionary rhetoric of emancipation and unmasking in favor of a reformist rhetoric about increased tolerance and decreased suffering. If we have an Idea (in the capitalized Kantian sense) in mind, it is that of Tolerance rather than of Emancipation. We see no reason why either recent social and political developments or recent philosophical thought should deter us from our attempt to build a cosmopolitan world-society—one which embodies the same sort of utopia with which the Christian Enlightenment and Marxist metanarratives of emancipation ended.

Consider, in this light, Lyotard's claim that his question "Can we continue to organize the crowd of human events into a universal history of humanity?" presupposes that there "persists" a "we," and his doubt that we can preserve a sense for "we" once we give up the Kantian idea of emancipation.[3] My first reaction to such doubts is that we need not presuppose a *persistent* "we," a transhistorical metaphysical subject, in order to tell stories of progress. The only "we" we need is a local and temporary one: "we" means something like "us twentieth-century Western social democrats." So we pragmatists are content to embrace the alternative which Lyotard calls "secondary narcissism."[4] We think that, once we give up metaphysical attempts to find a "true self" for man, we can continue to speak as the contingent historical selves we find ourselves to be.

Lyotard thinks that adopting this alternative will land us pragmatic liberals in the same position as the Nazis were in: in renouncing unanimity we shall fall back on terror, on a kind of terror "whose rationale is not in principle accessible to everybody and whose benefits are not shareable by everybody."[5] Against this assimilation of the pragmatists inevitable ethnocentrism to Nazism, I would insist that there is an important difference between saying "We admit that we cannot justify our beliefs or our actions to all human beings as they are at present,

but we hope to create a community of free human beings who will freely share many of our beliefs and hopes," and saying, with the Nazis, "We have no concern for legitimizing ourselves in the eyes of others." There is a difference between the Nazi who says "We are good because we are the particular group we are" and the reformist liberal who says "We are good because, by persuasion rather than force, we shall eventually convince everybody else that we are." Whether such a "narcissistic" self-justification can avoid terrorism depends on whether the notion of "persuasion rather than force" still makes sense after we renounce the idea of human nature and the search for transcultural and ahistorical criteria of justification. If I have correctly understood Lyotard's line of thought, he would argue that the existence of incommensurable, untranslatable discourses throws doubt on this contrast between force and persuasion. He has suggested that the collapse of metaphysics diagnosed by Adorno can be seen as a recognition of the "multiplicity of worlds of names, the insurmountable diversity of cultures."[6] I take him to be saying that, because of this insurmountability, one culture cannot convert another by persuasion, but only by some form of "imperialist" force. When, for example, he says that "Nothing in a savage community disposes it to argue itself into a society of citizens {of Kant's cosmopolitan world-state},"[7] I interpret him to mean that when people from preliterate cultures go to mission schools and European universities, they are not freely arguing themselves into cosmopolitanism but rather being "forcibly" changed, terrorized. I assume that he would say that, when an anthropologist is so charmed by the tribe he studies that he abandons Europe and "goes native," he too has not been persuaded but has been, equally, "terrorized." Lyotard would be justified in these distressing claims if it were the case, as he says it is, that the anthropologist describes "the savage narrations and their rules according to cognitive rules, without pretending to establish any continuity between the latter and his own mode of discourse." But surely this is overstated. The anthropologist and the native agree, after all, on an enormous number of platitudes.

3. Lyotard, "Histoire universelle," pp. 560-1.

4. Ibid., p. 561.

5. Ibid., p. 562.

6. Ibid., p. 564.

7. Ibid., p. 566.

They usually share beliefs about, for example, the desirability of finding waterholes, the danger of fondling poisonous snakes, the need for shelter in bad weather, the tragedy of the death of loved ones, the value of courage and endurance, and so on. If they did not, as Donald Davidson has remarked, it is hard to see how the two would ever have been able to learn enough of each other's languages to recognize the other as a language user.

This Davidsonian point amounts to saying that the notion of a language untranslatable into ours makes no sense, if "untranslatable" means "unlearnable." If I can learn a native language, then even if I cannot neatly pair off sentences in that language with sentences in English, I can certainly offer plausible explanations in English of why the natives are saying each of the funny-sounding things they say. I can provide the same sort of gloss on their utterances which a literary critic offers on poems written in a new idiom or a historian of the "barbarism" of our ancestors. Cultural differences are not different in kind from differences between old and ("revolutionary") new theories propounded within a single culture. The attempt to give a respectful hearing to Cashinahua views is not different in kind from the attempt to give a respectful hearing to some radically new scientific or political or philosophical suggestion offered by one of our fellow Westerners.

So I think it is misleading to say, as Lyotard does in an essay on Wittgenstein, that Wittgenstein has shown that "there is no unity of language, but rather islets of language, each governed by a system of rules untranslatable into those of the others."[8] We need to distinguish between the following two theses: (1) there is no single commensurating language, known in advance, which will provide an idiom into which to translate any new theory, poetic idiom, or narrative culture; (2) there are unlearnable languages. The first of these theses is common to Kuhn, Wittgenstein, and the common sense of the anthropological profession. It is a corollary of the general pragmatist claim that there is no permanent ahistorical metaphysical framework into which everything can be fitted. The second thesis seems

to me incoherent. I do not see how we could tell when we had come against a human practice which we knew to be linguistic and also knew to be so foreign that we must give up hope of knowing what it would be like to engage in it.

Whereas Lyotard takes Wittgenstein to be pointing out unbridgeable divisions between linguistic islets, I see him as recommending the constructions of causeways which will, in time, make the archipelago in question continuous with the mainland. These causeways do not take the form of translation manuals, but rather of the sort of cosmopolitan know-how whose acquisition enables us to move back and forth between sectors of our own culture and our own history—for example, between Aristotle and Freud, between the language-game of worship and that of commerce, between the idioms of Holbein and of Matisse. On my reading, Wittgenstein was not warning us against attempts to translate the untranslatable but rather against the unfortunate philosophical habit of seeing different languages as embodying incompatible systems of rules. If one does see them in this way, then the lack of an overarching system of metarules for pairing off sentences—the sort of system which metanarratives were once supposed to help us get—will strike one as a disaster. But if one sees language-learning as the acquisition of a skill, one will not be tempted to ask what metaskill permits such acquisition. One will assume that curiosity, tolerance, patience, luck, and hard work are all that is needed.

This difference between thinking of linguistic mastery as a grasping of rules and as an inarticulable technique may seem a long way from the question of the possibility of universal history. So let me now try to connect the two topics. I have been suggesting that Lyotard sees languages as divided from one another by incompatible systems of linguistic rules, and is thereby committed to what Davidson has called "the third, and perhaps last, dogma of empiricism: the distinction between scheme and content."[9] He is committed, in particular, to the

8. Jean-François Lyotard, *Tombeau de l'intellectuel* (Paris Éditions Galilée, 1984) p. 61.

9. Donald Davidson, "On the Very Idea of a Conceptual Scheme," in his *Inquiries into Truth and Interpretation* (Oxford: Oxford University Press, 1984), p. 189.

claim that we can usefully distinguish questions of fact from questions of language, a claim attacked by Dewey and Quine. It seems to me that only with the help of that distinction can Lyotard cast doubt on the pragmatist attempt to see the history of humanity as the history of the gradual replacement of force by persuasion, the gradual spread of certain virtues typical of the democratic West. For only the claim that commensuration is impossible will provide philosophical grounds for ruling out this suggestion, and only the language-fact distinction will make sense of the claim that incommensurability is something more than a temporary inconvenience.

I can try to put this point in Lyotard's own vocabulary by taking up his distinctions between *litige* and *différend*, and between *dommage* and *tort*. He defines a *différend* as a case in which "a plaintiff is deprived of means of arguing, and so becomes a victim," one in which the rules of conflict resolution which apply to a case are stated in the idiom of one of the parties in such a way that the other party cannot explain how he has been injured.[10] By contrast, in the case of *litige*, where it is a question of *dommage* rather than *tort*, both sides agree on how to state the issues and on what criteria are to be applied to resolve them. In a very interesting and enlightening synthesis of philosophical and political problems, Lyotard suggests that we can see everything from the semantic paradoxes of self-reference to anticolonialist struggles in terms of these contrasts. Using this vocabulary, Lyotard's doubts about universal history can be put by saying that the liberal-pragmatist attempt to see history as the triumph of persuasion over force tries to treat history as a long process of litigation, rather than a sequence of *différends*.

My general reply to these doubts is to say that political liberalism amounts to the suggestion that we try to substitute litigation for *différends* as far as we can, and that there is no *a priori* philosophical reason why this attempt must fail, just as (*pace* Christianity, Kant, and Marx) there is no *a priori* reason why it must succeed. But I also want to raise doubts about Lyotard's choice of terminology. It

seems a bad idea—and indeed a suspiciously Kantian idea—to think of inquiry on the model of judicial proceedings. The philosophical tradition has pictured institutions or theories as being brought before the tribunal of pure reason. If this were the only model available, then Lyotard would have a point when he asks "what language do the judges speak?" But Dewey wanted to get rid of the idea that new ideas or practices could be judged by antecedently existing criteria. He wanted everything to be as much up for grabs as feasible as much of the time as feasible. He suggested that we think of rationality not as the application of criteria (as in a tribunal) but as the achievement of consensus (as in a town meeting, or a bazaar).

This suggestion chimes with Wittgenstein's suggestion that we think of linguistic competence not as the mastery of rules but as the ability to get along with other players of a language-game, a game played without referees. Both Dewey and Wittgenstein made the point which Stanley Fish has recently restated: that attempts to erect "rules" or "criteria" turn into attempts to hypostatize and eternalize some past or present practice, thereby making it more difficult for that practice to be reformed or gradually replaced with a different practice.[11] The Deweyan idea that rationality is not the application of criteria goes together with holism in the philosophy of language, and in particular with the claim that there are no "linguistic islets," no such things as "conceptual schemes" but only slightly different sets of beliefs and desires. Pace Lyotard's interpretation of Wittgenstein, it seems to me profoundly unWittgensteinian to say as he does that "there is no unity of language," or that "there is an irredeemable opacity at the heart of language."[12] For language no more has a nature than humanity does; both have only a history. There is just as much unity or transparency of language as there is willingness to converse rather than fight. So

10. Jean-François Lyotard, *Le Différend* (Paris: Éditions Minuit, 1983), pp. 24-5.

11. See Stanley Fish, "Consequences," in his *Doing What Comes Naturally: Change, Rhetoric, and the Practice of Theory in Literary and Legal Studies* (Durham, N. C.: Duke University Press, 1989). This essay was delivered as a contribution to the same symposium for which Lyotard's and my papers were written, and was published along with ours as "La théorie est sans conséquences" in *Critique* 41 (May 1985).

12. Lyotard, *Tombeau*, p. 84.

there is as much of either as we shall make in the course of history. The history of humanity will be a universal history just in proportion to the amount of free consensus among human beings which is attained—that is, in proportion to the replacement of force by persuasion, of *différends* by litigation.

On the holistic view of language elaborated by Quine and Davidson, distinctions between cultures, theories, or discourses are just ways of dividing up the corpus of sentences so far asserted into clusters. These clusters are not divided from one another by incompatible linguistic rules, nor by reciprocally unlearnable grammars. They represent no more than differences of opinion—the sorts of differences which can get resolved by hashing things out. So when we say that Aristotle and Galileo, or the Greeks and the Cashinahua, or Holbein and Matisse, did not "speak the same language," we should not mean that they carried around different Kantian categories, of different "semantic rules," with which to organize their experiences. Rather, we should mean merely that they held such disparate beliefs that there would have been no simple, easy, quick way for either to convince the other to engage in a common project. This phenomenon of disagreement cannot be explained by saying that they speak different languages, for that is a *virtus dormitiva* sort of explanation—like explaining the fact that people do different things in different countries by pointing to the existence of different national customs.

I can put the disagreement between Lyotard and myself in another way by saying that what he calls the *défaillance* of modernity strikes me as little more than the loss of belief in the first of the two theses I distinguished earlier—a loss of faith in our ability to come up with a single set of criteria which everybody in all times and places can accept, invent a single language-game which can somehow take over all the jobs previously done by all the language-games ever played. But the loss of this theoretical goal merely shows that one of the less important sideshows of Western civilization—metaphysics—is in the process of closing down. This failure to find a single grand commensurating discourse, in which to write a universal translation manual (thereby doing away with the need to constantly learn new languages) does nothing to cast doubt on the possibility (as opposed to the difficulty) of peaceful social progress. In particular, the failure of metaphysics does not hinder us from making a useful distinction between persuasion and force. We can see the preliterate native as being persuaded rather than forced to become cosmopolitan just insofar as, having learned to play the language-games of Europe, he decides to abandon the ones he played earlier—without being threatened with loss of food, shelter, or *Lebensraum* if he makes the opposite decision.

It is, of course, rare for a native to have been granted this sort of free choice. We Western liberals have had the Gatling gun, and the native has not. So typically we *have* used force rather than persuasion to convince natives of our own goodness. It is useful to be reminded, as Lyotard reminds us, of our customary imperialist hypocrisy. But it is also the case that we Western liberals have raised up generations of historians of colonialism, anthropologists, sociologists, specialists in the economics of development, and so on, who have explained to us in detail just how violent and hypocritical we have been. The anthropologists have, in addition, shown us that the preliterate natives have some ideas and practices that we can usefully weave together with our own. These reformist arguments, of a sort familiar to the tradition of Western liberalism, are examples of the ability of that tradition to alter its direction from the inside, and thus to convert *différends* into processes of litigation. One does not have to be particularly cheerful or optimistic about the prospects for such internal reform, nor about the likelihood of a final victory of persuasion over force, to think that such a victory is the only plausible political goal we have managed to envisage—or to see ever more inclusive universal histories as useful instruments for the achievement of that goal.

By "ever more inclusive" I mean such that one's conception of the goal of history—of the nature of the future cosmopolitan society—constantly changes to accomodate the lessons learned from new experiences (e.g., the sort of experiences inflicted by Attila, Hitler, and Stalin, the sort reported by anthropologists, and the sort provided by artists).

This Deweyan program of constant, experimental reformulation means that (in Lyotard's phrase) "the place of the first person" is constantly changing. Deweyan pragmatists urge us to think of ourselves as part of a pageant of historical progress which will gradually encompass all of the human race, and are willing to argue that the vocabulary which twentieth-century Western social democrats use is the best vocabulary the race has come up with so far (by, e.g., arguing that the vocabulary of the Cashinahua cannot be combined with modern technology, and that abandoning that technology is too high a price to pay for the benefits the Cashinahua enjoy.) But pragmatists are quite sure that their own vocabulary will be superseded—and, from their point of view, the sooner the better. They expect their descendants to be as condescending about the vocabulary of the twentieth-century liberals as they are about the vocabulary of Aristotle or of Rousseau. What links them to the inhabitants of the utopia they foresee is not the belief that the future will still speak as they speak, but rather the hope that future human beings will think of Dewey as "one of us," just as we speak of Rousseau as "one of us." Pragmatists hope, but have no metaphysical justification for believing, that future universal histories of humanity will describe twentieth-century Western social democrats in favorable terms. But they admit that we have no very clear idea what those terms will be. They only insist that, if these new terms have been adopted as a result of persuasion rather than force, they will be better than the ones we are presently using—for that is analytic of their meaning of "better."

Let me close by making a general remark about the relations between French and American philosophy, taking off from a remark of Lyotard's. He has written that contemporary German and American philosophers think of current French thought as "neo-irrationalist," instancing Habermas's lectures in Paris, lectures which Lyotard describes as "giving lessons in how to be progressive to Derrida and Foucault."[13] The Deweyan line I have been taking in these remarks is reminiscent of Habermas's "consensus theory of truth," and it may seem that I

too have been offering "lessons in progressivism." But I think that Lyotard misstates the criticism which Habermasians and pragmatists are inclined to make of recent French thought. Given our noncriterial conception of rationality, we are not inclined to diagnose "irrationalism"; since for us "rational" merely means "persuasive," "irrational" can only mean "invoking force." We are not claiming that French thinkers resort to the lash and knout. But we *are* inclined to worry about their antiutopianism, their apparent loss of faith in liberal democracy. Even those who, like myself, think of France as the source of the most original philosophical thought currently being produced, cannot figure out why French thinkers are so willing to say things like "May 1968 refutes the doctrine of parliamentary liberalism."[14] From our standpoint, nothing could refute that doctrine except some better idea about how to organize society. No event—not even Auschwitz—can show that we should cease to work for a given utopia. Only another, more persuasive, utopia can do that.

More generally, we cannot figure out why philosophers like Lyotard are so inclined to take particular historical events as demonstrating the "bankruptcy" of long-term efforts at social reform. This willingness—which is, perhaps, an aftereffect of a long attempt to salvage something from Marxism, an attempt which has resulted in the retention of certain characteristically Marxist habits of thought—sets contemporary French philosophy apart from philosophy in Britain, America, and Germany. Such a willingness to interpret very specific political, economic, and technological developments as indications of decisive shifts in the course of history will, to be sure, make the idea of "the universal history of humanity" very dubious. Conversely, a willingness to see these as probably just more of the same old familiar vicissitudes is required to take the Dewey-Habermas line, to persist in using notions like "persuasion rather than force" and "consensus" to state one's political goals.

I find it strange, for example, that Lyotard should both drop the project of universal history and yet be willing to discover world-historical significance in, for example, new technologies of information

13. Ibid, p. 81.

14. Lyotard, "Histoire universelle," p. 563.

processing and new developments in the physical and biological sciences. The standard Anglo-Saxon assumption is that the determination of world-historical significance—deciding whether May 1968 or the development of the microchip was a decisive turning point or just more of the same—should be postponed until a century or so after the event in question has taken place. This hunch dictates a philosophical style which is very different from Lyotard's, one which does not try to make philosophical hay out of current events. The difference between that style and current French styles is, I think, the main reason for the frequent breakdowns of communication between American philosophers and their French colleagues.

Another way of formulating the difference between these two styles is to say that French philosophers specialize in trying to establish what Lyotard calls *maîtrise de la parole et du sens* by engaging in "radical critique"—that is, by inventing a new vocabulary which makes all the old political and philosophical issues obsolete. Anglo-Saxon philosophers, by contrast, often try to pretend that everybody has always spoken the same language, that questions of vocabulary are "merely verbal" and that what matters is *argument*—argument which appeals to "intuitions" statable in the universal vocabulary which everybody has always used. As long as we Anglo-Saxons affect this implausible view, we shall continue to resort to the clumsy and inapt epithet "irrationalist."

It is certainly the case that Anglo-Saxon philosophers would do better to renounce this epithet, to become a bit more "French," and to realize that a universal vocabulary has to be worked for rather than taken for granted. But we Anglo-Saxons suspect that French philosophy could profit from realizing that adopting a new vocabulary only makes sense if you can say something about the debilities of the old vocabulary from the inside, and can move back and forth, dialectically, between the old and the new vocabulary. It seems to us as if our French colleagues are too willing to find, or make, a linguistic islet and then invite people to move onto it, and not interested enough in building causeways between such islets and the mainland.

This difference between wanting new vocabularies and wanting new arguments is closely connected with the difference between revolutionary and reformist politics. Anglo-Saxon intellectuals take for granted that (in countries like France and the United States where the press and the elections remain free) "serious" politics is reformist. From this point of view, revolutionary politics in such countries can be no more than intellectual exhibitionism. By contrast, it seems to be taken for granted among French intellectuals that "serious" political thought is revolutionary thought, and that offering concrete suggestions, phrased in the current political idiom of the day, to the electorate or to elected leaders is beneath one's dignity—or, at best, something one does only in one's spare time. I suspect that the difference between what Lyotard gets out of Wittgenstein and what I get out of him, and also the difference between Lyotard's interpretation of "postmodernity" as a decisive shift which cuts right across culture and my view of it as merely the gradual encapsulation and forgetting of a certain philosophical tradition, reflect our different notions of how politically conscious intellectuals should spend their time.

Acknowledgements

Aristotle. *Poetics*. Trans. S. H. Butcher. From the internet e-text.

Barthes, Roland. "The Death of the Author." *Image-Music-Text*. Trans. Stephen Heath. New York: Hill and Wang, 1977: 142-148.

Battersby, Christine. "Situating the Aesthetic: A Feminist Defence." *Thinking Art: Beyond Traditional Aesthetics*. Andrew Benjamin and Peter Osborne, eds. London: Institute of Contemporary Arts, 1991: 31-44. By permission of the author.

_____. Chapters 14 and 15 reprinted on pages 518-531 from *Gender and Genius: Towards a Feminist Aesthetics* by Christine Battersby, first published by The Women's Press Ltd., 1989, 34 Great Sutton Street, London EC1V 0DX, are used by permission of The Women's Press Ltd.

Beardsley, Monroe. "The Aesthetic Point of View." *The Aesthetic Point of View: Selected Essays*. Cornell University Press, 1982: 15-34.

Benjamin, Walter. "The Work of Art in the Age of Mechanical Reproduction." *Illuminations*. Trans. Harry Zohn, H. Arendt, ed. New York: Harcourt Brace, 1968.

Bürger, Peter. *Theory of the Avant-Garde*. Trans. Michael Shaw. University of Minnesota Press, 1984: 15-34.

Cavell, Stanley. "Excursus on Wittgenstein's Vision of Language." From *The Claim of Reason: Wittgenstein, Skepticism, Morality and Tragedy* by Stanley Cavell. Copyright 1979 by Oxford University Press, Inc. Used by permission of Oxford University Press, Inc.

Clifford, James. "On Ethnographic Allegory." *Writing Culture*. Clifford and Marcus, eds. Berkeley: University of California Press, 1986: 98-121.

Collingwood, R. G. *The Principles of Art*. Oxford: Oxford University Press, 1938: 1-2; 5-7; 15-36; 105; 108-109; 121-123; 125-135; 139; 142-148; 151.

Danto, Arthur. "Artworks and Real Things." © 1973 by Arthur Danto. Reprinted by permission of Georges Borchardt, Inc. for the author. Originally appeared in *Theoria*.

Dewey, John. *Art as Experience*. pp. 3-8; 35-41; 58-61; 63-64; 82-85; 272-274. Reprinted by permission of The Putnam Publishing Group from ART AS EXPERIENCE by John Dewey. © 1934 by John Dewey; © 1962 by Roberta L. Dewey; Renewed © 1973 by the John Dewey Foundation.

Dickie, George. "The New Institutional Theory of Art." *Proceedings of the 8th International Wittgenstein Symposium*, Part 1. Vienna: Hölder-Pichler-Tempsky, 1984: 57-64. By permission of the author.

Feagin, Susan. "On Defining and Interpreting Art Intentionalistically." *British Journal of Aesthetics* 22 (Winter 1982): 65-77. By permission of Oxford University Press.

Freud, Sigmund. "The Relation of the Poet to Day-Dreaming." *Collected Papers* 4. By permission of Sigmund Freud Copyrights, The Institute of Psycho-Analysis and The Hogarth Press for permission to quote from THE STANDARD EDITION OF THE COMPLETE PSYCHOLOGICAL WORKS OF SIGMUND FREUD, translated and edited by James Strachey.

Gadamer, Hans Georg. "The Universality of the Hermeneutical Problem." *Philosophical Hermeneutics*. Trans. and ed. David Linge. Berkeley: University of California Press, 1976: 3-17.

Greenberg, Clement. "Modernist Painting." *Art and Literature*, 1961.

Habermas, Jürgen. "Modernity—an Incomplete Project." *The Anti-Aesthetic*. Trans. Seyla Ben-Habib, Hall Foster, ed. Port Townsend, WA: Bay Press, 1983: 3-15.

Hassan, Ihab. "The Culture of Postmodernism." *Modernism: Challenges and Perspectives*. Chefdor, Quinones and Wachtel, eds. Copyright 1986 by the Board of Trustees of the University of Illinois Press: 304-323.

Heidegger, Martin. *Being and Time*. Trans. John Macquarrie and Edward Robinson. Oxford: Basil Blackwell, 1962: 95-107; 262-173.

_____. "The Origin of the Work of Art." *Poetry, Language, Thought*. Trans. Albert Hofstadter. Harper and Row, 1971.

Hirsch, E. D. *Validity in Interpretation*. New Haven: Yale University Press, 1967: 1-23.

Hume, David. *Of the Standard of Taste*. *Essays, Moral, Political, and Literary*. Eugene F. Miller, ed. Indianapolis: Liberty Fund, Inc.

Hutcheon, Linda. *The Politics of Postmodernism*. London: Routledge, 1989: 1-4; 23-29.

Huyssen, Andras. "Mass Culture as Woman." *After the Great Divide*. Bloomington: Indiana University Press, 1986: 44-64; 225-227.

Ingarden, Roman. "Phenomenological Aesthetics: An Attempt to Define its Range." *Selected Papers in Aesthetics*. Philosophia Verlag, 1985: 29-43.

Jung, Carl Gustav. "Psychology and Literature." *Modern Man in Search of a Soul*. Dell and Baynes, eds. New York: Harcourt Brace, 1933.

Kant, Immanuel. *Critique of Judgement*. Trans. J. D. Bernard. New York: Hafner Press, 1951.

Krauss, Rosalind. "Poststructuralism and the Paraliterary." *The Originality of the Avant-Garde and Other Modernist Myths*. Cambridge: MIT Press, 1985: 291-295.

Langer, Susanne. "Expressiveness." *Problems of Art*. New York: Charles Scribner's Sons, 1957: 13-26.

LeGuin, Ursula K. "The Child and the Shadow." *The Language of the Night*. New York: G. P. Putnam's Sons, 1979: 59-70.

_____. "Some Thoughts on Narrative." *Dancing at the Edge of the World*. New York: Grove Press, 1989: 37-45.

Levinson, Jerrold. "Defining Art Historically." *British Journal of Aesthetics* 19 (1979): 232-250. By permission of Oxford University Press.

Lyotard, Jean-François. "Answering the Question: What is Postmodernism?" *The Postmodern Condition*. Trans. Régis Durand. Minneapolis: University of Minnesota Press, 1986: 71-81.

_____. "Universal History and Cultural Differences." *The Lyotard Reader*. Trans David Macey. Andrew Benjamin, ed. Oxford: Basil Blackwell, 1989: 314-323.

Mascia-Lees, Frances E., Patricia Sharpe, and Colleen Ballerino Cohen. "The Postmodern Turn in Anthropology: Cautions from a Feminist Perspective." *Signs* 15 (Autumn 1989): 7-33. By permission of the authors.

Marcuse, Herbert. *The Aesthetic Dimension*. English version translated and revised by Herbert Marcuse and Erica Sherover, 1978: 1-21. Reprinted by permission of Beacon Press, Boston.

Margolis, Joseph. "Reinterpreting Interpretation." *Journal of Aesthetics and Art Criticism* 43 (Summer 1989): 237-251. Reprinted by permission of the author.

Marx, Karl. "Alienated Labour." *Karl Marx, Early Writings*. Trans. T. B. Bottomore. New York: McGraw Hill, 1963: 120-134. Reprinted by permission of The McGraw-Hill Companies.

Mothersill, Mary. *Beauty Restored*. New York: Adams, Bannister, Cox, 1991: 74-93. By permission of Adams Bannister Cox.

Nietzsche, Friedrich. *The Birth of Tragedy from the Spirit of Music*. Trans. Clifton P. Fadiman. New York: Modern Library, 1927.

_____. "On Truth and Lies in a Non-moral Sense." *Philosophy and Truth*. Trans. Daniel Breazeale. Atlantic Highlands, N. J.: Humanities Press International, Inc., 1979: 79-91.

Pepper, Stephen. *The Work of Art*. Bloomington: Indiana University Press, 1955: 13-14; 16-22; 26-31; 43-55; 57-59.

Plato. *Symposium; Republic* Book X. Trans. Benjamin Jowett. From the internet e-text.

Ricoeur, Paul. "The Hermeneutical Function of Distanciation." *Hermeneutics and the Human Sciences*. Trans. John B. Thompson. Cambridge: Cambridge University Press, 1981: 131-144. Reprinted with permission of Cambridge University Press.

Robinson, Jenefer M. "Style and Personality in the Literary Work." *Philosophical Review* 94 (1985): 227-247.

Rorty, Richard. "Cosmopolitan Without Emancipation: A Response to Lyotard." *Objectivism, Relativism and Truth*. Cambridge: Cambridge University Press, 1991: 211-222. Reprinted with permission of Cambridge University Press.

Savedoff, Barbara. "The Art Object." *British Journal of Aesthetics* 29 (Spring 1989): 160-167. By permission of Oxford University Press.

Scheman, Naomi. "The Body Politic/The Impolitic Body/Bodily Politics." *Engenderings*. Routledge, 1993: 186-192.

Shelley, Percy Bysshe. "A Defense of Poetry." Published posthumously by Mary Shelley.

Wittgenstein, Ludwig. *Philosophical Investigations* I 66-72, II xi. Trans. G. E. M. Anscombe. Oxford: Basil Blackwell, 1953: 193e-200e.

Wolff, Janet. "Women's Knowledge and Women's Art." *Feminine Sentences: Essays on Women and Culture*. Berkeley: University of California Press, 1986: 67-84.

The Author of this book and the Publisher have made every attempt to locate the authors of the copyrighted material or their heirs or assigns, and would be grateful for information that would allow them to correct any errors or omissions in a subsequent edition of the work.